D1645533

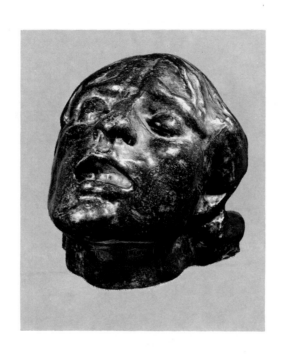

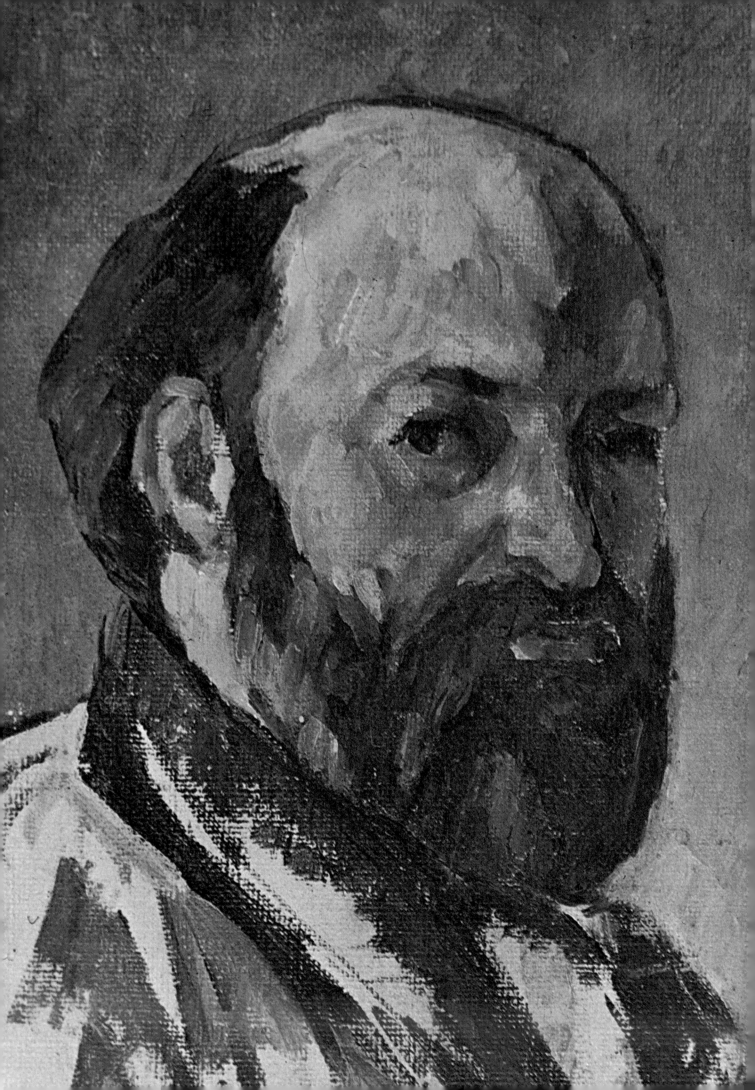

ART AND MANKIND

Half-title page: Auguste Rodin (1840-1917). *Head of Grief.* 1882. Musée Rodin, Paris. Photo: Michael Holford.
frontispiece: Paul Cézanne (1839-1906). *Self-portrait.* 1880-1881. Louvre, Paris. Photo: Michael Holford.

ART AND MANKIND

LAROUSSE ENCYCLOPEDIA OF
MODERN ART

ART AND MANKIND

LAROUSSE ENCYCLOPEDIA OF
MODERN ART

FROM 1800 TO THE PRESENT DAY

General Editor RENÉ HUYGHE

Member of the Académie Française
Professor in the Collège de France · Honorary Chief Curator of the Louvre

SPRING
BOOKS

front cover: Paul Klee (1979-1940). *Bust of a Child* (detail).
Klee Foundation, Kunstmuseum, Bern © S.P.A.D.E.M., Paris.
back cover: William Blake (1752-1827). *Simoniac Pope* (detail).
Tate Gallery, London. Photo: Hamlyn Group Picture Library.

Text prepared by Emily Evershed, Dennis Gilbert, Hugh Newbury,
Ralph de Saram, Richard Waterhouse and Katherine Watson
from the French original
L'ART ET L'HOMME

© copyright Augé, Gillon, Hollier-Larousse, Moreau et Cie
(Librarie Larousse, Paris) 1961

English-language edition © copyright The Hamlyn Publishing
Group Limited 1965

All rights reserved. No part of this publication may be
reproduced, stored in a retrieval system, or transmitted, in
any form or by any means, electronic, mechanical, photocopying,
recording or otherwise, without the permission of The
Hamlyn Publishing Group Limited.

First published 1965
Reprinted (paperback) 1967
Reprinted 1974
This updated edition printed in 1980

2nd impression 1984

This edition published in 1987 by Spring Books
an imprint of The Hamlyn Publishing Group Limited
Bridge House, 69 London Road
Twickenham, Middlesex TW1 3SB

ISBN 0 600 55426 0

Printed in Yugoslavia

CONTENTS

4 ART IN THE 20TH CENTURY

CONTRIBUTORS

JEANNINE AUBOYER, *Curator of the French national museums (Asiatic art, Musée Guimet)*

MARCEL BRION, *member of the Académie Française*

JEAN CASSOU, *Chief Curator of the Musée National d'Art Moderne, Paris*

BERNARD CHAMPIGNEULLE

MADELEINE PAUL-DAVID, *Deputy Curator at the Musée Cernuschi, Paris*

BERNARD DORIVAL, *Curator of the Musée des Granges, Paris*

FRANK ELGAR, *Director of the Amis de l'Art et des Jeunesses Artistiques*

MICHEL FLORISOONE, *Curator of the French national museums, General Administrator of the Mobilier National and of the Manufactures Nationales de Tapisseries des Gobelins et de Beauvais*

PIERRE FRANCASTEL, *Director of Studies at the Ecole des Hautes Etudes*

BASIL GRAY, *Keeper of Oriental Antiquities, British Museum*

SUSAN D. JOHNSON, *M.A., Courtauld Institute of Art, London*

GASTON WIET, *member of the Institut de France, Honorary Professor in the Collège de France, late Director of the Arab Museum in Cairo*

JACQUES WILHELM, *Curator of the Musée Carnavalet, Paris*

The late Sophie Essad-Arseven, Emily Evershed, Cécile Goldscheider, Agnès Humbert, Lydie Huyghe, Evelyn King and Gisèle Polaillon-Kerven wrote the Historical Summaries, which have been updated by Susan D. Johnson.

COLOUR PLATES

INTRODUCTION

This book covers a period of only a hundred and fifty years, but it has brought a reversal of all the established values in the visual arts — the severing of the traditional relationship between artist and patron; the impact of non-European civilisations, eclipsing the classical idea; the swing away from humanism and realism, accentuated by the acceptance of the machine and mass-production.

The first half of the 19th century brought a revolution in the whole political and economic structure echoed in the arts in the battle between classicism and Romanticism. Neoclassicism was based on a scholarly recreation of the past and a devotion to archaeological exactitude which hardened into academicism. Leaders of the Greek Revival in architecture included Percier and Fontaine in France, Schinkel in Prussia, von Klenze in Bavaria, Wilkins and Smirke in England, T. Hamilton and W. H. Playfair in Scotland. Sculpture was dominated by Canova in Italy, Thorvaldsen in Denmark and Flaxman in England. In painting Ingres succeeded David as the acknowledged leader, though his personal genius lay elsewhere, in his sensuality and abstract rhythmic line.

Romanticism, a predominantly literary movement, swept Europe as a ferment of ideas, among them that of the artist as a bohemian and of painting as the private art of the individual in opposition to society. Many of Romanticism's dominant concepts were implicit in the new feeling for nature as a universal spirit of elemental power and destructive energy. And the passionate identification of the artist with these overwhelming forces brought a new ideal of landscape painting, with Turner, Constable and C. D. Friedrich among the key figures.

Nostalgia for the past led to a yearning for the lost unity and spirituality of medieval Europe, instanced by the Nazarene community in Rome. This historicism led to a conception of architecture as the decoration of construction, with ornamentation as its chief aim. In England, with its High Victorian Gothic influenced by Pusey and the Ecclesiological Society, a building tended to be judged by the moral worth of its creator. Heralded by Barry and Pugin in the Houses of Parliament, Victorian Gothic's chief exponents were Scott, Butterfield, Street and Waterhouse. No other country was so whole-heartedly devoted to the Gothic Revival, but European monuments included Ste Clotilde, Paris, the Rathaus and the Votivkirche, Vienna, and the Kaiser-Wilhelm-Gedächtniskirche, Berlin. In painting Delacroix dominated the age, combining the conflicting passions of the time — its revolutionary liberalism, emergent nationalism, philhellenism, Byronic pessimism, historic medievalism, exoticism and love of force and energy.

The middle of the century saw a break with both the classical and Romantic worlds in favour of one based on the concrete. Advances in science and industry brought a new belief in progress and a spirit of positivism for which the visual was the only reality. With the proletariat replacing the artisan, themes of work and manual labour ousted religious and literary subjects. Courbet, the initiator and champion of Realism, was the incarnation of a generation which rejected all idealisation. He was followed at The Hague by Israëls, Mauve and the Maris brothers; in Belgium by Meunier; in Germany by Menzel and Leibl; in the United States by Winslow Homer. In England the Pre-Raphaelites made no attempt to seek their truth to nature in contemporary life, but their desire for new links with reality is apparent in their direct observation and in their technique.

The Second Empire style of architecture, originating in France with the completion of the Louvre by Visconti and Lefuel and the Opéra by Garnier, became the official style for public buildings, including Scott's Foreign Office in London, Semper's Burgtheater in Vienna, Poelaert's law courts in Brussels and the old State, War and Navy Department building in Washington. Hostility to the industrial revolution prevented any development of architecture as a social service, and it was left to engineers to show an awareness of the new technology and the use of iron — Paxton in his Crystal Palace, Brunel at Paddington station, Labrouste in the Bibliothèque Ste Geneviève, Paris, and Eiffel in his Tower.

In its fidelity to the visual sensation, realism culminated in Impressionism, which isolated optical impressions by exact analysis of tone and colour through divided touch, a prismatic palette and complementary colours. Though aware of the researches of Chevreul and Helmholtz, the Impressionists radiate not scientific detachment but joy — in the play of light on the surface of objects and the luminous vibrations of the atmospheric envelope. In spite of initial hostility, their vision, within a decade, had spread throughout Europe, while in France itself Symbolism, Neo-Impressionism and Post-Impressionism already marked a reaction against the purely visual. For Gauguin the change from perceptual to conceptual meant a decorative two-dimensionality and the rejection of Western civilisation; for van Gogh an emphasis on subjective expression; for Cézanne a concern for purely formal qualities heralding the 20th century.

But the style which swept Europe during the 1890s was that known as Art Nouveau, Jugendstil, Sezessionsstil or Stile Liberty. Its considerable historical importance lay in its being the first movement to break with historicism and period styles. Primarily decorative, it stressed the ornamental values of two-dimensional sinuous organic forms. Appearing first in applied arts, with glass by Gallé and jewellery by Tiffany, its leading exponents in architecture included Horta and van de Velde in Brussels, Guimard in Paris, Endell in Munich, Mackintosh in Glasgow, Wagner in Vienna and, above all, Gaudí in Barcelona. In the same decade in the United States the achievements of H. H. Richardson led to the Chicago school of skyscraper design, Sullivan being among the first to reveal the potentialities of the steel frame construction.

The early 20th century brought an increasing acceptance of the speed and dynamism of the machine and a series of creative explosions which, by the end of the First World War, had posed all the major problems of contemporary art. The desire to go back to first principles involved an increasing breakdown of the world of appearances. The first revolutionary movement, round the dominating personality of Matisse, was the short-lived Fauvism, with its formal distortion, flat patterning and violent colour. It was followed by Cubism, the most influential movement of the century, in which Picasso and Braque, by analysis and systematic experimentation, sought to define the permanent properties of objects in a closed space without perspective or light. Mondrian in Holland and Malevich in Russia carried this hermeticism to its logical conclusion in geometric abstraction. In Germany, the Brücke at Dresden drew inspiration

from Munch and Fauvism but added its own Expressionist and social emphasis. The most fertile pre-War group in Germany was the Blaue Reiter at Munich, which brought together Marc, Klee and Kandinsky, with the latter exploring a path to a more subjective abstraction.

Pre-1914 architecture achieved as complete a break with the past through isolated works by a number of outstanding men, mainly in America, Germany and France. In the United States it was Wright's prairie houses, with their predominant horizontals, flexible ground plans and open living space; in France, Garnier's and Perret's work in reinforced concrete; in Germany industrial buildings such as Behrens' AEG turbine factory in Berlin and Gropius' Fagus works at Alfeld. From these individual achievements developed in the 1920s the new aesthetic of the 'International Style', influenced by the abstract ideals of De Stijl in Holland and Constructivism in Russia. As much formalist as functional in inspiration, it had a link with Cubism in its emphasis on regular geometrical solids and white concrete surfaces. J. J. P. Oud in Holland, Le Corbusier in France, Mies van der Rohe and Gropius in Germany all employed this rational geometry, though Gropius' Bauhaus at Dessau, in the middle 1920s, already has a lightness, transparency and use of exposed steel which indicates a reaction from the dictatorship of cubes. The ideals and teaching of the Bauhaus school of design, building and craftsmanship had a profound and widespread influence. It wished to revive the lost unity of the arts, in relation to architecture on the one hand and to the needs of an industrial society on the other. And it was the first attempt at a total design education with emphasis on the importance of mass-production as the overriding factor in design. The sculpture and painting of the inter-War years swung between the Constructivist and Surrealist approaches; on the one hand were Gabo, Pevsner, Mondrian and Nicholson; on the other Dada and Surrealism, with their exploration of the irrational, the unconscious and the dream.

After the Second World War came a new creative outburst in all the arts. Architecture, faced with increasing internationalism, an impersonal clientèle and a growing scale of building, reflected a new awareness of space in the increasing definition of form as the articulation of voids and the interpenetration of outer and inner space. Great Britain now made an important individual contribution in schools and large-scale low-cost housing estates; while in the United States, where Gropius, Mies, Aalto and Breuer had settled, the ultimate refinement of the glass-sheathed tower was reached in the Lever and Seagram buildings. A revolt against the weightless cube, already visible in Gillet's French pavilion at the Brussels Exhibition, 1958, resulted in the curved forms of the shell construction and hyperbolic paraboloid, as used by Nowicki in the United States, Candela in Mexico, Niemeyer in Brazil, Nervi in Italy and Le Corbusier at Notre Dame du Haut, Ronchamp.

Sculpture, equally concerned with the defining of transparent space and the forms woven into it, exhibited a parallel Expressionism. The imagery of the 'Geometry of Fear', with its mood of insecurity and doubt, was interpreted in a new 'Iron Age' language, constructed rather than carved or modelled.

In painting the explosion of Abstract Expressionism from New York challenged the supremacy held by Paris since the reign of Louis XIV. With Pollock, de Kooning and Rothko among the leading figures, this 'action' painting revealed a new awareness of paint and a concern for the actual physical process as the prime instrument of expression. These large-scale works, with their advancing space-effect and expanding pressure beyond the limits of the frame, were influenced by Oriental calligraphy and Zen Buddhism. In France Hartung, Soulages and de Staël were already pursuing this trend. From avant garde to Establishment is now so short a step that this revolution has already passed into history, as has its figurative 'Pop' successor.

What future is there for art in an increasingly technological society? With science at the centre, will art become marginal? We are too close to draw more than tentative conclusions; but it would seem that a significant change of direction is bringing with it a rejection of personal commitment and a new detached assurance. Will the art of the near future be public and anonymous, exploring the collective fantasies of society rather than those of the individual? Or will the present *volte face* prove to have been only another swing between the poles of classicism and Romanticism with which this volume began? Whatever the answer, art and mankind will remain indissolubly linked.

EVELYN KING

1 CLASSICISM AND THE ROMANTIC MOVEMENT

ART FORMS AND SOCIETY *René Huyghe*

In the history of the West the 19th century is of vital importance: all the past seems to find fulfilment in it, and the germ of all the future can be seen there. So many varied riches, and ones often hard to reconcile, could not come together without a confused agitation in which solid traditions and new tendencies mingled and clashed, and in which the most conflicting aspirations found expression.

Beyond these partial and even incidental clashes which roused the passions of contemporaries hindsight now enables us to discern more clearly what was really at stake. Behind the ideological disputes that brought Neoclassicists and Romantics into opposition, followed by realists and many other groups, one can see the political, social and economic structure being overhauled down to its reputedly most inviolable foundations. Even man tried adapting himself to an entirely new way of life that did not fully reveal its disrupting novelty until the 20th century. At first Europe alone seems to be the subject of this upheaval; but in our own time the whole world has been reached by the fire whose first sparks appeared in Europe. Western civilisation was followed, with an eagerness growing in proportion to the delay, by all the others into the renovating adventure whose beginnings become apparent in the 19th century. The 20th century allows us to scrutinise its underlying nature; the 19th offers us the spectacle of its first developments, in which the meaning of our culture is seen to be already under review.

Europe's self-examination

The birth of this Europe came when the Mediterranean civilisation, at once enriched and unsettled by Christianity, moved its centre of gravity to the north, while its eastern part, transmuted into the Byzantine Empire, began to break away, and became completely detached during the 15th century with the Turkish conquest. From then on, Europe comprised two main elements, no longer the west and the east, as before, but the north, peopled by the descendants of the barbarians, and the south, where Italy assumed the Mediterranean heritage. Nevertheless Europe managed to consolidate its unity by drawing into a sometimes uneasy partnership a secular power in the north and a religious power in Rome. Dimly foreseen by Clovis and brought into being by Charlemagne, this alliance assumed its full, complex scope in the Holy Roman Empire of the German Nation, whose very name was an indication of the surprising union of the Latin world with its ancient Teutonic adversary. However, it was France that, through a series of vicissitudes among which the most notable were her hard-fought contests with England and with the ruling house of Austria, was to pursue and, under Louis XIV and for a time Napoleon, achieve the vision of a Latinised Europe. Steeped in classical culture and art, this Europe manifested its character by returning to the constants of rationalism, order and stability, once so solidly established by Rome.

The union thus sealed under its aegis was only an apparent one. By establishing itself chiefly in the non-Latin countries, from England to Germany, and by giving them once more an awareness of their anti-Roman nature, Protestantism revived an opposing atavism which grew increasingly eager to restore its own traditions. In the association which made up Europe the Latin civilisation, with the Italian Renaissance and then with French classicism, was dominant. Despite the dull rumblings of the Baroque, signs of a latent revolt, it looked as if what we might call the 'Greek binomial' would prevail, combining the cult of the real, that is to say the positive data provided by the senses, with the cult of reason. Even in Germany the 18th century appeared as the triumph of enlightenment — the *Aufklärung*. France had the role of undisputed leader: in 1776 an Italian, the Marquis of Carracioli, saw her as 'the model for foreign nations' and proclaimed the existence of 'French Europe'.

Yet it was in this same France, well before the significant coalition of Prussia, Britain and Russia ensured at Waterloo the military triumph of the ill-assorted partners, that signs of unrest had been discernible all through the 18th century. France seemed to have been seized with doubt about the culture she embodied.

Up to then, every civilisation had believed itself to be the only valid one, and had rejected as 'barbarous' whatever did not accord with its ideal and customs. Now 18th-century France displayed a liking for dissimilar societies and, from chinoiserie to exoticism, showed a desire to be renewed, to discover foreign ways of feeling and being: the theme of the 'parts of the world', well known to decorative painting from Le Brun to Tiepolo, and that of the 'Indies' in tapestries from Eckhout to Desportes, had been an early symptom of this. Scepticism crept in: the idea of the relativity of races, of their tastes and of their 'truths' that varied with the climate and physical conditions, came to the front, upheld by that great thinker Abbé Dubos, for whom Voltaire had such a high regard. What is more, as a counterpart to the new curiosity, there came a surfeit, a disaffection and soon a bitter and disillusioned irony with regard to traditional morality. In 1726, through his *Gulliver's Travels*, translated into French the next year, Swift raised into a system the invention of imaginary worlds that presented in their ludicrously distorting mirror a biting satire of those habits we accept as the most normal. However, as early as 1721 Montesquieu had shown even more audacity in his *Lettres Persanes*. Here it was not an imaginary European discovering strange lands, but an alien who, turning the telescope round, demonstrated that our own civilisation could look just as ridiculous and odd to a visitor from somewhere else as Brobdingnag would do to Swift's hero. The method had precedents, as has been shown: in 1684–1686 Marana's *Espion du Grand Seigneur* and in 1699 Dufresny's *Siamois* had, at the end of the 17th century, proved that our customs could appear dubious the moment one examined them from outside.

Besides, what was meant by 'our civilisation'? Was it as one and indivisible as had been claimed in France by the champions of the Graeco-Roman past? The argument between the 'ancients' and the 'moderns' had merely raised the possibility of a revival. Now there was an effort to confront the accepted official past with another over which there had been a conspiracy of silence since the Renaissance, even though it was the only native one. People had an inkling that the Middle Ages, proscribed and dishonoured, were its trustee. As early as 1699 Jean François Félibien, the son of Poussin's adulator, differentiated between the two strains in his *Dissertation Touchant l'Architecture Antique et l'Architecture Gothique*. The latter underwent a rapid revaluation: in 1741 Soufflot acknowledged its merits and even its occasional technical superiority in his famous discourse to the Academy at Lyon. In his *Vie des Architectes* of 1771 Pingeron made room for a Pierre de Montereau or Erwin

5
4

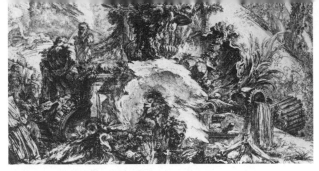

2. *Above*. ITALIAN. G. B. PIRANESI (1720–1778). Decorative capriccio (detail). *c*. 1745. The *Capricci* were combined with the *Prima Parte di Architettura* in 1750. Etching.

PRE-ROMANTICISM

We know today that nearly all the elements which fostered Romanticism had already been formulated by the 18th century, when boredom with classicism and its Graeco-Roman sources led to an awakening of Britain and Germany. But Italy [2] and even France [3] developed a taste for morbidity and death bordering on the fantastic, indeed the diabolical, whose transition to Romanticism was ensured by Goya [6]. The references to the past shifted from antiquity to the Middle Ages, to its ruins [4] and its mystery, which penetrated everyday life through the architectural follies built in gardens. And, further away still, it was Egypt [7] and the Orient, with all the glamour of esoteric cults, that haunted an imagination eager for renewal outside the known and the rational.

4. The ruin in the park at Betz (acquired by the Princess of Monaco in 1780). After A. Laborde, *Description des Nouveaux Jardins de la France*.

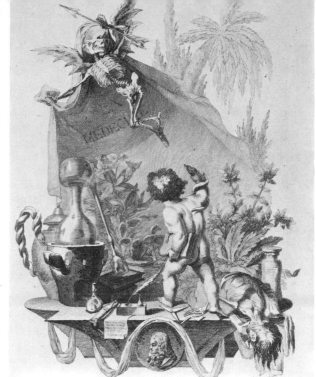

3. CLÉMENT PIERRE MARILLIER (1740–1808). Asclepius driving away Death. Engraving by Le Roy.

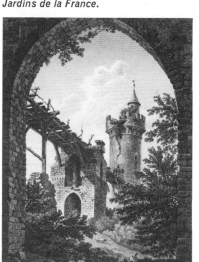

6. *Below*. SPANISH. FRANCISCO GOYA (1746–1828). The Devil's Lamp (scene from *El Hechizada por Fuerza* by Zamora). *c*. 1798. *National Gallery, London*.

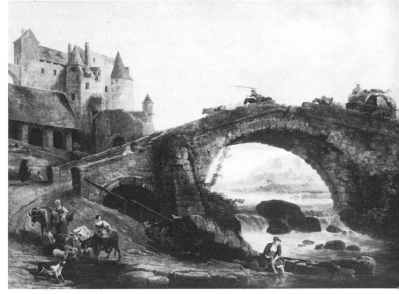

5, 7. FRENCH. HUBERT ROBERT (1733–1808). *Above*. The Bridge. *Montpellier Museum*. *Below*. The Pyramid. *Formerly Bardao Collection*.

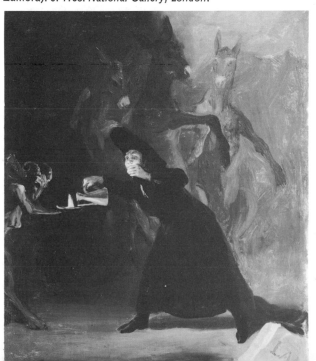

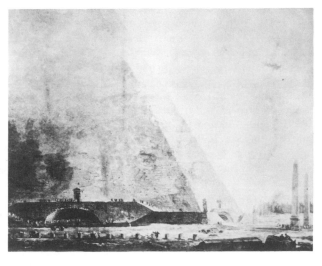

von Steinbach beside the great classical architects, declaring of Amiens cathedral: 'There are few such beautiful buildings.'

But where did this Gothic architecture come from? One instinctively senses in it an unexpected route that would allow an escape from Latinity (had not Vasari styled it *tedesco*?) to other origins — those northern origins whose claims were becoming insistent. The first theories about it show a strange confusion between the Middle Ages, the Gauls, the Druids and the 'ancient Celts known by the name of Bretons', who came and settled in 'Armorique'. This weird mixture was still active in 1802 in Chateaubriand's *Génie du Christianisme*, and was transmitted by it to the Romantic movement.

The Celts did indeed arouse curiosity: as early as 1703, Father Paul Yves Pezron published his *Antiquités de la Nation et de la Langue des Celtes*. Here the term ' antiquités nationales ' is foreshadowed: it was used as the name of the museum that was founded by Alexandre Lenoir at the end of the 18th century, and which, wholly orientated towards the Middle Ages, would act so strongly on the imagination of the Romantics. In 1740 appeared Pelloutin's *Histoire des Celtes* and in 1786 Mallet's *Monuments de la Mythologie et de la Poésie des Celtes*. By way of the works of Jacques Le Brigant in 1779 and the famous La Tour d'Auvergne in 1792 one has arrived at the proposition that it was there that the true roots of the European languages and even of Christianity were to be found! Having been overwhelmed by the Roman superiority, the barbarians were now back in the saddle. The title of a work by La Tour d'Auvergne is surely significant, proposing as it does the *Origines Gauloises Celtes des Anciens Peuples Celto-Scythes*. It was through the breach thus opened that a ghost raised and even virtually
17 created by James Macpherson swept in — 'Ossian', the 'Homer of the north ', to whom painters as classicist as Gérard, Girodet
19 or Ingres surprisingly devoted pictures. This prepared the way for the success of the British vein of Romanticism, triumphantly represented by Sir Walter Scott and Byron. 'Ossian, that poet of vagueness, that fog of the imagination, that inarticulate lament of the northern seas,' Lamartine exclaimed. One could hardly sum up better the disruptive attack about to be delivered on the 'clear and precise ideas' that sustained Latinity.

France's self-examination

Northern and Germanic Europe became once more a reality and presented its forgotten letters patent of nobility. It demanded the place it had been deprived of, and began to retrieve it through an increasingly relentless offensive. One can see the stages of this campaign in France during the 17th and 18th centuries: the official tradition of classical humanism, which the Renaissance re-established, was opposed by a yearning for the spirit of the north; the interest taken in the great Flemish and Dutch painters, in Rubens and Rembrandt, since the end of Louis XIV's reign already showed that the wind was changing. Then it was England that attracted Montesquieu and Voltaire, whose *Lettres Philosophiques sur les Anglais* date from 1733. The change at first was moderate. England was rationalist and sensual and from it would be derived the French 18th century's positivistic thought. European interest in Shakespeare began. At the same time in 1777, 'Ossian' was published — and the Goethe of *Werther*, which went through eighteen editions in twenty years. And into Europe, along with England's ideas, came England's sensibility and dreams. The poems of James Hervey, Grey or Edward Young, with his *The Complaint, or Night Thoughts on Life, Death and Immortality*, and the *romans noirs* of Ann Radcliffe or 'Monk' Lewis remoulded the
14 imagination, directing it towards Romantic subjects — graves, moonlight, phantoms.

Thus England led France towards the revolution that came with Romanticism. The England of the philosophers had prepared the way for that of the poets and for the discovery of the Celtic soul; this was only a step from the more rugged Germanic soul. As early as 1768 the shallow Dorat himself was moved: ' Today it is the Germanic muses that prevail. O Germania! Our days are over, yours are just beginning!' A year later Herder proclaimed from the other side of the frontier: ' France, her literary age is at an end . . . the great crop has been harvested.' Now, in his view, Germany's time was approaching. Since 1750, a pass had been open through Switzerland, and it was from there that the concept of a pastoral bucolic Germania came, an idea persistent in France and quite unlike the one that Wagner revealed. The first poets to be translated, Haller and above all Gessner with his *Idyllen*, were Swiss, just as Jean Jacques Rousseau and Mme de Staël had been. Of the last two, the first sensitised French reason and the second introduced it to a more irrational vision of the world. After Schiller and Goethe, obsessed by Italy and still dreaming of uniting Faust and Helen, came the full uncompromising Germanism — the lyric poetry of the *Sturm und Drang* group, Novalis and J. P. Richter, the metaphysicians, Kant and Herder, the music. Then the conversion would be complete, and Romanticism would dominate the 19th century. Quinet could then say: ' The biggest thing that is happening at present in France is the influence of the new ideas from Germany '

This was true only of the interchange of influences, for anyone inferring from it that France, the champion of Latin lucidity, was about to be eclipsed would have been utterly mistaken: French art never shone more brilliantly than during the 19th century. It became certain that her destiny was to be both geographically and spiritually the hinge of Europe. Mediterranean and Latin through her southern half, she had proved how highly she could be so with her Romanesque as well as her classical art; but she had shown herself to be northern beyond the Loire, above all in her Gothic works. She alone, it seemed, could effectively act as referee and peacemaker between the two parts of Europe that had just split again after seeking union under the too exclusive protection of Latinity.

Fate now changed tack. That part of European culture that up to then had kept in the background and been dominated by the other reawakened, asserted itself again, and compelled recognition. This produced a considerable widening of the bounds of European thought and feeling,

However, it was in the 18th century that the flow of consequences began which has found its issue in our time. It became apparent that there were other, ' different ' civilisations, that Europe's Latin unity was artificial and that there existed a second pole of attraction almost precisely opposed to it in all its features; it was even possible to question the expediency of culture itself. The first step was taken towards the return to the *tabula rasa* that our age has prided itself on achieving. What was

FRENCH. J. A. D. INGRES (1780–1867).
Mademoiselle Rivière. 1805.
Louvre. *Photo: Michael Holford.*

BRITISH. JOHN CONSTABLE (1776–1837).
The Leaping Horse (sketch). 1825.
Victoria and Albert Museum, London.
Photo: Michael Holford.

BRITISH. J. M. W. TURNER (1775–1851).
The Burning of the Houses of Parliament. 1834.
Museum of Art, Cleveland, Ohio. *Museum photograph.*

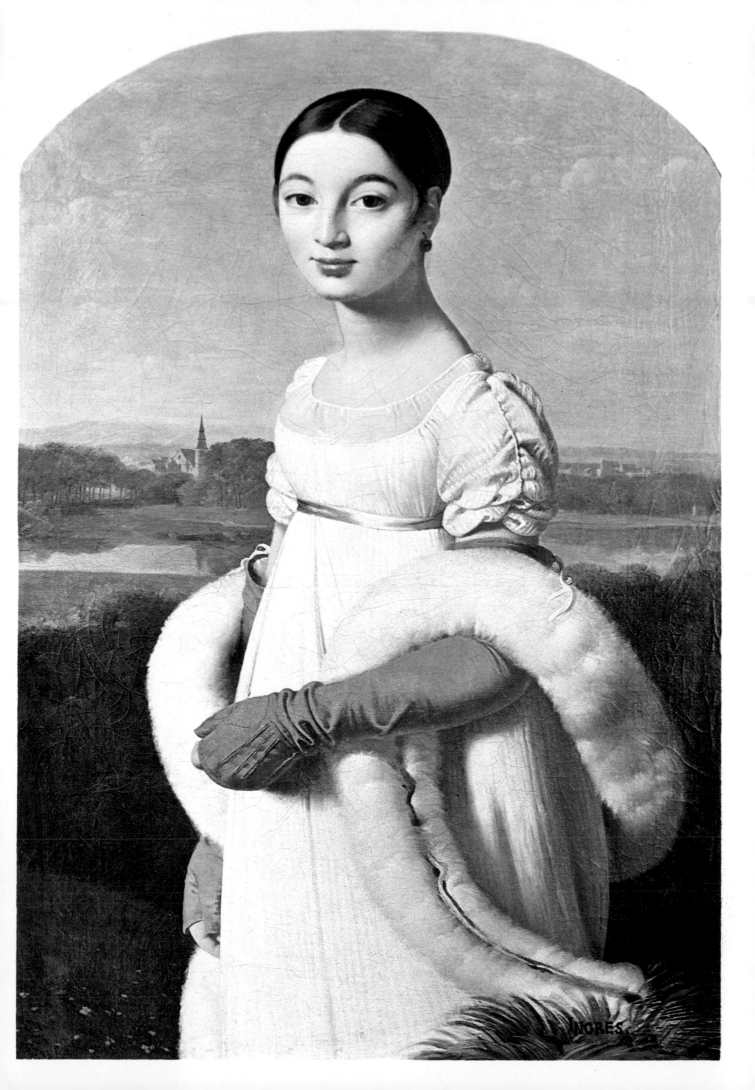

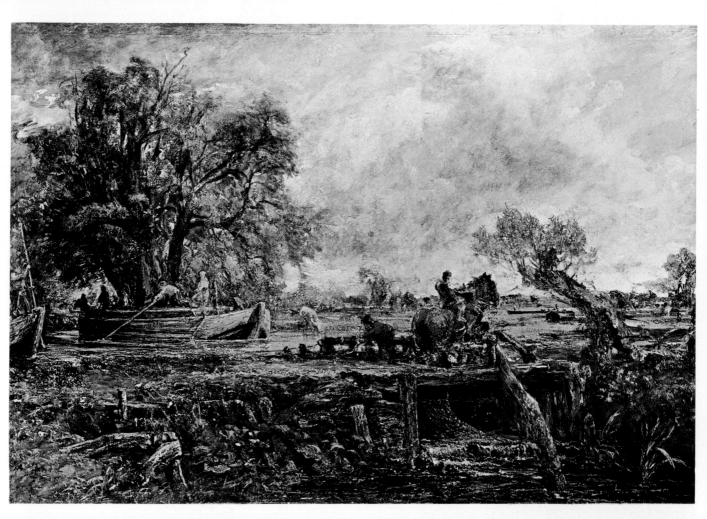

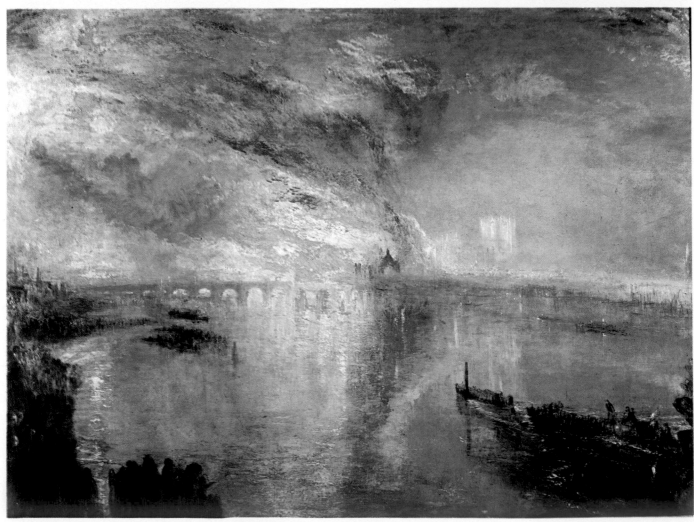

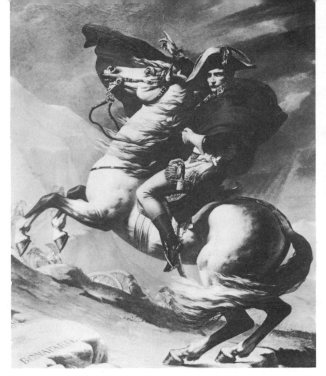

9. FRENCH. N. T. CHARLET (1792–1845). L'Intrépide Lefèvre. Lithograph.

THE CULT OF ENERGY

Modern times progressively substitute the pursuit of intensity for that of measure and proportion, on which the classical aesthetic was based. France, which from Corneille to Stendhal professed a cult of energy, because it is both more refined and more moral than force, was stimulated by the epic inspiration of the Revolution and the Empire, and it is through glorifying energy that she achieved a transition from Neoclassicism to Romanticism. The stormy, impetuous élan, expressed by the thrust of a diagonal, is found from the Neoclassicist David [8] to the Realist Daumier [10], by way of a Romantic like Charlet [9].

The theme of an antagonism with two violent forces confronting each other is central to the work of Delacroix, to his fights between men and beasts; but Géricault had already stated it in many variations with cavalryman, hunter and horse-breaker, in which the technique as well aimed at an intense opposition of light and shade [12]. Sculpture itself with du Seigneur [13] recaptured Michelangelo's evocation of muscle straining against its bonds, or, with Barye [11], presented combats displaying human and animal strength.

8. FRENCH. J. L. DAVID (1748–1825). Napoleon Crossing the Alps over the Great St Bernard Pass. 1800. *Versailles Museum.*

10. *Below.* FRENCH. H. DAUMIER (1808–1879). The Riot. *Private Collection.*

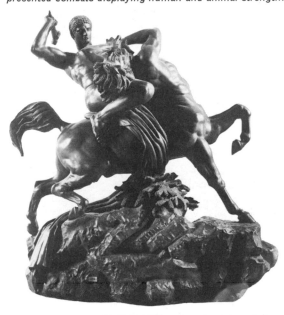

11. FRENCH. A. L. BARYE (1796–1875). Lapith and Centaur. Bronze. 1850. *Louvre.*

12. *Below.* FRENCH. T. GÉRICAULT (1791–1824). Stag Hunt. Drawing. 1817. *Louvre.*

13. *Below.* FRENCH. J. B. DU SEIGNEUR (1808–1866). Orlando Furioso. Bronze. Cast by Charnod in 1867; plaster cast in the Salon of 1831. *Louvre.*

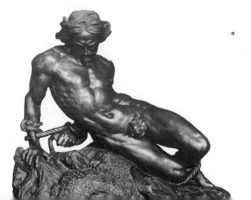

highly wrought and aristocratic, and therefore suspected of being decadent, was rejected in favour of things that were of the people, which were considered more wholesome because nearer to the origins. In 1615 the publication at Caen of a *Chansonnier Normand* had started the return to folklore. In England John Parry revived the 'Gaelic' melodies shortly before the middle of the century, and then the 'Antient British music of the Cimbro-Bretons', just as in France some thirty years later the *Journal de Musique* published the melodies of Languedoc and even ventured as far as Russian folk music.

The Trianon hamlet and dairy were the outcome of this return to the source, which went further and founded the cult of the 'noble savage', who was preferred to civilised man: was he not closer to the pristine truth, which had not yet been adulterated through the development of conventional morality? Jean Jacques Rousseau, who played a decisive part in this return, sought in him and others 'man in all the truth of nature'. These were crucial words. It was necessary to strip off the artificial veneer of customs and restore nature together with its primordial lesson. In 1750 Rousseau's *Discours sur les Sciences et les Arts* indicted the very notion of culture, and his *Emile*, applying the doctrine to the problem of education, demanded that the child 'shall not know anything because you have told it to him, but because he has understood it himself'.

The Gothic movement benefited from the new orientation. People did not wait for Chateaubriand to see this style as a translation into architectural terms of forest and plant motifs. The fashion for English gardens came from the same source. In 1717 the Princess Palatine foreshadowed Rousseau and the lesson that Germanic culture taught in the 19th century when she declared: 'Everything natural is infinitely more to my taste than the products of art and munificence.' Six years later, this time in England, Addison's paper the *Guardian* stated that all true art consisted in imitating nature. It was all up with the rules prescribed by classicism; it was all up even with the virtue of elaboration, and discredit was thrown upon the rational and scholarly disciplines extolled by Graeco-Roman culture. The *style rocaille*, completely impregnated with Germanic Rococo, had simply to transcribe into decoration the doctrine of irregularity that found its confirmation in China. Of the imperial garden at Peking Father Attiret wrote in 1743: 'A fine disorder reigns, an anti-symmetry'; and about twenty-five years later, Father Benoît praised the Oriental garden for having multiplied the irregularities. Henceforth the aesthetics of the ruler and compasses was held up to public obloquy.

The landscape cult, which triumphed in the 19th century, was from now on foreseeable. It followed as a direct result. But a more profound result was that, with man himself, it became important to discover his nature first of all — no longer the traditional or logical laws to which he was subject, but what was sensitive, spontaneous and intuitive. Thus, instead of the universal, one was dealing with the particular man, the individual. People endlessly explored this individual man, more to reach the foundations than to admire the edifice; they started searching for the 'depths'. From sensibility, which preoccupied the 18th century, they moved on to the passions, the instincts, the temperament, the basic drives and, finally, the unconscious. The road that was to end in surrealism had begun. An irreversible downward slope opposing the one that had been patiently climbed now came into view, and down it the West first walked, then soon ran, and almost fell. It led right away from the summit previously aimed at and conquered to that renouncement, that denial which was to become fevered and anguished in the 20th century.

But France, who gave the lead in the 19th century, did more than any other country to moderate this change of direction, to prevent a too exclusive preference for one of the henceforth warring aspects of European culture. This did not occur without internal conflict and division, and France appeared, especially in the first half of the century, as the battlefield on which the Neoclassicists, stubbornly lodged in their defensive positions, confronted the Romantics, who were impatient to move forward with their new ideas.

The action of the opposing forces must be followed in its successive phases.

The Neoclassical reaction

After having been profoundly shaken during the 18th century, the classical ideal regained its position at the end of the century and during the early 19th. If, confronted by the rising tide of the Baroque, France in the 17th century had raised the barrier of classicism and influenced the rest of Europe with it, in the 18th she only maintained it in official art, particularly in architecture. But in society, where women's tastes were dominant, the thirst for freedom expressed itself in a craze for the subordinate forms of the Baroque: furniture, decoration and the minor arts all went over to the enemy. The result was a paradoxical situation. In so far as France was represented by her aristocracy, which set the 'style' for Europe, she looked like the champion of the florid, over-elaborate manner. A shrewd observer would have noted, however, that this was something superficial, that the reaction of the fashionable world was limited and that, what is more, it simply implanted an art of foreign origin, whose leading exponents — decorators like the Italian Meissonier and the Belgian Cuvilliés, cabinet-makers like the Germans Roentgen, Oeben and Riesener — would hardly have passed for local artists. It mattered little to the patrons of the time; the new style was sanctified by Parisian prestige and therefore embodied French influence.

Now, the latter was beginning to weigh like a yoke on foreign countries where northern national feeling was reviving. Consequently, it was in opposition to France and to the deviation of taste for which she was held responsible (as Louis Réau has penetratingly shown) that the Germans called for a return to the ancient and pure source of culture. Just as Lessing began to counter French tragedy by a direct recourse to both Sophocles and Aristotle, so the painter Raphael Mengs and the archaeologist Winckelmann established themselves at Rome to cry up the return to antiquity at the expense of the 'fiddling manner' of the French. The title of the course given by Mengs at the Vatican, 'Against the French style characterised by its profusion of meaningless ornaments', speaks volumes. What an influence the German Grimm had on his friend Diderot and his hostile attitude towards Boucher's excessively frivolous art! Thus, in order to combat the cultural domination of France, Germany came paradoxically to favour a return to Latinity!

Prompted by the same feelings, she also encouraged a revival of Gothic, believing that she saw in it the expression of her national past. The very term 'Gothic', adopted at that time, bears witness to this.

In actual fact, both classicism and Gothic art are of French origin, and so their resurrection could not but revive in the land of their birth old instincts that had been diverted or were lying dormant. It is no surprise, therefore, that the Neoclassical movement, which seemed to be directed at first against the ascendancy of France, not only met with a swift and sympathetic response there but also enjoyed a remarkable long-term success. There was even a dispute over dates and whether a painter like Vien or a critic like Caylus was the first to advocate the return to antiquity. The driving force for this

NIGHT, DEATH AND THE DEVIL

The unsettling in the 18th century, then in the 19th, of Western culture's most stable traditions renewed the entire repertoire of the literary and artistic imagination. This effort of elimination reveals itself in a taste for negatory themes, or ones opening on the unknown. Night with its shadows and mystery took the place of day and inspired the Neoclassicists [14] as well as the Romantics [18] ; it presaged the obsession with death and its phantoms [16], rendered even stranger through their reliance on northern myths, on Walhalla and Ossian, who was equally inspiring to Isabey [17] and Ingres [19], despite their classicist attitudes. The Celtic bard, the ' Homer of the north ', became so popular that the caricaturists made use of him [20]. Finally the Devil, supreme denier, orchestrated this symphony of darkness, the Middle Ages and the void [15].

14. FRENCH. Mlle de La Vallière at the Convent of the Visitation. Engraving by Pauquet after Ducis.

15. *Right*. FRENCH. C. NANTEUIL (1813–1873). The Moon. Lithograph. 1830.

16. *Below*. FRENCH. TONY JOHANNOT (1803–1852). The Romantic Poet. Vignette.

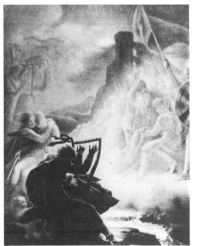

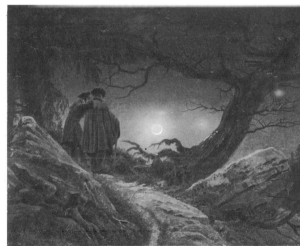

18. *Above*. GERMAN. C. D. FRIEDRICH (1774–1840). Gazing at the Moon. 1819. *Staatliche Gemälde-galerie, Dresden*.

17. *Above, centre*. FRENCH. E. ISABEY (1804–1886). Coloured drawing for the frontispiece to Ossian's *Poésies Galliques*.

19. *Far left*. FRENCH. J. A. D. INGRES (1780–1867). The Dream of Ossian. *Montauban Museum*.

20. *Left*. FRENCH. H. DAUMIER (1808–1879). The Poet. Wood engraving.

obviously came from the sensational excavation of Herculaneum and then of Pompeii, which drew attention to the neighbouring temples of Paestum as well.

The new concept of beauty, which, abroad, was used as a weapon against France as represented by her aristocracy, became an instrument of political conflict in France herself, because it opposed the tastes of this aristocracy. The bourgeoisie made use of it in its struggle for power, which had been begun during the 17th century by the parliaments and ended in the Revolution. An easy way of discrediting the nobility, which the middle class was trying to supplant, was to condemn its dissolute luxury, the excesses that distinguished it from what was regarded as proper by the bourgeoisie; the Rococo style was the unrepentant image of these excesses. On the other hand, Rome — and especially republican Rome, that of the origins — provided the example of an art devoted to 'truth' and 'nature', an art whose severe restraint seemed to condemn the aristocratic extravagances. The reaction speedily won over the fashionable class it was threatening, since they were always eager for novelty. Curved, tortuous lines disappeared, making way for the severity of pure, straight ones. The Louis XVI style began the new trend that, after the hesitation of the Directory with its nostalgia for the departed charms of the 18th 167 century, ended in the severity of the Empire style.

Afterwards, however, a strange thing was to happen. The middle class triumphed with the Revolution and, after coming near to being overthrown by the instrument of that Revolution, the common people, was set in the saddle by the Empire and kept there by the Restoration. Industriously consolidating its wealth, with the July Monarchy and then the Second Empire it was to take a firm hold of power. The bourgeoisie had dislodged the nobles and established itself in their place, and from now on thought less about criticising them than about copying them and taking advantage of the privileges of which it had but recently been the stern critic. It was tempted by luxury, which was not even balanced by good taste, for the latter's principle of selection was appropriate to a society founded on a scale of values and not on the possession of property. The style developed by the Empire therefore swiftly became heavily 169 opulent and overloaded. From the Restoration to Louis Philippe and Napoleon III, not to mention the Third Republic, it went on steadily swelling and distending. The new style revived the 18th century's curves, but thickened them, and soon was merely aping them more 'richly'. Thus, the transformation of the decorative arts and architecture concluded, in the hands of the 19th-century bourgeoisie, with the disowning of the ideal in which at the outset it had found its justification. Except for England, which stayed independent, the whole of Europe moved as one, all eyes being fixed on France, and wealth everywhere became the essential stimulus of the propertied classes, even when they remained aristocratic.

In spite of being an art more and more open to the individualist impulse, painting underwent a similar evolution in its official, that is bourgeois, tradition. Brought up at first on the lesson of the 18th century, then violently obsessed by the reformist ideas for which he was the harsh and austere spokesman, David, too, was affected during his last years by a significant enfeeblement, which led him back to the insipidities of the 57 previous century. Ingres, his successor, caused the severe antique ideal to slide for good towards an affectedness, a mannerism that amounted to its repudiation. Driven by a meticulous passion for reality, which was genuinely middle class, his art was devoured by a sensuality that looked for nothing in the 33 Orient but its harems, and dreamed of the soft, damp flesh of the *Turkish Bath*.

Thenceforth bourgeois art took as its own the impulses that it had condemned in the 18th century and that, under the cover of the official stamp and the pretext of the cult of form, were to reach their full development in the nudes of Baudry, Cabanel and Bouguereau.

In the Germanic, Scandinavian and English-speaking countries, Neoclassicism, which had been upheld there by artists ranging from Thorvaldsen to Flaxman, deviated 56, 159 differently but just as radically after it had lost its first glamour. This attraction to Rome, explained above all by a dislike of French culture, had something paradoxical about it. Artists sought in Rome attachments that did less violence to their own natures. To the rationalism of antiquity they preferred the 'naivety' of the primitives, whom they saw as embodying that primordial purity to which the rising nationalisms aspired. Accordingly they also contrived to build themselves a link between Neoclassicism and neo-Gothic, where they felt more at ease. The style was still linear and sculptural, the vision exact and meticulous, as in the work of David, but the subject became religious, and in England even 'Arthurian'. It was thus that the German group of the Nazarenes made its appearance, and 80 then the English Pre-Raphaelites, whose flowering in the 82 second half of the century, assisted and encouraged by Ruskin, led to Symbolism.

Neoclassicism remained of secondary importance. It represented a revulsion from the Baroque triumphing in Rococo, a reaction in which social and national impulses played a part; but it was based on false premises. In spite of being artificially prolonged by academicism, it did not accord with the new aspirations, and the future of art must be sought elsewhere.

The discovery of intensity and the inner life

Yet behind the barrenness of Neoclassicism, which formed the most evident aspect of David's art, an advance was preparing which was to lead to Romanticism. This art is not merely petrified by the close imitation of antique sculpture; it is also tensioned by a new feeling of energy. It is not just immobility, 8 as a superficial inspection might suggest, but also intensity. There exists in it an irresistible attraction to violence, perceptible in the fierce themes, which strangely recall Corneille's poetics, of battle and death. That explains why this art adapted itself so easily to the epic saga of Napoleon. If Gros in particular 143 felt torn between the two aspects, antique and modern, of his painting, it was because he did not have sufficient perspicacity to isolate the unifying principle that governed them both — the cult of the hero, to which Napoleon gave flesh and substance. By 'hero' is meant the exceptional individual who, if the occasion arises, will represent the nationalism still seeking definition, but whose superhuman nature (and here we have the germ of what at the end of the century would be Nietzsche's superman) now consists less of balance and perfection than of grandeur and both moral and physical strength. To sense this dream of forcefulness one has only to consider the place then occupied in art as well as in both civil and military life by the horseman, the man-centaur whose flashing vitality is increased 72 by the mastered mettle of the beast. Napoleon's tactics were expressed first and foremost by the speed of the cavalry, and the ride in poetry, above all that which inspired the Germanic ballads, and in music, swept by the wild gallops of Berlioz, Chopin and Wagner, was paralleled in painting by the horse. Its fiery pawing and flashing eye, which were derived from Rubens' paintings, filled the canvases of Gros, of Géricault and of Delacroix. And this horseman is himself simply the concrete image of man achieving self-realisation through his own intensity and energy: this type suddenly appeared in real life

21. FRENCH. EUGÈNE
DELACROIX (1798–1863).
Michelangelo in his Studio. 1850.
Montpellier Museum.

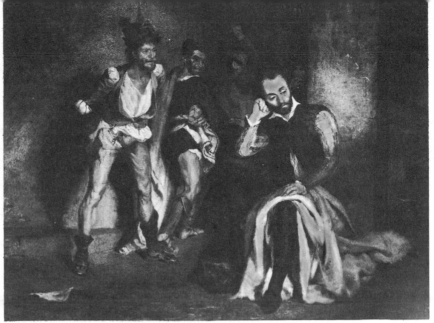

22. FRENCH. EUGÈNE DELACROIX
(1798–1863). Tasso in the Madhouse.
1824. *Kunstmuseum, Winterthur.*

THE ROMANTIC GENIUS
FROM SOLITUDE TO MADNESS

*Intentionally deviating from traditional norms the Romantic
isolates himself to seek within himself the revelations of genius,
the creator of a new world [21], or to commune in his soul
with that of nature, which exalts him to the dimensions of
infinity [23, 24].*

*The price of his solitude, like Baudelaire with L'Albatros,
is incomprehension and sarcasm from the public, who see only
his strangeness [22]. Turning his back he sets off to discover
unknown regions; ' powerful and solitary ', as Vigny puts it,
he feels the dizziness of the heights [23] and the anguish of
his isolation [21]. Through wanting to cross the bounds of
communal reason, there are even occasions when his mind
wanders, and certain works reveal, in the irresistible intrusion
of fantasy, the madness into which he sometimes sinks: such
is the case with Meryon [25], Grandville [27] and Gérard
de Nerval.*

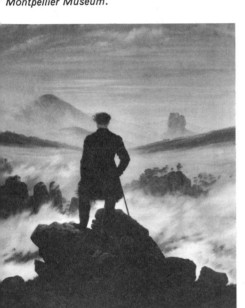

23. GERMAN. C. D. FRIEDRICH
(1774–1840). Journey above the
Clouds. c. 1815. *Private Collection.*

24. *Right.* FRENCH. A. DEVÉRIA
(1800–1857). Engraved vignette on the
theme of Manfred for Lamartine's
Méditations Poétiques. 1825.

26. *Below.* FRENCH. N. F.
CHIFFLART (1825–1901). The Mad
Draughtsman. Etching.

27. *Below, right.* FRENCH.
GRANDVILLE (1803–1847).
The People delivered up to the Blood-
sucking Taxes in the great Pit of the
Budget. Etching (detail).

25. *Below.* FRENCH. C. MERYON
(1821–1868). The Ministry of Naval
Affairs. Etching. 1866.

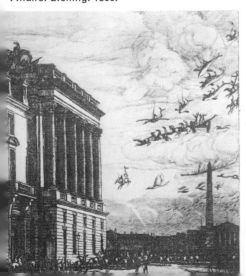

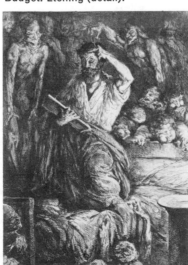

with Napoleon and in art with Géricault's Michelangelesque figures subjugating animal force, with Barye's statues, with Delacroix's combats and encounters of wild beasts and with Daumier's thick silhouettes, heavy-shouldered and massive. He arose in literature, dominating with his colossal stature the legendary life of the past in Hugo and modern life in Balzac, and earlier, opposing the universe with his solitude, in Byron. And it is he again who seems to have come, before Schopenhauer derived from it the 'will to power', from the most original philosophy of the times — that of Maine de Biran, a tremendous mind, whose reach was not suspected in his own day and has only been appreciated by a select few in ours.

Maine de Biran reconsidered the lesson of Descartes, seeking in the *cogito* a knowledge of the soul: its substance 'is just as completely unknown to us as every other substance in the universe'. Can man, then, grasp nothing about himself? On the contrary: 'each *individual* person knows, at least, *certissima scientia* and *clamante conscientia*, what he is as a *force that acts* and operates through the *will*.' Man apprehends himself, but as an 'individuality', and perceives himself, but as an effort: 'the force-me, the power-me . . . The immediate awareness of force . . . is none other than that of our very existence, from which that of activity is inseparable.' It brings an 'immediate and self-evident knowledge' that is not supplied by the senses, which are the basis of realism, or by ideas, the basis of classicism.

In a single sentence three foundations of Romanticism and of the 19th century have been laid and lucidly perceived — *individualism*, fostered by the intuition of the *subjective life*, which is apprehended as a *living intensity*. This intensity, moreover, implies a continual tendency to change state. One could hardly convey more clearly that the fixed and permanent rules were about to be abrogated, and that art was embarking on a great creative adventure with many radical leaps forward. Attempts at a definition of *being*, to which the old, particularly the Cartesian, philosophers applied themselves, were succeeded by the adventure of *becoming*, which excited German thinkers especially.

It was a period of triumph for German philosophy. Already Leibnitz, then Kant and then Herder, Fichte and Schelling had prepared, in one century, a new concept of man and his relationship with the world. It gave a new direction to the cultural and artistic drive of Europe, and Romanticism was, in a very large measure, a result of it. With this concept the Germanic northern spirit, whose reawakening had been foreshadowed in the 18th century, replaced the Latin culture with what that culture rejected or strove to keep in check. German philosophy had already started penetrating into France even before Mme de Staël had published, in 1810, her book *De l'Allemagne*, a bombshell banned by Napoleon whose Mediterranean mentality took it for a subversive attack, and before such men as Custine or Quinet. Emigration from France, which did so much to promote the discovery of England and Germany by French expatriates, gave Gérando and Charles de Villers (whose *Philosophie de Kant* dates from 1801) the opportunity to reveal to their fellow-countrymen doctrines that were then unknown to them. Strictly speaking, the introduction of Kant had begun as far back as 1773.

Maine de Biran, who was born in 1766 and died as early as 1824, did something more. Brought up on both Leibnitz and Descartes, he originated the French form of this new trend which distinguishes it from the Romanticism of the Germans. Whereas the latter, in their inner search, were looking principally for a way of re-uniting man and the universe and of becoming one with it, the French saw it as a discovery of man and his moral nature. The aim of Stendhal and Vigny, like that of Géricault and Delacroix, was already fixed: to search within oneself to find there, through discovering energy, the key to greatness. Latin humanism, beloved by France, would be safeguarded: it would merely change its appearance. Man would not get lost in the double temptation of making a meticulous inventory of the universe and indulging in an unchecked inward reverie, which were paradoxically combined by the German Romantics such as Friedrich or Carus. He would end at a deeper, richer, more revolutionary self-awareness, but without giving himself up to either the external world or his own dreams.

The stultifying bounds of the past had been broken. In the inner life, where 'everything is in a perpetual flux', Maine de Biran was seeking 'immediate and self-evident knowledge'. This would free art from the mechanical and realist knowledge derived from the senses which Condillac, following the English, regarded as the fount of all psychology; it would free it quite as much from the formal and petrified knowledge yielded by ideas and an exclusive use of them. Maine de Biran cautioned against these two threats: man, 'taken up with his senses or his ideas, is of necessity outside himself . . . directed by all that is alien to himself, i.e. to his ego and his personality'. The crucial word had been uttered — the personality, that is to say the individual.

Even though they were unaware of this very new philosophy, artists effected a change of direction which once again confirmed that ideas and images run parallel. Turning away from the exact observation of the visible world or the observance of a clearly defined ideal of beauty, they, too, devoted themselves to revealing the individual and what is unique about him. 'I am other,' Rousseau had already said. Then was not this uniqueness incommunicable? 'The inner man', Biran acknowledged, 'is beyond words in its essence.' The men of letters echoed him: 'We shall all die unknown,' lamented Balzac, and Musset alluded to, in each one of us, 'that unknown world which is born and dies in silence', and is, nevertheless, the true fount of poetry. From then on, the mission of artists was clear: they had to break this deadlock. Art should reveal this living fount, and make it flow freely.

Art as an expression of the inner life

Artists now started to abandon the domain of what is reproduced or measured; their thoughts turned to the domain of what is suggested, and set themselves the task of disclosing all that is most intimate, most deeply felt in a being. Here again, however, Romanticism reaped a harvest sown in the 18th century. Its development can be traced in philosophical texts, which expressed contemporary thought more and more clearly, especially in its application to art. Incidentally, it was in 1750 that Baumgarten, the German philosopher, pointed out the new tendency that was asserting itself, and it is symptomatic that the term he chose for it, 'aesthetics', conveys etymologically that this 'art of feeling' depends less on reason than on the emotions. Now, feeling is what defines man in his most personal individuality, that individuality which, in everybody's view, was becoming increasingly important. If Buffon still adhered in 1753 to the old conviction that 'an individual of any kind whatever does not exist in the universe', Bishop Berkeley, who died that same year, an Irishman whose Celtic origins allowed him to break away from Latin rationalism, had already stated that, on the contrary, nothing existed in the strict sense of the word except individual people; other things did not exist in their own right but depended on the existence of mind. The way was open for Hutcheson, a Scot and Berkeley's junior by ten years, to deduce that in art the term 'beauty' really

72
139

18

23

26

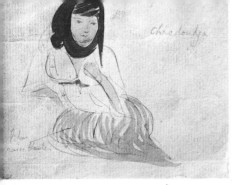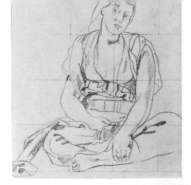

28, 29, 30. FRENCH. EUGÈNE DELACROIX (1798–1863).
Left. Khedoudha. Watercolour and pencil. *M. G. Bernheim de Villiers Collection*. *Centre*. Woman sitting cross-legged. Drawing. *Louvre*. *Right*. Study of Oriental slippers. Drawing heightened with pastel. *J. L. Vaudoyer Collection*.

REALITY AND IMAGINATION

Romanticism was essentially a flight from the real to the imaginary. The birth and development of a picture such as Delacroix's Women of Algiers *show in all its fullness the new concept of beauty embodied in the work of art [31]. The subject by itself, through its exoticism, reveals the painter's desire to escape to an ' elsewhere' that, by being remote in space or the past, does away with the triteness of what is familiar. Comparison with a more popular lithograph [34] and even with a picture by the contemporary leader of the Neoclassicists, Ingres [33], who was also affected by the fashionable interests, emphasises all that Delacroix added to the mere anecdotal documentation, or to the superficial picturesqueness craved by sensuality. Delacroix starts out from reality, which made its impact on him during his journey to Morocco, and draws nourishment from it by turning to account the freshness of notes jotted down from life [28] as well as the truth of details [30] that ballast subsequent reverie with its steadying load of fact. Likewise a study of the figures in their rigorous linear drawing and stable form ensures that the work has that other counterweight to the imagination, pure plastic beauty. On this strong foundation the sensibility is then allowed to soar aloft, transfiguring everything and giving access to an unknown world charged with the splendour of its materials, the mystery of its half-shadows, the languid sensuousness of its secluded beauties [31]. A repetition of the same theme a few years later increases the magic of the atmosphere by suppressing those details that are merely picturesque and making the figures disappear still further into a deep mass of shadows fleetingly pierced by a flash of light [32].*

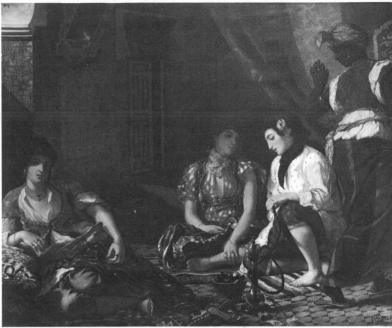

31. FRENCH. EUGÈNE DELACROIX (1798–1863). Women of Algiers in their Apartment. 1834. *Louvre*.

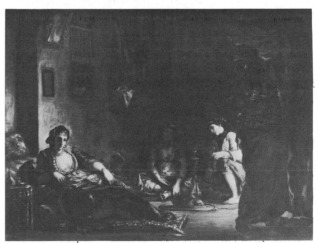

32. FRENCH. EUGÈNE DELACROIX (1798–1863). Women of Algiers in their Quarters. 1849. *Montpellier Museum*.

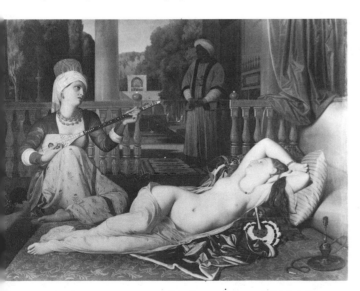

33. FRENCH. J. A. D. INGRES (1780–1867). The Odalisque with the Slave. 1842. *Fogg Art Museum, Cambridge, U.S.A.*

34. *Right*. Women of Algiers. Coloured lithograph by Bayot.

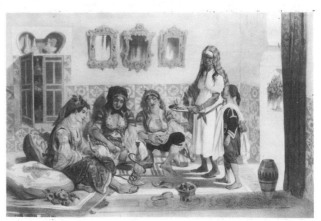

only expressed our own sensations, pure sensations in us. Certain Frenchmen had already had an inkling of this. They had very early on become aware of this quality proper to and inherent in everyone. In 1715 Crousaz noted in his *Traité sur le Beau* that tastes were 'born of the diversity of temperaments'. Four years later Abbé Dubos, whose *Réflexions Critiques sur la Poésie et la Peinture* reveal an original mind, opposed to the models or rules, common to all, the need 'for a propensity, ... for spirit', and stressed that every artist had 'his own which is unlike that of the others'. In 1759 Forney drew the conclusions from this recasting of ideas in his *Discours Préliminaire à 'L'Essai sur le Beau' du P. André*: henceforth art no longer consisted in 'copying some original', whether this original was 'an object existing in nature or some established idea that one has as a model'. This was to condemn the realist as well as the classicist doctrine. It was no longer an artist's duty to copy, to reproduce, but to produce, to create. Lessing adumbrated this conclusion in 1766 in his famous *Laokoön*: to the real world art superadded 'a new world'. The Germans thereupon drew the unavoidable inference. Kant, who had read Dubos, proclaimed in his *Critique of Judgment* (1790) that it was impossible to formulate a 'rule by which somebody could be compelled to admit the beauty of an object'. For the idea of a universal and absolute beauty it was necessary to substitute that of an 'ideal ... which everyone must produce within himself'. Aesthetic judgments could no longer be founded on anything but a 'subjective principle'. It could lead to a universal concordance of perception; it could not, as before, be deduced from a concordance of conception. Herder in his turn also produced a formulation of the new creed, basing himself on the undeniable but previously neglected fact that 'at its deepest level our existence is individual'. It was this that the artist made it his mission to reveal to others by powerfully exteriorising 'what is obscure and beyond words in our soul'. Thus the doctrine of Romanticism had been set forth. No longer was it the 'outer man', wholly taken up with 'sensation and reflection', who mattered, but henceforth, the 'inner man', as Maine de Biran had called him.

Delacroix deduced from this that it was becoming 'much more important for the artist to get close to the ideal that he carried inside himself' — we would say nowadays to his private and personal conception — than to a doctrinaire ideal or the 'transitory ideal that nature offers'. Yet here again an echo of German thought is audible. In 1785 Schiller had shown the same preference when he exclaimed: 'Be what you like, inanimate world, providing that my own self stays faithful to me!' Thus behind Romanticism one sees already taking shape the detachment from visible reality that was to triumph in later art.

Up to then people had thought principally of bringing together the external, physical world and the human intellect, which was charged with explaining and organising it. From that time onwards an opposition was apparent between what, on the initiative of such Germans as Kant, Fichte and Schelling, would be called the 'objective world' and the 'subjective world'. The former was the province of scientists, the latter that of poets and artists, who made it their business to explore and express it. French thought became accustomed to this distinction. Since 1812, when Abbé Mozin's French-German dictionary had established the word '*subjectif*', the knell of Neoclassicism had been tolled; but Charles de Villers, who introduced Kant, had already extracted the new faith from Fichte: 'We have no direct awareness of anything outside ourselves, and we are only conscious of our own feeling.'

Like the poet, the artist was someone whose 'feeling',

endowed with exceptional value, was worth revealing to others in order to move and enrich them. 'What makes the man who is out of the ordinary,' asserted Delacroix, 'is essentially a way of seeing things that is entirely his own.' It fell to perhaps the greatest painter of the 19th century, who was at the same time a deep thinker, to ponder and enunciate the revolutionary role that now devolved on artists. Baudelaire, who came under and acknowledged the influence of Delacroix, took over from him, and arrived at a theory which, though dispersed in his writings on art, is like the first consciousness of what the artist would from then on try to carry out. It is possible, basing oneself on both of them, to summarise this theory briefly.

The artist's soul resembles the bronze that gives each bell its particular tone: always outwardly the same, it is composed of subtle alloys whose combination is never repeated exactly as before. Like a bell the soul rings under the impact of an experience that wakens it. This impact can come from nature, just as from reading poetry (Delacroix gained inspiration from Goethe, Schiller, Byron and Shakespeare, among others), or from any emotion. Hence nature is no longer a model but a pretext. This is why the Romantic fled from the domineering touch of reality; it is why he tried to avoid its grip by painting not the familiar world, but exotic or far-off ones, often from the East or from the past, mainly the Middle Ages. The artist was looking not so much for a scene to reproduce as for a slightly blurred, indistinct fantasy, which could be easily moulded and in which truth and imagination (Goethe said 'truth and poetry') would mingle to the point of being indistinguishable.

22

31
22

The customary language of words and ideas conveys only collective notions. Art, by using images, could alone convey the inexpressible. And though it too had to use nature's images which all could understand, they would be chosen and grouped as one might compose, by combining flowers, the unusual perfume of a bouquet. One would thus succeed in raising an emotion similar to the one at the origin of the work of art; it would be recreated within other people. 'Nature is only a dictionary' (Delacroix), 'a storehouse of images and signs to which the imagination will give a place and a relative value' (Baudelaire).

Clear mention had thus been made of the faculty that, hitherto of secondary importance, now came to the fore. This faculty, imagination, selecting remarkable shapes and fantasy themes, distorting reality to make it more expressive of something glimpsed by the imagination, eliminating what produced no sympathetic vibration, and developing what seemed striking, led to this transmutation, this recreation; it used reality as a raw material, to give it significance. Its function was to carry out the 'soul's involuntary work of thrusting aside and suppressing, ... that kind of idealisation' which Delacroix was looking for. Moreover, it 'does not just picture this or that object, but combines them for the end it wishes to attain'. Finally, and this time Baudelaire is speaking, it would replace ordinary nature with 'a different one, corresponding to the spirit and temperament of the author'.

Here again, the 18th century had prepared the way, Hume having already dimly seen that imagination enabled feeling to spread over external objects and make them into bearers of the impressions they had induced. Mendelssohn had stressed this direct, immediate, emotive action that an object can exercise upon the sensibility, without there being any need for analysis or reflection. From now on, the artist cultivated this power of an image, a form, a colour, or simply a line to excite the sensibility and produce a vibration like the one set up by the plectrum in a string. Music provides the most obvious example

of this direct action, sounds and their arrangement being all it needs to convey a state of soul to the listener before he has even thought of analysing the effect and its cause. Accordingly, the other arts, with painting in the lead, turned to it as to a highly important model, particularly at this time. And it is probable that Germany's special aptitude for music made it easier for her to discover the new effects required of art and poetry, and led her to reflect on them and gain a better understanding of their nature.

This nature was no longer rational. It made manifest affinities that, though they were hard to analyse, the artist's instinct knew how to bring into play — 'correspondances', as Baudelaire called them. Intuition revealed them where the intellect became confused and stumbled. It took full advantage of this sympathetic communication between individual sensibilities that emotion could establish right away, and that did without dialectical and rational methods. To be sure, great artists of the past had had an inkling of these effects deep down inside themselves, and had even used them; but never before had there been this clear consciousness of them, and never had they been made the open and acknowledged aim of art.

From now on, the artist wanted and knew how to 'create a suggestive magic containing both the object and the subject, the world outside the artist and the artist himself' (Baudelaire).

He achieved it through ' an arrangement of colours, lights and shadows', through all ' that the soul has added to the colours and lines in order to reach the souls of others', as Delacroix said. This was the very heart of the matter: ' to reach all the souls that are able to understand yours'.

One could have emphasised many obvious features of Romanticism — its intensity, as opposed to the orderliness of classicism; its originality as against regularity; its use of vibrating colour to the detriment of precise drawing. All this is true, but it is the consequence of the profound development whose progress we have just followed. In actual fact, by demonstrating once more the close connection between art and thought, Romanticism marked the end of a slow spiritual evolution; man's conception of himself and his relationship with the universe have changed. The civilisation that had been firmly established from the Renaissance to the 17th century was overthrown, as though an earthquake had disrupted the order of the strata on which this civilisation rested. The lowest and most hidden layers rose up, dislocating the structure at the surface. Europe showed itself to be richer, more complex and more tumultuous than had ever been supposed. Nor had it reached the end of its surprises: the whole world was to transform itself, precipitating a crisis whose effects the 20th century is still a long way from having measured in full.

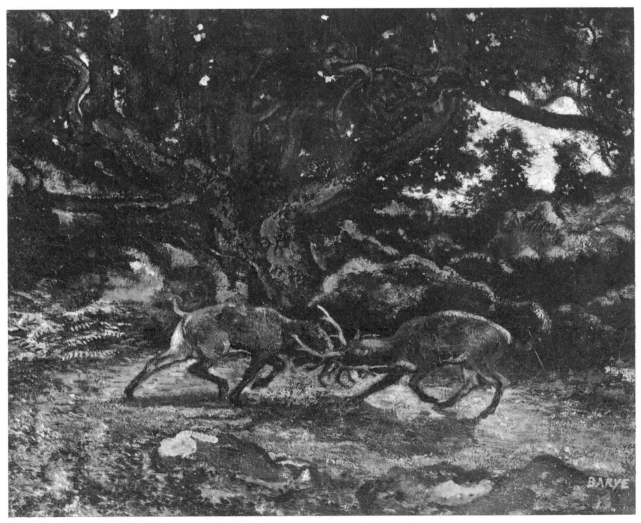

35. FRENCH. A. L. BARYE (1796–1875). Stags Fighting in a Landscape. *Louvre.*

THE CLASSICIST REACTION IN THE 18TH AND 19TH CENTURIES *Pierre Francastel*

It is arbitrary to divide the current of art history into clear-cut sections, whether centuries or movements. We have seen the classicism of the 17th century continue during the 18th its developments in architecture, in rivalry with Baroque or Rococo. Since the middle of this same century a renewal of momentum based on a fresh conception of antiquity had been preparing: this 'Neoclassicism' not only led, as is often thought, to the sterile academicism of the 19th century, but posed some of the problems whose solution would engross 20th-century art.

In 1829, in the first number of the *Revue de Paris*, Sainte-Beuve devoted the first of his celebrated *Portraits Littéraires* to Boileau. 'Since Boileau's death more than a century ago long and continual disputes have arisen concerning him,' he began. And the editor of the *Nouvelle Revue*, Véron, had entitled the column that was being started 'Antique Literature'. On Sainte-Beuve's testimony, it was another fifteen years before Victor Cousin officially proclaimed at the Académie, in connection with Pascal, that the makers of Louis XIV's century had entered into history. It does not seem to be understood everywhere even today that the more or less advanced forms of the Renaissance belong irrevocably to the past. Consequently, it is still necessary to make a double effort of learning and imagination to appreciate the movement that under the name of 'Neoclassicism', which it gave itself, dominated art in Europe from the second half of the 18th century.

Aesthetically speaking, we are confronted with a false problem. No art founded on the imitation of models has ever been creative. The Renaissance is of value in so far as it led and not in so far as it reproduced. Nevertheless, seeing that several generations of artists — and above all architects — were ready to draw their inspiration from speculation of a partly ideological, partly archaeological character, one cannot disregard this episode in the development of thought on art and form. It is an episode hard to justify from the standpoint of principles, but a very fruitful one if, on the other hand, we regard it as marking in its works the opening phase of the freeing of classicist art from ritualism. In other words, Neoclassicism is unjustifiable considered as a doctrine of imitation, but it acquires great importance the moment we see it as the first step taken during modern times towards a review of the principles involved in representing the universe sculpturally or pictorially.

The return to classicism and Palladianism

Only twenty-five years ago the historical problem was regarded as solved. Rome towards the middle of the 18th century had found itself the centre of the movement. The efforts of a number of antiquarians — such as Winckelmann, the most distinguished of them — and all the Scandinavian, English and particularly German travellers had succeeded in freeing European art from the formulas of the Italian Baroque and of French classicism. Returning to the direct sources of antique art, distorted by three centuries of the Renaissance, artists found themselves once more in the presence of the eternal norms of all beauty. The obtrusive and envied national marvels — of France and Italy, who had been the first to drink imprudently at the antique fount — were about to be followed by the pure style of the great minds of the modern world, freed from the national formulas that hid from individuals the cold but resplendent truth. In actual fact,

36. FRENCH. C. L. CLÉRISSEAU (1721–1820). Ancient Tomb near Pozzuoli in the Kingdom of Naples. Engraved by Cunego.

one of the last pilgrims to this mid-18th-century Rome had such a mind — Goethe, who in his *Iphigenie* as in his memoirs *Dichtung und Wahrheit* would best express this generation's ideal.

There is no need to question at once the validity of an attitude that, it should be noted, postulates the identity of all cultures, implies the existence of a single 'good form' of civilisation, and presupposes a belief that the artist does no more than interpret and reproduce fragments of an immutable reality outside man and independent of his spirit. But it is now beyond dispute that the Neoclassicist movement made its approaches before the international and eclectic Roman milieu of about 1750 had been constituted. It has also been established that there were conflicts within the city itself, and that it was largely as an anti-Roman current that what was most original about the period made itself felt.

A major difficulty lies in the fact that these investigations, being made most of the time at a national level, use the same terms in different senses. For example, the word 'Palladianism' does not mean at all the same thing to the English, the French and the Italians. The latter see it in a national style, whereas the French regard it as being bound up with the international traditions of the 16th century and the English make it a national style, a 'revival', supporting an anti-Italian, and more generally an anti-continental, reaction. Goethe's Palladianism will thus be opposed to Burlington's and Gabriel's. So it is necessary to go over the facts again objectively, without any underlying prejudices.

Chronologically, one can establish an exact starting-point for this investigation, the decade 1750–1760. For there is naturally no question of taking one single event from among the others to make it the turning-point of the century. It is clear that during these years and on the most varied planes many trends came to maturity. Though the first manifestations date from rather earlier, they had hitherto been scattered and so of little significance. The sources of the different tendencies that, united, supposedly made up Neoclassicism are unimportant. A work

39

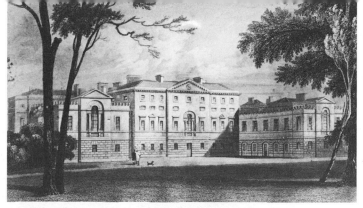

38. BRITAIN. JAMES PAINE (1716–1789). Wardour Castle. 1770–1776. Engraving.

37. BRITAIN. JOHN SOANE (1753–1837). Old Dividend Office, Bank of England, London. 1818–1823 (demolished 1927).

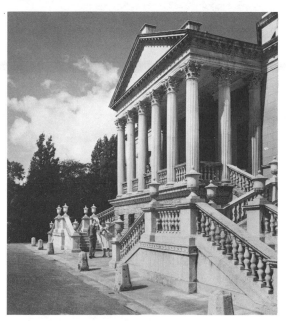

39. BRITAIN. LORD BURLINGTON (1694–1753). Chiswick House. Begun in 1725.

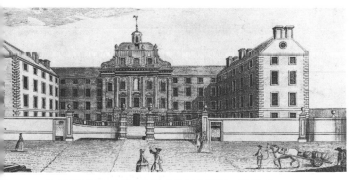

40. BRITAIN. WILLIAM ADAM (1688–1748). Royal Infirmary, Edinburgh. 1738. Engraving.

41. BRITAIN. WILLIAM CHAMBERS (1723–1796). Casina at Marino near Dublin. 1759–1769.

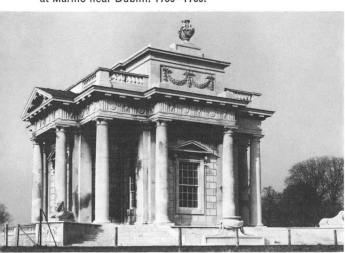

of art, and likewise a form of art, is never the sum of tendencies that have come from various points on the horizon. Integration in accordance with a certain overall pattern alone constitutes ' creation ', at the individual as at the general level.

Among the events that determined the emergence from 1750 to 1760 of a new art are the developments in architecture, much archaeological exploration and the publication of several big collections of documents.

As regards architectural developments, the situation varied greatly according to the country. Italy, impoverished and kept down by regimes opposed to progress, did little building. The academies were the meeting places of minds that kept alive the memory of their country's former glories, from Etruria to Galileo. Italy passively provided the raw material for the different movements and the place for them to come together. England on the other hand showed exceptional activity. She was rich; she was on the ascent materially; she was seeking an artistic originality. Palladianism belongs in England to the years 1710–1750, which means that it came before Neo-classicism. Palladio was discovered by Goethe at Rome in 1784, but was opposed by the Adam brothers in 1760 in London. It was oddly paradoxical, this movement that was by and large the product of a few men: the Earl of Burlington, and two architects, Campbell and Kent, working for him and for his circle. Burlington revived the tradition of the nobles who had made contact with the Renaissance during the 16th century. In Elizabeth I's reign the reinvigoration of modern architecture

40

42. FRANCE. J. N. SERVANDONI (1695–1766). Façade of
St Sulpice, Paris. 1733–1749. Church begun in 1646; north
tower rebuilt by Chalgrin, 1777.

43. FRANCE. F. J. BÉLANGER (1744–1818). Château de
Bagatelle, built for the Comte d'Artois in 1777.

44. FRANCE. E. L. BOULLÉE (1728–1799). Hôtel de Brunoy,
Paris. Wash drawing.

45. FRANCE. J. F. CHALGRIN (1739–1811). St Philippe
du Roule, Paris. 1774–1784. Façade. *Bibliothèque Nationale,
Paris.*

46. FRANCE. A. T. BRONGNIART (1739–1813). Le Couvent
des Capucins (Lycée Condorcet), Paris. 1783.

47. FRANCE. J. D. ANTOINE (1733–1801). Hôtel des
Monnaies, Paris. 1771–1775. *Bibliothèque Nationale, Paris.*

had even then been due to a few privileged art-lovers who
brought back collections of prints from abroad. English archi-
tecture was thus influenced by the foreign tradition, and in the
17th century its artistic development was helped by artists from
abroad. In France, too, such collections certainly made an
enormous contribution. But in France, where there was more
building, the middle class played an active part, whereas in
England modern architecture remained the work of the
dilettantes. Thus, by a strange paradox, Whig society at the
start of the 18th century was guided once again by a few
individuals, who turned back to the Palladianism of Inigo
Jones. This is in contrast to Rome, the home of the Baroque,
and to classicist France, both of which were regarded as having
directly inspired Wren and Vanbrugh. Inigo Jones was now
promoted, and rightly so, to the rank of a great national figure.
The *Vitruvius Britannicus* was published at the same time as a
translation of Palladio, and the England of Burlington, Kent,
Taylor and Paine was thus the first to start a 'neo' style
founded on scholarship.

38

48. The Oath of the Horatii. 1784. *Louvre.*

50. The Murdered Marat in his Bath. 1793. *Musées Royaux des Beaux Arts, Brussels.*

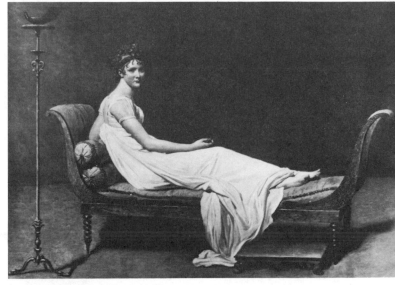

49. Madame Récamier. 1800. *Louvre.*

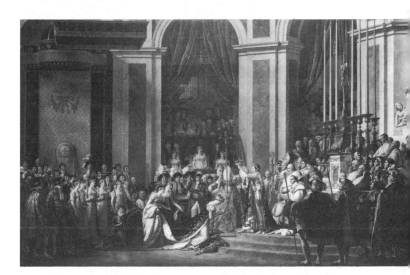

51. The Coronation of Napoleon. 1805-1807. *Louvre.*

52. Detail of 51.

To tell the truth, it is not certain that England's priority was as complete as has sometimes been supposed. By isolating the one architecture we artificially detach the episode of English 'Palladianism' of 1730 from a process of development that led all Europe to the experiments made at the end of the century. As just stated, Burlington's Palladianism had its place in the highly individual evolution of English architecture, an evolution with a bookish tradition, influenced by a general anti-Roman outlook. But when one looks at the works produced by this movement of dilettantes and scholars, one begins to doubt its creativeness. All the more so as it is often very hard to know how far any particular structure did or did not depend on the widespread taste for archaeology. In point of fact, Vanbrugh's Blenheim (1705-1724), for example, which was denounced as being tainted with the erroneous Baroque style, links up with an Italian — and French — tradition that, in the last analysis, is not completely at variance with the spirit of Palladio. Between Vignola and Palladio slight differences of style do exist, but there is no conflict over general principles. In a sense the garden

33

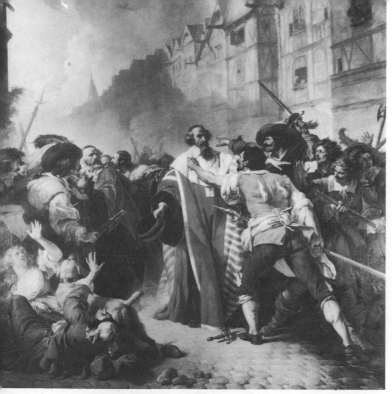

53. FRENCH. F. A. VINCENT (1746–1816). President Molé Attacked by the Frondists. 1779. *Palais Bourbon, Paris.*

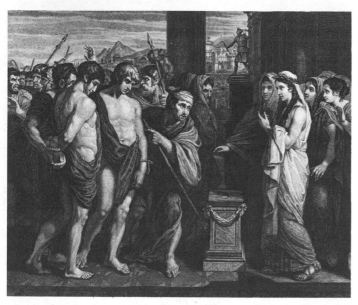

54. BRITISH. BENJAMIN WEST (born in America, 1738–1820). Orestes and Pylades. 1756. Engraving.

55. ITALIAN. ANTONIO CANOVA (1757–1822). Pauline Borghese as Venus. 1807. *Borghese Gallery, Rome.*

façade of Versailles and the Grand Trianon are both Palladian. Really the return to Palladianism hardly involved more than a somewhat artificial restriction of the models to be followed. Since its beginnings 18th-century Palladianism had been little more than a fashionable craze. At the end of the century Goethe's rather tentative Palladianism would mark the withdrawal of a watchword not really — or at most only partly — responsible for creating an academic spirit that had in fact already been making progress in France and Italy since the mid 17th century.

Hence, it is wrong to attribute too much importance to Palladianism in the development of Neoclassicism, of which, all things considered, it is only a secondary element. Academicism certainly did as much to form the international style of the 18th century. The place given to Palladianism simply emphasises the dominant role played, round about the 1750s, by the transmission of architectural models through books.

The rediscovery of antiquity

Simply by enumerating the great compilations of documents published during the crucial decade of 1750–1760, it can be clearly shown that the Palladian dispute was not at the centre of the true creative development.

People had been issuing editions of Palladio for two centuries. But now, since 1738 at Herculaneum and since 1748 at Pompeii, excavations were unearthing really new material that the investigators tended, naturally enough, to disperse. What is much more, the inquisitiveness of this period was driving antiquarians — the real ones — along unknown paths. It was not necessary to search the bed of the bay of Naples in order to discover wonderful monuments revealing, not nuances of style, but an antiquity suddenly enlarged, the remote but authentic source of all values. Consequently from 1760 onwards the movement of discovery and popularisation developed on two planes that were parallel but essentially distinct. On the one hand, there were the timid French or English explorers — those who confined their curiosity to Rome or Venice — and, on the other, those who found new fields of observation. One may mention as representatives of the latter group Wood, with his *Ruins of Palmyra* (1753) and his *Ruins of Balbec* (1757); Stuart and Revett, whose voyages to Greece in 1751 led to their *Antiquities of Athens* (1762); Revett and Chandler, who visited Ionia, and published the first part of their *Ionian Antiquities* in 1769; and lastly the two best exponents of modern architecture in England, Chambers and Adam, the first of whom published his *Designs of Chinese Buildings* in 1757, and the second his *Ruins of Spalato* in 1764, after making a journey in 1758 with the Frenchman Clérisseau, who did the drawings.

Unquestionably it was from this discovery of new monuments that the only original movement of the 18th century stemmed. In whatever it may have had of value to begin with, Neoclassicism was not Palladianism but a form of exoticism. And this enlargement of the archaeological records certainly opened a new era in man's knowledge of the history of the arts and civilisations, for it marked the beginning of a vast change of ideas from which modern civilisation would in part emerge. ' Neoclassicism ', people said at first, because they were simply unable to conceive that human history could have had several compartments; but the contents burst the wrapper. Palladianism was a response of narrow national inspiration; the exploring of new areas of the Mediterranean basin led to a first broadening out of the historical sense in the sphere of art. Here was the start of that vast inquiry into our planet's past which finally demolished the Renaissance. The intellectual conquest of the world and its past came two centuries after its physical and

41

economic exploration, but it was decisive. At the time people believed they were not leaving the domain of Rome, and this is why they identified their adventure with classicism. We no longer have any reason today for confusing as they did sterile academicism with fruitful discovery, just as we have no grounds for likening in all respects true exoticism to the developments of a strictly European style which made way for a better interpretation of Greece, now distinguished for the first time from Rome. For even if, in short, all the future watchwords — whether exoticism, feeling or primitivism — were implicit in the new explorations of the 1750s, there can be no question of making the mistake of identifying the great values of the 19th and 20th centuries with the first unconscious and piecemeal contacts to which a facile erudition could lead us to give too much importance. Around 1750 the vast historical investigation of the traces left by antiquity did not yet have either the historical or the exotic and primitive character that would distinguish the subsequent stages in the progress of history. The second half of the 18th century forms a true period, and a more careful examination of the works of the time can help us to appreciate it better.

We can consider this period either through the works it has left us or through its theories. As it was undoubtedly the latter that at first constituted its real originality — naturally enough in the century of the *Encyclopédie* and the general renewal of theoretical ethics and the sciences — we shall begin by examining the intellectual consequences of this fresh deposit of new documents.

All the old conflicts between Palladianism, classicism and Baroque were transcended by the discovery of Doric, which gave rise both to a long series of buildings — from James Stuart's temple at Hagley Park (1758) or Mistley church by Adam (1776) to Antoine's portal for the Hôpital de la Charité (1776) and the Paris Barrières of Ledoux (1785) — and to a complete revolution in the general views on the spirit of antiquity. Wishing to advance her little brother towards high office, Mme de Pompadour had arranged a journey to Italy for the future Marquis de Marigny during 1749–1750. As mentors she had given him Cochin and Soufflot. The first was to make his mark with a diatribe against Rococo published in 1754; the second, who is known above all as the architect of the Panthéon, deserves equally to be remembered as one of the first artists to have discovered the severe Greek style of the temples of Paestum. In France as in England it was not until twenty years later that buildings were raised in an austere style by the second generation of 'Greek' architects. As always it took time for a true revelation to be assimilated into a fully developed society. Hence that time-lag which interferes with our judgments. The majority of the works produced between 1750 and 1780 were still the result of compromising with the old views according to which antiquity was a single unit and Greece the initiator of Palladio's graceful style.

At the theoretical level, the major conflict of this period did not show itself principally in Italy and at Rome itself, but took the form of a three-cornered dialogue between Rome, Paris and London. The battle was fought mainly with a whole armoury of albums, but treatises and pamphlets extracted the lessons contained in the collections of documents. The advocates of pure Greek, who took their stand on the already mentioned compilations, included an important group of French theorists far in advance of the English Palladians — Caylus, who began publishing his *Recueil d'Antiquités* in 1752; J. D. Le Roy, the author of *Les Ruines des Plus Beaux Monuments de la Grèce* (1758); and Abbé Laugier who wrote in 1753 an *Essai sur l'Architecture*. From 1755 they had the support of the

56. DANISH. BERTEL THORVALDSEN (1770–1844). Mars and Cupid. *c.* 1810. *Thorvaldsen Museum, Copenhagen.*

famous Winckelmann's *Gedanken über die Nachahmung der griechischen Werke*. Confronting them there were above all the Romans, and first among these Piranesi, who was at once the author of the main ideological reaction against primitive simplicity and the forerunner of Romanticism through his depiction of ruins and feeling for the picturesque. *Prima Parte di Architettura* (1743), *Antichità Romane* (1748) and *Carceri* (1750) marked the calm affirmatory period of an attitude founded upon tradition. Ten years later *Della Magnificenza ed Architettura de' Romani* (1761) and *Parere su l'Architettura* (1765) were shots in a polemic war waged against adversaries comprising principally the Scots painter Allan Ramsay, who wrote a pamphlet entitled *The Investigator, a Dialogue on Taste*, and two Frenchmen, J. D. Le Roy and J. P. Mariette, the author of a letter-cum-programme published in the *Gazette Littéraire*. Truth to tell, the defenders of tradition were very weak, since they were at the same time the representatives of the new sentimentalism. Piranesi and Hubert Robert were closer to J. J. Rousseau (*La Nouvelle Héloïse* dates from 1761) than Winckelmann, Adam, Ledoux, Boullée and Brongniart. Piranesi waned during his last years.

In short, it would be fruitless to try to tabulate the champions of modernism and those of tradition. During the 18th century there was no single traditional school ignoring national boundaries on one side, and an innovating current responsive to a single inspiration on the other. Moreover the works, especially in architecture, were far from reflecting the state of doctrinal progress. As is natural the big commissions came from circles conservative by definition. For every avant garde monument there were a hundred academic ones. And as, in addition, the impetus of original invention found expression in highly conflicting attitudes that ranged from unadorned austerity to wild excess, it is no use trying to impose unity on

57. Self-portrait. 1804. *Musée Condé, Chantilly.*

58. Madame Moitessier seated. 1856. *National Gallery, London.*

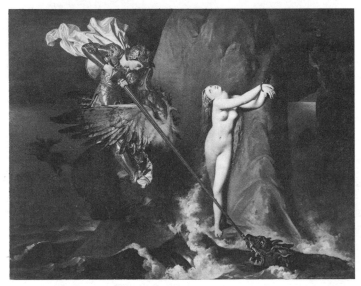

59. Roger Delivering Angelica. 1819. *Louvre.*

a movement that, both in time and in its variety, goes far beyond the rigid traditional notion of Neoclassicism. Without question more innovatory than Palladianism, Doric produced undistinguished works down to the middle of the 19th century. When one speaks of the return to antiquity, one habitually puts the 18th century back in the cycle of the Renaissance. It is high time to explore it as a revolutionary period. Besides being the century of the academies, it is the century of history. It is not the boudoirs and the mechanical beauty that have kept it alive; it is its discovery of historicity which implies not a return to the norms of purity, but a differential view of history.

If one also wants to appreciate not merely intentions but realities, it is advisable, nevertheless, not to look upon this century as the basis of the future. One cannot appraise art in terms of intellectual considerations or in relation to the subsequent development of history. Legitimate though it may be, the study of the main trends must not exclude consideration of individual works. In the picture of an age a place must be found

for those who achieve, as well as for those who promise. By thus combining an otherwise too exclusive consideration of the doctrines with an investigation of the positive contributions of the second half of the 18th century, we shall be able to get a more balanced view of it.

New vitality in architecture after 1750

Incidentally the study of artists and their works confines one to a definite time, while on the other hand the study of the great currents of ideas straddles frontiers and centuries. Though it is artificial to think in terms of a period or of a century, a generation enables us to determine the true creative capacity of men and milieux.

The first generation showing a real power to revitalise was, of course, the one contemporary with the publication of those books that in the course of time were to change the theoretical basis of figurative art.

However, whereas the great ideological currents at first appeared sporadically, and major works were produced even though other solutions were in the offing, the works themselves reflect a cultural atmosphere made up of complex or even contradictory tendencies. The case of Soufflot shows us that the discovery of Paestum in 1750 was not enough to support a new system of architecture. Back in Paris and entrusted with the construction of a big church on Ste Geneviève hill, Soufflot planned in 1757 and began to build in 1764 an edifice combining two formulas that, though clearly distinct, were both derived from the traditional principles of the Italian Renaissance. The dome is a Palladian rotunda and the portico a forceful interpretation of the traditional Vitruvian Orders, but the interior presents an austere appearance that makes use of great plain surfaces in a way which is reminiscent of Wren's St Paul's, and which could at that time be called classical. The one thing the Panthéon does not have is Baroque vitality — as is natural in a building designed by the man who was responsible for introducing the young Vandrières to Roman grandeur. In fact the most interesting thing about the Panthéon is the solution finally provided by Soufflot's successor, Rondelet, to a problem of balance that involved calling in new techniques: hence the interest lies in the absence rather than the presence of certain features of the reigning style. In any case Servandoni had already shown in 1733 in St Sulpice a desire for a severe style in architecture, with all the flowers and graces reserved for the decoration of private life. So it was that the split began to develop between high art and mere fashion, and for the first time a breach was made in a period's unity of taste. It is an important social phenomenon still lying heavy on art today, and a stylistic one that, contrary to what is thought, goes back a long way before the Revolution. In no sense a starting point, this was nevertheless a turning point at which the new ideas of the 18th century were selected. Furthermore a dual current, Palladian and classicist, likewise characterises English architecture of the years 1730–1750, with Burlington, Campbell and Kent. Sometimes we find a rotunda, sometimes, in spite of principles, a Vitruvian classicism. Sobriety everywhere, but no new spirit.

During the next decade the works of quality were those of Gabriel in France and the Adam brothers in England. It is easy

42

FRENCH. J. A. D. INGRES (1780–1867).
Mademoiselle Rivière. 1805.
Louvre. *Photo: Michael Holford.*

to say that Gabriel represents merely the last stage of classicism. In actual fact, his vast and poorly studied œuvre is a synthesis of all that was thought and built in Europe during a hundred and fifty years, from the chapel at Versailles to Garnier's Opéra: the Ecole Militaire (1751), as restrained as William Adam's Royal Infirmary at Edinburgh (1738); the Garde-Meuble de la Concorde (1754), as free from inessentials as James Paine's Wardour Castle (1770–1776); the Versailles Opéra (1753–1770), a synthesis of Louis XV decoration and the monumental Order; the Petit Trianon (1762–1764), in which Palladianism fades away because concealed plagiarism, such as that of Burlington's Chiswick House (1725) or the Assembly Rooms at York (1730), is replaced by a free interpretation no longer of imitated forms, but of rhythms and harmony. It is quite true that the Petit Trianon is the last building constructed according to the tenets of a musical geometry — the secret of Palladian architecture, as Wittkower has shown so clearly. It is quite true that the future belonged not to a musical, but to a visual and mathematical geometry, and that the Petit Trianon is the last flower of a long period of Western culture. But one cannot fairly contrast with it the Palladianism of Sir William Chambers' Casina at Marino near Dublin (1759–1769), which likewise has no share in the forms of the future, and lacks something of the Petit Trianon's personality and perfection.

In England, moreover, of the two great names of the generation active between 1750 and 1780, Chambers is rightly considered an eclectic despite his experiments, and in 1768 he and Reynolds founded the Royal Academy, an event that clearly marked the end of a way of thinking about art and form. As for the Adam brothers, they — with Clérisseau for decoration and with Chalgrin (St Philippe du Roule, 1774–1784) and Brongniart (Capuchin monastery) for Roman and Greek Doric — represent the second stage of assimilation completed by this generation, a stage corresponding no longer to the Palladian and classicist, but to the Greek, or at any rate Doric, phase, and they were active between 1758 and 1780. The last period of the Adams' activity, that of the great unrealised projects, continued till as late as 1792, and it coincided with Boullée's great projects, with the truly Doric creations of Ledoux or de Wailly, and with the buildings of Bélanger. At Bagatelle in 1778 the latter successfully employed a classicist Palladianism, which has been known since then in France as 'the English style'. The originality of the Adam brothers' work lies in its having been successively an architecture of country houses and one of terrace houses in London (the Adelphi). Far from contrasting, the developments of the French and English styles followed each other, and the disputes over priority gave way to a more profitable investigation of principles and solutions, and of their relationship to the needs of a developing society in which state commissions ceased to predominate, even in Marie Antoinette's Petit Trianon. It was in relation to the private individual of the 18th century that architecture, like interior decoration, really evolved.

As a matter of fact, it was in the field of decoration that a genuine advance occurred in England, Italy and France. In England the Pompeian trend directed by Robert Adam, Flaxman and Wedgwood, or the Etruscan fashion, and in France the Louis XVI style, resulted from the time lag between the public's fast-moving tastes and techniques that were over-traditional. To a far greater extent than that of Spalato, it was the lesson of the ancient houses of Pompeii that the public absorbed, much more because it filled a need than because of the ideas behind it which were only of interest to a narrow circle. Thus, round about 1775, the third stage of the Ancien Régime's last style came to fruition.

The triumph of Pompeian decoration in France as in England around 1775 accordingly marked the limit of the first Neoclassical generation's integration of the new ideas — or, if one prefers, of the Greek fashion. In actual fact the difference between Rome and Athens was composed by means of a compromise, since it was at Rome that Greece was going to be discovered. The conflict was settled as a question of taste; simplicity and purity in architecture defeated grandeur and emotionalism. Piranesi had a temporary set-back, and Romanticism was held back for another two generations. The taste for ruins showed itself mainly in the minor arts of decorative painting and garden design. Furthermore Rome, which had been overshadowed by London and Paris, now became once more an international centre of the first rank, and there around 1785 the art of David burst upon the world. It was he that, on the one hand, at last gave expression in painting to the ferment of modern ideas, and, on the other, marked the end of the movement we are studying.

David and dramatic painting

While historical ideas dominated the entire development of architecture and decoration from 1770 onwards, the figurative arts lagged behind. This certainly was not because the period lacked talent among either its painters or its sculptors. On the contrary, considered from the point of view of individual merits the real artists were painters and sculptors rather than architects — Chardin, Boucher, Fragonard, Hubert Robert and Reynolds on the one hand, Pigalle, Pajou, Falconet and Houdon on the other. It cannot be said that these artists merely prolonged the style of the past. Their original contribution was of very high quality, both in itself and in its direct impact on the century. In 1730 the researches of Bouchardon, a highly individual interpreter of the antique, foreshadowed the Greek-style purism and primitivism of the 1780s. *Cupid carving his Bow* expresses a slightly savage conception of antiquity, going beyond the marmoreal vision of Goethe's *Iphigenie* which came fifty years later. Moreover from 1750 onwards a great movement developed in France to replace the traditional iconography by a history painting as close as possible to life. And an artist like Vien, who was its spokesman about 1770, combined the Pompeian style and the fashion as far back as 1763 in his *Marchande d'Amours*. If we were describing the development of the arts in Europe during the 18th century, it would be necessary to give full coverage to the different movements that expressed exceptionally vividly the tastes and feelings of an age on the boil. The Pompadour style is not just a licentious boudoir art, for it stresses a merging of the different classes that had results of which we are not unaware. The contrast between the style of Reynolds or Gainsborough and that of Hogarth reveals the violence of the social conflicts produced in England by the development of a commercial and urban society that also supported the activity of the Adam brothers. Greuze's canvases and Diderot's art criticism show how the figurative arts shared the feelings expressed by Richardson and Rousseau. It is just as certain, however, that all these movements were different in nature from Neoclassicism. For they expressed new

60. GERMAN. K. F. SCHINKEL (1781–1841). Project for a palace on the Acropolis at Athens commissioned by Otto von Wittelsbach in 1832. View of the main room (1834). *Staatliche Museen, Berlin.*

ideas or feelings by means of a vocabulary — or, more precisely, techniques — derived from earlier forms of art. On the other hand Neoclassicism, which was infinitely less polished in technique and hesitant even in the search for its own principles, opened the way for a re-examination of the principles of art. Whereas this period's other forms — portraiture, landscape, genre, still life — thus prolonged the usefulness of the traditional vision by striving for improved quality of subject matter or execution, Neoclassicism raised the whole problem of the Renaissance. It opened the way for an historical speculation that a hundred and fifty years later has led us to differentiate between cultures. It involved reflecting on the question of the prototypes of beauty, which is to say that it has induced us, after one and a half centuries of strife, to separate the ideas of vision and representation, which are at the core of any discussion on aesthetics. That is why it is legitimate to give Neoclassicism a separate place in the development of art forms. From an aesthetical point of view, our roots are very largely in the 18th century.

Without David the Rome of the 1780s would not be one of the pivots of history. The little clique that gathered there around Pompeo Batoni, Raphael Mengs, Tischbein and Angelica Kauffmann would be quite forgotten. True, Gavin Hamilton, who was also a great connoisseur of Etruscan vases, had painted an *Andromache weeping over the Body of Hector* back in 1765, and David later remembered the gesture of one of his figures; true, Benjamin West had produced an *Orestes and Pylades* as early as 1756. But who would remember them any more than François André Vincent's *President Molé attacked by Frondists* (1779), if the Roman milieu were not being studied today because of David and his *Oath of the Horatii* (1785)? The showing of this canvas in the painter's studio at Rome was a remarkable event. Batoni wanted David to become the leader of an international Roman school. Instead David returned to Paris and made his own country one of the main creative centres of painting for well over a century.

The really new thing about David's *Horatii* was not the subject, which, be it noted, is Roman: Greek subjects only found their way into his work with *The Death of Socrates* (1787), *Paris and Helen* (1788) and *The Sabine Women ending the Battle between the Romans and the Sabines* (1794–1799) which is a Roman theme Hellenised by the treatment. As we have seen,

David was by no means the first painter to take his subject matter from classical antiquity. It is because the *Horatii* is not a narrative picture, but the thrilling expression of one dramatic moment, that it is so impressive. This being so, one ought to emphasise what David owed to the great French theatrical tradition of the late 18th century. With him Neoclassicism stopped being bookish and became visual. It no longer needed deciphering; it gripped like the climax of a fine play. Incidentally actors had considerable influence during the 18th century in England and France. Garrick, Le Kain and Talma established a bridge between the public and the decorative painters, who were really imbued with the modern spirit. Napoleon himself understood the importance of actors and artists in putting across a political view of history. David thus represents a new type of man for whom the expression of action was action itself. He is the first to have given utterance to something other than intellectual speculation, where the craze for antiquity was concerned. Logically he is at the same time the first revolutionary artist. Through David archaeological speculation became bound up with contemporary life.

David himself explained that in his *Horatii* he had used colour, the most physical element in art and the one that the spectator first notices, primarily to achieve plasticity. Thereafter he gave his whole attention to modelling, which he sought in the contrast of light and shadow, and to the nude, which he saw as a means of getting close, not to literature now, but to primitive reality. It was in his studio that the famous group of the Barbus was formed, whose members were the first to cultivate the primitive, which became one of the false myths of the 19th and 20th centuries. It was he, too, who formulated the proposition that true antiquity is identical with what is natural in all ages. His *Sabine Women* and *Paris and Helen* constitute the manifesto of 'Greek' painting, but it was by depicting young women from his circle that he managed to put life into the doctrine.

Thus the first Neoclassic generation had had the dispute over Greece and Rome as its main source of disagreement, while the second clashed over the relationship between culture and observation. The problem of Palladianism came to be replaced by that of nature. On one side there was David proclaiming that to vitalise a subject it was necessary to immerse oneself in real life, and on the other stood Quatremère de Quincy. According to this rigid theoretician, nature is non-existent and unknowable. It owes its manifestation solely to the artist's will. Sublime and severe, beauty can only be conceived by theory and approached by reason. One has to see what is, not as it is, but as it could and ought to be. The object of art is to represent an archetype, to paint or sculpt something that does not exist, but is the sum of the attributes of the ideal, isolated by aesthetic and moralising reflection. The one flaw in the system appeared on the day when, standing in front of a statue by Phidias in London, Quatremère's intellect caught up with Bouchardon's intuition and discovered, fifty years too late, a Greekness distinct from gracefulness.

Both as an artist and as an individual, David had more than one side to his character. As a politician he appeared partisan; but it was not because of this that, despite his extraordinary prestige and the influence throughout Europe of his studio, he was challenged during his own lifetime. There was perhaps not so much opportunism as has been supposed, if not in his decision to support the Empire, at least in the accentuation of his realism. Since *The Death of Marat* he had gone a long way 50 down this road, and we have seen that for him even the *Horatii* signified dramatic actuality, and that he treated it as an anecdote directly expressive through the effect of gestures and

61. FRANCE. La Halle au Blé, Paris, in 1786. Watercolour by Maréchal.

This first Halle au Blé, burned down in 1811, had been built *(1763–1767) open to the sky and had already been covered with a wooden dome (1783) and later (1809) with an iron one by F. J. Bélanger, who in 1811 constructed a second building on the site (the present Bourse du Commerce).*

expressions rather than the piling up of accessories. Thus as early as the revolutionary period David had in actual fact given up theorising about Greece to apply himself to the problem of the subject. And in that direction too he broke ground which proved exceptionally fertile, though he also marked the end of the vital period of international Neoclassicism.

Neoclassicism in the 19th century

Neoclassicism flourished everywhere. In Rome a new generation of artists replaced the old. It was chiefly the sculptors who now represented the strict cult of marmoreal beauty. Its high priest was Canova, whose fame eclipsed that of Thorvaldsen while the latter was still alive. For thirty years all over Europe Doric monuments and sightless statues were constructed. This movement continued well into the 19th century — indeed, right up to our own times. From the Russia of Thomas de Thomon to the America of Jefferson, via the France of Bosio and Pradier, the England of Soane and Westmacott, and the Germany of the Nazarenes, of Langhans, Schinkel and Klenze, builders of museums, triumphal arches or palaces at Berlin, Munich and other places — everywhere the Neoclassical movement was distorted into academicism. Winckelmann and Quatremère had won the day: a series of forms, derived from one another, was developing as part of a purely conceptual doctrine of beauty. There was no more room for feeling, which the developments of Romantic art now satisfied. A division thus occurred between forces that at the start had jointly inspired the pioneers. The moment was to come when Cornelius and other German painters proclaimed that it was definitely not good for painting to be coloured.

However, it is not true that Neoclassicism ended abruptly at the time of the French Revolution because it was betrayed by David, who became merely the chronicler of the opportunist Napoleon. It is a mistaken view that only includes academicism in all its varied and persistent forms, either to praise it or to condemn it. There exist at least two series of works that arose out of the Neoclassical tradition and formed crucial stages in the development of international art at the beginning of the 19th century. They thus provide the means of assessing the third Neoclassical generation.

Ingres, a pupil of David, extended and renewed his master's art, and showed that he alone was capable of developing along original lines a movement threatened, as regards facture, with stagnation. Neoclassicism's downfall was the interpretation of it as a doctrine capable of laying down standards applicable to individual creation. Trained in David's studio, Ingres on the contrary brought a personal vision back with him from his twenty-year stay in Italy, where he was entirely aloof from political activity and academic strife. David used line to establish the contours of real objects and thought it entirely dependent on the model; for Ingres line conveyed an impression received by the beholder and was not a natural reality. David based his style, not without hesitation, on anatomy, whereas Ingres regarded the visible as the only thing that concerned the painter. Certainly it was to works by David such as the *Mme Récamier* that Ingres went for his inspiration. It would be wrong to set in opposition two great artists who together represent the figurative outcome of the great Neoclassical adventure. The lesson of their joint experience is that a more attentive study of the works of the past leads, not to the outward imitation of forms, but to a deepening of the intellectual and sensient relationship between the artist and his work, and between the work as well as the artist and nature. Thus from Neoclassicism have sprung both the most tedious academicism and the most exciting experiments of our time.

The second movement to have issued from Neoclassicism at

54, 155
37, 60

122

57–59

62. FRANCE. HENRI LABROUSTE (1801–1875). Large
Reading Room at the Bibliothèque Nationale, Paris.
1862–1868.

*Iron and cast-iron, already used by him in the Paris Bibliothèque
Ste Geneviève (1843–1850), here reduce to a minimum the use
of supports.*

the beginning of the 19th century, and in which appeared one
more creative development, occurred in the domain of archi-
tecture. Here again all the trends involving too direct an inter-
pretation of past forms, no matter what these were, led to
sterility. In itself, Doric was no more creative than Palladianism.
And the Pompeian style of decoration ran dry as soon as it ceased
to foster original invention and turned into the basis for manu-
factured wallpaper. Neither the Arc de Triomphe nor the
Brandenburg Gate adds anything at all, where form is con-
cerned, to the wealth of nations. They are monuments of
literature or national history, not of art.

On the other hand, among the many visitors to the ruins of
Paestum or Greece, and among the many architects called upon
to build countless more or less 'antique' domes inspired by
Baalbek or the Baths of Caracalla, there were one or two who
took the trouble to consider the problems of construction, and
who saw that, to begin with, antique architecture was not
imitation nor divine inspiration but a technique. The dis-
cussion started in Paris in 1796 by the founding of the Ecole
Polytechnique, which opposed the Ecole des Beaux-Arts,
dependent on the Académie, marks the crucial moment in the
history of modern architecture. Some, like the American
Jenney, passed through both schools before creating the modern
skyscraper in their own country. Before them Labrouste in
62 France built the Bibliothèque Ste Geneviève and the Biblio-
thèque Nationale, public buildings so bold that they opened a
new era of international architecture. Brunet who constructed
61 the Halle au Blé in 1811 from designs by Bélanger, Renard
who erected the iron truss over the Salon Carré of the Louvre
in 1798, Seguin who constructed the suspension bridge across
the Rhône at Tournon in 1824, John Nash who transformed the
Royal Pavilion at Brighton in 1815–1821, Telford who
designed an iron bridge to span the Thames in 1801, Paine and

Burdon who began their Sunderland Bridge in 1793, and A.
Darby who began his iron bridge over the Severn in 1775 —
these were the real initiators of an intellectual revolution that
led to the idea of functionalism, and started the whole com-
plicated evolution of modern architecture. An essential part
was also played by books of drawings of different buildings,
such as those of Krafft and Ransonnette in France. They under-
line how important for the development of the characteristic
appearance of the modern town was the movement started in
the 18th century by the Adam brothers with the Adelphi and
by Louis at the Palais Royal with the object of setting a standard
for mansion blocks. Experts on town architecture, who, more
often than not, seem to deal only in plans and elevations, have
so far failed to present us with the story of the human habita-
tion, which should be the chief concern of a history of archi-
tecture. It is surely high time to take the history of art forward
from a stage corresponding to that of a history in terms of
kings and battles so as to get closer to true scholarship and real
life.

Thus, it appears that the very unexpected conclusion of Neo-
classicism was entirely opposed to its premises. Yet this proves
its real importance in history. Proceeding from an academic
dispute over the respective merits of Palladianism and an
inadequately known Greek antiquity, it certainly nurtured
pedants who still debate the intrinsic merits of fixed forms.
But it did not just give rise to an academicism, and it is not just
a false problem. It also led critics and artists to realise that the
past was not one and indivisible; it opened people's eyes to the
nuances of history. And, finally, it helped — perhaps more than
Romanticism which was for the most part literary — to prepare
the way for the preoccupations of 20th-century artists, now
speculating on the relations between function and form in
architecture, and between vision and style in the figurative arts.

THE ROMANTIC MOVEMENT *Marcel Brion*

*Like a forest fire Romanticism spread over the whole of Europe.
The Germanic or northern peoples welcomed it as a way of
expressing all the wild forces that had been repressed in them
since the Middle Ages. As they freed these forces they also
delivered the Middle Ages from the contemptuous oblivion in
which it had been buried. But France, which was playing a leading
part in Neoclassicism, contributed some of the finest achievements
to a new movement that seemed at first to run counter to France's
inclinations.*

'The word Romanticism means modern art — that is, intimacy,
spirituality, aspiration for the infinite expressed with all the
means open to the arts' (Baudelaire). 'If by Romanticism is
meant the free manifestation of one's personal impressions I am
a Romantic, and not only that, but I was a Romantic at the age
of fifteen' (Delacroix). 'Not for me the finite but the infinite'
(Préault). 'A man contemplating the magnificent unity of a
natural landscape becomes aware of his own smallness and,
feeling that everything is a part of God, he loses himself in that
infinity, giving up, in a sense, his individual existence. To be
engulfed in this way is not to be destroyed; it is to gain: what
normally one could only perceive with the spirit almost becomes
plain to the physical eye. It becomes convinced of the unity of
the infinite universe' (Carus). 'God is everywhere, even in a
grain of sand' (Friedrich). 'I advance through a sea without
shores or bottom' (Fuseli).

These texts, chosen to reveal the diverse facets of Romantic
art and to throw light on its ruling spirit, are more eloquent
than any commentary; and unless one has absorbed them, one
cannot fully understand the spiritual principles, human feelings
and aesthetic ideas that have ensued from it. For Romantic art
presents itself as an extremely new phenomenon, based on a
determination to break completely with both classicism and
Rococo. Socially a new man had been born of the political
upheavals and violent currents of ideas that had marked the end
of the 18th century. He wanted forms as free of tradition as the
new structure of society was. But, as often happens in the
history of ideas and forms, this appetite for novelty was
directed back towards the distant past out of hostility to the
recent one. To return to the Middle Ages and establish a neo-
medieval period was to break off all relations with Rococo.

The nostalgia for the Middle Ages

It was not only in a spirit of antagonism against the recent past
that Romantic man reached out towards the Gothic age. Above
all it was because, having effected the great breach, he wanted
to restore the lost unity, to rejoin that unanimous medieval
Europe, to create within himself the thought and feeling of the
bygone centuries. In this his individuality asserted itself at the
same time as his national spirit. The sham cosmopolitanism of
the 'Age of Enlightenment' was succeeded by a strong and
genuine sense of nationality, fed by the most invigorating well-
springs of the race. The nostalgia for what had been lost, for the
fresh, pure spirituality of the Middle Ages, for its joyous and
abundant fantasy, for sentiment lording it over reason, led to
the idealisation of those centuries that classicism described as
dark and that for the Romantics 'were illuminated by the
brightest and warmest of lights'.

With his *Génie du Christianisme* Chateaubriand fired people's
imaginations and brought them back to the ardour of medieval
piety, which was so rich in shades of feeling and thought

beside the 18th century's scepticism and pragmatism. A Catholic
revival flowered brilliantly, above all in France and Germany.
The Congrégation was founded in 1819, and the Jesuits were
re-established in 1814. Montalembert combated vandalism in
art and showed the kinship between Catholicism and the great
medieval concept of beauty. In Germany the celebrations in
honour of Albrecht Dürer, held at his house in Nuremberg
during 1828, confirmed the tendency to consider this painter
the most complete representative of medieval art, as had already
been done by Wackenroder in 1796 ('Homage to Albrecht
Dürer' in Reichardt's review *Deutschland*), and by Goethe in
his 'Hymn to German Architecture', where Dürer and the
Gothic are closely associated.

At the same time, there was a return to the poetic texts of the
Middle Ages — the *Chanson de Roland* in France, the *Nibelung-
enlied* and the Minnesänger in Germany, and the bogus
Ossian in Britain, which provided both subjects for artists and
a new moral and spiritual conception of the world. If people
went back to the Middle Ages, it was not, as in Orientalism,
because of an inclination to get away from their normal sur-
roundings, but so as to reach the essential source of European
thought and art. Schlegel, Tieck, Novalis and Herder had
an influence in Germany like that of Chateaubriand in France
and of Thomas Percy and Macpherson in Britain.

This return to the Middle Ages, to its religiosity and the
Christian unity represented by pre-Reformation Europe,
involved the conversion to Catholicism of a great many
Protestant artists, especially in Germany. Interest in the thought
and feeling of the Middle Ages was continued with a desire to
save what remained of the monuments from that period and to
restore them faithfully. The brothers Sulpiz and Melchior
Boisserée began their collection of medieval art at the moment
when the work on Cologne cathedral, which was regarded as
the centre of German culture, became the focus of people's
curiosity and enthusiasm. Lenoir gathered together in the
Musée des Monuments Français, which he founded, the re-
mains that had escaped the fury of the Revolution, and even
earlier Soufflot had in 1741 praised the great learning of the
Gothic architects, their boldness and their ingenuity; and in
1760 the Académie d'Architecture entered upon a methodical
study of Orléans and Strasbourg cathedrals. In 1845 opinion
had been won over, and Lassus wrote: 'For us Gothic art is a
fully developed language and the only one a French artist
should use to express his ideas.' Visits to the Petits Augustins
monastery where Lenoir had collected together a large quantity
of medieval sculpture, and the Jardin Elysée monastery where
Gothic tombs were on view in an appropriate sentimental
setting amid the weeping willows and cypresses, did much to
form the Romantic sensibility. The restoration of buildings

**63. FRENCH. ANNE LOUIS GIRODET-TRIOSON (1767–1824).
Burial of Atala. 1808. *Louvre.***

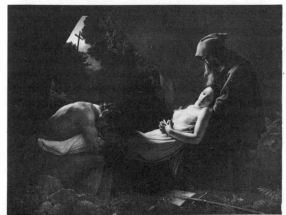

64. BRITAIN. CHARLES BARRY (1795–1860) and AUGUSTUS PUGIN (1812–1852). Palace of Westminster, London. Rebuilt in the Perpendicular Gothic style after the fire of 1834.

65. FRANCE. F. C. GAU (1790–1853). Ste Clotilde, Paris. 1846.

66. GERMANY. E. RIEDEL (1813–1885) and G. VON DOLLMANN (1830–1895). Schloss Neuschwanstein, Bavaria. Built for Ludwig II from 1869.

from the Middle Ages gave this sentimental tendency the support and reinforcement of the technical excellence and aesthetic perfection of medieval architecture.

The return to the Gothic

Naturally enough it was the restorers at that time who became the advocates and propagandists of this return to the Gothic. Romantic architecture did not create its own style, except perhaps in some of the detail; it contented itself with more or less successfully repeating the Gothic, the object of a universal craze. There was far more originality and real novelty in the Neoclassicism of Ledoux and his successors, above all Lequeu: the gigantic scale of their buildings is a romantic excursion into an archaic world. The repairs carried out by Debret at St Denis, by Alavoine at Rouen, and by Duban on the Sainte Chapelle led to the building of Ste Clotilde by Gau in 1846. To Gau, as 65 to Godde and Lesueur (Hôtel de Ville) or Labrouste (Bibliothèque Ste Geneviève, Bibliothèque Nationale), creating meant 62 copying. The copyist makes a virtue of renouncing invention, and Gau found in metal construction a convenient medium for imitating Gothic structures. Sometimes restoration and original creation merged, as in much of the work by Viollet-le-Duc, whose good intentions mixed the faithfulness of genuine restoration with the fantasy of personal interpretation. In architecture as in literature there was a tendency to be more Gothic than the real thing, to carry idealisation to the point of creating a myth of the Middle Ages (Victor Hugo with his 1 drawings and *Notre-Dame de Paris*, Aloysius Bertrand, the troubadour style, the *romans noirs* of the minor Romantics).

German architecture remained for a very long time under the stern domination of the antique. Berlin took pride in being known as 'the Athens of the Spree', and Munich wanted to have Propylaea like Athens. Winckelmann, the founder of the classicist cult, encouraged a large group of architects all much taken with the Greek Orders which they used repeatedly. For the monument to the glory of the German spirit and people, characteristically called 'Walhalla', Leo von Klenze could 194 think of nothing better than an imitation of a Greek temple. With Gottfried Semper the excessive devotion to antiquity changed into a new interest in the Italian Renaissance, which marked a stage in the journey back to the Middle Ages. Demmler, Forsmann and Rösner arbitrarily combined Renaissance and Gothic. Ziebland reproduced the early Christian style in his Bonifazius Basilika at Munich; but the poetry of the Middle Ages flowered in the castles that J. D. Ohlmüller built 186 for Ludwig I of Bavaria — Hohenschwangau among others — and this partiality for Gothic themes and forms also animates the creations of Georg Moller and K. A. von Heideloff. Germany's 'archaeologising' architecture remained attached to the copying of the Romanesque, Gothic or Renaissance, and even to an eclecticism that produced hybrid styles, as in F. von Schmidt's Vienna Rathaus or the Kaiser Wilhelm Memorial Church in Berlin by F. Schwechten. The Votivkirche in Vienna, designed by Heinrich von Ferstel, is a pastiche as devoid of character as Ste Clotilde at Paris.

English Gothic had never completely lapsed, even at the height of classicism, and in the late 18th century it had undergone some curious revivals. But the characteristics of Rococo — whimsicality, exaggeration, imbalance, overdecoration and disrespect for the basic structures, to say nothing of leanings towards the Orientalism that characterises Beckford's *Vathek* — really created a new Gothic in the houses built for Horace Walpole (Strawberry Hill) and Beckford (Fonthill). There was no archaeological bias there, no scruples about being true to the forms and spirit; the Gothic constant led to fantasies

worthy of 'opium eaters', to a captivating and amusing originality, which both disclosed the *fin de siècle* decadence of English Rococo, and foreshadowed a serious renaissance of Gothic.

A spiritual movement corresponding to that of the *Génie du Christianisme* in France and to the theories of Wackenroder in Germany on the interpenetration of religion and art developed in England through the influence of Pusey and the Ecclesiological Society and of the architect Augustus Pugin and his son A. W. N. Pugin, whose love of Gothic led him to become a Catholic. A great many Gothic churches were built in England, and also in the United States. Sir Charles Barry and A. W. N. **64** Pugin designed the new Houses of Parliament in the pure Perpendicular style, and Sir G. G. Scott, with many interesting neo-medieval buildings to his credit, deserved the title 'Europe's most important Gothicist'.

A pictorial and literary sculpture

Romantic sculpture appears to have been irrevocably condemned by the uncompromising attitude of Mme de Staël, who contrasted the 'Christian art' of painting with the 'pagan art' of sculpture, and also by Théophile Gautier's verdict: 'Of all the arts, the one that least lends itself to expressing the Romantic idea is undoubtedly sculpture. It seems to have received its final form from antiquity . . . Every sculptor is inevitably classicist. He is always wholeheartedly of the Olympians' religion.' The English Neoclassical sculptors bear out these incisive words, as do most of the Germans. But one must set apart from German academicism such a genuine artist, moving and refined, as **157** Gottfried Schadow, whose tomb of Count von der Mark (Dorotheenstadt church, Berlin) has the touching grace and plastic beauty of an Italian Renaissance tomb without being a pastiche, and even Ernst Rietschel, who designed the monument to the Reformation at Worms. The colossal statues, such as Hugo Lederer's Bismarck, are purely Romantic in having something of the gigantic and archaic qualities of the old medieval epics.

France created a Romantic sculpture that corresponded to her own personal sense of form. But after the classicists the approach was pictorial and picturesque, and even the best works, by sculptors from Rude to Rodin, are not free from 'literary' traits. The sculptors of this period read Shakespeare, Byron, Chateaubriand and Goethe, and were eager to illustrate passages from *Atala*, *Faust* or *Don Juan*. They readily turned towards the past and dreamed of representing the entire history of France. This accounts for the programmatic historical sculpture of **13, 68** Triqueti, Jean Bernard du Seigneur, Marochetti and Félicie du Fauveau, and for the invention of neo-Gothic pastiches and fantastic scenes — *Fighting Gnomes*, *Journeying Sprites*, *Witches' Sabbaths* — that Louis Boulanger composed in the spirit of *Gaspard de la Nuit*. An interpreter of the revolutionary and **69** Napoleonic epic, Rude was closer to the actual contemporary **447** world. Like Carpeaux, who analysed the charms of the Second **73** Empire, like David d'Angers, who portrayed all the contemporary glories with a very exact sense of grandeur, like the 'primitive' — as we should now say — Graillon, a self-taught **10** sculptor devoted to representing popular scenes, like Daumier and Dantan, both fierce critics of all the ugliness and stupidity **20, 74** of their times, Auguste Préault required sculpture to express the social thought of the 19th century, without, however, rejecting every link with the Middle Ages. At this period when small-sized sculpture — statuettes — was popular, and when large-scale works were themselves treated with a wholly pictorial minuteness that made them seem smaller, Préault dreamed of sculpting mountains. In 1865 he tried to interest Napoleon III

in his scheme for turning one of the Auvergne *puys* into a monument to the glory of Gaul. 'Grant me a mountain-peak. I shall take a volcanic *puy* towering over the heart of France and transform it into the acropolis of Gallic civilisation. I shall build from the foot to the summit a spiral way broad enough to allow the passage of an army or multitudes of people.' Huge bards and druids 'in brass, bronze, stone, granite or a dark material that weathers' were to demonstrate that appetite for

67. FRENCH. ANTONIN MOINE (1796–1849). Queen Marie Amélie, wife of Louis Philippe. Marble. *Musée Carnavalet, Paris.*

68. FRENCH. FÉLICIE DE FAUVEAU (1799–1886). Louise Favreau monument. 1856. Sta Croce, Florence.

69. Marshal Ney. Bronze. 1852–1853. Place de l'Observatoire, Paris.

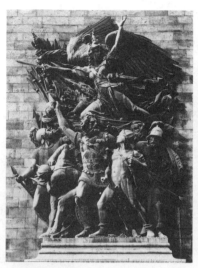

70. The Departure of the Volunteers in 1792. 1835–1836. Arc de Triomphe de l'Etoile, Paris.

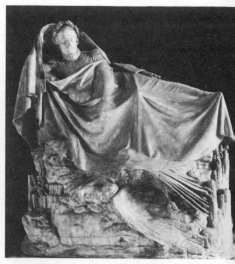

71. Napoleon Awakening to Immortality. Original plaster cast of the monument in bronze erected at Fixin, near Dijon in 1847. *Louvre.*

the colossal which we shall meet again at the end of Romantic sculpture, in Rodin's *Gate of Hell* and *Tower of Labour*. Beside the craftsmen who meekly decorated pseudo-Gothic daggers and silver ewers in the troubadour style, Préault's strong and over-emotional humanitarianism and his passion for exaggeration together made him a Romantic character *par excellence*. He took as subjects *Famine*, the *Pariahs* and, in his *Slaughter*, the horrors of war. In the religious sculpture of the period he was the only one not to lose his vigour in sentimental piety, and his *Christ* for the church of St Gervais et St Protais, hiding his face behind his arm, is among the most dramatic and moving successes of sacred art.

When Romantic sculptors consented to forget history, literature, the Middle Ages and the troubadours, their work acquired a forcefulness and originality that were not always acceptable to the tastes of the public and the officials dealing out

11 commissions. Barye's idea of using animals in sculpture no longer as accessories to human actions, but for themselves and for their own dramatic value, drew violent criticism down on his head. In Neoclassical sculpture animals were anecdotal or allegorical; Romanticism gave them back an epic grandeur, and all the more so as the fashion for things exotic required that an interest be taken in the wild-life of the jungle, the savanna

91 and the desert. Anglophile and passionately fond of horses, Géricault learned to carve stones in order to create his Barbary steeds in three dimensions, while Barye, a great reader of Buffon and a regular visitor to the natural history museum,

72 devised fabulous combats between elephant and tiger, lion and snake, much to the annoyance of David, who held it against him that these beasts were not 'conceived scientifically'. Julie Charpentier, too, was trained at the museum where, to earn her living, she worked at preparing and mounting stuffed animals. Her scientific knowledge ensured the strict accuracy of the bas-reliefs that she composed to decorate the plinth of the famous elephant 45 feet high erected by Bridan at Napoleon I's command in the Place de la Bastille.

69 The lyrical vigour of Rude, the sinuous, almost musical suppleness of Carpeaux, the mixture of the grand manner and

73 phrenology, according to Gall, of David d'Angers' portraits, and even the imagination of pleasing minor masters such as

Moine, Maindron, Fratin and Pradier, save Romantic sculpture 67, 155 from undeserved disrepute. Cathedrals reduced to the size of clocks, ogival centre-pieces, bogus knights in unglazed porcelain and sickly-sweet heroines in gilded zinc, produced by electroplating and reduction copiers, demonstrate that sculptors too often became purveyors of the 'troubadour style' which to us is touching but deplorably sentimental and of a feebleness of execution that betrays the bad taste of the period. However, the fact that the same period produced some beautiful and genuine works, above all those of Préault, is enough to save it 74 from being called mediocre. And if the Romantic sculptor too often sought effects of light and colour that lie within the competence of painting, it was because the goal of Romantic artists was a synthesis of all the arts, with poetry, painting, sculpture and music all contributing, which produced some most regrettable results.

French painting and the glorification of reality

Sculptors strove to imitate the effects of painting because the latter at this period enjoyed a predominance explained by the very nature of the Romantic sensibility, of the passions that quickened it and the feelings it aroused. During the 18th century Young, Voss and Rousseau ushered in a new way of looking at nature and of picturing man's place within the universe. Watteau and Fragonard in painting and Mozart in music aroused anxieties and awakened nostalgias that were Romantic. The 18th century ended in a mixture of spiritual anguish, physical hedonism and political and social reforms that threw into confusion the relationship of the individual with the world. The repercussions of European events — revolutions, the Napoleonic wars — transformed the artist's spirit and offered him brand-new themes. David's Neoclassicism became flexible in order to interpret contemporary happenings, and the *Coronation of Napoleon* is a great page of 51 modern history; but to the Romantic painters the historical document mattered less than the feeling flowing from it. Baron Gros succeeded in giving the Napoleonic epic that superhuman 84 and almost supernatural quality corresponding to Napoleon's place in the popular imagination. The radiantly god-like figure riding the battlefield of Eylau, or standing among the plague-

stricken at Jaffa in the stiffly heroic stance of a miracle-worker, was the focus of a whole mythology which continued as paintings, drawings and Epinal prints down to Charlet and Raffet. An important part of Romantic art in France developed around the Napoleonic legend with the same strength and brilliance as the 'sun' legend of Louis XIV at Versailles. Gros was the eager sincere high priest of this living myth which overshadowed the idyllic painting of Girodet, Guérin, Gérard and even Prud'hon. The latter's work was still imbued with a certain 18th-century spirit applied to twilit fantasies and wonderful chiaroscuro effects that revealed a lunar melancholy quite different from the one that had bathed in its russet gold the late afternoons of Watteau.

Wars and revolutions threw up new ways of feeling — dramatic ways heightened with passion and paroxysm which impelled the individual to study the tragic and unusual sides of life. The extraordinary complexity of Géricault — who would have appeared even more astounding if, instead of dying at the age of thirty-two, he had been able to complete an œuvre that opened up so many new paths — is the most striking example of Romanticism, and what is actual, living and dynamic about it. Géricault was not a history painter, as were Devéria, Delaroche and Scheffer who were more interested in costume and accessories than in emotional truth. His *Raft of the Medusa* is not a piece of reporting but a symbol of human destiny, and that is why it aroused so much enthusiasm, surprise and anger. Delacroix saw his future as a painter take shape before this great, tumultuous canvas, in which appeared the principle of a new beauty that even the Baroque masters had been unable to achieve. To capture the beauty of the uncommon and horrific which Géricault sought in his portraits of the insane and in his studies of heads severed by the guillotine became one of the chief aims of the young school, in reaction against the Neoclassicists' ideal beauty and the graceful beauty of Rococo. A great lover of racing and an accomplished horseman, Géricault found in the horse the combination of dramatic and ideal beauty that he could not give to man, except perhaps in his portraits of officers of the imperial army, which have a kind of heroic and legendary splendour. Realism was an essential ingredient in the Romantic appeal to the emotions since the story of Napoleon had proved more fabulous than any legend, and since by means of naturalism the Romantics hoped to be able to express the supernatural. Expressiveness was the sole raison d'être of form; and the more expressive form became — in other words, the more dramatically vivacious it was — the more it fulfilled the requirements of the new aesthetic.

Among these requirements was one that accorded well with the taste for exaggeration, namely the desire to compose great decorative ensembles. Delacroix satisfied it in the Palais du Luxembourg, in the Palais Bourbon and in the Chapelle des Anges of St Sulpice; Chassériau satisfied it in the Palais d'Orsay, in St Merri and in St Roch. Géricault did not have this good fortune, but his *Raft of the Medusa* allows us to imagine what might have been. France would have had a giant of Romanticism had he lived longer and overcome the hostility that his easily offended nature aroused.

Théodore Chassériau also died before his time, at the age of thirty-seven. He had been a pupil of Ingres, and a whole section of his work, distinguished by a pure and lyrical grace, continues the Ingres manner on a Romantic level to which Ingres himself had not carried it. Properly considered, however, Ingres is a model of false classicism, driven by the vigour of his imagination and temperament to burst the aesthetic boundaries within which he tried to confine himself. Infinitely varied, he gave a higher artistic status to the troubadour style in his *Paolo and*

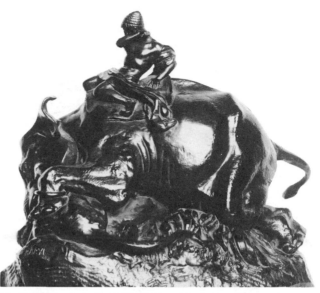

72. FRENCH. A. L. BARYE (1796–1875). Indian Mounted on an Elephant Vanquishing a Tiger. *Louvre.*

73. FRENCH. P. J. DAVID D'ANGERS (1788–1856). Nicolo Paganini. Medallion. *Private Collection.*

74. FRENCH. A. A. PRÉAULT (1810–1879). The Slaughter. Bas-relief. *Chartres Museum.*

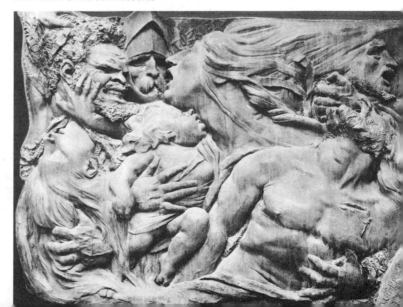

FROM NEOCLASSICISM TO REALISM VIA ROMANTICISM

FRANCE **BRITAIN** **GERMANY**

Beginning of the 19th century

75 76 77

First quarter of the 19th century

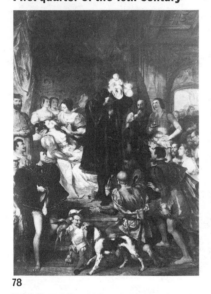

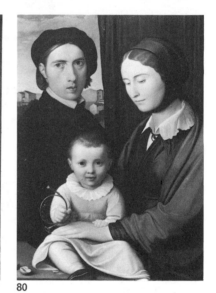

78 79 80

Middle of the 19th century

81 82 83

46

Francesca. The *Dream of Ossian*, which he painted to please the emperor, a great reader of Macpherson, in the room where Napoleon was to sleep at the Quirinale, is in its own way a Romantic masterpiece for the same reasons as the *Raft of the Medusa* and the *Death of Sardanapalus*. Taming with a great effort a romantic nature, Ingres, like Goethe, made Neoclassicism a controlled Romanticism.

Chassériau had even stronger sensuous longings than Ingres, and it is understandable that during the latter part of his life he moved closer to Delacroix. Baudelaire, in a fit of injustice provoked by his passionate admiration for Ingres, accused Chassériau of imitating him. This was far from being the case, for in every facet of his work, whether it be the portrait of Lacordaire or of the two sisters, the *Marine Venus* or the pictures with Oriental subjects, he remains completely original, and it can even be said that in what little survives of the Palais d'Orsay frescoes he is a finer decorative artist than Delacroix.

Delacroix, however, had a wider range than any of his contemporaries. Highly cultivated, widely read and with writers and musicians among his closest friends, he dominated the art of his time, and his spirit, at once feverish and orderly, restless and firmly based on a strongly personal aesthetic, was able to absorb the most diverse influences and to use them in the service of one of the most varied talents painting has ever produced.

Like a mirror, the spirit of Delacroix received and reflected all the passions that stirred his age: the revolutionary liberalism of *Liberty Guiding the People*, the philhellenism of the *Massacre of Chios*, the sombre pessimism in *Dante and Virgil Crossing the Styx*, the historical medievalism in the *Battle of Taillebourg*. He invented Orientalism, and in 1832 his first journey to Morocco marked the beginning of that fashion for Algeria, Morocco, Moorish Spain and Moslem Egypt to which we owe a whole exoticism in the decorative arts just as arbitrary as the chinoiseries of the previous century.

By means of movement, which Romantic artists succeeded in capturing and in which feelings become passions, Delacroix expressed the dramatic stirrings deep inside the individual. To movement he added the iridescence of a palette enriched by every shade of emotion and the warmth of a fluid fiery colour ensemble that sparkles with the clarity of precious

75. F. P. GÉRARD (1770–1837). Psyche Receiving Cupid's First Kiss. Salon of 1798. *Louvre.*

76. W. BLAKE (1757–1827). The Entombment. Pen and watercolour. *c.* 1800–1810. *Tate Gallery.*

77. P. O. RUNGE (1777–1810). The Painter's Wife and Son. 1807. *Staatliche Museen, Berlin.*

78. EUGÈNE DEVÉRIA (1808–1865). The Birth of Henry IV. 1827. *Louvre.*

79. R. P. BONINGTON (1802–1828). François I and Margaret of Navarre. 1827. *Wallace Collection, London.*

80. J. F. OVERBECK (1789–1869). Self-Portrait with Wife and Child. *Behnhaus, Lübeck.*

81. T. CHASSÉRIAU (1819–1856). Peace. Fragment of the decoration of the former Cour des Comptes, Palais d'Orsay, Paris. 1844–1848. *Louvre.*

82. J. E. MILLAIS (1829–1896). The Return of the Dove to the Ark. 1851. *Ashmolean Museum, Oxford.*

83. A. FEUERBACH (1829–1880). Musicians. Detail. 1854–1855. *Private Collection.*

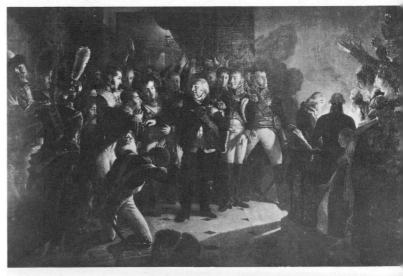

84. FRENCH. JEAN ANTOINE GROS (1771–1835). Louis XVIII Leaving the Tuileries during the Night of 19th–20th March 1815. Salon of 1817. *Versailles Museum.*

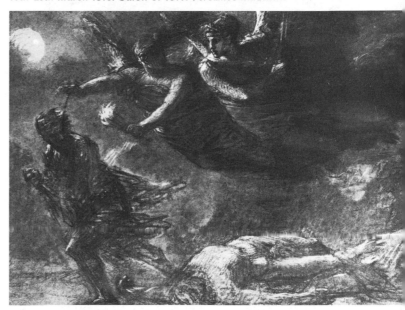

85. FRENCH. PIERRE PAUL PRUD'HON (1758–1823). Crime pursued by Vengeance and Justice. Preparatory drawing. *Louvre.*

86. FRENCH. T. GÉRICAULT (1791–1824). The Homicidal Maniac. *Musée des Beaux Arts, Ghent.*

21, 22
28–32
87
0–103

stones. Flesh, fabrics and the fur of animals burn with vitality, and matter is given all the splendours of the spirit. Reality is transfigured and exalted in the heroism of combat. A new world opens out in which the organic rhythms have a broader flow. Delacroix was an admirable painter of 'pieces' in the best tradition of Rubens and the Venetians, whom he studied in copies that have an inner vibrancy all his own. The subject of a painting, even a still life, is where an inner struggle is taking place between spirit and form, being and becoming. Everything was marvellous to his senses and sensibility, everything miraculous; and though the spirit never broke free from the flesh, though the angel of St Sulpice is, like Jacob, an earthly wrestler without a mystic aura, and though his religious art never rose above human emotions, Delacroix still attained a level of grandeur unequalled by any of his contemporaries. The resources of a learned art resulting from an alchemy of light, colour and form never dreamt of before him wrap his entire œuvre in a new mystery. He explored the highly adventurous paths of modern art with a boldness, certainty and thoroughness that harmonised with a proud reserve and an ardent love for the appearance of things and for the secret life that dominates them.

A new relationship between man and nature

Like all the artists of the period, Delacroix was affected by the English exhibition of 1824 which revealed to the French a relationship between man and nature which was quite new to them. Romanticism substituted the emotive for the decorative landscape; Watteau, Fragonard and Hubert Robert had known the emotive landscape but had not yet freed it from the presence of human beings. The fashion for dioramas at the beginning of the 19th century, following the peepshow pictures so numerous in the previous one, introduced a new conception of space, a combination of perception of reality and illusion which was to have an influence on landscape painting. Aligny and Berlin were still dominated by Poussin's classical and Baroque aesthetic, but their image of nature was simpler and without dramatic emphasis. Corot's simplicity of *matière* and colouring touches a primordial harmony emanating from the heart of things that we find again in the works of Georges Michel. More 'romantic' in the usual sense of this word, a landscape by Paul Huet is a less pure, less reserved 'state of mind'. It contains latent drama; anxiety inhabits its plains and forests in a stormy atmosphere whose pent-up violence is sometimes agonising because of all the repressed anguish one senses there. With Daubigny, Rousseau, Diaz, Dupré and Troyon the landscape became a glowing fragment of nature, the thick impasto gently filled out the forms, and the light combined with the colour to heighten the inner poetry. Working directly from nature promotes a lyrical communion between the artist and the world. Nature is no longer just seen but totally experienced, embraced by all the faculties together, and so acquires fuller, more complex resonances. Nature thus lends itself to a subjective approach that gives it the means of expressing human passions; and Douanier Rousseau's virgin forests and van Gogh's swirling cypresses and agonised stubble-fields are the supreme outcome of this romantic fusion of the artist and the landscape in an embrace where man and things lose their separate identity.

This exploration of the world by means of fantasy prepared the painter to recognise another reality, felt rather than seen, which the illustrator tried to match with the poet's imagination. Victor Hugo's drawings, executed almost in a state of grace with the materials available to the visionary at that particular moment — coffee-dregs, a cigar-butt — express an inner vision

87. FRENCH. EUGÈNE DELACROIX (1798–1863). Liberty Guiding the People. 1830. *Louvre.*

for which the objective reality of things simply provides a base. Draughtsmen such as Louis Boulanger, the Johannot, Grandville (a forerunner of the Surrealists and recognised by them as one of their masters) and Gustave Doré, who was in no way the inferior of the *Faust* and *Divine Comedy* that he illustrated, were even closer than the painters to this exploration of the supernatural, which is among the essential demands made by the Romantic spirit.

It was natural that this desire to fix rapidly a visionary state or a fleeting emotion should prompt artists to use techniques in which the work of the hand did not slow down the flights of the imagination. Watercolour painting, first practised by the English artists including Cozens, Girtin, Cotman and Turner, has all the limpidity and lightness of thought itself. Each stroke of the brush is irrevocable and this necessary spontaneity encourages felicity of expression and that perfection of form found in the freedom of a first sketch. For book illustrations, wood-engraving and etching were used, but they soon had to face competition from lithography, a new process which the German Senefelder invented at the beginning of the 19th century. The effects it permitted induced Delacroix to try to illustrate *Faust*. Lithography's popularity and the way it enabled a work to be executed very rapidly and diffused at little cost made the technique one of the most valuable means of introducing Romanticism to all the classes of society.

German Romanticism and the new idealism

Owing to the close ties in Germany between painting, music, poetry and philosophy, Romantic art became there the expression of the unconscious world, and artists regarded nature as the means of attaining the absolute, of merging the finite in the infinite. Form was now only a means of conveying an idea. The fact that Carl Gustav Carus, naturalist, philosopher and painter, formulated an aesthetic inspired by the theories of the Naturphilosophen draws attention to that spiritual characteristic which one can ignore only at a risk of not fully understanding the art in which the German soul is wholly and passionately expressed.

Poets influenced German Romantic art just as much as philosophers, including Homer, Dante, Milton, the Greek tragedians, Klopstock, Macpherson ('Ossian') and Shakespeare; then, later, Novalis, Tieck and Goethe. Often painters were content with being illustrators of the *Odyssey*, *Faust* or the *Divine Comedy*, for the reason that at this period in Germany just as in France and England a spiritual bond brought artists

103

92–95
104
128

348

374, 373

462

1

16, 2

112
96–9

and writers together. Artists tried to inject into their works all the music they felt within themselves, and in return the composers wrote 'landscape symphonies'.

Asmus Jakob Carstens wanted to blend plastic monumentality, learnt from the Greeks and from Giulio Romano, with inner drama. He tried to reconcile the forceful tranquillity of naked forms, inspired by the casts he had copied at Copenhagen, with the vibrant mobility of space, which became the chief expressive feature of his work. Owing to the power of his imagination and the vigour of his drawing the 'cartoon' was for him an end in itself; it created space in which there floated symbolic figures, meditative and calm. In the *Birth of Light* and *Night with her Children Sleep and Death* one can see the beginnings of that Dionysian renaissance of an antiquity of which Winckelmann had only seen the Apollonian or Olympian side, and on which Nietzsche was to base his philosophy.

77 Line was the most important element of a picture for Carstens, whereas it was colour for P. O. Runge, who wrote: 'Colour is the supreme art which is and must remain mystical...' In the spirit of Haydn's *Seasons*, Runge worked tirelessly on his *Four Phases of the Day*, and he wanted to execute a *Seasons of the Year* and a *Cosmic Seasons* as well. Almost forgotten for a century, it needed the exhibition of 1906 to make people acknowledge the magic of his musical painting — the phases seem to have been the equivalent of the movements of a symphony — the fresh purity of his children and maidens playing and dreaming in an idyllic landscape, as innocent as the first day of Creation. Colour is symbolic in Runge's concept of art, and form, to use his own term, is 'hieroglyphic', which means that a mystical message is communicated under cover of form and through the effect of the form itself.

Technically and spiritually Runge learned a great deal from an unjustly forgotten woman painter who played an important part in German Romanticism — Marla Alberti, Tieck's sister-in-law. She had looked after Novalis during his last years and gave Runge useful instruction on how to execute his first large picture, the *Nightingale's Music Lesson*. Later she devoted herself to religious painting in the style of Raphael, and ended her days nursing typhus cases at a convent she had entered after her conversion to Catholicism. Almost all her works are now in this convent of the Sisters of Mercy at Münster in Westphalia.

Raphael reigned supreme over the Nazarenes, a group that
80 gathered round Overbeck in the monastery of Sto Isidoro at Rome, where they founded a sort of lay community. Overbeck tried to compete with the painter of the *School of Athens* by depicting the *Triumph of Religion in the Arts*, whereas Peter
122 Cornelius came nearer to Fra Angelico. The German Nazarenes, like the English Pre-Raphaelites, went no further back in the history of Italian painting. Ignorant of Giotto (not to mention Cavallini and Cimabue), Masaccio and Piero della Francesca, they regarded Perugino as a primitive and as the representative of the simple medieval piety to which they aspired to return. A vast decorative movement, born of the paintings done for the Casa Bartholdy and Casino Massimo at Rome, lies behind the great historical fresco cycles executed by Julius Schnorr von
157 Carolsfeld, Alfred Rethel and Wilhelm Schadow. The strange Bonaventura Genelli, a friend of the Nazarenes, with whom he lived for a time, differed from them in his aesthetic views. His ideal was the beauty of antiquity, not pious asceticism, and he gave this beauty a certain piquancy by combining small, graceful, sensual heads with powerful bodies and a purely Baroque sense of dramatic movement.

107 Moritz von Schwind, on the other hand, represents popular

German Romanticism. He loved ancient legends, fairy tales, the intimacy of medieval towns, the picturesque fancifulness of Gothic pinnacles. Nowhere but in Germany would this mixture of simple good-heartedness with whimsical enchantment and of the pleasantness of everyday life with great heroic adventures have been possible. It was deliciously expressed by Schwind in his evocations of the Middle Ages and by Karl Spitzweg in fond and ironical representations of the trivial happenings of middle-class life. In the countless books he illustrated Ludwig Richter, for his part, excelled in restoring the 127 mystery of fairy tales, folk songs and children's roundelays. But he was equally able to show in his paintings the Romantic beauty of the German forest, with its fleet-footed deer and dancing elves.

Richter began his serious artistic education at Rome working beside J. A. Koch, the inventor of the 'ideal landscape'. Koch composed his pictures like poems, by assembling lyrical elements — waterfalls, glaciers, thick woods, peasants' huts — from his imagination or from the mountains of the Tyrol where he had been born. He had lived a long time in Switzerland, painting there directly from nature, which was then quite a novelty. At Rome he contributed episodes from the *Divine Comedy* to the decoration of the Casino Massimo, but later dedicated himself to executing those real or imaginary 'views' whose Romantic character lies above all in an entirely personal feeling for nature, which was inherited by Olivier and Hof.

Nature spiritualised and transcended

'A man contemplating the magnificent unity of a natural landscape becomes aware of his own smallness and, feeling that everything is a part of God, he loses himself in that infinity, giving up, in a sense, his individual existence.' Begun by Koch, this spiritualisation of landscape, to which Carus gave philosophical expression in his pictures and in his *Nine Letters on Landscape Painting*, the source of the above quotation, ended with Caspar David Friedrich's total mergence 18, 23 of nature and the artist. As David d'Angers very rightly said on visiting him at Greifswald, Friedrich really 'discovered the tragic landscape'. For he experienced and depicted a landscape as something holy. God was in nature; perhaps He actually was nature. 'God is everywhere, even in a grain of sand,' the painter said to Peter Cornelius. 'I wanted to represent him once in the reeds as well.' He loved nature with a passionate, almost religious devotion — once he bought a plot of land to save the willows growing there from being cut down — and a tree, the sea, a hillside were all to him the very embodiment of the cosmic soul. The Norwegian artist J. C. C. Dahl, a con- 130 temporary who greatly admired him, detected in the fragments of nature that Friedrich painted images of an unknown dream world pervaded by a tragic melancholy. German Romanticism never penetrated further into this conception of nature as a revelation of the universal spirit, which is why Friedrich's landscapes are always concerned with infinity — the sea, mountains, plains — or that other infinity, a graveyard. He did not paint some geographically well-defined locality, but a poetic state experienced in the form of a landscape. Likewise unappreciated and forgotten by his contemporaries and the generations that followed, he was rediscovered, principally by Aubert, thanks to the 1906 Exhibition which drew the attention of artists and art historians to those great Romantic painters whose message had not been understood.

However, the Romantic spirit remained alive in Germany all through the 19th century. It endured in the idyllic, mischievous, sensitive good-heartedness of Hans Thoma, the sombre lyricism of Feuerbach, and above all in the nostalgia of 83

49

MASTERPIECES OF T. GÉRICAULT (1791–1824)

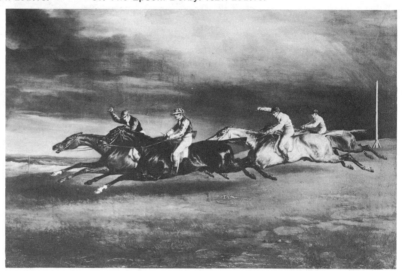

88. Officer of the Chasseurs Charging. 1812. *Louvre.*

89. The Raft of the Medusa. 1819. *Louvre.*

90. Wounded Cuirassier Leaving the Field. 1814. *Louvre.*

91. The Epsom Derby. 1821. *Louvre.*

MASTERPIECES OF C. COROT (1796–1875)

92. Claudian Aqueduct. *c.* 1825. *National Gallery, London.*

93. Homer and the Shepherds. 1845. *St Lô Museum.*

94. The Bridge at Narni. 1826. *Louvre.*

95. Repose. *c.* 1855. *Musée d'Art et d'Histoire, Geneva.*

MASTERPIECES OF J. M. W. TURNER (1775–1851)

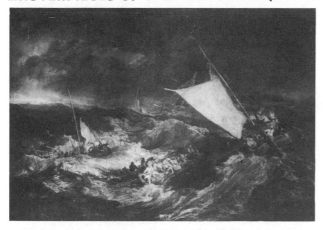

97. Petworth Park: Tillington Church in the Distance. 1831. *Tate Gallery.*

96. The Shipwreck: Fishing Boats Endeavouring to Rescue the Crew. *c.* 1805. *Tate Gallery.*

99. Rain, Steam and Speed: The Great Western Railway. 1844. *National Gallery, London.*

98. The 'Fighting Téméraire' Tugged to her Last Berth to be Broken up. 1838. *National Gallery, London.*

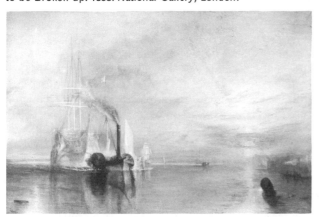

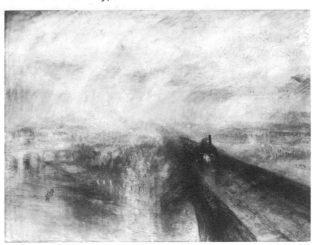

MASTERPIECES OF E. DELACROIX (1798–1863)

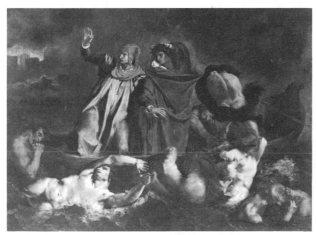

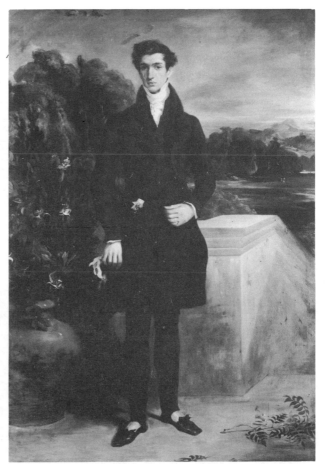

100. Dante and Virgil Crossing the Styx. 1821–1822. *Louvre.*

102. *Below, left.* The Massacre of Chios. 1821–1824. *Louvre.*

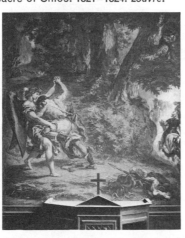

101. Baron Schwiter. *National Gallery, London.*

103. *Left.* Jacob Wrestling with the Angel. 1857. *St Sulpice, Paris.*

104. FRENCH. C. COROT (1796–1875). The Shepherd's Star. 1864. *Toulouse Museum.*

Hans von Marées, who was torn between the dream of an antiquity ruled by Pan and free from all spiritual anxiety, and the confusion of a soul drawn equally by pagan unawareness and emotional torment. Marées translated into thick impasto and visionary chiaroscuro the uneasiness of a mind for which the flesh has lost its innocence and suffers under the goad of the soul. In our own time some aspects of Expressionist painting should be regarded as being Romanticism's final state. With Oskar Kokoschka, Alfred Kubin, Emil Nolde and the sculptor Ernst Barlach, Expressionism takes the form of a more intense Romanticism, torn by the disharmony between the spirit and the senses, driven to extremes by the quest for an impossible absolute on a level of fantasy where vision and dreams disturb and distort the images of reality.

477 Yet another Romantic is the Basle painter Arnold Böcklin, whose powerful temperament is just as at home in the sumptuous play of colours and joyous vitality of mythological episodes like *Pan and the Shepherd* or *Tritons and Naiads* as in a melancholy evocation of the fields of asphodels where the shades of the departed are strolling, or of that grave, serene retreat on which all lives converge, the *Island of the Dead.* Böcklin has a vigour, even an excessive exuberance and sensuality that distinguish him from Agasse and the delicate Calame, who are the best Swiss Romantic landscape painters.

471 To the Italian Giovanni Segantini, who spent most of his life in Switzerland and owed the best of his inspiration to the mountains, nature appeared at once divine and demoniac, as it did to the German Romantics. Segantini was a faithful interpreter of nature who, to render the peculiar vibrancy of the high mountain air, devised a grainy texture that catches the light and makes apparent the palpitation of the earth. He felt a devotion to nature which was both pious like Friedrich's and symbolic like Runge's. He ardently wanted to paint an enormous canvas that would take in the entire length of a mountain range and be at the same time an allegory of the great moments of human life, related to the deep occult life of the elements.

No Swiss has been able to convey the mysterious spirituality of his mountains as Segantini did. On the other hand one of the most active energisers of English Romantic art — perhaps the closest to Shakespearean fantasy — was the painter Henry Fuseli from Zürich. He dazzled London with his prodigious gifts and was happy to be admired and appreciated there after having received nothing but incomprehension from his compatriots. He came to represent what is most characteristic of English fantasy, and was as familiar with the visionary world as with the tragic, ridiculous or fascinating side of reality. He was an even more ferocious critic of his times than Gillray or Rowlandson, and Hogarth's humour seems kindly compared with his cruel irony. ' His look is lightning, his word a storm, ' Lavater said to Herder when talking of Fuseli, and Lavater himself was quite at his ease among things supernatural. Haunted by an awareness of infinity, Fuseli seemed to him to be advancing ' through a sea without shores or bottom ', as he put it.

All this won him the admiration of William Blake, whose 76 visions are just as much a poetic exploration of the invisible as Fuseli's. The fantastic came naturally to Blake, as he made no distinction between what he perceived with his senses and the forms he saw in his waking dreams. This leaning towards the supernatural is part of the British character, and here English Romantics found in the nation's poets, especially Milton and Shakespeare, as also in the Bible, inexhaustible sources of inspiration.

Blake added to these already very numerous themes those of his own mythology — the landscapes and figures of a fabulous universe built to the same scale as his colossal dreams, and inhabited by allegorical giants whose impressive portraits he drew with a line at once fluid and firm. This he had borrowed from Flaxman, softening it and often shrouding it in mystery 159 after the manner of Fuseli. John Martin, the famous illustrator of Milton, also ranks among these visionaries of English Romanticism. Their influence is apparent in the work of the landscapist Samuel Palmer, who sought not to represent the 113 melodious charm of the English countryside as did Joseph Wright (usually known as Wright of Derby) or Richard Wilson, but to replace the visible and real by imaginary scenes from his dramatic fantasy. A pupil of Blake, Palmer too recognised ' eternity in a grain of sand ', and in his drawings he often seems to make use of the effect of darkness struggling with moonlight. With these English artists objective reality occasionally even became an imaginative vision by means of a multiplication of precise detail. For example Stubbs, who produced extraordinarily exact portraits of animals, mainly horses, also showed the magical and disturbing majesty of the horse, as in the strange landscape at the Liverpool art gallery showing a grey mare, which seems to have come from one of Fuseli's terrifying dreams, confronted by a mysterious lion lurking among the rocks.

The contribution of the English landscape painters

Two strands appeared at the beginning of landscape painting in England — that of poetic reality which reveals the poetry that dwells in the objective appearance of things, and that which turns the landscape, whether interpreted or imaginary, into a creation of emotive fantasy. William Marlow, John Crome and Richard Wilson belong to the first strand. In the second we find Palmer, who has just been mentioned, Thomas Gainsborough and of course J. M. W. Turner. Romanticism 96–99 proper is the preserve of those who are stimulated by the contemplation of nature to devise a ' landscape of the soul '. However close to reality Gainsborough may seem, it must not be forgotten that the same lack of realism affects both his portraits

GERMAN. C. D. FRIEDRICH (1774–1840).
The Cross on the Mountain. *c.* 1811.
Kunstmuseum, Düsseldorf.
Photo: Michael Holford.

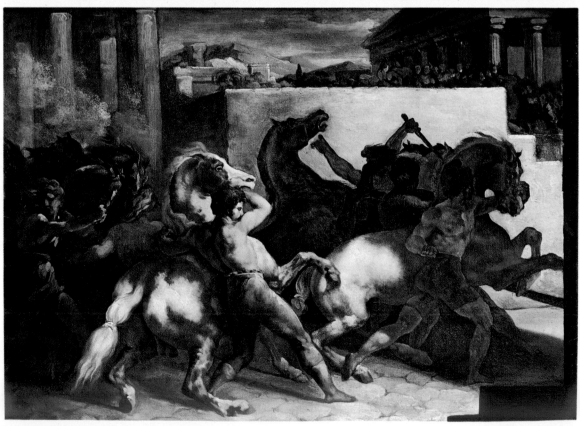

105. GERMAN. K. F. SCHINKEL (1781–1841). Moonlight. Destroyed. *Formerly Staatliche Museen, Berlin.*

106. SWISS. ALEXANDRE CALAME (1810–1864). Uri-Rotstock. *Gottfried Keller Stiftung, Zürich.*

107. GERMAN. MORITZ VON SCHWIND (1804–1871). Traveller Contemplating a Landscape. After 1860. Picture destroyed in 1931 at the Schackgalerie, Munich.

and his landscapes. In the former he has given his figures a kind of fairy-like grace and brought about a lyrical and 'ideal' transfiguration of the sitters. As for the landscapes, he did not paint them from nature, but composed them in his studio with the help of curious models made, as Reynolds tells us, of dried weeds, oddly shaped pebbles, bits of looking-glass, etc., which were transformed on the canvas into moss-grown rocks, dense foliage and ponds half hidden in the meadows.

This weird procedure, intended to fire the imagination and promote the construction of a reality beyond the real, is consistent with what Alexander Cozens, the watercolourist's father, suggested in his *New Method for Assisting the Invention in the Composition of Landscape.* The book appeared in 1785, three years before Gainsborough died. Cozens, following Leonardo, recommends the study of blots and, like the Chinese, of chance heaps of stones, as these can stimulate the imagination to create new forms.

Starting from a methodical observation of things, which earned him Ruskin's praise, Turner moved towards a purely visionary art, particularly in his later years. He began by painting invented landscapes, harmonious and majestic, which he liked to comment on in strange poems. But as form hindered his poetic inspiration, which he found increasingly demanding, he gave it less and less importance, and finally suppressed it altogether, and painted only the effects of light on water, and iridescences seen through damp and mist. The use of watercolour, a medium much favoured by Romantics in both France and England, helped him to achieve this spiritualisation of matter, this mergence of the object in a glow of pure colour. His earliest watercolours are scrupulously exact representations of Gothic abbeys (Tintern); but he soon saw that when it came to expressing fantasy watercolours ensured the spontaneity of

FRENCH. EUGÈNE DELACROIX (1798–1863). The Capture of Constantinople by the Crusaders. *c.* 1840. Louvre. *Photo: Michael Holford.*

FRENCH. THÉODORE GÉRICAULT (1791–1824). Race of Barbary Horses. 1817. Louvre. *Photo: Michael Holford.*

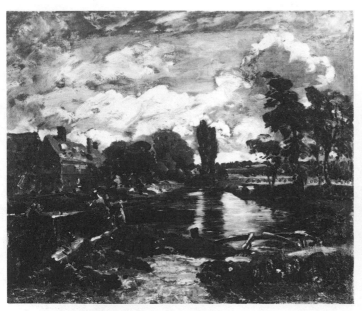

108. Lock and Cottages on the Stour. Sketch. 1811. *Victoria and Albert Museum, London.*

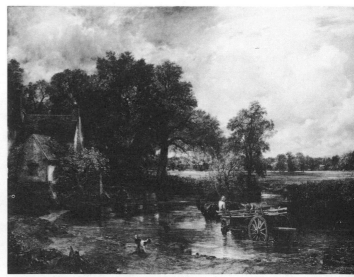

109. The Haywain. 1821. *National Gallery, London.*

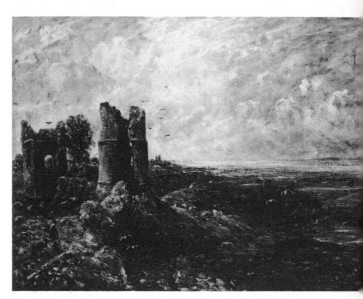

110. Hadleigh Castle. 1829. *Tate Gallery.*

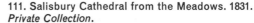

111. Salisbury Cathedral from the Meadows. 1831. *Private Collection.*

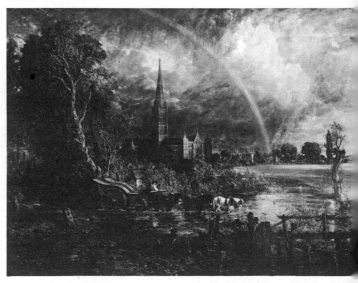

the hand, preserved the freshness of the impression and produced a translucency that gave real objects a poetic atmosphere.

112 It was on account of these qualities that the brilliant Thomas Girtin, who died at twenty-seven, John Sell Cotman, passionately fond of medieval architecture, and John R. Cozens preferred to all others this limpid medium, which sensibility can take to the limit of emotion without ever thickening it with retouching or making it heavy by over-elaboration. The genius of Keats and Shelley, transferred to watercolour, became ' all poetry ', as Constable said of Cozens, who was also, in his opinion, ' the greatest genius that ever touched landscape '.

 The master who at the Paris Salon of 1824 exerted such a powerful attraction on French painters, perhaps to the point of altering the direction of Delacroix's genius, deserves some credit for having passed this judgment, since he himself em-

108 ployed a thick, warm, solid *matière*. To Constable a landscape was a world of drama, filled with new suggestions for the eye and mind. Ruskin conveyed this ability to embrace the whole of nature, which he admired in Constable, when he said that the latter could perceive in a landscape ' about as much as, I suppose, might in general be apprehended, between them, by an intelligent fawn and a sky-lark '. His atmospheric effects are such that Fuseli, who felt very remote from him, owned that Constable made him want to take his coat and umbrella. This gibe was a reference to all that is profoundly natural, even naturalistic, in Constable's work.

79 Young Bonington — like Girtin, he died at twenty-seven — formed the link between English and French Romanticism: Delacroix owed a great deal to the almost Impressionist way he applied his colours. And the brilliance of his hues, the lightness of his touch and the spontaneity of his invention in his historical paintings make him one of the most remarkable artists of the early 19th century, a Romantic with casual grace and an air of detachment.

 The Pre-Raphaelites were Romantics, too — at least in the nature of their inspiration, in the yearning that one senses in the work of Dante Gabriel Rossetti for that unattainable absolute,

114 in the melancholy sensuality of Burne-Jones and in the pangs of human evolution apparent in all Watts' compositions. They were also Romantic in the defensive attitude they adopted

112. BRITISH. THOMAS GIRTIN (1775–1802). Mountains and River. Watercolour. *British Museum.*

113. BRITISH. SAMUEL PALMER (1805–1881). Shepherds under a Full Moon. *Ashmolean Museum, Oxford.*

towards the industrial era, pragmatism, and moral and religious conformism. They were out of their element in an age that was practical and heavily materialistic in spirit, and they sought to escape from it — in space, by living in Italy or by building a dream Italy around themselves in London, and in time, by going back to the legends of the holy grail and of King Cophetua, by transporting themselves to Dante's Florence, or like William Morris by restoring the artist-craftsman to a place of honour in accordance with Ruskin's theories. An escapist art, their painting is always tinged with literature, and often it appears too literary; but it is illuminated by an unreal, fantastic charm that still moves us today and which links them directly with the contemporary Romantic poets.

Romanticism in the rest of Europe

The Academy in Copenhagen was the great school at which Carstens, Runge and Friedrich were trained. Most Danish artists worked either in Italy or else at Dresden or Munich. Hansen mirrored picturesquely the life that the Scandinavian
129 artists led in the Eternal City; and only Købke, in landscapes tinted by the lovely gleams of a summer's night and possessing an emotional intensity as great as Andersen's realist writings, freed himself from the Italo-German aesthetic domination which weighed so heavily on Swedish and Norwegian landscapists. They paradoxically saw their own rugged countries in terms of pictures painted in 'Saxon Switzerland' or in the Roman Campagna.

Though traditionally faithful to the patient and loving realism of their old masters, the Belgians were also attracted by the example of Delaroche, Vernet and Devéria. They were discreetly Romantic in quite forceful history pictures, when inspired by the spirit of liberty and their love of independence like those of Wappers, or in merely decorative and anecdotal
403 ones like Hendrick Ley's *Les Trentaines de Berthal de Haze* and Louis Gallait's *Abdication of Charles V*. Quite different, and far more interesting, is the work of the visionary Antoine Wiertz, to whom Brussels has devoted a small museum in which are assembled the strange pictures of horror scenes with an exaggeratedly heroic Rubensian quality. Wiertz was by turns the melodramatic painter of the *Mad Mother* or *Buried Alive* and
163 an interpreter of the fantastic world we meet in his *Giant*. Having a morbid taste for the macabre without Bresdin's sombre fantasy, he loved the effects produced by fairground dioramas, and tried to make the 'horrors' that he painted with an odd relish even more sensational by means of screens and mirrors intended to give a startling illusion of reality.

How studied and artificial this laborious pursuit of sadistic thrills, rather like the novels of Pétrus Borel, the French Romantic, appears when we compare these works with those of the master of Romantic fantasy — for he was less arbitrary than Gustave Doré, and less literary than Victor Hugo — Francisco
6
118 Goya. He still belonged to the 18th century by virtue of a whole section of his work (tapestry cartoons, portraits) which he painted with a masterly brio inherited from Velasquez. This he applied to the most daring use of forms and colours which

114. BRITISH. EDWARD BURNE-JONES (1833–1898). Danaë and the Brazen Tower. 1872. Illustration to verses from William Morris's *Earthly Paradise*. Fogg Art Museum, Cambridge, Massachusetts.

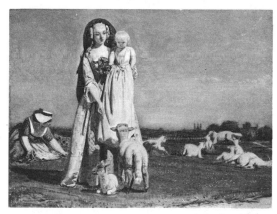

115. FORD MADOX BROWN (1821–1893). The Pretty Baa-Lambs. 1852. *Ashmolean Museum, Oxford.*

116. DANISH. CHRISTOFFER WILHELM ECKERSBERG (1783–1853). Doric Columns in the Gardens of the Villa Borghese. *Statens Museum for Kunst, Copenhagen.*

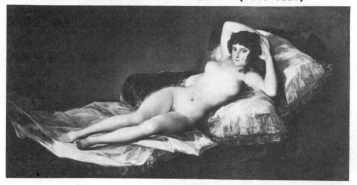

117. The Maja Nude. *c.* 1800. *Prado.*

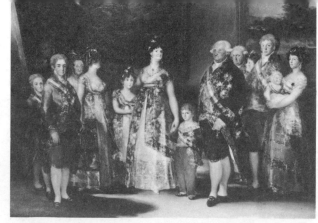

118. The Family of Charles IV. 1799–1800. *Prado.*

119. The Execution of the Rebels on 3rd May 1808. Painted in 1814. *Prado.*

120. Pilgrimage to the Fountain of San Isidro (detail). 1820–1822. *Prado.*

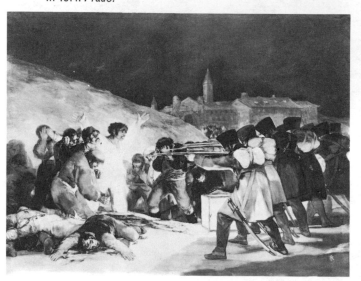

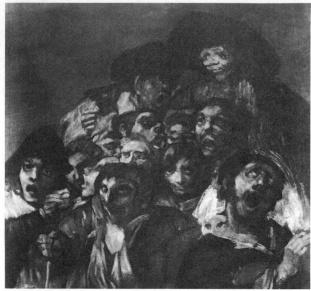

recall Tiepolo and Fragonard and also look forward to Manet and the whole of modern painting. But he was a Romantic when he let the old spirit of Spain, with its strange passion and savage humour, take charge of him. Every contrast was there inside him. The man who made the flesh of the *Maja Nude* shine with sensuality and who took pleasure in watching Aragonese peasants dancing on the grass like a scene from *The Marriage of Figaro* became towards the end of his life the fierce patriot of *3rd May* and the obsessed recluse of the Quinta del Sordo who surrounded himself with pictures of monsters and witches' sabbaths, as an anchorite would decorate his cell with images of the infernal regions. And in point of fact it was hell that haunted Goya's imagination when he brutally etched the appalling frays of the 'Disasters of War', the dark carnage of the 'Tauromachy', and the 'monsters' in that extraordinary 'diabolical comedy', that infernal parade of evil and suffering revealed by the musky delights of the 'Caprices'.

Goya is the Romantic *par excellence*, and has nothing to do with that Spain of noble bandits, melancholy Moors and plumed mules crossing the sierra whose stereotyped image was lovingly worked on by the French Romantics. He is the Romantic of senseless processions, of the Inquisition's tortures, of madhouses, and his followers — Juliá, Lucas, Elbo, Lopez — continued his strange and terrifying lunacy.

Perhaps we should number among the Romantics the academic painter Briullov and the coldly classical Ivanov who represent the best in Russian painting from this period. The want of national traditions left them both dependent on the teachings of western Europe. Whereas Russia provided in

Pushkin and Lermontov two of the greatest talents of Romantic poetry, her painters were still in the grip of a theatrical and bombastic sentimentality. Briullov himself does not escape it in his *Last Day of Pompeii*, so weak is its composition and forced its tragedy. There is a tradition that it was after visiting the ruins and attending a performance of Pacini's opera *L'Ultimo Giorno di Pompei* that Briullov conceived the idea of this melodramatic undertaking. He lacked neither technique nor ability, and Turgeniev was right when he contrasted Briullov 'who had received the gift of expressing whatever he wanted to, and had nothing to say' with Ivanov, the painter of *Christ's First Appearance to the People*, 'who had a great deal to say' but 'said it with a stammer'.

Living in Rome and fascinated by the Nazarenes, especially Overbeck, Ivanov left much still unfinished, a mark of his boundless ambition and unfortunate tendency to want to include in a single picture an entire philosophy, an entire mystique. The long years of preparation for his *Christ* ended in a big, cold, stiff composition, devoid even of religious feeling and frozen by the artist's efforts to achieve absolutely correct local colour. For the same reasons the colossal paintings that were to have decorated the 'Temple of Humanity' never got beyond the stage of studies and sketches. It was not so much conscientiousness about truth that paralysed him as his inability to breathe life into these huge reconstructions. Thus if his works are not strictly speaking Romantic the painter himself at least was, and in his unbounded aspirations as in his distressing impotency he was blood-brother of the hero of *La Recherche de l'Absolu*, one of Hoffmann's strange tales.

117

119

161

HISTORICAL SUMMARY: Early 19th-century art

General History. The French Revolution (1789–1794), the Napoleonic wars (1799–1815), the upheavals of the battles, the economic and financial difficulties, and the failure of the old structures (monarchies dependent on a military and political aristocracy, Papacy roughly handled by Napoleon, end of the Holy Roman Empire in 1806) together forged a new continent of Europe freed from Napoleon's tyranny. His attempt to impose on Europe the old Carolingian dream of a Latin-Rhenish empire with a single (French) ruler was prevented not only by Britain, the world's first industrial country, which disliked the idea of one dominant force in Europe, but also by the widespread phenomenon of incipient nationalism. The Peninsular War and the Russian campaign showed a people's unanimity in confronting the foreign invader. In 1810 was founded Berlin University, where a violent pan-Germanism came into being and throve to Prussia's advantage, and in the same year came the general revolt of Spain's South American colonies. In 1822 the Greeks proclaimed their independence and the United States recognised the new states of Central and South America (Brazil, Mexico, Ecuador).

The French armies spread revolutionary ideas throughout the continent of Europe, and the monarchies were less secure in spite of the mystical Holy Alliance inspired by Tsar Alexander I.

While large-scale industry, the fount of capitalism and creator of an urban proletariat, was beginning, the development of transport (Stephenson's first public passenger train in 1825), the great technical advances (progress of weaving due to Jacquard's loom of 1801; Niepce's first successful permanent photograph in 1822; development of mechanical reapers by McCormick and Hussey in 1834, of the sewing-

machine by Thimonnier in 1830; invention of the electric motor by J. Henry in 1829, of the marine propeller by Sauvage in 1832, of the electric telegraph by Gauss in 1833, of the power-hammer by J. Nasmyth in 1842), and an immense widening of knowledge (new sources of energy, electricity) transformed the world. Science, whose role had hitherto been speculative and philosophical, was pushed forward by technology; the advent of a chemical industry, an outcome of Lavoisier's discoveries, was a spur to scientists (Chevreul). In physics studies in electricity and the laws of electromagnetism (Faraday, Ampère, Joule) led to the first applications (telegraph). The academies, the societies for the advancement of scientific knowledge (United States, 1848), the great national and international exhibitions which became increasingly important in the second half of the century, the scientific press which grew (*Annales de Mathématiques*, 1810; *Journal für die Reine und Angewandte Mathematik*, 1813) — all these advances began the scientific age.

Art itself was fundamentally influenced by the scientific discoveries and by the new techniques. The architects met competition in the field of building from the engineers, who built not only bridges in iron (Thomas Telford's Waterloo Bridge at Bettws-y-Coed, 1815; Marc Seguin's bridge over the Rhône at Tournon, 1824), but also factories. The first of these, appearing as early as the end of the 18th century, already used iron, an uninflammable material (calico mill by Strutt at Derby, begun 1792; cotton twist mill by Boulton and Watt at Salford, 1799–1801). Likewise, markets and stations (Robert Stephenson's Euston station in London, 1835–1837).

In 1839 Daguerre, a talented landscape painter, improved on Niepce's work and received a vote of congratulation from the Chambre des Députés for his daguerreotype. With the arrival of this ancestor of the photograph, artists lost interest in the painted portrait. In 1837 the perfection of electroplating was of prime importance for engraving and sculpture.

19th-century man discovered through works of art, not just literature, unknown or little known civilisations: Napoleon took a group of scholars with him on his attempted conquest of Egypt; Champollion deciphered hieroglyphics in 1822; in the same year the Société Asiatique was founded in Paris; about 1838 Boucher de Perthes was the first to form the idea of a prehistory; Botta, a French diplomat, excavated at Khorsabad in 1844; archaeology, which

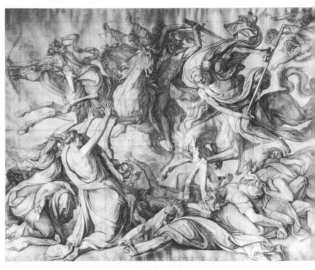
122. GERMAN. PETER CORNELIUS (1783–1867). The Four Horsemen of the Apocalypse. One of the cartoons for a projected Campo Santo in Berlin. 1843–1859. *Staatliche Museen, Berlin.*

123. GERMAN. ALFRED RETHEL (1816–1859). Charlemagne Entering Pavia. Fresco in the Rathaus at Aachen.

was born in the 18th century with the discoveries of Pompeii and Herculaneum, came into its own. Antiquarian museums were created in response to public request (Museo Pio-Clementino).

Influenced by Polish Messianism, Renan distinguishes the ' people ' and the ' nation '. The idea of nationalism emerged from the French Revolution and the revolutions of 1830 and 1848, and liberalism and nationalism went hand in hand with the popularity of folklore (folk-tune themes used more and more in music from Beethoven and the Romantics to the Russian and Spanish composers). The systematic study of languages and their origins (first Slovene grammar, 1808; Serbian, 1814) and the passion for history, often mingled with legend, determined the national myths, Romanticism's driving force. The 19th century was one of historical discovery and it inherited the enthusiasm for antiquity of the later

121. FRANCE. The Madeleine, Paris. 1808–1845. Built from designs by Pierre Alexandre Vignon (1763–1828).

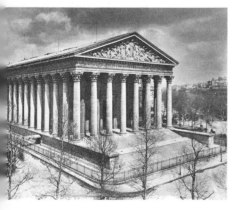

124. ITALIAN. ANDREA APPIANI (1754–1817). The Apotheosis of Napoleon. *Palazzo Reale, Milan.*

125. BELGIAN. FRANÇOIS JOSEPH NAVEZ (1787–1869). Portrait of the painter David. 1833. *Private Collection.*

18th century resulting from the finds at Pompeii. This vogue triumphed in the Neoclassical aesthetic developed in Rome by A. R. Mengs (1728–1779), a second-rate Bohemian painter trained at Dresden and Rome (necessity of a philosophical spirit in order to attain the beautiful) and the German antiquarian philosopher and Vatican librarian J. J. Winckelmann (1717–1768), whose influence is felt by David, Ingres, Girodet, Canova and Thorvaldsen, and by the German idealist philosophers Schelling and Hegel. The ideal of the Neoclassicists, in reactions against French Rococo art, materialised in 1785 with the *Oath of the Horatii*, painted in Rome by David, inspired by Roman republican ideals. With it France took the foremost place in art. Revolutionary France reinforced this ' antiquarian ' tendency, as is shown by the republican festivals that David organised in the classical manner, by the pompously Ciceronian speeches of the members of the Convention, by the Empire and Directoire styles of furniture.

New ideas vitalised the whole of literary and artistic Europe, and con-

flicted with each other. Classicism was devoted to rules and to the antique tradition, soon frozen in an academicism that lasted throughout the century. Romanticism — ' chaos ', according to Delécluze, but in fact a fruitful and dynamic force — perhaps came into being with the anti-rationalism of *Sturm und Drang*, the idealism of the German philosophers and the lyricism of the British poets. It swept Europe, still bearing the scars of the Napoleonic wars, into a nostalgic and mystical pessimism which rejected the 18th century's ' enlightenment ', sought the ' sublime ' already noted in 1756 by Edmund Burke, and yearned for an idyllic Christian Middle Ages, for a poetry touching the sensibility, for great emotive myths (Dante, Milton, Shakespeare). Only Goethe and, to some extent, Beethoven escaped the Romantic epidemic that drove young writers and artists into a rabid opposition to society (Shelley, Byron), and led to a despair that often resulted in their very early death (illness of Keats, Leopardi, Schumann and Chopin, suicide of Kleist and G. de Nerval, duels of Pushkin, Lermontov and the brilliant mathematician E. Galois) or else made them wander from country to country as far as Greece, Palestine (Byron's *Childe Harold* which was the gospel of a whole generation), Africa and the East.

Through the tragic, intensely exciting atmosphere they produced, the Napoleonic wars spread a taste of death and a desire for great terrifying myths, of which the *Saturn* painted by Goya on a wall of his house and Delacroix's *Attila* in the Palais Bourbon remain the most awe-inspiring examples.

Romanticism's great discovery was that of nature in all its immensity and truth. Landscape became an effusion of feeling: painter, poet and musician love and sing of a tormented, violent nature now with God as its measure and no longer man, a nature where storms and bursts of light create a disturbing atmosphere, which was rediscovered in the Dutch precursors, Rembrandt, Ruisdael or van Goyen.

During the Neoclassical period, there were still artists who may be called ' European ', such as the French architects Percier and Fontaine or the sculptors Canova (Italian) and Thorvaldsen (Danish); but from 1830 the quest for originality and for individuality prevailed. Though Goya, that precursor, died in 1828, Delacroix painted *Liberty Guiding the People* in 1830 and V. Hugo (preface to C. Dovalle's poems) declared: ' Romanticism…is, all things considered, just liberalism in literature…Freedom in art, freedom in society…that is the double banner which rallies…all the youth…of to-day. '

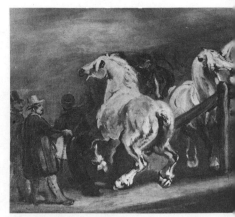

126. POLISH. PIOTR MICHALOWSKI (1800/01–1855). Horsemarket. *Belvedere (Österreichische Galerie), Vienna.*

German idealist thought triumphed in the first half of the century with a revival of metaphysics, whereas in France the system of ideas proceeding from Condillac, which influenced the Italians (Leopardi), effected the transition from the 18th century to positivism. A single great mind, Maine de Biran, heralded modern philosophy. The British were divided between the utilitarianism of Jeremy Bentham and W. Hamilton and the spiritualism of Coleridge and Carlyle. The social reformers (Saint-Simon, Auguste Comte, Fourier, Proudhon) first gave their attention to the results of industrial mechanisation. French utopian socialism passed to Germany, where K. Marx and Engels published the Communist manifesto in 1847.

Music was the major art of the 19th century. Romantic, it is an expression of ' reveries and passions ' enabling the composer to be a poet as well (symphonic poems of Berlioz and Liszt), a confident art, with piano triumphing (Chopin, Liszt), right up to the grandiose philosophical conception of Wagnerian opera. As the expression of national schools, of the soul of a people, it rediscovered or ennobled folk themes (Chopin, Liszt, Glinka and the great Russians, later the Czechs, Scandinavians and Spaniards). Notable are the growth in the number of public concerts, the building of opera houses (Dresden), the ostentatious patronage of certain princes, and the musical reputation of certain cities (Weimar, Dresden, Vienna, Paris, London).

Closely bound up with the literary and artistic movements, the religious renaissance was contemporaneous with Romantic religiosity (F. Schlegel's conversion to Catholicism, Chateaubriand and the *Génie du Christianisme*, Lamennais and his *Essai sur l'Indifférence en Matière de Religion*, J. de Maistre and Du Pape). The restoration of the Jesuit

Order in 1814 occurred as soon as Pius VII returned to Rome. Leo XII, Pius VIII and Gregory XVI were under the influence of the *zelanti*, who linked the papacy with the fate of the monarchies regardless of the problems of the modern world. The liberal Catholicism of Lamennais and his friends Lacordaire and Montalembert was further ahead of its time (*Paroles d'un Croyant*, written in 1834 and condemned by the Pope the same year). There was a parallel Protestant revival in France, Switzerland (Vinet) and England (Wesley, Ashley, Wilberforce): the Oxford Movement, contemporary with the Gothic Revival, took liberal forms.

FRANCE

History. The Consulate (1799–1804), then the First Empire (1804–1814), allowed Napoleon's talent for organisation to put France in order. The swift and crushing victories created an epic atmosphere which left in France the legacy of the hero myth.

The Restoration (the Congress of Vienna returned France to the frontiers of 1790), a difficult period despite the political skill of Louis XVIII (1814–1824), ended with the 1830 Revolution, due to the intransigence of Charles X (1824–1830). More flexible and diplomatic, Louis Philippe, who initiated the Orléans dynasty, gave France material prosperity and avoided wars. But he was unthroned by a popular movement which established the Second Republic in 1848.

Material progress began to change the French way of life. But France lagged behind England, and until about 1840 provincial life there remained fairly close to that before the Revolution.

Literature. Official Neoclassicism was expounded by Quatremère de Quincy in his *Essai sur l'Idéal*. French thought was represented by two disregarded men, both psychologists far in advance of their time: Benjamin Constant (1767–1830) and the mystical theosophist Maine de Biran (1766–1824). Mme de Staël, hostile to Napoleon, publicised German culture (*De l'Allemagne*, 1810) at the same time as the émigrés were introducing German (German library, *Über Dramatische Kunst und Literatur* by A. W. von Schlegel, French translation 1813), or English (Chateaubriand) thought. With *Atala* (1801), the *Génie du Christianisme* liberated Romanticism, and *René* unleashed the *mal du siècle* in 1802, two years before Sénancour's *Obermann*. The Restoration attempted a return to the ideal of a Christian Middle Ages (coronation of Charles X at Reims, last blaze of monarchical sentiment). Victor Cousin's spiritualist

eclecticism sought to parallel the political movement favouring restoration and declared that 'humanity's soul is a poetic one'. Romanticism was the triumph of poetry: V. Hugo (1802–1885) [1], the leader of the school, 'sonorous echo' of the period, was the greatest French lyric poet, with Lamartine, A. de Vigny, A. de Musset and G. de Nerval. The same exaltation of form and imagination also appeared in the theatre. Drama tempted all the great writers: Hugo and Vigny were haunted by Shakespeare, and the battle over *Hernani* is a symbol. Popular melodrama and the novel of imagination (A. Dumas and the historical novel, Eugène Sue and the success of the serial story) represent the democratisation of tragedy and the novel. The latter, a realm of dreams and of the expression of intense emotions, triumphed with two geniuses: Stendhal and H. de Balzac. History, an outburst of national feeling, a solace for the military defeats, and even a refuge of the imagination, also came into its own. But at the same time it developed a method that became scientific once the Romantic detour was over: founding of the Ecole des Chartes, 1821. F. Guizot and A. Thierry balanced learning and imagination, unlike Vico's disciple Michelet (1798–1874), a lyricist carried away by his emotions (*Histoire de France*). A. de Tocqueville was endowed with a brilliant political sense. The utopian Saint-Simon wanted to build a religion of humanity with scholars as its priests. C. Fourier's dream of the phalanstery affected G. Sand and Zola. L. Blanc and above all Proudhon (1809–1865) [386] extolled socialism.

Science. In the 19th century there was an increase in the 18th century's

LANDSCAPE IN EUROPE BEFORE 1850

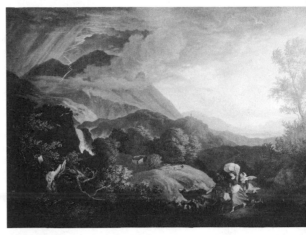

127. GERMAN. LUDWIG RICHTER (1803–1884). Storm over Monte Serone. *Städelsches Kunstinstitut, Frankfurt-am-Main.*

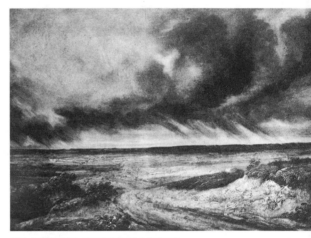

128. FRENCH. GEORGES MICHEL (1763–1843). The Storm. *Formerly Paul Bureau Collection.*

130. NORWEGIAN. JOHANN CHRISTIAN DAHL (1788–1857). The Birch in the Storm. 1849. *Formerly Bergens Blledgalleri, Bergen.*

129. DANISH. CHRISTEN KØBKE (1810–1848). Through the Barn Door. 1831. *Statens Museum for Kunst, Copenhagen.*

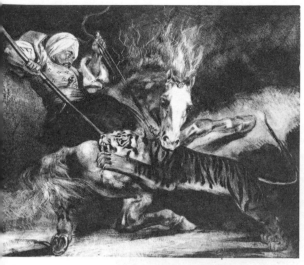

131. LOUIS BOULANGER
(1806–1867). Attacked by a Tiger.

133. AUGUSTE RAFFET (1804–1860).
Juguda Masaz Misiz, Sculptor of the
Tombs in the Valley of Jehoshaphat.
1840.

134. HENRI MONNIER (1805–1877).
Presumed portraits of Théophile
Gautier and Henri Monnier. 1860.

132. PAUL GAVARNI (1804–1866).
A Box at the Opera.

enthusiasm for mathematical research
(Lagrange, Monge, Lazare Carnot,
Laplace), physics (Arago, Ampère,
Fresnel, Gay-Lussac), chemistry (Lavoi-
sier, Ampère, Berthollet, Sainte-Claire-
Deville), zoology, geology and botany
(Lamarck, Cuvier, founder of palaeont-
ology, Geoffroy Saint-Hilaire).

Music. Traditional opera lasted until the
Restoration, with the Italian Cherubini,
Méhul, Spontini and Boieldieu. Rossini
became director of the Théâtre
Italien in 1824. After the Revolution,
Paris soon regained its prestige as a
musical city, and the literary and social
milieu of Romanticism attracted Chopin
(1810–1849) and Liszt (1811–1886)
who, with Berlioz (1803–1869), became
the avant garde musicians; but the
French inclined towards Italian melody
and the ballet (A. Adam's *Gisèle*). In
1831 G. Meyerbeer, an Italianised
German, created a Romantic opera at
Paris — *Robert le Diable*. Halévy was his
disciple.

Art history. The gap between artists and
the official doctrine of academic art,
which influenced the majority of a back-
ward public (Berlioz and Delacroix
suffered all their lives from the in-
comprehension of the 'bourgeois'),
widened throughout the century. The
drama of the artist alone in the face of a
society that rejects him started about
1830.

Owing to his dislike of self-deception
(Musset) and his taste for clear-headed-
ness, seldom renounced (Berlioz, Bal-
zac, Delacroix), the Frenchman re-
mained a Romantic of mode; Chateau-
briand in his early days, V. Hugo and
Michelet are the only Romantics of
passion. Moreover from 1850 onwards
there was a general reaction.

The museums are very important:
creation of twenty-two departmental
museums by the First Consul. Of capital
importance is the Louvre where up to
1815 the treasures seized by Napoleon
during his conquests were kept. When
the works were returned after the Con-
gress of Vienna, the museum was en-
riched with the Spanish collections of

Louis Philippe, withdrawn in 1848. In
1818 Luxembourg Palace became the
modern museum. Versailles was dedi-
cated by Louis Philippe to the glories of
France. In the Musée des Monuments
Français (1796–1816) A. Lenoir, despite
his errors over period, saved all that the
vandalism of the Revolution had left
undestroyed.

Architecture. Notwithstanding the
hiatus of the Revolution, which inter-
rupted the great building projects,
theories of architecture remained those
of the 18th century and preserved the
principles of Soufflot, Chalgrin, Boullée,
Ledoux, etc. The sacrosanct dogma of
the antique was the same as in the
Louis XVI style, and neither the Institut
nor the emperor opposed it. Imperial
influence operated in favour of classi-
cism owing to Napoleon's desire for
glory and immortality. He loved iron
and granite, materials of symbolic
strength, and wanted impressive but
restrained public buildings and vast
perspectives. (He had the façade of the
Palais Bourbon overlooking the Seine
made so that it lay on the axis of the
Madeleine — the Temple of Glory that
he dreamed of and whose design he
chose between two battles.) David,
whom he liked for his sense of simplicity
and the breadth of his vision, was in-
fluential. Perhaps he was responsive to
the architectural symbolism of C. N.
Ledoux's book *L'Architecture considérée
sous le Rapport de l'Art, des Mœurs et de
la Législation* (1804), which was widely
read and republished in 1846. An
important role was played by the Ecole
Polytechnique, founded in 1795. With
Monge teaching stereotomy and
Delorme and Baltard architecture, it
trained engineers who devised new
techniques, like Polonceau, the designer
of the Pont du Carrousel, Paris (1834).
The summary of the lectures given at
the Ecole (1802–1805), by J. N. L.
Durand (1760–1834), a pupil of
Boullée's, excited great interest in Ger-
many and Denmark, and suggested a
rational architecture: 'True beauty is
born of successful arrangements.' The
Ecole favoured functionalism, thus
clashing with the Beaux-Arts, where the
doctrine of the antique prevailed and led
to imitation (the Colonne Vendôme,
1806–1810, inspired by Trajan's
Column; the Arc de Triomphe du
Carrousel, once giving access to the
main courtyard of the Tuileries, in-
spired by the Arch of Septimius Severus;
the Arc de Triomphe de l'Etoile, 1806–
1836; the Madeleine, 1806–1842, a
rather heavy imitation of a Roman
temple; the Bourse, 1808, another
classical temple).

Iron, which was the material of the
later 19th century, was already used for
the Pont des Arts, Paris, built by Cessart

and Delon in 1803, and for the suspension bridge over the Rhône near Tournon by the engineer Marc Seguin in 1824. Bélanger reconstructed the roof of the Halle au Blé in iron during 1811. But it was Labrouste [62], with the Bibliothèque Ste Geneviève (1843–1850), and Duquesney, with the Gare de l'Est (1847–1852), who used iron and other materials, turning it to aesthetic as well as constructive account.

The first generation of classicising architects worked during or remained linked to the 18th century: Chalgrin [180], F. J. Bélanger (1744–1818), one of the most inventive decorators, who did much to help create the Empire style, P. Paris, the director of the Académie de Rome after 1806, Lequeu, B. Poyet (1742–1824), J. Legrand (1743–1807), Célérier (1742–1814) and J. Molinos (1743–1831), the authors of a plan to beautify Paris.

The masters of the Empire style, Pierre Fontaine (1762–1853) and Charles Percier (1764–1838) [183], who collaborated until 1814, were trained at Rome. They worked on the Louvre (Seine front to link up the Colonnade with Le Vau's part, staircases of the Colonnade on the Rue de Rivoli side, part between the Pavillon de Marsan and the Guichets du Carrousel, completion of the Salle des Cariatides), the Tuileries (Arc de Triomphe du Carrousel), Versailles, Compiègne, St Cloud and the Elysée Palace; project for the palace of the King of Rome at Chaillot. Their experience in creating opera décor qualified them as organisers of the great imperial festivals. They directed building operations at all the imperial residences and conquered cities: Laeken in Belgium, Antwerp, Mainz, Venice, Florence, Rome. Fontaine, also architect to the Duc d'Orléans and then to Louis Philippe, erected the Galerie d'Orléans. Through their liking for restraint, their culture, their versatility in using a scholarly decorative grammar, these two fertile artists were masters of a style that is sometimes a trifle heavy, but always included beautiful proportions and grandeur without exaggeration. They have neither the sectarianism of Quatremère de Quincy nor the rigidity of Rondelet (1743–1829), the opponent of decoration. The main Neoclassicists are Antoine Vaudoyer (1756–1846) with his Salle des Séances in the Institut and his Musée des Monuments Français, J. B. Lepère (1761–1844) who with his son-in-law Hittorff built the church of St Vincent de Paul on the basilican plan, Pierre Alexandre Vignon (1763–1828) with the Madeleine [121], E. H. Godde, who specialised in churches (the basilican St Pierre du Gros Caillou), Lesueur, Gisors and Leconte. Percier's pupils — F. Debret, a classicist in the Palladian tradition, L. H. Lebas (1782–1867), who was more eclectic and designed Notre Dame de Lorette (1823–1836), J. de Joly, who worked on the Palais Bourbon, L. Visconti (1791–1853), J. Huvé (1783–1852), who completed the Madeleine from 1828 to 1845, and Hittorff (1792–1867), who was above all the promoter of external polychromy on public buildings in the name of antiquity (Gare du Nord, 1861–1865, which combines the Orders with ironwork) — offered a very flexible Neoclassicism and retained their teacher's refinement of ornament.

More modern, and often hampered by their culture, are the rationalists: Duban (1797–1870), who worked on the Louvre and the Ecole des Beaux-Arts, Gau (Ste Clotilde [65] finished in 1957), Duc (Palais de Justice) and Dusillion, precursor of the Second Empire.

In garden design Romanticism prevailed after the Revolution: Anglomania was the fashion, and the gardens of the abandoned châteaux were put in order ' in the English manner '. The theorists of the Empire (J. M. Morel, Valenciennes who maintained that one had to see Switzerland, the Pyrenees, Italy and other Romantic lands in order to make a garden, Curten and Laborde) [4] praised the English landscape garden with few architectural features; those of the Restoration (Lalos, Thouin, Vitet, Richau, Loudon) stressed the need for picturesqueness, for colour and Gothic ruins.

Sculpture. During the opening years of the century sculpture came under the influence of Canova [55], although he refused to take over the direction of the Beaux-Arts, which Napoleon offered him to persuade him to settle in Paris. But Neoclassical sculpture retained, above all in portraiture, a touch of realism, a sense of life and an honesty free from show that are worthy of the sound 18th-century tradition of men like Houdon and Caffieri. Thus Corbet's *Bonaparte, First Consul*, Chinard's *Mme Récamier* (Lyon museum), Cartellier's *Vergniaud* (Versailles museum) and the portrait of the Marquise de La Carté, daughter of the very Canovian Bosio, are all masterpieces that avoid ideal beauty or imitation of the antique. But these ideas prevailed in official monumental sculpture. Lyrical subjects in the neo-Hellenic spirit were not propitious to the sculptors of either the Empire or the Restoration, who lapsed into insipidity, like Pradier. Typical creators of this Empire style are J. Chinard (1756–1813) [152], trained at Rome and able to preserve in his busts a sense of character, and P. Cartellier (1757–1831), who avoided the academic mould and retained a

ENGLISH WATERCOLOURS

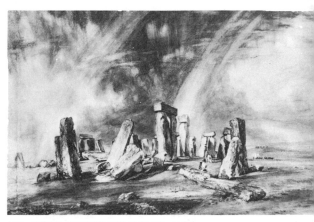

135. JOHN CONSTABLE (1776–1837). Stonehenge. 1836. *Victoria and Albert Museum, London.*

136. RICHARD PARKES BONINGTON (1802–1828). View of Bologna. c. 1826. *Louvre.*

137. JOHN SELL COTMAN (1782–1842). Greta Bridge. 1806. *British Museum.*

138. JACQUES LOUIS DAVID (1748–1825). Coronation of Napoleon. *Louvre.*

140. PIERRE PAUL PRUD'HON (1758–1823). Mlle Constance Mayer. *Louvre.*

142. JEAN AUGUSTE DOMINIQUE INGRES (1780–1867). Achille Leclère and Jean Louis Provost. 1812. *Smith College Museum of Art, Northampton, Massachusetts.*

139. EUGÈNE DELACROIX (1798–1863). Mounted Arab Attacking a Panther. *Fogg Art Museum, Cambridge, U.S.A.*

141. JEAN BAPTISTE COROT (1796–1875). St André en Morvan. 1841. *Louvre.*

vigour apparent in his funerary statue of Josephine at Rueil. Cartellier kept his official position after the Restoration (*Louis XIV* in the forecourt of Versailles). D. Chaudet (1763–1810), also a painter and draughtsman (*Racine*, published by Didot) and famous for his bronze *Belisarius* (1791) is, with the lyricism of his subjects taken from Bernardin de Saint-Pierre or ancient myth, the contemporary of Chénier, Prud'hon and Girodet. The same Anacreontic elegance is present in the work of Pajou's pupil C. Callamard and of the Monégasque F. J. Bosio (1769–1845) [**154**]. Another pupil of Pajou's who was also a pupil of Canova (*Salmacis*, Louvre, or *Indian Woman*, Avignon museum), Bosio was the favourite sculptor of Napoleon, Louis XVIII (*Henry IV as a Child*, 1824, Versailles), Charles X and Louis Philippe (*Louis XIV* of the Place des Victoires, *Louis XVI* of the Chapelle Expiatoire, quadriga of the Arc de Triomphe du Carrousel).

The artists of the Restoration were entrusted with exalting in historical effigies a monarchist or Bonapartist enthusiasm parallel to the taste for the troubadour style. This was ushered in by

Gois's *Joan of Arc* (1804, Orléans) and was given lustre by the prolific J. P. Cortot (1787–1843), F. Lemot of Lyon (1772–1827), the eclectic H. Lemaire (1798–1880), who worked in Russia, D. Foyatier (1793–1863) [**153**], A. M. Moine (1796–1849) [**67**], C. E. M. Seurre (1798–1858) and J. N. N. Jaley (1802–1866), son-in-law and pupil of Cartellier. More or less academic are P. N. Beauvallet (1750–1818), C. L. Corbet (1758–1808), A. Dumont (1801–1884), sculptor of the *Spirit of Liberty* of the Bastille, Triqueti (1804–1874) who worked on the Madeleine, St Germain l'Auxerrois and Ste Clotilde, and in England (Prince Albert memorial chapel, Windsor), Marochetti (1805–1867), responsible for the *Jemmapes* bas-relief on the Arc de Triomphe de l'Etoile and the *Richard Cœur de Lion* at Westminster, Simart (1806–1857), passionately fond of Greek art, A. Etex (1808–1888) and P. F. G. Giraud (1783–1836), sculptor of the tomb for his wife and two daughters now in the Louvre.

Romanticism, with the subversive impact of its more realist vision, its fresh choice of subjects and its need to create a new style in which movement and a lively conception of mass replace the smooth modelling dear to the academics, appeared at the Salon of 1831 in the *Orlando Furioso* [**13**] of Jean du Seigneur (1808–1866). The great Romantic Salon was that of 1833, but from 1835 to 1837 the Romantics were banished: Maindron, Préault, Moine and Barye did not figure at a Salon again, and the ' reptiles of the Institut ', as Préault says, were triumphant. The great Romantic was Auguste Préault (1810–1879) [**74**] whose fierce spirit and lyricism became famous (*The Slaughter*, *Famine*, *Destitution*, *The Pariahs*, the *Christ* of St Gervais et St Protais). He continued his impassioned art during the Second Empire (*Ophelia*, 1876, Marseille). François Rude (1784–1855) [**69–71**], a Burgundian trained by Cartellier, was independent and a realist despite his capricious style (*Mercury*, Louvre). In the *Departure of the Volunteers in 1792* (1835–1836), traditionally known as *The Marseillaise*, he created the finest bas-relief on the Arc de Triomphe. His masterpieces are the portrait of Monge (Beaune), the Cavaignac tomb (Paris) and the bronze *Awakening of Napoleon* (Fixin, near Dijon). David d'Angers (1788–1856) [**73**] was the ' balanced ' Romantic. His series of medallions and extensive production make him the portrayer of his age (Goethe, Paganini, Lamennais). But the most inspired Romantic sculptor was Antoine Barye (1796–1875). A pupil of Bosio and Gros, his animal sculpture conveys the tense energy of the wild beast, the violence

MASTERPIECES OF A. J. GROS (1771–1835)

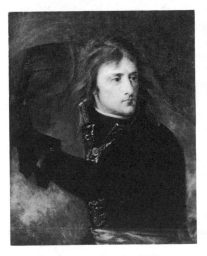

143. Bonaparte at Arcole. 1796. *Louvre.*

144. Christine Boyer, first wife of Lucien Bonaparte. *c.* 1800. *Louvre.*

145. The Pesthouse at Jaffa. 1804. *Louvre.*

and ardour of combat. He was Romantic in the same way as Géricault in his expression of vivid energy (*Battle between the Lapiths and Centaurs* [**11**, **35**, **72**], *Theseus Fighting the Minotaur*, about 1843, *Jaguar Devouring a Hare*, 1850). The Swiss James Pradier (1790–1852) [**155**], favourite artist of the July Monarchy (*Three Graces*, *Toilet of Atalanta*), and Bosio's pupil F. Duret (1804–1865) (*Chactas in Meditation before the Tomb of Atala*) are pleasant and charming but little more.

Painting. Jacques Louis David (1748–1825) [**48–51**] was one of the greatest artists France has produced. He was a pupil of Vien and won the Prix de Rome in 1774. He lived in Rome for five years and met Quatremère de Quincy who opened his eyes to Neoclassical aesthetics. David responded with enthusiasm to the ideal beauty and painted his *Belisarius* on returning to Paris, and then on a second visit to Rome the *Oath of the Horatii* (1785, Louvre). His Neoclassicism henceforth was impregnated with allusions to contemporary affairs: the *Death of Socrates* (1787) glorifies philosophy; *Brutus and his Dead Son* (1789) criticises Louis XVI's weakness for émigrés; the *Sabine Women* (1799) preaches reconciliation and *Leonidas at Thermopylae* (1804–1814) exalts patriotic sacrifice. In all these canvases the drawing is analytical and precise, movement banished, the colour is drab and the brushwork polished. He was admitted to the Academy in 1783 (*Andromache by the Body of Hector*). In the same year he painted the portrait of Mme Pécoul (Louvre) whose daughter he married; in 1785 the portrait of M. Pécoul and a self-portrait; in 1788 *Paris and Helen* (Louvre) for the Comte d'Artois; in 1789 a pen drawing with sepia wash, the *Serment du Jeu de Paume*

(Louvre). He was a Deputy at the Convention, where he voted in favour of the execution of the king, and in 1793 engineered the suppression of the Academy. The *Death of Lepeletier de Saint-Fargeau* and the *Assassination of Marat* [**50**] date from this period.

During the Revolution David exercised a real dictatorship over the arts; he also organised enormous national festivities (to celebrate the recapture of Toulon from the English; and for the Champ de Mars). He was President of the National Convention in 1794 and devoted to Robespierre, after whose fall he was imprisoned in the Luxembourg. Later he made the acquaintance of Napoleon, after the 18th Brumaire becoming a member of his entourage, and painted his *Bonaparte Crossing the St Bernard Pass*. When the Empire was established David's conversion to Bonapartism and the impact of his *Coronation of Napoleon* (1805–1807) [**51**, **138**], in which a sweeping sense of history is combined with a scrupulous realism in the portraits, liberated the desire for grandeur that made Gros, Géricault, Delacroix and Chassériau cover vast walls and huge canvases. The Napoleonic epic inspired David (*Coronation*, *Distribution of the Eagles*) and Gros (*Pesthouse at Jaffa*, 1804, Louvre; *Battle of Aboukir*, 1806, Versailles; *Napoleon at Eylau*, 1808, Louvre). It also excited the Michelangelesque imagination of Géricault and led to the great 'massacres' of Delacroix. The hero myth and tragic sense of history were born. David remained the admirable portraitist of Mme Récamier (1800) and Mme de Verninac (Louvre) and the *Old Man with a Hat* (Antwerp). He ended his life in exile at Brussels (*Ladies of Ghent*, Louvre) and his influence spread throughout Europe by his followers (J. Franque and J. B.

Wicar at Naples, Navez and Odevaere in Belgium, Riesener in Russia, Léopold Robert in Switzerland and Italy, Debret in Brazil). He had been the teacher of Gros, Gérard, Girodet, Ingres and Isabey, as well as of minor but respectable artists.

A. J. Gros (1771–1835) [**84**, **143–145**], trained by David but an admirer of Rubens, had an epic imagination and sense of movement. He met Napoleon in Italy, and from then on was the minstrel of the imperial saga and a lyric portraitist (*Napoleon at Arcole*, 1796; *Fournier-Sarlovèze*, 1812; *Murat*) or already a Romantic one (*Christine Boyer*, *Baroness Legrand*). François, Baron Gérard (1770–1837) [**75**], a contemporary of Gros and like him a painter of the memorable events of Napoleon's court and later of the Restoration, was an elegant, polished portraitist (*Mme Récamier*, 1802, *Countess R. de Saint Jean d'Angély*, *Mme Visconti*, Louvre). A. L. Girodet-Trioson (1767–1824), a strange pupil of David, responsive to Chateaubriand (*Burial of Atala*, 1808 [**63**]) and to Macpherson (*Shades of the French Warriors led to Odin*) as well as being a writer himself, had a slightly morbid charm and an inclination to poetry. J. B. Isabey (1767–1855) [**17**] retained a memory of David's teaching in his miniatures.

J. P. Regnault (1754–1829), David's rival as a modern Raphael, and his pupil P. N. Guérin (1774–1833) [**148**] remained cold classicising image-makers. Pierre Paul Prud'hon (1758–1823) [**85**, **140**], a Burgundian much influenced by Leonardo and Correggio, was an independent whose sad, Hellenistic grace is more at ease in the expression of feminine charm (*Empress Josephine*, 1805, Louvre) than in learned allegories (*Crime Pursued by Vengeance*

146. FRENCH. Romantic paperboard binding decorated with coloured lithographs in a 'cathedral' style framing. 1826. *Bibliothèque Nationale, Paris.*

147. FRENCH. Wood engraving after Charles Théodore Frère. An illustration from *Les Étrangers à Paris* by Louis Desnoyers, etc. c. 1845.

and Justice, decoration for the Palais de Justice, 1808).

Another great independent is J. A. D. Ingres (1780–1867) [**19**, **33**, **57–59**, **142**] whose career was marked by bitter hostility to Delacroix and Romanticism. After studying with David he won the Prix de Rome in 1801 and spent eighteen years in Florence and Rome (1806–1824), returning to Rome 1834–1841 as Director of the French Academy. His earliest portraits showed his quality of abstract rhythmic line, coupled with penetrating observation: *Self-portrait* (1804); portraits of M., Mme and Mlle Rivière (1805). In Florence he came under the influence of the Italian primitives, Greek vase painting and Flaxman's illustrations for Homer: *Bather of Valpinçon* (1814); *Oedipus and the Sphinx* (1808); *Jupiter and Thetis* (1811); *Odalisque* (1814); *Roger Delivering Angelica* (1819). In Rome the increasing influence of Raphael led to the *Vow of Louis XIII* (1821) and, after his return to France, to academicism in the *Apotheosis of Homer* (1827); *Stratonice* (1840). He aimed at finding 'the secret

of the beautiful through the true' but his masterpieces are not his attempts at the Grand Manner, such as the *Golden Age* (1842, Chateau Dampierre) but his portraits, either painted (*Granet*, 1807; *M. de Norvins*, 1811; *Mme de Senonnes*, 1814; *M. Bertin*, 1832; *Mme Moitessier*, 1856) or drawn (*Forestier family*, 1806; *Mme Destouches*, 1816; *Stamaty family*, 1818).

The influence of Ingres at Rome on his pupils, who learned from him to admire Raphael, and contact with the Nazarenes formed a few religious decorators: V. Mottez (1809–1897) and Ingres's most faithful follower H. Flandrin (1809–1864; mural in St Séverin and St Germain des Prés).

The conflict between Neoclassicism and Romanticism passed through a phase more bitter in France than in the rest of Europe at the moment when, as well as the quarrels over words and aesthetic doctrines, two hostile conceptions of painting confronted each other — that of Ingres, champion of the Neoclassicists, who preferred drawing, the sculpturesque, and stable, balanced form; and that of Delacroix and the Romantics who sought expression, movement and the emotional quality of colour. The first brilliant flash of Romantic painting lit up the Salon of 1819, at which was exhibited the *Raft of the Medusa*, a dramatic incident raised to the level of an epic by the genius of Géricault. Delacroix contributed his dramatic grandeur to the Salon of 1822, and to that of 1824 with *Dante and Virgil Crossing the Styx* and the *Massacre of Chios*. All the great Romantic driving forces had thus come into action — a tragic sense of life and death, exoticism, movement, colour, the influence of Rubens, Michelangelo and the English.

Théodore Géricault (1791–1824) [**12**, **86**, **88–91**] was a pupil of C. Vernet and Guérin, in whose studio he met Delacroix. He was influenced by Gros and by the imperial epic: *Officer Charging* (1812); *Wounded Cuirassier* (1814). In Rome in 1816 he was deeply impressed by Michelangelo: *Race of Barbary Horses* (1817; colour plate p. 54). His most influential work was the *Raft of the Medusa* (1819) inspired by a contemporary tragedy, which was later exhibited in England. He himself visited England in 1820–1822, met Lawrence, Constable and Bonington and in works like *The Epsom Derby* (1821) projected his conviction of the horse as a symbol of vital strength. His penetrating studies of the insane inmates of the Salpêtrière Hospital, Paris, confirm the belief that he would have been one of the greatest artists of the 19th century had he not died young.

Eugène Delacroix (1798–1863) is the embodiment of Romanticism [**21**, **22**], yet he would have liked to be a

'pure classicist'. With his cultured mind he drew his subjects from Dante, Shakespeare, Milton, Goethe, Byron and Sir Walter Scott. Conversant with the great ideological currents of his times and a writer himself (*Journal*), he studied under Guérin and by contact with the old masters — Rubens, the great Italians at the Louvre and contemporary English artists. His great early works are in the Louvre (*Dante and Virgil Crossing the Styx* [**100**]; *Massacre of Chios* [**102**]; *Death of Sardanapalus*, 1827; *Liberty Guiding the People*, 1830; *The Capture of Constantinople*, c. 1840 (colour plate p. 54). A journey to Morocco in 1832 revealed to him the poetry of exoticism [**28–32**, **139**], and disclosed new colour harmonies that made him the equal of the Venetians (*Women of Algiers*, 1834) and a precursor of the Impressionists. He was also a fine portraitist (*Baron Schwiter*, 1826; *Self-portrait in a Green Waistcoat*, 1835; *M. A. Bruyas*). His wild beasts, his fights between animals and his hunts are expressions of an unchained life-force. Above all, he was the 19th century's greatest decorator [**103**] (Hôtel de Ville, Paris, 1849–1853, now destroyed; Salon du Roi, 1833–1837, and library of the Palais Bourbon, 1838–1847, library of the Luxembourg Palace, 1845–1847; Chapelle des Anges in St Sulpice, 1849–1861). Théodore Chassériau (1819–1856), an extraordinarily gifted pupil of Ingres, was Delacroix's only real disciple, and had his inward fervour (portrait of Lacordaire), his instinctive relish for the power of colour (*The Two Sisters*) and for a noble, sincere, poetic exoticism, which came from his Creole origin and a journey to Algeria. An aristocrat among decorators, he painted his masterpieces *War* and *Peace* for the Cour des Comptes, Palais d'Orsay (almost completely destroyed in a fire).

The Levant attracted artists, whether precursors like J. R. Auguste (1789–1850), a friend of Géricault and Delacroix, lovers of the expressively picturesque like A. Decamps (1803–1860) [**164**], who went to Smyrna in 1827 with the marine painter Garneray, or discreet narrators like A. Dauzats, P. Marilhat, Alfred Dehodencq (1822–1882), a follower of Delacroix, H. P. L. P. Blanchard, who went to Mexico, or the elegant E. Fromentin (1820–1876), as much a writer as a painter.

Important about 1830–1840 and painters of literary, historical or martial themes, some Romantics or semi-Romantics had a talent for illustration and were excellent lithographers. Horace Vernet (1789–1863) painted battles for Versailles. N. T. Charlet (1792–1845) [**9**] and A. Raffet (1804–1860) [**133**] exalted and popularised the Napoleonic epic, which also affected H. Bellangé and Baudelaire's friend J. F. Boissard de

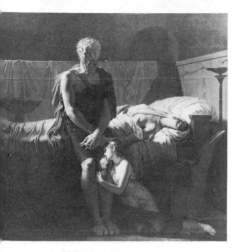

148. FRENCH. PIERRE NARCISSE GUÉRIN (1774–1833). The Return of Marcus Sextus. 1799. *Louvre.*

149. FRENCH. J. A. D. INGRES (1780–1867). The Vow of Louis XIII. 1824. *Montauban Museum.*

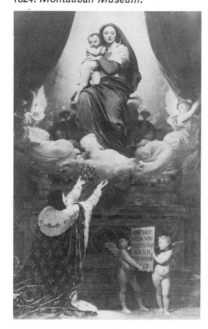

Boisdenier. E. Lami [405] and A. de Dreux were worldly illustrators of the courts of Louis Philippe and Napoleon III. All were artists of the second rank, on a level with the following more strongly marked Romantics: Eugène Isabey (1803–1886), the miniaturist's son and a painter of good seascapes in the English manner; Eugène Devéria (1808–1865) [78], who made his name in 1827 with his big picture, the *Birth of Henry IV*; his brother Achille (1800–1857), illustrator and lithographer; Louis Boulanger (1806–1867) [131], a friend of Victor Hugo and portraitist of his writer friends (*Balzac, Petrus Borel*); H. Poterlet and E. Deroy (portrait of Baudelaire), who both died young; C. E. Callande de Champmartin, mainly a portraitist; O. Tassaert, typical of the minor artists who continued the 18th-century tradition

into a Romantic sentimentalism; H. G. S. Chevalier, who took the name of Paul Gavarni in 1829, painter of lower-middle-class life, and an excellent draughtsman and lithographer [132].

Middle-of-the-road painters were Ary Scheffer (1795–1858) [162], who became famous through his sentimental, religious and historical works, and Paul Delaroche (1797–1856), who met with success all over Europe through his big historical scenes popularised by engravings (*Children of Edward IV, Death of Lady Jane Grey, Assassination of the Duc de Guise*) [399]. They are typical of a kind of picture that has more to do with theatrical staging than with painting. J. N. Robert-Fleury showed the same defects.

Theatrical decoration became more important with the success of Romantic drama and of opera. Daguerre (1787–1851), inventor of the diorama and then of the daguerreotype, painted numerous sets for the Opéra. Through his fondness for shadow and the mystery of ruins, P. L. C. Cicéri (1782–1868) was a Romantic decorator and principal set-designer at the Opéra.

19th-century painters discovered nature. The historical landscape died about 1820 with P. H. de Valenciennes (1750–1819) [346, 347] and A. E. Michallon (1769–1822). Between 1820 and 1840 J. J. Bidault (1758–1846), J. V. Bertin (1775–1843) and T. C. d'Aligny (1798–1871), the teachers and friends of Corot, tried to renovate the Neoclassical formula.

J. B. C. Corot (1796–1875) [92–95, 104, 141, 366, 391] was, in a sense, a Neoclassicist ('What I look for is form,' he said, ' colour, for me, comes afterwards'). After studying with Michallon and Bertin he visited Italy (1825–1828, 1834, 1843), where he painted many masterpieces from nature (*View of the Colosseum, Bridge at Narni*, 1826), and executed Poussinesque mythological landscapes. But he was also a lyricist (' Let your feeling be your only guide '), a Lamartinian, almost a Romantic through his sensibility, his capacity for making discreet confidences. A painter in greys shunning ostentation, he was perhaps the most typically French artist of the 19th century. Despite his huge œuvre, augmented by many ' innocent fakes ' (copies retouched by him or imitations by his pupils E. Poirot, A. J. Prévost, P. D. Trouillebert, C. P. Desavary, H. J. C. Dutilleux, P. Comairas, A. Robaut) it is hard to choose among his masterpieces (*Chartres Cathedral*, 1830; *Garden of the Villa d'Este*, 1843; *View of La Rochelle*, 1851; *View of Nantes; Souvenir de Mortefontaine*, 1864; *Douai Belfry*, 1871). From certain portraits (*Mlle Sennegon*, 1833; *Mme Charmois, c.* 1845) and certain figures from his old age (*Woman with*

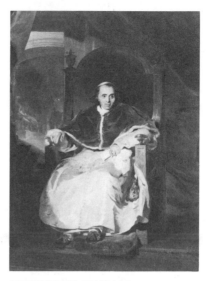

150. BRITISH. THOMAS LAWRENCE (1769–1830). Pope Pius VII. Reproduced by Gracious Permission of Her Majesty The Queen.

151. SPANISH. EUGENIO LUCAS THE ELDER (1824–1870). The Inquisition. *Fundación Lázaro Galdiano, Madrid.*

the Pearl, 1868–1870; *Woman in Blue*, 1874) there emanate a unique purity and poetry. Corot was the friend of Daumier and Pissarro, and the teacher of Berthe Morisot.

The Romantic landscape changed the feeling for nature. In actual fact, it had forebears in France who, from Claude le Lorrain to Joseph Vernet and Granet, sought the emotive effect of light. L. G. Moreau and Georges Michel, passionate admirers of the Dutch landscapists, further accentuated the tendency to choose great skies, contrasts between shadow and delicate patches of light, the dynamics of clouds and forests. But the Dutch vision was revived, and transposed through a rapid, supple handling, by the English — by Constable (*The Haywain*, shown at the 1824 Salon), by Turner and the watercolourists (the Fieldings and above all

Bonington) whose light and fluid technique, suited to the rendering of aerial effects, made a strong impression on the young Romantics.

Huet, Flers, Dupré, Cabat, Millet and Théodore Rousseau chose as themes the sky, the sea and especially the forest, where the tree symbolises a human presence, a hero triumphant or thrown down. The structure of the picture was built up of tone values. Corot painted from nature, and then corrected; the others worked in the studio from a sketch. All tried to obtain a very ordered effect of spontaneity.

Georges Michel (1763–1843) [128], restorer of the Dutch and Flemish pictures at the Louvre and devotee of Rembrandt, had a dramatic vision of the sky around Paris. Paul Huet (1804–1869) sought nature's dramas — floods, storms and the mystery of the forests (*Flood at St Cloud*, Louvre). In his late works he lost his chromatic qualities. Virgilio Narcisso Diaz de la Peña (1808–1876), an independent and a spirited colourist, painted flowers, Orientals and, above all, delicate forest interiors. After 1848 he worked at Barbizon with Millet and Rousseau. Monticelli and Renoir were struck by his original technique. At first a straightforward landscapist, Constant Troyon (1810–1865) became, following a journey to Holland, a sometimes successful animal painter.

The Barbizon school, called the 'school of 1830', reunited three friends, Théodore Rousseau, J. F. Millet and J. Dupré (1811–1889), whose vocation as a landscapist suddenly emerged, after a stay in the Morvan region, at the Salon of 1831, and who came under Dutch (van Goyen, Ruisdael, Rembrandt) and English influence. After an acutely and luminously truthful early style, Théodore Rousseau (1812–1867) [351, 373], trained by academics, was taken in the Auvergne during 1830 with a kind of mystique of nature. He 'heard the language of the forest'. 'One does not copy what one sees...but one feels and interprets a real world all of whose fatalities enfold us.' Passionate and incapable of compromise, he settled at Barbizon. He had a great success at the Paris World Exhibition of 1855, but the end of his life was clouded by illness. His masterpieces are often imposing portraits of trees: *Avenue of Chestnut Trees*, *Oaks in the Bas-Bréau*, *The Rock Oak*. The same gravity, the same religious views of nature, together with a Virgilian and biblical feeling for man in the simplicity of rural life, characterised Jean François Millet (1814–1875) [378–380], a Norman peasant trained by the masters of the Louvre and by the copies and imitations that he made for a living. He began by painting in a pleasant style with light colouring, and produced admirable portraits. At Barbizon in 1849 he discovered rustic grandeur and his art achieved a sad monumentality, which remained, however, an idealisation and glorification of peasant life (*The Sowers*, *The Gleaners*, 1857; *The Angelus*, 1857–1858; *The Man with the Hoe*). His last works are more atmospheric (*Spring*, *Church at Gréville*).

Whether from Lyon like Corot's friend Auguste Ravier (1814–1895), whose studies from nature were delicate and original, H. Allemand (1809–1886), a pupil of Rousseau, and the landscape painter and portraitist J. M. Grobon (1770–1853); or from Provence like E. Loubon (1809–1863), a history and genre painter, the provincial artists added a quality distinctive of their native region.

About 1840 a return to the classicist sense of landscape began in the Romantic studios. It shows clearly in the work of Decamps, Troyon, A. C. de la Berge and especially Louis Français and Louis Cabat (1812–1893), a pupil of Flers whose journey to Italy in 1837 made a strong impression on him. There he met disciples of Ingres who influenced him into becoming a Realist.

In reaction against the Romantic effect, the tendency to paint the countryside like Ingres, apparent in the coldly academic landscapes of P. Flandrin, A. Desgoffe or G. I. Flacheron, in search of the 'historical tone' beloved by Ingres, gave rise later to the purified art of Puvis de Chavannes.

The religious landscape came into being about 1830 with J. A. Benouville (*Death of St Francis*). Examples were painted by Corot between 1835 and 1850, by Flandrin and by Cabat.

With the admiration for Dutch and English art, animal painting was reborn. From noble animals — the horses and wild beasts of Géricault, Delacroix and Barye — there was a descent to rural livestock, to the cows of Troyon or J. R. Brascassat and the sheep of C. Jacques (1813–1894). The way to Realism was open.

Flower painting was a relic of the previous century. Though it was not disdained by Delacroix, who composed some admirable Baroque bouquets, this genre died out about 1840, with the death of P. J. Redouté, teacher of flower drawing at the Museum of Natural History, Paris, and of A. Berjon (1754–1843), who had a sense of style and light.

Through the Institut, teaching and the Salon selection committees, the academicians Heim (Salon of 1824), Hersent, Blondel, A. de Pujol, Picot and Léon Cogniet, who were pupils of Ingres, David and Guérin, exercised an outrageous dictatorship that denied honours

152. FRENCH. JOSEPH CHINARD (1756–1813). Mme Récamier. Marble. c. 1802. *Lyon Museum.*

to all the best painters (Delacroix had to apply as many as seven times before succeeding to Delaroche at the Institut).

A separate place must be made for the writer-draughtsmen T. Gautier, A. de Musset, Mérimée and Baudelaire. But the greatest of them was V. Hugo, who, starting his drawings with a blot, imagined mysterious and fantastic landscapes.

The minor arts. A. Lenoir preserved some ancient stained glass with which he adorned the windows of the Musée des Monuments Français. But it was in England that the glass-makers of the early 19th century relearned their craft, and it was English craftsmen who translated the cartoons of A. de Pujol for Ste Elisabeth, Paris. Enamel painting reproduced the pictures of the masters in stained glass windows, and Sèvres continued manufacturing until about 1825 for St Denis and for the Sorbonne chapel. Medieval techniques were rediscovered. At Choisy le Roi, the head of the factory discovered from 1826 to 1845 the composition of old coloured glass. Ingres (windows of St Ferdinand des Ternes, 1842) and his pupils Chassériau, Lamothe and Mottez designed cartoons. The systematic restoring of the windows of Gothic churches led to imitation. The growing success of the stained glass window was confirmed. In 1835 four factories existed in France; in 1863 there were 150.

Aubusson, Beauvais and the Gobelins tried to reproduce pictures in tapestry, but the skill of the weavers did not make up for the poverty of the style.

In textiles the firm policy of Napoleon, who wanted to develop the luxury industries and handicrafts for practical reasons as well as those of prestige, and the expensive tastes of Josephine, Marie Louise and the imperial court produced a considerable burst of artistic activity. The Lyon silk industry quickly revived

153. FRENCH. DENIS FOYATIER (1793–1863). Joan of Arc. 1855. Orléans.

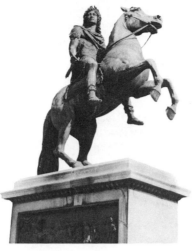

154. FRENCH. FRANÇOIS JOSEPH BOSIO (1769–1845). Louis XIV. 1822. Paris.

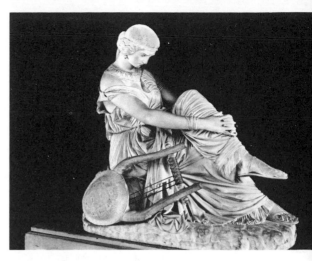

155. FRENCH. JAMES PRADIER (1790–1852). Sappho. 1852. *Louvre*.

after the Revolution. Linen and cotton were used instead of silk in the humbler homes. In Alsace, at Jouy en Josas, where the production of printed cloth with revolutionary or antique motifs increased because of the invention of the roller printing machine by an Englishman in 1783, the designers created light decorations (Huet) which became increasingly heavy after the Restoration. But, as a replacement for fabrics, wallpaper [176] in juxtaposed widths allowed charming decorative effects (Gohin, Jacquemart, Simon, Zuber). Paper even imitated draped muslin, lace and velvet.

Romanticism saw the triumph of the print. All the artists were to a great or lesser extent engravers. The contrast of blacks and whites, the battle of light and shade, the antithesis of opposites that V. Hugo presented as a dogma of Romantic aesthetics found its favourite field of action in the print. Book illustration is one of Romanticism's successes (Tony Johannot [16], Célestin Nanteuil [15]). When, after 1830, freedom of the press allowed political cartoons they proliferated: Decamps and Raffet, who soon tired, Grandville (J. I. T. Gérard, 1803–1847) [26], who applied to it his already surrealist verve, C. J. Traviès, the witty and delicate Gavarni (1804–1866), H. Monnier (1805–1877) and above all the genius Daumier [20] (*Le Ventre Législatif*, *Enfoncé Lafayette* and his masterpiece *Rue Transnonain, 15 Avril 1834*; see p. 164).

Artists made great use of lithography, a new process invented in 1796 by the Bavarian writer Senefelder, and introduced into France during the Empire. The first to practise lithography were Géricault, C. Vernet and Delacroix, who composed his 'Faust' series in 1828. Daumier's cartoons and Devéria's portraits [24] were drawn on the lithographic stone. Decamps, Chassériau, P. Huet, Isabey, E. Lami, C. Jacques, Raffet [133] and Charlet

were great engravers. Lithographic art had almost disappeared after 1850.

Etching reappeared after 1828: P. Huet (*Thatched Cottage*), and Chassériau ('Othello' series, 1844).

Wood engraving, i.e. using the end grain, invented in England about 1775 by Thomas Bewick, was used for Romantic illustration: Jean Gigoux (*Gil Blas*, 1835), Tony Johannot (Nodier's *Histoire du Roi de Bohême*, 1830; *Paul et Virginie*, 1838).

In photography N. Niepce (1765–1833) helped his associate the painter J. Daguerre (1787–1851) to invent in 1839 the daguerreotype, a plate of silvered copper developed with mercury vapour. The Englishman Fox Talbot in the same year announced a method of making first a negative from which positives could be taken, thus making possible an unlimited number of prints. Daguerre's method proved to be a dead end and it was Fox Talbot's which was developed.

The popularisation of books, which were often no longer bound, could have been a disaster but for the reaction of the Didot, admirable publishers whose typographical researches in the direction of purity, simplicity and legibility influenced all printing till about 1850. The bindings of Bozérian were in the same spirit.

Medals remained Neoclassical with Augustin Dupré (1748–1833), though he introduced a pre-Romantic note, and with Andrieu [175]. David d'Angers (see under *Sculpture*), in his vivid profiles, is the great Romantic medallist.

During the Empire, the traditions of 18th-century goldsmiths' work were continued by H. Auguste. But J. B. C. Odiot (1763–1850), surrounding himself with the best artists and designers (Percier and Fontaine, Laffitte, Moreau), brought a new spirit. He created a masterpiece in the Empress Marie Louise's dressing table, after drawings by Prud'hon. Biennais (1764–1843), Odiot's rival, worked for the court (Josephine's soup tureen, Napoleon's

tea urn) and for foreign customers, in the same classicising style and always with the same sharp, refined technique which was also responsible for the quality of Restoration goldsmiths' work. C. Cahier, Biennais's successor, through his brother the archaeologist, introduced Gothic. He engraved the coronation vessels. Charles Odiot brought back from England the English techniques and forms. In the same line are to be found Durant, Lebrun and Fauconnier, who made a tea service for the Duchesse de Berry adorned with animals by Barye.

The passion for Gothic brings into vogue *ferronnières*, ornaments in the style of Agnès Sorel or Joan of Arc. Chenavard (1798–1838) [177], a director of Sèvres, and then Liénart exerted an influence on taste, whose evolution can be followed in the industrial exhibitions of 1834, 1839, 1844 and 1849. Almost all the sculptors well known between 1830 and 1840 (Feuchères, Pradier, Préault, Cavelier, F. de Fauveau, etc.) made models for C. Wagner, Morel, A. Vechte, Duponchel and the famous Romantic goldsmith Froment-Meurice (1802–1855), whom the critics saw as a new Cellini (table centrepiece for the Duc de Luynes after a model by Feuchères).

Metal casting, the fashion for which began during the Empire, only produced mediocre standardised articles. A revival of the smith's art occurred from 1845 in the workshops of the historical monuments committee, at the instigation of Viollet-le-Duc and Lassus: strap hinges for the doors of the Madeleine at Vézelay and Notre Dame in Paris.

In ceramics Sèvres still kept, during the Empire, the traditions of the 18th century. For the creation of luxury articles, soft-paste porcelain retained its impeccable quality, owing to the difficulty of making it. With hard-paste porcelain, which is easier to prepare, the forms and decoration lost their

refinements as industrialisation increased in the course of the century. ' Pottery works on the model of the English ones ' — Pont aux Choux at the close of the 18th century and above all Mazois's factory at Montereau, which merged in 1818 with that of Creil [178], where English potters came to work — enjoyed a tremendous success. At Douai, Chantilly and Forges les Eaux (Ledoux-Wood), the English introduced their technique of making pottery with printed decoration. Under Louis Philippe, Jacob Petit, a pupil of Gros, created ornaments inspired by Capodimonte Rococo, in a fine-quality paste coloured with light, delicate tints.

As early as the Directory, artistic activity in furniture and interior decoration revived with a passion for luxury. The symbolism of the revolutionary attributes (fasces, pikes, compasses, cockades) in ornament showed a new taste for fantasy, just as did the Etruscan, Greek and Egyptian furniture. Georges Jacob made the ' antique ' furnishings for David's studio. Mahogany with bronze decoration was preferred. The Directoire style retains memories of Louis XVI (painted furniture) with the addition of antique, Oriental, Egyptian and Italian features (Percier and Fontaine reintroduced the rinceaux and arabesques of the 15th and 16th centuries). During the Empire [167, 171, 172], furniture grew heavier, overloaded with finely worked bronzes. Ravrio and Thomire decorated with often very delicate figurines the mahogany furniture designed by Riesener, Lignereux and the sons of Jacob the Elder, Georges Jacob and F. H. Jacob Desmalter. Marie Louise's jewel cabinet at Fontainebleau by Jacob Desmalter (bronzes by Chaudet) is typical of such work. The Marshals' table designed by Percier and constructed by Thomire, with its circular tray ornamented by Isabey, is a masterpiece of its kind.

After 1816 the role of the Duchesse de Berry in the evolution of the decorative arts was an important one. The *bal blanc* of the ' Angel of the Monarch ' and that of 'Marie Stuart' (1829) gave the festivities at the Tuileries a Romantic note. Infatuated with medieval art, she commissioned from Hittorff and Lecointe the Gothic decoration of Notre Dame for the christening of the Duc de Bordeaux [168, 169, 173]. She helped to spread the troubadour style, whose vogue corresponded with the success of Sir Walter Scott. Furniture kept its massive architectural forms, but the bronzes returned to Louis XVI motifs, to flowers and foliage, and the woods are often light (citronwood, box). The pattern books of the time give an idea of the Restoration decorators' fantasy. Hangings and carpets were brightly coloured. The domestic tapestry was included among the knick-knacks in which the period indulged to excess. These tendencies were accentuated under Louis Philippe. From 1835 the partiality for the Middle Ages was succeeded by one for the Renaissance, and the mania for antiques reigned everywhere. Furniture became pastiche, like its setting, and people were not shocked by copies. ' Reproduction ' was an industry. Iron came into use for making furniture (beds, chairs). Ornament was applied in light wood over mahogany or rosewood, or else in mother-of-pearl. The cabinet makers Bellangé, Werner and Grohé, of German extraction, tried to imitate everything, even the Louis XV style, or that of the Oriental bazaar. The fashion for indoor flowers shared in the general tendency towards excess.

ITALY

History. After the quarrels and Napoleon's seizure of the States and person of the Pope, Rome and the Church received Pius VII with veneration on his return to the Eternal City. The policy of his successors was ultramontane and absolutist. During his long reign (1846–1878) Pius IX undertook important doctrinal reforms.

The movement towards the emancipation of Italy came up against internal difficulties: geographical and political fragmentation, the influence of the Church, the mediocrity of a middle class unconcerned with modern problems. The Carbonari, members of a secret society with mystical and egalitarian tendencies, centred on Bologna, played a major part in the preparation of the Risorgimento. Austria's intervention in 1821 (Congress of Laibach) produced the first set-back. An intense national ferment was revealed by the revolutions of 1831 in the north and south, by writers' awareness of the sense of being one and scientists' realisation of the practical necessity of uniting, by the economic progress and by the influence of the liberal patriot G. Mazzini. The call of the Piedmontese abbot Gioberti (1843), who proclaimed the primacy of Italy and the need for the Italian rulers to form a union under the aegis of the Pope and the protection of the House of Savoy, created an enormous stir. By opposing Austria Charles Albert of Savoy (1831–1849) became the champion of the national cause.

Literature. Literature was closely bound up with the nationalist movement. G. Leopardi (1798–1837), a wonderful Romantic poet unrecognised during his own lifetime, provided the sole exception. A. Manzoni (1785–1873), poet and novelist, was the famous author of *I Promessi Sposi*. The writers of the Risorgimento were the novelists N. Tommasseo, T. Grossi, M. d'Azeglio, F. D. Guerrazzi; dramatists such as S. Pellico; the poets A. Poerio, C. Mameli, G. Giusti; the historians G. Capponi, C. Cantù; political theorists C. Balbo, V. Gioberti and above all G. Mazzini, who contributed many ideas.

Music. Italian musicians were attracted by Paris. G. Spontini (1774–1851) also lived for a time in Berlin; F. Paer became the rival of G. Rossini (1792–1868); the latter's lyrical talent, full of verve and melodic exuberance, delighted music-lovers with a fondness for bel canto (*Barber of Seville*, 1816; *William Tell*, 1829); all these, with the prolific Donizetti and the charming Bellini, won glory and honours in France. Despite its excessive facility, Italian opera remained unique for the possibilities of vocal expression that it developed.

Architecture. Remaining faithful to the theories of Neoclassicism, which led them to a lifeless academicism, Italian artists deftly repeated their formulas. In Rome, which kept its prestige and continued to attract Germans, Britons, Scandinavians, Slavs and Frenchmen, the big successes of town planning are the Piazza del Popolo and the Pincio park, both designed by Giuseppe Valadier (1762–1859), an architect brought up on Palladio and Vignola. He restored the Colosseum and the Arch of Titus. Other architects were R. Stern and L. Canina, who was responsible for the lovely park of the Villa Borghese. Milan took on the character of a capital at the start of the 19th century. The most gifted Milanese Neoclassicist was Giuseppe Piermarini, but his pupils are very academic. S. Cantoni (1736–1818), who designed the façade of the Palazzo Ducale at Genoa, and the Vienna-born L. Pollack, creator of the Villa Reale, Milan, which was decorated by A. Appiani and G. Albertolli, both had a certain lightness of touch. This was not so of Luigi Cagnola (1762–*c*. 1832) [181], who represents the monumental

BRITAIN. JOHN NASH (1752–1835). Chester Terrace, Regent's Park, London. *Photo: Hugh Newbury.*

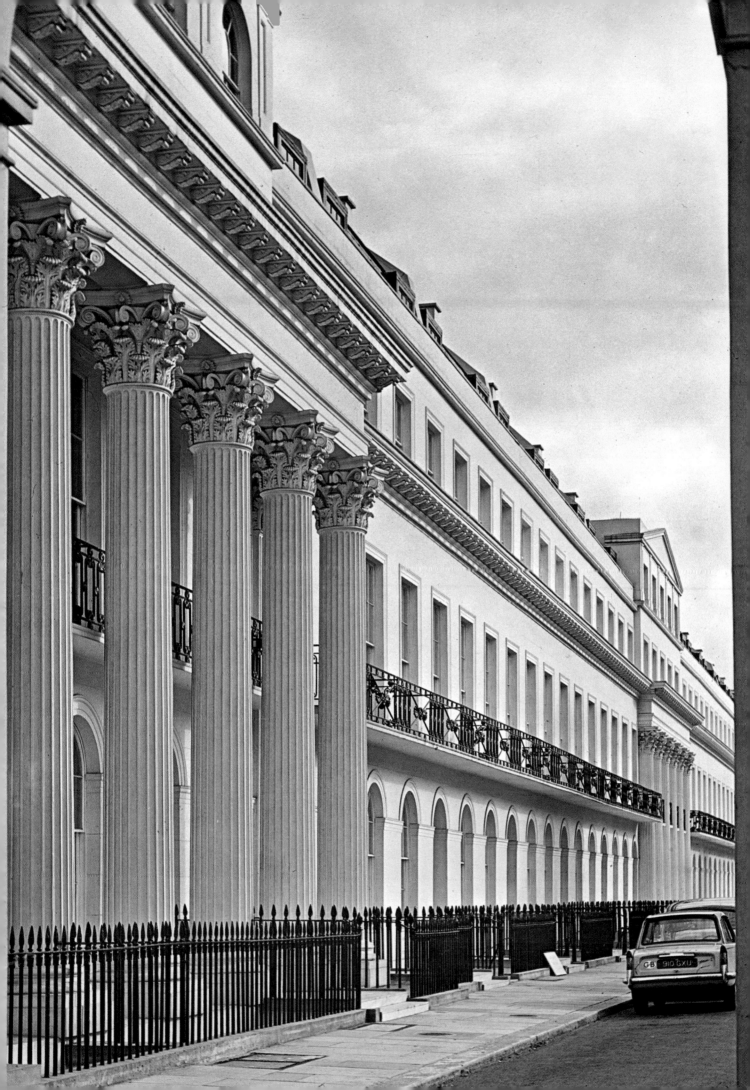

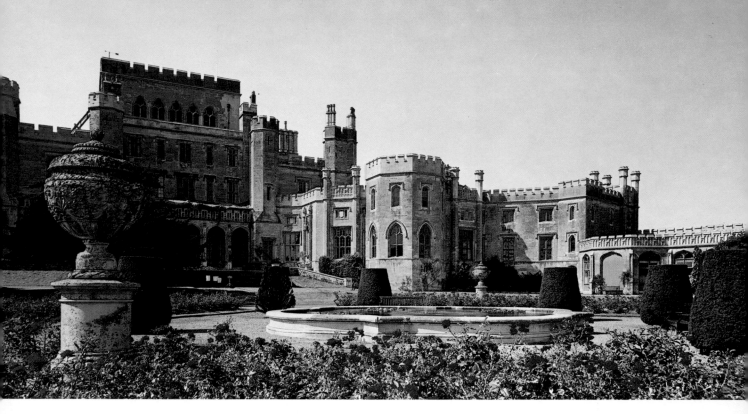

BRITAIN. JAMES WYATT (1746–1813).
Ashridge, Hertfordshire. Begun 1808.
Photo: A. F. Kersting.

Below. U.S.A. THOMAS JEFFERSON (1743–1826). Monticello, Virginia. Finished 1808.
Photo: Freelance Photographers Guild.

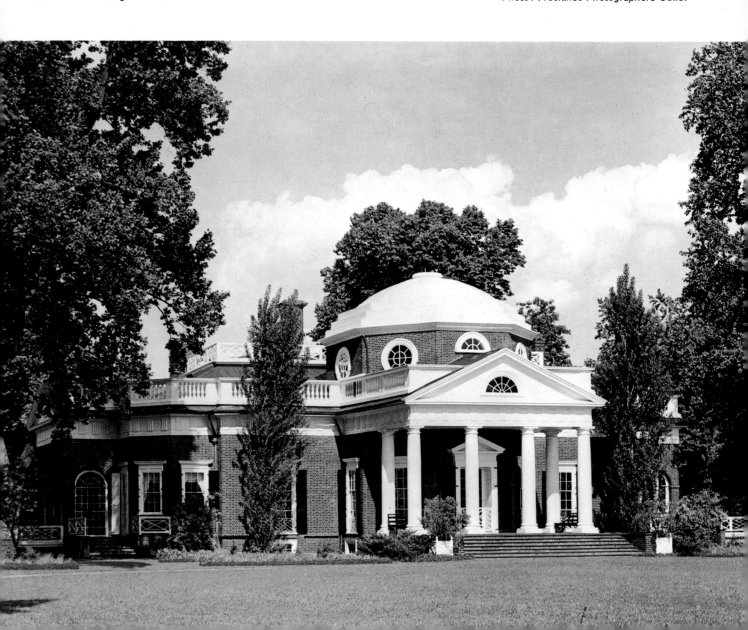

and massive Milanese variety of the Empire style: Propylaea of the Porta Ticinese, the Arco della Pace. At Genoa, C. F. Barabino (1768–1835) was the architect of the Teatro Carlo Felice. In Venice, where some architects still upheld the Baroque tradition, Neoclassicism was mixed with Palladian elements. The best architect there was G. Selva's pupil G. Jappelli (1783–1852), an eclectic and very much an 'engineer'. Having travelled in France and England, he introduced neo-Gothic to Venetia (Il Pedrocchino wing of the Caffè Pedrocchi at Padua). There was some fine town planning at Trieste by a pair of talented architects, Matthäus Pertsch (d. 1834) and Peter von Nobile (1774–1854), who worked mainly in Vienna.

Sculpture. There is no strictly Romantic sculpture, but a movement towards an honest reality. The best sculptor, Lorenzo Bartolini (1777–1850), a pupil of David and also of Ingres (monument to Countess Zamoyski, Sta Croce, Florence), had a great influence on the development of Italian sculpture. Pietro Tenerani subscribed to the purist manifesto of 1843, which mustered the artists in Rome against an outdated Neoclassicism. Only Giovanni Dupré (1817–1882) and V. Vela (1820–1891) are worthy of note.

Painting. Neoclassical painting in Rome was coldly decorous. Vincenzo Camuccini, Gaspare Landi and Filippo Agricola were interesting only in a few sketches. In Milan G. Bossi gained inspiration from Leonardo. The most gifted of the academics was A. Appiani (1754–1817) [124], a disciple of A. R. Mengs, M. Knoller and G. Traballesi. Despite his being Napoleon's favourite decorator, the best of his works were some portraits (*Countess Grimaldi*, *M. de Trévise*). The Academy at Bergamo had a skilful teacher in G. Diotti (1779–1846). Painting at Naples was more international, the many foreigners attracted by Pompeii, the English, the Germans, the French who came with Murat, all having had some influence there. The best portraitist is Gaetano Forte (1790–1871), a pupil of the Frenchman J. B. J. Wicar.

Romanticism took various forms. In Rome the leader of the purists was the painter and critic Tommaso Minardi (1787–1871) whose most famous work is his self-portrait in the Uffizi. Francesco Hayez (1791–1882) [401] was the chief Romantic in Milan, which was becoming an intellectual capital where French and German influences mingled. Trained in Venice and in the Canovan ambience in Rome, Hayez was a history painter (*Mary Queen of Scots*, *The Foscari*, *Marino Faliero*), but his portraits, where he had no ideological pretensions, have

more stylistic discipline. G. Carnovali, called Piccio (1806–1873) had a more romantic style, recalling Delacroix. He was the best of the Romantics influenced by the literary group known as the *scapigliatura lombarda* and a very imaginative landscapist.

Engraving. Engraving was practised by G. Longhi (1766–1831), R. Morghen (1758–1833) and L. Calamatta (1802–1869).

SPAIN

History. The 19th century was a tragic one for Spain; she lost her American colonies and had to unite all her material and moral forces against Napoleon. But being politically divided she was subsequently unable to re-establish a social and economic equilibrium. Galvanised into life after 1808, she succeeded in defeating the French, so that Napoleon had to come in person to install his brother Joseph, who ended feudal rights, abolished the Inquisition and suppressed numerous monasteries. A most terrible war began, a war whose memory has been preserved for ever by Goya, in which Wellington and the *guerrilleros* rid Spain of the French. The mediocrity of Ferdinand VII's reign maintained an atmosphere of civil war, which lasted during the regency of Maria Cristina (1833–1843) thanks to the Carlist agitation. The constitution of 1845, moderate in tendency, gave a few years of calm.

Literature. The clergy, who claimed to retain intellectual control over Spain, continued to have but little culture. Balmes, a Catalan priest, and Donoso Cortés were the best religious thinkers. Romanticism did not have the same range as elsewhere. It confined itself to the poetic theatre and to legend (Duke de Rivas' historical ballads, José Zorrilla's legends). M. J. de Larra (1809–1837) was the best Romantic prose writer, while J. de Espronceda (1808–1842) and Zorrilla (1817–1893) were the best poets. Spanish literature came into fashion, and foreigners discovered her heroic and Moslem past (A. de Laborde, *Voyage Pittoresque et Historique en Espagne*, 1806).

Music. The Catalan Fernando Sor expressed through the guitar an intensity of feeling that calls to mind Chopin or Schumann.

Architecture. Under Ferdinand VII architecture was dominated by Silvestre Perez (1767–1825), but his interesting projects were not built in a Spain at war. J. de Villanueva (1739–1811), Charles IV's best architect, designed the Prado and the Madrid observatory. His in-

fluence lived on in his pupil Antonio Lopez Aguado (1764–1831), who built the Puerta de Toledo, Madrid. Villanueva's son Martin was more individual. Custodio Moreno completed the Teatro Real, Madrid, in 1850, while Narciso Pascual y Coloner (1808–1870) built the Palace of the Congress in 1843–1850. During the regency, Madrid had an intelligent dictator of architecture in Francisco Javier de Mariateguí (obelisk of La Castellana). At Barcelona Garriga was the architect of the Liceo (1845–1847), the principal theatre of the period.

The best examples of Neoclassicism are the small country houses erected by a few courtiers in a style directly copied from the one at Pompeii, a fact explained by the connections of the court of Madrid with that of Naples.

Sculpture. Academic sculpture shows Canova's influence, as most of the artists were trained in Rome. The Neoclassical mould thwarted the realist and Baroque temperament of the Spanish. Only a few works inspired by the struggle against the French invaders have a quality worth noting: *Son Defending his Father* by J. Alvarez y Cubero (1768–1827), symbolising the defence of Saragossa. José Gines (1768–1823) [158] was the official sculptor.

Painting. Goya dominates all Spanish painting of his time. Francisco de Paula José Goya y Lucientes (1746–1828) [6, 117–120], was in 1760 a pupil of José Luzán and was in Italy about 1770. In 1771–1772 he painted a dome for the cathedral of El Pilar, Saragossa; in 1775 he returned to Madrid, married, and designed nearly 60 tapestry cartoons for the royal workshop (*The Picnic*, 1776; *The Parasol*, 1777; *The Swing*, 1778–1779; *The Bullfight*, etc.). In 1780 he was admitted to the Academy. In 1783 he painted the portrait of the Count of Floridablanca. He was appointed one of the 'King's Painters' in 1786, and one of the 'Painters to the Chamber' in 1789 after the accession of Charles IV. In 1792 Goya fell ill and became increasingly deaf; he then engraved his 'Caprichos' (1796–1798) and painted scenes of the Inquisition. At the same time he resumed his portrait painting (*Duchess of Alba*, 1795, Alba Collection, Madrid; *Francisco Bayeu*, 1796, Prado). He became 'First Painter to the King' in 1799 (*Family of Charles IV*, 1799–1800, Prado). His portraits of the early 1800s foreshadow Romanticism in their expression and freedom of handling: *Countess Chinchón* (1800), *Count Fernan Nuñez* (1803), *Doña Isabel de Porcel* (c. 1807), *Doña Antonia Zárate* (1808). After the abdication of Charles IV in 1808 he sympathised with republican ideas. His paintings of *2nd May* and *3rd May 1808*

156. SWEDISH. JOHAN TOBIAS SERGEL (1740–1814). Cupid and Psyche. 1787. *National Museum, Stockholm.*

157. GERMAN. GOTTFRIED SCHADOW (1764–1850). Tomb of Count Alexander von der Mark. Dorotheenstadt church, Berlin.

158. SPANISH. JOSÉ GINES (1768–1823). The Massacre of the Innocents (one of the groups). Coloured terra cotta. *S. Fernando Academy, Madrid.*

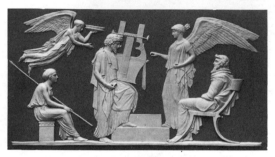

159. BRITISH. JOHN FLAXMAN (1755–1826). The Apotheosis of Homer. Relief in the classical style. Made for Wedgwood *c.* 1785.

(1814) and his etching of the 'Disasters of War' (85 plates, 1810–1813) convey a powerful expression of human anguish. He also worked for the Bonapartist court (*General Quéralt*) and portrayed Wellington after the French defeat (British Museum, Apsley House, London). In 1819 after a serious illness he painted the 'Pinturas Negras' on the walls of his house, the Quinta del Sordo, and etched the 18 plates of the 'Proverbios' ('Disparates') which reveal the same atmosphere of disquiet and fantasy. Genre scenes such as *The Water-seller* and *The Knife-grinder* (*c.* 1813) and *The Forge* (*c.* 1818) anticipate Realism both in their subject matter and freedom of brushwork. In 1824 he went into voluntary exile at Bordeaux, retaining to the end his vitality in works such as the four lithographs of Bordeaux bullfights (1825) and the tender *Milkmaid of Bordeaux* (1827). His outlook and handling influenced both Romanticism and Realism. Delacroix, Courbet, Daumier and Manet certainly owed much to him. His followers could not sustain such originality, and were content to imitate him: A. Juliá and R. Esteve. Eugenio Lucas the Elder [151] and Francisco Lameyer kept his

influence alive until the Impressionist generation.

José Madrazo, a pupil of David trained in Rome, and Vicente Lopez were rather pompous academics. Contact at Rome with followers of Ingres and the Nazarenes moulded a group in Barcelona (J. Espalter and P. Clavé).

The minor arts. Under the Bourbons French and Italian influences competed or mingled. England made an important contribution, especially in ceramics: Buen Retiro, closed in 1808, imitated Wedgwood; Seville had English craftsmen. But in furnishing and decoration an original character (furniture painted in dark colours, multiplicity of gilded ornaments) emerged in the Charles IV and 'Fernandino' styles.

PORTUGAL

History. Thrown into confusion by the Napoleonic wars (Lisbon was occupied by Junot in 1807, and John VI embarked for Brazil), the loss of Brazil in 1822 and the struggles between liberals and supporters of Dom Miguel (son of John VI) who was at first victorious and was later unthroned by Dom Pedro (Peter IV, brother of Miguel), Portugal developed slowly, only recovering her equilibrium after 1850.

Literature. J. B. de Almeida Garrett, the poet and dramatist, whose exile put him in contact with English Romanticism, introduced it to Portugal. A. Herculano, the prose writer, responded to German and French influences; he initiated Portuguese history.

Architecture. The buildings erected in Lisbon at the beginning of the century were often the work of Italian architects. The Portuguese preserved original traits in a certain taste for colour: Manuel Caetano de Sousa.

Sculpture. Joaquim Machado de Castro (1731–1822), responsive to the picturesque, was also an elegant modeller who kept alive an ancient tradition of terra-cotta work. António Ferreira was subtle and sensitive.

Painting. Pillement's pupil Francisco Vieira, called Vieira Portuense (1765–1805), who died young, was still in the 18th century. But the most gifted painter was Domingos António de Sequeira (1768–1837) in some of his portraits. Unfortunately he was too strongly influenced by David, Lawrence and Goya to preserve his originality.

THE LOW COUNTRIES

Belgium, out of Austrian hands since 1792, and the Netherlands, first the Batavian Republic, then Louis Bonaparte's kingdom from 1806, then transformed into eight French *départements* in 1811, both suffered from the Continental System. The Treaty of Vienna reunited the two countries, and the statute of 1814, promulgated by William I, established seventeen provinces, eight of which were Belgian, the capital being alternately The Hague and Brussels. But the problems of language and religion grew increasingly serious.

BELGIUM

History. The revolution of 1830 resulted in the independence of Belgium (4th October), with Leopold of Saxe-Coburg as king.

Literature. Culture was mainly French among the most educated classes, but a Flemish Romanticism led to the discovery of the medieval heritage. J. F. Willems was the father of the Flemish movement, H. Conscience the creator of the Flemish novel (*De Leeuw van*

Vlaanderen, 1838). The poet Guido Gezelle was a belated Romantic.

Architecture. French Neoclassicism triumphed in Brussels (Théâtre de la Monnaie by L. E. A. Damesme and E. J. Bonnevie), where David took refuge after 1815 and attracted round him his faithful followers such as T. F. Suys (1783–1861; church of St Joseph, Brussels).

Sculpture. The 18th-century tradition lived on in the work of G. L. Godecharle (1750–1835). Matthieu Kessels (1784–1836) was influenced by Thorvaldsen, his master, and Canova. Liberated Belgium was seized with a passion for historical statues, but there were only very second-rate artists to produce them: E. Simonis (*Godefroy de Bouillon*, Brussels), W. Geef (*General Belliard*, Brussels).

Painting. The Baroque tradition lingered on in P. Verhaeghen (1728–1811), a religious decorator, as in E. C. Lens, Guillaume Herreyns or the animal painters B. Ommeganck (1755–1826), his pupil E. Verboeckhoven and L. Robbe. The portraitists were influenced by France: C. Cels, a pupil of J. B. Suvée who worked at The Hague. David had a great effect on Belgian painting: J. Paelinck (1781–1839), Mathieu Ignace van Bree and his brother Philippe, J. D. Odevaere, J. F. Ducq, P. van Hanselaere, P. J. F. Heindricka, J. B. Duvivier. François Joseph Navez (1787–1869) [**125**] was the most famous of his Belgian pupils and an excellent portraitist (*The de Hemptinne Family*). G. Wappers (1803–1874) of Antwerp, a pupil of M. van Bree, originated Romantic history painting (*Episode during the Belgian Revolt of 1830*). Belgium discovered her heroes: N. de Keyser, E. de Bièfve, J. B. Vieillevoye and above all Louis Gallait (1810–1887), a Walloon famous for his *Brussels Guilds Paying their Last Tribute to Egmont and Hoorn* (1851), composed histories in the inflated manner of the Frenchman P. Delaroche. The most independent of the Romantics, who in his fiery passion echoed the great Flemish tradition, was Antoine Wiertz (1806–1865) [**163**], a noble Baroque spirit, and in a sense the ancestor of Belgian Expressionism. The Brussels artist J. B. Madou was a decorator.

The minor arts. Only lace-making kept up the old traditions.

HOLLAND

History. William I of Orange reigned over the Low Countries, then from 1830 over the Netherlands alone. He abdicated in favour of his son, William II (1840–1849).

Literature and Culture. Romanticism combined a mystical, a political and a social aspect: the poets W. Bilderdijk and I. da Costa, but above all the novelist E. D. Dekker who used the pseudonym Multatuli (1820–1887), creator of modern Dutch literature.

The founding of museums (Rijksmuseum, Amsterdam, in 1817, Mauritshuis, The Hague, in 1821, Museum Boymans, Rotterdam, in 1849) was the chief cultural manifestation of a sorely tried land that did no building and had no sculptors during the first half of the century.

Painting. History painting was initiated by J. W. Pieneman (1779–1853). The portraitists are more interesting: C. Kruseman, a respectable follower of David; H. A. de Bloeme (1802–1867), more individual and gifted; J. Schwartze (1814–1874), born in Philadelphia, who combined a mysticism due to his German training with the exoticism of his American memories.

A well-known Romantic, but one who made his career in France (see p. 67), is Ary Scheffer, born at Dordrecht (1795–1858). In 1844 he returned to Holland, where he came under the influence of Rembrandt.

The Romantic school, represented by the undistinguished Thomas Cool (1831–1870), P. van Schendel and J. Spoel, would be of little interest, were it not that a few landscapists brought to the study of light a freshness heralding the school of The Hague: D. J. van der Laen, Jan Kobell, the marine painter, A. Waldorp and especially Wynand van Nuyen, who died at twenty-six.

Lydie Huyghe

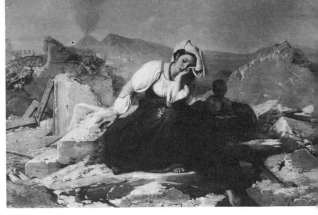

160. SWISS. LÉOPOLD ROBERT (1794–1835). Neapolitan Woman Weeping amid the Ruins of her House. 1830. *Musée Condé, Chantilly.*

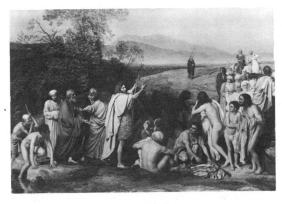

161. RUSSIAN. A. A. IVANOV (1806–1858). Christ's First Appearance to the People. 1833–1855. *Russian Museum, Leningrad.*

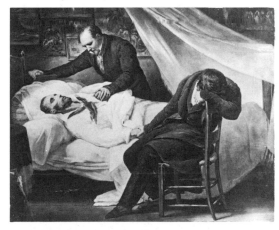

162. FRENCH. ARY SCHEFFER (1795–1858). The Death of Géricault. 1824. *Louvre.*

164. FRENCH. ALEXANDRE DECAMPS (1803–1860). The Punishment of the Hooks. 1839. *Wallace Collection, London.*

163. BELGIAN. ANTOINE WIERTZ (1806–1865). Un Grand de la Terre. 1860. *Wiertz Museum, Brussels.*

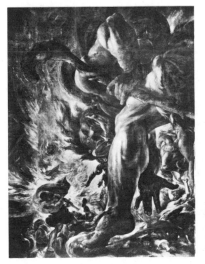

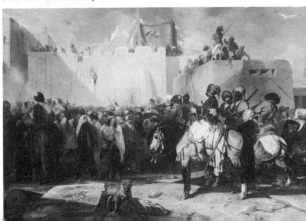

165. CANADIAN. ANTOINE
PLAMONDON (1802–1895).
Sister St Alphonse. 1841.
National Gallery of Canada, Ottawa.

166. CANADIAN. PAUL KANE
(1810–1871). Clal-Lum Women
Weaving a Blanket. *Royal Ontario
Museum, University of Toronto.*

GREAT BRITAIN

History. Britain's history was dominated by her conflict with France and Napoleon. Britain, as always, was totally opposed to any single nation becoming strong enough to rule Europe and fought a long war to thwart the ambitions of Napoleon. A series of brilliant naval victories by Nelson culminating in Trafalgar (1805) gave command of the seas to Britain, which became, after Waterloo, the most powerful and advanced nation. In 1815 she obtained Malta and the Ionian Islands, which ensured her control of the Mediterranean, and possessions in Africa (Cape Colony), Asia (Ceylon) and the Americas. London, already the largest port in the world, expanded rapidly.

A banking system, stimulated by the financial difficulties of the Napoleonic wars, concentrated capital in London where in 1815 British capitalism opened the era of the great speculative ventures (railways). But industry which had been stimulated by the war (Napoleon's attempts to exclude British trade from Europe were unsuccessful) developed outlets in the Near and Middle East, despite labour unrest (repeal of the Combination Acts, 1824). Internal problems dominated by the need for electoral reform, which in 1832 (Reform Act) enabled the new middle classes to take part in political life, the development towards free trade (repeal of the Corn Laws, 1846), and the Irish question show the increased importance of public opinion, apparent in the growing power of a rich and independent press.

The crown was weakened by the madness of George III (1760–1820) and the extravagance of the Prince Regent, later George IV (1820–1830). The evolution of parliament became more marked under William IV (1830–1837), and Victoria succeeded, during her long reign, in giving great dignity to royalty. The ministers Castlereagh, Canning, Wellington, Peel and Russell, then Disraeli and Gladstone, had the merit of regarding the measures demanded by public opinion as necessary, whatever their own personal opinion.

Literature. Romanticism had precursors: lovers of mystery, of the extraordinary, authors of Gothic novels (H. Walpole, Ann Radcliffe, 'Monk' Lewis), and poets (W. Blake, 1757–1827, a visionary writer and painter of the realm of imagination, with his *Poetical Sketches* and *Songs of Experience*).

Two generations of poets form the golden age of English Romanticism. The first, that of W. Wordsworth (1770–1850) and S. T. Coleridge (1772–1834), an explorer of the world of dreams, opens the gates of lyricism. The second has the fire of youth: Lord Byron died at thirty-six, Shelley at thirty, Keats at twenty-six. Byron (1788–1824) had international influence. He was famous at twenty-four (*Childe Harold*), and his restless peripatetic life, his melancholy, his moodiness and his death at Missolonghi in the cause of Greek independence, so close to the hearts of cultivated Europeans, made him the ideal of the Romantics (*Manfred, Cain* and *Don Juan*, an epic satire, 1819–1824). P. B. Shelley (1792–1822) was another passionate revolutionary as well as a poet of genius (*Prometheus Unbound*, 1820). J. Keats (1795–1821) was the poet of the imagination and beauty (odes *To a Nightingale* and *On a Grecian Urn, The Eve of St Agnes*, all about 1819).

The utilitarian philosophers stemmed from the 18th century and J. Bentham (1748–1832). T. R. Malthus (*An Essay on the Principle of Population*), the economist D. Ricardo and James Mill (1773–1836), father of J. S. Mill, analysed various aspects of the human condition. R. Owen (1771–1858), a great industrialist and utopian socialist, was a pioneer in education and social reform.

C. Lamb, essayist and poet, W. Hazlitt, the liberal critic, and the eccentric T. De Quincey (*Confessions of an English Opium Eater*, 1822) gave English prose much originality. Jane Austen (1775–1817) created the balanced form of the novel, and Sir Walter Scott (1771–1832) developed the historical novel. He had a tremendous success in England, where he influenced Dickens, Thackeray and George Eliot, and all over Europe, where writers and artists drew inspiration from his picturesque medieval subjects. E. Bulwer-Lytton was the celebrated author of many novels including *The Last Days of Pompeii* (1834).

The Gothic novel made use of the taste for the strange and terrifying (C. R. Maturin, *Melmoth the Wanderer*, 1820; Mary Wollstonecraft Shelley, *Frankenstein*, 1818). History was well served by two Scots: Lord Macaulay (1800–1859), statesman and author of a *History of England*, and T. Carlyle (1795–1881), whose *French Revolution* was published in 1837.

Science. There were many great scientists: J. Dalton (1766–1844), physicist, chemist and propounder of the first atomic theory (*New System of Chemical Philosophy*, 1808–1827); M. Faraday (1791–1867), who discovered electromagnetic induction; C. Darwin (1809–1882), the famous anthropologist (*The Origin of Species*, 1859). Interest focused on the human sciences: Royal Anthropological Institute founded 1843.

Music. Resident in England, M. Clementi, one of the masters of the keyboard, taught J. Field, who left his mark on M. I. Glinka in Russia. London was a great music centre: Beethoven wrote his 9th Symphony (and projected a 10th) for the Royal Philharmonic Society.

Architecture. By 1775 a new generation of architects in England was looking more to Chambers than Adam, but aiming at something more directly Neoclassical than either: Robert Mylne (1734–1811; Blackfriars Bridge, 1760–1769); Thomas Cooley (1740–1784; Dublin Exchange, 1779); and James Gandon (1743–1823) who erected in Dublin public buildings ranking as the finest products of the Chambers' school (Custom House, 1781–1789; The Four Courts, 1785–1796). More purely Neoclassical was George Dance II (1741–1825), son of the architect of the Mansion House (Newgate Prison, destroyed 1902; Stratton Park, Hants, 1803–1804, with a Greek Doric portico; Royal College of Surgeons, Lincoln's Inn Fields, 1806–1813). Dance left a deeper impression on his successors, especially Robert Smirke, than did the more popular James Wyatt (1747–1813) or Henry Holland (1745–1806; Carlton

FURNITURE AND THE DECORATIVE ARTS IN FRANCE BETWEEN 1800 AND 1850

167. Empire interior. Napoleon's bedroom at Fontainebleau.

168. Neo-Gothic interior. Boudoir. Watercolour. *Musée des Arts Décoratifs, Paris.*

169. Restoration interior. Bedroom. Watercolour. *Musée des Arts Décoratifs, Paris.*

170. Charles X interior. Furniture in light-coloured wood, dressing-table in bird's-eye maple inlaid with kingwood, grisaille paper screen, and Aubusson carpet with green ground.

171. Empire cheval-glass. *Fontainebleau Palace.*

172. Empire méridienne. *Compiègne Museum.*

173. Duc de Bordeaux's cradle. Restoration period. *Musée des Arts Décoratifs, Paris.*

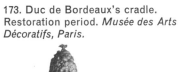

174. Empire clock. *Fontainebleau Palace.*

175. Medal by J. B. Andrieu (1763–1822) showing the Baptism of the King of Rome. 1811.

176. Wallpaper (1822) by the Dufour and Leroy factory showing the Bay of Naples. *Musée des Arts Décoratifs, Paris.*

177. Neo-Renaissance vase (1832) by C. A. Chenavard (1798–1838). Executed at Sèvres by A. M. Moine (1796–1849). *Fontainebleau Palace.*

178. Creil plate. Faience. Louis Philippe period.

179. Design for a neo-Gothic bracelet (1842) by Froment-Meurice (1802–1855) showing a scene from the life of St Louis.

House, London, 1783, for the Prince of Wales). Wyatt was a gifted eclectic with little personal style. In 1770, after six years in Venice, he won the competition for the rebuilding of the Pantheon, Oxford St (burnt 1792). His most famous works were in the Gothic style: Lee Priory, Kent (1782); Ashridge, Herts. (1806; see colour plate p. 72) and above all Fonthill, Wiltshire, for William Beckford (c. 1800; demolished). Among Wyatt's contemporaries were Thomas Leverton (1743–1824), a fine interior designer (Bedford Square, 1780), associated for a time with the Italian Joseph Bonomi (1739–1808); and Thomas Harrison (1744–1829) who worked outside London (Chester castle, 1793–1820).

The two most outstanding figures of the succeeding generation were Sir John Soane (1753–1837) and John Nash (1752–1835). Totally opposed in their approach to architecture, Nash was concerned with exteriors, Soane with interiors. Soane's early work was a personal Neoclassical, which he later reconciled with the 'Picturesque' ideal. After studying with Dance and Holland he visited Italy 1778–1780. In 1788 he

became Surveyor to the Bank of England and his early work included the Bank Stock Office (demolished 1927). Later works in a highly original style were the Dulwich Art Gallery (1811–1814); his own house at 13 Lincoln's Inn Fields (1812) and the Dividend Office, Bank of England [37] (1818–1823, demolished 1927).

The Picturesque introduced by R. P. Knight and Uvedale Price was developed by Humphrey Repton (1752–1818), a practising landscape gardener, and John Nash during their partnership c. 1795–1802. Nash's early works included his own house at East Cowes, Isle of Wight (1798, destroyed 1950); Luscombe, Devon (1800); Cronkhill, Salop (1802); cottages at Blaise Castle near Bristol (1811). The Picturesque encouraged exotic styles, such as the Indian of Sezincote, Glos. (1803) by Repton and S. P. Cockerell; the Stables, Royal Pavilion, Brighton, by William Porden (1803). The Pavilion itself, designed initially in the Indian style for the Prince of Wales by Repton, was extended and transformed by Nash from 1815 [190] with Gothic and Chinese detail and the frank use of structural cast iron. It was the patronage of the Prince which led to Nash's greatest town-planning achievement, the creation of the Royal Mile — from Regent's Park, with its terraces (see colour plate p. 71), through Park Crescent and Regent St to Carlton House (1811–1827). Nash's designs for Buckingham Palace (1826–1830) were unsuccessful.

In the early 1800s the Neoclassical tradition split itself into two movements, since labelled the 'Greek Revival' and the 'Gothic Revival'. The Greek Revival began about 1804

with Thomas Hope's pleas for Greek rather than Roman Orders. The two outstanding champions of the Revival were William Wilkins (1778–1839) and Robert Smirke (1781–1867). Wilkins had worked in Italy, Greece and Asia Minor and published his *Antiquities of Magna Graecia* in 1807. The two major buildings of his later years were University College, London (1827–1828) and the National Gallery (from 1833). Robert Smirke was even more influential than Wilkins. A pupil of Soane, he travelled abroad 1801–1805. His new Covent Garden theatre (1808, burnt 1856) was London's first Greek Doric building. His career was crowned by two London buildings, both with giant Ionic porticoes, the General Post Office (1824–1829, demolished 1913) and the British Museum (1823–1847).

After 1815 the movement spread rapidly, becoming the dominant style of the post-Waterloo period and finding its opportunities in new public buildings. Outstanding exponents were C. R. Cockerell (1788–1863; Fitzwilliam Museum, 1837–1847, begun by G. Basevi, 1794–1845; St George's Hall, Liverpool, the last of the major classical monuments in England, finished by Cockerell after the death of H. L. Elmes, 1814–1849); D. Burton (1800–1881; Athenaeum Club, 1829–1830) and H. W. Inwood (1794–1843) who produced one of the great representative buildings of the Greek Revival in St Pancras church (1818–1822) with its memories of the Erechtheum and the Tower of the Winds. It was in Scotland that the Greek Revival had its greatest success in the building of the 'new town' at Edinburgh (Waterloo Place by A. Elliot, 1761–1823); Calton Hill became a Scottish Acropolis with a

national monument in the shape of the Parthenon (never completed) and a monument to Burns (1830) by Thomas Hamilton (1785–1858). Hamilton also designed the noble High School (begun 1825) on the south side of the Hill. W. H. Playfair (1789–1857) was responsible for the city's two most conspicuous classical buildings — the Royal Institution (now the Royal Scottish Academy; begun 1826) and the National Gallery, both on the Mound.

The 'Gothic Revival' started as a second language for architects. Dance, Nash, Smirke, Wilkins, Cockerell, Barry and Burton all practised Gothic extensively, with insistence on detail but no understanding of the spirit. The Revival had essentially literary origins in John Carter's *Ancient Architecture of England* (1807), John Britton's *Cathedral Antiquities of Great Britain* (1814–1835) and A. C. Pugin's *Specimens of Gothic Architecture* (1821–1823). The real turning point came about 1840 when Sir Charles Barry (1795–1860), who had started in the Greek style but turned back to the Renaissance with the Travellers' Club (1829), was called in to rebuild the Houses of Parliament. His collaborator was A. W. N. Pugin (1812–1852), Catholic convert, writer (*Contrasts*, 1836) and deeply sincere architect, who sought not the outward form but the spirit of Gothic. The Houses of Parliament (1836–1860) have certain Picturesque aspects but the plan is classically logical. The rich Gothic detail in the Perpendicular style was by Pugin [64]. By 1850 Puginian Gothic, codified by the Cambridge Camden Society, had developed into High Victorian Gothic.

Concurrently with these styles were the practical constructions erected by engineers using cast iron, initiated by Pritchard and Strutt in the 18th century: T. Telford (1757–1834; Conway Bridge, 1819–1824, with castellated piers); I. K. Brunel (1806–1859; Clifton suspension bridge with Egyptian motifs; Temple Meads station, Bristol, 1839–1840; Paddington station with M. D. Wyatt).

Sculpture. Canova exerted a considerable influence on English Neoclassical sculptors, several of whom studied under him in Rome. J. Flaxman (1755–1826) [157] had a unique position, enjoying a European reputation and, with Thorvaldsen, being considered the best Neoclassical sculptor after Canova. After working for Wedgwood 1775–1787, he was in Italy 1787–1794. His great gift of linear design flowered in his outline illustrations for Homer (1793), Aeschylus (1795), Dante (1802), Hesiod (1817, engraved by Blake). His masterpieces were not his free-standing monuments (*Lord Mansfield*, 1801; *Nelson*, 1808–

1818, both in Westminster Abbey) but his reliefs (*William Collins*, 1785, Chichester cathedral; *John Sibthorpe*, 1799–1802, Bath; *Sir William Jones*, 1798, University College, Oxford).

The impact of the Parthenon sculptures, brought back in 1806 by Lord Elgin, then British Ambassador to Turkey, and purchased for the British Museum in 1816, was tremendous, shaking the prevailing ideas of finish and giving a new meaning to the word realism. Sculptors of this generation included Sir R. Westmacott (1775–1856) who worked under Canova in Rome 1793–1797. His large and successful practice included work at Brighton Pavilion, reliefs for the Marble Arch, the *Achilles* statue in Hyde Park and the pediment of the British Museum. John Gibson (1790–1866) settled in Rome in 1817, worked under Canova and Thorvaldsen and enjoyed a reputation little below theirs. His principal innovation was the reintroduction of the tinting of marble. Largely self-taught, Sir Francis Chantrey (1781–1841) ranks with Flaxman as one of the greatest English sculptors. His statues included *Washington* (Boston), *George III* (Guildhall), *Pitt* (Hanover Square), *Wellington* (Royal Exchange). But his finest works were his busts with their vivacity of expression and air of life. E. Bailly (1788–1867) designed Nelson's Column, Trafalgar Square.

Painting. During this period there were numerous contacts between London and Paris. Turner and Girtin visited France as early as 1802. Bonington was trained in France as a pupil of Gros. The French Romantics (Géricault, Charlet, Delacroix) were attracted to London and admired the work of Lawrence, Etty, Wilkie and Landseer. From 1815 the popularity of the Picturesque resulted in watercolours of Italian lakes, German rivers, Swiss mountains and Normandy architecture.

The visionary artist and writer William Blake (1757–1827) [76] stood apart from contemporary painting. After studying with the engraver J. Basire he earned a meagre living working as an engraver for publishers: Young's *Night Thoughts* (1796–1797), Blair's *Grave* (1804–1805). He published his own poems in books which he produced himself by engraving the text and surrounding it with hand-coloured illustrations: *Songs of Innocence* (1789), *Songs of Experience* (1794), 'Prophetic' books (1793–1804). His early work was Neoclassical in style, but as his visionary quality evolved he transformed his medieval and Mannerist formal sources by the power of his imagination. He worked either in watercolour or in a type of tempera (*Satan Smiting Job*). His greatest works were his 'colour-

printed' drawings, *Pity, Hecate, Newton, Elijah, Elohim Creating Adam* (1790s) and his large watercolours illustrating the Book of Job (c. 1820–1822). In his last years he was helped by Linnell: drawings for Dante's *Divine Comedy* (1824–1826), woodcuts for Thornton's *Virgil* (1821). He strongly influenced a circle of young artists, including Samuel Palmer (1805–1881) and Edward Calvert (1799–1883), who worked for a few visionary years at Shoreham.

From the beginning of the century landscape assumed a prime importance. It expressed the new Romantic pantheistic ideal of nature, and the self-identification of the painter with this overwhelming force. A unique watercolour school emerged, the three greatest figures being Girtin, Cotman and Turner. Thomas Girtin (1775–1802) in his short life bridged the gap between the topographical tinted drawing of the 18th century and the poetical watercolour of the 19th, with its transparent washes of pure colour. After studying with E. Dayes and working with Turner for Dr Monro, copying from J. R. Cozens' sketchbooks, Girtin toured England for engravers (*Durham Cathedral; Kirkstall Abbey; Cayne Waterfall; On the Wharfe; White House, Chelsea*). A series of softground etchings of views of Paris followed a visit, 1801–1802. He spent his last years painting a huge panorama of London. J. S. Cotman (1782–1842), born at Norwich, was the co-equal of J. Crome in the Norwich school. His finest works, with a feeling for flat pattern, silhouette and austere design, were done before 1806 on visits to Yorkshire (*Greta Bridge; Drop Gate, Dunscombe Park*). From 1806 to 1834 he was back in Norfolk at Norwich and Yarmouth as a drawing master and producing illustrations for Dawson Turner's publications, e.g. *Architectural Antiquities of Normandy* (1820–1822). Other capable watercolourists were D. Cox (1783–1859), P. de Wint (1784–1849), S. Prout (1783–1852) and R. P. Bonington (1802–1828) who was a friend of Delacroix and trained in France under L. Francia, 1817–1818, and Gros, 1819–1822. His precocious facility was cut short by his early death.

The two major landscape painters of the early 19th century were J. Constable (1776–1837) [108–111, 135, colour plate p. 36] and J. M. W. Turner (1775–1851). To his contemporaries Constable presented a revolutionary naturalism both in subject and treatment. His statement that 'there is room enough for a natural painter' (1802) implied an approach to nature like that of Wordsworth in the *Lyrical Ballads* — nature as a universal spirit open to human experience through feeling. For him painting was 'but

180. FRANCE. Grand staircase in the Luxembourg Palace, Paris, by J. F. T. Chalgrin (1739–1811). 1807.

181. ITALY. Arco della Pace, Milan, by Luigi Cagnola (1762–1832?).

182. BELGIUM. Palais des Académies, Brussels. 1823–1829.

183. FRANCE. Arc de Triomphe du Carrousel, Paris, by Charles Percier (1764–1838) and P. F. L. Fontaine (1762–1853). 1806–1808.

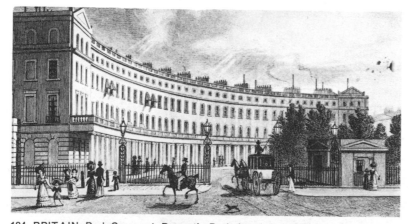

184. BRITAIN. Park Crescent, Regent's Park, London, by John Nash (1752–1835). Begun 1812. Engraving.

185. SPAIN. Palace of the Congress, Madrid, by Narciso Pascual y Coloner (1808–1870). 1843–1850.

another word for feeling' and this keynote of feeling gives his work an equally novel sense of dramatic unity. The mainspring of his endeavour was to express movement borne in a vehicle of light, with objects seen through a veil of drifting air. He desired to capture full out-of-doors light and movement throughout the whole picture and to achieve it he adopted a broken touch and spots of pure colour, to catch the effect of atmospheric vibration. Constable developed extremely slowly. His first works were founded on Gainsborough; then came a prolonged study of Claude, Rubens and the Dutch, whose study of skies and clouds encouraged him to use chiaroscuro as a unifying factor (*Dedham Vale*, 1802; *Malvern Hall*, 1809). It was not until after his marriage in 1816 that he began to retain in his finished works the spontaneity of his brilliant oil sketches (*Lock and Cottages on the Stour*, 1811). His deepest interpretations were of his native Suffolk countryside (*Flatford Mill*, 1817; *The White Horse*, 1819; *The Haywain*, 1821; *The Leaping Horse*, 1825). Salisbury, where lived his greatest friend Canon Fisher, ranked second only to Suffolk (*Salisbury Cathedral from the Close*, 1823; *Watermeadows near Salisbury*, 1829; *Salisbury Cathedral with a Rainbow*, 1831). After his wife's death in 1829 his work reflected his growing pessimism and melancholy. His colours lost their fresh greens; blues and browns predominated (*Hadleigh Castle*, 1829; *Dell in Helmingham Park*, 1830; *The Cenotaph*, 1836; *Stoke-by-Nayland*, 1836, Chicago). The grandeur of his late watercolours as a vehicle for personal emotion is illustrated in *Stonehenge* (1836). *The Haywain* and *View on the Stour* were exhibited at the Paris Salon in 1824 and awarded a Gold Medal. The success of these and other works imported into France had an appreciable effect on Delacroix and the development of the Barbizon school through their handling of divided touch and colour.

J. M. W. Turner (1775–1851) [96–99] is probably the greatest artist England has ever produced. His passionate observation of nature, his phenomenal visual memory, his range and technical virtuosity were all used in the service of a poetic temperament and an awareness of nature as an unsubduable hostile force. He began in 1790 as a topographical watercolourist, studying with Thomas Malton and at Dr Monro's house (1794–1797) copying J. R. Cozens' sketches with Girtin. His whole practice as an artist depended on his sketching tours and the notebooks filled on them. In the 1790s he travelled continuously throughout England, gathering material for engravers (*Tintern Abbey*; *Tom Tower, Oxford*; *Salisbury Cathedral Chapter House*; *Ewenny Priory*;

Lincoln Cathedral; *Islip Chapel, Westminster Abbey*). In the later 1790s his first oils showed the influence of Wilson in mythological subjects (*Aeneas with Sibyl*, 1800) and of the Dutch in seascapes (*Rising Storm*, 1800, Bridgwater; *Egremont seapiece*, 1801, Petworth). In 1802 he became an R.A. and made his first visit abroad, to France and Switzerland. Watercolours show the impact of mountain scenery (*Upper Falls of the Reichenbach*; *Passage of the St Gothard*; *Mer de Glace, Chamonix*); oil paintings reflect the study in the Louvre of treasures looted by Napoleon. From 1805 to 1819 came contrasts of seapieces like the *Shipwreck* (1805), *Teignmouth* (1811), *View of the Dart* (1818); of 'Great Stunners' in rivalry with Claude, like *Hannibal Crossing the Alps* (1812), *Dido Building Carthage* (1815); and of 'Pastorals' like *Windsor, Abingdon, Somer Hill, Frosty Morning, Crossing the Brook*. The *Liber Studiorum* produced during these years presented a series of engravings of landscape themes. Two visits to Italy in 1819 and 1828 resulted in the heightened colour of the *Bay of Baiae* (1823), *Ulysses Deriding Polyphemus* (1829). At the same time came hundreds of finished watercolours for engraved series like the 'Southern Coast' (1814–1826), 'Picturesque views of England and Wales' (1827–1831), 'Rivers of France' (1833–1835). In the 1830s he developed an increasing concern with colour at the expense of form, until light became the one visual reality (*Lake at Sunset*, 1831, Petworth; *Burning of the Houses of Parliament*, 1834, Cleveland, Ohio, colour plate p. 36). His growing awareness of nature's destructive forces and of man's insignificance resulted in works like the *Fire at Sea* (1834), the *Slave Ship* (1840, Boston), the *Steamer in a Snowstorm* (1842). These late works showed the influence of watercolour technique in their white priming and thin stains of primary colours (*Norham Castle, c.* 1835; *The Fighting Téméraire*, 1839; *Rain, Steam and Speed*, 1844). His last visions, in pure light and colour, were the watercolours of Venice and the Rhineland done in the 1840s.

Portraiture lost its importance when the generation of Romney, Raeburn and Lawrence [**150**] disappeared in 1830. Their followers W. Beechey (1735–1839), A. Shee (1769–1850), G. Harlow (1787–1819) and the miniaturist R. Cosway (1742–1821) could do little more than repeat the established formulas.

History painting was learnedly practised by B. West [**54**], J. S. Copley and J. Northcote. D. Scott (1806–1849) and W. Dyce (1806–1864) were in contact at Rome with the Nazarene group, the brotherhood whose ideas influenced the Pre-Raphaelites. Dyce

and D. Maclise (1811–1870) were among the painters who decorated the new Houses of Parliament with scenes from English history (from 1843).

Genre and subject painters included William Etty (1787–1849) a pupil of Lawrence, whose nudes reflected his life-long study in the R.A. schools; and Benjamin Robert Haydon (1786–1846), remembered for his autobiography rather than for his large-scale historical works. The two most popular genre painters were David Wilkie (1785–1841; *Village Politicians*, 1806; *Blind Man's Buff*, 1812) and William Mulready (1786–1863; *Fight Interrupted*, 1816).

The animal painters G. Stubbs and G. Morland were followed by Sir Edwin Landseer (1802–1873), whose trivial sentiment and absence of significant design outweighed his technical mastery, and J. Ward (1769–1859), also a fine landscapist.

Engraving. Caricature, often in colour, had the same success as in the 18th century. Caricaturists expressed the feelings roused by the war against Napoleon. J. Gillray, T. Rowlandson and G. Cruikshank (1792–1878) were the most famous of these engravers, who put popular vigour into a scathing satire. In 1841 *Punch* was founded (J. Leech, C. Keene after 1851). The great illustrated review the *Illustrated London News* first appeared in 1842.

Mezzotint remained the national technique, employed by C. H. Hodges, S. Reynolds and S. Cousins. Steel engraving enjoyed an enormous success (A. Raimbach). Wood engraving (i.e. on the endgrain) was perfected by T. Bewick (1753–1828), and one of his pupils, W. Harvey (1796–1866), turned it to the best account.

The minor arts. In goldsmiths' work the Regency master P. Storr (1771–1844) cast very large pieces while retaining the delicate chasing (Theocritus Cup, after Flaxman).

In ceramics, after the death of Wedgwood in 1795, his Etruria Works went on turning out high-quality products until his nephew Byerley died in 1810. Derby (factory of W. Duesbury III and R. Bloor), Worcester (Flight and Barr, and Chamberlain continued the tradition of landscape decoration) and Staffordshire (Minton) are the main centres.

The Regency style in furniture was mainly neo-Greek, with some Egyptian, Hindu or Chinese, as T. Hope's *Household Furniture and Interior Decoration* (1807) shows. The airy decorations in light, ornamental colours around delicate furniture in dark woods, or painted black, took on darker shades with Victoria's reign and grew heavier, expressing middle-class ostentation. In

decorating the Crystal Palace, Owen Jones (1809–1874) marks the transition to a new conception of the domestic setting.

Evelyn King

GERMANY

History. The most important event in the historical evolution of the German states was the birth of the idea of unity — no longer the unity of the Holy Roman Empire personified by the Emperor, the notion of which vanished with the institution itself in 1806, but physical union forged in the uprising against the French invader, a spiritual, linguistic, intellectual and moral community. Literature, philosophy and music attained their peaks, making the sense of nationality even more attractive than in the other European countries. The Habsburgs were from then on confined to the Austro-Hungarian Empire, and it was Prussia that gradually crystallised German aspirations. During the winter of 1807–1808, Fichte gave at the Berlin academy his fourteen *Addresses to the German Nation*, in which he told the Germans: 'It is to you...that precedence in the development of humanity belongs by right.' Pressed by popular agitation (War of Liberation, 1813–1815) the two largest German monarchies, Austria and Prussia, portioned out their zones of influence at the Congress of Vienna (1814–1815) without satisfying the national and political aspirations of the Germans. Formed in 1815, the German Confederation was only a manoeuvre of Metternich's for keeping a watch over Germany. The liberal agitation at the universities could have ended in the establishment of a unitary federation of constitutional sovereigns if at Carlsbad (1819) and Vienna (1820) Austria had not succeeded in checking the political ferment. In 1834 the start of the Zollverein, a customs union between the states of the Confederation, stimulated trade. German unity was delayed by the failure of the National Assembly at Frankfurt in 1848, and by the revolutionary movements disturbing Prussia, which had to retreat at the Olmütz conference (1850) and give way to Austria by returning to the old Confederation.

Literature. The German Romantic movement insisted on the absolute right of genius to follow its own path, and turned towards a religious mysticism, a spiritual exaltation, which forms the characteristic atmosphere of the Romantic school of Jena founded in 1798: Novalis, author of *Heinrich von Ofterdingen* which glorifies the Middle Ages, F. W. J. von Schelling, F. Schlegel (1772–1829), one of the discoverers of the German primitives and defender of

186. GERMANY. Schloss
Hohenschwangau, Bavaria, by
J. D. Ohlmüller (1791–1839).

187. BRITAIN. The Octagon,
Fonthill Abbey, by James Wyatt
(1747–1813). 1795–1807. Engraving.

188. BRITAIN. Conservatory of
Carlton House, London, by Thomas
Hopper. 1811–1812. Engraving.

189. BRITAIN. Interior of the Crystal
Palace, London, by Joseph Paxton
(1803–1865). 1851. Engraving.

191. *Below.* BRITAIN. The Menai
suspension bridge, Anglesey, by
Thomas Telford (1757–1834). 1819–
1826.

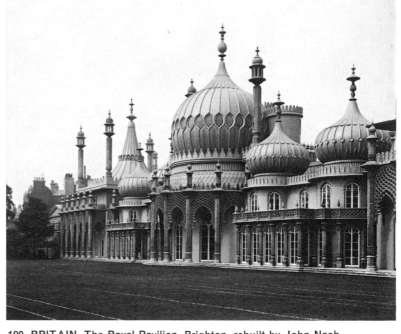

190. BRITAIN. The Royal Pavilion, Brighton, rebuilt by John Nash
(1752–1835). 1815–1823.

192. *Below.* BRITAIN. Coalbrookdale bridge, Shropshire, built by
T. F. Pritchard, the architect, and the local iron smelters Abraham
Darby and John Wilkinson. The first cast-iron bridge ever built. 1779.

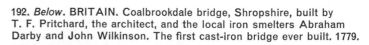

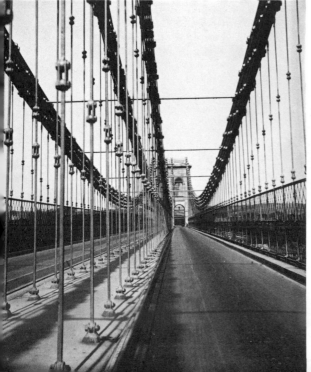

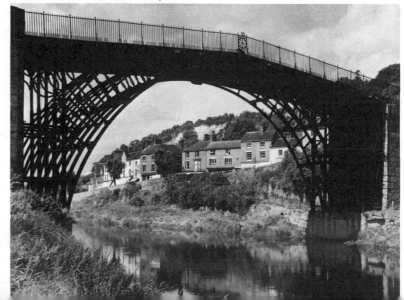

the Nazarenes against Goethe's attacks, L. Tieck, enthusiast for Shakespeare and for Spanish drama, W. H. Wackenroder, who expounded their theory of art in *Herzensergiessungen eines Kunstliebenden Klosterbruders*. Following after the more strictly literary movement of *Sturm und Drang* (title of a drama about the American War of Independence by F. W. von Klinger), German Romanticism cannot be separated from nationalist feeling and the religious revival (conversion to Catholicism of many writers and artists, such as F. Schlegel, 1808). K. Brentano, L. A. von Arnim, H. von Kleist, E. T. A. Hoffman, Jean Paul (J. P. F. Richter), A. von Chamisso and F. Hölderlin were extreme Romantic poets whose imagination led them into more fantastic paths than L. Uhland (*Balladen*, 1815) or H. Heine, an emigrant in Paris after 1830.

This wild Romanticism was opposed by the humanist serenity of Johann Wolfgang von Goethe (1749–1832) who settled in Weimar at the court of Karl August and published the first part of *Faust* (1808), followed by the second part (1832). He wished to maintain a supple, balanced classicism. Together with his friend J. F. Schiller (1759–1805) who wrote his masterpieces (*Balladen, Wallenstein*) towards the end of his life and continued the poet's moral role, he offered a clearly defined meaning of man and life, which is the antithesis of the ideal and of the Romantics' vague dream of the infinite. W. von Humboldt (1767–1835), the philologist, was also among the leading aestheticians of his time.

Philosophy. The post-Kantian philosophers were metaphysical idealists whose theories were derived from an emphasis on mind as opposed to matter and had affinities with the Romantic movement. J. G. Fichte (1762–1814), professor at Jena and then in Berlin, carried subjectivism to an extreme in his theory of the 'ego' and the 'non-ego'. Like Kant, he laid emphasis on the free spirit of man, and his philosophy fostered liberty, reform and even radicalism. F. W. J. von Schelling (1775–1854) posited the Absolute as God, and God as universal reason; he saw in art the identification of spirit and nature, of the ideal and the real (*On the Relationship between Art and Nature*, 1807), the embodiment of the infinite in the finite, while science was concerned only with knowledge of the finite. A friend of Hölderlin's, he became the acknowledged leader of the Jena Romantics. G. W. F. Hegel (1770–1831) was famous for his theory of the dialectic — a means of knowledge by the synthesis of opposites. He saw world history and the development of the spirit as repeating the transitions of the

dialectic. In his *Aesthetics* he states that beauty in art is the sensuous conformity of the idea and the form in which it is expressed. At first, when the expression is inadequate to the idea, it is symbolic; it then becomes classical through the balance of form and idea, and romantic through the pre-eminence of the idea over the temporal form. Architecture is symbolic art (the Gothic cathedral), sculpture classical art, and painting, music and poetry, romantic art. A. Schopenhauer (1788–1860) held that will is superior to knowledge (*The World as Will and Idea*, 1818), a doctrine which finally led him into a philosophy of pessimism. He established a hierarchy of the arts with music as the most perfect.

Music. Ludwig van Beethoven (1770–1827), the most influential 19th-century musician, settled permanently in Vienna (1792) and from 1794 published his thirty-two keyboard sonatas in which from 1802 he made use of the possibilities of the modern piano, as well as in his five concertos. His nine symphonies remain his capital achievement. *Fidelio*, his only opera, was not a success, but from his overtures (*Egmont, Coriolanus*, etc.) developed the later symphonic poem. C. M. von Weber (1786–1826) was the founder of 19th-century opera (*Der Freischütz* had a triumphant first performance in 1821 at Berlin; *Oberon* in London in 1826). R. Schumann (1810–1856) was an ultra-Romantic who frequently lapsed into empty sentimentality, but who had considerable influence on song writing. F. Mendelssohn (1809–1847) divided his time between Leipzig, Berlin and London, and, apart from his own works, created the modern interest in Bach.

Architecture. Prussia (Berlin) and Bavaria (Munich) were the centres of Neoclassicism. It was already well defined at the end of the 18th century in the work of K. G. Langhans (1733–1808), whose Brandenburg Gate at Berlin has the typical coldness and hugeness (his son Karl Ferdinand, 1781–1869, continued his Neoclassicism, specialising in theatre construction). Neoclassicism was also well defined in the work of H. Gentz (1766–1801), the designer of the old Mint, Berlin, who was, however, less accomplished than the short-lived F. Gilly (1772–1800) of French extraction. The architect with the most influence on the Winckelmann movement in Prussia was Gilly's pupil Karl Friedrich von Schinkel (1781–1841), also a painter and writer stirred by the Greek revelation [60, 105]. In Berlin he used Doric for the Neue Wache (1816) and Ionic for the Altes Museum. The Schauspielhaus and Charlottenhof, a small country house near

Potsdam, are his best known works. A cultured artist, he did not neglect medieval art, and even made use of brick (Werder church, Berlin). He had an unfortunate inclination towards historical reconstruction (designs of numerous country houses in Prussia, Silesia and Prussian Poland). F. A. Stüler (1800–1865) and L. Persius (1803–1845) were among his gifted pupils.

At Munich Ludwig I (1825–1848) was a great builder who seemed to have wanted to make his capital a pattern book of all the styles. His principal architect was Leo von Klenze (1784–1864) [194], a pupil of Gilly, trained in Berlin and Paris, who had been to Athens. He had a sense of showmanship: built on a hill overlooking the Danube his Walhalla (1831–1842) near Regensburg is a kind of Parthenon intended to perpetuate the glory of the most illustrious Germans. In the Königsbau section of Munich royal palace he copied the Palazzo Pitti in some respects. He built the Glyptothek, where Thorvaldsen restored the marbles taken from Aegina in 1816, and the Ältere Pinakothek, both at Munich. His museums became famous, and Tsar Nicholas I invited him to St Petersburg to design the new Hermitage there. The Leuchtenberg Palais, the Odeon and above all the Propylaeon are his best known Munich works. With Ludwig I as patron, Klenze was the first of a line of imitative architects — neo-Ottonian, neo-Romanesque, neo-Gothic, as much antiquarians as artists — of whom F. von Gärtner (1792–1847), who built the Ludwigskirche and the State Library, both in Munich, was one of the most important.

At Karlsruhe F. Weinbrenner (1766–1826) was one of the propagators of the new style (Marktplatz). One of his pupils, G. Moller (1784–1852), drew inspiration from the Pantheon for the Ludwigskirche (1822–1827), Darmstadt.

Romanticism found expression in the imitation of Gothic. The resumption of work on Cologne cathedral in 1824, under the direction of F. A. Ahlert (1755–1833), followed by E. F. Zwirner (1802–1861), a neo-Gothic specialist, and completed in 1880 by R. Voigtel (1829–1902), symbolised the revival of German nationalism, whose devotees saw in the Gothic a manifestation of their race in all its strength and grandeur. A nostalgia for 15th-century Italy followed with A. Soller (1805–1853) in the church of St Michael in Berlin. Gottfried Semper (1803–1879) [193] is the most famous representative of this 'Tuscan' style about 1840. He worked at Dresden (Synagogue, Palais Oppenheim, Gemäldegalerie, the opera house which was burned down and later rebuilt by Semper) and at the end of

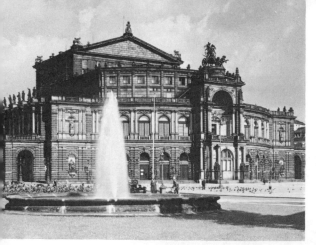

193. GERMANY. Dresden Opera House built (1871–1878) by Gottfried Semper (1803–1879).

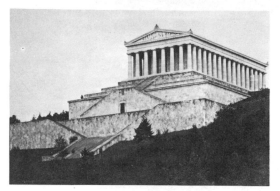

194. GERMANY. Walhalla, near Regensburg, by Leo von Klenze (1784–1864). 1831–1842.

his life in Vienna (Burgtheater). The Hanoverian architects were naturally influenced by the English Gothic Revival and brick architecture. However, H. Hübsch (1795–1863) in his churches, his art gallery and his theatre at Karlsruhe, and F. Eisenlohr (1804–1855), who designed many railway stations, heralded new developments.

Sculpture. Sculpture was fairly closely bound up with architecture. The influence of the Winckelmann circle at Rome (A. Kauffmann, the sculptor and teacher A. Trippel, trained at Copenhagen and Paris) was considerable. But the Danes — the painter A. J. Carstens, an ardent enthusiast for line, and particularly the sculptor Thorvaldsen, who had immense influence in Germany (equestrian statue of the Elector Maximilian at Munich, of Schiller at Stuttgart) — played a more important part than Canova. Gottfried Schadow (1764–1850) [**157**], a pupil of the Belgian J. P. A. Tassaert, retained a liking for grace and vitality that his stay in Rome, where he associated with Trippel and Canova, could not destroy. Characteristic works are the charming group of the two princesses Luise and Friedrike (Staatliche Museen, Berlin)

and many statuettes for the porcelain factories. His masterpieces are the tomb of Count Alexander von der Mark in the Dorotheenstadt church in Berlin and the famous Quadriga of the Brandenburg Gate. Less gifted but skilful, his pupil Christian Rauch (1777–1857) won fame with his funeral monument of Queen Luise (1810–1814), and then with the equestrian statue of Frederick the Great in Berlin (1839–1852). Rauch had many pupils: J. F. Drake, G. Blaser, A. K. E. Kiss, and above all E. Rietschel (1804–1861), founder of the Dresden school. In Bavaria L. Schwanthaler (1802–1848) merely imitated Thorvaldsen in his Munich decorations (monument to Bavaria); J. M. Wagner (1777–1858) bought antiques for Ludwig I (Aegina pediment) as well as being a painter, sculptor and engraver; K. Eberhard was a Romantic affected by Nazarene principles. More refined and much more gifted, J. H. von Dannecker (1758–1841) was a slightly heavy Canova (*Ariadne Riding on a Panther*).

Painting. Neoclassic painting came into being in Rome at the end of the 18th century under A. J. Carstens. He had a considerable influence on the German landscape painters who admired Poussin, Gaspard Dughet and the Dutch. J. C. Reinhart (1761–1847) was a Bavarian (decorations for the Villa Massimi, Rome, now in Berlin) established in Rome like Josef Anton Koch (1768–1839), probably the best Neoclassical landscape painter. His pupil Friedrich Preller the Elder (1804–1878) did a series of Odyssey illustrations (Weimar museum). The mediocre J. H. W. Tischbein (1751–1829) became famous through his portrait of Goethe in the Roman Campagna (Frankfurt am Main).

French influence is plain in the work of P. F. von Hetsch (1758–1838), a pupil of Vien and David, in the work of Gottlieb Schick (1776–1812), who derived his merits as a portraitist from a combination of German Classicism and the influence of David, in the work of Karl Begas (1794–1854), who had worked under Gros, and of Eberhard Wächter the Elder (1762–1852), a Regnault pupil. Ferdinand Olivier (1785–1841) and C. P. Fohr (1795–1818) followed Koch. Carl Rottmann (1798–1850) was famous for his heroic landscapes of Greece, while Johann Martin von Rohden (1778–1868) was more outspoken in his views of Italy.

Among architectural painters, E. Gärtner (1801–1877) did views of Berlin, D. Quaglio (1786–1837) of Munich. Johann Georg Dillis (1759–1841) was a subtle landscapist and talented engraver.

The religious reaction and mystique

of art, which appeared very early (W. H. Wackenroder, *Outpourings of the Heart of an Art-loving Monk*, 1797) impelled certain painters to leave for Rome and seek there the source of a purer Christianity. This half-religious half-aesthetic ideal guided the Nazarenes, who sought regeneration through a return to the primitives who, they felt, were less skilful but more sincere in their faith. The collection of primitives assembled at Cologne by the Boisserée brothers heightened this enthusiasm. Under the direction of J. F. Overbeck (1789–1869) [**80**] of Lübeck, a second-rate artist but one with the cultured mind, the Nazarenes installed at Rome in the monastery of S. Isidoro led a communal life governed by religious principles and by a shared passion for Perugino and Raphael. J. Wintergest, G. L. Vogel, J. K. Hottinger, J. Sutter, Overbeck and Franz Pforr were the first Nazarenes; then came J. E. Scheffer von Leonhardshoff, H. M. von Hess, J. A. Ramboux, J. Schnorr von Carolsfeld, W. von Schadow, the sculptor's son, who had great influence after 1826 as director of the Düsseldorf Akademie, Friedrich Olivier, J. Führich and the landscapist J. A. Koch. The frescoes of the Story of Joseph for the Prussian Consul-General J. S. Bartholdy (1816–1817, now in Berlin) were like a manifesto, and were followed by the Casino Massimo decorations. Peter Cornelius (1783–1867) was the most gifted [**122**]. He became director of the Düsseldorf Akademie, then of the Munich Akademie (12 drawings for *Faust*, 1816; decoration of the Munich Glyptothek, 1830). His pupil W. von Kaulbach (1805–1874) kept up the Nazarene tradition and owed his popularity to his theatrical sense of tragedy.

The Düsseldorf school, whose influence was very extensive, produced K. F. Lessing (1808–1880), painter of history pictures and admirer of the Reformation, and Ludwig Richter (1803–1884) of Dresden [**127**], who had a taste for folk tales. The only important artist, who died before his time, was Alfred Rethel (1816–1859), a fine illustrator obsessed with death.

Of the Romantic painters, two great artists, both trained in Copenhagen and Dresden, were conspicuous for a profound sense of poetry that made them true Romantics: P. O. Runge (1777–1810) [**77**] of Hamburg, who tried to express his love of nature by means of 'spiritual landscapes', though he also painted the amazing portraits of his family (Kunsthalle, Hamburg); and above all Caspar David Friedrich (1774–1840), the best Romantic landscape painter in Germany [**18**, **23**, colour plate p. 53]. He conveyed in a slightly cold, over-polished technique a philosophical meditation on nature, whose

disturbing, almost surrealist flavour often calls to mind his tragic end in madness (*Two Men Watching the Moon in the Mountains*, *The Cross on the Mountain*). C. G. Carus (1789–1869), a doctor, naturalist, philosopher and amateur painter, was the theorist of Romantic landscape painting (*Nine Letters on Landscape Painting*, 1831; *Twelve Letters on the Life of the Earth*, 1841). Friedrich influenced the architect K. F. Schinkel [60], the Dutch influenced W. von Kobell (1766–1855) and M. J. Wagenbauer (1775–1829). These landscape painters put into practice the philosophical theories of the period, but they sometimes lapsed into literariness or theatricality (K. Blechen, 1798–1840).

A representative of Biedermeier painting, the Berlin portraitist F. Krüger (1797–1857) was an anecdotal realist like his pupil K. Steffeck. C. Spitzweg (1808–1885) was an amusing illustrator influenced by the Barbizon school.

Engraving. Engraving underwent a revival. Etching, used for arabesques and for the surrounds of poems by Goethe, produced charming works. Ludwig Richter used it in his landscapes, his tales and his *Lebenserinnerungen eines Deutschen Malers*, as did Hugo Bürkner in his portraits and genre scenes, though the latter mostly used wood. Alfred Rethel sometimes recovered luminist qualities that had long been lost, and certain of his wood engravings show a fine harsh inspiration. Steel engraving had a success at the beginning of the century. The founding at Munich of two humorous journals, the *Münchner Bilderbogen* and the *Fliegende Blätter*, promoted its development.

Interior decoration. Neoclassicism brusquely put a stop to the excesses of Rococo. In the Rhineland direct French influence introduced a spare architectural style. Schinkel, restoring Friedrich II's rooms in the royal palace in Berlin (1825–1826), sought an effect of antique purity.

The Biedermeier style (an ironic term deriving from the names of two fictitious Philistines, Biedermann and Bummelmeier) was heavy in a rather naive and florid way, affecting a snugly opulent, amusing rusticity. Biedermeier furniture is in light-coloured woods.

Goldsmiths' work. Until 1848 goldsmiths' work kept to the neo-antique style. Schinkel designed Neoclassical models (plate and ewer for the garrison church at Potsdam) around 1820, Cornelius the Shield of the Faith sent by Friedrich Wilhelm IV to the Prince of Wales in 1847.

AUSTRO-HUNGARIAN EMPIRE

History. The medieval Holy Roman Empire was abolished in 1806 by Franz II (1804–1835), who ruled henceforth as emperor of Austria. But the Austro-Hungarian monarchy was run by Metternich, who from 1815 to 1848 was the real power in the land. Ferdinand I (1835–1848) abdicated in 1848 in favour of his nephew Franz Josef (1848–1916). Religion, the person of the Habsburg emperor and an administration centralised in Vienna were the bonds that kept Germans, Latins, Slavs and Magyars together. The policy of Metternich (1773–1859), aimed at stability at home by means of a balance of power abroad, involved illiberalism which provoked the revolution of 1848, the enthusiasm of the Italian, Hungarian and Czech separatist movements, suppressed by Prince Felix Schwarzenberg. In Hungary Russia had to intervene to overcome Magyar separatism, set ablaze by the fiery speeches of the energetic Lajos Kossuth, who founded the first newspaper in Hungarian, the *Literary Gazette*. The capitulation of the Hungarian forces at Világos (1849) delayed the creation of modern Hungary.

Literature. Vienna was the great intellectual centre. F. Grillparzer (1791–1872) was the greatest Austrian dramatist.

The Hungarian cultural revival dates from the creation of the Hungarian Academy of Sciences in 1825, at the prompting of Count István Széchenyi (1792–1860). The review *Auróra*, founded in 1822 by K. Kisfaludy, *The Flight of Zalán* (1825) by the poet M. Vorosmarty and the folk songs of the lyric poet S. Petöfi (1823–1849), Hungary's greatest Romantic, showed the extent of patriotic enthusiasm.

In Bohemia Father J. Dobrovský (1753–1829) gave the Czech language national importance and Pan-Slavism furthered the development of art, which was being increasingly based on folk traditions (forgeries by the poet Václav Hanka and others, who claimed to have discovered ancient Czech epics). The Romantic nationalist poets were P. J. Šafařík, F. Palacký and J. Kollár.

Music. Beethoven settled in Vienna (see p. 83) where F. Schubert (1797–1828) was at the centre of a group. The 'Unfinished' Symphony (1822), the A flat Mass and certain of his song cycles (*Erlkönig*, *Winterreise*, 1827) are the best known items of Schubert's production. Franz Liszt (1811–1886) was Hungarian. An infant prodigy, taught piano in Vienna by Czerny, he enraptured Europe with his virtuoso playing. In his life and his works he

was the typical Romantic. He lived at Weimar after 1847, then in Rome, where he took minor orders. He composed works in which he revealed himself as a precursor of modern music (Faust Symphony, symphonic poems, 13th Psalm, etc.). Prague kept up a fine tradition from the 18th century.

Architecture. Because of the Napoleonic wars, the bankruptcy of 1811 and the character of Franz II, who had little inclination to build, little construction was done in Vienna in the early 19th century. Only two architects were noteworthy: Peter von Nobile (1774–1854), a Swiss (the Burgtor, 1821–1824; the Theseus Temple, a copy of the Hephaisteion in Athens for Canova's *Theseus Fighting the Centaur*; theatre at Graz; Sto Antonio di Padova at Trieste); and T. von Hansen (1813–1891), of Danish extraction, who designed the parliament building. Among Nobile's pupils, the academic Paul Sprenger (1798–1854) is the most typical representative of the period (Mint, 1835–1837; Landeshauptmannschaft, 1846–1848). L. Ernst (1808–1862), who worked on the restoration of St Stephen's, Vienna, was the chief representative of the neo-Gothic style. Franz Josef's reign coincided with a need to regenerate Viennese architecture.

Sculpture. Antonio Canova (1757–1822), born at Venice, was an Austrian subject. He went to Vienna to execute the tomb of the Archduchess Maria Christina in the Augustinerkirche, possibly his masterpiece and rather similar to his own tomb in the Frari at Venice. Franz von Zauner (1746–1822), principal of the Academy, was responsible for the equestrian statue of Josef II in the Josefsplatz and for the funeral monument of Leopold II in the Augustinerkirche. Among the other academics are L. Kiesling (1770–1827), J. Klieber (1773–1850), J. M. Fischer (1741–1820) and J. N. Schaller (1777–1842). I. Ferenczy (1792–1856) was the chief Hungarian Neoclassical sculptor.

Painting. The influence of cold Neoclassical theories is apparent in the work of F. H. Füger (1751–1818). Vienna became the international centre of fashionable society thanks to the Congress of 1814–1815. The great English portraitist Sir Thomas Lawrence and the French miniaturist J. B. Isabey went there to paint rulers, diplomats and pretty women, and they had considerable influence on the Austrians. Lawrence brought the freedom of the English technique, Isabey a certain Romantic grace, perceptible in the miniatures of M. M. Daffinger (1790–1849). In some of his portraits

F. G. Waldmüller (1793–1865) achieved a distinction worthy of Lawrence (*Prince André Razumovsky*), and in many of his landscapes he shows a delicate sense of light. *The Eltz Family* has the meticulous and moving realism of the Biedermeier style, of which Waldmüller was among the most typical representatives. Portraiture was, moreover, the most important kind of painting, whether academic (the two Lampis, J. Grassi, J. G. Edlinger, J. Kreutzinger, Peter Krafft) or freer and influenced by Lawrence (K. J. Agricola, J. Lanzedelly, R. Theer, J. B. Reiter).

The Austrian landscape painters stand out. They have a slightly naive sensitivity and ingenuousness, a candour that is restful after the excesses of Romanticism or the Nazarene principles: Matthäus Loder (1781–1828), Jakob Alt (1789–1872), F. Steinfeld (1787–1868), P. Fendi (1796–1842) whose style recalls Bonington's.

The narrow Neoclassical doctrines gave rise to the revolt of the Nazarenes, when Overbeck left Vienna for Rome in 1809 with Pforr and others. Among the Nazarenes the Bohemian J. von Führich painted frescoes in the Altlerschenfeld church in Vienna and the Viennese E. von Steinle cartoons for stained glass and illustrations to *Parsifal*. J. E. Scheffer von Leonhardshoff, who died very young, was intensely religious. Established at Berlin, Moritz von Schwind (1804–1871) kept from his Viennese origins a youthful sentimentality: cycle of *The Seven Ravens* (Weimar) and *The Fair Melusine* (Vienna). The landscapist K. Markó the Elder (1791–1860) was a Hungarian living mainly in Italy. In Bohemia the Neoclassical period was dominated by J. Bergler the Younger (1753–1829), director of the Prague Academy.

The minor arts. Vienna porcelain, of fine quality, came from the state factory, abolished in 1864. But a little later the decoration, reproducing famous pictures, marred the purity of the forms.

Glassware, often coloured and highly ornate, had a Biedermeieresque charm.

Furniture and interior decoration followed the European trends but with a carefully finished 'Old Vienna' quality. Michael Thonet produced furniture with simple, elegant curves.

SWITZERLAND

History. In 1798 France invaded Switzerland and created a Helvetian republic of twenty-three cantons, keeping Geneva, Basle, Mulhouse and Neuchâtel. The treaties of 1814–1815 restored Valais, Basle and Geneva to the new confederation. After a small civil war a new and more democratic federal constitution was established in 1848.

Literature. French Switzerland, with Geneva, was a notable intellectual centre. Mme de Staël (1766–1817), who was of German and Swiss origin, brought together Frenchmen, Germans and Italians at her house on the Lake of Geneva (Benjamin Constant, Mme Récamier, Jean de Sismondi, author of *Littérature du Midi de l'Europe*, C. V. de Bonstetten, Z. Werner, A. W. Schlegel). V. Cherbuliez, H. F. Amiel and R. Toepffer wrote in French. But it was the German Swiss (J. J. Bodmer, J. H. Pestalozzi and J. Gotthelf) who exerted an increasing influence.

Architecture. French influence was dominant in French Switzerland: Lausanne (Asylum, 1837–1838) and Neuchâtel called in French architects and engineers. The start of the tourist trade and of mountaineering brought the first hotels.

Sculpture. All that existed was a rustic tradition of wood-carving. Thorvaldsen executed the *Lion of Lucerne* in 1821. J. E. Chaponnière (1801–1835) was the sculptor of the *Young Greek Woman Mourning at the Tomb of Byron*, famous at the period.

Painting. Painting was characterised by a sense of realism. There were many links with England at the beginning of the century. Cozens and Turner did watercolours of mountains, while J. L. Agasse, F. Ferrière and above all J. H. Fuseli (1741–1825), a native of Zürich living in London from 1781, an admirer of Shakespeare and Michelangelo, and one of the originators of Romanticism, all went to England.

The Neoclassicists were under the influence of Vien (J. P. Saint-Ours) or David (G. F. Reverdin, Léopold Robert [1794–1835; **160**]). This French Neoclassical influence accentuated the dogmatic coldness of some Swiss artists such as C. Gleyre (1806–1874).

Landscape in French Switzerland came into being at Geneva in 1762 with the painting academy of N. H. J. de Fassin (1728–1811) of Liége, who followed the Dutch landscape painters. P. L. de Larive (1735–1817), more Italianate, passed on the lesson of northern realism to W. A. Toepffer (1766–1847), father of the writer, who formed a friendship in Paris with J. L. Marne and, like him, painted rustic scenes as pretexts for landscapes. C. Auriol, pupil of Larive's, painted effects of mist. The landscapist of the mountains is François Diday (1802–1877), who discovered the poetry of the Alps in the Bernese Oberland and had many pupils including Germans, Italians, Poles and Russians. Alexandre Calame (1810–1864) [**106**] was his best pupil. More Romantic, he had a feeling for

195. RUSSIA. Main entrance of the Admiralty, St Petersburg, by A. Zakharov (1761–1811). 1806–1815.

196. POLAND. Prymasowski Palace, Warsaw. Early 19th century.

twisted trees, for torrents, for rugged or imposing peaks (*Storm over the Handeck*, 1839, Geneva museum). Diday and Calame gave the Geneva school international influence, particularly in Germany, Austria and Italy (G. Segantini). M. de Meuron (1785–1868) of Neuchâtel, on the other hand, was influenced by the Dutch and German painters in Italy.

DENMARK

History. During the reign of Frederick VI (1808–1839) Denmark endured the Napoleonic wars, financial difficulties and the cession of Norway to Sweden. Christian VIII (1839–1848) and Frederick VII (1848–1863) won a three-year war with Germany over the Schleswig-Holstein question, finally settled in 1852 by the London convention. In June 1849 Frederick VII established a constitutional monarchy.

Literature. National feelings, reawakened by the naval defeat in 1801 at the hands of Britain, were expressed in a return to the old Scandinavian poetry — the *Edda*, the chronicles of Saxo Grammaticus, folk-songs.

The Norwegian philosopher H. Steffens (1773–1845), interpreted F. W. Schelling's philosophy in Denmark. Adam Öhlenschläger (1779–1850) was the leader of Romanticism. N. F. S. Grundtvig (1783–1872), writer, educationalist, historian, philologist, politician and divine, retranslated the *folkehøjskolen*, a kind of popular university. B. S. Ingemann was the Danish Walter Scott, while S. Steensen Blicher, melancholy poet and short story writer,

was influenced by Ossian. The playwright and critic J. L. Heiberg introduced Hegel. Another contemporary was Hans Christian Andersen (1805–1875), with his *Fairy Tales and Stories*. Sören Kierkegaard (1813–1855), attached to none of the movements of the time, attacked ' official Christianity '.

Architecture. Neoclassicism continued until 1850, at first under the French influence. Danish artists spread this influence as far as Vienna and Greece, where Theophil von Hansen (1813–1891) and his brother H. C. Hansen (1803–1883) provided the plans for the university and the national library of Athens. C. F. Hansen (1756–1845) marked Copenhagen with his style: Palace of Justice with the gaol (1805–1815), the Vor Frue Kirke (designed 1808–1810, built 1811–1829), famous for its decorations by Thorvaldsen. M. G. B. Bindesbøll, a pupil of C. F. Hansen, was the severely purist designer of the Thorvaldsen Museum (1839–1848).

Sculpture. It is dominated by Bertel (called Alberto) Thorvaldsen (1770–1844) [56]. The son of an Icelandic wood-carver, he was trained at the Academy in Copenhagen and in Rome where he met the painter A. J. Carstens. After some difficult years, in 1803 he received a commission from the English collector Thomas Hope. This was the turning point and soon he was receiving commissions from all over Europe: Switzerland (*Lion of Lucerne*), Poland (statue of Prince Poniatowski, 1826–1827), Germany (monuments for the Elector Maximilian [1833–1835], Gutenberg [1833–1834], Schiller [1835]). He returned in glory to Copenhagen in 1838 and founded through his followers H. V. Bissen (1798–1868), H. E. Freund (1786–1840) and J. A. Jerichau (1816–1883) a style which, however, quickly degenerated into a feeble academicism.

Painting. C. W. Eckersberg (1783–1853) [116], a pupil of N. A. Abilgaard and David and a friend of Thorvaldsen's, painted calm precise landscapes and seascapes. His pupils maintained the tradition of a subtle realism: C. M. W. Rørbye, W. F. Bendz, J. Roed and especially Christen Købke (1810–1848) [129], a tranquil landscape painter and an excellent portraitist with an exquisite sense of colour, and Wilhelm Marstrand (1810–1873), a bustling genre painter. Trained at Munich, the landscape painter Jørgen Sonne (1801–1890) painted the successful frieze on the outside walls of the Thorvaldsen Museum in Copenhagen. C. Skovgaard (1817–1875), gifted and independent, and J. T. Lundbye (1818–1848), who died

young, showed increasing use of atmospheric moods in their landscapes.

The minor arts. Abilgaard and the disciples of Thorvaldsen designed furniture in the antique manner. From 1840 Skovgaard, Roed and the architect Bindesbøll used features derived from the Scandinavian past. The Royal Copenhagen porcelain factory, founded in 1775, imitated Meissen and Sèvres, and later produced classical subjects after models by Thorvaldsen.

SWEDEN

History. Bernadotte, king of Sweden and Norway in 1818 under the name of Charles XIV John, was a strong personality. His son Oscar I (1844–1859) began by being liberal but became anti-reformist after 1848.

Literature. The centres were the university towns of Uppsala and Lund. The Fosforister, a group named after their periodical *Fosforos* (1810–1813) with its leader P. D. A. Atterbom, the mystic poet Erik Stagnelius, Geijer, the historical novelist, and the talent of E. Tegnér (*Frithiofs Saga*) inaugurated Romanticism. K. J. L. Almqvist, poet and novelist, excelled in the short story. In Finland J. L. Runeberg (1804–1877) was a great Swedish-speaking poet.

Architecture. Swedish architecture has little to offer at this period. F. Blom (1781–1851) built the Skeppsholm church in Stockholm in 1824–1842, a competent but undistinguished building. As in Denmark, German influence superseded French.

Sculpture. J. T. Sergel (1740–1814) [156] executed a series of vital portraits and used a controlled form of Baroque dynamism. For J. N. Byström and B. E. Fogelberg Rome was the centre of gravity.

NORWAY

History. Oscar I (1844–1859) was more conciliatory towards the Norwegian half of the joint kingdom than his father Charles XIV John had been, and conditions in Norway improved.

Literature. H. A. Wergeland (1808–1845), poet (*The English Pilot*, 1844), dramatist, essayist, was the dominant writer of his time. P. C. Asbjörnsen (1812–1885) and J. Moe (1813–1882) collected and magnificently recorded a series of Norwegian folk tales.

Painting. J. C. C. Dahl (1788–1857) [130] was the great Norwegian Romantic, who trained at Copenhagen and

lived in Dresden from 1818. Though influenced by Friedrich, his landscapes are often closer to Constable's. T. Fearnley (1802–1842), Dahl's most brilliant pupil and a great traveller, combined much of his master's approach with elements of German Romanticism.

POLAND

History. The sudden, violent end of Stanislaw II Poniatowski's kingdom in 1795 stirred up and exalted national feeling. It was at the moment when Poland disappeared politically that a national art and literature reappeared. Recreated by Napoleon for Frederick Augustus, the Duchy of Warsaw gave an impetus to intellectual life, despite its brief existence (1807–1815). After the total defeat of Napoleon by Russia, Poland was occupied by the Russians who, however, imposed a less liberal constitution even than Napoleon's. But a revolution in 1830 failed and Poland was crushed and was incorporated in Russia by the decree of 1832.

Literature. Romanticism, intensified by the national misfortunes and by the individualistic and passionate nature of the Polish people, created a national and religious revival that lasted until the revolt of 1863.

A. Michiewicz (1798–1855), the great poet, was the leader of the Romantic movement (*Poems*, 1822–1823). J. Słowacki (1809–1849), a dramatist as well as a poet, was influenced by Shakespeare and Calderón. Z. Krasiński (1812–1859), poet and playwright, wrote a poem (*The Dawn*, 1843) on the concept, called Polish Messianism, of Poland as the ' Christ among the nations '. The poet C. Norwid (1821–1883), also a painter and engraver, was anti-revolutionary and anti-Messianic, and it was only after his death that his genius was recognised. These four great Polish poets all wrote in exile.

Music. J. Elsner, director of the Warsaw conservatoire, was the teacher of Frédéric Chopin (1810–1849). A strongly nationalist and lyrical composer, Chopin expressed his feelings in so violent a way that they could only be sustained through short pieces (nocturnes, études) in which, however, he was a master. S. Moniuszko (1819–1872), wrote the opera *Halka* (first produced in 1858).

Architecture. Architecture, heavily dependent on French styles, was halted by the 1830 revolution.

Painting. Piotr Michalowski (1800/01–1855) [126] of Cracow was, despite French influence, the most independent and interesting painter of the time.

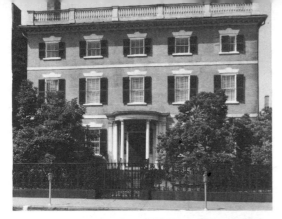

197. U.S.A. FEDERAL. SAMUEL McINTIRE (1757–1811). Gardner-White-Pingree house, Salem, Massachusetts. 1804–1805.

198. U.S.A. FEDERAL. BENJAMIN H. LATROBE (1764–1820). Baltimore cathedral. 1805–1821.

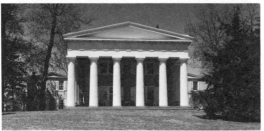

199. U.S.A. GREEK REVIVAL. THOMAS U. WALTER (1804–1887). Andalusia, Bucks County, Pennsylvania. 1833. The Greek portico (based on the Parthenon) was added in 1836.

200. U.S.A. GREEK REVIVAL. Belle Grove, near White Castle, Louisiana. 1857.

RUSSIA

History. The personal role of Tsar Alexander I (1801–1825) was very important. After the annihilation of Napoleon's army he organised a Holy Alliance in which the sovereigns were to settle their differences in accordance with Christian morals. Alexander, at first liberally inclined (Polish constitution of 1815), became increasingly reactionary. But the brutality of his minister A. A. Arakcheyev did not succeed in suppressing the liberal secret societies and political societies of officers who had seen conditions in other parts of Europe which contrasted with the virtual slavery of so many Russians. This brought about the Decembrist insurrection (December 1825) and the Polish revolt, both harshly put down by Nicholas I (1825–1855). Nicholas increased the autocracy of the monarchy.

Literature. N. M. Karamzin and M. V. Lomonosov were the creators of modern literary Russian. Karamzin in particular was receptive to ideas from the rest of Europe and was one of the first Russian Romantics. V. A. Zhukovsky (1783–1852), a subtle and scholarly poet, introduced the German and British Romantics. The genius A. Pushkin (1799–1837; *Boris Godunov*, 1830; *Eugene Onegin*, 1823–1831), M. Lermontov (1814–1841), a typical Romantic who died young, and E. Baratynsky (1800–1844) were all admirable poets. N. Gogol (1809–1852), visionary and satirist, had a gift for savage humour; he was the first Russian prose writer to be appreciated outside Russia (*The Overcoat*, *Dead Souls*). Between 1830 and 1840 the influence of German philosophy predominated. The philosophy of history, favourite subject of the intellectuals and students, posed the problem of Russian civilisation. Two parties converged, the Slavophils (A. Khomyakov, 1804–1860; I. Aksakov, 1823–1886) who were for the old Orthodox and patriarchal Russia, and the Westernisers who favoured a more modern evolution. All put their didactic and ethical preoccupations before form. After 1840 the aesthetics of the natural school prevailed among writers, who tried to be objective.

Catherine II's policy of prestige as regards the arts was continued, Alexander I acquiring whole collections for the Hermitage. In 1819 he instructed General Trubetskoi to bring back the best works from France and Italy. Nicholas I made the Hermitage a public museum.

Music. The modern Russian school came into being with Mikhail Glinka (1803–1857), the 'patriarch-prophet'

as his friend Liszt calls him. His works (*A Life for the Tsar, Russlan and Ludmilla*) form a European synthesis yet remain typically Russian.

Architecture. Russia offers the finest ensemble of Neoclassic architecture in Europe in St Petersburg and in Moscow where the fire of 1812 made it necessary to reconstruct in the 'modern' manner.

The main influences on Russian architecture were French and English. Wishing to embellish his capital, Alexander got in touch with Percier and Fontaine, and engaged Thomas de Thomon (1754–1813) who designed the splendid St Petersburg Bourse (1804–1816), and A. A. Monferran (1786–1858), a pupil of Percier, responsible for St Isaac's cathedral (1817–1857) and the Alexander Column (1829). Thomon's great Russian rival N. Voronikhin (1760–1814) built the Kazan cathedral, St Petersburg, inspired by St Peter's in Rome. Another great Russian architect was Chalgrin's pupil A. D. Zakharov (1761–1811), who designed the amazing Admiralty [195]. This Alexandrian style produced some fine colonnaded provincial mansions.

About 1840 the Slavophil trend in the capital made unfashionable so foreign a style. For Nicholas I K. A. Ton (1794–1881), a German, used neo-Byzantine for the Cathedral of the Redeemer at Moscow (1839–1883).

Sculpture. F. F. Shchedrin (1751–1825) was the principal monumental sculptor (caryatids in front of the main entrance to the Admiralty, St Petersburg). The art of Ivan Martos (1754–1835) excelled in funeral sculpture (*Minin and Pozharski*, Moscow, 1804–1818). Baron P. K. Klodt (1805–1867) had a real feeling for animals which was unfortunately stifled by the academicism of official sculpture.

Painting. Rome was the centre of attraction for Russian painters. O. A. Kiprenski (1773–1836) and K. Briullov (1799–1855) were the first Romantics. Briullov was a good portraitist, elegant and lively. He became internationally famous through his big picture *The Last Day of Pompeii* (1828–1830), and did the murals for St Isaac's in St Petersburg. Feodor Bruni (1800–1875), of Italian parentage, vied with Briullov in his religious decorations for St Isaac's. The only true religious painter, of some merit in his watercolours, was Alexander Ivanov (1806–1858), but his large paintings are laboured [161].

The true Russian temperament finds expression in genre painting. Alexis Venetsianov (1780–1847) was the best representative of this style with his calm dignified peasants. P. A. Fedotov (1815–1853) tended to naturalism.

201. U.S.A. GOTHIC REVIVAL. ALEXANDER JACKSON DAVIS (1803–1892). Henry Delamater's house, Rhinebeck, New York. 1844.

202. U.S.A. GOTHIC REVIVAL. RICHARD UPJOHN (1802–1878). Trinity Church, New York. 1839–1846.

203. AMERICAN. WASHINGTON ALLSTON (1779–1843). The Moonlit Landscape. 1819. *Museum of Fine Arts, Boston.*

Engraving. N. Utkin did line-engravings. Orlovski introduced lithography into Russia, and it was practised by Venetsianov, who produced good cartoons of the campaign of 1812.

The minor arts. The capitals always had the most luxurious European furnishings and decorations, while the provinces and countryside maintained fine peasant art: woodwork, textiles, embroideries.

In goldsmiths' work the court adopted classical models, but gradually the originality of works of inlaid silver, ornamented with niello, decorated with heavy stones or with sculpture in bold relief, became highly individual.

CANADA

History. The four colonies Upper and Lower Canada, Nova Scotia and New Brunswick each had a governor. There continued to be strong antagonism between Lower Canada, mainly French, and Upper Canada, whose institutions were modelled on those in Britain and which received 40,000 loyalist refugees from the United States. In 1840, after a revolt, Britain gave Canada a very broad constitution uniting Upper and Lower Canada and providing for a parliament and responsible ministers. From then on, the two communities, British and French, lived together with no great difficulty, and the country was settled further and further to the west.

Literature. In Nova Scotia appeared the first works of Canadian literature to win an international reputation (T. C. Haliburton). J. Richardson wrote historical novels and two sisters, Catherine Parr Traill and Susanna Moodie, wrote graphic autobiographical accounts of the early pioneers.

Architecture. In Canadian towns at the beginning of the 19th century architecture followed the English Georgian and Regency styles. But fairly soon the Gothic Revival enjoyed a great success: Notre Dame, Montreal (1824–

1843) by James O'Donnell. In French Canada the charming rustic simplicity of the early churches disappeared after 1830.

Sculpture. The tradition of the wood-carvers gradually faded, and its rustic vigour was replaced by a scholarly art.

Painting. The most important type of painting was the landscape, where resident artists were influenced by visiting English landscape painters. Among the residents Paul Kane (1810–1871) [166] was notable for his painting trips during which he visited and recorded the Indians of western Canada. Cornelius Krieghoff (1815–1872) did the same in Quebec. Portrait painters mostly followed established European styles: French classicism in French Canada (A. Plamondon, 1802–1895; T. Hamel, 1817–1870) and Zoffany, among others, in the English part (Wilhelm Berczy, 1748–1813).

Goldsmiths' work. In Quebec a high standard of craftsmanship was maintained in silverware by F. Ranvoyzé (1739–1819) and Amyot (1764–1839).

Lydie Huyghe

THE UNITED STATES

History. The new American republic unanimously elected George Washington (1789) as its first president, but during his administration two political factions arose over the issue (so important throughout the history of the country) of a strong central government versus states' rights. In 1803 the federal government purchased the Louisiana territory from France, thereby acquiring the entire area between the Mississippi and the Rockies. This purchase, together with the new national consciousness augmented by the 1812–1814 war with Britain, led to a westward migration and a consequent democratic and popular frontier society. Florida was purchased from Spain in 1819, and in 1845 Texas was annexed. The acquisition of the

Oregon country in 1846 and of the south-western lands at the close of the war with Mexico, in 1848, together with the Gadsden Purchase on the Mexican border in 1853, brought the country to its present boundaries. The discovery of gold in California in 1848 gave impetus to the westward expansion.

In the Southern states, owing partly to the invention of the cotton gin by Eli Whitney (1793), cotton had become the backbone of the economy. Thus both slavery and an agrarian society had become firmly entrenched.

In the north-eastern states an industrial society was developing. The gulf between this area and the South — especially over the issue of states' rights — continued to widen until the outbreak of the Civil War.

Culture. With the 19th century American literature came into its own. Strongly influenced by both English and German Romanticism, the new literary activity was centred first in New York and later in New England. Leading prose writers were Washington Irving (1783–1859), the first American writer of international reputation, best known for his humorous 'Knickerbocker' *History of New York* and for such tales as *Rip Van Winkle*; James Fenimore Cooper (1789–1851), remembered today for his frontier novels; Edgar Allan Poe (1809–1849), one of the greatest masters of the short story; Ralph Waldo Emerson (1803–1892), New England Transcendentalist, a philosophical essayist of distinction; Henry David Thoreau (1817–1862), whose *Walden*, an account of two years spent apart from his contemporaries and in the woods, is an American classic; Nathaniel Hawthorne (1804–1864), one of the most penetrating American writers of the century, preoccupied, in his pessimistic novels, with the savage Puritanism of New England (*The Scarlet Letter*, 1850); Herman Melville (1819–1891), whose masterpiece *Moby Dick* (1851), one of the greatest American novels, was for long unappreciated. An important and

204. AMERICAN. THOMAS DOUGHTY (1793–1856). In Nature's Wonderland. 1835. *Detroit Institute of Arts.*

205. AMERICAN. THOMAS COLE (1801–1848). In the Catskills. 1837. *Metropolitan Museum of Art.*

influential work of this period was the anti-slavery novel *Uncle Tom's Cabin* (1852), by Harriet Beecher Stowe (1811–1896).

Poets included William Cullen Bryant (1794–1878), Henry Wadsworth Longfellow (1807–1882), John Greenleaf Whittier (1807–1892), Poe and Emerson, James Russell Lowell (1819–1891), Oliver Wendell Holmes (1809–1894), also an essayist and novelist, and, far above the others in stature, Walt Whitman (1819–1892), poet of democracy, whose influence is still significant in poetry (*Leaves of Grass*).

There was a growing interest in the fine arts (new museums; founding of the Pennsylvania Academy of the Fine Arts, Philadelphia, 1805).

Architecture. With the establishment of the new republic there came a change in spirit which was reflected in the architecture of the Federal period (1790–*c.* 1825). The influence of Rome was important (owing largely to the new study of archaeology), as were the influences of the Adam brothers in England and, at times, the Louis XVI style in France.

In domestic architecture [197] the change was reflected in the roof pitch —

lower than ever — the popularity of the portico, the frequent use of elliptical shapes instead of rectangles in rooms, higher ceilings, and alcoves for beds.

Professional architects, as opposed to builders, appeared on the scene. Foremost among these in the South was Thomas Jefferson (1743–1826) [see colour plate p. 72], third president of the country. His state capitol in Richmond, Virginia (1785–1796), based on the Maison Carrée at Nîmes, was the first application of the Roman temple design to a practical building (it antedates the Madeleine in Paris). Monticello, his own home, near Charlottesville, Virginia (completed 1808), was ingenious both in design and in its interior ' gadgetry '. His greatest achievement was his campus for the University of Virginia, Charlottesville (1817–1826), with its buildings modelled on different Roman temples (the library being based on the Pantheon, Rome).

Benjamin Henry Latrobe (1764–1820) [198], who was trained in England where he came under the influence of the Greek Revival, was far in advance of his American contemporaries. He was responsible for parts of the Capitol in Washington. His distinguished Roman Catholic cathedral, Baltimore (1805–1821), shows a masterly handling of space and masses, reminiscent of Wren at St Paul's. In 1798 he designed a Gothic Revival mansion in Philadelphia which was one of the earliest examples of this style in the country.

Charles Bulfinch (1763–1844), the leading New England architect, was responsible for the State House, Boston (begun 1795). Other works by him include Franklin Place, Boston (1793), a crescent influenced by Bath, and the Old Meeting House, Lancaster, Massachusetts (1816).

Among other architects were: William Thornton (1759–1828), designer of the Capitol, Washington; Robert Mills (1781–1855; Washington monuments in Washington and Baltimore); Samuel McIntire (1757–1811) [197], a carver who built houses in Salem, Massachusetts. The French architects Maximilien Godefroy (active 1806–1824), Joseph Jacques Ramée (1764–1842), Joseph F. Mangin (City Hall, New York, completed 1812) and Pierre Charles L'Enfant (1754–1825), designer of the new capital city, Washington, brought European ideas to the young country.

The presidency of the frontier candidate Andrew Jackson (1829–1837) marked a new and democratic era in American history. This had been heralded earlier in the decade by a change in architectural taste — a shift from Rome to Greece (influence of the Englishmen Stuart and Revett and the German Winckelmann). Miniature Par-

thenons studded the landscape, and the Neoclassical Greek Revival builders translated a stone architecture into wood with results that were sometimes indifferent, sometimes perfect in concept. Architects working in this style included: William Strickland (1788–1854), whose best known work is the Second Bank of the United States, Philadelphia (completed 1824); Thomas U. Walter (1804–1887), who built Andalusia (1833) [199], home of the Pennsylvania banker Nicholas Biddle, and the Lee mansion in Arlington, Virginia; Ithiel Town (1784–1844) and Alexander Jackson Davis (1803–1892), builders of the New York Custom House; Minard Lafever (1798–1854), who adapted Egyptian architecture to a charming wooden church on Long Island, New York. Along the lower reaches of the Mississippi many beautiful mansions were built in the Greek Revival style [200].

By the 1840s this style had a rival in the Gothic Revival, which had finally reached the United States from England. The greatest builder in this idiom was Richard Upjohn (1802–1878) [202], architect of Trinity Church, New York (1839–1846), and St Mary's, Burlington, New Jersey (1846–1854). James Renwick, Jr (1818–1895), built Grace Church, New York (completed 1846), and the Smithsonian Institution, Washington (1846–1855). Andrew Jackson Downing (1815–1852) was the apostle of Gothic castles and villas; Alexander Jackson Davis was the most important and prolific builder of Gothic Revival mansions and houses [201].

Notable innovations of this period were the invention of balloon frame construction in the 1830s, which facilitated mass production in houses and helped to give rise to endless dreary suburbs of later decades, and, in 1848, the erection of a building with a cast-iron exterior, a factory in New York City by James Bogardus (1800–1874), a manufacturer, who popularised this type of structure.

Sculpture. The first half of the century produced little of distinction, and sculpture derived from such European artists as Canova. Best known sculptors of this period are Horatio Greenough (1805–1852), famous for his statue of Washington in the guise of Olympian Zeus (1832–1842), and Hiram Powers (1805–1873), whose chaste female nude *Greek Slave* (1843) was passed for exhibition by a committee of clergymen only on the grounds that her chained wrists proved that her nudity was beyond her control.

Painting. The art of portrait painting was kept alive in the early 19th century by such men as Samuel F. B. Morse

206. AMERICAN. GEORGE CALEB
BINGHAM (1811–1879). The County
Election. *c*. 1851. *City Art
Museum, St Louis.*

207. AMERICAN. EDWARD HICKS
(1780–1849). The Peaceable
Kingdom. *c*. 1830–1840. *Brooklyn
Museum.*

(1791–1872), inventor of the telegraph, Rembrandt Peale (1778–1860), son of the painter Charles Willson Peale, Thomas Sully (1783–1872) and John Neagle (1796–1865). Raphaelle Peale (1774–1825), another son of Charles Willson Peale, excelled in still lifes.

But it was in landscape that the American painters of the Romantic period found their most characteristic expression — particularly in scenes of that wilderness glorified in Cooper's novels. One of the first of these landscape painters was John Vanderlyn (1775–1852), author of the famous nude *Ariadne* (1808–1812; Pennsylvania Academy of the Fine Arts). A more important figure was Washington Allston (1779–1843) [203], whose subject matter was imaginary.

Several artists who turned for inspiration to the dramatic scenery of the Catskill Mountains are known as the Hudson River school. These men were the true founders of American landscape painting. The individual works of Thomas Doughty (1793–1856) [204] knew only a brief popularity. The best known artist of this school, Thomas Cole (1801–1848) [205], was an immigrant from England. Struck by the beauty of the Catskill scenery, he settled beside the Hudson in the village of Catskill and devoted himself to landscapes of a mastery and lyricism new to American art. Another of these painters, Asher B. Durand (1796–1886), began his career as an engraver and always retained his feeling for detail (the Romantic *Kindred Spirits*, 1849, New York Public Library, showing Cole and the poet Bryant against a mountainous landscape). These artists influenced such later landscapists as Inness.

A number of artists sought their inspiration in the west, among them George Catlin (1796–1872), who in the 1830s lived among the Indians and painted studies of their life. The most important painter of frontier life was George Caleb Bingham (1811–1879; *Fur Traders descending the Missouri, c.* 1845, Metropolitan Museum of Art), whose freshness of observation gave dignity to his traders and boatmen and humour to his election scenes [206].

An astonishing number of talented primitives were at work at this time (Thomas Chambers, active 1835–1855; Bard brothers). The best of these was Edward Hicks (1780–1849), a Quaker, visionary in spirit and a sign painter by trade, whose many versions of *The Peaceable Kingdom* [207] were painted for his co-religionists in his native Pennsylvania.

An interesting manifestation of popular art was the panorama on rollers, consisting of many scenes and unrolled before an audience with suitable commentary. In fact, it was a forerunner of sorts of our present-day travel film. The Mississippi River panorama of John Banvard (1815–1891) was advertised as three miles in length (it was in fact only 1,200 feet long).

John James Audubon (1785–1851) is remembered for his fine paintings of birds; engravings of these had a wide circulation.

The minor arts. The decorative arts in towns were strongly influenced by England (Adamesque furniture by Duncan Phyfe). Immigrants from Europe brought folk arts with them. Patchwork quilts and hooked rugs (rugs made of narrow strips of wool or cotton through a basic material of burlap or linen) were popular.

Emily Evershed

LATIN AMERICA

History. Several forces combined to help the Spanish and Portuguese colonies in South and Central America to overthrow their rulers. The example of United States independence, the ideas of the French 18th-century philosophers, the encouragement of the rebels by Britain which saw in the revolutions a means of striking at France and Spain, her enemies in the Napoleonic wars, and the blockade of Europe which promoted local industries — all these helped to bring about the successive revolts in Rio de la Plata in 1809 and in New Granada and Chile in 1810. Energetic men (M. Hidalgo, S. Bolivar, J. de San Martín, F. Miranda, A. J. de Sucre) led their people in the struggle and, after the failure of Bolivar to unite them into a confederation, the former colonial regions began to split into the countries we know today: Honduras, San Salvador and Guatemala broke away from Mexico; Peru and Bolivia split; and Argentina, Uruguay and Paraguay became separate. But there was unrest among the diverse elements of the population (Church, rich landowners, peasants, townspeople, Indians, Negroes) which made for instability.

Literature. Romanticism followed the lyrical glorification of freedom and the heroes of the liberation (A. Bello of Venezuela; J. J. Olmedo of Ecuador). The Argentine poet Esteban Echeverría published the first important Romantic poem, *La Cantiva* in 1830.

Architecture. Throughout the continent most of the architects were French and with few exceptions the buildings were competent but uninspired copies of French architecture. In 1816 Dom Pedro, later the first emperor, brought to Brazil a group of French artists, among them R. H. V. Grandjean de Montigny (1776–1850), who built the Imperial Academy of Fine Arts, modelled on the Paris Ecole des Beaux-Arts.

Sculpture. Rejection of Spanish culture meant rejection of Spanish religion as far as the arts are concerned. But religious domination gave way only to be followed by rule by the academics. Secular sculpture provided an iconography devoted to the liberators and heroes of the independence movements. These statues exciting patriotic emotion were often by Italians or descendants of Italian immigrants.

Painting. Painting, too, mainly consisted of formal academic work, with a strong French influence. Portraiture was much in demand, and the most accomplished artists were Antonio Salas of Ecuador and Prilidiano Pueyrredon of Argentina, who also painted genre subjects.

Romantic influence may be seen in paintings by the Indianist school, who showed idealised Incas or Aztecs in thoroughly artificial surroundings.

Lydie Huyghe

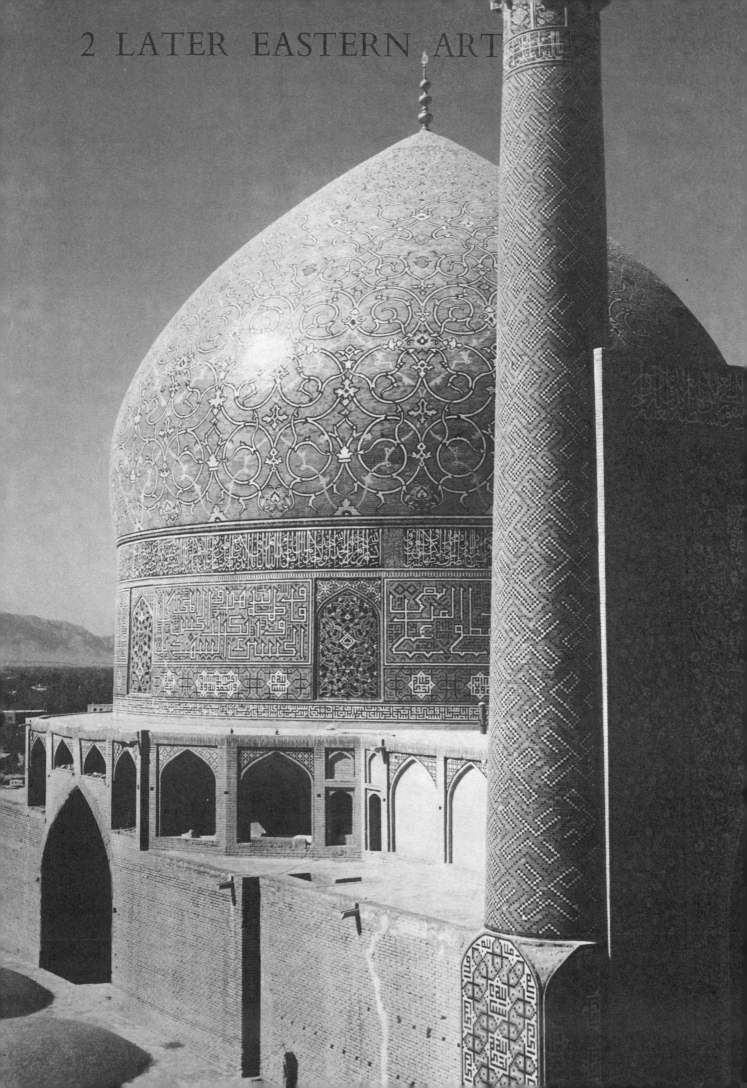

INTRODUCTION *René Huyghe*

Before the modern era the West had more or less ignored the East. After Christopher Columbus began his westward explorations and discovered America at the end of the 15th century, the new continent and the Atlantic sea routes occupied the greater part of the attention of Europe. In addition, the Eastern trade routes were being cut off by a hostile Islam. This same 15th century saw the crumbling of the Byzantine Empire which had formed the natural link with Asia.

During the 16th century the inquiring spirit of the Renaissance, the curiosity of the navigators and the daring of the merchants drove the Portuguese and their trading-posts beyond India to China and Japan, but their eastward movement collapsed at the end of the century after the defeat of the Portuguese by the Moors at Kasr al Kebir (Alcazarquivir) in Morocco; following this event Portugal was annexed by Spain. North Africa and the Middle East, which from the time of the ancient Persian empire had maintained links with Europe and had often been involved with it through wars, through the crusades and through trade, became a part of the virtually impassable barrier of Islam which was raised across the approaches to Asia.

However, the Portuguese were followed by the Dutch, French and English, who continued to establish contacts with Asia. Religious missions and voyages of discovery laid the foundations for the renewal of relations between East and West, which became important in the 18th century; these relations were even more firmly established by virtue of the commercial companies and the resultant colonisation. Public interest was aroused, and current taste showed the influence of the East.

European artists now sought a new source of inspiration in the Orient; at first this was restricted to a superficial response to the picturesque, but later this gave way to a more profound lesson, a lesson which upset the basic conceptions of the art of the West and contributed to the birth of modern art at the end of the 19th century.

On their part, the countries of the Far East became steadily more Westernised in the 19th century; Japan was the last to lower her jealously guarded barriers, but eventually she too capitulated, even to the extent of adopting the mechanised and industrial civilisation of the West. Economic and political competition now became world-wide.

In the 18th century contact with the East was sufficiently well established to make itself felt in Western art; in the 19th century it became decisive. Thus it is desirable, when we pass from the first of these centuries to the second, to turn our attention to the East and to observe the development of its artistic life during the phase corresponding to our modern times, from Persia and India to China and Japan. In the final section of this chapter the artistic links between the Orient and Europe are discussed.

THE MOSLEM WORLD

I. FROM THE MEDITERRANEAN TO IRAN *Gaston Wiet*

At the beginning of its last phase Islam had been weakened in the West by the Spanish reconquest and the crusades and in the East by the Mongol invasions. It attempted to restore its unity, but at the expense of its western provinces, and the cultural centres moved eastwards. The rising power of Ottoman Turkey, firmly established by its triumph over Byzantium, extended its political and artistic authority over the Mediterranean up to the borders of Morocco. But the influence it spread was that of the art of ancient Iran, which was then experiencing a revival.

Mediterranean Islam after the Fatimids

In the 12th century, after the downfall of the Fatimids, religious and social conformity brought about a significant innovation in architecture in Syria and Egypt. This was the adoption of the madrasa, the religious college which trained lawyers and state officials. The nature of their function gave these buildings a suggestion of severity; the word 'classical' springs to mind when we try to define this architecture.

Towards the second half of the 13th century there was a return to luxury and to beauty of materials. At that time buildings appeared which were decorated with bands of black-and-white marble. Arcades having voussoirs of alternating colours, and the decoration of some of these voussoirs, are reminiscent of braided garments. The halls are paved with multicoloured marble and the walls are inlaid with marble and mother-of-pearl in an infinite variety of designs. The outer doors appear to be encased in a covering of bronze.

On entering the mausoleum of Kala'un in Cairo one seems to be plunged into a strange environment; the decorator has created an atmosphere of mystery; the sudden silence, for the thick walls shut out the din of the street, the enveloping shadow, for light only penetrates through stained glass, and the numerous columns and piers, all combine to transport the visitor to an unreal world. He seems to feel a secret unrest. The subdued light which falls from the stained glass windows reveals a work of great geometric virtuosity. The work of the mosaicist, here related to that of the illuminator, has produced a masterpiece of detail which delights the visitor with the harmony and charm of its patterns. The play of light and shadow on this decoration seems to give it sculptural form.

The magnificent mosque of Sultan Hasan represents the high point of Mamluk art. This impregnable edifice, a solidly built fortress-like structure of simple, geometric plan, its minarets soaring heavenwards, represents the apotheosis of Islam. A vital and enterprising architect has produced a work which is eloquent without bombast and is a worthy realisation of a bold conception. The height of the building is accentuated by

208. ISLAMIC. Detail of the royal mosque, Isfahan. 1612–1627.

The great courtyard, the four iwans, the domes and the minarets, faced with tiles, are traditional elements of Persian mosques.

209

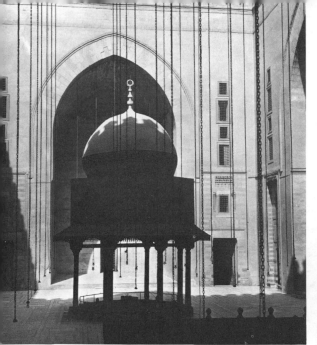

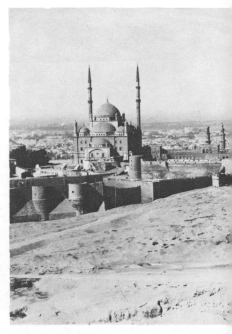

209. ISLAMIC. Court of the mosque of Sultan Hasan, Cairo. Mamluk period. 1356–1362.

210. ISLAMIC. Memorial mosque of Kait Bey, Cairo. Mamluk period. 1472.

211. ISLAMIC. The citadel, Cairo, showing the mosque of Mohammed Ali, by the Greek architect Yusuf Boshna. Ottoman period. 1824–1857.

narrow windows set in deep grooves in the façade. The decoration is subdued and plays a subordinate role; the architect has used it as a means of enhancing the architecture and has not sacrificed the latter to the arbitrary and sometimes unrestrained juxtaposition of ornamental themes. The ornamentation is severe, almost classical; we need only draw attention to the harmonious polychrome marbles with which the court is paved, and even more to the long band of inscription — a veritable lacework in plaster, with its simple, rhythmic patterns — which we find on the kiblah wall (wall on the Mecca side).

In short, the mosque of Sultan Hasan is perhaps the only Islamic building which combines a powerful general appearance with extreme delicacy of ornamentation. It is the culmination of the military period which began with the founding of
211 the citadel of Cairo by Saladin. We can better appreciate the development of Islamic architecture in Egypt by comparing the exquisite façade of the Fatimid mosque of El Akmar with the austere majesty of the Sultan Hasan mosque. The latter's severe almost military appearance recalls Albi cathedral.

A century later a new style appeared — a charming, graceful, lively style which is exemplified by the memorial mosque of
210 Kait Bey. We are struck by the delicacy and variety of the arabesques, unparalleled in their subtlety; we are in a world of fantasy. Elegance has here reached its apogee. As we study the intricate linear patterns we wonder whether we are looking at sculpture or at goldsmiths' work. History and the inscriptions tell us that it is a funerary monument. What we in fact feel, however, is the joy of living; the building is welcoming and intimate. The sanctuary arch and the one opposite, both horseshoe shaped, are impressive. The rich external decoration tempts the visitor to enter and see what wonders lie beyond.

The 15th century in Egypt was the heyday of virtuosity. Walls were sumptuously decorated, in a deliberate attempt to delight and ravish the eye. But there is the occasional jarring note, such as the motif of large tangential circular slabs, so successfully employed in the floor paving, which is unpleasing on the walls. The Kait Bey mosque is still a distinguished example of the flamboyant style, but the style declined and later buildings were mere pallid copies. The undeniable but conventional skill of the later craftsmen shows their technical virtuosity rather than their inventive genius. Their work is dry

212. ISLAMIC. Mausoleum of the Saadian princes, Marrakesh. c. 1603.

213. ISLAMIC. Bab Mansour el-Euldj gateway, Meknès. 17th–18th centuries.

214. MUDEJAR. Hall of the Ambassadors, in the Alcazar, Seville. The Alcazar (c. 1350-1369) was begun by Pedro the Cruel. It was altered in the 16th, 17th and 19th centuries.

215. Court of the Maidens, in the Alcazar, Seville.

and insipid, and this is accentuated by the mediocre quality of the materials used. The richness of the ornamentation, which is not without affectation, seems a mere surface luxury. The emptiness of the epigraphy is another sign of decadence, and the thin, rather comical appearance of the characters is more amusing than satisfying; they are devoid of originality and vitality and are obviously the work of minor craftsmen, and would be more suitable as headings to fairy tales. The artists of this period seem to have preferred fussiness to selection.

Up to Ottoman times Middle Eastern art evolved without marked advance or regression; the changes which occurred arose from the diversity of commissions or the skill of the craftsmen invited to work for the various dynasties. The Ottoman conquest, however, suppressed the rich by enslaving them and brought about a cultural crisis. North Africa (Morocco excepted), Egypt, Syria and Mesopotamia lost their importance as regional centres of artistic activity; they became provinces, or rather colonies, of the Ottoman empire. After the 16th century the leadership in art passed to Turkey and Persia.

The covering of wall surfaces, etc., with a mosaic of lustred tiles was a Persian tradition which spread to Asia Minor, Egypt and North Africa. This opulent decoration is seen at its best in Persian and Turkish architecture, where its jewel-like colours add a vivid note to façades and interiors.

Under the Safavids Persian art experienced an amazing renaissance; the delightful pages of Pierre Loti describe to perfection the splendour of the capital city, Isfahan, and Gobineau wrote the following: 'Its immense buildings, painted, gilded and faced with enamels; its walls, blue or covered with great floral motifs which reflect the sun's rays; its vast bazaars; its huge gardens, its plane trees, its roses, make it a triumph of elegance and a model of beauty. Isfahan could only have been conceived and executed by kings and architects who had spent their days and nights listening to marvellous fairy tales.'

, 238 Persian carpets never cease to fascinate us, with their exotic charm of colouring and their exuberance of decoration — their great flowerbeds, their landscapes with tall cypresses, sometimes enlivened by scenes of the hunt, and their enormous flowers. All of these were linked by powerful vine-tendril patterns.

Persia was the great centre for the art of illumination, and it was there that the miniaturists illustrated handwritten manuscripts. But they were preceded by the 12th-century painters of the Baghdad school, who produced masterpieces which reveal a marvellous sense of fantasy and humour and a verve and earthiness indicative of a realistic view of life. In the next section Basil Gray gives us a detailed study of the miniature. Here we shall merely make a few observations on the vigour with which the historic tradition persisted in this art. 232-235 231

The years had passed; Islam was successfully established. But the artists continued to utilise earlier themes, and these coincided with popular taste. The pre-Islamic rulers had had their exploits carved on the rock in the mountains. This tradition of imagery helped to keep the ancient legends alive in Persia. Better than texts, which were inaccessible to the people, painting placed the poetry of former deeds of heroism within the reach of all. The image-makers gave a concrete form to these acts in a style that was sometimes naively touching and sometimes powerfully emotional. The function of these artists was eminently nationalistic, almost religious, and however imaginative their painting they never omitted the essential detail which would identify their characters; in the same way, the attributes of the saints are often seen in Christian iconography.

Arabic literature — and this applies also to the histories — frequently portrays types rather than individuals; and the miniaturist offers us court scenes and outdoor festivities which are always the same and which show stock characters who, over the years, change only in their dress, which keeps pace with the fashions of the time.

In its beginnings Ottoman art, like the art of the Seljuks before it, was influenced by Persia — especially in architecture; after the taking of Constantinople, however, Sta Sophia became the model. The Ottoman period was characterised by great building activity, but its ceramics and carpets alone would have given it artistic importance. 218, 219 216, 217

Ottoman ceramics were also influenced by Persia. At the beginning of the 15th century, after his victory over their country, Sultan Selim imported Persian potters into Asia Minor, and these brought with them new ideas and techniques. Walls were now faced with decorative floral ensembles, often of cypresses, in which each tile had a definite function; blues, 223 222

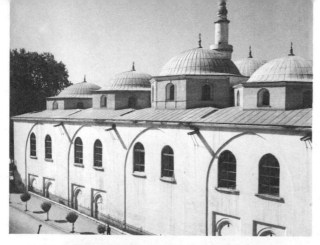

216. ISLAMIC. The Ulu Jami (Great Mosque) at Brusa, Turkey. Ottoman period. 1379–1414.

217. ISLAMIC. The Chinili kiosk in the Topkapi seraglio, Constantinople. Ottoman period. c. 1454–1456.

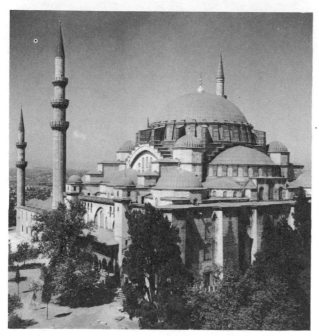

218. ISLAMIC. Mosque of Suleiman, Constantinople. Begun in 1550 by the architect Sinan (1498–1578). Ottoman period.

219. ISLAMIC. Shah Zadeh mosque, Constantinople. By the architect Sinan. Ottoman period. 1543–1547.

greens and reds predominated. In addition to tiles the workshops of Asia Minor, especially those of Isnik (Nicaea) and Kutahya, produced in the 17th and 18th centuries numerous objects such as mosque lamps, plates, bottles and mugs in the same colours, with the addition of violet and with admirable highly naturalistic floral designs representing tulips, carnations, roses and daisies; a fish-scale design was also common. Syrian potteries, which under the Mamluks had produced beautiful lustred white vases having inscriptions or floral decoration, produced under Ottoman influence facing-tiles and imprinted pieces which resembled the products of Asia Minor, but with less vivid colours and with a notable absence of red. 221

The carpet industry flourished in Asia Minor, particularly in the region of Smyrna. Prayer rugs were extremely popular. Characteristic of this kind of rug is the representation of the mihrab (niche in the kiblah wall), with its sharp angles and its violent colours which stand out against the merging softness of the borders. This mihrab seldom seems truly architectural; often the columns are omitted or are no longer functional. The arches vary, sometimes being sharply pointed, sometimes depressed like a Tudor arch. At times there is an attempt to simulate the stalactite ornament seen in the vaulting of some mihrabs. In the rug the mihrab is rarely left bare. Sometimes a lamp is shown suspended from the top, or instead of a lamp there may be a sort of hanging boss in the form of a large bouquet with a lamp or ewer; this motif developed into a floral spray. The arch of this mihrab rests on small columns; however, the carpet is not a building but a garden, and this brings about significant modifications: the capitals and bases change into bouquets and the columns are decorated with flowers and assume the outline of flowering shrubbery. The most classical frame in these rugs is composed of three floral borders — a broad central one flanked by two narrow ones. Their extremely varied design includes rosettes, bouquets and flowerbeds in an endless ordered procession. The light tones of these borders are in striking contrast to the harsh ones of the mihrab. 224

The textile centres of Brusa and Scutari, both in Turkey, produced velvets showing flowers — most often carnations — in full bloom and larger than life-size.

Meanwhile at the far end of the Moslem world, in India, the lessons of Persia were also being assimilated. Mahmud of Ghazni, whose conquests foreshadowed the later Moslem invasion of India, was fiercely iconoclastic. But such attitudes could not prevent the development in this region of an important school of painting — an additional testimony to the strength of Persian influence.

THE OTTOMANS

History. Shortly before the death of the last Seljuk sultan, Kaikobad III (about 1304), the Ottoman Turks had established themselves in Eskisehir. Osman I (or Othman the Victorious), from whom they took their name, had founded their dynasty in the 1280s. Subsequently (1326) they captured Brusa, their first capital, centre of a brilliant phase of Ottoman art, and became masters of Rodosto, Gallipoli and the Balkans, which augured well for future victories. The Ottomans maintained cordial diplomatic relations with neighbouring states. Their aim was the possession of Constantinople. However, this was delayed by the battle near Ankara in 1402 (in which Bayezid, the Turkish sultan, was defeated by Tamerlane who was leading the second Mongol invasion), which weakened the Turkish army. The active reigns of Mohammed I (d. 1421), who built the Green Mosque in Brusa, of Murad II (1421–1451) and of Mohammed II the Conqueror (1451–1481) made possible the conquest of the great city in 1453.

Selim I seized Egypt (1517), extending the frontiers of his realm into Africa; Suleiman the Magnificent governed an empire which stretched from the Persian Gulf to Vienna. By the end of the 17th century Ottoman power had begun to decline.

Architecture. The mosques of the first period (Isnik; Brusa) are of three types:

1. The rectangle covered by several domes, for example the Ulu Jami (Great Mosque) at Brusa (1379–1414), which has twenty domes and numerous aisles [**216**].

2. The square sanctuary with a portico and covered by a single dome, for example the Yesil Jami (Green Mosque) at Isnik and the Firuz Agha at Constantinople.

3. The madrasa-mosque, derived from the Seljuk model; the central courtyard, with its fountain, is covered by a dome; there is sometimes a double portico, as in the mosque of Murad II at Brusa.

The mosques of the second, and more important, period have a central dome flanked by two or four half-domes and covering the sanctuary, which is preceded by a vast courtyard surrounded by a portico. The minarets are cylindrical and slender and contrast with the pyramidal mass of the domes.

This group, adapted from the Turkish Anatolian model, includes many mosques in Constantinople: that of Bayezid (1497–1505), whose architect was Khair ud-Din; the Shah Zadeh mosque (1543–1547) [**219**]; the mosque

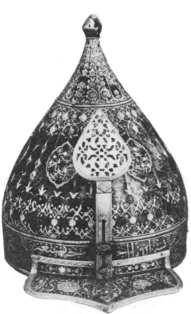

220. ISLAMIC. Ribbed helmet inlaid with gold and precious stones. Ottoman period. 16th century. *Topkapi Palace Museum, Istanbul.*

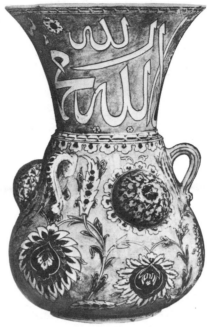

221. ISLAMIC. Mosque lamp in faience. Isnik. Ottoman period. Second half of the 16th century. *Istanbul Museum.*

of Suleiman (1550–1557) [**218**]. It also includes the mosque of Selim (1570–1574) at Adrianople (Edirne), where the dome is supported on eight piers and the inside is decorated in ceramics. The last three mosques were the work of the famous architect Sinan (1498–1578).

This architectural style ultimately spread to all the countries under Ottoman influence. It reached Algiers by 1660 ('Pêcherie' mosque), Tunis about 1675 (mosque of Sidi Mahrez) and Cairo as late as 1824 (mosque of Mohammed Ali [**211**]). These buildings were influenced by the large-domed mosques of Constantinople, but they retained earlier traditional features (mosques with four iwans, or vaulted halls, around the central courtyard in Egypt; prayer halls with columns in Tunisia). The mosques of Algiers tended, in addition, to be influenced by Anatolia.

Decoration was rather severe and was regulated by the materials themselves. Ceramics were used for interior facing [**222**].

The minor arts. Decorative arts reached their zenith from the 15th century on. Polychrome ceramics with plant decoration were produced in the workshops of Asia Minor, especially at Isnik [**221**], and in Damascus [**223**]. In the 17th and 18th centuries there were

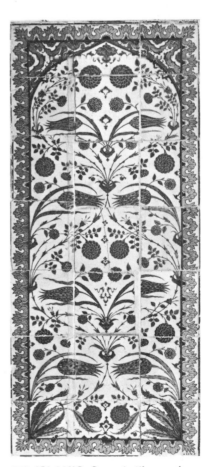

222. ISLAMIC. Ceramic tile panel. Isnik. 16th century. *Musée des Arts Décoratifs, Paris.*

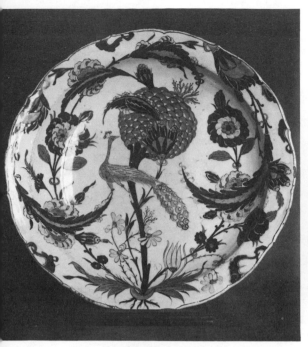

223. ISLAMIC. Large dish. Damascus ware. Ottoman period. 16th century. *Louvre.*

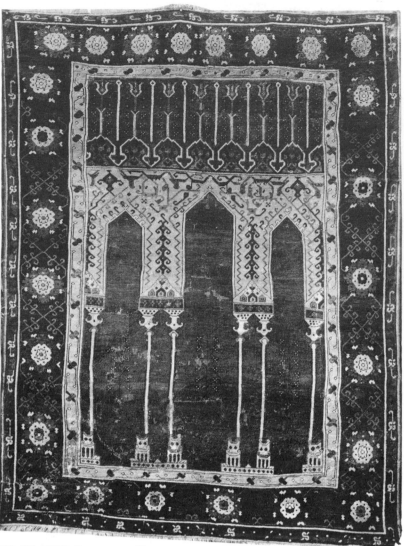

224. ISLAMIC. Prayer rug with mihrab. Turkish (Ladik). 17th–18th centuries. *Musée des Arts Décoratifs, Paris.*

ceramic workshops at Kutahya and Constantinople.

The miniature for the most part showed Persian influence. Copper work resembled that of Syria and Egypt. Carpets (workshops of Ghiordes and Konia in the 16th century; of Kula, Bergama and Ladik [224] in the 17th) and silks (Brusa) were decorated with floral and geometric motifs. Tunisian and Algerian carpets were influenced by those of Ghiordes and Kula, just as the copper work of Algiers and the ceramics of Tunis were affected by Persian motifs transmitted via Damascus and Brusa.

Turkish weapons were almost always decorated with gold; helmets were imposing and were worn over turbans [220].

Sophie Essad-Arseven

MOROCCO

History. Morocco escaped Turkish domination but had to defend itself against the Portuguese, who threatened its coasts. The Saadi dynasty, who came from the Atlas, took Fez in 1548 and pushed the Christians back by 1578. The Alaouite dynasty succeeded them in the 17th century; Mulai Ismail, a great admirer of Louis XIV, built palaces and monuments at Meknès.

Architecture. The Saadian rulers gave Marrakesh fine buildings (Bab Douk-kala mosque; royal tombs [212]). Under Mulai Ismail the fine Bab Mansour el-Euldj gateway at Meknès was built [213].

Military architecture was Byzantine in type (rectangular kasbahs or citadels, with bent entries), or was African (fortresses with towers in the shape of truncated pyramids). Decoration was inspired by Merinid examples, to which foreign influences were added, especially European (Portuguese Manueline; Spanish Plateresque; French late Flamboyant; Italian Baroque).

The minor arts. Both foreign influence and Moorish traditions can be seen in metalwork, ceramics, jewellery, carpets, brocades and embroidery.

MUDEJAR SPAIN

Islamic art in Spain did not die out with the fall of Granada in 1492 and the Christian reconquest, but lingered on for another century as Mudejar art. In point of fact this art was already in existence in the 12th, 13th and 14th centuries. Islamic influence can be seen in the decoration of French-inspired Gothic churches; in Renaissance architecture it is found together with influences from Italy. The Mudejar tradition in Spanish art persisted up to the 18th century. Mudejar art was at first a popular art, but later a court style developed; among the finest buildings are: S. Fernando chapel in the mosque of Cordova (now the cathedral), added by Henry II of Trastamara in 1371; the Alcazar, Seville (c. 1350–1369), begun by Pedro the Cruel [214, 215]; the royal monastery of Las Huelgas. In the 15th century the Mudejar style influenced the Alcazar at Segovia and the portal of S. Esteban at Burgos. In the 16th century it is evident in the chapter house of Toledo cathedral and in the Casa del Duque de Alba and the Casa de Pilatos at Seville.

Gisèle Polaillon-Kerven

II. PERSIAN ART AFTER 1200 *Basil Gray*

*The decline, during the Western Middle Ages, of Arab power
in the Islamic world brought a shift of influence to Persia, where
an artistic and intellectual revival was taking place under Turkish
rule. But the course of this renaissance was altered in the 13th
century by the Mongol invasion. Art received a fresh impetus,
in which Chinese influence played no small part; painting, in
particular, knew an astonishing efflorescence, which spread to
India. By the 16th century Persia had regained its autonomy.*

THE EFFECTS OF THE MONGOL INVASIONS

There is no distinct break in the development of Persian art
corresponding to the catastrophic invasion of the Mongols who
in campaign after campaign in the 13th century devastated the
countryside of Iran, razed her towns and cities to the ground
and reduced the population to a fraction of what it had been.
There was indeed, as is natural, a falling away of the production
of major works, but the tradition remained alive, no doubt
being pursued in areas such as Fars which escaped the full fury
of the invasion. So we find the transition from the Seljuk style
to the Mongol in Persia easy and not abrupt. Indeed, in the
history of the arts the major effect of the conquest was through
the resultant diffusion of artistic ideas and techniques. Although
themselves contributing nothing to the artistic heritage, the
Mongols did bring about certain fruitful developments through
sending craftsmen travelling in search of new patrons and
merchants, and also through opening up more regular and
secure trade routes over the vast distances of Asia. Thus Persian
metalworkers and faience inlayers were displaced to Iraq and
Asia Minor, and a little later craftsmen, and perhaps glass-
enamellers too, were brought back to Persia from Damascus.
On the other hand, the cosmopolitan group of specialists who
attended the Mongol courts brought ideas and techniques from
many lands which gave stimulus to the craftsmen of Persia as
well as of central Asia and China. This kind of penetration
came about more slowly, and it was not until shortly before
1300 that Chinese influence became noticeable in Persian art.

Meanwhile in architecture and architectural ornament of
various kinds, including the beautiful lustre tiles of Kashan,
Persian production, although at times scanty, still carried out
the ideas current in the later Seljuk period. No striking change
took place in the plans of buildings or in the basic structural
elements. A significant alteration in the profile of the dome was
made possible by the development of the double dome, the
outer one serving to counter the outward thrust of the lower
and acquiring thereby an elongated bubble shape which is so
characteristic a feature of the horizon in many Persian cities.
From a distance these domes are the more conspicuous for the
208 turquoise blue or green tiles which cover them and flash in the
sunlight. Such blue tiles were not new, but they were far more
conspicuously in use than ever before. Elsewhere in public
buildings — and all those which have survived are mosques or
tomb towers or madrasas — tiles were used more than ever
before. There are great lustre tile complexes to indicate the
mihrab or prayer orientation niche, in particular at Veramin, at
Qum and in or near Kashan, where they were made. In the best
of these naskhi (the early cursive Arabic script) inscriptions in
relief under a blue glaze are foiled against a flat gold lustre
pattern. More characteristic of the period, however, was the
tremendous development of stucco decoration, which is of all
ornament the most typical of the Mongol period in Persia.

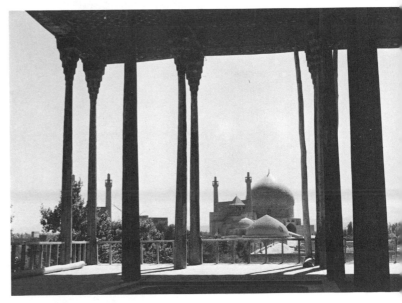

225. ISLAMIC. The royal mosque (Masjid-i-Shah) at
Isfahan. Built under Shah Abbas I between 1612 and 1627.

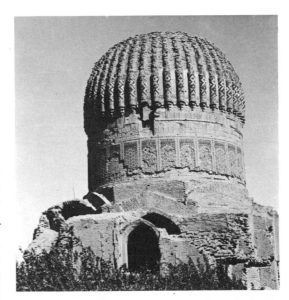

226. ISLAMIC. Mausoleum of Gauhar Shad (wife of
Tamerlane's son) at Herat, Afghanistan. The building was
modelled on the Gur Amir, Samarkand. Timurid period.
1457.

227. ISLAMIC. Dome of the Gur Amir, Samarkand. Built
as the mausoleum of Tamerlane (d. 1405).

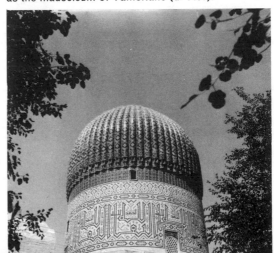

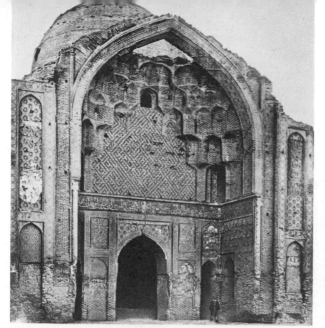

228. ISLAMIC. Iwan of the Friday mosque at Veramin, Persia. 1322–1326.

229. ISLAMIC. The Chihil Sutun pavilion, Isfahan. Built by Shah Abbas I. Restored in the 17th century.

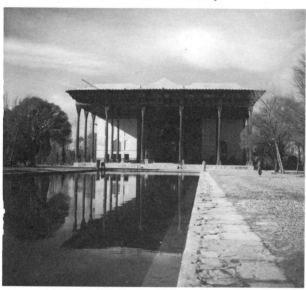

230. ISLAMIC. Bridge over the Zayinda River at Isfahan. 17th century.

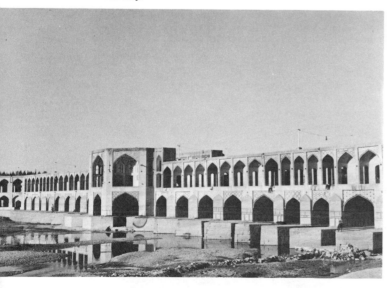

Carved and moulded stucco had been used as a wall covering since Sassanian times, but what was new was the greater architectonic value now placed upon it. Instead of small panels arranged as a dado or a simple frieze there were now composition schemes covering the whole façade of an iwan or of a mihrab wall. The relief was high enough to permit a composition on two or even three planes, which in practice suited the complex of architectural inscription in naskhi or Kufic (early vertical Arabic script) still in use for this purpose.

It is the play of light and shade, which gives plastic vitality to the wall surfaces so decorated, that makes the interiors of the Mongol period in Persia so noteworthy. The buildings may lack comprehensive unity, but each main member is conceived as a coherent design with a rich but controlled texture of light and shade. But in addition to this the whole effect was originally heightened with bright pigments. Colour became ever more dominant in Persian architecture, but at this time it was still used to enhance and supplement plastic treatment of surfaces. It was at this time too that tile mosaic came to be developed, though at first only to accent the carved stucco work. It was only in the 15th century that flat patterns in tile mosaic became the normal treatment of both interior and exterior surfaces.

The Mongol conquest of Persia brought a more centralised rule than the country had enjoyed for centuries, and with it came the concentration of economic power which made possible very large building plans. In fact, vast and massive constructions are typical of the later Mongol period in Persia. Much has perished, but from contemporary accounts and the records of early travellers it is possible to form an idea of the large mausoleums of the Ilkhan rulers Ghazan (1295–1304) and Uljaytu (1304–1316) at Tabriz and Sultaniya, and of the gigantic Ali Shah mosque at Tabriz (1310–1320). These structures were decorated with blue tiles on the outside and painted stucco within. The brick walls were of great strength but the methods of construction were not sound. The vault of Ghazan's mausoleum collapsed before it was quite finished, and the great arch of the iwan of the mosque of Ali Shah fell within a very few years of its building. There were wonderful decorative craftsmen in Persia at this time and there was a good tradition of building construction, but apparently there were no qualified architects capable of calculating stresses and of planning a building that was on a large scale. The lack of building stone and, in addition, the shortage of suitable timber, were severe handicaps to the growth of a sound tradition of construction. Nevertheless, for geometrical layout and satisfying proportions of the parts, the buildings of the early 14th century, which represent the full development of the Ilkhan style, are worthy of high praise. Magnificent even in decay, the interiors of the Masjid-i-Jami (Friday mosque or **228** congregational mosque) at Veramin and the great iwan of Pir-i-Bahran near Isfahan must impress the spectator with the grandeur of their conception.

This style has been called 'architectural geometry', but this description omits any reference to the dynamic quality of the curved structural line, particularly in the high pointed arches and in the multiple stalactite treatment of squinch angles and iwan and mihrab arches.

Towards the end of the Ilkhan period wall decoration became flatter; emphasis was placed on tile mosaic patterns and on painted arabesques against a white plastered ground, while the stucco facing was incised with shallow ornament instead of being deeply undercut. And so the powerful highly plastic Seljuk art was transformed into the elegant and rich surface decoration of the 14th century.

A similar stylistic transition may also be seen in pottery and

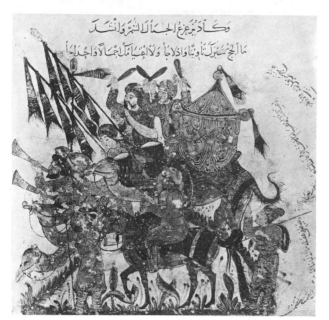

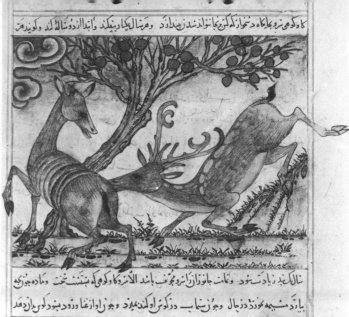

231. ISLAMIC. Miniature illustrating the writings of Hariri. Baghdad school. 12th–13th centuries. *Bibliothèque Nationale, Paris.*

232. ISLAMIC. Stag and Doe, from the Manafi' al-Hayawan. Persian. 1295–1297. *Morgan Library, New York.*

metalwork — a transition from the plastic emphasis of carved and moulded pots and embossed and faceted ewers and candlesticks to the flower-covered ground in which elegant figures are inlaid in lobed cartouches and to the painting and gilding of pottery. The Mongols seem to have loved colour and every kind of surface enrichment; the fact that under Mongol rule Persia was exposed to Chinese influence may have encouraged the creation of more naturalistic designs more freely treated. Various flowers, including the lotus which first appeared in metal inlay in Persia in 1302, were now a favourite motif.

The development of Persian painting

Although manuscript painting, like wall painting, was practised in Persia in the Seljuk period and earlier, there is no reason to think that it was then a major form of artistic expression. In fact almost nothing survives of this early school of painting, and this makes it more difficult to illustrate the radical change which took place in the Mongol period. It is valid, however, to cite as evidence miniatures from the conservative school of Shiraz, which, although no earlier than the 14th century, may be compared with those produced at the court of the Ilkhans in Azerbaijan. They show an art of a purely narrative kind. There is no attempt at a natural setting; the figures move against a red or yellow ground on which appear conventional symbols of mountains, clouds and trees, arranged as a decorative pattern without regard to scale.

In a group of illuminated manuscripts ranging in date from the very end of the 13th century to the middle of the 14th, a very different conception of the picture is found, showing a considerable advance in naturalism. The earliest of this group is a natural history, the *Manafi' al-Hayawan* in the Morgan Library, New York (1295–1297). Chinese influence is obvious in the landscapes and is even more fundamental to the entire pictorial conception. Trees and animals are drawn with vitality, and they have a natural relationship to each other; the margins of the manuscript page no longer contain the whole composition but simply serve as a focus for an image which forms part of a larger whole. This is indicated in two ways: limbs of animals and branches of trees extend beyond the margin; and the blank paper of the background allows the imagination to picture a deep spatial recession. Some of these miniatures are in fact like details from some large Chinese landscape painting; in

others the Iranian tradition is still strong enough for the animals to appear in a conceptual rather than a naturalistic grouping. The colouring in the manuscript is subdued in tone and entirely lacking in the strong reds and blues and yellows which had been traditional in Persian painting since Sassanian times.

Equally striking is the Sinicisation we find in the richly illustrated fragments of the great world history by Rashid al-Din, vizier to Ghazan and Uljaytu; this work was contemporary with the author and was in fact copied for him in 1306–1314 at his suburban library outside Tabriz. The figures are drawn with a calligraphic line in sanguine and are shaded with silver (now oxidised). Colour is confined to architecture, and there is little landscape. The expressive gestures and faces of the figures are in contrast to the grave poses of the old Iranian tradition. But the culmination of this new naturalism can be seen in a fine manuscript of the *Shah-nama* (*Book of Kings*) — now known only from some eighty miniatures divided up among many different collections — and in some miniatures cut from a fable book and mounted in an album now preserved in the university at Istanbul. Both manuscripts were of a large format and in both there is a stronger traditional Iranian element than in the miniatures already discussed. The entire picture space is now filled by a complex composition, and the problems raised by the new naturalism have been successfully worked out. The subject is truly set in space, is organised in depth and has a natural horizon. One of the most striking features of these miniatures is the way in which the frame cuts the composition. This is a most daring device; figures of men and horses are cut in two, and the trunks and lower foliage of trees are shown, just as they were to be two hundred and fifty years later on the screen paintings of the Kano school in Japan. This device heightens the tension and increases the sense of scale by suggesting a far larger world.

We have dwelt at some length on this short period of fifty years in the history of manuscript miniatures in Persia because it is a turning point in the history of the school. The world of nature retained thenceforth its value in the miniature; and the various devices for showing action in so small a space were retained. But the sober colouring and the emphasis on outline drawing disappeared, the painter preferring the quite unnaturalistic gamut of brilliant, pure colour which corresponded to the dazzling skies and jewel-like flowers of the Persian

232

234

plateau — so different from the tree-clad mountain valleys of China. The art of the miniature had thus passed from a conceptual art, through naturalism, to the most perfect romantic style that the world has seen. The entire transition was effected under the aegis of the Mongols, for although the Ilkhan line ended with the death of Abu Said in 1335, the Jalairs who ruled in Tabriz and Baghdad from 1365 to 1406 were also Mongols, and it was at their court that the final stages in the formation of the Persian style took place.

The miniatures of the Timurid school

The Jalair line was swept away, with much else, by Tamerlane (Timur), and his family became in their turn the patrons of miniature painting; this school of painting is generally known as the Timurid school. What were the characteristics which gave it such a unique quality? In the first place it was a true *miniature* style, painted with opaque enamelled colours and with a free use of gold and silver as well as other minerals — among them lapis lazuli in particular. Secondly it was a style appropriate to the book; its scale was related to the format, and it was in intimate accord with the text as set down by the calligrapher and illuminator. Thirdly, in it a solution had been found to the problem of conforming to the content of the book. The integrity of the page was not destroyed; there was no illusion of depth, of seeing through or beyond the page. At the same time, the supremacy accorded the natural world in the composition — an achievement of the Mongol masters — still persisted under the Timurids; but this natural world was fused more closely with the action, so that, more than ever, the latter was echoed in the sway of a tree trunk, the light of the moon or stars, or the golden glory of the sky. But in this setting, among the strange rock formations in orange and purple (which are actually to be seen in some parts of Iran) and among the flowers which for a short time in the spring bloom with unique brilliance in the desert, it is the human figures which hold the attention. With graceful stance and poignant gesture they play their part in the familiar stories of heroes and lovers. Shirin in the garden swoons at a portrait of Chosroes; Alexander goes by night to visit the hermit in his cave, or sees the Sirens bathing, or listens to the talking tree; Rustam catches his famous horse Raksh from the wild herd or slays the dragon. He is sleeping in the open when Raksh saves him from a prowling lion, or in his bedchamber when the Negro page ushers to his bedside the beautiful Tarmina. Chivalrous fights, earthly weddings, moon-faced beauties of earth or their counterparts the peris of heaven with their rainbow wings — all are depicted in glowing settings; the tiled floors are carpeted in colours as rich as the flowering hillsides, and there is always the runnel of clear water which is the essential part of any Persian garden. Age and death are not excluded, but all might be situated in paradise.

The greater number by far of these miniatures are used to illustrate manuscript volumes of poetry, either lyric or epic — or occasionally didactic. One could go further and say that nearly all the best Persian painting of the 15th century is found in the volumes of lyric poetry. The great epic of the *Shah-nama* naturally requires a number of paintings, but perhaps for that reason they do not reach the same heights as the former. Even the two most famous copies made in this period, the 1430 manuscript in Teheran and the Royal Asiatic Society's book of about 1440 (on loan to the British Museum), are more notable for splendour of colouring and richness of composition than for originality or sensibility. And so one is almost forced to the conclusion that what lends these miniatures intensity and power to move the imagination is the mystical faith in nature as the mirror of the divine, together with the currency of the

233

234

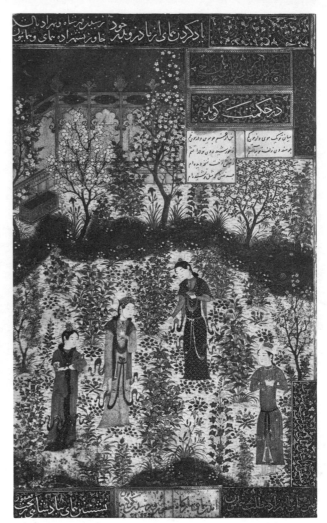

233. ISLAMIC. Humay and Humayun in the Garden of the Emperor of China. Persian miniature attributed to Ghiyath ad Din Khalil. Herat school. Timurid period. 15th century. *Musée des Arts Décoratifs, Paris.*

Chinese influence is noticeable in the style and composition.

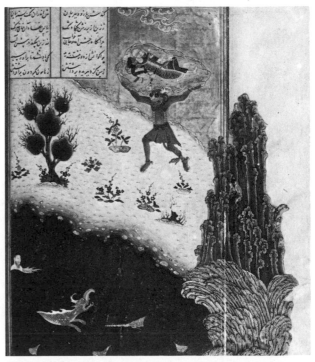

234. ISLAMIC. Rustam being thrown into the Sea. Persian miniature from a manuscript of the Shah-nama. c. 1440. *Royal Asiatic Society, London. On loan to the British Museum.*

symbolic language in which wine stands for gnosis and lovers for the soul in its quest for ultimate revelation; both symbols were current among the Sufi devotees who were so influential in court and literary circles at this time.

During the 15th century the style developed; in works of the earlier period compositions are closed and generally have a circular movement, with few straight lines apart from verticals; space is not clearly defined, but the figures are combined as in a tapestry to form a bouquet of colour and to create internal rhythms. In the late 15th century Persian painting was dominated by a genius, Bihzad, who worked at the court in Herat and who revitalised the Timurid school. He organised his space more coherently, and thus he was able to create more interesting and complex internal rhythms. Greater 'roominess' is already evident in the *Bustan* manuscript of 1488 in Cairo, but the full strength and subtlety of his compositions can only be seen in a manuscript of 1494 of Nizami's *Khamsa*, in the British Museum (Or. 6810). However, his appearance marked the end of the 'classical' period of the Persian miniature; in the 16th century, for all the richness of colour and mastery of line, there was a loss of tension and a decrease in vision. Landscape became pastoral, and the tone generally descriptive. But there were still exceptions, such as the famous painting of the night ride of Mohammed (attended by innumerable peris) through the heavens on his miraculous human-headed horse Buraq. Here a visionary presentation is achieved which is remarkable for its scope and is daring in its abandonment of any base line or horizon. Elsewhere the multiplication of figures and their increased agitation, expressed in a lighter colour key, makes a more superficial impression. It is true that mastery of draughtsmanship persisted at least till the end of the 16th century; indeed Muhammadi and after him Aga Riza seem to have introduced a virtuosity which was to lead in the first half of the next century to purely calligraphic drawing with the accented pen.

Persian carpets

236 Yet under Shah Abbas I (1587–1629) both carpets and woven textiles reached the highest point of excellence. Timurid carpets are now known only through their representation in miniatures. In the first half of the 15th century these show an all-over repeat design of medallions within a border made of a formalised Kufic script. In the second half of the 15th century carpets were arranged more in the manner of illuminated frontispieces, with a great central design set in a field of subordinate floral or arabesque motifs and with a more formal border framing the whole. This type reached its culmination in the first half of the 16th century in the Safavid royal workshop at Tabriz, where the establishment was on so great a scale that huge compositions were executed without sacrificing quality, for example the Ardebil carpets made as a royal gift to the mosque. About the middle of the century more pictorial carpets appear of the types known as 'garden carpets' and 'hunting carpets'. Splendidly conceived and executed, these are less satisfactory in design than the earlier ones, for they tend to be fragmentary and lacking in cohesion. Where, however, the field of design is dominated by a central motif and the other parts are subordinated to it, as in the 16th-century 'multiple medallion carpets', the design leads up to and radiates away from a great eight-pointed medallion, which is also the ornament in the smaller parts.

However, all these 16th-century types are quiet, flat designs; in the early 17th century so-called 'vase carpets' were produced which have a more dynamic character in spite of the regularity of the design which, although symmetrically laid out, is restless and lacks a dominant centre. At the same time the Safavid royal carpet factory was making silk carpets with

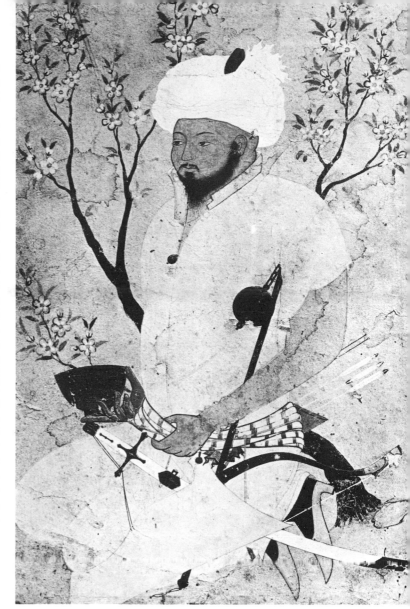

235. ISLAMIC. Portrait of a Sultan (?). Persian miniature of the early 16th century. *Museum of Fine Arts, Boston.*

gold and silver thread (so misleadingly named 'Polish carpets'). They are blond and sumptuous, and the agitated designs in which flowers continually break into arabesques are thoroughly baroque. The Safavid woven silks pass through the same phases, evolving from the regularly ordered small figure designs of the 16th century — some of the most exquisite textiles ever made — to the flamboyant patterns of the early 17th century, stiff with silver thread; in these the scale of the medallion is too big for any ordinary weaver. By one of those complete reversals of taste especially common in sophisticated societies, by the end of the 17th century the silk patterns had become very small, with narrow stripes or tight little bouquets of flowers. The baroque had evolved into mannerism.

But meanwhile the Persian ateliers had passed on their skill in carpet-making to India, where the Iranian tradition was continued; indeed, the Indian workshops were sometimes directed by Persian artists. But this tradition, like many others of similar origin, acquired new characteristics. We will discuss this art further in the article on Mogul India (see p. 112).

HISTORICAL SUMMARY: Islamic art in Persia

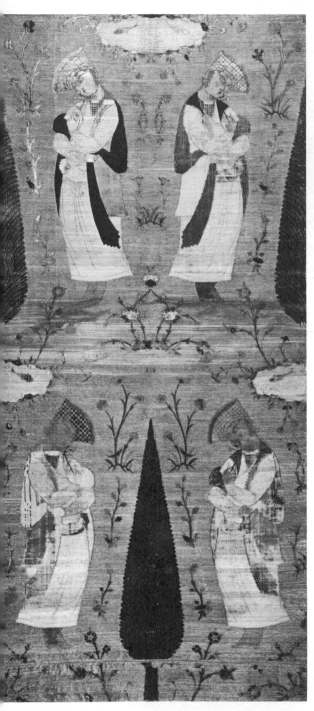

236. ISLAMIC. Cypress carpet, showing characters from paradise. Velvet on cloth of gold. Persian. Early 17th century. *Victoria and Albert Museum*.

History. From the 10th century the Arab element began to lose its political primacy and the Iranian element reasserted itself, in a peaceful manner, at the same time giving rise to a splendid artistic revival. It can indeed be called a renaissance, for it was faithful to the past while imbuing the arts with a new life. The Samanids ruled, during the whole of the 10th century, over Transoxiana (Bokhara); great poets were attached successively to the court (Rudagi, d. 954; Daqiqi, d. 952; Firdousi, before 941–1020); the most celebrated philosophers taught there (Avicenna 979–1037). Meanwhile the Buyids ruled in western Persia from 935 (Shiraz), also attracting men of talent; at this time, too, the Ghaznevids were increasing their power in Afghanistan. These last became the ruling dynasty in the area under Mahmud of Ghazni (971–1030); it was at his court that Firdousi composed his famous *Shah-nama*, completed 1010. From 1040 a new Turkish house came into power — the Seljuks, who united Persia with Mesopotamia, Syria and Asia Minor. The Seljuks patronised Arabo-Persian culture, which continued to develop despite its many vicissitudes; the poet Omar Khayyam and the philosopher Ghazali were active during their reign. At the end of the 12th century the Seljuks were overthrown, and another Turkish dynasty, that of the shahs of Khwarizm, took over; the latter continued to foster the arts; their court boasted the poets Nizami (d. *c.* 1202) and Sa'di (*c.* 1184–1291), the latter the greatest Persian poet.

But in 1220 came the Mongol invasion; it was one of the worst catastrophes in Iranian history, and was repeated in 1231 and again in 1258, the year in which the whole of Iran fell to Hulagu, the grandson of Genghis Khan. His dynasty (the Ilkhan), which lasted until about 1336, was both strong and liberal; the historian Rashid al-Din (d. 1318) was attached to its court. The Ilkhans maintained contact with the Mongol court in China, and Chinese influence in art was important at this time. With the decline of the Ilkhan house, however, the link was broken.

At this point Tamerlane (d. 1405) appeared and ultimately restored the unity of Persia — to his own advantage. Though a savage conqueror he was a patron of the arts, the centre for which was moved to Samarkand. His successors the Timurids supported the arts and letters (at Herat). The Timurids were conquered in 1500 by the Uzbeks (1500–1599), who perpetuated the Timurid tradition in Turkestan. The 15th and 16th centuries constituted one of the greatest periods of Persian painting, with such artists as the famous Bihzad (*c.* 1440–1524), who later worked at the court of the Safavids (1502–1722). These last, in spite of struggles with all their neighbours, maintained the high artistic standard of Iran. This culture became widespread and had a profound influence on the Islamic rulers of India, the Moguls, whose dynasty was founded by Babur, a descendant of Tamerlane.

Architecture. The successive capitals of the dynasties (Bokhara, Shiraz, Baghdad, Samarkand [**227**], Herat [**226**], Tabriz, Isfahan [**229**, **230**]) — have many buildings — mosques, madrasas, tombs, palaces — in which Islamic architecture has attained a great purity; domes, arcades, tall arched portals and tapering minarets are executed with a very sure taste; the same is true of such works as dams and bridges. Polychrome decoration of enamelled terra-cotta mosaics, plaster relief ornament and glazed tiles add a lavish facing to the elegant forms of the monuments. The prominent role played by this decoration is related to the polychromy of the carpets, which were now at peak production. Decorative motifs were borrowed from plants or were geometric and often included inscriptions in Kufic.

The most typical mosques are the Blue Mosque at Tabriz (*c.* 1437–1467) and the royal mosque at Isfahan (1612–1627) [**208**, **225**]. The beauty of Persian architecture greatly impressed the neighbouring countries, and the Mogul emperors made various attempts to use it as a model; their greatest success was probably the famous Taj Mahal [**246**], built by Shah Jahan between 1632 and 1653 to the memory of his favourite wife Mumtaz Mahal.

Painting. Architecture, however, never achieved the astonishing splendour of narrative painting and illumination. It was also a creative period in literature.

FRENCH. GUSTAVE COURBET (1819–1877). The Painter's Studio. 1855. Louvre. *Photo: Michael Holford*.

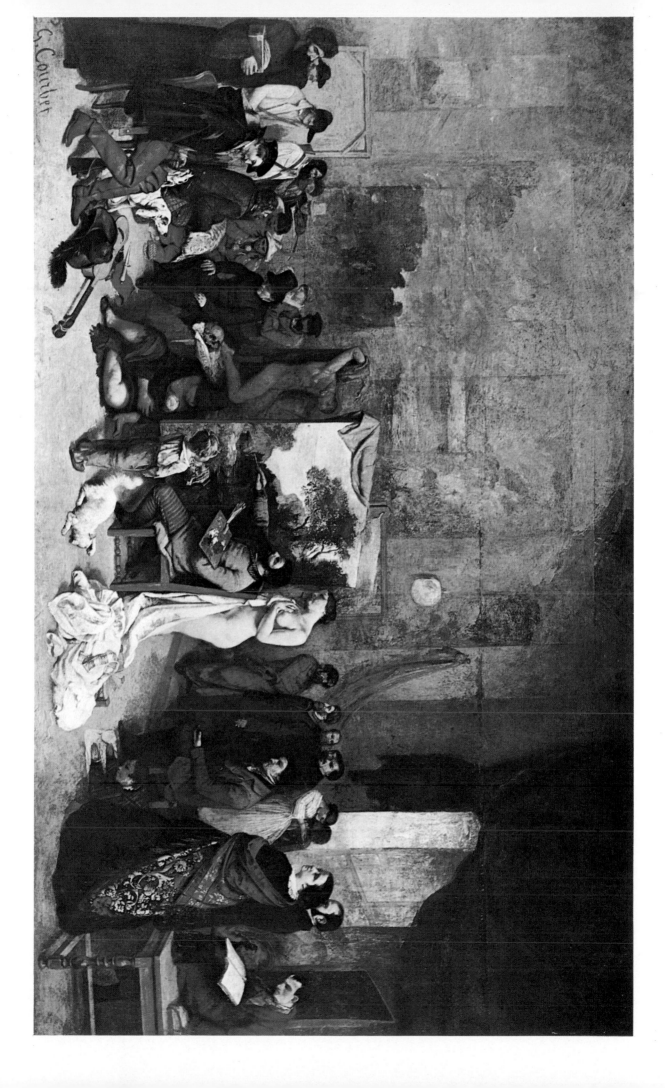

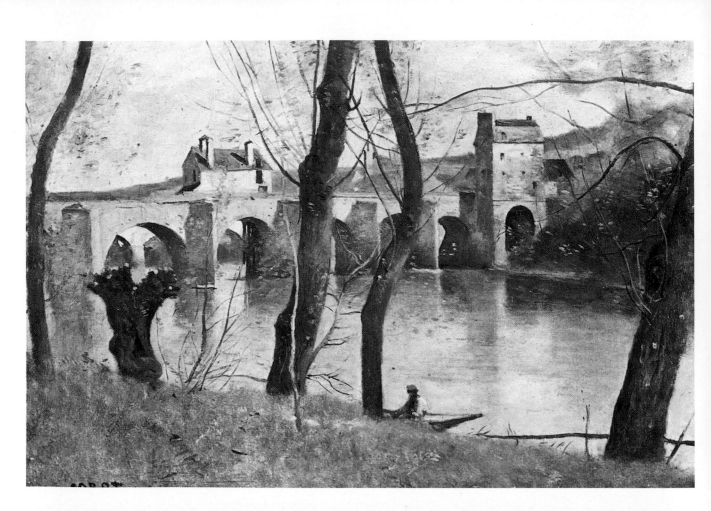

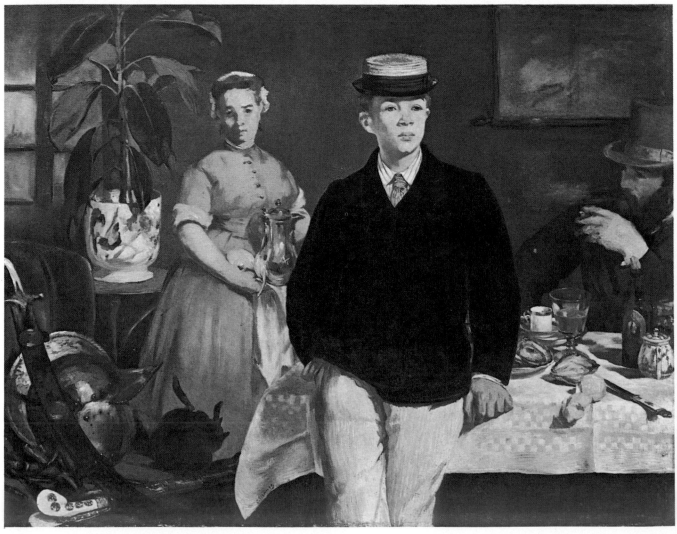

Firdousi's *Shah-nama* gave the Iranian epic its definitive form and became one of the favourite themes of miniaturists [234]; the poets expressed their romantic sentiments in a language that was incisive and highly polished. All this activity produced a cultural climate which gave to painting its characteristic refinement of accent. Influenced by the iridescent lustre ceramics of Rayy (Rhages) of the 12th and 13th centuries and by the Manichaean illuminated manuscripts of the 8th century, the early school of painting was that of Mesopotamia or Baghdad (12th–13th centuries) [231], which was more Arabic than Persian in style. It includes among other manuscripts the famous Hariri in the Bibliothèque Nationale, Paris. But it was on Iranian soil that Islamic art reached its peak from the Mongol period onwards.

Under Mongol rule Chinese influence manifested itself in the way in which mountains and rocks were depicted, in the stylisation of clouds and even in the appearance of some of the figures. This influence gave a special character to the productions of this period, which in other ways derive directly from the Abbasid school. A typical example of this style is the Rashid al-Din in the Bibliothèque Nationale, Paris (Tabriz, 1310–1315).

There was a true renaissance in painting under the Timurids, by which time the various influences had become assimilated [233, 235]. This was the greatest period of Persian painting. Its tradition was perpetuated under the Uzbeks and had a profound influence on the Indian Mogul school, which borrowed not only its themes and technique but also its painters. Some manuscripts show greater evidence of Chinese influence; an example is the *Apocalypse of Mohammed*, which was illuminated at Herat in 1436 (Bibliothèque Nationale). The Iranian element, on the other hand, predominates in other works (*Khwaju Kirmani*, Baghdad, dated 1396, British Museum).

The work of Bihzad, which dominated this period, is remarkably personal. Excellent portraits appear for the first time; also, the illustrations are unusually lively, observant and realistic. The movements of groups of figures are rendered with astonishing facility; at the same time each character is analysed with extraordinary precision of attitude and sureness of line.

The Safavid school inherited the principal characteristics of the Timurid school. Bihzad in fact taught the young painters of the new dynasty, passing on the tradition to them. Refinement was at its height; subtlety of composition, sumptuous colours, elegance of outline, graceful gestures, decorative beauty of flora and fauna, all combined to give a ravishing charm to these illustrations, a charm, however, which gradually faded into a decadent mannerism. Production was so abundant that it is impossible to cite even the masterpieces. The most we can do is to mention a few of the most famous painters: Aga Mirak (active *c.* 1524); Sultan Mohammed (d. 1555); Aga Riza (active *c.* 1600); Riza-i-Abbasi (*c.* 1598–1643); Mohammed Qasim (*c.* 1626); Mohammed Ali (*c.* 1700). Many works, however, remain anonymous; subjects were very varied and included portraits, epic or religious scenes, royal hunts, genre scenes, etc. These categories were taken over by the Mogul school, which gave them a realism and vigour unknown in Iran; these characteristics had their roots in the Indian tradition.

The minor arts. The minor arts flourished along with the major arts. We find the same refinement and perfection, whether it be in glazed ceramics [237], multicoloured carpets [236, 238], ivories (which are very fine), cloisonné or glass work. This last was taken up by the Moguls, who produced glassware inlaid with precious stones.

Jeannine Auboyer

237. ISLAMIC. Sultanabad vase. Persian. *c.* 1300. *British Museum.*

238. ISLAMIC. Kashan carpet. Persian. *Robert de Calatchi Collection, Paris.*

FRENCH. CAMILLE COROT (1796–1875). The Bridge at Nantes. Louvre. *Photo: Jacqueline Hyde.*

FRENCH. EDOUARD MANET (1832–1883). The Luncheon in the Studio. 1869. Neue Staatsgalerie, Munich. *Photo: Joachim Blauel.*

III. MOSLEM INDIA *Jeannine Auboyer*

The gradual conquest of India by the Moslems began in the 8th century. It continued for more than six centuries. In the Islamic art introduced by the conquerors we can trace the stages of the adjustment between the two fundamentally opposed civilisations. This adjustment, however, never went beyond a few concessions on either side.

'He who has made an image will be called upon, on the day of Resurrection, to give it a soul, but he will not be able to do it ... Woe unto him who has painted a living being! ... Paint only trees, flowers and inanimate things.' So reads a famous passage from the Hadith — an injunction which we know was far from being observed by the Islamic artists.

Here, on the other hand, is the voice of Buddhist India: 'All those who have images made of the Buddha in precious stones, in jewels, in copper, in bronze, lead, iron, clay, in masonry, those who paint them on the walls, even those who scratch them on with their fingernails or with pieces of wood, shall be rewarded with Enlightenment' (*Saddharma Pundarika*).

Both the above statements reveal an ancient substratum of magic based on the same fear of giving life to an image with impunity; for India too safeguarded herself, threatening with malediction those images which were not made to conform to the prescribed canons.

India gradually created her own pantheon, and her artists continued to produce a figurative art, while Islam turned to abstract decoration — geometric or floral — which played with a surface to impress upon it a particular rhythm; the arabesque is based on a hidden order which is revealed only through an intense linear profusion. Whereas Indian art strove for three-dimensional space, Islamic art remained a flat surface decoration. The one tried to idealise nature; the other ignored its real aspect and used it only in a stylised form. Even when the Islamic artists produced figurative art — in book illustrations for example — they felt this need for stylisation; it gave a particular flavour to their work.

In the same way, the conception of the mosque was opposed to that of the Hindu temple. The mosque was the place of prayer, intended solely for the community of the faithful, and offered no esoteric symbolism; its orientation alone was important, so that the mihrab should indicate the direction of Mecca. The Hindu temple, on the other hand, was intended solely for the divinity and was as much the repository of the divine as its earthly dwelling; it corresponded to a complex symbolism which equated it with the cosmos.

Thus when the Islamic world came into contact with the Indian tradition there was reason, because of these fundamental differences, to fear a conflict which could have grave consequences; and indeed for Buddhist art this was so — it was annihilated by the blow. Islam, however, reacted to Hindu art in quite another manner, and this was an interesting phenomenon. Islam considered Buddhism — a proselytising faith — to be a rival world religion, and also feared possible contamination; the measures taken were all the more violent in that it was the shock troops, still imbued with the spirit of holy war, who fell upon the Buddhist sanctuaries. It was a different matter in the profoundly Hindu provinces which the Moslems subjugated. Here they were obliged to come to terms, in some measure, with the local populations in order to reduce the chances of a resistance which might be dangerous. The results of this compromise are evident in the style of the mosques of

244
243

242

239. INDIA. View, showing dome, of the Mala Mandir at Dhinoj.

240. ISLAMIC. INDIA. The Qutb Minar, Delhi. *c.* 1225.

western India — the first area occupied by the Moslems; this style deserves, more than any other, the name 'Indo-Moslem'.

There was a further reason for this; the Moslems who settled in the western provinces (Gujarat; Kathiawar; Kach; Sind) often used Hindu temples as mosques, hardly altering them at all. In such cases representations of Hindu deities sometimes survive in the decoration. New mosques were built of materials taken from temples which had been destroyed or had fallen into ruin. The Moslem architects, who came from Delhi (where, at that time, buildings in the purest Islamic style were being erected), used mainly local artisans who had been trained in the Hindu tradition and whose craftsmanship was still at the height of its vitality. A sort of synthesis resulted which could be considered a colonial art; it was original, if not a complete aesthetic success.

Interchanges between Moslem and Hindu art

The Moslems found inspiration in certain elements in Indian art which seemed to them to approximate to their own ideas; the exterior aspect of domes (their method of construction being totally different), the use of arcading, the horseshoe-shaped opening, the pierced panels, the balustrade (vedika) and a number of decorative themes were at the foundation of this new style. Some 12th-century Jain temples in Gujarat and Kathiawar have admirable corbelled ceilings with pendentives; the Moslem builders usually adopted these ceilings and encased them in a dome of masonry (Tanka Masjid at Dholka, 1361). Thus we have an example of the combination of two techniques derived from conflicting traditions — the Indian corbelling allied to an exterior dome which was typically Islamic in form.

The multifoil arch had a similar history. Its evolution began about the 6th century in India with the horseshoe-shaped opening used in the wooden architecture of the ancient period. Gradually it was transformed from a single-curve arch into one with counter-curves; it continued to change during the 7th and 8th centuries. From the 10th century the arch began to break up into an increasing number of segments, sometimes forming S-curves and sometimes almost closed loops; a monster's head (kala) formed the centre, and each segment was also decorated with a monster (makara). It was this form of arch, by then quite stereotyped, which the Islamic builders found on their arrival in western India (temple of Kandariya at Khajuraho, Surya temple at Modhera, Surya temple at Vadnagar, Vimala temple at Mount Abu, 10th–12th centuries). They themselves were using multifoil arches obtained by the use of wedge-shaped stones; these arches can be seen wherever Islam penetrated — in Persia, in Afghanistan, in North Africa. Here again two motifs, separately evolved, were finally fused; in some cases the makaras decorating the segments persisted in the ornamentation of certain mihrabs — an additional proof of the concessions made by the Islamic builders in adopting local formulas.

Screens of pierced stone, which were among the most successful products of the Islamic craftsmen, had also been made in India from ancient times; they are known from the 1st century B.C. (Bhaja), then from the 5th (Aihole) and 6th (Badami) centuries A.D. Their very simple decorative motifs were carved on a monolithic slab; in the medieval period, at Mysore, they became somewhat more elaborate, but they cannot compare in virtuosity with the mosque screens. Nevertheless here was another instance in which the Moslems on their arrival in India found a theme corresponding to one of their own. And the Hindu craftsmen who executed the screens in the medieval mosques stamped them with the imprint of their own tradition. These craftsmen retained a number of decorative motifs which

241. JAIN. INDIA. Ceiling of the Bhulavani temple, on the Satrunjaya at Palitana.

242. ISLAMIC. INDIA. A mihrab from Ahmadabad.

243. INDIA. Curved arch, temple of Dwarkadish, Dwarka.

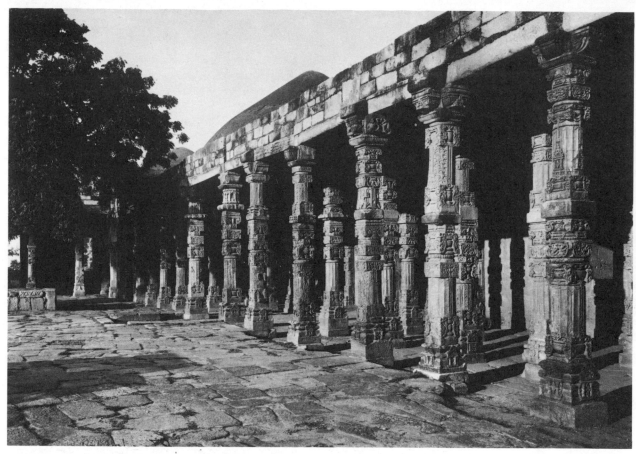

244. ISLAMIC. INDIA. Colonnade in the Qutb mosque, Delhi.

Features from Hindu temples are used here in a mosque.

formed part of their ancestral repertory; one of these was a stylisation of the balustrade (vedika) which is present in Indian art throughout the whole of its development and which is frequently found in the mosques of Gujarat and Kathiawar.

Another architectural element, the gateway or torana, was absorbed into the Indo-Moslem repertory; at first it was simply incorporated, Hindu toranas being used to form the mihrab; then it was imitated, but Islamic stylisation made the original theme more arid.

Lastly there was the decorative motif of merlons (solid parts of a battlement) alternating with a semifloret, which was adopted by the Indo-Moslems in the last stages of its development.

A new style thus came into being with the help of all these elements, which were either taken over or adapted from earlier motifs. This gave a distinctive character to the Indo-Moslem architecture of the western provinces of India, which stands in distinct contrast to the Islamic architecture built at the same time in regions more directly subject to the Delhi sultanate. While the latter was truly foreign to India both in conception and in detail, the art of the western provinces was completely Indianised. But this Indianisation, however obvious it may have been, was tempered by the desire of the Moslems to preserve an abstract decoration; everything which gave Hindu art its vitality, its exuberance and its profound beauty, was abolished; the details were more refined but were also sterile, were lighter but harder. It is easy to discern the hand of the Hindu craftsman in even the smallest details, but this hand was no longer guided by the exuberant mystique of Hinduism; instead it was attempting to carry over its earlier formulas into the geometric realm of the arabesque and to submit to the restrictions on

figurative representation — although, no doubt, with some reluctance.

However, while the Moslems made use of Hindu elements in their architecture, the Indians themselves were attracted by certain forms of Islamic art. Thus it is easy to discern themes transmitted by Islam to the school of album painting which flourished in Gujarat from about the 12th to the 15th centuries — a school which had a profound influence on the Rajput schools of western India and the schools of the Deccan. It could even be said that they were superimposed on the Indian elements rather than assimilated into them: the Moslem 'governors' are always seen full face or in three-quarter view and wearing their national costume, while the Indian figures are shown in profile, with the right shoulder bare; the architecture is Indian, but the details of the landscape are borrowed from the Iranian repertory and also show Chinese influence, especially in the stylised clouds and in the treatment of rocks.

With the Mogul conquest Moslem influence penetrated more deeply — but at the same time the art of the Indian miniature made, in its turn, a strong impact on Mogul art. In those forms of art which best reveal the Indian artistic sense we can observe a continual interchange between Islam and India. This interchange was at its greatest in mystical poetry; the famous Kabir (1440–1518) sang the praises of Islam along with those of Hinduism and declared himself the child of both Rama and Allah. This merely confirmed the discovery made by the Hindus, with some astonishment, on their first contacts with the Moslems — that Sufism was related to their own mysticism.

However, these were only chance links — almost exceptions in fact — in the history of Indo-Moslem relations; the two orthodoxies were so dissimilar that they could only retain their respective positions, in art as in other realms of life.

HISTORICAL SUMMARY: Islamic art in India before the Moguls

History. The Moslem conquest of India began in the early 8th century with the invasion of Sind. But it was confined mainly to the Kabul region, and only towards the end of the 10th century did India really become the objective of the armies of Islam. The Punjab, then Kanauj, Mathura, Gwalior and Kathiawar were all invaded by the troops of Mahmud of Ghazni. This fresh invasion was followed by a respite during which Hindu society endeavoured to recover its strength.

In the middle of the 12th century the sultanate of Ghor took the initiative in conquest; under the leadership of Mohammed of Ghor the Moslems seized the Gangetic Doab, where their attacks destroyed the Buddhist centres. Henceforth all northern India belonged to them. The sultanate of Delhi managed to retain these possessions and to repulse the attacks of the Mongols. There was a succession of dynasties on the throne of Delhi, whose reigns were marked by fearful acts of cruelty but also by the building of palaces, mosques and minarets.

At the beginning of the 14th century the Moslems penetrated the Deccan and advanced southwards, seizing Halebid and Madura. At the same time they protected India from the Mongol invasion which threatened the Punjab. The 14th century was a time of strife within the Delhi sultanate, of mass deportations of Indian populations and of the heavy demands of the Moslem masters, spoilt by the unaccustomed luxury of their new environment. The vast area conquered was too large for a government without a fixed administration; hence the first Moslem empire in India was soon divided up; independent kingdoms existed side by side with the Hindu states, which increased the disunity and instability.

Not until the beginning of the 16th century, with the advent of the Turk Babur, who founded the Mogul Dynasty, did the Moslem empire regain its unity and greatness.

Architecture. Although the Moslems were great builders, their own architecture in India dates only from the early 13th century. Before this they generally turned Hindu and Jain temples into mosques, using the materials and adopting the local forms to suit their needs. This gave rise to regional styles which, more than any others, merit the description Indo-Moslem; this art was located principally in the western provinces, which were the first to be invaded (Sind; Gujarat [**242, 245**]; Kathiawar). Parallel with this an official style was developing which is magnificently exemplified in the famous Qutb Minar at Delhi (*c.* 1225) [**240**].

Sculpture. Under Moslem domination sculpture became purely ornamental. Decorative themes were borrowed from flora or were geometrical, giving way in the regional styles to motifs belonging to Hindu art.

Painting. Islamic influence of Iranian origin permeated manuscript illustration, which was then a flourishing art in Hindu India. With it came certain elements deriving from China or elsewhere in the Far East (landscapes, clouds, etc.).

Jeannine Auboyer

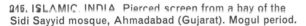

216. ISLAMIC INDIA. Pierced screen from a bay of the Sidi Sayyid mosque, Ahmadabad (Gujarat). Mogul period.

IV. MOGUL INDIA *Basil Gray*

In the 16th century Babur, a descendant of Tamerlane, conquered India and founded the Mogul Dynasty. This brought Iranian influence to India, but the hybrid art that resulted became progressively more Indian. Later, contact with the West brought about a decadence which, however, affected the provincial schools rather less.

The Mogul conquest ushered in a new era in the Moslem domination in India. The Moguls seem to have had a remarkable sympathy with the Indian tradition, and Indian influence had an increasing effect on the once predominant Iranian tradition of the Moguls. This tendency is most marked in Mogul architecture, which shows strong links with the traditional Indian styles. The white marble and red sandstone of these buildings are Indian materials and are not found in Persia, and, although the mosque is totally different in concept and use from the Hindu temple, the tomb chamber is very similar to the sanctuary, and the outer courtyard differs still less. The cusped or multifoil arches, heavily projecting eaves, and roof-turrets are all Indian features. Even architectural inlay in bright colours was used before Babur entered India. At Gwalior the use of yellow tile inlay on the walls of the palace, in silhouettes of trees and animals, prefigures the Mogul intarsia on marble. In fact it would seem that the Moguls had a remarkable sympathy with the Indian scene and tradition, and this enabled them to make such good use of native materials and to site their

248 palaces so well. At Fatehpur Sikri Akbar chose a bare rocky
255 citadel and gave it the regal air of a Rajput castle combined with the spacious grace of a Persian palace quarter. Shah Jahan replanned Delhi along the most spacious lines, and both he and
251 Jahangir understood the importance of landscape gardening.

In painting, too, the Moguls successfully grafted a new art on to the old stock of the Indian tradition. This was largely due
251 to the vision and organising power of the great Akbar, who determined to bring about a fusion of the cultures of his Persian and Turki courtiers and companions-in-arms with those of the lands they had conquered. Persian painting had become academic; it excelled in skill of brush work and mastery of colour, but it lacked spiritual energy and vitality and it had lost touch with life. India had a tradition of vital and rhythmic
260, 263 painting, especially in the Rajput states and in the Deccan, though it was limited in theme and crude in execution. By attracting painters from these and other Indian schools to his court, Akbar was able to build up rapidly a great library workshop capable of producing the many illustrated manuscripts of history and epic and the many portraits that he ordered. Persian masters saw to the proper proportions of miniatures to text and to the maintenance of a high technical standard. Akbar wished to record accurately the events of his reign, and he was quick to appreciate the realism in European engravings and paintings which were brought to his country by Jesuit and Dominican missionaries. He steered his painters towards greater naturalism and encouraged the use of modelling and of European perspective in landscape (obviously derived from Flemish manuscript style). Realism, dramatic power, atmosphere and an admirable colour sense are the characteristics of the Mogul school of miniature painters. Excellent in portraiture, whether of man or of animals, Mogul painters tended, as time went on, to an excessive idealisation and to an interest in lighting for its own sake. The late school was inclined to sentimentality as well as to mechanical repetition, but was still capable of producing splendidly romantic subjects.

246. MOGUL. INDIA. The Taj Mahal at Agra. Built between 1632 and 1653 by Shah Jahan for his favourite wife Mumtaz Mahal.

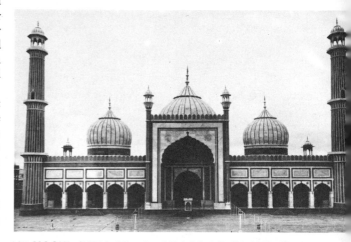

247. MOGUL. INDIA. The Jami Masjid at Delhi. 1644–1658.

The Mogul invaders drew to their courts some of the best 16th-century painters in India; at the same time they revitalised the local schools, so that first the Rajputana painters and later the painters of the Punjab hill states learned to organise their picture space and to increase dramatic force through the use of gesture. Thus when the Mogul school died out about the middle of the 18th century these local schools entered on a period of rich production of romantic and religious works and of portraits.

Mogul carpets, made under Iranian master craftsmen in Agra and Lahore, are distinguishable both by their colour scheme, in which hot reds and oranges appear, and by the sharpness and clarity of their design. The arabesque had practically disappeared, and flowering plants in the borders and floral medallions and swags in the main field showed a tendency towards naturalism, just as Persian carpets tended towards stylisation. The earth and vegetable dyes of India also gave these carpets a local flavour.

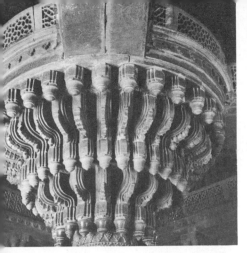

248. MOGUL. INDIA. Detail of pier in the Diwan-i-Khass (private audience chamber), Fatehpur Sikri. 1569–1575.

249. MOGUL. INDIA. The Diwan-i-Am (public audience hall), Agra. 1628–1658.

250. MOGUL. INDIAN. Majnun fraternising with the Wild Animals. Miniaturo from the Laila and Majnun of Nizami, by Dhanun. *c.* 1590. *Bodleian Library, Oxford.*

251. *Above.* MOGUL. INDIAN. Jahangir (1605–1627) holding a Portrait of his Father Akbar (1556–1605). Miniature. Early 17th century. *Louvre (Guimet).*

252. *Left.* MOGUL. INDIAN. The Feast. Painting on cotton illustrating the Amir Hamza. *c.* 1570. *British Museum.*

THE MOGULS

History. After several centuries of invasions a Moslem dynasty replaced the sultanate in Delhi. The first monarchs, Babur (1494–1530), the conqueror and founder of the dynasty, and Humayun (1530–1556), his son and successor, were Iranian in culture; and they had no leisure to interest themselves in the cultural problems of their new empire. Babur, who was engrossed in his military conquests, summoned architects from Constantinople. He was a kind of Renaissance man, and Iran had for him the position that Renaissance Italy had in Europe. Humayun's unhappy career was not conducive to an interest in the arts.

Mogul art had its real beginnings during the reign of Akbar (1556–1605) [251], who renewed the conquests of his predecessors. Akbar was trained from an early age in the rough life of military camps and became adept at all sports. He had tasted exile when he was captured by his father's enemies; he was both a successful conqueror and an administrator of genius. A strange personality, he had a streak of cruelty and of duplicity, a taste for conquest and an intemperate and incontinent way of life. His education had been neglected in his childhood and he remained illiterate. Yet he had a great love of the arts and of letters, and was particularly interested in religious questions. He was a practising Moslem until his adolescence and was something of a mystic despite his epicurean tendencies. His religious eclecticism revealed itself early on in his almost hostile severity towards his co-religionists and his positive sympathy with Hindus; he commissioned Hindi and Persian translations of the *Vedas* and other Indian works, and he published an edict of tolerance or protection for the Hindu cults. Inspired by 'visions' (the first occurred in 1578 during a hunt) and driven by his pride, and a degree of megalomania, Akbar broke with Islam in 1580 and attempted to found a new universal religion, Din Illahi; it was monotheistic with undertones of pantheism. This attempt met with no success with either Hindus or Moslems, but it is interesting for the light it throws on Akbar's character and on the strong impact on him of Indian thought. His new religion did not prevent him from bringing to his court representatives of all the other religions. On three different occasions Jesuit missionaries visited him, but he never became converted to Christianity.

His son Jahangir (1605–1627) [251] abandoned his father's religion and returned to the Moslem fold. Jahangir's son, who reigned under the name of Shah Jahan (1627–1658) [255], was typical of the Mogul sovereigns. His ambition led him to revolt against his father, whom he wished to depose; at his father's death he had still to fight for the throne. His life ended sadly; the four sons of his marriage to Mumtaz Mahal in their turn embarked on a bitter struggle for their father's throne.

The third son, Aurangzeb (1658–1707) [256], was victorious in 1658, taking his father captive until his death and ruthlessly suppressing his three brothers. He was a remarkable personality — a good leader and administrator, but hard, hypocritical and despotic. A fanatical Moslem, he destroyed the equilibrium of his empire by persecuting the Hindus, and his reign ended in near anarchy. He dealt a terrible blow to Mogul art by persecuting artists and proscribing the representation of the human figure.

Art history. With the establishment of a Moslem dynasty, reciprocal influences in art took on a new importance. Art was now primarily a court art, and as such reflected the personality of the emperor as well as the fashions of each reign — and the emperors were not wanting in personality.

Akbar, in particular, changed the course of development of art with the founding of his new religion which had many foreign, especially Indian,

253. MOGUL. INDIAN. Three Women bathing. Miniature. Reign of Shah Jahan (?). *Musée Guimet, Paris.*

254. MOGUL. INDIAN. Birds. Reign of Shah Jahan. *Musée Guimet, Paris.*

255. MOGUL. INDIAN. Portrait of Shah Jahan (1627–1658). Miniature. *Musée Guimet, Paris.*

elements. His successors were less affected by the Indian environment. His son Jahangir, who succeeded him, returned to Moslem orthodoxy. However, the stimulus given by Akbar to the arts was not lost, and under Jahangir Mogul art freed itself finally from servile imitation of Iranian styles.

Thus the rise and fall of this hybrid art was closely linked with the fortunes of the dynasty. After the very Iranian phase, during which the emperors were establishing themselves and were still faithful to their former artistic traditions, Indianisation proceeded with increasing rapidity because of the emperor's policy of treating the local populations with consistent benevolence. Next there was a period of equilibrium; Mogul art retained its hybrid character, producing new formulas from it. Eventually, Islam brutally reclaimed its rights and destroyed the Mogul school.

The impetus had been strong, however, and long after the disappearance of the dynasty the Mogul style persisted and was imitated. Its source had dried up, however, and it was no more than a decadent art for which there was no future.

Architecture. The new stimulus given by Akbar was reflected in Mogul architecture. The most typical example is the elegant ensemble of Fatehpur Sikri [**248**], a strange city of red sandstone whose life was cut short by the departure of the court because of the lack of water and the insalubrious site. Many ' Indianised ' features (stemming from the earlier style of the Indo-Moslem architecture of Gujarat) can be found there, such as the decoration in the form of a kudu on the base of some columns, and the arch with curved segments which issue from the mouth of a very stylised makara.

Under Akbar's successors architecture was Islamic in inspiration and showed less marked Indian influences than in the preceding reign [**247, 249**].

In 1631 Akbar's grandson Shah Jahan lost his favourite wife Mumtaz Mahal, who had borne him fourteen children; in her memory he built the mausoleum known as the Taj Mahal, at Agra [**246**]. There is no doubt that he personally supervised its plan and execution; here the Indian influence is virtually non-existent, and a typically Islamic building houses the bodies of the couple.

Painting. The Indianisation brought about by Akbar is even more evident in painting. He broke with the custom of his predecessors, who had filled their courts with Iranian artists, and employed painters of Indian origin to whom he entrusted the illustration of works for his own library. A new style was born. Indian miniatures took on a

new idiom, different from that of Iranian works; they glorified the emperor, described the splendours of his court, illustrated its favourite games and sports and entertainments, and portrayed its dignitaries [**252**].

Under Akbar's successor Jahangir the new style continued to develop, particularly in portraiture [**251**]. Jahangir took a personal interest in painting; he had a picture gallery, and he was interested in naturalism. He commissioned some admirable albums of flower and animal paintings, and he appreciated the novelty of Western art, of which he owned some examples; he had several European friends, among them Captain William Hawkins and Sir Thomas Roe, the English ambassador.

Indian illumination reached its peak in the reign of Jahangir who, like his predecessors, patronised the arts. Output continued to increase, influencing the local schools which remained faithful to Hindu themes. Local princes, whether or not they were subject to Mogul domination, imitated the splendour of the imperial court; their official painters, being good courtiers, followed the fashion of the times.

The minor arts. Mogul influence was beneficial to craft techniques. There was a veritable renaissance in metalwork. Enamel decoration, originating in Persia, reached a very high standard. The technique of inlay and marquetry in wood was particularly fine. Work in precious and semiprecious stones (popular since ancient times), particularly in rock crystal and jade, was highly prized (cups and bowls). Glass work and ceramics flourished anew under the Moguls, and fine carpets were made.

LOCAL SCHOOLS UP TO THE 19TH CENTURY

Art history. The Mogul school had a strong influence on the rest of India. Before the coming of the Moslems Indian art had experienced a magnificent flowering, but little by little its creative sources dried up — or perhaps this art had declined under the pressure of continuing invasions. While great Hindu temples were still being built in southern India (Srirangam, Vijayanagar and Madura, 16th–17th centuries) before the advent of Islamic domination, the occupied regions seemed, one after another, to be overcome by a kind of sclerosis. However, an Indo-Moslem style evolved in the south, where there are monuments reminiscent in certain of their features of Russian churches (Bijapur, Hyderabad, Golconda).

Painting. It was primarily in the field of album painting, commonly called miniature, that Indian India preserved a

256. MOGUL. INDIAN. Aurangzeb (1658–1707) being carried in a Palanquin. Miniature. *Louvre (Guimet).*

degree of its originality. Like the imperial Mogul court the princely courts maintained painters and gave them work. The traditional organisation of Indian artists into hereditary family workshops has persisted up to our own times. Many local schools developed in this way, endowing India with a valuable and interesting output of paintings. There were well over twenty regional schools, but their present classification is as yet only provisional. Until quite recently regional painting was eclipsed by the reputation of the Mogul miniature, but in the last fifteen years or so scholars have increasingly given their attention to them.

One of the oldest schools is the Bengal school, to which belong Buddhist paintings on palm leaves, dating from the 12th century, which influenced the art of Nepal and Tibet; they were produced on the eve of the annihilation of Buddhist Bengal by Islam. At the same time a Hindu school, popular in origin, was developing, the earliest examples of which are probably the paintings on cloth known as patas; these date from the 15th century but are probably of much earlier origin. Other paintings, on long rolls of paper, are in a rather crude style with figures in profile on a red ground. A third category, also on a red ground and of popular origin, testifies to a vigorous art; they date from the beginning of the 17th century. Lastly, still in Bengal, there developed around the 18th century a type of drawing called kalighat (continuing into our own times), which displays to

257. BENGAL. Morning Concert.
18th century (?). *Musée Guimet, Paris.*

258. BENGAL. Sleeping Woman.
Kalighat drawing. 18th century.
Ajit Ghose Collection, Calcutta.

259. GUJARAT. Illustration from
the Kalaka. Manuscript on paper.
15th–16th centuries. *Musée Guimet,
Paris.*

the full the virtuosity of the artist and in which the rapid, sure and diversely accented line is brought to the highest point of significance [**257**, **258**].

Almost contemporary with the Bengal school, the Gujarat school [**259**] also had a distinctive style. Although subject to a Moslem government from the 13th century onwards, this school continued to produce manuscript illustrations of principally Jain subjects. The earliest were painted on palm leaves (from about 1127 to the end of the 14th century); later, when paper came into use (about 1350), the artists still kept the elongated shape of the palm leaf. These illustrations remained in vogue until the beginning of the 17th century. They owed much to the Indian frescoes of Ellura (*c.* 10th–11th centuries) and influenced the earliest works of the Rajput school. Their style combined decorative elements borrowed from the Moslem repertory with a tradition stemming from medieval India. Through a curious convention they juxtaposed in the same scene figures seen in three-quarters view and having a pointed nose and a bulging eye with figures seen full face, the latter representing the Moslem 'governors' and the former the Indians. As Gujarat manuscripts are generally dated, it is possible to study their evolution.

The Rajput school takes pride of place among the local styles, as the Rajput princes were more closely linked than any others with the Mogul court. Many of their artists worked for the court and then returned to their provincial workshops, bringing about an exchange of influences between the court and local styles. There was an important difference, however; the subjects illustrated by the Rajput painters were never taken from Moslem court life as they were in Mogul miniatures but came from the Indian epics (*Mahabharata, Ramayana, Bhagavata Purana, Gita Govinda*). Two important groups stand out in Rajput painting — that of the hills, or the Pahari styles (the Punjab), and that of the plains, or the Rajasthani styles (Rajputana) [**260**].

The latter group was found in the following centres: Mewar, where the cult of Vishnu Nathadvara gave rise to a distinctive style (17th–18th centuries) and where the school of Udaipur reached its zenith during the same period; Malwa and Gujarat, which are believed to have given rise to the early Pahari styles; the state of Jodhpur, where the very graphic portraits were obviously influenced by Mogul painting; the state of Bikaner, where Mogul influence was predominant in the 17th century; the state of Jaipur, where Amber (16th–17th centuries) and then Jaipur (17th–18th centuries) were the main centres;

the state of Bundelkhand, still active in painting at the beginning of the 20th century.

Pahari styles issued from some forty different centres; the most important groups were:

1. The Basohli (16th–17th centuries) [**261**], whose style, formerly confused with that of Jammu, was at first crude and almost savage but gradually became a true Pahari style in the 17th century. At this period it showed a preference for subjects taken from music (ragmala) and for the legend of Krishna and the *Ramayana*. This art was continued in the Chamba style (first half of the 18th century) and was influenced by that of Kangra. The earlier themes appear again in this style, with its figures silhouetted against a monochrome background — generally yellow — and its physical type with immense eyes and a powerful nose coming straight down from the brow.

2. The group of Jammu and Kashmir and those of Guler/Kangra and of Tehri Garhwal (second half of the 18th century) influenced one another. Their development, though differing in time, followed a similar pattern: a 'primitive' period was followed by a period of more or less pronounced Mogul influence and finally by a predominant Sikh influence, which at the end of the 18th and in the 19th centuries dominated almost the whole of the Punjab and Kashmir [**264**]. The best known centre was Kangra (*c.* 1720–1929), whose style is perhaps the most typical; it is characterised by elegance, idealism and a mannerism which, though a little cold, is extremely refined. Perfected by contact with Mogul influence, it was an academic art with a grace that always remained serene and reserved; its figures were stately and its colours were sober and often pale. The landscapes in particular betray a European influence. This school declined in the 19th century, and its last painters were killed in the earthquake of 1929.

The southernmost local school was that of the Deccan [**263**]. Its principal centres were Bijapur and Ahmadnagar (second half of the 16th century and after) and Golconda and Hyderabad (18th century). Influenced at first by artists brought from Iran and Turkey to the Moslem courts, these centres were, from the reign of Jahangir (17th century), subject to Mogul influence. In general the Deccan styles favoured figures which were rather large in relation to the rest of the composition — a convention which sometimes tended to be clumsy; this art was usually heavy and awkward, except in Hyderabad where Mogul and European influences were more pronounced.

Jeannine Auboyer

260. RAJASTHAN. Woman at a
Spinning-wheel. Late 18th
century. *Musée Guimet, Paris.*

261. BASOHLI. Ragmala. 18th century. *Musée Guimet, Paris.*

262. HIMALAYAN. Couple in a
Park. 17th century. *Louvre (Guimet).*

263. DECCAN. Man with a Carnation.
17th century. *Louvre (Guimet).*

264. SIKH. Portrait of a dignitary.
18th–19th centuries. *Musée Guimet, Paris.*

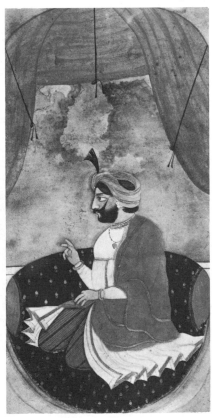

THE FAR EAST *Madeleine Paul-David*

I. CHINA UNDER THE MINGS

The approach of modern times and the confrontation with the West found the East in a decadent phase — a prelude, in fact, to a future renaissance. China, after a century and a half of Mongol domination, withdrew into itself and reverted to its earlier traditions — through a resurgence of nationalism under the Ming Dynasty and through sheer inertia under the Ch'ing or Manchu Dynasty; this return to tradition soon hardened into a rigid conformity. However, Far Eastern art continued to develop in Korea and in the Japan of the Muromachi and Momoyama periods. In the latter period the original genius of Japan produced an unexpected revival, fruitful in its innovation and its influence. Here again academic stagnation might have ensued, but the rise of the middle classes during the Tokugawa period brought with it an upsurge of creative activity in art, of which the print was the most popular manifestation and at first the best known abroad.

The return to a national dynasty

The Ming Dynasty was founded in 1368 by a peasant who led an insurrection which succeeded in driving the Mongols beyond the Great Wall. The advent of this dynasty marked a return to the national traditions of China. The Emperor Hung-wu made Nanking his capital and began a reorganisation of his empire under an autocratic government. The third Ming emperor, Yung-lo (1403–1424), was a Neo-Confucian and adopted the doctrines of Chu Hsi, which then became for centuries the basis of the civil service examinations giving qualification as a Mandarin. Thus he fixed Chinese thought in a rigid framework which permitted neither evolution nor innovation. This sclerosis was to prove catastrophic for the empire, for it was accompanied by absolutism and extreme nationalism; these degenerated into a xenophobia which underestimated the importance of developments in the outside world and, in particular, the importance of the Europeans who from the 16th century onwards visited the southern coasts of China.

The hope of returning to the past by obliterating more than a century of foreign domination was nothing more than a dream. The Mongols had to a great extent rendered the intelligentsia of China impotent by forcing them into a position of opposition and conservatism; they had disrupted the economy and had lowered the quality of artistic production. During their reign a by no means new phenomenon was accentuated: the predominance of the southern over the northern provinces. Henceforth the former supplanted the latter in both economic and intellectual matters, and the efforts of the Ming rulers to rectify this situation were of no avail. Yung-lo's choice of Peking in the north to replace the central capital did nothing to change the balance. This choice, essentially political and strategic (the vulnerable frontier needed watching), only increased the gulf between the court and the vital forces of the country. Indeed it made it easier for the Manchus (who in 1644 crossed the Great Wall through treachery) to seize the capital and win the whole empire.

Although it eventually met with disaster, the dynasty had made a brilliant beginning. Such strong personalities as Hung-wu and Yung-lo were able to restore China's prosperity. Population and production grew apace and, after the strengthening of the fleet under these sovereigns, the southern ports increased their commercial activity. Yung-lo sent a fleet

265. CHINA. View of the Ming tombs, near Peking.

266. Detail of a gateway at the Ming tombs.

of ships, under the command of a eunuch, on a long voyage which carried the Chinese flag as far as Aden, thereby greatly augmenting the prestige of the empire throughout south-east Asia. This undertaking was not followed up, however, and the court soon lost interest in maritime policies. The Ming Dynasty degenerated rapidly, the emperors relinquishing their power to eunuchs and corrupt officials who plunged the empire into new economic and social difficulties.

The court as an enemy of progress

At this juncture both science and letters suffered a kind of paralysis. An encyclopedia was compiled under the patronage of Yung-lo — an inventory of knowledge on the Sung model — but it occasioned no intellectual awakening. The timid idealism of Wang Yang-ming at the beginning of the 16th century was not strong enough to revitalise the Chinese spiritual climate, and there were no repercussions. The traditionalism and conformity imposed by the court were too strong, and only the minor art forms — the theatre and the novel, for example — showed any vitality.

One event was typical. In the 12th and 13th centuries China had been the foremost centre of mathematical studies in the world. At the beginning of the 17th century it was their knowledge in this very field which gave the Jesuits the freedom of

Peking, yet their science had little stimulating effect upon their Chinese emulators.

Artistic development too was fettered by a kind of ultra-conservatism. Peking remains the imposing symbol of Ming architecture. No praise is too high for the beauty of its plan and the colourful harmony of its buildings. But the balance and purity of the Temple of Heaven, its red columns and its circular three-tiered roofing of blue tiles rising above the white marble balustrades, should not blind us to the poverty of the play of masses, the lack of variety in the planes, the excessive increase of non-structural decorative detail and the disappearance of the functional character which had been the glory of Chinese architecture. This trend, already noticeable at the end of the Sung period, became increasingly prominent. In the shadow of the upcurving eaves the brackets, which were now entirely decorative and served no functional purpose, were more numerous than ever before.

The gradual decline of sculpture was now complete. If we compare them with the splendid chimeras which stand at the tombs of the Liang emperors (6th century), the animal statues which precede the famous Ming tombs not far from Peking seem clumsy and lifeless. It was not that the sculptors had lost their technical skill; indeed, the decorative art of the period shows them to have been true virtuosi, but they were pre-occupied with detail and with the narrative element. This characteristic could still be seen in the small bronzes and the jades and ivories which at the end of the last century provoked such admiration in the West. Some of these objects show a rare skill in the service of the trivial. All religious feeling is absent in these innumerable deities of the syncretic pantheon of China, whose devotees were moved by superstition rather than by mystical ardour.

This absence of the spiritual can be discerned in everything, although for a time it was masked in the minor arts by an exquisite technique. The Hsuan-te period bore witness to a final flowering of these declining arts. Here the carved lacquers with their large floral designs of balanced composition charm us, as do the cloisonné enamels with their vibrant and harmonious tones. But the dominating influence of painting tended to invade the surfaces of ornaments and figures increasingly, to the detriment of the earlier interest in form and design. As the economy deteriorated techniques became impoverished. This process was slower in ceramic art, which had been of a high standard in the early years of the dynasty. Hung-wu had given it great impetus by opening an imperial factory at Ching-te Chen, the important ceramic centre of Kiangsi province; here the court commissions were executed. Court taste was a factor in deflecting the potters from their true vocation and transforming them into decorators. For a time a balance between form and motif was preserved, particularly in 'blue and white' wares, which remain one of the most successful products of the period. New discoveries, especially in the technique of low-fired enamels, which gained in refinement and diversity of colour, produced pieces of great charm, but these works degenerated with the increasing poverty of the court. Furthermore the influence of the imperial factory was sovereign over the many private studios which surrounded it; thus Ching-te Chen became the ceramic capital of China, and this domination was not conducive to creative innovation.

Official painting and literati painting

Painting alone remained a creative art form during this period. It enjoyed considerable prestige and output was prolific. The sterility of the court outlook was soon reflected in official painting, however. This tendency was apparent from the reign

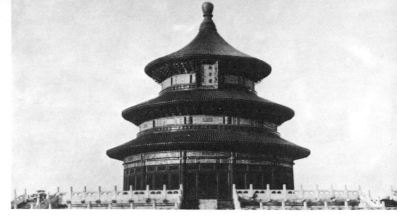

267. CHINA. Temple of Heaven, Peking. Begun in the reign of Yung-lo (1403–1424).

268. CHINA. Avenue leading to the tombs of the Ming emperors, near Peking. 15th–17th centuries.

269. CHINESE. TAI CHIN (15th century). River with Fishing-boats. Detail from a scroll. Ink on paper. Ming period. *Freer Gallery of Art, Washington.*

270. CHINESE. Attributed to CHOU CH'EN (active *c.* 1500–1535). Landscape. Detail. Ink and colour on paper. Ming period. *Freer Gallery of Art, Washington.*

271. CHINESE. CH'IU YING (16th century). Mountain
Landscape, after Li T'ang. Detail. Ink and colour on paper.
Ming period. *Freer Gallery of Art, Washington.*

of Hung-wu, who prided himself on his close control of the
arts, punishing severely those artists whose work did not reflect
his taste. He aimed at a revival of the Northern Sung decorative
style in flower painting and of the academic landscape style of
Ma Yuan and Hsia Kuei. His successors to the throne perpetu-
ated his orthodoxy; the intellectual climate of the court became
stultifying to truly creative artists, and they took refuge in
retirement. In conjunction with the court painters (whom the
dedicated artists considered mere lackeys), studios flourished
which provided paintings in the style of earlier artists for the
bourgeois clientele. These paintings reached Europe in large
numbers at the beginning of this century and played their part
in giving us a false idea of Chinese painting.

Among the literati pictorial art was more than ever a subject
of study and practice. They all painted, and although many
never got beyond the stage of preparatory exercises it was they
who kept alive the traditions of the masters of the past, to
whose works they devoted themselves. Connoisseurs and
collectors took inventories of these works, and met in groups to
compare and discuss them and to work out a technical and
aesthetic classification — which was codified at the beginning
of the 17th century by Mo Shih-lung and Tung Ch'i-ch'ang.
These intellectuals were mostly high officials disillusioned with
the exercise of power, or they were sons of well-to-do families
which had refused to serve it. They used painting as a means of
expressing, without danger to themselves, their resistance to
conformity. This skilled pastime symbolised for them their
independence, their imperative need to escape from the con-
ventions of the court, and this pastime could be undertaken
only for the love of it; they were in that sense amateurs, hence
their profound contempt for the 'professionals' who made
money from their art and bowed to the demands of a clientele
— though the patron might be the emperor himself. The only
authority these literati painters acknowledged was that of their
great Sung and Yuan predecessors, and their familiarity with
these earlier works tended to make them eclectic, both in
technique and inspiration. It was not that they were driven to
plagiarism by their acknowledged disciplehood; they aimed
rather at recapturing the mood of their favourite master and
recreating it in their own paintings. A personal factor was
always present in these transpositions, and these pictures were
in effect variations — of some originality — on a familiar theme.
Some of these painters, such as Tai Chin (first half of the
15th century), who retired from the court and who is regarded

as the founder of the Che school, drew inspiration from Li
T'ang and the Southern Sung academicians and were distin-
guished by a deep lyricism and a bold freedom in the handling
of the brush. Tai Chin's followers exaggerated these tendencies
and produced effects that are too facile and are often mechanical.

Shen Chou (1427–1509), the venerated patriarch of the Wu
school (at Soochow), was a refined scholar and an admirable
virtuoso who, while drawing inspiration from the example of
Tai Chin, still remained faithful to the masters of the Yuan
period; his technique is more structural and his work shows a
fine sense of composition. Among his followers were Wen
Cheng-ming (1470–1559), whose style was elegant, delicate
and austere, Lu Chih (1496–1576), more elegant but more
angular, and Wen Po-jen (1502–c. 1580), who manifested a
refined style in very calligraphic landscapes. Also painting in
Soochow, but outside the literati group, were the professionals
T'ang Yin (1470–1523) and Ch'iu Ying (first half of the 16th
century), whose vigorous and original work derived from that
of the Southern Sung academicians. Their far from exemplary
lives and their choice of discredited academicism, however,
placed them outside the circle of their contemporaries.

At the end of the 16th century Tung Ch'i-ch'ang (1555–
1636), a high official who was an excellent calligrapher, reintro-
duced the monumental style of the Sung and Yuan periods
into his landscapes, creating brilliantly composed works with
excellent brush work. He was preoccupied with the value of
brush strokes and the distribution of inking, and for him lines
and blobs became a language in themselves. His work has a
calligraphic and abstract character which is found later in the
paintings of the early Ch'ing artists, who considered him their
master.

A theoretician, Tung Ch'i-ch'ang was interested in technique
and originated the repertory of different brush strokes which
influenced painting in the Ch'ing period and, in more recent
times, has had some influence on Western art. An aesthetician,
Tung Ch'i-ch'ang defined the ideal of the literati and illus-
trated their taste by developing his classification of the Southern
school, which he considered the purest incarnation of landscape
art; against this he set the Northern school, which he con-
sidered more superficial. His writings became the Bible of the
literati and in time brought painting to a state of pedantic
formalism. However, those who penetrated his ideas more
deeply and who understood his message drew from it the fertile
inspiration which was to enliven the best Ch'ing painting.

HISTORICAL SUMMARY: Ming art

History. The Ming Dynasty (1368–1644) was born of a sudden resurgence of Chinese nationalism and from its inception was committed to restoring the ancestral traditions which had prevailed before the advent of the Mongol Yuan Dynasty. The T'ang Dynasty was the preferred model, and the Ming rulers wished to equal it in both power and splendour. The Emperor Yung-lo (1403–1424) moved the capital to Peking, which became a city of marvels. After having tried to renew the expansionist policy of their forebears, the Ming rulers abandoned the attempt and became, to their loss, embroiled in court intrigues. The first European settlement was made on their territory when they allowed the Portuguese to establish a trading-post at Macao, near Canton, in the 1550s. Towards the end of the 16th century a new confederation of barbarians came to the fore on the northern borders of China, in Manchuria. In 1644 the Manchus succeeded in capturing Peking; they deposed the Mings and occupied the throne as the Ch'ing Dynasty, conquering the rest of the empire without much difficulty.

Dependent on the literati, the Ming Dynasty had had a quietening effect on intellectual and artistic life, establishing a restrictive philosophy which favoured compilations and codifications as well as conformity to a tradition stripped of individual ideas.

Architecture. There was intensive building activity under the Mings, and town planning assumed considerable importance; it was based on traditional principles. The Great Wall, which had fallen into disrepair, was restored and provided with battlements and fortified towers. Whole towns were built or rebuilt; extensive in conception, they were on a square or rectangular plan and were surrounded by a wall and crossed by roads running north–south and east–west. In northern China the buildings were fairly severe and their roofs were only slightly concave. In the south the roofs had a much more pronounced curve and were covered with decorated tiles. The great achievement of Ming architecture was Peking [**267**, **297**]; the Imperial City and the Forbidden City inside it are a majestic group, brilliant with glazed tiles.

Sculpture. Decadence is cruelly apparent in Ming sculpture; this art was often used as a decorative complement to architecture — either as pure ornament or in the round [**268**] to accompany tombs, as in earlier times. Buddhist statuary consisted of mere expressionless stereotypes, and the statuettes placed in

tombs (ming-ch'i) were feeble imitations of those of the Sung period.

Painting. Painting activity was great and was extremely diverse. The artists of this time were highly cultivated men — poets and thinkers, most of whom lived in southern China; whether amateurs or professionals they possessed remarkable technical virtuosity. Steeped in past traditions, they painted both landscapes and portraits, sometimes using a wash heightened with light colour, and sometimes black and white, in which the Sung and Yuan artists had excelled. Their style might be delicate, almost affected, or alternatively quite powerful. Unfortunately Western knowledge of Ming painting comes from second-rate work and even from the numerous copies which veritable factories mass produced for the more modest purse; the latter are in a class with the popular colour prints. Modern scholarship has reinstated the Ming painters and has discovered some incontestably great masters among them. They can be grouped in several schools. The Wu school (at Soochow, Kiangsu province) consisted of amateurs, high officials and literati; important among them were Shen Chou (1427–1509) [**272**] and his skilful and sensitive follower Wen Cheng-ming (1470–1559) [**275**]. T'ang Yin (1470–1523), also active in Soochow, was inventive and varied in his style. Foremost among the theoreticians were Tung Ch'i-ch'ang (1555–1636) [**277**] and his associates Mo Shih-lung (active c. 1567–1582) and Ch'en Chi-ju (1558–1639). The Che school (Chekiang) was made up of a group of professional and bohemian painters; their work, although not highly esteemed by the Wu, was often very fine. Another artist, Lu Chi (active 1488–1505), specialised in bird and flower paintings.

272. CHINESE. SHEN CHOU (1427–1509). Boat in the Rain. Detail. Leaf from an album. Ink and colour on paper. Ming period.

273. CHINESE. Jade bowl. Ming period. 16th century. *Noufflard Collection, Paris.*

274. CHINESE. Carved red lacquer box. Ming period. Reign of Hsuan-te (1426–1435). *Musée Guimet, Paris.*

275. CHINESE. WEN CHENG-MING (1470–1559). Cypress and Rock. 1550. *Nelson Gallery of Art, Kansas City.*

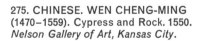

279. CHINESE. Jar. Porcelain three-coloured ware. Ming period. Reign of Chia-ching (1522–1566). *Musée Guimet, Paris.*

280. CHINESE. Stem bowl. Porcelain 'blue and white' ware. Ming period. Late 14th century. *Ashmolean Museum, Oxford.*

281. CHINESE. Vase. Porcelain, with white design on a blue ground. Ming period. 14th century. *Musée Guimet, Paris.*

276. *Above, left.* CHINESE. CH'IEN KU (1508–1572). A Gathering of Poets. Ink on paper. Ming period. 1550. *Musée Guimet, Paris.*

277. *Above, right.* CHINESE. TUNG CH'I-CH'ANG (1555–1636). Stately Trees and Mountain Peaks. *Museum of Fine Arts, Boston.*

Prints. In 1608 the first novel illustrated with black-and-white prints appeared, perhaps under the influence of European books imported by the Jesuits; the technique was not new but until then had been used only for religious imagery. About the same time wood blocks were first printed in colour or were touched up with the brush. The printing works at Nanking and Soochow were the main centres of production.

The minor arts. The ceramics industry developed prodigiously, benefiting from the technical improvements made during the Sung and Yuan periods and from economic conditions which increased the demand. The first Ming emperor founded a factory at Ching-te Chen (Kiangsi), round which a large number of private kilns became established. Henceforth production was officially controlled. Among the most notable successes of these factories were the famous 'blue and white' wares [**280**], the finest of which were produced in the first half of the 15th century. However every style, both monochrome and polychrome, as well as every shape and technique, was tackled — generally with success, owing to the extraordinary decorative sense of the Ming potters [**279, 281**].

Other materials were worked extensively; bronze, gems, ivory, jade [**273**], cloisonné enamel [**278**], carved lacquer [**274**], wood, textiles and metal were all exploited, but, as in ceramics, the creative force was gradually spent and mediocrity and bad taste gained the day. Lacquer alone was revived as an art under the influence of Japan.

Jeannine Auboyer

278. CHINESE. Cloisonné enamel box. Ming period. Reign of Hsuan-te (1426–1435). *Musée des Arts Décoratifs, Paris.*

AMERICAN. THOMAS EAKINS (1844–1916). The Biglen Brothers Racing. 1873. National Gallery, Washington. *Museum photograph.*

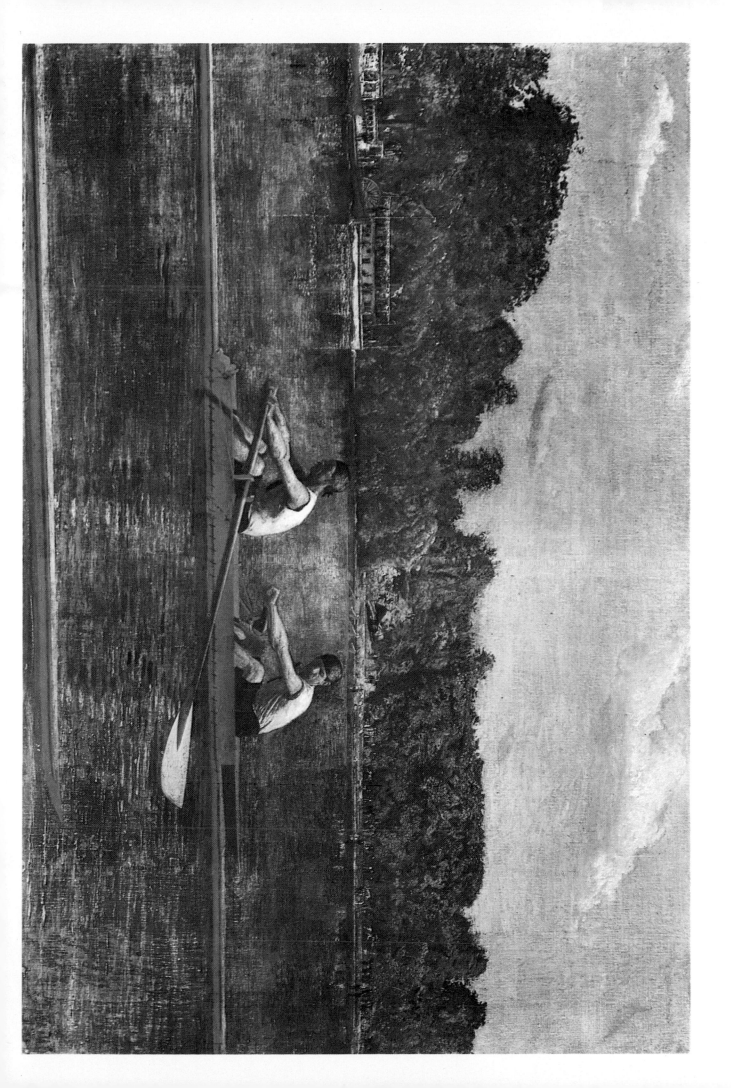

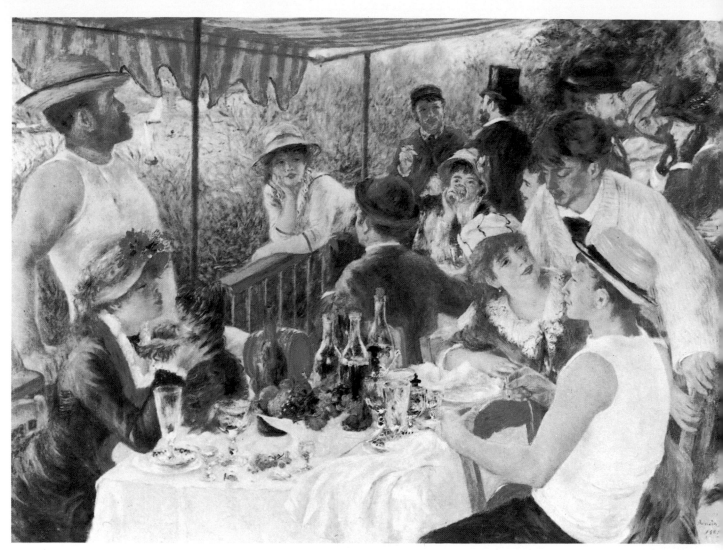

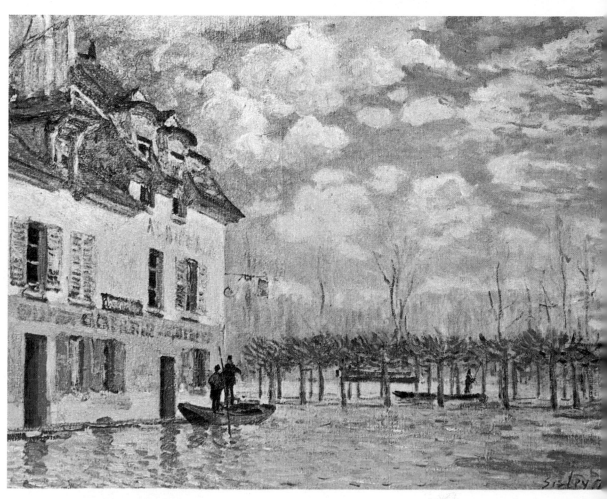

II. JAPANESE ART IN THE MUROMACHI AND MOMOYAMA PERIODS

The influence of Zen

Throughout the long period of unrest and upheaval during which their country gradually came abreast of the modern world, the Japanese were evolving the very original artistic character which has remained theirs up to our own times. The influence of Zen Buddhism was paramount in this development, though no clearly defined philosophical theories served as the basis of their aesthetics. These can be defined in three words, none of which has a true equivalent in English: *shibui* (astringency); *sabi* (the patina of time, which gives a metal object the appearance of a natural substance not fashioned by the hand of man); *wabi* (poverty, simplicity). No precise rules dictated their use, but they evoke the search undertaken by the Zen monks for everything that could bring man closer to nature and through it could allow him to discover the divine essence in himself, were it even the effect of surprise provoked by biting into an unripe fruit.

The influence of the Zen priests had grown increasingly. They stood for culture, in contrast to the rough warriors — that Chinese culture which was dominating Japan with renewed vigour. In the struggle for power between the great feudal lords and the leaders of the principal Buddhist sects these priests represented wisdom and moral stability. Though they were scholars and mystics they did not withdraw from ordinary life; thus they became the political advisers of the Shoguns (the heads of military and political life in Japan) of the Ashikaga line, whose authority had been constantly threatened ever since their rise to power in the 14th century. In order to increase the resources of these insecure rulers, the priests promoted a remunerative trade with China, using their own ships on behalf of the Ashikagas. They brought back works of art — paintings, ceramics and silks, treasures which appealed to the Japanese love of the new and original. At the end of the 14th century the Shogun Yoshimitsu invited a few connoisseurs to his sumptuous residence the Kinkakuji ('golden pavilion'), where they viewed these marvels and drank green tea — the latter a Chinese custom which gained tremendous popularity. This drink became a necessary part of such artistic gatherings, and the manner of taking it grew more formal after an etiquette was established by the priests, who laid down rules for the gestures and attitudes and chose the utensils. It was the priests, too, who selected the imported works of art — landscapes by Ma Yuan and Hsia Kuei, wash drawings by the independents working in the Ch'an (Chinese Zen) monasteries which suggested ecstatic visions, and tea bowls from Fukien and Honan with thick dark glazes (temmoku). The priests prescribed the use of and the surroundings for these works of art.

Architecture, too, was influenced by the Zen priests. In secular architecture the style of dwelling known as shinden-zukuri (comprising a mansion with gardens and subsidiary buildings, the whole a harmonious entity) gradually declined. In the 13th century the Zen priests introduced into their monasteries the Karayo or Chinese style (which was in fact the Southern Sung style); its use became widespread. The rich black lacquer decoration of the interior of the Kinkakuji (1397) gave way a century later, in Ashikaga Yoshimasa's Ginkakuji ('silver pavilion'), to a combination of natural wood, plaster in neutral tones, and papered sliding doors or wall panels through which light filtered. Interior arrangements of houses were based on the apartments of the superiors in the Zen monasteries and were particularly adapted to the comfort of

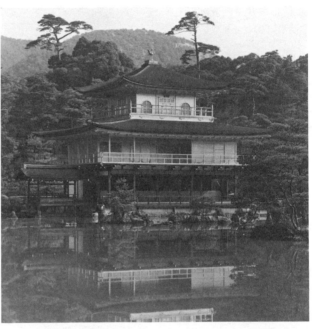

282. JAPAN. Kinkakuji ('golden pavilion') at Kyoto. Built 1397 for Ashikaga Yoshimitsu. Muromachi period.

283. JAPAN. Ginkakuji ('silver pavilion') at Kyoto. Built in the late 15th century for Ashikaga Yoshimasa. Muromachi period.

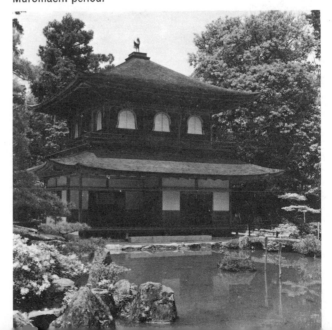

FRENCH. AUGUSTE RENOIR (1841–1919). The Luncheon of the Boating Party. 1881. Phillips Collection, Washington. *Photo: James Dunlop.*

FRENCH. ALFRED SISLEY (1840–1899). Boat during a Flood. Louvre. *Photo: Michael Holford.*

284. JAPANESE. HASEGAWA TOHAKU (1539–1610).
Monkeys. Screen. Ink on paper. Momoyama period.
Museum of Fine Arts, Boston.

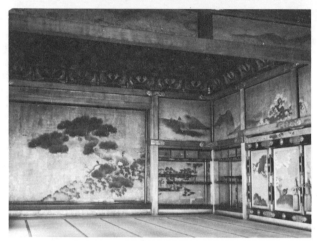

285. JAPAN. Part of the great hall in the Nijo palace
at Kyoto. Early 17th century.

286. JAPANESE. SESSHU (1420–1506). Ama-no-hashidate
(Bridge of Heaven). Ink on paper. Muromachi period.
*National Commission for the Preservation of Cultural
Properties, Tokyo.*

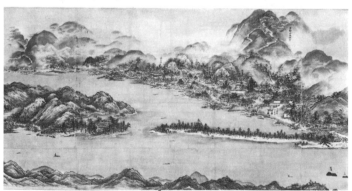

287. JAPANESE. SCHOOL OF SHUBUN (15th century).
Landscape of the Four Seasons. Screen. Ink and colour
on paper. *Ayako Matsudaira Collection, Tokyo.*

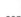

scholars; a special alcove, the tokonoma (of uncertain origin), 285
was reserved for the display of a painting or a drawing accom-
panied by a flower arrangement, both indispensable items in the
cha-no-yu or tea ceremony. At first Chinese objects were used
exclusively for this ceremony, but soon the cha-jin (tea
masters) turned to Japanese craftsmen; potters at Seto imitated
the temmoku of Fukien (Setoguro); the hard stoneware made
at Bizen was popular.

The revival of Chinese influence in painting

The ink paintings of the Sung artists were received with great
enthusiasm by the Japanese, and their own painters copied
them; the calligraphic character of the play of lines pleased
them, and the evocative use of ink in blurred patches appealed
to their love of nuance and suggestion. Their copies indicate
that the Japanese painters did not penetrate beyond the super-
ficial aspect of these landscape paintings; in their ignorance of
the Chinese countryside, the Japanese artists took their models
to be representations of dreams. Shubun (active *c.* 1414–1465), 287
and Josetsu (active early 15th century), were talented imitators.
Sesshu (1420–1506), who visited China, was acquainted with
the Chinese countryside and with the landscape painting, and
he was the first to paint Japanese subjects in the Chinese ink
style. His *Ama-no-hashidate* scroll shows how perfectly he had 286
assimilated the lessons of the mainland. Later painters in his
style, such as Sesson, Noami, Geiami and Soami, were more
superficial but were successful in adapting ink painting to the
decoration of the sliding wall panels in the Shoguns' residences.
The concepts of depth and space were foreign to the Japanese
and, as they had done two centuries earlier, they reduced the
Chinese compositions to two-dimensional representations. This
tendency was already evident in the work of Kano Motonobu 290
(1476–1559), whose father Kano Masanobu had been a con-
temporary and follower of Shubun. Motonobu, who had
perhaps seen Ming paintings, gave greater attention to line
and to decorative composition; his descendants, although
working in a different artistic climate, carried these tendencies
further.

The Momoyama period in art

The latter part of the Muromachi period was a time of civil
war, which undermined the central government in Japan.
Three men were responsible for reunifying the country in the
late 16th and early 17th centuries, and for restoring peace and
order. All three, Nobunaga, Hideyoshi and Tokugawa Ieyasu,
were military men who continued the struggle against the
feudal recalcitrants and reduced them to obedience; in 1603

288. JAPAN. View of the gardens of the Katsura palace, Kyoto.

289. JAPAN. The Katsura detached palace, Kyoto. 17th century.

Tokugawa Ieyasu founded the Tokugawa Shogunate on such a solid basis that it lasted until 1868.

To these dictators magnificence was a necessary condition of their prestige. They built great fortresses, on immense stone foundations, which were able to resist the firearms introduced by the Portuguese. These fortresses were also luxurious residences whose vast halls were ornamented with carvings and with paintings on gold or silver grounds. The halls at Nishi Honganji in Kyoto (containing salvage from Hideyoshi's palace at Fushimi), the Nijo palace in Kyoto (a residence of the Tokugawa), Nagoya castle, and the temples built at Sendai by Date Masamune, forerunners of the splendid Tokugawa tombs at Nikko — all are of an unparalleled richness and show the extremes of virtuosity of sculptural detail and polychrome decoration; it is possible to see the influence of Ming art in this pursuit of excess. China remained the ideal and the goal; the chief problem was the establishment of commercial relations with her, and when he had failed Hideyoshi attempted to conquer her by force of arms, via Korea.

The daimyo (feudal lords), too, were anxious to add to their riches; they secretly encouraged piratical expeditions which periodically ravaged the Fukien coast. This steady influence from China did not effect basic changes in Japanese architecture, but it is visible in many details as well as in the decorative ensembles of the Kano family and school. The use of colour by these adepts of ink painting is traditionally attributed to the marriage of the son of Motonobu to the daughter of a painter of the Tosa school — court painters of Yamato-e (the Japanese narrative scroll painting), which was now in a decadent phase. It seems probable that the flower and animal paintings from the court at Peking had some influence on the style of the Kano painters and on their use of brilliant colour set against a gold or silver ground. Indeed, the pupils showed themselves superior to their masters, creating admirably harmonious ensembles distinguished by variety and freedom of composition.

But this art of magnificence remained alien to the Japanese genius, and the palaces of the Shoguns had no influence beyond official architecture. The cha-jin, on the other hand, whose prestige remained great, built small pavilions for the celebration of the cha-no-yu, whose rules they had now fixed definitively. These tea-houses, with their roofs of thatch, were closely adapted to their natural surroundings, which in turn were carefully arranged so as to produce the correct atmosphere for the ceremony. The style of the tea-house (chashitsu) was later adapted to larger buildings, and the Katsura palace, built in the early 17th century for an imperial prince, is the best example of the sukiya taste (the taste for conscious artlessness), which is basic to the traditional Japanese house.

290. JAPANESE. Attributed to KANO MOTONOBU (1476–1559). Fusuma from the Daisenin, Kyoto. Ink and colour on paper. Muromachi period. 1509.

291. JAPAN. Great hall with interior window in the shoin style. Nishi Honganji, Kyoto.

History. Taking advantage of the increasing weakness of the Hojo rulers, the Emperor Go-Daigo conquered them in the early 1330s. Ashikaga Takauji, who had at first supported him, soon supplanted him and in 1338 took the title of Shogun and established a new Bakufu (military government) in Kyoto. The Ashikaga Shoguns lived luxuriously in their residence in the Muromachi quarter but were unable to impose their authority on the warrior-lords. The provincial daimyo continued to pursue his personal goals. Civil wars and peasant uprisings followed one upon the other; the great Buddhist monasteries participated in these, the monks becoming soldiers. By the end of the 15th century there was general anarchy. Nobunaga, a young daimyo, succeeded in supplanting the Ashikaga and in keeping his rivals under control. After his death one of his samurai, Hideyoshi, continued his work and established a strong dictatorship. Foreign enterprises tempted him, however, and in 1592 he sent troops to Korea. His sudden death in 1598 put an end to his conquests; his lieutenant Tokugawa Ieyasu soon seized power and founded a new military government at Edo (or Yedo), a village which is now Tokyo. This was the beginning of the Tokugawa Shogunate (1603–1868).

Out of these upheavals modern Japan was formed. Economic development was favoured by the situation, each daimyo seeking to enrich his own fief. Towns and markets grew, the merchant class gained in importance and internal trade flourished. The Ashikaga rulers were anxious to increase the resources of a country which was not rich in itself; they favoured trade with China, which was conducted by the Zen priests. Commerce was extended to the countries of south-east Asia. The 16th century saw the arrival of the Portuguese and of St Francis Xavier, whose evangelising had some small success.

Cultural and artistic developments were considerable, but the differences in the art of the two periods were marked. The Muromachi period (1333–1573) was dominated by Chinese influence, introduced chiefly through the Zen sect, which played a leading role in Japanese intellectual and artistic life. The Momoyama period (1573–1615), which takes its name from a palace built by Hideyoshi, saw the birth of an art of power, designed to express the desire for prestige and splendour on the part of the contemporary rulers. From the point of view of art history this period lasted until about 1640.

292. JAPAN. Garden of the Ryoanji temple, Kyoto. Muromachi period.

This is a ' dry ' garden, with fifteen rocks emerging from the white gravel, which is arranged in waves to imitate water.

Architecture. The Zen monasteries introduced the Karayo or Chinese style which, when united with the Wayo, or traditional Japanese Buddhist style, of the Kamakura period, influenced all the building of the time. The Kinkakuji (' golden pavilion ' [**282**]), built by Ashikaga Yoshimitsu at the end of the 14th century, combined the old shinden-zukuri style with the Karayo. The Ginkakuji (' silver pavilion ' [**283**]), built a century later for Ashikaga Yoshimasa, was in the Karayo style. Zen influence made itself felt equally in interiors, where the builders adopted various arrangements from the residences of the superiors of the monasteries; these innovations became popular with the buke (members of the warrior class). Such features as the entrance vestibule or genkan, the sliding doors or wall panels covered with translucent paper (shoji, or exterior panels; fusuma, or interior panels), the tatami (straw floor mats), the tokonoma or raised alcove in which paintings or flower arrangements were displayed, the tana (niche with shelves for decorative objects), the shoin (bay window with

293. JAPANESE. No mask. Carved wood with flesh-colour lacquer; eyes and teeth inlaid with gold. Momoyama period. *Moritatsu Hosokawa Collection, Tokyo.*

an alcove for reading), the engawa or veranda, constitute the shoin style, which has persisted to this day in Japanese domestic architecture [291].

Nobunaga, Hideyoshi and Tokugawa Ieyasu built fortresses rather than pleasure pavilions; princely residences went up alongside their massive strongholds, such as Nagoya castle. These residences or densha were luxuriously decorated with paintings and sculpture. The Nijo palace at Kyoto, built at the beginning of the Tokugawa Shogunate [285], is the most complete example of this type. The influence of Chinese Ming architecture perhaps played its part in this taste for excessive decoration and colour. It is discernible in the ensembles built at Sendai by Date Masamune (Zen temple of Zuiganji and Shinto shrine of Osaki Hachiman), which herald the style of the buildings at Nikko designed to glorify the memory of the Tokugawa Shoguns. However, alongside this official style another developed in which Zen aesthetics predominated, particularly the aesthetics of the tea masters (cha-jin); one of these, Sen no Rikyu (1520–1591), used natural wood and thatched roofing in the tea pavilion (chashitsu). The sukiya (consciously artless) style,

and the shoin style with it, are at the origins of the modern Japanese house.

Gardens. Japanese architecture tended more than ever to be related to its natural surroundings. Adherents of the Zen sect had introduced the Chinese garden, with its arrangement of rocks and water which symbolised the cosmos. Originally of small dimensions (garden of the Ryoanji temple, Kyoto [292]), Japanese gardens became large during the reign of Hideyoshi; early in the 17th century they became quite varied (Katsura palace gardens) [288, 289].

Sculpture. Apart from a few fine portraits of Zen monks, sculpture had become essentially decorative. There was a revival of the art, however, in the fine masks made for the actors of the No play, the Japanese musical drama which appeared early in the 15th century [293].

Painting. Ink painting flourished in the Muromachi period; it was taken over from the Chinese painting of the Sung and Yuan periods and was patronised by the Ashikaga Shoguns. In the 15th century Shubun [287] and Josetsu imitated Chinese landscape paintings. Sesshu

(1420–1506) [286], who visited China and therefore had a much more profound appreciation of this art, adapted the Chinese style to the landscape of his own country. The influence of the academic Southern Sung painters Ma Yuan and Hsia Kuei is evident in composition and in the importance of line. The fusuma in princely residences were decorated with large ink compositions. Kano Motonobu (1476–1559) [290] combined ink painting with the brilliant colouring of the Tosa school, which derived from the earlier Yamato-e tradition and which remained the official school of the imperial court. Thus Motonobu founded the Kano school whose artists decorated the palaces of Nobunaga, Hideyoshi and Tokugawa Ieyasu with richly coloured paintings on gold or silver grounds [296].

The minor arts. The minor arts were rich and varied, from brocades enriched with gold and silver to armour decorated with precious metals and gold lacquer. With the growing popularity of the tea ceremony pottery attained a new importance; the chief influence was the sober and austere one of Zen [294, 295].

Madeleine Paul-David

294. JAPANESE. Oribe ware dish. Mino province. Momoyama period. *Musée Guimet, Paris.*

295. JAPANESE. Oribe ware dish. Mino province. Momoyama period. *Musée Guimet, Paris.*

296. JAPANESE. SCHOOL OF KANO MITSUNOBU (end of the 16th century). Two fusuma. Colour on gold paper. From a residence at the Myohoin, Kyoto. Momoyama period.

III. CHINESE ART OF THE CH'ING PERIOD

The conservative barbarians

The advent of the Manchus produced no break in continuity in Chinese civilisation. The culture of the invaders was at too low a level to be an enriching element. Instead the new masters were happy to follow the secular tradition embodied in Neo-Confucianism, encouraging its retrograde tendencies. Scholars were preoccupied with compilations, and much effort was devoted to anthologies of and commentary on the most important works of earlier authors. The first Manchu (or Ch'ing) emperors, who were intelligent and far-sighted rulers, restored order and brought China back to its former greatness, extending its frontiers beyond those of the T'ang period and imposing its suzerainty on Tibet. However, the successors of K'ang-hsi (1662–1722), Yung-cheng (1723–1735) and Ch'ien-lung (1736–1795) proved unequal to the task of governing so vast an empire. Their authority declined, and China was once more beset by agrarian crises, economic crises and local separatism — aggravated now by the intrigues of the European nations whose culture and whose technical resources the Chinese persisted in ignoring.

Virtuosity and academicism

The foreign Manchu rulers, with their barbarian traditions, responded to the external in art — to colour and the sumptuous. Official art, subject to court taste, veered towards a sterile and superficial virtuosity, and innovations in technique were used to further a decadent art.

Ch'ing ceramics

The history of the imperial porcelain factory at Ching-te Chen, however, parallels the political evolution of the Ch'ing Dynasty. At the beginning of K'ang-hsi's reign this factory, still influenced by Ming pottery, produced pieces whose harmonious, well conceived shapes are set off by a free, vigorous decoration. In 1682 the imperial factory (which had just been rebuilt) was put under the directorship of Ts'ang Ying-hsuan, who supervised both administration and production. The refinement of technique — purity of porcelain and glazes, control of firing, extent of colour range — involved a high degree of organisation and team-work, a single piece passing in the course of its manufacture through many hands (as many as eighty-four workers in the time of Ch'ien-lung). Such a division of labour could not but be detrimental to the artistic unity of the piece. The part played by the painters of ornament became supreme, each excelling in a special subject — one flowers and birds, another figures, another landscape and another decorative motifs or inscriptions. Everything was gradually sacrificed to this obsession with decoration, and technical research was aimed principally at facilitating the work of the painter. Thus 308 were evolved the series called *famille verte* (in which a muddy blue enamel was substituted for the deep colouring of under-304 glaze blue of the Ming period) and *famille rose* (in which a violet-tinted pink with a gold base was predominant). In the Yung-cheng period a vogue for archaism emerged. Sung pottery was copied with extreme care, but its greatness was never equalled. The very care necessary to perfect this technique worked against the aims of the Ch'ing potters, who were consciously imitating effects which had been arrived at empirically by craftsmen using glazes which were incompletely purified.

297. CHINA. View of the Forbidden City, Peking.

The taste for the exotic

The influence of Ch'ien-lung was particularly unfortunate; the emperor was a collector, poet and calligrapher and his tastes were catholic. He was interested in archaic jades and bronzes as well as in Sung ceramics and, again, in Western objects brought by the Jesuits, who sought to win him over to their cause by flattering his mania for the exotic.

The Rococo then flourishing in Europe was by a strange coincidence perfectly suited to the Chinese taste for the contorted and the bizarre. T'ang Ying, who directed the imperial kiln from 1736 to 1749, encouraged on behalf of Ch'ien-lung all efforts to produce the most unusual effects and to display a consummate technique; the potter imitated jade, inlaid lacquer, glass, bronze and jewellery. The court was eager for copies of European motifs. This taste for the exotic soon had its counterpart in the European vogue for Chinese porcelain; orders poured in, via the East India companies, to the private kilns of Ching-te Chen, and the potters reproduced the shapes and motifs demanded by the European clientele. At first these pieces were executed solely for the European market; soon, however, they influenced the wares made for home consumption and contributed to the decline of Chinese taste. The same thing happened in the other minor arts, which manifested an increasing search for unusual effects and a preoccupation with the narrative — to the ultimate detriment of technique.

The same tendencies were evident in architecture, where the decline of interest in structure and the absence of originality of plan went hand in hand with a superabundance of decoration. The delicate kiosks built in gardens illustrate the endless search for the bizarre and unusual. The Emperor Ch'ien-lung asked the Jesuits to build for him at his summer residence at Jehol an ensemble of pavilions with fountains modelled on Versailles.

The survival of painting

One branch of art alone retained its vitality. This was painting, although for a long time its creativity in this period was obscured for European scholars by the mediocrity of official art. The academic painters submitted to court taste in their brightly coloured paintings which were decorative or narrative in tradition. One of these painters, Leng Mei, showed Western influence in his fine, pliant outlines, which are also seen on the 'egg-shell' plates decorated for the European market by the enamellers of Canton. The Jesuits attached to the court also had

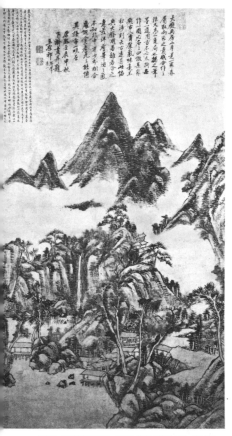

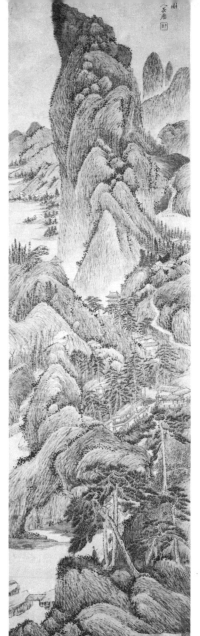

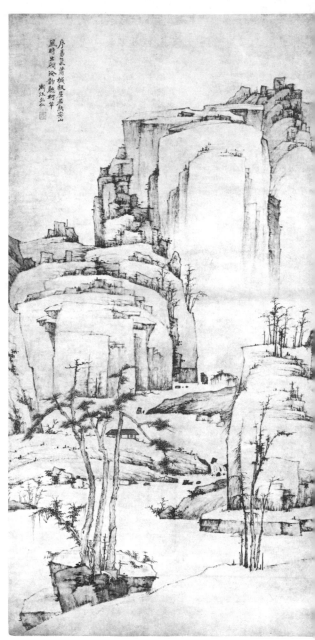

298. CHINESE. WANG YUAN-CH'I
(1642–1715). Landscape. Ink and
colour on paper. Ch'ing period. 1712.
Musée Guimet, Paris.

299. *Right.* CHINESE. WU LI (1632–
1718). Pine Wind from Myriad Valleys.
Ink and colour on paper. Ch'ing
period. *Cleveland Museum of Art.*

300. *Far right.* CHINESE. HUNG-JEN
(d. 1663). The Coming of Autumn. Ink
on paper. Ch'ing period. *c.* 1650.
Honolulu Academy of Arts.

some influence there; Father Giuseppe Castiglione, called Lang Shih-ning (1698–1768), was commissioned to illustrate on enormous scrolls, with the help of his Chinese pupils, the conquests of Ch'ien-lung. He combined local and European traditions, but his contribution was short-lived and did not survive the departure of the Christians.

However, among the literati who had retired to the southern provinces and who refused to serve the foreign masters, the example of the late Ming painter and aesthetician T'ung Ch'i-ch'ang had engendered a veritable renaissance. Western art historians for a long time mistakenly believed that this great painter influenced only painting manuals, such as the *Treatise on the Paintings and Writings of the Ten Bamboo Studio* and the *Mustard Seed Garden Painting Manual*. Charmingly illustrated, these works captivated European art-lovers. The introductions, based on the theories of Tung Ch'i-ch'ang and Mo Shih-lung, were followed by chapters devoted to the best methods for representing mountains, clouds, rocks, bamboos, flowers and birds. The insistence of these texts on the different kinds of brush strokes to use, and the constant references to the old masters, give the impression that the Ch'ing painters followed these manuals slavishly. This was certainly not the case; the

formulas were stated simply to allow the beginner to acquire the necessary skill to paint at all.

Wang Shih-min (1592–1680), founder of the Lou-tung school, had been a pupil of T'ung Ch'i-ch'ang and was, like him, influenced by the 10th-century master Tung Yuan and by the Yuan Dynasty painter Huang Kung-wang (who had felt the influence of Tung Yuan). T'ung Ch'i-ch'ang's return to the monumental style had involved a more penetrating study of space, and this concern with space characterises the art of his followers. With all due allowances for the differences in artistic tradition, we still may (as J. P. Dubosc has done) compare their quest with that of a Cézanne. The artists of the Lou-tung school, Wang Shih-min, his friend Wang Chien (1598–1677), his pupil Wang Hui (1632–1717) and his grandson Wang Yuan- 298 ch'i (1642–1715), were less preoccupied than their 10th- and 11th-century predecessors with the unity of a work and possessed a more polished and varied technique. They rendered space with a freedom which was not, however, without discipline. Despite an eclecticism which provided them with a great variety of means and possibilities of expression they maintained their individuality. We see this in the albums of Wang Hui, in which each page is dedicated to a particular

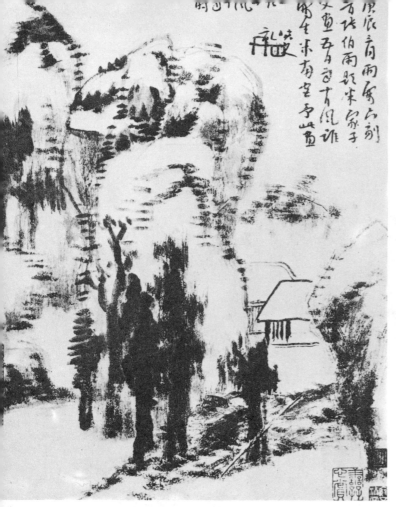

303. CHINESE. SHIH-T'AO (TAO-CHI; 1630–1707). Landscape. Ink and colour on paper. Ch'ing period. *Chang Ta-ch'ien Collection, São Paulo.*

301. CHINESE. PA-TA SHAN-JEN (CHU TA; *c.* 1625–*c.* 1700). Landscape. Ink on paper. Ch'ing period. *Chang Ta-ch'ien Collection, São Paulo.*

302. CHINESE. K'UN-TS'AN (active *c.* 1650–1675). Pao-en Monastery. Ch'ing period. 1663. *K. Sumitomo Collection, Oiso.*

master and each is in a different style — yet each conveys the same message, which is that of the artist himself. These artists had the misfortune to please the court and to see their works and their styles copied there. The painting of their numerous followers was characterised by mannerism and repetition.

Yun Shou-p'ing (1633–1690) had a similar popularity with his flower paintings in the ' boneless ' style (ink or wash painting with no outlines); these were pleasantly enhanced with transparent colours which were echoed in the earliest *famille rose* porcelains. Yun Shou-p'ing was a fine landscape painter, using ink with great sensitivity and obtaining silver-greys which recall those of Ni Tsan. Wu Li (1632–1718) infused his work with a more personal and tragic expression. His style was influenced by Tung Chi-ch'ang but was freer than the latter's.

299

The individualists

In opposition to these classical masters, the individualist painters expressed the revolt of eternal China against the barbarian usurpers, smug conformity and reaction. Two of these painters, who were related to the Ming imperial family, had taken refuge in monasteries at the time of the Manchu invasion. Chu Ta (*c.* 1625–*c.* 1700), better known as Pa-ta Shan-jen, hid his rebellion behind a mask of madness or eccentricity and continued working to an advanced age. His earlier works consisted of large, beautifully composed and decisively drawn landscapes, but over the years his style grew freer; his wash drawings, landscapes, birds and flowers are all strikingly powerful. Shih-t'ao (Tao-chi, 1630–1707), who made no secret of his desire for independence, scorned eclecticism and the work of the old masters. His dramatic landscapes with their heavily inked brush strokes and intricate composition alternate with simpler paintings characterised by more empty space and by delicate transparent colours. He was a superb calligrapher, and his paintings cannot be dissociated from his inscriptions, which form an integral part of the composition and are balanced with the elements of the landscape. K'un Ts'an (active *c.* 1650–1675), a Buddhist monk, and Kung Hsien (active 1656–1682), both individualists, painted vast landscapes of great originality.

301

303

302

All these artists were a part of the final flowering of the art of old China — the period of its greatest degree of freedom and expressiveness; but already this art was becoming a formal language, in which nature was gradually losing its place. This tendency was perhaps one reason for the decline of Chinese art in the last two centuries, a decline which is temporary and which, we hope, will end in the near future.

HISTORICAL SUMMARY: Ch'ing art

History. After seizing the imperial throne the Manchus, under the name of Ch'ing, became Sinicised fairly rapidly and took up on their own account the traditional policies of China. They annexed Mongolia, ruled Tibet and conquered Turkestan and part of Vietnam. The early history of the Ch'ings was marked by two glorious eras — the reign of K'ang-hsi (1662–1722) and that of his grandson Ch'ien-lung (1736–1795). After this, the coming of the Europeans helped to bring about the gradual decline of an empire which had already been weakened by excessive refinement. In more recent times Europe played a role in certain important military events, for example the Opium War of 1840, the Taiping rebellion (1850–1864), the Japanese victory of 1894 and the Boxer uprising of 1900. Eventually the Ch'ing Dynasty came to an end with the revolution, and in 1912 the republic was proclaimed.

The Ch'ing rulers were impressed with Chinese culture and favoured conservative and Confucian traditions. In addition, they made use of the scientific and technical knowledge of the Jesuits who visited the court.

For more than five centuries, from the accession of the Mings, China was held in the grip of a kind of sclerosis, remaining a repository of immutable traditions. This was, however, only an apparent lethargy; beneath it were the beginnings of the revival which recent events have made manifest.

Architecture. The Ch'ing period was a continuation of the Ming in every sphere. Respecting the centuries-old Chinese traditions and anxious to preserve them, the Manchu emperors kept the earlier architectural forms, adding only a superabundance of ornamentation. The Manchus were fond of pleasure gardens, in the middle of which they built agreeable residences which were less formal than their official palaces [**297**].

Painting. During the reign of K'ang-hsi painting, based on the developments of the Ming period, experienced a final flowering. The Lou-tung school followed the tradition of the literati painters; good painters were also found in the contemporary Anhwei school. A number of individualists dissociated themselves from traditional painting and from the various schools. Under Ch'ien-lung painting became more stereotyped; European influence accelerated this decadence. In this period, too, prints became popular.

The minor arts. Ch'ing potters achieved a perfect mastery of their craft, but their aim was directed increasingly towards technical virtuosity. However, the fine monochrome pottery was worthy of earlier periods; the famous *famille verte, famille rose, famille noire* and *famille jaune* series were also among the finest works of the late 17th and of the 18th centuries [**304, 308**].

The other minor arts had a parallel evolution; technical virtuosity destroyed artistic sense and good taste; only the so-called Coromandel lacquers and the lacquers decorated with polychrome relief maintained a standard comparable to those of earlier times [**306**].

Jeannine Auboyer

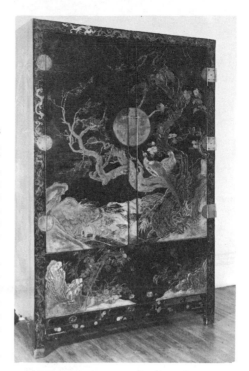

306. CHINESE. Armoire, decorated in relief in polychrome lacquer on a black ground. Reign of K'ang-hsi (1662–1722). *Musée Guimet, Paris.*

304. CHINESE. Famille rose bowl. Reign of Yung-cheng (1723–1735). *Musée Guimet, Paris.*

305. CHINESE. Porcelain jar with polychrome decoration. Reign of K'ang-hsi (1662–1722). *Musée Guimet, Paris.*

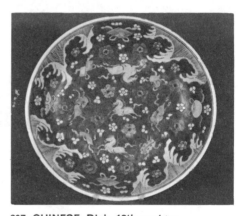

307. CHINESE. Dish. 18th century. *Musée Guimet, Paris.*

308. CHINESE. Famille verte vase. Reign of K'ang-hsi (1662–1722). *Musée Guimet, Paris.*

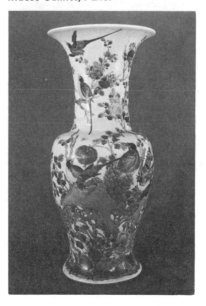

IV. THE TOKUGAWA PERIOD IN JAPAN

The decadence of official art

If we regard the development of official art under the Tokugawa Shoguns as the highest expression of the achievement of the period, we might conclude that the brilliant contributions of Momoyama art became academic as the upper levels of society, subject to the yoke of the Shoguns, grew progressively more conservative.

In the field of painting the Kano artists typified this. The genius of the founders of the school had reflected the thousand and one aspects of their time — the many-faceted 16th century in which age-old traditions combined with both the contemporary and the exotic to stimulate the artist. Kano Eitoku (1543–1590) and his followers dominated the painting of their time; virtually all the important artists of the period had passed
284 through their studio. Among these was Hasegawa Tohaku (1539–1610), a man of diverse talents who followed the romantic tradition of ink painting; he also (according to the latest researches) decorated the fusuma at Chishakuin with large-scale compositions on a gold ground in a vigorous style markedly less linear than that of the Kano painters.

The descendants of the latter, although serving as official painters to both the imperial court and the Shoguns, lacked the creative power of their masters. In 1621, while Kano Sanraku (1559–1635) and Kano Sansetsu (1589–1651) were working at Kyoto, Kano Tanyu (1602–1674) was made chief official painter by the Shogun and went to Edo to decorate the new Tokugawa residence. There he founded a branch of the Kano school which adopted his style — a style that was elegant but rather dry and that had a stiffer, thicker line than that of Tanyu's predecessors. Established in a new town which was devoid of tradition, the school became official and hierarchic, like the society of the period. It remained an active school until 1868, portraying for the Tokugawa and the feudal lords edifying subjects drawn from the Confucian ethics which the Shoguns employed to inculcate respect and obedience in their vassals.

In Kyoto the official school soon sank into obscurity, but many artists perpetuated the traditions of the Momoyama masters.

In spite of having been superseded as a political centre, the older capital remained important in the arts. Though the court was no longer a directing force, the aristocracy was still the guardian of national culture, and its taste, refined by centuries of patronage, influenced intellectuals and artists. There was an active group of craftsmen in Kyoto; lacquer workers, potters, weavers and embroiderers in the Nishijin quarter rivalled one another in ingenuity and also drew upon the painters for new designs. The rich middle class now patronised both artists and craftsmen. Thus there were trends in art which reflected both aristocratic and middle class milieux.

The decorative school

310 At the beginning of the 17th century Honnami Koetsu (1558–1637), connoisseur of swords, amateur potter, master of lacquerwork and superb calligrapher, took up cha-no-yu with some of the court nobles. Into this aesthetic milieu he introduced a painter of humble origins who did the paintings for the paper on which the distinguished calligrapher transcribed poems. It
310, 311 was perhaps in this refined circle that this painter, Nonomura (or Tarawaya) Sotatsu (d. 1643), found the inspiration for his

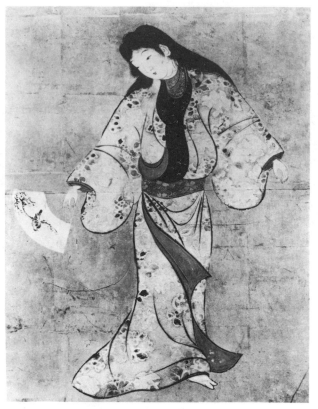

309. JAPANESE. Dancer. Detail of a screen. Colour on gold paper. 17th century. *Municipal Museum, Kyoto.*

paintings perpetuating the literary themes of the Heian period. The Tosa and Kano painters had treated similar subjects, but in his illustrations for the famous *Genji Monogatari* (*Tale of Genji*) Sotatsu shows neither the narrative preoccupation of the Tosa nor the linear emphasis of the Kano. A born painter with a magnificent colour sense, who could give colour values even to black, he was primarily concerned with the subtle play of tones and with a skilful distribution of empty spaces to show up the movement of his figures. His two-dimensional painting is definitely decorative, but his breadth of composition and harmony of tones make him one of the greatest Japanese artists. In spite of, or perhaps because of, his originality Sotatsu has only recently been appreciated by his compatriots. His followers remained obscure, but in the late 17th century Korin, who was distantly related to Koetsu, revived and amplified his formulas and gained official approval for them.

Ogata Korin (1658–1716) was the foremost painter of the 312 Genroku period (1688–1703), one of the most elegant and luxury loving in Japanese history. He chose his themes from nature which, as his sketchbooks show, he observed with great realism, but he transcended his subject matter in his painting by a powerful talent for synthesis. He retained only the essentials both in line and colour, using a broad and supple brush-stroke. Early in the 19th century Sakai Hoitsu (1761–1828) revived his style, and towards the middle of the century this style was introduced to the West in Hokusai's set of prints known as the *Larger Flowers*. However, Korin's influence was spread less through his paintings than through his designs for textiles, lacquerware and ceramics, in which he collaborated with his

310. JAPANESE. Calligraphy by Honnami Koetsu on a scroll decorated with painting in gold and silver ink by Nonomura Sotatsu. First half of the 17th century. *Atami Art Museum, Japan.*

311. JAPANESE. NONOMURA SOTATSU (d. 1643). Fan painting, from a screen.

312. JAPANESE. OGATA KORIN (1658–1716). Thunder God. Colour on gold paper. Tokugawa period.

318 brother Ogata Kenzan (1663–1743). The work of these two men was of paramount importance in the minor arts, and the bourgeoisie, from which they themselves came, had a great appreciation of them.

Realism and bourgeois art

The art of Maruyama Okyo (1733–1795) also appealed to the bourgeoisie. He painted numerous flower and animal pieces in a realistic style which was saved from being overly precise by his great virtuosity in composition. Like all Japanese, the newly rich merchants appreciated the beauties of nature, and they enjoyed these faithful representations of it. Such work made the fortune of Mutsumura Goshun (1752–1811), a pupil of Okyo and the founder of the Shijo school. Other realists were Kishi Ganku (1749–1835), famous for his paintings of tigers, and Mori Sosen (1747–1821), whose studies of monkeys were popular in Europe at the end of the 19th century. Political events played their part in this new realism. Isolated from the rest of the world by their government, the Japanese were the more avid for all that came their way from China or the West. Dutch engravings, with their attention to detail, and Chinese paintings arrived at Nagasaki and, whatever their quality, were popular as curiosities and served as an inspiration to artists.

The literati

The prestige of China was still high and, although artistic exchanges were less frequent than in the past, second-rate Chinese painters came to try their luck at Nagasaki, where they could be sure of finding an audience. Here they introduced the

313. JAPANESE. URAGAMI GYOKUDO (1745–1820). Landscape. Ink and colour on paper. Tokugawa period. *Akaboshi Collection, Kanagawa.*

314. HARUNOBU (1725–1770). Young Woman playing a Flute. Colour print. Tokugawa period. *Musée Guimet, Paris*.

315. UTAMARO (1753–1806). Going to Bed. Colour print. Tokugawa period.

now classical style of the literati, whose numerous painting manuals spread their theories and methods among the Japanese intellectuals. This gave rise to the Bunjinga, or literary men's style (also called Nanga). This new mode of expression was adopted with enthusiasm. Among its most important exponents were Ikeno Taiga (1723–1776), Yosa Buson (1716–1783), the eclectic Tani Buncho (1765–1842) and Watanabe Kazan (1793–1841), who discovered in illustrated books from China both Western perspective and the perspective used by Wang Hui. As their knowledge of the great Chinese paintings came from books rather than from the originals, the approach of the Japanese to literati painting was superficial; they understood neither its spiritual nor its intellectual content and filled these in from their own sensibility. Uragami Gyokudo (1745–1820) alone (still unappreciated in the West) seems to have had some familiarity with the art of such a painter as Shih-t'ao.

Ukiyo-e, a genre art

The popular art known as Ukiyo-e, which in the West has played a part out of all proportion to its role in Japan, had its beginnings in earlier times. Its origin has sometimes been attributed to Iwasa Matabei (1578–1650). In reality, however, Matabei was one of the last painters in the Tosa manner so popular with the imperial court. Ukiyo-e themes appeared, in fact, in the 16th century in certain paintings by the Kano for the rulers Nobunaga and Hideyoshi. These dealt with a variety of subjects, including such popular ones as court ceremonies, scenes of everyday life in Kyoto, the viewing of cherry blossoms in spring and of maples in autumn, and scenes showing the Portuguese, who arrived at Kyushu in the middle of the 16th century. This diversity perfectly expressed the unrest of this period — a period of intellectual ferment in which class distinctions were beginning to break down. The advent of the Tokugawa did not put an end to this popular trend; although

it disappeared from conformist official art it was perpetuated in many anonymous works of undeniable talent.

Technical improvements in print-making for book illustration and the work done in the medium by such artists as Hishikawa Moronobu (c. 1625–c. 1695) and Okumura Masonobu (1686–1764) made this art form popular with the middle classes of Edo, who were less refined in their tastes than those of Kyoto. In the 18th and early 19th centuries a brilliant group of artists, many of whom became famous in the West, developed new repertories for this clientele. Here were the legends, poems and pastimes dear to the bourgeoisie. Subjects included scenes from the theatre, portraits of actors, wrestlers and famous courtesans, scenes from everyday life and, somewhat later, favourite landscapes. Craftsmen vied in virtuosity, thereby broadening their technical scope. The range of colours increased; fur, feathers, drapery folds, etc., were embossed; mica was used on backgrounds. Indeed, in many cases the art of the printers was superior to that of the painters who provided the models. A significant exhibition was held not long ago in Kyoto, which showed paintings by the artists so much admired in the West in the late 19th century by lovers of the Japanese print. A fair number of the works recalled, with their inharmonious tones, the more unfortunate aspects of Art Nouveau and the feeble work of Chéret. There were exceptions, however, and in the work of a Sharaku or a Hokusai the painter equalled and surpassed the craftsman who had faithfully reproduced him. A hundred and fifty years of prints, transitory works reflecting passing fashions and events, are a summary of the social history of the Japanese people during this period.

By the end of the 19th century Japanese art had sunk to its nadir; the onset of Western influence seemed to have dealt it a death-blow. However, we have seen it recover its strength, drawing on its ancient traditions for forms which are in harmony with the most modern trends.

HISTORICAL SUMMARY: Later Japanese and Korean art

JAPAN

History. Ieyasu founded the Tokugawa Shogunate in 1603 and, anxious to establish a firm hold over all of Japan, he set up a dictatorial government at Edo (present-day Tokyo) which was based on a strictly hierarchical society. The emperor and his court at Kyoto lost most of their power, and the feudal lords, samurai, peasants, artisans and merchants were subjected to a strict discipline. To avoid foreign interference the Shoguns kept the archipelago in isolation, allowing only Dutch and Chinese ships to enter the port of Nagasaki. It was a period of peace, in which agriculture and the crafts developed. The financial power of the merchant class grew apace; although despised by the court they made themselves masters of the towns and in the end controlled all the wealth of the country. The impoverished court could no longer patronise artists; the Shoguns, and following their example the feudal lords, fostered a sterile traditionalism. However, the development of printing brought the arts to the merchants. Their tastes were less classical than those of the aristocracy. Eager for diversion and followers of fashion, this bourgeoisie found realism to their liking. The novels of Bakin were written for them, and it was for them that Chikamatsu increased the repertory of the puppet theatre, out of which grew the Kabuki or popular theatre. It was for the merchants that the craftsmen produced innumerable examples of their virtuosity, and for them that the Ukiyo-e artists worked.

Architecture and sculpture. There were no new developments in architecture and sculpture. The urban residences of the merchants were modelled on the shoin style, and sculpture was limited to decorative work and to masks for the No play.

Painting. While the Tosa school, which perpetuated the earlier Yamato-e tradition, was now declining, the Kano painters reigned supreme at the courts of Kyoto and Edo; but in time their art became academic.

Despite its political eclipse Kyoto remained the artistic centre of Japan throughout the 17th and 18th centuries. The aristocracy was behind this activity, which fostered the talents of such artists as Nonomura Sotatsu (d. 1643) [**310, 311**]; this painter borrowed from the Yamato-e repertory for his remarkable works, which show such a talent for composition and colour. The great master of the Genroku period (1688-

1703) — the high point of Tokugawa art — was Ogata Korin (1658–1716) [**312**], whose realist style harked back to Sotatsu and whose paintings show a fine talent for synthesis. Maruyama Okyo (1733–1795) produced realistic paintings of flowers and animals. Realism was also seen in the work of Ukiyo-e artists such as Moronobu, an adept at this form of genre painting which was later popularised by the print.

The print was extremely popular because of its cheapness. It was first pulled in black and white and was coloured by hand, but during the 18th century colour printing developed. Leading masters of this art were: Suzuki Harunobu (1725–1770) [**314**], Kitagawa Utamaro (1753–1806) [**315**] and Torii Kiyonaga (1752–1815), all of whom portrayed women; Toshusai Sharaku (active 1794–1795), whose subject was actors; Katsukawa Shunsho (1726–1792), who depicted wrestlers; Katsushika Hokusai (1760–1849) [**316**] and Ando Hiroshige (1797–1858), whose landscapes symbolised Japan for their contemporaries. The work of the Chinese literati painters reached Japan via Nagasaki, where it gave rise to the popular literary men's style; a leading painter in this style was Uragami Gyokudo (1745–1820) [**313**].

At the beginning of the 19th century the Japanese became acquainted with Western painting through the Dutch; after the opening up of Japan to the outside world, Western art influenced a number of Japanese painters.

The minor arts. The minor arts flourished. For a long while Kyoto remained the spiritual centre, but production became decentralised. The feudal lords encouraged craftsmen in their own fiefs, and this led to remunerative trade. Important painters interested themselves in the minor arts: Koetsu, a great calligrapher [**310**], worked in pottery and lacquer; Korin [**312**] designed for the crafts, especially for lacquer, while his brother Kenzan decorated excellent ceramics [**318**].

However, encouraged by their patrons, the craftsmen succumbed in time to the temptations of virtuosity; this can be seen in the finely carved tsuba (sword guards) and in the netsuke, those delicately carved ' buttons ' (of ivory, wood or other materials) which fastened objects such as medicine boxes (inro) to the girdle. These inro were often of gold or silver lacquer inlaid with mother-of-pearl.

316. HOKUSAI (1760–1849). Man with Rushes. Colour print. Tokugawa period. *Musée Guimet, Paris.*

This was an active period in ceramics. In the 17th century the manufacture of porcelain was begun at Arita [317]; the earliest production was modelled on wares from Korea and China. Among the notable manufactures at Arita was Kakiemon ware. By placing numerous orders, the Dutch promoted the development of this industry, and other factories were opened. The European demand contributed to the deterioration of Japanese taste, and in time decoration took precedence over design and technique. By the end of the Tokugawa period the ceramics industry, although prosperous, was completely decadent as regards artistic merit.

KOREA

History. In 1392 General Yi Tae-jo deposed the Koryo house and founded the Yi Dynasty, which reigned until 1910. During this period Korea was for centuries a cultural colony of China; the influence of the Neo-Confucianists was paramount, and Buddhism was relegated to second place. The arts flourished, and Korea led the Far East in printing. The Yi rulers established their capital at Seoul, which was completely Chinese in plan and architecture.

In 1592 Hideyoshi's army invaded the peninsula and war raged until 1598, when the death of the Japanese dictator put an end to these attempts at conquest. The invaders retired, leaving the decimated country with most of its monuments and art treasures destroyed. Korea never completely recovered its former vitality. To avoid another such intrusion the Yi rulers forbade foreigners access to the country and isolated it from the rest of the world. In the first half of the 17th century Korea was forced to recognise the sovereignty of the Manchus. Korea's internal autonomy remained intact, however, and China intervened only in 1894, in a vain attempt to save Korea from a new Japanese invasion.

Painting and ceramics. The long reign of the Yi Dynasty can be divided into two periods in art: from 1392 to 1592; from 1592 to the beginning of the 20th century.

Yi art at first sprang directly from Koryo art. An-kyen (middle of the 15th century) followed the monumental style of the Northern Sung painter Kuo Hsi in his landscapes. Kong Oingan (1419–1465), on the other hand, borrowed the academic style of the Southern Sung painters, which had derived from Ma Yuan and Hsia Kuei. The literati took up painting (bamboos, flowers, birds), while many court artists worked in various genres.

Ceramic production was abundant. Shapes were not as elegant as in the

317. JAPANESE. Porcelain dish. Nabeshima kiln, Arita. Tokugawa period. 18th century. *Musée Guimet, Paris.*

Koryo period. The clear green glazes were superseded by greyish and yellowish tones. Inlay, in use in the Koryo period when its designs were incised by hand, was still found on mishima ware, but the designs were stamped on and the effect was one of mass production. Experiments with technique continued, and the Korean work was greeted with enthusiasm by the Japanese tea masters. Thus during Hideyoshi's expedition to Korea ('the ceramic war') many potters were brought to Japan to start new kilns.

In the second Yi period art recovered very slowly from the results of the Japanese invasion and never regained its former vigour. Henceforth it was no more than a provincial branch of Chinese art, in whose decadence it participated. There was a large output of painting; portraits, animal representations and genre subjects showed the greatest originality. Ceramic production was distinctly inferior.

Madeleine Paul-David

318. JAPANESE. Stoneware tea bowl, decorated by Ogata Kenzan. Tokugawa period. 18th century. *Musée Guimet, Paris.*

CONTACTS BETWEEN EAST AND WEST

Jacques Wilhelm

From time immemorial the East and the West had maintained mutual contacts and exchanges, regardless of the difficulties of communications. After the fall of the Roman Empire in the West, the Christian world turned in upon itself and European contacts with the Orient declined — this despite the Eastern influences in the Byzantine Empire and despite the crusades. However, communications were renewed, and gained momentum, with the economic development of modern Europe. At first intrigued only by the novelty and the exotic quality of Eastern art, Europe later saw it as a possible source of its own artistic renewal. The Orient, however, despite its centuries of mistrust of the West, progressively repudiated its own ideals — at least ostensibly — as it adopted the technical progress and the artistic realism of the West.

Trade with the Orient

The Portuguese discovery at the end of the 15th century of the sea route to the Indies gave considerable impetus to European trade with the East. The establishment of a Portuguese trading-post at Macao and of a Spanish colony in the Philippines made these two countries the principal purveyors to Europe of Eastern wares until the end of the 16th century.

Competition soon developed. The English established an East India Company in 1600; in the same year the Dutch first reached Japan and in a few years opened a factory there. The French enterprise in China and the French East India Company (formed in 1664) were unsuccessful, and up till about 1700 the French got their Far Eastern imports from Lisbon, London or Amsterdam. The reorganisation of the French East India Company by the 1720s increased the volume of imports. But as early as 1686 some Chinese objects had been brought to France by such sources as the Siamese embassy to the French court.

The Chinese porcelains which first came to Europe were costly, and they were soon imitated. As early as 1614 at Rotterdam and 1640 at Nevers faiences were decorated with Chinese motifs. These motifs spread throughout Europe, owing largely to the enormous productivity of Delft. By the end of the 17th century the soft-paste porcelains of Rouen and St Cloud had a fine enough paste to simulate the original models. At St Cloud decoration was often Chinese. In the 18th century the factory at Chantilly copied the Japanese porcelains in the Duke of Bourbon's collection and made grotesque figures in the Chinese manner — as did the factory at Mennecy.

In 1710, after the discovery of kaolin in Germany, the first European hard-paste porcelain factory was opened at Meissen, and the earliest wares were decorated in the Chinese style. In 1768 kaolin was discovered in France and from 1769 hard-paste porcelains were produced at Sèvres. This European production, however, did not curtail the importation of large quantities of Chinese and Japanese porcelains. The Chinese wares often had European shapes and were decorated with Western type scenes. Pieces without decoration or with little decoration were sometimes imported from the factories of Ching-te Chen and were decorated in Europe. European potteries continued to imitate Far Eastern motifs, which appealed to the taste for the quaint and exotic. Indeed, whatever its origin, porcelain is still called 'china' in English.

Although imported from the Far East in large quantities, carved and painted lacquerware was also copied in Europe.

319. SWISS. JEAN ETIENNE LIOTARD (1702–1789). R. Pococke. *Musée d'Art et d'Histoire, Geneva.*

Around 1680 the Dutch and the English were manufacturing lacquered furniture decorated with Chinese motifs. In Paris as early as 1691 the Sieur des Essarts 'imitates lachinage [Chinese lacquer] both in intaglio and in relief'. The workshop of the brothers Martin (who were famous for their imitations of Chinese lacquer) was made a royal factory in 1748. The Martins also had a branch in Berlin, and their work was so much admired that the name 'vernis Martin' is still applied to the majority of European imitations of Eastern lacquer.

Chinese wallpaper was also in great demand, especially in England about the middle of the 18th century. Mme de Pompadour had many pieces at Bellevue. English imitations were used in Europe more often than original papers.

Raw or woven silk was the biggest import, together with Indian linens and muslins. The term 'Indian cloth' meant at this time almost all cloths from the Orient. These were popular owing to their variety, the beauty of their material, their imaginative designs and the brilliance and fastness of their colours. They had a great influence on fashion; around 1672 the *Mercure Galant* shows evidence of the vogue for cloaks of Indian linen or printed taffeta. These Oriental cloths were copied all over Europe, and raw silk was in demand for this.

The vogue for imported cottons threatened the French

320. FRENCH. FRANÇOIS BOUCHER (1703–1770). Chinese Curiosity. 1742. *Musée des Beaux-Arts, Besançon.*

321. *Below, left.* FRENCH. FRANÇOIS MARIE QUEVERDO (1748–1797). Kiosk in the Chinese style. Engraving. 1788.

322. *Below, right.* FRENCH. FRANÇOIS MARIE QUEVERDO. Kiosk in the Turkish style. Engraving. 1788.

323. ITALIAN. FLORENTINE. Detail from an allegory, with clouds in the shape of dragons. 15th century. *Staatliche Museen, Berlin.*

324. DUTCH. REMBRANDT (1606–1669). Four seated Orientals. Drawing after a Persian miniature. *British Museum.*

325. PORTUGUESE. Japanese screen with Portuguese scene. *Lisbon Museum.*

looms with ruin, and from 1686 edicts were issued forbidding the importation, and later the imitation, of these fabrics. But they continued to be brought in, either illegally or by special authorisation, and they were found in plenty in the royal residences. Restrictions against them were not lifted until 1759, at which date Oberkampf founded the factory at Jouy.

The Oriental influence

Although the French were comparatively late in establishing direct contacts with the Far East, it was at Versailles that the first ensemble in the Oriental style was carried out, although in fact the style of the Trianon de Porcelaine (1670) was Chinese via the intermediary of Holland. However, pavilions modelled on it were numerous in the Germanic countries in the 18th century. The walls of the Trianon de Porcelaine were decorated with blue, white and yellow faience tiles from Delft and Lisieux. Its high roof of glazed tiles was heavily ornamented with pottery vases and polychrome lead animals. Its regular flowerbeds, planted with hyacinths, tulips and jasmine, had faience vases as decoration. Inside, the walls and ceilings of white stucco were covered with azure ornament 'in the Chinese manner'. Tables, chairs, etc., were painted with 'porcelain style' motifs, and fabrics were embroidered with 'fleurs de la Chine de rapport' (Chinese flowers in a repeat pattern). Nothing remains of these objects, but the lacquered furniture of Genoa and Venice and of Spain and Portugal can give us some idea of them.

In the 18th century ceramics, lacquers, textiles and wallpapers were combined with decorative elements, usually in the Rococo style, to make up picturesque and colourful ensembles. Daniel Marot designed a Chinese salon at Hampton Court. Here, between lacquer panels, were small console tables with ceramics on them, and ceramics also appeared on the cornices and the mantelpiece. Rooms were sometimes decorated to show off a collection, as in the Japanisches Palais, Dresden, which housed Augustus the Strong's collection of sixty thousand Chinese and Japanese porcelains. Other examples of such interiors, in which ceramics play the principal part, abound in Germany and Austria. In 1706 a room at Charlottenburg was covered with plates and dishes which echoed the pattern of the pilasters and panels.

Ensembles combining decoration and the minor arts were also built at Pommersfelden and Ansbach, where we see the play of mirror reflections on sinuous mouldings of gilded wood. In the boudoirs at Schönbrunn leaves of lacquer screens are inlaid in the panelling; these are combined with Chinese 'blue and white' or *famille rose* porcelains to form scintillating and extravagant ensembles.

Ceramics were important at Nymphenburg, where a salon was faced with Delft tiles framed by black and gold mouldings. At Capodimonte, Madrid and Aranjuez the palaces have an extraordinary room with walls made entirely of porcelain. Mouldings, flowers and palm trees in relief are all combined with large Chinese figures. Mirror frames, chandeliers and brackets are of the same material. The king of Naples, later king of Spain, commissioned these interiors, with their brilliant colours and delicate Rococo designs, from his factories at Capodimonte and Buen Retiro in the middle of the 18th century.

Lacquer and gilded wood were used together successfully all over Europe from the middle of the 17th century. Chinese and Japanese coffers and cabinets were placed on gilded bases; leaves of screens were held in wood frames which sometimes (as at the hôtel d'Evreux, Paris) were carved with small Chinese

337

326. DUTCH. HERKULES SEGHERS (*c.* 1590–before 1638). Tree. Engraving.

327. CHINESE. Export armorial plate. East India Company. 18th century. *Musée des Arts Décoratifs, Paris.*

328. DUTCH. Plate with Chinese pavilions. Delft. 18th century. *Musée des Arts Décoratifs, Paris.*

329. FRENCH. Plate with Chinese landscape. Lunéville. 18th century. *Sèvres Museum.*

330. FRENCH. Plate with Chinese decoration. Rouen. 18th century. *Musée des Arts Décoratifs, Paris.*

331. GERMAN. Figurine of a Turk with a guitar. Meissen. 1744. *Kunstgewerbemuseum, Cologne.*

332. FRENCH. Figurine of a Chinese. Soft-paste porcelain from Mennecy. Beginning of the 18th century.

333. FRENCH. Toilet jar with Far Eastern decoration. Soft-paste porcelain from Chantilly. 1744–1750. *Musée des Arts Décoratifs, Paris.*

334. FRENCH. Lampas (flowered silk) with Oriental motifs. 18th century. *Musée des Tissus, Lyon.*

335. FRENCH. Soup tureen with polychrome Chinese decoration. Hard-paste porcelain from Strasbourg. 18th century. *Strasbourg Museum.*

336. Inkstand. Indo-Portuguese work. Late 16th–early 17th centuries. *Lisbon Museum.*

figures. These effects were also sought in panelling, which was lacquered (as at Bruchsal) in red and yellow with Chinese figures. The designers of the singeries (monkey scenes) at Chantilly, Champs and the hôtel de Rohan, Strasbourg, however, made no attempt to imitate lacquer. Instead they adapted these motifs to their own settings (as the Italians had done in the 16th century with the grotesques of antiquity) and painted them on light backgrounds in fresh and brilliant colours. Decorative artists elaborated Chinese themes freely, and their ideas were spread throughout Europe by engravings. Bérain, Audran, Huquier, Boucher, Huet and Peyrotte in France, Decker in Germany and Vivares in England were among those who provided models for the decorations, or themselves painted panels. Pillement did this, working in London, Paris, Lisbon, Madrid, Vienna and Turin. Such mobility on the part of artists partially accounts for the many common features in the chinoiserie of different countries.

320

Chinese scenes adapted to Western taste served as themes for tapestries and printed textiles; the tapestries after Vernansal and Blin de Fontenay, the Chinese series by Boucher at Beauvais,

340

the series woven in Soho in imitation of lacquer and that by Charles Vigne at Berlin were all highly successful. 339

Lacquer had a lasting vogue in furniture. Lacquer panels were inlaid in a lacquered or marquetry framework; they were used on the front of commodes, etc. Under Louis XVI, Carlin and Weisweiller framed Japanese lacquer panels in ebony or mahogany. It was customary, too, to imitate lacquer, sometimes in surprising colours. It was rare, however, to find furniture which followed the actual forms of the Chinese models. 343 342

The landscape garden showed the Oriental taste in such buildings as William Chambers' pagoda at Kew. 344

Certain writers once thought that the mobile forms of Chinese Ch'ing art inspired the sinuous lines and the irregular shapes of Rococo. The dragons and phoenixes adorning the woodwork and bronzes of the Louis XV period were also attributed to Far Eastern influence. This idea is no longer supported. It was surely rather a matter of rapport between two forms of art whose independent evolution had reached a similar stage in the early 18th century — a stage at which

337. FRENCH. Regency panel with Chinese decoration, from the hôtel d'Evreux, Paris.

338. FRENCH. Negro horseman and camel. 'New Indies' tapestry, after Desportes. Gobelins. 1773. *Palazzo del Quirinale, Rome.*

339. ENGLISH. Soho tapestry, from a cartoon by Vanderbank. 18th century.

decorative art predominated over the 'major' arts, movement over calm form and asymmetry over regularity. It would seem that receptivity to the Oriental influence was related to receptivity to the Rococo.

European art in the East

Weighed against the Eastern influence, the European contribution to the Orient appears almost negligible. China and Japan had always regarded the West with suspicion. Even in the 18th century the merchants established in China were obliged to live in a special quarter of Canton; only missionaries were allowed to live in Peking, but the favour they had enjoyed under K'ang-hsi was partially curtailed under Ch'ien-lung. These missionaries, who were Jesuits, acted as diplomats, cultural or commercial attachés, teachers, astronomers, geographers, architects and painters. No Western ideas or inventions penetrated to the Far East except through them. K'ang-hsi wished to benefit from Western civilisation without opening up his country, and he permitted some French Jesuit astronomers to set up a splendid observatory in Peking in the 1680s.

340. FRENCH. The Prince in a Junk. 'Chinese' tapestry scene, after G. L. Vernansal and Blin de Fontenay. Beauvais. Late 17th–early 18th centuries. *Lejart Collection.*

143

341. ENGLISH. Lacquered bed. 18th century. *Victoria and Albert Museum*.

342. FRENCH. Corner cupboard in ebony and Japanese lacquer, by M. Carlin. Louis XVI style. *Louvre*.

343. FRENCH. Desk in ebony and Japanese lacquer, by J. Dubois (c. 1693–1763). Louis XV style. *Private Collection*.

344. ENGLAND. WILLIAM CHAMBERS (1723–1796). The pagoda, Kew Gardens.

Father Giuseppe Castiglione became a painter; he worked in the Chinese style, producing the scrolls in the Musée Guimet, Paris, and also portraits of the emperor and his favourites in European costume. The Jesuit fathers trained a few pupils in European perspective. Ch'ien-lung had Father Castiglione and his pupils illustrate his conquests, and these works were engraved in Paris. The largest undertaking was the construction of several pleasure pavilions in the gardens of the Summer Palace at Peking by Father Castiglione in 1747; these were in the Italian Baroque style. Father Benoît added water-towers and fountains, and their Chinese pupils made engravings of these strange edifices.

The Jesuits' stay in China had no lasting results, for it affected only the imperial court.

During the 18th century Japan was completely closed to Europeans. In India European influence was slight, although miniatures show some assimilation of Western perspective.

The East instinctively realised that its art had nothing to gain from contact with the West, and the few examples of European influence which we have mentioned above are of interest only as curiosities.

345. FRENCH. CLAUDE MONET (1840–1926). Rouen Cathedral: Bright Sunshine. 1894. *Louvre*.

ART FORMS AND SOCIETY *René Huyghe*

The 19th century was a complex period. Till about 1850 the main struggle was between the conflicting aims of classicism and Romanticism; afterwards these were replaced, almost brutally, by other ambitions. Classical artists used the past as their model, Romantic artists tried to escape through the imagination. The realists who followed aimed to express the 'real' as it existed, to present the 'here and now' without any reference to the past. They regarded it as a token of the future promised by a new divinity — progress. This meant a complete break with the ancient classical tradition, and also a rejection of the Romantic's escape into personal dreamworlds. The Realist artist grappled with the problems of creating a new order based on the direct observation of what was around him.

The break of 1848

Contemporary events are always reflected in changes of thought and aesthetic feeling. The 1848 revolution marked the end of a regime and the end of a way of life, whose knell had already been sounded sixty years earlier in the French Revolution of 1789. This time, however, the whole civilisation of western Europe was involved in the catastrophe. The republican movement arose in Italy, in Germany and in Austria. Metternich, the champion of the old order, was crushed. Socialism became the policy under the July monarchy. What the French Revolution had begun in 1789 had since been thwarted despite a clear aggravation of its causes. Now, in 1848, though the socialists held power for only a few months, the way to the future was signposted, and during these few months universal adult suffrage became established.

During the previous twenty years the economic structure of life had been changing. Men had learnt how to make use of energy which was latent in nature, and to apply it to work the newly invented machines which were to become the whole basis of industry. In 1830, the first train to carry passengers travelled between Liverpool and Manchester at 35 m.p.h. London became the focal point of a rapidly growing railway system. The first Atlantic shipping line was opened at the same time as steamships began to replace sail. The invention of the telegraph and the telephone and the introduction of the postage stamp all took place in the twenty years from 1835 to 1855. As industry became revolutionised so it caused repercussions in the national economy and in everyday life. Within a few years a new civilisation was born, but not without upheavals. Scientific discoveries and their practical application during the first half of the century had made this new civilisation possible. They raised up great hopes for the future.

The forward march of ideas went step by step with events, and gave them an intellectual counterpart. From 1830 to 1842 Auguste Comte developed positivist philosophy. He was followed three years later by Littré, and six years later still by Renan, who caught glimpses of what was to come in his *L'Avenir de la Science*.

From then on the theory of progress took shape. In earlier societies agricultural life demanded a conservative outlook. Agricultural methods could only be perfected slowly and conditions of life changed little over long periods of time. The new society was marked by constant transformations as invention followed invention, all of which were based on the scientific observation of fact. Man now controlled his own destiny and could reshape, rearrange or turn his new tools to his own

purposes. He no longer sought refuge from an unchanging world in ideas and dreams. Instead he faced 'reality' and, in making use of it, developed ambitions and hopes.

At the same time all industrial advancement seemed to be to the detriment of the working classes, who nevertheless multiplied in number and grew in importance, and who replaced the craftsmen of earlier times. A. C. de Tocqueville had already noted this in relation to America. As mechanical progress accelerated so restlessness among the working classes became more clearly apparent. The dates of P. J. Proudhon's works coincide with events: in 1840 he published his well known essay, *Qu'est-ce que la Propriété?* and in 1849 his *Système des Contradictions Economiques*. He wrote of the machine: ' May no one accuse me of malevolence towards the finest invention of our century ', but ' nothing will stop me from saying that the principal result of the railways, after serving industry, will be to create a population of degraded workers... 2500 miles of railway will give France an extra 50,000 serfs.' It became necessary, therefore, to think in terms of the welfare of the workers as well as in terms of material advancement. Auguste Comte arrived at the same conclusion during the years 1851–1854 with his *Système de Politique Positive* which inaugurated a religion of ' humanity '.

Within fifty years western Europe found itself faced with radically new problems. On the one hand the incredible developments of science and industry created immense hopes whose limits could not even be guessed. On the other hand the plight of the working class created an immediate danger which demanded urgent attention. In both cases the problems were of a material order and brought about a condemnation of the classical attitude in the first case and of the Romantic attitude in the second, but it had taken half a century for it to be realised.

At first the conservative elements refused to recognise the change or the new order of things, and they stiffened their attitude both in politics and in art. After the first shocks the traditionally monarchic powers united their forces in the Holy Alliance. In art classicism led to an official academic style. This ' ideal ' conception was based on the old order, but was doomed to disappear as an agricultural civilisation gave way to an industrial civilisation.

The ' ideal ' of classicism could only be approached by a certain self-denial and by means of great effort. Its place became challenged by the wish-fulfilment potentialities of Romanticism. The epic expansion under Napoleon had brought comparable aesthetic desires in its wake. For France the defeat was terrible. Contemporary writers have related how these unchained appetites became completely frustrated. For years French morale had become elated by victories and conquests, but now it found itself in the strait-jacket of bourgeois practical interests with their cramped outlook and their quest of money. The aesthetic and intellectual spirit could find no outlet under the materialism of the Restoration and the July monarchy. Théophile Gautier expressed the artist's nostalgia when he wrote: ' They were the Day, of which we are the Evening and perhaps the Night.' A. de Lamartine, in his *Chute d'un Ange*, showed the anguish of the creative spirit thrown ' into the middle of this brutal and perverse society where the idea of God had been eclipsed and where the most abject sensualism replaced everything spiritual '. Yet again A. de Musset, who wrote *Confession*

346. FRENCH. PIERRE HENRI DE VALENCIENNES (1750–1819). View of Castelgandolfo (?). *Louvre.*

Even the painters who remained faithful to the classical tradition of Poussin and Claude produced new and unusual work. In addition to their ' composed ' landscapes painted for exhibition [346], they made private studies which revealed an interest in aerial perspective and light foreshadowing Boudin and the Impressionists [347].

347. FRENCH. PIERRE HENRI DE VALENCIENNES (1750–1819). Study of Clouds in the Roman Campagna. *Louvre.*

d'un Enfant du Siècle, concluded: ' Henceforth, there were two camps. The exalted and expansive mind suffered, and all those souls seeking the infinite bowed their head in tears…On the other hand men of flesh remained upright, enjoyed life and had nothing better to do than to count their possessions. ' The whole of Europe was in this plight. The aristocracy and the belief in ideal values had disappeared. The people, whose fury in the past had risen to the accomplishment of the revolution, were now dulled and enslaved. They had been prepared for the fulfilment of ambitions which were quite limitless and they were suddenly thrown back into a narrower channel than ever. The fruit of this crisis was Romanticism. There was no other outlet than by dreams, and the free play of the imagination was the most effective means of flight from present reality. Round about 1830 artists turned for their subjects to the world of fiction and chose themes out of the past or from distant lands, or they allowed their fantasy free rein. This could not last, just as the normal way of life in the past could not be artificially extended. Man finally had to accept the authentic pressure of the times, and in the 19th century this led in the opposite direction, back to the ' real ' which imposed itself and its rule. There was no other possible future for the new phase upon which humanity had embarked.

The transition reflected in landscape painting

To go from the individualism of 1830, founded on dreams, to the strict positivism of 1850, based on concrete realities, it was necessary to pass through a period of transition. In art, I believe, this was achieved through the landscape painters. Only nature could satisfy simultaneously the contradictory demands made by this transition. In nature the Romantic individualist could find solitude, he could extend himself to the limits of the world and find fusion of his human soul in the universal soul of nature. To the nascent Realist nature offered the immediate solution of naturalism. The artist could contemplate what he saw and render it authentically, and thus he learned to communicate with the ' real '. The Realist artist tried to avoid preconceived notions — Utopian idealism or escapist Romanticism. The classical landscapes of P. H. de Valenciennes and of A. E. Michallon were still ruled by convention, as were the Romantic landscapes with figures by the Nazarenes, by Corot and by V. N. Diaz, and those by Michel and Huet in France and by John Martin and J. M. W. Turner in England which placed no restrictions on the imagination. Following them the new landscape of the intermediate phase preceded the landscape of strict optical observation which was to come with the Impressionists. Both the Romantic and the Realist felt equally at home in this lyrical phase, for in it the visible and the sensuous were almost indistinguishable.

346

94

348

The Barbizon school in France most clearly reflected the aesthetic mood of the period. There lingered the subjective rapture of the Romantics so well expressed by Custine in his *Mémoires et Voyages* written in 1830: ' The senses are neglected, art is neglected, even a fine physique is neglected. The external world disappears, and nature comes to an end. The supernatural begins to reign. and man no longer looks outwards but only into himself. ' Something of this remained in the work of Théodore Rousseau, the greatest landscape painter of the Barbizon school, whose art is so completely misunderstood today. He acknowledged it: ' He who lives in silence becomes the centre of the world; for a moment I could believe myself to be the sun of a little universe. ' This intoxication by human pride remained close to Romanticism. Yet he added, implying the new spirit in its reserve and humility: '…if my studies had not reminded me of the trouble I had to mimic a poor tree or a clump of heather. ' And to Guizot he later spoke of the ' sincerity of portraiture ' and of ' exact truth '. The excesses of the subjective approach gave way to the probity of the objective approach, which was to be the preoccupation of the following generation. *Mes Cahiers* by M. Barrès bore evidence of the third phase, which corresponded to Impressionism: ' When I pass so insignificantly through a landscape, how can I avoid knowing that it exists independently of me and trying to represent it in this way? '

351

The changes in painting were accompanied by changes in thought, and in the same way there were three important stages.

The Romantic took refuge in the ego, to which he led everything back. Lamartine's poetry took him deeply into this school of thought which was about to disappear, but he sought the new developments in politics. He thus eventually came to repudiate the god of the times and began to talk about ' odious individualism '. By 1850 the reversal was complete, and objectivity had become the aim of man's ambitions. It is important to remember that this objectivity attempted to be free from all influence or distortion due to the ' personal factor ', as it was disdainfully called. The cult of material fact was taken to an extreme. Objectivity similarly required the submission of the

individual to the collective, which demanded the use of all his faculties and the sacrifice of any differing point of view. 'Humanity' became virtually a sacred myth. In the new pantheon it took its place beside two other new divinities, 'the future' and 'progress'. The first apostle of this transformation was Auguste Comte, and he stated clearly the link-up by which he arrived at his conclusions: 'The human mind has conceived astronomical and terrestrial physics and chemistry and organic physics relating to plant or animal life. There only remains, in order to complete this system of science by observation, for man to establish social physics. This is, in many ways, the most urgent problem now to be solved.'

From then on everything became related to the sciences which were based on observation. Imagination had been the faculty by which the Romantic artist turned everything which he gained from the exterior world to his own inner purposes. Now instead, in order to make the fullest use of objective reality, he gave first place to the opposite faculty, that of observation. So that observation should in no way be tainted by any personal feeling, it was made to obey the universal and intangible rules of science. Whereas the Romantic had responded to poetic or musical aspirations, the new artists and writers regarded science as the paragon of the only possible truth.

Facts versus imagination

Baudelaire was as horrified by this new movement, which he considered to be a monstrous development, as he had been earlier by the classical outlook. He felt the dangers to be the same, for both denied the powers of the imagination, or in other words, the subjective approach. In his *Curiosités Esthétiques* he attacked Ingres on one side and Courbet on the other. Both ' are so narrow in their outlook that their faculties become atrophied... The difference is that Monsieur Ingres makes a heroic sacrifice in honour of tradition and the idea of Raphaelesque beauty, whereas Monsieur Courbet makes his sacrifice to nature, as it appears here and now. Their opposing fanaticisms feed on different forces but lead them to the same end.' Courbet, in talking to his students, wanted to destroy even the word 'imagination'. He said: 'The imagination in art consists in being able to find the most complete expression for an *existing thing*, but never consists in creating the thing itself.' Elsewhere he enlarged on this belief: 'I hold that painting is an art which is essentially *concrete* and can only consist in representing *real* and *existing* things. Painting is a physical language and deals with the visible world. Things which are abstract, invisible or non-existent do not belong to the domain of painting.'

The same convictions ran through all the arts and through all fields of study. Facts, realities which could be universally observed, belonged by definition to the physical world. They could be perceived by the senses and measured. From this time anything relating to the psyche was considered suspect since it was uncontrollable, tendentious and tainted with individualism. Psychology itself was soon to be valid only when supported by material manifestations, or when, through psycho-physiology, it yielded results by physico-chemical examination.

From science there spread a universal cult of fact. ' Obtain the precise facts by means of exact observation' (Claude Bernard). ' Since the time of Bacon the most brilliant brains have repeated again and again that real knowledge can only be founded on observed fact' (Auguste Comte). ' Tiny but significant facts, fully detailed and minutely recorded, have given us the material of present-day science' (H. Taine). The respect for fact spread into the study of history, now called ' human science'. ' As in all science it is necessary to deduce the facts, to analyse them, to compare them and to note their

348. FRENCH. PAUL HUET (1803–1869). Breakers at Granville. Exhibited at the 1853 Salon. *Louvre.*

VISION OF NATURE

In classical landscape the discipline of form was imposed on nature [346]. In Romantic landscape elemental forces were unleashed in a lyrical and passionate revolt [348]. The Realist landscape emerged in the middle of the 19th century. The transition was achieved by the Barbizon painters working in the forest of Fontainebleau [351]. Nature still seemed to them powerful and dramatic, as it did to the Romantic painters, but their new cult of objectivity coincided with the arrival of the spirit of positivism. Naturalism took a further step forward. Painters such as Courbet were only interested in concrete reality [349]. Painting developed on a parallel course to that of science, which accepted a new concept of matter, leading to the gradual discovery of the characteristics of energy. The painter moved from solid to fluid matter, and he chose to express atmospheric vibration in space [350] or the ceaseless movement of water and its reflections. A field of impalpable vibrations—that was all that nature became for the Impressionists [352]. The old tactile values gave way to optical excitement.

351. FRENCH. THÉODORE ROUSSEAU (1812–1867). Oak tree and rocks. Exhibited at the 1861 Salon. *Private Collection.*

349. FRENCH. GUSTAVE COURBET (1819–1877). Cliffs at Etretat. About 1860. *Louvre.*

350. FRENCH. ANTOINE CHINTREUIL (1816–1873). Space. Exhibited at the 1869 Salon. *Louvre.*

352. FRENCH. CLAUDE MONET (1840–1926). Rough Sea. About 1884. *National Gallery, Ottawa.*

relationships' (N. D. Fustel de Coulanges). It spread into literature: ' He who gives as much importance to the little facts as to the large makes you feel almost materially the things he reproduces' (G. Flaubert). It also spread to the visual arts: ' Imagination and style give way to a rational painting, which is a direct expression of nature and of life...the exact representation of society' (Castagnary).

All this represented a complete reversal of the Romantic outlook. With the Romantics facts only counted to the extent that they awoke interior responses through which could be translated the unique feelings of a single individual. It was much the same in the case of the classical artists. The classical painter elaborated an idea of the mind according to classical rules; mere fact was only a point of departure and a structural element.

The two ways of thinking

It is, at first sight, surprising that a reaction can completely change the direction of development, in so few years, and within a single culture. It cannot be explained nor understood without first considering one unique peculiarity of our Western civilisation. This civilisation rests on two traditions, which originally existed side by side, then divided, and finally became so opposite as to lead to the existence of two cultures, each with its own technique of understanding. These two intellectual orders have been recognised in teaching — the arts and the sciences. This strange anomaly has its roots far back in history, and an understanding of these will go a long way towards elucidating the problem of the West and the complexity of its art. Though these problems merit an extended study, we have only space here for a brief sketch.

The Greeks founded a new method of thought which was to underlie the whole development of Western civilisation. They started with a knowledge of the real based on positive data and controlled by the senses. Secondly, they believed that the powers of human reason were identical with the senses which registered phenomena. The explanation of the world came to be submitted to logic, and henceforth this explanation rested essentially on the relation of cause to effect and on the idea of permanence. Experience is based primarily on the observation of our senses and, following this, on what belongs to space, to its measurement and to the physical matter which exists in space. The desire to submit this experience to universal rules, which would be universally valid, led to the basic concept of objectivity. The object observed was clearly separated from the subject who observes. In the objective view of an object the interior life and inherent characteristics of the observer are eliminated as far as humanly possible. The subject alone possesses a soul and lives in time. The object belongs to space, where it can be defined and measured, and where it obeys the laws of logic whose regularity and incessant repetition involves an evolution in time. Forms, if abstracted by a definition from this movement, take on the fixity the truth demands. The mind is troublesome because of its unexpectedness and illogicality, so an explanation is given by means of the predictable and logical movements of the stars and planets in space. The feelings of man are undefined and fleeting, and result from the sum of the experiences which have made up his life so far. These feelings could be defined by reference to mental forms — ideas as clearly demarcated and stabilised as the forms in space. We have been so profoundly penetrated by this tradition of the subjective and the objective that we accept it as natural, spontaneous and inherent in man. This process of thought born in Greece remains the foundation of our thought processes today.

Before the Greeks there existed a quite different way of

thinking, sometimes expressively called 'pre-logical'. This has been proved by sociologists and ethnographists. It consisted fundamentally in relating the object and the observer without isolating one from the other. They are related, as is the whole universe, by a common animating spirit or 'animism' of beings and things. Everything becomes related in this universal soul to which objects belong as much as people. The relation is no longer according to mechanical or physical laws, but follows a system based on sympathies and antipathies, which imply attraction and repulsion. The key to this system is analogy. Resemblance makes things interdependent and subject to the same destiny. By means of an image made in resemblance to a living body, the spirit may be transferred by the use of magic. Even the word belongs to the thing which it designates and can react on it, and is thus used in incantations. Complex relationships become elaborated from the ideas of the microcosm and the macrocosm, of man and the universe, of the destiny of the individual and the movement of the stars. Perfect knowledge results from the fusion of the individual with the object of his quest. At its most primitive it is expressed by magic. Its highest achievement results in mysticism, in which God is revealed to man, and one becomes absorbed into the other through an expression of love.

The Greek way of thinking was quite different. Apart from the act of observation itself, the subject cuts all other ties with the object of its attention. There is no longer any participation of soul or emotion, but complete neutrality, or even a withdrawal away from the object. Observation does not permit appreciation, which remains subjective; it consists in an impartial physical definition which can be stated in terms of measurement. Over the entrance to the Academy is written: 'No one may enter unless he is schooled in geometry.'

This way of thinking was invented by Greece and it gave man a hitherto unknown power over the physical world. It was passed on to the Romans, who made use of it to develop their practical genius. Rome codified it, and gave it a simple and well defined basis of order and method. The foundations of Western civilisation had been laid, and it became impossible for this system to have any relation whatsoever with the opposing system which prevailed in the East. Nevertheless the Eastern outlook did make attempts at infiltration, as a result of political, military and economic contacts with the extended Roman Empire. Alexandria, which was both Hellenic and Near Eastern, acted as a bridge over which old Egyptian cults, neo-Platonism and their magic sequels were to pass in confusion. Another bridge was Christianity, born to the east of the Mediterranean. To this Christian religion a mystical love took precedence over traditional rationalism. Rome resisted to begin with, but eventually absorbed this assailant and made it her ally. The break with Byzantium confirmed the Romanisation of Christianity, which evolved through the chain of medieval scholasticism, seeking an equilibrium between the rights of reason and those of faith. It reintegrated the heritage of ancient philosophy, which had descended from Plato and Aristotle, into its dogma. The Renaissance developed in Italy, on the soil and amid the remnants of classical antiquity. For a second time Mediterranean thought was to be expressed in classical terms. At the end of the Middle Ages renewed interest in Aristotle had prepared the way. A new discipline of thought slowly revealed itself, and this was to lead to the present-day scientific outlook. Francis Bacon made important contributions even though he remained tainted by 'animism' in his thought. He spoke of the 'properties' or 'qualities' of things, thereby implying their 'sympathies'. His contemporary, Galileo, continued to make use of qualitative considerations in science, in

relation to the perfection of the universe. Such qualitative ideas are incompatible with the quantitative system of measurement which Galileo himself brilliantly advanced through his experiments with the pendulum, the thermometer and the hydrostatic balance. It was not until Descartes that science rid itself of the questionable notion of the 'better' or the 'best'. Such notion is foreign to exact objectivity since it by-passes efficient observation to arrive at final results.

Descartes finally succeeded in making objects clear, in their dimensions, their forms and their relative positions. The impact of a force can modify these, but as it is considered instantaneous, it does not imply the element of time. Descartes so completely eliminated 'animism' that he refused to admit any form of love or affection and its power of attraction. The whole of nature became subject to the laws of geometry and mechanics. Physics became the queen of the sciences, all of which were now 'positivist'. The 19th century was to see the full development of positivist thought.

The 'animist' way of thinking seemed to have been overthrown and exiled. The mysticism which had developed in the 13th century and given rise to nominalism was now finished. However, from Meister Eckhart to Jan van Ruysbroeck, the medieval mystics, especially those from the Rhineland and Flanders, knew where to find a refuge to preserve the line of their mysticism. The essential knowledge, that of God, could only be found through an intimate union, in which the principal factor was love. The Renaissance gave new lustre to Plato, but his thought had become so permeated by Plotinus that strict objectivity had become mixed with a belief in occult forces and with the analogy of a sympathetic order existing between the microcosm and the macrocosm. Even the Aristotelians, such as Pomponazzi, and their opponents, such as Giordano Bruno and Tommaso Campanella, accepted the existence of a universal system. Kepler tried to break away, and uneasily he attempted to separate astronomy, an exact science, from astrology, which was founded on symbolic analogies.

The most tenacious resistance to objective and scientific knowledge was met outside Italy, where Roman influence had been the most superficial as is confirmed by the Protestant schism, and especially in the Germanic countries. The original home of the biological sciences, such as medicine and chemistry, was with the alchemist. In the 16th century Paracelsus liberated medicine from its traditional empiricism, but he made it unintelligible, founding it on correspondence between the macrocosm and the microcosm, and on visual or verbal analogies between the remedy and the wound or ailment to be treated. This esoteric tradition was likewise the basis of the work of H. C. Agrippa von Nettesheim, and of that of Valentin Weigel and Jakob Boehme in Germany and of Robert Fludd in England. It persisted into the 17th century and even beyond. Weigel admired both Paracelsus and the Rhenish mystic Johann Tauler. He made a clear distinction between 'natural knowledge', which he reserved to material reality existing in space, and 'supernatural knowledge', where quantitative analysis is insufficient.

The modern outlook

After Descartes the two currents could no longer coexist. Science was based on rigorous objectivity, and to the scientific mind animism was intolerable. Nevertheless science unconsciously felt its presence.

In the 18th century science took an important step forward, but only by bending its strict method to reconsider the forbidden and suspect deductions which belonged to the other

353. FRENCH. JEAN JACQUES DE BOISSIEU (1734–1810).
Work in the cellar. Engraving.

354. FRENCH. IGNACE FRANÇOIS BONHOMME
(1809–1881). Copper foundry at Toulon.

INDUSTRY AND THE PROLETARIAT

*The development of positivist thought accompanied the
practical application of science to everyday life. Industry
was born, and with it a new social class, the proletariat.
The new spirit turned away from conventional subject matter,
with its moral and aristocratic values. Instead it turned
towards objectivity, and revealed the undisguised realities
of life. During the 18th century, industry [355] and the
working class [353] had become accepted as subject matter
for art. In the 19th century, the Realists painted the large
factories [354] and the workers in them [356]. Socialism
attracted the more adventurous artists and set its approval
on inspiration drawn from the people, and especially from the
manual worker [358]. Subject matter which had been an
inspiration in the past, in particular religion, was denied
or even ridiculed [357].*

355. FRENCH. Cannon foundry, after Cochin Fils. Engraved
by Pierre Soubeyran (1709–1775).

356. FRENCH. HONORÉ DAUMIER (1808–1879). The Painter
(The Man on the Rope). About 1860. *National Gallery, Ottawa.*

358. BELGIAN. CONSTANTIN MEUNIER (1831–1905). The
Puddler. *Brussels Museum.*

357. FRENCH. GUSTAVE COURBET (1819–1877). The
Return from the Lecture (sketch). About 1863.
Private Collection.

side. Newton opened a new and immense field of study but had to admit the phenomenon of attraction without direct mechanical action — at the distance of the planets. In a similar way chemistry made fruitful discoveries by accepting the existence of affinities. 'Attraction' and 'affinities' seemed to imply the acceptance of phenomena based on the force of immaterial sympathies. Fontenelle, a follower of Descartes, would not accept this treachery, which he proclaimed to be 'scarcely more supportable in chemistry than in astronomy'. He objected: 'When one has pronounced the word "attraction", what has one said?' Here followed magnetism, which made possible the discovery of electricity, where the positive and the negative attract one another or repel one another depending on whether they are 'unlike' or 'like'. The vocabulary forbidden to science since the condemnation of 'animism' and the ideas which this vocabulary covers were entering the laboratory where the scientist was at work. The scientist submitted them to his experimental technique and thus prepared the way for limitless progress. However the road was not easy and there were pitfalls. Mesmer tried to approach the psychic through 'animal magnetism' but found himself baulked. Likewise Gall, by the study of phrenology, attempted to establish connections between mental faculties and the configuration of the skull.

The breakthrough had now been made. A non-objective approach to science became possible and, especially in the realm of philosophy, new ideas were about to be developed. The most striking of these ideas were formed in northern Europe, where classical culture had least permeated. The most vital new philosophy was that of Swedenborg, who divided his time between Stockholm and London. He had begun by studying science and then turned away to follow a spiritual quest. This led to the 19th-century Romantic doctrine of the fusion of the individual soul with the universal soul which merged again in the work of Baudelaire and of the symbolists, particularly in the theme of *correspondances*. This path was that of 'animist' understanding. It turned back towards metaphysics, literature and poetry, and assured its own future by accepting that the gateway to science had been closed. In the arts 'animism' grew more and more powerful, so that it confirmed the dominance of German thought and Romanticism, which seemed to be its natural media.

The true founder of German philosophy was Leibnitz, who opened the way to a dynamic conception of thought. Here forces which exist in time took the place of forms which exist in space. He anticipated the discovery of the unconscious with its illogical mental forms. From then on the Germans occupied themselves with the problem of a perpetual equilibrium existing in time, where opposing forces ultimately become fused; this was the basis of ideas already sketched out by Paracelsus. In this may also be recognised the source of the rejuvenating principle of Schelling, of the 'universal oxygenism' of Novalis, and of the logically worked out dialectics of Hegel.

Poetry reawakened the old dream of man who seeks to find union with nature by absorption into the universal soul. 'The transformation of oneself into object, and of object into oneself' was an idea of Giordano Bruno, which now gave poetry new aesthetic possibilities. The 'animist' ambition is to find fulfilment through the union of one with another, and it achieved this through the arts. Beethoven, Delacroix and Rimbaud aimed to achieve this passage from 'soul to soul' and also the intimate union of the soul of man with that of things. Delacroix said: 'The principal source of interest comes from the soul, and it goes right to the soul of the spectator in an irresistible manner.' Music most easily overrides material

limitations. It now took a primary place among the arts, especially in Germany, and became the model for the other arts. Previously, in the Graeco-Roman tradition, architecture and sculpture, the arts of form, held first place. Poetry of a descriptive or explanatory kind gave way to poetry which was suggestive or 'animist'.

In this way, Europe accepted the coexistence of two very opposite ways of thought. One is the literary, the other the scientific. This distinction was to be made likewise in schools and universities.

From Romanticism to Impressionism

The literary approach had been given opportunities by Romanticism. The experimental or scientific approach gained more and more strength as a result of its discoveries and their adaptations, and in effect prepared for an annihilating counter-attack on the 'animist' way of thinking. From about 1850 scientific thought laid claim to literature and art through the Realist movement. It gained ascendancy over the moral sciences and philosophy, and even made attempts to dominate religion through Auguste Comte's positivism, which he himself pressed to its extreme limits. As science took to itself responsibility for the whole future of humanity it led art into accepting its technique of objective observation, and this way of thinking

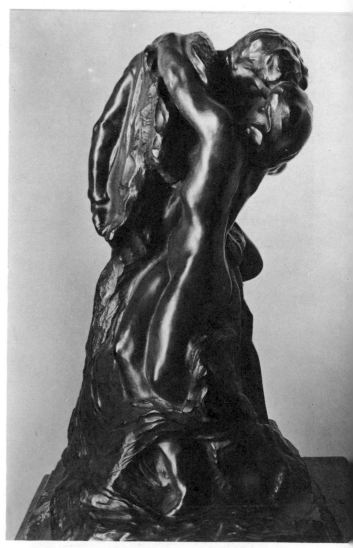

359. FRENCH. AUGUSTE RODIN (1840–1917). Romeo and Juliet. Bronze. 1902. *Musée Rodin, Paris.*

100

360. FRENCH. H. DE TOULOUSE-LAUTREC (1864–1901).
Au Nouveau Cirque: The Five Shirt Fronts. 1891. Oil on
cardboard. *Philadelphia Museum of Art.*

VOLUME DESTROYED BY LINE

*Realism instinctively drew from ' material evidence ' the
solid substance of objects which can be perceived by the sense
of touch. At the end of the century, Symbolism brought
back the value of intuition. Solidity lost its importance:
instead artists preferred undulating arabesques bounding
flat areas of colour or tone. This feeling affected not
only graphic artists [361], but also painters such as
Gauguin and Toulouse-Lautrec [360]. The influence of the
Japanese colour print was visible in the work of van Gogh
and Mary Cassatt [362].*
*Even in sculpture, primarily an art of volumes, the forms
became softened and fused [359]. Architecture was affected
in its turn and a new style evolved. This ' Art Nouveau ' style
also reigned over the decorative arts, where the flowing
curves were carried to such excess that they provoked the
ridicule of caricaturists [364].*

363. SPAIN. ANTONI GAUDÍ (1852–1926). Casa Milá,
Barcelona. 1905–1910. Detail of the façade.

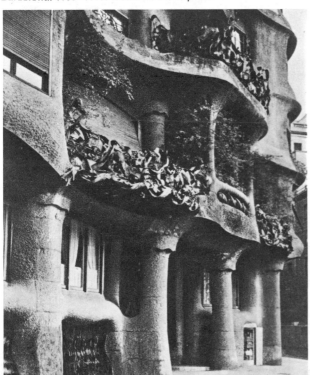

361. SWISS. T. STEINLEN (1859–1923). Declaration
(Songs of the ' Chat Noir '). Lithograph.

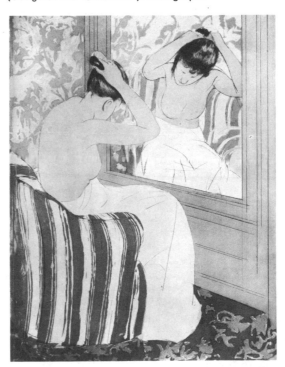

362. AMERICAN. MARY CASSATT (1845–1926). Woman
doing her hair. Coloured dry-point.

364. AUSTRIAN. Caricature from *L'Assiette au Beurre*,
special number on Art Nouveau (1901), by Raphael Kirchner.

was also applied to resolve the social problems created by the development of the machine. This programme was basic to Realist aesthetics. Millet refused to be moved by politics and the democratic outlook. His art was dedicated to the life of the peasant in the fields. Daumier, in a similar way, was moved by the force of Romanticism and translated it into a large and grandiose vision. Daumier, however, went one stage further and accepted politics. His people were the newcomers in the towns — the proletariat. It was Courbet who finally accepted the Realist and socialist credo. Courbet's art had first passed through the Romantic pictures of his youth, with their Rembrandtesque chiaroscuro, such as *The Cello Player* and the *Après-Dîner à Ornans*. His friends, and especially Proudhon, led him to a total acceptance of objective Realism, in art and in politics. Nevertheless into his ambition to go beyond the frontiers of the art of painting and to be associated with aims basically foreign to him, there entered the last remnants of ' literature'. The generation which followed Courbet found a more accurate pictorial solution to the 'scientific' problem. They accepted the idea of Realist objectivity, but took it to the point of optical objectivity. Impressionism was born; it was the supreme pictorial incarnation of the Realism of the 19th century, even though it was to precipitate the downfall of this very Realism. From one point of view, Impressionism was the most refined expression of Realist aesthetics; from the other point of view, it opened the way for 20th-century art, with all its audacity, subjectivity and 'animism'. This apparent paradox requires justification and explanation by careful examination.

Firstly, Impressionism would seem to be merely a new episode in the development of Realism, resulting from the increasing pressure of scientific scruples. From Descartes onwards scientists had avoided preconceived ideas and theories, in order to work strictly from data gained by experience. 18th-century thought, strengthened by English psychological studies, led to defining ' experience', from which man's mind derives everything, as the exercise of the senses. The senses became the primary elements for the whole elaboration of the study of psychology. Everything else was only the result of mental organisation due to the physical structure of the mind. E. B. de Condillac in France made use of the philosophic doctrines expressed by Locke in England: the senses were the origin of human knowledge which could afterwards be applied by means of thought. In 1754 Condillac published his *Traité des Sensations* which set out a conception supported by studies in all the sciences, and which for a long time seemed to have the force of a law. In the 19th century, using Condillac as the starting point, scientists believed that if instead of approaching the object which caused the sensation they approached directly to the sensation itself they would penetrate into the world of psychology. In the middle of the century the Germans undertook a systematic study on these lines. W. Weber published in 1851 a work on the sense of touch; and G. T. Fechner in 1860 set forth his studies of the elements of psycho-physiology. W. Wundt set up a laboratory in Leipzig for the study of psycho-physiology, and his studies were soon followed and extended in other countries. Optical studies had already been undertaken in France by M. E. Chevreul, who influenced the Post-Impressionist painters, in particular Seurat. Research by H. L. F. von Helmholtz in Germany brought more and more attention to the analysis of physical sensation.

It was no longer sufficient to speak of the ' real', a philosophic term; it became necessary to state precisely, and to investigate, optical truth, which for the painter amounts to visual perception. It would be to no purpose to argue how much the artists knew about these scientific studies; what is important is that through conversations and articles they developed a questioning attitude which, however confused it may have been, could not but affect their conception of reality.

Even though the Graeco-Roman tradition had resulted in the development of science, there followed an unexpected break in its evolution. The rational outlook had given art a basis of forms, which the mind assembled in space from the confused data of experience. In order to return to the source of this experience, it became necessary to analyse the senses themselves, as they were the primary means of knowing the exterior world. To do this, the forms had to be eliminated, as well as the ideas which belonged to the mind. When one looks at an apple and sees that it is round, one is already interpreting a colour sensation received by the eye. Proust represented the Impressionist painter in the character of Elstir when he wrote *Le Côté de Guermantes*, and he explained this: ' Surfaces and volumes are quite independent of the names of the objects, which our memory imposes on them, once they are recognised…Elstir tried to separate what he saw from what he already knew. He often succeeded in dissolving that product of reason that we call vision.' Proust's character, in *A l'Ombre des Jeunes Filles en Fleurs*, ' cast off, in the presence of reality, all the ideas of the mind'. Therefore to construct a form is to interpose an intellectual idea because of the complexity of visual sensations. Courbet's Realism had already suggested this. There is a well known story about him that when asked what he was painting he had to step back and look at his canvas before he could reply: ' It is a faggot!' Whilst painting he did not think, but asked only that his hand should automatically reconstitute in paint what his eye registered. Courbet had renounced the classical representation by means of form and substituted a rendering by material means, by paint which was the equivalent of what he saw.

The Impressionists' elimination of matter

Impressionism, which derived from Courbet, was to go further. The Realism of the middle of the century was materialist. There was a kind of concrete security in the density and actual presence of material which corresponded to the demands of science. Sensation is as distinct from matter as it is from form. The eye perceives simply luminous spots modulated in colour which merely correspond to the wavelength of the light acting on the optic nerve. Courbet had complete faith in material reality, but the question now was whether material possessed any more ' reality' than form. The Impressionists intuitively thought not, and they proceeded to eliminate the last element of cohesion, which would enable things to be recognisably defined. Thus the Impressionists, while achieving the most scientific vision known till then, at the same time dealt a mortal blow to that Realism of which they believed their art to be the apotheosis. The rendering of the form or the material of visible things in the eyes of the public gave these things their essential identity. By trying to reproduce more exactly what was seen by the eye the Impressionists gave the public, accustomed to academic painting, the idea that painting had stopped imitating nature. Impressionism brought Realism to its greatest heights, but unwittingly allowed, for the first time in the West, the conception of a painting which would renounce nature. Unconsciously Impressionism had liberated art for the audacity of 20th-century developments.

It is possible to follow the slow and surprising development of art which, tackling the problem of solidity, progressively suppressed form and matter and ended with the pure luminous irradiation seized on by the Impressionists. At the beginning of the century the classical painter had represented nature by

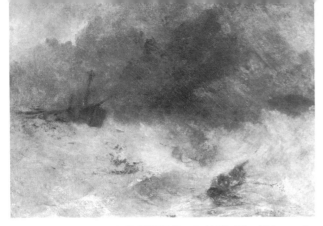

365. BRITISH. J. M. W. TURNER (1775–1851). The Shipwreck. *National Gallery, Ottawa.*

366. FRENCH. J. B. C. COROT (1796–1875). Landscape. Formerly in a private collection in the U.S.S.R.

VOLUME DESTROYED BY LIGHT

Form was attacked on one front by line and on the other by light. ' Form is mysterious,' wrote Plotinus. The arabesque rendered it in a flowing and inconsistent shape. Light went further: it disintegrated and volatilised it.
Turner had already rendered the whirling forces of water and air [365]; Corot bathed his landscapes in mist where all became indistinct [366]. They prepared the way for the radical innovation of Impressionism where space is filled only with luminous vibrations. Its successors went further. The landscapes of van Gogh were whipped up into a tempestuous frenzy [367]. Seurat's landscapes seem to be covered with ' atomic ' dust [369]. In this way Post-Impressionism [368] evolved. Under the pretext of optical truth, the century ended with an amorphous mass of broken brush-strokes [370]. Form and mass had become completely fragmented.

367. FRENCH. VINCENT VAN GOGH (1853–1890). Cornfield. *Municipal Museums, Amsterdam.*

368. FRENCH. HENRI EDMOND CROSS (1856–1910). Les Iles d'Or. *Musée d'Art Moderne, Paris.*

370. Detail of 368 much enlarged.

369. FRENCH. GEORGES SEURAT (1859–1891). Cornfield. About 1885. *Home House Collection, on loan to the Courtauld Institute, London.*

155

masses solidly defined by their contours. Paul de Saint-Victor praised C. F. T. Aligny as a 'landscape sculptor'; and Taine admired Bidault for his 'anatomy of the soil'. The Barbizon artists emphasised the heavy density of tree trunks and compact massing of foliage, and their skies were reflected in the mirror of the still water which later was increasingly used to soften and dissolve landscapes. Already in Courbet one senses a certain dampness in nature which made things softer and more supple; the greenery became almost spongy and the earth loamy. In his *Wave* a massive and dense volume of water is about to fall and break into spreading foam. With Corot water began to flow and vaporise; it scintillated with light and became diffused into vapour. The contours everywhere became melted by the effect of reflection or vapour. Chintreuil's work suggests a painting of immaterial air combining light and space. About 1860 Baudelaire expressed the delight to be found 'in the changeable, the fugitive and the infinite'. From Verlaine to Debussy the 'vague' and the 'soluble' flowed through poetry as in music. (I have made a more complete study of this, which appeared in *L'Amour de l'Art*, February 1939.)

This 'process of dematerialisation' which took place during the 19th century worked in two ways. The first, the most tentative, reduced form and strong lines to soft fluid undulations. This occurred in the linear quality of Gauguin's work, influenced by the Japanese arabesque, and also in the sculpture of Rodin and Medardo Rosso. It led to Art Nouveau, which was called the 'noodle style' by its detractors. Secondly, there was the development away from linear constraints to a complete volatilisation of matter. It became a complete disintegration of matter into energy expressed by light. Colours were applied in dots of absolute purity, and nature vibrated with infinite modulations in which the passage from one form to another became indistinct or was lost.

Once again it is possible to establish the surprising connections which exist between the artist's vision and current thought. This dematerialised vision concurs with the unforeseen ideas which were simultaneously being elaborated by scientists. Scientists had begun to reconsider material and our ideas of it. In the study mentioned above I attempted to show that art and science followed parallel paths — that matter considered as light ultimately resulted at the turn of the century in the final reality of energy. Faraday conceived the idea of the atom as the ultimate minute body, and went so far that P. Janet in his *Leçons d'Electricité* was able to write: 'The world we live in is composed of two distinct worlds, the world of matter and the world of energy.' Within a few years, Reichenbach arrived at the fundamental identity of mass and electricity. Lecomte du Nouy, in *Le Temps et la Vie*, wrote: 'The properties of things are due to the movements of the elements which seem to have no other existence outside this movement' because they seem 'to be composed of pure speed, that is to say, of space in time'. The Impressionist vision would seem to make use of such a concept, and it even anticipated it, for art, with its incredible sensitivity, is always the first to record changes in thought. Clemenceau, an old friend of Monet and a man of vast culture, remarked of *The Water-lilies* that they were 'the pictorial equivalent of Brownian movement'. (Robert Brown, a Scot, had discovered the oscillating movement of infinitely tiny particles in liquids.) Clemenceau continued: 'They are separated by all that distance between science and art and have at the same time the unity of all cosmic phenomena.'

This theme is the basis of this history of art. It is only a short step to show how in the 20th century the art which followed Impressionism, by abandoning the tangible and logical appearances of reality, was in the same line of thought as the inspired guesses of science, which in both cases led to a new interpretation of the world. Delevsky, in an examination of scientific thought, wrote in 1938: 'Modern physics uses mathematical symbols which strangely seem to pin down reality...Energy, the fundamental basis of the universe, must likewise be treated as a mathematical abstraction.' Sir James Jeans confessed that all these concepts seemed to him to be the product of pure thought which could not be achieved in any material sense. The proposition put forward by science bears a striking resemblance to the freedom and daring of abstract art.

The 19th century ended in an unexpected confusion of subjectivity, 'animism' and Romanticism on the one hand with objectivity, logical understanding and positivism on the other, and this led to a split in Western culture in its concept of reality.

To say that reality exists only in sensation, that is, in the impression one receives, seems to place it once more in man's senses. The change in vision between Théodore Rousseau or Courbet and Monet in his late works seems to illustrate this. Monet, when he painted his haystack or cathedral 'series' in successive canvases, emphasised the discontinuity and lack of identity between different aspects of a single object, seen at different moments in time. He seems to think of 'reality' as existing in time rather than in space. It should be remembered that Berkeley, a contemporary of the 18th-century English sensualists, had thrown doubt on the reality of the exterior world, and had come to similar conclusions on subjectivity.

Impressionism had not completed its course when art seemed to somersault into the interior universe, where it was to be ruled by the subjective experiences of the artist himself. Art ceased to be attached to the physical world, to which the Realists thought they had finally anchored it. The last artists belonging to Impressionism went further than Monet or Renoir. Monet had assimilated the 'real' as luminous energy vibrating on his retina, and Renoir saw in it only a sign of pulsating life. But now Gauguin led it towards symbolism which, opposed to scientific positivism, had stemmed from the tradition of Delacroix to Baudelaire and Odilon Redon. The visible world was to be thought of as the image of spiritual realities. Van Gogh, essentially a Romantic individualist, used it only to bear the sharp imprint of his own personal drama. As the appearance of things was released from the need for objective veracity, the things began to lose their concrete existence. From now on they were used as signs or symbols by which the artist conveys spiritual truths, general or personal, felt intuitively by him.

The West bypassed its internal contradictions and seemed to aspire to a new understanding of life and of the 'real' which overflowed its accustomed concept on all sides. A curious proof of this change is that the West drew nearer to the East in its thought, not only superficially by 'exotic' curiosity, but quite suddenly seemed to be able to assimilate and even imitate Eastern thought. Manet and the artists who followed him, especially Gauguin and van Gogh, opened the way to our understanding of the civilisations most foreign to our ways, and furthest removed in space and in spirit, such as Japan and the South Sea Islands. Thus art, by its profound sensitivity, enables us to understand the changes through which the most firmly established societies continue to evolve.

FRENCH. CLAUDE MONET (1840–1926).
The Gare St Lazare. 1877.
Louvre. *Photo: Michael Holford.*

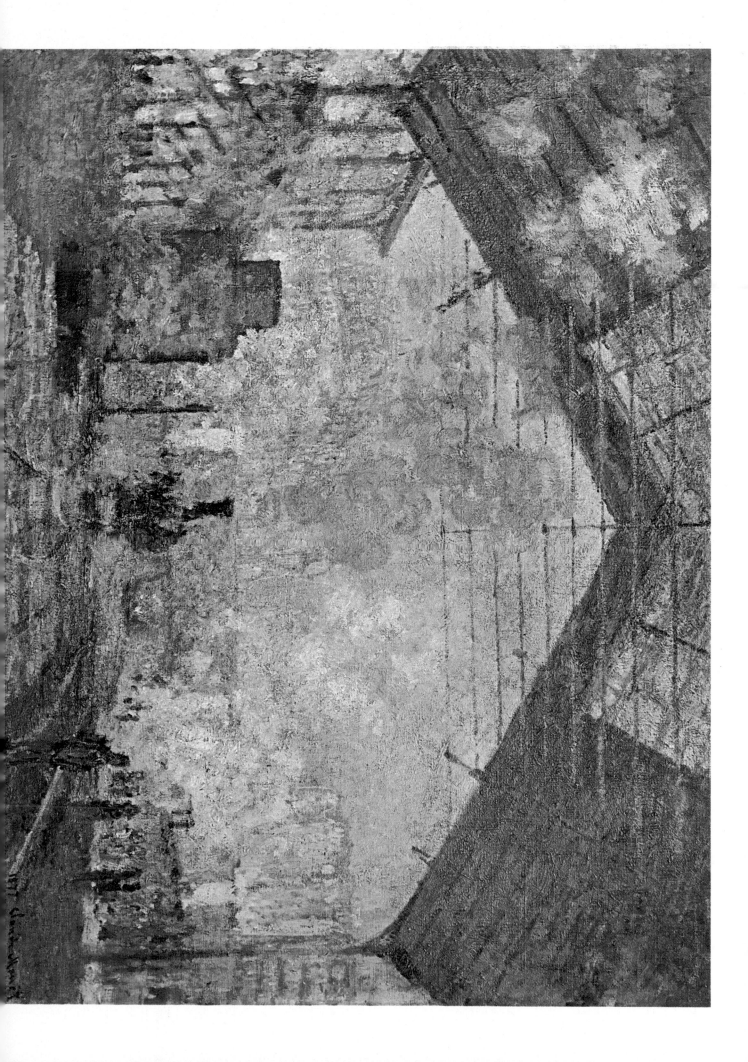

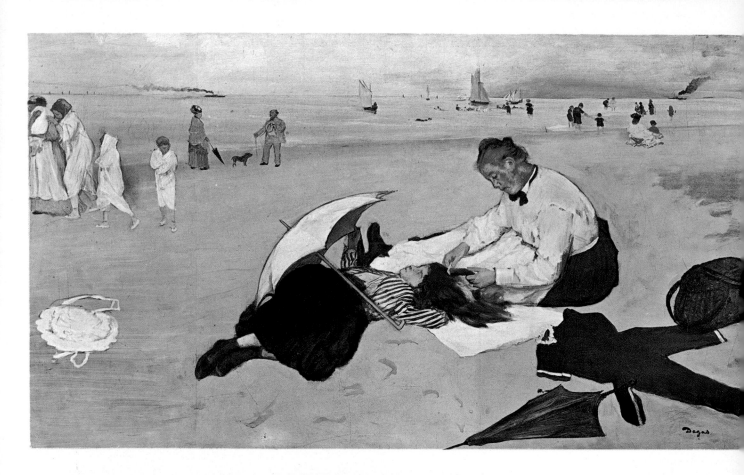

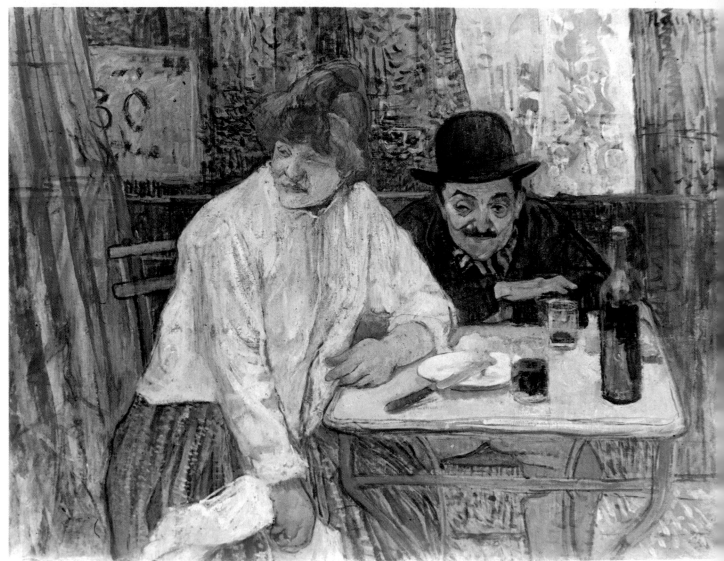

THE REALIST MOVEMENT *Bernard Dorival*

Life in the middle of the 19th century was completely changed by the growth of science and industry. This resulted in art and taste developing steadily in the direction of realism. To begin with, this new orientation was strongly felt in France and later spread throughout Europe. It became intermingled with early 19th-century art, which was divided between Romanticism and classicism.

In France, from 1830 to 1840, the Romantic outlook showed signs of decline. It is difficult to pick out the symptoms of this decline, for Romantic art was to survive for many years yet, continuing in the works of Rodin, Gustave Moreau and Odilon Redon.

In literature, the works of Baudelaire and Rimbaud continued Romanticism up to the Symbolist movement and even as far as Claudel and Barbey d'Aurevilly, and Villiers de l'Isle-Adam extended it as far as Huysmans, Léon Bloy and Barrès. Zola deeply regretted the false education which Romanticism had given him, but nevertheless recognised that fundamentally he belonged to that school. Many others throughout Europe and even in America belonged to or had their roots in this Romanticism: Poe, Whitman, Nietzsche, Wagner and Ruskin, and later Tolstoy, Tchaikovsky, Kipling and D'Annunzio, may all be included. In many respects the aesthetic outlook of the entire 19th century may be regarded as Romantic.

It is equally true to say that from the time of the 1830 revolution the Romantic movement was on the wane. From 1830 until 1860 a new and very different spirit was growing. The Romantics avoided contemporary reality by losing themselves in the past or in distant lands; they tended towards pessimism or religiosity, and in general were subjective in their outlook. The new movement, on the other hand, idolised the present moment and the immediate surroundings. They believed in progress, they were materialistic, and above all they approached their work in a spirit of objective observation.

The development of the objective outlook

The most important characteristic of the new spirit which was spreading throughout Europe, was the multiplication of scientific discoveries. Physics made decisive strides through the work of Helmholtz, Carnot, Joule and Maxwell; a little later chemistry made important advances in the work of Sainte-Claire Deville and Berthelot. Darwin published various papers as early as 1839 which were virtually a prelude to his *Origin of Species* which was to come twenty years later. In 1849 Claude Bernard discovered the glycogenic function of the liver, thereby establishing at the same time both modern biology and modern medicine. The new scientific spirit permeated secular and religious historical studies. *The Life of Jesus*, written in 1833 by Strauss, was 28 years before the one by Renan. And it may be claimed that the new outlook also penetrated the study of sociology. The study of pure philosophical truth by Cournot was superseded by the study of natural phenomena in the

objective reality of things by Claude Bernard. John Stuart Mill and Auguste Comte had no time for metaphysics, and passed instead to scientific method.

Science made claims on the place held by religion. The practical applications of scientific discoveries took the form of a succession of inventions. As a dazzled and grateful public began to accept the idea of progress, so the inroads of science on religion became so much greater. An age of riches stretched into the future, and the Romantic nostalgia became a thing of the past, as may be seen in the development of Lamartine, Hugo, George Sand and Michelet. The change from the spirit of the past to that of the future was effected with much greater ease than the dechristianisation of the obscurantist Dark Ages, denounced by Monsieur Homais, a character in *Madame Bovary*. The religion of the *vil Galiléen* (Leconte de Lisle) became exposed to the attacks of free-thinkers, socialists and freemasons.

The new and positive thought infiltrated into literature, bringing at the same time fresh subject matter and fresh attitudes. The writer began to realise that he had his subject matter immediately around him, in the life of his own time, in the setting of his own environment. Finished were the excursions into the past, into distant lands and into mythical worlds. Lamartine, in his *Jocelyn* (1837), was affected by this taste for the contemporary, as was Sainte-Beuve in his *Vie, Poésies et Pensées de Joseph Delorme* (1829). Balzac exercised a fascination over the novelists. In the theatre in 1843, the *Burgraves* was a failure, whereas a pseudo-classic by Ponsard, *Lucrèce*, was a success. More significant, however, is that the audience were enraptured by *Un Caprice* (1847) staged by de Musset. In this play the actors belonged to the period and spoke in the contemporary idiom instead of the artificial declamations of the Romantics.

371. FRENCH. AIMÉ JULES DALOU (1838–1902). Woman Reading. About 1880. *Petit Palais, Paris.*

Another version of this favourite theme shows the model nude.

FRENCH. EDGAR DEGAS (1834–1917).
Bains de Mer: Petite Fille Peignée par sa Bonne.
National Gallery, London.
Photo: Michael Holford.

FRENCH. HENRI DE TOULOUSE-LAUTREC (1864–1901).
A la Mie.
Museum of Fine Arts, Boston. *Museum photograph.*

442
444

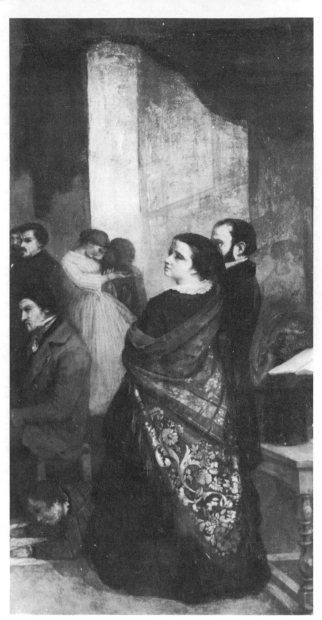

372. FRENCH. GUSTAVE COURBET (1819–1877). The Painter's Studio (detail). 1855. See colour plate p. 105. *Louvre.*

This new interest in the contemporary scene derived its outlook from the world of science. Leconte de Lisle, in the preface to his *Poèmes Antiques* (1852), wrote: ' Poetry looks to science in order to relearn forgotten traditions.' Zola admitted in an article called ' Mon Salon ' published in *L'Evénement* in 1866: ' The wind lies with science; we are forced, despite ourselves, to undertake a scrupulous and objective study of the facts.' As a result it became necessary for the writer to examine his subject matter with the same observation, analysis and objectivity that the physicist brings to the study of a scientific phenomenon. Further, the writer had to set his material down conscientiously and impersonally, in precise detail, just as a doctor describes the state of a patient, before attempting diagnosis. Imagination, which Delacroix had described as being the queen of human faculties, was no longer fashionable. Flaubert wrote that we should aim at true representation, and Dickens that what he wanted were the facts and that the word ' imagination ' must be banished for ever. The literal observation of facts penetrated literature, the theatre and the novel. In France two literary events marked its triumph and are like symbols in its struggle for victory: firstly the publication in 1852 of Dumas's play *La Dame aux Camélias*, and secondly in

1857 the lawsuit — and acquittal — of Flaubert following the publication in 1856 of *Madame Bovary*.

In painting the new spirit of objectivity is seen in the movement which is called Realism. The name is far from ideal and is even less appropriate than those of Romanticism, Baroque, or Gothic. Since the 15th century artists had struggled to represent reality. From time to time artists had chosen to paint the life and people of their time, and the landscape that surrounded them. This was especially so in the 17th century in the works of Caravaggio and his school, and of the Dutch artists. That the period between Romanticism and Impressionism should be called Realism is unfortunate when there have been other periods and schools where the same underlying aesthetic aims may be found. But the painters of the period, those in favour of Realism as well as those against, themselves gave the movement this title. In 1850 Delécluze described, with horror, the *Funeral at Ornans*: ' Realism is a barbarous style of painting **384** where art is debased and degraded.' In the same year, in a revue by Banville, one of the characters, referring undoubtedly to Courbet, remarked: ' To represent truth is nothing; to be Realist it is ugliness that counts.' Five years later Courbet himself confirmed the title: ' Realism by Gustave Courbet — Exhibition of forty of his works.' He placed this inscription on the pavilion in the Place de l'Alma, Paris, where he organised an exhibition in 1855; the purpose of the exhibition was to protest against the Salon for slighting him. There were, however, reservations which he made in the preface to the catalogue: ' The title of Realism has been imposed on me, just as the title of Romantic was imposed on the artists of 1830.' Then he added, immediately afterwards, that titles had never given, at any time, a true description. He later used the term frequently in defining his art. In *Le Précurseur d'Anvers* of 2nd August 1861, he stated: ' The heart of Realism is in the negation of the ideal.' However, the important fact is that his contemporaries made use of the title ' Realism ', which became accepted by general use. In 1856 Duranty used the title *Le Réalisme* for a journal which he founded, and Champfleury used the same title for a book he published the following year.

The word ' Realism ', then, must be accepted for the style existing from the time of the Second Republic to the beginning of the Second Empire. This acceptance, however, must not be allowed to conceal that there were pictures painted in this spirit before 1848, and that there were others painted up to and even after the end of the reign of Napoleon III. A pre-Realism became apparent in the middle of the Romantic period, and a post-Realism continued side by side with Impressionism. The first prepared for, the second prolonged, and the two together framed the period of Realism. From these neighbours, Realism gained its personality and ultimately its various offshoots.

The beginnings of Realism, 1830–1848

The French artists of the Romantic period frequently looked back into history for heroic or colourful subject matter, or they turned to Turkey or North Africa for the exotic. Some of the greatest among them found in contemporary life and in their own French landscape subjects with a beauty or picturesque quality, which often they were able to express with fluency.

There were several factors which caused painters to take a greater interest in reality. They were living in a bourgeois society, and though they were in conflict with it, and though they treated the bourgeois as Philistines, they nevertheless shared their tastes. All bourgeois societies, for example in 15th-century Flanders and again in 17th-century Holland, have shown a liking for pictures which relate to themselves, their environment and their day-to-day life. Rather than paintings

of medieval or Oriental subjects the ordinary Frenchman preferred French themes such as those based on the character of Monsieur Prudhomme, especially when they attempted the picturesque anecdote. Monsieur Joseph Prudhomme expressed the pompous stupidities of a caricatured middle class bourgeois; he was the creation of the writer and caricaturist Henri Monnier. With the exception of the greatest painters, few artists rebelled against anecdotal subject matter.

109
112
136
Artists were more willing to use this bourgeois realism because English and Dutch painters whom they most admired had revealed its possibilities. Constable met success when he exhibited at the Salon in 1824. The works of Girtin, Glover and Crome had become known in France. Bonington spent the greater part of his life in France. Frenchmen were delighted with the stables of George Morland, the animals of Sir Edwin Landseer, the amusing or sentimental anecdotes of C. R. Leslie and Sir David Wilkie, and the story-telling of William Mulready. Yet the French looked to Amsterdam even more than towards London. Balzac's character Cousin Pons gathered together a miscellaneous collection of Dutch pictures, both good and bad. In the Rijksmuseum and in the Mauritshuis Fromentin, author of *Les Maîtres d'Autrefois*, not only makes the reader pause in front of landscapes by Ruisdael, but also in front of *The Bull* by Paulus Potter. Thoré-Bürger 'discovered' Vermeer; the less well informed average collector raved over Dou, Mieris and van Ostade. So great was the reputation of Netherlandish painting that everything about it seemed admirable. Never had it received so much acclamation in France, not even during the 18th century. It is not surprising, therefore, that the 18th-century style likewise regained the popularity which it had lost with the rise of David. The painters who had continued this tradition under the Revolution and the Empire gained in popularity too. L. L. Boilly, Martin Drolling and J. L. Demarne passed on the lessons of the minor masters of the reign of Louis XV to those of the reign of Louis Philippe. The style was so much appreciated that it attracted pasticheurs, such as C. E. Wattier and P. F. E. Giraud.

To these influences which affected the pre-Realism of the July monarchy should be added those coming from Spain. Since the end of the 18th century Spanish art had been appreciated in France. Fragonard had been inspired by Murillo. During the Napoleonic wars many fine Spanish paintings had been looted and had found their way into the Louvre and into private collections, in particular that of Marshal Soult. The example of these great masters, as well as those of the Italian 17th century admired so much by Stendhal, strongly affected the Xavier Sigalon of *La Jeune Courtisane* (Salon of 1822). Etchings by Goya had become widespread since the Empire, and Delacroix, as a young man, had sketched some of the prints which he admired. Yet nevertheless it was only in the Louis Philippe Gallery that a Frenchman could form a complete idea of Spanish painting. It was not until 1838 that these treasures became generally accessible, and this was too late for them to have a determining influence on the painters of the pre-Realist generation. Spanish works by Velasquez, Zurbarán, Murillo, Ribera and Goya were to affect not so much the Realist artists — Courbet and Bonvin were more influenced by the Dutch than the Spanish — but those artists who were in their adolescence during the period 1838 to 1848. Pre-Realism, then, was not influenced by the proud and aristocratic quality, the poetry and grandeur, of 17th-century Spanish realism. It was drawn instead towards the bourgeois outlook to be found in English and Dutch art and in the little masters of the French 18th century. The pre-Realist artists, therefore, tended to turn towards landscape, animal painting and, finally, genre.

The discovery of French landscape

The Prix de Rome for 'historical landscape' was founded in 1817, and this hallowed the Neoclassical landscape with all its convention and pedantry. Against this style the Romantic landscape painters preferred to paint the landscape of their own country, just as Ruisdael, Hobbema, Crome and Constable had done, and as the Frenchman Georges Michel had already done. 108
128 The painting of their own landscape was the first step towards objective reality. Michel was the forerunner of genius, who not only paved the way for Romanticism, but also seemed to foreshadow Fauvism by the breadth of his vision and the expressionist lyricism of his brush work. These French landscapes were peopled with ordinary peasants in place of the old classical heroes. Nothing was lacking in the works of a Paul Huet for 348 his paintings to be faithful images of French nature and French reality. He did not attempt effects such as the theatrical *mise en scène*, which at the time was strongly influenced by the popular diorama. He was less interested in literary subject matter, and he avoided the artificial intrusion of poetry. Whilst the works of Huet had something rhetorical about them, this became a sort of pantheistic mysticism and adoration of the infinitely little in the art of Charles de la Berge — who strongly influenced Théodore Rousseau.

The aim of Rousseau was to be more direct and more objective. His proud genius affected Jules Dupré and V. N. Diaz de la Peña, and attracted them to the village of Barbizon in the forest of Fontainebleau, where the group thus formed about 1830 became known as the Barbizon school. Though unjustly neglected at the present day, this school deserves attention both for the quality of the works and for the historical importance of the movement. It may be added that the finest works by Rousseau count among the masterpieces of 19th- 373 century landscape. Rousseau and his followers renounced the picturesque, they renounced the anecdotal interpretation of nature which had encumbered the works of the Romantics, and they renounced the elaboration of the scene or the heightening of the emotional tension. Instead they applied themselves passionately to the analysis of reality. They analysed the structure of a tree, their main motif, just as the 15th-century Italians studied the anatomy of the human figure. They turned their attention to the form of the ground itself, to the sense of space, to the limitless unfolding of planes and to the representation of atmosphere. According to a brilliant dictum of Rousseau, the atmosphere should be 'modelled to infinity', and light itself became the object of their scrupulous examination. From the foregoing a synthesis resulted giving to the whole cohesion, power and poetry. They were lovers of nature, and they painted portraits of nature. Nothing was sacrificed; a brushstroke would render solidity and at the same time give the sense of rugged life. Rousseau stated accurately their feelings: ' Our art can only move the onlooker through its sincerity.'

Sincerity was the outstanding merit of his work and the basis of his innovation, and this sincerity was turned towards pathos in the work of Rousseau and his friends. They belonged to their century, they felt nature intensely, loved it jealously and with so much pleasure. Their shy melancholy projects into their landscapes a restrained lyricism which runs throughout their work. This lyricism tends to lead them back towards drama, by which convention again creeps into their pictures. Sometimes their paintings became *machinées* to excess — the word used by Rousseau. This tendency was most marked in major works carried out entirely in the studio, away from the open-air source of inspiration which had given them birth. The results showed a weakness which echoed the taste of their time for the highly finished glossy painting. Also as innovators they could

373. FRENCH. THÉODORE ROUSSEAU (1812–1867). The Oak Trees. *Louvre.*

374. FRENCH. CHARLES DAUBIGNY (1817–1878). The Seine at Bezons. About 1855–1860. *Louvre.*

Realism is developing towards Impressionism.

375. FRENCH. CHARLES JACQUES (1813–1894). La Bergerie. 1881. *Louvre.*

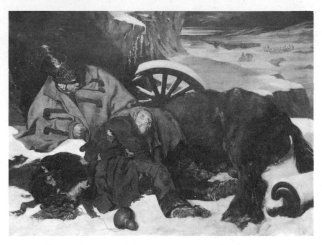

376. FRENCH. J. F. BOISSARD DE BOISDENIER (1813–1866). Episode during the Retreat from Moscow. 1835. *Rouen Museum.*

377. FRENCH. FRANÇOIS BONVIN (1817–1887). Still Life. *Matsukata Collection, Japan.*

not avoid leaning upon the past in developing their new language. Thus, the treatment sometimes detracted from the truth and the sincerity of their work. Even though the images are correct, even though they are touching and often moving, they remain unreal. The air does not circulate and the light does not vibrate. This is the reason for their neglect by our contemporaries who have been brought up on Impressionism, which scarcely ever looked back to the Barbizon school.

The Barbizon painters had a powerful influence on the generation of Realists who followed them. They taught them that all landscape, not only the picturesque, was beautiful. They taught them to look at landscape and to copy it with humility. They also bequeathed to them their sensibility with its powerful and permanent qualities, and they gave them the gift of being able to render landscape with grandeur. The landscapes of Courbet owed much to the Barbizon school, which however had little influence abroad.

Besides being the residence for landscape painters, Barbizon was also the centre for animal painters, who devoted a similar loving patience to the study of animals. If one compares the neat and tidy bulls of J. R. Brascassat with the robust and convincing beasts to be found in the best work of Constant Troyon or of Rosa Bonheur, one can see immediately what is meant by the spirit of Barbizon. These artists became victims of a success that forced them to multiply their production, and it is perhaps to the work of Charles Jacques that we should turn to see the Barbizon spirit expressed at its best, and to his etchings rather than to his paintings. His observation was fortunately animated

375

378. FRENCH. JEAN FRANÇOIS MILLET (1814–1875).
Hameau-Cousin. About 1871. *Reims Museum.*

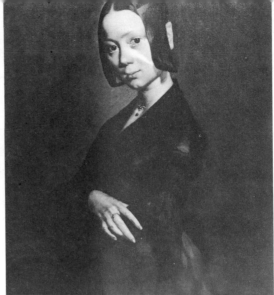

379. FRENCH. JEAN FRANÇOIS MILLET (1814–1875).
Portrait of Mlle Ono. About 1841. *Cherbourg Museum.*

380. FRENCH. JEAN FRANÇOIS MILLET (1814–1875). The
Man with the Hoe. 1862. *San Francisco Museum of Art.*

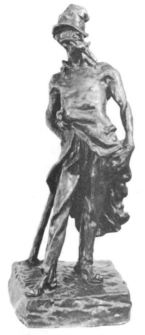 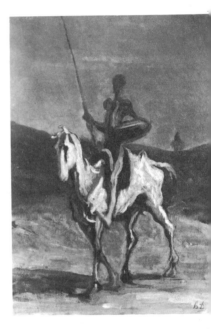

381. FRENCH. HONORÉ DAUMIER (1808–1879). Ratapoil.
Bronze statuette. About 1850. *Louvre.*

382. FRENCH. HONORÉ DAUMIER (1808–1879). Don Quixote.
Bavarian State Collections, Munich.

383. FRENCH. HONORÉ DAUMIER (1808–1879). La Fine
Bouteille. Watercolour. 1856–1860. *National Museum,
Stockholm.*

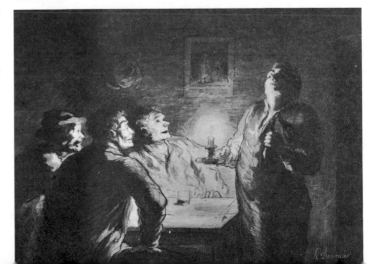

by a discreet and slightly prosaic poetry, which saved it from
banality. By contrast the horses of Alfred Dedreux had elegance
and a certain monotonous panache. They remained convincing
even though the artist sacrificed himself to the artificial
brilliance demanded by the English gentry. In his own subject
he represented that mundane realism which was partly respon-
sible for the genre painting of the period. With Roqueplan
and Jadin, he was much indebted to British animal painting.

Genre and contemporary life

Genre pictures have nearly always been painted with a facile
technique and an acute but unsympathetic observation. This is
405 so in the spirited oils and watercolours of Eugène Lami, which
were more successful than his military scenes. It is so in the
witty love scenes of J. P. A. Tassaert, his best work, and also in
his more frequent scenes of the poor, even when he reaches his
most sentimental. It is likewise to be found in the caricatures of
Henri Monnier who created Monsieur Prudhomme, the bour-
geois type full of solemn and stupid remarks. And it is also to
be found in the watercolours and lithographs of Gavarni, which
with faultless drawing, humour and bite reveal the society of
the period. Little of all this was to influence the art which
followed, apart from its realism, a feeling for the pace of modern
life and a certain ephemeral charm. Constantin Guys made use
of these qualities in his little masterpieces, and thereby passed
them on to the Impressionists.

 If A. G. Decamps had not frequently abandoned his Oriental
subjects in favour of contemporary French themes, there would

have been little of value in the subject of 'genre' for the Realists who immediately followed the Romantics. Decamps was excessively praised in his own day, though he is now, perhaps unjustly, neglected. Apart from his animal scenes inspired by La Fontaine, he often painted the life of the town or the country. In his works the unity of design, the fullness of form and the economy of colour controlled by the chiaroscuro derive from the analytical approach of Ingres and the colour of Delacroix. These qualities were used in a new way and were to pass into Realist painting. Apart from his lack of genius, Decamps would have been the equal of Daumier, on whom he had a decisive influence. He felt the heroism of contemporary life and he loved its ordinariness, which inspired both him and his contemporaries.

164

Many painters still felt the glory of the Napoleonic era which was so close in time and so dear to Frenchmen that it had not yet passed into history. Subject matter was drawn from the Napoleonic wars by the military painter N. T. Charlet, and by Auguste Raffet, and occasionally by J. F. Boissard de Bois-denier. During these years when the followers of Saint-Simon joined forces with the followers of de Lamennais, and the liberal Catholics joined with Lamartine and the republicans, many works revealed a love of the lower classes and attempted to create a social art capable, as Decamps remarked, of 'reaching the people and instructing them'. George Sand, in the preface to *La Mare au Diable* (1846) wrote: 'The mission of art is a mission of feeling and love.' And again in *Le Compagnon du Tour de France* (1841): 'One has come to realise that the people are the source of intelligence and inspiration.' Even earlier than the writers, painters had honoured the ordinary workman. As early as 1836 P. A. Jeanron exhibited his *Blacksmiths of Corrèze*, and two years later François Bonhomme painted his *Furnace Workers of Abbainville*.

133, 376

Following the middle class spirit of 1848, the art of the middle classes became an act of love, of teaching and of propaganda. As they wanted to preach democracy, to educate the public and to praise goodness, these painters almost at one go saw everyday reality with fresh eyes. Whereas Decamps and the traditional genre painters only saw in day-to-day life subject matter for the picturesque, these new painters discovered a new dimension which had been felt at an earlier time by the Le Nain brothers, accurately described by Champfleury as the painters of the forgotten. In this way was born the new outlook of the pre-Realist painters who were richer in ideas and more generous in their intentions than they were prolific in major works. To them were indebted the painters of the 1848 generation, the champions of Realism proper.

Realism

The Realists of 1848 were more objective and more direct than the Barbizon painters, in whose work the permanent quality of perceived reality was mingled with certain conventions inherited from Romanticism. They looked at life as did the painters of contemporary genre under Louis Philippe, and they painted it in all its variety, even at its most humble. In painting it, they hoped that it would become ennobled by the love they bore to their subject, and by the gift they had for disclosing its hidden majesty. 'They made use of the trivial in expressing the sublime,' as Millet so aptly said. They responded to the comment of Baudelaire in his *Salon of 1845*: 'It will be painting, true painting, which can extract from the life of today that which is epic and can make us understand…that we are great and poetic in our cravats and our polished boots.' They intensified this magnified picture of contemporary life and social preoccupation until they arrived at the equation: Realist

art=everyday art=social art. This aesthetic equation which suited them so admirably they passed on to their successors (who were to forget it quite suddenly, despite the example of 17th-century Italy, Spain and Holland that the equation was quite unnecessary). The Realists aimed, by the foregoing means, to produce a style of painting which should rest on truth, but they also brought to it a strong poetry which for us remains the finest and most convincing element and is as strong today as it was then. The majesty of this poetry was enhanced by the simplicity of technique, in which the unity and chiaroscuro is related to Géricault and through him to Rembrandt and Caravaggio. Painters such as Félix Trutat, Jules Breton, François Bonvin and some of the Orientalists never achieved the heights of the greatest of their colleagues because of the mediocrity of their talent and their attachment to the past and the formulas of their genre, even though they made so essential a contribution to the art of their time. Félix Trutat, who died prematurely, revealed a wonderful feeling for grandeur in his portraits and in his *Reclining Nude* of 1848. Though the work of Jules Breton is feeble in technique and stereotyped in its sentimentality, van Gogh saw in it 'the precious pearl, the human soul' and a certain touching nobility. Bonvin, like many painters of his time, is unjustly neglected today. Despite the influence of Granet and of 17th-century Holland, Bonvin in his best moments attained a grandeur which owed something to Chardin, as in *La Fontaine de Cuivre* (1863), or to Zurbarán, as in *The Hare*. These pictures are even more permeated by the spirit of his generation, which was made up of generosity and at the same time a sensitivity to familiar things and ordinary people. In the art of Dehodencq there was more truth, and an intense feeling for the teeming quality of life, which may be found in his paintings of the Arabs, the Jews of North Africa and the Andalusian gipsies, with all of whom he showed a brotherly sympathy. In his Orientalism he virtually discarded exoticism. In the case of Fromentin, who was a better critic and novelist than painter, one may find in his precise and sensitive pictures of Algeria and of Egypt a delicately observed visual poetry. The spirit of Realism was able to save mediocre painters from oblivion, and to bring forth a rich harvest from the greatest painters. Especially was this so in the case of Daumier, Millet and Courbet, who may be regarded as the trinity of the movement.

377

Honoré Daumier, as was natural for the oldest of the three, was the one most attached to the spirit of Romanticism. His inspiration, as in the case of Delacroix, was frequently drawn from the Bible, from classical mythology, from literary sources such as La Fontaine, Molière and Cervantes. Examples include *Mary Magdalen* (1848) and *The Good Samaritan* (*c*. 1850) taken from the scriptures; *Oedipus* (1849) and *Nymphs and Satyrs* (*c*. 1850) from mythology; *The Thieves and the Ass* (*c*. 1856) from La Fontaine; *Crispin and Scapin* (*c*. 1860) from Molière and a whole series taken from Cervantes' *Don Quixote*. His preferences among the old masters were also Romantic and led him to imitate Rubens in such a work as *The Miller, his Son and his Ass* (*c*. 1848). His passion for movement and his insight into character which he developed in the practice of caricature were also due to Romanticism. The epic quality which culminated in paintings like *The Emigrants* (1848) relates him to the creators of the Romantic movement, men like Hugo, Michelet, Balzac, Berlioz and Delacroix, who founded an inspired and superhuman universe. He is linked likewise to the irrealist art of the 20th century, to masters such as Rouault, Soutine and the German Expressionists. Daumier, though a visionary artist, also loved to observe the life of his times. He laughed at the bourgeoisie, the doctors and the lawyers; he felt

381-

356 tenderly towards children (*La Ronde*, 1855), towards mothers (*In the Road*, 1850), working women (*The Washerwoman*, 1860), workmen (*The Painter*, c. 1860), circus families (*La Parade*, c. 1866) and all the ordinary people who go to the theatre (*The Melodrama*, c. 1856), visit the public baths (*The First Bath*, c. 1860), or make use of public transport (*The Third Class Railway Carriage*, c. 1862). But Daumier, with his brush, crayon or pen, completely recreated the world he saw. He peopled it with massively and powerfully constructed beings who have a heroic force. Daumier was a sculptor too, among the greatest of the century, and his drawn figures owed much to this. They stand out from a chiaroscuro, which is richer in poetry than in the works of his contemporaries Millet and Courbet, and is on a level with that to be found in the work of Goya and Rembrandt.

Millet was close to Daumier in his treatment of light, in his simply but sculpturally conceived figures, and also in his use of colour. Like Daumier his draughtsmanship was better than his handling of paint, which was more studied and heavier. Millet approached Daumier in the warmth and sympathy he felt towards the peasants. He differed from Daumier in his complete abandonment of Romanticism and also in the direction of his inspiration. Millet did not make a study of the light and shade contrasts, or the characterisation of the individual which Daumier stressed in paintings such as *The Chess Players*. Millet's figures have monumentality without movement. Nearly all his paintings aimed to capture the toil and sweat and suffering of his fellow peasants. Examples include *The Winnower* (1848), *The Sower* (1850), *The Gleaners* (1857), and *The*
380 *Man with the Hoe* (1863). Millet was born in the country and brought up in the fields. In 1849 he moved to Barbizon. It was natural that landscape should occupy in his work a more important place than it did with Daumier, a painter belonging to the town. Millet could understand the voices of the earth and of the sky, and those of the cow bells in the fields. His feeling for nature was that of Jean Jacques Rousseau. It was expressed as a primitive force where the denseness of growth and the ruggedness of the ground (*The Church of Gréville*,
378 *Hameau-Cousin*) echo the timeless way of life of the peasant (*The Cowherd*, 1859; *The Angelus*, 1858–1859; *The Shepherdess*, 1864). By his monumental quality and his sense of the eternal and the universal, Millet represented the classical version of Realism as Daumier represented its Baroque expression. Millet revealed his classical feelings when he said: 'I could spend my life with the work of Poussin and still not be satisfied.' From Poussin's art he was able to introduce into his own that harmony and majesty which make of his works the *Georgics* of painting. It is sad that he should now be underrated.

Courbet and the climax of Realist painting

Millet painted the peasants in the country, Daumier the people in the town. Courbet became the painter of the provinces, of its half-bourgeois half-rural population, and its prosperous market towns. His work might have been prosaic but for a deep love of nature, a sense of the dignity of man and, more important still, the genius of a born painter. Whereas Daumier drew on Romanticism and Millet on Poussin, Courbet developed his art on the example of the Caravaggio school and Rembrandt. It was thus Courbet who was to take Realism to its greatest heights.

Firstly, Courbet was a Realist by his choice of subject matter,
387 based on direct observation — seascapes (*The Wave*), landscapes, especially from the Jura (*The Stream of the Puits Noir*), the animal life of the mountains (*Deer in a Covert*, *The Trout*), and above all the everyday life of his times, especially in Ornans

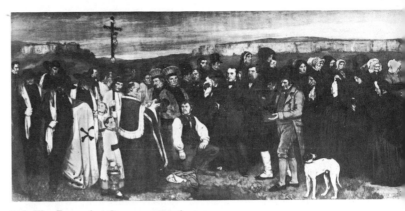

384. The Funeral at Ornans. 1850. *Louvre.*

385. The Stone Breakers. 1849. Destroyed 1945 (formerly Dresden Museum).

386. *Below.* Proudhon and his children. 1865. *Petit Palais, Paris.*

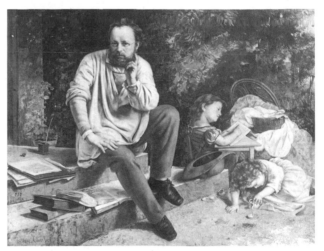

387. *Below.* The Wave. 1870. *Matsukata Collection, Japan.*

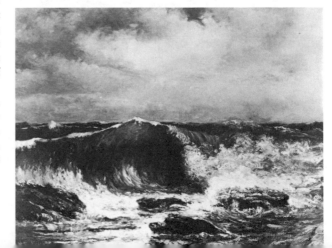

384 and in Paris (*After the Meal*, 1849; *The Funeral at Ornans*, 1850; *The Peasants of Flagey returning from Market*, 1850; *The Village Girls*, 1852; *Girls on the Banks of the Seine*, 1856). To Courbet, the portrait was more important than it was to either Daumier or Millet, and particularly the self-portrait. He also painted nudes and still life. All that life put before him was subject matter for his brush.

Secondly, he was a Realist, in that he frequently set forth his
385 republican and socialist convictions. *The Stone-breakers* (1849),
357 *The Studio* (1855), *The Return from the Lecture* (1863), and even
386 the portrait of Proudhon (1865), are manifestations and also proofs of his fervent belief in social art, so characteristic of the Realism of his times.

In the work of Courbet one may look almost in vain for the love that Daumier and Millet expressed for ordinary people. He was a man less of tenderness than of grandeur. He felt the grandeur and nobility of modern life and he made it perceptible to all in his canvases, which it is important to note were much larger than those of other Realists. He was so convinced about the strength and majesty of the humanity of his times and of the life of his times, that he needed the resources and the scale of the grand history painters.

As a painter Courbet was equal to his ambitions as a man. Though he was an inferior draughtsman when compared with Daumier or Millet, he was their superior by his genius as a painter. He shared their unified vision, their taste for chiaroscuro, their preference for powerful and static figures modelled by means of light and also their preference for sober colours. Like them he frequently chose the solid and immovable aspects of nature: his *Wave* is as compact and eternal as his *Cliffs at Etretat*. With all his generation, he enjoyed richness of textures and of flesh, a sense of the abundance of nature and a feeling for what was timeless. With his consummate technique he enjoyed manipulating his rich impastos, laying on the paint with decisive strokes of brush or palette knife, which were varied in thickness, strength and texture (note the nude in *The Studio*, for example). He handled his materials with the same technical skill as a master mason or a superb cook. His paintings are superior to those of Caravaggio and Ribera, and to all those Realists whose materialistic outlook on the world and to their painting restricted them to being little more than master craftsmen.

He was a painter of genius, he had a sense of grandeur, and he was also a convinced and convincing propagandist. These factors explain and justify his immense influence. It is from Courbet, more than from any painter of his time, that the third generation of Realist artists derived their art. They continued the formulas of Courbet's predecessors, they scarcely ever invented, and their art rapidly became academic.

The academic phase of Realism after 1860

All the great Realist painters of 1848 had their followers from 1860 onwards. Some of these lacked neither skill nor sincerity. The art of Bonvin, echoed by Antoine Jean Bail and his sons, Franck Antoine and Joseph Bail, influenced several still-life painters, notably Philippe Rousseau and Antoine Vollon. From Millet and still more from Jules Breton there arose unfortunately a set of painters of peasant subjects, of whom the best remembered is Léon Augustin Lhermitte. Jules Bastien-Lepage belonged to this group and, through him, Alfred Roll. Jean Charles Cazin was more sensitive and individual, and was sometimes a fine artist, particularly in his landscapes of the countryside around Boulogne sur Gesse (Haute Garonne). Courbet, however, had the largest and longest group of followers. It ran from Legros and Régamey to the painters of

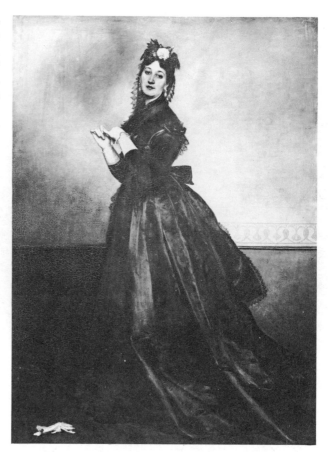

388. FRENCH. E. A. CAROLUS-DURAN (1838–1917). Woman with a Glove. 1869. *Louvre.*

the *Bande-Noire* (so called because of their austere colour) such as Lucien Simon and Charles Cottet, through whom his ideas were extended well into the 20th century. Horace Lecoq de Boisbaudran, an aristocratic teacher, had as pupils Fantin-Latour and Guillaume Régamey. Régamey in his military paintings revealed the same keen observation and vigorous brush work as Courbet. His friend Alphonse Legros vitalised and brought up to date the lessons of Holbein, his first love, by what he gained from the work of Courbet. Legros's paintings
390 *L'Ex-Voto* (1861), *Les Demoiselles du Mois de Marie* (1875), and *The Pilgrimage* show how the influence of Courbet continued in the paintings of this Burgundian artist, who settled in London in 1863 and became a naturalised Englishman.

Several of the paintings done when he was a young man, *A Scene from the Inquisition* (1867), *L'Amende Honorable* (1868), were in imitation of 17th-century art, which had far reaching influence on the painters of his time. Théodule Ribot, for
389 example, derived his entire aesthetic outlook from them.

The example of the great Spanish painters together with that of Courbet explains the early style of Léon Bonnat and E. A. Carolus-Duran. This style is represented by the *Young Neapolitan Beggar* (1863) by Bonnat, the *Murdered Man* (1866) and the famous *Woman with a Glove* (1869) by Carolus-Duran. After
388 these there followed a long production of second-rate works which was so mediocre that it may be wondered if the influence of the Spanish artists and of Courbet was not an unfortunate one for French painting. However, against the name of Henri Regnault may be put the names of Manet, who reminds us of the good influence of the Spanish, and of Monet who owed so much, especially in his youthful work, to Courbet. The *Déjeuner*

sur l'Herbe (1865) by Manet also recalls the *Girls on the Banks of the Seine*, the *Repas de Chasse* and *The Studio*. But Corot and his circle had even more impact on early Impressionism.

Corot and his followers

92–95
104
The independent and personal genius of Camille Corot developed in isolation. It nevertheless owed something to the movements of his time. His art stood above them, yet summed them up, and at the same time prepared more than any other for the art of the future. He began from a Neoclassical background. The influence of his teachers, Michallon and Victor Bertin, and also that of Aligny, turned his vision towards Poussin and Claude, masters of the historic landscape. As a result he exhibited at the Salon throughout his life works such
391 as *Hagar in the Wilderness* (1835), *St Jerome* (1837), *The Destruction of Sodom* (1844–1858), and *Dante and Virgil* (1859). From them, too, he inherited a love for Italy which he first visited in 1825. It was there that he painted his earliest important works, full of truth and following the directions of Michallon: ' Look searchingly at nature, and reproduce her faithfully and conscientiously.' This he did, but sensitively, emotionally and with a painterly quality. These paintings already show the whole spirit of Corot. They reveal a fresh and penetrating eye, a natural modesty and a sure and persevering hand. His innate classicism enabled him to revive a worn-out tradition, making it vital and fruitful again. The quality of his painting was due to his direct contact with nature, his observation of light, his judgment of colour tone values, his sense of structure and his feeling for atmosphere.

On his return to France he was affected by Romanticism. He painted, earlier than the Barbizon painters, in the forest of Fontainebleau. For a short while he painted good pictures on literary themes, perhaps influenced by Huet. He was romantic and fond of nature, and he shared with the writers Nerval and Lamartine a taste for mist, twilight, and for what was indistinct or fluid. His paintings of the lakes of Ville d'Avray, his *Dance of the Nymphs* (1850), his *Souvenir de Mortefontaine* (1864) and his *Etoile du Berger* were essentially Romantic. So too, by reason of their fantasy and their poetry, were his pictures of monks, of women in Italian or Oriental costumes, and of his models, whose reading, painting, playing the guitar, or whose jewels, plunge them into a deep dream or pensive melancholy. Gradually as he became more familiar with nature he began to paint directly from the subject out of doors. He shunned the picturesque and painted simply and without affectation works like *The Valley* (c. 1855–1860), *Souvenir of Marissel* (1867), *The Road at Sin le Noble* (1873); or he chose unpicturesque views such as in *Chartres Cathedral* (1830), *The Port of La Rochelle* (1851), *The Bridge of Mantes* (1870). He no longer created elaborate settings or complex compositions. He painted directly from nature, emphasising the construction and formal qualities of the subject. His colour was fresh and atmospheric. His views of the French countryside and towns were Realist, but they were also already Impressionist. He enjoyed shimmering forms and transient effects.

He loved the changing light of the sky and painted from what have since become regarded as quite ordinary subjects. This direct accent was an entirely new convention. Corot influenced several landscape painters who in turn affected the Impressionists. His formulas were repeated by F. L. Français and E. A. S. Lavieille, and pastiched by P. D. Trouillebert. The more original artists absorbed the spirit of his work: men such as Antoine Chintreuil, Henri Harpignies, and Charles Daubigny.
350
Chintreuil painted the extraordinary *Space* (1869) now in the Louvre. Harpignies, in his best works and his early style, and

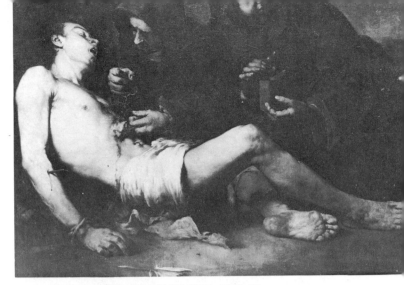

389. FRENCH. THÉODULE RIBOT (1823–1891). The Martyrdom of St Sebastian. 1865. *Louvre.*

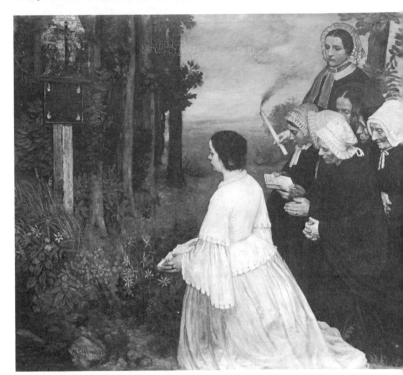

390. FRENCH. ALPHONSE LEGROS (1837–1911). The Ex-Voto. 1861. *Dijon Museum.*

391. FRENCH. J. B. C. COROT (1796–1875). St Jerome. 1837. *Church of Ville d'Avray.*

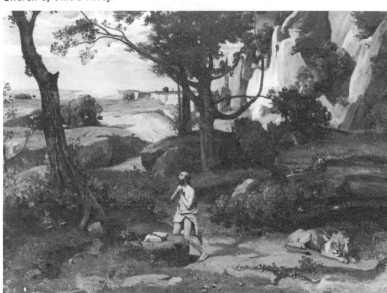

392. RUMANIAN. NICOLAE JON GRIGORESCU (1838–1907).
The Forest of Fontainebleau. *Simu Museum, Bucharest.*

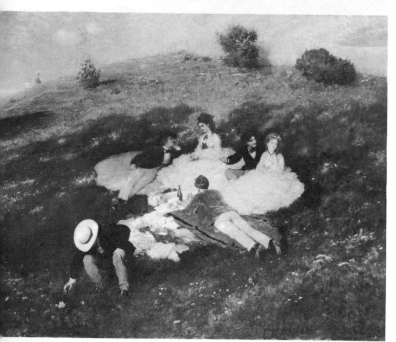

393. HUNGARIAN. PÁL VON SZINYEI MERSE (1845–1920).
The Picnic in May. 1873. *Museum of Fine Arts, Budapest.*

394. GERMAN. ADOLF MENZEL (1815–1905). Room with a
Balcony. 1845. *Staatliche Museen, Berlin.*

Daubigny, the most important of these landscape painters, drew on the essence of Corot. Daubigny was an intimate friend of the Barbizon painters, but it was to Corot that he was most indebted, and also to a number of painters of a 'friendly' countryside, such as Camille Flers and Adolphe Cals. Straightforward views, flowing water and passing clouds attracted Daubigny, who enjoyed the ephemeral charm of the seasons (*Spring*, 1857) which he set down with delicacy and conviction.

The Impressionists were quite right in studying the work and respecting the talent of the most Realist perhaps among their forerunners.

The influence of Realism

The Realists Daubigny and Courbet prepared the way for Impressionism. The Realists destroyed the old hierarchy of subject matter, whereby history painting was considered a more important art than landscape or still life. Without them Impressionism could not have existed. Realism taught them to look directly at life in all its aspects without prejudice, to discover beauty everywhere, especially in everyday existence, to paint it with truth; and that this was sufficient in itself. For their technique the Realists looked back to the past; they rarely made innovations, far less than Ingres or Delacroix. The great revolutionary of 19th-century painting was not Courbet, the last in line from Caravaggio, but Manet.

It is immediately apparent that academic art was able to profit from Realism without difficulty. For a time there was some struggle; academic artists reproached the Realists for their cult of ugliness, their choice of everyday life as subject matter, their truthful instead of idealised representation and their vigorous brush work. Likewise critics found the work of Winterhalter, Gleyre, Hébert, Gérôme, Paul Baudry and Cabanel over-polished, conventional and literary. But the two styles could be quite compatible, as was demonstrated in the works of Thomas Couture, who painted his *Romans of the Period of Decline* (1847) and, almost at the same time, fine portraits and robust nudes. In fact the academic and the Realist style became one in the work of most official painters under the Third Republic. Of these, Bonnat painted portraits, and Carolus-Duran social subjects. N. Goeneutte, H. Gervex and P. A. J. Dagnan-Bouveret painted genre as had Meissonier, military subjects as had Edouard Detaille, history as Jean Paul Laurens and Biblical subjects as had Bouguereau. All used with ease the technique which was most suitable in rendering their quasi-photographic vision. They were convinced of the need to copy unquestioningly what was in front of them, and that there was only 'painting as imitation of nature', as Bouguereau had remarked. This, then, was the heritage of Realism, both excellent and detestable, in France; but it was to spread much further afield.

The influence of Realism in Europe

Realist painting affected most European countries, arriving with a delay in time corresponding to the distance from France.

This spread was largely the fruit of a general development in Europe towards a positivist outlook, a belief in literal fact and a new way of looking at truth. It was so general a movement that it affected countries which would seem to be most deaf to the calls of Realism, such as England, Spain and Italy. In painting, the diffusion of Realism was favoured by events such as Courbet visiting Belgium in 1851 and Germany in 1869, by the visits to Paris of numerous foreign painters such as Menzel, W. Leibl, J. Israëls and N. J. Grigorescu, and by international exhibitions, especially the one in 1855.

394
392

Dickens and Thackeray gave England a Realist literature. In

395. Still Life. Photograph by Adolphe Braun (1811–1877).

The invention of photography was to have its effect on painting and contributed to the realist vision of the period (see pp. 172, 173).

painting, even though Ruskin led artists to take an interest in the past, in legend and in a pseudo-mysticism, there were artists who nevertheless had a fervent belief in reality. From one point of view the Pre-Raphaelites were Realists, eagerly seeking in 15th-century Italian art a fresh if myopic approach to nature. A love for reality is at the heart of their art even though they were encumbered by literature, piety and pastiche. These painters, Holman Hunt, D. G. Rossetti and Millais, and also their spiritual father, Ford Madox Brown, who inspired them to paint in minute detail, had something in common with the miniaturist vision of a Meissonier.

The Catalan artist Mariano Fortuny also brings to mind Meissonier whom incidentally he knew in Paris. He too was a Realist orientated towards the past, who loved to reproduce a junk shop's bric-à-brac with microscopic accuracy which he painted with hollow brilliance.

Fortuny, who was acclaimed throughout Europe, established this bastard genre, a compromise between Romantic chocolate box painting and a sweetened Realism. He died in Italy, where his influence affected every sort of pretty or meretricious painting. D. Morelli, who remained uninfluenced by the lively qualities of Courbet, was a prisoner of history painting — or rather of melodrama. History painting, however, plus the influence of the Barbizon painters and of Daubigny, opened the way for the landscape painting of G. Fontanesi.

The tendency towards Realism was strong everywhere, but except in France it always came up against an entrenched

academicism. Romanticism in France had set in motion currents which resulted in a magnificent harvest from the Realist painters; elsewhere, instead of growing and developing, it was still-born. Realism was denied its full fruition due to the docility of painters towards the past and towards a literary approach, and this was so even in countries whose traditional genius might have predisposed them to its acceptance. In 1867 the Société Libre des Beaux Arts was founded in Belgium. Charles de Groux, who worked in Brussels, was the Belgian counterpart to Legros; he developed an honest and vigorous style based on Courbet.

The Barbizon painters influenced a fine school of landscape artists at Tervueren, among whom Hippolyte Boulenger was outstanding. Daubigny's influence appeared in the sensitive seascapes and rainscapes of Louis Artan and Guillaume Vogels. Realism soon became academic in the work of Alfred Stevens, a Belgian who moved to Paris (not to be confused with the English artist of the same name). As in the case of Henri de Braekeleer, a sort of Fortuny from Antwerp, Stevens produced a mundane version of Realism. Braekeleer and Fortuny, however, were finer artists than either Stevens or Meissonier; they made use of broader brushwork, could interpret the play of light and had an appreciation for simple things. Their admiration for David Teniers and Gonzales Coques, though it helped their work, confined them somewhere between the Flemish 17th century and the French 19th century; the latter they could not fully accept because of a conscious or unconscious fidelity to their national tradition. The same was true of the animal painter Jan Stobbaerts, and also of their Netherlandish neighbours.

Earlier, 17th-century Dutch art had very much influenced the Barbizon school. The Barbizon school now repaid its debt to Holland by influencing the school of The Hague, many of whose works are in the Mesdag Museum there. These Dutch artists passionately admired their French forerunners. The artists of The Hague were diverse in their outlook, but they had some things in common. They joined the ideas underlying the art of Rousseau and Millet to their own national heritage. Using these they created a precise and literal Realism which avoided paltriness by means of the traditions of Dutch painters who made an intense study of the effects of light and the use of chiaroscuro. Their work carries conviction and reveals a sensitive melancholy. Johannes Bosboom was enthralled by the examples of the past. J. H. Weissenbruch and P. J. C. Gabriel echoed both the recent Romanticism and the more distant period of van de Velde and Hobbema. Israëls spent three years in France; this, together with his poverty and perhaps the influence of his Jewish origin, awakened in him a taste for 'social art'. The 'spirit of 1848' passed into his sentimental pictures of daily life. In the works of Anton Mauve the same tendency towards the sentimental was mitigated by the delicacy of his light and colour. The Maris brothers, Jacob, Matthijs and Willem, seemed almost to be the Daubignys of their country; they were truthful to their landscape without being conventional, and they were sensitive to the play of light which gave their works a hint of Impressionism. The greatest of these Dutch painters was undoubtedly J. B. Jongkind, who was French as well as Dutch. He paved the way towards Impressionism, having first passed through a period of anecdotal Romanticism and then one of Realism.

French Realist landscape painters also influenced the Swiss. Karl Bodmer, who frequented Barbizon, and Barthélemy Menn, who was a friend of Corot, delivered Swiss painting from the picturesque tourist landscape of Calame and the overworked Romanticism of alpine scenes.

82
115
404
397
374
396
398
422
106

BELGIAN AND DUTCH REALISM

396. HENRI DE BRAEKELEER (1840–1888). The Man in the Chair. *Royal Museum of Fine Arts, Antwerp.*

397. CHARLES DE GROUX (1825–1870). Grace. *Ghent Museum.*

398. JOZEF ISRAËLS (1824–1911). Alone in the World. *Rijksmuseum, Amsterdam.*

Anecdotal Realism in Germany and Russia

German painting of the 19th century was idealist, philosophic and literary. 19th-century painters such as Piloty, Böcklin and Feuerbach were led towards Realism by the detailed anecdotal art of the Biedermeier painters. Austrian art developed in a similar way.

Among the painters of everyday life, Krüger in Prussia, Spitzweg in Bavaria, Jakob Alt and Moritz von Schwind in Austria had their counterpart in the Frenchman Lami. Landscape artists with a photographic and touching anecdotal style included Eduard Gärtner in Berlin and F. G. Waldmüller in Vienna. The two best German painters, Menzel and Leibl, were both influenced by French Realism. Menzel (1815–1905) visited Paris on three occasions, and there painted his best known work, *Memories of the Théâtre Gymnase* (1856). The striking use of colour combines happily with sharp observation and wit. Leibl also painted some of his best work in Paris, for example, *Cocotte* of 1869. When he returned to Germany his observation became photographically exact, and he strove to find a complete balance between colour and drawing. *Three Women in Church* (1882) is his best known work of this period.

German painters often lapsed into story-telling. Hans Thoma was drawn towards a realist conception of landscape by the fleeting influence of Courbet in 1868, but later he became a sort of poet-painter in whom the narrative urge was uppermost. Franz von Lenbach, a portrait painter, borrowed in turn from the 15th-century Flemish painters, the Venetians, Rembrandt and Velasquez.

In eastern Europe, Russia, Hungary and Rumania were influenced by French Realism. The mystic and humanitarian Russia of Gogol was ready to accept the 1848 aesthetics of France, in feeling though not in technique, for academicism was more strongly entrenched there than in any other country. In 1863 the younger artists rebelled against the Academy. N. G. Chernyshevski in 1855 wrote *The Aesthetic Relations of Art to Reality* setting forth the new realist and 'social' doctrines. His friends formed the Society for Travelling Art Exhibitions in 1870, with the intention of educating all Russia to their new outlook in art, but unfortunately their works only stemmed from the old fashioned techniques which had been taught them. They confused painting and subject matter, and their art was only superficially Realist. Perov painted anticlerical genre scenes. Kramskoi painted *The Temptation of Christ*, Ge Golgotha (1892); there is in both something of the religious disillusionment of their time. Pacifism permeated the military paintings of Vereshchagin, who had seen the horrors of war at first hand. Surikov protested against the abuse of power in his *The Boyarin Morisova* (1887) and his *Morning of the Execution of the Streltsy* (1881). Ilya Repin was the most important Slav painter of the period. He sympathised with the suffering of the people as in *The Bargemen* (1870–1873), or pleaded the cause of the revolutionaries as in *Revolutionary Awaiting Execution* or *They Did Not Expect Him*. The quality of even Repin's work was not equal to the nobility of his intentions. Russia was so deeply immersed in academic habits that even her greatest artist could not throw off the old confusion between subject and picture, between what was represented and its representation.

Hungarian artists, especially Mihaly von Munkácsy, were equally enthusiastic towards 'social' art. In paintings such as *Peasant Idyll* (1865), *The Last Day of the Prisoner condemned to Death* (1870), *The Poachers* (1874), he revealed the virtues and sufferings of the people, a sense of national glory and a humanised Christ. These works recalled Courbet and the Caravaggio school, yet unfortunately remained in a museum

477
83
107
405
410
400
408
402

tradition. Pál von Szinyei Merse painted contemporary life in Hungary in a lively way with a free technique and a lively appreciation for his period (*Picnic in May*, first exhibited 1873); and László Paál painted landscapes in the Barbizon tradition and, indeed, spent his most fruitful years there.

In Rumania N. J. Grigorescu, who had worked in the forest of Fontainebleau, continued the Barbizon style into pictures of his own countryside and its peasantry.

French Realism spread across the whole of Europe, though it found no equal to Courbet or Daumier. Repin was little more than a Slavonic Jules Breton. The *Cocotte* by Leibl was more a cousin of the *Woman with a Glove* than any relation of the *Girls on the Banks of the Seine*. This Realism, however, made the first breach in the academic outlook of several countries; it encouraged painters to look differently at life around them, so that they came to reconsider the basis of their painting. It also prepared the ground for Ensor in Belgium, the young van Gogh in Holland, and Liebermann and Corinth in Germany. The liberation of art due to Realism was to bear fruit, sooner or later, in all countries.

Influence on the other arts

Realism, which was so fundamentally important to European painting, also affected the graphic arts. Many of the painters showed the same qualities in their prints as in their paintings, and in such cases it will not be necessary to reconsider them now. The most important painter-etchers and painter-lithographers were the landscape artists Théodore Rousseau, Charles Jacques, Daubigny and Corot, the caricaturists Henri Monnier and Gavarni, the genre artists Bonvin, Ribot and Legros; and far above all these towered Daumier and Millet. Outside France the best painters were also the best print-makers. These included Henri de Braekeleer, Israëls, Menzel, Leibl and Fortuny. Apart from Claude Ferdinand Gaillard in France, Seymour Haden in England and Wilhelm Busch in Germany, there were few Realist artists who specialised in graphic art. The others working at this period as etchers, wood engravers or lithographers rather continued the spirit of Romanticism than expressed Realist ideas — for example, Meryon, Bresdin, Gustave Doré in France, and Félicien Rops in Belgium. It was as if the art of black and white were more suitable to expressing the anguish of visionaries. They were introverts in their art, whereas the Realists were extroverts.

Sculpture was even less affected by Realist painting, for several reasons. An independent style of painting in conflict with official art could not have a decisive influence on a technique which depended so much on official commissions. Academic traditions therefore weighed heavily on sculpture, and the innovations of Realism were difficult for it to assimilate. Nevertheless, following the example of Millet, Courbet and their associates, a few sculptors did seek inspiration from contemporary life. They attempted to translate modern dress into bronze, stone or terracotta, and this very superficial effort was practically the limit of their Realism. Jules Dalou, a Frenchman, and Constantin Meunier, a Belgian, were affected by Realism in this way, though only after a considerable time lag.

Dalou, exiled after the Commune, came to England, as his friend Legros had done. For nine years Dalou made statuettes and on one occasion a large work entitled *La Berceuse*. These statuettes showed his wife in the dress of the period or in peasant costume, in the act of reading, sewing, embroidering, or nursing their child. In these works Dalou revealed keen observation and a sense of style. They were his best works, for when he returned to France in 1879 he became academic and produced allegorical works in the conventional manner. These

included the *Triumph of the Republic* and the monument to Delacroix, and from these he moved to pathos in his tomb of Victor Noir and to anecdote in the *Peasant with a Hoe*. This last was the only figure he carried out for what was to have been a grandiose monument on the theme of 'Work'.

Constantin Meunier was a better artist; he began as a sculptor but worked only as a painter from 1857 to 1884, and then returned to sculpture, which was his true vocation. In his paintings of the workers and factories of the St Lambert Valley done after 1880 he was preoccupied with the social realism he had inherited from Charles de Groux, which he was later to carry into his sculpture. The miners of the Borinage, the dockers of Antwerp, the metalworkers and women haulers inspired him to large and powerful sculptures. In these the form was not lost but emphasised by the closely clinging draperies modelled from contemporary clothes. The grandeur of these sculptures was not destroyed by sentimentalism; their convincing quality was enhanced by his love for ordinary people, their work and their suffering, and also by his technique in which he never attempted things foreign to sculpture. Unfortunately, it is not possible to say the same of other artists who attempted Realist sculpture.

The failure of nearly all of the few sculptors who made the attempt proves that the form was difficult, and perhaps unsuitable to the medium. This is emphasised when one considers Daumier, a sculptor of genius. Though one of the foremost among Realist painters, he did not even attempt social realism in sculpture. His *Ratapoil*, his *Emigrants* and his busts are far from being mere copies of the contemporary scene. He was too good a sculptor not to know that what is suitable for painting is not necessarily suitable for sculpture. His sculptures reveal the expressionist romantic aspect of his character. For the same reasons Carpeaux, the greatest painterly sculptor of the middle of the 19th century, remained a stranger to Realism, even though he was on familiar terms with Guys and Manet, and even though he sensed the general excitement of the period.

If Realism only related to the subject matter chosen by artists, their taste for contemporary truth and the social message they attempted to convey, then the style could have nothing whatever to do with architecture. However, Realism also implied a way of thinking, a love for one's fellow men and for one's time, a belief in progress and in the 19th century. Consequently there were architects moved by the same strong urges as the painters. They were forced to wage a struggle against similar academic traditions.

In the middle of the 19th century the past weighed more heavily on architects than on painters. It was a period of pastiche and this was so throughout Europe. England wavered between the Palladian and the neo-Gothic of Pugin and Charles Barry, who built the Houses of Parliament. Germany and Austria used Gothic, Renaissance, old German and neo-Greek styles, the last being favoured by Leo von Klenze, Schinkel and Nobile. The architects of Belgium, Holland and Switzerland were condemned to neo-Gothic and neo-Renaissance. Russia was even more enchained to a neo-Byzantine and the traditions of the old Russian style, which were upheld by the English architect V. O. Sherwood, among others. The same taste for the composite pastiche reigned in Italy, Spain and France. Théodore Ballu, a French architect, used the Romanesque style for St Ambroise and the Renaissance style for La Trinité, both in Paris. Napoleon III entrusted the completion of the Louvre to Visconti and, when he died, to Lefuel, and the building of the Opéra to Garnier.

There were attempts in France, however, to create a new architectural style more in keeping with the spirit of the 19th

399. FRENCH. P. DELAROCHE (1797–1856). The Assassination of the Duc de Guise. Exhibited at the 1835 Salon. *Château de Chantilly.*

400. RUSSIAN. V. V. VERESHCHAGIN (1842–1904). The Plevna Road. 1877. *Tretiakov Gallery, Moscow.*

REALISM IN FRANCE AND ABROAD

Anecdotal realism, whether of past history or of contemporary events, was much appreciated by the public of the 19th century. Today it is considered, often justly, as lacking aesthetic value, but if its importance and its wide diffusion are under-estimated, the true face of the art of the period becomes distorted.

401. ITALIAN. F. HAYEZ (1791–1882). Sicilian Vespers. *Brera, Milan.*

403. BELGIAN. H. LEYS (1815–1869). Return from Mass. 1866. *Royal Museum of Fine Arts, Antwerp.*

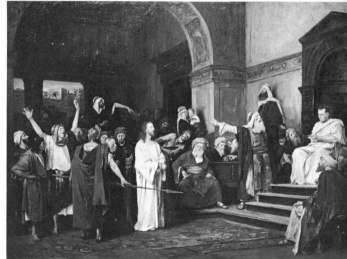

402. HUNGARIAN. M. VON MUNKÁCSY (1844–1909). Christ before Pilate. 1881. *National Gallery, Budapest.*

404. SPANISH. M. FORTUNY (1838–1874). La Vicaria. 1870. *Museum of Modern Arts, Barcelona.*

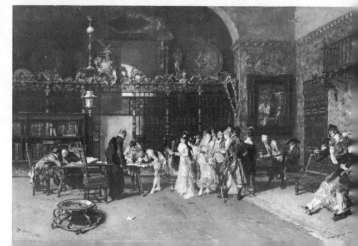

405. FRENCH. E. LAMI (1800–1890). A Reception at the time of Louis Philippe. Wash drawing. 1832. *Louvre.*

406. ITALIAN. F. PALIZZI (1818–1899). The Buffaloes. *Galleria d'Arte Moderna, Rome.*

408. RUSSIAN. I. E. REPIN (1844–1930). The Bargemen. 1873. *Russian Museum, Leningrad*

410. GERMAN. W. LEIBL (1844–1900). The Young Parisienne. 1869. *Wallraf-Richartz Museum, Cologne.*

407. BELGIAN. A. STEVENS (1828–1906). The Bath. *Compiègne Museum.*

409. BRITISH. W. P. FRITH (1819–1909). Derby Day (detail). *Tate Gallery.*

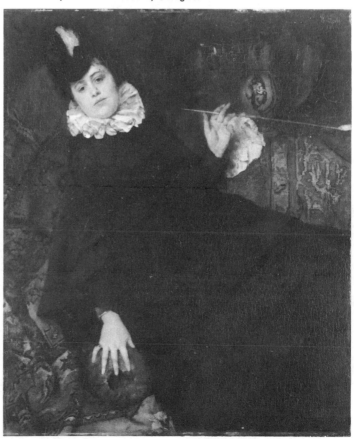

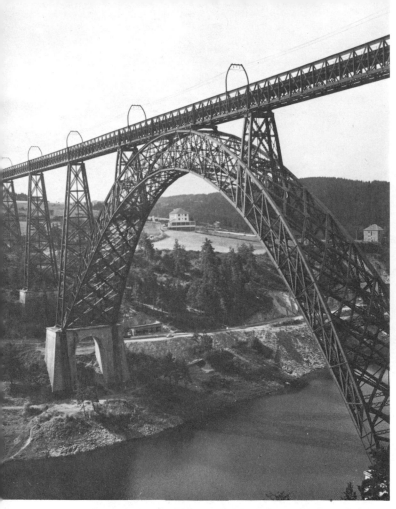

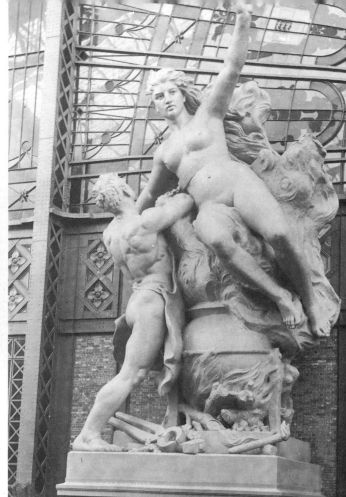

411. FRANCE. GUSTAVE EIFFEL (1832–1923). Iron viaduct at Garabit, spanning the River Truyère (Cantal). 1885–1889. Height 410 feet, overall length 1880 feet, span of central arch 550 feet.

412. FRENCH. H. CHAPU (1833–1891). Steam. Designed for the Machinery Hall, Paris, 1889.

413. FRENCH. The Machinery Hall constructed in Paris for the International Exhibition of 1889 by the architect F. Dutert (1845–1906) in collaboration with the engineer Victor Contamin (1840–1893). Height 150 feet, length 1400 feet, span 370 feet.

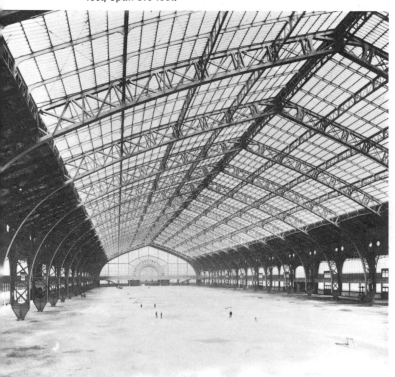

century. Viollet le Duc, architect and writer, had put forward ideas on medieval rationalism, and suggested that art had a duty to express the civilisation to which it belonged, and that it should cater for its needs. In Germany Semper advanced similar views, but they remained unheeded by German architects. Several architects in France and elsewhere, however, were to make use of the new structural material — iron. And they responded to the needs of the times in creating new buildings which were practical, if not beautiful. Structural iron was used for a neo-Gothic building, St Eugène, Paris, by Boileau in 1854–1855, and again in 1860–1867 by Baltard for a pastiche of Brunelleschi, St Augustin, Paris. In civil architecture it was to be put to more rational use by both Boileau and Baltard, and also by Labrouste, Horeau, and Hittorff. Labrouste used iron for the Bibliothèque Ste Geneviève, Paris (1843–1850), and he used it so superbly that he was called on to use it again for the Bibliothèque Nationale. Horeau submitted a design for the Crystal Palace, but it was rejected. Other buildings of the sort included the Halles by Baltard, the Gare du Nord by Hittorff and the Bon Marché of Boileau, all in Paris. These were so successful that they were much imitated.

Reinforced concrete was invented in 1849 by Joseph Monnier, a French gardener who used it for flowerpots. It was first used for building in a house designed by Coignet at St Denis in 1852, but its possibilities remained unexplored. It was the rational use of iron construction which was to be important in the 19th century, giving birth to the only new and practical architecture of the century.

62

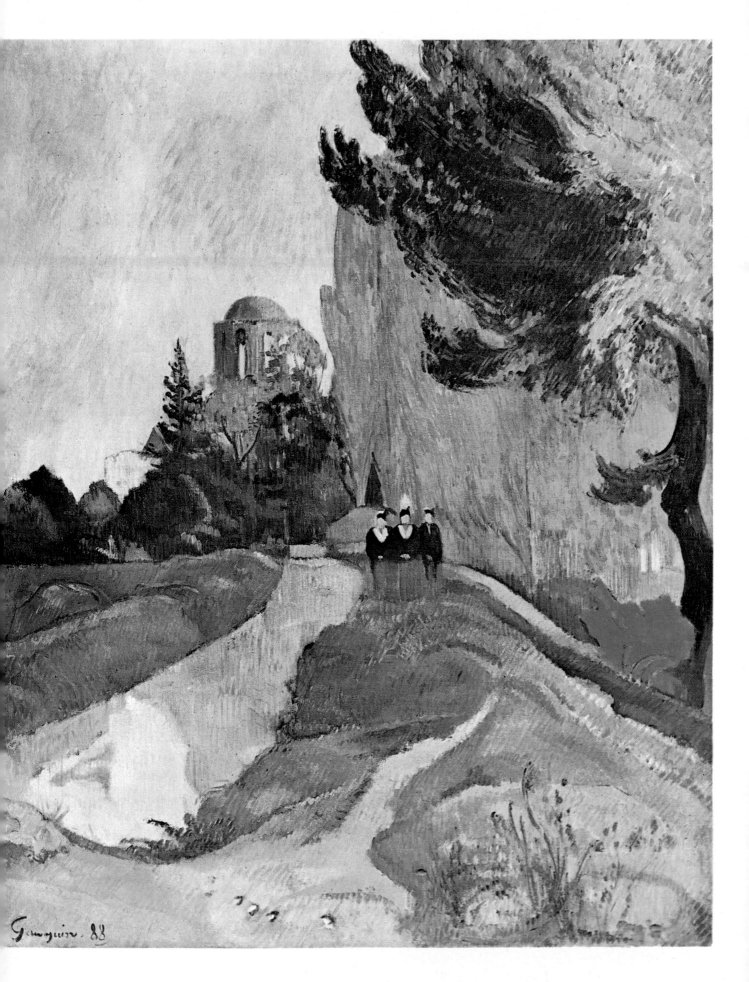

FRENCH. PAUL GAUGUIN (1848–1903).
The Alyscamps at Arles. 1888.
Louvre. *Photo: Michael Holford.*

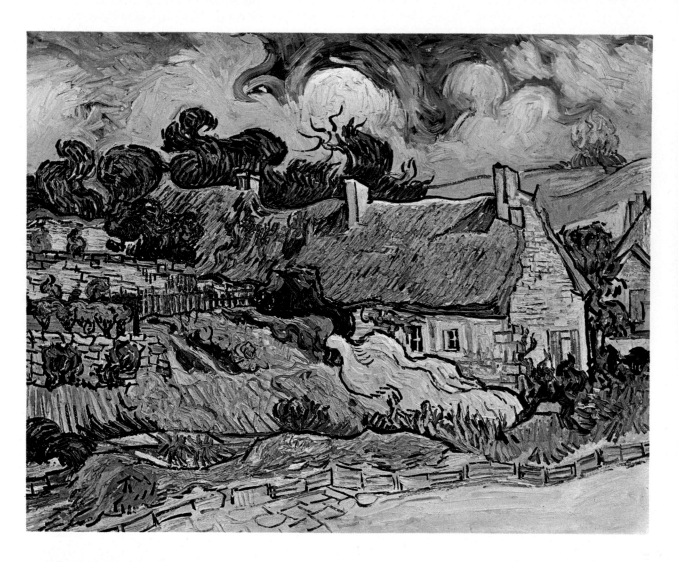

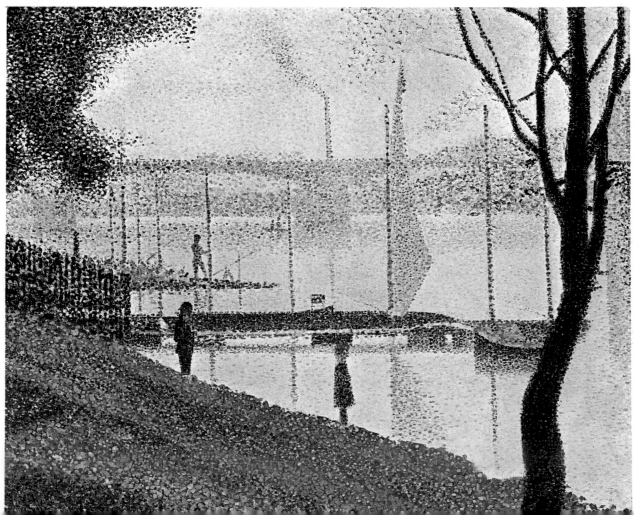

IMPRESSIONISM AND SYMBOLISM *Michel Florisoone*

*Realism gradually gave rise to Impressionism. The advocates of the
new style, in their quest for truth, aimed at the optical
impression of what was luminous and transitory, and as a result
form became neglected. Both subject matter and the vision of the
artist had to change. Though not understood by the man in the
street, Impressionism accorded with the evolution of contemporary
ideas. As soon as initial resistance had been overcome,
Impressionism spread irresistibly throughout the world.*

*The success of the new style was so great that it quickly brought
a reaction in its trail. The artist's thought was being thwarted in
favour of his vision. The reaction took the form of Symbolism,
which was to have an even greater effect on 20th-century art than
Impressionism, for it released art from its slavery to appearances.*

Impressionism was the last rapturous expression of an art style
which was six hundred years old. Classical art, after a quiet
beginning and a masterly development, reached the end of its
mission in this final splendour. The last opportunities of classical
art were exploited by two generations of artists, the first purely
Impressionist, the second Neo-Impressionist. During this happy
period painters did not aim at being revolutionary. They
pursued a logical and predetermined course. A prophet living
at the time of Giotto might have predicted this final phase.

Though Impressionism only followed the natural course of
events, it nevertheless shocked the public at the time. Both
middle and upper classes rejected it violently, as a body defends
itself against an illness that threatens its very life. But the
materialism of Impressionism was an outcome of love and not
of science, and no one suspected that it was on the point of
discovering the mysteries of the intellect.

The position of Impressionism

'Impressionism', originally a term of abuse, is now com-
pletely accepted. Though one style, it had two facets: firstly
Impressionism is an aesthetic constant, and secondly it was a
phenomenon of the period. Throughout the centuries, since the
painting of Roman times, in the luminous landscapes of the
illuminated manuscripts by Fouquet, until the 18th century of
Largillierre and Fragonard, artists had attempted to represent
what they saw. They had studied, one by one, the various
elements of reality, or the appearances of things. The one which
interested them most was light, its source and its effect, but they
only arrived at a full understanding of light towards the end of
the 19th century, after many hesitations and after having
followed many false trails. The problem of linear perspective,

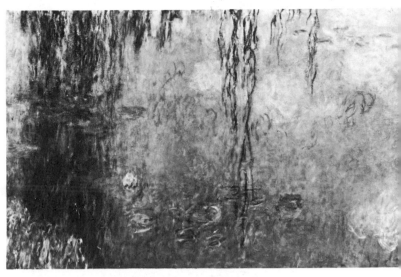

414. FRENCH. CLAUDE MONET (1840–1926). Water-Lilies.
1915–1923. Detail of mural, panel no. 15. *Orangery, Paris.*

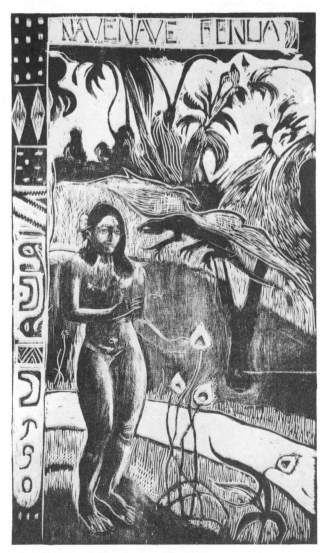

FRENCH. VINCENT VAN GOGH (1853–1890).
Cottages at Cordeville. 1890.
Louvre. *Photo: Michael Holford.*

FRENCH. GEORGES SEURAT (1859–1891).
The Bridge at Courbevoie.
Courtauld Institute of Art, London.
Photo: Michael Holford.

415. FRENCH. PAUL GAUGUIN (1848–1903). Nave Nave
Fenua. Woodcut executed during his second period in
Tahiti. 1895–1903. *Bibliothèque Nationale, Paris.*

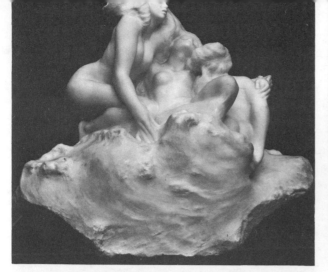

416. FRENCH. AUGUSTE RODIN (1840–1917). Three Sirens. Marble. 1889. *Ny Carlsberg Glyptotek, Copenhagen.*

417. FRENCH. EDOUARD MANET (1832–1883). In the Conservatory. 1879. *Staatliche Museen, Berlin.*

which was pushed to absurd lengths, distracted them from, and hid for a time, the other problems of aerial perspective. By using artificial sources of illumination, the fall of light could be directed so that it played a constructive role, revealing form by means of light and shade, reflected light and shadow. Light, in fact, had been made a stock-in-trade of the artist, to be used within narrow limits.

However, it was bound to happen that one day the painter would see the visual truth of reality, which he had glimpsed from time to time when relating objects to their setting. It had become necessary for painters to look at the true appearance of nature which had become falsified by the scientific visual understanding of the Renaissance. They had to look at nature freshly and forget the techniques they had been taught in the studios.

Impressionism freed itself completely from the restrictions of science, only to meet it on another level in company with the philosophy of the period. It inherited the naturalism of the Barbizon school and the Realism of Courbet. It belonged to the positivist outlook of Auguste Comte, and it was formed in the atmosphere created by the research work of Claude Bernard and his *Introduction to Experimental Medicine.* It became an integral part of the period that followed and contributed as much as the most advanced science to the whole character of the *fin de siècle*, where physics and physiology were recognised to be of the greatest importance. During the 19th century scientists began by experimenting with matter and arrived at the atomic discoveries of physics. The painters arrived at the same point intuitively. From the centuries-old quest for tactile values (tactile values enable the spectator mentally to ' feel' the form) the Impressionists turned to attempting the impossible — to capture that which was fugitive, fluid, impalpable and moving. They turned away from the rocks of Fontainebleau and paid no more attention to the drama of the elements. They chose instead to paint the rivers. They preferred moments of transformation, vapour rising in the warm glow of the setting sun, or the freezing of the water in midwinter; and they always enjoyed painting mists. They loved the London fogs which veiled the architecture, and the smoke from trains which made iron and brick buildings seem weightless. The reality of the Impressionists was a solution of liquid and of light in which everything was plunged.

Impressionism may be considered as in the line of the great artistic current which, often flowing deeply underground, reappears from time to time and threatens the embankments of orthodox classicism, sometimes overwhelming them, as it did at the time of the Baroque and later the Romantic.

The Baroque with its complex composition, dynamic construction and sweeping diagonal movements also succeeded in expressing the essence of time, inexorably passing and eternal. Baroque artists translated the idea of time into a plastic equivalent, more sensuously than intellectually organised, but nevertheless deliberate. The Impressionists attempted to reproduce the flight of time by an unreasoning imitation of its effects; this puerile ingenuousness ultimately led to disaster. They thought they were merely spectators of light, regarding its free play artlessly and without preconceptions, but instead they were undermining the very basis of painting. They scarcely noticed this aesthetic catastrophe. They were not conscious of the tragedy of this dispersion of all in all, nor of the general uncertainty which followed. Instead they continued to sing their joyous hymn to the beauties of nature, painting time and light and neglecting form completely.

The renewal of vision

They painted as a bird sings, as Renoir said, and, just as a nightingale is only a silver throat, so the Impressionist painter was only an eye. To the historic and aesthetic opportunities which made the birth of Impressionism possible should be added the qualities of the human eye. Though the Impressionists did not use its power of acute vision as did van Eyck, they nevertheless made use of its exceptional powers of discernment. They summed up a multiplicity of nuances and their complexity of fusion. There arose an absolute tyranny of the optic nerve from the time of Courbet (of whom Ingres remarked, admiring the power of his visual mechanism: ' He is an eye ') to the time of Claude Monet, of whom Cézanne said: ' He is only an eye, but what an eye! ' Mallarmé also said of Manet: ' This fresh eye, virgin, calm and absorbed, on an object, on people...' The Impressionist vision oscillated, as between two poles, between the eye of Manet and that of Monet, between the healthy and the abnormal. The eye of Manet was sane, traditional and French, according to Mallarmé, who continued that Manet's vision descended from the 18th century, having been formed by Watteau, Desportes, Oudry and Fragonard. Manet inherited their finesse, intuition and enchanting clarity of vision. Monet's vision seemed abnormal, as though he saw some parts of a scene with hypersensitivity, while others remained blurred. As for the vision of the general public towards the arts, it was completely atrophied.

During the course of the century physics established many of the optical laws relating to light and colour. The painters arrived at the same laws on the banks of the Seine and the Oise.

418. Olympia. 1865. *Louvre.*

419. The Fifer. 1866. *Louvre.*

420. *Above, right.* Emile Zola. 1868. *Louvre.*

They loved to watch light reflecting in water and shafts of light penetrating through mists, and the way in which light becomes broken into the spectrum colours in rainbows and in spray. They noticed that light could alter form and the great difference atmosphere made to everything. Painters gradually made these discoveries by using their eyes, and they arrived at a new view of the world ceaselessly being revealed and changed by daylight. To this idol of light the Impressionists now sacrificed everything. They chose light as the only element and laid aside all the hypocrisies of tenebrism and all the doubtful temptations of chiaroscuro. Light was the creative principle underlying appearances; light was colour, movement, time and life itself. Light quite naturally found its plastic equivalent in water, which was fluid, dissolving and transparent. Water shared with air the parenthood of Impressionism, which was born on the Channel coast between Rouelles and Frileuse. It was here that one day Boudin brought the young Monet (then aged 17) to paint. It was on this coast, at Le Havre, Honfleur and Trouville, that Monet developed artistically. The sea was to be one of the favourite subjects of the Impressionists. They liked the constantly changing rhythm of the waves, the inconstancy of its substance, its varied and varying colours, its reflection and absorption of light and its destructive force, slow or sudden, which hollowed out the cliffs of Etretat or eroded the rocks of Brittany. Thus the subject of Impressionist art was not the emotion provoked by the presence or beauty of an object, but the observation of its varied physical behaviour in the environment which hems it in, decomposes or disintegrates it. Forms no longer existed except in so far as their visual exteriors became surfaces for the play of light and colour. Objects were described no longer by lines and contours but by the interpenetration of colours which became fragmented into their component parts. The whole picture was unified by relationships of light and the aim was to establish the light by purely pictorial means. Thus there resulted a double change in the methods of painting: first, painters used a new palette; and, second, they invented a new technique in handling the brush.

The Impressionists found that the colours used by Delacroix and the other Romantic painters of the early 19th century were too dark for their purposes. They preferred to limit their range more or less to the spectrum colours, and chose yellow, orange, vermilion, crimson, violet, blue and green. These were in line with the scientific studies of Chevreul earlier in the century that had been known to Delacroix, and with the studies of Maxwell, Young and Lambert who had transformed colour chemistry. From a pictorial point of view this change was the most

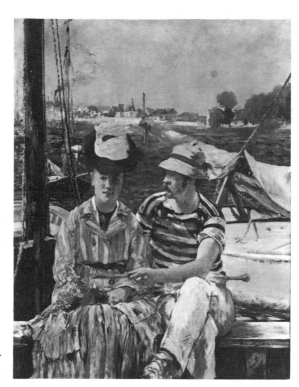

421. Boating at Argenteuil. 1874. *Tournai Museum.*

important since van Eyck and Antonello da Messina had developed the use of oil paint.

According to Chevreul's theory, colours may be divided into two groups: the primary colours, yellow, red and blue; and the secondary colours, orange formed by mixing red and yellow, green by mixing yellow and blue, and violet by the mixing of red and blue. A secondary colour appears stronger when next to the primary colour not included in its mixture. For example, orange is enhanced when placed next to blue, and the blue is called the complementary of orange; in the same way red is the complementary colour of green, and yellow is the complementary of violet; Chevreul noted that complementary colours destroy one another when mixed in equal proportions, which from the painter's point of view means that they produce a neutral grey. He also noticed that when mixed in unequal proportions two complementary colours give a degraded colour, that is, a neutral colour tending towards brown, grey or olive. From all this there results a series of optical laws which may be stated in quasi-algebraic terms. Pure complementary

179

422. DUTCH. JOHANN BARTHOLD JONGKIND (1819–1891). The Ourcq Canal. 1865.

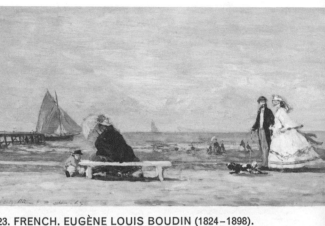

423. FRENCH. EUGÈNE LOUIS BOUDIN (1824–1898). The Beach at Trouville. 1863. *Phillips Collection, Washington.*

adjacent to broken complementary = dominance of one, and harmony of the two; pure complementary in a light tint adjacent to pure complementary in a dark shade = difference in intensity, and harmony; two similar colours next to one another, one pure, the other degraded, make a subtle contrast with one another.

The Impressionists were intuitive in their painting rather than intellectual. They studied nature, and any scientific equations were used to suit their convenience in their striving for luminosity. However, the laws of science gave a moral support to the Impressionist painter. He now dared to do what 100–103 Delacroix would not have done. The scientist studied light in order to analyse its qualities or to seek artificial means of producing it, but the painter tried to express its poetic quality. The negative mixture of colours on the palette reduced their purity, so the artist tried to achieve the positive mixture received by the eye, in which colours retained their purity and appeared to vibrate. When viewed from a suitable distance the juxtaposed pure colours appeared to mix on the surface of the canvas to give this positive mixture which reproduced the appearance of nature. The Impressionist painting was formed by the juxtaposition of pure colours, arranged according to the optical laws of the complementaries, to give the appearance of nature in a luminous atmosphere. Thus an Impressionist painting, and even more a Neo-Impressionist painting, consisted of a conglomeration of coloured particles, points or blobs. At the same time as interpreting light, this method resulted in the fragmentation of all the forms in the picture.

School or group?

Impressionism never produced a school in the proper sense of the term, even though it was the product of intuition and experiment, and despite its pseudo-scientific analogies. There was no set of rules or code for Impressionism. The Impressionists were a group of painters, or would be better described as a series of parallel or successive groups. There were those who grew towards Impressionism as a group, those who exhibited together in a group, those who shared a similar style or outlook and those who worked together or near one another. Impressionism had an obsession for the group, yet each member lived in fear of compromising his individuality by belonging to the group.

Three groups created Impressionism. Firstly, the one which may be called the St Simon school, in which Boudin, Jongkind 423, 422 and Courbet gathered together at Honfleur, and where the destiny of Impressionism was affected by their meeting the

young Monet. Two other fortuitously formed groups followed, the group from the Académie Suisse, including Cézanne, 455 Guillaumin and Pissarro; and the 'Group of Four' which met 431 at Gleyre's studio, consisting of Bazille, Sisley, Renoir and Monet. The Académie Suisse and the Gleyre's studio groups each had a recognisable and distinct character which lasted throughout the great adventure of Impressionism, even though the two groups became so very closely interrelated. The conception of landscapes of these two groups was subtly different. They both used the same Impressionist principles, but their poetic attitudes were not the same. Monet was a painter of water. Artistically he remained faithful to his origins on the Channel coast, though he matured on the banks of the Seine, at Bougival and Argenteuil. By comparison Pissarro painted the land. He was more moderate and less violent. He preferred the hills of the Oise valley, between Pontoise and Auvers, and often deliberately turned his back and looked away from the river. His subject matter and even the district where he worked linked him with Daubigny and Corot. There was a continuous overlapping between the painters who preferred water as their subject and those who preferred the land. Sisley perhaps was to be the most faithful to the general spirit of Impressionism. Chronologically Impressionism tended to the painting of water until 1880, and then to the painting of the land after the fifth exhibition of the Société Anonyme des Peintres, Sculpteurs et Graveurs, as the Impressionists called themselves.

Even earlier than Pissarro and Monet, Manet was the leader of the Impressionist movement. Manet's aesthetic and social background was different from that of the other Impressionists; he never became fully integrated with the movement. For him, Impressionism was little more than a passing experience; he felt sincerely enough about it, nevertheless, and it affected the growth of his art. It would be better to describe Manet not as the leader of the Impressionists, but as the leader of the revolutionary painters, those rejected by the Salon and those rejected by society; he was the leader of a mixed group of artists who met at the Café Guerbois in the Batignolles. Manet's *Déjeuner sur l'Herbe* and his *Olympia* were in the style known as *peinture* 418 *claire*, but they were not yet Impressionist. Manet arrived at Impressionism by his own means and step by step: firstly, at Boulogne in some seascapes and beach scenes; secondly and most importantly, while watching the bull-fights in the vibrating glare and blazing colours of Spain; and finally, on the Atlantic coast of Arcachon and Bordeaux. Manet was never converted to Impressionism and never exhibited with them; it accentuated his own personal tendencies. He was encouraged

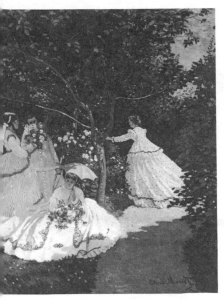

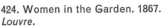

424. Women in the Garden. 1867. *Louvre*.

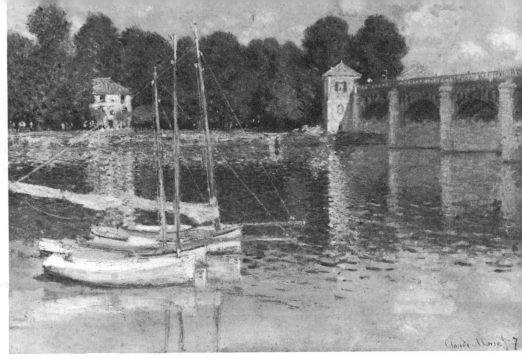

425. Railway Bridge at Argenteuil. 1874. *Louvre*.

426. Impression: Sunrise. 1872. *Musée Marmottan, Paris*.

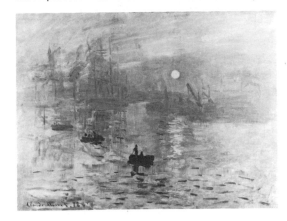

495 by Berthe Morisot, a pupil of Corot, who in Manet's studio was like a breath of contemporary air. Manet pressed the experience to its limit and in 1874 went to the extent of staying at Argenteuil and painting river scenes.

Manet, however, left the direction of Impressionism to Monet, whom he considered as the high priest of Impressionism. The theory of Impressionism was formulated from Monet's experimental work. Later, Monet was to leave his friends, because 'the select group had become an uncritical rabble, ready to admit anyone into its ranks'. Monet remained the guardian of the Impressionist ideal, even though he eventually became accepted by the Salon, and even though a few discerning collectors bought his work. His paintings could be seen in certain salons of the Faubourg St Germain hanging with those of Renoir, who was by now a relatively academic painter. It is essential to realise that Monet was the cornerstone of Impressionism, the style which spread through all the arts on an international scale and reflected so accurately the materialistic spirit of the age.

Three-dimensional art

All the arts except architecture gladly adopted the liberty of Impressionism. The steady hostility of the middle class prevented it from affecting interior decoration till Vuillard.

Monet and Manet enjoyed painting the newly built iron bridges and stations. They relished their decorative columns, and the delicacy of their geometric fretwork, especially when billows of smoke or steam made a contrast with the crisp metal structure.

These engineering constructions themselves often originated from a way of thinking not far removed from the Impressionist spirit. Stations and markets were covered or walled by glass or ceramic tiles set into and supported by iron. Light and air penetrated and filled these buildings, just as it did in Impressionist paintings.

One would expect sculpture by its very nature to have been alien to this spirit. Sculpture remained essentially academic and classical, had become isolated from architecture and had been

69 very little affected by Romanticism. However, with Rude and
72 Barye, and then Carpeaux, sculpture became realistic. The
450 sculpture of Carpeaux grasped the physical appearances of life passionately, reflecting its pleasure and pain. Though it

remained traditional, it ceased to be conventional and became both expressive and sensitive. Carpeaux also had a talent for painting. His paintings were made up of touches of colour, hatchings and stripes. They left the literal representation of daily life to recreate and extend the moral and physical atmosphere of their time. These paintings and drawings were earlier than the Impressionists and may really be considered as leading in their direction. They also explain the direction that was taken by sculptors of the period. Especially is this so in the case of Rodin, who was a pupil of Carpeaux. Rodin, who so much admired the 18th-century sculptors and Michelangelo, during the last quarter of the 19th century produced sculpture in complete harmony with the work of the painters. It can be said that the sculpture of Rodin was Impressionist. It was Impressionist in the way that his single figures were modelled in terms of light; also his compositions were not based on written laws, but on those of nature. Light, 'the great collaborator' suggested the planes and defined the forms. Convincing as stone or bronze, the sculpture was also convincing as flesh; the surface vibrated as the light played on the undulations of form in an ever changing but unified complexity. Rodin's own collection of pictures included *The Cliffs at Port Coton* by Monet, *Seated Woman* by Renoir, three paintings by van Gogh and seven by Carrière. It should be noted that his work joined together a number of complementary tendencies of the period. These will be dealt with later on under the heading of Symbolism.

427. FRENCH. J. F. BAZILLE (1841–1870). The Artist's Studio. 1870. From right to left (according to Moreau-Nélaton): the musician Maître, Bazille (painted by Manet), Manet, Astruc, Monet, Sisley. *Louvre.*

428. FRENCH. ALFRED SISLEY (1838–1899). Flood at Port Marly. 1878.

Sisley, in becoming enthusiastic about this motif, emphasised the Impressionist interest in the reflections and the fluidity of water.

430. *Below.* FRENCH. CAMILLE PISSARRO (1830–1903). Evening on the Boulevard Montmartre. *National Gallery, London.*

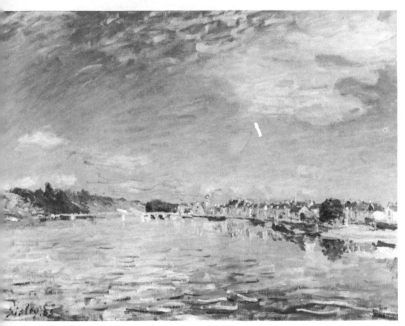

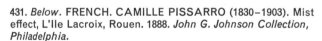

429. FRENCH. ALFRED SISLEY (1838–1899). St Mammès. 1885. *Louvre.*

431. *Below.* FRENCH. CAMILLE PISSARRO (1830–1903). Mist effect, L'Ile Lacroix, Rouen. 1888. *John G. Johnson Collection, Philadelphia.*

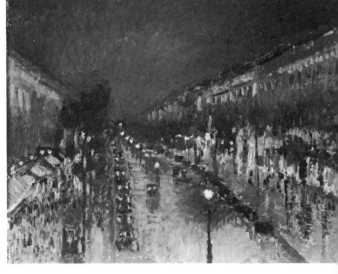

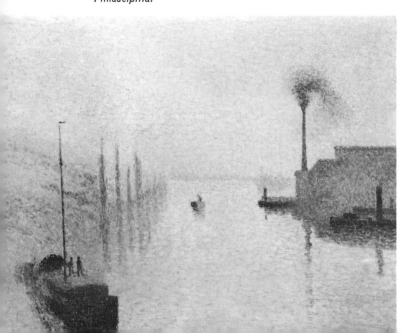

Impressionism outside France

Scientific discoveries sometimes occur simultaneously in several countries. Somewhat in the same way the thought underlying Impressionism was a phenomenon of the period and it is interesting to notice to what extent it appeared in countries outside France at about the same time. In Italy the Florentine Macchiaioli, deriving from the events of 1848, and a group influenced by the literary movement Scapigliatura Milanese appear to correspond to French Impressionism, though they were not directly related. 19th-century Florentine painters had a technique of applying rich and low-keyed colours with an Impressionistic handling. They renounced their heritage, which had created a pictorial world of volumes existing in space. Form and light struggled for power, and then quite suddenly light, which for centuries had served to enhance form, turned executioner. The Macchiaioli, supported by one of their theorists Adriano Cecioni, aimed at rendering the impression of visual truth as seen from a distance. They painted in colour tones distributed in blobs, and it was the tone which gave a feeling of depth. Giovanni Fattori and other Macchiaioli tried a new method for representing form, which no Italian could completely ignore. They made use of both colour and brush work; the brush was used broadly and with directional strokes

to suggest volume. French and Italian artists almost met in their new taste for colour: the French artist used colour for creating pictorial light, the Italian for creating volume, and both used it to give a sense of space. They also used similar brush work. The Caffè Michelangelo, meeting-place of the Macchiaioli, was not entirely different from the Café Guerbois and the Nouvelle-Athènes. Serafino De Tivoli travelled widely and introduced foreign ideas into Florentine thought, especially that of the emphasis on light. Vito D'Ancona remained determinedly faithful to constructive volume; Telemaco Signorini approached close to the French outlook; and Vicenzo Cabianca used strong brush work to obtain violent contrasts. Giovanni Boldini was one of the most audacious of the Macchiaioli. Whilst in Italy he used broken brush work to give an illusion of movement. When he came to France, strange as it may seem, he would have nothing to do with Impressionism. Working in France he produced pedestrian pictures which were as superficial as they were contrived. Similarly the early style of Giuseppe De Nittis was related to the Macchiaioli. He met Degas in Paris and became influenced by Impressionism. His interpretation of this new style remained an entirely personal one: his contours were drawn with precise detail, and to these he added a nice distinction of tonal values. Federigo Zandomeneghi was probably the most Impressionist of all the Italians, and while still in Florence he distinguished himself among his contemporaries with his study of light. When he came to Paris he met Manet, Degas, Renoir and Pissarro, with whom he exhibited, but his Venetian background was always visible.

One of the curious effects of the art of the Macchiaioli was that it created an Impressionist sculpture, in which light played across the forms in a disintegrating manner. This pictorial echo in sculpture is best seen in the works of Achille d'Orsi, Adriano Cecioni, and two Lombard sculptors, Giuseppe Grandi and Medardo Rosso.

In Spain the modern developments of landscape and the treatment of light were discovered by Martin Rico and Aureliano de Beruete. These three were very much influenced by the Barbizon school. Other painters included Pedro Villaalmil who was a Romantic, Carlos de Haes, and Ceferino Araujo y Sanchez. Despite the fierce individuality of Spanish artists they were not unaware of French developments. The Basque painter, Zuloaga, in his early style, made use of the Impressionist technique. The liberation of Iberian painting was, however, largely due to the work of Joaquin Sorolla y Bastida. In Madrid he led the way towards plein air painting. He was then followed by Dario de Regoyos, Joaquin Mir, and Herman Anglada-Camarosa, and those who were later to be known as the ' 1910 generation ', in particular Francisco Merenciano, whose work represents the last flicker of Spanish Impressionism.

German artists had the opportunity of seeing paintings by the French Impressionists when an exhibition of their work was held in Munich in 1879. Some artists who had already met the Realism of Courbet and Manet knew what to expect at this exhibition. There were Mihály von Munkácsy, Wilhelm Leibl and Otto Scholderer, as well as the Viennese painters Carl Schuch and Hans Thoma. Franz von Lenbach and Anton von Werner, who were academic painters, failed to grasp its significance. In Italy the new aesthetic of light had come up against a tradition of form; in Germany it was to meet the deeply ingrained tradition of draughtsmanship and graphic art. The conflict was between ' colour-space ' and analytical line. The *Freilichtmalerei* artists remained closer to the Realist-inspired French Impressionists such as Manet and Degas than to Monet and Pissarro, the masters of painting in a high key. (Degas remarked: ' They shoot at us but they also pick our

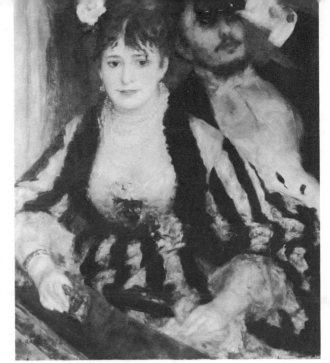

432. FRENCH. AUGUSTE RENOIR (1841–1919). La Loge.
Courtauld Institute Galleries, London.

pockets. ') Among them were Alfred Roll, Henri Gervex and Jules Bastien-Lepage. In Germany, Impressionism had its strongest influence in Berlin. Max Liebermann went beyond the plein air work of T. Hagen. He was inspired by the example of Manet and Degas and, with the exhibitors of the Sezession, approached Impressionist colour and movement; but his work always retained a certain coldness. The late works of Lovis Corinth were painted with a violent and brutal technique. In his work matter itself seemed to vibrate as a result of his complete understanding of light and air. Max Slevogt, the Bavarian Impressionist, could not bring himself to renounce line; Emil Nolde, in one sweep, leapt the gulf separating Manet and van Gogh.

Impressionism reached Switzerland in the works of A. Baud-Bovy and Arnold Böcklin. It came to Austria in the paintings of G. Klimt and to Hungary with the work of Pál von Szinyei Merse, Karoly Ferenczy, Etienne Csok and Jozef Rippl-Ronai. The *Picnic in May* by Szinyei Merse derives from Courbet and Manet. Ferenczy was influenced by Bastien-Lepage; Rippl-Ronai was on friendly terms with Vuillard, Bonnard and Maillol; and Etienne Csok painted pictures in series as had Monet.

Belgium and Holland echoed all the French artistic developments of the century and played their part in the Impressionist movement. In Belgium Emile Claus was influenced by Monet and Pissarro, H. Evenepoel was related artistically to Manet and Toulouse-Lautrec, and Albert Baertsoen to Roll. Holland with its damp climate and clouded skies was visited by several Impressionists. Boudin went there and studied the works of Ludolf Bakhuyzen and Willem van de Velde; Monet painted at Zaandam and Amsterdam in 1871, and at Leyden and The Hague in 1886; Albert Lebourg paid a visit there in 1896. Jongkind was Dutch and was also one of the earliest of the Impressionists who joined the others in France. Vincent van Gogh, too, was Dutch; his art was created by contact with the Impressionists in France; he went further than Impressionism, and may be said to have brought the movement to its conclusion. England, like Holland, made a number of contributions. Pissarro and Monet came here and found inspiration in the mists and fogs and rain of northern Europe; they also

472

477
480

393

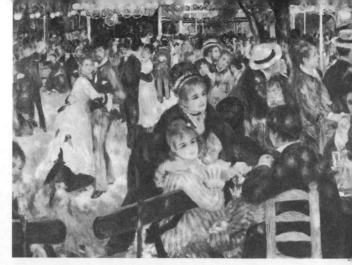

434. Le Moulin de la Galette. 1876. *Louvre.*

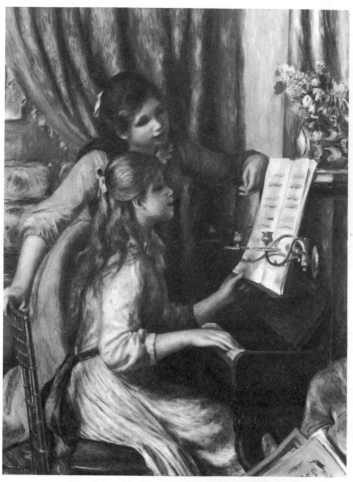

433. At the Piano. 1892. *Lehmann Collection, New York.*

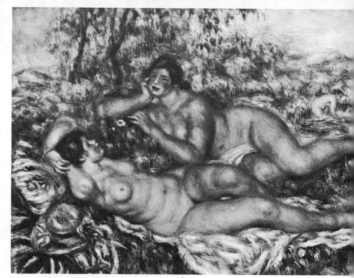

435. The Bathers. About 1918. *Louvre.*

discovered the work of Turner, which filled them with enthusiasm. Sisley and Sickert were Englishmen; Dieppe especially attracted Sickert, whose art was immensely enriched by the influence of Degas and Whistler.

In Denmark the most important Impressionist was Peter Severin Kröyer, who has been described as the virtuoso of diffused light. Swedish painters not only gathered in the country at Grez sur Loing. A group of them looked towards the new Paris of the Batignolles. They included Anders Zorn, whose career was Parisian as much as international; Ernst Josephson, who recognised Manet as his master; Carl Larsson who preferred Sisley; and Bruno Liljefors. In Norway Impressionism took the form of a great interest in the painting of moving waters. Christian Krohg was known as the Norwegian Manet, and there was also Fritz Thaulow. Edvard Munch and Erik Werenskiold were figure painters. Munch began as a pupil of Bonnat and then was for some time under the influence of Cézanne, Degas and Odilon Redon.

Outside France, Impressionism arrived slowly. It frequently became confused with subsequent movements such as Neo-Impressionism and Symbolism. There was a general mix-up of French styles, frequently mingled with an indigenous and opportunity-seeking academicism. Impressionism continued to influence countries outside France as late as the First World War. In Poland painting in a high key was introduced by Joseph Pankiewicz, a friend of Renoir, Bonnard, Signac and Vuillard.

Pankiewicz continued the Impressionist style until his death in 1940. The group known as the Mir Iskusstva ('The World of Art', after their publication) was orientated towards France despite the resistance of Repin and the Travelling Art Exhibitions group. Isaak Levitan was inspired by Monet, and Maria Bashkirtsev by Bastien-Lepage; the dying embers of Impressionism attracted Pavel Kusnetsov to France, where he died in 1935.

Impressionism was not confined to Europe. It already owed a great debt to the New World, for Pissarro came from the West Indies. He was in fact more a cosmopolitan in that his ancestors were Portuguese, French and Jewish and they had settled on a Danish island. In addition, before North America became enthusiastic about Impressionist painting, it made a contribution of a number of artists — Whistler, who became very French and was strongly influenced by Courbet, Manet and Fantin-Latour; Mary Cassatt, the young admirer of Degas; and Childe Hassam, John Twachtmann and J. Alden Weir.

The Symbolists

Impressionism carried the seeds of its own destruction within itself, both intellectually and physically. It carried them both for itself and for realism in general, of which Impressionism was the final and extreme consequence. Courbet had said: 'Painting is an essentially physical language made up of what is visible' and 'That which is abstract and invisible does not belong to the

408

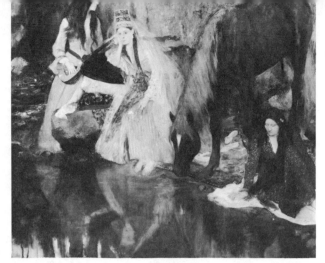

436. FRENCH. EDGAR DEGAS (1834–1917). Mlle Fiocre in the Ballet ' La Source '. 1866–1868. *Brooklyn Museum, New York.*

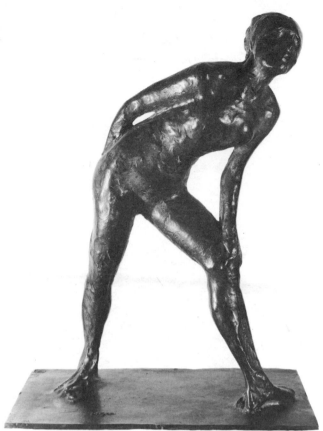

437. FRENCH. EDGAR DEGAS (1834–1917). Dancer. Sculpture. *Museum of Fine Arts, Algiers.*

domain of painting.' By narrow obedience to these laws painters had been forced to jettison the limitless possibilities of the imagination. Following the volte face of Flaubert and the repentance of Taine the philosophers of historic determinism and certain novelists of the experimental school realised in time that the systematic neglect of the imagination could only lead to the collapse of realism, which they already saw to be imminent. The Impressionist painters remained tied to the earlier outlook of Taine: ' Make the causes understandable in order to approach the heart and senses of the ordinary man.' There were other painters, however, whose work derived from Realism, who were able to remain ardent idealists, without contradicting themselves. These painters were known as Symbolists, and the most important were Gustave Moreau, Odilon Redon, Eugène Carrière and Puvis de Chavannes. Their art may appear minor and somewhat suspect at the present day, but their influence was considerable in their own time. Impressionist art had scarcely any public, nor did it inspire confidence for the future; it is not surprising therefore that art from 1860 to 1900 became increasingly attached to the philosophic, scientific and literary interests of the period. Especially after 1880, due to Symbolism and to the influence of the Englishman William Morris, painting became free from servile imitation and could make fresh contributions. The Symbolist spirit affected design, especially that of the cabinet-makers, the ceramists and glass workers. From all this, Art Nouveau was to evolve.

The Symbolism of 1860–1870 was the first Symbolist movement of the century and should be distinguished from the Symbolism of the Pont Aven group which came later. This first movement included Moreau, Redon, Carrière and Puvis, artists whose directions and achievements were extremely varied. Important events of the 1860s included the painting of *War and Peace* by Puvis de Chavannes, Redon's meeting with Bresdin, and also Redon's arrival in Paris. The Symbolism of 1860–1870 was to be extended, in the work of Carrière and Rodin, right into the early years of the 20th century. This Symbolism came just before Impressionism and then the two styles ran concurrently, as well as the style of Gauguin and that known as ' Cloisonnism ' which will be defined later (see p. 189). The Symbolists aimed to re-establish the sovereignty of the mind and the idea, in place of the mere representation of nature, but they should not be accused of completely repudiating nature. They even gave enough tokens to science to warrant their being called intellectual. According to Symbolist theory reality is not limited to physical matter, but includes thought. The mind, continuously meditating, steadily unearths the

significance underlying outward appearances. So Symbolism may be described as a search for the mysterious meanings hidden in physical things, with magic and religious nuances.

Gustave Moreau was strongly attracted by the scientific method and made use of the archaeological and historical principles formulated by Taine, which in literature had already been used by Flaubert and Leconte de Lisle. The precision in Moreau's paintings approached that of the goldsmith. His mind overflowed with idealistic visions, and he turned towards a documentary study of mythology and religions. Despite utter confusion caused by his interest in various religions, mixed up with his own personal beliefs, he nevertheless arrived at a general and precise aesthetic analysis. His work cast a spell over the generation of the writer J. K. Huysmans, the Rosicrucians and the Belgian painter Fernand Khnopff. The younger artists were influenced by contemporary scientific research, but Redon recognised that if philosophy put ' one side of truth ', then this was not ' the whole truth '. At the same time Redon held that Impressionism was exhausted. He considered the Impressionists as ' real parasites of their subject matter, which they looked at from a single viewpoint, and that they were blind to anything beyond what they saw '. He formulated the basic law of Symbolism: ' Nothing can be created in art by the will alone. All art is the result of submission to the unconscious.' Beauty is only attained through the quality of the thought.

Carrière effected a valid compromise between the 1848 Realist outlook, in which he had been brought up, and the truth of his personal experiences as an artist. ' The eye ', he said, ' is dependent on the mind.' He entitled one of his lectures: ' Man, visionary of reality '. Nevertheless he discovered the principle of all beauty in the anatomical gallery of the Muséum d'Histoire Naturelle, ' a great forest of life where the spirit trembles '. There was no contradiction in the work of Carrière

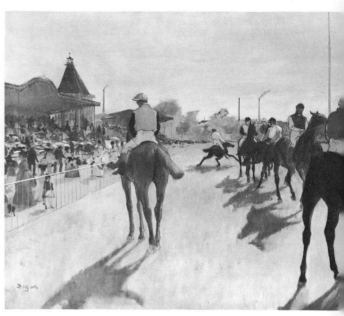

439. At the Races. About 1869-1872. *Louvre.*

438. The Bellelli Family. 1860. *Louvre.*

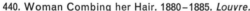

440. Woman Combing her Hair. 1880-1885. *Louvre.*

between his sense of the universal and his intimate feeling for the family. He recognised, without emphasising either, that the mind with its deductive logic and spontaneous intuition was in control. His art was one of confidences, introvert and to some extent sentimental. He worked in restrained colour and subtle tonal contrasts, with sure draughtsmanship, and a freedom of brush work. With a high-minded and generous spirit he attempted a coherent explanation of the world. Rodin found this atmosphere of scientific symbolism to his liking; there exists a deep affinity between the female busts and the interlaced couples of the sculptor and the pictures of mothers and children by the painter. They met one another often in the course of their professional life; together they formed the Société Nationale des Beaux-Arts in 1890; they often went to artistic functions; and to the Café Voltaire, the new rendezvous of the Symbolists. They influenced one another: Carrière's work owed much to high relief sculpture; and Rodin's series of sculptures were essentially a creation of the mind, deriving nothing from Impressionism. Puvis de Chavannes was a third founder of the Société Nationale des Beaux-Arts, and he played a curious role in the history of 19th-century painting. In an unexpected way he brought Impressionism out of its impasse by revealing to Gauguin, who had been till then a follower of Pissarro, the potentialities of Symbolism, the suggestive power of decorative painting and the importance of the idea. Puvis in his own works provided the contemporary example of this classical approach, proving to Gauguin that such a dream was not chimeric.

Doubts about Impressionism

The Impressionists began to have doubts about their art even before it was attacked at its roots by Symbolism. The followers of Manet soon saw the dangers they ran; it was clear how Monet would flounder, though Manet himself knew instinctively the

359

453

limitations of Impressionism. Though he recognised the artist's right to distort an object because of the play of light upon it, he shrank from doing so because he had a horror of the inconsistent and the formless. Visual suggestion was insufficient for him; he had to be able to control his painting. He did not like the despotism of colour, and preferred to order it musically, seeking subtle relationships but not accepting them readymade. He accepted some of the technical methods of the Impressionists and explored these fully in his paintings done at Argenteuil in 1874. Then between these paintings and those he did at Venice he rid himself of Impressionism. *The Laundress* painted in the next year, 1875, despite its staccato brush work, marked the point where he reverted to his own style. His actions confirmed his aesthetic change of heart: he did not exhibit with the other Impressionists, and in 1875 he showed at the Salon his portrait of Marcellin Desboutin called *The Artist*. This painting indicated a return to the Spanish influence already encountered in his early *Philosophers*. Manet painted a portrait in 1877 of the worst enemy of the Impressionists, Albert Wolff, and this would seem to be an act of complete repudiation. This repudiation was not absolute, for in *Nana* Manet revealed that he would use the technique when and where it pleased him. Manet attempted a compromise between the ephemeral quality of Impressionism and the permanency of values to be found among the old masters. He hoped that his *Bar at the Folies-Bergère* might hang between a Titian and the *Fable of Arachne* (formerly called *The Tapestry Weavers*) of Velasquez.

Just before 1880 a number of other artists, as well as Manet, were beginning to doubt the Impressionist theories. Cézanne looked back to Poussin, Renoir became entranced by Raphael, Degas held to the tradition of Ingres, and the younger generation, particularly Seurat, had uncertainties from the beginning. Cézanne, after a short period of romantic painting, remained with Impressionism for a brief time. From Pissarro at Saint-Ouen l'Aumône and at Auvers sur Oise he learned to use lighter colours and to analyse nature, especially light. In his first Impressionist pictures he used thick impasto, but later preferred working with thinly applied paint. For Cézanne Impressionism was an enriching experience; but a visual transcription was not sufficient for him, and he went on to elaborate it and to give it unity. The Impressionist fragmentation of form was alien to his architectural spirit. He now based his pictures upon a 'motif' but was interested in structure and spatial relationship. From Impressionism he wanted to create '...something as solid and permanent as the old masters'. He struggled to recover on his canvas, by means of accuracy of colour, not only light, but also three-dimensional form, the old and abandoned conquest of the Italian Renaissance. 'When colour is at its richest, the form is at its plenitude; in the contrast and the relation of colour is to be found the secret of drawing and of modelling.' These words were addressed by Cézanne to Emile Bernard, who was the founder of Cloisonnism and the one who initiated Gauguin to Symbolism. They contained a lesson of clear thinking where the use of thought was reintroduced into art without calling on the subconscious. They were also a reply to the 1860–1870 Symbolists, as was another comment of Cézanne's, this time made to Gasquet: 'Everything else [apart from the study of the model] belongs to poetry [to the idea of the symbol]; this must be in the brain perhaps, but one must never attempt to introduce it consciously into the work. It will come by itself.'

Renoir in 1880 disengaged himself from the Impressionist impasse, as Cézanne had done in 1877. He came suddenly to the conclusion that at bottom he 'knew neither how to paint nor how to draw'. He felt that the Italians alone could give him a solution, such as Cézanne now possessed. The two artists

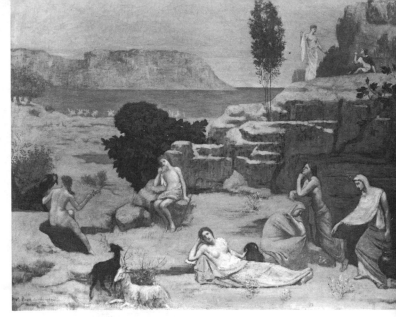

441. FRENCH. PUVIS DE CHAVANNES (1824–1898). A Vision of Antiquity: Symbol of Form. 1884–1885. *Carnegie Institute, Pittsburg, Pennsylvania.*

442. FRENCH. GUSTAVE MOREAU (1826–1898). Helen on the Walls of Troy. *Gustave Moreau Museum, Paris.*

443. FRENCH. EUGÈNE CARRIÈRE (1849–1906). The Sick Child. 1886. *Louvre.*

444. FRENCH. ODILON REDON (1840–1916). Birth of Venus. *Private Collection, Paris.*

445. FRENCH. JEAN BAPTISTE CARPEAUX (1827–1875). Masked Ball at the Tuileries in 1867. *Louvre.*

frequently met in and around Paris, at Aix, at the Jas de Bouffan and at Estaque. Renoir went to Italy, where he saw the Raphaels in the Villa Farnesina, and also the Roman paintings at Pompeii. He read and wrote a preface to a translation of the treatise on painting written by Cennino Cennini. The translation was by V. L. Mottez, who was a pupil of Ingres. The time was ready for Renoir to take stock of his position, and he looked clearly and honestly at the art of his time in relation to the art of centuries. He noted two significant gaps in the Impressionist armoury — firstly the absence of a controlling mind, without which inspiration had become exhausted and unity destroyed; secondly a deficiency in technique, where form immediately became lost. Renoir, a master of movement and air, now wanted to attain something more permanent. He perceived that it was vanity to try to mirror nature in her changing play of light and colour, and that being charmed by a multitude of visual sensations led the painter to lose control. He realised the necessity for composition: ' A painting should be the result of the artist's imagination and never be mere copying '; ' One cannot breathe the air in pictures. ' For six years he underwent a self-imposed discipline in his work, producing his so-called ' classical ' paintings. He succeeded finally in creating a rich and monumental art firmly founded on the art of the old masters.

430, 431 Pissarro experienced similar uncertainties; he continued to paint his earthy landscapes, even though he came under the influence of Seurat. In the crisis Renoir turned to Italy, Monet found the Impressionist climate had changed and exhibited by himself, and Cézanne was following an entirely different path. But in 1879 Gauguin joined the group and participated in the fifth Impressionist exhibition in 1880. The entry of Gauguin coincided with the break-up of the movement. Its members dispersed, left Paris and worked in Normandy or in the Midi. Several years passed, and then in 1886 Pissarro invited the Divisionists to take part in the eighth exhibition of the group.

In 1886 Neo-Impressionism became known to the public. In the same year the Symbolist manifesto was written by Jean Moréas. Two years later came the Cloisonnism of the Pont Aven group. Van Gogh arrived in Paris in 1886. The destiny of painting had changed its course.

Neo-Impressionism

Divisionism or Neo-Impressionism was an attempt to rescue Impressionism by systematising its limitations. An intellectual approach replaced instinct; what the Impressionists had arrived at by experiment was now reduced to rules. The Impressionists had made full use of the scientific studies of light and colour undertaken by Chevreul, O. N. Rood, Helmholtz and David Sutter. The new developments were the fruit of the joint studies of Seurat and E. F. Aman-Jean, the teaching of Puvis de Chavannes, and of Charles Henry's development of a colour harmony circle. The aesthetic studies of Henry covered colour, rhythm and proportion. Signac, who wrote on Divisionism, extended his theories from colour to the composition generally and in his *D'Eugène Delacroix au Néo-Impressionisme* (1899) he wrote down these theories. They aimed at gaining full advantage of light, colour and harmony, ' firstly, by the optical mixture of pure pigments (all the colours of the spectrum in all their tints); secondly, by analysis of the various elements (local colour, colour of light, colour of reflections); thirdly, by the balance of these elements and their proportion, depending on contrast, change in strength according to light or other cause, and reflections; fourthly, by the choice of a brush-stroke related in size to the dimensions of the painting '. He continued that ' a Neo-Impressionist, when composing his picture, will arrange the directions of lines and the angles they form, the value of the tones, and the colour harmonies according to the mood he wishes to predominate' . Ascending lines (from left to right), warm colours and light tones suggest joy; descending lines, cool colours and dark tones suggest sadness; and horizontal lines

446. FRENCH. ODILON REDON (1840–1916). Day. Part of a mural decoration in Fontfroide abbey (Aude), completed in 1911. *Mme Fayet Collection, Fontfroide.*

447. Fisher-Boy with a Shell. 1858. *Louvre.*

448. Flora. 1866. High relief from the Pavillon de Flore, in Paris.

449. *Below, left.* Charles Garnier. 1869. *Louvre.*

450. *Below, right.* The Dance. Plaster model for the group on the façade of the Paris Opéra. 1869. *Louvre.*

with a balance of warm and cool colours and of light and dark tones suggest calm. The Neo-Impressionist painter aimed at a scientific integration of tone, colour and line.

Seurat died seven years later while still a young man. He made systematic use of these strict principles, but in spite of them, or because of them, he produced paintings of exceptional sensitivity and refinement. His technique made use of dots or brush-strokes of colour drawn together as though in a closely meshed fishing net. In this way he reintegrated the form fragmented by the Impressionists. Camille Pissarro, who was always interested in new methods, completely understood Divisionism, which he used for a time, as did his son Lucien. Divisionism was not only a. method of applying paint to canvas; it was also a transitional style which cleared the way towards the 20th-century art of Picasso, La Fresnaye, Braque and Matisse. Artists who belonged to Neo-Impressionism included Paul Signac, Lucie Cousturier, Henri Edmond Cross, Maximilien Luce, who all followed Seurat; and on a lesser plane Charles Angrand, Albert Dubois-Pillet and Hippolyte Petitjean. Artists outside France who arrived at similar conclusions included Theo van Rysselberghe from Belgium and Giovanni Segantini from Italy. Academic painters also tried to 'classicise' Impressionism but it soon became played out.

Gauguin's flight

Gauguin abandoned a career in finance because of his passion for painting. Pissarro introduced him to painting in a high key. Following a period of attachment to Cézanne, Gauguin made use of the Divisionist technique. Then at Pont Aven he learnt the method of Cloisonnism, invented by Emile Bernard and Anquetin. Gauguin transformed this style by his inspired brilliance. Cloisonnism or Synthetism consisted of painting in flat areas of colour, as used in Japanese prints, and by enclosing these with intensely coloured outlines, in the manner of the lead supports of stained glass. Gauguin at once made use of the full possibilities of this style. Around him were grouped Paul Sérusier, Henry Moret, C. E. Shuffenecker, Charles Laval and others. Sérusier later passed the style on to the future Nabis, who included Bonnard and Vuillard. After the 1889 exhibition in the Café Volpini Gauguin met the Symbolist poets. He was introduced to Albert Aurier who frequented the Café Voltaire. He was accepted into the company of Carrière and Moréas,

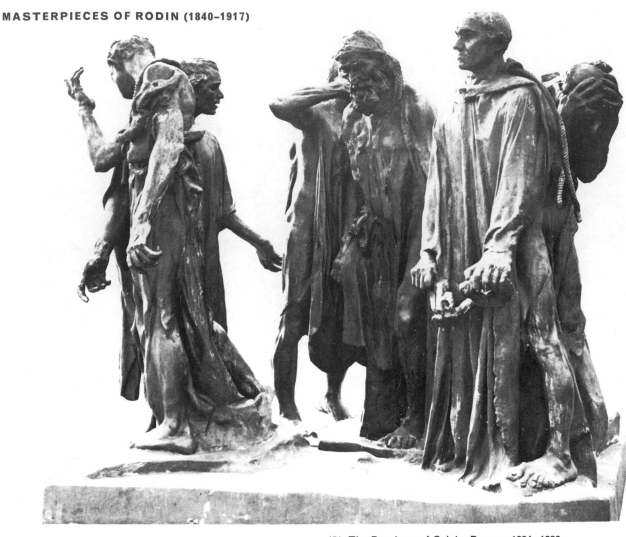

451. The Burghers of Calais. Bronze. 1884–1886.

This group was unveiled in Calais in 1895 after ten years of negotiation with the municipal council. Another cast stands in the Victoria Tower Gardens near the Houses of Parliament, London.

452. The Thinker. Bronze. 1889. *Rodin Museum, Paris.*

This theme also figured in the middle of the tympanum of the ' Portals of Hell '.

453. Puvis de Chavannes. Bronze. 1895. *Rodin Museum, Paris.*

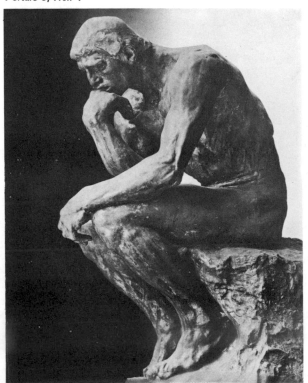

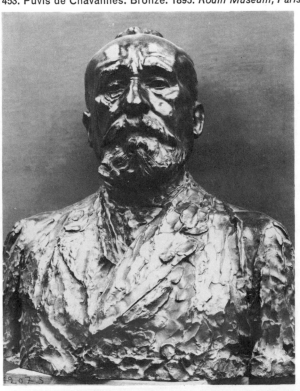

454. The Black Marble Clock. 1869–1870. *Niarchos Collection.*

who was the high priest of Symbolist painting. He was finally invited to the Tuesday evening gatherings held by Mallarmé.

Albert Aurier set out the rules of Symbolist painting in the *Mercure de France* in 1891. ' The work of art must be, firstly, ideological, since the only aim is the expression of an idea; secondly, symbolist, since the abstract idea must be expressed in visual forms; thirdly, synthetic, since these forms or signs must be stated in understandable manner; fourthly, subjective, since what is presented will be considered not only for what it is, but as an image of something perceived by the subject; and fifthly, decorative; this follows naturally, for decorative painting, such as that done by the Egyptians and probably by the Greeks and the primitives, is essentially the manifestation of an art at once subjective, synthetic, symbolist and ideological. But all these attributes would only give the artist the means which without emotion would not produce art. '

Because of Gauguin Impressionism culminated in Symbolism and naturalism was absorbed by ideology; whereas before artists painted because they saw something, they now painted because they thought something. Through the work of Gauguin the Symbolism of 1860–1870 became important, but Impressionism showed no signs of decline. Impressionism had made valuable contributions to art; colour had regained a position of paramount importance and was the medium through which form and light were represented. Cloisonnism with its flatness and its strong outlines would appear to be the exact opposite of that ephemeral quality which came from vagueness, indeterminacy and ambiguity; Redon's drawings were called ' metaphorical ' by Remy de Gourmont. There was a strong leaning away from the present towards any mythological, exotic, classical, primitive, imaginary or sentimental theme. The idealised line of Moreau gave way to the abstract line of Redon, thence to the decorative arabesque of Puvis de Chavannes and finally to Cloisonnism. Technique became more and more simplified even though the painter's state of mind became more involved, yet the technique, and the use of colour especially, remained true to the expression of the artist. Redon, later, again recognised the importance of colour.

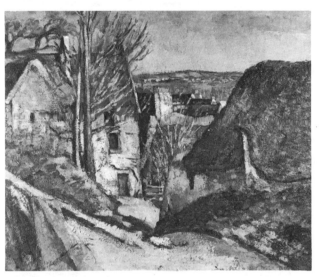

455. La Maison du Pendu, Auvers. 1873. *Louvre.*

456. Lac d'Annecy. *Courtauld Institute Galleries, London.*

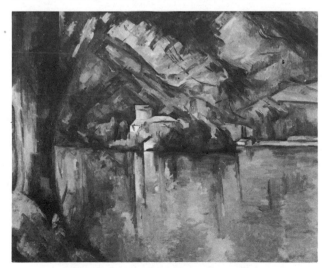

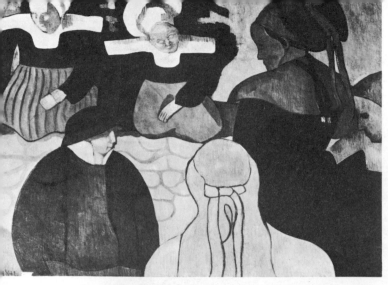

457. FRENCH. EMILE BERNARD (1868–1941). Breton peasants ('Bretonnerie'). 1892. *Altarriba Collection.*

458. FRENCH. GEORGES SEURAT (1859–1891). Les Poseuses. 1888. *Henry McIlhenny Collection, Philadelphia.*

This is the final study for the large composition in the Barnes Foundation, Merion, Pennsylvania. Three studies made in 1887 are in the Louvre.

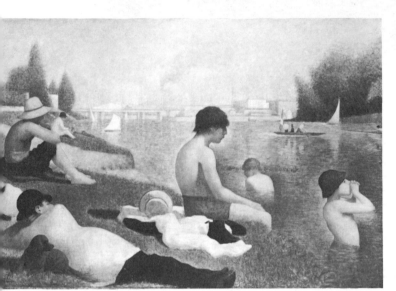

459. FRENCH. GEORGES SEURAT (1859–1891). La Baignade. *National Gallery, London.*

460. FRENCH. PAUL GAUGUIN (1848–1903). Ia Orana Maria. *Metropolitan Museum of Art (Samuel A. Lewisohn Bequest).*

462. FRENCH. VINCENT VAN GOGH (Holland, 1853–1890). Field with Poppies, St Rémy. April 1890. *Kunsthalle, Bremen.*

461. FRENCH. PAUL SIGNAC (1863–1935). Les Sables-d'Olonne. Watercolour. 1912. *Petit Palais, Paris.*

MASTERPIECES OF GAUGUIN (1848–1903)

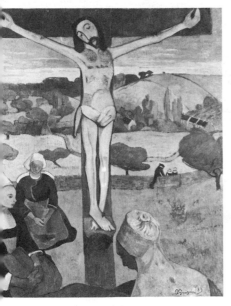

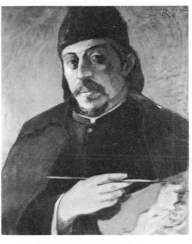

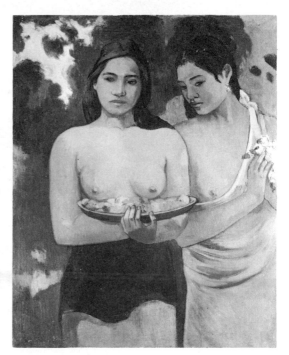

463. The Yellow Christ. 1889.
Albright Art Gallery, Buffalo.

464. Self-Portrait with Palette.
1893–1894. *Formerly Arthur Sachs
Collection.*

465. Two Tahitian Women. 1899.
Metropolitan Museum of Art.

MASTERPIECES OF VAN GOGH (1853–1890)

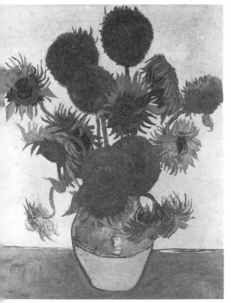

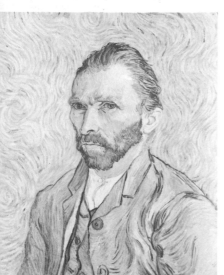

467. *Above.* The Potato Eaters. Nuenen, 1885. *V. W. van Gogh
Collection, Amsterdam.*

466. *Above, left.* Sunflowers. Arles, August 1888. *National
Gallery, London.*

468. *Left.* Self-Portrait. 1890. *Louvre.*

469. FRENCH. HENRI DE TOULOUSE-LAUTREC (1864–1901). Jane Avril in the Entrance of the Moulin Rouge. *Courtauld Institute of Art, London.*

470. FRENCH. HENRI DE TOULOUSE-LAUTREC (1864–1901). Marcelle Lender in the Ballet ' Chilpéric '. 1896. *John Hay Whitney Collection, New York.*

It is significant to note Gauguin's obsession for the art of Puvis, which he used as a yardstick. In Arles Gauguin dreamed of a modern style which he would create by adding to the classical Puvis the colour of the Japanese. While the girls of Arles promenaded ' as virgin in appearance as Juno ', Gauguin constructed his synthesis of Greek beauty and Impressionist colour. In Tahiti he was sustained by the thought of ' the noble example of Puvis du Chavannes ', the painter who had produced the most important work of the Symbolist movement, *The Poor Fisherman*. In homage to the memory of Puvis Gauguin introduced into the background of a still life with wild flowers a reproduction of *Hope* painted by him. There were many evidences in Gauguin's work of the similarity of his ideas to those of his former Symbolist friends. This was especially so in the case of Carrière and Odilon Redon, who with Mallarmé tried to raise funds towards the expenses of his voyage to the Pacific. Redon twice painted the portrait of his absent friend whose savage mastery of colour he admired, and Gauguin gave a dedicated portrait to his ' ami Carrière '. Whatever Gauguin was to achieve later in a distant and primitive country, he had already launched what he described as a ' machine ', which was to develop the power of an electric generator. In considering the future it is essential not to separate Gauguin from Cézanne, Seurat and van Gogh, for each made a fruitful contribution to the art of the 20th century.

The way ahead

466–468 Van Gogh arrived in Paris in 1886, the same year as Seurat exhibited *La Grande Jatte*. In Paris van Gogh discovered Impressionism, and at the same time the antidote to Im-

pressionism. Though he became converted to painting in bright colours, this never led him to neglect form. As he broke up his subject matter into hatched brush-strokes, so he began immediately to strengthen the construction and the outlines. He preferred the architectural motifs of the suburbs to the less resolved motifs of the countryside. His style moved away from Monet and rapidly towards Cézanne, Degas and Toulouse-Lautrec, all painters who considered construction fundamental. He sent the young Bernard to Gauguin to experiment with Cloisonnism. From Divisionism van Gogh derived a technique of brush work which he experimented with to create an atmosphere rather than to apply as an optical theory. Vincent learnt much from living for several months among Parisian painters. He learnt about the subtlety of atmospheric painting, its aerial vibration and its luminous colour. He also learnt about the spectrum palette and the new methods of composition. Van Gogh left Montmartre for Asnières where he worked with Emile Bernard. He was influenced by Paris; his brush work became less heavily loaded, his design became less packed, and his imagination slackened, leaving him in danger of aesthetic impoverishment. It became urgent for him to abandon both Impressionism and Neo-Impressionism. In the brilliant sunshine of Arles van Gogh found once more the freedom of a Delacroix. He began again from the Impressionist origins, but took another route, this time by way of Japan and the Far East, the Mediterranean, the antique, and classical art.

Impressionism, direct or indirect, pure or derived, had run its course. In Arles towards the end of 1888 with van Gogh and Gauguin the final sequels of naturalism were suddenly ended by a dramatic and bloody sacrifice. Van Gogh attempted to murder Gauguin and then cut off his own ear. They parted. From that time they took their own directions away from Impressionism and towards the future. Events occurred rapidly in the fatal years that followed. In May 1890 van Gogh committed suicide; in March 1891 Seurat died. In the same year Gauguin left for Tahiti, where he became isolated from Western civilisation. The glory of the solitary genius of Aix was soon to radiate far and wide. The seeds scattered in the earth of Auvers and Hiva Oa were soon to germinate and bring forth a magnificent harvest of flowers in the work of the Nabis, the Fauves, the Cubists, the Expressionists and the Surrealists, and to make possible the recent and most advanced developments of abstract painting.

IMPRESSIONISM OUTSIDE FRANCE

Impressionism in creating a style where light was all-important opened the way on the one hand to a neo-realism of atmosphere and on the other to a research into musical vibration. Masters of Impressionist atmosphere included the Englishman Sickert [475], the German Liebermann [472], the Italian Segantini [471] and the Spaniard Gimeno [473]. Neo-Impressionism, which directly influenced van Rysselberghe and took a decorative turn in the work of Prendergast [476], transformed the initial realism of the Impressionist touch into a palpitating harmony of brush work.

472. GERMAN. M. LIEBERMANN (1847–1935). Open-air café in Bavaria. *Musée d'Art Moderne, Paris.*

471. ITALIAN. G. SEGANTINI (1858–1899). Cattle. *Galleria Nazionale d'Arte Moderna, Rome.*

473. SPANISH. GIMENO (1858–1927). Aigua Blava. *Museum of Modern Art, Madrid.*

474. BELGIAN. T. VAN RYSSELBERGHE (1862–1926). The Reading (Verhaeren, Maeterlinck, Gide, Vielé-Griffin, Ghéon, etc.). 1903. *Ghent Museum.*

475. BRITISH. W. R. SICKERT (1860–1942). The Old Bedford. About 1890. *Walker Art Gallery, Liverpool.*

476. AMERICAN. M. PRENDERGAST (1859–1924). Ponte della Paglia. 1899. *Phillips Collection, Washington.*

SYMBOLISM OUTSIDE FRANCE

Symbolism, essentially a literary movement, reacted against fin de siècle realism. Artists rediscovered their intuitive powers, in an unexpected resurgence of romanticism, which was world-wide. Some artists, such as the Austrian Klimt [480], fought to liberate the imaginary through an almost orientalised technique. Others, such as Smits [481], the Belgian, used a technique based on chiaroscuro. Böcklin [477], the Swiss, and Toorop [479], the Dutch artist, chose romantic themes.

477. *Below*. SWISS. A. BÖCKLIN (1827–1901). Island of the Dead. First version, 1880. *Basle Museum.*

478. DANISH. J. F. WILLUMSEN (1863–1958). Stonecutters. Low relief in bronze, stucco and wood. 1891. *Statens Museum for Kunst, Copenhagen.*

480. AUSTRIAN. GUSTAV KLIMT (1862–1918). Portrait of Mme Adèle Bloch-Bauer. *Private Collection.*

479. *Below*. DUTCH. JAN TOOROP (1858–1928). Holy Flight. *Municipal Museums, Amsterdam.*

482. *Below*. BRITISH. G. F. WATTS (1817–1904). Hope. *Tate Gallery.*

481. *Below*. BELGIAN. JACOBS SMITS (Holland, 1855–1928). The Creed of Kempen. About 1895. *Brussels Museum.*

HISTORICAL SUMMARY: Later 19th-century art

FRANCE

History. After the short period of the Second Republic (1848–1852), Louis Napoleon re-established the Empire. Napoleon III tried to regain international prestige for France. His reign was a fortunate one for French domestic affairs. Industry, commerce and banking flourished; transport was greatly improved with the extending of the railways; and the merchant navy was increased. The major enterprise of the Suez Canal was undertaken; it was built by Ferdinand de Lesseps in 1869. Trade expanded as a result of sound commercial treaties being made with England, Belgium, Italy and other countries. Towns increased in size and population. For political reasons Haussmann laid the foundations of modern Paris, in spite of the wholesale destructions this necessitated.

The International Exhibition of 1867 was a tribute to French prosperity and European peace. Despite the Franco-Prussian War (1870) resulting in the French defeat at Sedan, the fall of the Empire, the Commune of 1871, the loss of Alsace-Lorraine, and the Third Republic's salvaging policy, France rose again. The International Exhibition of 1889 was evidence of the vitality of France. An African and Asiatic empire was formed, including countries such as Cochin China, Annam and Tonkin. There developed a spirit of adventure towards distant countries, led by soldiers, explorers and pioneers. Exoticism enriched French thought and French art which, from 1890, turned from a blind confidence in realism and science to discover in man and in spiritual values a hope which was only to be shattered in 1914.

Literature. Following the efforts of Victor Duruy, laws were passed making education compulsory for all, thereby opening culture to even the less favoured classes.

Literature spread by means of periodicals such as the *Artiste*, the *Revue de Paris*, the *Revue des Deux Mondes*, and by means of the newspapers; *Le Temps* was founded in 1861. T. Gautier, who wrote *Emaux et Camées* in 1852, became the leader in poetry of art for art's sake, in opposition to the individualism and the ' useful art ' of the Romantics. T. de Banville (1823–1891), who wrote *Odes Funambulesques* (1857), L. Ménard and L. Bouilhet, a friend of Flaubert, were followed by C. Leconte de Lisle (1818–1894). It was Leconte de Lisle who dominated the Parnassian group; his harsh style, which derived from the Greek and was affected by Hinduism,

marked his *Poèmes Antiques* and his *Poèmes Barbares*. The Parnassian school which emerged in 1866 included L. Dierx, A. Sully Prudhomme, F. Coppée, and ended with J. M. de Heredia, whose sonnets, *Trophées*, were published in 1893. The independent Baudelaire (1821–1867) gave a new turn to literature with his *Fleurs du Mal* published in 1857; his *Salon de 1845* and *Salon de 1846* postulated a modern aesthetic in advance of his times. Baudelaire was an ardent admirer of Edgar Allan Poe, of Delacroix to whom he owed his aesthetic outlook, and of Wagner. He was to reorientate poetry in the direction of Symbolism. P. Verlaine (1844–1896), the inventor of new poetic rhythms, based his work on Baudelaire's fluid style which drew on new psychological depths. Other writers also influenced by Baudelaire included A. Rimbaud (1854–1891), a precocious creator of satanic dream images (*Les Illuminations*, 1886); Stéphane Mallarmé (1842–1898), with his refined and disciplined style tending towards musical poetry; Lautréamont, the author of the *Chants de Maldoror*; Jules Laforgue, a poet who had profound views on Impressionism. Henri de Régnier (1864–1936) and Jean Moréas (1856–1910), returned to more classical forms though they remained more or less Symbolist; they reacted against the scientific and materialistic realism of their period. Frédéric Mistral, who wrote *Mireille* in 1859, was the most important author of a local literary group, known as the Félibrige school, formed in Provence in 1854.

Positivism was a realist philosophy developed by Auguste Comte which claimed that truth could only be known with certainty by observation or experience. The positivism of A. Comte and the scholarly Emile Littré (1801–1881) strongly influenced the following generation of writers, including Ernest Renan (1823–1892) and Hippolyte Taine (1828–1893). Renan, a brilliant linguist and erudite religious historian, a realist who would not accept the existence of the supernatural, yet was obsessed by it, was the author of *Histoire des Origines du Christianisme* and also a life of Jesus which was published in 1863. Taine had immense influence because of his lucidity of thought and his encyclopedic knowledge of philosophy, history and art; he wrote *De l'Intelligence*, *Origines de la France Contemporaine* and *Philosophie de l'Art* (1882). For Taine a work of art was the product of period and environment.

The positivist spirit permeated histori-

cal works, but it was the novel more than any other form that was dominated by realism. Before Zola the most important novelists were: Champfleury, a friend of Courbet (*Realism*, 1857); Gustave Flaubert (1821–1880) whose *Madame Bovary* (1857) gave fresh life to the novel; the Goncourt brothers, writers of memoires which began a fashionable taste for Japanese art and helped to popularise the 18th century; E. Fromentin, painter and writer (*Dominique*, 1863), and Gobineau, whose racial theories foreshadow those of the Nazis. The novel gained in brilliance with the writing of Emile Zola (1840–1902), theorist of the experimental novel and friend of the Impressionists; Guy de Maupassant (1850–1893), an incisive, if at times brutal, realist; Alphonse Daudet (1840–1897), an author with poetic feeling; Paul Bourget, a psychological writer (*Le Disciple*, 1889); Anatole France (1844–1924) who owed much to Voltaire.

Many plays were very successful though they lacked any profound quality. After Baudelaire art criticism reached great heights. The Realism of Courbet was shared by the writers Champfleury, L. E. Duranty and Castagnary. P. J. Proudhon put forward socialist theory in his book *Du Principe de l'Art et de sa Destination Sociale* (1865) which was influenced by the ideas of Courbet. Fromentin wrote a good aesthetic and historical analysis in his *Maîtres d'Autrefois* (1876). Duranty (1835–1880) and Zola championed the cause of the Impressionists.

Philosophy ran parallel to the brilliant scientific advances of the time, and tackled the problem of relating science to man. Important names included Louis Pasteur (1822–1895), Marcelin Berthelot (1827–1907), Claude Bernard (1813–1878) who wrote an introduction to experimental medicine, and Henri Poincaré (1854–1912), an inspired scientific philosopher. After the positivism of A. Comte and the ideas of Taine and Renan, C. Renouvier renewed interest in Kant. This was followed by a fresh interest in metaphysics, shown in the work of F. Ravaisson-Mollien and E. Boutroux, and the foundation of the *Revue de Métaphysique et de Morale* in 1890. Experimental psychology advanced with the researches of T. Ribot, P. Janet and G. Dumas. A new outlook on sociology was established by L. Lévy-Bruhl and E. Durkheim. But it was Henri Bergson (1859–1941), born in Paris of Anglo-Jewish parents, who revolutionised philosophy and attempted

483. LOUBON (1809–1863). Leaders
of a Herd of Goats. 1855. *Aix Museum*.

484. A. MONTICELLI (1824–1886).
Ladies and Cavaliers.

485. P. GUIGOU (1834–1871).
Landscape. 1869. *Fabre Museum,
Montpellier*.

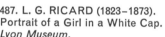

487. L. G. RICARD (1823–1873).
Portrait of a Girl in a White Cap.
Lyon Museum.

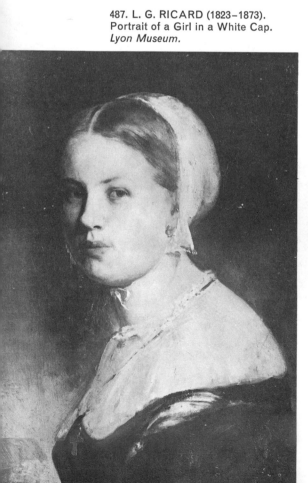

486. F. ZIEM (1821–1911). The
Thatched Cottage. *Reims Museum*.

488. F. VERNAY (1821–1896).
Flowers and Fruit. *Lyon Museum*.

489. L. CARRAND (1821–1899). The
River Bank. *Lyon Museum*.

to resolve the problems of metaphysics; he wrote *Essai sur les Données Immédiates de la Conscience* (1889), *Matière et Mémoire* (1896), *L'Evolution Créatrice* (1907), *L'Energie Spirituelle* (1919) and *Les Deux Sources de la Morale et de la Religion* (1932).

Music. H. Berlioz brought fresh ideas to music, but the public preferred A. Thomas (*Mignon, Hamlet*) and the Italo-Meyerbeerian style which gained notable successes with *Faust, Romeo and Juliet* and *Mireille* by Charles Gounod (1818–1893). *Carmen* by G. Bizet (1838–1875), performed at the Opéra Comique in 1875, opened a new era for French lyrical music. The principal composers producing colourful and lively work often bearing the influence of Wagner included L. Delibes, C. Saint-Saëns (1835–1921) whose output was enormous, E. Lalo (1823–1892) and E. Chabrier (1841–1894), a friend of Manet whose influence was far-reaching. J. Massenet, A. Messager, A. Bruneau and G. Charpentier were the most important representatives of Realism, which corresponded to a similar movement in Italy known as Verismo. With J. Offenbach opera lightened into operetta. In instrumental and symphonic music the Belgian César Franck (1822–1890) contributed to the evolution of the symphony, by his teaching, by the influence of his style and through the Société Nationale de Musique which was founded in 1871. His pupils included Vincent d'Indy (1851–1931) who in 1896 founded the Schola Cantorum. Gabriel Fauré (1845–1924) was gifted with an exceptional harmonic sense.

Architecture. The official, academic and eclectic architecture known as the Napoleon III style was used by Haussmann for the reconstruction of Paris. His great avenues, more significant than any individual building, are the urban masterpieces of the mid-19th century. He created a new cross-axis from Gare de l'Est to the Observatoire, extended the Rue de Rivoli along the north side of the Louvre the entire length of the palace, without changing the original Percier and Fontaine design, and in 1876 completed the Avenue de l'Opéra as a major cross-axis north-west from the Place du Théâtre Français. Concern for the prestige of Paris led in 1852 to the decision to complete the Louvre by connecting it with the Tuileries Palace [**546**]. The work was undertaken first by Visconti (1791–1853) and then by H. Lefuel (1810–1881) with a lavish use of mansard roofs and square-based domes. After the Louvre the most conspicuous product of the second Empire was the Opéra by Charles Garnier (1861–1875) in a neo-Baroque style with Renaissance

elements, producing a lushness and parvenu quality characteristic of its time and place. Similar characteristics recurred in his other works, the Monte Carlo Casino (1878), the Cercle de la Librairie, Paris and the Villa Garnier, Bordighera. G. Davioud (1823–1881) used the same eclectic style for many buildings in Haussmann's Paris including the two theatres in the Place du Châtelet, the fountains of the Château d'Eau, of the Observatoire (with Carpeaux), of the Place St Michel and the Trocadero (1878). J. F. Duban (1797–1870) and L. J. Duc (1802–1879) worked in a severe academic style. Duban was responsible for the façade of the Ecole des Beaux Arts (1860–1862), and Duc for the Palais de Justice [**543**]. J. Vaudremer (1829–1914), a learned academic architect, built the Santé prison, the Buffon and Molière schools, St Pierre de Montrouge (1864–1870) and Notre Dame at Auteuil (1876–1883). J. Guadet (1834–1908) with his Paris Post Office (1880), P. Nénot (1853–1934) with the Sorbonne, and V. Laloux (1856–1937) with the Gare d'Orsay made use of the same massive proportions. In Marseille and Lyon wide boulevards were laid out. The Palais Longchamp (1862–1869) in Marseille was erected by H. J. Espérandieu and the cathedral in Marseille by L. Vaudoyer (1803–1872) [**548**].

NATURE IN FRANCE

490. C. TROYON (1810–1865). Stream beneath trees. *Louvre.*

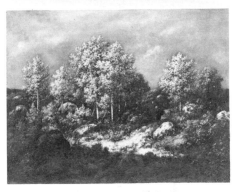

491. V. N. DIAZ DE LA PEÑA (1807–1876). The Heights of Jean de Paris (Forest of Fontainebleau). 1868. *Louvre.*

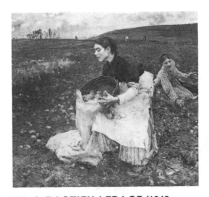

492. J. BASTIEN-LEPAGE (1848–1884). The Potato Harvest.

494. *Below.* S. LÉPINE (1835–1892). View of Charenton. *Formerly Llobet Collection, Buenos Aires.*

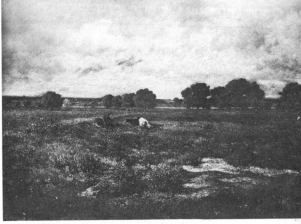

493. JULES DUPRÉ (1811–1889). Moorland. *Louvre.*

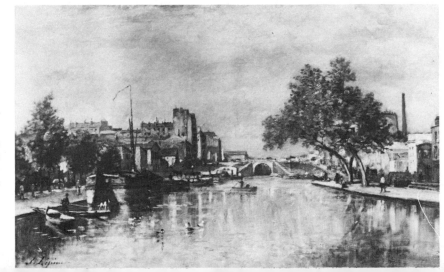

Neo-Gothic and neo-Renaissance appeared everywhere: one example is Ste Clotilde, Paris, by F. C. Gau and T. Ballu; another, St Augustin, Paris, by V. Baltard, whose iron construction was completely hidden by stone [**553**]. The Romanesque style inspired Vaudoyer in his cathedral at Marseille [**548**], and P. Abadie (1812–1884) in Sacré Cœur in Paris. The most original ideas were put forth by J. B. A. Lassus and his friend Eugène Viollet-le-Duc (1814–1879), restorers of medieval churches. The latter carried out restorations in Paris at St Germain l'Auxerrois, St Séverin, the Sainte Chapelle and Notre Dame, and at Carcassonne, Pierrefonds, Amiens and Vézelay. Though his work as a restorer may be controversial, his theories were quite new. He considered architecture as a complex where each part must be functional in order to be aesthetically beautiful. This rationalist conception anticipated Gaudí, Sullivan, Perret and Le Corbusier. He was far in advance of his time in advocating a 'dynamic' architecture and dreaming of flexible materials.

Architecture of iron and glass was first used in France in 1833 by C. Rohault de Fleury for the greenhouses of the Jardin des Plantes, then by Hittorff for the Palais de l'Industrie and by V. Baltard for the Halles (1853–1858). H. Labrouste (1801–1875) made very great use of iron construction (Bibliothèque Nationale, Paris, 1858–1868), which reached its climax in the hands of Gustave Eiffel (1832–1923) [**411, 680**] who previously had been an engineer constructing bridges. Examples of these include one at Bordeaux, the viaducts at Garabit (1880–1884) and at Rio Cris, and the Maria Pia bridge over the Douro (1877–1878). He was, however, primarily interested in technical problems such as foundations and wind resistance. For the International Exhibition of 1889 he erected the Eiffel Tower, a form of skyscraper which, in its sheer audacity and its complete absence of internal space, was the world's first modern building. The well known Machinery Hall (1889) was also erected by an architect, F. Dutert (1845–1906), and an engineer, Contamin [**413**]; it is a vast hall constructed of iron measuring 1400 feet by 400 feet and 150 feet high. Functionalism in architecture also appeared in the early Paris department stores, the Bon Marché (1876) by Eiffel and Boileau, the Printemps (1881–1889) by P. Sédille, and the Samaritaine (1905) where C. R. F. M. Jourdain (1847–1935) made use of iron for the construction and ceramics for the decoration. Iron was used for the Gare St Lazare by Lenoir and the Gare du Nord by Hittorff. Reinforced concrete had been used by F. Coignet in 1852 for a house at St Denis, but was then neglected until used systematically by F. Hennebique (1842–1921) and by A. de Baudot (1836–1915): e.g. church of St Jean de Montmartre (1897–1904).

Sculpture. The tradition of decorative sculpture continued for important official commissions. Carpeaux was employed to enrich the Opéra and the Louvre; Dalou created the monument called the *Allegory of the Triumph of the Republic*. Increasingly, however, decorative sculpture gave way to a more expressive sculpture. The most important figure of the Second Empire was Jean Baptiste Carpeaux (1827–1875) [**447–450**], a pupil of Rude. The busts of Carpeaux, as much as his large scale works, revealed a vibrant and sensitive realism. The versatility of the sculptor is shown in his powerful *Ugolino* which recalls Michelangelo, in his lyrical *Flora* in Lefuel's pavilion of the Louvre, in the exuberant rhythm of *The Dance* at the Opéra and in the Fontaine des Quatre Parties du Monde. Carpeaux was also a highly original painter preoccupied with effects of light which anticipated Impressionism. Other sculptors who were more interesting than the academics included J. P. Dantan (1800–1869), E. H. Maindron (1801–1884), F. Duret (1804–1865), P. Mène (1810–1879), and A. Clésinger (1814–1883). Dantan was a caricaturist; Maindron remained Romantic in his subject matter (*Velléda*); Duret sculpted the St Michel fountain; Mène was an important animal sculptor of his period; and Clésinger became famous through his *Woman Bitten by a Snake* (1847). J. A. J. Falguière (1831–1900), who admired the Florentines, worked largely in Italy. The *St Joan of Arc* at Domrémy (1872) was sculpted by H. Chapu (1833–1891) [**412**]. P. Bartholdi (1834–1904) became well known for the monumental scale of his sculptures, which included the *Lion of Belfort* (1875–1880) and the statue of *Liberty* in New York. Jules Dalou (1838–1902) [**371**] was the most typical of the Realists. After his stay in England he spent twenty years creating the vast *Allegory of the Triumph of the Republic* (1889–1899) in the Place de la Nation.

Auguste Rodin (1840–1917) [**359, 416, 451–453**, half-title page] was the most celebrated sculptor of the late 19th century, achieving during his lifetime a fame which has done much to obscure his real qualities. After working as a mason he became an assistant of Carrier-Belleuse and in this capacity worked in Brussels on decorations for the Bourse and the Palais des Académies. In 1874 he studied in Italy, particularly the works of Michelangelo. His first independent free-standing figure, the *Age of Bronze* (1877) had an accuracy of proportion and anatomy, a lifelike quality and a rendering of movement which gave rise to the accusation that it had been moulded on the living model. In fact his realism and profound knowledge of the human body came from watching his models moving freely about his studio. His public commissions roused violent controversy: the base of the Claude le Lorrain monument, Nancy, was altered to suit the town council; Calais refused to erect his *Burghers of Calais* (1884–1886) according to his design; his monument to Victor Hugo (1896) had to be produced in several versions; and his Balzac monument (1891–1898) was refused by the commissioning committee of the Société des Gens de Lettres. In 1880 he was commissioned for the door for the Musée des Arts Décoratifs; unfinished at his death, it was the origin of the *Gate of Hell* (*The Thinker*; *Three Shades*; *Paolo and Francesca*) which provided him with ideas which he used over and over again in large independent works in marble and bronze. He was an innovator of a new form in sculpture — the fragment as a finished work — some parts highly polished, others buried in the uncut block. This and his expression of emotion and movement, his symbolism and distortion and the sensitivity of his modelling are facets of a protean genius.

Extremely important sculptures were produced by the painters of the 19th century. Daumier [**381**] possessed expressive and caricatural power. In 1832, at the request of Philipon, he did about 40 clay busts, intended for firing, as models for his caricature portraits. His masterpieces like *Ratapoil* (1850) are a rare combination of spontaneity and control. His bas-reliefs (*Emigrants*, 1871; *Panathenaea of Poverty*) embody his keen sense of observation and astonishing memory. Degas [**437**], self-taught as a sculptor, was concerned with the same preoccupations and subjects as in his paintings: horses, dancers, women at their toilet in momentary attitudes and with apparent spontaneity of technique. His *Little Dancer* (1881) was the only sculpture ever exhibited; the others, in clay and wax, were found in his studio after his death and about 70 were cast in bronze after 1919. Renoir did not turn to sculpture until late in life, as a means of giving relief and solidity to his voluptuous forms. The only works modelled by him were the bust and medallion of his son Coco (1907). The rest were done in collaboration with Guino, 1913–1918 (*Venus, Washerwoman, Judgment of Paris*) and had considerable influence on French sculpture between the two wars. Paul Gauguin [**415**] took up ceramics in Brittany, but the majority of his wood-carvings date from the 1890s, after he had settled in Tahiti. Inspired by the art of the South Sea Islands, he invented his own mythology in magical, barbaric figures.

Painting. The general run of French painting in the 19th century was academic. Art teaching was controlled by the Ecole des Beaux-Arts, and official commissions were channelled by the Académie des Beaux-Arts. The Salon exhibited such official and academic works together with the fashionable portraits of the period. The masters of the undistinguished artists were skilful technicians such as Léon Cogniet and Thomas Couture (1815–1879) [**499**]. Winterhalter, the German painter of the Imperial court, E. Dubuffe and A. Cabanel produced flattering portraits. J. L. Gérôme (1824–1904) [**502**], A. W. Bouguereau (1825–1905) [**503**] and A. Cabanel (1823–1889) delighted in the academic nude or in scenes based on archaeological reconstructions. E. Meissonier (1815–1891) [**501**] was a minor master lacking imagination. Like Fortuny and Baron, he was influenced by a Dutch love of detail. Spanish influence improved the skilful and prosaic painting of T. Ribot (1823–1891) [**389**], Léon Bonnat (1834–1922), E. A. Carolus-Duran (1838–1917) [**388**] and H. Regnault (1843–1871), who were also affected by Realism. A. A. E. Hébert (1817–1908) and Paul Baudry (1828–1886) [**500**] were influenced by the Italians, and the latter derived the style of his decorations for the Opéra from Venetian painting. E. Delaunay (1828–1891), who did decorative work in the Panthéon and in the Palais de Justice, also owed a debt to the Italians. J. J. Henner (1829–1905) in his nudes and his landscapes stemmed from Correggio. James Tissot, the Belgian Alfred Stevens and J. Chéret (1836–1933) were fashionable portrait painters. After 1870 history painting returned to favour with the work of J. P. Laurens (1838–1921) who constructed large scale works with the aid of archaeological documents.

1863 marked the turning point for modern painting. The Salon des Refusés was ordered by the emperor for the benefit of artists rejected by the official Salon. A decree was passed making the Ecole des Beaux-Arts a state school independent of the Institut. These measures were the result of the emperor's taking the advice of Viollet-le-Duc. The exhibition of 1867, which included Courbet and Manet, repeated the scandal of the Salon des Refusés. It reaffirmed the importance of the new painting which remained totally unacceptable to a public used to the sentimentality of the academic painters. The new painters were cut off from exhibiting to the general public. Sustained by faith in themselves and their art, supported by a number of sensitive and generous collectors, and by dealers whose role was to become very important, they exhibited their pictures independently of the official Salon.

ON THE FRINGES OF IMPRESSIONISM

495. FRENCH. BERTHE MORISOT (1841–1895). Mme Boursier and her Daughter. *Brooklyn Museum, New York.*

Honoré Daumier (1808–1879) [**10, 356, 382, 383**] was the earliest of these great independent artists. A pupil of A. Lenoir's by the age of fourteen, he was for a long time known only as a lithographer and caricaturist, first on *La Caricature* (1830–1832) and then for *Charivari* (1833–1875) for whom he produced 4000 lithographic political and social satires. His watercolours and wash drawings of everyday life and scenes in the Courts of Justice were free from picturesque sentiment, and his large oil paintings, many on the theme of Don Quixote, are freely handled, with calligraphic brush work and intense chiaroscuro. His romanticism affected the early works of both Cézanne and van Gogh. Constantin Guys (1802–1892) [**511**] was a draughtsman who chronicled the wars and fashions of contemporary Europe. He travelled widely and reported the Crimean war as correspondent of the *Illustrated London News*. Baudelaire wrote a long essay on him as 'le peintre de la vie moderne'.

Two brilliant schools emerged in the provinces. The first was at Lyon and included L. Carrand (1821–1899) [**489**] who painted bleak landscapes; P. Chenavard (1807–1895) whose aesthetic and moral theories influenced Carrière; J. L. Janmot (1814–1892), a religious painter influenced by Ingres; L. Lamothe (1822–1869) who passed on the ideals of Ingres to Degas; J. Seignemartin (1848–1875), a very gifted artist; and F. Vernay (1821–1896) [**488**], a powerful colourist. The second school was in Provence, and included L. G. Ricard (1823–1873) [**487**], A. Monticelli (1824–1886) [**484**] and P. Guigou (1834–1871) [**485**]. Ricard was an

496. FRENCH. G. CAILLEBOTTE (1848–1894). Island in the Boulevard Haussmann. 1880. *Private Collection.*

497. ITALIAN. F. ZANDOMENEGHI (1841–1917). The Moulin de la Galette. *Private Collection, Milan.*

498. FRENCH. A. GUILLAUMIN (1841–1927). Pont Louis Philippe, Paris. 1875. *Chester Dale Collection, National Gallery, Washington.*

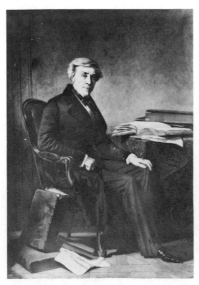

499. T. COUTURE (1815–1879). Jules Michelet. *Carnavalet Museum, Paris.*

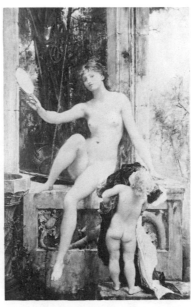

500. P. BAUDRY (1828–1886). Truth. *Louvre.*

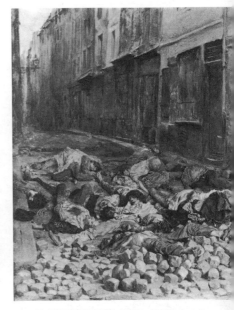

501. E. MEISSONIER (1815–1891). The Barricade. *Louvre.*

503. A. W. BOUGUEREAU (1825–1905). The Flagellation of Christ. *La Rochelle Museum.*

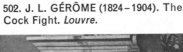

502. J. L. GÉRÔME (1824–1904). The Cock Fight. *Louvre.*

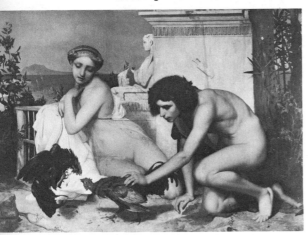

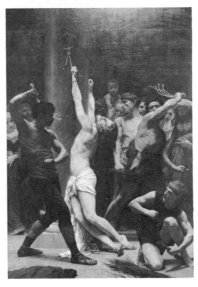

excellent portrait painter. Monticelli, admired by both van Gogh and Cézanne, was a direct heir of the Venetians and a precursor of modern Expressionism. After two visits to Paris (1846–1849, 1863–1870) he settled back in his native Marseille. His early work, precious, brilliant and mannered, revealed the influence of Watteau, Veronese, Delacroix and Courbet (*The Courts of Love, Scenes of the Park*). From 1870 in his portraits and flower pieces he developed a more personal imagination, interpreted in vivid, glowing colours and rich impasto. Guigou had been a pupil of Loubon [483], and was able to translate the hard light of Provence in the manner of Courbet.

Gustave Courbet (1819–1877) [349, 357, 372, 384–387, colour plate p. 105], born at Ornans, was the champion

and initiator of Realism. Almost entirely self-taught, he evolved a vigorous naturalism influenced by Spanish, Dutch and Italian paintings in the Louvre. He outraged public opinion with scenes from daily life such as *The Stone-breakers* (1849; destroyed 1945); the *Funeral at Ornans* (1850) and the *Painter's Studio* (1855). The last two, rejected by the Salon, were included in a private exhibition of his works at the International Exhibition of 1855. He was implicated in the Commune of 1871 and spent his last years in exile in Switzerland. The friend of Baudelaire, Proudhon and the collector Bruyas, he rejected all idealisation in art, claiming that only Realism was democratic and that the noblest subjects were the worker and peasant. His deep love of nature was expressed in vivid, uncon-

ventional landscapes, with broad brush work and use of the palette knife (*Rocks at Ornans*, 1853–1854; *The Wave*, 1870). He had a considerable influence on Manet, Fantin-Latour, Boudin, Renoir and Monet.

Edouard Manet (1832–1883) [417–421, colour plate p. 106] after study with Couture (1850–1856) travelled in Italy, Holland, Germany and Spain, reacting strongly against academic history painting under the influence of Hals, Velasquez and Goya. His work was frequently rejected by the Salon, Zola being almost alone in defending him. He played an important part in the 1863 Salon des Refusés, where his *Déjeuner sur l'Herbe* created a sensation repeated by his *Olympia* (1865) and *Fifer* (1867). The reaction was due partly to his painting direct from the model with intense immediacy and partly to his brilliant technique with its areas of flat, clear colours with little shading and a restricted palette in which black played an important part (*Execution of Emperor Maximilian*, 1867). These qualities made him the inspiration of the young Impressionists Bazille, Monet, Renoir, Pissarro, Sisley and the artists and writers who met at the Café Guerbois, including A. Silvestre, Astruc, L. Cladel, Zola, P. Alexis and Clemenceau. After 1870, partly through the influence of Berthe Morisot, his pupil and later his sister-in-law, he adopted the Impressionist technique, palette and habit of working out of doors (*Washing Day* 1870; *Chez le Père Lathuille*, 1880; *Bar at the Folies-Bergère*, 1882), although he never took part in any of the Impressionist exhibitions.

He was one of the finest portraitists of his age (*Zola, Mallarmé*).

The derisive name given to Impressionism was coined from the title of a picture by Monet, *Impression, Sunrise* (1872), in the first Impressionist exhibition, which was held in 1874 at the photographer Nadar's studio, 35 Boulevard des Capucines. Seven further exhibitions were held, the last in 1886, and exhibitors included Monet, Renoir, Pissarro, Sisley, Degas, Cézanne, Boudin and Berthe Morisot. The aim of the movement was the faithful pursuit of the optical expression of reality, through the exact analysis of tone and colour and the rendering of the play of light on the surfaces of objects. The interest in light and colour was partly the result of researches into the physics of colour carried out by scientists like Chevreul, the fact that any object casts a shadow tinged with its complementary being one of the principal ways in which the Impressionists animated their surfaces. To catch the fleeting impression involved painting out of doors, and their flickering touch, lack of firm outline and lightness of colour alienated the public.

The Impressionist painters, born between 1830 and 1841, came together in Paris soon after 1860. Pissarro, Cézanne and Guillaumin met at the Académie Suisse; Monet, Renoir, Bazille and Sisley at the Atelier Gleyre. After painting at Fontainebleau, where they met Millet, Corot and Diaz, they went to the Seine estuary and the Channel beaches; Monet came into contact with Boudin and Jongkind, the two innovators of light- and water-saturated air. Pissarro and Sisley remained close to Corot, Renoir to Courbet and Delacroix. At Bougival in 1869 Monet and Renoir pioneered the new vision of Impressionism in on-the-spot observation coupled with the technical principles of divided touch and shimmering spots of colour. The Franco-Prussian war in 1870 dispersed the group. Renoir, Degas and Bazille joined up and Bazille was killed. Monet, Pissarro and Sisley came to London, where they met Durand-Ruel, the art dealer, who was to become their chief defender. In 1872 Monet and Renoir at Argenteuil, Pissarro at Pontoise evolved the new open-air landscape which was revealed at the first Impressionist exhibition in 1874. The 1870s was the great decade of Impressionism; after 1880 it ceased to exist as a spontaneous ideal and each of the major figures followed his own individual path — Pissarro to Ergany, Monet to Giverny, Sisley to Moret, Cézanne to Aix. New movements sprang up — Neo-Impressionism, Symbolism, Expressionism — reacting against Impressionism although deriving from it.

Two forerunners of Impressionism, painting at Honfleur and Le Havre, were E. Boudin (1824–1898) [**423**] and C. Jongkind (1819–1891) (*see under* Netherlands). Boudin painted seascapes and harbour scenes with luminous skies occupying most of the canvas. Light dominated all his work and his skies are a link between Corot and the young Monet. Frédéric Bazille (1841–1871) [**427**] was an artist whose promise was cut short by his early death. His restricted œuvre has an individual firmness of design, a limpidity of light and tranquillity of mood (*Family Reunion*, 1867; *The Studio*, 1870).

Claude Monet (1840–1926) [**345, 414, 424–426**, colour plate p. 157] was the leading member of the Impressionist group and the one who practised longest the principle of absolute fidelity to the visual sensation. Brought up in Le Havre, he was persuaded by Boudin (*c.* 1856) to turn from portraiture to landscape. In the 1860s in Paris he met Pissarro, Bazille, Sisley, Renoir and Manet. In 1870 in London he saw works by Turner and Constable. In 1872 at Argenteuil, with Renoir, came the attempts to capture an instantaneous moment of time, environment and atmosphere through divided touch, a rainbow palette and complementary colours. After a residence at Vétheuil in the 1880s he settled at Giverny and in the 1890s began to paint subjects in series under different light effects at different times of day (*Haystacks*, 1891, *Poplars on the Epte*, *Rouen Cathedral*, 1892–1895; *Thames* series, 1899–1904). In the most famous series of all, the *Water-lilies* (National Gallery, London; Chicago; Orangerie, Paris, 1899–1923), the shimmering pools are less important than the atmosphere enveloping them, with light as independent of reality as in abstract painting.

Camille Pissarro (1831–1903) [**430, 431**], born in the West Indies, came to Paris in 1855 and was initially influenced by Corot. At Louveciennes 1866–1869, he returned there in 1872 and introduced Cézanne to the Impressionist palette. He exhibited in all the Impressionist exhibitions and introduced Gauguin, Seurat and Signac into them. From 1885, at Eragny, he was himself influenced by Seurat's theories of optical mixtures and pointillist handling. From 1895 he executed a fine series of town views from windows in Paris and Rouen. He was the most consistent of the Impressionists and attracted respect for his principles as much as for his art.

Alfred Sisley (1839–1899) [**428, 429**, colour plate p. 124] came of English parentage and was in England 1857–1862, 1871 and again in 1874 when he painted at Hampton Court and in the London suburbs. One of the purest Impressionists, he confined himself

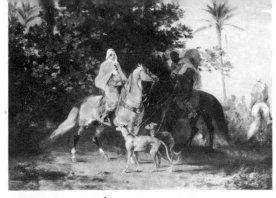

504. FRENCH. EUGÈNE FROMENTIN (1820–1876). Arab Horsemen Setting Out for a Hunt. *La Rochelle Museum.*

505. FRENCH. H. FANTIN-LATOUR (1836–1904). Head of a Girl. *Rijksmuseum Kröller-Müller, Otterlo.*

506. FRENCH. J. F. MILLET (1814–1875). Woman Sewing by Lamplight. *Frick Collection, New York.*

almost exclusively to landscapes in the valley of the Seine, the Ile de France and Moret where he settled in 1879 and which he evoked with poetry and grace. Berthe Morisot (1841–1895), from a cultivated middle class background at Bourges, was encouraged by Corot 1860–1868, who influenced her early work. She met Manet in 1868 and married his brother Eugène in 1874; and it was through her that he adopted brighter colours and outdoor painting. From 1885 she herself was strongly influenced by Renoir.

Auguste Renoir (1841–1919) [432–435, colour plate p. 124] was one of the greatest painters affected by Impressionism. Born at Limoges, he began there as a painter of porcelain before working in Gleyre's studio 1862–1863. He also studied Watteau, Boucher and Fragonard in the Louvre. The main influence on his early work, with its heavy impasto and dark colour, was Courbet. From 1868 to 1870 he worked with Monet on the Seine at La Grenouillère, his colour becoming lighter and handling freer. In the 1870s his preference was less for landscape than for group studies and portraits, and his scenes of cafés, dance halls and river banks have a lyrical gaiety (*La Loge*, 1874; *Moulin de la Galette*, 1876; *Déjeuner des Canotiers*, 1879). In 1881 he made the first of several visits to Italy, later travelling widely in England, Holland, Spain and Germany. The Italian visit intensified his dissatisfaction with the purely visual aspects of Impressionism. Under the influence of Raphael and Ingres came a stylistic change, with greater emphasis on drawing, more solid form and a departure from open-air painting (*Les Grandes Baigneuses*). In 1906 he settled in Cagnes, becoming progressively crippled with arthritis. His late works are mostly nudes or near-nudes, imbued with a mature serene beauty and ample volume and with vibrant red as the dominant colour.

The evolution of the art of Edgar Degas (1834–1917) [436, 438–440, colour plate p. 158] explains his special position in relation to Impressionism. Trained under Lamothe, a pupil of Ingres, his early works were classical (*Spartan Girls and Boys Exercising*, 1860) with colour subordinate to meticulous draughtsmanship. It was not until the 1870s, after a visit to New Orleans, that he became Impressionist in his desire to capture the fleeting moment and in his choice of contemporary subject matter. Drawing for him was the result of swift observation, though his paintings, with their air of spontaneity, were never painted from nature. His first paintings of dancers dated from 1873, and from then on the ballet, cabaret artists, working girls, models dressing and bathing became his principal subject matter.

Technically he was a great innovator and as his eyesight weakened he used pastel, in broad, free strokes, for his studies of women at their toilet.

Neo-Impressionism, which has little to do with Impressionism, involved the use of Divisionism and a strict, formal composition. It was first seen in 1884 in the Salon des Artistes Indépendants at which Seurat exhibited *Une Baignade* (National Gallery, London). In 1886, at the last Impressionist exhibition, Seurat, Signac and Pissarro all showed works based on Seurat's theories (*Sunday Afternoon on the Island of the Grande Jatte*, Chicago). The most important adherents were P. Signac (1863–1935) whose book *From Delacroix to Neo-Impressionism* (1899) is the text-book of the movement, H. E. Cross (1856–1910), M. Luce (1858–1941), C. Angrand (1854–1926) and the Belgian T. van Rysselberghe (1862–1926). The aim of the Société des Indépendants, founded in 1884, was to rationalise the expression of light with pure colours and substitute a scientific method for the empirical fleeting colour effects of the Impressionists. Gauguin in 1886, Lautrec in 1887, van Gogh in 1886–1888 all underwent Seurat's influence and practised Divisionism for a time.

Georges Seurat (1859–1891) [369, 458, 513], a pupil of Ingres's follower Lehmann, studied Chevreul, Charles Blanc, David Sutter and other theoreticians of colour. These led him to evolve first the theory of Divisionism and then a method of painting in tiny dots of pure colour, creating contrasts in which light itself is broken down into local colour, the colour of the light and of its reflections. He also evolved a formal type of composition based on the Golden Section, aiming at a static, monumental quality (*Le Chahut*, 1889–1890; *Le Cirque*, 1890–1891). During the summers he worked on the Channel coast, producing a series of lyrical landscapes (Courbevoie, Honfleur, Gravelines, Port-en-Bessin).

Post-Impressionism is a general term for the movement which developed in reaction against both Impressionism and Neo-Impressionism and had as its main aim either a return to a more formal conception or a new stress on the importance of the subject; the most important figures were Cézanne, Gauguin and van Gogh.

Paul Cézanne (1839–1906) [454–456, 510, frontispiece] was one of the greatest painters of the last century and the most important single influence on modern painting. Born in Aix en Provence, the son of a wealthy banker and the friend from childhood of Zola, he came to Paris in 1861. His early works, influenced by Daumier and Delacroix, reflect his basic romanticism, being theatrical in subject matter, violent in

treatment, lurid in colour and solid in impasto (*The Rape*; *Temptation of St Anthony*; *Olympia*). In 1872 at Auvers under the influence of Pissarro he toned down his romanticism and adopted a lighter palette (*Maison du Pendu*). In the later 1870s he gave up small brush-strokes and the division of tones. By the 1880s he was living primarily in seclusion at Aix. His great achievement lay in a subtle analysis of colour and tone quite different from the Impressionist capturing of surface impressions. It was a laborious analysis because he sought to use colouring as a means of modelling and as the expression of the underlying form of visible objects. He wanted to show that drawing and painting were not distinct from one another and that ' when colour is at its richest form has its plenitude '. His desire to ' do Poussin over again from nature ' and ' to make of Impressionism something solid like the art of the museums ' was achieved in his landscapes and still lifes of the 1880s (*Gardanne*; *Mont Ste Victoire*; *L'Estaque*; *Blue Vase*). In his last years lyricism increased and solid volume in depth gave way to flat two-dimensional surface pattern created by overlapping planes, while blues and violets supplanted yellows and greens (*Lac d'Annecy*; *Card-players*; *Château Noir*).

Paul Gauguin (1848–1903) [415, 460, 463–465, colour plate p. 175] was initially a stockbroker who collected Impressionist paintings and joined in their exhibitions from 1881 to 1886 as a Sunday painter. He gave up his job in 1883 and worked from 1886 to 1890 in Brittany at Pont Aven and Le Pouldu, with visits to Paris, Martinique (1887) and van Gogh in Arles (1888). At Pont Aven he met Emile Bernard (1868–1941), whose knowledge of medieval art, coupled with Gauguin's interest in primitive art, Japanese prints and stained glass resulted in Synthetism. Its principal features were flat colours, Cloisonnism, shadowless drawing, abstraction of design and the abandonment of naturalistic representation (*Jacob and the Angel*; *The Yellow Christ*). Gauguin's rejection of Western civilisation led to his departure for Tahiti in 1891 and to his efforts to express in non-naturalistic terms the simplicity of life among a primitive people (*Ia Orana Maria*; *Nevermore*; *Whence do we come? what are we? where do we go?*). His manuscript of ' Noa-Noa ' appeared in the *Revue Blanche* and his ideas were influential for the Symbolists.

Vincent van Gogh (1853–1890) [367, 462, 466–468, colour plate p. 176], son of a Dutch pastor, worked as an art dealer, a teacher and a lay preacher before turning to art as a means of self-expression in 1880. After study at Brussels, The Hague and Antwerp, where he was influenced by Rubens and

Japanese prints, he joined his brother Theo in Paris in 1886. His Dutch period had been characterised by dark colour, heavy forms and subject matter chosen from peasants and their work (*Potato Eaters*). In Paris, after contact with Impressionism, his palette and subject matter changed. He adopted the Impressionist technique and turned to views of Paris, portraits and self-portraits (*Interior of Café*, *Père Tanguy*). In 1888 he went to Arles, where his landscapes and portraits took on a heightened colour and a vivid expression of light and feeling (*Orchard in Blossom*, *Pont de L'Anglois*, *Harvest in the Crau*, *Sunflowers*). After Gauguin's arrival his work showed the influence of Synthetism in its greater simplification of forms and less modulated colour (*Les Alyscamps*, *The Sower*). In December 1888 he had his first attack of madness and subsequently suffered intermittent periods of mental illness. In 1889, in the asylum at St Rémy, and in 1890 at Auvers, where he committed suicide, his works were vivid in colour, with writhing flame-like forms expressive of his tormented sensibility (*Cornfield with Cypresses*, *Dr Gachet*, *Cornfield with*

THE GRAPHIC ARTS IN FRANCE

507. FRENCH. H. DE TOULOUSE-LAUTREC (1864–1901). Jane Avril. Drawing. 1897. *Fogg Art Museum, Harvard.*

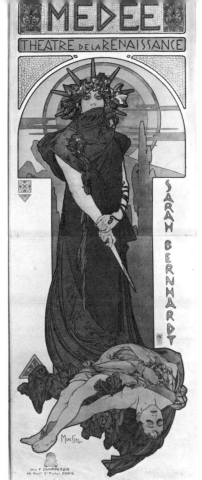

508. CZECHOSLOVAK. A. M. MUCHA (1869–1939). Poster for ' Medea ' with Sarah Bernhardt. Lithograph. 1898.

509. FRENCH. R. BRESDIN (1825–1885). Comedy of Death (detail). Lithograph. 1854.

510. FRENCH. PAUL CÉZANNE (1839–1906). The Artist's Son. Drawing. *Chapuis Collection.*

511. FRENCH. CONSTANTIN GUYS (1802–1892). Spanish Women. Watercolour. *British Museum.*

512. FRENCH. GUSTAVE DORÉ (1832–1883). The Carnal Sinners. Engraving illustrating Dante's ' Inferno '. Paris, 1861.

513. FRENCH. GEORGES SEURAT (1859–1891). Café Concert. Black chalk. About 1887. *Rhode Island School of Design Museum.*

514. A. NADAR (1820–1910). Photograph of Offenbach.

Crows). His letters to his brother Theo are moving human documents and indispensable to an understanding of his intentions. He left a vast volume of work, the majority in the collection of Theo's son at Laren, Holland, and in the Kröller-Müller Museum, Otterlo, Holland.

Symbolism, first expressed in literature from 1886, was an idealistic reaction away from Impressionism. Its first manifestation in art was the exhibition at the Café Volpini in 1889 of Gauguin and the school of Pont Aven (Bernard, Laval, Anquetin, Sérusier). The emphasis was on painting not from life but from memory, and after simplification, retaining a synthesis. These characteristics applied also to the Nabi group (see p. 328) and to three isolated artists, Gustave Moreau, Puvis de Chavannes and Odilon Redon. Pierre Puvis de Chavannes (1824–1898) [**441**], born in Lyon, studied first under Henry Scheffer and then under Couture. He translated the spiritual in a stylised form where every detail takes on the value of a symbol. His painting had purity without coldness and lent itself to large scale decoration. Examples include *The Poor Fisherman*, *War and Peace* (Amiens), *Massilia* (1867–1869), *Charles Martel at Poitiers* (1872–1875), *The Sacred Grove* at the Sorbonne (1887), *Summer* and *Winter* for the Hôtel de Ville (1891–1892), *The Life of Ste Geneviève* (1874–1898) for the Panthéon, and *The Muses* (Boston). Gustave Moreau (1826–1898) [**442**] was a cultivated admirer and collector of Byzantine, Persian and Hindu art. He was violently anti-Realist: 'I believe neither in what I touch nor in what I see . . . I believe in what I feel.' He had considerable influence through his teaching, and his pupils included Rouault. The poetic and mysterious Odilon Redon (1840–1916) [**444**, **446**] was a literary Symbolist influenced by Delacroix and introduced to the technique of engraving by Bresdin. He was highly cultivated, a musician and a writer (*A Soi-Même*); he was friendly with Mallarmé. He could invoke in a bouquet of flowers or in a face a complete visionary world (*Christ of the Sacred Heart*, *Buddha*, *Night* and *Day*). His poetry was expressed in almost abstract paintings, such as *The Sphinx* and *Vision Sous-marine*. He first became famous in Belgium where Symbolism was accepted before 1885, and then in Holland. Eugène Carrière (1849–1906) [**443**] showed a strong tendency towards Symbolism, through his use of line and chiaroscuro, rather than through his near monochromatic colour. In 1901 he summed up his aesthetic in a lecture entitled: 'Man, Visionary of Reality'. Matisse, Derain, Laprade and Jean Puy were among his pupils.

Henri de Toulouse-Lautrec (1864–1901) [**360**, **469**, **470**, colour plate p. 158], studied in Paris from 1882, met van Gogh and Emile Bernard and was influenced by Degas and Japanese prints. He chose his subjects chiefly from cafés, circuses, bars and dance halls in Montmartre, where he lived in 1885–1900. He had a wide technical range and made over 350 lithographs, his posters giving a new impetus to that art. He was a superb draughtsman with a gift for conveying rapid movement and the atmosphere of a scene with a few strokes.

The graphic arts. A new illustrative art form developed with the lithograph of the Romantic era. This was extended in books and reviews and, towards the end of the century, by the poster. Charles Meryon (1821–1868) [**25**] and Gustave Doré (1832–1883) [**512**] were both romantic in outlook. Meryon, an etcher, died before his imaginative style had time to mature. Doré's imagination in his illustrations, especially for Jerrold's *London*, tended towards the fantastic. Rodolphe Bresdin (1825–1885) [**509**] was nicknamed Chien-Caillou by Champfleury; he was a brilliant etcher and produced a series of thirteen highly detailed illustrations for *La Revue Fantaisiste*. His art achieved mystery through the fantastic accumulation of precisely rendered detail. Félicien Rops (1833–1898), a Belgian, was influenced by Gavarni and Daumier. The leading Impressionists all produced prints. Gauguin revived the woodcut [**415**]. Illustrated books were given new life when the Société des Aquafortistes was formed in 1862. Manet illustrated works by Edgar Allan Poe and Mallarmé; Toulouse-Lautrec, works by Jules Renard; and O. Redon, works by Flaubert. Artists and poets collaborated in the production of *La Revue Blanche* published in 1891–1903. From 1890 poster art made enormous strides, and artists made use of colour lithography. Toulouse-Lautrec was the finest master of this new medium, which he used for his poster for the Moulin-Rouge in 1891, and for that for Jane Avril in 1893. He invented a whole series of new methods and in particular he made constant use of areas of flat colour. He considerably influenced the lithography of Vuillard, Bonnard, Valloton, Sérusier, Ranson, M. Denis and Steinlen. The early lithographs of Bonnard and Vuillard in *La Revue Blanche* owed much to Toulouse-Lautrec. Chéret created a lighter and more facile style. Caricature made use of the sharp and ironic bite of Lautrec, as may be seen in the work of Forain.

Photography. The printing of photographs on paper was perfected. A. Braun [**395**] and Nadar [**514**], excited

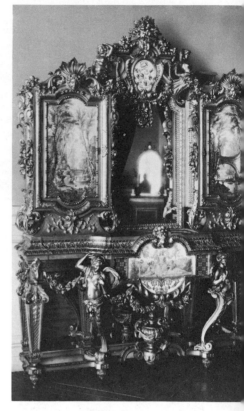

515. Jewellery cabinet made for the Empress Eugénie. About 1860. *Compiègne Museum.*

516. Detail of a Napoleon III style chimney piece, with horn held by a putto. *Louvre.*

517. *Above.* CHARLES CHRISTOFLE (1805–1863). Table centre made for Napoleon III. 1855. *Musée des Arts Décoratifs, Paris.*

519. *Below.* Settee called an 'indiscret' with three seats. 1860–1870. *Musée des Arts Décoratifs, Paris.*

518. Garden chair with springing of strip metal.

522. *Below.* BARYE (1795–1875). Bronze candelabra. About 1858. *Fabius Collection.*

521. *Below.* Furniture in the 'colonial style' in natural bamboo. 1870–1880.

520. ' Renaissance ' cabinet of the time of Napoleon III by Pierre Manguin (1815–1869). *Musée des Arts Décoratifs, Paris.*

523. Napoleon III style wallpaper, designed by Muller. *Musée des Arts Décoratifs, Paris.*

about the new realistic medium, produced many portraits, still lifes, landscapes and street scenes. The medium fascinated Degas and other artists.

The minor arts. Viollet-le-Duc and other restorers of medieval buildings caused a revival of stained glass work.

Official commissions were carried out at the Gobelins and the Beauvais tapestry works; private commissions were executed by Aubusson. The subjects were platitudinous and over-ornate, and the quality of the dyes deplorable. Embroidery, so vulgar since Louis Philippe, was often naively charming in its floral themes.

The Second Empire was a retrograde period for the applied arts. Artists were working for an increasingly affluent society, but without an original style. They imitated 18th-century productions but their attempt at a luxurious effect lacked unity of conception. The Empress Eugénie, enamoured of Queen Marie Antoinette, called for a revival of the 18th-century style, adding to it a touch of Spanish Baroque. The Green, Rose and Blue Salons in the imperial apartments of the Tuileries commissioned by her from Lefuel were typical of the period: a heavy richness resulted from the accumulation of gilded decoration, upholstered furniture, hangings and dull decorative paintings commissioned from Chaplin and Dubufe. The interior of the Opéra and the Hôtel de la Païva in the Champs-Elysées were also typical of this style. The latter was built by Manguin and decorated with sculptures by Dalou, Delaplanche and A. E. Carrier-Belleuse and with paintings by Baudry, Delaunay, Boulanger and Comte. The most extravagant materials used in the interior, including onyx for the staircase and silver for the furniture, combined with sumptuous silks to create an Oriental splendour. However a few artists resisted the tendency to over-ornamentation, including the decorator H. Penon, the furniture makers Henri Fourdinois and Sauvrezy, the superb goldsmiths Christofle [517] and A. and J. Fannière.

The enormous demand for luxury articles and the example of England encouraged the growth of industrialisation, and created a demand for pieces that were both practical and comfortable. Machines made it possible to mass-produce ornamental motifs for furniture and metalwork, as well as to reproduce the complex weave of tapestry, brocades and lace. The Union Centrale des Beaux-Arts Appliquées à l'Industrie, formed in 1863, was the result of Laborde's celebrated report on the Great Exhibition of 1851 held in London, together with the recommendations of Mérimée in 1862, and the influence of Viollet-le-Duc. The Union Centrale held exhibitions, such as the one of 1869, which included the work of contemporary artists, goldsmiths, glassworkers, furniture makers, and also examples of Oriental art. This last contributed largely towards the spread of Japanese influence. The director of the Beaux-Arts, P. de Chennevières, between 1874 and 1877 influenced the national production of applied art by reorganising the Ecole des Arts Décoratifs and by creating a chair of decorative composition at the Ecole des Beaux-Arts, where design was taught. In 1882 the Société des Arts Décoratifs and the Union Centrale des Beaux-Arts were amalgamated into the Union Centrale des Arts Décoratifs. This body attempted to improve public taste away from its deplorable delight in false luxury and the pseudo-Japanese exotic. Furniture made of engraved glass set into bamboo, and Bayeux porcelain which imitated Oriental wares were highly popular. The International Exhibition of 1889 opened new horizons for decorative art as it did for architecture. The artist became independent of the past. Art Nouveau was born partly in the Orientalising milieu of the dealer S. Bing, established in Paris since 1871, who introduced a fashion for Far Eastern art, and partly through the American influence of Tiffany stained glass. 1896 was the date of the Salon de l'Art Nouveau.

Secondary techniques in goldsmiths' work and jewellery returned to favour: inlaid enamel work deriving from 16th-century Germany, enamel and cloisonné enamel from the East, introduced by the American Tiffany.

Patents for gold and silver electroplating were acquired by C. Christofle from Ruolz. Christofle [517] produced the sumptuous dinner table service and centre piece for the Tuileries, now in the Musée des Arts Décoratifs. This new process made silverware far more economic. Paul Christofle and his cousin, H. Bouilhet, produced large masterpieces plated with gold and silver, for the Vatican, for Napoleon, and for Baron Haussmann. For la Païva they made a table of bronze inlaid with gold and silver. Their silver plate was of high quality. The Fannière brothers inherited the business of their uncle Fauconnier and made articles in a neo-Renaissance style. The son of Froment-Meurice produced a chimneypiece in aquamarine and crystal for the Hôtel de Ville based on a design of Baltard. This was destroyed by fire in 1871. L. Falize (1839–1897) was probably the finest metal engraver, and one of the first to make use of stylised plant decoration, which foreshadowed Art Nouveau, as in his plate bordered with a celery motif in the Musée des Arts Décoratifs. Sculptors including Carrier-Belleuse and Mallet, and architects including Viollet-le-Duc, Lefuel, Rossigneux and Baltard willingly made designs for goldsmiths' work.

The jewellery industry flourished. From 1880 the settings became lighter and plant and floral motifs became popular, possibly due in part to the Exposition des Arts de Métal from the Cernuschi collection.

Ornamental ironwork again became popular. It began with reproduction work and then from 1875 new designs were created.

Paris porcelain continued, and at the same time vulgarised, the Empire-Restoration style and the Baroque style of Jacob-Petit. Bayeux continued the Oriental tradition, but their products were heavier. The taste for the exotic persisted. Chinese and Turkish styles were followed by a 'Negro' style which became fashionable in 1852 following the publication of *Uncle Tom's Cabin*. The fame of Palissy ware revived trompe-l'œil in pottery, exploited by the ceramist Avisseau of Tours. T. Deck (1823–1891), the director of Sèvres, was a skilful and knowledgeable ceramist influenced by Persian, Turkish and Chinese styles. The imitation of Japanese colour, delicacy and stylisation gave a delightful turn to the work of Haviland and Dammouse from 1870 to 1880. Opalescent colour was fashionable under the Second Empire, and was often painted on after 1845. The glass works at Baccarat, Mont Cenis and St Louis produced chandeliers and other types of glassware.

The interior decorators and furniture makers were skilful pasticheurs. They all made use of dark woods, ebony and rosewood. They included J. Klagman (1810–1869) who emulated Feuchère; Protat, Guichard and Liénard who were enthusiastic admirers of Italian and German Renaissance styles; Tahan who created small pieces; Beurdeley who

U.S.A. L. H. SULLIVAN (1856–1924). Auditorium building, now Roosevelt College, Chicago. 1887–1889. *Photo: Hedrich Blessing.*

SPAIN. A. GAUDÍ (1852–1926). Casa Milá, Barcelona. 1905–1910. *Photo: Mas.*

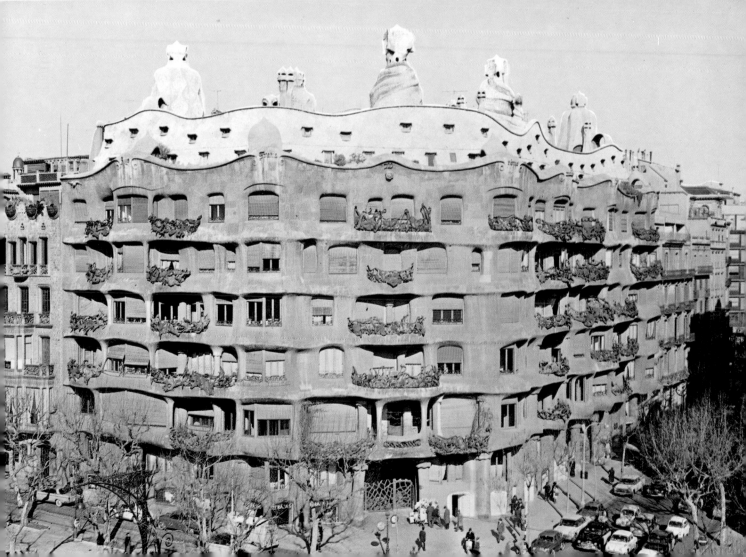

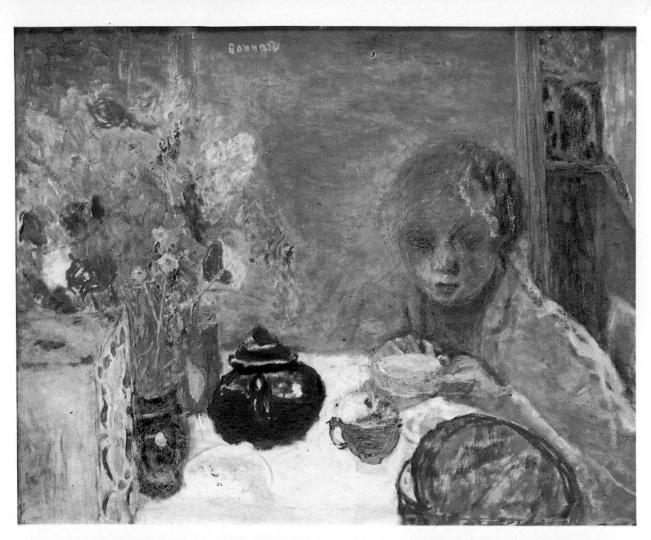

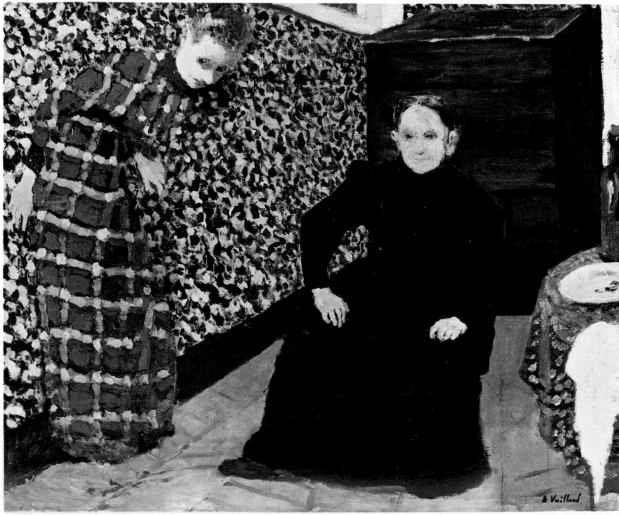

made use of bronze; Grohé who worked for the empress; Roux and Wassmus who specialised in the imitation of Boulle. Boutmy and Godin were clever workers in veneer; Callais, Raulin and Germains used lacquer. Embroidery was used for upholstered furniture [519] in the English style: circular and S-shaped conversation chairs and love chairs, tuffets, often decorated with gilded wood, suggesting knotted cords or bamboo. The neo-antique villa of Prince Bonaparte was typical.

ITALY

History. Italian unity resulted from the brilliant statesmanship of the king of Sardinia, Victor Emmanuel (1820–1878), and his minister Cavour (1810–1861). They eventually succeeded in driving the Austrians out of Italy. The courage of Garibaldi and his troops made a legend of a popular movement. With the help of Napoleon III the Sardinians united central Italy. Giuseppe Garibaldi (1807–1882), a generous adventurer, subdued the Sicilian rebels. The Italian parliament, reunited in 1861, gave Victor Emmanuel the title of King of Italy. The Venetians joined the Italian kingdom in 1866, and the more complex question of Rome was settled in 1870: the Pope was assured of temporal sovereignty over the Vatican City. Victor Emmanuel entered Rome on 2nd July 1871.

The population of the young nation increased rapidly, from 18,000,000 in 1800 to 33,000,000 in 1901. Despite social unrest and economic difficulties, agriculture and fishing were improved, the merchant marine increased, and tourism encouraged.

Literature. After 1860 the literature of the Risorgimento was no longer held back by romanticism. The Scapigliatura Milanese, lured by satanism and naturalism, was a group of poets and novelists, including E. Praga, Arrigo Boito and Giuseppe Rovani. Arturo Graf was a gifted poet. From now on the universities dominated intellectual life with Giosuè Carducci (1835–1907) and his followers. The erudite, vehement and authoritarian Carducci was the founder of a formal and slightly anachronistic Neoclassicism. The Sicilian Giovanni Verga (1840–1922) created the brusque style known as Verismo which he used in his novels and short stories.

Gabriele D'Annunzio (1863–1938), was a magnificent writer, and a better novelist than dramatist. Aesthetics and art criticism continued a historical and idealistic outlook: P. Salvatico came under the influence of Hegel, and both he and Rio extolled a 'philosophic' art and approved of the purists. Benedetto Croce (1866–1952) was an idealist who through his review *Critica* had a powerful influence which continued well into the 20th century. Writers on the history of art included two great connoisseurs. The first was G. B. Cavalcaselle (1819–1897), who with J. A. Crowe, an Englishman, wrote a massive and authoritative work on Italian painting from its beginning to the 16th century, published in London in 1864–1866, which is still one of the main reference books on the subject. The second was Giovanni Morelli (1816–1891), a shrewd judge of style, whose attributions helped to bring order into the œuvre of the great Italian painters.

In philosophy the influence of A. Comte and Spencer affected R. Ardigo, and the school of criminologists who included Lombroso. After 1880, an anti-determinist reaction made itself felt in the works of Cantoni, Barzellotti and Chiappelli.

Music. Italian music reached great heights in the work of Giuseppe Verdi (1813–1901) who is usually contrasted with his contemporary, Wagner. His considerable production included *Rigoletto*, *La Traviata* and *Il Trovatore*. In his later works, such as *Aida*, *Otello* and *Falstaff*, he showed deep sincerity and brilliant orchestral quality. Around Verdi was the 'Verist' school, which included Ponchielli, R. Leoncavallo (1858–1919), G. Puccini (1854–1924), and Mascagni (1863–1945). Ponchielli wrote *La Gioconda*; Leoncavallo *I Pagliacci*; Puccini *Madame Butterfly*, *La Tosca* and *Gianni Schicchi*; Mascagni became well known with his *Cavalleria Rusticana*. The only follower of Wagner was Arrigo Boito (1842–1918). Opera did not completely eclipse symphonic and instrumental music in Italy. Important composers included C. Sgambati, influenced by Liszt and Chopin, Martucci who wrote chamber music, and Bossi, primarily an organist.

Architecture. Rome, the new capital of united Italy, suffered through the eagerness for new construction and urbanisation. New districts were quickly built for the expanding population by speculative entrepreneurs. Unfortunately architectural masterpieces were often destroyed, for example the roads alongside the Tiber and the Villa Ludovisi on the Pincio. The main urban developments resulted from the laying out of important roads, such as the Via Venti Settembre and the Via Nazionale with the Piazza della Repubblica (1855; formerly the Piazza dell'Esedra), the work of Gaetano Koch (1849–1910). The most important buildings, erected in a massive eclectic style, included the huge Finance Ministry by R. Canevari (1825–1900), the Palace of Justice (1883–1910) by G. Calderini (1837–1916), the Palace of Fine Arts by P. Piacentini (1846–1928). The heavy and pretentious monument to Victor Emmanuel [545], the symbol of unified Italy, stands in front of the Forum. This project of G. Sacconi (1854–1905) was carried out by Koch, Piacentini, Manfredi and Raffaelli in 1885–1911.

In Turin a local tradition (G. Bollati) plus the important work of engineers (A. Mazzuchetti) resulted in a noble eclectic style, which unfortunately came under the influence of Paris during the Second Empire. The arcades of the Corso Vittorio Emmanuele II were very fine. The most outstanding architect was A. Antonelli (1798–1880) whose poetic and simplified functionalism resulted in the 'Mole' of Turin whose enormous height makes it a rival of the much later Eiffel Tower, and the dome of S. Gaudenzio at Novara [536].

Milan became the important commercial and industrial centre of Italy. G. Mengoni (1829–1877), who had studied in Bologna, created the vast Galleria Vittorio Emmanuele II (1865–1877) which joins the Piazza del Duomo to the Piazza della Scala. This was a vigorous attempt to animate the academic style, and was imitated by E. Rocco in the Galleria Umberto I in Naples. C. Boito (1836–1914) was a very eclectic architect who worked at Padua and built the Gallarate hospital.

In Florence G. Poggi (1811–1901), admirer of the works of San Gallo and Vignola, was a town planner with a feeling for landscape. He built the Villa Favart, the Palazzo Capponi, and the Loggia della Piazzale Michelangelo.

Raimondo d'Aronco (1857–1932) was influenced by the Sezession movement in Vienna, and by Horta and Mackintosh. He introduced the Art Nouveau style to Turin in 1902.

Religious architecture was mainly neo-Gothic or Baroque pastiche; English architects even built neo-Gothic churches in Rome.

PIERRE BONNARD (1867–1947). The Breakfast. *c.* 1907. Petit Palais, Paris. *Photo: Michael Holford.*

EDOUARD VUILLARD (1868–1940). Mother and Sister of the Artist. *c.* 1893. Museum of Modern Art, New York. (Gift of Mrs Saidie A. May). *Museum photograph.*

525. *Above*. Dining-room designed by E. Vallin (1856–1922), with leather panels and ceiling by C. Prouté. 1903–1906. *Musée des Arts Décoratifs, Nancy.*

527. *Below*. OTTO ECKMANN (Germany, 1865–1902). Electric table lamp in wrought iron.

524. Staircase in the Studio Elvira, Munich. 1897–1898. Designed by August Endell (1871–1925).

526. *Right*. AUGUSTE DAUM (1853–1909) and ANTONI DAUM (1864–1930). Vase. 1890.

528. WILLIAM MORRIS (England, 1834–1896). Wallpaper. *Victoria and Albert Museum*.

529. *Below*. EMILE GALLÉ (1846–1904). Vase with thistle decoration. About 1888. *Lorie Collection.*

530. *Below*. JAN TOOROP (Holland, 1858–1928). Delftsche Slaolie. Poster. 1895. *Stedelijk Museum, Amsterdam.*

531. HECTOR GUIMARD (1867–1942).
Railings to Métro entrance in Paris.
1898–1901.

532. Title page by F. Mason to
Huon de Bordeaux.

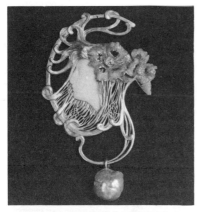

533. RENÉ LALIQUE (1860–1945).
Pendant. 1900. *Musée des Arts
Décoratifs, Paris.*

534. DELAHERCHE (1857–1940). Vase.
Musée des Arts Décoratifs, Paris.

Sculpture. Sculpture was both academic and patriotic, and many statues honouring Victor Emmanuel, Cavour and Garibaldi were erected. Realistic sculpture for funerary statues was important only in its quantity. Bartolini's influence continued through his pupils. Pietro Tenerani (1789–1869) participated in the purist movement; Giovanni Duprè (1817–1882) was a Florentine with a feeling for the dramatic. Giuseppe Grandi (1843–1894), a member of the 'Scapigliati' group, attempted to make use of the play of light in his elegant sculptures. The works of Vincenzo Gemito in Naples had a sense of life. Medardo Rosso (1858–1928) [**535**] was the only really important sculptor. He developed through Realism to Impressionism, and his works have a unique and original quality. He went to Paris in 1884, the following year to Vienna, and then to London. His vision was so close to Rodin's that it caused a quarrel between them. He made use of light as a dynamic element in his sculpture, and the modulations of light and shade over the surface give his work its highly expressive quality. Towards the end of his life he settled in Milan.

Painting. In Lombardy T. Cremona (1837–1878) and D. Ranzoni (1843–1889) continued to work in the Romantic tradition seeking technical or melodramatic effects. Their best works were portraits.

The leader of the Piedmontese artists was Antonio Fontanesi (1818–1882) [**541**] who studied in Geneva under Calame; he was struck by the landscapes of Corot and other French landscape artists at the 1855 exhibition, and later by Ravier, Turner and Constable. Fontanesi's lyrical art may appear simple, but was the result of considerable effort.

The school of Posillipo near Naples rediscovered the realistic character of the 17th century. G. Gigante (1806–1876) sought for effects of chiaroscuro in his landscapes; F. Palizzi (1818–1899) [**406**], educated in Naples, preferred rural scenery; Domenico Morelli (1826–1901) achieved dramatic effects of light and colour.

The tachistes were young artists who revolted against Neoclassical or Romantic academicism. They used to meet in Florence at the Caffè Michelangelo in the Via Largo. The 'Macchiaioli' were revolutionaries who claimed the right to realism, the use of light and direct emotion in front of nature. They included Serafino De Tivoli, G. Fattori and V. D'Ancona. Several young Macchiaioli were encouraged by their visit to the 1855 exhibition in Paris. They were supported by Diego Martelli, the able critic

of the group. Several Neapolitans joined the group including D. Morelli, G. Costa, G. Abbati and S. Lega. The movement now centred in Tuscany, but its reunions ceased after 1866. Giovanni Fattori (1825–1908) [**538**] and Silvestro Lega (1826–1895) [**537**] were the two most important painters of this group. Fattori began with historical pictures, before being introduced by Costa to the style of Corot. His sure eye, vigorous style and melancholy temperament gave a rare poetry to his best works, such as *The Women from Sardinia* and *The Rotonda of Palmieri*. Lega began with purist-romantic tendencies and later became tachiste. From 1870 he developed a monumental simplicity of form, perhaps enhanced by the pessimism of his subjects. Serafino De Tivoli (1826–1892) was one of the founders of the tachiste group, and in certain works foreshadowed the Impressionists. Telemaco Signorini (1835–1901) reminds one of Monticelli. Raffaele Sernesi (1838–1866), highly gifted, died while still in his twenties.

In Venice and Naples there were realistic artists who were also interested in effects of light. Gioacchino Toma (1836–1891) was an independent artist working in Naples who, like Lega, had a feeling for atmosphere and a sensitive dignity which refused to accept merely external effects. He painted *Luisa Sanfelice in Prison*, now in the Galleria Nazionale d'Arte Moderna in Rome. M. Cammarano (1819–1920) retained the Neapolitan taste for strong tonal contrasts. His work reminds one of Daumier, and in his sense of contemporary life he suggests Manet.

A Venetian group of realistic painters was headed by G. Favretto (1849–1887) who was influenced by Manet. G. Giardi (1843–1917) became tachiste after a stay in Florence; his paintings have a luminous naturalism.

In Lombardy D. and G. Induno painted patriotic works lacking in any personality.

French Impressionism was not readily accepted in Italy. The fragmentation of colour was opposed to the aims of tachisme, which made use of brutal contrasts of light and dark to give the maximum illusion of solid form. Several painters went to work in France and used the Impressionist technique, but with nervous and rapid brush work. They included G. De Nittis who exhibited with the Impressionists in 1874; G. Boldini (1842–1931) [**539**], a fashionable portrait painter who settled in Paris, like the Venetian F. Zandomeneghi (1841–1917) [**497**], a friend of Degas and Renoir.

The echo of French Impressionism was felt in Piedmont. It affected V. Avondo (1836–1910), it transformed the naturalism of L. Delleani (1840–1908),

535. ITALIAN. MEDARDO ROSSO (1858–1928). Conversation in a garden. 1893. *Galleria Nazionale d'Arte Moderna, Rome.*

and to the melancholy art of Enrico Reycend (1855–1928) gave a finesse of technique which turned him into the best Impressionist artist in northern Italy. G. Segantini (1858–1899) [**471**], an independent painter influenced by the lyricism of Cremona, has a feeling for nature reminiscent of Millet.

The minor arts. Craftsmen were so permeated by classical traditions that they merely imitated earlier styles. This was equally true of the goldsmiths' work produced in Venice and Florence, and of ceramics and furniture.

SPAIN

History. Isabella II reigned over a kingdom divided between liberal and reactionary forces. She was badly advised by a corrupt court, and was eventually forced to abdicate as a result of the 1868 revolution. Seven years of unrest and civil war ensued.

Alphonso XII established a constitutional monarchy in 1875. From then on, with the Constitution of 1876, Spain enjoyed a period of peace. The country was impoverished and most of the mines were under foreign ownership. From 1880 industry developed only in the region of Bilbao and in Catalonia.

Literature. Poets developed an anti-Romantic attitude much later than in France. A realistic outlook, deriving from France and England and affected by local themes, resulted in an efflorescence of fiction writing, as in the work of J. M. de Pereda. The first generation of novelists was realist and included Catholics like Fernán Caballero, the pseudonym of Cecilia Böhl de Faber, and P. A. de Alarcón. It also included rationalists such as the Andalusian J. Valera, and B. Perez Galdós, an objective writer with tolerant views. The second generation was inspired by Galdós, Zola and the Russian novelists, and included Emilia Pardo Bazán. The Spanish novel became a European success with the works of A. Palacio Valdés and V. Blasco Ibañez, still 19th-century in spirit. Philosophical poets included R. de Campoamor and G. Noñez de Arce. G. A. Becquer was a poet who had considerable influence though he died very young. The theatre, especially satirical comedy, enjoyed considerable success. A. Lopez de Ayala wrote moralising dramatic comedy, and J. Echegaray melodrama.

A reaction broke out about 1898 among authors disgusted with the political decadence of their country and opposed to realism. Miguel de Unamuno belonged to this group, and by his moral Hispanism paved the way for 20th-century Spain.

Music. There was at this time a magnificent revival of music which made use of the forgotten riches of a wonderful folklore. Felipe Pedrell (1841–1922) initiated this renaissance by editing and publishing ancient masterpieces; he was also a composer himself. I. Albeniz (1860–1909) with melodic verve produced piano music marked by amazing rhythms; an example of his work is the *Iberia* suite. E. Granados (1867–1916), a more refined musician, drew inspiration from Goya for his opera *Goyescas*, a masterpiece of Iberian music. A generation later M. de Falla and J. Turina continued the brilliance of this school.

Architecture. A classical style survived in the Palace of the Congress, built by N. Pascual y Coloner, in the national library and museums erected by F. Jareño y Alarcón (1818–1892) and in the Chamber of Commerce (1893) by E. M. Repulles y Vargas (1845–1922).

Antoni Gaudí y Cornet (1852–1926) [**363, 563, 681, 682**, colour plate p. 209] of Barcelona was undoubtedly the greatest Spanish architect. His inventive and lyrical art may be controversial, but his creative imagination and his technical audacity make him an important pioneer of modern architecture. In 1883 he was commissioned to continue work on the church of the Sagrada Familia (still unfinished). His Nativity façade of the east transept consists of three open portals between four towers, over three hundred feet high and terminating in curved features covered with mosaic. In his secular buildings in Barcelona he made use of the parabolic arch. In the Casa Batlló (1905–1907) organic forms are no longer a kind of ornament but constitute essentially structural elements. His most original work is the Casa Milá ('La Pedrera', 1905–1910), a block of flats in cut stone with undulating walls like organic sculpture.

Sculpture. Sculpture remained academic. The most important masters were Manuel Oms (1842–1889), A. Querol (1865–1909), Arturo Melida (1848–1902) and R. Bellver (1845–1924). Melida, an architect as well as a sculptor, was responsible for the tomb of Christopher Columbus in Seville cathedral [**564**].

Painting. Spanish painting had always tended towards realism, so that of the 19th century was readily accepted. It overcame the laborious history painting of men like J. Moreno Carbonero, F. Pradilla, S. Martinez Cubella and A. Muñoz-Degrain, followers of E. Rosales Martinez. Rosales in 1864 had painted *Isabella the Catholic Dictating her Will*. In the 1870s his followers carried out vast ambitious canvases.

Barcelona became an important centre for painters. Genre triumphed with the fashionable Catalan Mariano Fortuny y Carbó (1838–1874) [**404**]. He was a gifted illustrator whose sketches of Morocco were finer than his facile finished works. The baroque dazzle of Fortuny was modified by Impressionism in the work of the Catalan Santiago Rusiñol (1861–1931). Other painters preoccupied with the interpretation of light included Joaquin Sorolla (1863–1923) from Valencia who chose his models from among peasants and fishermen, and D. de Regoyos (1857–1913), a pupil of Pissarro and Monet.

The minor arts. An ornate and ostentatious neo-Baroque, which was even more eclectic than either the Victorian or the Napoleon III style,

resulted in heavy furniture and over-decorated gold- and silversmiths' work. Only in ceramics was a healthy tradition continued.

PORTUGAL

History. The Braganza dynasty was unable to restore the country, despite the personality of Luis I, himself an artist.

Literature. J. P. de Oliveira Martins, politician and administrator, was also a gifted historical writer. Literature reflected a pessimism which sometimes went to the extremes of suicide (C. Castelo Branco). J. M. Eça de Queirós who owed much to French influence was the best realistic novelist. In Coimbra there was a renaissance of poetry which included Antero de Quental, João de Deus, A. M. Guerra Junquiero, A. Nobre, and the symbolists A. Lopes Vieira and Teixeira de Pascoais. Antero de Quental, a metaphysical poet, wrote his sonnets in 1890, and later committed suicide.

Music. Lisbon was a musical centre where young musicians preserved the lyricism of the traditional *fados*. A very interesting school included D. Bontemps, the founder of the Conservatoire, A. Keil (1854–1907), Augusto Machado (1845–1924) who composed operas, the very gifted A. Fragoso who died at the age of twenty and L. de Freitas-Branco.

Architecture. Portugal lacked pretension in its architecture and was thereby protected from ambitious projects, whether good or bad, inspired by the internationally current neo-Gothic and neo-Renaissance styles. There was a functional English influence at Oporto, and a classical Italian influence in Lisbon which affected the Municipal Chamber and the Garret Theatre.

Sculpture. The principal sculptors were A. Soares dos Reis (1847–1889) and A. Teixeira Lopes. Soares dos Reis gained fame for his *Exile* in the Oporto museum, which was marked by a personal technique. Teixeira Lopes was born in Oporto and worked in Spain; among his works was the statue of Eça de Queirós in Lisbon.

Painting. Some painters were attracted to France where they developed a sensitive finesse and a remarkable acuity of vision. M. A. Lupi (1826–1883) painted good portraits but dull history pictures. Henrique Pousão (1859–1884), a sensitive interpreter of light, studied in France and Italy but unfortunately died young. Columbano

536. ITALIAN. ALESSANDRO ANTONELLI (1798–1880). S. Gaudenzio, Novara. Begun in 1840.

539. ITALIAN. GIOVANNI BOLDINI (1842–1931). Princess Bibesco.

(1856–1929) was a decorative artist who painted the ceiling of the National Theatre, and worked in the Palace of Belem and the Palace of Congress.

BELGIUM

History. The judicious reign of Leopold I was followed by the brilliant and energetic leadership of Leopold II (1865–1909) who was very advanced in his economic and political concepts. As a result Belgium developed a parliamentary system which enabled her to become a great modern power, despite her internal problems. Antwerp was made a free port. There was a policy of free trade in contrast to the protectionist tariffs existing elsewhere, and industry thrived. By his adroit statesmanship Leopold II annexed the Congo, the richest territory in equatorial Africa. Belgium regained the prosperity which she had experienced in the Middle Ages.

537. ITALIAN. SILVESTRO LEGA (1826–1895). The Visit. 1868. *Galleria Nazionale d'Arte Moderna, Rome.*

538. ITALIAN. GIOVANNI FATTORI (1825–1908). Woman with Sunshade on the Beach. 1866–1868. *Private Collection, Milan.*

540. ITALIAN. GIUSEPPE DE NITTIS (1846–1884). The Carriages. *Private Collection.*

541. ITALIAN. ANTONIO FONTANESI (1818–1882). The Mill. *Turin Museum.*

542. ITALIAN. RAFFAELO SERNESI (1838–1866). Sunlit Roofs. 1862–1866. *Galleria Nazionale d'Arte Moderna, Rome.*

I. ACADEMIC ARCHITECTURE 1850–1900

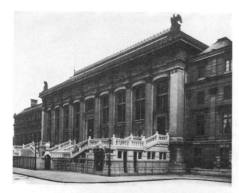

543. FRANCE. L. J. DUC (1802–1879). The Palais de Justice, Paris. 1867.

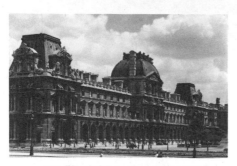

546. FRANCE. L. T. J. VISCONTI (1791–1853) and H. M. LEFUEL (1810–1881). Additions to the Louvre (Ministry of Finance). 1852–1857.

548. *Below*. FRANCE. L. VAUDOYER (1803–1872). Marseille cathedral. 1852–1893.

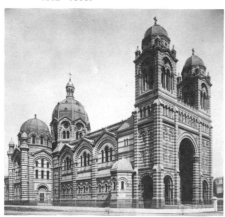

551. *Below*. GERMANY. G. VON DOLLMANN (1830–1895). Schloss Linderhof, near Oberammergau. 1870–1886.

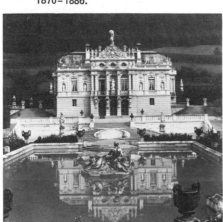

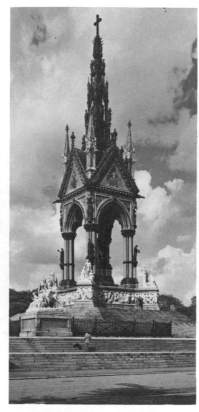

544. BRITAIN. G. G. SCOTT (1811–1878). The Albert Memorial, London. 1863–1872.

549. BRITAIN. WILLIAM BUTTERFIELD (1814–1900). Church of All Saints, Margaret Street, London. 1849–1859.

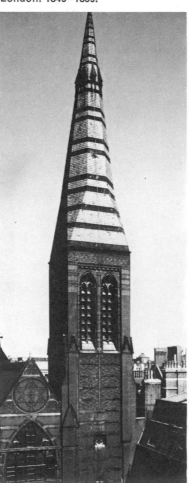

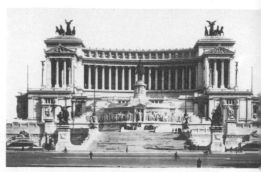

545. ITALY. G. SACCONI (1854–1905). Victor Emmanuel II monument, Rome. Begun in 1885, continued by G. Kodi, P. Piacentini and M. Manfredi, and completed in 1911 by R. Raffaelli.

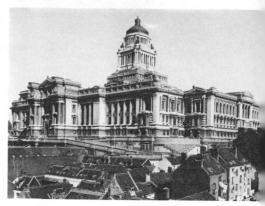

547. BELGIUM. J. POELAERT (1817–1879). The Palais de Justice, Brussels. 1866–1883.

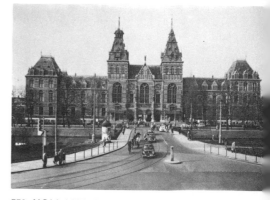

550. HOLLAND. P. J. H. CUIJPERS (1827–1921). The Rijksmuseum, Amsterdam. 1877–1885.

552. FRANCE. J. L. C. GARNIER (1825–1898). The Opéra, Paris. 1861–1875.

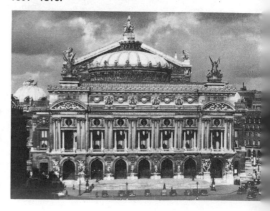

II. ARCHITECTURE INFLUENCED BY ENGINEERING

553. FRANCE. V. BALTARD (1805–1874). Interior of the church of St Augustin, Paris. 1860–1867.

558. *Below*. BRITAIN. SIR THOMAS DEANE (1792–1871) and BENJAMIN WOODWARD (1815–1861). Interior of the University Museum, Oxford. 1855–1859.

559. *Below*. BRITAIN. PETER ELLIS (fl. 1835–1884). Oriel Chambers, Liverpool. 1864–1865.

554. BELGIUM. VICTOR HORTA (1861–1947). Stair-hall in the Tassel House, Brussels. 1892–1893.

556. *Below*. U.S.A. D. H. BURNHAM (1846–1912) and J. W. ROOT (1850–1891). Reliance Building, Chicago. 1890–1894.

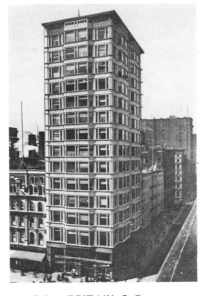

560. *Below*. BRITAIN. C. R. MACKINTOSH (1868–1928). School of Art, Glasgow. 1898–1909.

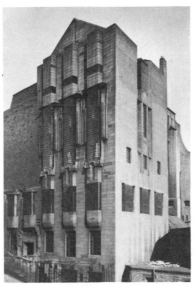

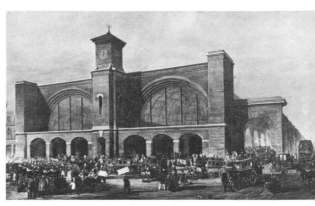

555. BRITAIN. LEWIS CUBITT (1799– ?). King's Cross station, London. 1851–1852.

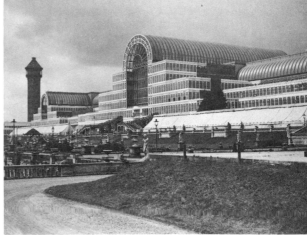

557. BRITAIN. JOSEPH PAXTON (1803–1865). The Crystal Palace, London. 1851.

561. GERMANY. AUGUST ENDELL (1871–1925). Studio Elvira, Munich. 1897–1898.

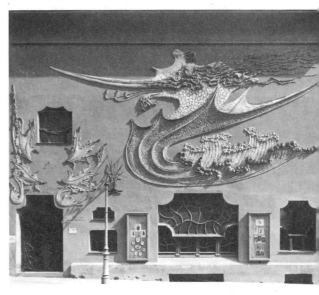

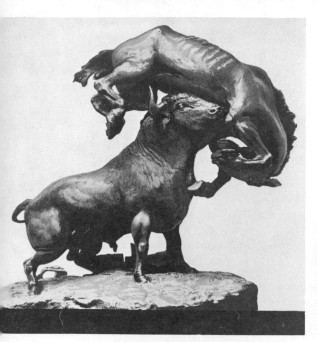

562. SPANISH. MARIANO BENLLIURE (1866–1947). The Two Victims of the Fiesta.

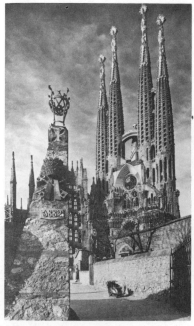

563. SPAIN. ANTONI GAUDÍ Y CORNET (1852–1926). Unfinished church of the Sagrada Familia, Barcelona. Begun 1884.

564. SPANISH. ARTURO MELIDA Y ALINARI (1848–1902). Tomb of Christopher Columbus. *Seville Cathedral.*

565. SPANISH. SANTIAGO RUSIÑOL (1861–1931). Señorita Nantas. *Barcelona Museum.*

Literature. Bilingualism is a source of literary enrichment. After the Romantic revival, Guido Gezelle (1830–1899) was a fine poet writing in Flemish. In a very personal impressionist style he translated his love of life. He influenced Hugo Verriest and Albrecht Rodenbach who died at the age of twenty-four. D. Sleeckx was the theoretician of realism. There were few important poets writing in French before 1880, but C. de Coster and O. Pirmez were excellent prose authors. De Coster wrote *Légendes Flamandes* and *Ulenspiegel* in a truculent and malicious style; Pirmez was a scholarly and introvert essayist whose style at times reminds one of Maeterlinck. In 1880 a new spirit, similar to that inspiring painters, affected writers. Reviews appeared,

including *L'Artiste* and *La Jeune Belgique.* *L'Artiste*, published by the painter-poet Théodore Hannon (1851–1917), played an important part from 1876 to 1879. *La Jeune Belgique* appeared in 1881 and contained the work of young poets who wanted to give Belgium an indigenous literature. The review was guided by the energetic C. Lemonnier, and contained works by A. Giraud, E. Verhaeren, I. Gilkin, A. Mockel and Georges Rodenbach, the last as much Parisian as Belgian. In opposition to *La Jeune Belgique* which was Hellenic in outlook, *L'Art Moderne* was published. This review defended social art and was directed by E. Picard, the critic and dramatist. Symbolism, which was born in the Walloon district (e.g., *Wallonie*, a review published by Mockel from Liége), found itself at home in Flanders. Symbolist authors included C. van Lerberghe, M. Elskamp and above all the charming M. Maeterlinck (1862–1949).

Music. César Franck (1822–1890), born at Liége, was a musician of genius. His oratorio *Les Béatitudes* was written in 1870–1880 and his Symphonic Variations in 1885. He had a strong influence on his pupils and friends, who included Vincent d'Indy and H. Duparc, and through them he released French music from the influence of Wagner to regain its own melodic tradition.

Architecture. Architecture did not escape the eclectic style current in Europe. In Belgium this was made worse by a disastrous taste for the gigantic, paramount in Brussels at the end of the century. Interest in archaeo-

logy led to pastiche. J. Schadde (1818–1892), of Antwerp, made skilful use of iron in his Gothic stock exchange in Antwerp (1866–1872). He also built the stations at Bruges and Trooz, as well as churches and hospitals. Van Ysendijk and Cloquet were architects with a similar outlook.

Brussels, the capital of a prosperous country, started an impressive building programme. The enormous Palais de Justice (1866–1883) dominating the town was the work of J. Poelaert (1817–1879). L. P. Suys (1823–1887) built the exchange (1868–1873) and A. Balat (1818–1895) the Musée Royale des Beaux Arts (1875–1881).

Sculpture. There were few original sculptors apart from Constantin Meunier (1831–1905). F. Bouré and B. van Hove made some Romantic sculpture of no particular importance. H. Pickery was intuitively realist in his approach. P. de Vigne, P. C. van der Stappen, J. Dillens and T. J. de Vincotte were skilful academic artists born in the 1840s. Léon Mignon (1847–1898) was an animal sculptor of some power. Constantin Meunier [358] was a sincere and original artist who avoided being literary or over-sentimental. Under the influence of Charles de Groux he gave up sculpture temporarily for painting. But in 1878 at Seraing he discovered the industrial region which played such an important part in his later work. Deeply impressed by the life of the miners in the Borinage, he began to sculpt again in 1885 (*Puddler*) being hailed as the representative of a new style inspired by the realities of everyday life. He never ceased to draw inspiration from the world of labourers

566. BELGIAN. HIPPOLYTE BOULENGER (1837–1874). Avenue of Hornbeams at Tervueren. 1871. *Musée d'Art Moderne, Brussels.*

567. BELGIAN. FÉLICIEN ROPS (1833–1898). The Little Sorceress. Frontispiece to ' Baisers morts '. Engraving.

and their sufferings (*Firedamp Explosion, Monument of Labour*). Jef Lambeaux (1852–1908) was full of Flemish vitality; he erected the fountain in the Grand' Place at Antwerp, which has a Rubensian Baroque flavour. L. P. van Biesbroek (1839–1919) achieved the same Baroque spirit. Vincotte, I. de Rudder, Dillens and J. Lagae were fine medallists.

Painting. Hendrik Leys (1815–1869) [**403**] was a gifted artist from Antwerp whose early work was Romantic. He escaped from Delacroix's influence when, during a visit to Germany in 1854, he discovered the work of Dürer and Cranach. This resulted in a skilful but dry Pre-Raphaelite style. T. Fourmois (1814–1871), A. de Knyff (1819–1885) and J. P. F. Lamorinière (1828–1911) were the first landscape painters of the group known as the Tervueren school. This school united realistic landscape painters who loved the forest of Soignes, and included H. Boulenger, L. A. Dubois and J. T. Coosemans. Boulenger was a realist whose subtlety lay in his understanding of light and its reflections; Dubois was a friend of Courbet. I. Verheyden, another landscape painter from Tervueren, helped to found the Société des XX. The aesthetic atmosphere in Belgium suited realism. In 1868 Dubois founded the Société Libre des Beaux Arts, and in 1871 *L'Art Libre*. The artists of this group fought against academic art; some of them were good painters, whose richly applied paint masks a poverty of inspiration. Among them were E. J. A. Agneessens, L. Artan, Eugène Smits and the animal painters C. M. M. Verlat and A. J. Verwée. Artan was Dutch, and in his

sea paintings was already pre-Impressionist in spirit. Félicien Rops (1833–1898), who did much of his work in France, was a painter, etcher and lithographer. His brilliant satirical draughtsmanship stemmed from C. Guys and Daumier. The two finest realistic painters were Charles de Groux (1825–1870), the initiator in Belgium of social realism, and Constantin Meunier, as distinguished a painter as he was a sculptor.

Henri de Braekeleer (1840–1888) [**396**], from Antwerp, was perhaps the most important artist after Ensor. He was the nephew of the painter Hendrik Leys. Braekeleer loved his rather stuffy provincial surroundings, and could endow common things with that same quiet and meditative reality found in paintings by Vuillard, Bonnard and Ensor. Jan Stobbaerts (1838–1914), who was also influenced by Leys, preferred country themes. The brothers Alfred and Joseph Stevens were opposed to this typically Flemish painting. Alfred Stevens (1823–1906) was an elegant portrait painter of the Second Empire. The two brothers, like F. Rops, settled in Paris. The Société des XX and the Salon de la Libre Esthétique ran parallel to French Impressionism in claiming freedom for artists and in linking artists of dissimilar tastes. Ensor was probably the most important of them (see p. 357). A. Heymans was a friend of Corot and Daubigny; A. Baertsoen helped to found the Société des XX and was a very influential teacher; P. Pantazis was Greek and a pupil of Chintreuil and Courbet; T. van Rysselberghe (1862–1926) [**474**] became a pointillist in Paris where he settled. The Libre Esthétique, to which

French painters contributed, continued to hold exhibitions until 1914. G. Vogels (1836–1896) painted rainy landscapes and bleak snowscapes. If H. Evenpoel (1872–1899) had not died at the age of twenty-seven, he would probably have become an outstanding painter.

The graphic arts. In Brussels the Italian artist Luigi Calamatta was nominated professor of fine art. His influence resulted in a strong school. Félicien Rops worked first in lithography, and then did some excellent etchings, such as the *Woman drinking Absinthe* and *The Hanged Man*. He made astonishing illustrations for the works of Baudelaire and Barbey d'Aurevilly. A. L. A. Rassenfosse and A. Donney, who were excellent poster artists, came under his influence, as did François Maréchal.

The minor arts. There was a break away from pastiche and over-ornamentation in the last quarter of the century, and as a result good designs were produced by artists such as Horta, van de Velde and Serrurier-Bovy. Original work was produced in iron and pewter. The Art Nouveau style was introduced into gold- and silversmiths' work by P. Wolfers (1858–1929). His highly original style made use of stones for their intrinsic beauty, and of floral themes for linear effects.

HOLLAND

History. William III (1849–1890) reigned during a long period of peace. By a liberal economic policy he led the country, at first slowly, and then after 1860 rapidly, towards an increasing prosperity, which was reflected in the architecture of the larger towns.

Literature. Louis Couperus was a successful realistic novelist, whose books are packed with carefully observed detail. H. Heijermans (1864–1924) wrote religious novels and plays of Jewish family life whose success extended to Germany, England, France.

Architecture. P. J. H. Cuijpers (1827–1921) made use of past styles in his pastiche architecture which included the Maria Magdalenakerk, the Rijksmuseum [**550**], and Central Station in Amsterdam; he also restored numerous Gothic churches. Modern architecture in Holland was pioneered by H. P. Berlage (1856–1934) and fine buildings were erected from the turn of the century. Berlage in 1897 was the first to visit the United States, where he studied the work of Frank Lloyd Wright and H. H. Richardson. He designed the Amsterdam stock exchange (1897–1903) and inspired the

568. DUTCH. W. ROELOFS (1822–1897). The Rainbow. *Municipal Museum, The Hague.*

569. DUTCH. J. BOSBOOM (1817–1891). Church of St Peter, Leyden. 1868. *Municipal Museum, The Hague.*

570. DUTCH. J. MARIS (1837–1899). Boat on the Beach. 1878. *Municipal Museum, The Hague.*

571. DUTCH. ANTON MAUVE (1838–1888). Fishing Boat Being Hauled on to the Beach. 1883. *Municipal Museum, The Hague.*

town planning of The Hague and Amsterdam. His influence was felt by all the younger Dutch architects, who followed his style of uncluttered functionalism, which gave Holland an important place in 20th-century architecture.

Sculpture. The Stracke brothers, Frans and Johannes, F. Leenhogg and C. van Wyk (1875–1917) were still working in a dull academic or realist style. B. van Hove worked at the Rijksmuseum with the architect Cuijpers.

Painting. The genre tradition continued with endless repetition in the work by David Bles, H. van Hove and others. Romanticism scarcely affected Holland which was rooted in its 17th-century naturalist tradition. Simon Cool, J. van de Laar and J. Spoel were successful painters in this tradition. C. Rochussen painted battle scenes, and A. Allebe humorous subjects. Sir Lawrence Alma-Tadema came to England, where he painted dry archaeological pictures.

J. H. Weissenbruch and J. Bosboom of the school of The Hague were two innovators who discovered a new realism influenced by Millet and the Barbizon school, with echoes from Rembrandt and Ruisdael. Bosboom painted town views and churches [569]. Jozef Israëls (1824–1911) was the most famous painter at The Hague

[398]. After a period in Paris and among poor fishermen, he earned the title of the Dutch Millet through his grey, atmospheric paintings of maritime life. He strongly influenced the German painters Uhde and Liebermann. The landscapist Anton Mauve (1838–1888) [571] also admired the Barbizon school. His nephew van Gogh studied under him at The Hague for a short time. The three Maris brothers, Mathis (1835–1917), Jakob (1837–1899) and Willem (1843–1910), were also influential in the revival of landscape [570]. Influenced by the Barbizon school, they in turn influenced the Glasgow school. H. W. Mesdag (1831–1915) painted marine subjects and also collected French pictures. It was in the company of Mauve and Mesdag that van Gogh (1853–1890) as a young man first began to take an interest in art (see under *France*). At The Hague J. B. Jongkind (1819–1891) [422] started to paint in watercolour and in the open air. In 1846 in France he met at Auvers Daubigny, Boudin and Lépine. With Boudin he was one of the precursors of Impressionism in his fluid atmosphere, glittering changeableness of water and taste for wide horizons in his seascapes which link back to Ruisdael and van Goyen. Yet much of his work, especially his night scenes, were potboilers, reflecting his miserable, unstable life which ended in an asylum at Grenoble. G. H. Breitner (1857–1923), who studied under Israëls, was a powerful expressionist inspired by the technique of Hals and Rembrandt. Jacobs Smits (1856–1928) [481], whose best work was after 1890, took Belgian nationality. His originality stemmed from his simplified if coarse vision and his thick, expressive handling of paint. J. Toorop (1858–1928) [479], born in Java, was influenced by many of the styles of his time, including Impressionism, Symbolism and Divisionism; but his linear draughtsmanship was excellent. A. J. Derkinderen (1859–1925) was primarily a decorative painter.

The minor arts. The Dutch were influenced by the arts and technique of the Far East, including those of the East Indies — for example, the technique of batik (a wax resist is applied to cloth which is then dyed). Ceramics became more modern in their simplified form and in their use of materials. At Delft, Amsterdam and Haarlem the Art Nouveau style developed during the closing years of the century. Typically Dutch and interesting work resulted from the effort to originate new designs for furniture, carpets, fabrics, silver, wrought iron and bookbinding.

Lydie Huyghe

GREAT BRITAIN

History. Under the long reign of Queen Victoria (1837–1901) England was brilliantly governed alternately by two great ministers, the Conservative Benjamin Disraeli (1804–1881) and the Liberal W. E. Gladstone (1809–1898), despite internal difficulties caused by electoral problems, the Irish question, and then, after the economic crisis of 1875, social problems. At the same time England was involved with imperialist expansion in Africa, in the Middle and the Far East. By her adroit statesmanship in internal and external affairs England maintained her material superiority and her political and social balance by accepting reforms at the right time. When the 20th century opened Britain had been for over half a century the foremost European power and the most advanced socially, despite the growing industrial power of Germany. She possessed considerable material power and had unique opportunities for intellectual and cultural enrichment through her contact with the many countries of her Empire. These included the old, the new, and the savage primitive civilisations in Africa, Asia and Australasia.

Literature. English science and literature prospered. The shock of Darwin's theories posed the problem of the

incompatibility of science and faith, while the evident paradox of man and machine raised doubts as to the value of civilisation and of art. These problems released a passionate questioning among writers, philosophers and artists. After 1880 came a reaction in the form of art for art's sake. Victorian poetry, typified by Lord Tennyson (1809–1892), the benevolent poet laureate, followed in the wake of Romanticism. Robert Browning (1812–1889), his wife Elizabeth, Matthew Arnold (1822–1888), A. H. Clough, and J. Thomson wrote sincere and beautiful poetry. Matthew Arnold sought despairingly for the place of the artist in an apparently hostile and uncomprehending world. Dante Gabriel Rossetti (see p. 222) was a better poet than painter as is shown in *The Blessed Damozel* and *The House of Life*, a sequence of love sonnets. His sister Christina wrote more simply and with greater clarity. A. C. Swinburne (1837–1909) was complicated and refined in his poetry. George Meredith (1828–1909) and Thomas Hardy (1840–1928) were novelists and also good poets. From 1890 a new outlook developed. This showed itself in the early poems of Rudyard Kipling (1865–1936) in their rough vigour and non-conformist realism, and in the very different aesthetic and decadent poems of the Rhymers' Club and *The Yellow Book* whose exponents included Oscar Wilde (1854–1900), L. Johnson, E. Dowson and the Irish J. B. Yeats. G. M. Hopkins (1844–1889) was a fine poet who did not achieve recognition during his life.

Novelists were interested in all facets of life, psychological analysis, sociology, dramatic situations, mystery and exoticism. Among the realistic writers Charles Dickens (1812–1870) was a writer of genius with a great command of English character; W. Thackeray (1811–1863) was a subtle satirist; and George Eliot was a woman writer interested above all in moral problems. By contrast, the Brontë sisters, especially Emily, were essentially Romantic in temperament. Emily Brontë wrote *Wuthering Heights*, which was outstanding in its imaginative and poetic description of her tragic world. The following generation continued a realistic and moralising style, and included the authors G. Meredith, Henry James (American), Thomas Hardy, G. Gissing, W. Hale White and Samuel Butler, who was a painter and musician as well as a writer. George Moore was more naturalistic. The Scottish author R. L. Stevenson had a passion for adventure, as had Rudyard Kipling. H. G. Wells invented science fiction with *The Time Machine* (1898) and *The War of the Worlds*. Oscar Wilde was an individualist.

Outstanding in dramatic writing

were Oscar Wilde and J. M. Synge (1871–1909), an Irish symbolist. Plays about the English middle class showed strong French influence, and those concerned with controversial problems and atmosphere that of Ibsen.

John Ruskin (1819–1900) taught aesthetic theory at Oxford from 1870. He attempted to relate man to the machine age and to reinstate the artist and craftsman. He greatly admired Gothic and medieval Italian art, and wrote *The Seven Lamps of Architecture*. He was a friend and defender of the pre-Raphaelites. Ruskin's influence was considerable in the United States. He had as disciple William Morris, a poet and interior designer full of social ideas who was to play a major role in English art. Walter Pater, affected by German idealism, was a critic with a great admiration for Botticelli.

Philosophy and science. Charles Darwin published *The Origin of Species* in 1859. He was a biologist who posed the problem of the origin of man, at the moment when anthropologists discovered in 1856 the skull of Neanderthal man. Questions relating to the beginnings of prehistory and the development of the brain, with its mental, moral and social functions, created a strong belief in the theory of evolution. In Germany Darwin had an ardent follower in E. Haeckel. John Stuart Mill (1806–1873) developed a utilitarianism which was in effect a logical and moral positivism. H. Spencer (1820–1903) replaced philosophic studies relating to the nature of the universe by the study of its rhythms and tried to determine them scientifically. He arrived at a conception of the continued progression of man in society. His work was widely acclaimed.

English science led the world in the study of physics, electricity (Sir William Thomson, James Clerk-Maxwell) and chemistry. Anthropology became an important study: Sir Edward Tylor published *Researches into the Early History of Mankind* in 1865 and created a philosophical theory which lasted until the 20th century.

Music. London was a major musical centre and attracted all the best performers; but English composers made no original contribution to music.

Architecture. Neo-Gothic was the style favoured by English architects for official and religious buildings during the Victorian period, which was romantic in outlook. The perpendicular style, being essentially English, was at first favoured. The taste for the past was accentuated by works published on historical architecture, by Ruskin's philosophy, and by Newman and other

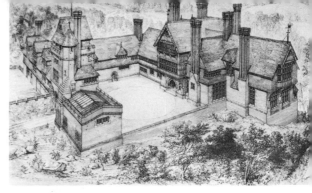

572. BRITAIN. NORMAN SHAW (1831–1912). Design for a country house at Leyswood, near Withyham. 1868. *Royal Institute of British Architects.*

573. BRITAIN. The Firth of Forth railway bridge. 1882–1889. Constructed by Sir John Fowler and Sir Benjamin Baker.

theologians within the Roman Catholic Church. The Gothic style also suited new building techniques which made use of an iron skeleton framework. The rich bourgeoisie, however, preferred a Victorian style, practical but overladen with ornament and eclectic in the extreme — a mixture of Gothic, Palladian, Tuscan, Renaissance, Queen Anne and Romanesque.

About 1850 the Gothic revival entered a new and creative phase with the adoption of Pugin's belief that a building's ethical value was more important than its aesthetic one. Ecclesiology exercised an overwhelming influence, through the Cambridge Camden Society and its choice of the Decorated period as the finest style. Ruskin's publications (*The Seven Lamps of Architecture*, 1849; *The Stones of Venice*, 1851) endorsed the importance of ornament and popularised Italian Gothic with its polychromy of brick and stone. The principal Gothic revival architects were G. G. Scott (1811–1878), W. Butterfield (1814–1900), G. E. Street (1824–1881) and A. Waterhouse (1830–1905). Scott was the most representative practitioner of High Victorian Gothic. After his early Martyrs' Memorial, Oxford (1841) he established his reputation with his prize-winning design for St Nicholas, Hamburg. Other well known works included the Albert Memorial (1863–1873), a reliquary on a monumental scale in stone, bronze and mosaic, and the St Pancras Hotel, London (1865–1875) based on a rejected design for the

Foreign Office. More considerable architects were Butterfield and Street. Butterfield, who had an utter ruthlessness and hatred of taste, was a keen churchman intimately associated with the revival. His masterpiece was the early All Saints, Margaret Street, London (1849–1859) [549] built for the Ecclesiological Society. Its polychromy (exterior banded in red and black; interior with marble marquetry and onyx tiling) indicated one of the hallmarks of High Victorian Gothic. G. E. Street worked under Scott for five years, advocated the use of Tuscan Gothic in his book *Brick and Marble Architecture of the Middle Ages in Italy* and in 1868 won the competition for the new law courts in London (completed 1882). A. Waterhouse had a heavy hand and an uncertain eclectic taste (Natural History Museum, London; Metropole Hotel, Brighton) but considerable ability as a planner of large, complex buildings (Manchester town hall, 1869). T. Deane and B. Woodward, both much influenced by Ruskin, added to Trinity College, Dublin, in a Venetian style, and built the University Museum, Oxford [558], and the Crown Life Office at Blackfriars. J. Prichard (1818–1886) made great use of polychromy; S. S. Teulon (1812–1873) and J. L. Pearson (1817–1897) produced a more austere style, typical of Late Victorian Gothic, which was used for Brisbane cathedral (started 1901, unfinished).

William Morris (1834–1896) and Philip Webb (1831–1915) worked in Street's architectural office. Morris founded the Arts and Crafts movement which gave more attention to the private house and its decoration, which he felt should be considered functionally and in relation to its surroundings. Webb and Nesfield built the Red House near Bexley Heath, Kent (1859), for Morris. Inspired by the Queen Anne style, they designed comfortable and beautiful country houses. R. Norman Shaw (1831–1912) had great success with his large country houses [572], much copied in America; he had an important influence on Richardson. Sensitive to fashion rather than original, Shaw represented the taste of his period for stylishness and refinement (Old Swan House, Chelsea). His architecture included New Scotland Yard (1887–1888), the reconstruction of Regent Street, and the Piccadilly Hotel. C. F. A. Voysey (1857–1941) became interested in the Arts and Crafts movement in 1888. He designed small houses which harmonised well with the surrounding landscape, and he was also a designer of furniture and fabrics.

It was in the field of engineering rather than architecture that the new materials of metal and glass were used in England, remaining unappreciated by the general public. The Crystal Palace (burnt 1936) [557] was originally erected in Hyde Park for the Great Exhibition of 1851 at the instigation of the Prince Consort. It was designed by Joseph Paxton (1803–1865), head gardener to the Duke of Devonshire and erected with the contractors Fox and Henderson and the glass-maker Chance. It was an early example of the right use of mass-production — a completely prefabricated structure of standardised parts, covering an area of nearly twenty acres and even enclosing fully grown trees. Equally significant were the iron and glass railway station sheds, with masonry fronts juxtaposed rather than amalgamated (King's Cross, 1851–1852 by Cubitt [555]; Paddington, 1852–1854 by Brunel & Wyatt). The Reading Room at the British Museum was one of the last major monuments in cast iron. In advance of its time also was the architecture of A. H. Mackmurdo (1851–1942) and C. R. Mackintosh (1868–1928) which remained localised in Glasgow. Mackmurdo was an architect and decorator, belonging to the early years of Art Nouveau, who founded the Century Guild (1882) and the review *Hobby Horse*. Mackintosh was one of the most brilliant precursors of 20th-century architecture and the leader of the Art Nouveau movement in Great Britain. His fundamental importance lay in his reappraisal of the role of function in building, in a style influenced by Celtic ornament and Japanese traditions. In 1895 he participated in the opening exhibition of the Maison de l'Art Nouveau in Paris with posters displaying the linear symbolic style of the Glasgow school. In 1897 he won the competition for extending the Glasgow School of Art (1898–1909) [560]. In the Library, added in 1907–1909, straight lines dominate and the subtleties of horizontals and verticals punctuate space in a novel way. The interior of his Hill House, Helensburgh (1902–1905) combines light, colour, openwork partitions and light furniture in a manner anticipating Dutch De Stijl. After he moved to London in 1913, his activities were confined to designing furniture and fabrics.

Sculpture. Sculpture remained very academic. G. F. Watts (1817–1904) was a slave to Greek idealism; A. Stevens (1817–1875), who studied under Thorvaldsen, had his first success in 1856 with the commission for the Wellington monument in St Paul's cathedral (models and drawings in the Tate Gallery), although the equestrian statue of the Duke was not erected until 1920. Lord Leighton produced highly skilled but frigid work; A. Gilbert raised numerous commemorative monuments; H. Thornycroft and F. W. Pomeroy came under the influence of Dalou when he came to London in 1871; H. Ward brought back exotic themes from a trip he made to Africa. T. Woolner, the creator of the enormous *Moses* at Manchester, was the only pre-Raphaelite sculptor.

Painting. The Pre-Raphaelite Brotherhood was formed in 1848, its members including the young painters W. Holman Hunt, J. E. Millais, D. G. Rossetti and J. Collinson, the sculptor T. Woolner and the critics F. G. Stephens and W. M. Rossetti. The choice of the term Pre-Raphaelite was fortuitous, since the Nazarenes had already sought inspiration in painters earlier than Raphael. The movement was essentially literary, the members insisting on the importance of subject matter, elaborate symbolism and fresh iconography. They sought their truth to nature not in the life around them but in microscopic detail and piecemeal forcing of vivid colour. The group initially came under attack, but in 1851 Ruskin came to their defence and success followed. The group dissolved shortly after, Millais becoming a successful R.A. and Rossetti founding a second movement at Oxford with Morris and Burne-Jones.

Ford Madox Brown (1821–1893) studied in Belgium, Paris and Rome where he was influenced by Overbeck, before returning to England in 1845. Through Rossetti, whom he taught in 1848, he came into contact with the P.R.B. He never became a member but was for long influenced by the group (*The Last of England*, 1845 [574]; *Work*, 1852–1865; decorations for Manchester town hall, 1878–1893). W. Holman Hunt (1827–1910) met Millais and Rossetti at the R.A. schools in 1844 and with them founded the P.R.B. in 1848, being the only member of the group to remain faithful to P.R.B. ideals (*The Hireling Shepherd*, 1851; *The Awakened Conscience*, 1853). He went to Egypt and the Holy Land in 1852, 1869 and 1873 to paint Biblical scenes with accurate local settings and types (*The Scapegoat*). His *Pre-Raphaelitism and the Pre-Raphaelite Brotherhood*, published in 1905, is the best documented memoir of the movement. John Everett Millais (1829–1896) went to the R.A. schools in 1840 as an infant prodigy. In 1848 he founded the P.R.B. with Hunt and Rossetti. In 1853 his friendship with Ruskin ended when he married Ruskin's former wife. He forsook his original P.R.B. ideals (*The Carpenter's Shop*, 1850; *Ophelia*, 1852; *The Blind Girl*, 1855) and developed into a fashionable academic painter of portraits and genre (*The North-West Passage*; *Bubbles*). Dante Gabriel Rossetti

574. BRITISH. FORD MADOX BROWN (1821–1893). The Last of England. 1845. *Tate Gallery.*

576. BRITISH. D. G. ROSSETTI (1828–1882). The Annunciation. *Tate Gallery.*

577. BRITISH. AUBREY BEARDSLEY (1872–1898). Isolde. Drawing and gouache. About 1890. *Cesar de Haucke Collection.*

575. BRITISH. W. HOLMAN HUNT (1827–1910). The Light of the World. *St Paul's Cathedral, London.*

(1828–1882), poet and painter, the son of an Italian political refugee, worked under F. M. Brown and Hunt. His adherence to the tenets of the P.R.B. was short-lived. His subjects were drawn mostly from Dante and a medieval dream-world (*Dante's Dream*, 1853; *Beata Beatrix*, 1863). In 1857 with W. Morris and Burne-Jones he projected decorations for the Oxford Union. Edward Burne-Jones (1833–1898) met Morris and Rossetti at Oxford in 1852. On his travels in Italy (1859–1862) he was strongly influenced by Mantegna and Botticelli. His paintings evoke a dreamy, romantic literary never-never land (*King Cophetua and the Beggar-Maid*, 1844). He produced many tapestry and stained glass designs for Morris's firm. Other artists sympathetic to P.R.B. ideals included Robert Martineau (1826–1869), John Brett (1830–1902) and Arthur Hughes (1830–1915).

Two artists who stand apart from contemporary movements are Alfred Stevens and George Frederick Watts. Stevens (1817–1875) was already a competent portraitist by 1833. In Italy (1833–1842) he studied under Thorvaldsen in Rome, 1840–1842. After working as an industrial designer for the firm of Hoole in Sheffield he carried out decorations in Dorchester House (1852–1862; destroyed) and mosaics in St Paul's cathedral (1862–1864). He painted occasional portraits (*Mrs Collman*; *Mrs Young Mitchell*), but his principal surviving works are drawings, chiefly in sanguine, imbued with the spirit of the Italian Renaissance. Watts (1817–1904) studied under the sculptor Behnes before winning a prize in the competition for the decoration of the Houses of Parliament, 1843. In 1887 he began his series of famous men (*Walter Crane*; *William Morris*) in which he strove to portray character and personality as well as appearance. His large allegories express high-minded generalities in trite, literary symbolism (*Mammon*; *Life's Illusions*; *Love and Death*; *Hope* [482]). He attempted, without a true understanding of the medium, to revive fresco painting (*Justice*, Lincoln's Inn, 1853–1859).

Frederick Leighton (1830–1896), Edward Poynter (1836–1919) and Sir Lawrence Alma-Tadema (1836–1912) were among the many academic painters. Painters who satisfied the public's taste for anecdote included Luke Fildes (1844–1927), Hubert Herkomer (1849–1914), Frank Holl (1845–1888) and W. P. Frith (1819–1909) [409].

The American painter Whistler (see under *America*) settled in England in 1859. He brought the Impressionist technique across the Channel, and started a reaction against ideological subject matter. Sickert, who was a disciple of both Whistler and Degas, completed the reaction. Monticelli had an influence in Scotland, where the most original painter was W. MacTaggart (1835–1910). MacTaggart created his own Impressionist technique from 1875 in works such as *The Storm*.

Aubrey Beardsley (1872–1898) was an illustrator whose highly wrought, stylised black and white drawings embody a *fin de siècle* atmosphere and are a perfect expression of the Art Nouveau style, of which they were an important part [577]. His best known works are his illustrations for *The Yellow Book* (1894), Wilde's *Salome* and Pope's *The Rape of the Lock*.

The minor arts. Victorian art was overladen with heavy and ostentatious decoration and with an accumulation of knick-knacks and curios of every kind. John Ruskin fought against mass-production and bad taste with a firm belief in the superiority of the craftsman over the machine. In 1861 William Morris founded Morris & Co. to produce wallpapers [528], furniture, tapestries, stained glass windows, carpets and furnishing materials in a style fundamentally different from contemporary Victorian in its restraint and lack of ostentatious decoration. His anti-industrialist theories for the regeneration of men through handicraft led to the foundation of the Arts and Crafts movement in 1886. His Kelmscott Press, founded in 1890, did much to raise the standards of book design and printing. In Scotland Mackintosh, his wife Margaret Macdonald, her sister Frances and the latter's husband, the

223

578. GERMAN. HANS VON MARÉES (1837–1887). The Hesperides. *Schleissheim Museum.*

579. GERMAN. VIKTOR MÜLLER (1829–1879). Portrait of a Woman. 1863. *Städelsches Kunstinstitut, Frankfurt.*

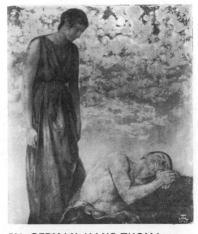

580. GERMAN. HANS THOMA (1832–1924). The Moon and Endymion. 1900. *Kaiser Wilhelm Museum, Krefeld.*

architect Herbert McNair, formed the group 'The Four'. They aimed at a simplification of the whole interior setting, which Mackintosh carried into effect when commissioned in 1897 to design the furniture and decorations for Miss Cranston's chain of tea rooms in Glasgow. In the Buchanan Street tea room (1897–1898), known on the continent through illustrations, and the Ingram Street tea room (1907–1911) the accent is on austerity, slenderness and light tones.

Evelyn King

GERMANY

History. The national movement for unity was led by intellectuals in the Parliament at Frankfurt and by German artists. The Prussian-Austrian dualism was aggravated by religious differences. Austria championed the cause of the German Catholics, while Prussia identified Germany with Protestantism.

The reaction against liberal and revolutionary movements became general after 1848. Prussia, despite the 1850 constitution, introduced an authoritarian and hierarchic régime. Prussia unified Germany during the reign, and to the advantage, of Wilhelm I (1861–1888) who was an energetic and resolute sovereign. His chief of state and major-general was Moltke. With the aid of Moltke and General Count von Roon, Wilhelm I successfully undertook three wars skilfully organised by the Iron Chancellor, Otto von Bismarck (1815–1898), who from 1862 to 1890 was the key man in Prussian politics and in the new imperial Germany. The first war was against Denmark, and as a result the duchies of Schleswig, Holstein and Lauenburg became annexed to Germany in 1865. Secondly there was the lightning campaign in Bohemia which culminated in victory at Sadowa (1866), resulting in the complete elimination of Austria from German territory. Finally

in 1870 France declared war on Germany and was decisively defeated. As a result Bismarck achieved the complete unification of Germany, and Wilhelm I was crowned emperor.

From 1870 to 1914 the German population increased from 40,000,000 to 56,000,000 inhabitants. German industry expanded rapidly and a well organised system of syndicates and cartels was established. The boom in industry gave rise to a strong socialist government, to national pride and to an external policy founded on the belief in the superiority of the German army. Germany became the strongest power in Europe, the balance of power was upset and a general uneasiness began to be felt throughout Europe. The population centred on the larger towns, areas of intense economic activity sprang up, and the railway network became the densest in Europe. All this affected the arts and resulted in a taste for the colossal.

Literature. Poetry came almost to a standstill after its great achievements during the Romantic period. The play and the novel were the literary forms most favoured by the realistic writers. Tolstoy and the Russian novel were powerful influences towards the end of the century in the works of W. Raabe and G. Freytag. Dramatists such as G. Hauptmann, Frank Wedekind and Christian Morgenstern were preoccupied with social problems. Hauptmann wrote *Vor Sonnenaufgang* (1887) and *Die Weber*; Wedekind wrote naturalist dramas; and Morgenstern was noteworthy for his black comedies. R. M. Rilke, Czech by origin but German in spirit, was among the poets in the 1890s who were influenced by the anti-naturalistic reaction of Stefan George, who in 1892 founded the journal *Blätter für die Kunst*.

German thought dominated its writers, especially the historians and philosophers. Historians included

Theodor Mommsen (1817–1903) and H. von Treitschke (1834–1896). Treitschke was a patriotic historian of Germany, and Mommsen, also an archaeologist, wrote mainly on the Roman period. Philosophers included L. Feuerbach (1804–1872) and F. Nietzsche (1844–1900). Feuerbach applied himself to humanise theology; and Nietzsche, poet as well as philosopher, pushed individualism to its most extreme lengths; he wrote *Thus spoke Zarathustra*, his masterpiece. W. Wundt (1832–1920) was more scientific and created psycho-physiology, and in his ten-volume work *Völkerpsychologie* he made a study of the psychology of nations. E. H. Haeckel (1834–1919) set forth a monist philosophy. Karl Marx (1818–1883) founded the idea of collectivism and in 1847 wrote the communist manifesto. *Das Kapital* (first volume 1867) became one of the most important books of the 19th century in its far-reaching consequences; Marx was exiled to London, where he directed the first International Working Men's Association. Communism in Russia, Germany and elsewhere had its origin in Karl Marx.

German artists wished to create an art that was typically German (completion of Cologne cathedral, 1880; establishment of a German Museum, Nuremberg, 1852), but they were enmeshed by their theories, their culture and their hankering for the past, which led to a pastiche style and tended towards the grandiloquent. The main centres were Düsseldorf, Darmstadt and especially Munich, under Maximilian II and Ludwig II (1864–1886), patron of Wagner.

Science. German scientists made discoveries of fundamental importance. K. Weierstrass and G. F. B. Riemann made advances in mathematics. In physics, R. J. E. Clausius established the principle of the conservation of energy, H. R. Hertz developed the study of

581. GERMANY. ALFRED MESSEL (1853–1909). The Wertheim store, Berlin. 1896–1904.

582. GERMAN. MAX KLINGER (1857–1920). Nietzsche. *Städelsches Kunstinstitut, Frankfurt.*

583. GERMAN. KARL KÖPPING (d. 1914). Two decorative glasses. *Kunstindustrimuseet, Copenhagen.*

electrical waves, and W. K. Röntgen discovered X-rays in 1895.

Music. Dramatic music rose to great heights with the musical genius of Richard Wagner (1813–1883), born in Saxony. Besides being a musician, he was also a philosopher, influenced by Schopenhauer, haunted by the problems of liberty and of redemption. He was a poet and man of the theatre who chose his subjects from mythology, where the symbolic sense was directly accessible to ' the feelings . . . which understand without the need of any intermediary '. Wagnerian opera was an art form in itself. It came to fruition in Bayreuth, in the theatre built for Ludwig II of Bavaria in 1876, where were staged *Der Ring des Nibelungen, Parsifal* and *Tristan und Isolde.* Wagner's influence was enormous and spread rapidly throughout the world. It affected E. Humperdinck who taught in Barcelona, H. Wolf and A. Bruckner in Austria, and in Italy even Verdi himself. Poets including Baudelaire, and painters including Fantin-Latour and Redon also came under his influence.

Johannes Brahms (1833–1897) sought a purity of style in a severe but expressive form. He wanted to unite Romantic sentiment with the discipline of musical structure. He settled in Vienna and became the representative of a pure style which was opposed to that of Wagner.

Architecture. Historical eclecticism continued like a chronic illness in Germany, in spite of an intense desire, and the necessity for national prestige, to create an original German style. G. Semper put forward his ideas of functionalism, and the Bavarian kings Maximilian I and Ludwig II gave full official support, but it was no use. The Rundbogenstil (literally ' round arch style ', i.e. Byzantine, Romanesque or Quattrocento in influence), the neo-Gothic, the old German style favoured by the

middle classes, and even a neo-Louis XIV for the use of Ludwig II of Bavaria himself, all completely lacked any true architectural character or any aesthetic of their own time. Stations, post offices, schools and factories were often ingeniously arranged internally, but their exteriors were conceived in Romanesque, Gothic or Renaissance terms. Heaviness and over-ornamentation were the marks of Berlin cathedral (1894–1905) built by J. Raschdorf (1823–1914), the Reichstag building (1884–1894) designed by Paul Wallot (1841–1912) and the Hamburg Rathaus (1886–1897). What might be called the ' Bismarck style ' in brick and stone lacked originality, though most large towns were built in this style. Typical exponents in Berlin were Julius Benda (1838–1897) and Gustav Ebe (1834–1916) who built the von Tiele house.

Bavarian neo-Baroque was created to please Ludwig II. The castle of Linderhof [551] was by G. von Dollmann (1830–1895) the initiator of this style. The style spread to Berlin where it affected the Reichstag and the Palais Mosse by Ebe and Benda. The castle of Neuschwanstein, designed by E. Riedel (1813–1885), was in a sort of Wagnerian Gothic; it was completed in 1881. Characteristic eclectic architects included G. A. Demmler (1804–1886), F. Hitzig (1811–1881), H. F. Waesemann (1813–1879), G. J. von Hauberisser (1841–1922), and F. von Schmidt (1825–1891). Hitzig was responsible for the Berlin Exchange and Schmidt for the predominance of Gothic in Vienna after 1860. F. A. Stüler (1800–1865) designed the church of St Bartholomew in Berlin, which was completed by F. Adler.

Gardens. Landscape architects began to design gardens in relation to the beauty of the surrounding countryside. Among these, Effner, the gardener to Ludwig II, designed the gardens at Linderhof.

Sculpture. Reinhold Begas (1831–1911) was the favourite artist of Wilhelm II. He was a pupil of Rauch with a taste for the baroque who made most of the monuments in the famous Sieges-Allée in Berlin, now mostly destroyed. Adolf von Hildebrand (1847–1921), the most influential German sculptor, studied at Nuremberg before going to Rome in 1867 where he studied under Hans von Marées. He lived near Florence for twenty years before settling in Munich. His taste for classical antiquity and the early Renaissance indicated a return to more monumental sculptural values. Among his most notable works are the fountains of Wittelsbach and Hubertus, Munich and the equestrian statue of Prince Regent Luitpold, Munich. L. Tuaillon (1862–1919) was a student of Marées and Hildebrand. Max Klinger (1857–1920), painter, engraver and sculptor, sought a total art form and produced polychrome sculpture. His best works were his busts, e.g. of Nietzsche [582]. J. Schilling (1828–1910) and Siemering (1835–1905), pupils of Rietschel, were half realist and half academic.

Painting. The school of Düsseldorf, whose principles were continued in Munich, came to an end with Karl von Piloty (1826–1886); though a follower of Delaroche, he was an able director of the Munich Academy. Realism gained strength through the influence of French and Belgian artists; Courbet spent several months of 1858 in Frankfurt, and held an exhibition in Munich in 1869 which was a resounding success. French influence also came through Couture who had a number of German pupils, including Feuerbach.

Hans Thoma (1832–1924) [580] studied in Paris with O. Scholderer (1834–1902), a friend of Fantin-Latour. Thoma was typical of the tendency towards lyrical realism. Like Wilhelm Leibl (1844–1900) [410] he preferred rural subjects. Leibl, a hard-working, serious

artist, was strongly influenced by Courbet; he painted *Peasants at Dachau* (Berlin). His friend Karl Haider (1846–1912), who admired Italy and also Böcklin, was a gifted and sensitive artist. W. Trübner (1851–1917) was a good landscape painter who had considerable influence; he painted *Hemsbach Castle* (Munich). Adolf von Menzel (1815–1905) was an independent artist, who as well as being a painter was a fine lithographer. In his historical works, such as the 400 wood engravings illustrating Franz Kugler's *History of Frederick the Great* (1840–1842) he often lapsed into mediocrity because of his excessive detail, but in less pretentious subjects he showed a wonderful feeling for light [394]. Under the influence of Daumier and Manet he developed towards realism.

The religious naturalism of Fritz von Uhde (1848–1911) was a reaction against the archaeological reconstructions of Karl Gebhardt. Uhde was the leading spirit behind the Munich Sezession. A little later the same truthful spirit is apparent in the revival of religious painting at Worpswede, near Bremen. It was still rather literary in character. A neo-Nazarene spirit existed in certain monasteries (Beuron).

Portrait painting was well represented by the elegance of F. von Rayski (1806–1890) and F. X. Winterhalter (1805–1873), and by the brio of Franz von Lenbach (1836–1894). Winterhalter emigrated to the French imperial court; and Lenbach, the brilliant pupil of Piloty, worked for Wilhelm I and Bismarck.

The Swiss artists A. Böcklin, Anselm Feuerbach (1829–1880) [83] and Hans von Marées (1837–1887) were neo-Romantic painters. Feuerbach studied under W. Schadow in Düsseldorf, under C. Rahl in Munich, and under Couture in Paris; his historical and mythological scenes were well painted but uninspired. Marées was fascinated by the art of antiquity, by Rome and by Michelangelo; his mythological compositions in a Rembrandtesque technique were often poetic, as in *The Hesperides* [578], *The Judgment of Paris* and *Diana Resting*. The work of M. Klinger and Franz von Stuck was pretentious. Max Liebermann (1847–1935) [472] was the champion of French Impressionism. He studied at Weimar, Paris and Munich before settling in his native Berlin in 1884. The influence of Courbet and Millet helped him to a personal realism (*Plucking the Geese*, 1873). After 1890, under the influence of Manet, his palette lightened and his landscapes and beach scenes acquired a new unity of tone and colour. In his last works portraits and self-portraits occupied a prominent place. Lovis Corinth (1858–1925), after ten years

in Munich, settled in Berlin about 1900. With Liebermann he belongs to German Impressionism, though the brilliance of his early style owes more to Hals than to the French Impressionists. In 1911, after a stroke, his painting underwent a transformation. His later flower-pieces and landscapes of the Côte d'Azur and the Walchensee, painted in strong colours, no longer depend on subject matter for their vitality; while his later portraits and religious works (*Meier-Graefe*, 1917; *Ecce Homo*, 1925) have a deep emotional power.

The graphic arts. Menzel was a fine lithographer and Klinger a master of etching. Caricature, with its tendency to extremes and its taste for ugliness, prepared the way for 20th-century graphic art in Germany. W. Busch (1832–1908) worked mainly as a pen and ink caricaturist; his burlesque humour often foreshadowed surrealism.

AUSTRO-HUNGARIAN EMPIRE

History. After the rebellions of 1848, Bach and his authoritarian government which remained in power until 1859 aimed at superimposing a German culture on all the Magyar and Slav provinces of the empire. Attempts at federation had little success. There were several defeats in Italy and then in 1866, by the Peace of Prague, Austria was excluded from Germany. As a result the compromise of 1867 forced Franz Josef (1848–1916) to accept an Austro-Hungarian dualism. The Austrian empire and the dependent kingdom of Hungary had in common only the sovereign, the administration for foreign affairs, finance and war.

From the period when Count Julius Andrássy was in power (1871–1879), Hungary steadily gained in importance owing to her new industrial strength. Budapest soon rivalled Vienna. There was a battle for supremacy between the official German and the various Slav languages. This, together with the claims of the Czechs, kept up a climate of unrest in Bohemia. Towards the end of the century, threatened by Hungarian separatism and by Slav and German fanaticism, the Habsburg monarchy was on the brink of disaster.

Literature. Austrian literature had little to do with Austrian life. A. Stifter was an ardent Catholic poet and novelist who wrote against the régime

of Bismarck's Prussia. Sigmund Freud (1856–1939) was the brilliant inventor of psychoanalysis, which was to have a world-wide influence on thought.

In Czech literature the Romantic illusions of P. J. Šafařík, F. Palacký, J. Kollár, F. L. Čelakovský, K. J. Erben and J. Neruda gave place to more realistic writing. The review *Lumír* founded in 1873 by Neruda aimed at perfection of form and at cosmopolitanism. J. Vrchlický, a prolific poet, put an end to the exclusive influence of Germany. The poems of S. Čech returned to a passionate Romanticism. A Czech university founded in Prague 1882 and the creation of a national theatre were signs of Bohemian unity. Symbolism arrived about 1890, and ran parallel to Russian symbolism and to the 'Young Poland' movement. Social realism came later than in other parts of Europe; it corresponded to the very advanced industrialisation of the country.

In Hungary F. Deák was a brilliant orator and politician. J. Arany (1817–1882) wrote good epic poems and so did several other writers. From 1850 the influence of the English realism of Dickens and Thackeray led writers towards naturalism, which was confirmed by the lessons of Gogol and Turgeniev and of the French realists. Important novelists included Z. Ambrus (1861–1932) who translated Bourget and Ibsen.

Music. In 1863 Brahms (1833–1897) settled in Vienna. Brahms was a symphony writer who united construction and emotion. Through him Vienna became the major musical centre with Brahms's purity of form set in opposition to Wagner's Romantic style. A. Bruckner (1824–1896) was a fine symphonist and organist. Hugo Wolf (1860–1903) gave new life to the German Lied. G. Mahler (1860–1911) studied under Bruckner and was a fervent follower of Wagner. He was the most original of modern Viennese composers and prepared the way for A. Schönberg. Vienna became, as a result of the work of Johann Strauss, the capital of the waltz.

The school of Prague, brilliant and highly original, gained international prestige through the works of B. Smetana (1824–1884), who wrote the masterpiece of Czech opera *The Bartered Bride*, and by the work of A. Dvořák (1841–1904) whose music was often based on Bohemian folk songs.

HENRI MATISSE (1869–1954). Moroccan Landscape. 1911. National Museum, Stockholm. *Museum photograph.*

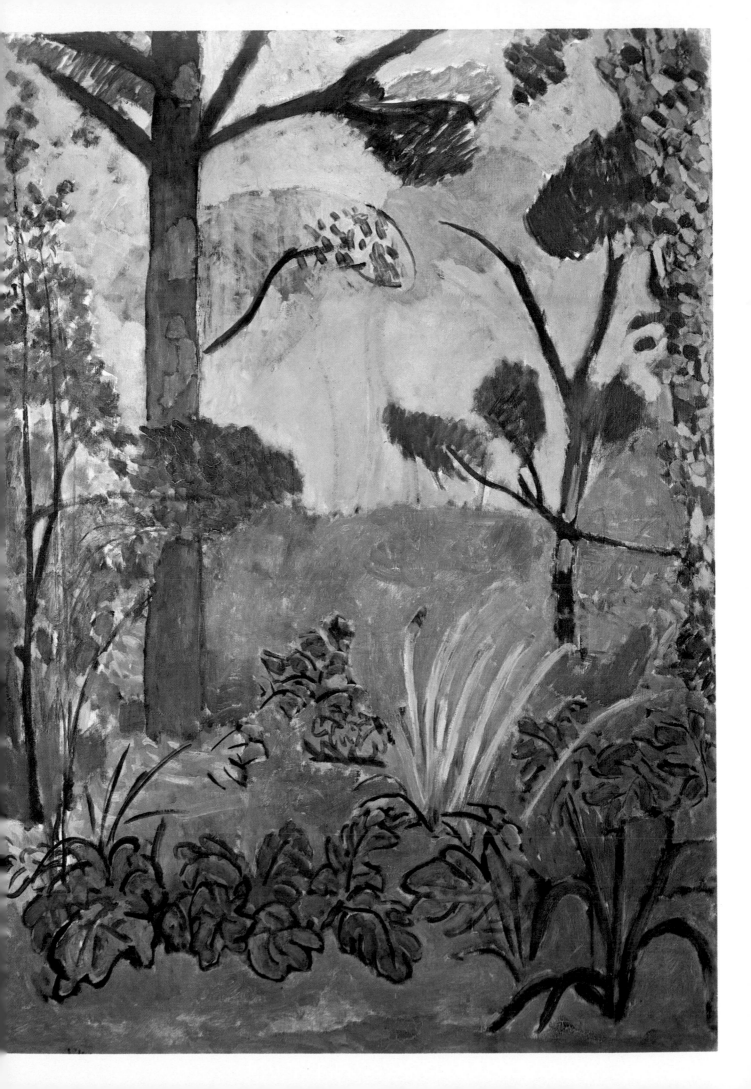

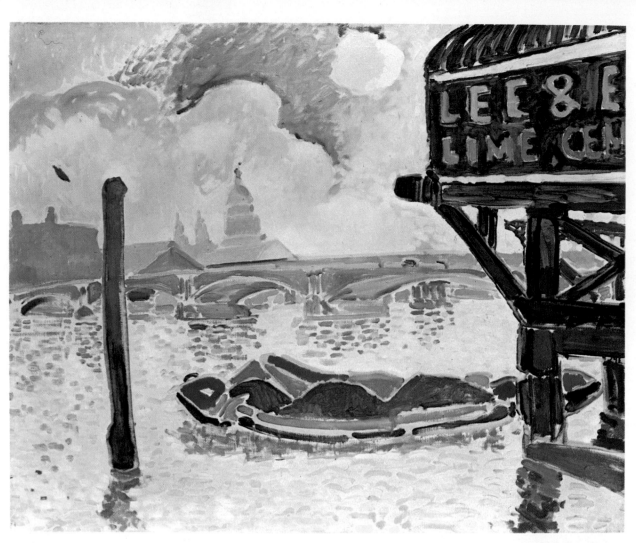
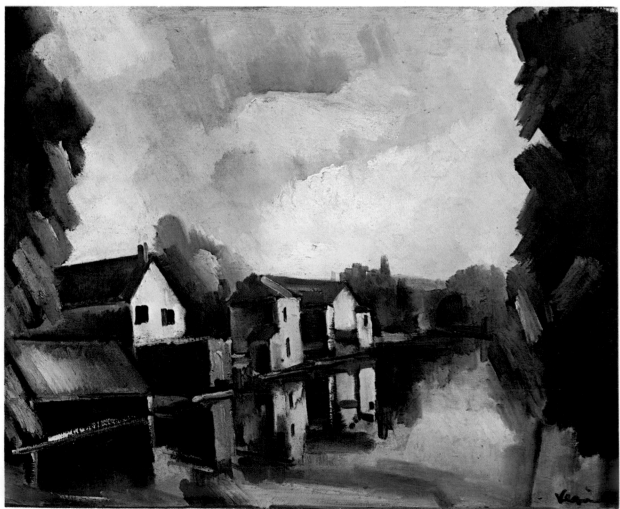

Architecture. Vienna was transformed by Franz Josef's decision to replace the old walls of the city with a series of wide tree-lined boulevards known as the Ringstrasse. The work was undertaken in 1858 by L. Förster (1797–1863), who alternated the boulevards with open spaces in which major public buildings were grouped. The North railway station (1858–1865) by T. Hoffmann and the South station (1869–1873) by W. Flattich (1826–1900), were typical of the eclectic taste which overlaid a Renaissance style with heavy ornamental decoration. Neo-Gothic works included the Rathaus (1872–1883) by F. von Schmidt (1825–1891) and the Votivkirche (1856–1879) by H. von Ferstel (1828–1883), the most important Austrian church in this style. Von Schmidt worked under Zwirner on Cologne cathedral. The parliament buildings of T. von Hansen (1813–1891) were Neoclassical in style. Von Hansen was of Danish descent; he had worked in Athens, and his eclecticism did not lack quality in his Heinrichshof. Ferstel in his Vienna university building (1873–1874), which is situated on the Ring, drew inspiration from Renaissance models. The Burgtheater (1874–1888), also on the Ring, was built by the German architect G. Semper and the Viennese K. von Hasenauer (1833–1894); it was far more original. These two architects also designed (1872–1881) the two symmetrical museums, of natural history and of the history of art, but they were heavy and overladen with Renaissance ornament. The Opera (1861–1869) was the Viennese counterpart to the one in Paris and was built by E. van der Null and A. S. von Siccardsburg, who together also designed the Arsenal.

Franz Josef was also responsible for important buildings in Budapest, his second capital. Here a very German Rundbogenstil was employed. No local originality entered into the parliament building (1883–1902), the Opera (1879–1884), the Academy of Sciences or the town hall. The parliament building, based on the Houses of Parliament in London, was designed by Imre Steindl (1839–1902), the Opera by Miklós Ybl (1814–1891), and the Academy of Sciences by Stüler, the Berlin architect. The Vigadó concert hall (Redoute building, 1859–1865) was erected by Frigyes Feszl (1821–1884) in a neo-Romantic style which mingled Moorish and Romanesque. Ybl and Hauszmann completed the Royal Palace. E. Lechner attempted to find a new Hungarian style in his design for the Hungarian Industrial Art Museum (1893–1897).

Prague, like Vienna, experienced a banal neo-Renaissance style which came from Germany and Austria. The buildings of I. Ullmann and Joseph Zitek were typical. Zitek designed (1868–1881) the famous national theatre in Prague. It was inaugurated in 1883, after remodelling by J. Schulz following a fire in 1881, and became a symbol of Czech resurgence.

The following generation of architects tried to find a more original style drawn from Baroque and folk art sources.

Sculpture. Austrian sculptors were dull, though technically excellent. Commemorative monuments were created by J. Schilling (1828–1910), C. von Zumbusch (1830–1915), E. Hellmer and V. Tilgner (1844–1896). The monument to Schiller (1876) in Vienna was the work of Schilling; that of Goethe (1900) was designed by Hellmer; and Zumbusch created the monument to Beethoven (1880).

Hungary, however, produced fine sculptors who attempted to break away from academic art. They included J. Fadrusz (1858–1903), C. Zala (1858–1937), and A. Strobl von Liptoujvar (1856–1926). Fadrusz had a feeling for the monumental, and Strobl an expressive quality. They all studied in Vienna or Munich. The sculptors who followed them were inspired by Constantin Meunier and Rodin.

Medallists followed I. Ferenczy (1792–1856), who studied under Thorvaldsen and was a friend of Canova in Rome.

Prague had a fine religious sculptor in V. Levy (1820–1870). J. Myslbek (1848–1922) created the equestrian statue of St Wenceslaus and statues for the national theatre, Prague. He had a following of younger sculptors.

Painting. During the Franz Josef period Viennese painters were outclassed by their contemporaries in Berlin and Munich before the Sezession group.

After F. G. Waldmüller there were few interesting artists, even among portrait painters. Hans Makart (1840–1884) was pompously banal. G. von Max (1840–1915) was born in Prague and studied under Piloty; his mysterious realism, full of subtleties, reminds one of Ensor. Anton Romako (1832–1889) influenced Kokoschka by his strangely poetic and somewhat wry portraits. The symbolism and anti-realist tendencies of the Sezession paved the way for Art Nouveau, especially in the decorative paintings of Gustav Klimt (1862–1918) dating from 1892. In 1897 Klimt was elected the first president of the Vienna Sezession group but separated from them in 1905. He collaborated in the production of the periodical *Ver Sacrum*. His refinement of line and sense of tonal values, and his departure from representation, made him one of the important forerunners of 20th-century art [**480**]. He decorated the Hôtel Stocklet in Brussels.

In Hungary, about 1870–1875, a group of painters made use of the lessons of French Realism and Impressionism; their work had vitality and lyricism and they knew how to make use of light and nature. K. Lotz (1833–1904), who worked for the Opera in Pest, and C. Mészöly (1844–1887) were good landscape painters. G. Benczúr (1844–1920) was a pompous history painter. His contemporary, Mihály von Munkácsy (1844–1909), studied in Germany, was influenced by Courbet, and emigrated to Paris; his landscapes, portraits and flower paintings were far superior to his large works which brought him fame [**402**]. L. Paál (1846–1879) studied the Barbizon painters and produced melancholy landscapes in which light played a dominant part. Pál von Szinyei Merse (1845–1920) studied under Piloty in Germany; he admired Böcklin, Millet, Courbet and Manet; and he painted *Picnic in May* [**393**] (exhibited 1873). Munkácsy, Paál and von Szinyei Merse were the painters through whom Hungary gained an international reputation.

Josef Mánes (1820–1871), who painted landscapes, portraits and genre, was the leader of the young Czech painters. His art was original and free from German influence. After him Czech painters studied abroad in Paris or Brussels, but were also conscious of the art of the Polish painter Jan Matejko. I. Cermak (1831–1878), a pupil of

ANDRÉ DERAIN (1880–1954). Blackfriars. 1907. Glasgow Art Gallery and Museum. *Museum photograph.*

MAURICE DE VLAMINCK (1876–1958). The River. 1910. National Gallery, Washington (Chester Dale Collection). *Museum photograph.*

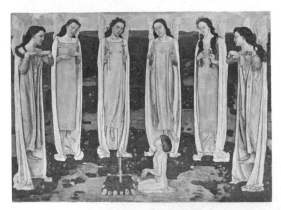

584. SWISS. FERDINAND HODLER (1853–1918). The Elect. *Kunstmuseum, Berne.*

585. SWISS. FERDINAND HODLER (1853–1918). The Jungfrau in Mist. 1908. *Musée d'Art et d'Histoire, Geneva.*

586. SWISS. A. NIEDERHÄUSERN, known as RODO (1863–1913). Jeremiah. Bronze. About 1913. *Musée d'Art et d'Histoire, Geneva.*

Gallait, settled in Paris. S. Pinkas (1827–1901) became a pupil of Couture. W. Brozik (1851–1901) painted history pictures. A. Chittussi (1848–1891) was a landscape painter who studied at Barbizon. The Mánes Society came into being with the new generation of artists. This included Joza Uprka and Antonin Slaviček the Elder, both influenced by Impressionism, and Jan Preisler who decorated Prague town hall. They published the art review *Volne Smery*.

The minor arts. Vienna produced small bronzes, wrought ironwork and jewellery, all in Baroque style. Bohemian glass, heavy and highly coloured, spread throughout Europe.

SWITZERLAND

History. Switzerland became prosperous as the railways were developed; the tourist trade increased and with it the reputation of the high class, hand-made goods. A unified and democratic government untrammelled by religious frictions took full advantage of the new opportunities.

Literature. H. F. Amiel (1821–1881), an introvert moralist and psychologist, reflected the tone of French Swiss culture, which was very European in spirit. Jakob Burckhardt (1818–1897), the Basle historian, achieved lasting international fame. His greatest follower was Heinrich Wölfflin who concentrated on the history of art.

Architecture. Public buildings were mostly in an eclectic style, even when the architect was inspired by earlier local styles, as was G. Gull for the Zürich museum. Architects created their best works in some of the country villas built on the outskirts of growing towns, adapting traditional character to suit the new simplicity, which was both functional and comfortable. Such architects included Karl Moser and du Kirchenfeld in Zürich, Wurstemberger and H. de Fischer in Berne, and Camoletti, Morsier and E. Fatio in Geneva. The restoration of ancient buildings was strongly influenced by Viollet-le-Duc.

Sculpture. Academic sculpture was represented by the work of the Tessinois sculptor Vincenzo Vela (1820–1891) and L. F. Schlöth (1818–1891). K. Stauffer-Bern (1857–1891) and M. Leu (1862–1899), who both died young, did not have time to develop their talents. The monument by R. Kissling (1848–1919) to William Tell had a certain grandeur. A. de Niederhäusern, called Niederhäusern-Rodo (1863–1913), a symbolist friend of Verlaine, was inspired by Rodin [**586**].

Painting. The descendants of French Swiss mountain painters continued very late, and included A. van Muyden (1818–1898) and A. Baud-Bovy (1848–1899), who was linked in Paris with Puvis de Chavannes and Rodin. E. Burnand (1850–1921) was a religious painter, sincere but not outstanding. B. Menn (1815–1893), important as a teacher, was a landscape painter and friend of Corot. Eugène Grasset (1841–1917), architect, illustrator and pupil of Viollet-le-Duc, made use of stylised floral decoration.

The French Swiss artists were attracted by Paris or Rome; the German Swiss went to study in Munich or Düsseldorf. G. L. Vogel (1785–1879) from Zürich was impressed by the Nazarenes. J. R. Koller (1828–1905), a realistic animal painter, studied in Belgium and Paris. Albert Anker (1831–1910), from Berne, was a pupil of Gleyre, and succeeded with portraits of charming simplicity. Frank Buchser (1828–1890) possessed the same honesty of vision with a pre-Impressionist style. T. Steinlen (1859–1923) [**361**] born at Lausanne, settled in Paris in 1883. In lithographs and posters, influenced by Japanese woodcuts, he vividly depicted the popular life of the city and contributed to the 1890s style. The two outstanding painters were Arnold Böcklin (1827–1901) and Ferdinand Hodler (1853–1918). After study at Düsseldorf and Rome (1850–1857) Böcklin settled permanently near Florence in 1893. His mingling of romantic and Latin ideals can be seen in works like the *Island of the Dead* ([**477**] Basle, 1880). In later years his fantastic, macabre suggestiveness frequently lapsed into bad taste (*Death, The Plague*). Ferdinand Hodler (1853–1918) [**584, 585**] is an artist whose fame has dwindled since his death. After studying at Geneva under B. Menn, a pupil of Ingres, he alternated portraits of labourers and artisans with luminous, limpid landscapes (*The Schoolboy*, 1875; *Night*, 1891). In the early 1890s the influence of Symbolism gave him a taste for grandiloquence (*Disillusioned Souls, The Elect*) which he embodied in a succession of large historical pictures (*The Retreat from Marignan*, 1899; *Departure of the Jena Volunteers*, 1908). Some of his canvases have a powerful significance and sure draughtsmanship but conflicting influence often resulted in work of uneven quality (*Towards the Infinite*).

SCANDINAVIA

The countries which made up Scandinavia were poor economically and geographically. 8,000,000 Scandinavians emigrated to the United States during the 19th century. Scandinavia became more up to date as a

587. DANISH. V. HAMMERSHÖI (1864–1916). Artemis. 1893–1894. *Statens Museum for Kunst, Copenhagen.*

588. DANISH. W. MARSTRAND (1810–1873). Musical Evening. About 1833. *Frederiksborg Palace.*

589. DANISH. T. BINDESBØLL (1846–1908). Enamelled plate decorated in sgraffito. 1901. *Museum of Decorative Arts, Copenhagen.*

590. DANISH. J. ROHDE (1856–1935). Teapot. About 1906. *H. P. Rohde Collection, Copenhagen.*

result of a long period of peace: the war between Denmark and Germany in 1864 did not last long. Agricultural methods were improved. Swedish iron of high quality and readily available hydro-electric power permitted industrial expansion. Denmark, Sweden and Norway were to make important contributions to music and literature at the turn of the century. A united Scandinavia might have come about but for Norwegian separatism, encouraged by the work of Grieg, Ibsen and Nansen.

DENMARK

Literature. Copenhagen was an important artistic, literary and scientific centre. The critic Georg Brandes (1842–1927), a disciple of J. S. Mill, was very influential during the post-Romantic period. Danish realism introduced a frozen and pessimistic atmosphere. J. P. Jacobsen (1847–1885), a despondent Impressionist, was a poet and novelist who died young. The writing of Herman Bang (1857–1912) was marked by a very personal pessimism. H. Drachmann wrote novels and poetry. H. Pontoppidan (1857–1943) believed in the superiority of primitive man over civilised man. Symbolism brought an aesthetic and spiritual change of outlook, but also a rather *fin de siècle* climate with the review *La Tour*. J. Jørgensen, L. Holstein and H. Rode responded emotionally to nature. Sophus Claussen's poetry was closely constructed. G. Wied (1858–1914), a bitter playwright, was a pupil of Strindberg.

Music. Copenhagen was a lively musical centre, with musicians of two opposing trends, one nationalist and the other German-influenced. The German style remained Romantic and the best composer was Niels Gade whose work derived from Mendelssohn. The nationalist style was more modern; Carl Nielsen developed contrapuntal music, reacting against folk song and local tradition.

Museums. In 1880 Carl Jacobsen created the Ny Carlsberg Glyptotek, which spread the influence of Carpeaux and Rodin. Later the private collection of W. Hansen, with its paintings by Delacroix, Courbet, Daumier and the Impressionists, was also to have a very considerable influence.

Architecture. Neoclassicism lingered, due partly to the prestige of Thorvaldsen, and partly to contacts with the Greek royal family, Danish in origin. Eventually neo-Gothic and neo-Renaissance styles reached Copenhagen through German influence.

J. D. Herholdt (1818–1902) was adept in using the Rundbogenstil and possibly created the finest work in this style with his National Bank in Copenhagen (1866–1870). He made brilliant use of brick with an iron skeleton structure in his university library. His lead was followed by several architects including Borch, an innovator in the use of wood, which he employed for the reconstruction of Trondheim after the fire of 1841; he also built Copenhagen railway station (1863–1864) in wood. Many large buildings were erected in Copenhagen including those by V. Petersen (1830–1913) and F. V. Jensen (1837–1890), who together designed the Søtorvet, a piece of town planning in the Napoleon III style. Other architects included G. F. Hetsch (1830–1903), F. Meldahl (1827–1908), A. C. Jensen (1847–1913), Martin Nyrop (1849–1925), H. Kampmann (1856–1920) and T. Bindesbøll (1846–1908). Frederiksborg castle was built by Meldahl; and the Magasin du Nord department store in Copenhagen (1893–1894) by A. C. Jensen. Nyrop in a somewhat local style made use of brick for the town hall in Copenhagen (1892–1902). Kampmann worked at Aarhus. Bindesbøll marked an important development towards a 20th-century style.

Sculpture. In between H. V. Bissen (1798–1868) and Jerichau (1816–1883), who prolonged the Neoclassical style, and Kai Nielsen (1882–1924), who prepared the way for modern sculpture, there was little of character.

Painting. L. Frölich (1820–1908), influenced by E. Bendemann in Dresden and by Couture in Paris, was a Romantic painter. The most interesting artists were landscape painters and painters of domestic interiors; both were often moved by a poetic sense of light. P. S. Kröyer (1851–1909) was technically a fine painter; T. Philipsen (1840–1920) painted animals; and Vilhelm Hammershöi (1864–1916) [587] painted scenes of middle class life.

The minor arts. Arnold Krog, a Norwegian painter, reformed the royal porcelain factory in Copenhagen in 1885. He used floral and animal themes in his designs. His successor, C. H. Joachim, made fine stoneware. T. Bindesbøll [589] was architect, decorator and ceramist; he was influenced by Far Eastern art, and created an abstract style which was very personal, owing nothing to Art Nouveau. He worked independently of other artists. The Bing and Gröndahl factories produced important work, due to the enthusiasm of J. F. Willumsen, a painter, sculptor and friend of Gauguin.

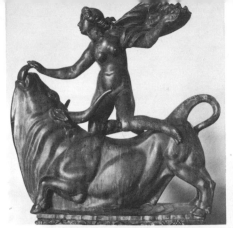

591. SWEDISH. C. MILLES (1875–1955). Europa and the Bull. About 1895. *Konstmuseum, Göteborg.*

592. SWEDISH. ERNST JOSEPHSON (1851–1906). The Spirit of the Water. *Konstmuseum, Göteborg.*

593. SWEDISH. CARL LARSSON (1853–1919). In the Corner. *National Museum, Stockholm.*

594. SWEDISH. ANDERS ZORN (1860–1920). Verlaine. Etching. 1895.

SWEDEN

History. King Oscar I (1844–1859) worked at modernising Sweden by developing her railways and reforming her laws; Charles XV (1859–1872) favoured an up to date liberal policy in government; and Oscar II (1872–1907) accepted the idea of universal suffrage. This Bernadotte family would have liked to see Sweden lead a unified Scandinavia.

Literature. Certain academic poets and the group known as the 'Pseudonym Poets' were the only men who curbed the blossoming of a modern intellectual school of writers. Count C. Snoilsky (1841–1903) was the most notable of the Pseudonym Poets, who were preoccupied with the technical perfection of their work. The new writers were antagonistic to a middle class society interested only in material riches. A romantic revival and a gloomy but refined and decadent style both developed from the same sources.

A. Strindberg (1849–1912) was a playwright who mixed the real and the dream world. He also wrote novels such as *The People of Hemsö*, and pamphlets of which *Black Flags* is important. In *Miss Julie* he was scrupulously realist; in *The Dance of Death* he revealed an outrageous sense of drama. His passion and his incapability of separating his life and his work permeated *A Fool's Defence*. He was a symbolist deeply affected by Swedenborg and Nietzsche, with a European influence. He also possessed uncanny foresight in painting. His most important experiments in painting were from 1900 to 1907, and his technique, with its use of the accidental, made him a pioneer of modern abstract expressionism. O. Hannson (1860–1925), a refined poet, and Ernest Josephson, who produced *Red Roses* and *Yellow Roses*, began a poetic renaissance about 1890, making the final years of the century the richest poetic period in Sweden's history. Poets included V. von Heidenstam, Gustav Fröding and O. Levertin. Selma Lagerlöf (1858–1940) was a woman author whose prose writing had a poetic sense of the supernatural. Per Hallström was a novelist of audacious fantasy who was also a master of poetic prose.

Museums. Two museums were built — the Northern Museum and the open air museum of Skansen. These gave incentive to the creation of a national Swedish art.

Architecture. Scandinavian architects made use of brick or wood and thereby avoided the international eclectic style and the style which derived from Napoleon III (the brothers A. F. and K. H. Kumlien and J. F. Åbom). I. G. Clason (1856–1930) built the Northern Museum (1889–1907) in a national Scandinavian style, though there remained traces of Berlin and Munich influence. A. Johansson (1860–1936) built the Parliament House and the National Bank (1897–1905) which were Baroque in their effect. E. V. Langlet (1824–1898) worked mainly in Norway, where he designed the parliament building in Oslo (1861–1866). R. Östberg (1866–1945) in his Stockholm town hall made use of a simplified style which despite vestiges of earlier styles cleared the way for 20th-century architecture.

Sculpture. Swedish artists went to Paris seeking the method and the impetus to break away from the academic stranglehold of Thorvaldsen. J. P. Molin (1814–1873) in his *Wrestlers* (1857) was the first to free himself. J. L. H. Börjeson (1835–1910) was an official sculptor and K. P. Hasselberg (1850–1894) a lively realist.

Painting. As so many painters worked in Paris, it was natural that Swedish painting was strongly influenced by that of France. A. Wahlberg (1834–1906) was influenced by the Barbizon. Ernst Josephson (1851–1906) [592] lived mainly in France and owed much to Manet and the Impressionists; he founded the *Konstnärs förbundet* association in 1886. C. F. Hill (1849–1911) admired the work of Corot and the Impressionists and painted vibrant landscapes; unfortunately he went mad (as, indeed, in 1888, did Josephson) and after 1877 did strange graphic work. Carl Larsson (1853–1919) [593] painted intimate interiors and was also a decorative artist. B. Liljefors was an animal painter, wildly enthusiastic about Japanese art. Anders Zorn (1860–1920) [594] spent a nomadic life, with frequent visits to London and Paris. On his first visit to Paris in 1881 he was influenced by Manet, Degas, Renoir and Rodin, becoming the latter's friend. His paintings of voluptuous nudes have a violence and aggressiveness echoed in his engravings with their powerful strokes and coarse incisions. He turned to sculpture to achieve a more direct grasp of the human figure in three dimensions (*Nymph and Faun*, 1895; *Gustav Vasa*, 1903; *Alma*, 1911). G. O. Björck painted official portraits.

The minor arts. The glass works of Orrefors produced glass of high quality.

595. NORWEGIAN. G. MUNTHE (1849–1929). Odin. *National Gallery, Oslo.*

596. NORWEGIAN. GUSTAV VIGELAND (1869–1943). Female Torso. *National Gallery, Oslo.*

NORWAY

History. Norway was attached to Sweden by royal family ties. But because of the economic wealth of her fishing industry and her mounting intellectual and artistic prestige from 1850, she succeeded in gaining her freedom in 1905.

Literature. Norwegian literature of the 19th century played a leading European role. Henrik Ibsen (1828–1906) wrote plays and poetry; B. Björnson (1832–1910) wrote plays, novels and poetry. Ibsen's writings posed anti-conventional moral problems and his art was half-realist and half-symbolist. His most important works included *Brand* (1866), *Peer Gynt* (1867), *A Doll's House* (1879) and *The Wild Duck* (1884). B. Björnson was Romantic and liberal and was one of the leaders of the United Scandinavia movement. He became well known for his short stories based on the old sagas, and he wrote epic plays, such as *Sigurd the Crusader* and *Arnljot Gelline*. Following Ibsen and Björnson, the best writers were the novelists Jonas Lie (1833–1908) and Alexander Kielland

(1849–1906), the first a tranquil realist, the second biting and brilliant. Knut Hamsun (1859–1952) foreshadowed 20th-century literature with his novel *Hunger* (1888).

Music. E. Grieg (1843–1907) and J. Svendsen made Norwegian music internationally important. Grieg, the greatest Scandinavian composer, expressed a Nordic dream-world in works such as *Peer Gynt*. His works charmed the musicians of the time, and they influenced both Debussy and Ravel.

Architecture. There were few architects of note. Neither C. H. Grosch (1801–1865) nor the Schirmers possessed originality. Holm Munthe revived the use of wood and the ' Viking ' style. H. Bull also used timber; his technique was ideally suited to the climate, and he drew inspiration from traditional Norwegian house design. In Oslo he built government offices, the national theatre and the museum.

Sculpture. Sculpture had remained academic since Thorvaldsen. It gained new life in the work of Gustav Vigeland (1869–1943) and Stefan Sinding (1846–1922) who was strongly influenced by French art. Vigeland has been described as the Norwegian Rodin; from his earliest years he revealed his epic power, as in his works on the theme of the *Divine Comedy*.

Painting. After J. C. Dahl many Norwegian artists painted landscapes, often going to work in Germany. They included Hans Gude (1825–1903) who studied in Düsseldorf, and Frits Thaulow (1847–1906), a pupil of Gude in Karlsruhe who came under Impressionist influence in France. But Realism, French Impressionism and the human problems which preoccupied the writers tended to direct interest more towards portrait painting. Erik Werenskiold (1855–1938), who studied in Munich and Paris, painted subtle and moving portraits. Halfdan Egedius (1877–1899), who died at the age of twenty-one, left a most interesting portrait of the painter T. J. Stadskleiv, now in the Oslo museum. Kristian Krohg (1852–1925) became notorious for his aggressive naturalism and socialist outlook. Gerhard Munthe (1849–1929), the ' Norwegian William Morris ', did decorations and illustrations based on the traditional sagas. He was of great importance in the development of the visual arts [595].

The minor arts. The most important craft was tapestry. G. Munthe designed a tapestry of the saga of King Sigurd, woven by Frida Hansen.

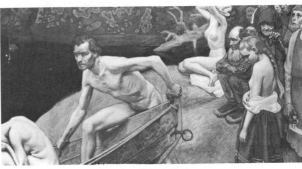

597. FINNISH. A. GALLEN-KALLELA (1865–1931). By the River of Tuonela. 1903. *Ateneumin Taidemuseo, Helsinki.*

POLAND

History. The badly prepared 1863 revolt was a final effort to regain independence.

Literature. The Prussian part of Poland was naturally much influenced by Germany. In the Russian part, a policy aimed at absorbing the area into Russia prevented any intellectual freedom. However, in Austrian Poland, at Cracow, where there were the Academy of Sciences, the national museum and the Czartoryski Museum, Polish artistic life continued.

The realist literature was inferior to the Romantic. There were few poets, though there were three notable novelists, H. Sienkiewicz, Boleslaw Prus and Eliza Orzeszkowa. Sienkiewicz became celebrated with *Quo Vadis* which was not, however, his best work; in other books he exalted the fighting history of Poland. Orzeszkowa was a feminist who influenced Russian authors. The Symbolist and neo-Romantic movement of 1880 known as ' Young Poland ' was somewhat analogous to Russian Symbolism; both had refinement, a tendency towards the esoteric and the decadent. The two leaders of ' Young Poland ' were S. Przybyszewski (1868–1927) and S. Wyspianski (1869–1907). The latter was a fine poet as well as painter, who had trained under Jan Matejko. He dreamed of a total art; he wrote and directed his own plays, for which he also painted the scenery, at the Cracow theatre. The best novelists at the end of the century were Wladyslas Reymont (1868–1925), who wrote *The Peasants*, and Stefan Zeromski (1864–1925) who embodied the Polish conscience.

Music. The only notable musician was S. Moniuszko who wrote *Halka*, the first Polish opera.

Architecture. Neo-Gothic only lasted a short while. Neo-Renaissance was introduced by the Italian architect Enrico Marconi (1795–1863) who built the Land Credit building in Warsaw.

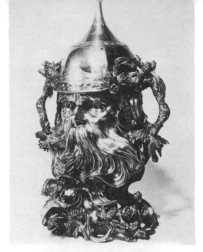

598. RUSSIAN. Silver samovar by Carl Fabergé.

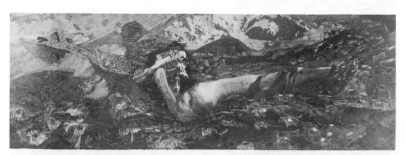

599. RUSSIAN. M. A. V. VRUBEL (1856–1911). The Demon. About 1900. *Formerly Meck Collection.*

Sculpture.

A number of sculptors emigrated, including V. Brodzki (1825–1904), who went to Rome, and C. Godebski (1835–1909) who left for Paris.

Nearly all sculptors aimed at the exaltation of national glory and most of them produced some work of character, including M. Guyski (1830–1893), A. Kurzawa (1843–1898) and T. Rygier (1841–1913) who sculpted several portraits of Mickiewicz, notably the monument at Cracow. P. Welonski (1849–1931) and W. Szymanowski (1859–1930) were more academic.

Painting.

After the 1863 rising, painting tried to eliminate German influence from Vienna, Munich and Berlin. Polish painters were endowed with powerful and original imaginations. A. Grottger (1837–1867) and Jan Matejko (1838–1893), the best artists, painted historical frescoes; less gifted were J. von Brandt (1841–1928) and H. Siemiradzki (1843–1903), decorator of the Cracow theatre. J. Chelmonski (1849–1914) recreated landscape, atmosphere and Polish life. J. G. Stanilawski (1860–1907) was also a good landscape painter, influenced by Impressionism. S. Wyspianski (1869–1907) brought genre painting up to date; he was a painter, poet and excellent decorator.

RUSSIA

History. Nicholas I attempted to protect Russia from western ideas. The autocratic tsarist regime governed a rich and lazy upper class, an indifferent middle class and a doleful working class. Russia clashed with other and more advanced European powers in the Crimean War (1854–1856). Despite the fine qualities of the Russian army, Sevastopol revealed the shortcomings of a country behind the times. Alexander II (1855–1881) realised the necessity for reforms. He abolished serfdom in 1861, redistributed the land and created democratic councils for local administra-

tion. These innovations, however, satisfied neither the Westernisers with liberal views nor the Slavophils; the first judged them insufficient, and the second wished to hold to a purely Russian tradition.

The terrorist movement which followed the assassination of Alexander II was crushed by Alexander III (1881–1894). Politically Alexander III tried to annex the Baltic countries and Poland by forcing on them the Russian language and religion. He was interested in the welfare of the peasants, and it was during his reign that Russia became industrialised. Textile and metallurgical factories were set up, and the railways extended, the Trans-Siberian Railway being begun in 1891. The population grew and a poor proletariat came into being. Meanwhile Russia continued to expand and attempted to reach open sea in the Mediterranean, in the Persian Gulf and in the Pacific, but each time met British or Japanese resistance.

Literature. Literature blossomed from 1850. Hegel's influence introduced a philosophy of history which brought about new ideas on Russian culture and politics. The Westernisers would not accept the medieval period and believed that Russia was born with Peter the Great; they were liberal in their outlook. The Slavophils under the leadership of A. Khomyakov and I. S. Aksakov wanted to set up as their ideal the old medieval Russia. Both factions had blind faith in the virtue of the Russian people. Didactic and ethical preoccupations dominated the scene.

The golden age of Russian prose began about 1850 with realism which aimed at representing facts truthfully and without affectation. The earliest realistic writers included Aksakov, I. Turgeniev (1818–1883), I. Goncharov and A. Pisemsky. The *Chronicles of a Russian Family* by Aksakov was a masterpiece; Turgeniev was one of the greatest of Russian novelists; Goncharov was more bourgeois in his work which included *Oblomov*. Pisemsky was less gifted, but his works had a biting power. F. Dostoievsky (1821–1881) was a novelist who spent years of hard labour in Siberia for subversive activities; he was a great tragic writer whose works

included *Crime and Punishment* (1866), *The Idiot* (1868–1869) and *The Brothers Karamazov* (1880). Count L. Tolstoy (1828–1910) created his own revolutionary and ascetic philosophy; he was also a psychologist capable of introspective finesse. His lively novels had world-wide influence, and included *War and Peace* (1863–1866) and *Anna Karenina* (1875–1877). N. Leskov was independent and original in his writings, but unequal. His work had subtle humour, and was both realist and symbolic. The principal poets were N. A. Nekrassov, A. Tolstoy and F. Shenshin.

In the last third of the 19th century the intelligentsia seethed with new ideas, which blossomed with the opening of the 20th century. A frenzied individualism characterised Russian music, poetry and painting. About 1880 there was a reaction against realism and positivism, which began with Grigoriev and Leontiev, the Russian equivalent of Nietzsche. Dostoievsky and Vladimir Soloviev, a philosopher and visionary, were the chief exponents of a reaction against realism and positivism during the closing years of the 19th century. Anton Chekhov (1800–1904) was a dramatist and novelist whose melancholy and impressionistic realism were unique. Works such as *The Cherry Orchard* were to have a world-wide influence.

Music. Russian music reached its zenith with the group called 'the mighty handful' which included M. A. Balakirev (1837–1910), C. A. Cui (1835–1918), A. P. Borodin (1833–1887), M. P. Mussorgsky (1839–1881) and N. A. Rimsky-Korsakov (1844–1908), who were all admirers of Glinka and Romantic music, especially Liszt, Berlioz and Schumann; Dargomijsky was Glinka's disciple. The group chose themes from national history and folklore, preferring the dramatic expression of song. Their music is colourful; their patriotism, which made them turn away both from Wagner and from Italian opera, mistrusted the formalism of early music. Balakirev was the first of the group and wrote fine melodic music. C. Cui created operas such as *The Captive in the Caucasus* (1857) and wrote

numerous songs. Alexander Borodin was a doctor and professor of chemistry, widely travelled and extraordinarily gifted. His opera, *Prince Igor*, was a masterpiece. Modest Mussorgsky was a splendid composer reviled and misunderstood. He loved people, especially children, whom he brought into his operas and his songs (*Boris Godunov*, *Songs and Dances of Death*, *From Memories of Childhood* and *The Orphan*). He moved from realism to fantasy in his *Night on the Bare Mountain*, and he would probably have developed this spirit of fantasy but for his untimely death. Nicolas Rimsky-Korsakov was the only professional musician of the five. He was professor at the St Petersburg conservatoire, and had a tremendous influence on his pupils and followers, including Stravinsky.

The Rubinstein brothers, Anton and Nikolai, in 1859 founded the far more cosmopolitan Imperial Russian Musical Society and also a conservatoire in which Tchaikovsky (1840–1893), a sensitive and lyrical composer of international status, drew inspiration from European music. He was especially influenced by the French in his striving for pure form.

Architecture. Nicholas I would have liked Russian architecture to follow an official national style like that of certain German architects including L. von Klenze. Alexander II and Alexander III employed English architects. V. O. Sherwood (1832–1897) designed the Historical Museum of Moscow on the traditional lines but with little understanding of the forms used. A. A. Parland built the Church of the Resurrection in St Petersburg also in a pastiche style. From then on a mediocre eclectic style persisted.

Sculpture. The exaltation of national sentiment and of Russian heroes produced hardly any originality. M. M. Antokolski (1843–1902) sculpted a famous effigy of Ivan the Terrible but it was no more than theatrical in its effect.

Painting. Social realism was much in vogue, following a parallel course to political and literary developments. From 1863 the struggle against the Academy took the form of a nationalist movement which aimed at discarding all foreign influences in order to create a truly Russian art. The Society for Travelling Art Exhibitions was formed in 1870 by the revolutionary artists of 1867. They hoped to educate the people by arranging travelling exhibitions throughout Russia. I. N. Kramskoi (1837–1887), who organised the group, painted religious pictures and exceedingly realistic portraits; his con-

ception of Christ is reminiscent of Dostoievsky. N. N. Ge (1831–1894), while in Rome, came under the influence of Ivanov, and was later affected by Tolstoy. His *Crucifixion* (1891), with its agonising naturalism, caused a scandal. V. M. Vasnetsov (1848–1927), in his decorative works in St Vladimir at Kiev, attempted to renew the tradition of the icon painters by giving his decorations a feeling of popular imagery. M. V. Nesterov (1862–1942) was more naively sincere and simple. Ilya Repin (1844–1930) trained under Kramskoi. He was in Paris from 1873 to 1876, and exhibited in Europe and America. His realistic verve shows in the *Bargemen* (1870–1873) [408]. Besides being a painter, he was also an engraver and sculptor. V. I. Surikov (1848–1916) painted great historical events in pictures crowded with figures; his best works included *The Morning of the Execution of the Streltsy* and *The Boyarin Morosova*. V. V. Vereshchagin (1842–1904) [400] travelled in Europe and all over Asia. He worked in Munich, Paris and Moscow and painted above all the horrors of war. Genre painting lacked the charm of the preceding generation. V. E. Makovski (1841–1920) and V. G. Perov (1833–1882), who was a follower of Courbet, were painters of social realism. The most interesting outcome of the Travelling Exhibitions was the discovery of landscape. I. Ayvazovski (1817–1900) painted marine subjects without originality, but A. K. Savrasov (1830–1897) expressed a sincere emotion in front of nature. It was Isaak Levitan (1861–1900) who best translated the coldness and bleakness of Russian landscape. In Paris he had learnt from the Barbizon painters and from the Impressionists that light was the major factor in expressing the poetry of nature.

The group called *Mir Iskusstva* ('the world of art') was created in the early 1890s as a reaction against the tight social realism of the Travelling Exhibitions society. It accepted European culture and a more liberal aesthetic outlook. The initiators were Alexander Benois and Serge Diaghilev. These two artists, together with C. A. Somov, K. A. Korovin, A. Y. Golovin and L. Bakst, were to play a major role in the development of 20th-century art, especially through their stage designs for theatre and ballet. In 1908 the first Russian ballet, *Boris Godunov*, was presented in Paris. Mikhail Vrubel (1856–1911) came from Poland and studied in Italy, Switzerland and France; he was mainly a decorative painter, and among his early works were the frescoes in St Cyril at Kiev. He also worked as illustrator and sculptor. His rich colours, his introspection and his sense of the bizarre made him one of the ancestors of Expressionism [599]. V. A. Serov

(1865–1911) studied under Repin, travelled widely in Europe and met Bastien-Lepage. His fashionable portraits evoke Sargent; he also worked as a decorative painter. Maria Bashkirtsev (1860–1884) was a pupil of Bastien-Lepage.

The minor arts. Despite the heaviness, gold- and silversmiths produced works of great decorative beauty, and they made clever use of precious stones; but there was little development. For the coronation of Alexander III Ovchinikov designed a large silver salver covered with typically Russian medallions and ornaments. Inlay and enamel techniques continued to be used. But the most sumptuous and imaginative work was that done by Carl Fabergé [598], an individual mannerist.

CANADA

History. In 1867 the four main provinces formed a federation called the Dominion of Canada under the authority of one governor and one parliament. Ottawa became the capital. The transcontinental Canadian Pacific Railway (completed 1885) created civilisation along its path. It opened the way to agriculture and commerce west of the Great Lakes and the St Lawrence, and towns grew up along its route.

Literature. A varied English Canadian literature found local support. W. Kirby (1817–1906) wrote a historic novel called *The Golden Dog* (1877). C. G. D. Roberts and William Bliss Carman were good poets. At the end of the century A. Lampman was preoccupied with social problems. Duncan Scott displayed a lyrical energy not without its grandeur. Among French Canadian writers there were good historians, including F. X. Garneau (1809–1866) and the Abbé J. B. A. Ferland (1805–1865). The Abbé R. Casgrain (1831–1904) started the patriotic movement of 1860, which through reviews maintained a lively literary circle which was very Canadian in spirit. P. Aubert de Gaspé (1786–1871) was the most popular novelist of the generation of 1860. The Romantic phase of poetry, represented by O. Crémazie (1822–1879), was followed by the discreet lyricism of writers among whom Louis Fréchette (1839–1908) was the most famous.

The collecting of works of art became fashionable about 1860, first in Montreal and then in Toronto. Collectors showed a preference for Dutch 17th-century works, English 18th-century portraits and French works of the Barbizon school as well as Corot, Courbet and Daumier. Their taste was similar to that of collectors in Boston.

600. CANADIAN. J. A. FRASER (1838–1898). The Rogers Pass. *National Gallery, Ottawa.*

601. CANADIAN. H. R. WATSON (1855–1936). A Coming Storm in the Adirondacks. *Museum of Fine Arts, Montreal.*

The Art Association of Montreal was formed in 1860 and was responsible for the earliest museum in Canada. In 1872 the Art Society of Ontario was organised in Toronto. The Royal Canadian Academy and the National Museum were opened in 1880.

Architecture. From 1850, Victorian neo-Gothic was largely used in the growing towns, especially the churches (Notre Dame, Ottawa). William Thomas (1800–1860) built the Presbyterian church of St Paul in Hamilton (1857) and the cathedral of St Michael in Toronto (1845–1847). F. Wills designed Christ Church in Montreal (1857) and other churches of the same type.

The most typical Victorian building was the Parliament at Ottawa, where the original plan was on a gigantic scale. The central body by Thomas Fuller (1822–1898) was a triumph of eclecticism. The two lateral wings were added by F. Stent and A. Laver. Another important building was the University College, Toronto (1856–1859), built by F. W. Cumberland (1821–1881). The massive style of H. Richardson is apparent especially in Toronto — in the Ontario Parliament by Waite, and in the Victoria College by W. Storm.

Sculpture. Sculpture was primarily figurative. L. P. Hébert (1850–1917), who studied under Falguière and M. J. A. Mercié in France, designed the decorative sculpture for the legislative building in Quebec.

The old tradition of wood carving had completely disappeared. But the wonderful carving of the Eskimos, still a living tradition, at times produced astonishing achievements.

Painting. Between 1860 and 1880 there was a mixture of realism, the picturesque and the anecdotal. Allan Edson (1846–1888), and the more realistic Henry Sandham (1842–1912) and L. R. O'Brien (1832–1890) painted narrative pictures somewhat in the manner of Cornelius Krieghoff (1815–1872), or picturesque works in the style of the Hudson River school. J. A. Fraser (1838–1898) [600], a Scot, acquired a strong realism through working in Notman's studio in Montreal colouring photographs. These landscape artists made engravings of views of Canada which were published in 1882. R. Harris (1849–1919) painted genre scenes, and C. Huot (1855–1930) painted history pictures as in his mural decorations in the Parliament Buildings of Quebec. W. Brymner (1855–1925) was a sensitive landscape painter. F. Brownell (1857–1946) painted landscapes in western Canada and also fashionable portraits. His works lacked the quality of Horatio Walker (1858–1938) whose paintings were permeated by the rural poetry of the Ile d'Orléans. He was a Canadian counterpart of Millet; his *Cattle at a Watering Place* is in Ottawa. Homer Watson (1855–1936) [601], had a larger, more philosophic vision of nature. W. Blair Bruce (1859–1906), Paul Peel (1861–1892) and Florence Carlyle (1864–1923) were more academic. Ozias Leduc (1864–1955) was an independent artist who gave a sense of mystery to things and people. He had a strong influence on modern Canadian painters such as P. E. Borduas. With James Wilson Morrice (1864–1925), a refined Post-Impressionist, he prepared the way for a very original and vigorous modern Canadian art.

Lydie Huyghe

THE UNITED STATES

History. The Civil War (1861–1865), which was among other things a conflict between two different ways of life, marked the end of an era. The agrarian South, with its leisurely planter society, was ruined by the years of combat on its own soil and by the ensuing Reconstruction period. The nascent industrial society in the north, however, was given tremendous impetus by the War. In the prosperous post-War years the eastern cities grew rapidly. A tremendous wave of immigration from all parts of Europe in the latter half of the century helped fill the growing demands of industry and compensated for the loss of population to the expanding west.

The discovery of gold and other metals and the rich oil deposits stimulated the westward trek. In 1869 the first transcontinental railway was completed, giving rise to new communities and business enterprises. The linking of the Great Plains with the industrial cities of the Midwest made cattle raising a lucrative enterprise. As the tremendous agricultural potential of this area was discovered, the farmer followed the rancher. By 1890 the Indians had given up the struggle for their last free home.

There was, as well, expansion beyond the country's boundaries (Alaska purchased from Russia in 1867; growing American community in Hawaii); by the end of the century this expansion had acquired strong imperialistic overtones (Hawaii annexed 1898; Spanish-American War and acquisition of the Philippines and Puerto Rico, 1898).

Industry, railroads, mining, oil and cattle produced incredible wealth; it was an era of great, untaxed fortunes and powerful business empires — of energy and optimism and of party strife, political corruption, urban poverty and the exploitation of labour with the resultant strikes and agitation. It was an era, too, of opulent vulgarity in taste, but it also saw the rise and growth of a progressive trend in architecture.

Culture. The Civil War hastened the decline of romanticism in American literature. A new realism made itself felt — timidly at first — in the work of writers who still deferred to the current optimism and to the sensibilities of the middle classes. By 1890, however, romanticism had succumbed to a literature of naturalistic realism — deeply pessimistic and tinged with both determinism and a concern with social evils. Writers were disillusioned with a materialistic age and its attendant greed, struggles for power, loss of values, chauvinism and social ills.

The greatest of the fiction writers were Mark Twain (Samuel Langhorne Clemens, 1835–1910), the giant among the Midwestern writers and a leading figure in American literature, humorous and romantic in his early stories and novels (*Tom Sawyer*, 1876; *Huckleberry Finn*, 1884) but later expressing a deep and bitter pessimism and disgust with his fellow men, and the unique Henry James (1843–1916) — at the opposite pole — a cultivated and travelled New Yorker resident in England and dealing in his stories and novels with an upper class milieu, who is perhaps unsurpassed

in his penetrating studies of people reacting to a variety of situations (*Portrait of a Lady*, 1881; *The Ambassadors*, 1903).

Other novelists and short story writers include: William Dean Howells (1837–1920), whose realism paved the way for later writers (*Rise of Silas Lapham*, 1885); Hamlin Garland (1860–1940), whose stories in *Main-Travelled Roads* (1891) are masterpieces of realism; Bret Harte (1836–1902), whose stories dealt with the west; Sarah Orne Jewett (1849–1909) and Mary E. Wilkins Freeman (1852–1930), whose theme was the New England scene; the utopian Edward Bellamy (1850–1898; *Looking Backward*, 1888), Stephen Crane (1871–1900), whose brilliant *Red Badge of Courage* (1895) is an outstanding work of naturalistic fiction; Frank Norris (1870–1902), like Crane, a pioneer of naturalism (*McTeague*, 1898).

In poetry there were only two major figures — the still-active Whitman, and Emily Dickinson (1830–1886), who led a secluded life and whose work was published posthumously (from 1890); her timeless, compact poems were far in advance of their day. Other poets of this period tended towards mediocrity, with a few exceptions: Sidney Lanier (1842–1881), the Georgia poet, whose melodious lyricism was unappreciated by his fellow countrymen; William Vaughn Moody, who had a fine lyrical talent.

In philosophy the psychologist William James (1842–1910; the brother of Henry James) opposed scientific determinism with Pragmatism. Psychology became an important study.

Inventors included Alexander Graham Bell (telephone, 1876) and Thomas A. Edison, who applied for a patent for his phonograph in 1877.

Many important private art collections were started; these were often made available to the public, and a number of important art museums had their beginnings at this time.

Music schools and symphony orchestras were founded. John Knowles Paine (1839–1906), who put music on an equal footing with other studies at Harvard, helped to found an American school of symphonic music, as did George Whitefield Chadwick (1854–1931), Horatio William Parker (1863–1919) and Edward MacDowell (1861–1908). MacDowell, the most important 19th-century American composer, made use of folk songs and Indian themes. In 1883 the Metropolitan Opera was formed; it attracted the world's finest performers.

Architecture. An era of eclecticism in architecture followed the Civil War — a taste in keeping with the new wealth and the materialism of the times. But side by side with this trend, from about the late 1870s, a modern movement of extraordinary originality was developing, a movement which produced the two greatest creations of American architecture — the skyscraper and a type of detached private house which in the 20th century would be intimately and beautifully adapted to man and the landscape.

Building continued on the Capitol in Washington during the War (new wings and cast-iron dome, by Thomas U. Walters with the assistance of Richard Morris Hunt, completed 1865). In the 1860s and 1870s the French Second Empire style, with its mansard roofs, became popular. Appearing in 1849–1850 in a New York house built by Detlef Lienau, a French-trained Danish architect, it was employed extensively in the decade after the War for public buildings, hotels and domestic buildings. One of the best extant examples of this style is the old State, War and Navy Department building in Washington, D.C. (1871–1875) [**602**]. In domestic architecture this style later moved westward, becoming increasingly garish [**603**].

The post-War decade also marked the peak period of High Victorian Gothic. In America Ruskin's ideas were received with the greatest enthusiasm, and the first examples of High Victorian Gothic were built in the early 1860s by Edward T. Potter (1831–1904) and Peter B. Wight (1838–1925). The American architects handled this style with much less skill and taste than their contemporaries in England, but there were a few notable exceptions such as the Philadelphia architect Frank Furness (1839–1912; Provident Life and Trust Company, 1879, demolished [**604**]), in whose office Sullivan at one time worked. An interesting development in domestic architecture was the wooden 'stick' style, in which the 'stick' decoration on the outside of the house frankly reflected the balloon framing; the honesty of this style, its freedom from historical influences and its suggestion, in the stickwork, of the Japanese house, foreshadowed modern trends. Gothic was prolonged in the work of Richard Morris Hunt (1827–1895), who built François I châteaux for his millionaire clients (Vanderbilt residence, New York City, 1881).

The true revolution in American architecture was begun by Henry Hobson Richardson (1838–1886) [**605–607**]. Born in New Orleans and educated at Harvard, Richardson travelled in Britain (he was influenced by such British architects as Godwin and Shaw) and then settled in Paris, where he studied at the Ecole des Beaux-Arts and worked in the office of Théodore Labrouste. Back in America, he remained unknown until his 'Romanesque' Trinity Church, Boston (1872–1877), brought him fame. Although many of its details derived from French

602. U.S.A. A. B. MULLET (1834–1890). State, War and Navy Department building, Washington. 1871–1875.

603. U.S.A. Carson house, Eureka, California. 1885.

604. U.S.A. FRANK FURNESS (1839–1912). Provident Life and Trust Company, Philadelphia. 1879.

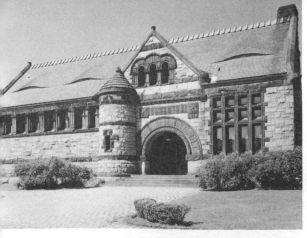

605. U.S.A. HENRY HOBSON
RICHARDSON (1838–1886).
Crane Memorial Library, Quincy,
Massachusetts. 1880–1883.

606. U.S.A. HENRY HOBSON
RICHARDSON. Marshall Field
wholesale store, Chicago.
1885–1887.

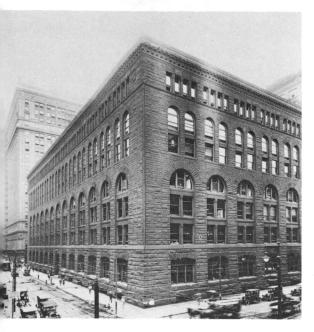

and Spanish Romanesque, this building was no copy but a new and personal expression with a bold handling of masses. It was imitated, like so much of Richardson's work, by inferior talents who reproduced its heavy, rusticated masonry without comprehending its ingenuity and cohesion of plan. Richardson's libraries [605], stations and houses contributed to his reputation, but his greatest achievement was the Marshall Field wholesale store, Chicago (1885–1887 [606], demolished to make way for a parking lot). Here was a truly functional building, frank in its use of materials, its design suiting its use. The architect employed little ornament but achieved a pleasing exterior through the contrast of smooth and rusticated stone and the ingenious vertical arrangement of the fenestration. This building had a profound influence on the young Chicago architects, and particularly on Sullivan. Richardson's early houses

showed the influence of Shaw in England but had a more open plan. Later he worked in the new Shingle Style, producing houses with well organised exteriors [607] and continuity of space in floor plans. These shingled houses, which recalled the simpler architecture of the Colonial period, tended towards open planning. In this and in their good design and absence of fussy detail they foreshadowed later developments in architecture.

The early 1880s saw the beginnings of an academic revival, headed by McKim, Mead and White (Charles Follen McKim, 1847–1909; William Rutherford Mead, 1846–1928; Stanford White, 1853–1906; McKim and White had worked in Richardson's office). These men adapted Renaissance and Roman classical styles with great skill in public buildings (Boston Public Library, 1888–1892) and mansions. McKim was responsible (with D. H. Burnham) for the Chicago world's fair of 1893 — an excellent example of planning; its white edifices established the classical and Renaissance as official styles for public buildings for a long time to come. McKim, Mead and White, like Richardson, built houses in the Shingle Style, one of their best, the Low house, Bristol, Rhode Island (1887) [608], being a masterpiece of classical unity which yet avoided the slightest use of classical detail. Certain of their interiors show in their details and interwoven unity of space the influence of the Japanese house [609, 285] and also foreshadow Frank Lloyd Wright [291].

As commerce became increasingly important, business sections developed and became more concentrated, and the need for office space increased. The constant improvements in the passenger elevator (first installed in New York in 1857), the adoption of the Bessemer process of steel manufacture and the increasing awareness of the load-bearing properties of steel (Brooklyn Bridge, New York, 1869–1883; designed by the German immigrant John Roebling, 1806–1869, completed by his son Washington Roebling, 1837–1926 [610]) led to the rapid development of the skyscraper. An early skyscraper in New York was the Tribune building (1873, by Richard Morris Hunt), a kind of elongated Old World town hall, partially iron-framed. Depression in New York halted this type of building in the 1870s, and Chicago (recovering from the fire of 1871) became its centre instead. The first true skyscraper construction (iron and steel skeleton framework, with curtain walls) was the Home Life Insurance building, Chicago (1883–1885, demolished 1931 [611]), by William Le Baron Jenney (1832–1907). A later Chicago skyscraper of his, the Leiter building (1889–1890, now Sears,

607. U.S.A. HENRY HOBSON
RICHARDSON. Stoughton house,
Cambridge, Massachusetts.
1882–1883.

608. U.S.A. McKIM, MEAD and
WHITE. W. G. Low house, Bristol,
Rhode Island. 1887.

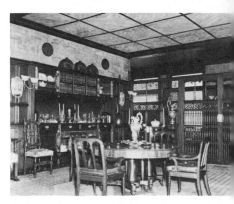

609. U.S.A. McKIM, MEAD and
WHITE. Dining-room, Kingscote, at
Newport, Rhode Island, 1880. Here
the lesson of Japanese architecture
has been fully realised.

610. U.S.A. Brooklyn Bridge, New
York City. Begun 1869 by John
Roebling; completed 1883 by
Washington Roebling.

Roebuck and Company), better expresses its construction and shows the influence of Richardson's Marshall Field wholesale store. The Tacoma building, Chicago (1887–1889, demolished 1929), by William Holabird (1854–1923) and Martin Roche (1855–1927), both of whom trained with Jenney, was the first skyscraper with a riveted skeleton. Other important Chicago skyscrapers were built by the partners Daniel Hudson Burnham, 1846–1912, and John Wellborn Root, 1850–1891 (Rookery, 1885–1886; Monadnock building, 1889–1891; Reliance building, 1890–1895 [**556**], by Burnham and Company, with its striking treatment of windows and of the curtain wall, which has so nearly vanished as to foreshadow the work of Le Corbusier and Mies van der Rohe).

The greatest master of the skyscraper — and possibly the most important architect of the century — was Louis H. Sullivan (1856–1924). A Bostonian, Sullivan went to Philadelphia in 1873 and worked for Furness. In the same year he moved to Chicago, spending a few months in the office of Jenney before going on to Paris and the Ecole des Beaux-Arts. In 1879, in Chicago, he found the perfect partner in Dankmar Adler. In touch with the important ideas of his time, Sullivan was a functionalist — eschewing tradition and adhering to the concept 'form follows function'. But to him this approach involved far more than utility and structure; it was part of his belief in an 'organic architecture' — an architecture which evolves naturally out of the social and technical background of its society. (This attitude no doubt owed much to Sullivan's interest in biology, which also may partially explain his fondness for ornament deriving from plant life [**614**].) The first of his great works with Adler was the Auditorium building, Chicago (1887–1889) [colour plate p. 209], which on the outside shows the impact on Sullivan of Richardson's Marshall Field wholesale store [**606**]. The rich ornament of the interior may have been influenced by Sullivan's new draughtsman, a young man named Frank Lloyd Wright. In his first skyscraper, the Wainwright building, St Louis (1890–1891; with Adler), Sullivan stressed the height and nature of his building in the unbroken line of the vertical piers. This same device he repeated in the Guaranty building, Buffalo (1894–1895; with Adler [**613**]), perhaps his greatest work. Here the ground-floor windows are bent back and are penetrated by the supporting piers, which seem almost free-standing — the whole suggesting the free flow of space (such an important feature in 20th-century architecture). Sullivan's last skyscrapers are the Gage building (1898–1899) [**673**] and the

611. U.S.A. WILLIAM LE BARON JENNEY (1832–1907). Home Life Insurance building, Chicago. 1883–1885.

613. U.S.A. LOUIS H. SULLIVAN (1856–1924). Guaranty building, Buffalo, New York. 1894–1895.

614. U.S.A. LOUIS H. SULLIVAN. Detail of ground floor of the Guaranty building, Buffalo.

612. AMERICAN. AUGUSTUS SAINT-GAUDENS (1848–1907). The Adams memorial, Rock Creek Cemetery, Washington. 1891.

Carson, Pirie and Scott department store (1889–1904), both in Chicago. In these works the architect has given superb expression to the underlying structure. Sullivan's ideas were expanded in the 20th century in the work of Frank Lloyd Wright (see Chapter 4).

Sculpture. About the middle of the century Neoclassicism gave way to greater realism (Henry Kirke Brown, 1814–1886; John Quincy Adams Ward, 1830–1910). Later in the century sculptors turned to Paris for inspiration. Best among the 19th-century American sculptors was Augustus Saint-Gaudens (1848–1907) [**612**], more versatile and more powerful than his contemporaries. Other sculptors included Daniel Chester French (1850–1931; statue of Lincoln in the Lincoln Memorial, Washington), George Grey Barnard (1863–1938), Lorado Taft (1860–1936) and William Rimmer (1825–1874). Frederic Remington (1861–1909) executed western subjects (cowboys on horseback) with intense realism (*Off the Range*, Corcoran Gallery of Art, Washington).

Painting. As in the other arts, there was a shift from romanticism to realism in painting. The landscape painter George Inness (1825–1894) [**615**], who had lived in France and knew the work of Corot and the Barbizon school, rejected the linear quality of Durand and Cole, substituting colour and light and shade for line (*Peace and Plenty*, 1865, Metropolitan Museum of Art). He later gave up his naturalistic style for a more subjective approach. Eastman Johnson (1824–1906) [**617**], from Maine, spent several years in Holland studying Rembrandt and the Dutch genre painters. Returning home, he moved from genre paintings of American subjects, through objective realism, to portrait painting. William Morris Hunt (1824–1879), brother of the architect Richard Morris Hunt,

615. AMERICAN. GEORGE INNESS (1825–1894). Delaware Water Gap. 1861. *Metropolitan Museum of Art.*

617. AMERICAN. EASTMAN JOHNSON (1824–1906). The Old Kentucky Home; Life in the South. 1859. *New York Historical Society.*

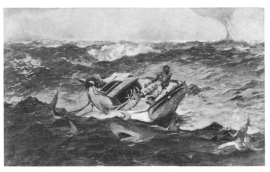

618. AMERICAN. WINSLOW HOMER (1836–1910). The Gulf Stream. 1899. *Metropolitan Museum of Art.*

620. AMERICAN. THOMAS EAKINS (1844–1916). The Concert Singer. 1892. *Philadelphia Museum of Art.*

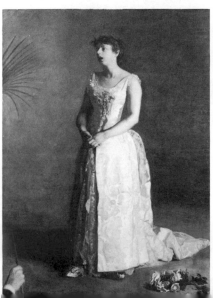

616. AMERICAN. WILLIAM HARNETT (1848–1892). Old Models. *c.* 1890–1892. *Museum of Fine Arts, Boston.*

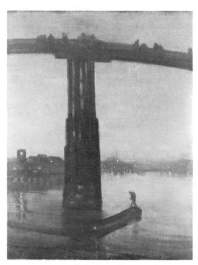

619. AMERICAN. JAMES ABBOTT McNEILL WHISTLER (1834–1903). Old Battersea Bridge: Nocturne — Blue and Gold. *c.* 1865. *Tate Gallery.*

621. AMERICAN. JOHN SINGER SARGENT (1856–1925). Mrs Charles Gifford Dyer. 1880. *Art Institute of Chicago.*

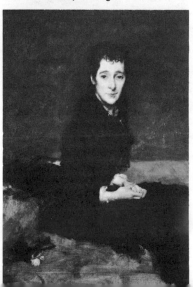

studied with Millet at Barbizon. He was an important influence in Boston, where he eventually taught. His career came to a tragic end when worry over the acceptance of his first major work (a mural decoration, the *Flight of Night*, for the Capitol at Albany, New York) caused his collapse and death (probably suicide). Shortly afterwards the murals were destroyed by damp. His excellent studies for them are all that remain.

The post-War years saw the rise of a group of highly independent naturalistic painters. Of the two leading representatives of this tendency, only Winslow Homer (1836–1910) [**618**] was appreciated in his lifetime. After a two-year stay on the North Sea coast of England, he settled on the coast of Maine, abandoning his earlier studies of country life (which recall, in their treatment of light, the early Impressionists) for dramatic seascapes and the theme of man's struggle with natural forces (*Undertow*, 1886, Philadelphia Museum of Art). The other important independent painter was Thomas Eakins (1844–1916) [**620**, colour plate p. 123], perhaps the greatest American painter of the century. Eakins studied in Paris with Gérome, later training the factual vision acquired from his master on his native Philadelphia, painting his friends at their favourite pursuits (*Max Schmitt in a Single Scull*, 1871, Metropolitan Museum of Art) and executing penetrating portrait studies. *The Gross Clinic* (1875, Jefferson Medical College, Philadelphia), which shows how well he absorbed the lesson of Rembrandt, was rejected by the public. William Harnett (1848–1892) [**616**] painted forceful trompe l'oeil still lifes, as did his more poetic and less well known friend John Peto (1854–1907).

Certain artists who were dissatisfied with the America of the post-War years settled in Europe, virtually becoming a part of the European art scene. James Abbott McNeill Whistler (1834–1903) [**619**] studied in Paris, later settling in England. Influenced by Courbet and Velasquez and later by the Impressionists, he was one of the first painters to make use of Japanese art. Unlike so many of his contemporaries he did not imitate this art; he understood and absorbed its lessons — the cool tones, the two-dimensional quality, the significant placing of detail. His concern with the tonal, spatial and decorative aspect of his subject matter marked an advance in the direction of abstraction. John Singer Sargent (1856–1925) [**621**], who was born in Florence of American parents, studied in Paris and eventually settled in England, dividing his time between that country and the United States. He is best known for his portraits with their skilful brush work. Mary Cassatt (1845–1926) [**362**, **623**], who lived in

622. AMERICAN. CHILDE HASSAM (1859–1935). Fifth Avenue in Winter. *Carnegie Institute, Pittsburgh.*

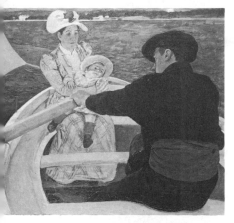

623. AMERICAN. MARY CASSATT (1845–1926). The Boating Party. *National Gallery, Washington.*

624. AMERICAN. ALBERT PINKHAM RYDER (1847–1917). The Race Track, or Death on a Pale Horse. *Cleveland Museum of Art.*

France, was a friend of Degas and a talented Impressionist. Influenced by Degas, Manet and the Japanese print, she had a brilliant, bold style, but her subject matter (usually a mother and child) was unadventurous. Painters who brought their Impressionist training back to the United States included William M. Chase (1849–1916), Childe Hassam (1859–1935) [**622**] and Maurice Prendergast (1859–1924) [**476**], later a member of the Eight (see Chapter 4).

John La Farge, whose only training was a brief period first with Couture and then with William Morris Hunt, is better known for his great influence on 19th-century American culture than for his painting.

A unique talent of this period was Albert Ryder (1847–1917), a belated Romantic and a mystic, largely self-taught. A solitary figure who spent most of his adult life in New York, he took as his subjects the sea (by which he grew up, on Cape Cod) and the world of his imagination. The suicide of a man who lost all his savings on a racehorse inspired his *Race Track, or Death on a Pale Horse* [**624**].

The Minor Arts. The mass-production of the industrial age cheapened and debased the decorative arts and contributed to the decline in taste. Towards the latter part of the century the Japanese influence played a small part in combating this decline. Louis Comfort Tiffany (1848–1933) produced fine Art Nouveau glass in the 1890s.

Emily Evershed

LATIN AMERICA

History. In Mexico the period of reforms was marked by the personality of Benito Juarez, a Zapotec Indian. The 1857 Constitution was too anti-clerical, and civil war broke out in 1858, in which England, Spain and France intervened. After a short period under the Austrian archduke Maximilian, power was left in the hands of Juarez, who was himself displaced in the 1876 presidential elections by the half-caste José de la Cruz Porfirio Diaz.

Venezuela was in the throes of almost continuous civil war until 1869.

In Colombia the struggle between Catholics and liberals disturbed and divided the country.

García Moreno ruled Ecuador as a Catholic dictator.

Peru developed an up to date army.

In Bolivia the quarrels of tribes caused continuous restlessness.

In Chile, as a result of sound government, important works were undertaken. Foreign technicians, mainly German, were called upon to enable these projects to be carried through.

Argentina's political interests were bound up with her economic well-being, based on cattle farming. Buenos Aires grew rapidly. Under the presidency of General B. Mitre (1862–1868), important projects were undertaken, in particular the building of railways.

In Brazil Dom Pedro II was an enlightened monarch (1831–1889). His reign was marked by a policy of modernisation. The war against Paraguay united the country.

Latin America was dependent on Europe for finance and for manufactured goods. Capital was usually raised in London. Cultural unity was preserved by the unity of language.

Literature. Latin American Romanticism was based on the exaltation of the Indians as in the *Peruvian Ballads* of M. Gonzalez Prada, or was related to the *gauchos* (cowboys). J. Hernandez of Argentina wrote *Martín Fierro*, a national epic. Literature about the *gauchos* continued into the 20th century.

Spanish and French realism gave zest to the novel which, however, often remained tinged with Romanticism. From about 1880 literature departed from national and political themes. Poets searched for simple and delicate musical effects, and were affected by Baudelaire, Verlaine, the Parnassians, the French Symbolists and Scandinavian mythology. Rubén Dario (1867–1916) from Nicaragua was the finest of these poets and influenced Spanish literature.

The positivism of Auguste Comte had a strong following in Brazil.

Architecture. European influence was very strong because of emigration and the new facilities for ocean travel. The new wealth and the taste for luxury and ornament that went with it, resulted in a heavy eclectic style, similar to the European style of 1860–1870. The Colon Theatre in Buenos Aires was typical. It mingled together the traditions of the Renaissance, of Palladio, of the French architect Gabriel, and of a French 18th-century style which had come by way of Washington.

Sculpture. Large works were commissioned in Paris. Rodin made a plaster model for the equestrian statue of General Lynch for Chile, but the final work was never carried out. He also designed one for President Sarmiento of Argentina.

Painting. In Brazil a museum was opened and exhibitions encouraged good work from young artists. Official needs led to the vast patriotic canvases of Pedro di Figuiredo Americo (1843–1905). In Chile an academy gave new opportunities to a whole generation of Peruvian as well as Chilean painters. In Peru Romantic history painting was much in vogue. Ignacio Merino (1817–1876), a pupil of Monvoisin and Delaroche, was one of the Nativist painters who reduced their subjects to drawing-room banality.

At the end of the century, wealthy collectors bought paintings by the Barbizon school and by the Impressionists. These works had a great influence on the younger painters and helped them towards the freedom of the 20th century.

Lydie Huyghe

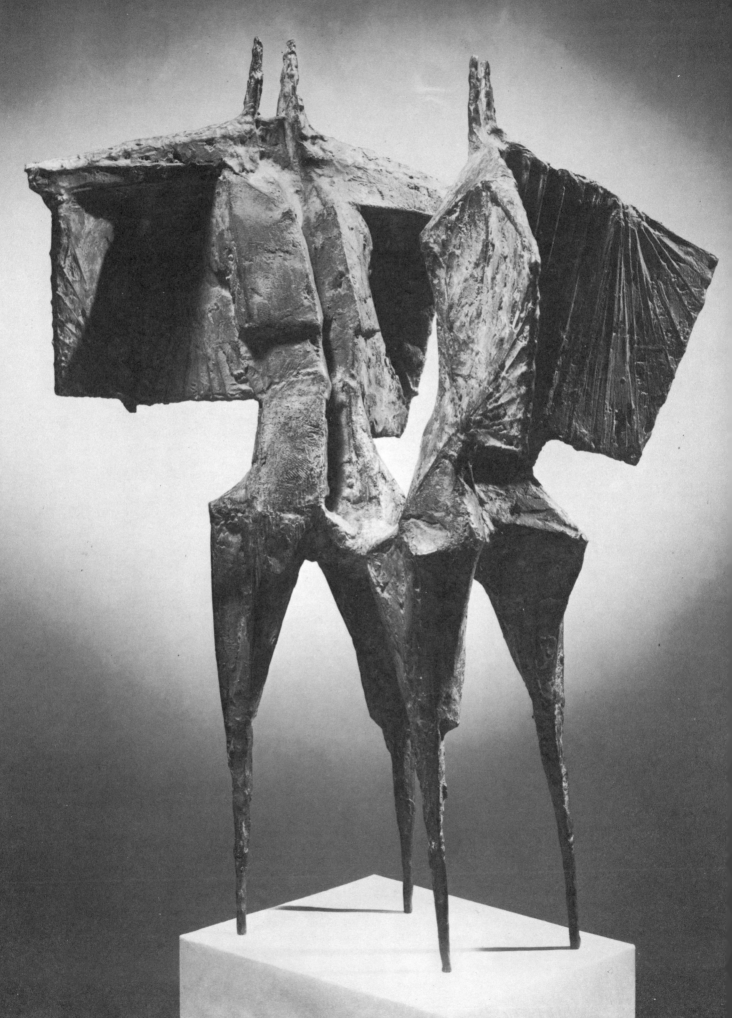

ART FORMS AND SOCIETY *René Huyghe*

Is it necessary, in treating the subject of modern art, to be drawn into a discussion of the various aesthetic theories which successive movements have considered the basis of their work? Or should we set about refuting these theories as outworn convention and muddled thinking, as some critics still do; or, alternatively, should we undertake to give an exposition of some aesthetic doctrine of our own choosing? Surely one expects something more of the art historian, such as an explanation of the characteristics common to all these apparently confusing and divergent movements. This book is based on the assumption that man of a given time and place, in creating the ideological and artistic systems by which he has expressed himself, has projected into his philosophy, his literature and his art a reflection of the same fundamental preoccupations. These preoccupations, which may be expressed in various media, are those of his time and of its material, moral, economic, social and spiritual circumstances. The genius of the individual serves only to give a more universal and eternal significance to them through the amplitude and quality of his vision.

If it is true that art, like his other creative activities, is a reflection of man, the moment has come when we most need to apply this principle. For history, with the advantage of retrospect, has already provided an explanation of the past. Now, in attempting to understand the present, we ourselves must undertake the historian's work.

The advent of an age of energy

We all see in 20th-century art a radically new endeavour, a total revision of acquired values and an effort to base the visual arts on revolutionary principles. Over the years this endeavour has shown an increasing audacity. Without doubt there is in our time a crisis in Western art. If our thesis is correct, there must be a concurrent crisis in Western man and in his civilisation. Indeed, we see it spreading throughout the entire world. Art inevitably bears the signs of this crisis, and it is in these spontaneous authentic signs that we must look for the key to our time and to the values it rejects and the attitudes it reveals.

The first of these signs is undoubtedly the repudiation of both the ideas and the forms of the past. Every civilisation is a systematic attempt to organise and arrange the world so as to better the understanding of it. In the course of its development a civilisation achieves a certain order, not so much through a style as through a system of conventions which suitably express its fundamental attitude. As soon as this system is outworn it becomes distorted and degenerate. Through a twofold and contradictory process, it hardens into a fixed academicism on the one hand and on the other hand renounces those conventions, yielding to the liberating and disruptive forces of life. In this way Gothic became Flamboyant, Renaissance became Baroque, etc. The 19th century revealed the same characteristics. Alongside a sterile academicism which repeated the old formulas *ad nauseam* there was, from the Romantics to the Impressionists, a loosening up of the established system of forms. Undermined at first by the vitality and passion of the Romantic artists, academic form eventually disappeared in the quivering light of

the Impressionists. But because even this last still reflected the mirage of reality (however faint it had become), modern artists have felt the need to return to that which is basic. This has culminated in their latest essay — 'informal art', whose very name tells us that it has succeeded in dispensing with conventional form.

This symptom of profound human change may be verified in our time in an even wider context than one might at first have supposed. What is disintegrating and disappearing under our very eyes in the confusion felt everywhere as a growing and overwhelming crisis is nothing less than civilisation itself — that agrarian civilisation which emerged from prehistory and attained such great heights in the Mediterranean area and in India and China. In the West this civilisation, enriched rather than changed by the discovery of metal, slowly perfected itself, from Egypt and Mesopotamia through Greece and Rome to Europe. Based on the cultivation of the soil and on the geometric forms which made their appearance with the surveying of land, this civilisation has been essentially conservative; indeed, from its beginnings it had to adapt itself to nature and to nature's regular, perpetual rhythm — to the constant repetition of the seasons and their crops. Accustomed to the gradual advances that come of experience, it has seldom tried to innovate but has instead perfected its acquired knowledge. In this it has constantly shown the desire for quality and refinement. Its aesthetic philosophy has rested on a respect for existing reality combined with an effort to raise its artistic standards.

In the 18th century, however, a new element manifested itself — energy and the creation of energy; this developed until it surpassed the normal contribution of nature. The old limits, so painstakingly established, began henceforth to disintegrate. The Western world, embarked on a new venture, demanded that these limits be modified, then adapted, and finally rejected and replaced. The will to produce and accumulate new energy, instead of gathering the natural fruits of the earth, opened the way for an ever quickening progression of discoveries. Primitive steam engines were made in the 17th century; with Watt's 18th-century engine steam came into use as a source of power. Electricity followed; and now in the 20th century we have atomic energy. The machine, as well as engendering industry and a hitherto inconceivable production capacity, also had the unexpected consequence of bringing into being a new class of workers, the proletariat, whose requirements were to change society drastically.

Another new phenomenon grew out of these inventions — speed, which transformed the very conditions of life. Man, who for millions of years had relied for transport on his own legs or at most on those of animals, in particular the horse, now launched a frenzied attack on the limits of time and space natural to his condition. He has now broken the sound barrier. This conquest of speed has brought with it certain intellectual and emotional changes, which I have already discussed at length in *The Discovery of Art*. We may here mention the most important of them: an impatient eagerness for the future, for the new and unexpected, has replaced the conservatism of the past; intensity is valued above quality. The result has been that need for energy, tension, violence, even paroxysm, that we have noted throughout the 19th century, from its earliest manifestations, which appeared, paradoxically, in the school of David, through its unleashing in Romanticism of human passion, to its explosion in Impressionism which, in dissolving

56

359

414

625. LYNN CHADWICK (b. 1914). Winged Figures. Bronze. 1955. Tate Gallery.

8

12

414

form and matter together with the familiar appearance of things, caused the disintegration of reality itself.

At the same time the old social structures that grew out of the union of rural and urban society have been drastically whittled away as town has absorbed country and as peasants and craftsmen have become factory workers. Those institutions dating from the earliest times, such as monarchy, a development of the king-priest association (originating with the first agrarian civilisations), have been upset, weakened and rejected. In the midst of a deep-seated uneasiness the body politic has sought a new regime adapted to its requirements and functions, and this search has moved from capitalism, widespread in the 19th century, to socialism and Communism, which lay claim to the succession. Philosophers and scientists have been working out explanations (many as yet unknown to the world) which are sweeping away principles established from time immemorial and, in rejecting the hallowed order of the past, are seeking to grasp the vital flux, to seize phenomena in their direct 'existential' state. All this has favoured the increasingly bold liberation of the primordial power of nuclear energy.

The breaking up of the Western tradition

It is clear that our epoch is the scene of a profound change. The evidence of the renunciation of the past, of the elimination of established norms, is visible all around us. Culture, always a spiritual reflection of civilisation, has set about the unconscious but systematic work of demolition. The stages can be followed in art.

In the 18th century, when the least Latinised peoples of Europe — the Anglo-Saxon, then the Germanic — became predominant in the Romantic movement, the crisis spread 341 beyond Europe. At this time the vogue for chinoiserie was the beginning of a tendency which in the 19th century became an indefatigable pursuit of the exotic. The Greek war of independence made the East more accessible, and the travels of various 31 artists — Delacroix, Decamps, Raffet, Dehodencq, Marilhat, Fromentin, etc. — provided an authentic introduction to an art different in its principles and its sensibility. This was the heyday of an Orientalism whose influence may be traced even 630 to Matisse.

Interest in Asia increased after India's religion and thought were revealed to the Romantics by Burnouf; by the end of the 19th century this interest was centred on the Far East — on Japan in particular. Japanese influence was felt not only in the decorative arts but in painting and graphic art as well. Millet and Théodore Rousseau were among the first to collect the 314–316 Japanese prints whose lesson inspired such painters as Manet, 362 Degas, Monet, van Gogh, Lautrec and Mary Cassatt.

By this time archaeologists had shown that the ancient world had encompassed more than just Greece and Rome. Exploration in Egypt and Mesopotamia had a striking effect on artists. Europe was captivated by the discovery of civilisations different from its own and separated from its own by space or time. The concepts of primitivism and exoticism, launched concurrently in the 18th century, soon converged, and we can 465 see the efforts of such a painter as Gauguin to shake off the influence of Greece, the Parthenon and ideal beauty and to steep himself in new sources — in Eastern art, whose prestige grew owing to the 1889 Exhibition and the reproductions of Angkor, and in 'savage' primitive art. (At the time of the 1889 Exhibition Gauguin wrote to Emile Bernard: 'In the Java village they have Hindu dances. All the art of India can be seen there, and the photographs I have of Cambodia have their 627–629 exact counterpart there.') So Gauguin groped his way, searching in Martinique, dreaming in Tahiti, till he finally took

refuge on the Marquesas, dying far from our exhausted world.

Thinking people were thus brought to the threshold of a new stage in their culture. Not only did they recognise the value of civilisations having no contact with their own, but they even preferred them, accepting Jean Jacques Rousseau's thesis that art is more 'authentic' when it has least suffered the refining process of culture.

The so-called primitive or archaic arts were henceforth to take precedence over the sophisticated ones in the eyes first of artists and then of the public. It was at the beginning of this century, from 1906, that African Negro art was revealed to 632 Europe. Masks discovered in junk shops were the origin of a craze which, thanks to Matisse and his juniors Vlaminck, Derain and Picasso, spread to important collectors. 633

This desire to go back to original sources, to rejoin art in its supposed pure state before it had been led astray by the lure of sophisticated refinement (now considered meretricious) gave rise to a concern with the art of primitive peoples, of children (the first unsophisticated through its collective youth, the second through individual youth) and of the insane. An entire attitude, often adopted with much credulity, attributed a new virtue to the 'uncultivated', as if 'cultivated' were synonymous with 'adulterated'. Apollinaire and his friends idolised an inspired 'naive' painter, the Douanier Rousseau, who 634 exemplified their ideal and who was considered a first-rate artist. Similarly, it was fashionable to believe that knowledge and erudition could only spoil the mind; the university, with its 'professor' whose word had been law in the 19th century, was now discredited. All that was elementary and unformulated, 635 all that was symbolised by brute nature, was valued; it was merely another aspect of a movement which rejected quality in favour of intensity. If Poussin typified the artist who derives his art from his intellect, modern painters such as Vlaminck 655 positioned their centre of gravity perceptibly lower — in the 'guts', the 'loins' and the organs of genetic energy. Shock and violence were henceforth at a premium. Shaking off the effects that had clothed civilisation and culture, man wished to be new-born and innocent and to return to original impulse.

A similar regression followed in the choice of materials. The popularity of the uncultivated arts and of 'informal art', also the abandoning of marble in favour of scrap iron and 637 gravel — these were signs linked in spirit with the total renunciation of the refining process of centuries of tradition, a tradition whose very bases were now questioned. The same spirit was reflected inevitably in politics. Europe and the white races in general were stricken by a kind of guilt complex regarding peoples formerly thought of only as objects of domination; this complex has become, in certain cases, a sort of restless masochism. Taken together, these symptoms reflect the obscure need felt in our time to break out of a shell and to return to a sort of purity that will enable us to attempt the new adventure which seems to beckon so insistently. The sense of shame, of hatred sometimes, for what one has been and for what one still is by heredity is significant proof of an eagerness to start afresh and to be rid of all barriers to an as yet indeterminate resurrection.

Descartes, in rejecting the outmoded world of medieval thought, had recourse to a *tabula rasa*, and in our own times there is a desperate attempt to burrow under the layers of dead culture to find a solid foundation on which to build anew. A whole series of experiments in modern art can only be explained in terms of this instinctive need — fumbling at first and then brutally assertive. The return to 'nature' in the 18th century, the retreat to the forests of the landscapists of the 1830s, the proclamation of naturalism which began with Courbet — all 384

626. KHMER. Goddess. Detail from the Terrace of the Leper King, Angkor Thom. End of the 12th – beginning of the 13th centuries.

627. PAUL GAUGUIN (1848–1903). Buddha. Woodcut.

628. PAUL GAUGUIN. Idol. Wood.

629. PAUL GAUGUIN. Arearea. Detail. 1892.

THE BREAK WITH THE WESTERN TRADITION

One of the notable phenomena that first reflected the crisis of European civilisation implicit in modern Western art was the break with traditional values. This ' revision of values ' brought with it a marked interest in other civilisations, which were recognised and studied as a new artistic heritage. This change was unique in history. It broadened and revitalised Western art, but at the same time it destroyed its continuity and opened it to new ventures into the unknown.
The affinity for the Oriental in art, which had its beginnings in the 18th century, reached its climax in Matisse [630, 631].
Far Eastern art [626–629] had already given Gauguin access to the civilisation of the so-called ' savage ' Pacific Islands. The search for an original purity led in time to an interest in African art [632, 633], which seemed the key to the primeval laws of plastic language.

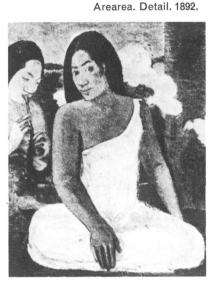

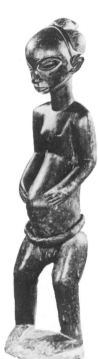

630. HENRI MATISSE (1869–1954). Odalisque with Tambourine. 1926. *William S. Paley Collection, New York.*

631. INDIAN. KANGRA SCHOOL. Radha's Toilet. Detail. Paper. *Indian Museum, Calcutta.*

632. *Right.* AFRICAN. CONGO (LEOPOLDVILLE). BALUBA. Statuette of a pregnant woman. *Tervuren Museum, Brussels.*

633. PABLO PICASSO (1881–1973). Les Demoiselles d'Avignon. 1907. *Museum of Modern Art, New York.*

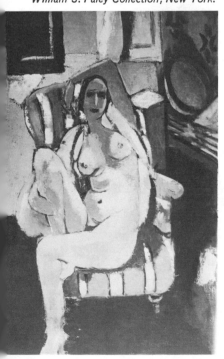

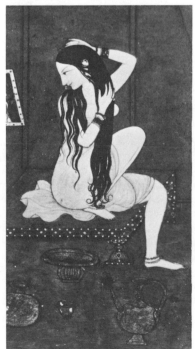

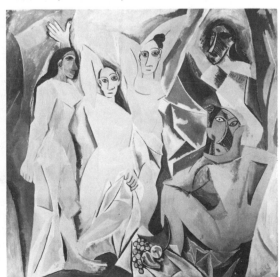

these were on a par with the rejection of aristocratic values and the adulation of the people as healthier because less sophisticated in their way of life. This pursuit of the basic authenticity led to Impressionism and, going even further in an attempt to define visual truth, to Art Nouveau. The Art Nouveau style (already evident in the Symbolists but only taking on its present name when it became vulgarised in the decorative arts) attempted to forget conventional forms and to derive the spontaneous

363 structure of its lines from life and nature. In its desire to break free of the European tradition and to establish foreign points of reference Art Nouveau found a dual inspiration — in Japanese art with its arabesques and in Cretan art, rescued from oblivion by the excavations of Sir Arthur Evans.

The search for a definition of art

Until this time the rejection of the past had been seen only as a search for truth as opposed to the conventions gradually imposed by tradition, a truth to be found at its sources by a return to the real and to nature. But art, even when it sets out to mirror nature, remains outside nature. Art has its own particular laws, its own objectives. To achieve a *tabula rasa* it is essential to go back to the beginning. And this involves a process of drastic pruning. Since definitions which had formerly been accepted universally were now rejected, it was thought necessary to postulate a new and more absolute definition and to face up to the consequent obligations. A philosophic examination more thorough than any yet undertaken by either artist or critic was to ruthlessly attack the very foundations of the ultimate principle of art. The Impressionists had not dreamed of questioning the fundamental dogma of realism in their pursuit of truth and their hostility to all convention.

Now the question 'What is art?' was posed. The answer
462 varied according to temperament. Some saw it as the expressive
456 impulse which is its origin; others saw it as the plastic construction which is its outcome. The first considered art as a means of revealing man's profound and authentic reality. But where was this reality? Beyond the grasp of conventional thought, accord-
444 ing to Gauguin, Redon and the Symbolists. Yet some still found this answer too literary. One must look to organic nature, to the temperament, from which the creative impulse springs. Was not van Gogh proof of this? So argued Fauve painters such
655 as Vlaminck. German painters and other northern painters, accustomed to a more anxious and troubled view of man, accentuated the vehemence of this revelation and its aggressive
656 attitude towards the rational; the outcome was Expressionism. But could one not go further still, to the dim untouched source of all conscious activity? Psychology had formulated its theories of the unconscious, and the way was paved for the advent of
644 Surrealism. But was there not still something contrived about such outpourings? The last word belongs to 'informal art', which shuns both form and image, steeping itself in the
658 living stuff of life and recording only the primordial forces and vibrations. Can art be carried still further?

Alongside those who saw art as a projection of the expressive impulse were the artists who valued above all a visual art of forms and colours 'organised in a certain order', as Maurice Denis put it. Was it not by starting from this point and this point alone that a work of art was created? Analysed in this way art was reduced to a combination of lines and colour areas. Gauguin, who had explored the depths of the psyche, had, however, also used this type of intellectual organisation in his
686 painting. But it was Cézanne's reconstruction of nature according to basic forms and planes of colour that had the greatest and the most shattering influence. And the ideas embodied in

his work were soon carried to an inevitable conclusion. Why retain our preconceived notions regarding the appearance of the natural world? Why not merely *start* from nature to range freely beyond it in the invention of forms suggested by it? Why not break nature up by such an analysis and reassemble the elements of the world of appearances, not according to nature's own laws but according to the exigencies of composition? Thus Cubism was born. A new wave followed, 688 carrying these ideas still further. Why scruple to retain nature as the starting point? If plastic harmony must be the final result why not seek that harmony directly by obeying only the laws of harmony and discipline? Now abstract art took over and gave rise to the geometrical compositions of such painters as Mondrian and Herbin. 689

In taking over the work of defining art and in doing so relentlessly and often with intolerance, artists reduced the field of possibilities by dint of following the narrow groove needled out by the ceaseless probing for an ultimate and absolute principle. This frenetic and single-minded quest had an element of that dialectic fatalism found in scholasticism in the Middle Ages. The human intellect, without a fixed point of reference, was involved in an intense but uncontrolled activity.

Thus 20th-century art succeeded in breaking with the Graeco-Roman tradition. Gauguin was the source of almost all subsequent experiments, for he had made such a repudiation an essential part of his credo. This tradition in art had been based on two principles. The first was a faith in the veracity of sense perception — as experienced by all men — in approaching reality in its physical aspect; this was the basis of realism. The second was a faith in reason and the laws of reason, which alone are capable of penetrating the world of appearances and of revealing the hidden logic of its mechanism according to rules general among civilised men; this was the basis of the search for ideal beauty. Art therefore had only to reflect visible reality and to bend it to the laws of intellectual organisation in order to bring order and harmony to it. Reality and rationality, these were the pillars of a temple built by a continuous effort from Greece to Rome, from the Renaissance to Neoclassicism. The 20th century has brutally uprooted and destroyed them.

The repudiation of realism

Reality was the more severely challenged in its role in art. The Impressionists, while not rejecting it, had in fact shown that reality could be depicted in a way no longer corresponding to accepted ideas of it. Kandinsky, one of the first abstract painters, had shown how the initial impulse to abstraction sprang involuntarily from this. He gave us his account of the shock he received as a young man when confronted with Monet's *Haystacks*: 'Till then I had known only naturalistic art . . . and suddenly I found myself, for the first time, looking at a painting which according to the catalogue represented a haystack, but which I did not recognise . . . The subject represented in the work lost for me its importance as an indispensable element. All this remained confused in me and I could not then foresee the natural consequences of that discovery.' The consequences followed quickly enough once the first step had been taken. Championed by critics whose minds were open to all these developments (critics whose brilliant prototype was Apollinaire), the succession of daring innovations, from Cubism to abstract art, treated reality as no more than a springboard. At first the artist used conventional reality as a point of departure for an art of abstract form. In time he dispensed with the real and used abstraction itself as his point of departure. Henceforth art moved further and further away from the real, becoming ever more inward-looking.

634. HENRI ROUSSEAU (1844–1910). Aerial Navigation.

636. JOAN MIRÓ (b. 1893). Woman and Bird by Moonlight.

THE RETURN TO AN ORIGINAL POINT

*After drawing inspiration from what men thought were less
developed civilisations, artists wished to rediscover a basic
'authentic' element in art; this resulted in an interest in the
least intellectual and most spontaneous works. Out of this
came the vogue for 'naive' or 'primitive' painters; the first of
these was Henri Rousseau [634].*
*This growing tendency to reject all acquired knowledge in
order to return to a supposed original point at first caused
artists to revert to the world of childhood [636]. Then followed
a search for a problematic point zero which would yield a new
aesthetic genesis: form was eliminated; the presence of raw
materials in their original state was sufficient to constitute a
work of art. We find this in both painting [638] and sculpture
[637]. This asceticism led, if not actually to nothingness, to —
in certain extreme cases [635] — the accidental. Thus purified,
art was open to an as yet unpredictable future.*

637. CLAIRE FALKENSTEIN (b. 1909). Sun XIX. 1956–1959.

638. *Below*. ALBERTO BURRI (b. 1915). Sack 5. 1953.

635. LUCIO FONTANA (1889–1968). Canvas

In 1955 André Breton summarised, with his customary lucidity, this fundamental 20th-century trend: ' We have gazed long at that fleeting angle from which we see *things* fade away till they disappear, and it is only then that the *spirit* of things begins to unveil itself. The great achievement of modern art — of poetry from Lautréamont and Rimbaud, of painting from Seurat, Gauguin and Rousseau — will be to have breached the wall of appearances with ever greater force, to have attempted to reject the mere husk and to seek the living core . . . In art in the last seventy-five years this search has taken on an increasing urgency. To cut the rope that binds us — as much through habit as through sentiment — to a banal *perception* is something that cannot be accomplished in a day.'

Painting was now faced with a singular problem. Previously a means of transcribing physical reality or of expressing inner reality, painting was now limited to the cultivation of its own language — line and colour — and this became an end in itself. Freed of everything not strictly proper to its own nature, painting became increasingly ' pure '. It approached the absolute, the pure nothingness, when Malevich painted a white square on a white background. Here is a commentary by Michel Seuphor on Mondrian: ' Mondrian paints the great void, the nothingness, and in this nothingness a white colour as pure as the nothingness . . . Sweep, sweep, sweep away to make emptiness, sweep away and sow the seed of purity . . . to create the void is the principal act . . . for the void is positive, it contains the germ of the absolutely new.' In this revealing text Seuphor betrays almost unconsciously the secret motive, the profound impulse, behind this undertaking: to obliterate to the very roots the tradition built up by the past so as to reach a ' point zero ' from which to make a fresh start which accords with the totally new circumstances in which man finds himself.

However, the art historian cannot regard abstract art merely as a theory justified by the objective it offers the artist. He must recognise it as a transition, as a means of arriving at a new order which, starting from zero, will inevitably find its as yet un-formulated mode of expression. Art, for centuries a vehicle of expression for agrarian civilisations, was of necessity founded on a respect for the natural environment in which such civilisations existed. The world of tomorrow, on the other hand, is divorced from nature by the arbitrary character of its activities. So the modern artist has made his first assault on the real world, the world of nature. The modern world has witnessed, for a start, the transmutation of energies concealed in the heart of the real — energies which have had to be activated by a creative effort unforeseen in the normal order of things. Science too has gone far beyond mere deduction based on observation, which was the basis of its first exhilarating successes. Science has had to penetrate a field outside the boundaries of sense perception — a field governed by the pure abstractions of mathematics, where concepts are created first to be verified afterwards by experiment.

The repudiation of rationalism and the will

Abstract art and modern science demonstrate the victory of rational deduction over material reality. If they discredit the reality apprehended through the senses, we might expect them to extol that power of reason fundamental to the Graeco-Latin tradition. But, on the contrary, 20th-century man's desire to be free of past encumbrances has caused him to attack even this basic attitude.

Modern psychology has taught that reason and logical thought form the superstructure of the mind; they are the fruit of the slow process of maturity and not the essential reality of man. To find that reality it is necessary to sound the depths to which the light of reason does not penetrate — the depths of that unconscious which Bergson, on the eve of the 20th century, prophesied would be the great revelation. It was Bergson, moreover, who in the last years of the previous century had spoken of the fundamental limitations and artificiality of rational thought which, though no doubt admirably adapted to certain areas, is inept in providing a total and final account of truth in its existential, and not merely its apparent, reality.

At this time too the Symbolists were trying to penetrate beyond the rational mode of thought. They sought the profound and indefinable meaning of the world through the ' word association ' of Baudelaire and through images which evoke far more than the precise meaning of words (the ' tribal language ' of Mallarmé). Odilon Redon, whose depth and vision are still not fully appreciated, wished to gain access ' to the misty world of the indeterminate '. ' Everything,' he declared, ' comes about through passive submission to the unconscious.' This was an early statement of the ideas of Surrealism, a movement which did not appear till after the First World War.

One of the first numbers of *La Révolution Surréaliste* summed up the new policy clearly and aggressively: ' Ideas, logic, order, Truth (with a capital T), reason: we will give everything to the nothingness of death.' There remained only the recourse to that depth psychology with which our era has been so pre-occupied and which has opened up new avenues, psycho-analysis having been the most systematised and vulgarised. But this recourse implies the abandonment not only of the rational but of the conscious, and involves the passive collecting of the inorganic images with which the unconscious mind tries to express itself.

Still more recently, after the Second World War, what is known as Abstract Expressionism or ' informal art ' has tried to go beyond the limitations of the image, which is always the result of conscious organisation; streaks and splashes of paint are used in an attempt to fix on the canvas the expression of the primordial emotions.

With the rejection of the reality of the senses and the order of the reason, the domination of the Graeco-Latin tradition may have vanished for ever. This tradition had striven to distinguish man from the chaos of the universe, to endow him with a certain detachment towards this universe so that he could observe, reflect and act. The 20th century, with its passion for kicking over the traces, has gone to the extreme of banishing all conscious control that is allied to the will.

The Surrealists had already advocated (for example in auto-matic writing) spontaneous methods of creation derived from phenomena observed in the psychology of the unconscious. Abstract Expressionism tunes in directly to those impulses in man which merely register the vibrations of the universe. Let us hear the confession of an artist. In 1957 Ackerman wrote: ' This work of the last three years is based on the pleasure of painting and on the idea of the *tabula rasa* . . . I set off on an adventure, forcing myself, when beginning a canvas, to empty my consciousness, guided only by the sheer joy of painting. It is clear that this void is created by an act of the will — the will negating itself.'

' Point zero ' has been reached; the final traces of a tradition acquired over centuries are now effaced. Resuming the earlier attempts of André Masson, Pollock and the painters of the new American school have tried to paint using gestures governed by chance; they study this chance result in order to participate in it, to react to it, and to turn this reaction to good account. Conscious control is seemingly eliminated; the final result, according to a text by Francis Ponge on Fautrier in 1956, is totally responsible for itself: ' Burst, words, like bubbles . . .

644

635

692

695

248

639. JEAN DUBOSCQ (b. 1928). The Roads of Death. 1954.

640. HANS HARTUNG (b. 1904). T 1952–50.

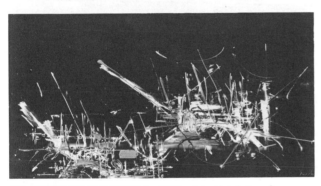

641. GEORGES MATHIEU (b. 1922). Admiral John of Vienna at the Battle of Nicopolis. 1959.

642. MAX ERNST (1891–1976). Painting-construction in cork.

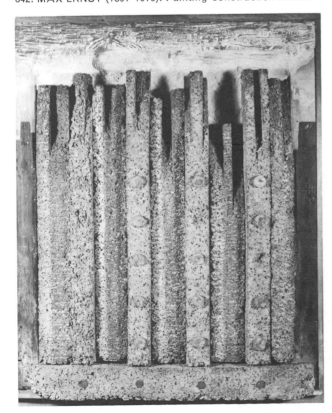

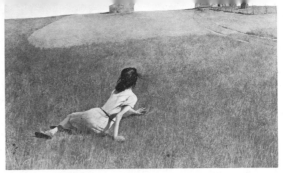

643. ANDREW WYETH (b. 1917). Christina's World. 1948. *Museum of Modern Art, New York.*

SYMBOLISM IN MODERN ART: THE VOID AND THE BARRIER

The artist's imagery is a projection of his acknowledged or secret obsessions. Whether figurative [643], Surrealist [644] or abstract, painters and sculptors often seem to be fascinated by a terrifying deserted space in which man is dwarfed or disappears. At times access to space seems to be blocked — either by a more or less figurative obstacle [639, 642] or by a barrier of abstract signs which may be powerful [640] or aggressive [641].

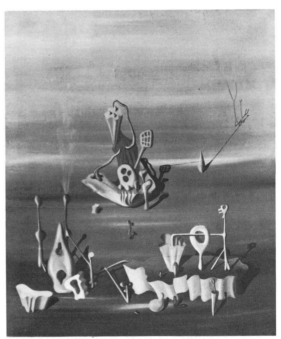

644. YVES TANGUY (1900–1955). Luke, the Cheat. 1936.

645. ALBERTO GIACOMETTI (1901–1966). Seven Figures and a Head. Painted bronze. 1950.

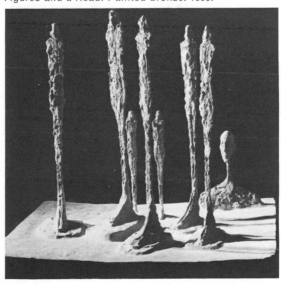

bubbling and exploding in the artist's own language. Words nearer the flower than the symbol, nearer the substance than the concept — we know the risk, the risk of the absurd. We accept responsibility for that risk. ' From this, it follows that ' . . . we men, animals with speech, we are the hostages of the dumb world. '

In short, these men have returned to their starting-point. They have artificially reconstructed a situation almost analogous not to that of the primeval world (we are well beyond that) but to that of prehistory when, faced with menacing forces he had not yet learned to master — either in himself or in his environment — our original ancestor grappled with the then total enigma of the world. And in that state he knew anxiety — the anxiety of being unprotected, overwhelmed and at the mercy of the uncontrollable. He was ' the hostage of the dumb world '. This same anxiety reappears inevitably in the situation created by modern thought. And art is bound to express it.

Image and anxiety

If the modern school believes itself isolated in what it calls its ' purity ' and ' gratuitousness ', if it believes itself freed from the external conventions — especially the social ones — that used to make art the spokesman of contemporary convictions and problems, it is deceiving itself. Art has never expressed the condition of contemporary man more openly or more spontaneously. The controversy over ' committed art ' is ironic. It is not by serving political causes and dogmas that art becomes part of its times; art can never in fact divorce itself from its times, and it reflects them all the more profoundly when it tries to escape them. The passenger who, on the deck of a ship, resolves to read poetry rather than a nautical textbook is no less affected by the ship's progress, its motion, its angle of pitch, etc. Certainly an artist expresses himself through the lucid development of his theories and of their application, but he does so even more through the images and forms that he creates spontaneously. The theories reflect the preoccupations with which he believes himself concerned — but in this he is sometimes deceived. The images are an unconscious reflection of his inner life; the forms represent the structure by means of which he organises his existence and his thought. We have already outlined the various successive theories. We must now examine the images to see what light they throw on contemporary art and on the nature of its sensibility.

I shall keep faithfully to the method that looks to the images (whose eloquent convergence reveals the pressure of inner obsessions) for the secret of the contemporary soul. We notice first that the aggressively negative themes so dear to the Romantics — night, the moon, death, phantoms, the devil — no longer answered the needs of a newly evolved situation. When the realist phase which from naturalism to Impressionism had curbed the imagination came to an end, there was, starting with Gauguin, Redon and van Gogh, a growing preoccupation with invisible forces; for Gauguin and Redon they were the autonomous spiritual forces hidden in the mystery of things; for van Gogh they were the essential life force that bursts the material envelope.

In any case, the accepted meaning of appearances was abjured in an obsessive desire to penetrate beyond. This was the moment when the modern artist broke with the old tradition, sensing within himself the presence of powers stronger than established conventions, powers which had not yet fully revealed themselves.

When the Surrealists believed that they had gained access to these powers in the secret vaults of the unconscious and that they had completed the demolition of the reassuring props of

reason, a new theme manifested itself, the theme of the void. In the work of Tanguy and Dali man is once more in a primordial state; amid desert or submarine wastes he participates in the original genesis; he witnesses the birth processes of amorphous matter, of primary organisms, of life in its pre-evolutionary state. **644,**

After this a whole generation stemming from Surrealism, the Neo-humanist painters in particular, expanded the theme of emptiness with their deserted and sterile waste lands, beaches and salt-marshes — or with images of young people in troubled sleep, trapped between bare walls that are pierced with gaping apertures through which night penetrates. Thus the emptiness began to take shape as the anxiety of solitude, abandon and misery; lost beings on precipitous islands overhung by stormy **648** skies, and Gruber's Job naked among hovels, are typical examples. Buffet has had a belated success with such images, his simplified presentation being merely the outcome of that trend.

In the United States an apparent realism sometimes gives these obsessions the aura of waking nightmares; we see this in **1132** Wyeth's painting of a girl seated in an endless field, her body **643** turned towards a house she will never reach. It is more evident still in *The Subway* by Tooker; here, in a prison-like universe **1130** where they are confined between stark partitions and iron bars, the passers-by have a hunted expression, and this same expression begins to transform the face of the watching woman in the centre.

Sometimes, as in the sculptures of Giacometti and of Germaine Richier, man seems to be reduced to raw matter and to **645** be eaten away by space. Giacometti's thin fibrous figures meet **792** without seeing each other in a void that is both spatial and spiritual. Sometimes, as in Bacon's paintings, we see, through **1011** a kind of mist, figures which seem to be caricatured in a distorting mirror. Everywhere men seem to be lost in a strange world in which they are strangers to one another.

The Swiss critic Jacques Monnier summarised his impressions of a group of three figures by Giacometti in this way: ' On seeing this work we become dizzy with the dizziness induced by the void. The void appears to be Giacometti's primary material. He takes sculpture to its extreme limits, almost to the point of negation . . . What remains of man? A figure on the frontiers of nothingness . . . This sculpture of the void borders on the absurd. Is it the sculpture of despair? '

At this point the theme of the obstacle or the barrier appears. From Pierre Dmitrienko's *Crucifixion* or the *Roads of Death* by Jean Duboscq to the most abstract works of Soulages, **639** Hartung or Mathieu, the white space of the canvas is enclosed **640,** or barred by powerful black inexorable forms, or else by jagged, aggressive, piercing, jerky forms. Depth, openings, access — all are gone. There is only a wall of signs that can no longer be surmounted.

Emptiness, sterility, misery, solitude — all terminate finally in fear. The unreal landscapes of Max Ernst are also blocked by **642** a wall — often a wall of mineral or vegetable substances, and sometimes even of tentacle-like movements and eyes without a face, casting anxious glances. Man projects his own image and his image of a world which he feels is devoid of clarity, of meaning and even of any recognisable order; the animal kingdom is confounded with that of plants or rocks. Nothing is understood any longer except that all is menaced.

It was inevitable that the monster should emerge once more — the same monster which primitive peoples had adopted to describe their impressions of a world manipulated by terrible and incomprehensible forces, forces ready to attack or annihilate them, they knew not why. The monster was kept at bay by

Graeco-Latin humanism, which tolerated it only when it was graced with a human face and torso (although this did not apply to the Minotaur). In our time, however, the monster has, significantly, been resurrected and once more obsesses the imagination. Elsewhere I have shown at greater length how, with strip cartoons and science fiction films, our children have their imagination fed on a curious mixture of the hypermodern, symbolised by space rockets, and the prehistoric, represented by the gigantic monsters of the Tertiary.

, 652
654
, 653

In the same way, from the sculpture of Chadwick in England, the Swiss Robert Müller and the American Theodore Roszak, to the engravings of Picasso we find a weird collection of monstrosities, of insects and crustaceans that evoke a world of aggression and laceration. Jacques Monnier has once again given us his reactions, this time to Müller's work: 'Each of his animals obeys unknown laws and defies our imagination: he seems to escape our grasp, and it is in this that he is hostile and disconcerting to us. We seem to have become primitive men again, faced with a strange inexplicable world peopled by spirits, a world which must be conciliated.' This is a particularly acute and intuitive impression of what the psychologist and the historian feel is basic to our time — the return to the terrors of prehistoric man when he faced problems which were beyond his intellectual capacities and material equipment.

779

There are, of course, artists who are trying to maintain the threatened equilibrium and who, like Chapelain-Midy, wish to preserve the clear and serene structures of the past, of a Piero della Francesca for example. But despite these efforts we see, in the work of Rohner or Humblot for example, that it has not been possible to keep the implacable anguish of death from seeping through. And Aujame's passion for nature becomes a delirium of nature's secrets, transforming a simple stone into a mysterious message of threat.

915

The Individual outpaced by events

Such a survey of contemporary imagery can only be a rough outline. At any rate, the coincidence of certain themes which spring from the unconscious in artists of often opposing aesthetic tendencies is eloquent enough. Such themes record the preoccupations of a generation which has renounced the culture sanctioned by centuries of tradition and has returned to the initial void; there it experiences the thrill of intimate contact with a reality stripped of familiarity, a reality all the more terrifying because of the blind anonymity of its unleashed brute forces. An artist's confession of his deepest desires is revealing; in 1957 Serpan wrote: 'The widespread use of automatism, spasms of signs or calligraphy, Tachisme, etc., represents so many returns to the profound sources of the psyche. Never has a more radical effort been made by painters to transpose on canvas the *primordial sincerity* of existing.'

But in the same breath he admitted his perplexity in the face of the infinite possibilities open to man once he has thus stripped off, bit by bit, the protective armour of culture: 'Deprived henceforth of recourse to some Greece or other or to the norms of the reason-panacea, he is free of all attachments, and is lost in that freedom. My choice of this or that mode of expression is no longer of any great importance; the decision is arbitrary . . . This is the crucial fact: henceforth any gesture may be an excuse for painting. Everything is permissible once the canker of the possible sets in.'

Like Hercules before the many-headed Hydra, modern man feels that he has to begin all over again. He must understand in a different way and must learn to master in a different way; and he feels that science only serves to define the extent of the menacing jungle surrounding him. The individualism of the 19th century made the artist an inexorably solitary man, and the solitary man himself shared humanity's overwhelming responsibility for revision and control. Seen from this angle modern art, whatever its excesses, naiveties or impudences, remains in its most fundamental and authentic aspects the moving language of a civilisation which believes, too radically, that it must renounce its past in order to create an inevitable but as yet unclear future.

21
23

The void, anxiety, the absurd — such are the words used by those critics who are in sympathy with the modern artist and his attitude. Having liberated himself from that past whose paralysing effect he dreaded, has the modern artist succumbed to the terror of his new task? Is his ultimate outlet the bitter despair of an essentially *human* failure, poorly disguised under aesthetic programmes and proclamations? An examination of his images might suggest this, for these reflect above all a sincere sensibility — a sensibility in which man's intellect is still at the mercy of the forces of life. Such images are the language of Expressionism. Through them the individual confesses his secret; exalted in the 19th century and encouraged to detach himself from the collective, the individual, however talented, finds himself too weak to cope on his own with the problems of his time — problems which are epochal in scale and whose resolution is always a task for a whole generation.

646

The perspicacious writer Alain Jouffroy made a similar diagnosis in 1955 which explodes that aesthetic rationalising so common in our times: 'Men today seem inhibited by their anxiety . . . Their art testifies to this. One might say that Europeans have abandoned the wish to conquer the world: the will to power has ceased to inspire them. Painters have become Orientalised; their work expresses the desire for effacement, for annihilation. The desire to impose order on the universe is replaced by a terror in the face of chaos. Each painter, in the West, is alone vis-à-vis the contradictions of the present world; on the individual level these contradictions cannot be resolved. The impossibility the painter feels of *imagining* a solution to the conflicts that rend us is no doubt the real and secret reason behind all non-figurative work.' Every word carries weight in these few compressed lines by a critic whose lucid judgment combines that of the psychologist with that of the historian.

We must not therefore look to painting, an art of individual expression and confession, for the most creative aspect of our times. It is wiser to seek this in a constructive art, an art dependent on form, an art which produces the great collective work by which a new civilisation expresses itself. It is perhaps in architecture that the mental and visual constructions which will characterise our epoch and fix it in history are being evolved. For there is a greater chance of finding the future in the world of forms than in the too subjective world of images.

Indeed the artists of tomorrow may, like the primitives of a new era, have little use for those individual confessions which in periods of achievement and maturity are so much more the rule than is the collective enterprise. It is not impossible that easel painting — the major art in times of individualism — will be considered a sign of regression and will be replaced by a more all-embracing mode of expression. Indeed, for several years there has been a growing movement to revive mural painting; this has culminated in a revival of the art of the tapestry. And curiously enough the imagery of, for example, its leading exponent Lurçat dispenses with themes of anxiety; instead we find cocks, suns, grapes — all the warmth of nature, from the plant world to the planetary, radiant with the pure joy of life. The abrupt change of key when we pass from the individual to the collective level should give the psychologist food for thought.

But the image is only the reflection of one or other of these levels; it expresses only that which *is*. Forms, on the contrary, help to build that which is *striving to be*, for forms are the result of the impulse of entire generations to consolidate and establish themselves in a new reality. Do these forms — of architecture and sculpture — speak to us in a different language? If so, their language is not that of a desperate present but rather of an embryonic future.

Forms and energy

As a last resort the most advanced schools of painting have turned to 'informal art', that is, they have rejected form in an effort to understand and control the chaos of the world. But if, in the face of this bankruptcy which is contrary to the very genius of man and to his basic needs, a number of artists feel the pain and anxiety of that nothingness (so absurd a state for the human spirit), if they echo similar themes found in contemporary philosophy, these negative signs are nevertheless opposed by positive ones. At the end of this discarding process, and in order to justify its tremendous cost, there must be some innovating principle for the future. This principle we have dimly sensed since it first manifested itself in the 19th century; it is energy.

In fact certain painters concerned with the extremes of 'informal' experiment have discovered the exhilarating presence of energy, but this discovery is still in a state of fusion. They have renounced nature, that is the reality of the senses; in a state of voluntary blindness they feel the heat and power of an explosive centre. For the term 'nature', considered outmoded, they substitute the term 'cosmos' to designate this new reality apprehended at its core where the central fire rages and consumes. They try to portray the pure ardour of primeval energy, to capture it in the gesture, in raw matter. Certain Abstract (or semi-abstract) Expressionists come near to this— Appel in Holland and de Kooning in the United States. An exhibition in Venice in 1959, which had the significant title 'Vitalità nell'Arte', grouped together painters concerned with this type of experiment. Most of the works exhibited were subjective and were almost unbearably painful, convulsive and strident. Rare were the artists who had overcome the despair of having renounced everything only to be overwhelmed and crushed by the new situation. Some, however, went beyond this, conveying only a kind of delirious joy — a fierce outpouring akin to geysers spitting steam. But no one broke this barrier and entered that constructive phase which our epoch must attain if it is not to commit artistic suicide. Till now painting has not, in general, reached this stage. It has braved the trial by fire which would seem to have been a historical necessity, but it is being consumed in that fire. The world of tomorrow will take shape only when new forms are once more being invented, for it is form that defines civilisation and provides it with a framework.

Are these forms taking shape already? In sculpture, architecture and the applied arts new forms are being developed under our very noses; we have only to open our eyes to see and understand them. We can but summarise here developments which merit considerable attention.

The early agrarian civilisations, static by nature and in outlook and concerned with the partitioning of land, created a lasting system of forms based essentially on straight lines arranged at varying angles. The fundamental volume of their architecture was the parallelepiped, combined with triangular devices such as pyramids and pediments. Added to this, through contact with the East, was the circle (another closed and perfect form) with its derivatives, the cylinder, the dome,

658

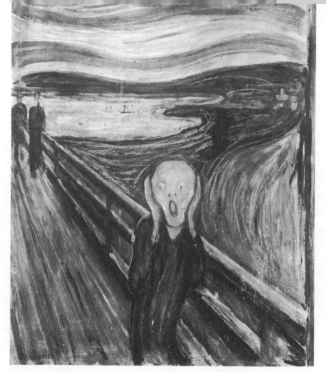

646. EDVARD MUNCH (1863–1944). The Cry. 1895. *National Gallery, Oslo.*

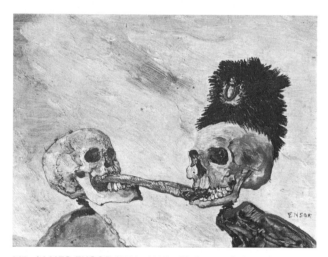

647. JAMES ENSOR (1860–1949). Skeletons fighting over a Herring. *Museum of Modern Art, New York.*

648. FRANCIS GRUBER (1912–1948). What means Death to One means Life and Splendour to Another. 1939.

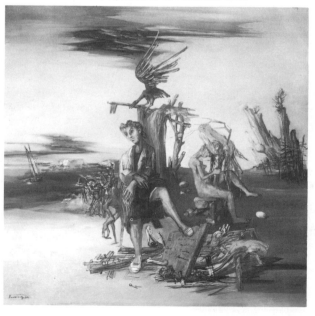

649. AGENORE FABBRI (b. 1911). Atomised Man. Detail.

650. SALAH ABDEL KERIM. The Cry of the Animal. Screw bolts and machine pieces. 1960.

651. PABLO PICASSO (1881–1973). Four children viewing a Monster. Mixed technique. c. 1933.

652. LYNN CHADWICK (b. 1914). Bird. Iron. 1956.

SYMBOLISM IN MODERN ART: ANXIETY AND THE MONSTER

The void is revealed as an expectation, a waiting filled with menace. Anxiety is expressed by figures of despair [648], panic [646, 649] or death [647] and is embodied in monsters that recall the ferocity of primitive art [650–654].

653. THEODORE ROSZAK (b. 1907). Spectre of Kitty Hawk. Welded and hammered steel brazed with bronze and brass. 1946–1947. *Museum of Modern Art, New York.*

654. ROBERT MÜLLER (b. 1920). The Spit. Wrought iron. 1953.

etc. There the repertory was closed; and it remained essentially
the same from the Parthenon to the Madeleine. Just as in
figurative art the suggestion of the wear and tear of time was
kept at bay by the striving for perfection — unshakable once
it has achieved the aspect of eternity — so in the constructive
arts all was based on the equilibrium of fixity, typified by walls
rising vertically from the ground and topped by a more or less
horizontal roof.

Once the principle of energy is admitted into art everything
changes. In view of their mobility, nomadic or maritime
civilisations have had to consider space as an open field of
activity and travel rather than as a stable surface to be divided
up, and they have created supple undulating art forms which
express the fluctuations of increase and decrease; the spiral is
typical of this, as are the hyperbola and the parabola and,
generally speaking, all curves expressing the variations of a
function. It is such curves, corresponding to the calculations of
conic sections, that have in fact given these art forms their
dynamic character.

The two opposing systems of forms outlined above are found
again in the Middle Ages, when static Romanesque was re-
placed by dynamic Gothic; and they are seen at a later time
when the Baroque overthrew static classicism to affirm the
dynamism of life.

It is obvious that with the conclusive victory of energy and
with its exploitation and the resultant transformations as
principles of existence, the 20th century can only break with
the agrarian and static Mediterranean tradition as embodied in
our Graeco-Latin heritage. The 19th century was the scene of
the conflict. Architects, trained by the Ecole des Beaux-Arts in
the tradition of the past, maintained the forms of that tradition.
Construction engineers, who were given at the beginning
of the century an opposing school (the Polytechnique in
Paris, which was exclusively concerned with contemporary
problems), developed metal architecture. This architecture,
very naturally, approached construction problems from an
angle approximating to that of Gothic, which had created
daring new forms dictated by practical problems.

The new spirit of forms

Though later rejuvenated in their thinking by the principle of
functionalism, modern architects kept at first to the old forms
— forms with which Perret and even Mies van der Rohe were
imbued — not realising that they marked the conclusion of the
past tradition rather than an opening towards a future world.
In time came the rejection of all over-systematic doctrine and
all aestheticism, and the recognition of the demands of existing
conditions. A radically new style was then conceived, expressive
of contemporary facts and geared to our epoch. The astonish-
ing potentialities of this style can be seen today in the master-
pieces of such architects as Niemeyer in Brazil, Nervi in Italy
and Zehrfuss and Gillet in France. These potentialities were
revealed earlier by Eiffel in metal and Freyssinet in concrete.

The new materials (which unlike stone did not need cutting
into the blocks that give rise to parallelepipedal constructions)
were flexible and therefore allowed tension and compression.
When moulded (as with concrete, and no doubt with plastics
in the future) they were extremely adaptable. Consequently,
instead of being built in a series of rectilinear layers walls could
be suspended from a supple framework, which could receive and
compensate the internal stresses of the forces of gravity as well
as the external stresses of the wind. Straight lines and angles
gave way to hyperbolas or parabolas; flat surfaces were replaced
by planes whose sweeping curves grew out of the rectilinear
elements of the framework.

121

685, 934
665, 684
680, 683

254

655. MAURICE DE VLAMINCK (1876–1958). Bay of the
Dead. 1949.

656. EMIL NOLDE (1867–1956). The Life of St Mary
Aegyptiaca. Left panel of a triptych. 1912. *Kunsthalle, Hamburg.*

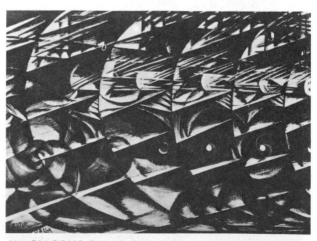

657. GIACOMO BALLA (1871–1958). Automobile and Noise.
1912.

658. KAREL APPEL (b. 1921). Flowering Heads. 1958.
Mr and Mrs Arnold H. Maremont Collection, Winnetka, Illinois.

659. AUGUSTE RODIN (1840–1917).
Man Walking. Study for St John the
Baptist. Bronze. 1877.
Musée Rodin, Paris.

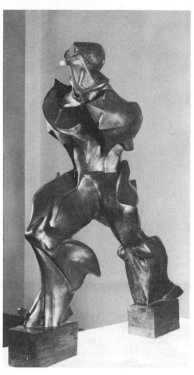

660. UMBERTO BOCCIONI
(1882–1916). Unique Forms of
Continuity in Space. Bronze. 1913.
Museum of Modern Art, New York.

661. CONSTANTIN BRANCUSI
(1876–1957). Bird in Space.
Polished bronze. 1925.
Philadelphia Museum of Art.

DYNAMISM

*We have already mentioned the effort to eliminate earlier
conventions that has animated modern art, and the anxieties
of man stripped and deprived of his usual protections. We
must now look at the corresponding positive principle that
heralds a new world in the process of supplanting the ruins
of the old. In widely varying forms, there is an insistence on the
need for energy. This energy, not yet free of anxiety, lends a
violent intensity to the Fauves [655] as it does to the
Expressionists of both yesterday [656] and today [658]. It can
be seen as an obsession with movement, from Rodin [659]
to the Futurists [660], who amplified its dynamic content [657].
A vertical impulse can also be seen at times in architecture
[664] and sculpture [661]. An obsession with speed, which is
reflected in both advertising [662] and the aerodynamic lines
of motor cars [663], has been passed on to architecture [665].*

662. CASSANDRE (b. 1901).
Poster for L'Intransigeant. 1925.

663. Car body by Ghia (Turin).
1959–1960.

664. GERMANY. FRITZ HÖGER
(1877–1949). Chilehaus,
Hamburg. 1923.

665. GUILLAUME GILLET (b. 1912).
Model of the French pavilion at the
Brussels Exhibition. 1958.

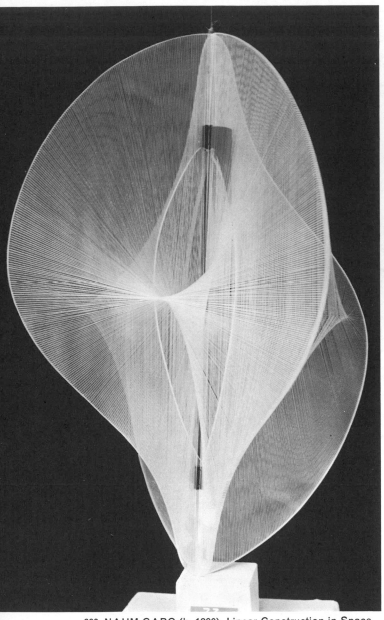

666. NAUM GABO (b. 1890). Linear Construction in Space No. 2. Plastic and nylon. 1949. *Stedelijk Museum, Amsterdam.*

667. RICHARD LIPPOLD (b. 1915). Variation within a Sphere, No. 10: the Sun. Gold-filled wire. 1953–1956. *Metropolitan Museum of Art.*

taste. Dynamic forms infiltrate even where they have no proper function. A chair may be logically considered as the problem of resistance posed by the weight of a seated body and may therefore be constructed by combining the elasticity of upholstery with the flexibility of metal supports. But why does a table-top cease to be rectangular? Because ideas and sensibility evolve and make new demands.

This is not simply the mimicry of fashion but a deep inner need which is trying to express itself. The proof is that the new forms have been conceived and cultivated by artists to whom technical problems are alien. I refer to sculptors. Gratuitously, through the sheer need to create an art form corresponding to the still unformulated aspirations of the epoch, Brancusi has **661** developed a plastic vision that responds to the necessities of aerodynamics, and Gabo and Pevsner have created abstract **666,** constructions which are based on the solids by which mathematicians represent a function. This disquieting coincidence provides an ultimate confirmation of the total unity imposed by a period on all its practical and spiritual manifestations, whether in the form of ideas or of plastic creations.

It is highly significant that the work of a younger sculptor, Lippold, expresses a luminous, vibrant radiation round a **667** reinstated centre of gravity. This no doubt is a sign that the future is already in sight. But this book has reached the ultimate point beyond which it can no longer pursue its inquiry. The historian treats of the past — perhaps, at a stretch, of the present; the future is outside his scope. His method, which depends on the authority of evidence, reaches its boundaries here, where the domain of inventive art begins. In this domain, more than any other, no one can predict the course of human freedom. It is this human freedom which must resolve the problems posed by destiny. And it is incumbent on the artist to give to the necessary solutions that further quality which enables man to rise above determinism. What the art of tomorrow will be history cannot say; that is for creative genius to accomplish.

Here we see the development of solutions in use for centuries, whenever the problems have arisen which concern moving bodies and the strains induced by the resistance of the element in which they move. The modern architect has rediscovered the forms invented in earliest antiquity for ships; these forms have been transferred to land vehicles, and then to aircraft since increased speeds have given air a consistency, which for practical purposes had never been considered before and which has given rise to aerodynamics. A carriage was still basically a parallelepiped like the ancient temple before it, but **663** a sports car adopts lines which are also used for modern buildings!

The above phenomenon is not merely the result of technical progress. Its significance goes deeper. It expresses the new outlook of our times; this is corroborated by the evolution of

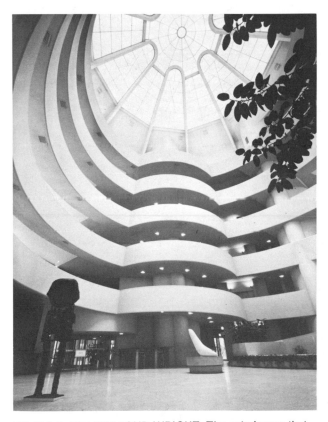

668. U.S.A. FRANK LLOYD WRIGHT (1867–1959). Falling Water (Kaufmann house), Bear Run, Pennsylvania. 1936–1937.

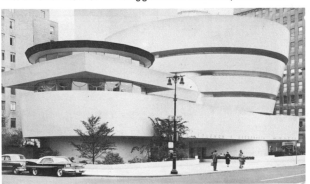

669. U.S.A. FRANK LLOYD WRIGHT. The spiral ramp that serves as a picture gallery, Solomon R. Guggenheim Museum, New York. Completed 1959.

670. Exterior view of the Guggenheim Museum, New York.

DUALITY IN MODERN TRENDS

Before the 20th century art had been above all a means of conveying visually a message (religious, literary, historical, narrative) extraneous to itself. In this century, however, art found its definition in its own particular nature. This opened the way to purely aesthetic theories; it also enabled artists to define and classify tendencies that had so far only been revealed instinctively. Each important spiritual family asserted itself and pursued exclusively its own particular artistic objectives. Without wishing to divide varying temperaments into over-simplified categories, we may observe that certain minds which are inclined to intellectualism and abstract thinking tend to prefer the cerebral and the search for the absolute to the turbulence of life, which they ignore or eliminate. Others, on the contrary, are repelled by the fixity thus imposed on the flux of reality and choose to abandon themselves to life and to the unexpected forces of natural impulses, thereby creating, in a sense, disorder but also a lyrical warmth. Further, we might stress that, beyond the division into various schools that has become such an essential part of manuals on modern art, there exist side by side two contrasting mainstreams which, though varying in mode of expression with each successive phase, are always in opposition to one another. The first of these adheres in all the visual arts (architecture, sculpture, painting, the minor arts) to static composition, with a preference for rigid forms that evoke fundamental geometric constructions such as parallelograms, triangles and circles; this tendency is based on the juxtaposition of elements and the interrelation of their proportions. The second tendency rejects the immobility resulting from these simple fixed elements and employs sweeping lines that evoke tension, elasticity, soaring trajectories, etc.
In the following pages we shall show how this dichotomy recurs at different moments in the evolution of art and in different guises. But it is important to mention that certain outstanding artists have at different times employed both forms of expression. A Le Corbusier or a Frank Lloyd Wright can express himself in terms of both the fitting together of volumes in a rational Cubism [668, 671] and the dynamic curves produced by surging directional lines [669, 670, 672].

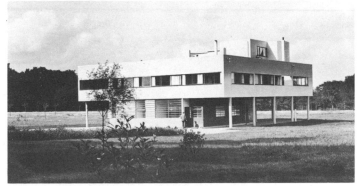

671. FRANCE. LE CORBUSIER (1887–1965). Villa Savoye, Poissy. 1929–1931.

672. FRANCE. LE CORBUSIER. Chapel of Notre Dame du Haut, Ronchamp. 1950–1955.

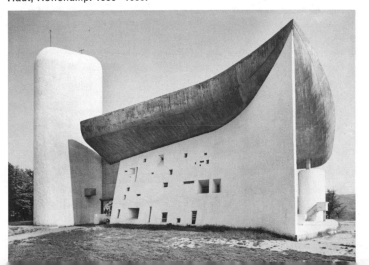

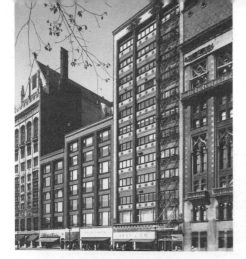

673. U.S.A. LOUIS H. SULLIVAN
(1856–1924). Gage building, Chicago
(three centre blocks). 1898–1899.

674. FRANCE. AUGUSTE PERRET
(1874–1954). Garage Ponthieu, Paris.
1905–1906.

675. AUSTRIA. ADOLF LOOS
(1870–1933). Steiner house,
Vienna. 1910.

Although modern architects are unanimously in favour of
functionalism, their interpretations of it have differed. At first
they proceeded mainly by superimposing parallelepipedal
volumes, echoing in horizontals and verticals the grid pattern
of the metal rods in the concrete. About the end of the 19th
century the English-speaking countries, bent on practical
simplicity, established a type of building that clearly shows
the crossing of horizontal floor divisions and vertical supports
[673]. At the beginning of the 20th century, with Perret [674],
this rational and utilitarian style became increasingly classical
in spirit and slowly but surely moved towards an aestheticism
paralleling that of Cubism [675, 677, 679]. The ideas of certain
early abstract painters (Mondrian and the De Stijl group)
contributed to this style [676], which has reached its apogee in
recent American skyscrapers [678].

676. INDIA. PIERRE JEANNERET (b. 1896). Block of flats
in Chandigarh, new capital of the Punjab, where Le Corbusier
has been architectural adviser. 1955.

677. FRANCE. ROBERT
MALLET-STEVENS (1886–1945). House
in the rue Mallet-Stevens, Paris. 1927.

678. U.S.A. LUDWIG MIES
VAN DER ROHE (1886–1969) Lake
Shore Drive apartments, Chicago. 1951.

679. ITALY. ANTONIO SANT'ELIA
(1888–1916). Project for a skyscraper.
1913. *Museo Civico, Turin.*

680. FRANCE. GUSTAVE EIFFEL (1832–1923). The Eiffel Tower in Paris in the course of construction in 1888. Completed 1889.

681. SPAIN. ANTONI GAUDI. Drawing room of the Casa Batlló, Barcelona. 1905–1907.

682. SPAIN. ANTONI GAUDÍ (1852–1926). Loft of The Casa Milá, Barcelona. 1905–1910.

In resolving the practical problems of construction through the use of metal, such engineers as the great pioneer Eiffel [680] eschewed the straight lines and rectilinear shapes so dear to modernism in favour of the flexibility and dynamic equilibrium of more organic forms whose internal tensions made for a homogeneous whole. Another precursor, Gaudí, In combining the flowing lines of Art Nouveau decoration [681] with supple rhythmic curves in the construction itself [682], showed how this tendency was inspired by natural life rather than by the arbitrarily geometric. Henceforth this ' engineer's style ', which was able by means of iron and concrete to exploit the harmony of forces in opposition, adopted hyperbolas, parabolas and exponential curves [683]; this same approach has triumphed in the most recent aesthetic expressions [684, 685].

683. FRANCE. EUGÈNE FREYSSINET (1879–1962). Airship hangar at Orly Airport. 1916–1924. Destroyed 1944.

685. BRAZIL. OSCAR NIEMEYER (b. 1901). São Francisco chapel, Pampulha, with façade decorated in *azulejos* (glazed tiles) by Candido Portinari. 1943.

684. FRANCE. BERNARD ZEHRFUSS (b. 1911). Centre National des Industries et Techniques, Paris. Built in collaboration with R. Camelot and J. De Mailly. 1958.

686. PAUL CÉZANNE (1839–1906). Montagnes, L'Estaque.
c. 1880. *National Museum of Wales, Cardiff*.

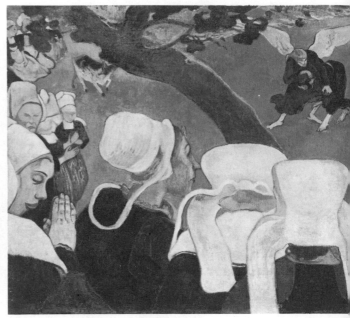

687. PAUL GAUGUIN (1848–1903). Vision after the
Sermon (Jacob wrestling with the Angel). 1888. *National
Gallery of Scotland, Edinburgh*.

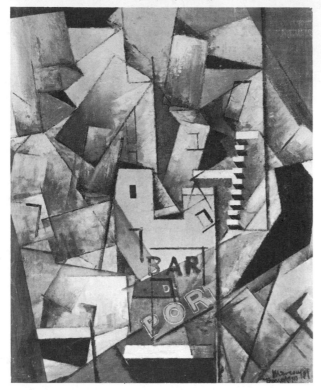

688. LOUIS MARCOUSSIS (1883–1941). Bar du Port. 1913.
Mme Halicka-Marcoussis Collection.

689. PIET MONDRIAN (1872–1944). Composition. 1929.
Solomon R. Guggenheim Museum, New York.

*The duality found in architecture is seen again in painting,
though in another guise. Successive attempts were made to
fix in a solid form that flux of appearances captured by the
Impressionists. Cézanne inaugurated this with his use of
colour to express modelling and his employment of basic
geometric forms [686]. Gauguin's interpretation was different;
instead of geometric forms he used flat areas of colour sharply
defined by sinuous outlines [687]. But towards 1910 the
Cubists broke up objective forms, forcing them into a kind of
polyhedral crystallisation which only faintly recalled their
normal appearance [688]. Shortly afterwards abstract painters
dispensed with appearances, retaining only the elemental
structures, combining the geometry of Cézanne with the flat
areas of Gauguin [689]. Even in the most recent Abstract
Expressionist painting, in which the direct projection of
gesture with its pictorial and calligraphic qualities is paramount
(so much so that it is called action painting), there is still a
tendency to control impulses and to re-establish an
authoritative structure [690].*

690. PIERRE SOULAGES (b. 1919). Painting. 1960.
H. G. Clouzot Collection.

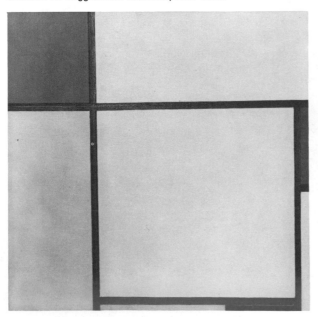

691. VINCENT VAN GOGH (1853–1890). Road Menders at Arles. 1889. *Cleveland Museum of Art*.

693. *Right*. GEORGES ROUAULT (1871–1958). M. and Mme Poulot (Léon Bloy, La Femme Pauvre). Watercolour. 1905. *Philippe Leclercq Collection*.

By contrast there are the artists who rebel against the intellectual discipline explicit in a preoccupation with forms. They seek to portray the deeply buried, obscure and unintelligible sources of life, a life that lies beyond linear definition and beyond conceptual ideas. Among the Post-Impressionists it was van Gogh who led the revolt of instinctive forces against strict form [691], while Odilon Redon submerged form in the indefinable shadows of the hidden depths of the soul [692]. The following generation of Fauves and Expressionists produced a vital and energetic dislocation of appearances [693]. The Surrealists then dissolved reality into a shadowy world of the unconscious [694]. Finally, with the Abstract Expressionists, reality has disappeared completely in seething torrents of paint and heavy impasto which are stirred by purely organic rhythms [695]. Life, de-intellectualised, has sought renewal in its primeval sources.

694. ANDRÉ MASSON (b. 1896). Dead Horses. Sand painting. 1927.

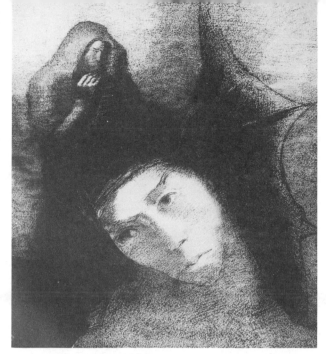

692. ODILON REDON (1840–1916). Illustration for the Temptation of St Anthony, by Flaubert. Lithograph.

695. JEAN PAUL RIOPELLE (b. 1924). Country. 1959. *Department of External Affairs, Canada*.

696. CONSTANTIN BRANCUSI (1876–1957). The Kiss.
Limestone. 1908. *Philadelphia Museum of Art.*

699. RAOUL LARCHE (1860–1912). Loïe Fuller Dancing.
Table lamp. c. 1900. *Musée des Arts Décoratifs, Paris.*

697. GASTON LACHAISE (1882–1935). Dolphin Fountain.
1924. *Whitney Museum of American Art, New York.*

*If we compare a Brancusi dating from early in the 20th century,
a construction by Vantongerloo dating from the 1920s and
an abstract relief by Nicholson done in 1939 we can see the
continuity in sculpture of the intellectual tradition of
plastic purity, which has evolved from stylised representation
[696] to total abstraction [698, 700]. But the opposite tendency
has also shown a vital development — from the figurative
[699] through the stylised [697] to the non-objective [701] —
always, however, maintaining the dynamism of the curved line
and always refusing to enclose the composition within a
limiting and geometric frame.*

700. BEN NICHOLSON (b. 1894). Relief. Synthetic material,
painted. 1939. *Museum of Modern Art, New York.*

701. ANTOINE PEVSNER (1886–1962). Sense of Movement:
Spatial Construction. 1956.

698. GEORGES VANTONGERLOO (1886–1965). Construction
in an Inscribed and a Circumscribed Square of a Circle.
Cement. 1924. *Peggy Guggenheim Collection, Venice.*

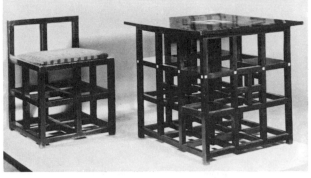

702. CHARLES RENNIE MACKINTOSH (1868–1928). Table and chair for Miss Cranston's tea rooms in Glasgow. *Victoria and Albert Museum.*

The decorative arts do not escape the duality found in the other fields of art. For over half a century the evolution of furniture design has faithfully followed one or other of the two tendencies — either the geometric tradition, in which forms can be reduced to a parallelogram [702, 703, 707], or the tradition of flexible curves which follow the dynamic freedom of projectiles in space [705, 706, 704].

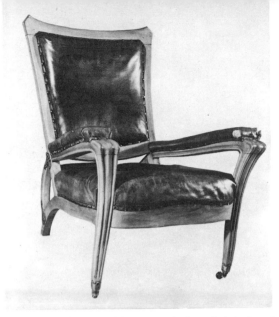

705. OTTO ECKMANN (1865–1902). Armchair in beechwood and copper with leather upholstery. *Prince Ludwig of Hesse Collection, Wolfsgarten.*

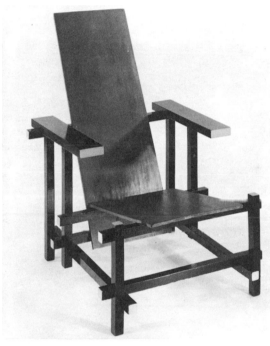

706. LUDWIG MIES VAN DER ROHE (1886–1969). Lounge chair (Barcelona chair). Leather, with chrome-plated steel bars. 1929. *Museum of Modern Art, New York.*

703. GERRIT RIETVELD (1888–1964). Armchair in painted wood. 1917. *Museum of Modern Art, New York.*

707. GIO PONTI (b. 1891). Dining chair with ebonised frame and twisted silver cellophane seat.

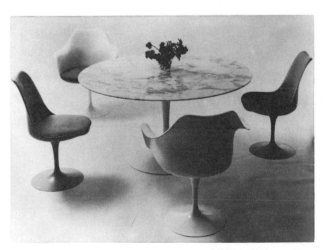

704. EERO SAARINEN (1910–1961). Pedestal chairs. Fibreglass and spun aluminium. 1956.

THE BEGINNINGS OF MODERN ART

Jean Cassou

Modern art has its beginnings not with the advent of the 20th century, but with the conclusion of the Impressionist movement. The last painters to be associated (somewhat incorrectly) with the movement were dissatisfied with it as a means of expression and had begun to question the validity of the realist postulate on which art had rested for centuries. Could not the image of the real be used in a new way, to express the indefinable element of individuality, or even to create a world of plastic form which would abandon nature's laws for its own? It was the beginning of experiment and adventure.

On the death of the painter-collector Caillebotte in 1894, his legacy of his collection of Impressionist paintings was bequeathed to the state. After lengthy debate and with great reluctance the public authorities accepted seven pastels by Degas, eight Monets, two Cézannes, seven Pissarros, six Sisleys, Manet's *Balcony* and *Angélina* and six Renoirs including the *Moulin de la Galette*. But twenty-seven works were returned to the heirs; they were not acceptable. The exhibition of the accepted paintings in the Luxembourg palace in 1896 sparked off the greatest furore — questions in the Chambre, etc. Impressionism, whose début in 1874 had been a hilarious joke, had become, at the end of the century, a seriously debated scandal.

The 19th-century contribution

In the meantime Impressionism had produced three geniuses, Cézanne, van Gogh and Gauguin, each of whom abandoned its nebulous play of light to follow his own bent and to pave the way for new trends in art. The individuality of these three was so powerful and so inimitable and their contributions were so definitive and so much a break with the past that the scandal became a hue and cry. Thus all modern art springs from an *art maudit*. This has conferred a very special significance on the act of painting or of carving a work of sculpture as it has been conceived and practised since the end of the 19th century. It has become in fact a subversive activity stamped with an infamous character; it has become an act of opposition, and thus it takes on a responsibility. It was given this significance by the three above-mentioned masters, whose example was a synthesis and a condensation of all the artistic tradition of the past. Henceforth to choose to be a painter was to accept a personal risk, to give oneself up to a singular activity utterly different to what society meant by the word ' painter ' (a term it reserved for a whole category of civil servants whose career took them from art schools via official exhibitions to the Academy). But art as practised after the Impressionists by Cézanne, van Gogh and Gauguin was not a social function; it was an act of the intellect drawing on all its resources to achieve an unlimited freedom of invention. So the history of art inevitably took on the aspect of a series of revolutions.

With this entirely new outlook one can discern, in each of the styles initiated by the last great 19th-century painters, a fertile contribution and a powerful potential. Each of these styles is not only of value in itself and for the masterpieces it produced; it is also of value for those movements which often went beyond it in innovation and scope. Cézanne gains in significance through Cubism and the other constructivist movements which stem from him; van Gogh gains through the Fauves and Expressionists, and Gauguin through his violent

reaction against Impressionism and his Symbolism, which generated later tendencies in style and expression.

If for a time painters tired of those supreme examples of Impressionism, Monet's *Water-lilies*, these works yet retained 414 sufficient magic power to eventually re-emerge to inspire certain trends in present-day non-figurative art. Renoir in his late work applied his brilliant technique to paintings of nude 435 women; these works involved studies of volume entirely different from the original orthodox aesthetics of Impressionism. A new use was made of pointillist technique with the Divisionism that was the final phase of Impressionism. Seurat, 458, a gifted theoretician, formulated and systematised the discoveries of Impressionism and created Neo-Impressionism, a scientific Impressionism. Seurat's more formalised genius organised the Impressionists' juxtaposition of colour patches and changing play of light into a static and clear-cut composition in which the forms of objects and figures regain substance. Thus light, of sovereign importance to the Impressionists, loses with Seurat the power of dissolving things, giving them new solidity instead. Later painters who were concerned with construction owed much to his theories.

The Impressionists' preoccupation with light had led them to study not only the effects of natural light but also those of artificial light, of gaslight; they sought these effects in nocturnal pleasure spots such as dance-halls, popular or fashionable theatres, the opera, fairground booths and cabarets. These places were interesting for their setting and their characters as well as for their lighting effects. Those Impressionists who frequented them found occasion to satisfy a curiosity other than a pure interest in colour and light, a curiosity that enables us

708. PIERRE BONNARD (1867–1947). Two sections of a screen printed in lithography. 1899.

686
691
687

to observe the life and entertainments characteristic of the times. We must not forget that Impressionism was contemporary with naturalism in literature, whose leading advocate was Zola, and that a current of realism, always present in French art, also emerged from Impressionism. If Degas belongs to Impressionism he is no less, by his draughtsmanship and by his melancholy upper-class Parisian temperament, representative of that realism. One of the greatest realist painters was Toulouse-Lautrec. He too was a draughtsman. Unlike the Impressionists, who presented the viewer with an optical apparatus exclusively sensitive to colour, he thought in terms of line, using it to create space and to place living characters in it, characters whose gestures, movements, grimaces, whose tragi-comic existences, were drawn with an ironic line.

In direct contrast to this realist trend were the paintings of Odilon Redon, whose work was akin to that of the Symbolist poets. His art delighted des Esseintes, Huysmans' decadent aesthete, who, however, only enjoyed the fantastic aspect of Redon's work without appreciating the conscientious craftsmanship and the solid knowledgeable technique. And what he could not of course foresee was that Redon's strange black-and-white portrayals of an inner world, as well as the electric colouring of his paintings, would be assimilated by the Surrealists, as would his technique of combining purely plastic elements with a mysterious poetic quality.

Modern art at the end of the 19th century was a dynamic and a dialectic. It was an interplay of conflicting forces. In each work of art one had to elicit a *significance*, and considered as a whole this art had a meaning and a direction. The work of each artist signified something, and that something required a development, which could lead to an expanded, unexpected or even contradictory significance. A work of art was not limited to its current existence and to the powerful shock it might produce; it was pregnant with the future — with many possible futures.

Art Nouveau

All the experiment and innovation of the art of the end of the 19th century took place beyond the bounds of society, official sanction and public taste. Nevertheless this art held a certain allure for that world. If to society modern art was a dangerous enemy, a kind of evil genius, it exercised like all such forces an insidious attraction. In due course even the most conventional circles adopted 'modernism'. In France artists such as Le Sidaner and Besnard introduced a kind of vulgarised Impressionism to society. Whistler's work and the Japanese influence were popular, together with a sort of cosmopolitan art brought in by brilliant foreign artists living in Paris. The exhibitions of the Society of Pastel Artists revealed an agreeable and fleeting freedom of colour which was in keeping with the grace and feminine sensibility of the times. Indeed, throughout his early youth Proust was enchanted by this art.

The modern style, however, really came into its own in those arts to which social life is most closely tied, that is, in architecture, furniture, interior decoration, etc. Nothing is so dismal as the domestic architecture of the years preceding 1900 — an eclectic, composite architecture — and the correspondingly dingy interiors with their dreary curtains and stained glass windows. The European taste of that period, which the French call *bourgeois*, the Germans *Kitsch*, the Spanish *cursi* and the Russians *mestchanstvo*, is appalling, and understandably certain artists wished to endow the period with a style. It would have to be a decorative style and should therefore be found in one's everyday surroundings. These artists wished to incorporate recent technical and industrial developments, to make

use of manufactured materials — ceramics and glass — as well as wood, pewter, silverware, etc.; in short, the arts formerly decried as minor or mechanical arts. Similar ideas had been voiced earlier in England (by William Morris and the Pre-Raphaelites) and occasionally in the France of Napoleon III. Though we may smile at the floral arabesque of the *fin de siècle*, or 'Modern Style', or 'Art Nouveau', or even 'noodle style', or at the Parisian girl in the flared skirt who stood at the entrance to the 1900 Exhibition, we should do justice to the efforts of the true craftsmen of this style, such as Gallé, Majorelle and Grasset, and to an architect such as Hector Guimard. They have created a kind of breathless Baroque which one can compare with certain debased phases of Baroque, such as Rococo. The iron flora of the Métro, or such a work as the delightful theatre of the Musée Grévin, with its curtain by Chéret, are not without a certain bizarre charm. But it was in the architecture, with its daring use of the new materials offered by industry, that changes occurred which were something more than mere amusing or charming whims but were in fact the beginnings of a revolution — a revolution capable of continuing development and appropriate as an expression on the artistic level of the industrial revolution. Two important metal constructions were built for the Paris Exhibition of 1889 — the Galerie des Machines and the iron Eiffel Tower.

Art Nouveau (sometimes called the 1900 Style) was international. In England, where the style had been endorsed by the ideas of William Morris, Art Nouveau was developed by the Glasgow school. In Germany the movement was known as the *Jugendstil*. In Belgium Victor Horta and Henri van de Velde developed the style to a point which anticipated functionalism, for the future building material was to be reinforced concrete, which called for a new aesthetic principle. Enormous frameworks gave buildings an appearance of simplicity that was inconsistent with the old ornamental devices. Nevertheless, many possibilities for decoration (such as frescoes) were offered by the facings; also blank areas could be filled by other materials such as bricks or ceramics, which produced interesting contrasts.

The only great architect of the Art Nouveau style was the Catalan Antoni Gaudí, who attained the creative power characteristic of the Baroque grand manner. Although his imagination was extravagant it was also founded on sound mathematics and a prodigious technique. Gaudí's fantasy was, moreover, characteristic of that rich complexity and vitality that characterised Barcelona at the time and that made up the climate in which Picasso grew up. It was a climate favourable to genius.

The Nabis

Traces of the 1900 spirit and its taste can be seen in the work of the Nabis, artists who, while borrowing certain elements from Impressionism, formed a new group at the end of the century. The Nabis were interested in the contemporary scene and came under the influence of the newly popular Japanese print. This art form had been much admired by the Impressionists and by van Gogh and Gauguin; it had then become fashionable, and the fashion had pervaded the luxury shops and smart drawing-rooms. The Nabis were following the current taste. But the Japanese print was also in keeping with their own artistic bent and represented as well the heritage of their masters. It had been accepted by Gauguin in his use of flat colour.

Indeed, it was Gauguin's example that they followed above all. In 1888, during his second stay at Pont Aven and before the Arles crisis, Gauguin had inspired Sérusier to paint an arrangement of pure colours on a wooden box lid; this was the

470

692

619

531

413, 680

554

563

463, 687

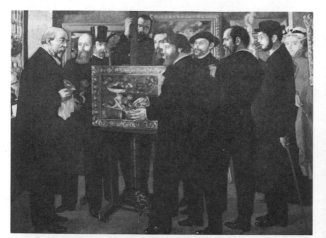

709. MAURICE DENIS (1870–1943). Homage to Cézanne. The figures are, from left to right: Redon, Vuillard, Mellerio, Vollard, Maurice Denis, Sérusier, Ranson, Roussel, Bonnard and Mme Maurice Denis. 1900. *Musée d'Art Moderne, Paris.*

In their reaction against Impressionism the Nabis found themselves in agreement with Cézanne. Maurice Denis said, 'Cézanne's example taught us to transpose given sensations in terms of artistic expression.'

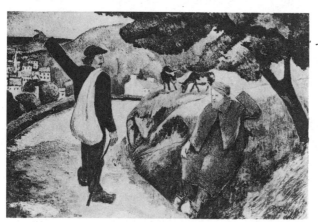

710. PAUL SÉRUSIER (1865–1927). Farewell to Gauguin. 1906.

711. EDOUARD VUILLARD (1868–1940). Wall decoration for Dr Vaquez. 1896. *Petit Palais, Paris.*

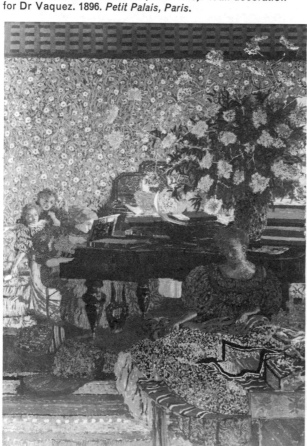

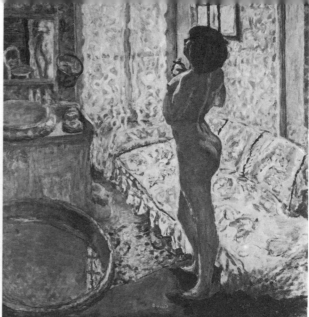

712. PIERRE BONNARD (1867–1947). The Eau de Cologne. 1908–1909. *Musées Royaux des Beaux-Arts, Brussels.*

713. FÉLIX VALLOTTON (1865–1925). The Rape of Europa. 1908. *Kunstmuseum, Berne.*

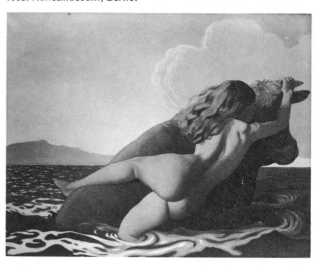

Talisman that Sérusier showed, on his return to Paris, to his friends at the Académie Julian. This painting was the origin of Maurice Denis' famous definition of contemporary painting: ' . . . before being a charger, a nude woman or any anecdote, [a picture] is essentially a flat surface covered with colours arranged in a certain order'. This vindication of pure and autonomous painting continues to serve, under various forms, as a signpost for all modern art.

The Nabis, with their awareness of the various aspects of modern life, participated, with their posters, programmes, stage settings, illustrations, etc., in the various new ventures such as the *Revue Blanche* and the Théâtre de l'Oeuvre. A new bourgeoisie had come into power, a liberal bourgeoisie of administrators, managers, art patrons and enlightened industrialists, and these people had the insides of their houses decorated by the Nabis. The art of the Nabis was an intimate art, an art of domestic interiors, whose most exquisite master was Vuillard. Bonnard carried this intimacy beyond the window to gardens and other outdoor scenes. But his genius was such that a mere detail of nature suffices to sum up all nature and to express a kind of cosmic intoxication. And his clever and delicate brush strokes and subtle colour values became, in his mature and late periods, a frenzy of colour, a hymn to nature in which forms, proportions and distances are

709

711
708

fused, an eternally youthful art which, with its arbitrary arrangements and capricious placing of dazzling highlights, seems to foreshadow Tachisme.

A definite spiritual quality in the painting of the Nabis seems contrary to the fundamental anarchy of the movement, but we find this quality in other arts at this time — in the poetry of Francis Jammes, for example, and in Gide's *Fruits of the Earth* (*Nourritures Terrestres*), with their nostalgia for the primitive and for nature. This attitude was championed in painting by Maurice Denis; it also appeared in religious art. Various Catholic circles in France, Germany and Switzerland wished to integrate art with religion. There were two currents to this movement. One took the form of an attempt to reconcile Thomist scholasticism with the modern world and to return to the fundamental principles of art. The other tried to adapt Christianity to the economic, social and technical conditions of the modern world, to make bold use of industrial techniques, new materials and contemporary style in church architecture 859 and interior arrangement (Perret's church at Le Raincy, France).

The sculptor Aristide Maillol had been associated with the Nabis early in his career. With him sculpture acquired new aims that were in keeping with the times. Rodin's influence was still paramount, with its twin currents of Romanticism and Impressionism (the monumental pathos of the former, the fluid dynamism of the latter). Feelings, inner impulses (stemming from Romanticism) and a submission to the mobility of light and the fleeting passage of time (stemming from Impressionism) quicken the images wrought by Rodin's hand. One of the fundamental aims of the modern spirit was to restore the autonomy of painting and to free it of anecdote and representation; the same applied to sculpture. Even the emotional 715 Bourdelle played his part in restoring to sculpture its quality of monumental composition, bringing it to something approach-714 ing architectural detachment. Maillol, a Mediterranean man and a true heir of the Greeks, confined his sculpture to studies of the female nude which are truly classical in their monumentality and timelessness and their objective treatment of form.

The predominant aim of the modern artist, starting with Cézanne, van Gogh and Gauguin, or even Manet, has been to discover the basic nature of art. The predominating activity of the times has been analysis, the search for the fundamental principle. And this aim on the part of the modern artist has been reinforced from without. His own lack of official recognition has placed him on the outskirts of society, painting for himself and possessing nothing but his own destiny — a destiny which is a process of analysis intended to lead painting and sculpture back to their specific function — that of inventing forms and producing objects with lines, colours, proportions, surfaces, masses and volumes.

Expressionism

Gradually, despite the government and academic authorities and despite public censure, Impressionist paintings were being bought by collectors and museums in Europe and America. Everywhere a lively interest arose in the aesthetic revolutions taking place in France which seemed to confirm the idea that all artistic creation was essentially subversive. This idea spread. The act of painting was regarded as dangerous and offensive. And indeed, painting took on such characteristics with ever greater violence.

This violence made itself felt with the founding of the Brücke (Bridge) group in Dresden in 1905 and with the Fauve room at the Salon d'Automne in Paris in 1905. The Brücke had

714. ARISTIDE MAILLOL (1861–1944). Venus with Necklace. 1930.

715. ANTOINE BOURDELLE (1861–1929). Noble Burdens. 1912. *Musée Bourdelle, Paris.*

been preceded by the various trends in both literature and art which led to the movement known as Expressionism. Here was a new manifestation of the eternal Germanic Romanticism, of the *Sturm und Drang*, in which deep instinctive forces reappeared. Strongly influenced by van Gogh and Gauguin, these Expressionists owed much to the Swiss painter Böcklin, 477 to Hodler, and above all to the Norwegian painter Munch, that 646, 717 powerful visionary who could fill an everyday scene with a sense of panic and anguish. Munch had had some contact with the Nabis in Paris, and one can find in his work echoes of the Parisian atmosphere of the period, of the bitter and rebellious humanitarianism and of the sarcastic realism of the Nabi Vallotton. But it was in central Europe that Munch's work had 713 its greatest success. The influence of his woodcuts, in particular, resulted in an entire idiom of torment and pathos which remains one of the most characteristic aspects of the Expressionist school.

Expressionism needed to create an imagery. This art, composed as it was of action and struggle, could not divorce itself from social revolt. This art was not a decorative embellishment to life, as art had been in periods in which it was in some harmony with the ruling classes; it was rather an illustration of all that was contradictory, gloomy, disagreeable and monstrously iniquitous in life. Indeed, Expressionism gave rise to that social art vigorously typified by Grosz. This attitude to 721 life — even when below the surface — is always implicit in Expressionism as a movement in art; it is true of the Brücke and of the even more important group which succeeded it in 1911 in Munich, the Blaue Reiter.

The Expressionists felt a rapport with the Fauves and Cubists (particularly with Le Fauconnier and Delaunay) and invited them to their exhibitions. They also sought the patronage of Odilon Redon, whose lyricism and mystery was akin to their 692 art. This leads us to consider the part played in Expressionism by the Symbolist heritage. Though French in origin, Symbolism had been marked by cosmopolitan influences, the most important being the Belgian, or Flemish. Indeed, this survey of European art at the beginning of the 20th century would not

EXPRESSIONISM

716. JAMES ENSOR (1860–1949). Skeleton looking at Chinoiseries. 1885. *Louis Bogaerts Collection, Brussels.*

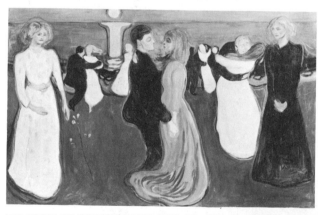

717. EDVARD MUNCH (1863–1944). The Dance of Life. 1899–1900. *National Gallery, Oslo.*

718. ERNST BARLACH (1870–1938). The Avenger. Bronze. 1923. *Ernst Barlach Haus, Hamburg.*

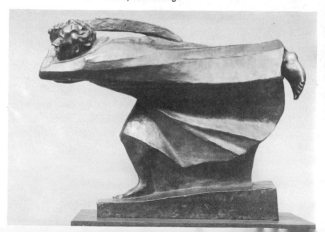

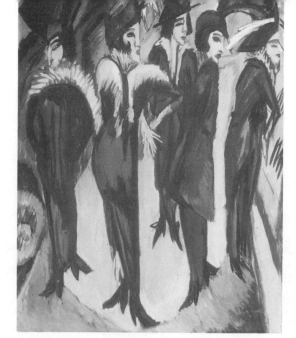

719. ERNST LUDWIG KIRCHNER (1880–1938). Five Women in the Street. 1913. *Wallraf-Richartz Museum, Cologne.*

720. EGON SCHIELE (1890–1918). Portrait of Edward Kosmack. 1910. *Österreichische Galerie, Vienna.*

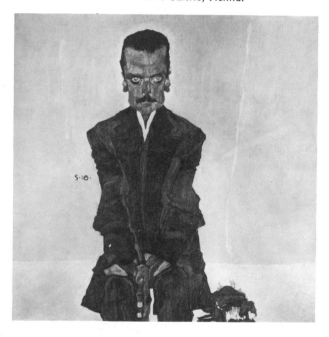

721. GEORGE GROSZ (1893–1959). Homage to Edgar Allan Poe. *c.* 1920.

be complete without an examination of Flemish Expressionism.

Expressionism was not only a manifestation of the Germanic genius but of the northern European genius as a whole. Russian and other Slavic influences also played their part — particularly with the contribution of Wassily Kandinsky. We find ourselves here in the presence of one of those vast, passionate impulses from the northern and eastern plains which have often in the past confronted the more rational and cerebral French art. There was passion too in French art, and the break with tradition as well — especially among the contemporary avant garde, and among this avant garde were painters who had much in common with the Germanic and Slavic Expressionists. There is none the less a certain amount of truth in the somewhat over-simplified theories of certain Germanic aestheticians who contrast symbolically Rome and the Mediterranean and Latin traditions with their intuitive, expressive, dynamic, 'informal' art and the purely metaphysical, religious, musical, decorative, abstract tendencies of the nomadic and barbarian traditions.

So, towards the turn of the century, a great painter of mysterious and fantastic poetic genius appeared in Belgium, in Ostend on the North Sea. This was James Ensor, whose painting was typically Expressionist. About this time, too, artists and poets came together in the small Flemish village of Laethem St Martin, creating a kind of spiritual community in which various Expressionist painters developed (Gustave de Smet, Frits van den Berghe and the robust Constant Permeke).

The Fauves

Fauvism may appear, because of its explosive character, to be a form of Expressionism — and perhaps for that very reason it could not last. Dependent on instinct and emotion, on a moment of illumination captured in arbitrary and pure colours, Fauvism, after producing in a few years a series of dazzling paintings, came to an end. The Fauves went on to pursue their individual careers. The greatest of these was Matisse. It was Matisse who asserted the importance of sustaining the impulses with intellectual effort, of subjecting the intuitive vision to a long process of lucid methodical thought developed during the course of a lifetime.

In all Matisse's work, which is consistently brilliant, one can recognise traces of Fauvism; the same is true of Dufy, that prodigious designer and colourist. Marquet, who retained from his Fauvist phase an extraordinary vivacity of eye and hand, turned it to a more serene expression of nature. Rouault, who like Matisse and Marquet had studied with Gustave Moreau, never exhibited with the Fauves and was in fact one of the rare French painters whom one can call an Expressionist. And the roots of his Expressionism lie in his feeling for medieval art. (Rouault began his career as a restorer of medieval stained glass windows.)

One of the happy features of 20th-century art is that it has produced decisive aesthetic revolutions and, at the same time, powerful and original individuals. Individual artists made the revolutions, but the revolutions were experiences which brought out their particular talents and allowed these artists to develop along their own lines. Matisse, Dufy, Marquet, Friesz, Vlaminck, Derain and van Dongen were all Fauves at one time, subsequently each pursued his own artistic ends according to his own particular temperament. Henceforth we must follow the separate destinies of each painter, and — in studying the art of our century — we must examine their later phases, for example Derain's return to the classical spirit and the return to nature of Marquet and Vlaminck.

722. GEORGES ROUAULT (1871–1958). The Old King. *Carnegie Institute, Pittsburgh.*

The Cubist revolution

The Cubist movement was the most extraordinary artistic revolution of the century. Cubism followed immediately upon Fauvism, to which it was fundamentally opposed in its theories, as it was opposed to all expressionistic art. With Cubism painting was brought to the peak of intellectualism. In its day, however, Cubism was considered absurd and freakish, and the question was raised as to whether innovations of a sensory nature relating to colour and form, such as were proposed by the Fauves and the Expressionists, were not less sacrilegious than innovations presented to the intellect and stemming from the intellect, and consisting of geometrical speculations instead of and in place of representational objects. It seemed that such subjects as a red tree by Vlaminck, a yellow London sky by Derain, an opalescent Matisse nude, simplified like a primitive or child drawing, a dynamic abstract colour composition by Kandinsky or a mottled and minutely detailed Klee landscape whose secret might lie in its inner poetry, were less offensive, all things considered, than those odd Cubist canvases which invited the intellect alone to consider the interaction and correlation of planes, angles, curves and geometrical solids — austere compositions devoid of the natural elements (light, atmosphere, space) that make up the richness of the visible world. The Cubists tried to reduce painting to a few basic principles accessible only to the intellect. Certain concepts were broken down and separated from each other — the concept of light from that of shade, the concept of ground plan from that of elevation, the obverse from the hidden but known reverse. These separate concepts were treated simultaneously on the same canvas. And we are so made (and herein lies a remarkable paradox) that the audacities of reason outrage us to a greater degree than does the excess of feeling.

A few objects sufficed as subjects for the Cubist painter's analysis, objects which make up the restricted world of the still life, a world ready to hand and entirely submissive to the will of the artist in his studio; these objects included pipes, carafes and guitars, and other items which are typical of everyday life, and in these the form or shape, the essential pictorial (rather

723. HENRI MATISSE (1869–1954). St Tropez. 1901. *Musée Léon-Alègre, Bagnols sur Cèze.*

724. GEORGES BRAQUE (1882–1963). Landscape at L'Estaque. 1907. *Pierre Lévy Collection, Troyes.*

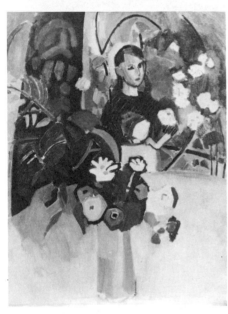

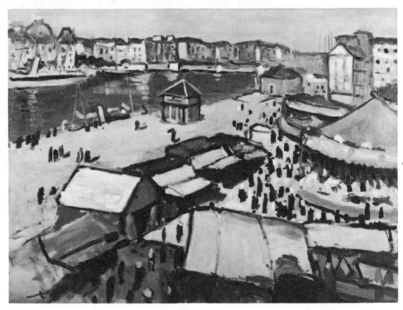

725. RAOUL DUFY (1877–1953). Among the Flowers. 1907. *Private Collection.*

726. ALBERT MARQUET (1875–1947). Street Fair at Le Havre. 1906. *Musée des Beaux-Arts, Bordeaux.*

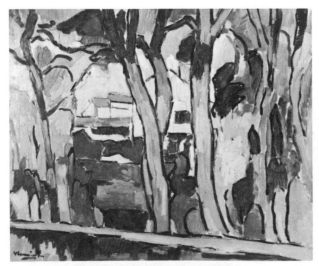

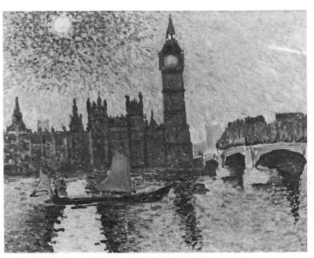

727. MAURICE DE VLAMINCK (1876–1958). Landscape with Red Trees. 1906. *Musée d'Art Moderne, Paris.*

728. ANDRÉ DERAIN (1880–1954). Big Ben. *c.* 1905. *Pierre Lévy Collection, Troyes.*

729. PABLO PICASSO (1881–1973).
Reservoir at Horta de Ebro. 1909.
Private Collection.

730. GEORGES BRAQUE (1882–1963).
Violin and Palette. 1910. *Solomon
R. Guggenheim Museum, New York*.

731. FERNAND LÉGER (1881–1955).
Nudes in the Forest. 1908–1910.
Rijksmuseum Kröller-Müller, Otterlo.

732. *Above.* JUAN GRIS (1887–1927).
La Place Ravignan (Still Life before
an Open Window). 1915. *Philadelphia
Museum of Art*.

733. RAYMOND DUCHAMP-VILLON
(1876–1918). The Horse. Bronze. 1914.
Museum of Modern Art, New York.

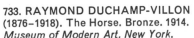

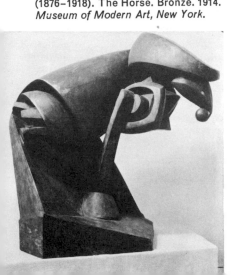

734. *Above.* JACQUES LIPCHITZ
(b. 1891). Man with a Guitar. 1915.
Museum of Modern Art, New York.

735. PABLO PICASSO.
Woman's Head. 1909. *Museum of
Modern Art, New York*.

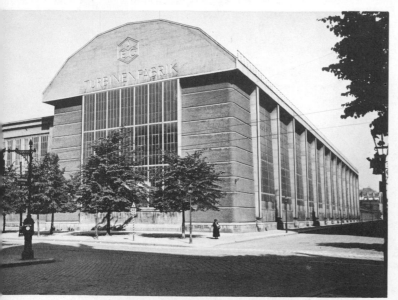

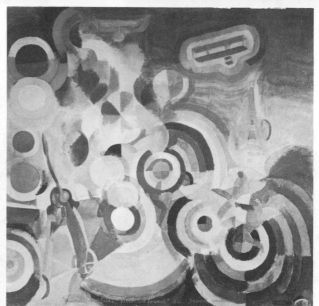

736. GERMANY. PETER BEHRENS (1868–1940). AEG turbine factory, Berlin. 1909.

737. ROBERT DELAUNAY (1885–1941). Homage to Blériot. 1914. *Private Collection*.

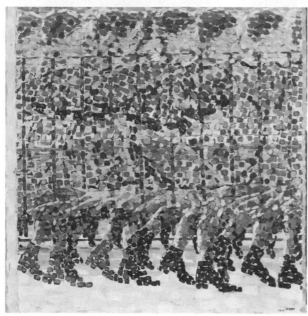

738. GIACOMO BALLA (1871–1958). Girl running along a Balcony. 1912. *Galleria d'Arte Moderna, Milan*.

739. FRANZ MARC (1880–1916). Fighting Forms. 1914. *Bayerische Staatsgemäldesammlungen, Munich*.

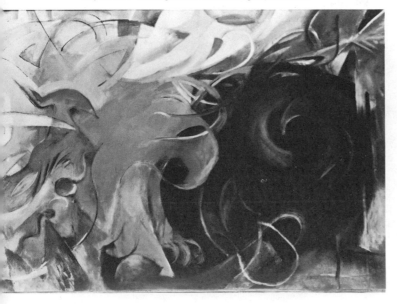

than sentimental) quality, was emphasised; also these objects tended to be standardised, and thereby their significance was generalised. They were combined in an objective, mathematical and mechanical way, almost as if they were machinery. Léger became convinced that Cubism was the art of the machine age; and indeed his painting is the very essence of the 20th century. The First World War, the first great war of this century, contributed to the Cubist conviction that man is confronted by a naked world, stripped of its adorning vegetation and of all natural life, a world animated solely — in the murderous pursuit of victory — by the calculations of machines and projectiles.

The Cubist revolution was the major artistic revolution of this century. It originated seven years before the First World War in places which have since become legendary, such as the Bateau-Lavoir in Montmartre; it was championed by such poets as Apollinaire, Max Jacob and Blaise Cendrars. The upheaval occasioned by Cubism in art brought with it other new trends: the discovery of African art, which upset European ideas of taste and of the hierarchy of styles and broadened European knowledge of the history of civilisations; the appreciation of the naive, popular and masterly genius of Douanier Rousseau; the contribution of the sumptuous Ballets Russes. This last, after its earlier and exclusively Russian period, became in its second period a kind of synthesis of all the arts of the pre-War years. Indeed, all the important discoveries were brought together in the Ballets Russes and presented by the impressive genius of Diaghilev. Stravinsky, Satie, Milhaud, de Falla, jazz, all the latest innovations in music — these were combined with those in painting and with a great deal of ingenuity and fairground gusto. The result was to produce *entertainment*, in other words to impose art finally on a vast public.

Cubism contributed to architecture and the industrial arts in completely transforming our way of life and our surroundings, introducing everywhere the brightness and clean lines of formal simplicity. The Théâtre des Champs Elysées (completed 1913), Auguste Perret's masterpiece, is an excellent example of that architectural revival whose guiding spirits were Berlage in Holland, van de Velde in Belgium, Frank Lloyd Wright in the United States, and in Germany Behrens, in whose studio Gropius, Mies van der Rohe and Le Corbusier all worked. (During the First World War Gropius succeeded van de Velde as head of the Weimar art school, which in 1919 became the Bauhaus.)

740. MARCEL DUCHAMP (1887–1968).
Nude descending a Staircase, No. 2.
1912. *Philadelphia Museum of Art.*

741. MAURICE UTRILLO (1883–1955).
Church at Châtillon. 1911.

742. SUZANNE VALADON
(1867–1938). Nude with Striped
Blanket. 1922. *Musée d'Art Moderne
de la Ville de Paris.*

Cubism also helped bring sculpture back to pure form and volume, to the fundamental discipline of first principles.

In reverting to their initial purity and original immediacy the arts became free of the narrow academic prejudices which had encumbered them. For example, the assumption that certain materials are appropriate for each of the arts had become a strict dogma (oils for painting, stone for sculpture, etc.). But the act of creating, in its initial state and therefore in its essence, is a unity, and it is creation alone that is important, not the medium which official habit assigns to it. The creative impulse may express itself with whatever comes to hand — metal, a bit of string or a piece of cardboard; sand may be mixed with paint, and paper or scraps of newspaper may be stuck on the canvas. Art is an arrangement of various things with a view to producing from them another, new and unusual thing. Art is essentially metaphor — one might even say poetry.

After Cubism

The Cubist and Cubist-influenced sculptors (Laurens, Brancusi, Lipchitz, Zadkine) developed their individual powers of imagination and invention from this new freedom. In addition, the genius of each of them soon appeared to be decisive and original. It was the same with those painters who had moved from Cubism to other developments — Léger to monumental compositions of popular inspiration, Braque to a classicism in the deepest sense of the term. Braque, who was one of the first Cubists, remained Cubist in spirit throughout his career with a classicism which reminds one of Poussin. With Picasso, who might be called the first Cubist, the development of the artist does not show the same continuity. Picasso's genius shines forth in a series of heterogeneous but equally astonishing phases. He symbolises all the extreme, striking, powerfully arbitrary and unexpected aspects of modern art. Indeed, few centuries have known a single individual who so sums up the artistic contributions of his era — and an individual in whom

the spirit of adventure is so strong and so invariably constant.

The founder of Orphism, Delaunay, moved from a Cubist technique in which colour and construction were all-important towards non-objective colour compositions which foreshadow later developments. It is important to study the work of all those Cubists who were later swept along by the same wave of discovery: Gris, Gleizes, Marcoussis, Lhote, Jacques Villon and so many others, including Roger de la Fresnaye and the sculptor Raymond Duchamp-Villon (the last two of whom died of illnesses contracted during the First World War).

Indeed, a veritable Renaissance, international in scope and universal in significance, was taking place in art. Its hub was Montparnasse which, with its cafés and studios, drew to itself the leading talents of Spain, Italy and the ghettoes of eastern Europe — and even of countries as distant as Japan. To the names already mentioned we must add those of Modigliani, Soutine and Chagall, and other painters not originally from France who made up the school of Paris.

In Paris in 1909 Marinetti's Futurist manifesto appeared in *Le Figaro*; this was followed in 1910 in Turin by the proclamation of the manifesto of the Futurist painters. Italian Futurism, which was dominated by the genius of Boccioni (a painter and sculptor who died during the First World War), introduced into the new — and generally static — plastic inventions the time factor and a lyricism inspired by the dynamism of modern life. Similar aims appeared at this time in French art. A short time later the avant garde movements which at first accompanied the Revolution in Russia put out new shoots in Paris. The Dutch movement De Stijl, precursor of the most severe current in abstract art, originated in 1917; its artists have worked in Paris at various times. Thus during this period Paris was the centre of ideas and trends in art.

If Montparnasse was the current nucleus of artistic ferment, the more romantic tendency in painting was continued in Montmartre by Suzanne Valadon and her son Maurice Utrillo.

791
788

902

770

-760
914

737

688, 749
750, 751
733

747
745, 746

660, 941

741, 742

ART AFTER THE FIRST WORLD WAR

I. THE EXPLOITATION OF THE EARLIER DISCOVERIES

Bernard Champigneulle

After the First World War the movements in art become so complex and so numerous that it seems preferable to deal with them in two separate sections, one concerned with those artists who chose to limit themselves to developing and expanding the existing ideas, the other concerned with artists who broke radically with the past and created new movements. The following section deals with the former group, whose work either stemmed from or perpetuated the pre-War discoveries.

By the end of the First World War the important problems of contemporary art had all been stated, and the trends in present-day art had already been foreshadowed.

The reversal of values

Cubism, which had had its beginnings some ten years earlier, had known its zenith and its decline. Its spokesman Guillaume Apollinaire was dead. Braque, Picasso and many other artists had turned to other experiments. Having run its course and come to a standstill (despite the enthusiasm with which it had been greeted a short time previously) Cubism degenerated into sterile formulas and soon ceased to exist as a movement.

In the period between the Wars extraordinary changes took place. Greece and Rome ceased to be the leading authorities. The canons of classical art fell out of favour. There was a complete reversal of values. Artists, critics, art historians and a part of the public, following in the footsteps of the great precursors of the previous century, turned to primitive art or the nearest thing to it.

They were drawn to Romanesque and earlier medieval architecture rather than to Gothic. Frescoes, illuminated manuscripts, and sculptures which had previously been considered barbaric, were now 'discovered'. African and Oceanic art were given a place of honour. Automatic drawings and the art of mental patients were studied, and the direct and unsophisticated art produced by children was greeted with interest. As if tormented by the fear of decadence, man sought to renew himself at the fresh springs of primitivism and 'art brut'.

Certain artists wished to free themselves completely of all restraint and to renounce a tradition that weighed too heavily on them. They rebelled against everything that vaguely resembled an artistic prejudice. Other artists, either by instinct or as a deliberate policy, retained an often nostalgic respect for the past. Even when they took part in the great artistic revolts of the 20th century they eventually took up earlier trends again. Such artists synthesise and perpetuate the shifting currents in art which are for ever conflicting or mingling. And these artists will be the object of our attention in this section.

The Cubist movement had been so sudden and so violent, in its brutality as well as its refinements, and had responded to such deep needs, that it inevitably influenced the development of painting. Even those who were opposed to it were affected and fascinated by it. The construction, the synthesis, the disdain for conventional realism and the use of schema and abstraction — all had paved the way to new forms. Everywhere painting, sculpture and even architecture were taking new bearings.

Another feature of early 20th-century art was the resurgence of a sort of Romantic spirit; this spirit expressed itself virulently in both satire and pathos and employed subjective distortion to make its point. The Norwegian Munch, the Austrian Kokoschka, the German Nolde and the Belgians Ensor and Permeke, together with others, mostly from the Germanic countries, were the principal representatives of this movement, which the Munich review *Der Sturm* had named *Expressionismus*. In France a somewhat similar tendency appeared with Le Fauconnier, with Fautrier who turned to abstract painting, and with Gromaire, whose Expressionism took the form of sculptural shapes and architecturally organised composition.

Marinetti's Futurist manifesto had appeared some ten years before the Armistice. The first exhibition of the Blaue Reiter had been held eight years earlier. Abstraction had in fact been pushed to its limits in 1913, when Malevich exhibited in Moscow a painting showing nothing more than a black square on a white background.

The War years, which had done much to disperse the art world, were not, however, a period of stagnation. In Holland Mondrian and van Doesburg, precursors of geometrical abstraction, were publishing the review *De Stijl*, and in Zürich the Dada movement, which ridiculed all existing values in art, was organised. By this time too de Chirico was portraying

717, 7
647, 6
716

817
743

689

944

743. MARCEL GROMAIRE (b. 1892). Woman. 1929.

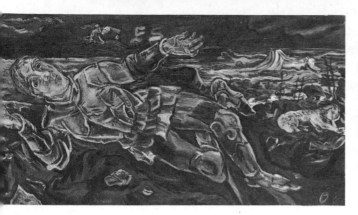

744. OSKAR KOKOSCHKA (1886–1980). Knight Errant, 1915. *Solomon R. Guggenheim Museum, New York.*

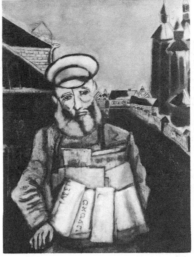

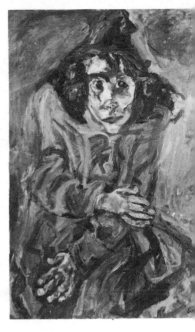

745. MARC CHAGALL (b. 1887). The Newspaper Seller. 1914. *Ida Meyer Chagall Collection, Berne.*

746. CHAIM SOUTINE (1894–1943). The Madwoman. 1920. *Private Collection.*

747. AMEDEO MODIGLIANI (1884–1920). Nude. *Private Collection.*

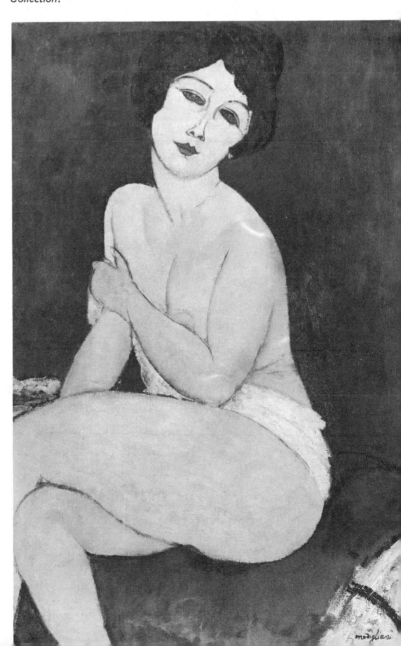

946 those mannequins which people the deserts of the Meta-
physical paintings. Paris was still reeling from the impact of
Diaghilev's Ballets Russes. On 10th November 1918, a few
748 hours before the Armistice was proclaimed, Amédée Ozenfant
and Charles Edouard Jeanneret (who later called himself Le
Corbusier) launched Purism; their manifesto *Après le Cubisme*
acclaimed the machine civilisation which, they said, called for
painting that was rigorous, clear and of a pure graphic style; they
condemned the 'narcissism' of Cubist and abstract painters.

At the end of those four years of total war what was the
position of art? Confusion was at its peak. Individualism was a
kind of dogma. However, the centring of the new movements
around a Parisian nucleus — a process which had largely begun
before the War — became fairly general. From about 1920 the
now universal spirit of revolt and of creation found particularly
fertile ground in Montparnasse, which had supplanted Mont-
martre. The economic inflation had contributed to an artificial
prosperity profitable to both dealers and artists. Americans
were avidly collecting works of art. The material and moral
conditions of the artist-innovator were transformed. Com
mercialism had arrived to augment an unprecedented intellec-
tual curiosity for all that was daring and original. Cocteau
seems to have provided the password: 'Audacity is knowing
how far one can overstep the bounds.' It was in an atmosphere
of feverish discussion and competitive manifestos and contracts
that reputations — both lasting and ephemeral — were made.

The school of Paris (really a misnomer, for nothing could
have been less like a school) grew out of chance meetings
between artists from many countries who lived in Paris and who
generally had no ties, no roots and no real homeland. Far from
forming a group or finding a tradition or seeking (like the
17th-century artists who set out for Rome) to learn from their
elders, they pursued their own personal adventures in complete
independence. Paris for them was not a centre of culture but
the exciting, stimulating city in which they felt able to create
freely. Working in Montparnasse were a few artists of genius
whose paintings bewitched a cosmopolitan and sophisticated
public; and so powerful was their appeal that they gradually
imposed on the world the extravagant impertinences of 'art
vivant'.

A singular contribution was made by those acutely sensitive
Jewish painters of unrest, for whom the instability of life seems
745 to have been a perpetual source of grief. Apart from Chagall
(himself a Wandering Jew) they met with tragic fates, dying
young without having tasted success.

After having depicted with poignant tenderness models as
747 slim and pliant as flowers, Modigliani died in hospital in 1920,
906 wasted by tuberculosis and alcoholism. Pascin, whose delicate
paintings captured the tender melancholy of those disturbing
746 young girls, committed suicide in 1930. And by 1943 Soutine

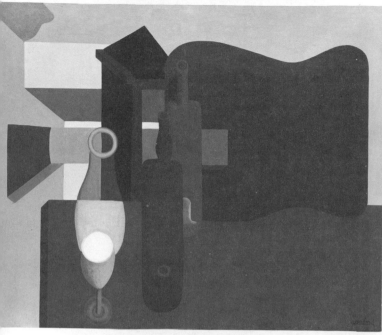

748. AMÉDÉE OZENFANT (1886–1966). Still Life. 1920.
Solomon R. Guggenheim Museum, New York.

749. ALBERT GLEIZES (1881–1953). Composition. 1934.

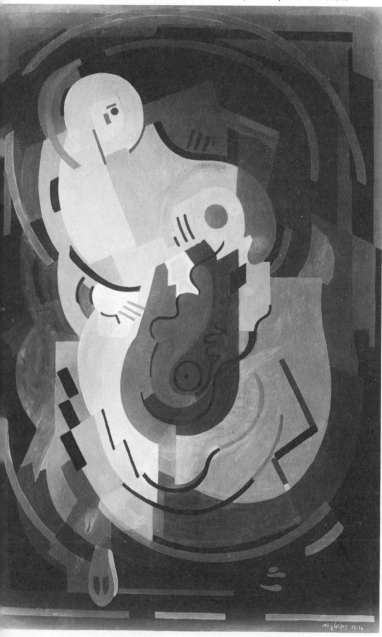

was dead; his paintings of disintegrating flesh and of beings marked for death make a spectacular display of the colours of corruption and decay. Chagall escapes to a dream world, to old dreams inspired by the Yiddish folklore of his childhood, dreams in which it comes as no surprise to see men and animals floating in the sky and lovers joined together above the roof-tops.

From the work of these painters comes a sense of morbid despair, of aversion to life, with, however, an undertone of nostalgic compassion. But if we compare this contempt for the real world with the full-blooded vehemence of Rouault, who **693** flogs vice and fustigates hypocrisy, we realise how far Christian compassion is from Messianic melancholy and to what degree Oriental pessimism is diametrically opposed to the Occidental tradition in art.

These school of Paris painters, however, had little in common with one another. Modigliani's portraits are vividly and solidly modelled, like Cézanne's. In Pascin's work all is fluid, evanescent. Soutine seems to model, without drawing, the flamboyant impasto of his colours. Chagall achieves in his arabesques the simplicity of colour prints.

We also find considerable individuality in the other school of Paris painters: in van Dongen, the ultra-Parisian Dutch painter, **896** whose women from high and low life, portrayed with an acid brush, betray the artist's earlier adherence to Fauvism; in the Polish painter Eugène Zak with his exhausted marionettes; in Severini who introduced Futurism to France (with no great **943** success); in Foujita, a descriptive and meticulous Japanese artist who bridged the gap between Far Eastern and Western art; in the Spaniard Mariano Andreu, an illustrator whose work is delicate to the point of preciosity; in the Polish painter Kisling, with his brilliantly coloured, somewhat stylised works.

The only significance of the short-lived group which at the end of the War took the name 'Jeune Peinture Française' seems to have been the bringing together of French-born painters who had taken part in the Cubist movement or had been influenced by it; these painters, in their turn, helped to spread the influence of Cubism.

Was Cubism truly dead? And what of the 'lesson of Cubism', of its 'beneficial disciplines'? Juan Gris continued to **903** pursue its tradition with discipline and refinement. The more brutal Léger moved away from it. Artists such as Gleizes, who **749, 9** with Metzinger had been one of its theoreticians, moved on to **897** new experiments which had grown out of their earlier Cubist training. Cubism had earlier been considered above all a setting in order, a logical analysis; it was now necessary to fight against the danger of desiccation. This had been of concern earlier to Robert and Sonia Delaunay when they created **737** Orphism (given its name by Apollinaire in 1912), which restored the primacy of colour and which, like Futurism, was concerned with achieving dynamism in art.

The painter Jacques Villon, who with his brothers the painter **751** Marcel Duchamp and the sculptor Raymond Duchamp- **733, 7** Villon had organised in his Puteaux studio the group known as the Section d'Or, gave a perfect description of this phase of Cubism (and of its aftermath): 'Deliberately rejecting

JAMES ENSOR (1860–1949).
The Astonishment of the Mask Wouse. 1889.
Musée Royal des Beaux-Arts, Antwerp. *Museum photograph.*

EDVARD MUNCH (1863–1944). By the Death-bed. 1895.
Rasmus Meyer Collection, Bergen. *Photo: K. Heienberg.*

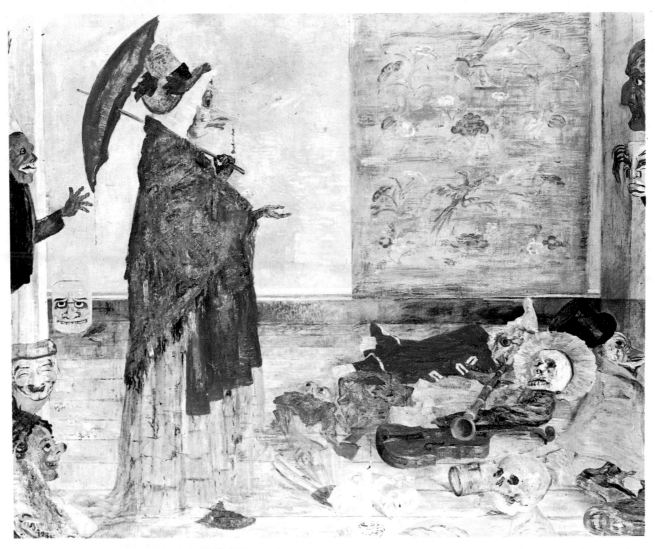

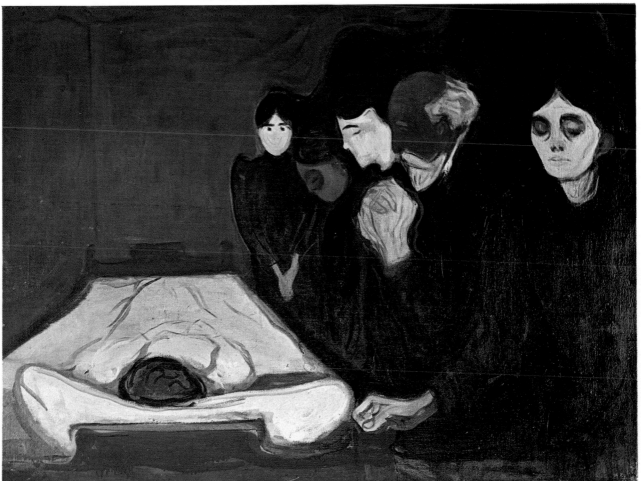

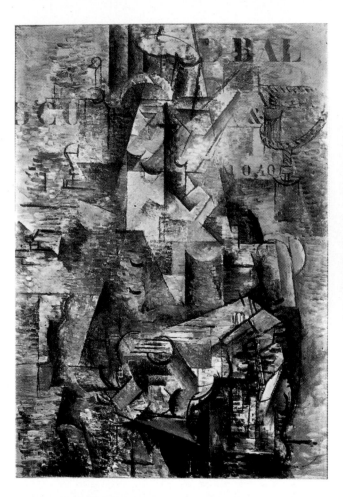

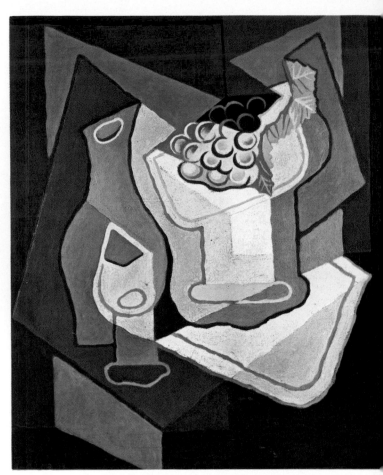

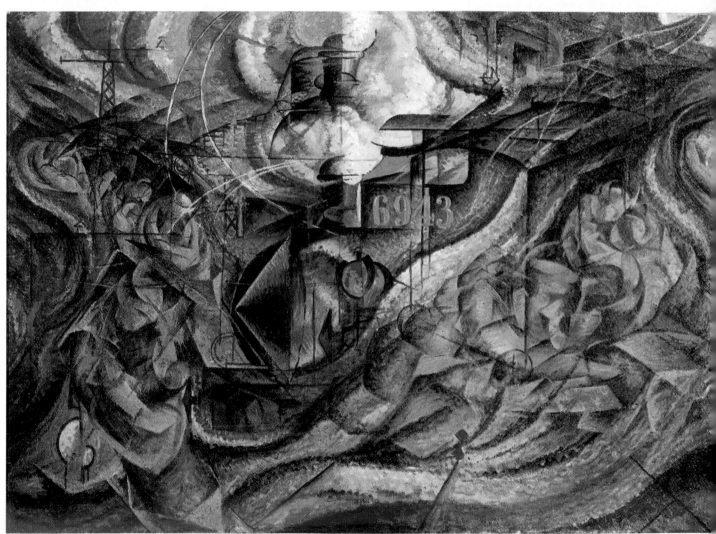

atmosphere, the Cubists at first turned their attention to the object . . . analysed, dissected it. Next, with the elements they had obtained, they created, within the frame of the canvas and in obedience to their intuition, various syntheses… Then colour began to come into its own again, pursuing a steady course until its power was such that it dominated the entire painting (whether or not this painting was representational) . . . The Cubist canvas, more and more an object in itself, moved towards abstraction, then towards complete non-objective invention, until it found its end in its means. In reaction to this, young painters would like to return to the expression of feeling, but not wishing to adopt the point of view of the cinema, they turn instead to explosive drama, still adhering to Cubism, but a Cubism which is no longer in the object but in the subject and in the denuded, geometric atmosphere. '

At this time Jacques Villon was not yet well known. He led a retiring existence and lived by selling his graphic works. André Lhote, on the other hand, received acclaim early in his career; he soon had a large number of pupils, and his influence was widespread and lasting. He expressed with firm conviction the aesthetic principles to which he remained faithful. He expounded these principles when, in paraphrasing Maurice Denis's formula, he gave the following definition of what a painting should be: ' The painting is a flat surface covered with allusive signs and metaphorical colours whose conjunction, made coherent by the effect of a strict composition, produces the only reality acceptable to modernity. '

The only acceptable reality? Indeed, leading painters were
750 soon pursuing very different ends. La Fresnaye was only one of many of these artists. Exactly the same age as Lhote, he had attained considerable mastery as a Cubist but had gradually broken away from the movement.

The development of the masters

Painting, like the other arts, had now become extremely eclectic, and art historians find it difficult to define a style characteristic of the period.

Picasso's dramatic changes in direction during the years between the two Wars helped to perpetuate a dynamic spirit in
729 contemporary art. At any time his style might change as he
-760 moved back and forth exploring the various opposing ten-
914 dencies in which his innovations had their roots. In the early 1920s he was painting the monumental figures of antiquity of his neoclassical period; at about the same time he composed decorative still lifes made up of geometrical abstractions of real objects. Also dating from this period are such canvases as the
913 *Three Musicians*, in which he revives the idiom of Cubism, and such contrasting works as the Harlequin series which are drawn with realistic perfection. In the later 1920s there appeared strange human figures whose limbs and features appeared in unexpected dislocation. Some ten years later this dislocation reached its peak in those obsessional full-face-cum-profile studies which have nothing in common with the graceful scenes
651 of antiquity, with the graphic works (*Sculptor's Studio*;

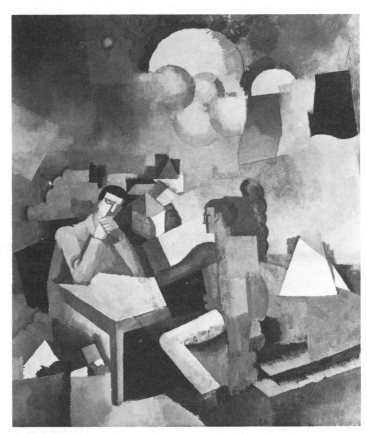

750. ROGER DE LA FRESNAYE (1885–1925). The Conquest of the Air. 1913. *Museum of Modern Art, New York.*

751. JACQUES VILLON (1875–1963). Space. 1932.

Top left. GEORGES BRAQUE (1882–1963). The Portuguese. 1911. Kunstmuseum, Basle. *Photo: Hans Hinz.*

Top right. JUAN GRIS (1887–1927). Bottle, Glass and Fruit Dish. 1921. Kunstmuseum, Basle (Hoffmann-Stiftung). *Photo: Hans Hinz.*

UMBERTO BOCCIONI (1882–1916). States of Mind, I: The Farewells. 1911. Private Collection, New York.

MASTERPIECES OF PICASSO (b. 1881)

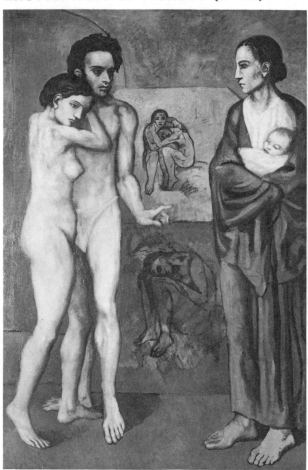

752. La Vie. 1903. *Cleveland Museum of Art.*

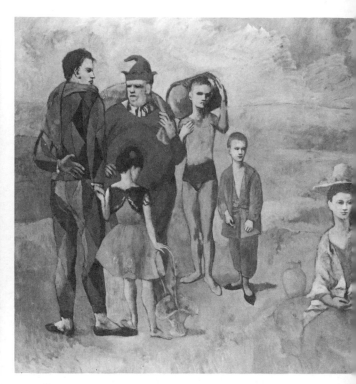

753. Family of Saltimbanques. 1905. *National Gallery, Washington.*

754. Girl with Mandolin. 1910. *Private Collection.*

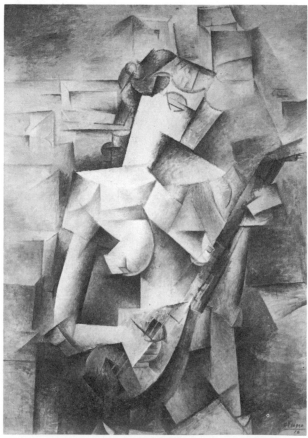

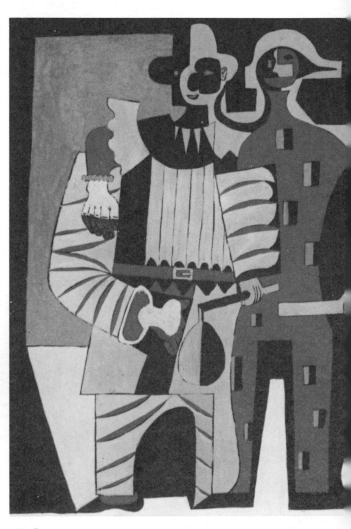

755. Pierrot and Harlequin. Gouache. 1919. *Mrs Gilbert W. Chapman Collection, New York.*

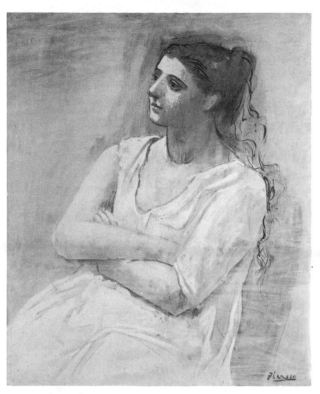

756. Woman in White. 1923. *Metropolitan Museum of Art.*

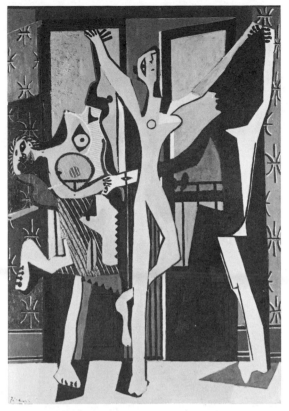

757. Three Dancers. 1925. *Tate Gallery.*

758. Weeping Woman. 1937. *Mrs Lee Miller Penrose Collection, London.*

759. Guernica. Mural. 1937. *On extended loan to the Museum of Modern Art, New York, from the artist.*

760. Women of Algiers XIV, after Delacroix. 1955.

MASTERPIECES OF MATISSE (1869–1954)

761. The Blue Nude. 1907. *Baltimore Museum of Art.*

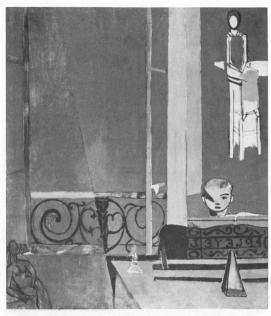

762. Piano Lesson. 1916. *Museum of Modern Art, New York.*

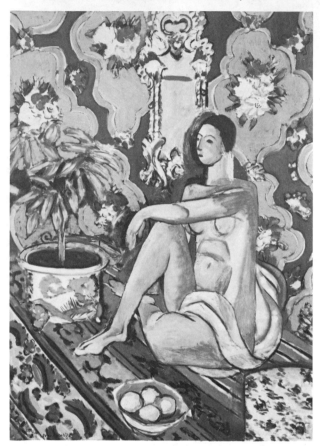

763. Decorative Figure on an Ornamental Background.
c. 1927. *Musée d'Art Moderne, Paris.*

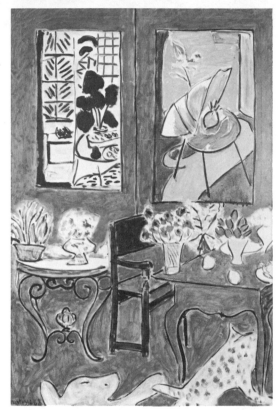

764. Large Red Interior. 1948. *Musée d'Art Moderne, Paris.*

765. The Pink Nude. 1935. *Baltimore Museum of Art.*

766. Nude. Bronze. 1929.

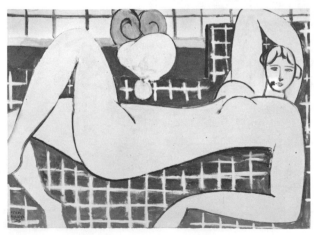

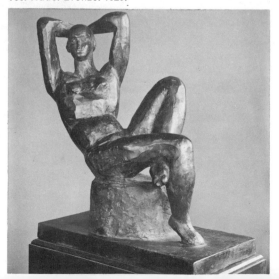

Minotauromachy), with the much more expressive sculptures or with the ceramics to which Picasso has devoted himself for a long time. The only common denominator is a brilliant virtuosity. Although representative of his time, Picasso is an exceptional case. He oscillates between a classicism which periodically re-emerges and a baroque quality of tremendous dramatic intensity which leads him to the most provocative and explosive disintegrations of plastic structure. He exercises a fascination and a magical power that inspire the awe of the whole world, so much so that for many the very name of Picasso symbolises all modern painting. And yet on the purely pictorial level his influence has not perhaps been as far-reaching as his unprecedented fame.

723 –766 The influence of Matisse, however, continues to increase. During the ten years following the First World War his favourite subject was the odalisque. This woman (whose repetition is not without a certain monotony) seems to become a part of the richly ornamental background. The atmosphere of cushioned intimacy, at which the artist excelled, is sacrificed increasingly to the exigencies of design. Light is no longer an atmospheric effect but a tonal value, a bright colour as important as the other colours. Bodies and faces are no more prominent in the organisation of the painting than are the patterns of carpets, curtains and wallpaper. Matisse liked to introduce decorative motifs. 'They do not overcrowd my painting,' he said, 'they are a part of my orchestra.'

From this time onwards the principles which guide some of our present-day painters emerge more clearly; we see, for example, the growing tendency to reject naturalism, relief, volume, nuance, transition and perspective. Painting tended increasingly to have a shock value and to be confined to purely plastic research. Pure colours were juxtaposed and subtly arranged in relationships which led to those great symphonies of colour in which nature is no more than the point of departure. Painting became flat composition without shadow — its essential justification no longer being imitation (and still less the expression of sentiments) but rather a harmony of colour and a perfect relationship between the various parts.

One needed the acute sense of composition and of the monumental of a Matisse — one needed, in short, the taste of a Matisse — to escape the facility to which his followers succumbed. Matisse chose his violent colours with subtlety; his colour combinations were bold; he sacrificed all that was not strictly necessary to the picture; he outlined those masses which needed emphasis; he rejected the accidental, he simplified and he imposed order. Everything was meticulously worked out. Effects which seem to represent emancipation, freedom and improvisation stem in fact from technique, knowledge and careful calculation.

The large decorative composition in the Barnes Foundation in Merion, Pennsylvania, *The Dance* (1931–1933), surprises us by the extreme simplification of its figures. This work is in fact not so much an innovation as a natural result of his prior development. Contemporary with the still lifes painted around 1940, into which he seems to have decanted his discoveries over the previous thirty years, were his line drawings, which he regarded not as an exercise but as a self-sufficient art form capable of transcribing emotion directly. Through these Matisse became interested not only in book illustration but in typography and design.

Matisse had faithfully carried out the true aim of Fauvism in the significance he gave to colour. The other Fauves had developed in quite different ways.

Robust, vital and vehement, the impetuous Vlaminck painted stormy landscapes, forlorn villages and overcast skies, in cool colours, which are charged with drama and humanity.

His friend Derain pursued a different course. The daring of his early work soon seemed empty to him. The painter who had squeezed tubes of bright colours on the canvas later used a limited and deliberately sombre palette. A man of acute and polished intelligence, sensitive to all the art of the past but sickened by that of his time, Derain sought refuge until his death in a seclusion from which he could scorn the artistic activity of Paris. He painted, but did not exhibit, still lifes of a sombre brilliance, landscapes of a classical restraint and several portraits (of Mme Paul Guillaume, of Dignimont, etc.) which reveal him as one of the last great portrait painters. (The figures in brown and russet tones, which preoccupied him for so long, are not the best examples of his uneven output.) When at times Derain seemed to catch up with his epoch, as in his illustrations for *Pantagruel*, it was through the intermediary of a literary work of the past. Yet throughout his work one senses beneath his reaction a feeling that had he wished he could have surpassed his contemporaries in audacity of innovation. 772

Dufy was the painter of joy: the joy of drawing, the joy of painting, the joy of living. A lover of music and of poetry, Dufy produced works of sensitive draughtsmanship which are imbued with a kind of poetic musicality. He depicted an enchanted world, and a world of highly personal symbols. His watercolours evoke fleeting but intense sensations. From the sparkling wavelets of his seascapes and from the blue or red horses of his racecourses he easily made the transition to textile design and to decorative painting, in which he excelled. 725

Like Derain, Othon Friesz renounced Fauvism and the use of pure colour. He returned to Cézanne's lesson and constructed his paintings with an eye to volume and tone. A baroque flavour added zest to the classicism of his compositions. 774

Marquet's break with Fauvism was the most drastic of all. In a spirit of modesty and humble devotion he made use of low-keyed harmonies with which he extolled the beauties of the countryside, the Seine and the misty transparency of the atmosphere.

Braque, who in his Cubist period before the War was very close to Picasso, later changed his style considerably. His influence was and remains profound in different fields of contemporary painting. Braque tempered the severity of Cubism with a subtle sense of pictorial design and a rare orchestration of colour. He was a master of the still life; breaking up objects into a multiplicity of subtly arranged planes, he then built them up into a magnificently and architecturally composed construction. Underlying his modernity was a deeply classical intellect and, at the same time, a barely restrained emotion. Preferring muted tones, Braque created an original scale in which he contrasted matt with translucent areas and smooth surfaces with areas made up of fine little brush strokes. His technical skill is also seen in his sculpture and in the precise graphic works with which he illustrated poetry. 724, 730 767–771

The 'Jeune Peinture' of 1920 included, in addition to Braque, Bissière, Friesz and Dufy, certain painters, very different in style, who were united in the devotion they brought to the disciplines of the medium. This was true of Dunoyer de Segonzac, whose name is synonymous with serenity and solidity. His mastery combines strength with delicacy. He loves life and has an almost pantheistic love of nature. Of lively intellect, he is prone to scepticism; current theories have no hold on him. 773

Waroquier's austere and tormented painting, on the other hand, inclines towards tragic intensity and inner force. A spiritual descendant of the Cubists, Gernez tended towards a dense and rich style of painting, reminiscent of enamel work,

MASTERPIECES OF BRAQUE (1882–1963)

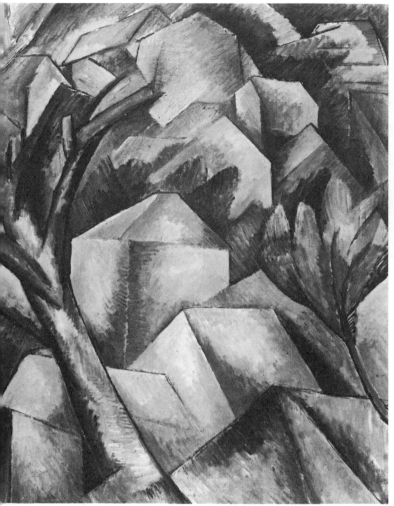

767. Houses at L'Estaque. 1908. *Kunstmuseum, Berne.*

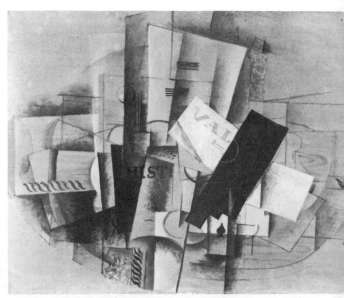

768. The Musician's Table. 1913. *Kunstmuseum, Basle.*

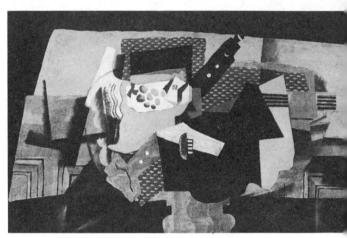

769. The Black Pedestal Table. 1919. *Musée d'Art Moderne, Paris.*

770. The Salon. 1944. *Musée d'Art Moderne, Paris.*

771. Horse's Head. Bronze. 1943. *Musée d'Art Moderne, Paris.*

284

and he took up the almost forgotten art of pastels, which he
743 employed with extreme refinement. Gromaire's powerful yet
rhythmic and decorative canvases are painted with a restrained
and sober, yet warm, palette and at times have a luminosity
that reminds us of stained glass. This solid painter, untouched
by current influences, has remained true to his own talent.

A deep religious sense lends weight to the rough and
722 vehement work of Rouault. Faithful to his plastic language and
more faithful still to his vocation as a Catholic painter, Rouault
gave us as he grew older an increasingly serene vision of the
world. Half a century of meditation and solitude mellowed his
inspiration. We can follow this development from his monu-
mental album of etchings, *Miserere*, in which the tragic and the
burlesque mingle, up to the series *Stella Vespertina*, whose
evangelical scenes take place in an atmosphere heavy with the
mystery of heavenly communion. In his own incisive language
Rouault has given us an image of the noble dignity of God and
man.

Vuillard and Bonnard, who were still active at this time,
belong to an earlier tradition in modern painting. However,
their genius left its mark on the new generation. In his old age
Bonnard returned to a youthful exuberance of light and colour.
A brilliant landscape painter, he remained detached from
realism, producing a sort of synthesis of nature, a nature which
he seemed to rediscover every time he sat down to paint.

, 902 To go from these two painters to the work of Fernand Léger
is to be transported to another world. He was one of the rare
painters who entered into the materialism of his age — the
machine age. This 'primitive of modern times', impassive and
impersonal, painted factory chimneys, cog-wheels and scaffold-
ings with an objectivity which he applied equally to his paint-
ings of the people, bereft of mind and soul, who are enslaved
by them. At his command trees and flowers submit to an
abstract and mechanical balance. All painting seems precious
alongside Léger's monumental forms, striking colours (the
latter sometimes dissociated from the former), eloquence and
power of expression, which carry his treatment of the real
world to something beyond realism.

In an entirely separate category are the popular realistic
painters, whom Bernard Dorival calls 'painters of instinct and
heart' — a title that is in itself a definition. Much has been made
of these sentimental 'instinctives', for they bring a breath of
fresh air to an atmosphere weighed down by cerebral com-
plexities.

Actually there have always been popular painters who have
a certain quality which is refreshing when compared with more
sophisticated art. The exceptional case of Henri (Douanier)
634 Rousseau has contributed much to our interest in primitives.
Rousseau had genius, and some of his pictures bear com-
parison with the masterpieces of trained artists. However,
20th-century primitives owe nothing to him. Indeed, they owe
nothing to anyone; they are even unknown to one another.
If they have in common a love of finical detail, the bugbear of
modern art, they have few other mutual ties. There is no
904 connection between Vivin's buildings, in which each stone
seems to be accounted for, and the florid compositions of
Bauchant; between the panoramic views of Jean Eve and the
rounded charms of Bombois's buxom dancers; between a dis-
905 turbing, ethereal bouquet of imaginary flowers by Séraphine (a
charwoman from Senlis) and the deliciously artless rural scenes
painted in her old age by an American farmer's wife, Grandma
Moses.

741 While Utrillo is in some ways close to the popular painters,
he is not one of them. Though self-taught, and resembling them
in his ingenuous style and authentic earthiness — even if it is

772. ANDRÉ DERAIN (1880–1954). The Painter and his
Family. 1921. *Private Collection.*

773. ANDRÉ DUNOYER DE SEGONZAC (b. 1884). Road
near Lagny in Winter. Watercolour. *c.* 1933.

774. OTHON FRIESZ (1879–1949). View of Coudon (Toulon).
1923.

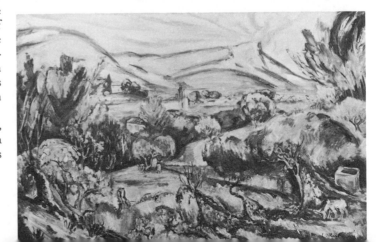

only the 'earth' of Montmartre — he also differs from them profoundly. These primitives were for the most part artisans who painted as a hobby, but Utrillo seemed compelled to paint from his youth, and he painted ceaselessly, doggedly, with a constancy that not even bouts of alcoholism could interrupt. What made this man, so burdened with failings and weaknesses, the innocent portrayer of white churches and limpid skies which radiate a beatific spirituality? Indeed, the spiritual quality of his vision has seldom been transcended and, though often imitated, Utrillo's contribution has never been equalled on its own unique ground.

While so many revolutions were taking place in painting, the public remained by and large indifferent, scornful or hostile. Any picture which did not fit into the category of imitative art as envisaged by academic teaching was considered 'Cubist', a pejorative term applied to a variety of painters from Picasso to Segonzac. The Salon des Artistes Français continued to be filled with hundreds of pictures which might well have been painted at the end of the 19th century. The Salon des Indépendants lost its initial aggressiveness. The Ecole des Beaux-Arts went on with its traditional teachings, and young men with something to say broke away from its conventional rules. A few honest and conscientious painters who were not lacking in talent remained attached to the old disciplines, but it became more apparent every day that genius was no longer to be found in those quarters.

The post-War generation and after

A new generation appeared about 1925–1930, a generation which had not been involved in the pre-War movements. Contrary to what might have been expected, this generation did not perpetuate the work of the great pioneers of the century. Instead of rebelling against the earlier movements of the century, which some held in distant respect and others preferred to ignore, they turned to a poetic treatment of reality, expressed by each according to his personal bent. We cannot place them in neat categories nor can we speak of a theory or school — or even a trend. They were isolated individuals, desperately isolated, and were torn between the academic tradition of their teachers and the unresolved confusion of their elders. Troubled and lacking masters, they were often unsure of their own positions. Sometimes they found a spiritual kinship with painters whose style was of the recent, or 775 even the more distant, past. Brianchon and Legueult, born colourists of exquisite taste, seem to prolong, each in his own way, the art of Bonnard and Vuillard; Oudot is more directly linked to earlier French masters in his rather modestly expressed 779 love of nature; Chapelain-Midy is nearer to the Quattrocento. But these resemblances to earlier artists are mere tendencies or affinities rather than direct descent.

The post-War generation was suspicious of intellectualism, placing its trust rather in instinct and personal preference. These artists strove more or less consciously to regain more dependable, more concrete and more certain values in the face of the great upheaval that had thrown the world of art into a turmoil. Chapelain-Midy has written: 'We arrive after the fun and games. The windows have been broken long ago and grass is growing on the barricades. Our job is less heroic, no doubt, but perhaps more difficult. There are no more collective enthusiasms. Each artist fights his own battle!'

The majority of independent painters who had passed through the Ecole des Beaux-Arts had bitter memories of it. Where they had sought masters they had found only professors.

Their sensibility, deeper and more complex than their pictures might lead one to believe, caused them to attempt a compromise with the old values. Some were obsessed by large, animated compositions (so important in earlier times), but this type of painting had so depreciated in value that these works had little popularity or influence. Many of these painters returned to studies of nudes, to still lifes and to nostalgic landscapes; these works possessed a kind of poetic warmth which had been lacking in painting owing to the influence of the official salons. A number of young painters such as Planson, Aujame, Cavailles, Limouse, Chastel, Tailleux, Venard, Despierre, Bezombes, Caillard and Brayer turned enthusiastically to nature, which they interpreted freely.

At this time too the graphic arts experienced a revival. Immediately after the First World War woodcuts became popular. Jean Gabriel Daragnès proved to be one of the masters of book illustration. The freedom prevailing in art brought about, as a reaction, the revival of interest in line engraving, drypoint and etching, which required an exact technique, the technique of a craftsman. Segonzac, Luc Albert Moreau and Edouard Goerg produced fine illustrations. Most painters have 776 done engraving at some time in their career, and often these works are particularly successful, as is the case with the graphic art of Picasso, Dufy, Matisse and Derain, and many others 651 whose illustrated books are justly valued.

The loss of interest in the human being as a subject became noticeable in all fields of modern art. For long considered the only subject worthy of the painter's interest, the human visage was now neglected, avoided or ridiculed. This attitude was disturbing to certain artists, and Neo-humanism, a movement advocating a return to the human being and to certain spiritual values, was started. Christian Bérard belonged to this group before dedicating himself to theatrical design and becoming the spoilt child of Paris society. But despite its return to traditional values Neo-humanism largely expressed the anxiety of the times, of morbid beings astray in a despairing world.

A spirit of disgust with and revolt against the various trends in painting in the previous fifty years resulted about 1935 in the formation of a group which took the name of 'Forces Nouvelles'. The masters of modern painting were taken down from their pedestals and were accused of indulging in an audacious modernism to disguise their inadequacies. Certain young painters reacted against non-representational painting by seeking refuge in an ascetic tradition.

Which way was painting going? The number of inquiries multiplied. But in the face of so many contradictory directions one was forced to admit that painting was going nowhere or that one could not tell where it was going. Many artists, such as André Masson, escaped classification or changed styles 694 constantly. Others turned to the subtle atmospheres of the Impressionists, the pure colour of the Fauves, the logical constructions of the Cubists or the dreams of the Surrealists.

Certain strong personalities emerged who seemed to pursue a course outside their environment. Francis Gruber (1912– 648 1948) attracted attention early in his all too brief career. A kind of Romantic Claude, Gruber worked on a monumental scale and at times on monumental subject matter. Though there is often a touch of the mannered in his trenchant, sometimes morbid, subjects, few painters of his generation gave their work such 'presence'. André Marchand's Expressionistic paintings capture the spirit of Provence. His hieratic Arlésiennes are like figures from Greek drama.

Among the non-figurative artists between the Wars were a number of Spanish painters. Many of them either lived in France or visited it frequently. Picasso's frequent changes of style did not alter his impact on art. In a timeless universe Miró 636 evolved magical signs that transport us to an enchanted world.

775. MAURICE BRIANCHON (b. 1899). The River Loing.

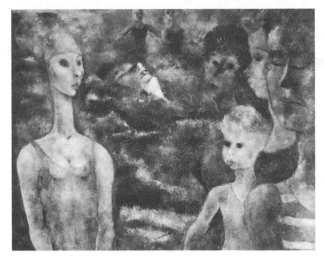

776. EDOUARD GOERG (b. 1893). The Stroke of Lightning. c. 1920–1930. *Art Institute of Chicago.*

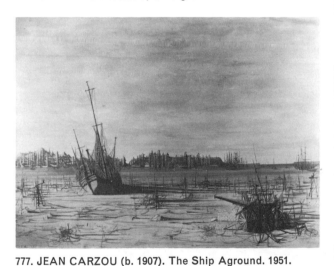

777. JEAN CARZOU (b. 1907). The Ship Aground. 1951.

778. NICOLAS DE STAËL (1914–1955). Still Life with Jar. 1955. *Mr and Mrs Chester Beatty Collection, London.*

779. ROGER CHAPELAIN-MIDY (b. 1904). Diana. 1961.

780. BERNARD BUFFET (b. 1928). Landscape in Provence. 1957.

Non-representational painting was on the increase in Paris during the Occupation. The 'Young Painters of the French Tradition' (a paradoxical title), who came to the fore without noisy manifestos and who followed in the wake of Desnoyer, included Pignon, Estève, Bazaine, Le Moal, Fougeron, Gischia, Singier, Lapicque and Manessier. These men formed a kind of advance guard. Virtually unknown to the general public, and like the painters of the previous generation very different from one another in style, they took part in a common aesthetic trend which seemed to spring from the current situation and the consequent national consciousness. These painters adopted Jean Bazaine's declaration: 'The daring enterprise of French painting during the last fifty years is the only reasonable course.' This did not mean that they continued the work of the Fauves or Cubists, but rather that they perpetuated the tradition of search and research laid down by the earlier artists.

Their aim was above all to achieve a picture-object which would be a synthesis of plastic and poetic values but which would eschew modelling and perspective as well as all concern

807
808, 810
809

781. GUSTAVE DE SMET (1877–1943). The Lovers. 1931. *Private Collection.*

782. PHILIP EVERGOOD (b. 1901). My Forbears were Pioneers. *Mrs Benjamin C. Betner Collection, New York.*

783. PAUL NASH (1889–1946). Landscape from a Dream. 1938. *Tate Gallery.*

784. STANLEY SPENCER (1891–1959). Silent Prayer. 1951. *Wadsworth Atheneum, Hartford, Connecticut.*

with external reality. If the real appeared in their works it did so only as a pretext for an arrangement of lines which left colour free and autonomous. Colours were used arbitrarily and often violently (a tendency which owed much to Gauguin). But the true affinity of these painters is perhaps at one and the same time with the Romanesque fresco painters and the late Matisse; they seem to reject the Renaissance tradition in art.

These painters, most of whom were then in their thirties, have since developed along different lines. Faithful to his political beliefs, Fougeron has turned to Social Realism. Pignon, a gifted draughtsman, paints powerful and emotional 916 works which show his talent as a colourist. Bazaine, Manessier, 810, Singier and Le Moal produce abstract works whose play of 917, colour is evocative.

Since then other painters have become prominent. Early in his career Bernard Buffet showed an exceptional talent; he is 780 quite unlike anyone else in style, and his cruel, gloomy, somewhat sketchy imagery is peculiarly his own. The Spanish painter Antoni Clavé depicts a world of mysterious objects in sumptuous chiaroscuro, while Lorjou, a violent satirist, expresses himself in acid contrasts of lighting. Carzou uses an 777 incisive line to create an unreal world. Nicolas de Staël, in his 778 last phase when he was becoming more representational, evoked the world of reality by means of large areas of intense colour. The diversity, the freedom and the ease with which all these painters have developed seems proof that the difference between figurative and non-figurative art, between concrete and abstract tendencies, is not the major problem of contemporary painting. Far from being alien to each other both currents often mingle, frequently in the work of one artist.

Throughout the period between the Wars the major artists were for the most part centred in Paris. It is difficult to speak of national schools at this time, as modern art is in essence so perfectly cosmopolitan. An example of this is Kandinsky, who 805 grew up in Moscow and studied in Munich, where he painted his first abstract works. He returned to Moscow after the Revolution, went back to Germany in 1921 and in 1922 became a teacher at the Bauhaus in Weimar (later in Dessau); in the

785. DIEGO RIVERA (1886-1957). Woman grinding Maize. 1926. *Private Collection.*

early 1930s he came to Paris, where he remained. Although a number of vital national art centres have existed, the term 'national schools' would seem to be a misnomer (except when used to designate art that is entirely in the service of a political regime, as was the case in Nazi Germany and as is the case in the Soviet Union).

Flemish Expressionism, after the example of Ensor, flourished in Belgium (Permeke; de Smet), and Surrealism had a surprisingly large following there (Magritte). England, which for so long had remained outside the main currents of modern art, saw the rise of a generation distinguished by its originality — whether in the delicate landscapes of John Piper or in works in the Cubist tradition, such as those of Ben Nicholson.

The dynamism that had produced Futurism, that 'movement of Italian pride', seemed to find further expression in the nationalistic outburst of Fascism. But the leading Futurist painters followed different paths. Severini, whose aesthetic principles stemmed from the Renaissance, turned to monumental art and dedicated a great deal of his activity to church decoration. Carlo Carrà chose to recreate a fabulous universe symbolised by the 'mechanical mannequin'; he turned to the Metaphysical movement, a movement whose influence was profound in Italian painting. Giorgio de Chirico was its most famous exponent. He peopled his paintings with hallucinatory figures, automatons lost in an archaeological repository of temples, of deserted towns and of monumental perspectives reminiscent of Serlio which establish his work in the long tradition of Italian culture. Later on de Chirico rejected his former style and returned to more conventional painting.

Mario Tozzi experiments with volume, producing a personal interpretation of aggressively academic elements. Campigli remains obsessed by Etruscan pottery shapes and decoration. Magnelli has become a leading abstract painter. The sculptor Marino Marini expresses a kind of primitive purity with an accomplished sense of plastic values.

The New World set out to compensate for its lack of traditions by the search for new principles. John Marin, a pioneer of independent American art, painted boldly constructed

7,716
, 962
964

1008
, 815

946

944

948
812
793

1122

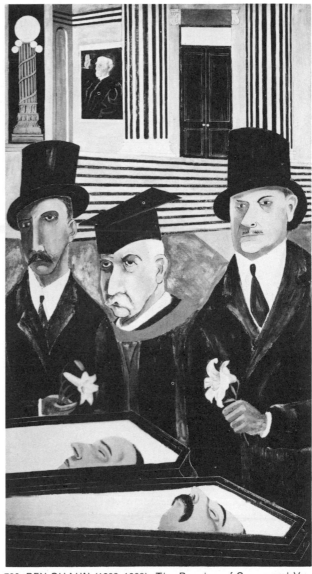

786. BEN SHAHN (1898-1969). The Passion of Sacco and Vanzetti. 1931-1932. *Whitney Museum of American Art, New York.*

787. CHARLES DESPIAU (1874-1946). Paulette. 1939. *R. Lopez Collection, Algiers.*

watercolours. Surrealism, Expressionism and abstract art were all taken up by the younger generation. And a new group of artists were bent on renouncing the European heritage.

785, 1157 An incontestably original school grew up in Mexico with the Revolution; Rivera, Orozco and others glorified the proletarian mystique in gigantic images of compelling violence.
1156 Siqueiros has sought inspiration in autochthonous traditions.

Sculpture steadies the balance

Rodin died in 1917 at the height of his fame. That startling innovator, so important to his time, created no school. He had numerous pupils and a crowd of admirers; he had drawn round him all those who counted as sculptors of talent; but he had no disciples. After Rodin, sculpture knew an incredible revival, but along different lines from his.

While the salons continued to award their medals to conventional painters, many artists worked far from honours and subsidies in close contact with nature; they re-established a balance in art by returning to the sources of the Mediterranean tradition.

714, 865 Maillol was the great artisan of this regeneration, which was born of the forces of nature. 'I invent nothing,' he said, 'no more than the apple tree invents the apples.' The wise southerner despised theories and created forms dictated by a magnificent sense of harmonious proportion which marks him as a direct descendant of the classical tradition. His fiery temperament and his lust for fleshy beauty enabled him to rediscover the great laws of classical harmony without lapsing into academic platitudes. He revelled in craftsmanship and in the restraints imposed by materials. The fresh robust girls that took shape under his hands possess a kind of animal ardour which is not without heaviness, but they seem created with such ingenuous ease that they escape all convention.

787 Despiau was not a spontaneous artist. He struggled constantly against disappointment and anguish. And yet, though his work has delicacy, it has also a physical robustness. He left a gallery of portrait sculpture which is without equal in our time. He did not attempt to reproduce some singular aspect of the physiognomy; rather, a hundred studied details were combined in a harmonious rhythm. He thus achieved a spiritual synthesis and, in Baudelaire's words, a 'moral likeness'.

One of the plagues afflicting some sculpture in about 1925 was the decorative stylisation practised by certain artists of unquestionable talent, such as Joseph Bernard. Another, diametrically opposed, tendency was characterised by the work of Charles Malfray, a great draughtsman, preoccupied with the problems of movement and of monumentality, who had a weakness for heavy twisted forms; this trend was also exemplified by Robert Wlérick, in whose work all forms radiate elegant simplicity and fresh vitality.

864 The somewhat severe work of Marcel Gimond has acquired an authoritative strength. Since 1944 he has dedicated himself exclusively to the study of the human head, on which he confers a kind of universal dignity. His busts answer perfectly to his own definition: 'A bust should be the embodiment in concrete form of an interior drama, a plastic poem having as its starting point a face whose share of the infinite is revealed to us.'

Emmanuel Auricoste, Hubert Yencesse and the Spaniard Manolo are among those who also interpret the great classical precepts in modern terms.

Even after the great anti-realist revolution had been going on for some time in the field of painting, French sculptors, even those who were quite detached from academic convention, were working in the tradition of representational art. Sculptors who had been associated with Cubism remained without much

788. OSSIP ZADKINE (b. 1890). Cast of a bronze sculpture for the van Leer Foundation, Jerusalem. 1961.

789. HENRY MOORE (b. 1898). Family Group. 1945–1949. Bronze cast. 1950. *Museum of Modern Art, New York.*

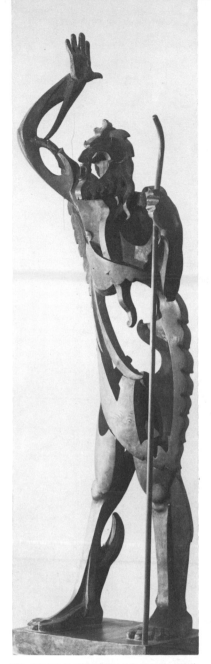

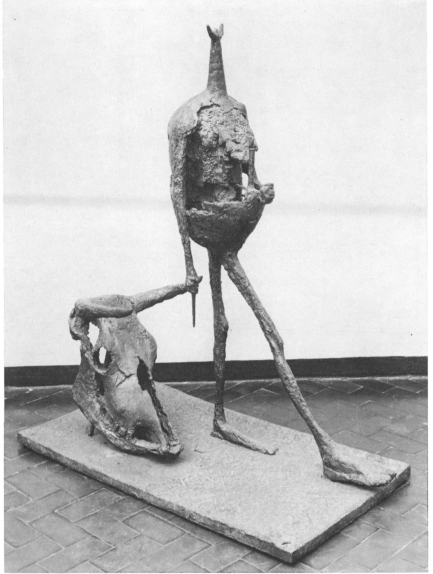

790. PABLO GARGALLO (1881–1934).
The Prophet. Bronze. 1933.
Musée d'Art Moderne, Paris.

791. HENRI LAURENS (1885–1954).
Woman with a Bird. Marble. 1943.

792. GERMAINE RICHIER (1904–1959). Tauromachy
(The Bullfight). Gilded bronze. 1953. *Peggy Guggenheim
Collection, Venice.*

793. MARINO MARINI (1901–1980) Miracolo. Bronze. 1959–1960.
Kunsthaus, Zurich.

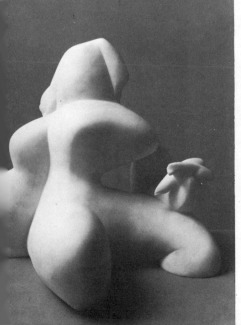

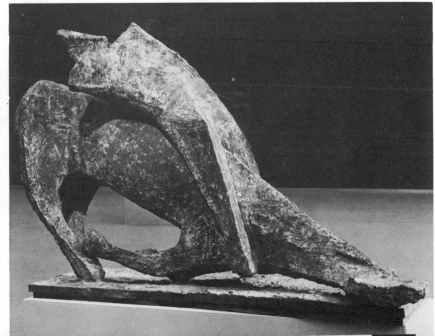

794. AUSTRIA. OTTO WAGNER (1841–1918). Post Office Savings Bank, Vienna. 1904–1906.

795. BELGIUM. HENRI VAN DE VELDE (1863–1957). University library, Ghent. 1936.

796. FRANCE. TONY GARNIER (1867–1948). Great hall of the slaughterhouse at La Mouche, Lyon. 1909–1913.

797. GERMANY. JOSEPH OLBRICH (1867–1908). Hochzeitsturm (Wedding Tower), Darmstadt. 1907.

influence. Henry Moore, however, was organising forms into
a more or less expressive design which was part of a resolutely
anti-naturalistic current. His work, with its mysterious power,
has had great influence on younger sculptors.

Even before the First World War Cubism had influenced
Zadkine, who broke down his subject matter with strikingly
dramatic results; Cubism had also influenced Lipchitz, whose
rhythmic constructions evoke fabulous beings. The work of the
Spanish sculptor Pablo Gargallo, who bent sheet metal into
descriptive scrolls and practised an open-work sculpture which
has a number of adepts today, also shows this influence. The
massive yet supple figures of Laurens show a concern with the
balance of masses and a refinement in the subtle play of light
and shadow which make them highly polished works of art.

Couturier has moved increasingly towards an elliptical
representation which is charged with the irony of reality.
Giacometti, in a Surrealist spirit, reduces the object to a few
magical signs. Among the younger generation are the fierce and
powerfully talented Etienne-Martin and the serious plastic
genius Adam.

We should point out that painters (and by no means the less
important ones) were also drawn to sculpture — as Degas and
Renoir had been. The most influential sculptures by a painter
are those by Picasso, who gives a phantasmagoric quality to all
his creations. Matisse, Braque and Derain all worked in sculp-
ture, a medium to which they attached great importance.

The revival of architecture and the applied arts

In architecture as in painting all the bearings had been taken in
the first quarter of the 20th century; but it is necessary to add
that the architectural revolution of our time remained for long
on a more or less theoretical plane. The vast majority of build-
ings constructed until very recent times — houses, public
buildings, churches — were based on the aesthetics that had
been in currency for nearly a hundred years and that borrowed
at random from various styles of the past. It was in the utili-
tarian buildings — factories, shops, stations, bridges, etc. —
that the use of new techniques led to experiments in original
construction. In Belgium (van de Velde), in the Germanic
countries (Behrens, Otto Wagner, Olbrich, Mendelsohn,
Loos) and in the United States (Frank Lloyd Wright) architects
preached the necessity of conceiving an architecture adapted at
long last to contemporary techniques and ways of life. Perret
had given dignity to architecture in reinforced concrete, a
material whose possibilities had previously scarcely been
exploited. Tony Garnier had also foreseen the potentialities of
reinforced concrete at the beginning of the century in his
project for a Cité Industrielle — a project that remains a master-
piece of town planning.

The use of iron and concrete led to the construction of
buildings having a visible framework and without supporting
walls; this was to give to buildings of the industrial civilisation
a note of candour utterly opposed to the architectural pastiche
that had been rife until then.

In 1919 Gropius founded the Bauhaus at Weimar (later
moved to Dessau). The Bauhaus was an experimental laboratory
in which architects, engineers, painters, sculptors and designers
cooperated in working out the kinds of forms demanded by
modern methods, by standardisation and by prefabrication.
The entire doctrine of functionalism was thrashed out there:
construction in all its aspects, whether architecture or furniture
and everyday objects, must be useful and above all must
correspond to the function of the object. Function should
control structure, which should never be hidden under super-
imposed decoration.

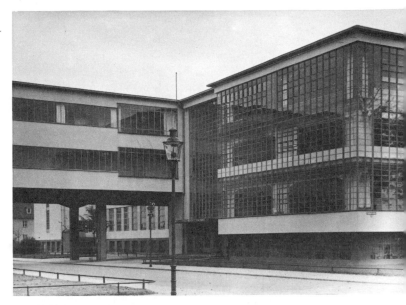

798. GERMANY. WALTER GROPIUS (b. 1883). Bauhaus,
Dessau. 1925–1926.

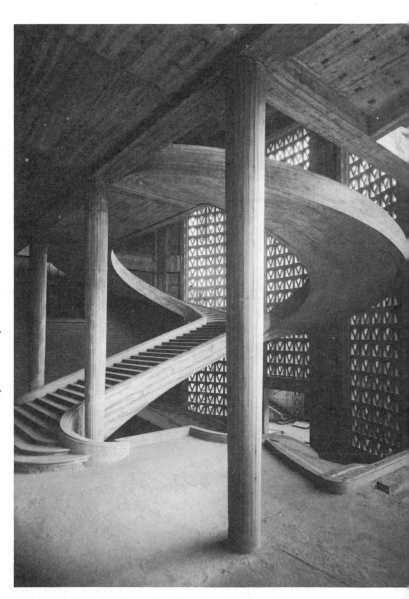

799. FRANCE. AUGUSTE PERRET (1874–1954). Staircase of
the Musée des Travaux Publics, Paris. 1937–1938.

293

In fact decoration responded so closely to man's instinctive desires that it did not disappear abruptly. Thus two tendencies confronted each other. At the Paris Exhibition of Decorative Arts in 1925 (from which all pastiche was excluded) a new decorative vocabulary called 'modern' appeared. It was seen on the façades of buildings and on carpets, textiles, glass and silver; it owed something to Cubism and was characterised by an exuberance of flowers and other motifs stylised in a geometrical spirit and having a wide range of contrasting colours. As a reaction against Art Nouveau, there was a tendency to replace curves with straight lines and sharp angles.

In interior decoration the metal chair and the plate-glass table were the prerogatives of a few purists who worked almost entirely for a small coterie of aesthetes. Raoul Dufy designed tapestries and upholstery, Lalique glassware and Subes ironwork, whose style he never ceased to refine. Ceramics had as remarkable a revival.

779, 859 Auguste Perret showed the extent of his genius in his church at Le Raincy and his Musée des Travaux Publics in Paris. A tendency known as 'nudist' was exemplified by the work of 671, 672 Le Corbusier who, greatly influenced by the Bauhaus, published in his review *L'Esprit Nouveau* some pithy ideas on the future of architecture. In order to respond to the material needs of

modern society, not only were modern houses to be built but entire towns were to be transformed by the building of 'radiant cities' having a core of skyscrapers, which would leave much of the ground free.

In the United States Wright advocated a return to nature; he 668 condemned the skyscraper and proposed that the population be spread out in order to have contact with the land. He initiated a daring 'organic architecture' whose volumes were subjected to strict planning and were incorporated with the natural surroundings. In Holland J. J. P. Oud contributed much 968, to the spread of buildings which were functional in form and balanced in appearance (Rotterdam). Dudok carried out similar ideas with greater flexibility (Hilversum).

In the early 1930s many German and Austrian architects came to the United States, where they found the facilities and financial means lacking in Europe. Gropius, Mies van der Rohe 1095 and Marcel Breuer have become the masters of an international 857, architecture in which steel, concrete and glass predominate and which is mostly concerned with technical considerations: the beauty must grow out of the structural lines decreed by the purpose for which the building has been designed. Markelius, 1075 Saarinen and Aalto have brought great potentiality to this often 1071 monotonous style of rationalist architecture. In Italy Gio Ponti 826 is one of the vital spirits of a movement which is not afraid of bold originality. A group of Brazilian architects, with Niemeyer 685 and Costa, has constructed, under the influence of Le Corbusier's principles, gigantic buildings with façades pierced by cellular openings. Thus new forms have been worked out, forms which we will examine later on.

Concurrently with these developments a furniture style has been evolved, principally by the Swedes who favour simple interiors. The new materials that have rapidly been perfected have enlarged the field of possibilities open to interior decorators. Hygiene, comfort and the economical prices of mass-produced articles have resulted in the development of a style which has tended to become cosmopolitan with the increasingly rapid exchange of ideas between countries. As a reaction against post-Cubist decoration, forms have become free and flexible. A functionalism often more apparent than real serves as a pretext for lines which are far removed from the geometrical.

There has, however, been some turning away from products standardised and simplified sometimes to the point of poverty, in favour of richer, more personal creations. Also, to give colour and character to interiors, artists have fashioned objects inspired by the crafts or by contemporary art (coloured glass, in which the Italians excel; fine goldsmiths' work, in which the Scandinavians and Germans are past masters; ceramics, always an important art in France).

Tapestry, which had been in a decadent state since the 17th century, has had an unexpected revival. Jean Lurçat, a painter 801 of the fantastic, has studied the techniques of the tapestry weavers of the Middle Ages and has adapted these skills to his own creative imagination. The Aubusson factories produce wall hangings of great decorative appeal and remarkable poetic quality; artists such as Marcel Gromaire, Marc Saint-Saens, 800 Jean Picart Le Doux, Lucien Coutaud, Dom Robert and Henri Georges Adam have worked in this medium with great success.

We should remember, too, that since Diaghilev the theatre has often had its sets and costumes designed by well known painters who, although finding themselves in a new domain with its own particular laws, manage to achieve remarkable results. Thus artists have entered into direct communication with the vast public that has for so long refused them a hearing.

800. MARCEL GROMAIRE (b. 1892). Landscape with Hoopoe. Detail of Aubusson tapestry. 1941.

801. JEAN LURÇAT (b. 1892). Man. Aubusson tapestry.

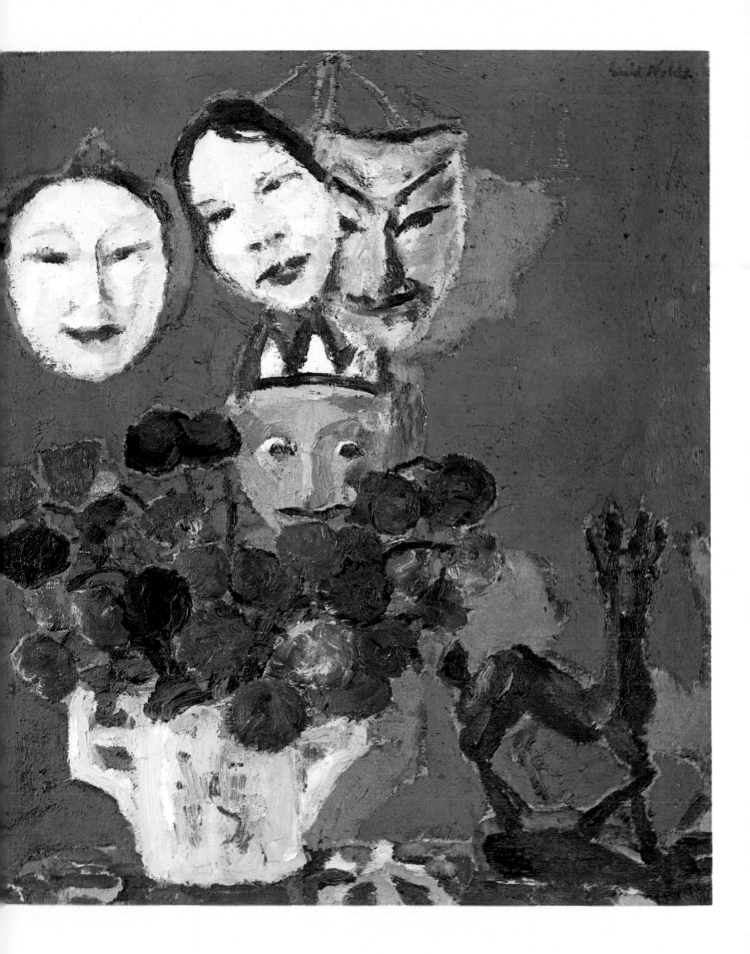

EMIL NOLDE (1867–1956). Masks and Dahlias. 1919.
Nolde Museum, Neukirchen über Niebüll.
Photo: Marlborough Fine Art Ltd, London.

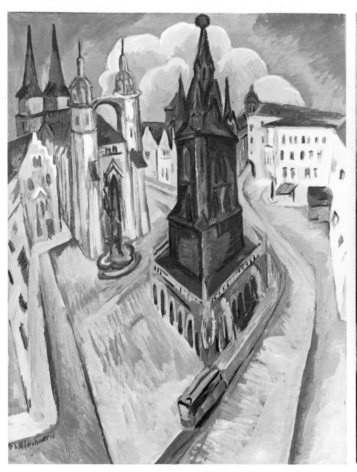

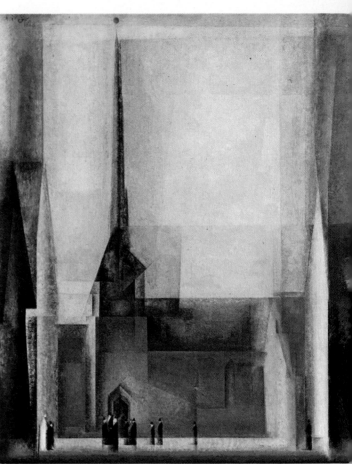

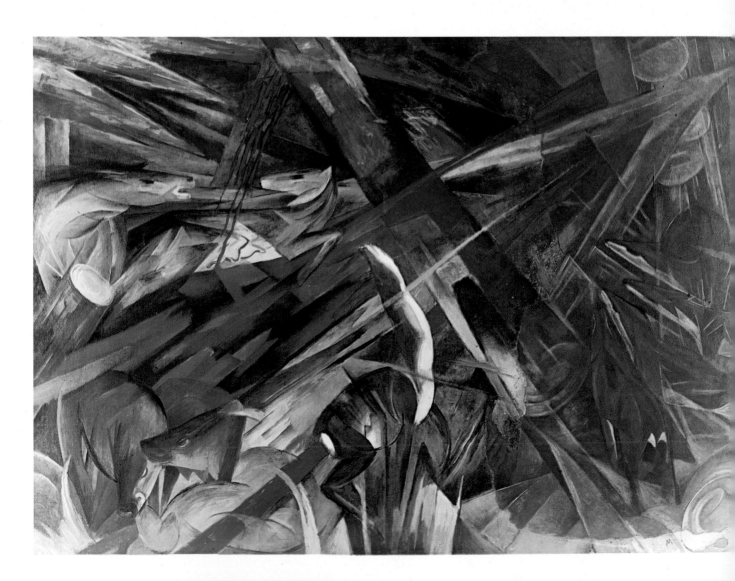

II. THE NEW DEPARTURES *Frank Elgar*

For some, modern art had accomplished its revolution at the beginning of the century, and all that remained to be done was to follow up the consequences. But for others, that revolution had only been a preliminary step, and the essentials had still to be carried through in yet more daring developments. Surrealism, with its exploration of the unconscious, and abstract art, with its two almost contradictory phases — the first mainly plastic, the second Expressionistic — mark the significant stages of this probe into the unknown.

The vicissitudes of war, especially of a long and cruel one, always provoke, in addition to political and social upheaval, problems of conscience. Even before the combatants have laid down their arms, questioning, doubt and anger worm their way into the mind. Whatever their temperament, whatever their beliefs, artists feel resentment towards the world that has betrayed their hopes, and experience the desire, if not the need, to detach themselves from that world, even to object to it. Some move ahead, but without renouncing the past, striving to add to the territory acquired by their predecessors. Others blame the preceding generations for all the ills that have been suffered. Negation of the past and of accepted traditions is for them the only possible attitude. They do not believe in the virtues of evolution, reform and makeshift improvement. The old cannot be made new, they argue; one does not compromise with conventions that have died of old age. So it was that World War I gave birth to Dada, which was followed shortly afterwards by Surrealism, and that after World War II the abstract tendency in art made surprising progress.

Negation and subversion: from Dada to Surrealism

It was the meeting in Zürich of refugees — the Rumanian Tristan Tzara, the Alsatian Hans Arp, the Germans Hugo Ball and Richard Huelsenbeck — that gave birth early in 1916 to that movement of negation and subversion known as Dada. In permanent revolt against logic, morality, society and art both present and past, these aggressive individualists were not long in combining forces. Tzara and Arp soon associated themselves with Marcel Duchamp, who had founded a similar movement in New York together with Picabia and Man Ray. Richard Huelsenbeck organised a group in Berlin and Max Ernst another group in Cologne. By 1919 Paris had become the centre for all Dada groups. When Ernst arrived in Paris in 1922 it was to witness the disintegration of Dada. In endeavouring to destroy everything, Dada destroyed itself. But its shibboleths survived it — the anarchic desire to demolish, the cult of the irrational, the extreme hostility to logical, moral and aesthetic values. If the Surrealists adopted such attitudes on their own account they did so in order to reconstruct an original system of knowledge. André Breton was the leader and theoretician of this system. He was surrounded by such poets

as Aragon, Benjamin Péret, René Char, etc., and by such artists as Max Ernst, Yves Tanguy, Salvador Dali, André Masson, Joan Miró and Hans Arp. And when in 1924 Breton published his first Surrealist manifesto the movement had already acquired an explosive vigour.

In their passionate desire to go back to the very sources of creation the Surrealists were led to explore the unconscious and the dream, to advocate recourse to childlike spontaneity and to supernatural powers, to claim for themselves the fascinations of the marvellous, the mysteries of primitive magic and ancient esoteric ritual. In so doing, they gave substance to the profound spiritual aspirations so long constrained by reason, withered by intellect and imprisoned by the subtly woven mesh of culture. To enter into contact with the unknown regions of the self, to reunite directly personality and being, to restore the natural freshness of faith, inspiration, love and all that liberates the mind from the corruption of reflective thought — no programme seemed more opportune or legitimate. Unfortunately it was not enough to replace the tyranny of reason with the spell of the irrational, especially if to express the irrational one called upon the reason. To propose as a model the virtues of a child's or primitive's sensibility and then to try to ape one or the other when one is a civilised adult is a contradiction which may well stimulate a writer but which condemns a painter to contrived affectation. So it was that Surrealism was advantageous to poetry but precipitated painting into the dead end of a new academicism. The freak encounters between images of contrasting significance could not disguise the plastic poverty and the utterly threadbare banality of Surrealist painting. In deliberately neglecting the conquests of modern art, particularly those of Fauvism and Cubism, the Surrealist painters were obliged to resort to techniques used in a tradition for which they had had nothing but scorn. At the same time they created, as a reaction to this, tendencies which, after passing unnoticed during the period of stagnation between the Wars, emerged with brilliance once peace was restored to the world.

The revival of forms

In fact, while Surrealism, though attempting to destroy traditions, was proving to be conservative in the realm of plastic and pictorial values, painting continued to feel the impact of Cubism, which still attempted either to continue and surpass or else to combat. Juan Gris remained faithful to Cubism up to his death in 1927, but Delaunay and Léger, unable to accommodate themselves to the static, monochromatic nature of Cubism, soon repudiated it. Jacques Villon did his utmost to reconcile Cubist construction with Impressionist colour. In Italy the Futurists Carrà, Boccioni, Russolo, Balla and Severini maintained a realism based on the retinal perception of movement. The Russian painter Kandinsky, who with Franz Marc founded the Blaue Reiter group in Munich, was impelled by his need for effusive lyricism to eliminate from his painting the object, so dear to the French Cubists; Mondrian and Malevich arrived at the same result by taking to extremes the very bases of Cubism. In short, by 1918 Cubism, the most important plastic revolution since Paolo Uccello, seemed to have nothing more to offer. At this point the artists who had been dispersed by the War returned to Paris. Museums and salons reopened. Art galleries increased in number, art reviews were launched and collectors busied themselves. An enthusiastic interest in modern art drew a bigger and bigger public to exhibitions, plays and the

802, 908, 903, 898, 902, 751, 657, 738, 942, 943, 739, 805, 689, 1082, 642, 804, 644, 803, 636, 802

Top left. ERNST LUDWIG KIRCHNER (1880–1938). Red Tower in Halle. 1915. Folkwang Museum, Essen. *Photo: C. and H. Milch.*

Top right. LYONEL FEININGER (1871–1956). Gelmeroda IX. 1926. Folkwang Museum, Essen. *Photo: C. and H. Milch.*

FRANZ MARC (1880–1916). The Fate of Animals. 1913. Kunstmuseum, Basle. *Photo: Hans Hinz.*

802. HANS ARP (1887–1966). Constellation according to the Laws of Chance, Painted wood relief. c, 1932. *Tate Gallery*.

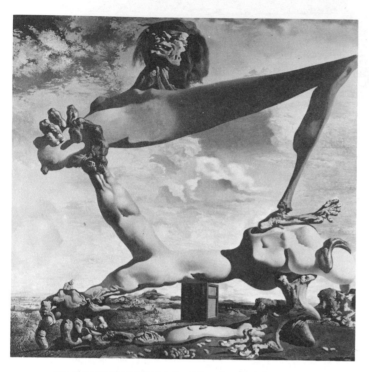

803. SALVADOR DALI (b. 1904). Soft Construction with Boiled Beans; Premonition of Civil War. 1936. *Philadelphia Museum of Art*.

804. MAX ERNST (1891–1976). Euclid. 1945. *Dominique and John de Menil Collection, New York*.

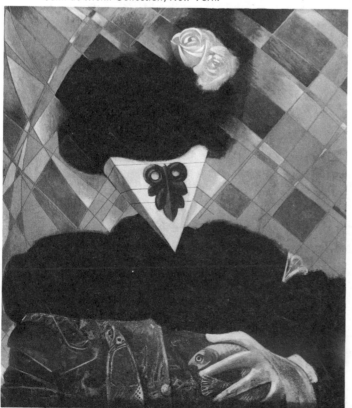

Ballets Russes, whose director Diaghilev surrounded himself with original artists. And musicians, painters and poets collaborated not only for the ballet but also for the theatre and the cinema. Painters illustrated the work of poets; poets praised the work of painters. In Montparnasse and St Germain des Prés the cafés were thronged with a cosmopolitan clientele of artists, students, political refugees and restless intellectuals.

For the first time since the advent of the Impressionists the public no longer greeted the living forms of art with that scornful indifference accorded the great precursors. On the contrary, the public were inclined to be so free with their admiration that they showed a lack of judgment. The fame of the French masters spread to other countries, which purchased their pictures and commissioned decorative work. In return a host of painters from all parts of the world flocked to Paris. France became the favourite centre for painters and sculptors of all nationalities, who came there to find the stimulus necessary for the development of their talent; at the same time these artists introduced new ways of thinking and feeling which enriched contemporary art. Paris not only absorbed artists and ideas from abroad; it was open also to the arts of bygone civilisations and of primitive peoples. For it was at this time that archaeology and ethnology, but recently elevated to the rank of sciences, revealed the exotic objects — the statues and the frescoes several thousand years old and yet still charged with poetry — which artists were to marvel at. Thus the West was confronted by a multitude of hitherto unknown forms of extraordinary genius, whose emotive vitality gave a worn-out humanity the image of its fervent youth. A bovid discovered on the wall of a Magdalenian cave, a fragment of pottery dug out of the sands of ancient Mesopotamia, a worm-eaten mask from the Ivory Coast or some mutilated god brought to light in Mexico or Turkestan — these opened up new lines of inspiration, resolved doubts and confirmed convictions which gave an unexpected turn to the evolution of art. Romanesque art was not composed of the Graeco-Roman vestiges which were scattered throughout Europe, but of Oriental influences. In the same way artists of our own time have preferred to look to the fabulous repertory of forms exhumed from the past or collected from distant lands. They have suddenly recognised in their ancestors and in their so-called barbarous fellow men a profound feeling for life, and a love and a need of beauty; they have realised that the great human values are as old and eternal as mankind itself, that art preceded technique and that perhaps technique has only served to degrade art. Romanesque art, which had ignored the classical buildings left behind by the Roman legions, was still almost unknown to the general public a mere twenty-five years or so ago. Since then a number of painters have found in the frescoes at Tavant or at St Savin, or in the illuminated manuscript of the *Apocalypse of St Sever*, the answers to their own questions. The art of the Middle Ages has now become the object of detailed study and fruitful commentary. The arts of the tapestry, of stained glass and of enamel are again being practised, and with such understanding of the original processes that one can truly speak of a renascence of these techniques.

The Middle Ages was not the only period which aroused the insatiable curiosity of contemporary artists. It was not Impressionism and Cubism which were the origins of the first essays in non-figurative art; it was rather the signs drawn on the pebbles of the Mas d'Azil, the intricate ornamentation of Islam's art, the dynamic stylisations of Ireland, the open-work woodcarvings of Oceania and the striking abstract art of Africa. It is not with Surrealist painting that the most Surrealist of painters, Joan Miró, has the greatest affinity, but rather with the sculptures of Easter Island or with the schematic designs of Pre-

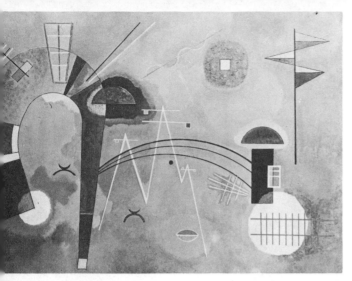

805. WASSILY KANDINSKY (1866–1944). Curves and Angles. 1930.

806. PAUL KLEE (1879–1940). Glance of a Landscape. Gouache and airbrush on paper. 1926. *Philadelphia Museum of Art*.

806 Columbian pottery. In endeavouring to reach the profound and complex reality of things — what he called 'the prehistory of the visible' — Paul Klee, in his hieroglyphics and pictographs, looked to the sources of language, and in the late works of
805 Kandinsky one distinguishes not so much the romanticism of the Blaue Reiter as the suggestion of the art forms of the great plains of Asia. Art does not develop in a vacuum, especially when the speed of communications reduces space and time to a scale compatible with man's desire for knowledge.

Art between the Wars

If the twenty years separating the two World Wars did not produce artists as powerful as those who had emerged in the course of the two preceding decades, they were nevertheless a period of stormy, almost delirious activity, for the artist had the wherewithal to exercise his talents and the public were prepared to receive his work. Matisse, Léger, Picasso, Braque, Bonnard, Rouault, Dufy, Maillol and others were at the height of their powers. Despite the events of the late 19th and early 20th centuries, the naturalistic tradition was still being patched up by its last supporters — first of all by craftsmanlike painters who still believed in skill and technique rather than in originality and imagination, secondly by the new recruits to realism who accentuated to the utmost degree the given data of nature.

These 'Expressionists' complacently followed the mournful voices of their egos rather than the achievements of Munch, Kirchner or Ensor. This particular return to the human was especially noticeable in Germany, central Europe and Belgium. France felt this influence only via the foreign painters living there — the painters of the so-called school of Paris.

The defeat of their country by no means prevented French artists from carrying on their work. Indeed, the enemy Occupation greatly increased the activity of these artists and encouraged them to look to the national heritage. It was not without reason therefore that the exhibition which brought these artists together on 10th May 1941 was called 'Young Painters in the French Tradition'. These 'young painters' included Bazaine, Estève, Gischia, Lapicque, Pignon and 808–810 Manessier. They figured again in the 1944 Salon d'Automne, 916, 919 which was perhaps as memorable as the Fauve exhibition in the 1905 Salon d'Automne and the Cubist exhibition in the 1911 Salon. Accepting the heritage of their predecessors, they had in common the will to continue the pioneering work begun at the beginning of the century; furthermore, they and they alone heralded the dawn of revolutionary painting in Europe. But a few more years were to pass before there emerged, in both the victorious and the vanquished countries, a new avant garde of painters — we repeat, of *painters*. It has been painting which has led and stimulated the other arts for the last hundred years, and it has been the painters who have been the pioneers. Like Degas, Gauguin and Renoir before them, Picasso, Matisse, Braque and Léger all tried their hand at sculpture, to which they gave a healthy impetus. It was from a movement in painting — from Cubism, as we have seen — that the sculptors Duchamp- 733 Villon, Brancusi, Laurens, Gonzalez, Zadkine and Lipchitz first 734, 788 borrowed their creative methods. It was Cubism again which influenced architects and interior decorators who had become exasperated with the undisciplined exuberance of Art Nouveau. Fauvism too had played its part in so far as it had emancipated colour; wherever colour was required as an accompaniment to the schematised forms, the articulated geometric volumes, the clear-cut intersecting planes, splashes of brilliant tones were used.

The phenomenon which had taken place soon after the First World War occurred again after the Second, and to an even greater degree. Each nation was bent on proving its vitality in all fields. Furthermore, each nation encouraged the talents of its intellectuals and artists. There was not one country that was not soon to pride itself on a national literature, a national theatre and a national school of painting, architecture or sculpture. And the hegemony of French art, undisputed for three centuries (that French art which was still very much alive despite the political and military disasters of the country), was challenged — all the more in that it had been so envied. Today London, New York, Rome and Milan contend for the honour of being the centre of the art of the future. And if foreign painters and sculptors continue to flock to Paris it is not so much to find there an indispensable stimulus but rather to have their work recognised and sanctioned. Thus a new school of Paris has grown up which dresses the lucid, permanent values of the French genius in imported forms of expression. There now arises that paradox by which competition between the various nationalisms, far from accentuating the originality of each country, engenders a barely differentiated cosmopolitanism. Individual inspirations tend to lose their integrity in favour of a generalised, multiple, international confusion from which the style of the period emerges triumphant — at least when it has not been buried beneath stereotyped conceptions, or for that matter aborted by the clash of opposing tendencies.

807. FRANÇOIS DESNOYER (b. 1894). Reading.

808. MAURICE ESTÈVE (b. 1904). The Sioule. 1956.

809. CHARLES LAPICQUE (b. 1898). The Jetty. 1945.

810. JEAN BAZAINE (b. 1904). The Painter and his Model. 1944.

The emancipation of the creative forces

The cosmopolitanism of recent years, however, cannot be explained away as the result of nationalism alone. Other causes, arising from the evolution of forms, the new aesthetic principles and the new techniques, have contributed to its growth. Cosmopolitanism is the ultimate result of those experiments and discoveries which from the beginning of the century had been leading up to a complete re-examination of established values and a no less complete liberation of the creative forces. The pioneers of modern art had merely pointed the way which their successors were to follow so fearlessly. They had aimed at rendering nature in the most complete manner possible; their ambition went no further. From Rembrandt to van Gogh, as from Poussin to Cézanne, painting may be considered as a unified whole. Cézanne wished to ' do Poussin over again on nature ', van Gogh ' to add man to nature '. Between Poussin and Cézanne and between Rembrandt and van Gogh there is only a shade of difference. Between Cézanne and Léger and between van Gogh and Mondrian there is a chasm. Goujon and Rodin are not so very different, but Rodin and Laurens are diametrically opposed. We are forced to admit that though the great precursors renewed the *means*, they did not attack the basic *principle* of their art. The contemporary artist, on the contrary, questions that principle itself. What has happened? How can we account for so complete a rupture?

Throughout Fauvism, Cubism and certain individual experiments one could see a determined effort to break free of imitation and of the traditional ideas of form. In a process that seems to be characteristic of contemporary art the creative artist starts from the general to end up with the particular. The work of art is no longer an image of something else, but an object in itself. The artist is concerned less with providing an

illusion of concrete reality than with abstracting from that external reality a new autonomous reality created directly by the spirit. Vigorously opposed to those who persist in the tradition of the old masters and who take only cautious liberties with reality are others who want to wipe out the past completely and cut the last ties that bind art to nature. Artistic activity is now carried out on two fronts. Where the two converge, it becomes difficult to distinguish the revolutionaries from the bolder members of the reform party. Although Paul Klee's creative process may seem curious and unusual, there is always some perceptible contact with the tangible world; however Wols, who had been influenced by him, broke that contact and took refuge in the irrational part of his being. Léger remained at the juncture of the two tendencies, but his friend Robert Delaunay turned, around 1912, to pure abstraction. In 1910 Kandinsky left Fauvism behind and painted his first non-representational work. A long series of simplifications led Mondrian to reduce the language he had inherited from Cubism to horizontal-vertical rhythms; at the same time Malevich passed abruptly from Cubist constructions to compositions of circles, triangles and squares. With less perseverance and sometimes with less clarity other painters made similar attempts to escape from the constraints of representation. In 1910 Larionov exhibited his Rayonist paintings in Moscow, and in Paris the Czech painter Kupka and the Spanish painter Picabia produced non-figurative works. Later such artists as Pettoruti, and Hans Arp and Sophie Taeuber-Arp in Zürich, contributed to the growth of an aesthetic trend that was to percolate through a number of studios in Europe and America before gathering, at the end of the Second World War, an irresistible momentum.

This trend was all the more powerful in that it followed the path traced by the initiators of contemporary art — Matisse, Braque, Picasso, Léger and Klee. So many liberties had been taken in the representation of the object that the object ended up by disappearing altogether. Even the generation from André Beaudin to Bazaine, which in 1941 in Paris had asserted its loyalty to the French tradition while at the same time expressing its desire for renewal, later renounced the facility of narrative painting. It is true that the most daring experiments of these painters still preserve a sense of reality, but it is a reality that is felt and experienced to the full. One can assume that they were part of the turning point at which the 'evolutionary revolution' became the 'negatory revolution'. At all events, formalism and convention having been rejected, painting was now defined as an assemblage of lines and colours which, no longer needing to represent or signify something, were valid in themselves. But if pictorial art tended towards this end it arrived there by following the very different paths opened up by the romanticism of Kandinsky and the classicism of Mondrian — the first being the forerunner of lyrical, effusive, neo-Expressionist painting, the second of intellectual, constructivist, geometrical painting. The latter style, as illustrated by Herbin, Magnelli, Mortensen, Vasarely, Nicholson, Glarner and Albers, has been losing ground continually to such lyrical painters as de Staël, Hartung, Schneider, Lanskoy and Zack in France, Afro, Corpora and Vedova in Italy, Pollock, Kline and Guston in the United States — not to mention the German, Swiss, Spanish, Dutch and Japanese painters. Their number has increased daily, for the enjoyment of liberty arouses a need for still more liberty, till the artist slips into facility, excess and in the end nihilism. No more form, no more colour harmony, no more discipline, no more composition. Nothing but a tangle of lines, a hotch-potch of thick impasto and a torrent of colours. All is well so long as each individual can express his sensations without hindrance. And then even the sensations

806
1049
921

689

1082

811

802

310

814
815

819

811. MICHEL LARIONOV (b. 1881). Rayonism. 1911. *Artist's Collection*.

cease to control the brush; now it is the noxious exhalations of the unconscious, the feverish vapours of the humours, the dumb throb of organic life which seem to animate the surface of the canvas. Now we see the various brands of Tachisme and 'informal art' in Europe, of action painting in America.

There are nevertheless some non-figurative painters who abjure such extreme movements, nor do they content themselves with the frigid puritanism of Mondrian and his followers. Manessier, for example, and Estève, Bissière and Piaubert have refrained from sacrificing sensibility to intelligence or intelligence to sensibility. And as one must provide references to justify even the most extravagant actions, the partisans of spontaneous, diffuse, empirical art quote Monet, the Monet of the *Water-lilies*, when really they, or at least the more passionate of them, would do better to claim the sponsorship of the northern Expressionists. In any case, from Impressionism, which had dissolved form, to a Neo-Impressionism which suppresses it, and from Expressionism, which tortured form, to a neo-Expressionism which smashes it to smithereens, one cannot help but marvel that the distance has been so quickly covered.

808

The consequences of the pictorial revolution

In its voracious exigencies the pictorial revolution seems to have driven painting to the point of self-destruction — and sculpture too as a consequence. Laurens, Brancusi and Moore are already on the other side of the fence. Calder, with his mobile articulations of metallic stalks and flowers, is just at the limit. It is Pevsner, his brother Naum Gabo, Arp and Max Bill who have established the tone for sculpture today — a tone already dulled, it would seem, by sculptors of shapeless, invertebrate forms, sculptors who scoff at the laws proper to their art, at volume, density and mass, and who weld pieces of sheet iron and make tangles of wire in an attempt to imprison the void within their open-work snares. There has been a decline in monumental statuary, which is no longer produced except by rare sculptors such as Henri Georges Adam. Anti-sculpture has caught up with anti-painting in the international exhibitions. And it has found theoreticians who, with entire good faith, explain and justify the spirit of negation that has produced it. Thus, having reached this ultimate point of rebellion, non-figurative art has reverted, paradoxically, to what it has so violently condemned — realism. The painter imitates the rough surfaces of walls, the markings on rotting wood, the wrinkles on old leather. The sculptor subscribes to gnarled roots, scrap iron and wreckage.

661
820

666, 701

880

814. AUGUSTE HERBIN (1882–1960). Hell. 1959. *Private Collection.*

815. BEN NICHOLSON (b. 1894). Half Moon. 1959.

812. ALBERTO MAGNELLI (1888–1971). Composition. 1945. *Riccardo Jucker Collection, Milan.*

813. FRITZ GLARNER (b. 1899). Relational Painting. 1949–1951. *Whitney Museum of American Art, New York.*

And yet this will to rebellion, this progressive detachment from the real, this wind of freedom that has destroyed so many shackles, have introduced beneficial and no doubt necessary changes in the world of form. All branches of artistic activity have derived a vital stimulus, and vast horizons have been revealed. Feeling themselves cramped by the too rigid limitations of easel painting, painters have learned to use new tools and have explored new territory. The arts of the tapestry, of stained glass, mosaics, ceramics, etc., which for centuries had been preserved in a state of lethargy by academicism, have now been revived. But this revival has not followed the course prescribed by the Bauhaus (founded in 1919 at Weimar by Gropius) and by De Stijl (founded in Holland a little earlier by van Doesburg and Mondrian), nor has it pursued the theories on style proposed by the French decorative artists who were brought together at the 1937 Exhibition. The taste for geometrical construction, for lines intersecting at right angles, has given way to a taste for curves, broken surfaces and splashes of colour. The ceramics created by Picasso at Vallauris, the Matisse chapel at Vence, Lurçat's tapestries, Léger's decorations for the United Nations building, etc., have given rise to a lively spirit of competition. Exactly suited to the needs of

816. JACKSON POLLOCK (1912–1956). Grayod Rainbow. 1953. *Art Institute of Chicago.*

817. JFAN FAUTRIER (b, 1897). Painting. 1960.

818. AFRO (1912–1976). Painting. 1960.

819. FRANZ KLINE (1910–1962). Painting No. 7. 1952. *Solomon R. Guggenheim Museum, New York.*

contemporary life and to the plastic qualities of new materials, abstract art, with its freedom and its million rhythmic possibilities, has extended its empire — to such an extent that today the idea of a narrative or figurative composition at the entrance to a stadium, on the façade of a factory or on the walls of a church would be almost unthinkable. A clerical élite has not hesitated to commission the most revolutionary artists to decorate the churches of Assy, Audincourt, Tiquetonne, Bressieux, Metz, etc. And now the factories, laboratories and restaurants are employing the painters and sculptors. The cinema too has drawn inspiration from their innovations; from **843** Léger's *Ballet Mécanique* to the strictly abstract films of MacLaren there emerges an increasingly acute awareness of the intellectual possibilities.

The avant garde in architecture

As we have now seen, the art of today is not as anomalous as one might suppose from the apparent disorder, confusion and excess inseparable from so effervescent an activity. A brief examination of the innovations in the most concrete, the most universal and the most directly accessible of the arts, architecture, should reassure us. The appearance of such materials as iron

and steel, reinforced concrete, aluminium, structural glass and plastics has swept away the traditional laws of architecture and has modified profoundly the problems relating to the balance of stresses, the calculation of resistances, and even to aesthetics itself. The modern architect collaborates of necessity with the engineer. Or else he is an engineer himself, like Eiffel, Freyssinet, Maillart and Nervi — men whose names will go down in history. Famous though they may be at present, Auguste Perret, Mies van der Rohe, Gropius and J. J. P. Oud belong to the past, to a rationalistic system which is now outmoded. Euclidean geometry and static forms have, in effect, tended to disappear. The architect now turns not so much to stringency of concept as to the infinite variety of nature — to the subtle textures and supple forms of living organisms — for the fundamental principles of his creation. The time-honoured convention of the supporting wall has been replaced by that of internal structure, curtain walls (non-supporting walls) and curved surfaces. In twenty-five years architecture has changed more than it had in twenty-five centuries. A building is no longer a mass of stone or brick resting on vertical supports; rather it is reminiscent of an ensemble of parabolas which have metallic girders as their axes and directrices. Le Corbusier's **672**

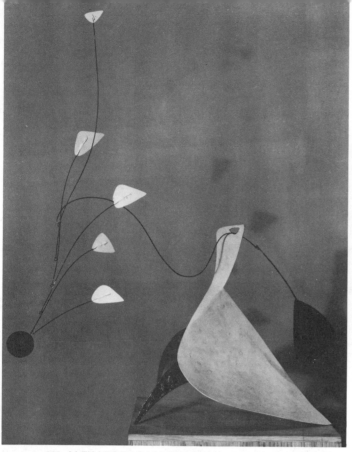

820. ALEXANDER CALDER (1898–1976). Yellow Bottle. Mobile. 1945.

821. BERTO LARDERA (b. 1911). Antique Goddess No. 3. Iron and steel. 1958.

822. RICHARD STANKIEWICZ (b. 1922). Kabuki Dancer. Iron and steel. 1956. *Whitney Museum of American Art, New York.*

823. EDUARDO PAOLOZZI (b. 1924). Medea. Welded aluminium. 1964. *Robert Fraser Gallery, London.*

824. ANTHONY CARO (b. 1924). Pompadour. Aluminium painted pink. 1963. *Kasmin Gallery, London.*

9, 670 chapel at Ronchamp, Frank Lloyd Wright's Guggenheim Museum in New York, Aalto's sanatorium at Paimio in Finland,
934 Nervi's Palazzetto dello Sport in Rome, the exhibition
684 building of the Centre National des Industries et Techniques in Paris by De Mailly, Zehrfuss and Camelot, the buildings in
1160 Brasilia designed by Niemeyer — all these astonishingly bold works are made up of sinuous lines and inflected planes centred on supports which determine the forces of weight and tension. Guillaume Gillet's French pavilion at the 1958 Brussels Exhibition was roofed over with taut cables supporting sheets of metal. The walls of the Allocations Familiales by Lopez (1959), in the rue Viala, Paris, are like leaves of a folding screen hung from the framework of the roof.

With the help of the new freedom and dynamism architecture is producing forms which would appear bizarre to us were it not for their obvious affinity to the forms of ships,
663 aeroplanes, cars and other such completely original creations of the modern genius. And these forms, released from the laws of weight, symmetry and the right angle, are to be found again in the applied arts, particularly in furniture design. Through the contraction of the forces of tension, the studied play of curves and the combined use of textiles, foam rubber, plywood
704 and metal, chairs have taken on wide, sweeping shapes with curving outlines which terminate at the base in arcs or clustered struts. Tables, traditionally rectangular, now often describe the pleasing curve of a hyperbola. Household utensils have adopted elegant floral lines which are as varied as the fantastic inventions of nature. Instead of verticals and horizontals, rigid symmetry and the arid monotony of flat surfaces, cabinet-makers, ironsmiths and decorators resort to the resilient curving lines which are more satisfying to the modern sensibility.

Thus the specifically functional arts have rallied to the new aesthetic trend. Does this mean that the latter is going to consolidate its field of influence and to entrench itself finally as a style — the style which will be characteristic of our particular epoch? No one can tell at present, for geometric form still has stubborn supporters who, however, relieve its severity and monotony by the skilful breaking up of planes, by the use of contrasting colours and by the juxtaposition of filled with empty space and of the opaque with the transparent. At all events, abstract art has found in the progress of science, in the discovery of new materials, in the need for economy and in the aggressive questioning of all values (but also, let us remember, in a mode of expression established from Neolithic times), a highly favourable field of expansion. The fact that the artist today insists on absolute freedom of creativity should not perturb us. Grant him the possibility of exercising that freedom according to his means; let him abuse that freedom if he will. Let him redouble his attacks on a tyrannical tradition if such a combat will result in the birth of a new tradition which will supplant the preceding one (as it will be supplanted in its turn). Between the freedom which prohibits everything and the freedom which permits everything art is sure to regain its balance in the end.

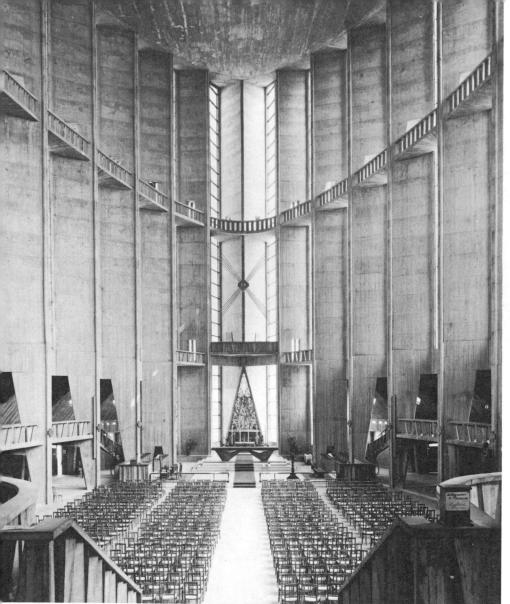

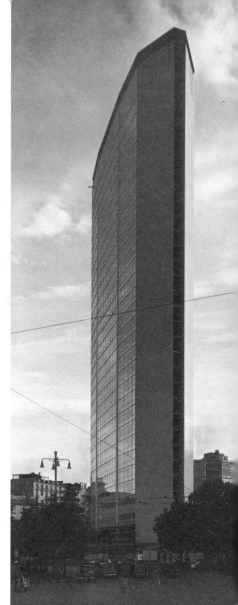

825. FRANCE. GUILLAUME GILLET (b. 1912). Interior of the church of Notre Dame at Royan. 1954–1959.

827. *Below.* AUSTRALIA. JØRN UTZON (b. 1918). Opera house, Sydney (with Ove Arup). Model. Designed 1956.

826. ITALY. GIO PONTI (b. 1891). Pirelli building, Milan (in collaboration with Fornaroli, Rosselli, Valtolina, Dell'Orto, Nervi and Danusso). Completed 1960.

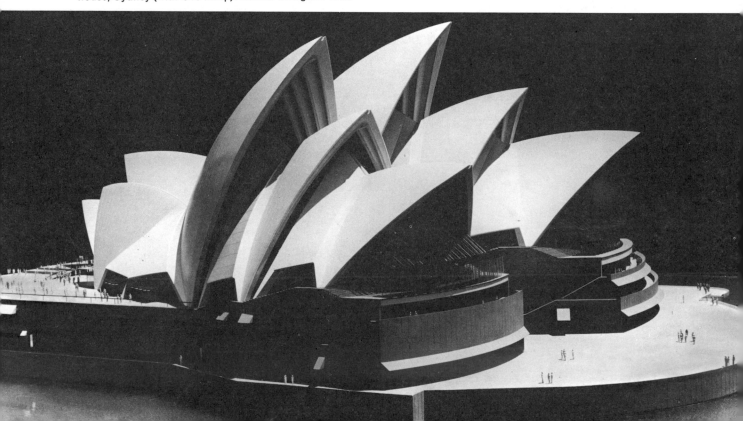

HISTORICAL SUMMARY: 20th-century art

The 20th century poses new problems; we lack the detachment of retrospect, and the quantity of factual data is overwhelming. It has therefore been necessary in this particular summary to abandon the usual articles which, under the headings of the individual countries, aim to give an account of the development of events and culture and to limit ourselves here to a general survey of the epoch as a whole, incorporating special headings for the two new arts included (photography and the cinema) as well as some general comment on the major tendencies in architecture, town planning and the decorative or minor arts. Furthermore, this summary of the 20th century does not pretend to mention — and still less to illustrate — all the artists who are representative of the contemporary scene and who would deserve a place here; we do not disguise the fact that space has prevented us from including more than a mere selection of examples. In addition, since recent information for certain headings under distant countries can only be obtained on the spot, and since the sources consulted do not all provide an equal amount of detail, we beg to be excused any resultant lack of balance.

History. The beginning of the 20th century marked the peak of European power. The undisputed superiority of the Old World in technical and intellectual fields (discovery of X-rays; Freud's theories), its material power in the form of colonial or economic domination, all these causes seemed to have converged to establish the permanent hegemony of Europe. The confidence in a system based on an economic prosperity made possible by greater and faster means of transport, by the free movement of men and capital and by financial stability, remained unshaken by social disturbances (strikes of a revolutionary character from about the beginning of the century onwards in England, France, Italy and Russia) and by imperialist rivalries (Germany's desire for power).

The First World War (1914–1918) was a severe blow to the stability of the world — economically, politically, socially and above all morally and intellectually. Faith in science and in the civilisation evolved during the 19th century was dead. Devastated, ruined, its balance destroyed by treaties which had created small and weak states, Europe was exposed to minority claims and was a prey to social revolt — the latter the result of the hardships of war and the Russian Revolution (1917). The sudden prosperity of the United States and Japan, arising from the needs of wartime Europe, gave those two countries an economic lead and soon a corresponding political influence among the world powers. The Soviet Union became a magnetic symbol, a political myth and, for these reasons as much as for its part in the Second World War, assumed a major role. But neither Marxism with its worship of material progress, nor Fascism whose proposed ideal of national socialism was capable of developing into Nazi fanaticism, nor any of the stern totalitarian doctrines that deny the individual, nor even democratic capitalism, was able to satisfy the profound aspirations of man who, between the two Wars, revealed in his art and in his thought a total bewilderment arising from his loss of faith in the human values accepted for two centuries.

With the Second World War (1939–1945) the anxious uneasiness became a metaphysical shock. Man's condition has been completely transformed by science (discovery of antibiotics; the atomic and hydrogen bombs; atomic energy; supersonic speed). The possibilities of reaching outer space, of analysing and transforming matter, of creating new substances (synthetics, plastics) which give rise to new forms, have led us to revise drastically our way of life. The democratisation and internationalisation of scientific and technical knowledge through the press, the radio and television, the international cultural organisations (UNESCO) and the mass industrialisation in certain artistic fields have tended to create a uniform view of civilisation and thought.

Art, always one of the first fields to assume a revolutionary aspect, has become in a more or less vulgarised form one of the major needs of modern man. The increasing number of museums and exhibitions, the experiments in industrial aesthetics (the practical application of colour psychology in factories and to manufactured articles), the importance of art books and magazines, the number of collectors and speculators, the economic role of dealers, the great public auctions (London, Paris, New York) — all are proof of the need for art in modern civilisation. Art, like politics, has become something passionate and dynamic. Characteristic is the growing violence since 1945 of the antagonism between abstract and figurative artists — or again between the partisans of atonal, dodecaphonic serial music and of concrete music and those who remain faithful to traditional contrapuntal forms.

The dramatic arts have flourished, for they satisfy both visual demands and the growing desire for greater communion between artist and spectator. In the theatre there have been the revolutionary scenic ideas of Adolphe Appia, the theories of Gordon Craig, the plays of Pirandello in Italy, Claudel in France, Brecht in Germany, Čapek in Czechoslovakia and Chekhov and Andreyev in Russia, and the avant garde influence at the Comédie Française (Louis Jouvet, Charles Dullin, Gaston Baty, Jean Louis Barrault). The popular shows in Moscow and Leningrad, the open-air productions at Salzburg, Paris, Avignon, Florence, etc., and the numerous international festivals, have reached all sections of the public. The ballet has been transformed by a new conception of the dance as it was revealed by Diaghilev's Ballets Russes, and has been closely linked with the plastic arts — with Expressionism and Surrealism, and with Oriental influence, all of which has given it a new lease of life [**829**].

Finally the mechanisation of music (records, radio) and the mechanisation of visual images (photography, colour reproduction, cinema, television) are significant phenomena of modern civilisation, and their aesthetic, social, moral and psychological consequences are manifold.

Photography. Since its early years (see Chapters 1 and 3) photography has been ceaselessly perfected, to the point where, about the 1920s during the Surrealist period, it vied with painting (it had done so earlier during the period of realism). Today photography in black and white, in colour and in three-dimensional relief — to say nothing of aerial and underwater photography, microphotography and macrophotography — has developed considerably in all fields (reproduction of works of art, archaeology, the sciences, publishing, journalism, publicity); illustrations tend to take the place of texts, thereby becoming a visual instrument of work, communication, culture and even of propaganda for all countries.

Early in the 20th century photography was elevated to the rank of a fine art by such modern pioneers as P. H. Emerson in England, Alfred Stieglitz [**830**] and Edward Steichen in the United States, Robert Demachy and Eugène Atget in France and Hugo Erfurth in Germany.

Early in the 1920s Man Ray (rayographs [**831**]) and Laszlo Moholy-Nagy (photograms and photomontages [**832**]) brought the new movements in art to photography. The 1930s generation was concerned with composition

828. NATHALIE GONTCHAROVA
(1881–1962). Design for scenery for
the Coq d'Or, produced by the
Ballets Russes, Paris. Gouache. 1914.
Museum of Modern Art, New York.

829. E. McKNIGHT KAUFFER.
Costumes and setting for Checkmate,
produced by Sadler's Wells, London.
1937.

830. ALFRED STIEGLITZ. Winter on
Fifth Avenue. 1893. *George Eastman
House, Rochester, New York.*

and was influenced by paintings and the
cinema. There was a return to realism
(Brassai's work), a realism which became
characteristic of the 1950s generation.
Its exponents were concerned with
documenting everyday life. The pathetic
or poetic side of life is seen in the work
of Werner Bischof and Henri Cartier-
Bresson [**836**], the humorous in the
work of Robert Doisneau. The un-
expected oddities of existence are re-
corded by Agnès Varda. The American
photographer Edward Weston's work
has an extraordinary plastic purity [**835**],
and a deeply expressive quality can be
found in the poignant masks of Thérèse
Le Prat [**834**].

Among other important names in
photography are: in Italy — Toni del
Tin, Pablo Monti, Fulvio Roiter; in
Holland — Emmy Andriesse, Ed van
der Elsken; in England — Bill Brandt
[**838**], Roger Mayne [**839**], Brian
Griffin, Raymond Palmer, Sarah Mc-
Carthy, Valerie Wilmer, The Hackney
Flashers Collective; in Germany —
Peter Keetman, Albert Renger-Patzsch,
Max Scheler, Toni Schneiders; in
North America — Berenice Abbott,
Ansel Adams [**837**], Margaret Bourke-
White, Harry Callahan, Robert Capa,
Robert Adams, Ralph Gibson, Mark
Cohen, Diane Keaton [**834**], Kenneth
McGowan and Lewis Baltz, as well as
the German Alfred Eisenstadt, Eliot
Elisofon, Walker Evans, Yousuf Karsh,
Dorothea Lange, Aaron Siskind,
Bradley Smith, Paul Strand; in Japan —
Toshiji Mukai, Takeno Tanuma; in
France — Laure Albin-Guillot, Pierre
Boucher, Boudot-Lamotte, Jean Rou-
bier, Roger Schall, and Bernard Faucon.

In the second half of the 19th century
photographers tended to 'imitate with-
out expressing', in Daumier's words;
later they sought to make the subject
look like a painting by using chiaro-
scuro effects reminiscent of the
Impressionists or of the narrative
paintings of the salons. In the con-
temporary period, however, photo-
graphers have had other aspirations and
have developed individual styles of their
own. Many have realised that photo-
graphy is not opposed to art and have
created evocative and personal images
of life aided by a free and imaginative
use of camera technique.

Cinema. This art, closely associated with
industrial, economic, technical and social
developments, falls into seven periods:

1. Technical inventions: the device
for showing rotating sequences of
drawings, invented simultaneously and
independently in 1832 by the Belgian
Joseph Antoine Plateau and the Austrian
Simon Ritter von Stampfer; the
Englishman W. G. Horner's Zoetrope
(1834); the experiments in the United
States in photographing moving

831. MAN RAY (b. 1890). Rayograph.
1923.

832. LASZLO MOHOLY-NAGY
(1895–1946). Jealousy. Photomontage.
1930. *George Eastman House,
Rochester, New York.*

833. ANDRÉ BRETON (b. 1896).
The Egg of the Church. 1933.

834. DIANE KEATON. The George Washington Hotel, New York. *Castelli Graphics, New York.*

animals by J. D. Isaacs and Eadweard Muybridge; the early experiments in the 1870s–1890s in motion-picture cameras by E. J. Marey in France and W. Donisthorpe, W. C. Crofts, William Friese-Greene, J. A. R. Rudge, Mortimer Evans, F. Varley and the Frenchman L. A. A. Le Prince in England; the kinetoscope of Thomas A. Edison and W. K. L. Dickson in America (early 1890s); the cinématographe of the Lumière brothers in France (1895). In 1895 projectors by R. W. Paul and Birt Acres appeared in England.

2. Pioneers of the cinema: productions of Georges Méliès (*A Trip to the Moon,* 1902), the Pathé studios (Ferdinand Zecca's *Life and Passion of Our Lord Jesus Christ,* 1902–1905) and the Lafitte brothers (*Assassination of the Duc de Guise,* 1908) in France; early films of Edison and Edwin S. Porter in the United States; films of Cecil Hepworth, etc., in England.

3. The cinema as art: advent of the great screen comedians Max Linder, Charlie Chaplin [846], Buster Keaton and Harold Lloyd; the films of L. Feuillade in France; impressive work and technical advances of the American film-maker D. W. Griffith (*Birth of a Nation,* 1915; *Intolerance,* 1916 [841]). During and after the First World War the Swedish cinema came into prominence (Victor Sjöström, Mauritz Stiller), as did the German cinema, the latter with the Expressionist works of Robert Wiene (*Cabinet of Dr Caligari,* 1919 [842]), Fritz Lang (*Metropolis,* 1926) and F. W. Murnau (*Nosferatu,* 1922) and the realistic work of G. W. Pabst (*The Joyless Street,* 1925). The French developed an Impressionist school about 1920, with Louis Delluc, Germaine Dulac, Abel Gance and Jean Epstein. Early in the 1920s Lenin declared that of all the arts the cinema was the most important for Soviet Russia; Sergei M. Eisenstein, one of the greatest film directors of all, brought the cinema to

new heights with his *Battleship Potemkin* in 1925.

4. The avant garde cinema made its appearance in the 1920s but lagged far behind the avant garde in the other arts; this type of film was supported by the ciné clubs and by the intellectual élite. It was influenced by abstract art and Dada (films by the Germans Hans Richter and Walther Ruttman; *Retour à la Raison,* 1923, by the painter Man Ray; *Ballet Mécanique,* 1924, by Léger [843]; *Entr'acte,* 1924, by Francis Picabia, directed by René Clair). Surrealism directly inspired the Spanish poet Luis Buñuel (*Chien Andalou,* 1928, and *L'Age d'Or,* a sound film, 1930, in collaboration with Salvador Dali) and indirectly inspired Jean Cocteau in *Sang d'un Poète* (1931; sound) [840]. The French avant garde helped to form such top-ranking directors as the French Marcel Carné, Jean Renoir, Claude Autant-Lara and Jean Vigo, the Italian Alberto Cavalcanti and the Dutch film-maker Joris Ivens. Outside the avant garde was the work of René Clair (*The Italian Straw Hat,* 1927), Jacques Feyder (*Thérèse Raquin,* 1927) and Gance in France, of the Austrians Erich von Stroheim (*Greed,* 1924) [844] and Josef von Sternberg in America, of the Dane Carl Dreyer (*Passion of Joan of Arc,* 1927 [845]), of the Russians V. I. Pudovkin (*Storm over Asia,* 1928) and Alexander Dovzhenko (*Earth,* 1930), of Chaplin (*The Gold Rush,* 1925; *City Lights,* 1931 [846]) and of the American King Vidor (*The Crowd,* 1928).

5. The early talkies were launched with a mediocre, partly silent film, *The Jazz Singer* (1927), starring Al Jolson; the masters of the silent film condemned dialogue as incompatible with art. The commercial success of the sound film, however, brought considerable prosperity to Hollywood (films of Ernst Lubitsch, Frank Capra, John Ford). Germany made a brilliant start with the work of Pabst (*Westfront 1918,* 1930; *Threepenny Opera,* 1931), von Sternberg (*The Blue Angel,* with Marlene Dietrich, 1930), Lang (*M,* 1931) and Leontine Sagan (*Mädchen in Uniform,* 1931). France produced some great directors in this period: René Clair (*Le Million,* 1931; *À Nous la Liberté,* 1932); Jean Vigo (*Zéro de Conduite,* 1933; *L'Atalante,* 1934); Jean Renoir (*La Bête Humaine,* 1938; *La Grande Illusion,* 1938); Jacques Feyder (*Kermesse Héroïque,* 1935); Julien Duvivier (*Poil de Carotte,* 1932; *Un Carnet de Bal,* 1937); Marcel Carné (*Quai des Brumes,* 1938; *Le Jour se Lève,* 1939). At this time a bitter, morbid realism dominated the French school. The Soviet Union turned to historical films with Dovzhenko and Eisenstein (*Alexander Nevsky,* 1938, and later *Ivan the Terrible,* 1941–1944 [848]). Among leading American film-makers

of this period were: Frank Capra (*Mr Deeds Goes to Town,* 1936); Walt Disney (cartoons); John Ford (*The Informer,* 1935; *The Grapes of Wrath,* 1940); Mervyn Le Roy (*I am a Fugitive from a Chain Gang,* 1932); Lewis Milestone (*All Quiet on the Western Front,* 1930); William Wyler (*Dead End,* 1937); the Marx brothers (*Monkey Business,* 1931; *Duck Soup,* 1933) and Chaplin (*Modern Times,* 1936) in comedy; Robert Flaherty (1920s–1940s) and Pare Lorentz (*The River,* 1938) in documentary. After a slow beginning the British cinema came into its own with Alexander Korda (*Private Life of Henry VIII,* 1933), Anthony Asquith (*Tell England,* 1930; *Pygmalion,* 1938), Carol Reed (*The Stars Look Down,* 1939) and Alfred Hitchcock (*The Thirty-nine Steps,* 1935), and the documentaries of Basil Wright (*Night Mail,* 1936, with Harry Watt), Paul Rotha and others.

6. 1940–1950. The 1940s saw important work by Orson Welles (*Citizen Kane,* 1941), William Wellman (*Oxbow Incident,* 1943) and Billy Wilder (*Lost Weekend,* 1945) in America, by Carné (*Visiteurs du Soir,* 1942; *Les Enfants du Paradis,* 1943–1945 [847]), Grémillon (*Lumière d'Eté,* 1942), H. G. Clouzot (*Le Corbeau,* 1943; *Quai des Ofrèvres,* 1947) and Jean Cocteau (*La Belle et La Bête,* 1946; *Orphée,* 1950) in France. From 1945 onwards the cinema was marked by the development of Italian neo-realism, with the work of Roberto Rossellini (*Rome, Open City,* 1945; *Paisa,* 1946), Vittorio de Sica (*Shoeshine,* 1946; *Bicycle Thieves,* 1948), Luchino Visconti (*La Terra Trema,* 1948) and others. There was a revival in the Swedish cinema with the documentaries of Arne Sucksdorff and films of Alf Sjöberg (*Frenzy,* 1944) and Ingmar Bergman (*Thirst,* 1949). In Denmark Dreyer made his *Day of Wrath* (1947). Britain produced such films as Cavalcanti's *Dead of Night* (1945), Noel Coward and David Lean's *Brief Encounter* (1945) and Carol Reed's *Third Man* (1949). Sir Laurence Olivier scored a great triumph with his *Hamlet* (1948).

7. From 1950 to the present day. The art of the film became throughout the world a means of expression on a par with the other arts. Colour films, stereophonic sound, etc., were perfected. Cinerama and the wide screen made their appearance. New directors made their mark, and earlier directors were still active. Important names are: in Italy, Federico Fellini (*La Strada,* 1954; *La Dolce Vita,* 1960; *8½,* 1962; *Giulietta of the Ghosts,* 1964), Michelangelo Antonioni (*Cronaca di un Amore,* 1950; *La Notte,* 1960 [852]; *The Red Desert,* 1964), Pier Paolo Pasolini (*Accattone,* 1961), Visconti (*Rocco and his Brothers,* 1960), de Sica (*Umberto D,*

835. EDWARD WESTON. Artichoke Halved. 1930. *George Eastman House, Rochester, New York.*

836. HENRI CARTIER-BRESSON. Two Prostitutes' Cribs, Mexico City. 1934.

837. ANSEL ADAMS. Moonrise over Hernandez, New Mexico. 1941.

838. BILL BRANDT. Child Resting. 1955.

839. ROGER MAYNE. Tears. 1956.

1952; *Yesterday, Today and Tomorrow,* 1964); in Germany, Helmut Käutner (*Devil's General,* 1955), Bernhard Wicki, Michael Pfleghar; in France, Robert Bresson (*Trial of Joan of Arc,* 1961), René Clément (*Jeux Interdits,* 1952), H. G. Clouzot (*La Vérité,* 1960), Jean Luc Godard (*Bande à Part,* 1964), Louis Malle (*A Time to Live and a Time to Die,* 1963), Alain Resnais (*Last Year in Marienbad,* 1961 [**853**]; *Muriel,* 1963), Jacques Tati (*Monsieur Hulot's Holiday,* 1953), François Truffaut (*Les Quatre Cents Coups,* 1958; *Jules et Jim,* 1961; *La Peau Douce,* 1964), Roger Vadim (*Repos du Guerrier,* 1962); in Britain, Peter Brook (*Lord of the Flies,* 1963), Jack Clayton (*Room at the Top,* 1958; *Pumpkin Eater,* 1964), David Lean (*Bridge on the River Kwai,* 1957; *Lawrence of Arabia,* 1962), Joseph Losey (*The Servant,* 1963 [**854**]), Tony Richardson (*Tom Jones,* 1963); in Spain, J. A. Bardem (*Death of a Cyclist,* 1955), Buñuel (*Viridiana,* 1961); in Sweden, Ingmar Bergman (*The Seventh Seal,* 1957 [**849**]; *Wild Strawberries,* 1957; *The Silence,* 1963), Alf Sjöberg and Arne Mattsson (*One Summer of Happiness,* 1951; *Yellow Car,* 1964); in Greece, Michael Cacoyannis (*Stella,* 1954; *Elektra,* 1961), Jules Dassin (*He Who Must Die,* 1957; *Never on Sunday,* 1961); in the Soviet Union, Grigori Chukhrai (*Ballad of a Soldier,* 1959), Joseph Heifitz (*Lady with the Little Dog,* 1960) and Mikhail Kalatozov (*The Cranes are Flying,* 1957); in Poland, Jerzy Kawalerowicz (*Mother Joan of the Angels,* 1961), Andrzej Munk (*The Passenger,* 1961–1963), Roman Polanski (*Knife in the Water,* 1962), Andrzej Wajda (*Ashes and Diamonds,* 1958); in Czechoslovakia, Jiří Trnka (puppet films); in the United States, John Cassavetes (*Shadows,* 1960 [**851**]), John Huston (*The Misfits,* 1961), Elia Kazan (*On the Waterfront,* 1954; *America, America* [*Anatolian Smile*], 1963), Stanley Kubrick (*Paths of Glory,* 1957; *Dr Strangelove,* 1963), Sidney Lumet

(*Twelve Angry Men,* 1957), Delbert Mann (*Marty,* 1955), Adolfas Mekas (*Hallelujah the Hills,* 1962) and Fred Zinnemann (*High Noon,* 1952); in Brazil, Nelson Pereira dos Santos (*Vidas Secas,* 1963); in Argentina, Leopoldo Torre Nilsson (*Summer Skin,* 1961); in Mexico, Luis Alcoriza (*The Gangster,* 1964); in Japan, Teinosuke Kinugasa (*Gate of Hell,* 1953 [**850**]), Masaki Kobayashi (*Hara-Kiri,* 1962), Akira Kurosawa (*Rashomon,* 1950; *Seven Samurai,* 1954; *Heaven and Hell,* 1963), Kenji Mizoguchi (*Ugetsu Monogatari,* 1953), Kaneto Shindo (*The Man,* 1964); in India, Satyajit Ray (*Pather Panchali,* 1952–1953; *Devi,* 1960; *Nashta Neerh,* 1964).

Architecture. By 1900 iron construction, which had been the principal contribution to architecture in the 19th century, began to be eclipsed by steel. The principle of the honest expression of structural design and form was no longer applied except in industrial construction. The architecture schools, with the support of public taste, tolerated the metal framework when it was disguised by more or less traditional decoration. The year 1900 marked the height of incongruous eclecticism. The old formulas were still being repeated in hybrid pastiches of earlier styles which, when funds permitted, were heavily ornamented. For years it was a foregone conclusion that a church could be built only in a Gothic or Byzantine style and that a mansion or town hall must be Renaissance in appearance.

The theory of functionalism, early exponents of which were the Belgians Henri van de Velde [**795**], Victor Horta [**554**] and Paul Hankar, was a reaction against the excesses of a hybrid style which in public buildings employed an ornate classicism (or a neo-Baroque) and in church architecture an imitation Gothic. The disciples of functionalism

841. AMERICAN. D. W. GRIFFITH. Intolerance. 1916.

842. GERMAN. ROBERT WIENE. The Cabinet of Dr Caligari. 1919.

843. FRENCH. FERNAND LÉGER. Ballet Mécanique (the figure of Charlie Chaplin). 1924.

844. AMERICAN. ERICH VON STROHEIM. Greed. 1924.

840. FRENCH. JEAN COCTEAU. Sang d'un Poète. 1931.

845. FRENCH. CARL DREYER. The Passion of Joan of Arc. 1927.

846. AMERICAN. CHARLIE CHAPLIN. City Lights. 1931.

847. FRENCH. MARCEL CARNÉ. Les Enfants du Paradis. 1943–1945.

848. RUSSIAN. SERGEI M. EISENSTEIN. Ivan the Terrible. 1941–1944.

did not believe in disguising the structure of a building and considered ornamentation not as a superimposed decoration but (following the medieval convention) as an incorporation of elements drawn from nature. The ideas of these early functionalists culminated in the movement known in Belgium as Art Nouveau, in France as the Modern Style, in England as Art Nouveau or the Modern Style, in Germany as the Jugendstil and in Italy as Stile Floreale or Stile Liberty.

Gaudí, in Spain, was the most original representative of this style; he combined experimental structures with ornamental devices inspired by nature (irregular rock formations, spiky floral forms, curious animal motifs, etc.) which are reminiscent of the Baroque tradition [**363**, **563**, **681**, **682**].

But the true architecture of our time is that of reinforced concrete, which has been widely used in industry since 1900. Anatole de Baudot, a pupil of Viollet-le-Duc, used it for the church of St Jean de Montmartre, Paris (1897–1904), which marks a major step in the evolution of modern architecture. Architecture soon experienced an aesthetic revolution which radically modified the laws of structure. The extensive possibilities of reinforced concrete, which can be used to cover an immense area without support, made conventional vaulting, which had governed the entire development of European architecture, unnecessary and illogical. Thus the traditional verticals were replaced by a structural system of superimposed horizontal layers; it is true, however, that Gothic continued for some time to influence the decoration of skyscrapers in the United States (Woolworth building, New York, by Cass Gilbert, completed 1913 [**1105**]; Tribune Tower, Chicago, by Raymond Hood and J. M. Howells). The use of the structural framework in building opened the way, as regards plan and elevation, to new and original solutions of increasing freedom as hermetic buildings gave way, with the discovery of new synthetic materials, to open volumes. The relationship of architecture to nature now came fully into its own; interest in the interrelation of horizontal planes and vertical surfaces — a subject upon which Theo van Doesburg elaborated — stimulated Gropius and Le Corbusier to build the daring creations which opened a new chapter in the history of architecture. Human proportions ceased to be the yardstick for building, as they had been in traditional Vitruvian theory (which was still respected by Perret); an architectural entity became an autonomous organism which found in itself and in its relationship to its natural surroundings its own laws of structural proportion and spatial harmony.

Architecture thus developed in a direction already glimpsed by a few precursors. A new concept of form was discovered — a concept governed by and voluntarily dependent on technique. Planes and volumes were organised according to practical considerations and gave rise to a new kind of beauty. Ornamentation became superfluous. The rhythms inherent in the architecture itself became the only acceptable decoration. After the First World War the theory of functionalism assumed paramount importance with the founding by Gropius of the Bauhaus, where artists designed the models for industrial production and standardisation. Le Corbusier's articles in *L'Esprit Nouveau*, later published in book form in the early 1920s, launched these new ideas which, however, were slow to gain acceptance.

Subject to commissions, architecture abandoned academicism slowly, but in time found expression in a new language evolved through new techniques which themselves developed with great rapidity. It was inevitable that a split occurred between the engineer, whose function became of paramount importance, and the architect, whose raison d'être in the machine age had begun to be questioned. Fundamental social changes and increasing industrialisation led to the use of mass-produced constructional elements which made it possible to erect buildings of extraordinary height and size.

Architects, who for centuries had considered building in stone or brick as a system of supporting walls surmounted by a flat roof or a vault, had to revise their acquired notions and to adapt themselves first to architecture in reinforced concrete, which permitted previously unimaginable departures from conventional construction, then to metal frameworks in light alloys, to curtain walls and to a number of other inventions indicative of the fundamental changes in the art of building. The new solutions afforded by such technical developments quickly spread throughout the world. Architecture tended increasingly to follow an international pattern and a universal norm governed above all by functional considerations.

PABLO PICASSO (b. 1881). Night Fishing at Antibes. 1939. Museum of Modern Art, New York (Mrs Simon Guggenheim Fund). *Museum photograph.*

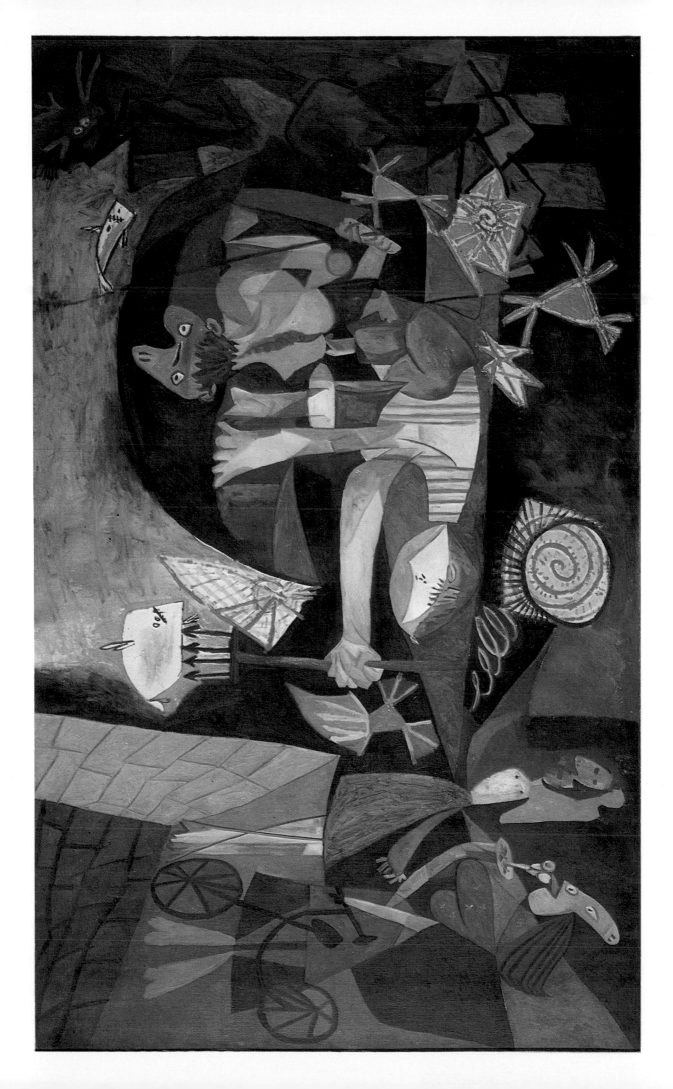

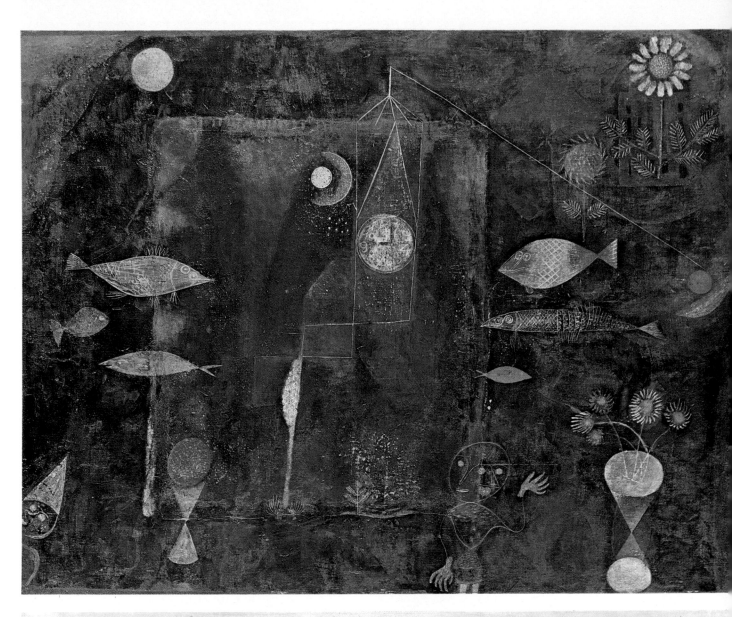

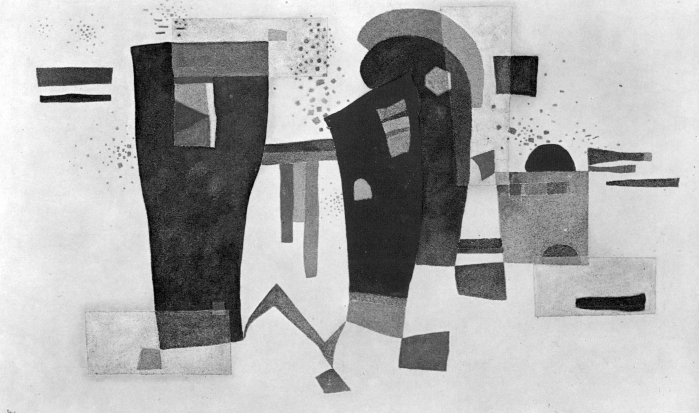

Town planning. Industrialisation and the rapid growth of population in towns presented entirely new problems. The authorities were slow to appreciate the dangers inherent in overcrowding and haphazard control. It was in England, the first country to be heavily industrialised, that the possibility was first fully appreciated of fighting the evils of overcrowding in towns by the building of 'garden cities'. At the turn of the century Ebenezer Howard championed the garden city, in which each family would have a house and garden and could live in contact with nature. After the construction of the model village of Port Sunlight, Cheshire, the theory of satellite towns was put into practice elsewhere in England in the garden cities of Letchworth (1903) and Welwyn (1920) in Hertfordshire, and the idea spread to other countries.

Tony Garnier played the role of prophet when he drew up the plan for his Cité Industrielle (1901–1904) [**855**], in which areas for work, residence and administration were clearly separated, and schools, hospitals, etc., were surrounded by greenery.

However, suburbs continued to spread without planning, and the crowding of town centres, as in New York, reached disastrous proportions. Ideas on hygiene, ventilation, sunlight, traffic control, etc., evolved. In the Germanic countries architects began to take existing historic quarters into consideration when planning. Successful results were produced by certain exceptional partnerships, such as that of Marshal Louis Lyautey and the town planner Prost in Morocco (c. 1914–1923), who designed European districts without disturbing existing native quarters.

In 1928 under the influence of Le Corbusier, who popularised certain ideas basic to town planning, CIAM (Congrès Internationaux d'Architecture Moderne) was founded; this organisation linked architecture with town planning and also brought together the exponents of the contemporary style. Opposing academic and ornate styles, these men dedicated themselves to the technical problems of housing in a modern society. Their influence was considerable. They drew up the Athens Charter (1933), which made proposals, considered advanced at the time, concerning town planning (relationship between residential quarters and areas for work and leisure, and transportation).

Jean Giraudoux, who wrote the preface to the French edition of the Athens Charter, made a study of the causes of urban decadence. Although his work went beyond the purely technical and material considerations which are the normal concern of present-day planners, it helped to further the movement, which bore fruit during post-War rebuilding. The approach to planning today is so profoundly different from what it used to be that it is difficult to harmonise the old with the new. It is in the completely new towns which have been planned on the scale of capitals (Chandigarh [**858**, **1166**] and Brasilia [**1160**, **1161**]) that we find the new theories applied in their entirety.

The minor arts. The transition from one century to another coincided with a revival in the minor arts. Craftsmen had been seeking to avoid copying or reinterpreting old formulas but had not yet replaced these with something new. Varying tendencies began to crystallise in England, Germany, Belgium, Italy and France, tendencies which gave rise to an original style. To designate this style the French adopted the term Modern Style (concurrently with the expression Art Nouveau — the title used by S. Bing for the shop he opened in 1896). While Art Nouveau, with its curves and convolutions, its elongated and undulating forms, had some influence on architecture, its true domain was in the decorative arts [**524–532**].

Most designers of furniture and craftsmen continued (and were to continue for a long while) to produce a pastiche of earlier styles, but, owing to the enthusiasm of a few innovators, a movement arose that was all the more remarkable in that, contrary to all precedent, it was not the result of an evolutionary process but was a deliberate break with the past; ornamental motifs of earlier times were abandoned in favour of a fresh decorative repertory — a repertory stemming from nature, especially from plant forms.

Although Art Nouveau was greeted with a lively interest it had little effect on the general public, who continued to favour decorative styles copied from the past and who considered the new style a passing fancy.

Creative people had, however, been

849. SWEDISH. INGMAR BERGMAN. The Seventh Seal. 1957.

850. JAPANESE. TEINOSUKE KINUGASA. Gate of Hell. 1953.

851. AMERICAN. JOHN CASSAVETES. Shadows. 1960.

852. ITALIAN. MICHELANGELO ANTONIONI. La Notte. 1960.

PAUL KLEE (1879–1940). Fish Magic. 1925. Philadelphia Museum of Art (Louise and Walter Arensberg Collection). *Museum photograph.*

WASSILY KANDINSKY (1866–1944). Accompanied Contrast. 1935. Solomon R. Guggenheim Museum, New York. *Museum photograph.*

853. AMERICAN. GEORGE LUCAS.
Star Wars. 1977.

854. AMERICAN. SIDNEY LUMET,
Network. 1976.

fired by the audacity of the movement, and henceforth artists and decorators were inclined to look increasingly for a style that broke away from tradition. Craftsmen appeared who no longer believed that the machine was of necessity the enemy of beauty. Gradually the elongated forms and intertwining floral decoration gave way to straight lines with more discreet ornamentation. There was a growing tendency to use flat, smooth surfaces and geometric stylisation.

Work in this style, and with rather marked individual characteristics, was being produced in Glasgow, Brussels, Munich, Nancy and Paris. The same spirit was found in the graphic arts, illustration, ceramics, glassware, iron, etc. After the First World War functionalism in design had a parallel

development with that in architecture. At first the new style remained the perquisite of the rich and was mainly confined to luxury decoration, but after a time there was a growing desire to transform the home into something utilitarian, to experiment with practical forms and comfortable and practical furniture — objects stripped of superfluous ornamentation in order to facilitate handling and upkeep. The theory of the aesthetics of utility, which appeared first in Germany, became widespread; it was claimed that any form, provided it clearly revealed its use, was beautiful, that materials such as steel and glass, easily workable in industry, were suitable for furniture, that the machine must replace the costly work of the craftsman and that decoration should be banned as useless.

The new movement gathered momentum after the Second World War, producing a certain uniformity in furniture (as in architecture) throughout the world. The other decorative arts were also influenced by the international trend [**704**, **707**].

FRANCE

Architecture. The Paris Exhibition of 1900 marked a regression in the movement which had evolved during the preceding period with iron architecture and the tendency towards functionalism. The Grand Palais, which was built for the Exhibition, consisted of an immense metal arcade, but it was felt necessary to hide this structure behind a stone façade and stone colonnades which were academic in design. All the pavilions betrayed a concern with pompous decoration in the most varied styles.

Art Nouveau, on the other hand, was an attempt to establish an original art which would be a break with the past. Although mainly seen in furniture and other decorative arts, the style was assured a fleeting success through the talent of a few architects. Hector Guimard (1867–1942), influenced by Victor Horta, was the most gifted architect of the French Art Nouveau. His chief works are Castel Béranger, a block of flats in Paris (1894–1898), the Paris Métro entrances (1898–1901) [**531**], with their organic plant forms, and the Humbert de Romans Building, Paris (1902), which is no longer in existence. His supple nervous style declined rapidly with his imitators into superficial ornamentation. Many houses built during the first quarter of the century, however, were more or less derivative of the aesthetic language made fashionable by Art Nouveau (undulating lines, curved windows, etc.).

The advent of reinforced concrete brought about an architectural revolution of the utmost importance. This

French invention was much exploited in other countries, notably in Germany. But for nearly half a century the possibilities offered by this new material — resistance, flexibility, economy, speed of execution — had been utilised only by engineers (who were not concerned with aesthetic considerations) in the building of hangars, docks, bridges, aqueducts. Architects made only a partial and timid use of it.

In collaboration with his brother Gustave, a contractor, Auguste Perret (1874–1954) built in 1902–1903 in the rue Franklin, Paris, a block of flats in concrete with a clearly stated structure. Later he built the Garage Ponthieu, Paris (1905–1906) [**674**], its large glass openings stressed by the rectangles of its horizontals and uprights. In the Théâtre des Champs Elysées, Paris (completed 1913), Perret created a complex and extremely large building which demonstrated for the first time that concrete could be used in a work of prestige and luxury. A number of painters and sculptors (Bourdelle, Maurice Denis) collaborated in this work. His church of Notre Dame at Le Raincy (1922–1923) [**859**] was the first religious building to owe its entirely new design to a type of construction hitherto employed only in utilitarian buildings. Perret's works are all of striking significance: exhibition halls (combination of wood and concrete); Musée des Travaux Publics, Paris (1937–1938) [**799**], with its slender tapering columns. After the War Perret worked on the reconstruction of Le Havre, where he built the church of St Joseph, whose lantern tower rises to a height of some 358 feet, and much of the Place de l'Hôtel de Ville. Perret's architecture, though revolutionary in its principles, was traditional in spirit, but this innovator remains one of the great architects.

Among others who wished to escape from eclecticism and to create something new was Tony Garnier (1867–1948), one of the key figures of the beginning of the century. His early project for a Cité Industrielle (1901–1904) [**855**] presented many radical solutions to the problems of present-day town planning and influenced Le Corbusier considerably. His chief works are in his native Lyon (slaughterhouse at La Mouche, 1909–1913 [**796**]; Olympic stadium, 1913–1916; Herriot hospital at Grange Blanche, 1915–1930). François Le Coeur was the architect of the Reims post office (1922). Henri Sauvage, who was concerned with social facilities and urban living, built, in the rue des Amiraux (1925) [**856**] and in the rue Vavin, Paris, blocks of flats set back on the upper floors to form terraces and faced with glazed brick; these were original works which, however, had little effect on contemporary building.

855. FRANCE. TONY GARNIER
(1867–1948). Project for a Cité
Industrielle. 1901–1904.

856. FRANCE. HENRI SAUVAGE
(1873–1932). Block of flats in glazed
brick, rue des Amiraux, Paris. 1925.

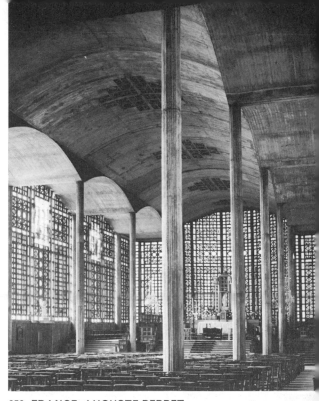

859. FRANCE. AUGUSTE PERRET
(1874–1954). Interior of Notre Dame
at Le Raincy. 1922–1923.

857. *Above.* FRANCE. MARCEL
BREUER, BERNARD ZEHRFUSS
and PIER LUIGI NERVI. UNESCO
building, Paris. 1953–1958.

858. *Below.* INDIA. LE CORBUSIER.
View of the Secretariat, Chandigarh.
1952–1956.

860. *Above.* FRANCE. LE CORBUSIER
(1887–1965). Swiss pavilion, Cité
Universitaire, Paris. 1931–1932.

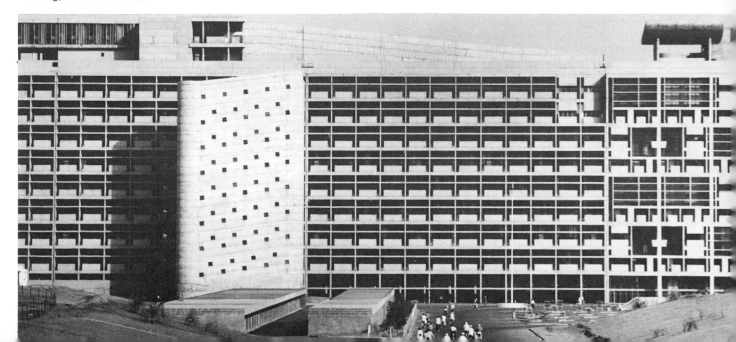

861. FRANCE. ALBERT LAPRADE
(b. 1883). Project for the Génissiat
dam (in collaboration with Bourdeix).
Completed 1949.

862. FRANCE. PIERRE VAGO
(b. 1910). Basilica of St Pius X,
Lourdes (with Freyssinet). 1958.

863. FRANCE. RICHARD
ROGERS AND RENZO PIANO. The
Georges Pompidou Centre, Paris. 1977.

In purely utilitarian works engineers created forms of great purity of expression. Eugène Freyssinet (1879–1962) built bridges which are outstanding examples of early reinforced concrete construction (Boutiron, 1902; Le Veurdre, 1907, destroyed during the last War; St Pierre du Vauvray, 1922; Traneberg bridge in Stockholm, 1932). His best known works, the airship hangars at Orly (1916–1924) [683], were destroyed in 1944. Apart from the above he designed mainly industrial buildings, evolving the use of pre-stressed concrete (reinforcement subjected to previous tensile stresses). Some architects, working along the same lines as Freyssinet, have inclined towards extreme simplicity. Others have tried to reconcile luxury with severity (residential blocks built by Michel Roux-Spitz). André Lurçat, an architectural theoretician, expresses himself in geometrical volumes (school at Villejuif).

Robert Mallet-Stevens (1886–1945) was a leader of the avant garde between the Wars. His work was a kind of architectural transcription of Cubist aesthetics; it was angular and restless, with stark planes and irregularly superimposed volumes offering a great diversity of angles from which to view the building. He often sought the collaboration of painters and sculptors who in the middle of the 1920s were noted for their modern tendencies (houses in the rue Mallet-Stevens, 1926–1927 [677]; casino at St Jean de Luz).

Born in Switzerland in 1887, the naturalised French citizen Charles Edouard Jeanneret, known as Le Corbusier, has had a tremendous influence on modern architecture. He worked at first with Perret in Paris (1908–1909) and then with Behrens in Berlin (1910). He settled in Paris in 1917, and in time joined forces with his cousin Pierre Jeanneret [676]. Le Corbusier's systematic doctrines and original polemics soon had an impact (his review *L'Esprit Nouveau*, from 1920; his book *Towards a New Architecture*, 1923; his book on town planning, 1925). He wanted to endow the machine civilisation with housing adapted to its needs, and he championed the building methods devised by the new architects. He launched the concept of the 'radiant city'. His arguments in favour of that which is functional showed him to be a brilliant logician. But he also proved himself as an artist when he produced his first major work, the Villa Savoye at Poissy (1929–1931) [671]; this was followed by the Swiss pavilion at the Cité Universitaire, Paris (1931–1932) [860], and the Salvation Army hostel, Paris (1931–1932); then, together with Brazilian architects, he worked on the plans for the Ministry of Education building in Rio de Janeiro (1936–1945).

His projects were received with suspicion and hostility by the public and in official circles, but he continued to promulgate his ideas in books (*The Home of Man*; *Concerning Town Planning*) and pamphlets; he formulated a scale of proportions, based on human proportions and on the Golden Section, which he called the Modulor. In 1947 in the midst of considerable controversy he started work on the Unité d'Habitation, his block of flats in Marseille (completed 1952), in which he put into practice the ideas he had propounded throughout his career. In 1951 he was commissioned to direct the building of Chandigarh, the new capital of the Punjab [858]. The chapel of Notre Dame du Haut at Ronchamp (1950–1955) [672] is strikingly novel in conception. In 1961 he completed the Dominican monastery of La Tourette at Eveux sur l'Arbresle and undertook the building of flats at Meaux.

Among the most important buildings put up in France since the last War are: the locomotive roundhouses designed by the engineer Bernard Lafaille; Albert Laprade's Génissiat dam [861]; the exhibition building of the Centre National des Industries et Techniques, Paris, by Zehrfuss, with R. Camelot and J. De Mailly (1958) [684]; the UNESCO building in Paris (1953–1958) [857], by Breuer, Zehrfuss and Nervi; the church of Notre Dame at Royan (1954–1959) [825], by Guillaume Gillet, who also built the strikingly original French pavilion for the Brussels Exhibition of 1958 [665]; the underground church of St Pius X at Lourdes, by Pierre Vago (with Freyssinet) [862]; the church of St Rémy at Baccarat (1957), by Nicolas Kazis; the church of Ste Agnès at Fontaines les Grès (1956), by Michel Marot; the elegant blocks of flats in Paris by Ginsberg; the Paris office buildings by Lopez; the remarkable housing estates by Emile Aillaud at Aubervilliers and Bobigny (1959); the University of Caen by Henry Bernard who also designed the Palais de Radio [863]; the IBM-France Research Centre, La Gaude Var (1962) designed by Marcel Breuer; the Centre Régional D'Informatique, Nemours with its smooth, curved surfaces and areas of glass by François Deslaugiers and the Pompidou Centre in Paris, completed in 1977 by the Anglo-Italian partnership of Richard Rogers and Renzo Piano [863].

Gardens. The English garden, popular since the 18th century, with its winding paths and contrived disorder resembling nature, gave way to regular lay-outs similar to the French gardens of the Le Notre period. Gardens were smaller, planned with foreshortened perspective and designed in geometric

patterns. J. C. N. Forestier designed some fragmentary landscapes in this spirit which are of great merit (Sceaux; Bagatelle).

Paul and André Véra turned to Cubism for new decorative effects. The latter published in 1913 a manifesto which was the basis of a new movement whose principal innovations followed upon the 1925 Exhibition of Decorative Arts. Regular gardens were often called classical gardens as opposed to Romantic gardens. The architect Jean Charles Moreux (1889–1956), who had begun by following the ideas of Le Corbusier, reverted to a refined classical spirit (Jacques Rouche garden).

Sculpture. *Official art.* Scarcely affected by the controversy produced by his statue of Balzac, Rodin alone in 1900 held the privilege of teaching at the Ecole des Beaux-Arts. Antonin Mercié, Denis Puech, Jules Coutan, Jean Antoine Injalbert and others had trained a new generation of sculptors, the eldest of whom had at first pursued an arid academicism. About 1920 a freer tendency manifested itself. Jean Boucher (1870–1939), a pupil of Falguière and one of the most respected masters of his generation, was an official sculptor of independent ideas (Renan monument at Tréguier, of a narrative Romanticism). Henri Bouchard (1875–1960), a pupil of Barrias, glorified the beauty of manual labour (*Haymakers*); his monuments to Pierre de Montereau (1908) and Klaus Sluter (1911) evoke the Middle Ages. Pierre Poisson (1876–1953) followed the classical tradition; in his nudes and in the War memorial at Le Havre (1921) he avoided academic formulas. In the same way Paul Niclausse (1879–1958) always succeeded in expressing the individuality of his realistic subjects (portrait busts; statues of Pasteur and Lamartine). Paul Landowsky (1875–1960) was closely linked to the Ecole des Beaux-Arts, where he taught in the 1920s; he was Director of the French Academy in Rome (1933–1937), after which he returned to the Beaux-Arts as Director; his works include the Reformation monument in Geneva (1910) and the tomb of Marshal Foch in the Invalides (in collaboration with Henri Bouchard). He pointed out the need for unity and collaboration between sculptors and architects; André Abbal, Marcel Gaumont, Joachim Costa, Charles Sarrabezolles and others subscribed to his views.

Alfred Janniot, a pupil of Injalbert, is more personal; Bourdelle was influential in his tendency towards monumental composition. Georges Saupique (1889–1961) was a pupil of Coutan and of Rousaud, an assistant to Rodin and a teacher at the Ecole des Beaux-

Arts. His monumental style is reminiscent of the 12th century (Romanesque decoration of the Cité Universitaire church, Paris, 1933–1936; tympanum of the church of Notre Dame de France, London, 1957); commissioned to replace some of the destroyed statues of Reims cathedral, he avoided pastiche and created works of real feeling; his Marshal Leclerc monument in Strasbourg (1951) and his other statues, decorative bas-reliefs and portraits bear witness to his personal style. A decorative spirit dominates the work of Pierre Traverse (b. 1892) and of Paul Belmondo (b. 1898), a pupil of Jean Boucher, who afterwards collaborated with Charles Despiau. The influence of the latter is noticeable in Belmondo's busts and drawings. Maillol was a determining force in the career of Hubert Yencesse (b. 1900); elegance of form predominates in his reclining figures (League of Nations palace, Geneva). The figurative tendency has been perpetuated by François Pimienta (b. 1888), Georges Salendre (b. 1890), Pierre Honoré (b. 1908), Jean Baumel (b. 1911), Louis Derbré (b. 1925) and others.

Independent sculpture. Independent sculpture felt the decisive influence of Rodin. Independent sculptors exhibited in the Salon des Indépendants, the Salon d'Automne and the Salon des Tuileries. Some of them had been disciples of Rodin, for example: Jules Desbois (1851–1935), Rodin's right-hand man and friend, who did not free himself from an often despotic tutelage (bust of Rodin; *Misery*); Lucien Schnegg (1864–1909), who on the contrary kept his freedom of expression and became in his turn the leader of a school; Alfred Halou (1875–1939), who in 1904 collaborated with Rodin in decorating Baron Vitta's villa; Camille Claudel (1856–1945), whose sketch for *Clotho* (1893) is the work of a precursor in that it heralds the experiments which led to space being incorporated into sculptural form. Louis Dejean (1872–1951) was self-taught; he perfected his technique by working for Cariès and Rodin (*Young Girl Kneeling*, 1931). A term in Rodin's studio enabled Léon Drivier (1878–1951) to express his personal vision of beauty; he explored various sources of inspiration before attaining a classical harmony. The first works of Antoine Bourdelle (1861–1929) [**715**], *Adam after the Fall*, the numerous studies of Beethoven, etc., betray the influence of Rodin, with whom he had studied. Inspired by ancient Greece and by Romanesque and Gothic sculpture, he began to develop an individual style in 1902. The lyrical power of his temperament can be seen in his *Penelope* (1907),

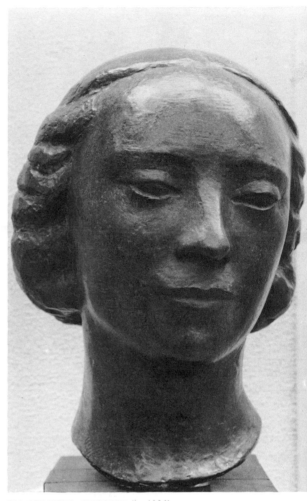

864. MARCEL GIMOND (b. 1894). Head of Young Woman. Bronze. *Oran Museum.*

865. ARISTIDE MAILLOL (1861–1944). The River. Lead. *c.* 1939–1943. *Museum of Modern Art, New York.*

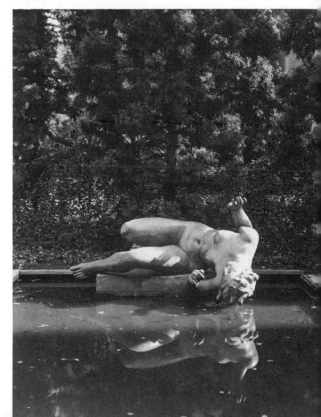

866. RAYMOND DUCHAMP-VILLON (1876–1918). Seated Woman. Bronze. 1914. *Galerie Louis Carré, Paris.*

867. ALEXANDER ARCHIPENKO (1887–1964). Woman combing her Hair. Bronze. *c.* 1915.

868. ALEXANDER ARCHIPENKO. Boxers. Terra cotta. 1935. Second version of a 1914 work. *Peggy Guggenheim Collection, Venice.*

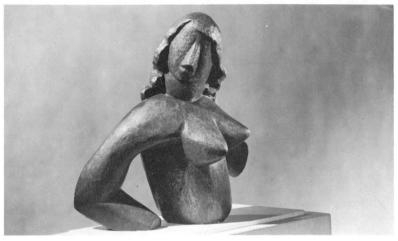

869. *Left.* JACQUES LIPCHITZ (b. 1891). Figure. Bronze. 1930. *Joseph H. Hirschhorn Collection, New York.*

870. *Above.* HENRI LAURENS (1885–1954). Baigneuse. Bronze. 1931. *Tate Gallery.*

Hercules the Archer (1909), and the *Dying Centaur* (1914). He decorated the Théâtre des Champs Elysées with frescoes and bas-reliefs (1912); in his monument to General Alvear in Buenos Aires (1923) he followed the tradition of Italian Renaissance equestrian statues; the statue of Mickiewicz in Paris, together with his numerous allegorical statues and his busts (*Rodin*; *Anatole France*; *Auguste Perret*), have assured his fame and have justified his position as one of the most important heads of a school of modern sculpture. Charles Despiau (1874–1946) [**787**] was influenced by Lucien Schnegg and Rodin. He was an assistant of the latter for several years, and the works he executed for him (*Spirit of Eternal Rest*) have a supple modelling; fullness of form, absence of inner drama and restraint of movement are characteristic of his work (*Eve*, 1925; *Dionysus*, 1945; *Apollo*, 1946); his individuality is evident in his portraits (*Princess Murat*, 1934).

About 1910 there was a reaction against Rodin's aesthetics, a reaction that had already been set in motion by some of his closest associates. This was the case with François Pompon (1855–1933), who was assistant to Mercié and Falguière and then to Rodin. His early works have a pictorial and naive realism; however, his modelling soon freed itself of all realistic detail, leaving only volume; the play of muscle is suggested by modulations of plane. His *White Bear* (1922) brought him recognition. His *Deer* (1929) and *Bull* (1933) gave a new direction to the art of animal sculpture.

The sculpture of Aristide Maillol (1861–1944) [**714, 865**] was in complete opposition aesthetically to that of Rodin. At first a painter, Maillol broke away from official attitudes and allied himself with the Nabis. Obsessed with an ideal of simplification and purity, he tried to bring about a revival in the art of tapestry; his vocation as a sculptor only made itself felt about 1900. In art school he had done some clay modelling; now his first works were executed directly in wood. With the exception of his

early work the *Racing Cyclist*, his sculpture is a hymn to the female body. Restrained attitudes and gestures, serene faces almost empty of expression and supple but full volumes characterise his work (*Eve*, 1900; *The Mediterranean*; *The Mountain*; *Night*; the Cézanne monument, 1912–1925; the Debussy monument, 1935; and his last unfinished work *Harmony*). The agitated figure of *Chained Action* (1905, the Blanqui monument, full figure in the Musée d'Art Moderne, Paris; torso in the Tate Gallery), together with *The River* [**865**], is of a different character to his other work. Maillol's drawings and graphic work follow the same quest for simplicity of form and truth of expression. A similar attitude inspired the Catalan sculptor Manuel Hugué, known as Manolo (1872–1945), who settled in Paris in 1900 (see under *Spain*). The groups by Joseph Antoine Bernard (1866–1928) are less forceful in treatment (*Young Girl with a Pitcher*, 1910); however, his monument to Michel Servet (1907–1912) reveals a strong dramatic sense, as does his unfinished *Athlete* (1931).

The *Petite Landaise* (1910) was the first important work by Robert Wlérick (1882–1944), who was a follower of Schnegg and of Despiau; his monuments reveal an architectural sense (Condorcet monument at Ribemont; Victor Bérard monument at Morez du Jura; equestrian statue of Marshal Foch). The work of the solitary Charles Malfray (1887–1940) is more dynamic. His War memorial for Orléans (1924) gave rise to bitter controversy; he continued to work without making concessions to public opinion (*Spring* and *Summer*, in the Chaillot palace, 1937; the *Swimmers*, 1940). He taught at the Académie Ranson, where he had a profound influence on his pupils.

Marcel Gimond (b. 1894) [**864**], like Despiau, has helped to bring new life to the art of portrait sculpture. His *Woman arranging her Hair*, in the Chaillot palace, his imposing *St Thomas Aquinas* (1938) and other works bear witness to his independence. René Iché (1897–1955) sought to express a dramatic aspect of human passion in his muscular thickset groups of upright or reclining wrestlers. A similar intention is apparent in the work of Bernard Milleret (1904–1957), whose statues of women have the strength of caryatids. Marcel Damboise (b. 1903), Léopold Kretz (b. Poland, 1907), Raymond Martin (b. 1910), Jean Carton (b. 1912), a pupil of Malfray, and Jacques Gestalder (b. 1918) show how stimulating Rodin's influence, tempered by that of Despiau and Wlérick, continues to be, while the ample, voluptuous forms of Maillol reappear in the work of Volti (b. Italy, 1915).

Cubism and the school of Paris. In 1907 Cubism embarked on the great adventure of recreating the world of forms. Its influence on sculpture, rather limited at first, increased in time and led eventually to certain tendencies in abstract art. The new Cubist doctrine did not hamper the individual development of its followers. Many of them were born outside France, and they formed the nucleus around which the school of Paris developed. Pablo Ruiz Picasso (1881–1973) [**735**] here heads the list; his sculptural creations are as rich in invention as his painting. In 1905 he took up sculpture. His *Harlequin* in bronze still shows the influence of Rodin, but the 1906 *Head* breaks with naturalism. The 1907 bronze *Mask* recalls African sculpture; the versions of the *Woman's Head* (1907–1910) and the *Glass of Absinthe* (1914, in painted bronze) are analogous to his Cubist work in painting. After abandoning sculpture for some fifteen years he returned to it in 1928. He soon turned from monumental works to a sculpture of sheet metal and iron wire (under the influence of his compatriots Gonzalez and Gargallo). In 1932 in his studio at Boisgeloup he worked on a series of large female heads. During the Second World War he was in Paris, where he worked in painted cardboard, paper, plaster, metal (*Bull's Head*, 1943; *Man with a Sheep*). After the War he completed the bronze *Pregnant Woman* (1950), the *Crane* (1952) and the *Goat* (1950).

Alexander Archipenko (1887–1964) became converted to Cubism early in his career. Born in Kiev, he came to Paris in 1908 and attended the Ecole des Beaux-Arts. His *Black Torso* (1909) shows recognition of the need to simplify form while preserving volume; from 1910 he preached a revolutionary doctrine — the abandoning of classical forms for the suggestion of protuberances by means of hollows; the reconstruction of form in terms of geometrical volumes; the juxtaposition of curved and oblique lines to give rhythm to composition (*Boxers*, 1914 and 1935, Peggy Guggenheim Collection, Venice [**868**]; *Gondolier*, 1914; *Standing Figure*, 1920, Darmstadt Museum). After three years of experiment, the most productive of his long career, he left France (see under *United States*). Joseph Csaky (b. Hungary, 1888) studied at the School of Decorative Arts in Budapest (1904–1905); his early work was influenced by Rodin. In Paris from 1908, he became a Cubist in 1911. He was then making constructions using geometrical figures. He gradually turned to a more figurative style but without rejecting the Cubist spirit. After a stay in Greece in 1935 he returned imbued with the spirit of classical art.

In his *On the Beach* (1946) and his more recent *Purity* (1958) his forms have lost their angularity.

The first sculpture of Raymond Duchamp-Villon (1876–1918) dates from 1898, and up to his *Torso of a Woman* (1907) he remained under the influence of Rodin. The *Torso of a Young Man* (1910) departs from imitation of the model; the emphasis on planes, even more marked in his portrait head of Baudelaire (1911), became systematic distortion in his *Maggy*. The *Seated Woman* (1914) [**866**] belongs to analytical Cubism, as does the part animal part mechanical *Horse* (1914) [**733**], in which the movement is related to the Futurism of Boccioni. One of the most significant sculptors of his time, he met with an early death from an illness contracted during the War.

The Cubist works of Henri Laurens (1885–1954) [**791**, **870**] fall between 1913 and 1925. He met Braque in 1911; in 1912 he executed his draped figure of a woman for his mother's tomb. In 1913 he began his constructions in various materials. He exhibited in the Salon des Indépendants; his work of this period presents an assemblage of simple forms made up of numerous articulations, such as one finds in his collages (1916–1918). *Woman in a Mantilla* (construction in polychrome wood, 1918) was followed by sculptures in the round: *Man with a Clarinet* (1919); *Head of a Young Girl* (1920); his tomb for the flyer Touchard shows a search for greater stylistic simplicity. After 1926 his forms became rounded; his association with Maillol (1932) lent considerable fullness to his work, which was now devoted to the female figure; his sculptures in marble of 1939–1944 express a direct sensuality despite a certain bodily stiffness. The relationship between volume and space was resolved in his *Musician* (1938). The poetic imagination characteristic of all Laurens' work can be seen in his figures of mermaids and his *Amphion* (1937).

Jacques Lipchitz (b. 1891) [**734**, **869**], born in Lithuania, came to Paris in 1909 and attended the Ecole des Beaux-Arts and the Académie Julian. His first works were realistic (portrait of the poet Sofianopoulo, 1911) or had a certain academicism (*Woman with Gazelles*, 1912). Soon he moved towards Cubism, with his *Dancer* of 1914, his *Acrobat on Horseback* (1914) and other works. In 1915 he began constructing his sculptures architecturally; they were stripped of unnecessary detail in the manner of abstract painting; soon the lines became harsher (*Guitar Player*, 1918, Stadt Kunstmuseum, Duisburg). His bas-reliefs and still lifes brought him close to the painters of this period. Around 1925 he became preoccupied

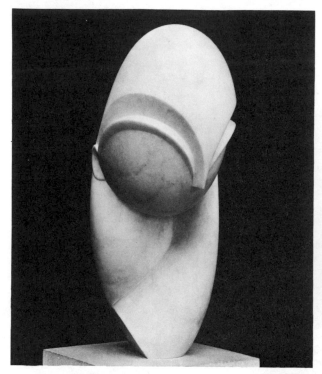

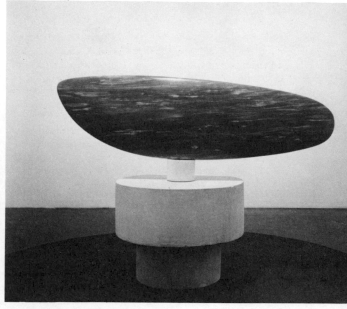

872. CONSTANTIN BRANCUSI.
Fish. Grey marble. 1930. *Museum of
Modern Art, New York.*

871. CONSTANTIN BRANCUSI
(1876–1957). Mlle Pogany. Marble.
1931. *Philadelphia Museum of Art.*

873. *Right.* HENRI GAUDIER-
BRZESKA (1891–1915). Stags. 1914.
Art Institute of Chicago.

874. JULIO GONZALEZ (1876–1942).
Woman arranging her Hair. 1937.
*Mme R. Gonzalez-Hartung Collection,
Paris.*

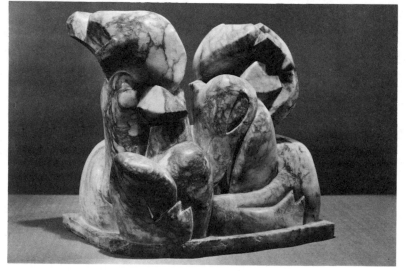

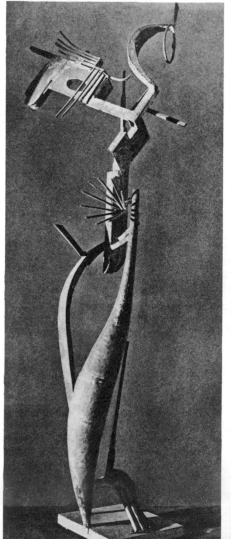

875. ALBERTO GIACOMETTI
(1901–1966). Man Pointing. Bronze.
1947. *Tate Gallery.*

876. GERMAINE RICHIER (1904–
1959). Water. Bronze. 1953–1954.
Tate Gallery.

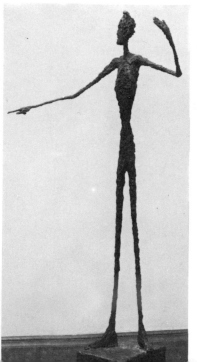

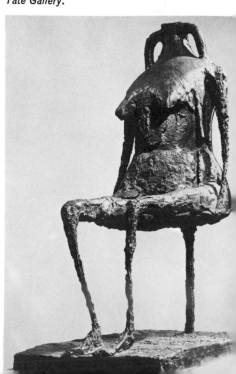

with transparent sculpture and super-imposed contours (*Harlequin with a Mandolin*, 1925); from 1930 he reverted to concrete form and his work took on a monumental aspect (*Song of the Vowels*, 1931; *Prometheus*, 1937). Since 1941 he has lived in the United States.

Ossip Zadkine (b. 1890) [**788**] was born in Smolensk; he studied in England before coming to Paris in 1909. He supported the new ideas and was influenced by African art. A skilful craftsman, he employed wood and stone as well as bronze and clay; the choice of materials influences the character of his sculpture. In his *Female Form* (1918, stone), the hollows suggest volume and the shadows create the illusion of modelling; details such as hair and features are indicated by means of linear incisions (*Young Girl with a Bird*, 1926). Around 1930, he carved group compositions and freed his forms of all classical shackles; his sculpture became charged with symbols (*Homage to J. S. Bach*, 1932; *Poet*, 1956). His individuality animated the projects for monuments to Alfred Jarry (1938) and Guillaume Apollinaire (1943). His *Orpheus* (1938) is a symbol of harmony, poetry and music and epitomises the aspirations of an artist who, severely shaken by the horrors of war, erected in Rotterdam in the early 1950s the monument to the destruction of the city; his statue of van Gogh (1956) stands at Auvers in memory of the painter. The brilliant vision of Zadkine continues in his influence on his pupils.

Sculpture related to Cubism. The work of Constantin Brancusi (b. Rumania, 1876; d. Paris, 1957) [**661, 696, 871, 872**] defies classification. He settled in Paris in 1904, where he studied with Mercié. He exhibited at the Salon d'Automne in 1906 (his first version of the *Sleeping Muse* dates from this time) and was invited by Rodin (but in vain) to work with him at Meudon. Already Brancusi was searching for a return to simplicity, and his *Prayer* (1907) was the first stage in an evolution towards pure form. In some of his studies of women's heads he came close to Cubism. In 1909 he carved the second version of the *Sleeping Muse* (a subject he repeated several times). Brancusi's later important works include: the phallic *Princess X*, which caused a scandal when it was exhibited in 1920; *Leda* (1924); *Beginning of the World*, 1934; the many versions of *Mlle Pogany* (1912–1931) [**871**]; the variations on the *Bird in Space* (*c.*1919–1940) [**661**]. In contrast to the precious quality of his sculptures in marble and bronze, with their polished perfection, there are his roughly hewn works in wood, often in oak (*Adam and Eve*, 1921, and the *Spirit of the Buddha*,

1937, both of them in the Guggenheim Museum, New York). In 1933 the Maharajah of Indore commissioned him to submit designs for the construction of the Temple of Deliverance. The work was never built, but the remarkable model remains.

Julio Gonzalez (1876–1942) [**874**] inaugurated with Gargallo the use of iron in contemporary sculpture. Born in Barcelona, he came to Paris with his family in 1900; about 1910 he executed masks in hammered bronze, as well as jewellery. The technique of oxy-acetylene welding enabled him to bend iron to all the demands of his imagination (*Don Quixote*, 1929; *Angel*, 1933); he suggested form by means of line. *Maternity* (1933) and *Woman with a Mirror* (1936) are abstract works, as are the haunting, strange figures of the *Cactus-Man*. The diversity of his invented forms has influenced later sculpture. The work of Pablo Gargallo (1881–1934) [**790**] is more figurative; he came to Paris in 1911 but returned to his native Spain from 1914 to 1923; his first sculptures (about 1900) were realistic; he executed sculpture in the round and also took up work in iron (masks, *c.* 1913). He juxtaposed concave and convex forms; he cut iron and copper into thin strips which he twisted to represent hair in his series of masks of 1915–1922. With his copper *Christ on the Cross* (1923) and *Bacchante* (1926) he embarked on larger works. His fantasy, freed from the strictures of material substance, created ethereal dancers and Harlequins with mandolins or flutes. He suggested muscles by means of empty space, the thickness of a body or the features of a face by means of ridged protuberances, the volume of a head by a curve of flat metal (portraits of Chagall, 1923, and of Greta Garbo, 1931). The brilliant talent and promise of Henri Gaudier, known as Henri Gaudier-Brzeska (1891–1915) [**873**], was eclipsed by his early death in action in 1915. After studying painting in England (1908) and Germany (1909), he took up sculpture in 1910. He settled in London in 1911 with Sophie Brzeska and was associated with the Vorticists, contributing to the magazine *Blast* and exhibiting with the London Group. His works are of uneven merit but reveal his potential greatness. In addition to his brilliant animal drawings, his works range from the classical to the *Dancer* reminiscent of Rodin's work, and from Vorticism to more or less abstract sculpture (*Birds Erect*, Museum of Modern Art, New York).

Expressionism. The Expressionist tendency manifested itself in a number of artists who were too young to take part in the Cubist movement but were nevertheless affected by its lingering

influence. They inclined more readily towards the dynamic expression of feeling found in Rodin's *Balzac*. Chana Orloff (b. 1888) was only partially associated with this movement; born in Russia, she visited Palestine in 1905–1910 and then settled in Paris. At first she produced stylised work in wood. From 1919 to 1925 she was influenced by her Cubist friends (busts of M. Volgel, 1922). After 1930, such works as her *Sailor* and *Man with a Pipe* are realistic in their humour and expressive in their treatment of volume. Animal sculpture had a major place in her work (fish and bird themes; mermaids). She has executed some monumental works for Israel.

Alberto Giacometti (1901–1966) [**645, 875**] was both a painter and poet as well as a sculptor. After a two year stay in Italy he came to Paris to study with Bourdelle (1922–1925); at this time he did polychrome sculptures; his experiments led him along several lines of development; he simplified the human form, reducing it to a symbol (*The Couple*, 1926, plaster; *Spoon-Woman*, 1926); drawn towards abstraction, he reached solutions that were taken up by others twenty years later (*Hands holding the Void*, 1935). He took part in the Surrealist movement (*The Palace at 4 a.m.*, 1932–1933, construction in glass, wood and wire, Museum of Modern Art, New York). After 1945 he became increasingly preoccupied with movement (*Man Pointing*, 1947, Tate Gallery; *City Square*, 1948–1949, Peggy Guggenheim Collection, Venice). His creatures, without volume or weight, become monumental in spatial dimensions of their own making. Giacometti's graphic work and painting showed the same tendencies.

The sculpture of Germaine Richier (1904–1959) [**792, 876**] may be defined as fantastic Expressionism. A pupil at the art school in Montpellier, she came to Paris to work with Bourdelle in 1925. After 1940 she was preoccupied with strange aspects of nature, combining animal and plant life in the invention of an imaginary world; the *Praying Mantis* (1946) and the *Bat* (1952) are fixed to the ground by taut threads which give definition to the surrounding space. The human body returns to its primeval form with the *Forest* (1946), the *Storm* (1948), the *Don Quixote* (1949) and the *Christ* at Assy (1950); these figures were followed by the series of monsters (*Horse with Seven Heads*; *Bird-Man* series, 1953–1955); the *Tauromachy* (1953) and the *Mountain* (1956) verged on Surrealism. In collaboration with Vieira da Silva and Hartung, she tried to fuse sculpture with painting; her work, including her drawings and engravings, ranks among the most original in contemporary art.

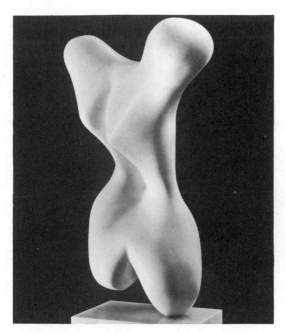

877. HANS ARP (1887–1966). Torso. Marble. 1931 *Muller-Widmann Collection, Basle.*

878. HANS ARP. Shell and Head. Bronze. 1933. *Peggy Guggenheim Collection, Venice.*

Robert Couturier (b. 1905) was a favourite pupil of Maillol, and his first works in stone show the influence of the latter (*Leda*, 1944). In his bronzes the volumes are slimmer than Maillol's (*Adam and Eve*, 1945; *St Sebastian*, 1946; monument to Etienne Dolet, 1947, for the Place Maubert, Paris). His forms became 'allusive' and insubstantial as his original, ironic, terse style developed (*Woman in an Armchair*; *Shepherd*, 1950; faun series, 1959). His drawings consist of a single stroke on the paper, a short-hand gesture which, like Laurens' drawing, manages to convey volume and form. Emmanuel Auricoste (b. 1908) was a pupil at first of Bourdelle and then of Despiau. His first works betray these influences. He created monumental sculpture which was in harmony with architecture (bronze door, League

of Nations palace, Geneva). About 1949 he produced bas-reliefs whose draughtsmanship and technique recall Assyrian work. About 1954 he was working on little rustic figures and animal groups in lead. He returned to monumental sculpture with a statue of Henri IV. He executed for the town of Marvejols the gigantic *Beast of Gévaudan* in hammered and welded iron (1958). With Germaine Richier and Couturier he founded the Salon de Mai. Louis Leygue (b. 1905) was a pupil of Wlérick. His monumental work is characterised by careful construction on architectural principles. In his later work he has often expressed himself in metal. Other representatives of the same tendency include: André Arbus (1903–1969), an architect and decorator, took up sculpture late in life; Salomé Venard (b. 1904); Renée Vautier (b. 1908); André Moirignot (b. 1913).

Recent figurative sculptors. A new generation of sculptors has continued to take man as its model but to subject him to aesthetic laws which transform him into purely architectural forms. These artists work in a wide variety of materials. This group includes the following: Odette Aramond (b. 1909); Joseph Rivière (1912–1961); Marcel Gili (b. 1914); Georges Oudot (b. 1928). Some of this group are close to abstract art (Karl Jean Longuet, b. 1904; María Teresa Pinto, b. Chile, 1910 [see under *Chile*]; Balthazar Lobo, b. Spain, 1911, a follower of Laurens; Raymond Veysset, b. 1913; Louis Chavignier, b. 1922).

Non-figurative sculpture. Cubism was the first stage in an evolution of forms that became increasingly removed from naturalism. The new theories being developed in various countries — Italian Futurism, Russian Constructivism and Suprematism, Dutch Neoplasticism and Franco-Swiss Dada — showed a tendency towards a universal plastic language that was the outcome of the intellect rather than the emotions. What had seemed in 1910 a mere adventure had pushed artistic possibilities to their extreme limits; the artist was aided by the variety of materials offered by modern industry and was supported by the doctrines of the new architect-engineers. The result was a variety of trends which had in common a complete indifference to the representation of the living forms which for centuries had been considered the unique source of beauty. Among the pioneers was Henri Hamm (1871–1961). An early associate of the Cubists, whose rigorous disciplines he adopted, he persistently defended the aims of avant garde artists. His art is characterised by its architectural nature and by the use which is made of geometrical forms.

Hans (Jean) Arp (1887–1966) **[802, 878]**, also a poet and painter, studied in Weimar and Paris and participated in 1912 in the second Blaue Reiter exhibition in Munich. In 1916 he helped to found the Dada movement in Zürich. His first reliefs in polychrome wood date from 1917; with his wife Sophie Taeuber-Arp he took part in the Surrealist movement. From about 1930 he favoured expanding forms and supple curves (*Torso*, 1931, Müller-Widmann Collection, Basle **[877]**). He invented a fantastic world of talons (*Skeleton of a Bird*, 1947); later he employed open space (*Ptolemy I*, 1953). His work is based on nature, which he then transmutes, uniting organic growth with architectural severity. Louis Chauvin (b. 1889) studied and worked with Joseph Bernard. Since 1913 he has moved in a direction parallel to that of Brancusi. In his work the human being becomes a symbol (*Maternity*, 1913); a poetic dream-world emerges (*Golden Bird*, 1939). An imaginative lyricism inspires certain works which approach Surrealism (*Man with a Veil*, 1958); a concern with technical perfection and with highly polished surfaces emphasises the purity of Chauvin's style. Alexandre Noll (b. 1890) works in wood. He made furniture and other objects for everyday use before taking up sculpture. He shows great skill in handling the balance between filled and empty spaces; his colour and his use of texture add to the originality of his forms.

The sculpture of André Bloc (b. Algiers, 1896) **[879]** is the work of an engineer and a founder of various reviews (*Architecture d'Aujourd'hui*, 1930; *Art d'Aujourd'hui*, 1951). For the centenary of reinforced concrete in 1949 he executed his important *Signal* (Place d'Iéna, Paris). Favouring the union of the plastic arts with architecture, he has participated in collective works (mosaic for the student hostel at the university of Caracas, 1954; tomb of the musician Abolhassan Saba in Teheran, 1959; monumental sculpture for Brasilia). About 1953 he began to use polished metal (bronze; iron; metal wire, which he employed in a series of cage-like structures that fit into one another). Etienne Béothy (b. Hungary, 1897), a friend of Moholy-Nagy, arrived in Paris in 1925; he soon abandoned the human form (*The Kiss*, 1926; *Cossack Dance*, 1930). The elegant curves of his wood sculpture are characteristic of his style (*Wasp*, 1957). A founder of avant garde movements, Béothy arranged the first exhibition of abstract art in Budapest (1938); he founded the Salon des Réalités Nouvelles (1946) and, with Bloc, the group 'Espace' (1951); a theoretician, he expounded his ideas in books and reviews (editor of first issue of *Formes et Vie*, with Léger and

870. ANDRÉ BLOC (b. 1896). Double
Interrogation. Bronze. 1958.

880. HENRI GEORGES ADAM
(b. 1904). Trois Pointes. Bronze. 1959.

881. ETIENNE HAJDU (b. 1907).
Cock. Brass. 1954. *Solomon R.
Guggenheim Museum, New York.*

882. EMILE GILIOLI (b. 1911).
Prayer and Force. Marble. 1952.
Tate Gallery.

883. FRANÇOIS STAHLY (b. 1911).
Le Grand Portique. Wood. 1964.

fected the use of polyester, a new material which makes it possible to execute large-scale sculptures that are light in weight, are transparent or opaque and can be coloured according to the artist's wishes. Etienne Hajdu (b. Rumania, 1907) [881] came to Paris in 1927 after a brief stay in Vienna; he was a pupil of Niclausse and then of Bourdelle; about 1934 his works became abstract. During the early 1940s he worked principally in marble. His later experiments in form have been carried out in metal. Some of his recent works include: *Cock* (1954, brass, Guggenheim Museum, New York), of which he, like Brancusi, retains only the comb; *Bonds* (1958, hammered aluminium); *Delphine* (1960, marble); Hajdu has made an original contribution to art.

After a figurative period, Maxime Descombin (b. 1909) became abstract about 1946; he uses wood, iron, aluminium and Plexiglas; he invented the 'dynamistic relief' — plates of coloured glass arranged against a wall so as to give changing patterns of coloured light. Geometric form characterises the work of Emile Gilioli (b. 1911) [882], a pupil of Jean Boucher; the brilliance of polished bronze, the smooth surfaces of coloured marble and the transparency of glass accentuate the interplay of his rhythmic volumes. François Stahly (b. Germany, 1911) [883] worked at first under the guidance of Malfray (1931–1938). His non-figurative wood sculptures are characterised by harmony of line and interlacing curves imbued with light (*Castle of Tears*, 1952); more monumental are his works in stone or cement, built up from the rhythms of diagonal lines. He worked on the mural decorations for the Vatican chapel at the Brussels Exhibition in 1958 and on the stained glass reliefs for the church at Baccarat. Juana Muller (b. Chile, 1911; d. Paris, 1952) came to Paris in 1937. A pupil of Zadkine and a friend of Brancusi, she took part in that intellectual movement which gives a mystical meaning to form; her sculptures have the mysterious quality of totems or idols.

Etienne-Martin (b. 1913) was a pupil of Malfray in Paris (1933); a friend of Stahly, he belonged to the same group but his work developed along different lines. The expressive *Head of a Man* (1948) was followed by large wood sculptures (*Dragon*, 1959); since 1956 his work has been on a monumental scale (*Lanleff*, *Demeure no. 4*, 1962). Stanislas Wostan (b. Poland, 1915), painter, poet and sculptor, came to Paris in 1945; he has executed some cement bas-reliefs on the theme of the Wailing Wall (1952); he works in wood, bronze and sheet metal. José Charlet (b. 1916), architect, painter and engraver, took up sculpture only in 1951; he works primarily in wood.

884. PHILIPPE HIQUILY (b. 1925).
Calvary. Forged iron. 1962.

Isabelle Waldberg (b. Switzerland, 1917) studied with Hans Meyer in Zürich and then with Gimond, Malfray and Wlérick in Paris; after a Surrealist phase inspired by Giacometti's work, her sculpture became abstract.

Constantin Andréou (b. Brazil, 1917) was a pupil of Jenny Maroussi in Athens; in Paris from 1945, he worked first in conventional materials and then in hammered and welded sheets of brass, a material well suited to his use of forms inspired by nature and of clearly defined abstract forms (*Icarus*, 1958). The works in iron and lead of Costas Coulentianos (b. Greece, 1918), a disciple of Laurens, present combinations of volumes separated by thin metal stems which create the illusion of substance independent of space. Laszlo Szabo (b. Hungary, 1917) is self-taught; he has moved from symbolic bas-reliefs to abstract constructions which evoke a new and disquieting world. The early works in wood by Eugène Dodeigne (b. 1923) were close to Surrealism but have been succeeded by works in hammered and polished stone which lends itself to his monumental compositions which blend with their outdoor surroundings. Jean Robert Ipousteguy (b. 1920) has been a painter and a worker in stained glass; he uses iron, wood, marble, clay, plaster, bronze (*Earth*, 1962). Among other abstract sculptors are: Robert Fachard (b. 1921); Simone Boisecq-Longuet (b. Algiers, 1922); Jacques Dufresne (b. 1922); Roger Desserprit (b. 1923), who tries to synthesise painting and sculpture in his work; Martine Boileau (b. 1923), a pupil of Zorach in New York and of

Le Corbusier); he took part in the movement for the synthesis of the plastic arts.

Morice Lipsi (b. Poland, 1898) developed in the direction of abstract art; his precocious talent was first revealed in figurative work; in the early 1940s he employed plant and animal forms; his later work has been more architectural and monumental. Jacques Zwobada (b. 1900), who was influenced at first by Rodin, has done commemorative monuments (to André Caplet at Le Havre, 1926; to Simon Bolívar at Quito, Ecuador, 1933); his treatment of the human form has grown more free in the course of his career (*Dance*, 1952); his works (like certain sculptures by Stahly and Etienne-Martin) are part of a baroque trend in abstract art (*Night Ride*, 1957, and *Vertical*, 1960, both in the Campo Santo Mentana, near Rome).

Henri Georges Adam (b. 1904) [880] has been a goldsmith, painter, engraver and tapestry designer. In the early 1940s he took up sculpture; in 1943 the exhibition of his *Reclining Figure* caused a scandal but resulted in his friendship with Picasso. His *Scarecrow* and *Sleeping Woman* were shown in 1945; in 1949 he exhibited his *Large Nude* (Musée d'Art Moderne, Paris), a monumental embodiment of simplified feminine forms. He achieved an impressive synthesis of architecture and sculpture in his model for the Monument to an Unknown Political Prisoner (1952) and in his *Beacon of the Dead* (1957–1958), which is the memorial of Auschwitz. The surfaces of his more recent works are covered with engraved or slightly raised abstract designs and patterns. Saint-Maur (b. 1906) has per-

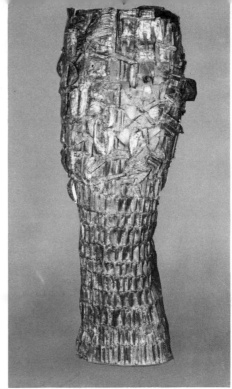

885. ROBERT MÜLLER (b. 1920).
Archangel. Iron. 1963. *Galerie de France, Paris.*

886. CÉSAR (b. 1921). La Soeur de l'Autre. Iron. 1962. *Hanover Gallery, London.*

Zadkine and Germaine Richier, whose abstract works are often concerned with movement; Philippe Hiquily (b. 1925) [**884**], who has invented a world that reflects the originality of his personality and who works in iron and makes mobiles that are activated by water; S. Varaud (1925–1956); Michel Guino (b. 1928); Gérard Mannoni (b. 1928).

Abstract sculpture in metal. Since Gargallo and Gonzalez, iron has been employed by some abstract sculptors who adapt themselves to its strict laws. Berto Lardera (b. Italy, 1911) [**821**] came to Paris in 1947. Figurative at first, he became more abstract with his flattened 'two-dimensional' metal sculptures; he has worked exclusively in metal since 1948 and has executed large compositions in which iron, steel and copper are often used together; his cut-out sheets of metal create dynamic empty spaces which give light a place in the composition (*Heroic Rhythm No. 3*, 1957–1958, iron and copper, Hamburg Museum). The first works of Robert Jacobsen (b. Copenhagen, 1912) [**1076**] were in wood; later he worked in stone and then in metal (in Paris, from 1947); his works, in which he often makes use of colour, are composed of dislocated forms and broken rhythms; he is concerned with problems of movement. Robert Müller (b. Zürich, 1920) [**654, 885**] has a different approach. A pupil of Germaine Richier, he became interested in metal sculpture and settled in Paris in 1950. His work is characterised by rounded volumes which have a certain dynamic quality (*Crawfish*, 1955). Movement and the play of light on sur-

faces also concern him. César (César Baldaccini; b. 1921) [**886**] showed an early predilection for metal. He creates imaginary insects, weird animals and amalgams of heterogeneous materials (scrap iron, springs, etc.) put together in a way that is reminiscent of Jacobsen (*Relief* [compressed automobile], 1961); he exercises a profound influence on his generation.

Constructivism and Neo-plasticism. Naum Gabo (b. Russia, 1890; see under *United States*) [**666, 888, 889**] and his brother Antoine Pevsner (b. Russia, 1886; d. Paris, 1962) [**701, 887**] stated, in their realistic manifesto of 1920, the principles of Constructivism, a movement born in Russia primarily as a result of their experiments (see under *Soviet Union*). Form was studied independently of volume; surfaces were developed in space; a solution was provided to the space–time problem. From 1902 to 1909 Pevsner was at the art school in Kiev; a stay in Paris (1911–1913) brought him into contact with the Cubists, and he did some Cubist paintings. He lived in Oslo for a time and returned to Russia in 1917, where his painting was influenced by Gabo's Constructivist theories. Pevsner settled in Paris in 1924. In his early sculptures he used plastic (*Portrait of Marcel Duchamp*, 1926 [**887**]), which he also combined with copper (*Torso*, 1924–1926, Museum of Modern Art, New York), glass or Plexiglas. His surfaces are curved and follow the rhythms imposed by metal wires which are welded together. These welded wires become a new material (*Developable*

Column, 1942, Museum of Modern Art, New York; *Spectral Vision*, 1959). For the university buildings in Caracas he executed the monumental *Dynamic Projection* (1951); the title *Liberation of the Spirit* that he gave to his project for a Monument to an Unknown Political Prisoner (1953–1956) sums up the severity of his thinking. After the War Pevsner helped found the Réalités Nouvelles group. His work, and that of Gabo, was responsible for a new trend in abstract art.

Piet Mondrian's essay on Neo-plasticism appeared in 1920 in Paris; it took up the ideas previously expounded in the Dutch review *De Stijl* (1917), which gave its name to a group of painters and architects. The painter, architect and sculptor Georges Vantongerloo (b. Antwerp, 1886) was associated with De Stijl until 1919. His sculptures are significant realisations of his pre-occupation with the representation of space [**698, 890**] (*Construction de Rapports de Volumes Ellipsoïdes*, 1926; *Un Rayon Lumineux dans un Champ Magnétique ou un Champ de Réfraction*, 1960); colour and space are employed to express his ideas. In France from 1919 and in Paris from 1927, he was vice-president of the Abstraction-Création group from 1931 to 1957. The work of Jean Gorin (b. 1899) also stems from Neo-plasticism and De Stijl; a sculptor and painter, he met Mondrian in 1926 and in 1927 held his first exhibition — of paintings, sculpture and architectural models (wood); his polychrome spatial constructions are experiments in the fusion of the arts as advocated by the Espace group, whose manifesto he signed

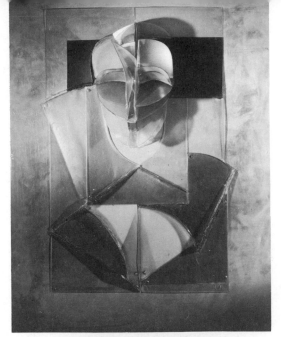

887. ANTOINE PEVSNER (1886–1962). Portrait of Marcel Duchamp. Celluloid on copper (zinc). 1926. *Yale University Art Gallery, New Haven.*

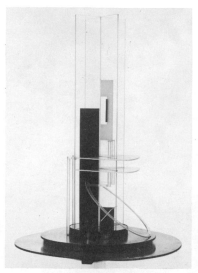

888. NAUM GABO (b. 1890). Column. Plastic, wood and metal. 1923. *Solomon R. Guggenheim Museum, New York.*

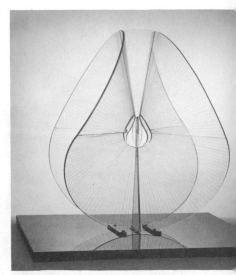

889. NAUM GABO. Translucent Variation on Spheric Theme. Plastic. 1951 version of 1937 original. *Solomon R. Guggenheim Museum, New York.*

890. GEORGES VANTONGERLOO (1886–1965). Rapport en Trois Volumes. *Marlborough Fine Art Ltd, London.*

in 1952. Stephen Gilbert (b. Scotland, 1910) initially made slender steel constructions in which vertical and horizontal lines cut at right angles; in 1957 curved elements began to predominate in his painted and polished metal works (*Structure 15A*, 1961).

Sculpture and movement. A static art, figurative or abstract sculpture may suggest movement, but it is not engendered by movement. The experiments of the Bauhaus in Weimar and Dessau (see under *Germany*) were of great importance to movement in sculpture. In inventing mobiles, Alexander Calder [820] (see under *United States*) introduced an infinite variety of combinations of form. With less fantasy Jean Peyrissac (b. 1895) began by using iron, wood and rope for his 'plastic machines' and 'constructions in space'.

He employs metal in his more recent 'static equilibrium' series and his 'dances' (1960). The spatiodynamism (sculpture having colour and movement in space) of Nicolas Schöffer (b. Hungary, 1912) [891] has introduced a new factor. Living in Paris since 1937, he was at first a painter; after 1945 he produced works in metal which were inspired by Constructivism and Neo-plasticism. By introducing a motor, a projector and a sound recording into a mobile sculpture he was able to achieve a synthesis of painting, sculpture, cinema and music (luminodynamism). Equipped with an inexhaustible source of colour and form combinations which follow each other without interruption, this process has been used in stage productions and has been seen (in 1957) in New York's Grand Central Station. A recent work which continues his theories is his *Chronos 5* (1962). Jean Tinguely (b. Basle, 1925) [892] works in cut-out metal, wire, junk, etc. He combines shapes in space, using motion as an additional dimension. Shapes rotated by a mechanism strike objects and produce sound. In his 'metamechanical' works, with their gears, he has experimented with 'organised breakdown'. More recently his preoccupation with constant change and flux has led him to create a machine which gradually destroys itself as it operates.

With Victor Vasarely (b. Hungary, 1908; in Paris from 1930) [929, 932], problems of movement which are applicable to both sculpture and painting are worked out by means of transparent partitions whose panels are arranged so as to constantly modify the appearance of the background.

In 1960 the Groupe de Recherche d'art Visuel was formed in Paris, with

François Morellet, Julio le Parc [893] (b. Argentina, 1928) and Yvaral (b. 1934) [894], the son of Vasarely. This group's concern with movement allies it with the Zero Group in Germany, whose works are a link between science and technology. In contrast, Anne and Patrick Poirier construct mystical temples of the past.

Conceptual artists in France include Bernar Venet (b. 1941), Daniel Buren (b. 1938), Louis Cane (b. 1943), Marc Devade (b. 1943) and Roland Baladi (b. 1942).

Painting. *The Nabis* The little painting 'dictated' by Gaugin was executed by Paul Sérusier at Pont Aven in 1888, and became the *Talisman* for his friends at the Academie Julian in Paris. The first to be interested in this work were Ranson, Bonnard, Ibels and Maurice Denis; later they were joined by K. X. Roussel and Vuillard, who were disillusioned with official teaching. The Nabi group was soon founded. 'Nabi' is the Hebrew word for 'prophet'; they were, in effect, the prophets of a new aesthetic movement deriving from Gauguin. They met every Saturday at the 'temple', Paul Ranson's studio, where Gauguin put in an occasional appearance. Soon they were joined by the Hungarian painter Jozsef Rippl-Ronai, by Félix Vallotton [713], Georges Lacombe, René Piot (1869–1934), the Dutch painter Verkade (1868–1946) and the Danish painter Ballin (1872–1914). The theoretician of the Nabis, Maurice Denis (1870–1943) [709], was akin to Gauguin in his *Breton Women* of 1890 and typically Nabi in his *Mellerio Family* of 1897 (both in the Musée d'Art Moderne, Paris); he later painted religious subjects, and his trips to Italy

891. NICOLAS SCHÖFFER (b. 1912).
Chronos 5. Mixed media. 1962.
Artist's Collection.

892. JEAN TINGUELY (b. 1925).
Monstranz. Junk mobile. 1960.
Staempfli Gallery, New York.

in 1895 and 1897 inclined him towards a more traditional style often reminiscent of Impressionism (*Annunciation*, 1913, Musée d'Art Moderne, Paris). In 1890 in the review *Art et Critique* he published, under the pseudonym of Pierre Louis, a controversial article in which he asserted that a painting . . . ' before being a charger, a nude woman or any anecdote, is essentially a flat surface covered with colours arranged in a certain order.' This famous definition demonstrates the essentially intellectual tendencies of the group. The Nabis found inspiration in Gauguin, Cézanne and Odilon Redon, and their literary tastes ranged from Mallarmé and the Symbolists to Alfred Jarry. About 1900 the movement broke up.

Pierre Bonnard (1867–1947) [**708, 712**; see colour plate p. 210], after painting the very Japanese *Peignoir* (1890, Musée d'Art Moderne, Paris), developed a freer style which echoes Impressionism in its shimmering colour (*Toilette*, *c.* 1922, Musée d'Art Moderne, Paris; *The Bath*, 1925, Tate Gallery). Edouard Vuillard (1868–1940) [**711**; see colour plate p. 210], a Nabi early in his career (*Au Lit*, 1891, Musée d'Art Moderne, Paris), painted, about 1900, his *Déjeuner du Matin*, in which theory gives way to feeling; he also painted interiors and portraits in which human beings are seen among household objects and seem to merge with their surroundings (*Mme Vaquez*, 1918, Musée d'Art Moderne). Félix Vallotton (1865–1925) [**713**] in his *Troisième Galerie au Châtelet* of 1895 and his *Dinner, Lamp Effect* of 1899 (both in the Musée d'Art Moderne), remains faithful to Nabi aesthetics. His admiration for Holbein and Ingres can be seen in his acid and pessimistic portraits.

The Société Nouvelle and the Bande-Noire. Parallel with the efforts of the Société Nationale des Beaux-Arts to present modern work were the exhibitions organised from 1900 by the Société Nouvelle at the Galerie Georges Petit. The public and critics soon gave this group the nickname *Bande-Noire* (or Black Gang). The leader of this ' gang ' was Charles Cottet (1863–1924). His extremely sombre painting with its austere themes shocked those who expected painting to please. He found his tragic subjects in Brittany among the fishermen whose harsh lives he depicted. René Xavier Prinet (1861–1946), René Ménard (1862–1930) and André Dauchez (1870–1948) formed a group round him. Julien Lenormand took up the ideas of the *Bande-Noire* until he was blinded in the First World War. Edmond Aman-Jean (1860–1935), Henri Martin (1860–1943) and Lucien Le Sidaner (1862–1939) used pointillist technique in a rather superficial way, without giving it structural discipline. Lucien Simon (1861–1945) chose Breton subjects, painting them in a traditional manner in pale colours; Jacques Emile Blanche (1862–1942) used a similar technique in his fashionable portraits.

Expressionism. Certain painters aimed at representing things not as they saw them but as they felt them; they painted the profound reality of existence, generally in terms of pathos and suffering. Gustave Moreau (1826–1898) [**442**] cannot actually be considered an Expressionist; the Fauves Matisse and Marquet had worked in his studio and he has been called the ' midwife of Fauvism '. Georges Rouault (1871–1958) [**693, 722**] had an

893. JULIO LE PARC (b. 1928).
Continuel-Mobile. 1963. *Tate Gallery.*

894. YVARAL (Jean Pierre Vasarely; b. 1934). Accélération Optique. Relief. 1963. *Artist's Collection.*

early apprenticeship to a stained glass worker and from this training retained a feeling for iridescence and for colours outlined in black. From 1891 he studied for five years at the Ecole des Beaux-Arts under Moreau. His early works (*Christ mourned by the Holy Women*, 1895, Grenoble) were influenced by Moreau and Rembrandt, but by 1903, when he participated in the founding of the Salon d'Automne, he had developed a highly personal style in religious subjects, landscapes and themes of prostitutes, judges and clowns, mostly in watercolour. His later works continued to treat social and religious themes (*De Profundis*, 1946, and *Christian Nocturne*, 1952, both in the Musée d'Art Moderne), but with a simplified technique and expressive colour. From 1917 to 1927 he undertook a series of etchings for Vollard, including his *Miserere* (published 1948).

Other pupils of Gustave Moreau showing similar characteristics were Georges Desvallières (1861–1950) and Léon Lehmann (1873–1953). Later painters showing Expressionistic tendencies included Henri Le Fauconnier (1881–1946), Maurice Loutreuil (1885–1925) and Marc Chagall (see under *Surrealism*), who often verges on Expressionism (*War*, 1943, Musée d'Art Moderne). Amédée de La Patellière (1890–1932) worked at the Académie Julian in 1912 and was three times wounded during the War; he continued to suffer until his death, and a sadness pervades his work. A visionary, magic, poetic quality, but also a heavy, coarse rural character, are the apparently contradictory elements that give his work a mysterious personal flavour. Marcel Gromaire (1892–1971) [**743**] mixed a certain Expressionism with a Cubist tendency. Edouard Goerg (b. Australia, 1893) [**776**] interprets vice convincingly in his paintings and engravings. Chaim Soutine (1894–1943) [**746**; see colour plate p. 349], who was born in Russia, settled in Paris in 1911. At Céret, 1919–1922, in contact with the dazzling southern light, he painted some of his most Expressionistic and vivid landscapes. In the later 1920s, at Cagnes and Châtel Guyon, his tortured vision reached a height of interpretation in still lifes (animal carcasses) and figures (choirboys). Francis Gruber (1912–1948) [**648**], with his desolate landscapes and interiors and his weird characters, created a private world that is deserted, miserable and bitter — a world of wreckage.

The first Salon d'Automne. This Salon reflected a stricter choice of paintings than that of the Salon des Indépendants; it was founded in 1903 by a group of painters presided over by the architect Frantz Jourdain. From 1904

it presented the public not only with the work of young innovators but with entire rooms each of which was dedicated to a particular painter (Cézanne, Puvis de Chavannes, Redon, Renoir, Toulouse-Lautrec); at the time, all of them were still unaccepted, if not despised. 1905 was a historic date for the Salon. It was then that the term 'Fauves' (wild beasts) was applied derisively to certain artists because of their violent colours and bold technique (Camoin, Derain, van Dongen, Manguin, Matisse, Marquet, Puy, Valtat, Vlaminck, etc.). The Salon also exhibited the avant garde works of Picabia, his *Carburettor Child* and his *Heliotrope Venus*, as well as works by the Cubists (Delaunay, Léger, Lhote, Picasso). Another important Salon d'Automne was that of 1919.

The Fauves. The van Gogh retrospective exhibition at the Galerie Bernheim-Jeune in 1901 had a strong influence on the future Fauves. Fauvism, based on the use of pure colour, was less a coherent group than a temporary banding together of certain painters having a similar interest in flat patterning and violent colour. Matisse was the central figure of the group. The three chief groups making up this movement were: the Atelier Gustave Moreau and the Académie Carrière (Marquet, Camoin, Manguin, Puy); the Châtou group (including Derain and Vlaminck); the Le Havre group (Braque, Dufy, Friesz). They were joined by van Dongen. The 1905 Salon brought these artists together for the first time. The Salon des Indépendants of 1906 and the Salon d'Automne of the same year marked their high point. By 1908 the movement had broken up and a number of its members had turned to Cubism.

The art of Henri Matisse (1869–1954) [**630, 723, 761–766**; see colour plate p. 227] is characterised by logic and lucidity combined with flexibility of line and a pure brilliance of colour. In the *Grande Revue* in 1908 he claimed, 'What I look for above all else is expression.' At the Ecole des Beaux-Arts, where he studied with Gustave Moreau (1892–1897), he met Rouault, Marquet, Manguin and Camoin. His early work was conservative and traditional, based on copying in the Louvre and on the influence of Impressionism (*La Desserte*, 1897). In Corsica and on the French Riviera (1900–1904), under the influence of Neo-Impressionism and of Cézanne, his palette grew brighter and his drawing less conventional (*Luxe, Calme et Volupté*, 1905; *Collioure*, 1905, Royal Museum of Fine Arts, Copenhagen). During his Fauve period (1905–1908) colour, line and rhythm predominated (*Still Life*

with *a Red Carpet*, 1906, Grenoble Museum; *Blue Nude*, 1907, Baltimore Museum of Art). From 1909 to 1914 he came close to Cubism in his subdued colour and austere form (*The Dance*, 1909–1910, Museum of Modern Western Art, Moscow; *Mme Matisse*, 1913, Hermitage, Leningrad; *Piano Lesson*, 1916, Museum of Modern Art, New York). During the 1920s at Nice his style grew freer, with flat patterns and arabesques, flowered backgrounds and pure colours producing an overall decorative effect (odalisques). In 1928 came a renewed grandeur (*Decorative Figure on an Ornamental Background*, c. 1927, Musée d'Art Moderne, Paris), which led to the famous decorative composition *The Dance* (1931–1933), for the Barnes Foundation in Merion, Pennsylvania, and to the powerful forms and more abstract drawing of his late works (*Lady in Blue*, 1937, Mrs John Wintersteen Collection, Philadelphia; *Large Red Interior*, 1948, Musée d'Art Moderne). An important aspect of his later art can be seen in his collages (in coloured paper with gouache and crayon), in which he produced such excellent works as *Sadness of the King* (1952, Musée d'Art Moderne) and the *Snail* (Tate Gallery), and in his design and decoration of the Chapel of the Rosary at Vence (completed 1950).

Maurice de Vlaminck (1876–1958) [**655, 727**; see colour plate p. 228] retained his own particular technique throughout his life. He was a true Fauve in his earlier work, with its fierce and passionate use of colour; he became preoccupied, about 1909, with Cubist construction in his landscapes and still lifes. By this time, too, he had manifested his preference for the deep blues and pure whites which we find in his later, more expressive and often melancholy landscapes. André Derain (1880–1954) [**728, 772**; see colour plate p. 228] was a pupil at the Académie Julian. He later met Matisse, Vlaminck, Braque and Picasso. His true artistic personality came to the fore in 1903 (*Christ carrying the Cross*, after Ghirlandaio) and then in his Fauve period; from a concern with line and colour, he moved on to a preoccupation with form and structure. Cubism, archaism, his 'Gothic' period of stylisation, his classicism which was more Roman than Greek — these were the later stages of his career. Albert Marquet (1875–1947) [**726**] employed a range of colours of extraordinary delicacy and distinction; about 1904–1906 he participated in the Fauve movement.

Raoul Dufy (1877–1953) [**725, 895**] very soon abandoned 'orthodox' Fauvism to produce his luminous paintings of the fashionable world of regattas, racecourses and casinos; he

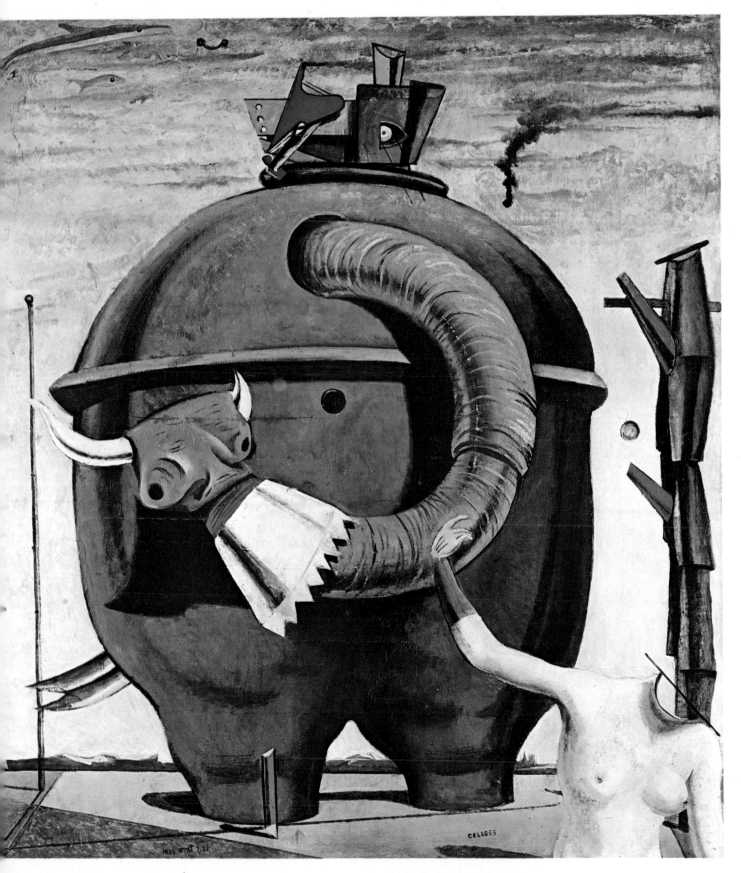

MAX ERNST (1881–1976). The Elephant Celebes. 1921.
Roland Penrose Collection, London. *Photo: Michael Holford.*

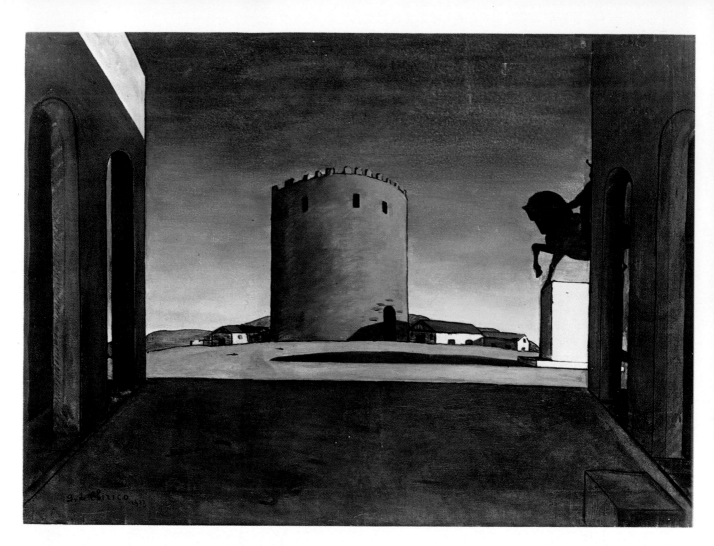

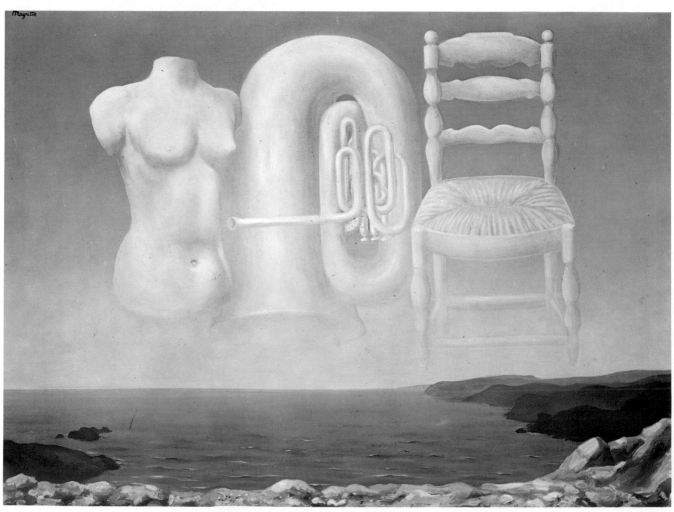

rejuvenated textile design with his silks and other furnishing materials, and contributed to ceramic decoration. Georges Braque, whose name remains linked with Cubism, also experimented with a Fauvism having traces of Divisionism. He influenced among others Robert Delaunay, a pioneer of abstract art. Even the Neo-Impressionists were to be affected by Fauvism, notably Paul Signac, Lucie Cousturier and Maximilien Luce. Other Fauves included: Louis Valtat (1869–1952); Charles Camoin (b. 1879); Othon Friesz (1879–1949) [**774**]; Henri Manguin (1874–1949); Jean Puy (1876–1960), Kees van Dongen (1877–1968) [**896**] and Maurice Marinot (1882–1960). Fauvinism had links with similar movements in other countries, particularly in Germany and Belgium.

The great independents. Among the painters who belonged to no school were Suzanne Valadon and her illegitimate son Maurice Utrillo, who though largely self taught cannot be classed among primitives, for their work is not as unsophisticated as is sometimes claimed. Suzanne Valadon (1867–1938) [**742**], a working-class girl, went at an early age to Paris, where she did humble manual work before becoming a circus acrobat. An accident caused her to leave the circus and become a model for such painters as Renoir, Lautrec and Degas, who guided her talent — a talent for portraying scenes of sour wilfulness (*Dressmaker*, 1914, Musée d'Art Moderne, Paris) and astringent bitterness (*Blue Room*, 1923, Musée d'Art Moderne); objects and figures are delineated with sombre arbitrary contours which give her style a particular kind of violence. The best work of Maurice Utrillo (1883–1955) [**741**] was produced in his tragic earlier years. He became an alcoholic when still quite young. To distract him his mother urged him, in about 1902, to paint. He studied Sisley and Pissarro before developing, about 1907, a particularly melancholy idiom for his townscapes (*Porte St Martin*, c. 1911, Tate Gallery).

The work of Amedeo Modigliani (1884–1920) [**747**; see colour plate p. 349] bears no relation to that of Valadon and Utrillo except in that it also stands in spiritual isolation. Born in Leghorn of a distinguished Italian Jewish family, he had his first training in Italy before going to Paris in 1906, where he spent the rest of his short life. His early works

were influenced by Toulouse-Lautrec, but his mature style was based on African sculpture, Cézanne, Picasso and above all on his Italian heritage. Encouraged by his friend Brancusi he executed some sculptures in 1909–1915. A superb draughtsman, his work is reminiscent of Botticelli, Sienese Trecento painting and Italian Mannerism (portraits of Cocteau, Zborowski, Jeanne Hébuterne). Most of his surviving paintings, almost exclusively nudes and portraits, date from the years 1915–1920 and show a kind of personal Expressionism held in check by a sense of dignity and nobility.

Pioneers of Cubism. With its triumphant, intuitive brutality Fauvism inevitably provoked a reaction towards order, reflection and construction. Cubism represents one of the great phenomena in art. It grew out of the efforts of Picasso and Braque to replace the visual effects of Impressionist preoccupation with the surface of objects by an intellectual conception of form and colour. As Picasso claimed, 'We had no intention of creating Cubism, but only of expressing what was inside us. Pablo Picasso (b. Malaga 1881–1973) [**633**, **729**, **752–760**; see colour plate p. 313] first visited Paris in 1900, settling there in 1904. The influence of Lautrec, Gauguin, van Gogh, Steinlen and late Impressionism, superimposed on his Spanish heritage and Catalan education, resulted in the pessimism of his Blue Period (1901–1904), with its pervasive blue tones (*Two Sisters*, 1902, Hermitage, Leningrad), which was succeeded in the Rose Period (1905), with its pale pinks, by themes of actors, mountebanks and Harlequins (*Family of Saltimbanques*). Georges Braque (1882–1963) [**730**, **767–771**; see colour plate p. 278] came from Le Havre to Paris in 1900 and by 1906 was a member of the Fauve circle. In 1907 at L'Estaque his landscapes became strongly influenced by Cézanne; with Picasso, he embarked on the artistic revolution of Cubism, a movement evolving from the collaboration between these contrasting spirits.

Cubism developed in three stages — the Cézanne period [**633**, **729**, **767**] (1907–1909), the analytical period (1910–1912) and the synthetic period (1912–1914). The way had been prepared for it by the influence of African sculpture and the Cézanne retrospective exhibition of 1907. In the spring of this year Picasso completed the *Demoiselles*

d'Avignon (Museum of Modern Art, New York [**633**]), whose right-hand side with its violent simplifications and lack of chiaroscuro marks the advent of Cubism. Its evolution resulted in a new plastic language, lyrical yet conceptual, which rejected objective appearances and atmospheric effects. Cubism was an attempt to record the permanent, the essential, characteristics of objects without the use of conventional perspective or light. The choice of subjects was limited to a few objects which were then broken down into geometric forms. In the analytical phase [**730**, **754**] there was an increasing breakdown of form and a use of monochrome simultaneity (several aspects of the same object seen in one picture, as if the object were opened up and seen from the inside, the reverse, etc.). Volumes were fragmented, planes flattened and superimposed. This extreme analysis brought with it the risk of ending in a blind alley; this was counteracted in the

895. RAOUL DUFY (1877–1953). Deauville, drying the Sails. 1933. *Tate Gallery.*

896. KEES VAN DONGEN (1877–1968). Dancer, c. 1921. *Musée d'Art Moderne, Paris.*

GIORGIO DE CHIRICO (1888–1973). The Rose Tower, 1913. Peggy Guggenheim Collection, Venice. *Photo: Michael Holford.*

RENÉ MAGRITTE (1898–1967). Threatening Weather. 1928. Roland Penrose Collection, London. *Photo: Michael Holford.*

897. JEAN METZINGER (1883–1956).
Dancer in Café. 1912. *Albright-Knox
Art Gallery, Buffalo.*

898. ROBERT DELAUNAY (1885–
1941). Runners. 1926.

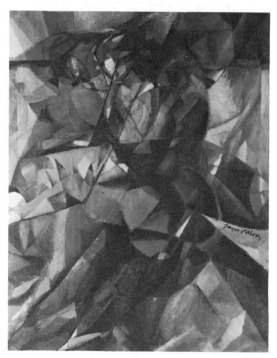

899. JACQUES VILLON. Young Girl.
1912. *Philadelphia Museum of Art.*

900. SONIA DELAUNAY (b. 1886).
Simultaneous Colours. 1913.
Kunsthaus, Bielefeld.

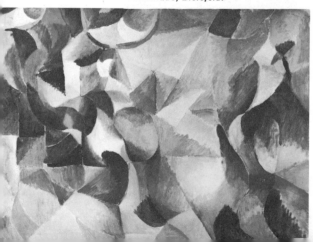

synthetic phase [**732**, **768**] by the use of collage — the application of printer's type and the introduction of materials such as sand, glass, newspaper or cloth. In this new phase (from 1912) the process of breaking down was reversed, and a stage of building up from geometric shapes, etc., began. Imitation was discarded for freely invented signs; bright colours reappeared and collage became more frequent. The First World War dispersed the movement, but it had already influenced the majority of avant garde artists, prominent among them Gris, Léger, Herbin and Delaunay, and was widely publicised by Gleizes and Metzinger.

Other young painters and sculptors were working along the same lines. Jacques Villon (1875–1963) [**751**, **899**] at first followed scientific Cubism; he later found it too arid and antihumanistic; about 1912 he made his Puteaux studio the centre of the Section d'Or movement. After the War he abandoned painting for engraving, then began painting in luminous colours; finally, while in Gascony from 1940 to 1944, he found his own formula — 'Cubist Impressionism' (*Between Toulouse and Albi*, 1941, Musée d'Art Moderne, Paris); his work became increasingly abstract. Francis Picabia (1879–1953), a singular character, followed Cubism in 1908, then abstraction from 1909, then joined the Dada movement and later became a Surrealist (see under *The Dada movement*). Albert Gleizes (1881–1953) [**749**] joined the Cubist movement about 1909 and in 1912 edited with Jean Metzinger a theoretical book on Cubism; he then joined the Section d'Or movement and

concerned himself with the rhythm and cadence of forms and colours, which led him towards abstraction.

Fernand Léger (1881–1955) [**731, 902**] met Braque and Picasso in 1910 and by 1912 had evolved a personal idiom having elements of both Cubism and Futurism. During the War he became fascinated with the beauty of machine forms and about 1917 evolved a kind of curvilinear Cubism dependent on the dynamic shapes of machinery and their geometrical cones, cylinders, wheels and pistons. These forms also influenced his massive, robot-like figures and increased the effect of his strong flat colours. From 1921 the human figure began to dominate the broad planes and large areas of colour, though with impersonal precision (*Woman with a Bouquet*, 1921). His later works reveal an increasing preoccupation with the problem of creating space through colour, always in terms of the conditions of modern life (*Transport of Forces*, 1937; *Grand Parade*, 1954). Henri Le Fauconnier (1881–1946) exhibited at the 1911 Salon des Indépendants in the room in which the Cubist works were assembled. After 1913, however, he abandoned Cubism for an austere Expressionism. Auguste Herbin (1882–1960) [**814**] broke away from objective painting after 1909 and explored Cubism; after the First World War his works became dry, geometrical and abstract.

Georges Braque [**724,730,767–771**; see colour plate p. 278] shared with Picasso in the creation of Cubism. When he resumed painting in 1917 after having been severely wounded in the War, he no longer worked with Picasso but followed his own course, turning to a

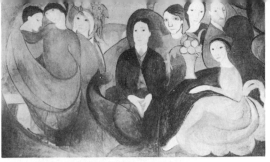

901. MARIE LAURENCIN (1885–1956). The Assembly. 1910. Left to right: Gertrude Stein, Fernande Olivier, an angel, Apollinaire, Picasso, an angel, Cremnitz and the artist.

freer, quieter style, a style that was less angular, with a greater use of colour and a more supple handling. A less arbitrary spatial composition and an admission of the existence of the real world led in the 1920s to vigorous, splendid still lifes and figure compositions having a perfection of balance and harmony of colour and design. Towards 1930 his line grew more dynamic with a greater use of the arabesque; colour grew brighter and there was more expressiveness in the drawing (beach series, 1931). The mid-1930s brought a harmony of feeling and intellect and of expression and technique. He eventually attained a monumentality which is illustrated by his great series of studios (1947–1955). Louis Marcoussis (1883–1941) [**688**] was a Cubist from 1912; his *Still Life with a Chessboard* (1912, Musée d'Art Moderne) epitomises his experiments at a time when the rigour of Cubism was tempered by a certain Expressionism.

Jean Metzinger (1883–1956) [**897**] came into contact with the Cubists in 1907. He exhibited with them in 1911 at the Salon des Indépendants and then joined the Section d'Or; he published with Gleizes the first theoretical work on the new aesthetics, *Du Cubisme* (1912). Alfred Reth (b. 1884) exhibited with the Cubists at the 1911 Salon des Indépendants. His canvas *Restaurant Hubin* (1912, Musée d'Art Moderne) illustrates the original form Cubism took on in his hands.

Robert Delaunay (1885–1941) [**737**, **898**], after being influenced in a very personal way by Cézanne (*Laon Tower*, 1911, Musée d'Art Moderne), painted his series of windows in which, using contrasting colours, he broke up space in an entirely new way. Apollinaire coined the name Orphism to describe this primacy of pure colour. In his *Circular Forms* (1912) Delaunay foreshadowed total abstraction, and his influence was felt beyond Paris by both the Futurists and the Blaue Reiter. Sonia Terk Delaunay (b. 1886) [**900**] married Robert Delaunay in 1910; she was influenced by him in her vast compositions, but she has preserved her own individuality in her Cubist designs for textiles, ceramics, etc. André Lhote (1885–1962) came under Cézanne's influence from 1910; he remained a Cubist, but he never completely rejected visual reality (*Rugby*, 1917, Musée d'Art Moderne); he is a peerless draughtsman, and some of his drawings in black chalk are comparable to those of Ingres. In 1918 he became a critic and published numerous books on art; he spread Cubist influence to young artists from many countries. Roger de La Fresnaye (1885–1925) [**750**], who has been called 'the most French of the Cubists', feared the over-systematisa-

tion of Cubism and joined the Section d'Or. Gassed in 1917, he dedicated his last years to experimenting with watercolour and gouache, ranging from Neoclassicism almost to abstraction. Companion to Apollinaire, Marie Laurencin (1885–1956) [**901**], nicknamed 'the Fauvette', was for a time linked with the Cubist movement but moved away from it in her elegant and feminine compositions.

Juan Gris (1887–1927) [**732**, **903**; see colour plate p. 278], who was born in Madrid, at first made his living by doing humorous drawings for the Press; he came to Paris at the age of nineteen and moved into the Bateau-Lavoir, where Picasso lived, and in time he became a Cubist. In 1912–1913 he played a decisive part in synthetic Cubism ('From a cylinder I make a bottle . . .'), reversing the direction from a breaking down to a building up. His austere, classical works in this style have a lyrical poetry. His exquisite still lifes are painted in refined, harmonious colours. His original and classical style marks him as one of the important figures of his time in painting, in addition to being a significant contributor.

The 20th-century primitives. Of the exceptional crop of naive paintings in our time many have been the fruit of leisure hours or retirement. Apart from one brilliant exception, Séraphine (Séraphine Louis), with her extraordinary technique, all the 'Sunday painters' have retained to their old age a naive childlike style guided by pure unspoilt feelings. With these painters one cannot talk of schools or groups. Henri Rousseau, known as 'the Douanier' (1844–1910) [**634**], began to paint regularly when he was about forty. His work attracted the attention of Pissarro and Gauguin and later the enthusiasm of Apollinaire and Picasso; the banquet organised at the Bateau-Lavoir in 1908 by Picasso and his friends in honour of Rousseau was a historic occasion. Louis Vivin (1861–1936) [**904**], a retired Post Office employee, painted many scenes of Paris in which historic buildings are ingenuously presented as unusual novelties. Séraphine Louis, known as Séraphine (1864–1934) [**905**], was a shepherdess before becoming a housemaid; as a hobby, on Sundays she painted bouquets of dream flowers; her technique and colour are at times almost worthy of a van Gogh. Dominique Peyronnet (1872–1943) was a printer and André Bauchant (1873–1958) a market gardener. Camille Bombois (b. 1883), who is known for his paintings of circus people, has practised many trades, from masonry to conjuring.

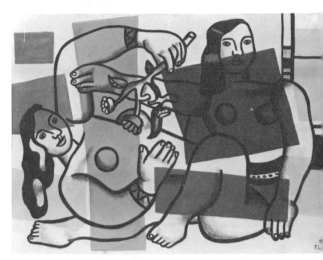

902. FERNAND LÉGER (1881–1955). Two Women holding Flowers. 1954. *Tate Gallery.*

903. JUAN GRIS (1887–1927). Le Violon devant la Fenêtre Ouverte. 1926. *Kunsthalle, Bremen.*

904. LOUIS VIVIN (1861–1936). Notre Dame. c. 1933. *Musée d'Art Moderne, Paris.*

905. SÉRAPHINE (1864–1934).
Flower Still Life.

Futurism. In 1909 the Italian writer Marinetti founded the Futurist movement in Milan. The first Futurist manifesto was published in *Le Figaro* in the same year. The exhibition of Italian Futurist painters at the Galerie Bernheim-Jeune in Paris in 1910 caused a considerable stir; the catalogue announced the movement's scorn for all imitation, the necessity for originality, the rejection of 'harmony and good taste', the need to express modern life — the 'life of steel, fever, pride and headlong speed' — and the need for rendering dynamism in painting. The painters who took part in this exhibition were Carlo Carrà, Umberto Boccioni, Luigi Russolo and Gino Severini. (Giacomo Balla also belonged to the group.) The exhibition afterwards went to England, Germany, Belgium, Holland, Switzerland and Austria (see under *Italy*).

The Puteaux school and the Section d'Or. Even before it had reached its peak Cubism was questioned by certain of its followers, such as Jacques Villon (1875–1963) [**751**, **899**], who by 1912 had begun to feel that the Cubists, interested in still life, were too rigidly systematic and that it was perhaps a mistake to exclude man and humanist values from painting.

A group of artists began to meet together at Puteaux, where Villon had a studio with his two brothers, the painter Marcel Duchamp (1887–1968) [**740**, **907**, **908**] and sculptor Raymond Duchamp-Villon (1876–1918) [**733**, **866**]. Villon was interested in Leonardo da Vinci's inventions and in geometry. His studies led him to severe construc-

tions with pyramidal forms. Some of his Puteaux friends had been influenced by Italian Futurism. Marcel Duchamp's appreciation of the Futurists' ideas would seem to be borne out by his famous *Nude descending a Staircase, No. 2* (1912, Philadelphia Museum of Art). After this more Futurist than Cubist work, the aesthetics advocated by Braque and Picasso had no further part in Marcel Duchamp's art. The principal artists, of varying tendencies, who took part in discussions at the Puteaux studio decided to form a group which Jacques Villon named the Section d'Or (one of these artists' constants being the Renaissance Golden Section). Its exhibitions played an important role in the evolution of art immediately before the First World War. The artists of the Section d'Or had at one time been drawn to Cubism but had eventually rejected its static compositions and somewhat subdued colours; they now experimented with rhythmic forms and more appealing colours. The War put an end to the group.

The pioneers of non-figurative art. It is difficult to give the exact date of the birth of non-figurative art in modern Europe; the first works should not be confused with Cubism. Certain unmistakably non-figurative works appeared as early as 1909 with Picabia (*Rubber*, Musée d'Art Moderne, Paris), Kandinsky (*Abstract Watercolour*, 1910), František Kupka (*Yellow Scale*, 1910), Alfred Reth (*Relationship of Straight and Curved Lines*, drawing, 1910), Vladimir Rossine (*Abstract Composition*, 1910, Musée d'Art Moderne), Robert Delaunay (*Simultaneous Disc*, 1912) [**737**, **898**], Sonia Delaunay (*Simultaneous Colours*, 1913 [**900**]), Antoine Pevsner (*Abstract Forms*, 1913, Museum of Modern Art, New York), Fernand Léger (*Contrasts of Forms*, 1913, H. Rupf Collection, Berne), Albert Gleizes [**749**], Michel Larionov [**811**] and Nathalie Gontcharova [**1081**]. Just after the First World War Purism, a rigorous and austere abstract movement, was launched by Le Corbusier, Amédée Ozenfant [**748**] and Auguste Herbin [**814**].

The reaction against Cubism and non-figurative art. The experiments carried out by the abstract painters brought about a violent reaction in favour of realism. Before the First World War three friends perpetuated the earlier ideas of harmony, tradition and realism; these men were Luc Albert Moreau (1882–1948), Jean Louis Boussingault (1883–1943) and André Dunoyer de Segonzac (b. 1884) [**773**], a fine draughtsman, whose *Drinkers* (1910), painted in earth colours with a liberal use of impasto, caused a sensation; this

canvas was followed by a good many others in which the colours vary from ochre to earth browns — figurative landscapes of the Ile de France and of Provence and solidly and richly painted still lifes. (His drawings and water-colours are equal in quality to his oils.) Other artists having similar aims included Henry de Waroquier (b. 1881), Charles Dufresne (1876–1938), with his warm compositions which were often translated into tapestries, André Mare (1885–1932) and two former Fauves who still retained their taste for colour — Charles Camoin and Jean Puy, who had often exhibited with the *Bande-Noire*. Jules Pascin (1885–1930) [**906**] was not affected by Cubism and did not belong to any school.

The Dada movement. The First World War drove artists and writers from many countries to Switzerland. There in Zürich in 1916 Dada — that strange movement whose name was discovered by means of a pin stuck at random in a German-French dictionary — made its appearance. The Alsatian painter-sculptor Hans Arp (1887–1966) [**802**, **877**, **878**] and the Rumanian poet Tristan Tzara were among the founders of the venture, which soon spread to other countries (France, Germany, the United States, Italy). A Dada review was founded, and in the third issue in 1918 a manifesto was published: 'Art is nonsense . . . everything one looks at is false . . . thought is created in the mouth.' A negative movement, aimed at shaking off the shackles of tradition and destroying preconceived ideas of art, Dada attempted to shock the beholder. Objects such as urinals were exhibited as works of art. Picabia invented impossible fantastic machines in his paintings of this period and in addition produced ready-mades (everyday objects presented as works of art) and humorous photographic collages. Marcel Duchamp [**907**, **908**] produced a facsimile of the *Mona Lisa* with her smile wreathed in an enormous moustache. The same artist exhibited a glass ampoule containing fifty cubic centimetres of Paris air and also produced a ball of twine placed in a metal frame, the latter having word puzzles on it; a hidden noise was added to this ready-made. Duchamp and Picabia brought Dada to the United States, where it had a brief existence. In 1919 Tzara left Zürich for Paris, and Dada began its Parisian career. At first this group was a purely literary one, led by the poets Paul Eluard, Louis Aragon and André Breton, but later painters joined the writers. In painting the movement was above all a reaction against Cubism and its links with industrial civilisation. The ideas of

the Dadaists influenced Surrealist writing and painting.

Surrealism. Surrealism (the word was coined in 1917 by Guillaume Apollinaire) claimed kinship with Freudianism. It aimed to give expression to subconscious mental activity, to mental activity that is not controlled by reason. Dreams and erotic fantasies took on a major importance. The realm of the fantastic had appeared in the past in the works of Bosch, Blake, Goya and Redon. Some Surrealist painters, for example Pierre Roy (1880–1950) [909], employed trompe l'oeil. For a time Picasso approached Surrealism. Marc Chagall (b. Russia, 1887) [745, 912; see colour plate p. 349], with his sense of the fantastic, has points of contact with Surrealism, but like Picasso he was never directly associated with the movement. Always an independent artist, Chagall returned often to the peasant scenes and folklore of his native Russia and to eastern European Jewish folklore for his inspiration. His fantastic scenes, with their people and animals soaring above the rooftops, and their brilliant colour, haunt the imagination. The work of this notable member of the 'school of Paris' is extremely influential.

Max Ernst (1891–1976) [642, 804; see colour plate p. 331] helped to found the Dada movement in Cologne. In 1922 he settled in Paris and became active with the Surrealists. His evocative and original paintings — into some of which he has incorporated black lead rubbings (frottages) of the textures of cloths, the grain of wood, etc. — are perfect expressions of this movement. He lived in the United States from 1941 to 1949. Ernst's technique of frottage, which lent an air of mystery and imagination to his works, gave a new dimension to Surrealism. Ernst also exploited collage, where the juxtaposition of elements could often lend a bizarre appeal. Much of his work explores a world of the imagination and the unconscious. Salvador Dali (b. Spain, 1904) [803] studied in Madrid and was later influenced by Chirico and Carrà; in time he joined the Surrealists. His Surrealist works show a technical excellence and make much use of the unconscious and of Freudian symbolism. In the 1940s he was in the United States; there his art came under the influence of the Italian Renaissance and he painted religious subjects (*Last Supper*, 1955, National Gallery, Washington). Yves Tanguy (1900–1955) [644], a Breton and a great traveller in his youth, began to paint in 1923, after having been impressed by the work of Chirico. He joined the Surrealists in 1925; he went to the United States in 1939 and remained there

(Retrospective at the Museum of Modern Art, New York, 1955). His paintings show strange unearthly forms which seem to exist in a sort of limitless desert.

Joan Miró (b. Spain, 1893) [636, 910], from Catalonia like Dali, studied in Barcelona and settled in Paris in the 1920s. Influenced at first by van Gogh and later by Cubism (*Farm*, 1921–1922), he soon began to manifest his own original personality in subjective works in which he abandoned realism. In 1925 he exhibited with the Surrealist group at the Galerie Pierre. His *Carnival of Harlequin* (1924–1925; Albright-Knox Art Gallery, Buffalo) and *Dutch Interior* (1928, Museum of Modern Art, New York) date from this period. Miró's mature works reflect his humour, his powers of fantastic invention and his originality of vision in a calligraphic style; his imagery is always poetic and evocative.

André Masson (b. 1896) [694] studied in Brussels and at the Ecole des Beaux-Arts in Paris. From 1924 to 1929 he took part in the Surrealist movement and was interested in 'automatic writing'. He lived in Spain in 1934–1937. In the later 1940s he settled in Provence, after a stay in the West Indies and the United States. His sand paintings and his later calligraphic style have influenced recent developments in American abstract painting.

Giorgio de Chirico (b. Greece, 1888) [944; see colour plate p. 332], the Italian Metaphysical painter, can be considered a precursor of Surrealism. He exhibited with the Surrealists in Paris in the 1920s. By the 1930s he had reverted to an academicism (see under *Italy*). Jean Lurçat (b. 1892), cultivated, quick-witted and strong-minded, was an original painter, obsessed by strangely poetic theories in the Surrealist vein,

906. JULES PASCIN (1885–1930). Young Woman in Red. 1924. *Musée d'Art Moderne, Paris.*

907 MARCEL DUCHAMP (1887–1968). In advance of a Broken Arm. Ready-made. 1915. *Yale University Art Gallery, New Haven.*

908. MARCEL DUCHAMP. Girl with Bedstead (Apolinère Enameled). Made from advertisement for Sapolin Enamel. 1917. *Philadelphia Museum of Art.*

909. PIERRE ROY. L'Eté de la saint Michel. *c.* 1932. *Musée d'Art Moderne.*

910. JOAN MIRÓ (b. 1893). Carnival of Harlequin. 1924–1925. *Albright-Knox Art Gallery, Buffalo.*

911. JEAN DUBUFFET (b. 1901). Vache la Belle Allègre. 1954. *Peter Cochrane Collection, London.*

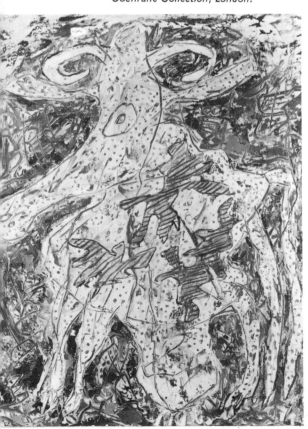

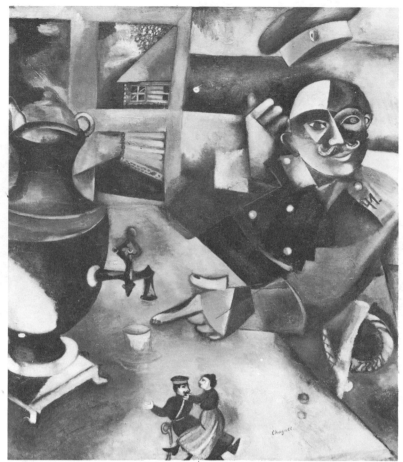

912. MARC CHAGALL (b. 1887). The Soldier Drinks. 1912. *Solomon R. Guggenheim Museum, New York.*

before he dedicated himself to reviving the art of tapestry [**801**]. Though Surrealism as a form of anarchical individualism died out about 1930, a new generation with less vehemently Surrealist tendencies has appeared; its principal representatives include Henri Michaux (b. Belgium, 1899), Jean Dubuffet (b. 1901), Victor Brauner (1903–1966), Lucien Coutaud (b. 1904), Félix Labisse (b. 1905) and Leonor Fini (b. Argentina, 1908). Dubuffet's intuitive work has been influenced by the painting of children, the art of mental patients, etc. He incorporates materials such as sand, coal and glass into his paintings, whose eerie magic contains elements of both the world of reality and images from the unconscious psyche [**911**].

The later work of Picasso. After the War Picasso, the most original creative artist of the 20th century, continued to produce an immense body of work in every conceivable medium [**755**; see colour plate p. 313]. Though apparently lacking in continuity, his work has a prodigious vitality which expresses, above all, an incurable unrest, that of man in revolt against his destiny. In 1917 he met Diaghilev in Rome and from 1917 to 1924 designed for the Ballets Russes (costumes and settings for *Parade* and

Three-cornered Hat). About this time he returned to his earlier subjects — acrobats, Harlequins, etc. In the early 1920s he painted his late Cubist works such as the two versions of *The Three Musicians* (Museum of Modern Art, New York, and Philadelphia Museum of Art [**913**]) and worked in his calm and realistic neoclassical style (*Woman in White*, 1923) [**756**]. About 1925 he participated in the Surrealist movement and under its influence produced paintings of a metamorphic character (*Three Dancers*, 1925 [**757**]; *Figure by the Sea*, 1929). About 1932 flexible curves, arabesques and acid colours appeared (*Girl before a Mirror*, 1932, Museum of Modern Art, New York; *Nude Woman in a Red Armchair*, 1932, Tate Gallery [**914**]). In the later 1930s Expressionism reappeared in his work in themes of bullfights and Minotaurs; this tendency culminated in *Guernica* (1937) [**759**]. During the Occupation he stayed in Paris, painting sombre still lifes, tormented figures and tortured, tragic faces [**758**]; he also produced the bronze *Man with a Sheep* (1943). He returned to the Mediterranean coast in 1946 and has worked at Golfe Juan, Antibes and Vallauris, where he has produced and painted hundreds of ceramics. Since 1955 his diverse creations have included variations on Delacroix's *Women of Algiers* [**760**] and

Velasquez's *Las Meninas* and a large mural for the UNESCO building in Paris.

The Salon des Tuileries. In 1923 Charles Dufresne brought together a few artists who on the one hand deplored the Salon d'Automne because of the mediocre works it accepted and on the other hand accused the Cubists and abstract painters of inhuman aridity. They founded the Salon des Tuileries with Albert Besnard as president and Edmond Aman-Jean and Antoine Bourdelle as vice-presidents. These artists of varying styles often revealed a moderate tendency to prolong Fauvism or Cubism. Among those connected with this group were Albert André (1869–1954), Louise Hervieu (1878–1954), Henry de Waroquier (b. 1881), and Maurice Asselin (1882–1947) and Valentine Prax (Mme Zadkine).

The return to figurative art in the 1930s. Certain young artists, born around 1900, though not linked together in any other way, were concerned with figurative art. They claimed kinship in various ways with Renoir, Matisse and Bonnard. Some had been influenced by the Fauves, others superficially by the Surrealists. Most of them pursued a figurative ideal with the aid of bright, clear colours. Their subject matter was traditional, intended to please and not to surprise. These painters included François Desnoyer (b. 1894) [**807**], Roger Limouse (b. Algeria, 1894), Roland Oudot (b. 1897), Raymond Legueult (b. 1898), Maurice Brianchon (b. 1899) [**775**], Jules Cavailles (b. 1901), Roger Chapelain-Midy (b. 1904) [**779**], who seeks to restore to art a feeling for the human being and a sense of inner life, Jean Claude Aujame (b. 1905), with his feeling for the mystery of things, Yves Brayer (b. 1907), Charles Walch (1898–1948), with his popular imagery, who was influenced by Chagall, and Jean Pougny (1894–1956), born in Russia, whose exquisite little canvases suggest a combination of Vuillard and Fauvism.

The 'Forces Nouvelles'. This group of young painters in search of strict aesthetic principles based on tradition took an enthusiastic interest in the exhibition of 'Painters of Reality in France in the 17th Century', held at the Orangerie in 1934. The group was dispersed by the War and the Occupation. Most of its members, however, have retained something of the group's collective aims. Among the painters most representative of this group are Robert Humblot (1907–1962), Francis Gruber (1912–1948) [**648**], Claude

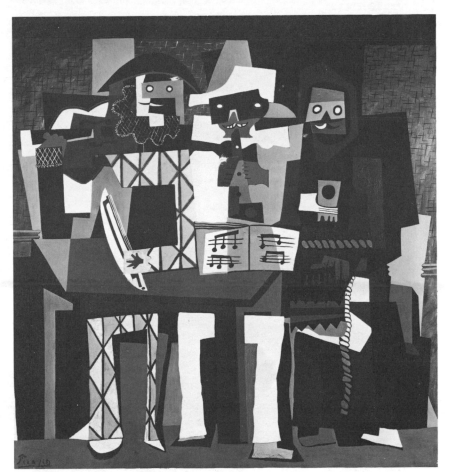

913. PABLO PICASSO. The Three Musicians. 1921.
Philadelphia Museum of Art.

914. PABLO PICASSO. Nude Woman In a Red Armchair.
1932. *Tate Gallery.*

Venard (b. 1913) and Georges Rohner (b. 1913) [**915**].

The 'Young Painters in the French Tradition'. In rebellion against the Occupation government, a group of painters backed by André Lhote organised an exhibition at the Galerie Braun in 1941 entitled 'Young Painters in the French Tradition' (Jeunes Peintres de Tradition Française). The styles of these artists ranged from the figurative, along the lines of Matisse, to a Cubism inspired by Picasso, and between these two tendencies came various shades of everything from Fauvism to Surrealism. This exhibition, which included works by established painters as well as by completely unknown ones, marked a change of direction in 20th-century painting and is as important in the history of art as the Impressionist exhibition at Nadar's in 1874. Those who took part included François Desnoyer (b. 1894) [**807**], André Beaudin (b. 1895), Charles Lapicque (b. 1898) [**809**], Charles Walch, Raymond Legueult, Francisco Borès (b. Madrid, 1898) [**954**], Jean Bazaine (b. 1904) [**810**], Maurice Estève (b. 1904) [**808**], Léon Gischia (b. 1904), Lucien Coutaud (b. 1904), Pierre Tal Coat (b. 1905) [**918**], Edouard Pignon (b. 1905) [**916**], André Marchand (b. 1907), Gustave Singier (b. Belgium, 1909) [**917**], Lucien Lautrec (b. 1909), Jean Bartholle (b. 1909) and Alfred Manessier (b. 1911) [**919**].

Post-War trends. The 1944 Salon d'Automne caused a sensation with its exhibitions of Picasso, Soutine and Georges Dufrenoy (1870–1943). The Salon also showed a selection of the pictorial tendencies which had developed since Fauvism. The labels of realism, Cubism, Surrealism and abstraction became thoroughly confused, for there was a lack of accurate terms to define all the subtle gradations of style between figurative and non-figurative art, and, also, artistic freedom allows a painter to cross the frontiers between the different modes of plastic expression. Among innumerable exhibitions those of three groups were quite important: the Salon de Mai (organised 1945), whose contributors belonged to the avant garde (but some of whom had not repudiated figurative art); the Salon des Réalités Nouvelles (organised 1946), which insisted on completely non-figurative work; the Salon des Peintres témoins de leur Temps (founded 1951), which in opposition to the other two salons imposed a set theme every year.

The first Salon de Mai included works by mature artists and also works by those 'Young Painters in the French Tradition' who had exhibited in 1941 at the Galerie Braun. The tendencies of

915. GEORGES ROHNER (b. 1913). Homage to Ingres. 1959. *Algiers Museum.*

916. EDOUARD PIGNON (b. 1905). Cock-fight. 1960. *Galerie de France, Paris.*

917. GUSTAVE SINGIER (b. 1909). Dutch Town. 1952–1953. *Solomon R. Guggenheim Museum, New York.*

918. PIERRE TAL COAT (b. 1905).
Colza. 1962. *Galerie Maeght, Paris.*

919. ALFRED MANESSIER (b. 1911).
Alleluia Pascal. 1964. *Galerie de
France, Paris.*

920. *Above.* JEAN LE MOAL (b. 1909).
Roots and Water. 1959.

921. *Right.* WOLS (1913–1951). Paint-
ing. 1947. *Galerie Alexandre Iolas, Paris.*

922. *Left.* MARIO PRASSINOS
(b. 1916). The Idol. 1964.

923. ZAO WOU-KI (b. 1920). Cathedral
and its Surroundings. 1955.

924. FRANTIŠEK KUPKA (1871–1957).
Arrangement in Yellow Verticals.
1913. *Musée d'Art Moderne, Paris.*

925. ROGER BISSIÈRE (b. 1888).
Agonie des Feuilles. 1962. *Galerie
Jeanne Bucher, Paris.*

this salon ranged from the non-figurative, with Singier [917], Jean Le Moal (b. 1909) [920] and Alfred Manessier [919], to the figurative with Bernard Lorjou (b. 1908) and Bernard Buffet (b. 1928) [780]. The exhibitors at this salon included François Desnoyer [807], André Beaudin, Serge Poliakoff (b. Russia, 1906) [928], André Lanskoy (b. Russia, 1902), Hans Hartung (b. Germany, 1904) [640, 926], Maurice Estève [808], Léon Gischia, Lucien Coutaud, Jean Bazaine [810], Pierre Tal Coat [918], Jean Claude Aujame, Edouard Pignon [916], André Marchand, Jean Deyrolle (b. 1911), Francis Gruber [648], Francis Tailleux (b. 1913), Jean Atlan (1913–1960) Claude Venard, Nicolas de Staël (1914–1955) [778, 927], Mario Prassinos

(b. Istanbul, 1916) [922], Pierre Soulages (b. 1919) [690, 930], Zao Wou-ki (b. Peking, 1920) [923], Jean Dewasne (b. 1921) and Jean Paul Riopelle (b. Canada, 1924) [695].

The only condition imposed on the artists of the Salon des Réalités Nouvelles was that they be non-figurative. The older generation of this group included František Kupka [924], Picabia, Albert Gleizes [749], Auguste Herbin [814], Sonia Delaunay [900], Alberto Magnelli (1888–1971) [812], Roger Bissière (b. 1888) [925], Leon Zack (b. 1892), Jean Fautrier (1897–1964) [817], Jean Piaubert (b. 1900), Cesar Domela (b. Amsterdam, 1900), Victor Vasarely (b. Hungary, 1908) [929, 932], Maria Elena Vieira da Silva (b. Portugal, 1908) [956], Georges Mathieu (b. 1922) [641] and Roger Edgar Gillet (b. 1924).

The exhibitions of non-figurative works inevitably led to a reaction in favour of figurative painting and realism. It was decided that the Salon des Peintres témoins de leur Temps ('painters as witnesses of their time') would be dedicated to a particular theme. The theme set in 1951 was Work. Since then some themes have been Sunday, People in Cities, Happiness, the Portrait, Sport, Parisians, the Machine Age, Youth. Among the painters who have shown in these exhibitions are Bernard Lorjou, Jean Carzou (b. Syria, 1907) [777], Claude Venard, Roger Bezombes (b. 1913), Antoni Clavé (b. Spain, 1913) and Bernard Buffet [780].

Among the generation of abstract painters born between 1900 and 1920 Hartung, Wols and de Staël (none of them French by birth) are outstanding. Hans Hartung (b. Germany, 1904) [640, 926] — an important and independent figure — settled in Paris in 1935. Hauntingly evocative, and dynamic yet disciplined, his canvases, in which he often makes great use of line, have imaginative power and expressive colour. Wols (A. O. W. Schülze; 1913–1951) [921], who was born in Berlin, worked as a photographer in Berlin and Spain before he took up painting. His works, sometimes composed of small delicate patches which make up a mass that seems to change as one views it, have a powerful nervous energy. He subtly transposes Surrealist elements into a personal emotional symbolism. Nicolas de Staël (1914–1955) [778, 927], whose premature death ended a promising career, was one of the most gifted and influential artists of the post-War years. Russian by birth, he grew up in Brussels and settled in France in the late 1930s. His finest works (1950–1952) are in a lyrical style characterised by broad architectural surfaces and richly contrasting colours. From 1953 his work

gradually became increasingly representational; his colours were muted to grey. Overcome by some inner conflict, he committed suicide by jumping from his studio window in Antibes.

The abstractions of Victor Vasarely (b. Hungary, 1908) [929, 932] are more geometric in character. In 1929 he came into contact with the principles of the Bauhaus through the lectures of Moholy-Nagy. The refinement of his clear-cut forms is enhanced by sober colours and harmonious surfaces.

Pierre Soulages (b. 1919) [660, 930] is one of the most prominent of post-War abstract artists. His works embody a natural and simple strength. His massive, vigorous lines suggest a basic symbolic alphabet, and the severity of his forms is emphasised by dark colours, clear backgrounds and dramatic lighting.

Tachisme, with its emphasis on the art of painting as a physical gesture, parallels post-War Abstract Expressionism in America. Its immediate ancestors were Hartung and the Belgian painter Henri Michaux, and its outstanding exponents include Georges Mathieu (b. 1922) [641], Jean Paul Riopelle (b. 1924) [695] and Sam Francis (b. 1923) [931]. Mathieu settled in Paris in 1947 and has organised several exhibitions of 'psychic' abstract art. Riopelle came to Paris from Canada in 1946. His large canvases are symphonies in sparkling, radiant colour, the fury of execution giving them an explosive vigour. Sam Francis studied medicine in California before settling in Paris in 1950. Study under Rothko and Clyfford Still influenced his 'drip' paintings, in which fairly small areas of brilliant colour are juxtaposed and sometimes overlap.

More recent non-figurative painters include Olivier Debre (b. 1920), Frederic Benrath (b. 1930), Bernard Aubertin (b. 1934), Kumi Sugai (b. Japan, 1919) and François Morellet (b. 1926). Figurative painters related to the New Realist and Pop movements are Peter Staempfli (b. 1937), Raymond Hains (b. 1926), Martial Raysse (b. 1936), Gérard Gasiorowski (b. 1930), Alain Jacquet (b. 1939), Jacques Monory (b. 1934) and Hervé Télémaque (b. 1937).

Closer to sculpture are the relief paintings or collages (composed of such materials as string, cut-out papers, etc.) of Fernandez Arman (b. 1928) and Bernard Requichot (1928–1961).

Stained Glass. In order to alleviate the deterioration of style and technique in 19th century stained glass, certain painters made use of boldly coloured glass within sharply defined lead compartments. Maurice Denis decorated the church at Vésinet (1901) as well as his private chapel in the priory of St. Germain en Laye.

342

926. HANS HARTUNG (b. 1904).
T 1961–H 25. 1961.
Gimpel Fils Gallery Ltd, London.

927. NICOLAS DE STAËL (1914–
1955). Marathon. 1948. *Tate Gallery.*

928. SERGE POLIAKOFF (b. 1906).
Composition. 1959. *Hanover Gallery,
London.*

929. VICTOR VASARELY (b. 1908).
Biforme—Oeuvre Profonde Cinótique.
Glass. 1962. *Artist's Collection.*

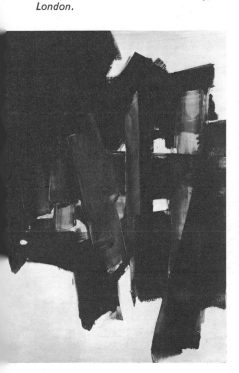

931. SAM FRANCIS (b. 1923).
Composition in Blue and Black. 1955.
E. J. Power Collection, London.

932. VICTOR VASARELY.
Supernovae. Oil. 1961. *Tate
Gallery.*

343

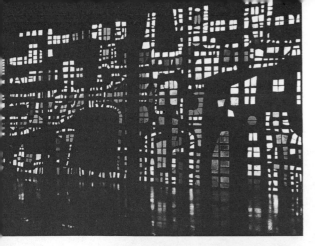

933. ALFRED MANESSIER (b. 1911).
Stained glass window, in collaboration with the architect Hermann Baur. 1958. *Chapel, Hem (Nord)*.

were still being decorated in the 19th-century style, the impetus given by Maurice Denis, backed by the strong personality of the Swiss Cingria, did produce results (windows by Barillet, Hébert-Stévens, Hanssen and J. Le Chevallier).

After 1940 [933] a new generation carried these ideas further (windows by Max Ingrand). Partly owing to the influence of the Reverend Father Couturier, certain well known painters worked in this medium (Waroquier, Gromaire, Gruber, Rouault, Le Moal, Manessier, Bazaine, Braque). For his chapel at Vence, Matisse designed windows of a dazzling transparency (completed 1951); in the new church at Audincourt, Léger constructed an enclosure with slabs of glass set in concrete (1951). By 1961 Chagall had completed his exquisitely glowing series of twelve windows for the synagogue of the Hadasseh hospital in Jerusalem.

Tapestry. The Gobelins and Beauvais workshops perpetuated the academic tradition in tapestry. Under the management of Jean Ajalbert, Beauvais did, however, become more modern in its choice of cartoon painters (furnishing ensemble by Dufy, 1929). In the same year, at Aubusson, tapestries were woven in wool of the paintings of Rouault, Braque, Picasso, Miró and Matisse. But although the artistic level was higher, the gulf between artist and craftsman was not yet bridged.

In revolt against the current industry Jean Lurçat (b. 1892) [801] undertook, concurrently with Marcel Gromaire (b. 1892) [800], a revival of this art. At Aubusson Lurçat returned to earlier techniques, which led him to reduce the number of colours (a maximum of forty instead of the hundreds of tints employed previously). His art, which is often Surrealist in nature, is characterised by his highly personal animal motifs. Among his best known tapes-

tries are the *Homage to the Dead of the Resistance and Deportation* (1954, Musée d'Art Moderne, Paris) and *Song of the World* (1957–1960), his enormous hanging which measures some 5,382 square feet. He has helped to train a number of cartoonists. Owing to his efforts a new generation of artists, unequalled in talent and output, is designing tapestries (Dom Robert, Maurice André, Manessier, Piaubert, Prassinos and others). Matisse, Léger and Le Corbusier have all produced tapestry cartoons. This new approach has given the tapestry a place in the modern home, offsetting the austerity of modern interiors. New manufacturing methods (gros point), by reducing costs, have made tapestries available to a wider public. The Gobelins factory, influenced by trends in modern painting, continues to produce tapestries of high quality which are mainly destined for official premises.

Carpets. These have been transformed under the influence of modern interior decoration. From 1911 Da Silva Brunhs, a Parisian of Brazilian origin, exhibited at the Salon d'Automne carpets in which the usual floral stylisations were absent. The carpet, conceived as a flat surface, became an integral part of the floor and had purely geometrical designs. The fine wool carpet has become a remarkable means of expression in the hands of certain designers (Leleu). Well known painters and sculptors have also worked in this medium.

Textiles. Designs for furnishing materials have followed the stylistic trends of the time. Gustave Jaulmes modernised printed fabrics, using a Neo-classical style. About 1925 Dufy designed silks; Paul Poiret produced sumptuous effects inspired by the Ballets Russes. For some years decorative art was influenced by Cubism; fabrics and wallpapers had imaginative geometrical patterns in vivid colours. The fashion for self-coloured materials gave rise to experiments in textural effects (Hélène Henry). Printed materials have been inspired by abstract art. Hand-weaving techniques have been explored by Plasse Le Caisne as well as by well known painters.

Graphic arts. In 1900 lithographic reproduction was a dead art, but woodcuts were still used in book illustration; the Ecole des Beaux-Arts continued to teach copperplate engraving; reviews gave up engraved reproductions and a single engraving, an original one, was henceforth preferred.

After the First World War many luxury books were illustrated with original woodcuts. Lithography made a comeback with Dufy and Laboureur. Rouault took part in the revival of

colour lithography with his series on acrobats and the circus.

Many of the masters of contemporary painting and sculpture have made their contribution to the graphic arts (Matisse, Maillol, Vlaminck, Derain, Picasso [651], Braque, Chagall, Villon, Goerg, Gromaire, Hartung, Manessier, Masson, Fautrier).

Books. The revival of the art of the book was begun by the Société des Amis des Livres (1880), the publisher Pelletan, who produced a manifesto (1896) on the illustrated book, Floury, who published the *Histoires Naturelles* of J. Renard, illustrated by Toulouse-Lautrec (1898–1899), and the great bibliophile Béraldi, who commissioned Lepère to do the *Paysages Parisiens* (1894–1895). In the first two decades of the 20th century books appeared with illustrations by Dufy, Maurice Denis, Bonnard, Chagall, Picasso and Rouault.

Between the Wars illustrated books were sought after by an increasingly large public; societies of bibliophiles sprang up in Paris and the provinces; reviews were started. Typography improved in appearance and legibility, and certain books were a credit to the typographic art. The cinema influenced certain aspects of composition; lay-outs became daringly original (Cocteau's *Escales*; Apollinaire's *Calligrammes*, 1930). Colour became increasingly popular. Certain affinities arose between authors and illustrators (Vertès and Colette, Vlaminck and Duhamel, Dunoyer de Segonzac and Dorgelès).

All schools of painting found a means of expression in book illustration: Cubism with Picasso, Braque, Juan Gris and Marcoussis, who illustrated Satie, Reverdy and Tzara; Surrealism with Dali (*Chants de Maldoror*, by Lautréamont, 1934), Masson and Chirico. Artists have conformed to the demands of book illustration without sacrificing their individuality. The finest achievements of this period include: Montherlant's *Pasiphaé*, by Matisse (1932); *Tartarin de Tarascon*, by Dufy (1937); Buffon's *Natural History*, by Picasso (1942).

The books that appeared after the Second World War reflected the nightmare of the Occupation (*Apocalypse*, by Goerg). In 1948 tragic symbolism appeared in Rouault's superb *Miserere* (done many years earlier) and in Picasso's illustrations for *Le Chant des Morts* (written by Reverdy during the War). Chagall's verve found free expression in Gogol's *Dead Souls*. In 1949 André Masson produced notable illustrations for Malraux. In 1952 Chagall's etchings for La Fontaine's *Fables* appeared. Among the many works published in recent years is Chagall's Bible (1956).

Bookbinding. About the time of the First World War Pierre Legrain adapted the binding to the content of the book; the lettering of his titles took on great importance. After 1925 Laure Albin-Guillot made use in bookbinding of his experiments in photography and micro-photography. One name in particular stands out among the bookbinders of that period — that of Rose Adler, a disciple of Legrain; she used a subtle choice of tones, sober abstract decoration, effects of relief and ironical stylisations (Zola's *Nana*). Paul Bonet, who displays an extraordinary resourcefulness, uses such techniques as ' radiant ' bindings and Surrealist bindings (Apollinaire's *Calligrammes*).

Posters. After the masterly creations of Toulouse-Lautrec, the poster went through another successful phase with Jules Chéret, who originated a convention of sprightly women and delicate colours which are very evocative of the 1900 period. Well known artists who have designed posters include Vuillard, Bonnard and Villon.

The true master of commercial posters as we know them today was the Italian-born Leonetto Cappiello (1875–1942). His influence has been considerable. He was responsible for the poster-symbol, expressing a simple and readily perceptible idea with vivid colouring, which imposes itself on the eye and impresses itself on the memory. Among his most successful posters was the rearing zebra for Cinzano.

Other poster artists followed his style, but it was not until after the First World War that artists completely renewed the poster art by discovering formulas whose fascination lies both in their particular content and in a new spirit.

The first poster by Paul Colin (who was interested in African art) for the Ballets Nègres appeared in 1923 and was extraordinarily dynamic. Colin founded a school which trained many French and foreign poster artists. His principal works included portraits of famous entertainers (Loïe Fuller).

In 1923 Cassandre [**662**] revolutionised this art. He gave his subject a kind of synthetic definition which takes on a Surrealistic magic; he combined the architectural quality of the lettering with the graphic quality of the image; he has designed some of the most remarkable posters of our time (Triplex, Dubonnet).

Among the outstanding present-day poster artists are Vuillemot, Hervé Morvan, Guy Georget and Savignac.

The minor arts. For a long time an imitation Louis XV style predominated in goldsmiths' work. In 1925 objects in a decidedly modern style were introduced. They were made by Jean Puiforcat (1897–1945), who kept strictly to the principles then in vogue (logical forms, absence of ornamentation, purity of line and fine quality materials being the only valid decorative elements). At first a designer of table ware, Puiforcat later made liturgical objects; he helped to revitalise this field. Daurat works in pewter in particular. Metalwork today tends towards clean, simple lines.

The Sèvres factory has contributed greatly to the revival in ceramics. Handmade pottery has become widespread. A number of famous painters have taken it up. Picasso's ceramics have stimulated the Vallauris potters. Braque's experiments in pottery are an important part of his artistic work. Chagall, Miró, Lurçat and Léger have all devoted some time to this art.

Art Nouveau found an ideal field of application in ceramics [**534**] and glassware. Emile Gallé (1846–1904) [**529**] was the principal initiator of the movement in glassware; he employed a skilful technique by which he superimposed transparent layers of different colours so as to obtain finely cut decorations in relief. His motifs were mostly inspired by natural vegetation, and in his treatment of them he achieved rare effects with shimmering reflections that are perfect examples of the style of that period. René Lalique (1860–1945) [**533**], at first a jewellery designer, became more and more interested in glass techniques, which he practised together with sculpture, enamelling and goldsmiths' work. In his own house (1904) decorated glass was much in use, for example in the doors. It was owing to him that glass played an increasingly important role in architectural decoration (fountains, luminous basins, etc.); he also made sets of drinking glasses. Glass has evolved towards fuller forms and a more sober treatment with Marinot, Decorchemont and Navarre — who executes actual sculptures in glass. Paul Daum and Michel Daum have used white crystal in abstract forms.

As a reaction against the ' antique ' styles which had predominated in furniture since the time of Louis Philippe, artists wanted to break with the past completely and to create a modern style. Most of these designers were centred round the salesrooms of S. Bing from 1895 to 1903. It was there that these decorators (together with artists in other branches of the applied arts) exhibited Art Nouveau furniture. Georges de Feure (1868–1928) designed not only furniture but stained glass windows, tapestries and porcelain objects; Eugène Colonna occasionally extended his activities to textiles, jewellery and ceramics. Eugène Gaillard (1862–1933) had a great influence on furniture design. All three were represented in the Art Nouveau pavilion at the Exhibition of 1900. They were actively supported by the architect Charles Plumet (1861–1928), and were joined by the architect Tony Selmersheim, who sought to accentuate the logical form and structural line of furniture.

At about this time there was a group at Nancy working along the same lines under the instruction of Emile Gallé. Gallé, whose work in glass was well known, created furniture having richly decorated marquetry; his original style revealed a strong Japanese influence. Louis Majorelle (1859–1926) injected a spirit of innovation into the old family furniture factory. Eugène Vallin (1856–1922), who had at first worked on neo-Gothic church furnishings, now followed the new trend. Work presented by Munich designers at the 1910 Salon d'Automne brought about a more strictly functional approach on the part of the French designers, though they retained the lightness of line which distinguishes them from the Germans.

By the end of the First World War designers had moved far away from the Art Nouveau spirit. Furniture designers frequently became interior decorators, designing entire houses or rooms — organising the relationships of volumes, selecting the colour schemes, etc.; they also sometimes designed textiles and wallpapers.

The ornate decoration of the earlier part of the century was superseded by a taste for the plain and sober; ornamentation, however, whether carved or applied, remained an inseparable element of furniture in most cases and for all classes of society; to the public simplicity was a sign of poverty. Léon Jallot, Louis Süe and André Mare were active in the movement calling for modern design in furniture.

The 1926 Exhibition of Decorative Arts marked the turning point in the evolution of modern furniture in France. Decorators became increasingly anxious to abandon eclecticism. Straight lines and flat surfaces came into their own. Ornamentation grew more restrained and localised.

A more functional tendency developed among a few designers. René Herbst was one of the leaders of this trend. For him furniture had above all to be logically adapted to its function, according to the needs of man in the machine age. Pierre Chareau (1883–1950) produced revolutionary and imaginative experiments in design (glass house for Dr Dalsace). Charlotte Perriand, who worked with Le Corbusier, designed functional furniture.

The present generation of furniture designers and interior decorators

934. ITALY. PIER LUIGI NERVI
(b. 1891). Palazzetto dello Sport,
Rome (with A. Vitellozzi). 1959.

935. ITALY. PIER LUIGI NERVI.
Aircraft hangar, Orvieto. 1936.
Destroyed.

**936. ITALY. LUIGI FIGINI and GINO
POLLINI.** Church of the Madonna
dei Poveri, Milan. 1953–1954.

includes such varied talents as André
Arbus, who is also an architect and
sculptor, René Gabriel (1890–1950),
who designed mass-produced furniture,
J. Royère, Jacques Dumond, Maxime
Old, André Renou and J. P. Génisset.

ITALY

Architecture. Italy embraced modern
architecture more slowly than did the
rest of Europe. The importance of the
Futurist work of Antonio Sant'Elia
(1888–1916) [**679**], who died during
the First World War, was not ap-
preciated until quite recently. Sant'Elia,
who was connected with the Futurists,
exhibited in 1914 a project for a ' città
nuova ' in which he outlined a Utopian
city. Under Fascism modern architecture
was more or less eclipsed by a re-
actionary architecture of a neoclassical
style that was considered more in
keeping with the spiritual heritage of
Imperial Rome. However, during this
period two outstanding architects were
active — Gio Ponti (b. 1891 [**826**];
Montecatini offices, Milan, 1936) and
Pier Luigi Nervi (b. 1891 [**934, 935**];
stadium at Florence, 1930–1932). Nervi,
an architectural engineer, was a
specialist in wide-span vaulting (air-
craft hangars). More recent buildings
by Nervi include the Palazzo delle
Esposizioni, Turin 1948–1950; Italia 61
pavilion, Turin, 1961; Palazzetto dello
Sport, Rome, 1959 [**934**]; Palazzo dello
Sport, Rome, 1960).

The Rome school counts some of the
best architects among its members:
Ludovico Quaroni (experimental
village at Matera) and Eugenio
Montuori, the designer, with others, of
the new Termini station in Rome
(completed 1950) [**937**]. The centre of
modern Italian architecture is Milan,
with its exhibitions and its recently
founded museum of architecture, as
well as its flourishing industries. In and
around the city are new flats, factories,
offices and skyscrapers, including the
Pirelli building by Gio Ponti (1960)
[**826**], the Torre Galfa by Bega, the
Torre al Parco by Magistretti; the
Madonna dei Poveri church by L.
Fingini and G. Pillini and the apart-
ment block in the Gallarates district
(1968–1976) by Aldo Rossi which
evokes the traditional Milanese tena-
ment block. Other notable buildings in
Italy include the covered market at
Pescia (1951), the Palazzo Bianco
Museum, Genoa (1951), by Franco
Albini; the automobile pavilion, Turin
(1959) by Riccardo Morandi; Trieste
town hall (1973), Modena cemetery
(1971) and the floating 'World Theatre'
in Venice, all by Aldo Rossi; the
housing structures of Gincarlo de Carlo
in Urbino (1964) and the holiday homes
in Sardinia by Alberto and Aldo Ponis.

937. ITALY. EUGENIO MONTUORI
(b. 1907). Termini station, Rome
(with Leo Calini and others).
Completed 1950.

Sculpture. At the beginning of the 20th century, when the country was still enjoying its new unity and freedom, the plastic arts suffered from the bad taste of the new middle class. Artists adhered to neoclassicism or remained entrenched in a narrow realism. Official sculptors glorified national heroes in the public squares and prepared pompous monuments to the dead (Leonardo Bistolfi's statue of Garibaldi, 1887; Ettore Ximenes' faithful portrait of the jurist Giuseppe Zanardelli, 1905). Libero Andreotti (1877–1933) was influenced by Donatello and Ghiberti. The best works of Quirino Ruggeri (1883–1955), inspired by a savage primitivism, were done between 1924 and 1930. The female figures of Arturo Dazzi (b. 1882) and Antonio Maraini (b. 1886) have the fragile, mannered charm of D'Annunzio's heroines. Francesco Messina (b. 1900) and Nicola Rubino (b. 1909) remain faithful to the classical tradition in spite of the emergence of new liberating tendencies.

Impressionism found its sculptural equivalent in the work of Medardo Rosso (1858–1928) [535]. A friend of Rodin, Rosso took part in the founding of the Salon d'Automne. The delicacy of his modelling in terra cotta and lost wax, and the play of reflections enveloping his forms in a diffused light, show a fine poetic talent. Medardo Rosso was regarded as an innovator by the Futurists. To the concept of interpenetrating planes, as studied by certain Cubist sculptors, the Futurists added the notion of dynamic form through the prolongation of planes into space. Boccioni's first sculptures, dating from 1912 (*Artist's Mother*, Galleria Civica d'Arte Moderna, Rome), remained attached to realism despite their novel

conception. He was more adventurous in the works which followed — such works, for example, as his *Unique Forms of Continuity in Space* (1913, Museum of Modern Art, New York [660]). In the *Development of a Bottle in Space* (1912, Museum of Modern Art, New York) he replaced the human figure with an object in order to study the relationship between the interior and exterior space of an inanimate form; such studies were taken up in the 1930s by Henry Moore. Although more Expressionistic, the sculptures of Roberto Melli (1885–1958) dating from 1909–1914 were a kind of synthesis of Rosso's and Boccioni's work (*Woman with a Black Hat*, 1913, Galleria Civica d'Arte Moderna, Rome). The plastic experiments of Amedeo Modigliani (1884–1920) were of a different order. His sculptural works date back to 1906, before he met Brancusi, but he was indebted to Brancusi for his simplification of forms, which he developed later in his painting (see under *France*). The long mysterious female heads are evidence of his skill as a sculptor.

Arturo Martini (1889–1947) was inspired by a nostalgia for antiquity. After his first stay in Paris, he studied under Adolf Hildebrand in Munich in 1909. In 1912 he met Maillol. In 1920 he joined a movement which attempted to revive the classical conception of form. His *Pisan Woman* (stone) and *Maternity* (wood), and other works dating from the late 1920s and early 1930s, show a deep feeling of serenity. The *Palinurus* (marble, 1946) and other later works were more daring and helped to transform contemporary Italian sculpture. Marino Marini (1901–1980) [793, 939] was a painter, lithographer and sculptor. After teaching at the art school in Monza (1929–1940) he was made Professor of Sculpture at the Brera Academy, Milan, in 1940. One of the leading figures in contemporary sculpture, he often worked from an instantaneous impression whose impact he tried to preserve. He limited himself to a few themes and showed superb ability to transcribe nature into purely plastic terms, as in his nudes (*Pomona*, 1940; *Venus*, 1942), seated or standing figures (*Juggler*, 1946; *Susanna*, 1943; *Judith*, 1945) and portraits (*Stravinsky*, 1951, Kunsthalle, Hamburg). The striking nobility of his figures and the quiet rhythm of their contours derives from archaic sculpture. The theme of horse and horseman, which comes from his memories of Lombard peasants fleeing from bombings on frightened horses, is one to which he returned time and again. After 1955 his works became progressively more dramatic, with an increasing distortion of mass and a distinctive roughening of surface (monument at The Hague, 1958).

Giacomo Manzù (b. 1908) [938], who was self-taught and was influenced by Medardo Rosso, took up sculpture in 1930; he too restricts his field of study to a few subjects such as portraits (portrait of his wife, 1935), scenes of the Passion, cardinals and dancing women. Among the scenes from the Passion, he has done a *Crucifixion* and a *Deposition*; in his bas-reliefs he introduces a sense of the cruelty of his time. In 1949 he was commissioned to execute the fifth bronze door of St Peter's in Rome; in 1955 he was commissioned to do the central portal for Salzburg cathedral. His cardinals (1950–1954) have a timeless quality as they stand or sit in distant meditation. The dancing girls preserve the same continuity of style, their vibrant inner emotion untouched by intellectualism. Marcello Mascherini (b. 1906) and Emilio Greco (b. 1913) represent a somewhat mannered tendency. *Summer* (1934) and *Eve* (1939) reveal Mascherini's debt to Martini. After 1945 Mascherini adopted an archaic form of stylisation with fine, sometimes pointed forms. Greco does more animated compositions on the theme of women bathing. Full, rounded female figures are placed rhythmically along different axes with a decorative elegance. Marino Mazzacurati (b. 1908) was a pupil of Martini. After working in various styles he has reverted to a kind of neo-realism (dead partisan for the Parma monument, 1955). Pericle Fazzini (b. 1913), Alfio Castelli (b. 1917) and Augusto Perez (b. 1929) give an individual interpretation of the human form.

The sculptures of Sandro Cherchi (b. 1911) and Mino Trafeli (b. 1922) are closer to abstract art. Certain artists who followed a similar line of development have abandoned figurative art for abstraction. Luciano Minguzzi (b. 1911), who was influenced at first by Manzù, adopted a nervous structure, having an element of distortion, in his acrobats and animals. Agenore Fabbri (b. 1911) [649] has abandoned the rather morbid tendency of the *Massacre of the Innocents* (1954) for phantasmagoric creations inspired by cosmic dreams (*Moon Man*, 1959). Leoncillo (1915–1968) was a ceramic artist who produced richly coloured figurative and abstract work. Mario Negri (b. 1916), who is self-taught, employs the structure of the human body in strict classical compositions that suggest the relationship between man and his environment.

Foremost among non-figurative sculptors in Italy are Fausto Melotti (b. 1901) and Lucio Fontana (1899–1968). The latter took part in 1934 in the Abstraction-Creation movement. An unusual experimenter, he uses many kinds of materials. In his *Technical Manifesto on Spatialism* he explained his

347

938. GIACOMO MANZÙ (b. 1908). Cardinal. Bronze. 1947–1948. *Tate Gallery.*

939 MARINO MARINI (1901–1980). Horse and Rider. Bronze. *c.* 1949. *Walker Art Center, Minneapolis.*

ideas on the synthesis of sculpture-painting and relief [635]. Alberto Viani (b. 1906), pupil and assistant of Arturo Martini, was influenced by the latter's late work and was also drawn to Arp's work. He seeks pure form in an abstract-figurative synthesis. Carlo Sergio Signori (b. 1906), a pupil of Malfray, uses polished Carrara marble, in which he executed his *Black Virgin* (1950), *Venus* (1955) and *Giuliana* (1958). Umberto Mastroianni (b. 1910) exhibited in Venice in 1936 some figurative works which were reminiscent of Boccioni's Futurism. He has turned to abstract sculpture of rhythmic, angular masses. Mirko (Mirko Basaldella, 1910–1969) [940], brother of the painter Afro, used unusual materials to create imaginative totemic forms (*Stele*, 1954) and chimerical animals. In his objects in cut-out iron, the solid areas balance with the empty spaces (*Apollo and Daphne*, 1948). He integrated sculpture with architecture (ceiling decoration for the assembly hall of the FAO building in Rome). Carmelo Cappello (b. 1912) has been influenced by the work of Henry Moore. His sculptures, with their wide undulating planes, incorporate the light that comes through their openings; his recent works are reminiscent of signs hurled into space (*Eclipse*, 1959). Partly owing to his contacts with France and England (where he worked with Henry Moore), Aldo Calò (b. 1910) has arrived at an original art form characterised by its powerful volumes and by its combination of wood and iron. The title *Biform*, which he uses frequently, expresses this duality of material. Salvatore (Messina Salvatore, b. 1916) works in a similar vein but with greater use of a curving, sweeping line. The sculptures of Lorenzo Guerrini (b. 1914) are reminiscent, in their architectonic treatment of mass, of Wotruba, but have no figurative reference. Other non-figurative sculptors include Franco Garelli (b. 1909) with his aggressive iron forms, Nino Franchina (b. 1912), whose metallic leaf forms quiver ethereally and Pietro Consagra (b. 1920), who helped found the Forma group in Rome in 1947 and who published his doctrines in *The Necessity for Sculpture* (1952). His series of 'colloquies' are made up of juxtaposed flat surfaces

in iron, bronze and wood. Other noteworthy sculptors are Roberta Crippa (1921–1972), Francesco Somaini (b. 1926) and Gio Pomodore (b. 1930). Edgardo Mannucci (b. 1904) produces monumental abstract sculpture. Nicola Carrino (b. 1932) creates large environmental structures as does Gianni Colombo (b. 1937). Valentina Berardinone (b. 1929) sets illusionistic stairs against the gallery wall. Peter Agostini (b. 1913) and Claudio Costa (b. 1942) assemble pop objects. Leading Povera artists include Mario Merz (b. 1924), Michelangelo Pistoletto (b. 1933), Giovanni Anselmo (b. 1934), Luciano Fabro (b. 1936), Alighiero Boetti (b. 1940), Giuseppe Penone, Jannis Kounellis (b. Greece, 1936), Gilberto Zorio (b. 1944), Pier Paolo Calzolari (b. 1943) and Piero Gilardi (b. 1942).

Painting. The 19th century witnessed the almost total eclipse of Italian painting. It was only with the advent of Futurism that Italy regained its place in the world of art.

In 1909 the writer F. T. Marinetti's Futurist manifesto was published in *Le Figaro* in Paris. In 1912 at the Galerie Bernheim-Jeune in Paris the first French exhibition of the Italian Futurist painters was held and had considerable repercussions. The four painters at this exhibition were Carlo Carra (1881–1966), Umberto Boccioni (1882–1916) [941; see colour plate p. 278], Luigi Russolo (1885–1947) [942] and Gino Severini (1883–1966) [943]. Giacomo Balla (1871–1958) [657, 738] was also a member of the group.

This group of painters made the following declaration: 1. One should scorn all forms of imitation and glorify all forms of originality; 2. One should revolt against the tyranny of the words 'harmony' and 'good taste', over-elastic expressions which could easily be used to decry the works of Rembrandt, Goya, Rodin; 3. Art critics are useless or else harmful; 4. One should do away with hackneyed subject matter in order to express our modern world of steel, fever, pride and speed; 5. One should regard it as a mark of honour to be called 'madmen', an epithet used in an effort to silence all innovation; 6. Innate

MARC CHAGALL (b. 1887). Paris through the Window. 1913. Solomon R. Guggenheim Museum, New York. *Museum photograph.*

Bottom left. CHAIM SOUTINE (1894–1943). Carcass of Beef. *c.* 1925. Albright-Knox Art Gallery, Buffalo. *Photo: Michael Holford.*

Bottom right. AMEDEO MODIGLIANI (1884–1920). Mme Czechowska with a Fan. 1919. Musée d'Art Moderne de la Ville de Paris. *Photo: Michael Holford.*

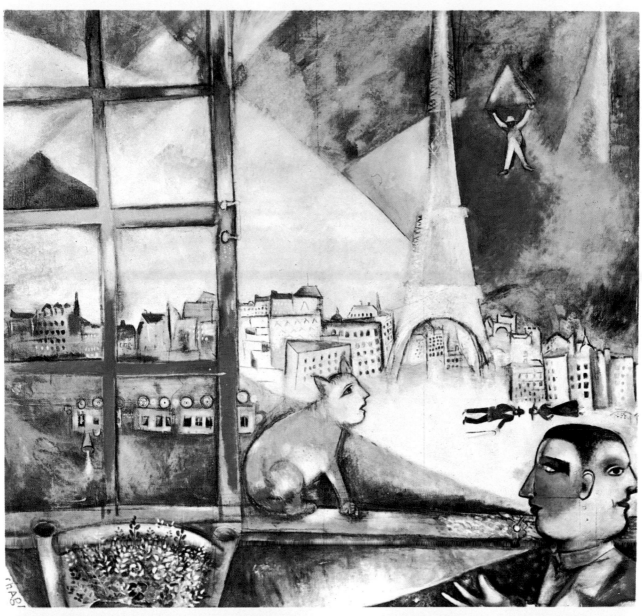

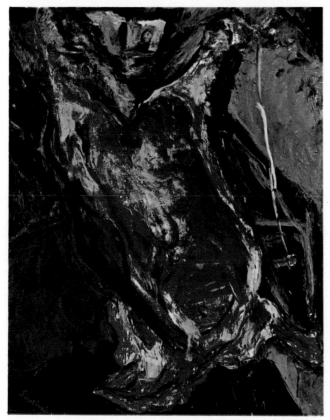

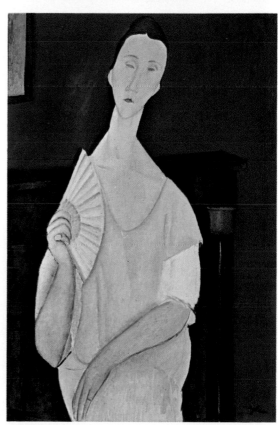

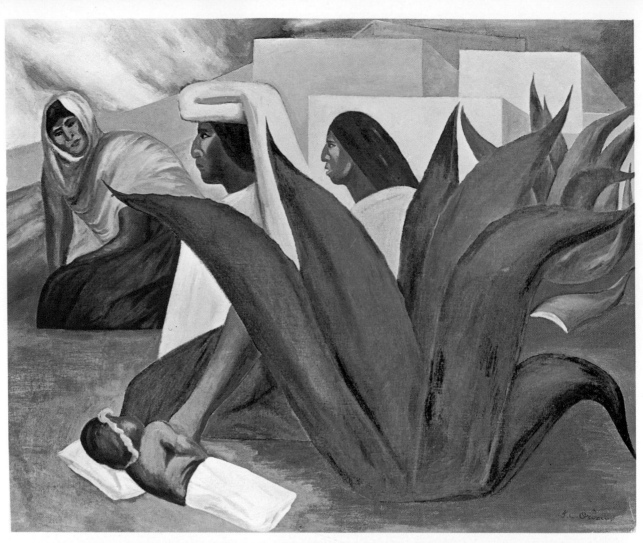

complementarism is an absolute necessity in painting, as free verse is in poetry and polyphony in music; 7. Universal dynamism should be rendered in painting as dynamic sensation; 8. In interpreting nature, the most important quality is sincerity and virginity; 9. Movement and light destroy the substance of objects (see under *France*).

Giorgio de Chirico (1888–1973) [**944**; see colour plate p. 332] was an influential precursor of the Surrealists. Born in Greece, he studied in Athens and Munich, where he was influenced by Böcklin. In Paris (1911–1915) he met Raynal, Apollinaire, Picasso and others and executed a highly influential group of paintings which evoked fantastic architectural visions of Italy. Back in Italy, he met Carlo Carrà [**946**] and later Morandi, and they termed their new style, which Chirico had already been using in France, Metaphysical painting. In his haunting paintings of deserted streets and of strange mannequin-like figures Chirico strove to discover new relationships and hidden links between objects, to create unusual associations of images and ideas and to arrange objects so as to create limitless possibilities of mystery. In 1925 Chirico returned to Paris and joined the Surrealist movement, of which he had been a forerunner (paintings of gladiators, horses, open-air interiors). By the 1930s he had abandoned his earlier style for a traditional manner.

Giorgio Morandi (1890–1964) [**945**] took part in the Metaphysical movement; he later painted still lifes in an entirely personal ascetic style.

The Novecento group, which returned to the traditional in art, came into being in Milan about 1920. It had certain links with Fascism without, however, having any very definite ideological programme. Among its founders were Piero Marussig (1879–1937) and Mario Sironi (1885–1961).

Certain innovators among Italian painters were a part of the school of Paris, but their initial artistic background had been acquired in Italy. Severini, at first a Futurist, in time developed a neoclassical style. Modigliani spent most of his creative life in Paris (see under *France*). Alberto Magnelli (1888–1971) [**812**] was a leading non-figurative painter; Massimo Campigli (1895–1971) [**948**] had a highly personal and poetic Surrealist style. Antonio Music (b. 1909) is one of a number of excellent non-figurative painters.

Outstanding among 20th-century

Afro (A. Basaldella, 1912–1976), Alberto Burri (b. 1915) and Renato Guttuso (b. 1912). Birolli visited Paris for the first time in 1947 and was influenced by Picasso and Matisse, but by 1952 his work had become abstract; for him abstraction is the free interpretation of reality. His great influence in post-War Italy has been as much through his ideas as through his painting. Afro [**818**] was influenced by Picasso, Braque and Klee before evolving his own form of abstraction with its vigorous use of colour and its suppleness of form (murals for Banco Nazionale del Lavoro, Rome, 1954). Burri [**638**], who initially studied medicine, began painting in 1944 when in Texas as a prisoner of war. His works, made up of oil paint and of pieces of cloth sewn together, show the artist's ability to combine awkward materials. Guttuso [**947**], a painter and a writer on art, heads the social realist group in Italy. In Rome in 1933 he formed part of a reaction against Novecento classicism. The *Flight into Egypt* of 1938 was his first large realist composition of contemporary Italian life; many of his works are inspired by the struggle for existence of the peasants of his native Sicily.

Other important painters (most of them non-figurative) include: Felice Casorati (1886–1963), Atanasio Soldati (1887–1953), Enrico Prampolini (1894–1956), Mario Tozzi (b. 1895), Giuseppe Capogrossi (1900–1972), Giuseppe Santomaso (b. 1907), Antonio Corpora (b. Tunis, 1909), Emilio Vedova (b. 1919), Mattia Moreni (b. 1920), Arturo Carmassi (b. 1925), Giuseppe Banchieri (b. 1927), Giacomo Soffiantino (b. 1929), Alberto Manfredi (b. 1930), Vittorio Badaglia (b. 1936), Piero Dorazio (b. 1927), Enrico Castalini (b. 1930) with his patterns of light on delicately shaped canvases, Carla Accardi (b. 1924), Marco Cordioli (b. 1934) and the Pop artists Domenico Gnoli (1933–1970) and Valerie Adami (b. 1935). Enrico Baj (b. 1924) and Mimmo Rotella (b. 1918) employ collage and photomontage in their paintings.

Tapestry. Vittorio Ferrari (1862–1948) worked energetically on hand-knotted carpets and tapestries; Guido Ravasi (1877–1946) also made tapestries and was one of the master silk-weavers (pontifical mantle for Pius XI, in gold and silver brocade, 1925, Vatican Museum; tapestry for Sta Maria delle Grazie, Milan).

Graphic arts. At the end of the 19th century and the beginning of the 20th, Italian engraving was in a state of decline, even from the technical point of view; large formats were often adopted, with facile veiled effects and clever inking methods; there was a preference for bright reds and oranges. Giulio Aristide Sartorio produced etchings suggesting a decadent Symbolism. In a separate category were the literary, 'Satanic' and pre-Surrealist works of Alberto Martini, the large lithographs of Romani and the graphic works of Casorati, Boccioni and Spadini.

After the First World War there was a revival of Italian graphic arts ('Savage' group). Carrà, Morandi, de Chirico, Severini and Campigli have all practised etching and lithography, as have the sculptors Manzù and Marini.

After the Second World War many other artists took up engraving, particularly colour lithography (Ciarocchi and Bruscaglia).

Contemporary poster art is typified by the work of E. Carboni, E. Carmi and Albe Steiner.

The minor arts. In goldsmiths' work, Alfredo Ravasco (1873–1958) combined gems, coral or rock crystal with gold and platinum (tiara for Pius XI, in the Vatican).

Alessandro Mazzucotelli (1865–1938), Alberto Galligaris (1880–1960;

940. MIRKO (1910–1969). Architectural Element. Copper. 1953. *Peggy Guggenheim Collection, Venice.*

JOSÉ CLEMENTE OROZCO (1883–1949). Mexican Pueblo. Detroit Institute of Arts. *Photo: Joseph Klima, Jr.*

MATTA (b. 1912). Le Vertige d'Eros. 1944. Museum of Modern Art, New York. *Museum photograph.*

941. UMBERTO BOCCIONI (1882–
1916). Elasticity. 1912. *Riccardo
Jucker Collection, Milan.*

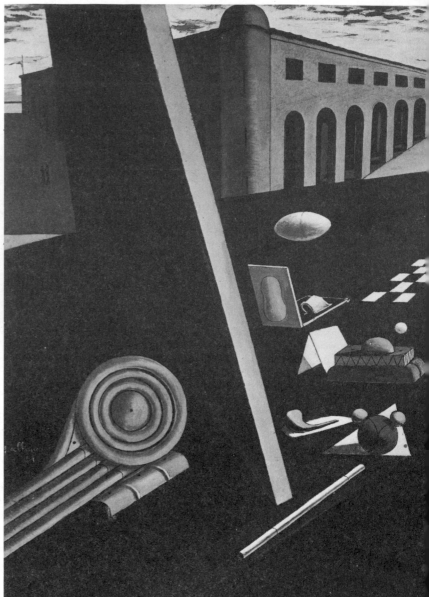

942. LUIGI RUSSOLO (1885–1947).
Houses and Light and Sky. *c.* 1911.
Kunstmuseum, Basle.

943. GINO SEVERINI (1883–1966).
Dancer=Sea. 1913. *Peggy
Guggenheim Collection, Venice.*

944. GIORGIO DE CHIRICO (1888–1973).
Sailors' Barracks. 1914. *Norton
Gallery and School of Art, West Palm
Beach, Florida.*

945. GIORGIO MORANDI (1890–
1964). Still Life. 1946. *Tate Gallery.*

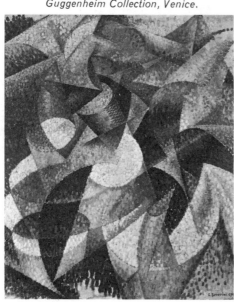

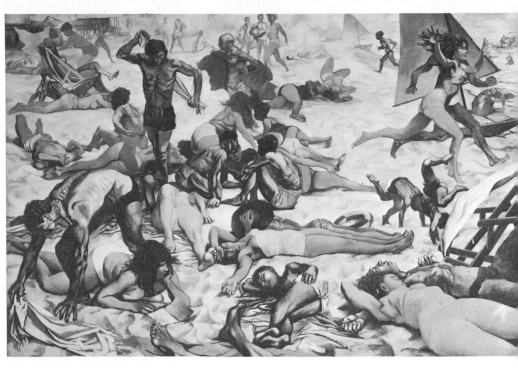

946. CARLO CARRA (1881–1966).
Enchanted Room. 1917. *Kunsthaus,
Zurich.*

947. RENATO GUTTUSO (b. 1912).
Beach. 1955. *Galleria Nazionale, Parma.*

948. MASSIMO CAMPIGLI (b. 1895).
The Game of Ball. 1946. *Peggy
Guggenheim Collection, Venice.*

portals for the Udine town hall) and
Alberto Gerardi (b. 1889) are the chief
workers in iron.

Leading potters and workers in
ceramics include Anselmo Bucci (1887–
1959), Pietro Melandri and Guido
Gambone. Fired enamel on metal is a
speciality of Paolo de Poli, who has
devoted himself to this difficult tech-
nique since 1934 (decorations for
luxury liners).

The revival of glass technique after
the First World War was the work of
the Venetian craftsman Giacomo
Cappelin (b. 1887). He surrounded
himself with young artists who formed
a school and produced work that was
completely original, if still traditional;
he avoided the virtuosity and ornate
decoration that had been rife in Murano.
Paolo Venini (1895–1959) opened a
workshop in 1921 which is still in the
forefront in glass design. He began by
reviving 16th- and 17th-century forms
and later made opaque glassware
decorated with gold (1925–1935); he
enriched and refined his range of colours
(1936–1940). Flavio Poli (b. 1900) aims
at expressing purity of line.

Architects were closely involved in
the development of furniture design;
Gio Ponti has played an active part in
rejuvenating the decorative arts — in
particular furniture [707] — by moving
progressively from neoclassicism to
functionalism; he has also decorated
porcelain and fabrics. The architect
Franco Albini teaches interior archi-
tecture and decoration and furniture
design at the Istituto Universitario di
Architettura, Venice. Carlo De Carli
(b. 1910) is also an important figure in
furniture design.

949. SPAIN. EDUARDO TORROJA (1899–1961). Grandstand at the Zarzuela racecourse, near Madrid. 1935.

950. SPAIN. EDUARDO TORROJA. Coal bunker of the Instituto Técnico de la Construcción y del Cemento, Madrid. 1951.

951. SPAIN. MIGUEL FISAC. Coronación church, Vitoria. 1960.

SPAIN

Architecture. Despite cultural isolation and terrible poverty Spain has produced some of the most surprising architectural works in present-day Europe. The first R. S. Reynolds Memorial Award (1957) went to Spanish architects for the dining pavilions of the SEAT factory. Eduardo Torroja (1899–1961) [**949, 950**] was one of the great creators of architectural forms of the 20th century. His most famous early work is the Zarzuela racecourse near Madrid (1935). Later works include: the church at Xerrallo (1952); the Táchira Club, Caracas (1957); the Sidi Bernoussi water-tower, Casablanca (1960). His essential ideas are found in his book *Philosophy of Structure*. Miguel Fisac produced an extraordinarily dynamic church in the Iglesia de la Coronación, Vitoria [**951**], and unusual design and landscaping in his School Centre in the University City, Madrid.

Sculpture. The facile narrative style of the 19th century was prolonged to as late as 1925 in the works of a few artists, such as Eduardo Barone (1858–1911), Ricardo Bellver (1845–1924), Miguel Blay (1866–1935) and the more talented Mariano Benlliure (1862–1947) [**562**], who executed many town monuments. Manuel Innurria (1869–1924) had a more personal individual style.

The Mediterranean spirit, which in France was personified by Maillol, knew a renaissance in Catalonia about 1910. Manolo (Manuel Hugué; 1872–1945) was a self-taught wanderer who settled in Paris in 1900. He later became acquainted with Picasso, Braque and Gris. His work includes small figures inspired by popular art in which he captured the character of peasants, bullfighters and dancing girls; his female nudes, smaller than life-size, are thickset with full, fleshy forms, and are the image of fecundity. Enrique Casanovas (1882–1948) was inspired by Greek art. His portraits of young girls are close to Despiau in sensitivity and conception. José Viladomat (b. 1898) is eclectic. Federico Mares (b. 1897), who has skilfully restored the Gothic tombs of Poblet, combines the classical and the medieval traditions. Martin Llaurado (b. 1903) and José Canas (b. 1905) carry on this classical tradition. Certain Catalan sculptors have adopted a different style — a Manneristic one: José Granyer (b. 1889) produces works of charm and humour in this style. Apelles Fenosa (b. 1899), a pupil of Casanovas, lives in Paris. He has developed fragile restless forms which he used in the memorial to the Oradour martyrs (1945). He has done excellent

portrait busts (*Eluard, Colette, Poulenc*). Juan Rebul (b. 1899) adopts forms simplified to the point of starkness.

Leading figurative sculptors outside Catalonia include: Julio Antonio (1889–1919; busts and monuments); Victorio Macho (b. 1887); Emiliano Barral (1896–1936; busts in stone or marble); Antonio Failde Gago (b. 1907), who draws his inspiration from Romanesque art; Juan Gonzalez Moreno (b. 1908), whose nudes are reminiscent of the work of Manolo. Francisco Perez Mateos (1904–1936) expressed a personal style in forms stripped of all narrative detail; he was one of the first in Spain to employ aluminium. Eduardo Gregorio (b. 1904) represents the transition from figurative to abstract art.

The Spanish artists Picasso, Gargallo and Gonzalez played a vital part in the evolution of non-figurative sculpture in Spain (see under *France*). Of equal importance is Angel Ferrant (b. 1891), who was self-taught and was a great traveller. After 1928 he took part in avant garde movements in Barcelona; he became a teacher and has had an important influence on young artists. He transforms the human figure into semi-abstract forms in stone (*Mediterranean*; *The Lovers*); since 1950 he has constructed witty mobiles. The first sculptures of Miró (1893) date from 1922. Since the 1930s his sculpture has shown the influence of Surrealism; he uses a variety of materials, such as chalk, pebbles, tiles, eggs. The work of Alberto Sanchez (b. 1897) is also influenced by Surrealism. Eduardo Yepez (b. 1910), who helped found the Arte Constructivo group in Madrid in 1931, pursues to extremes the spirit of synthesis. Eudaldo Serra Guell (b. 1911), a pupil of Angel Ferrant, has lived in the Far East; somewhat Surrealist, his work is concerned with the importance of spaces within volumes. Carlos Ferreira (b. 1914) resembles Brancusi and Arp in the purity of his polished forms. The work of Jorge de Oteyza (b. 1908) is characterised by powerful, balanced, architectural structures and by expressive vigour. He has lived in South America, where he has taught ceramics in Buenos Aires and in Bogotá. Honorio Garcia Condoy (1900–1953) met Manolo in Paris and was influenced by Cubism in his wooden sculptures. After periods of psychological realism and objective realism his style grew mannered and forceful. Eduardo Chillida (b. 1924) [**952**] is one of the leading sculptors of his generation. He worked at first in stone; then a stay in Paris (1948–1951) introduced him to iron. He does his own welding, creating abstract works remarkable for their ascetic treatment of forms. He also works in wood, with the same feeling for the relationship of forms. José

Ramón Azpiazu (b. 1927), who qualified as an architect in 1954, studied stone carving and composition with Angel Ferrant. José Subirachs (b. 1927) uses iron as well as terra cotta and concrete. Sergi Aquilar (b. 1946) gives a mechanical metallic finish to his black marble minimal shapes.

Painting. Spanish painting is austere not only in colour but in choice of subject: poignant drama seems to be traditional. Ignacio Zuloaga (1870–1945), Isidro Nonell (1873–1911), who influenced Picasso's Blue Period, the decorator Jose María Sert (1876–1945), José Gutierrez Solana (1886–1945) [**953**] and many later painters all have a typically Spanish harshness, Baroque quality, or tragic sense. The younger Social Realists include Darío Villalba (b. 1939), Juan Genovés (b. 1930) and Rafael Garcia Canogar (b. 1935).

The Spanish innovators who are considered part of the school of Paris include: Picasso, María Blanchard, Gris, Miró, Francisco Borès [**954**], Mariano Andreu, Dali, Antoni Clavé (b. 1913), Tapies (b. 1923).

A considerable number of Spanish painters are non-figurative. Spanish critics speak of 'dramatic', 'Romantic' or 'geometric' abstraction. Outstanding among 'dramatic' abstractionists is Antonio Tapies (b. 1923) [**955**]. Born in Barcelona and self-taught, he has evolved, from various influences, including those of Miró and Dubuffet, an intense, dramatic incantatory style. Among other abstract artists are: Juan Tharrats (b. 1918), Manolo Millares (b. 1926), Luis Feito (b. 1929), Antonio Saura (b. 1930), Nela Arias-Misson (b. 1925), Antonio Saura (b. 1930) and Jorge Texidor (b. 1941). Miguel Navarro (b. 1945) and Carmen Calvo (b. 1950) are part of the craft tradition of Valencia with their use of terra cotta.

The minor arts. Gaudí (see Chapter 3) designed furniture and ceramic tiles to go with his architecture; he was also highly skilled in the use of wrought iron. The Catalan potter Josep Llorens Artigas has collaborated with Miró.

PORTUGAL

Architecture. Modern architecture has made less progress in Portugal than in Spain. Planning is poor and official architecture dominant. Exceptional examples, however, are the Infante Santo housing unit, Lisbon, 1958 (A. J. Pessoa, H. Gandra and J. A. Manta), the São João de Deus housing development, Lisbon, 1953 (R. Jervis d'Athouguia and S. Formosinho Sanchez) and the new exhibition hall, Lisbon, 1956 (F. K. Amaral).

952. EDUARDO CHILLIDA (b. 1924). Enclume de Rêve No. 9. 1960.

Sculpture. Jorge Vieira (b. 1922) produces abstract works in iron.

Painting. Columbano (1856–1929), whose style is solid and realistic, influenced the young painters of the first quarter of the 20th century. Abel Manta (b. 1886), Carlos Botelho (b. 1889), Mario Eloy (1900–1950) and Candido Pinto (b. 1911) are among the most interesting painters of the first third of the century.

Maria Elena Vieira da Silva (b. 1908) [**956**] came to Paris in 1928 and studied sculpture with Bourdelle and Despiau and painting with Friesz and Léger. She returned to Paris in 1947 after having been in Brazil during the War. The suspension bridge at Marseille and the criss-cross of the Lisbon streets have had a decisive influence on her style. She paints with a poetic and refined abstract technique. With the aid of dynamic lines and mosaic-like touches she suggests endless space. In her subtle and vigorous work she combines discipline with powerful imagination.

The younger generation is particularly dynamic and, while fully aware of Cubist, Surrealist and abstract theories, reveals an individual approach (José Andrade Dos Santos, b. 1916, Fernando Lanhas, b. 1923, Jorge de Oliveira, b. 1924, Querubim Lapa, b. 1926, Martha Teles, b. 1930, Antonio Cardoso, b. 1932).

BELGIUM

Architecture. Belgium played an early and active role in developing the new theories in architecture. Victor Horta (1861–1947) [**554, 957**] a follower of Viollet-le-Duc, was a leading

953. JOSÉ GUTIERREZ SOLANA (1886–1945). The Masks (detail). 1938. *Private Collection.*

954. FRANCISCO BORÈS (b. 1898). Beach. 1957. *Galerie Louis Carré, Paris.*

955. ANTONIO TAPIES (b. 1923). Green and Grey Painting. Oil and sand. 1957. *Tate Gallery.*

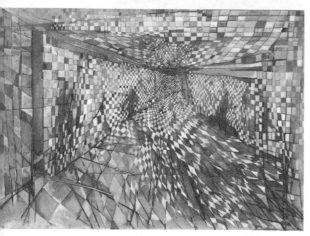

956. MARIA ELENA VIEIRA DA SILVA (b. 1908). Grey Room. 1950. *Tate Gallery.*

957. BELGIUM. VICTOR HORTA. Solvay house, Brussels. 1895–1900.

contributor, in architecture and ornament, to the Art Nouveau style. His Tassel house, Brussels (1892–1893), remarkable for its revolutionary design and structure and its novel plan, was the first private house to make use of iron both in its structural elements and in the decoration. The Solvay house, Brussels (1895–1900), is built in a mature Art Nouveau style and was furnished by Horta. His Maison du Peuple, Brussels (1896–1899), and his Innovation department store (1901), with their structural use of iron and their glass façades, anticipate the end of the load-bearing wall.

Henri van de Velde (1863–1957) [**795**], the apostle of functionalism, was a decisive influence in the first years of the 20th century in architecture and the decorative arts, especially in Germany. In Paris about 1884 he was impressed by Seurat's Divisionist technique, which he felt embodied ideas on space which could bring about new developments in architecture. In 1895 he built and furnished his own house at Uccle, near Brussels. Here the design and furnishings form an organic whole. He made use of linear ornament and undulating lines in the furniture he designed for Bing's Art Nouveau shop. In 1899 he settled in Germany, where he became head of the Weimar arts and crafts school (which later became the Bauhaus) and helped to found the Werkbund, whose aim was to encourage artists, architects, engineers and industrial companies to work in collaboration. He designed the Werkbund Theatre for the 1914 Exhibition in Cologne. He produced little of merit after the First World War; he settled in Holland in 1921, where he designed the Kröller-Müller Museum at Otterlo (1937–1954). The high standard set at the beginning of the century by the two architects mentioned above has not been maintained in Belgian architecture.

Sculpture. Figurative sculpture predominated in the first half of the 20th century; however there was quite a

wide variety of styles. Georges Verbanck (1881–1961) carved child figures and portraits directly in wood and marble. Antoine Vriens (b. 1902) though very much influenced by Maillol, is dynamic in style.

The independent school of sculpture is dominated by the influence of Rodin and Constantin Meunier. Georges Minne (1866–1941) [**958**], the spiritual leader of the school of Laethem St Martin, was influenced by Rodin; he then went through a period of ascetic forms which he abandoned about 1910 for a melancholy realism. Rik Wouters (1882–1916), painter and sculptor, was also influenced by Rodin. He expresses a zest for life in dynamic figures such as the *Mad Virgin* (1912) [**959**], inspired by Isadora Duncan; he combines lively attitudes with a rough modelling that catches the light. The painter Permeke took up sculpture about 1935 (*Marie Lou*, bronze, 1935–1936, Musée Royal des Beaux-Arts, Antwerp). Jean Canneel (b. 1899) and Arthur Dupon execute monumental sculpture. Some artists express a sensuous realism; these include Henri Puvrez (1893–1971) and Georges Grard (b. 1901), whose female nudes suggest Rubens or Renoir. Others give the human figure an unearthly quality by eliminating all descriptive detail. Oscar Jespers (1887–1970) was at first influenced by Rodin and Rik Wouters; he went through a Cubist phase and later turned to a simplified classicism (portrait of the architect van de Velde). Joseph Cantré (1890–1957), a leader in the Belgian Expressionist movement, was also a wood-engraver, illustrator and book designer. Initially influenced by Constantin Meunier and Georges Minne, he was led by his work in wood-engraving to abandon modelling and to carve directly in wood and stone. His severe style, with its clear outlines, shows remarkably pure geometric forms. He executed monumental works in Holland (sculpture for churches at Heeswijck and Hilversum). Later works (tomb of René de Clercq, at Lage

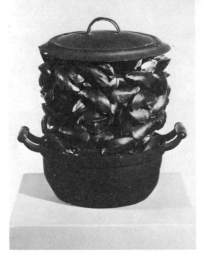

958. MARCEL BROODTHAERS (1924–1976). Casserole and Closed Mussels. 1964. *Tate Gallery, London.*

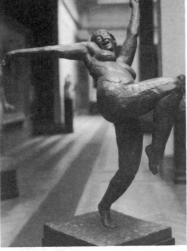

959. RIK WOUTERS (1882–1916). The Mad Virgin. Bronze. 1912. *Musée Royal des Beaux-Arts, Antwerp.*

Vuurse, Holland; monument to Edouard Anseele, Ghent) were less rigidly geometric. Charles Leplae (b. 1903), a pupil of Despiau and like him a portraitist, reproduced, in a harmonious and restrained style, the simplicity of his models.

The greatest Belgian abstract sculptor was Georges Vantongerloo (1886–1965) [**698**, **890**]. A painter, sculptor, architect and theoretician, he produced his first abstract sculptures in the spirit of the De Stijl group. His *Construction in a Sphere* (1917) led him to the horizontal-vertical rhythm of Neo-plasticism. He settled in France and early in the 1930s founded, with Herbin, the Abstraction-Création group. His works, which are studies in the expression of space, are executed in a variety of materials, including white and coloured Plexiglas. Victor Servranckx (1897–1965) experimented with round, concave and convex forms which fit into each other. Frans Lamberechts (b. 1909), traditional at first, moved on to an Expressionist style and then to abstract art. Jan Cobaert (b. 1909), also a painter, works in wrought iron. The compositions of Willy Anthoons (b. 1911) are carved in massive blocks of wood or stone with a minimum of surfaces susceptible to light (*Ascetic*, gilded wood, 1957). Pierre Caille (b. 1912) creates unusual forms in ceramics or in hammered bronze. Jacques Moeschal (b. 1913) favours the integration of sculpture with architecture; strictly abstract, his works have a certain aggressive quality. Madeleine Forani (b. 1916) has made use of coloured enamels and glass paste in her abstract metal sculptures. Roel d'Haese (b. 1921), who is a leading figure in an international movement stemming from Surrealism, creates, like César in France, a fantastic world in iron and sheet metal. Pol Bury (b. 1922) follows Schöffer's spatiodynamism; in his work volumes and colours in motion offer ever changing harmonies. Marcel Broodthaers creates surreal as well as conceptual works [**958**].

Painting. James Ensor (1860–1949) [**647**, **716**; see colour plate p. 277] stands out from his contemporaries by virtue of both his great talent and his isolation. (He spent most of his life in his native Ostend and he kept himself apart from the schools and movements of his time.) He began as a watercolourist and developed into a brilliant oil painter, attuning his mood to his subject matter — by turns malicious, disquieting, Symbolist and almost Surrealist (scenes with weird and grimacing masked figures, and scenes with skeletons — all painted with a distinctive use of brilliant colour). His descent from Bosch and Bruegel is apparent in his predilection for the fantastic and the macabre (*Entry of Christ into Brussels*, 1888, Musée Royal des Beaux-Arts, Antwerp). An original draughtsman and an admirable colourist, he painted his best works between 1888 and 1892. He is one of the most important precursors of the Expressionist movement. Among the traditional painters were: Jacobs Smits (1856–1928) [**481**], August Oleffe (1867–1932), Henri Evenepoel (1872–1899) and Philibert Cockx (1879–1949).

Theo van Rysselberghe (1862–1926) [**474**], friend of Seurat and Signac, remained faithful to Neo-Impressionist theory until about 1910. He often expressed himself in brilliant colour.

The two successive art colonies at the village of Laethem St Martin, near Ghent, played a vital part in the development of modern Belgian painting. Some of these artists (Minne, for example) produced works which were religious in inspiration; others created an Expressionist idiom of considerable power. The first group to settle there included Valerius de Saedeleer (1867–1941), Gustave van de Woestijne (1881–1947) [**960**], the sculptor Georges Minne (1866–1941) and Albert Servaes (b. 1883). The second group to form there included Gustave de Smet (1877–1943) [**781**], Frits van den Berghe (1883–1939) [**961**] and Permeke. Constant

Permeke (1886–1952) [**962**] was a leading figure in the Belgian Expressionist movement. At Ghent he met Frits van den Berghe and the brothers Gustave and Léon de Smet and joined them at Laethem St Martin in 1910–1912. He painted some of his most characteristic works in England during the latter part of the First World War before settling at Jabbeke, near Bruges. Influenced at first by Impressionism (*Winter in Flanders*, 1912), he later manifested a baroque tendency common to his particular group of Belgian painters. Solid and sincere, Permeke was a true painter in the Flemish tradition. His seascapes, harbour scenes and studies of fishermen and peasants convey the vitality of ordinary people and everyday toil in full forms and thick dark colours.

Two avant garde groups had a decisive influence on the development of modern Belgian art forms: the Société des XX, founded in 1883 (see Chapter 3), and the Libre Esthétique, founded in 1894. These salons, while exhibiting new Belgian painters, provided considerable space for French avant garde painters (Seurat, Signac). Fauvism had a number of adherents, the most important without doubt being Rik Wouters (1882–1916), a powerful colourist. Surrealism is represented principally by Paul Delvaux (b. 1897) [**963**] and René Magritte (1898–1967 [**964**]; colour plate p. 332]). Delvaux's early works were influenced by Permeke and de Smet. In 1936, after contact with Magritte and Chirico, he turned to paintings of female nudes in architectural settings. He used objective reality only as a setting for dreams, and his strange juxtapositions of people and places have a disturbing poetry. Magritte, a friend of the poet Paul Eluard, became a Surrealist in Paris in 1925. Unlike most Surrealist painters, who are preoccupied with automatism, the unconscious and the significance of dreams, Magritte shows a concern with the world around him. He achieves shock effects through the juxtaposition of incongruous objects and the metamorphosis of familiar ones; the precision of his style recalls de Chirico. Between 1936 and 1940 he dropped this manner in order to explore the problems of the isolated object, using lighter tones (*Summer Steps*, 1937). About 1946 he returned to his earlier style, expressing his gift for irony in such masterpieces as his repainting of Gérard's *Madame Récamier*, in which a coffin takes the place of the figure [**964**].

The first painter to embrace abstract art was Victor Servranckx. His abstract works incorporate either rounded shapes or rectangular elements reminiscent of Futurism. His later works (after 1946) are allied to Neo-plasticism. Joseph Peeters, a geometrical abstractionist,

357

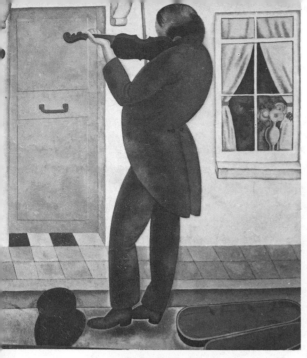

960. GUSTAVE VAN DE WOE-STIJNE (1881–1947). The Blind Violin-ist. 1920. Musée des Beaux-Arts, Liége.

961. FRITS VAN DEN BERGHE. Genealogy. 1929. Kunstmuseum, Basle.

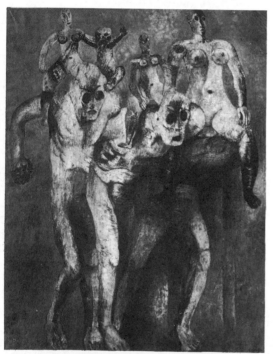

962. CONSTANT PERMEKE (1886–1952). The Oarsmen. 1921. Musées Royaux des Beaux-Arts, Brussels.

963. PAUL DELVAUX (b. 1897). Venus Asleep. 1944. Tate Gallery.

co-edited the review *Het Overzicht*, in which he opposed the ideas of the De Stijl group. *Het Overzicht* repro-duced works by other Belgian abstract artists. Other abstract painters include: Louis van Lint (b. 1909); Anne Bonnet (1908–1960); Gaston Bertrand (b. 1910) [**965**]; Jo Delahaut (b. 1911); Marc Mendelson (b. 1915); Pol Bury (b. 1922); Pierre Alechinsky (b. 1927); Jean Duboscq (b. 1928) [**639**]. Raoul de Keyser (b. 1930) and Jef Verheyen (b. 1932).

Graphic Arts. Ensor stood far above his contemporaries in graphic art as well as in painting, with such works as the *Battle of the Golden Spurs* (1895) which captures the spirit of Breugel with his crowded scene, his mockery and his sense of irony. About 1898 some important original woodcuts were pro-duced by Georges Minne and Max Elkamp. Contemporary graphic artists include Frans Dille, Floris Jespers, Joris Minne and the painter and book illus-trator Frans Masereel (b. 1889), who illustrated Romain Rolland.

The minor arts. Until the Second World War the United States and the northern European countries looked to Belgium for fine goldsmiths' work (Coosemans, 1870–1931, an excellent jeweller).

In 1894 a technical college was founded (Université Nouvelle Popu-laire); here van de Velde taught art, design and decoration. Shortly after-wards he opened a workshop at Uccle. Paul Hankar, in collaboration with Adolphe Crespin, designed a series of shops having linear floral decoration in the Art Nouveau style. Horta did the interior decoration for his town man-sions and designed furniture which

harmonised with his architecture [**957**], as did van de Velde.

HOLLAND

Architecture. Modern architecture in the Netherlands began with Hendrik Petrus Berlage (1856–1934) [**966**], the leading Dutch architect of his time, whose lectures and writings exerted a great influence. Anxious to combat 19th-century eclecticism, he aimed at an awareness of the demands of reason and logic in the use of materials and in con-struction. Though he rejected the historic styles, his buildings, with their semicircular arches and large areas of unbroken wall, reflect the Romanesque in a way that recalls the work of H. H. Richardson, who may have influenced Berlage when he visited America. Ber-lage's works include the Diamond Workers' Union building, Amsterdam (1899–1900), Holland House, London (1914), and the Amsterdam stock exchange (completed 1903), which eschews all extraneous ornamentation and where the steel roof structure is exposed.

About 1910 a diametrically opposed movement, headed by Michael de Klerk (1884–1923) began. This new Amsterdam school aimed at individual artistic design and personal idiosyn-crasies of detail. This movement, which was closely related to Expressionism, produced buildings with elegant façades having considerable decorative detail which was, however, often architec-tonic. De Klerk's first Eigen Haard housing estate recalls the American Shingle Style of a generation earlier [**967, 607, 608**]. Another member of the Amsterdam school was P. L. Kramer.

A new tendency emerged with the

964. RENÉ MAGRITTE (1898–1967).
Madame Récamier. 1951. *Hanover
Gallery, London.*

965. GASTON BERTRAND (b. 1910).
La Source. 1956. *Georges Everaert
Collection, Brussels.*

founding of De Stijl in 1917. Its members included Piet Mondrian, J. J. P. Oud, Theo van Doesburg, Gerrit Rietveld and the sculptor and painter Georges Vantongerloo. It was primarily concerned with problems of space and colour, the latter being used to define space. Design was largely determined by the Neo-plasticism of Mondrian and van Doesburg, and involved right angles and smooth walls and a cubic shape as a point of departure; this shape was not considered static but was regarded as part of an infinite environment. Typical examples of this style include Rietveld's Schroeder house, Utrecht (1924), and Oud's Café de Unie, Rotterdam (1924–1925; destroyed 1940). After breaking with van Doesburg, J. J. P. Oud (1890–1963) [**968, 971**] played a leading part in the development of functionalism in western Europe. His finest buildings are his workers' housing schemes (Hook of Holland, 1924–1927; Rotterdam, 1925–1927). Later works in a less functionalist style include the Shell building, The Hague (1938–1942).

A completely independent part was played by Willem Marinus Dudok (1884–1974), municipal architect at Hilversum, 1915–1947. His extremely personal style can be seen in the Hilversum town hall (1928–1930), which was frequently imitated in the 1930s.

In 1925 came the appointment of Professor G. M. Granpré Molière to the Delft technical college. His aesthetics, closely linked with the Roman Catholic religion, are reflected in G. Friedhoff's town hall at Enschede (1933). This Delft school, with its opposition to functionalism and its emphasis on philosophical considerations, dominated

Dutch architecture until 1955, and its architects were commissioned to reconstruct bombed cities after the War. From 1948 their ideas were challenged by J. H. van den Broek (1898–1978) and J. B. Bakema (b. 1914), whose names are associated with post-War building and the reconstruction of Rotterdam [**969**]. Aldo van Eyck (b. 1918), who is interested in education, built the orphanage at Amsterdam (1955). Both Bakema and van Eijck were members of Team X, which reacted against CIAM's (Congrès Internationaux d'Architecture Moderne) doctrinaire outlook. Herman Hertzberger, influenced by van Eyck, designed the Central Insurance Office Buildings, Apeldoorn (1974); their irregular spaces and clusters of platforms create a 'city within a city' to be adapted to individual needs. His Music Centre in Utrecht (complete 1980) combines a variety of functions and successfully blends in with the Old Town.

Sculpture. The revival of Dutch sculpture begins with Lambertus Zijl and Joseph Mendes da Costa (1863–1939) who decorated the Amsterdam Stock Exchange by Berlage. Between 1898 and 1910 Mendes da Costa worked in stoneware; later he turned to monumental sculpture. His best known work is the monument to Christiaan de Wet (1917) at Otterlo. Between 1915 and 1925 an Expressionist tendency became clear. Hildo Krop (1884–1970) was a pupil of Laurens in Paris; in 1916 he became sculptor to the city of Amsterdam. This official post did not deter him from developing stylised forms and a personal idiom. John Raedecker (1885–1956) was influenced by Cubism

during an early stay in Paris. He reverted to national tradition in his War memorial at Waalwijk (1947). His most famous work is his strange cement *Man with Wings* (1922); he is also well known for his portraits. J. Bronner (1881–1972) contributed, through his long career as a teacher, to the development of the next generation. He was interested in an architecture of form rather than a modelling of form, and he inclined his pupils towards simplification and balanced composition. He allowed his pupils, who included Albert Termote (1887–1978) and Frits van Hall (1899–1945), to develop along individual lines. Among other figurative sculptors are Charlotte van Pallandt, J. G. Wertheim (1898–1977), Fred Carasso (b. 1899). Titus Leeser (b. 1903), Paul Koning (b. 1916) and Hans Verhulst (b. 1921). Piet Esser (b. 1914), a pupil of Meštrovic, introduced a new spirit, with his fluid handling of modelling. Wessel Couzijn (b. 1912) has considerable influence on his generation. He has broken with previous

966. HOLLAND. HENDRIK PETRUS
BERLAGE (1856–1934). Interior of
the stock exchange, Amsterdam.
Completed 1903.

967. HOLLAND. MICHAEL DE
KLERK (1884–1923). Eigen Haard
housing estate, Amsterdam. 1917.

968. HOLLAND. J. J. P. OUD.
Workers' housing estate, Hook of
Holland. 1924–1927.

969. HOLLAND. J. H. VAN DEN
BROEK and J. B. BAKEMA. The
Lijnbaan development, Rotterdam.
1953–1954.

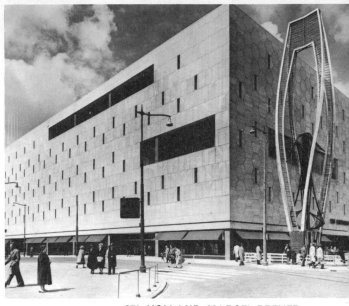

970. HOLLAND. MARCEL BREUER
(b. 1902). Bijenkorf store, Rotterdam.
1955–1957. Sculpture by Gabo in the
foreground.

tendencies and has moved away from figurative art. His sculpture is intense, with a skilful handling of volumes.

A leading figure in abstract sculpture is the painter Cesar Domela (b. 1900), who has been associated with Mondrian and van Doesburg. Sculptors working in iron include Siem van den Hoonard (1900–1938), Andre Volten (b. 1925) [972], Shinkichi Tajiri (b. U.S.A., 1923) and Carel Visser (b. 1928). Ad Dekkers (1938–1974) produced clean, cool geometrical reliefs. The exponents of Post-Object Art include Marinus Boezem (b. 1934), Jan Dibbets (b. 1941), Ger van Elk (b. 1941), Sjoerd Buisman (b. 1948), Theo Botschuyver (b. 1943) with his enormous inflatables, and Bas Jan Ader (1942–?1976).

Painting. Expressionism has attracted many Dutch painters, among them Jan Sluyters (1881–1957), whose studies of miserable, toil-worn peasants are painted largely in sombre colours.

The school of Paris is represented by one of the most famous Dutch artists, resident in Paris since 1897, Kees (Cornelis) van Dongen (1877–1968) [896]. In 1906 he joined the Fauves, a group to which he was sympathetic, ·with his latent Expressionism and fine colour sense. His flexible lines, intense colour and rich matière resulted in such striking works as the *Fellahin* (*c*. 1912, Musée d'Art Moderne, Paris). Between the Wars he portrayed fashionable Parisian society with sarcasm, expressive force and incomparable colour.

The most influential Dutch artist of the 20th century is Piet Mondrian (1872–1944) [689, 974], whose mystical pursuit of the absolute ended in the severe abstraction of Neo-plasticism, where truth is embodied in the horizontal and vertical and in pure primary colours. Influenced by Cubism while in Paris in 1912–1914, he reached

abstraction through his favourite themes of the tree, scaffolding and cathedral façades (plus and minus series, 1915). In 1917, with Theo van Doesburg (1883–1931) [975], he founded in Leyden the review *De Stijl*, which was very influential, particularly in Germany, and in which he expounded the doctrine of Neo-plasticism with its exclusive use of right angles and primary colours. Other contributors included the architects Oud and Rietveld and the sculptor Vantongerloo. In 1927 van Doesburg abandoned Neo-plasticism's rigorous principles for a more dynamic ideal which he called Elementarism, which was less strict and made use of inclined planes. He was followed by Domela. In 1940 Mondrian went to New York. His last works there have an unexpected lyricism and new richness (boogie-woogie series). His work is a source of inspiration to American artists. Cesar Domela (b. 1900) met Mondrian in Paris in 1924 and

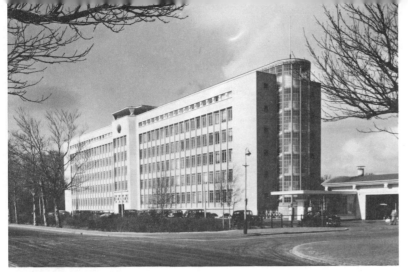

971. HOLLAND. J. J. P. OUD
(1890–1963). Shell building, The
Hague. 1938–1942.

974. PIET MONDRIAN (1872–1944).
Composition 7. 1913. *Solomon R.
Guggenheim Museum, New York.*

972. ANDRÉ VOLTEN (b. 1925).
Construction. Galvanised steel. 1958.
Stedelijk Museum, Amsterdam.

973. CHARLEY TOOROP (1891–1955).
Friends at a Meal. 1932. *Museum
Boymans-van Beuningen, Rotterdam.*

975. THEO VAN DOESBURG
(1883–1931). Counter Composition.
1924. *Stedelijk Museum, Amsterdam.*

976. BART VAN DER LECK
(1876–1958). Geometrical Composition
II. *Rijksmuseum Kröller-Müller, Otterlo.*

977. CORNEILLE (b. 1922). Spanish Town. 1958. *Stedelijk Museum, Amsterdam.*

joined the De Stijl movement. He settled in Paris in 1933 after a stay in Berlin (1927–1933) and was co-publisher, with Arp and Sophie Taeuber-Arp, of the review *Plastique*. In 1946 he founded the Centre de Recherche group. Bart van der Leck (1876–1958) [**976**] began as a realistic painter, later adopted a monumental linear stylisation, and in time became abstract. He joined De Stijl, but in a short time reverted to figurative painting.

Foremost among the painters known as Monumental Realists is Charley Toorop (1891–1955) [**973**], daughter of Jan Toorop.

In 1948 Karel Appel (b. 1921) [**658**], Corneille and the sculptor Constant founded the Dutch Experimental Group and also participated in COBRA (founded in Paris in the same year), which established contact with other young painters in Denmark and Belgium. Appel, one of the outstanding post-War artists, has lived in Paris since 1950. His large paintings contain powerful, dynamic forms, and their colours have a fierce, slashed look (*Sandberg*, 1956; *Horses and Man*, 1963). His work includes murals for the Stedelijk Museum, Amsterdam (1951), and illustrations for several volumes of poetry. Corneille (Cornelis van Beverloo, b. 1922) [**977**] is now resident in Paris. Less aggressive and more poetic than Appel, he at first showed the influence of Miró and Klee. More recently he has used powerful, arched structural motifs.

Other abstract painters include: P. Ouborg (1893–1956); Hendrik Nicolaas Werkman (1882–1945), who used typographical elements in his paintings; the brothers Bram van Velde (b. 1895) and Geer van Velde (1898–1977), the former fluid and expressive, the latter polished, rectilinear and subtle in colour.

The minor arts. Goldsmiths' work is represented by Eissenlöffel (1876–1957) and the Zwollos. In ceramics, active workers have been Brouwer (1877–1933), Colenbrandert, Lancroy, Nienhuis and Hoef, who creates utilitarian objects.

After 1900 furniture generally became much more severe and functional in design. Architects such as Berlage and de Klerk designed furniture, as did Rietveld [**703**]. H. Wouda (1885–1946), with his functional furniture, was the Dutch exponent of the ideas of Frank Lloyd Wright.

LUXEMBOURG

Painting. Luxembourg's leading modern painter was Joseph Kutter (1894–1941), who was unrecognised in his lifetime. His strong, dramatic but somewhat restrained style verges on Expressionism and Fauvism. Among the post-War generation are Coryse Kieffer (b. 1928) and Jean Pierre Janius (b. 1925).

GREAT BRITAIN

Architecture. Modern architecture was late in appearing in England. The buildings of Philip Webb, Norman Shaw and C. F. A. Voysey (see Chapter 3) were examples of design that was a logical answer to needs, but apart from isolated examples (Royal Horticultural Hall, London, by J. M. Easton and Howard Robertson, 1923; Boots' factory at Beeston, near Nottingham, completed 1932, by Sir Owen Williams [**978**]; 'High and Over', 1929, the house in Amersham, Bucks., by Amyas Connell [**979**]), it was not until the 1930s that development along functionalist lines took place. The stimulus given by the arrival of German architects, including Gropius, Breuer and Mendelsohn, led to progressive work in individually designed houses (house in Frognal, Hampstead, London, 1936, by Maxwell Fry [**980**]) and to the achievements of the Tecton group (Highpoint flats, Highgate, London, 1934–1935; Finsbury Health Centre, 1939; penguin pool, London Zoo, 1933–1935 [**981**]).

Just after the War the most outstanding architecture was in schools (Croxley Green Junior School, Herts., 1947–1949, by C. H. Aslin; Bousfield Primary School, Old Brompton Road, London, 1956, by Chamberlin, Powell and Bon [**982**]). Examples of excellent housing can be seen in some of the blocks of flats in and near London. The Alton estate in Roehampton is an impressive local authority project; it contains ten-storey tower blocks, six-storey slab blocks, four-storey maisonette blocks and two- and three-storey houses sited in rolling wooded country [**984**]. Other excellent London estates are the Spa Green flats, Finsbury, by the Tecton group (1946–1950), Churchill Gardens, Pimlico, by Powell and Moya (1947–1953) and the Golden Lane estate, City of London, by

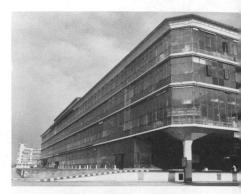

978. BRITAIN. E. OWEN WILLIAMS (b. 1890). Boots' factory, Beeston, near Nottingham. Completed 1932.

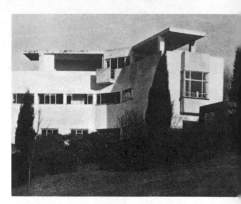

979. BRITAIN. AMYAS CONNELL (b. 1901). 'High and Over', Amersham, Buckinghamshire. 1929.

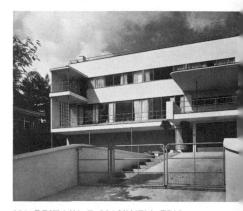

980. BRITAIN. E. MAXWELL FRY (b. 1899). House in Frognal, Hampstead, London. 1936.

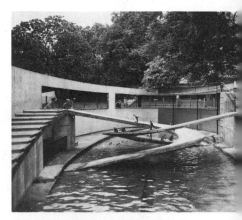

981. BRITAIN. TECTON GROUP. Penguin Pool, Regent's Park Zoo, London. 1933–1935.

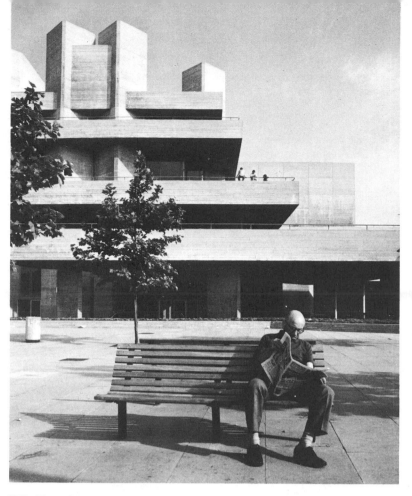

982. *Above:* BRITAIN. DENNIS LASDUN. National Theatre, South Bank, London. 1977.

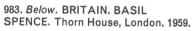

983. *Below.* BRITAIN. BASIL SPENCE. Thorn House, London. 1959.

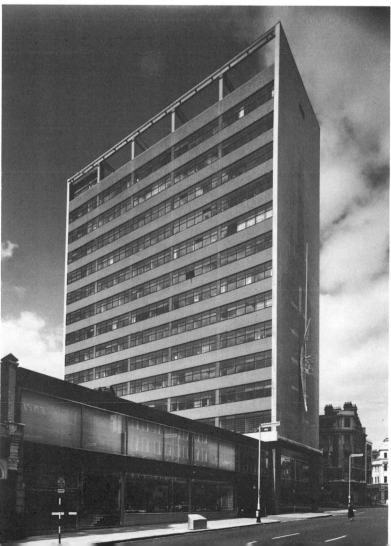

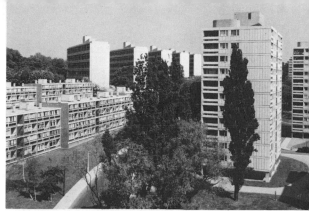

984. BRITAIN. LONDON COUNTY COUNCIL. Alton housing estate, Roehampton, London. 1956–1957.

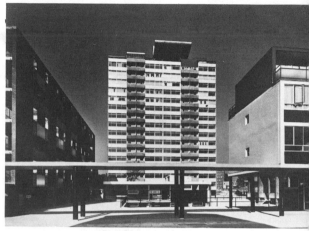

985. BRITAIN. CHAMBERLIN, POWELL and BON. Golden Lane housing estate, City of London. 1954–1963.

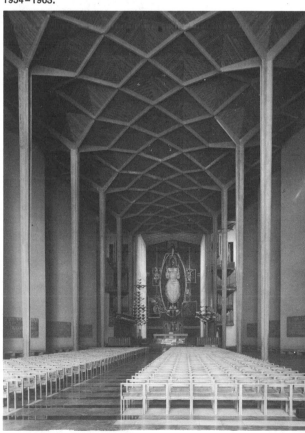

986. BRITAIN. BASIL SPENCE (b. 1907). View of the interior, Coventry cathedral. Completed 1962.

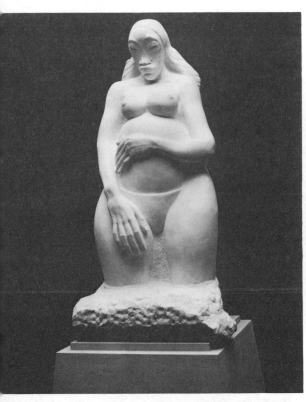

987. JACOB EPSTEIN (1880–1959).
Genesis. Marble. 1931.

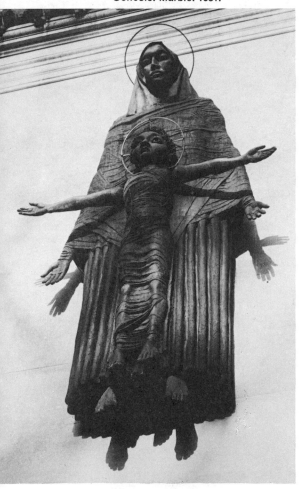

988. JACOB EPSTEIN. Madonna and
Child. Bronze. 1952. *Convent of the
Holy Child Jesus, London.*

Chamberlin, Powell and Bon (1954–1963) [985]. The best low-cost small-unit housing in the 1950s was in the New Towns such as Stevenage, Harlow, Basildon and Crawley, near London, and East Kilbride and Cumbernauld in Scotland. In office blocks the distinguishing architectural element has been the curtain wall and a tower block of some fifteen to twenty storeys rising from a lower block (Castrol House, by Gollins, Melvin, Ward and Partners; Thorn House, by Sir Basil Spence [983]). Other notable office blocks include the Economist Buildings (1964) in London, designed by Alison and Peter Smithson and the Willis–Faber and Dumas Building (1974), Ipswich, designed by Foster Associates. The latter's tinted glass walls reflect its surroundings in the day, and reveal its interior at night. In religious architecture, Liverpool Roman Catholic Cathedral (consecrated 1967) by Sir Frederick Gibberd and Coventry Cathedral (complete 1962) [986] by Sir Basil Spence are imaginative designs. In London, there is the National Theatre by Sir Dennis Lasdun (1978)

Sculpture. In figuration, the 19th-century spirit continued with Eric Gill (1882–1940), the last survivor of the Arts and Crafts Group started by William Morris. Gill revived the art of carving directly in stone; he was also a wood-engraver and a designer of type. Other sculptors include Siegfried Charoux (b. 1896), Uli Nimptsch (b. 1897), Karin Jonzen (b. 1914), Ralph Brown (b. 1928), Michael Rizillo (b. 1926) and Roşemary Young (b. 1930). Leon Underwood (b. 1890) has a fiery rhythm combined with toughness of line (monument for the London County Council's Hilgrove estate, 1960). John Skeaping (b. 1901) treats the human figure as an architectural structure. Vorticism, which roused the world of English art from about 1912 to about 1915 and resulted in a plastic revival, attracted two sculptors: Gaudier-Brzeska [873] (see under *France*) and Sir Jacob Epstein (1880–1959) [987, 988], born in New York, whose work was not accepted by the public, yet who remained apart from avant garde trends. Keeping independent of both traditionalism and abstraction, he either executed large works in direct carving or else modelled in clay. His often massive works are sometimes reminiscent of Expressionism. Among his leading religious works are the *Genesis* (1931), the *Madonna and Child* for the convent in Cavendish Square, London (1952), and the *Christ in Majesty* for Llandaff cathedral (commissioned 1957). His portraits are justly famous (*Einstein, Conrad, Nehru*).

Between 1920 and 1935 a group of artists appeared who sought a greater

break with the past. They adopted the ideas of Arp and Brancusi, explored the problems of internal volume (concavity) or experimented with flat forms in space. At first an isolated figure, Henry Moore (b. 1898) [789, 989, 990, 992] has had a great influence on the course of sculpture and has an international reputation. His appearance in a country almost lacking in a sculptural tradition emphasises the strength of his contribution to modern sculpture as a whole. During his formative years the British doctrine of direct carving and 'truth to material' coloured his approach, while his vision was formed by such diverse influences as Pre-Columbian art, Romanesque sculpture, Masaccio, Michelangelo, Brancusi and Picasso. He now works simultaneously in figurative and non-figurative styles, and equally freely as carver and modeller. In the 1930s his humanistic approach was diverted to abstract forms (wood and metal stringed figures of 1938–1939) in which empty spaces are articulated by interweaving strings or wires. The main themes which preoccupy him had all appeared by the early 1930s. Prominent among them is the reclining figure, in various styles from the near-figurative to the abstract. These figures are severe, pathetic, tragic, yet they evoke natural forms. Other themes include the mother and child, the family group, the fallen warrior and one sculpture within another. His public commissions include: the screen for the Time-Life building, London (1952); *King and Queen,* for the Open-air Museum, Middelheim (1953); *Reclining Figure,* UNESCO building, Paris (1958). His graphic work echoes his sculpture, and the sketches done in London air-raid shelters during the War demonstrate the depth of his observation.

Barbara Hepworth (b. 1903) [991, 993] comes from the same mining region as Henry Moore, and until the mid-1930s her work developed along parallel lines to his, with her desire to open up and hollow out sculptural volume. She was later influenced by Brancusi, Arp and Mondrian. The bulk of her output is non-figurative. She is above all a carver, responding to the natural qualities of her materials. Her treatment of planes is subtle and the overall conception has a monumental simplicity. The technical virtuosity of F. E. McWilliam (b. Ireland, 1909) [998] explains the diversity of his work. His earlier sculptures in the round, in which he broke up the human figure, have given way to thin, spindly figures in metal (*Puy de Dôme Figure,* 1962, Southampton University). An architect, Reg Butler (b. 1913) [994, 995] has devoted himself to sculpture since 1944. Technical experiment led him to adopt metal. His structures in wrought

989. HENRY MOORE (b. 1898).
Warrior with Shield. Bronze. 1953–1954. *City Museum and Art Gallery, Birmingham (Warwickshire).*

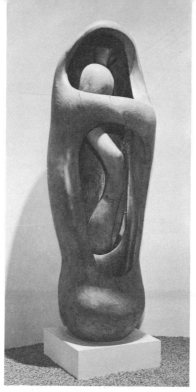

990. HENRY MOORE. Internal and External Forms. Wood. 1953–1954. *Albright-Knox Art Gallery, Buffalo.*

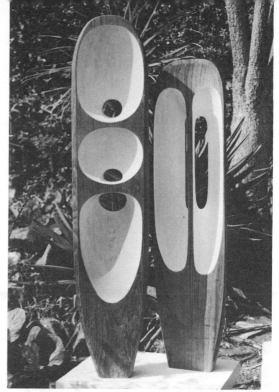

991. BARBARA HEPWORTH (1903–1975).
Two Figures (Menhirs). Teak. 1954–1955. *S. B. Smith, Collection, Chicago.*

992. HENRY MOORE. Sculpture (Locking Piece). Bronze. 1963–1964. *Artist's Collection.*

993. BARBARA HEPWORTH.
Squares with Two Circles. Bronze. 1963. *Tate Gallery.*

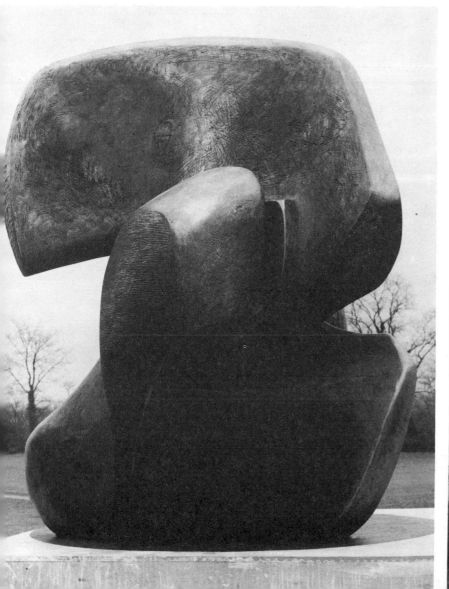

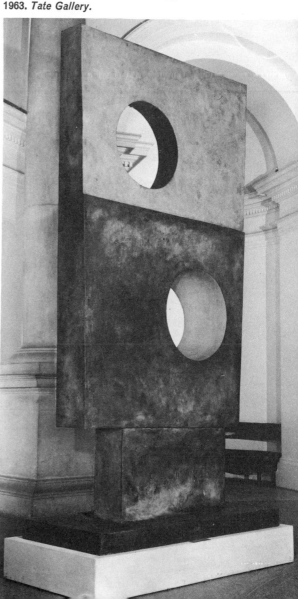

994. REG BUTLER (b. 1913). Study for Woman Resting. Bronze wire. 1950. *Tate Gallery.*

iron were followed by open works made up of linear arabesques; this work culminated in 1952 in his *Monument to the Unknown Political Prisoner.* He abandoned iron in 1954 for work in bronze. Lynn Chadwick (b. 1914) [**625, 652, 999**] is also an architect; he became a sculptor in 1945 and at first made mobiles. In 1951 his style changed; pieces of metal were constructed on architectural principles; the various elements fit into each other, creating a spatial dimension. His techniques and materials changed again about 1955; a mixture of gypsum and iron filings is poured into a geometrical steel armature and then modelled and chiselled (*Teddy Boy and Girl,* 1956). A similar process is used by Bernard Meadows (b. 1915), a pupil of Moore. He takes as his starting point a limited number of subjects borrowed from the animal kingdom (crabs, cocks, birds), concentrating on the feeling of combat and movement. Kenneth Armitage (b. 1916) [**996**] uses the human figure but eliminates all traces of individuality to develop the theme of the group in an original way. Like Butler and Chadwick, he has moved towards sculpture in the round.

Eduardo Paolozzi (b. 1924)[**823, 1000**], perhaps the most radical of the younger sculptors, represents a swing to an anti-rational approach related to Dada and Surrealism. His early works were influenced by Giacometti. His bizarre, richly incrusted inventions have a similar ability to suggest the surrounding space in which the movement is contained. His later figures have the air of battered robots that have emerged from an atomic holocaust; their symbolic nature is underlined by their titles (*Japanese War God*; *Jason*; *Icarus*). In his most recent work the coruscated surface of multitudinous mechanical components has been replaced by a smoother assemblage of machine-made units.

Clatworthy (b. 1928) [**997**] carries Expressionistic modelling to the limit. He has a particular gift for rendering the nature of animals, and a favourite theme is the bull. Elizabeth Frink (b. 1930), who often works in bronze, creates fabulous beings based on animal forms.

Working in the field of non-figurative sculpture, Kenneth Martin (b. 1905) [**1002**] makes mobiles which derive from Pevsner's constructions. Stephen Gilbert (b. 1910), resident in France, uses steel and polished aluminium in his polychrome 'structures'. Robert Adams (b. 1917) keeps within the realm of geometry with his reliefs in bronze or concrete. Geoffrey Clarke (b. 1924) has produced striking symbolic compositions using iron rods which have been hammered by hand. Leslie Thornton (b. 1925), who has experimented in spatial problems, using welded metal rods, has moved to more solid forms. John Hoskin (b. 1921) works in steel. Brian Kneale (b. 1930) does sculptures in welded sheet iron.

The Primary Structuralists influenced by Anthony Caro (b. 1924) [**824**] include Tim Scott (b. 1936), Michael Bolus (b. 1934), Philip King (b. 1934) and Derek Woodham (b. 1940). Other non-figurative sculptors concerned with delineating space include William Tucker (b. 1935), Garth Evans (b. 1934) and Nigel Hall (b. 1943). Clive Barker (b. 1940) and Anthony Donaldson (b. 1934) work in a pop style. John Latham (b. 1921) makes assemblages from books, Mark Boyle faithfully reproduces sections of paving. Julian Hawkes (b. 1944) is a modern constructivist. Hamish Fulton (b. 1945), Richard Long (b.), Stuart Brinsley (b. 1933) and David Medalla (b. 1942) are representative of Post Object Art.

Painting. The Slade School of Art was reorganised in 1876. Among painters trained there was Augustus John (1878–1961). Early in the century a break with academicism was introduced through such painters as Walter Richard Sickert (1860–1942), Matthew Smith (1879–1959) [**1003**], Duncan Grant (1885–1978) and Mark Gertler (1891–1939) [**1004**].

Vorticism dates from about 1912 to 1915 and owes its advent to Wyndham Lewis (1882–1957) [**1005**], painter, novelist and critic. The movement stemmed in part from Cubism and in part from Futurism. As aggressive as the title of its review *Blast*, it aimed at bringing English painting into line with the continental avant garde by integrating art with industry and mechanisation.

Gaudier-Brzeska and Jacob Epstein, and such literary figures as Ezra Pound, T. E. Hulme and Richard Aldington, were all associated with this short-lived movement.

During the inter-War years groups included the 7 and 5 Society (1920) and Unit One (early 1930s), in which Paul Nash (1889–1946) [**783**] played a prominent role. They pointed up the growing trend towards an abstraction, for which English art offered no precedent and out of which Ben Nicholson (b. 1894) [**700, 815**] has emerged as the leading figure. His arrangements of formal shapes, his fine sense of line and balanced geometrical proportions, are combined with a harmonious use of colour. His post-War work reveals an increasingly complex series of linear paintings having lightness of touch and transparency of colour; his three-dimensional relief constructions mark a significant contribution.

The International Surrealist Exhibition of 1936 had a strong influence on Graham Sutherland (b. 1903) [**1009**], who has evolved a new conception of reality, basing his forms on principles of organic growth. Since 1945 his work has become more varied, though a sense of strangeness remains, his images possessing an eerie life of their own. He has produced powerful portraits (*Somerset Maugham, Winston Churchill, Helena Rubinstein*). Ceri Richards (1903–1971) [**1018**] was an artist of poetic imagination who used abstract methods for imaginative ends (Variations on Debussy's *Cathédrale Engloutie*). John Piper (b. 1903) [**1008**] became abstract in the early 1930s and later reverted to romantic views of English architecture and landscape. L. S. Lowry (1887–1976)[**1007**] stood alone in his depiction of figures lost in an industrial landscape of factories, chimneys and canals. The Euston Road school (1937–1939) expressed an objective approach through a restrained style. Members included Sir William Coldstream (b. 1908), who employs a fastidious style in his figure painting, Lawrence Gowing (b. 1918), Graham Bell (1907–1943), Claude Rogers (1907–1979) and Victor Pasmore (b. 1908) [**1017, 1019**]. In the late 1940s Pasmore's work underwent a radical change of

Top left. FRANCIS BACON (b. 1909). Red Figure on a Predella. 1962. Julian J. and Joachim Jean Aberbach Collection, New York. *Photo: Marlborough Fine Art Ltd, London.*

Top right. BRITAIN. STIRLING AND GOWAN. Engineering building, Leicester University. 1963. *Photo: Brecht-Einzig.*

WILLIAM SCOTT (b. 1913). Composition 39. 1959. Galerie Charles Lienhard, Zürich. *Photo: Galerie Charles Lienhard.*

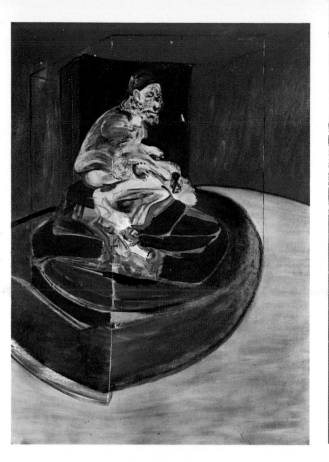

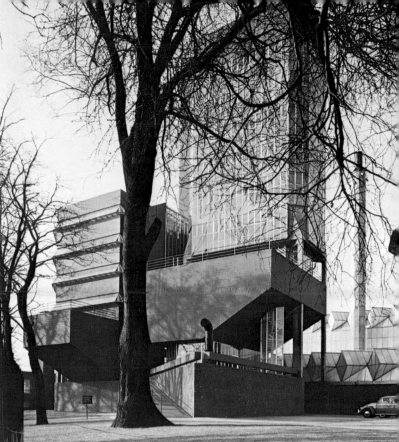

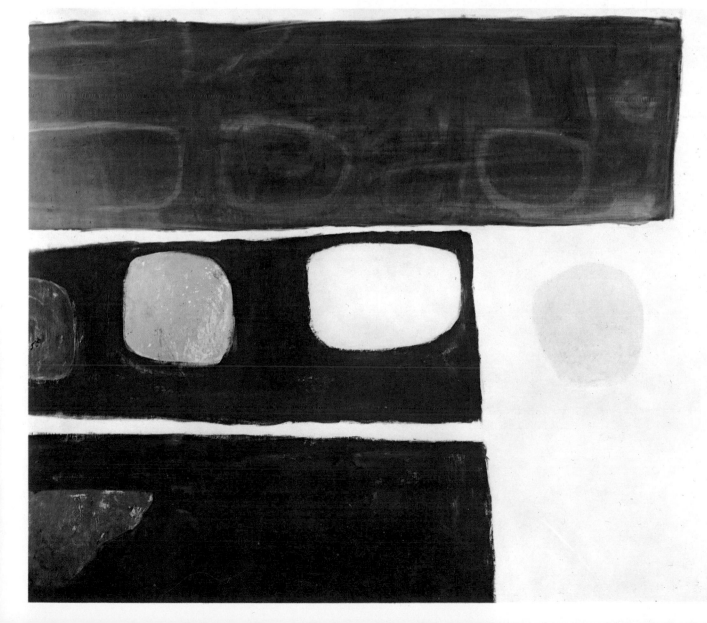

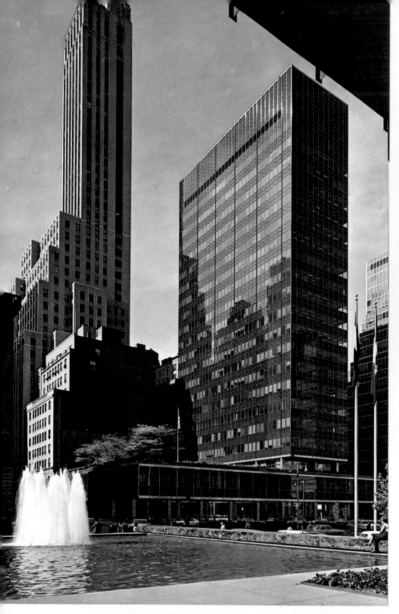

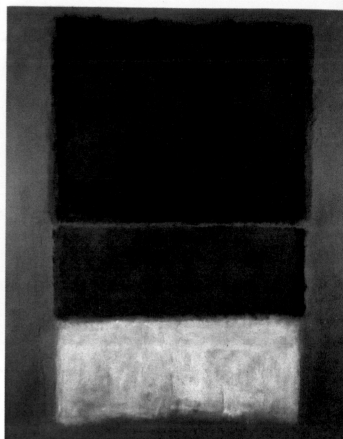

Top left. U.S.A. SKIDMORE, OWINGS AND MERRILL. Lever House, New York. 1952. *Photo: Julius Shulman.*

Top right. MARK ROTHKO (1903–1970). White and Greens in Blue. 1957. Private Collection, New York.

JACKSON POLLOCK (1912–1956). Convergence. 1952. Albright-Knox Art Gallery, Buffalo. *Photo: Sherwin Greenberg.*

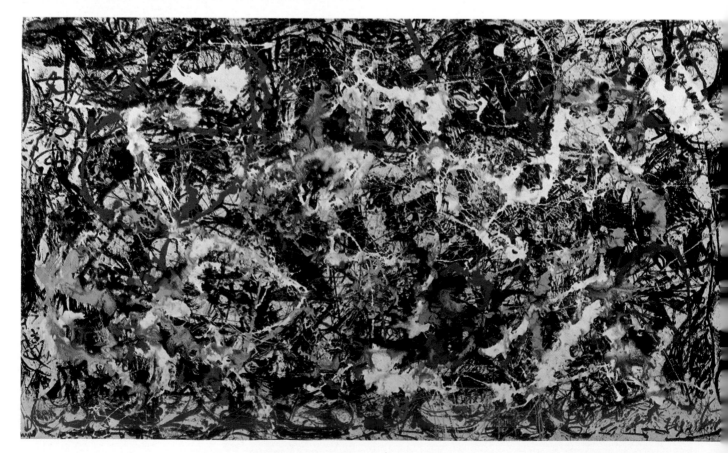

direction to complete abstraction. Among his abstract works are his relief constructions — spatial compositions made up of painted blocks of wood.

A number of figurative painters came into prominence after the War: John Minton (1917–1957), Robert Colquhoun (1914–1962) [**1010**], Robert MacBryde (b. 1913), John Craxton (b. 1922), Tom Nash and Keith Vaughan (b. 1912) [**1012**]. The most powerful and original figurative painter is Francis Bacon (b. Ireland, 1909) [**1011**; see colour plate p. 367]. A self-taught painter, he has created a modern variation on the moment of terror, on the horror present in contemporary life. In his adaptations of Velasquez's *Innocent X*, the static dignity of the seated figure contrasts with the agitated, disturbing features. He has made creative use of the film still (the nurse in *Battleship Potemkin*). Stanley Spencer (1891–1959 [**784**] produced an imaginative body of figurative paintings which are independent of any movement and are stamped with the artist's individuality. He spent most of his life in his native Cookham, which furnished the setting for his large religious subjects (*The Resurrection, Cookham*, 1923–1927, Tate Gallery). His photographic accuracy of style combined with the almost surreal atmosphere which pervades his works reminds one of the American Magic Realists. Edward Burra (b. 1905) [**1006**] recalls the latter trend to a greater degree.

Social realism (sometimes called the 'kitchen sink' school), a figurative movement of considerable independence, appeared after the War. Its chief adherents have been Edward Middleditch (b. 1923), John Bratby (b. 1928) and Jack Smith (b. 1928) [**1016**].

In the 1950s there was a greater tendency towards non-representational painting in a free style influenced by American Abstract Expressionism. Some painters retained an evocative feeling for landscape: Robert Medley (b. 1909), Alan Reynolds (b. 1926). Among abstract artists are: Peter Lanyon (1918–1964) [**1013**], Roger Hilton (b. 1911) [**1014**], William Scott (b. 1913) [see colour plate p. 367], whose abstract compositions, with their rectangles and circles, their feeling of movement and tension and their asymmetry of composition, are distinctive in British art, Terry Frost (b. 1915), Patrick Heron (b. 1920), Alan Davie (b. 1920) [**1015**], John Walker (b. 1939), Bridget Riley (b. 1931) [**1021**], Howard Hodgkin (b. 1932), Mark Lancaster (b. 1938) with his literary references to the Bloomsbury set, John Hoyland (b. 1934) [**1023**], Kenneth Martin (b. 1905), Paul Huxley (b. 1938), Fiona Henderson (b. 1955), John Golding (b. 1929) [**1024**] with his

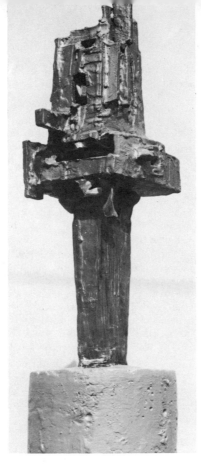

995. REG BUTLER. Tower. Bronze. 1963. *Hanover Gallery, London.*

996. KENNETH ARMITAGE (b. 1916). Pandarus IV. Bronze. 1963. *Marlborough Fine Art Ltd, London.*

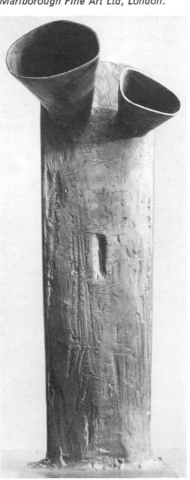

997. *Top.* ROBERT CLATWORTHY (b. 1928). Bull. Bronze. 1956. *Tate Gallery.*

998. F. E. McWILLIAM (b. 1909). Crankshaft Figure II. Bronze. 1963. *Waddington Galleries, London.*

999. LYNN CHADWICK (b. 1914). Monitor. 1964. *Artist's Collection.*

1000. EDUARDO PAOLOZZI (b. 1924).
Hermaphroditic Idol No. 1.
Aluminium. 1962. *Museu de Arte
Moderna, São Paulo.*

1001. WILLIAM TURNBULL (b. 1922).
No. 3. Steel painted silver. 1964.
Artist's Collection.

diffuse bands of luscious colour, Robyn Denny (b. 1930) and Alan Charlton (b. 1948).

Hard Edge style with its effects obtained through linear pattern and flat, clearly defined areas of colour rather than the free use of paint. Painters such as John Plumb (b. 1927), Robyn Denny (b. 1930), John Hoyland (b. 1934) [1023] and Bridget Riley (b. 1931) [1021] present clear-cut outlines, aiming at making light and movement optically perceptible. The same effect is sought by Gwyther Irwin (b. 1931) in his collages.

' Pop ' art, with its interest in popular imagery and its witty adaptations of commercial art themes, resulted from the attempt to bring contemporary life again within the artist's vision. Adherents include Richard Smith (b. 1931), Peter Blake (b. 1932), Allen Jones (b. 1937) [1022] and the American R. B. Kitaj (b. 1932), also Derek Boshier (b. 1937), Joe Tilson (b. 1928), Tom Philips (b. 1937), Richard Hamilton (b. 1922) and Patrick Caulfield (b. 1936) and the painters who can roughly be called the New Realists including Malcolm Morley (b. 1931), Anthony Green (b. 1939), John Salt (b. 1937) and the popular David Hockney (b. 1937).

Stained glass. John Piper has executed some windows for Eton, and the baptistery window for Coventry cathedral. The ten large windows in Coventry cathedral are the work of Lawrence Lew (b. 1909), Geoffrey Clarke (b. 1924) and Keith New (b. 1927).

Tapestry and textiles. *Christ in Glory surrounded by the Apostles* was designed by Graham Sutherland for Coventry cathedral. Prominent among weavers is Peter Collingwood (b. 1922).

Graphic arts. In his work in the graphic arts Paul Nash was influenced first by Cubism and then by Surrealism. Stanley William Hayter (b. 1901) has done pioneering non-figurative work that has influenced North American artists as well as the Chilean painter Matta [1024].

The minor arts. Leading potters include: W. S. Murray (b. 1881), Bernard Leach (b. 1887), M. Cardew (b. 1901), Lucie Rie (b. Australia, 1902) and H. Coper (b. 1920). Sir Ambrose Heal (1872–1959) was a pioneer of modern furniture; among the leading designers today are Ernest Gordon Russell (b. 1892) and Robin Day (b. 1915).

IRELAND

Painting. Irish painters have turned away from traditionalism and are deeply interested in the geometrical abstractions of Celtic art. This is true

1002. KENNETH MARTIN (b. 1905).
Screw Mobile. Phosphor bronze and steel. 1956–1959. *Artist's Collection.*

1003. MATTHEW SMITH (1879–1959).
Model Turning. 1924. *Tate Gallery.*

1004. MARK GERTLER (1891–1939).
Merry-Go-Round. 1916. *Ben Uri Art Gallery, London.*

1005. WYNDHAM LEWIS (1882–1957). The Surrender of Barcelona. 1937. *Tate Gallery.*

1006. EDWARD BURRA (1905–1976). Harlem. 1934. *Tate Gallery.*

1007. L. S. LOWRY (1887–1976). The Pond. 1950. *Tate Gallery.*

of Louis Le Brocquy (b. 1916), whose irregular and angular figures are curiously simplified. Mano Reid (b. 1910) studied in London and Paris before developing a vigorous, personal form of expression.

GERMANY

Architecture. The battle on behalf of a modern architecture, which at first implied Art Nouveau and later functionalism, was fought principally in the Germanic countries. Although at the beginning of the 20th century Germany still preferred a heavy, robust, neo-medieval style, the ruling powers, the Grand Dukes, had begun to show an interest in innovations. Thus they summoned from Brussels, London and Vienna architects such as van de Velde, Baillie Scott and Olbrich, who all helped to formulate the Jugendstil (Art Nouveau). Other architects who were utterly opposed to the Jugendstil experimented along different lines. Among these was Alfred Messel (1853–1909), the first modern German architect. He studied in Cassel, Berlin and Rome. His first buildings were eclectic, but he soon began to search for unified forms and learnt much from the structural use of iron and glass, which he employed for the Wertheim store (1896–1904) [581] in Berlin. Avant garde architects and designers formed a group in Munich about 1900. Dutch, Belgian, Scottish and French influences affected them, especially those of Mackintosh, the Scottish architect, and van de Velde, the Dutch architect who taught at Weimar. This Munich group collaborated in the production of the review *Jugend* and created the *Vereinigten Werkstätten für Kunst im Handwerk* (working class art studios).

The man who had the greatest influence, not only in his own country but on international architecture as a whole, was Peter Behrens (1868–1940) [736, 1025]. His influence came not only from his work but from his teaching, as well as from the exceptional ability of his disciples; Gropius, Mies van der Rohe and Le Corbusier worked with him before going on to their own individual achievements. Invited to Darmstadt in 1899, he built his own house in 1901 on Art Nouveau principles. While head of the Düsseldorf art school (1903–1907) he developed a geometrical and increasingly sober style (concert hall, Cologne; Schroeder house, Eppenhausen, 1909). In 1909 he succeeded Messel as architect to AEG, the electricity company, one of the most powerful firms in Europe. His contacts with engineers and the utilitarian nature of the building programme inclined him towards bare, logical constructions in which he

1008. JOHN PIPER (b. 1903). St Mary le Port, Bristol. 1940. *Tate Gallery.*

1009. GRAHAM SUTHERLAND (1903–1980). Owl in Tree Form. 1962. *Marlborough Fine Art Ltd, London.*

1010. ROBERT COLQUHOUN (1914–1962). Woman with Still Life. 1958. *Tate Gallery.*

1011. FRANCIS BACON (b. 1909). Study for Figure at the base of a Crucifixion. c. 1944. *Tate Gallery.*

1015. ALAN DAVIE (b. 1920). Entrance for a Red Temple No. 1. 1960. *Tate Gallery.*

1012. KEITH VAUGHAN (b. 1912). Keddington Triptych. 1959. *Mr and Mrs Jim Holman Collection, London.*

1013. PETER LANYON (1918–1964). Thermal. 1960. *Tate Gallery.*

1016. JACK SMITH (1925–1965). Bottles in Light and Shadow. 1959. *Tate Gallery.*

1018. *Left.* CERI RICHARDS (1903–1971). La Cathédrale Engloutie (Profondement Calme). 1961. *British Council, London.*

1019. *Right.* VICTOR PASMORE. Abstract in White, Black, Indian and Lilac. Painted relief construction. 1957. *Tate Gallery.*

1014. ROGER HILTON (b. 1911). The Aral Sea. 1958. *Peter Stuyvesant Foundation Ltd.*

1017. VICTOR PASMORE (b. 1908). Spiral Motif in Green, Violet, Blue and Gold: The Coast of the Inland Sea. 1950. *Tate Gallery.*

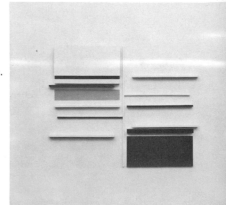

1020. JOHN ERNEST (b. 1922). Mosaic Relief I. Cellulose on hardboard-aluminium. 1960. *Artist's Collection.*

1021. BRIDGET RILEY (b. 1931). White Disks II. 1964. *Victor Musgrove Collection.*

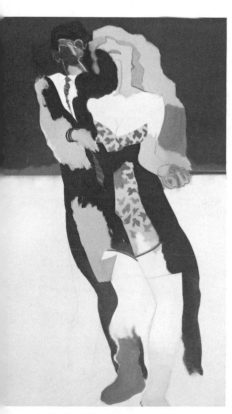

1022. ALLEN JONES (b. 1937). Hermaphrodite. 1963. *Walker Art Gallery, Liverpool.*

1023. JOHN HOYLAND (b. 1934). No. 42. 1961. *Albright-Knox Art Gallery, Buffalo.*

1024. JOHN GOLDING. G (BE) XI. Acrylic on cotton duck. 1979. Rowan Gallery, London.

employed iron, concrete and glass (AEG turbine factory, Berlin, 1909 [736]); housing at Henningsdorf in the Berlin suburbs, 1910–1911; office blocks in Hanover, 1911–1912, and Düsseldorf). In 1930 he was appointed Director of the School of Architecture in the Vienna Academy. His wide range of activities was linked with the industrial growth of Germany, and his ideas were amplified by the fact that he occupied leading posts; he took part in the creation of the Deutscher Werkbund (1907), whose avowed aim was to select the best artists and craftsmen and to secure a high quality in industrial art. Among those associated with the venture in its early years were Theodor Fischer, Richard Riemerschmid, Hans Poelzig, Joseph Hoffmann and van de Velde. In 1914, just before the War, the Werkbund held an important exhibition of industrial art at Cologne to demonstrate the close links between architecture and industry. The buildings included some of the most significant early examples of modern architecture in steel, concrete and glass. Bruno Taut's contribution was a pavilion for the German glass industry, consisting of a glass drum with a pointed glass dome. But the most notable building of the exhibition was the model factory administrative unit and garage designed by Walter Gropius and Adolf Meyer. Both buildings exhibited the close connection between function and expressive form which continued into the 1920s. Nearly all the architects who made a significant contribution during this period went through an Expressionist phase (Mendelsohn's Einstein Tower at Potsdam, 1921 [1026]; Hans Poelzig's Grosses Schauspielhaus, Berlin, 1919; Mies van der Rohe's memorial to Karl Liebknecht and Rosa Luxemburg, 1926; Gropius' War memorial at Weimar, 1922).

Walter Gropius (1883–1969) [798, 1095] was one of the greatest architects and teachers of the 20th century. He trained at Munich (1903–1905) and then in Berlin (1905–1907) in the office of Behrens. His first important building was the Fagus shoelace factory at Alfeld

an der Leine, built in 1911 in collaboration with Adolf Meyer, which marked a significant advance in steel and glass construction. For the famous Deutscher Werkbund Exhibition at Cologne in 1914, Gropius and Meyer designed the administrative office building, in which the circular glass towers enclosing the staircase represent the first use of such a feature in modern building. Gropius believed in the unity of design and craft, of art and technics, and was able to implement his ideas as Director of the Bauhaus, first at Weimar (1919–1925) and then at Dessau (1925–1928). The Bauhaus building itself, which shows a classical restraint and an excellence of proportion, embodies Gropius' belief that a building should be the product of team-work [798]. The ideas and teaching of the Bauhaus exercised a profound influence. One of the chief aims of the Bauhaus was to unite art and craft, training being directed to the creation of forms to serve as models for mass-production. (Ultimately the Bauhaus was moved to Berlin, where it closed in 1933.)

At the Stuttgart Exhibition in 1927, organised by the Deutscher Werkbund, Gropius presented two types of private house as well as some houses in light prefabricated alloys. Gropius resigned from the directorship of the Bauhaus in 1928 and was replaced by Mies van der Rohe.

In 1934, after the advent of national socialism Gropius, like many of his collaborators, had to emigrate. He took refuge at first in England, where he went into partnership with Maxwell Fry. In 1937 he was appointed Professor of Architecture at Harvard; later he became an American citizen.

The career of Ludwig Mies van der Rohe (1886–1969) [678, 1027, 1098, 1106] resembled that of Gropius. His first training was given him by his father, a master mason at Aachen. After working with various architects in Berlin he entered Behrens' office in 1908, before branching out on his own in 1913. His underlying concern has been to create a modern architecture with a neoclassical severity of means, purity of form,

1025. GERMANY. PETER BEHRENS (1868–1940). Entrance hall of the I. G. Farben dye-works at Höchst. 1920–1924.

perfection of proportions, elegance of detail and dignity of expression. He joined the November Gruppe, founded in 1918, and in their annual exhibitions launched a series of astonishingly varied and original projects, including plans for two glass skyscrapers and a reinforced concrete office building with ribbon windows. His two major works in the 1920s were the Weissenhof in Stuttgart (1927) and the German pavilion for the Barcelona Exhibition (1929). The latter remained a model for a long time, not only for its structural design but for the interior lay-out, and also for the furniture which he designed himself. The work is remarkable not only for its general harmony of line but also for the meticulous finish of the details. The following year he became Director of the Bauhaus; he built private houses which open on to interior gardens (Tugendhat house, Brno, 1930, the most important of his European career). Two years before the War he moved to the United States,

becoming an American citizen in 1944 (see under *United States*).

Erich Mendelsohn (1887–1953) [1026] used the new methods of construction with originality and imagination, and he embodied in his buildings the quality of organic unity. The influence of the Expressionist movement can be seen in some of his early work (Einstein Tower at Potsdam, 1921). The Columbus Haus, Berlin (1931), and the Schocken store at Chemnitz (1928) represent his best work in Germany. The façades of both have long bands of fenestration alternating with opaque bands; the effect is one of both lightness and grandeur. In 1933 he left Germany and until 1939 divided his practice between England and Palestine before settling in the United States in 1941.

Hitler's Germany was anxious to produce a Germanic architecture which would oppose international trends. There were in fact several different styles, according to the nature and purpose of the building. The big state

1026. GERMANY. ERICH MENDELSOHN (1887–1953). Einstein Tower, Potsdam. 1921.

1028. GERMANY. HARALD DEILMANN (b. 1920). Municipal theatre, Münster (with von Hausen, Rave and Ruhnan). 1956.

1027. CZECHOSLOVAKIA. LUDWIG MIES VAN DER ROHE (1886–1969). Tugendhat house, Brno. 1930.

1029. GERMANY. DIETER OESTERLEN. Nave, St Martin, Hanover. 1957.

374

buildings had to provide an image of power and permanence. Grandiose plans were drawn up by Albert Speer to endow the capital and the big towns with vast monumental vistas leading up to pompous neoclassical buildings (the Reichstag, 1938). On the other hand, educational, recreational and social buildings aimed to blend in with their regional and rural surroundings. Factories, shops, laboratories and hospitals benefited from the functional programme worked out previously by the Bauhaus.

Since the War there has been extensive rebuilding. Among the more interesting theatres are those at Münster (1954–1956) [**1028**], Gelsenkirchen (1958–1959), the concert hall at Stuttgart (1955–1956) and the Philharmonic Hall, Berlin (1956–1963) by Hans Scharoun (b. 1893) where Gropius' concept of Total Theatre, in which the audience surrounds the performers, is explored. New churches are unsurpassed in Europe for quality or quantity: St Martin, Hanover (Oesterlen) [**1029**]; St Anna, Düren (1951–1956) and St Michael, Frankfurt (1953–1954), by Rudolf Schwarz (1897–1961). The reconstruction of the ruined Hansa quarter of Berlin was undertaken by leading architects (Gropius, Aalton, Niemeyer) and opened in 1957 as the Interbau Exhibition. More recent buildings in Berlin include the stark, simple National Gallery (1968) by Mies van der Rohe, the State Library by Hans Scharoun (1971–1978) the block housing of Josef Kliehuis and the Free University (1963–1973) by the Team X architects Wood and Schiedheim. The Municipal Museum, Münchengladbach by Hans Hollein and Thomas van den Valentyn has a simple white interior with natural, controlled lighting; the Phoenix–Rheinrohr Building, Düsseldorf (1957–1960) by Hentrich and Petschnigg is a monumental high-rise building.

Sculpture. In Germany, Adolf von Hildebrand (1847–1921) was influenced by classical art and by the Florentine Renaissance, which enabled him to escape from the literary naturalism of the 19th century; he advocated a return to direct carving and embodied this doctrine in his monuments. His ideas were perpetuated by Hermann Hahn (1868–1942), who remained within the Munich tradition. August Gaul (1869–1921) gave new life to the art of animal sculpture; Ludwig Kasper (1893–1934), a pupil of Hahn, was interested in a static composition. A new and significant quality underlies the paintings and sculpture of Käthe Kollwitz (1867–1945). She turned to social realism, and her rather Expressionistic work is imbued with a sense of suffering (*Circle of Mothers*,

bronze, 1937). Ernst Barlach (1870–1938) [**718**], after a training at Dresden and in Paris, did illustrations for the review *Jugend* (1898–1902). After a visit to Russia in 1906, decisive in his development, he settled in Güstrow in 1910. In his Expressionist works he combined Cubist construction with a powerful dramatic manner, animated by a single, dynamic movement (*Avenger*, 1923; *Fugitive*, 1920). Working primarily in wood, he was always concerned with full-length figures whose draped bodies remain anonymous. In his groups the figures merge to express a single unified idea (*Women Singing*, 1911; *Death*, 1925). His affinity with Gothic art is obvious, especially in his War memorials at Kiel and Güstrow (both destroyed by the Nazis). Bernhard Hoetger (1874–1939), an architect as well as a sculptor, vacillated between various influences without finding a personal style. In the figures of George Kolbe (1877–1947) elegance outweighs strength. Karl Albiker (b. 1878) was a pupil of Rodin, by whom he was influenced before turning to a heroic form of expression (monument to Count Zeppelin, at Constance). Clara Westhoff-Rilke (1878–1954) had been a pupil of Rodin; it was she who led the poet Rilke to make a literary study of sculpture.

Wilhelm Lehmbruck (1881–1919) [**1030**], whose work is in the Expressionist tradition, trained at Düsseldorf and came under the influence of Meunier and then of Rodin. After going to Paris in 1910 he was influenced by Maillol and became more concerned with an architectural quality (*Nude Woman Standing*, 1910). In the following year he executed his *Kneeling Woman*, a work of great intellectual refinement and purity of feeling. In his male nudes (*Seated Youth*, 1918, Städtisches Kunstmuseum, Duisburg) the limbs are elongated to the point of slenderness but without losing their inner structure or vitality. While his female nudes remain thoughtful and solemn, his men seem crushed by melancholy. His portrait busts show dejection or grief. He committed suicide in 1919. Renée Sintenis (b. 1888), who is more Impressionistic, captures fleeting movement in her animal forms. In the work of Hermann Blumenthal (1905–1942) the structural frame of the human body is emphasised while the features are expressionless. The same concern for basic form is to be found in the work of Edwin Scharff (1887–1955), but the geometrical aspect of the body is less marked. A pupil of Hahn in Munich and later influenced by Maillol in Paris (1925–1927), Toni Stadler (b. 1888) is attracted by the Mediterranean spirit and is 'archaistic' in style. Gerhard Marks (b. 1889) was invited by Gropius to teach at the Bauhaus in

1030. WILHELM LEHMBRUCK (1881–1919). Seated Youth. Bronze. 1918. *Städtisches Kunstmuseum und Lehmbruck-Sammlung, Duisburg.*

1031. OSKAR SCHLEMMER (1888–1943). Abstrakte Rindplastik. Gilded bronze. 1921. *Bayerische Staatsgemäldesammlungen, Munich.*

375

1032. HANS UHLMANN (b. 1900).
Steel Relief. 1959. *Physics Institute,
University of Freiburg (Breisgau).*

1033. GUNTHER UECKER (b. 1930).
White Field. 1964. *Tate Gallery.*

1034. HEINZ MACK (b. 1931).
Silver-Dynamo. Aluminium and
glass, with motorised rotor. 1960.
Artist's Collection.

1035. HANS UHLMANN. Rondo.
Brass. 1958–1959. *Artist's Collection.*

1036. NORBERT KRICKE (b. 1922).
Space Sculpture. Steel. 1960.
*Countess J. de Beaumont
Collection, Paris.*

Weimar (1920–1925). Black-listed by
the Nazis, he returned in 1946 to teach
at Hamburg. His work is of a pure,
simplified, sober style. The same ten-
dency can be seen in the work of Emy
Roeder (b. 1890). The tendency to
archaism can be seen in the work of
Gustav Seitz (b. 1908). Known ini-
tially as an animal sculptor, Ewald
Matore (b. 1887) remains faithful to the
process of simplifying the human form;
his work falls largely into the category
of decoration; he combines polychrome
enamel with bronze (doors for Cologne
cathedral and for the church at Hiro-
shima). The sculpture of Kurt Lehmann
(b. 1905), Bernhard Heiliger (b. 1915)
and Fritz Koenig (b. 1924) is closer to
abstract art.

Hermann Obrist (1873–1927), one
of the spokesmen of the Jugendstil, was
a pioneer of abstract sculpture; he created
imaginary forms (*Evolution*, plaster,
1914). Rudolf Belling (b. 1886) was one
of the founders of the November
Gruppe in 1918. With Obrist he is one
of the pioneers of abstract sculpture in
Germany. His experiments in the
relationship of volume to space led to a
counterpoint of hollow and solid forms
(*Threefold Harmony*, wood, 1919). In
1933 he emigrated to Turkey where he
teaches sculpture at the Istanbul
Academy. Oskar Schlemmer (1888–
1943) [**1031**] was invited by Gropius to
the Bauhaus in 1920, where he taught
sculpture and theatrical production.
Although primarily a painter, he pro-
duced sculpture of considerable impor-
tance. At the Bauhaus he executed a
series of reliefs in coloured cement which
combined painting and sculpture into
architectural units intended to define
space. In 1931 he produced the first
German iron-wire construction, con-
sisting of a stylised figure of circles and
curves having a head made of blades of
steel. Important from the point of view
of Surrealism are the sculptures of Max
Ernst, the first experiments of Otto
Baum (b. 1900), and also his abstract
reliefs, and above all the work of Karl
Hartung (b. 1908), who is reminiscent
of Arp and Brancusi in his love
of beautiful materials — marble,
granite, wood and bronze. In addition to
his geometric compositions, there are
others, equally abstract, which preserve
the formalised shape of the human body
within a massive, block-like contour.
Apart from Schlemmer, Hans Uhlmann
(b. 1900) [**1032, 1035**] was the first Ger-
man sculptor to work in iron wire; he
used thin plates which he cut out and
superimposed in a way reminiscent of
Cubist collages. In his later works he
has replaced light metal rods by strips
of steel in rectangular sections. Norbert
Kricke (b. 1922) [**1036**] has throughout
his career been concerned with open
constructions. His first works consisted

of metal bands or tubes in zigzag arrangements which reach out into the surrounding space. More recently the contours have been broken up and the tubes trace restless curves. Gunther Haese (b. 1924) creates light and fragile constructions in contrast to the solid blocks of Ulrich Rückriem (b. 1938).

Gunther Uecker (b. 1930) [1033] and Heinz Mack (b. 1931) [1034] are both members of the avant garde Zero group in Düsseldorf. This group resembles the Groupe de Recherche d'Art Visuel in Paris in its desire for a 'kinetic' art closely linked to technology.

Exponents of Post-Object Art include Heiner Ruthenbeck (b. 1937), Klaus Rinke (b. 1939), Hans Haacke (b. 1936) and Bernhard and Hilda Becher (b. 1931 and 1934). Wold Vostell (b. 1932), Albrecht D. (b. 1944), Franz Erhard Walther (b. 1939), Josef Beuys (b. 1921, Peter Kuttner and Carolee Schneeman are involved in Body and Performance Art.

Painting. Expressionism, a movement whose roots were deep in the northern European tradition, was foreshadowed in Germany in the work of Paula Modersohn-Becker (1876–1907) [1037]. The group with which the tendency took shape as a movement, the Brücke (the Bridge), was a federation of artists founded in 1905 in Dresden by Fritz Bleyl and some artists from the Dresden technical school — Ernst Ludwig Kirchner (1880–1938) [719; see colour plate p. 296], Erich Heckel (1883–1970) [1040] and Karl Schmidt-Rottluff (1884–1976) [1041]. They tried to attract all the revolutionary elements of the period. In 1906 Emil Nolde (1867–1956) [656, 1038; see colour plate p. 295] and Max Pechstein (1881–1955) [1042] joined, and in 1910, Otto Müller (1874–1930). The group moved to Berlin in 1910 and was dissolved in 1913. This movement, the beginning of modern art in Germany, was the contemporary equivalent of Fauvism, which was its main inspiration. After the move to Berlin individual styles became more pronounced; Heckel and Kirchner evolved in the direction of an Expressionism intensified by broken forms and dissonant colours. Kirchner was the dominant personality of the group, the influences of Munch and African art leading him to simplify form and colour. In Berlin after 1911 his portraits and street scenes conveyed the acid flavour of the intense, artificial life of that city. He left Germany in 1917 for Switzerland, where the mountain scenery deeply impressed him. Schmidt-Rottluff's lithography and woodcuts influenced his painting, in which simple flat forms in pure colours are united in a vigorous rhythm. Within the group his works stand out through their

1037. PAULA MODERSOHN-BECKER (1876–1907). Self-portrait. 1907. *Folkwang Museum, Essen.*

1038. EMIL NOLDE (1867–1956). The Prophet. Woodcut. *National Gallery, Washington.*

1039. ALEXEI VON JAWLENSKY (1864–1941). Peonies. *Städtisches Museum, Wuppertal.*

1040. ERICH HECKEL (1883–1970). Spring in Flanders. 1916. *Karl-Ernst-Osthaus Museum, Hagen.*

1041. KARL SCHMIDT-ROTTLUFF (1884–1976). Landscape, Lofthus, Norway. 1911. *Kunsthalle, Hamburg.*

1042. MAX PECHSTEIN (1881–1955). Under the Trees. 1915. *Detroit Institute of Arts.*

377

1043. AUGUST MACKE (1887–1914).
Woman with a Green Jacket. 1913.
Wallraf-Richartz Museum, Cologne.

1044. FRANZ MARC (1880–1916).
Blue Horses. *c.* 1911. *Walker Art
Center, Minneapolis.*

architectural quality and their synthesis
between the illusion of space and the
organisation of the surface. Nolde
studied in Munich, Paris and Copen-
hagen. In 1904, after Impressionist
beginnings, his touch became stronger
and his colour more dominant. In
addition to landscapes of his native
Schleswig region, he painted fantastic
and grotesque figures. In 1908 his art
attained its peak of monumentality;
expressive colour emerged forcefully.
To this period belong his large religious
compositions (*Last Supper*), his figures
from his personal mythology (*Warrior
and his Wife*) and the still lifes with
masks, the primitive statuettes and the
exotic textiles. His graphic work is
among the most exciting in modern
German art.

The Blaue Reiter (the Blue Rider),
derived from the title of a picture by
Kandinsky, was the most fertile artistic
movement in Germany before 1914.
Munich was one of the main centres of
artistic activity at the beginning of the
century and in 1896, when Kandinsky

settled there, the Jugendstil was para-
mount. In 1902 he opened his own
school of art and became head of the
Phalanx group. In 1909 Kandinsky,
Alexei von Jawlensky (1864–1941)
[**1039**], Kubin and others formed the
New Artists' Federation (which Franz
Marc joined). The first exhibition of the
Blaue Reiter group was held in 1911,
and in the following year Paul Klee
joined. The War dispersed the group;
Macke and Marc were killed; Klee and
Kandinsky went on to the Bauhaus in
the 1920s.

Wassily Kandinsky (1866–1944)
[**805**; see colour plate p. 314], who was
born in Russia, began his studies in
Odessa before studying law in Moscow.
He abandoned law for painting in 1896
and came to Munich. His Impressionist
period was succeeded by a lively
Fauvism, better adapted to imaginative
themes than to realism and accentuated
by a year in Paris (1906–1907). In 1910
he painted his first non-representational
works, and between 1910 and 1920 he
painted works characterised by their
violent movement and vivid colours.
He returned to Russia in 1914–1921; in
1922 he became a teacher at the Bau-
haus in Weimar. There, with Klee,
Jawlensky and Feininger, he formed the
Four Blues group (1924). From 1920
more precise forms began to emerge in
his works — dots, broken lines, seg-
ments of circles and rectangles — signs
employed for their own sake. In 1933,
after the closing of the Bauhaus, he
moved to Paris. He has had a great
influence through his theoretical writ-
ings (*Concerning the Spiritual in Art*,
1912).

Paul Klee (1879–1940) [**806, 1045–
1049**; see colour plate p. 314], is one of
the most inventive and imaginative
artists of the 20th century. Although
born in Switzerland, he made his career
in Germany, settling in Munich; be-
tween 1908 and 1910 he was influenced
by Cézanne, van Gogh and Matisse. In
1914 a decisive journey to Tunisia
brought him a new awareness of colour.
From 1920 he taught at the Bauhaus,
returning to Switzerland in 1933. His is
an art of free fantasy, revealing a hidden
dream existence which emerges in his
drawings as well as his paintings. In the
former he creates his own world of
twisting lines, hieroglyphics, fluid signs,
with a rhythm based on association and
a suggestion of perpetual activity. In
his paintings, mostly on small canvases
or paper, he achieves space and vibrancy
with coloured planes. A rare feeling
gives his work an association with
music and poetry and lends form to the
fleeting and evanescent. 'Nothing can
replace intuition,' he wrote in his *Peda-
gogical Sketchbook* (Munich, 1925).

The other important members of the
Blaue Reiter were Franz Marc (1880–

1916) [**739, 1044**; see colour plate p. 296]
and August Macke (1887–1914) [**1043**].
Marc attained a personal style after
years of struggle, partly through the
influence of Delaunay. He aimed at a
spiritual reality beyond the illusion of
nature, his studies of animals enabling
him to find an essential form in which
to convey tenderness and nobility (*Blue
Horses*, 1911 [**1044**], Walker Art Center,
Minneapolis; *Tigers*, 1912, Brooklyn
Museum of Art). In 1913 the forms
began to interpenetrate, while the
colours brightened and grew more
transparent (*The Fate of Animals*, 1913
[see colour plate p. 296]); still later,
the paintings became abstract (*Fighting
Forms*, 1914 [**739**]). Where Marc turned
towards the expression of a spiritual
reality, Macke remained deeply con-
cerned with visual experience. The
influence of Cubism and Futurism and
of Delaunay helped him to find his own
idiom of graceful forms and luminous
colour. Heinrich Campendonk (b. 1889)
was also a member of the Blaue
Reiter.

After 1918 German painting turned
either to political and social commit-
ment or to Expressionism. Among the
leading figures was George Grosz (1893–
1959) [**721, 1050**], at first a caricaturist
for satirical papers. In 1918–1920
he was a member of the Dada move-
ment; in 1925 he joined the Neue Sach-
lichkeit movement. His ferocious satires
attacked the social corruption of Ger-
many (capitalists; prostitutes; Prussian
military caste; Nazi brutality). He
settled in the United States in 1933.
Max Beckmann (1884–1950) [**1051**]
worked in Berlin and Frankfurt before
going to Amsterdam in 1936. His main
theme was the human figure — its vital
force, its misery and debasement, its
nightmarish visions. In his later works
he was concerned with the enigma of
existence, which he portrayed in
allegorical language and with a free use
of colour. Otto Dix (1891–1969) [**1052**]
was also concerned with society.
His symbolic and bitter paintings were
dismissed by the Nazis as ' decadent
art '. Karl Hofer (1878–1955) also
worked in an Expressionist style.

Kurt Schwitters (1887–1948) [**1053**]
was influenced initially by Cubism; he
created his own form of Dada at
Hanover during the 1920s and called it
Merz; using such materials as tickets,
feathers, cork and wood he produced
collages and constructions transfigured
by his imagination. In his first Merzbau
(a column decorated with collected
odds and ends) in his house in Hanover
he combined and superimposed similar
ready-made elements. During the War
he came to England and was working
on his third Merzbau when·he died.
Willi Baumeister (1889–1955) [**1054**]
developed from 1919 to 1931 a highly

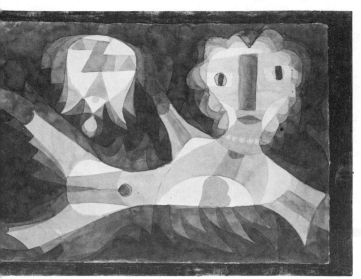

1045. Goldfish Wife. Watercolour. 1921. *Philadelphia Museum of Art.*

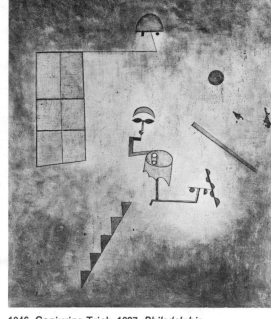

1046. Conjuring Trick. 1927. *Philadelphia Museum of Art.*

1047. La Belle Jardinière. 1939. *Klee Foundation, Berne.*

1048. Jörg. Watercolour. 1924. *Philadelphia Museum of Art.*

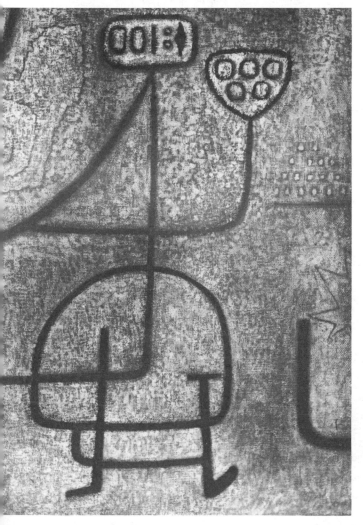

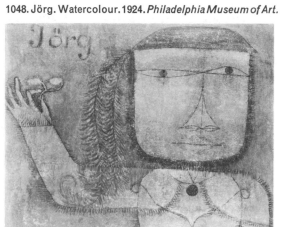

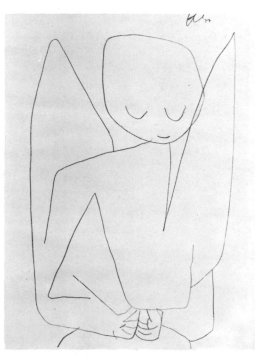

1049. *Right.* Forgetful Angel. Pencil. 1939. *Klee Foundation, Berne.*

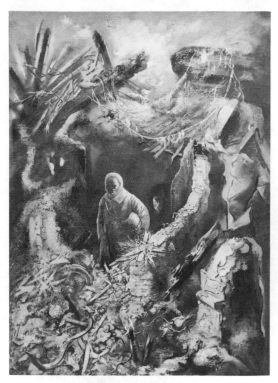

1050. GEORGE GROSZ (1893–1959). Peace II. 1946. *Whitney Museum of American Art, New York.*

1051. MAX BECKMANN (1884–1950). Self-portrait with Saxophone. 1930. *Kunsthalle, Bremen.*

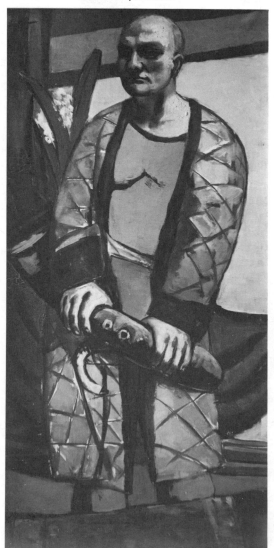

personal style, embracing both Cubist and Constructivist elements, which had a great influence on the younger generation.

The Bauhaus, a school of design, architecture and the crafts, founded by Gropius in Weimar in 1919, was transferred to Dessau in 1925 and closed down in 1933 (after having been transferred once again, to Berlin). Gropius' ideal of reviving the lost unity in the arts, in relation to modern architecture on the one hand and the needs of an industrial civilisation on the other, had an immense influence. He brought together at the Bauhaus the most brilliant and original teachers of the period: Kandinsky, Klee, Oskar Schlemmer (1921), Laszlo Moholy-Nagy and Lyonel Feininger. Schlemmer and Moholy-Nagy [832] promoted the technique of working in metal and plastic and gave new life to the arts of the theatre and the ballet and photography and typography. Feininger (1871–1956) [1135; see colour plate p. 296] best exemplified the constructivist aesthetic doctrine in the transparent fluidity of his colours, in interpenetrating segmented planes, which create a pure and crystalline atmosphere. In 1937 Feininger left Germany and went to New York (see under *United States*). Another Bauhaus painter who settled in America was Josef Albers (1888–1976) [**1055**]. In 1933–1950 he taught at Black Mountain College, North Carolina, where he helped to spread the Bauhaus ideas. In 1955 he was given a professorship at Yale University.

1053. KURT SCHWITTERS (1887–1948). Opened by Customs. Collage. *c.* 1937–1939. *Tate Gallery.*

1052. *Below*. OTTO DIX (1891–1969). The Artist's Parents. 1924. *Niedersachsisches Landesmuseum, Hanover.*

1054. *Above*. WILLI BAUMEISTER (1889–1955). Jour Heureux. 1947. *Musée d'Art Moderne, Paris.*

Since the Second World War an interesting generation of painters has appeared, which includes: K. R. H. Sonderborg (b. Denmark, 1923), Walter Raum (b. 1923), Alfred Winter-Rust (b. 1923), Hal Busse (b. 1926), Peter Bruning (b. 1929), Raimund Girke (b. 1930), Bernhard Boes (b. 1931), Heimrad Perm (b. 1934), Horst Antes (b. 1936), Walter Stöhrer (b. 1937), Peter Brüning (b. 1929) with his cartographical symbols, Michael Buthe (b. 1944), Gerhard Richter (b. 1932), Peter Klasen (b. 1935), George Karl Pfahlen (b. 1926), Lothar Quinte (b. 1923), Maina-Miriam Munsky (b. 1943) and Herbert Oehm (b. 1935).

The minor arts. The industrial arts followed the same trends as architecture, and for that reason broke away from the Art Nouveau stylisations much sooner than in other countries. The exhibition at the Bing gallery in 1896 of furniture by van de Velde, who ran a workshop in Weimar from 1902, steered taste towards more abstract forms; English furniture was also influential. Before 1914 Germany made important advances in modernisation and comfort (interiors by Behrens, Bruno Paul, Margold). In 1924 the architect Marcel Breuer (b. Hungary, 1902; see under *United States*) took over the direction of the department of furniture design at the Bauhaus. His standardised furniture was the most notable contribution in this field in the 1920s. In 1925 he invented a series of systems employing continuously bent steel tubes as the structural frames of stools, chairs and tables. His S-shaped cantilever chair of tubular steel (1928) remains the most commonly used commercial chair. Later he developed some of the first bent and moulded plywood chairs.

AUSTRIA

Architecture. Otto Wagner (1841–1918) [**794**], a precursor of 20th-century architecture, was the founder of the Vienna school, which achieved fame through Adolf Loos, Joseph Hoffmann and Joseph Olbrich. In the 1890s, while teaching at the Vienna Academy, he formulated the view that architecture must take the requirements of modern life as its point of departure; he extolled horizontal lines, flat roofs and sparing use of ornament. The influence of Art Nouveau was apparent in his Stadtbahn Station in the Karlsplatz (1899–1901), with its steel frame and floral decoration, but in the later Post Office Savings Bank in Vienna (1904–1906) the economy of plan and flexible handling of space and the absence of ornament truly illustrate his ideals. Joseph Maria Olbrich (1867–1908) [**797**], the pupil of Wagner, was a co-founder of the Vienna Sezession, whose exhibition building he designed in 1898–1899. He developed towards the rationalism of Loos in his Hochzeitsturm at Darmstadt (1907). In 1900 C. R. Mackintosh's decoration of a room in the Sezession gallery strengthened the influence of Art Nouveau. His rationalistic theories had a decisive influence on his disciple Joseph Hoffmann (1870–1945). Hoffmann taught at the applied arts school from 1899 and with Karl Moser set up a group of studios and workshops which, as the Wiener Werkstätte, enjoyed fame for thirty years. In 1897 he joined with other artists, including Olbrich, in founding the Vienna Sezession; influenced by the Glasgow school and Belgian and French Art Nouveau, its aims were more radically modernist than Wagner's. In 1907, with Gustav Klimt, Hoffmann founded the Kunstschau, a new avant garde movement. The Purkersdorf sanatorium (1903) established him as one of the leaders of the new style. His Stoclet house, Brussels (1905–1911), although based on rationalist theories, is exquisitely refined. In 1920 he was appointed city architect to Vienna, but with the rise of De Stijl and the Bauhaus his work became anachronistic [**1056**].

Adolf Loos (1870–1933) was one of the first architects to react against the decorative trends of Art Nouveau. In the United States in 1893–1896 he was able to study the innovations of the Chicago school. In Vienna in 1896 he reacted against the aestheticising doctrines of Klimt, Olbrich and Hoffmann,

1055. JOSEF ALBERS (1888–1976). Homage to the Square: Apparition. 1959. *Solomon R. Guggenheim Museum, New York.*

1056. BELGIUM. JOSEPH HOFFMANN (1870–1945). Stoclet house, Brussels. 1905–1911.

1057. *Above, left.* FRITZ WOTRUBA (1907–1975). Figure with Raised Arms. Bronze. 1956–1957. *Joseph H. Hirshhorn Collection, New York.*

1058. *Above, right.* JOANNIS AVRAMIDIS (b. 1922). Large Figure. Bronze. 1958. *Rijksmuseum Kröller-Müller, Otterlo.*

holding that good form must find its beauty in the unity of its parts rather than in ornamentation. This rationalist philosophy underlies the Steiner house (Vienna, 1910) [675], one of the first private houses in reinforced concrete and a turning point in modern architecture, with its re-thinking in the matter of plan, its articulation of internal space, its flat roof, horizontal fenestration and plain, bare walls. In 1923 he settled in Paris where he built a house for Tristan Tzara (1926). His finest work is probably the Müller house in Prague (1930).

Marcel Breuer and Richard Neutra work mainly in the United States (see under *United States*).

Sculpture. Anton Hanak (1875–1934) joined the Vienna Sezession in 1911; he taught Wotruba and Leinfellner and is the link between two generations of sculptors of opposing tendencies. Fritz Wotruba (1907–1975) [**1057**], whose early style was classical, changed between 1939 and 1945; he sought to give the human form a primitive simplicity, and pursued an architectural treatment of the human figure, using juxtaposed angular blocks with rough surfaces. Since 1952 the blocks have become smoother and more refined. Heinz Leinfellner (1911–1974) used all materials; his compositions, at first dry and geometrical, became more supple and more decorative.

1059. *Above.* OSKAR KOKOSCHKA (1886–1980). Portrait of Professor Forel. 1910. *Stadtische Kunsthalle, Mannheim.*

1060. *Below.* OSKAR KOKOSCHKA. Delphi. 1956. *Niedersächsisches Landesmuseum, Hanover.*

Rudolf Hoflehner (b. 1916) fragments the human figure until it is no more than a construction of iron and steel. Joannis Avramidis (b. Russia, 1922) [**1058**], a pupil of Wotruba, also follows this tendency, but works in the round. Josef Pillhofer (b. 1921), a pupil of Wotruba, Karl Prantl (b. 1923), Hermann Walenta (b. 1923) and Wander Bertoni (b. 1925) give their own interpretations of forms inspired by nature. Hermann Nitsch (b. 1938), Gunter Brus (b. 1938), Rudolf Schwarzkogler (1940–1969) and Otto Muehl (b. 1925) are Viennese performance artists

Painting. It was in the cosmopolitan, sophisticated Vienna of the end of the 19th century that Art Nouveau found its supreme expression. Its leader there was Gustav Klimt (1862–1918) [**480**], who was responsible for the decoration of the university (1899–1900) and was until 1905 head of the Sezession. Hugo von Hofmannsthal, Peter Altenberg and Gustav Mahler all contributed to this atmosphere of aestheticism, an atmosphere which was evident even in the furniture and other household objects made by the Wiener Werkstätte. The masterpiece of Art Nouveau was Kokoschka's book *Die Träumenden Knaben (The Boy Dreamers*, 1908).

Oskar Kokoschka (1886–1980) [**774**, **1059**, **1060**] painted, between 1908 and 1914 in Vienna, Switzerland and Berlin, a series of Expressionistic portraits,

1061. *Above.* FRITZ HUNDERTWASSER (b. 1928). Der Grosse Weg. Plastic paint. 1959. *Österreichische Galerie, Vienna.*

1062. *Below.* SWITZERLAND. DANZEISEN and VOSER. Goldzack Elasticised Fabric plant, Gossau. 1955.

1063. *Above.* SWITZERLAND. WERNER MOSER (b. 1896). Interior of Reformed church, Reihen-Basle. 1964.

1064. *Below.* SWITZERLAND. HERMANN BAUR. Tower of the Bruder Klaus church, Birsfelden. 1958.

particularly of writers and actors, which are psychological documents of haunting insight. The colour is gloomy, the drawing nervous, the interest concentrated on character. Seriously wounded in the War in 1915, he settled at Dresden and came under the influence of the Brücke, particularly of their brilliant colour. Gradually his psychological concerns became less intense. From 1924 to 1930 he travelled in Europe, North Africa and Asia Minor painting cities and mountains, generally from an elevated or distant viewpoint (Paris, Lyon, Jerusalem, London, Prague). In his visionary works cities appear to be alive with legends and secrets. In 1938 he came to London, where he produced a number of large allegorical and historical pictures. After the War he took up landscape again, especially in Italy and Greece, with works dazzling in their colour. Egon Schiele (1890– 1918) [720], also an Expressionist, painted haunting, bitter works, often erotic, having a deeply personal symbolism.

An outstanding and individual talent among the younger painters is Fritz Hundertwasser (b. 1928) [1061], whose abstract paintings have a strong Surrealist undercurrent and are frequently brilliant in their colour.

1065. SWITZERLAND. WERNER
MOSER, Reformed church, Reihen-
Basle (with A. M. Studer).

The minor arts. The Viennese work-
shops produced wallpapers and hang-
ings and a variety of small objects of
great originality and impeccable taste.

The architects Peche and Reinhold
have worked in stained glass. Von
Gutersloh designs tapestry cartoons for
the Gobelins factory, as do Broeckl,
Eisenmenger and Kokoschka. Textiles
were designed by the architect Joseph
Hoffmann, who also had a great
influence on bookbinding, furniture,
goldsmiths' work, iron and pottery. The
potter Powolny makes models for glass
work, as did Adolf Loos.

SWITZERLAND

Architecture. From about 1901 Robert
Maillart (1872–1940) constructed
reinforced concrete bridges as techni-
cally daring as they are aesthetically
perfect (Rhine bridge, Tavanasa, 1905;
Arve bridge near Versey, 1936; Aire
bridge, Lancy, 1952–1954). Karl Moser
(1860–1936), whose church of St
Anthony, Basle (1926–1927), was the
first ecclesiastical building in Switzer-
land built entirely of reinforced con-
crete, taught the next generation at the
Zürich technical college (1915–1928).
Above all, Le Corbusier's ideas exerted
great influence, as did the Bauhaus,

directed by Hannes Meyer after
Gropius' resignation. CIAM was
founded at La Sarraz in 1928. The
buildings erected between 1930 and
1940 were excellent examples of func-
tional ideas; a high standard of housing
was achieved (Neubühl estate, Zürich,
1930–1932). Paul Artaria, E. F. Burck-
hardt, Karl Egender, Max Haefeli,
Werner Moser, Emil and Alfred Roth,
Hans Schmidt, Otto Senn and Rudolf
Steiger began to practise at this time.
Max Bill and Hans Fischli came from
the Bauhaus. New buildings since 1940
include: Freudenberg high school,
Zürich, 1960, by Jacques Schader;
Reformed church, Reihen-Basle, 1964,
by Werner Moser [**1063**, **1065**]; Gold-
zack Elasticised Fabric plant, Gossau,
1955, by Danzeisen and Voser [**1062**];
Bruder Klaus church, Birsfelden, 1958,
by Hermann Baur [**1064**]; Terrace
Apartments, Zug, 1960–1962, by
Stucky and Meuli. Max Bill (b. 1908),
architect, painter, sculptor and designer
of furniture and other objects, hopes
to found a new Bauhaus.

Sculpture. A number of Swiss sculp-
tors have played a significant part in the
evolution of contemporary sculpture.

In figurative sculpture, Hermann
Haller (1880–1950) remained aloof

from the aesthetic preoccupations of his
time and expressed the sensitivity of the
youthful female form with insight and
subtle modelling (portrait of Marie
Laurencin, 1920). Carl Burckhardt
(1878–1923) was the most important
figurative sculptor of his generation. He
was the first to achieve an authentic
return to the austerity of elemental
forms (fountains for Basle station, 1914–
1921). Karl Geiser (1898–1957), in-
spired by Maillol in his female nudes
(1943–1957), was architectural in the
composition of the two groups for the
Berne gymnase (1926–1938), powerful
and austere in the *David* (at Soleure,
1944).

Figurative sculpture took a new turn
about 1925; the influence of Bourdelle
was augmented by that of Germaine
Richier, who lived in Switzerland from
1939 to 1945. Louis Conne (b. 1905), a
pupil of Bourdelle, worked for Braque
and also took part in the Abstraction-
Création movement; he incorporates
space into his sculptures in the manner
of Zadkine (*Orpheus*, 1958). Remo
Rossi (b. 1909) has evolved from full,
rounded classical forms towards geo-
metrical forms; he is an excellent
animal sculptor. Max Weiss (b. 1921)
and Erick Müller (b. 1927) eliminate
all detail in an increasingly free

1066. MAX BILL (b. 1908). Hexagonal
Curses in Space. Gold-plated
bronze. 1951. *Marlborough Fine Art
Ltd, London.*

1067. ANDRÉ RAMSEYER (b. 1914).
Eurhythmy. Bronze. 1955. *Swiss
Embassy, Washington.*

1068. ZOLTAN KEMENY (1907–1965).
Trois Vents. Coloured aluminium. 1963.
Baron Lambert Collection, Brussels.

1069. RICHARD LOHSE (b. 1902).
30 Systematische Farbtonreihen.
1955–1963. *Artist's Collection.*

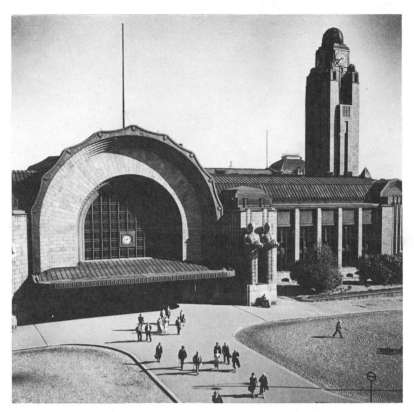

1070. FINLAND. ELIEL SAARINEN
(1873–1950). Railway station,
Helsinki. 1910–1914.

interpretation of the human form. Arnold d'Altri (1904–1980) first modelled powerful figures before moving towards Expressionism; his later, more or less abstract, stick-like figures are reminiscent of Surrealist work. André Ramseyer (b. 1914) [**1067**], a pupil of Zadkine, was figurative but has become abstract (*Eurhythmy*, bronze, 1955, Swiss Embassy, Washington). Robert Lienhard (b. 1919) began with spatial constructions and then looked to the real world (*Mounted Herdsman*, 1954) and employed inward-curving planes (*Skaters*, 1957).

Non-figurative sculptors have included Sophie Taeuber-Arp (1889–1943), who took part in the Dada movement and made reliefs in polychrome wood. With Arp she participated in the decoration of the Aubette in Strasbourg. Serge Brignoni (b. 1903), painter and sculptor, after executing some Surrealist works in wood and iron, changed (from 1931) to a more abstract manner. Hans Aeschbacher (1906–1980) was figurative until 1946. From 1948 he aimed at architectonic volumes defined by vertical and oblique lines. Ödön Koch (1906–1977), who was self-taught, carved huge volumes in stone with curved surfaces or angular volumes. An architect, painter and

sculptor, Max Bill (b. 1908) [**1066**] was a pupil at the Bauhaus (1927–1929), all his subsequent activities being influenced by his training there. He is an advocate of a synthesis of the arts centred on architecture, which would determine not only the styles of painting and sculpture but of utilitarian objects as well. In 1930 he settled in Zürich as an architect and extended his activity to painting, sculpture and typography. In sculpture he aims at placing plastic works in space, thereby freeing them of their frontal, static quality (*Construction from a Ring*, 1942–1953). His main preoccupation remains the problem of perpetual movement in sculpture. Mary Vieira (b. 1927), a pupil of Bill, does spatial constructions in polished steel and in aluminium.

Joseph Lachat (b. 1908), a painter and mosaicist, uses mosaics on his sculptures which take the form of savage idols. Siegfried Jonas (b. 1909), René Monney (b. 1919), André Gondé (b. 1920), who uses synthetic materials, Johannes Burla (b. 1922), Adrien Liegme (b. 1922) and Antoine Poncet (b. 1928) make their contribution to that antifigurative movement which still employs sculpture in the round, while Joseph Wyss (b. 1922), André Gigon (b. 1924) and Henri Presset (b. 1928) work

with architectural forms. Hammered and welded iron was used by Eugène Häfelfinger (1898–1979), Arnold Zurcher (b. 1904), in his supple forms drawn out into points, Jean Gisiger (b. 1919), who is more schematic, Robert Müller (see under *France*) and Bernard Luginbühl (b. 1929). Walter Bodmer (1903–1973), a painter, first made wire sculptures in 1936. His metal sculpture, often coloured, is a kind of spatial calligraphy; he executed a monumental work for a park in Antwerp using the same technique. Walter Linck (1903–1975), at first figurative and Surrealist, executed his first iron sculptures in 1951, and began to make mobiles in 1953; his delicately poetic coloured mobiles and stabiles date from 1958. Werner Witschi (b. 1906) has some affinities with Constructivism in his fan-shaped arrangements of metal discs and bars. Jean Tinguely (see under *France*) and Walter Vögeli (b. 1929) achieve unusual and original effects in metal which defy all attempts at classification. The same is true of the luminous sculptures of Rehmann (b. 1921) and of the work of Zoltan Kemeny (1907–1965) [**1068**]. Trained as a cabinet-maker, Kemeny studied architecture and fashion design before taking up painting and sculpture. He builds up his reliefs from ready-made materials such as scrap metal, wires, nails and springs. Carl Bucher (b. 1935) experiments with pumice, stone powder, plastics, etc. in his creations. Gianfredo Camesi (b. 1940) also creates assemblages. The best known Swiss sculptor, Alberto Giacometti, lives in Paris (see under *France*).

Painting. The work of Ferdinand Hodler marks the beginning of modern Swiss painting (see Chapter 3); together with the austere René Auberjonois (1872–1957) and Otto Meyer-Amden (1885–1933), whose rigorously ordered work recalls Mondrian, Hodler is the most significant painter of the period. The independent painters Félix Vallotton and Paul Klee lived mostly abroad (see under *France* and *Germany*). Although proud of certain national characteristics, the Swiss form part of the international trends. Among the painters whose names are associated with Expressionism and Fauvism are: the landscape painter Edouard Vallet (1876–1929), Ernst Morgenthaller (1887–1967), Hans Berger (1882–1977), whose colours resemble van Gogh's, and Alexandre Blanchet (1882–1961), Maurice Barraud (1889–1945) and Max Gubler (1898–1973) were influenced by Cèzanne. Louis Maillet (b. 1880), an associate of Paul Klee, may in some of his work be classed a Cubist and in some of his

work as an abstract painter. Sophie Taeuber-Arp (1889–1943) was one of the central figures in abstract art between the Wars. After studying applied art in Munich and Hamburg she became a member of the Dada movement with Hans Arp, whom she married in 1921. She executed a large number of gouaches, drawings, water-colours and oils of crystalline purity, whose importance rests in their simplicity combined with richness of invention.

Although during the First World War many foreign intellectuals resided there, and although Dada had its beginnings there, Switzerland remained indifferent to the avant garde. It was not until 1936 that an exhibition at Zürich drew attention to the abstractionist Max Bill, and the foundation of the Die Allianz group led to other exhibitions. The best Swiss painters between the Wars were: Leo Leuppi (1893–1972), the founder of the Die Allianz society, whose thickly painted canvases are constructed of combined transparent planes; Camille Graeser (1892–1980), also an architect and interior decorator, who produces pure geometrical abstractions; Fritz Glarner (1899–1972) [813], whose 'relational paintings' modified Neo-plasticism by bringing in the slanted line; Richard Lohse (b. 1902) [1069], a member of the Die Allianz group, whose rhythmical colour studies in verticals and horizontals are related to Neo-plasticism. The architect Le Corbusier (1887–1965), from Switzerland, has painted under his real name, Charles Edouard Jeanneret. Younger painters include: Lenz Klotz (b. 1925); Rolf Durig (b. 1926); Wolf Barth (b. 1926); Jean Lecoultre (b. 1930); Rolf Lehmann (b. 1930); Willy Mueller-Brittnau (b. 1938); Franz Gertsch (b. 1930) and Luciano Castelli (b. 1951).

Posters. Contemporary poster designers include: Henri Steiner (b. 1906); Donald Brun (b. 1909); Fritz Buhler (b. 1909); Pierre Gauchat; Walter Herdeg (of *Graphis*); Herbert Leupin (b. 1916); Hans Falk (b. 1918).

The minor arts. The man who did most to stimulate religious art in Switzerland was Cingria, who executed some very original stained glass windows and mosaics.

SCANDINAVIA

Architecture. With such outstanding pioneers as Sven Markelius and Gunnar Asplund in Sweden, a genius such as Alvar Aalto in Finland, and Arne Jacobsen in Denmark, Scandinavian architecture has reached a very high level.

Finland is possibly the most interesting country architecturally in Scandinavia and is in fact one of the leading countries in the world in architectural design. Finland's first notable architect was Eliel Saarinen (1873–1950), who made his mark initially with his famous Helsinki railway station (1910–1914) [1070]. He settled in the United States in 1922, where his son Eero (1911–1961) achieved even greater distinction (see under *United States*).

The most famous Finnish architect is Alvar Aalto (b. 1898), who has become increasingly dissatisfied with the cube, preferring to design his work as a sympathetic environment for human beings rather than as an aesthetic end in itself. His most famous pre-War buildings are: the Turun Sanomat plant, Turku (1930); the tuberculosis sanatorium at Paimio (1933); the city library, Viipuri (1927–1935); the Sunila plant near Kotka (1936–1939). In his more recent works, such as the town hall, Säynätsälo (1950–1952), the Vuoksenniska church, Imatra (1956–1958) [1071, 1072], and the university at Jyväskylä (1952–1957), we see the embodiment of the principle of organic architecture and an incomparable mastery of space and three-dimensional design. In the next generation Viljo Revell (1910–1977) was outstanding In 1958 he won the competition for the Toronto City Hall with a project which exemplifies his ideas on free form. His Kudeneule textile works at Hanko (1955) climaxed his Finnish successes. Aarne Ervi (1910–1977) was the chief architect of the Tapiola Garden City, near Helsinki. Heikki (b. 1918) and Kaija (b. 1920) Sirén are a husband and

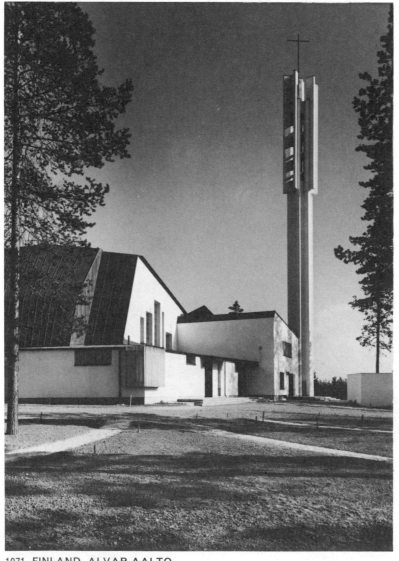

1071. FINLAND. ALVAR AALTO (1898–1976). Church at Vuoksenniska, near Imatra. 1956–1958.

1072. FINLAND. ALVAR AALTO. Interior, church at Vuoksenniska.

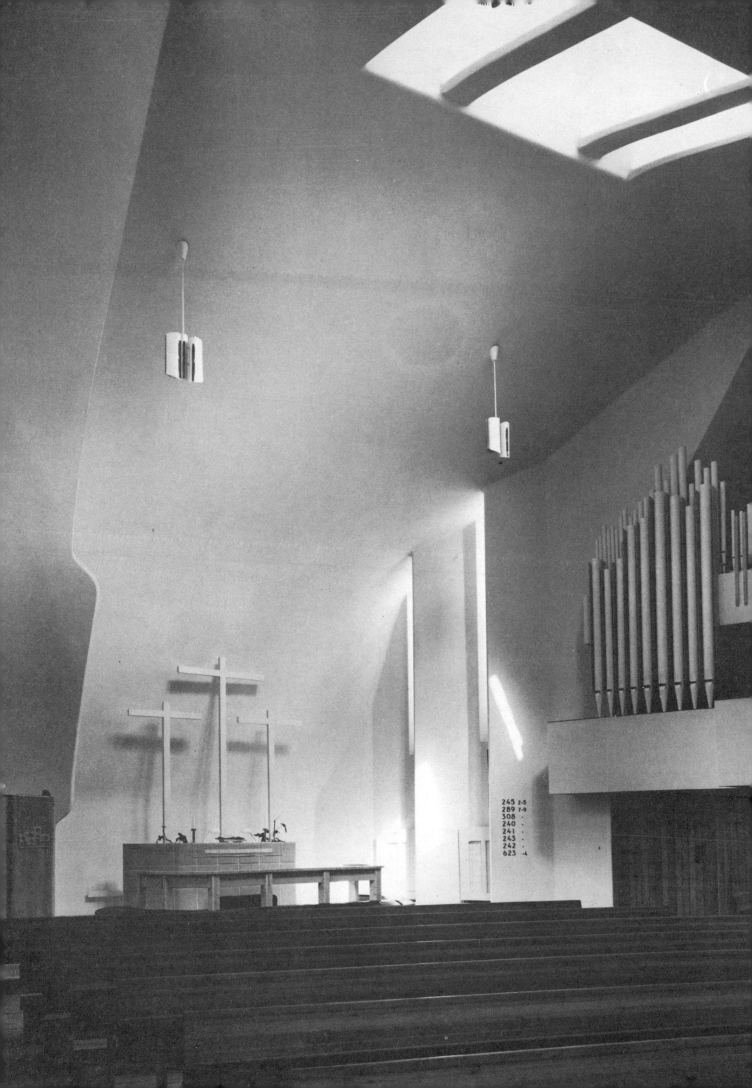

245 2-3
289 7-9
308 ·
240 ·
241 ·
243 ·
242 ·
623 -4

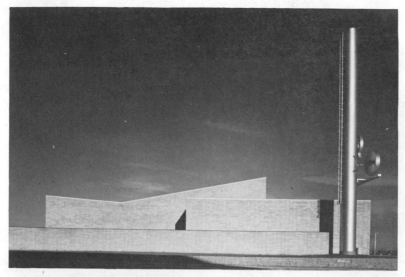

1073. DENMARK. ARNE JACOBSEN (b. 1902). Carl Christensen motor works, Aalborg. 1956.

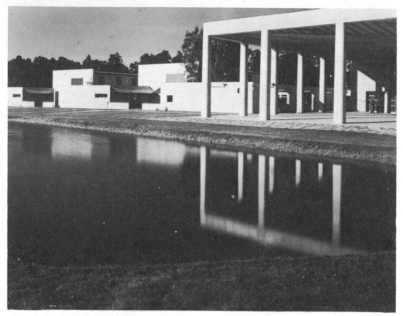

1074. SWEDEN. GUNNAR ASPLUND (1885–1940). Forest Crematorium, Stockholm. 1935–1940.

wife team whose chapel at the technical college at Otaniemi (1957) has received world acclaim. All the above architects manifest a reaction against technology and stress the use of natural materials, particularly wood and brick.

In Denmark the imaginative new architecture has manifested itself chiefly in small-scale building and in interior design. The Stockholm Exhibition of 1930 was a revelation to young Danish architects, who were still under the shadow of Neoclassicism. The outstanding architect was Arne Jabobsen (1902–1977), whose feeling for modular rhythms and natural proportions has led to restraint combined with precision of detail and excellence of workmanship. Contact with the architecture of Le Corbusier and Mies van der Rohe resulted in the early Bellavista housing estate near Copenhagen (1933) and the

Aarhus town hall (1937, in collaboration with Erik Møller). Jacobsen has been the leading architect since the War, with his large administrative buildings such as the Rødovre town hall (1955), the SAS building, Copenhagen (1960) and the Carl Christensen motor works, Aalborg (1956) [1073]. Since 1959 he has been engaged in work on St Catherine's College, Oxford. Among the younger generation are Halldor Gunnløgsson (Kastrup town hall) and Jørn Utzon, who did the prize-winning design for the Sydney Opera House, Australia [827].

In the early years of the century a school of national realism still dominated Swedish architecture; this school emphasised traditional techniques and materials (red brick or timber). These theories were exploited by Ragner Östberg (1866–1945) in his greatest

work, the Stockholm town hall (completed 1923). Reacting against this national realism in the next generation were Osvald Almquist (1884–1950), Gunnar Asplund (1885–1940) and Sigurd Lewerentz (b. 1885), whose highly individual works include the remarkable church at Skarpnäck, near Stockholm (1960). Asplund embodies the transition from traditional to modern. Among his early works were the Stockholm South Cemetery (1918–1920, in collaboration with Lewerentz) and the Stockholm city library (1924–1927). His later works included the Bredenburg store, Stockholm (1933–1935), and his masterpiece, the simple, dramatic and original Forest Crematorium, Stockholm South Cemetery (1935–1940) [1074]. With the 1950s a new wave of international influence swept Sweden. The most important work has been in civic planning; Sven Markelius (b. 1889) is head of the town planning department [1075]. The new hospital at Herlev, Copenhagen, by Bornebusch, Brüel and Selchau, with its clean lines and large spaces, is decorated by bright bands of colour.

Sculpture. *Denmark.* The Neoclassical tradition stemming from Thorvaldsen prevailed in Danish sculpture until Kai Nielsen (1882–1924) and Einar Utzon-Frank (b. 1888) broke free of it. Gerhard Henning (b. 1880), of Swedish origin, gives the human figure a fullbodied, monumental treatment that recalls Maillol. He has decorated several public buildings and is one of the best known contemporary masters. Adam Fischer (b. 1888) lived in Paris from 1913 to 1933; at first a painter, he taught himself sculpture. His works are robust, with simplified forms; his style has affinities with that of Johannes Bjerg (1884–1954), whose work is of an elegant classicism. Astrid Noack (1889–1954) lived in Paris; she was a pupil of Cornet at the Scandinavian Academy; influenced by Maillol and Despiau, she created sensitive and static works (*Anna Archer*, 1939). Gudmundsen Holmgreen (b. 1895) decorates public buildings; his modelling at times lacks firmness (*Joseph*, 1939). Hugo Lijsberg (b. 1896) is a fine animal sculptor. Gottfred Eickhoff (b. 1920), a pupil of Despiau, is more realistic (maternities). After 1935 new plastic problems were attacked; sculptors turned to a less formal art and employed new techniques and materials. The most original is Robert Jacobsen (b. 1912 [1076]; see under *France*). Henry Heerup (b. 1907) and Helge Holmskov (b. 1912) have very individual styles. Erik Thommesen (b. 1916) carves abstract compositions in wood; S. Georg Jensen (b. 1917) carries out his abstract works in blocks of granite.

Sweden. An academic tendency survived in Sweden to about 1920. Johan Börjesen (1836–1910) endeavoured to free himself of it towards the end of his life, while Christian Eriksson (1858–1935), a pupil of Falguière in Paris, continued the narrative and decorative tradition. The painter Anders Zorn (1860–1920), who was a friend of Rodin and was influenced by him, adopted an aggressive style (*Nymph and Faun*, 1895; *Gustavus Vasa*, 1903). Ellen von Hallwyl-Roosval (1867–1952), a pupil of Bourdelle and of Carl Milles, and Alice Nordin (1871–1948), a pupil of Injalbert, both adopted a sober style that is not overly realistic. Carl Eldh (1873–1954), a pupil of Injalbert in Paris in 1895 and a friend of Strindberg, brought a new vigour to Swedish sculpture (restoration of Uppsala cathedral). Classical in the child figure of *Innocence* (1900), he is Impressionistic in his portraits of Strindberg (1903); his Strindberg monument in Stockholm (1942) has greater power. Carl Milles (1875–1955) [**591**], perhaps the best known Swedish sculptor, was influenced by Rodin in Paris. In Munich (1905–1906) he was impressed by Hildebrand's theories of architectural form. Many of his best works are fountains, where the figures stand out against the water and sky as part of an architectural unit. After 1929 he worked in America, and much of his later work is there. The best has a vigorous Baroque feeling. His style is eclectic, and reflects the new interest in the medieval and the archaic (*Orpheus Fountain*, Stockholm, 1936). Among other figurative sculptors who show similar tendencies are Stig Blomberg (1901–1970) and Carl Frisendahl (1886–1948), who was more Expressionistic. Erik Grate (b. 1896) at first created robust female figures in the manner of Despiau, but has since developed an imaginative abstract style. Arne Jones (1914–1976) [**1077**] experimented with twisting and coiling spatial constructions. For his fountain at Norrköping he has executed a spiral worked by a hydraulic mechanism. Other abstract sculptors include: Eric H. Olson (b. 1909); Per Olof Ultvedt (b. 1927) [**1078**], who makes mobiles; Calle Lunding (b. 1930).

Norway. Until 1925 Gustav Vigeland [**596**], who worked in wood and who was influenced by Rodin, dominated his generation. He worked on the carving of the Gothic statues for Trondheim cathedral. His most important work is the monumental ensemble for Frogner Park, Oslo. Wilhelm Rasmussen (1879–1965) also worked for Trondheim cathedral; his portraits have a delicate realism. A freer tendency resulted from contact with independent

1075. *Above,* SWEDEN SVEN MARKELIUS (1889–1972). Satellite town of Vällingby, Stockholm, 1953.

1076. *Below.* ROBERT JACOBSEN (b. 1912). Spatial Sculpture in Space. Iron. 1951. *Philippe Dotremont Collection, Brussels.*

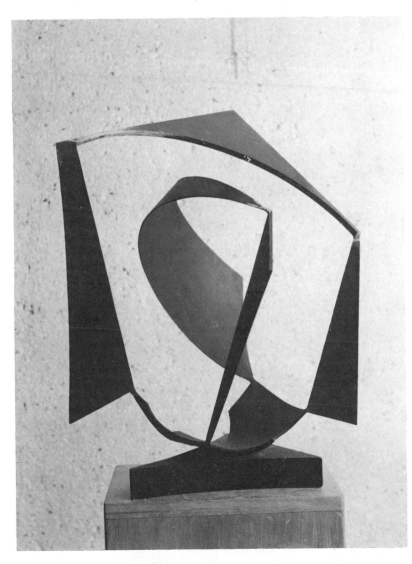

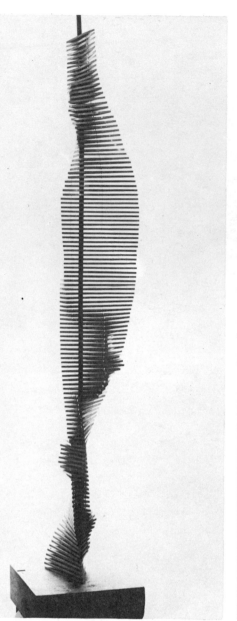

1077, ARNE JONES (1914–1976) Dodeka. Aluminium. 1962.

1078. PER OLOF ULTVEDT (b. 1927). Mobile Sculpture. *Artist's Collection.*

French sculpture; Rolf Lunde (1891–1928), Emil Lie (1897–1976) and Stinius Frederiksen (1902–1977), a pupil of Despiau, all worked for Trondheim cathedral from 1930. Ornulf Bast (1907–1974), a sculptor-engraver, and Hans Meyer (b. 1907), a pupil of Despiau, portray the human body with simplicity and realism. Per Palle Storm (b. 1908), who is more naturalistic, executes monuments and has a profound influence on his pupils. Dyre Vaa and Anne Grimdalen produce lively rhythmic works. Nils Flakstad (1908–1979) produced robustly-modelled sculptures. Per Hurum (b. 1910) blends his classical culture with a feeling for nature in his animal groups. Karl Orud (b. 1914) and Anne Baknes (b. 1917) work in a less traditional vein.

Finland. 19th-century Finnish sculptors came under the influence of Sweden and Denmark, where they pursued their studies before going on to Rome. After 1870 sculptors began to go to Paris, where they came under the influence of Rodin after 1880 (Johannes Haapasalo, Emil Vikstrom). To these foreign influences was added a national tradition which had developed after the country became independent. Vaino Aaltonen (1894–1966), sculptor and painter, favoured granite, which imposed a severity of style. About 1920 he was attracted to Cubism. He sculpted some important monuments. Viljo Savikurki (b. 1905) has a style reminiscent of primitive art; Aimo Tukiainen (b. 1917), who has executed monuments, has turned to abstract forms.

Elia Hiltunen (b. 1922) works in metal, in which she has developed a personal style while remaining figurative.

Painting. *Denmark.* Jens Ferdinand Willumsen (1863–1958) [478] holds first place in Danish painting of the last quarter of the 19th century. He met Gauguin at Pont Aven and also met Odilon Redon, under whose influence he came. Mogens Ballin (1871–1914) joined the Nabis while staying in France. The solid, virile colours of Harald Giersing (1881–1927) are related to Fauvism. Cubist ideas find an original echo in the work of Wilhelm Lundstrom (1893–1950); abstract theories have been followed by Egill Jacobsen (b. 1910), Richard Mortensen (b. 1910) and Ole Schwalbe (b. 1929).

1079. ERIK OLSON (b. 1901). Day
seen through Night. 1935. *National
Museum, Stockholm.*

where he worked in the country. For the
university at Oslo he painted mural
decorations in 1909–1911. His later
works, including the moving series of
self-portraits, are characterised by
lighter colours and a freedom from his
earlier obsession with the awe-inspiring
element in nature. His graphic works
(*The Cry* [**646**]) had an even greater
influence than his paintings. Munch
helped bring large mural decorations
into favour. Finn Faaborg (b. 1902) is
an Expressionist who is interested in
plastic experiments.

Finland. National and at the same
time cosmopolitan, Finnish painting
was influenced until 1917 by Russian
realism. Its official representative was
Albert Edelfelt (1854–1905). A. V.
Gallen-Kallela (1865–1931) [**597**],
Magnus Enckell (1870–1925) and
Juho Rissanen (1873–1950) devoted
themselves to popular subjects, while
Marcus Colin (1882–1966), a pupil of
Sérusier, was influenced indirectly by
the Nabis.

The first painter to be affected by
Cubist theory was Olli Miettinen (1899–
1969); Ernst Mether-Borgstrom (b.
1917) is an Abstract Expressionist. The
younger generation, while fully aware
of international trends in contemporary
painting, preserve a traditional taste for
delicate and often pale colours (Jaakko
Manninen, b. 1926; Rafael Wardi, b.
1928; Tor Arne, b. 1934). Yryo Juhana
Blomstedt (b. 1937) produces minimal
canvases with overtones of landscape.

The minor arts. The Scandinavian
countries have arrived at a truly suc-
cessful modern design. Using traditional
materials (glass, wood, iron, porcelain,
paper) they have invented an entirely
original functional style. Their success
is due mainly to a mutual understanding
between artists and industrialists.

Denmark. The principal designers
include Arne Jacobsen, Paul Kjaerholm,
Johannes Hansen, Stähr-Nielsen,
Gertrude Vasegaard, Kay Bojeson and
Henning Koppel.

Sweden. The Swedish Society of
Arts and Crafts conducts a regular
crusade against bad taste.
Märta Maas-Fjetterström (1873–
1941) founded, in the small town of
Bastad, a workshop for the weaving of
carpets and hangings. Elsa Gullberg (b.
1886) has played an important role in
textile design. Sofia Widén (1900–
1961) devoted herself almost exclusively
to religious art. Alice Lund (b. 1900)
supervises a hand-weaving concern in
central Sweden. Astrid Sampe (b. 1909)
runs a textile works for the big shops of
the Nordiska Kompani; Viola Grasten
(b. 1910), of Finnish origin, created

Sweden. The first experiments in
abstract painting were made by Evan
Aguéli (1869–1917). Karl Isakson
(1878–1922), who lived in Denmark,
was inspired by Cézanne and the Cubists.
His influence is important. The Expres-
sionist landscape painter Carl Kylberg
(1878–1952) recalls Turner; his work is
naive and tinged with irony; Vera
Nilsson (1888–1979) was influenced by
German Expressionism, Bror Hjort
(1894–1968) by Chagall; Erik Olson
(b. 1901) [**1079**] is a Surrealist.
Olle Baertling (b. 1911) is a
non-objective purist, while Öyvind
Pahlströmm (b. Brazil, 1928) works in a
pop style.

Norway. The greatest Norwegian
artist was Edvard Munch (1863–1944)

[**646, 717**; see colour plate p. 277], the
most important precursor of German
Expressionism. After studying in Oslo
under Christian Krogh, the Norwegian
Impressionist, he spent twenty years
(1889–1909) in Paris and Berlin, fre-
quenting literary avant garde circles and
becoming friendly with Strindberg and
Fénéon. In his early works, in which he
was much influenced by Gauguin and
Seurat, he dealt with basic themes,
such as love and death, melancholy and
loneliness, for which he sought pictorial
equivalents. The unreality of the
dream mingles with the reality of
nature to create symbols surpassing
those of Böcklin and Hodler (*The Sick
Child*, 1906–1907, Tate Gallery). In
1908, after a serious emotional and
mental crisis, he returned to Norway

1080. VLADIMIR TATLIN (1885–1956).
Model for a glass and iron monument
to the Third International. Wood.
1919. *Russian Museum, Leningrad.*

1081. NATHALIE GONTCHAROVA
(1881–1962). The Laundry. 1912.
Tate Gallery.

carpets for the same works (1944–1956) before joining the Mölnlycke textile industry. Also active in this field are Anna-Lisa Odelqvist-Ekström, Marianne Richter, Barbro Nilsson and Göta Trägardh.

Jacob Ängman (1876–1942) gave a new impetus to Swedish silversmiths. Erik Fleming (1894–1954) produced religious art. Wiwen Nilsson (1897–1974), who worked in Lund sought to simplify form. Sven Arne Gillgren (b. 1913) creates original, elegant jewellery, and Sigurd Persson (b. 1914) produces daringly new forms. Folke Arström (b. 1907) keeps strictly within limits imposed by the materials.

Ceramics are produced at Rörstrand and Gustavsberg. Alf Wallande (1863–1914) introduced objects in the Art Nouveau style; Wennerberg, after studying at Sèvres, adopted techniques such as sgraffito, and stoneware with underglaze decoration. Wilhem Käge (1889–1960) promoted the 'argenta' technique. Arthur Percy (1886–1976) ran the Gefle works which produces colours evocative of the earlier faience. Carl Harry Stälhane (b. 1920) produces solid, imposing pieces in stoneware.

Other potters include Stig Lindberg (b. 1916), Hertha Hillfon, Anders Liljefors, Karin Björqvist, Sven Erik Skawonius, Edgar Böckman and Marianne Westman.

Swedish glass manufacture dates back to the 17th century, but in about 1915 it became modern in design. The Kosta works continues to produce crystal; the Orrefors factory has an international reputation. Leading craftsmen include Simon Gate (1883–1945), Elis Bergh (1881–1954), Edward Hald (1883–1980). Vicke Lindstrand (b. 1904), Erik Höglund (b. 1932), Sven Palmquist and Nils Landberg.

Wood plays an important part in Swedish interiors. Furniture is designed for all classes of society. Simple, sober lines are characteristic of the contemporary style. Leading designers include Westman (1866–1936), Malmsten (b. 1888), Bruno Mathsson (b. 1907), Acking (b. 1910), Karl Erik Ekselius (b. 1914), Bertil Fridhagen, Carl Axel Acking and Nisse Strinning.

Finland. The stoneware sculptures of Michael Schilkin, the tableware by Kaj Franck, the cutlery by Bertel

Gardberg, the carpets by Kirsti Ilvessalo, the crystal vases by R. Lasi and the textiles by Sarpaneva are all outstanding. Aalto's furniture designs are as significant in their field as is his architecture.

POLAND

Sculpture. Xaver Dunikowski (b. 1876), who is also a painter, dominates the development of contemporary Polish art. With the group Young Poland, he seeks the roots of a national style. Inspired by history, he treats the monument as a permanent symbol (Mickiewicz monument, Poznan, 1948). Tradition also dominates the work of Szczepkowski (b. 1878) and Tadeusz Breyer, who belongs to the following generation. Between the Wars, Formism united painters and sculptors and rejuvenated traditional sculpture by combining the lessons of Cubism with the elements of popular art. Wostowicz (b. 1889), Nitschowa (b. 1889) and Dobrzycki (b. 1896) work along these lines. Strynkiewicz (b. 1893) and Horno-Poplawski (b. 1902) have a very severe style. Trenarowski (b. 1907), Wozna (b. 1911) and Bandura

1082. KASIMIR MALEVICH
(1878–1935). Eight Red Rectangles.
Before 1915. *Stedelijk Museum,*
Amsterdam.

1083. EL LISSITSKY (1890–1941).
Composition. 1921. *Peggy Guggenheim*
Collection, Venice.

(b. 1915) express the drama of their time. The abstract tendency does not go so far as to explore pure form. Young sculptors are content to break away from pseudo-realism and pseudo-classicism. Alina Szapocznikow (b. 1926), a pupil of Niclausse (1947–1950), sublimates the sense of tragedy; Magdalena Wiecek's work is severe and brutal. Lisowski escapes naturalism by reducing the human form to a series of volumes and planes; Smolana simplifies, but remains lyrical. Sieklucki makes a more adventurous study of the relationships between form and space, as does Alina Slesinska (b. 1926), who binds modelled forms together with twisted wire. Szwarc (1892–1958) gave new life to the technique of hammered metal in his bas-reliefs; he devoted himself to religious art. Jan Berdyszak (b. 1934) relates voids and surfaces; Magdalena Abakanowicz (b. 1930) creates organic 'tents'.

Painting. The sculptor Dunikowski is also a leading painter. Typical of the tendency to monumental painting is Kowarski (1890–1948), with his tragic, romantic vision; he taught Sokolowski

(1904–1953) and Studnicki (b. 1906). Between the Wars Formism, which reconciled Cubism, Expressionism and popular art, played an important role; Pronaszko (1885–1958) was a leading exponent. Artists influenced by Impressionism include Pankiewicz and his pupils Cybis (b. 1897) and Rudzka-Cybis (b. 1897), Eibisch (b. 1896) and Taranczewski (b. 1903).

After the Second World War, Strzeminski (1893–1952) initiated a movement known as Unism, a kind of intellectual plastic synthesis, that was also adopted by Stazewski. A few artists (Modzelewski) practise a dramatic or emotional form of abstract painting. The socialist current is marked by a feeling of rebellion (Fangor, Strumillo, Wroblewski). Some freedom of expression is apparent in Tchorzewski, Brzozowski and Cwenarski (1926–1953).

The influence of the school of Paris is evident throughout Polish painting. Among the artists belonging to this school are: Olga Boznanska (1865–1940), a portraitist much admired in fashionable circles; Malowski (1882–1932), tragic and Expressionistic; Louis

Marcoussis (1883–1941) [688], a leading exponent of Cubism; Eugène Zak (1884–1926), a figurative painter with Symbolist tendencies who painted simplified, poetic figures; Henri Hayden (1885–1970) was a 'Cézannist', then became an authentic Cubist; the abstract painters Kijno (b. 1921), Maryan (b. 1927) and Jean Lebenstein. Henryk Berlewi (b. 1894) produces hard-edge, geometric canvases, unlike Tadeusz Brzozowski (b. 1918) who is an Abstract Expressionist.

THE SOVIET UNION

Architecture. The advent of the 1917 Revolutionary government gave rise to an experimental movement whose aim was to create a proletarian architecture based on avant garde ideas. In spite of the authoritative influence of Joltovski, a great theoretician and President of the Moscow Academy of Architecture, the younger generation devised new projects (which could not be carried out because of the economic circumstances of the country) which incorporated extravagant structural innovations; these

1084. VOJIN BAKIC (b. 1915).
Deployed Form. Plaster cast. 1958.
Drian Gallery, London.

1085. IVAN MEŠTROVIC (1883-1963).
Portrait of the Artist. Plaster. 1915.
Tate Gallery.

were intended primarily as a break with tradition (Russian pavilion by Melnikoff, Decorative Arts Exhibition, Paris, 1925).

The theories of the Constructivists were soon condemned as 'decadent', and reactionary architecture became the general rule. The Soviet Union devoted its first programme of reconstruction to collective buildings (administrative offices, schools, universities, workmen's clubs, assembly halls); working in a frankly traditionalist style, B. M. Iofan was the chief official architect (pavilion for international exhibitions). A. V. Shchusev championed a kind of neoclassicism (Marx-Engels-Lenin Institute in Tiflis). In 1931 some of the best known international architects took part in a competition to design a palace for the Soviet, but the prize went to Iofan's project, a monumental affair with colonnades some 1,000 feet high; it was never built. The state sponsored an academic type of architecture and favoured all forms of classical ornamentation, even in big industrial buildings and public works (dams; the Moscow

Underground). This tendency became very marked in the palace of the Supreme Soviet in Kiev, by Zabolotni (1939) and in the Red Army Theatre in Moscow, by Trotzky (1941). After the Second World War some monumental public buildings were constructed (Moscow university). In 1955, after the authorities had condemned costly ornamentation, architecture became simpler.

Sculpture. Prince Paul Troubetskoy (1866-1938), influenced by Rodin and Medardo Rosso, was one of the best sculptors of his generation (small bronzes of a narrative, pictorial character; equestrian statue of Alexander III, Leningrad). The figurative tradition continues to prevail, but between 1910 and 1920 some exchanges took place between western Europe and the Russian avant garde. Vladimir Tatlin (1885-1956) [**1080**], after being influenced by Picasso in Paris in 1912, abandoned his early figurative style for 'relief-pictures' in many different materials (wood, metal, cardboard, plaster and tar) and in strict, geometric

1086. PAVEL TCHELITCHEW
(1898-1957). The Whirlwind. 1939.
Metropolitan Museum of Art.

396

forms. In 1915 he began his 'counter-reliefs', constructions without any base, destined to hang in the angles of walls. At the beginning of the Revolution the government called on the services of artists, and Tatlin, Malevich, Kandinsky and Pevsner were appointed to teach at the Moscow Academy. In 1919 Tatlin executed his model for a monument to the Third International, one of the first building designs completely abstract in principle; it consisted of a glass cylinder, a glass cube and a glass cone revolving at different speeds, round which an iron spiral twisted. As a pioneer of abstract art in its strictest form Tatlin had a considerable influence, particularly on Malevich.

Constructivism originated in Moscow just after the First World War in the work and theories of two sculptor brothers, Naum Gabo (b. 1890) [666, 888, 889] and Antoine Pevsner (1886–1962) [701, 887], who issued a realistic manifesto in 1920 indicating the aims of the movement. Other artists associated with the movement included Malevich and El Lissitsky. Their purpose was to make constructions in space, eliminating the distinction between painting and sculpture, discarding ornament and, through formal relations of mass and space, producing symbolic forms expressive of the modern scientific age. They replaced mass by a conception of voids, with an emphasis on depth and transparency which was heightened by their use of cut-out and superimposed plastic. Both left Russia in the early 1920s when non-figurative art lost official approval.

From that time onwards, Russian art has been dominated by a socialist realism. Konenkov's works draw inspiration from national folklore. Matveev (b. 1878) is a sculptor of female figures; Vataghin (b. 1883) is a good animal sculptor. Chadr (1887–1941) worked in Paris (1910–1912) and was one of the first to turn to popular subjects after the Revolution; he worked on the Gorky monument in Moscow, completed by Vera Mukhina (1889–1953), a pupil of Bourdelle. Other sculptors include: Sara Lebedeva (b. 1892); Tomski (b. 1900); Voutetich (b. 1908); Kibalnikov (b. 1912); Nikogossian (b. 1918).

Painting. The Jack of Diamonds was an avant garde group founded by Larionov in about 1910, at a time when, thanks to the two great collectors S. I. Shchukin and Ivan Morozov, Russian painters began to be aware of the new trends in France. These two collections in Moscow included a large number of Impressionist, Nabi and Fauve paintings, some Cézannes, van Goghs and Gauguins, and several Matisses. The startling originality of the French paintings produced a pictorial revolution in Russia.

Michel Larionov (b. 1881) [811] was at first a traditional painter. By 1909 he had been influenced by Cubism and was moving towards non-figurative painting (he was one of the first abstract painters). In 1911–1912 he founded Rayonism, a form of abstract painting which was concerned with expression through the medium of colour. In this venture he was joined by Gontcharova. In 1914 he settled in Paris, where he designed for the Ballets Russes. Nathalie Gontcharova (1881–1962) [1081] began her career as a sculptor; she had abandoned sculpture for painting by 1904. By 1908 she had been influenced by Cubism, and her brilliantly coloured abstract style was carried over into Rayonism. Her melancholy interpretations of city streets influenced the film *Cabinet of Dr Caligari*. In 1914 she moved to Paris.

Kasimir Malevich (1878–1935) [1082] was also one of the pioneers of abstract art. In 1911 as a member of the Jack of Diamonds group he exhibited works of Cubist inspiration and became the leader of the Russian Cubist movement. In 1912 he began to paint in the manner of Léger, emphasising straight lines and geometric figures, and this brought him close to complete abstraction. In 1913 he exhibited the first Suprematist work, a black square on a white background. The square was the first element of Suprematism and was soon joined by the circle, cross and triangle, in pure colours on a white background. The manifesto of Suprematism was published in 1915. It was chiefly through the activity of El Lissitsky (1890–1941) [1083] that Suprematist ideas were introduced into Germany in the early 1920s. Lissitsky's very personal art was based on the combining of three-dimensional and flat forms in space. From 1921 to 1928 he published the German review G (*Gestaltung*) with Hans Richter, created the group and review A B C in Switzerland, and in 1925 in collaboration with Arp published *The Isms of Art*. No other Russian modern artist has exercised such a radical influence, especially through the teaching of Moholy-Nagy at the Bauhaus. In the early 1920s the change in Soviet artistic policy forced the innovators into exile.

Among the many artists who left Russia and came to Paris at this time was Pavel Tchelitchew (1898–1957) [1086], who painted in a style very different from Rayonism or Suprematism. Called Neo-Romanticism, this dreamlike, escapist style was brought close to Surrealism by Tchelitchew.

Contemporary artists in the Soviet Union are taught that their 'civic duty towards humanity is to depict, in an artistic and documentary way, the most

1087. TAKIS (b. 1925). The First Vibrating Electro-Signals. 1964.

1088. *Above.* U.S.A. FRANK LLOYD
WRIGHT (1867–1959). Avery Coonley
house, Riverside, Illinois (showing
Japanese influence). 1908.

1089. *Below.* U.S.A. FRANK LLOYD
WRIGHT. Robie house, Chicago.
1909.

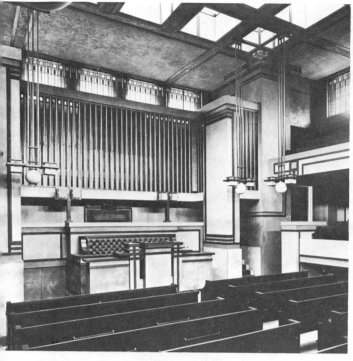

1090. U.S.A. FRANK LLOYD WRIGHT.
Unity Temple, Oak Park, Illinois. 1906.

1091. U.S.A. FRANK LLOYD
WRIGHT. Millard house, Pasadena,
California. 1923.

1092. U.S.A. FRANK LLOYD
WRIGHT. Interior, administration
building, Johnson Wax Company,
Racine, Wisconsin. 1936–1939.

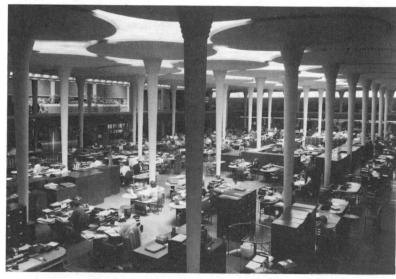

important stage of history in the throes
of revolution.' Nesterov (1862–1942),
Kontchalovsky (1876–1956), Gerassimov (b. 1885), Isaac Brodsky
(1884–1939), Deincka (b. 1899),
Chimarinov (b. 1907), Pimentov (b.
1903), Tatiana Yablonskaya (b. 1917)
and Levitine glorify the Red Army, the
worker, the peasant and the family.

CZECHOSLOVAKIA

Sculpture. The influence of Myslbek
(see Chapter 3), who represented
classical realism, was superseded by the
influence of Rodin and Bourdelle after
the exhibition of their works in Prague
(1902–1906). Stanislav Sucharda (1866–
1916) worked in Vienna before becoming a pupil of Myslbek. His most
famous work is the František Palacky
monument (1898–1912). Josef Maratka
(1874–1937), a pupil of Myslbek, is
important for his role in introducing
French influence into Czech art. A
grant enabled him to go to Paris where
he became an assistant and friend of
Rodin; he organised an exhibition of
Rodin's work in Prague in 1902 and
remained under his influence until 1910
(Santos Dumont monument in Buenos
Aires, 1903–1904); later his work
became more traditional (Monument to
the Dead, Prague, 1931). Bohumil Kafka
(1878–1942), a pupil of Myslbek and
assistant to Sucharda, was in Paris from
1904 to 1908 and came under Rodin's
influence. Jan Stursa (1880–1925)

1093. U.S.A. FRANK LLOYD
WRIGHT. Taliesin West, near
Phoenix, Arizona. 1938–1959.

399

1094. U.S.A. EERO SAARINEN
(1910–1961). General Motors
Technical Institute, Warren, Michigan.
1951–1955.

1095. *Above.* U.S.A. WALTER
GROPIUS (1883-1969). Detail of Harvard
University Graduate Center (with The
Architects' Collaborative). 1949–1950.

1096. *Below.* U.S.A. PAUL RUDOLPH
(b. 1918). School of Art
and Architecture, Yale University,
New Haven. 1958–1963.

was more poetic; he was assistant
to Myslbek. Otokar Spaniel (1881–
1955), a portrait painter, executed the
doors of Prague cathedral. Guttfreund
(1889–1927), a pupil of Bourdelle,
adopted the principles of analytical
Cubism about 1911 but reverted to a
classical realism after 1918. Karel
Pokorny (b. 1891), a pupil of Myslbek,
executed the Liberation Monument in
Prague (1936–1938). The animal
sculptor Jan Lauda (b. 1898), a pupil of
Sucharda and then of Stursa, took part
in 1920 in the Social Art movement.
Karel Lidicky (b. 1900), a pupil of
Spaniel, did the John Huss monument
for the university of Prague. Vincenc
Makovsky (b. 1900), a pupil of Kafka,
and Josef Wagner (1901–1957) guided
the new generation which in the late
1940s turned to socialist realism. Karel
Hladik (b. 1912) has developed a style
stripped of incidental detail; Josef
Malejovsky (b. 1914) is more realistic.
Jan Krizek (b. 1919), who lives in
Germany, and Otto Hajek (b. 1927),
who lives in Paris, illustrate the vitality
of the Czech spirit in a more abstract
vein.

Painting. At the beginning of the
century a modern school of painting
appeared in Prague; it evolved gradually
from Post-Impressionism and the in-
fluence of Gauguin towards Expres-
sionism and Cubism (Antonin Slaviček,
1870–1910; Miloš Jiranek; Emil Filla,
1892–1953). Bohumil Kubišta (1884–
1918) came to Cubism via Futurism.
František Kupka (1871–1957) [924],
who became an abstract painter, lived
in France (see under *France*). Surrealism
was an important tendency in Prague
before 1939. Folklore is a favourite
theme of Ludo Fulla (b. 1902). The
present-day avant garde are inspired
by a neo-Baroque style; the most
interesting of its artists are Medek,
Vesely and Jiří Balcar, whose style is
similar to that of the Italian Novelli.
Iaroslav Serpan (b. 1922) belongs to
the school of Paris.

Graphic arts. A number of artists
have studied or resided in France. At
the end of the 19th century František
Kupka worked on the review *L'Assiette
au Beurre*. Alphonse Mucha [508] was
an Art Nouveau illustrator and poster
artist who employed the characteristic
undulating line and floral decoration.
Leading 20th-century artists include:
T. F. Simon (1877–1942); Fiala Vaclav
(b. 1896); Jaroslav Skrbek (1888–1954);
Viktor Stretti (1878–1957); Adolf
Hoffmeister (b. 1902). Leading book
illustrators include: Josef Čapek (1887–
1945); Vaclav Karel (b. 1902); Jiří
Trnka (b. 1912), who also makes
puppet films. Bradac (1887–1947) was
the pioneer of modern bookbinding.

The minor arts. Miloslav Klinger (b. 1922) and Bretislav Novak are leading designers of glass. Representative functional furniture designers include Koter (1871–1923), Vanek (b. 1891), Koula (b. 1896) and Koselk (b. 1909).

HUNGARY

Sculpture. Until 1925 Hungarian sculpture followed the 19th-century tradition and glorified its national heroes with academic monuments. The forceful talent of Aloïs Strobl (1856–1926) makes up for the narrative aspect of his work. Julius Bezeredi (1858–1925) executed the statue of Washington, in Budapest (1906). Gyorgy Zala (1858–1937) was more emotional in his Millenary Monument (Budapest, 1906), in which horsemen are grouped round a central column. Zsigmond Kisfaludi-Strobl (1884–1975) did a fine portrait of George Bernard Shaw (1932); in 1947 he executed the Liberation Monument in Budapest, aided by Kocsis (b. 1905) and Hungari (b. 1902), Benjamin Ferenczy (1890–1967) carved female nudes recalling Maillol; he has done fine portraits. A few sculptors sought greater stylistic simplicity, attaching more importance to the structure of the body than to its outward appearance (Goldman, 1908–1945, who treated form as a series of juxtaposed volumes but did not abandon objective reality). These experiments were abandoned in the late 1940s, when traditional themes were resumed. Borsos (b. 1905) and Kerenyi (b. 1908) execute competent statues to the glory of heroism and sacrifice. Beck (b. 1911) and Somogyi (b. 1926) pay tribute to youth and the worker. A number of Hungarian sculptors have played an important role in the avant garde movements (Csaky, Schöffer [**891**], Marta Pan (b. 1923), Moholy-Nagy [**832**]; see under *France* and *United States*).

Painting. The great painter Jozsef Rippl-Ronai (1861–1927) was connected with the Nabis in Paris between 1895 and 1902. The Expressionist movement was not without its adherents in Hungary (Etienne Farkas, 1887–1944, killed by the Nazis; Derkovits, 1894–1934; Desi-Huber, 1895–1944; Bernath, b. 1895). The organisation known as the Group of Eight brought together those painters who were related to the French Fauves; among them were Bertalan Por (1880–1964), Bela Czobel (1883–1976) and Robert Bereny (1887–1953). Cubism was represented by Vilmos Aba-Novak (1894–1941). Jozsef Egry (1883–1951) and Endre Domanovsky (1907–1974) were also eminent. The younger generation includes Csernus (b. 1927), Stettner (b. 1928), Gabriella

1097. *Above.* U.S.A. RICHARD J. NEUTRA. Kaufmann desert house, Palm Springs, California. 1946–1947.

1098. *Below.* U.S.A. MIES VAN DER ROHE (1886–1969). Farnsworth house, Plano, Illinois. 1950.

1099. U.S.A. PHILIP JOHNSON
(b. 1906). Johnson house, New
Canaan, Connecticut. 1947–1950.

1100. U.S.A. MARCEL BREUER
(b. 1902). Breuer house, New Canaan,
Connecticut. 1947.

Hajnal (b. 1929), Maria Tury (b. 1930)
and Orosz (b. 1932). The school of
Paris includes: Henri Nouveau (1901–
1959), whose small, precious, abstract
works convey a poetic message analo-
gous to that of Klee; Victor Vasarely
(b. 1908; see under *France*).

RUMANIA

Architecture. Before Rumanian art
was influenced by western Europe it
was purely religious and was Byzantine
in character. The 19th-century interest
in the Latin origins of Rumanian history,
literature and language helped bring
about the change. Architecture shows a
French influence (restoration of historic
buildings by Lecomte du Nouy, pupil
of Viollet le Duc); there was a taste for
the Neoclassical and for German neo-
Gothic.

Sculpture. French sculptors executed
statues to the glory of various national
heroes. Later Rodin and Bourdelle in-
fluenced the young artists who went to
Paris to complete their studies, and
Simu, a great collector, gave consider-
able space to French art in the museum
he founded. The rapid development of
Rumanian sculpture was due to the
creation in Bucharest of a teaching
post; the first to hold the position was
Karl Storck; his son Carol (1854–1926)
studied under him before becoming the
pupil of Augusto Rivera in Florence
(1870–1875). After a stay in the United
States, he collaborated with his father.
His works are decorative or allegorical
(law courts, Bucharest, 1895). Joan
Georgescu (1857–1899) is more varied;
he went to Paris where his work was
much appreciated; his sculptures are in
the Renaissance tradition and, though
pleasing, have not the emotional power
of the sculptures of Ionescu-Valbudea
(1856–1918), a pupil of Frémiet in
Paris; his work has a power that is
unusual for its time and milieu; his
portraits are more traditional. Fritz
Storck (1872–1942), who was a metic-
ulous craftsman, trained in the Munich
school; he did portraits and nudes
remarkable for their supple modelling
(*Repentance*, 1904); he worked on the
decoration of buildings (law courts,
Bucharest). Dumitru Paciurea (1875–
1932), influenced by Rodin, was one of
the outstanding Rumanian sculptors.
He was a particularly fine portraitist;
an exceptional work by him is in a
funerary chapel in the Bellu cemetery —
the *Death of the Virgin*, a return to the
traditional religious art of Rumania.
Born in the same year, Constantin Bran-
cusi (1876–1957) [**661, 696, 871, 872**]
was one of the greatest sculptors of our
time (see under *France*). His followers
Petrasco and Han simplify and stylise
form. Jalea (b. 1887), a pupil of Paciurea,

remains realistic in his portraits and monumental works (monument to the French killed in action, Bucharest). Medrea (b. 1888) is more Romantic; he visited Germany and was influenced by Barlach. He simplifies form, treating the body as a solid block. Gheorghe Anghel (1904–1966) was self-taught and worked in Paris; he stripped his subject of detail. Ion Irimesco (b. 1903) works along the same lines. In the later 1940s these stylistic experiments were abandoned and socialist realism became the norm. Among Rumanian artists living abroad are Etienne Hajdu (see *France*), Zoltan Kemeny (see *Switzerland*), and Daniel Spoerri.

Painting. The forerunner of the modern school, Nicolae Grigorescu (1838–1907) [**392**], genre and landscape painter, was influenced by the Barbizon school. The highly individual Vorel (1876–1918) was interested in the experiments of the German Expressionists. Nicolas Tonitza (1886–1938) depicted Rumanian peasant life in a realistic manner; Samuel Mützner (b. 1885) favours the Impressionist approach and devotes himself to landscapes. Iser (b. 1881) has a forceful talent, and in his technique and colour may sometimes be compared to the Fauves.

The next generation was mainly realistic (Geza Vida, 1913–1980; Lidia Agricola, b. 1914; Gheorge Glaube, b. 1921; Paul Atanasiu, b. 1922).

BULGARIA

Sculpture. Apart from religious and popular art there is no long-standing tradition in Bulgarian sculpture. After the Turkish conquest historical scenes and portraits of statesmen were popular. Following independence in 1878, new tendencies emerged. Andrei Nikoloff (b. 1878) was influenced by French sculpture. Between 1919 and 1940 the Association of New Artists brought together sculptors of a realist tendency. The influence of French sculpture was also important. In the later 1940s sculpture became official.

Painting. Maistrora (b. 1882), Lavrenov (b. 1896), Ouzounov (b. 1899) and Nenov (b. 1902) have endeavoured to break with the past while at the same time preserving their national characteristics. Among the post-War generation are Goev (b. 1925), Detcheva (b. 1926), Kirov (b. 1932) and Bosilov (b. 1935). The Bulgarian painter Jules Pascin (1885–1930) [**906**] lived in Paris (see under *France*).

YUGOSLAVIA

Sculpture. Sculpture developed around three teaching centres — Zagreb, Belgrade and Ljubljana; it gradually evolved from figurative to abstract. Ivan Meštrovic (1883–1963) [**1085**] was influenced by Maillol in Paris (1907–1908). In 1907–1912 he worked on his project for the Temple of Kosovo; this work expresses Croatian and Serbian nationalism. He was appointed head of the Academy at Zagreb in 1919. In addition to single sculptures he designed memorial chapels at Cavtat and Otavice. Since 1947 he has been in the United States. Vojin Bakic (b. 1915) [**1084**] was influenced by Rodin in his portraits (about 1945); since 1953 his forms have become geometrical. Radovani (b. 1916) uses powerful and simple forms. Sabolic has abandoned Impressionistic modelling in order to emphasise mass. Kozaric (b. 1921) moved from direct representation to simplified or distorted human figures and has moved on to schematic work. Dzamonja (b. 1928) combines glass and metal in his abstract forms. In Belgrade between the Wars original experimental work was done. Streten Stojanovic (1898–1960), a pupil of Bourdelle, and Palavicini paved the way for a more

1101. U.S.A. EERO SAARINEN (1910–1961). Ingalls hockey rink, Yale University, New Haven. Completed 1958.

1102. U.S.A. EERO SAARINEN.
TWA building, Kennedy (Idlewild)
Airport, New York. Completed 1961.

1103. *Above:* U.S.A. I.M. Pei. East
Building, National Gallery of Art,
Washington.

1104. *Below.* U.S.A. HELLMUTH,
OBATA and KASSABAUM. Priory
church of St Mary and St Louis,
St Louis. 1962.

enterprising generation of sculptors, for
example: Anastasijevic, a pupil of
Zadkine; Soldatovic (b. 1920), who
elongates his human figures; Anna
Beslic (b. 1912), a non-figurative
sculptor with a feeling for full, vital
forms; Olga Jevric (b. 1924), also
abstract; Olga Jancic (b. 1929), who
draws inspiration from nature, as
does Lidija Salvaro (b. 1931). The
Ljubljana school tends to be non-
figurative. Drago Trsar (b. 1927) is out-
standing in his dynamic treatment of
line and volume.

Painting. At the beginning of the cen-
tury Impressionism flourished in
Slovenia and Fauvism in Croatia with
Racic (1885–1908) and Babic (b. 1890).

Naive painting has predominated in
Croatia with Hegedusic (b. 1901) and
Generalic (b. 1914).

Two outstanding Expressionists are
Petrovic (b. 1894) and Konjovic (b.
1898); Cubism inspired the work of
Sumanovic (1896–1942). Among those
related to Surrealism are Stupica (b.
1913), Vujaklija (b. 1914), Stanic (b.
1924) and Vozarevic (b. 1925). Among
non-figurative painters are: Maskarelli
(b. 1919); Stojanovic-Sip (b. 1920);
Srnec (b. 1924); Srbinovic (b. 1925);
Edo Murtic (b. 1921). The austere and
striking work of Miljenlo Stancic (b.
1926) stands on its own.

GREECE

Sculpture. The classical spirit and the
figurative tradition prevailed in the early
part of the century. Between 1918 and
1940 new trends arose under the in-
fluence of western European art. Bella
Raftopoulo, a pupil of Bourdelle, who
has lived in Paris since 1945, simplifies
human and animal forms, incorporating
them into rhythmic compositions in
which the interrelations of volumes and
hollows are finely balanced. Abstract
sculpture developed after 1945. Two
artists living in Paris, Constantin
Andréou (b. 1917) and Costas Coulen-
tianos (b. 1918) work in welded metal
(see under *France*). Aperghis (b. 1909)
turned to non-figurative art in 1950; he
owes his technique to Pevsner, but his
works are conceived along several
different axes and take on the frag-
mentary aspect of disintegrating sub-
stance. Jeanne Spiteris (b. 1922) pro-
duces powerfully emotional works built
up of aggressive, conflicting planes.
Aglaia Liberaki (b. 1923) produces
strange hallucinatory reliefs which are
akin to Surrealism. Mylona (b. 1923) uses
thick metal plates in two-dimensional
structures mounted upright like sign-
posts. Takis (Vassilakis) (b. 1925) [**1087**]
moved from figurative to abstract
sculpture after settling in Paris; his linear
' signals ' rear up like flexible antennae.

1105. U.S.A. CASS GILBERT
(1859–1934). Woolworth building,
New York. 1913.

1106. U.S.A. MIES VAN DER ROHE
(1886–1969). Seagram building,
New York. 1958.

405

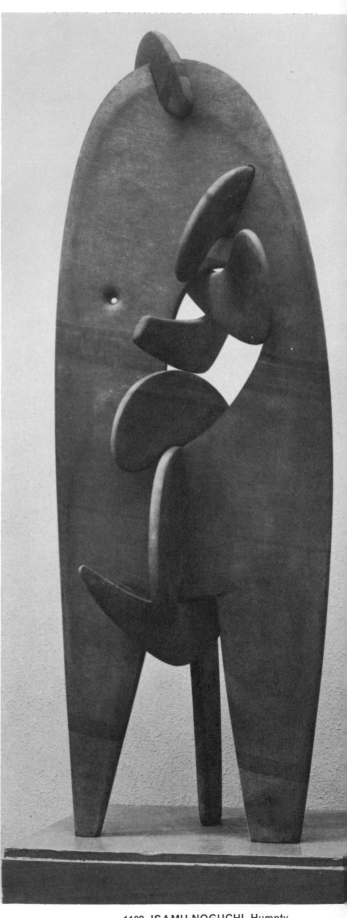

1107. ISAMU NOGUCHI (b. 1904).
Integral. Greek marble. 1959. *Whitney
Museum of American Art, New York.*

1108. ISAMU NOGUCHI. Humpty
Dumpty. Ribbon slate. 1946. *Whitney
Museum of American Art, New York.*

Painting. The veterans of contemporary painting are Papadimitriou (b. 1895) and Mitarachi (b. 1898). A form of Surrealism is apparent in the works of Engonopoulos (b. 1910), who often incorporates elements from classical Greek art. Moralis (b. 1916), though figurative, is not realistic; his nudes are simplified and structural, his composition strictly worked out. Other contemporary painters include: Tsarouchis (b. 1910), Spyropoulos (b. 1912), Mavroidi (b. 1913) and Tetsis (b. 1925). Belonging to the school of Paris are the non-figurative painters Thanos Tsingos (b. 1914), Manolis Calliyannis (b. 1926) and Mario Prassinos (b. 1916) [**922**], a painter of poetic, melancholy and anguished abstract compositions (see under *France*).

THE UNITED STATES

Architecture. The leading figure in American architecture is Frank Lloyd Wright (1867–1959), one of the great architects of this century. Influenced by Richardson and by the Shingle Style, he worked early in his career in the office of Louis Sullivan (see Chapter 3); he was in sympathy with the older man's theories of honest design and with his use of natural forms (the Art Nouveau influence). But while to Sullivan these forms were merely sources for a new kind of ornament, to Wright they formed a basis for his theory of ' organic architecture '. The house, he felt, should be one with the land surrounding it. Thus Falling Water, the Kaufmann house at Bear Run, Pennsylvania (1937) [**668**], is built on a rocky ledge, part of which emerges from the living-room floor as a central hearth. Below the house is a natural waterfall, overhung by the dramatic cantilevered terraces of the house. Inner and outer space are united by the use of glass.

A basic preoccupation — and contribution — of Wright was the problem of the organisation of space: plan was important, as was proportion. Wright also stressed the significance of the use of appropriate materials. His radical ideas did not find general acceptance until the second decade of the century (and at this time, when severe functionalism was the rule in modern architecture, he was still covering his buildings with ornament — a tendency stemming from his early training).

Quite early in his career Wright was impressed with a large model of the Japanese Katsura palace [**289**], which was shown at the Chicago Exhibition of 1893. The integration of the house with its garden, the ' open plan ' with its sliding screens, the overhanging roof and the horizontal nature of the building all found their way into his early work (Hickox house, Kanakee, Illinois, 1900;

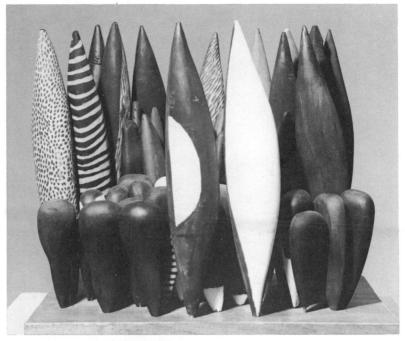

1109. LOUISE BOURGEOIS (b. 1911). One and Others. Wood. 1955. *Whitney Museum of American Art, New York.*

1110. LOUISE NEVELSON (b. 1900). Sky Cathedral. Wood. *Tate Gallery.*

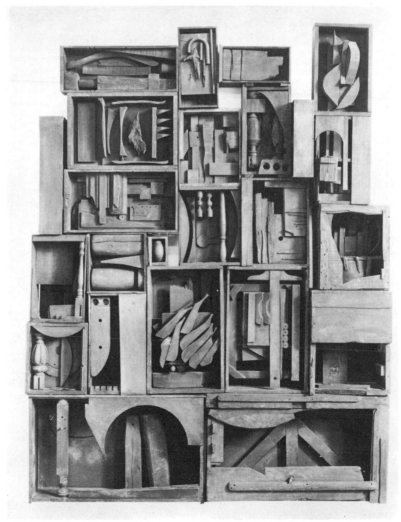

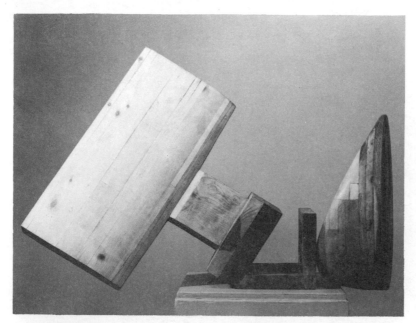

1111. GABRIEL KOHN (b. 1910).
Square Root. Laminated and
dowelled wood. 1958. *Whitney
Museum of American Art, New York.*

1112. JOSEPH CORNELL (b. 1903).
Shadow Box. Interior White with
Yellow Sand and ' Seaside '
Atmosphere. *Hanover Gallery, London.*

Coonley house, Riverside, Illinois, 1908
[**1088**]; Robie house, Chicago, 1909
[**1089**]).

In 1906 Wright produced one of his
masterpieces — Unity Temple, Oak
Park, Illinois [**1090**]. The remarkable
geometric organisation of the volumes
of the interior space of this reinforced
concrete church foreshadowed the new
experiments in European art. Indeed,
the geometric ornament he used in the
building reached Holland (by way of an
exhibition of Wright's work in 1910)
and influenced the future De Stijl
artists. Another outstanding work of
this period was the Larkin office build-
ing, Buffalo, New York (1904), de-
molished in 1949.

Wright's later work includes: the

remarkable Imperial Hotel, Tokyo
(1916–1922); the Millard house, Pasa-
dena, California (1923) [**1091**]; his own
house Taliesin, Spring Green, Illinois
(begun in 1925 and still not completed
at the architect's death); the Johnson
Wax Company's offices, Racine,
Wisconsin (1936–1939 [**1092**], research
tower completed 1949), in which
structure, space and materials were
handled with great ingenuity; Taliesin
West, near Phoenix, Arizona (1938–
1959) [**1093**]; the Price Tower, Bartles-
ville, Oklahoma (1953–1956); the
Guggenheim Museum, New York
(completed 1959) [**669, 670**].

Since the last War the United States
has become a great experimental
laboratory and the most important

centre of world architecture. New
influences have been introduced by the
great European pioneers who emigrated
to the States, where the vast material
resources offered creative possibilities
such as they had never enjoyed before.
Apart from numerous private residences
built in collaboration with Breuer,
Gropius executed some outstanding
educational buildings (Harvard Univer-
sity Graduate Center, 1949–1950[**1095**]).
Mies van der Rohe's most important
works in the United States include: the
buildings for the campus of the Illinois
Institute of Technology (begun in the
1940s); the glass and steel Farnsworth
house, Plano, Illinois (completed 1950)
[**1098**], with its radical construction (the
floor and roof consisting of two slabs
suspended between steel columns); the
Lake Shore Drive apartments, Chicago
(1951) [**678**]; the Seagram building,
New York (1958) [**1106**], with its
façade of grey glass and bronze.

A leading architect influenced by
Mies is Philip Johnson (b. 1906), who
built for himself the very original glass
house in New Canaan, Connecticut
(1947–1950) [**1099**]. Marcel Breuer (b.
1902) [**857, 970, 1100**], after leaving the
Bauhaus (see under *Germany*) in 1928,
spent several years in London (1933–
1937) before settling in the United
States, where he joined Gropius at
Harvard. Both his buildings, with their
clarity of structure and organisation,
and his teaching have left a profound
impression on a new generation of
American architects; his students have
included Johnson, Paul Rudolph [**1096**],
John Johansen and Willo von Moltke.
In 1952 he was chosen as one of the three
architects (with Nervi and Zehrfuss) for
the new UNESCO headquarters [**857**].
Other important works by him include:
the Breuer house, New Canaan, Con-
necticut (1947) [**1100**]; the gymnasium
for Litchfield High School, Litchfield,
Connecticut (1954–1956); St John's
church, Collegeville, Minnesota (1953–
1961) Richard Josef Neutra (b.
1892), of Viennese origin, settled in the
United States in 1923. The peak of his
career came just after the War, with the
Kaufmann desert house, Palm Springs,
California (1946–1947) [**1097**], and the
Tremaine house, Santa Barbara, Cali-
fornia (1947–1948), both distinguished
by elegance, precision and excellent
siting. This period also witnessed the
emergence of Eero Saarinen (1910–
1961), son of the pioneer Finnish archi-
tect Eliel Saarinen (1873–1950), whose
remarkable design for the Chicago
Tribune Tower (1922) received only
second prize. Among the younger
Saarinen's most interesting buildings are
the General Motors Technical Institute,
Warren, Michigan (completed 1955)
[**1094**], the domical Kresge Auditorium,
Massachusetts Institute of Technology,

1113. IBRAM LASSAW (b. 1913).
Sculpture. 1950.

Cambridge, Massachusetts (completed 1955), and the Yale University hockey rink (completed 1958) [**1101**]. One of his last works was the TWA building, Kennedy (Idlewild) Airport, New York [**1102**].

Other leading architects include the late Bernard Maybeck (1862–1957), William W. Wurster (b. 1895) and H. H. Harris (b. 1903) — all of whom have worked in California — and Minoru Yamasaki (b. 1912). An unusual innovator is Richard Buckminster Fuller (b. 1895), whose 'dymaxion house' is designed as a 'machine for living'. His leading contribution is his geodesic dome (of metal or plastic), which is easily mass-produced. The skyscraper became increasingly popular in New York [**1105**, **1106**]. More recent are the Kevin Roche Ford Foundation Building (1967) with its landscaped courtyard; the Everson Museum, Syracuse (1965) by I. M. Pei; the Lincoln Centre for the performing Arts (1966) with contributions by Johnson and Saarinen.

Sculpture. At the beginning of the 20th century a few artists, though continuing to take man as their model, reacted against the idealistic interpretations of Augustus Saint-Gaudens [**612**] (see Chapter 3) and his followers. Malvina Hoffman (b. 1887), a pupil of Rodin, still showed the influence of Impressionism. The main theme of Gaston Lachaise (1882–1935) [**697**], born in Paris, was woman. His women

1114. DAVID HARE (b. 1917). Juggler. Steel. 1950–1951. *Whitney Museum of American Art, New York.*

1115. *Above.* MARY CALLERY (b. 1903). Symbol ' A ' 1960. Steel and brass. *M. Knoedler and Co. Inc., New York.*

1116. *Below.* DAVID SMITH. Lectern Sentinel. Stainless steel. 1961. *Whitney Museum of American Art, New York.*

have a physical grandeur, an effect he obtained by systematically distorting and emphasising certain parts of the body. He created bold effects of movement (*Acrobat*, 1934). Elie Nadelman (1882–1946), born in Warsaw, lived in Munich and Paris before coming to the United States. In 1909 he did a series of drawings that anticipated Cubism; in the United States (from 1914) he studied popular and primitive art and developed a somewhat mannered personal style (*Man in a Top Hat*, 1927). Jo Davidson (1883–1952) was renowned for his portraits. José de Creeft (b. 1884), born in Spain, carves directly in stone. Another advocate of direct carving, William Zorach (b. 1887), embraced a monumental and classical simplicity. Saul Baizerman (1889–1957), born in Russia, worked in hammered copper.

One of the older sculptors working in a modern idiom is Ralph Stackpole (b. 1885) who, working mostly in stone, produces monumental sculpture reminiscent of the totem poles of the Indians or of Aztec art. Sculpture was also influenced by certain European avant garde artists who sought refuge in the United States (Archipenko, Moholy-Nagy, Jacques Lipchitz, Naum Gabo). Archipenko (1887–1964; see under *France*) [868] was a promoter of Cubism; after 1923 he settled in the United States, where he taught in universities and in his own school in New York. His best work dates from 1910 to 1920. Laszlo Moholy-Nagy (1895–1946) [832] was influenced by the Constructivists in his three-dimensional compositions combining various metals with transparent materials; he taught at the Bauhaus, and he brought its theories to Chicago. He was preoccupied with experiments in spatiodynamism.

The creative genius of the artists born at the beginning of the century takes on a variety of forms. Mary Callery (b. 1903) [1115], figurative in her groups of acrobats, dancers, animals and birds, treated in arabesques that are full of humour, gradually changed to abstract work. Isamu Noguchi (b. 1904) [1107, 1108] has undergone a variety of influences (Brancusi, Calder, Giacometti). His strangely haunting — often bonelike — vertical figures are among the most original contributions to contemporary sculpture. Noguchi also designs gardens in which sculpture and nature are interrelated (garden of the UNESCO headquarters in Paris, 1958). Day Schnabel (b. Vienna, 1905), a pupil of Gimond and Malfray in Paris, then of Zadkine, is concerned with a synthesis of the plastic arts and integrates her sculpture with architecture. Louise Bourgeois (b. Paris, 1911) [1109], who has lived in New York since 1938, creates forms that evoke plant life; she employs painted wood to produce varying effects.

Helen Phillips (b. 1913) creates simple, rudimentary forms that take on the appearance of totems. Patricia Diska (b. 1924) uses hard stone which she transforms into supple volumes. Gabriel Kohn (b. 1910) [**1111**] makes geometric constructions in wood. Louise Nevelson (b. 1900) [**1110**], whose work stems from Cubism and has affinities with Surrealism, constructs huge compositions of discarded odds and ends of wooden architectural elements and bits of furniture. Joseph Cornell (b. 1903) [**1112**] makes shadow boxes into which he puts compasses, matchboxes, postage stamps and similar souvenirs. Wood has been employed in an original way by Marisol (b. France, 1930). American sculptors continuing in a figurative tradition are Robert Arneson (b. 1930) and the New Realists Robert Graham (b. 1938), Duane Hanson (b. 1925), John de Andrea (b. 1941), Edward Keinholtz (b. 1927) and George Segal (b. 1924), Claes Oldenburg (b. 1929) and Roy Lichtenstein (b. 1923) produce sculptures in the Pop style. Lucas Samaras (b. Greece, 1936) creates witty surrealist assemblages and Marjorie Strider produces assemblages of metal fruit.

A leading sculptor working in metal was Alexander Calder (1898–1976) [**820**], who introduced kinetics into sculpture and is best known as the inventor of mobiles. José de Rivera (b. 1904) selects materials immune to atmospheric changes; his thin strips and flexible struts are developed from a single point of departure. Clair Falkenstein (b. 1909) [**637**] uses an original technique in her light, buoyant wire sculptures. Harry Bertoia (b. 1915) creates metal wall-decorations that hang freely in space. Harold Cousins (b. 1916) combines metal plate with wire. Sydney Gordin (b. 1918) uses steel to produce pure geometric forms. Raymond Rocklin (b. 1922) employs overlapping layers of metal. James Metcalf (b. 1925) produces abstract metal forms which recall Surrealism in certain respects.

One may classify as Abstract Expressionists certain artists who enjoy an international reputation, for example Seymour Lipton (b. 1903), who used to do figurative work in wood but became abstract in 1950 when he began using sheet metal. He employs steel plates which he curves and welds into dynamic compositions. The great contribution of David Smith (1906–1965) [**1116**] was his welded metal sculpture. His large and powerful works are impressive contemporary symbols. Herbert Ferber (b. 1906) fashions lead and bronze for his sharply angled forms which rend the surrounding space. Theodore Roszak (b. 1907) [**653**] moved gradually from drawing to painting, from modelling to Constructivism and Neo-plasticism. After 1945 his forms became freer but

1117. *Above.* CHARLES MATTOX. Slow Disk Movement (in motion). Kinetic sculpture. 1964. *Lanyon Gallery, Palo Alto.*

1118. *Below.* TONY DE LAP. Arje. Aluminium, board, Plexiglas and lacquer. 1964. *Dilexi Gallery, La Jolla.*

1119. JOHN SLOAN (1871–1951).
The Wake of the Ferry. 1907.
Phillips Collection, Washington.

1120. *Above.* GEORGE BELLOWS
(1882–1925). Both Members of this
Club. 1909. *National Gallery,
Washington.*

1121. *Below.* MARSDEN HARTLEY.
The Old Bars, Dogtown. 1936. *Whitney
Museum of American Art, New York.*

remain tense and dramatic. Ibram
Lassaw (b. 1913) [**1113**] makes welded
metal constructions of geometrical con-
tours juxtaposed in space, suggesting a
space geometry of variegated texture.
David Hare (b. 1917) produces abstract
works which incorporate naturalistic
elements [**1114**].

Constructivism is represented by one
of the authors of the original manifesto,
Naum Gabo (b. 1890) [**666, 888, 889**].
Gabo left Russia in 1922, spent ten years
in Germany, and settled in Paris in 1932
and then in England (1936–1946),
before finally moving to the United
States; he applies the principles of Con-
structivism in his work, using alumi-
nium, bronze, steel, precious-metal wire
and transparent materials (*Translucent
Variation on Spheric Theme*, 1951,
Guggenheim Museum, New York
[**889**]). His most active disciple, Richard
Lippold (b. 1915) [**667**], adheres faith-
fully to the technique of his first abstract
compositions, of brass, nickel or silver
wire stretched out in space from certain
central axes according to the laws of
geometry. Richard Stankiewicz (b.
1922) and Joseph Chamberlain (b. 1927)
create sculptures from metal wreckage
and 'found objects'. Recent work in
California includes Tony De Lap's metal
constructions [**1118**] and the mechanical
works of Charles Mattox [**1117**].

Painting. At the beginning of the
20th century American art reflected the
European trends of the previous fifty
years. The first challenge came in 1908
with the exhibition of The Eight, a
group of painters opposed to the narrow
provincialism of contemporary paint-
ing. The outstanding artist of this group,
known derisively because of its realism
as the Ashcan school, was John Sloan
(1871–1951) [**1119**]. Another prominent
realist of this period was George
Bellows (1882–1925) [**1120**], whose
paintings of boxing matches are well
known. In 1910 Max Weber (1881–
1961) [**1123**], then a Cubist, ex-
hibited at '291', the Photo-Secession
gallery of Alfred Stieglitz. Other
exhibitors at the gallery included John
Marin (1870–1953), who later gained
wide fame as a watercolourist [**1122**],
and Marsden Hartley (1877–1943)
[**1121**]. In 1913 the Armory Show in
New York brought the full impact of
Fauvist, Cubist and Expressionist ideas
to the country and had a powerful
influence on artists and art collectors.
(The greatest furore over this exhibition
was centred on Marcel Duchamp's *Nude
descending a Staircase, No. 2* [**740**].) In
the same year the painting of expatriate
Americans was noticed by European
critics. Lyonel Feininger (1871–1956;
see under *Germany* [**1135**; see colour

1122. JOHN MARIN (1870–1953).
Maine Islands. Watercolour. 1922.
Phillips Collection, Washington.

1123. MAX WEBER (1881–1961).
Chinese Restaurant, 1915. *Whitney
Museum of American Art, New York*

1125. CHARLES BURCHFIELD
(b. 1893). Ice Glare. Watercolour.
1933. *Whitney Museum of American
Art, New York.*

1124. MORGAN RUSSELL (1886–1953).
Synchromy Number 4 (1914) to Form.
Walker Art Center, Minneapolis.

1126. *Right.* EDWARD HOPPER.
Early Sunday Morning. 1930. *Whitney
Museum of American Art, New York.*

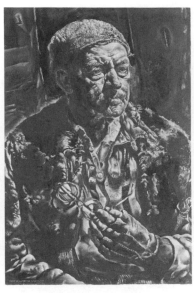

1127. GRANT WOOD (1892–1942).
American Gothic. 1930. *Art Institute
of Chicago.*

1128. IVAN LE LORRAINE
ALBRIGHT (b. 1897). Fleeting Time
Thou hast left Me Old. 1929–1930.
Metropolitan Museum of Art.

1129. JOSEPH STELLA (1880–1946).
The Bridge. 1922. *Newark Museum.*

1130. *Above.* GEORGE TOOKER (b.
1920). The Subway. 1950. *Whitney
Museum of American Art, New York.*

1131. *Right.* CHARLES DEMUTH (1883–
1935). Buildings, Lancaster. 1930. *Whit-
ney Museum of American Art, New York.*

1132. LOUIS GUGLIELMI (1906–1956).
Terror in Brooklyn. 1941. *Whitney
Museum of American Art, New York.*

1133. CHARLES SHEELER (1883–1965).
Architectural Cadences. 1954. *Whitney
Museum of American Art, New York.*

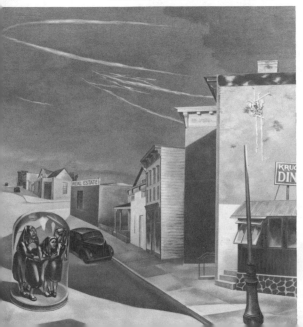

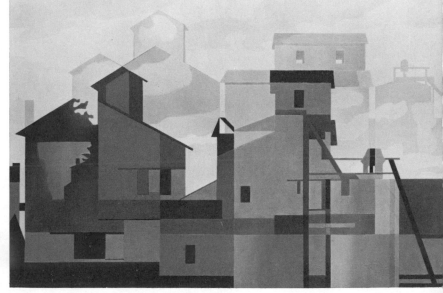

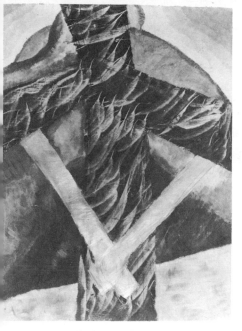

1134. ARTHUR DOVE (1880–1946). Telephone Pole. Oil and metallic paint on metal. 1929. *Art Institute of Chicago.*

1135. LYONEL FEININGER (1871–1956). Blue Coast. *Columbus Gallery of Fine Arts.*

1136. GEORGIA O'KEEFFE (b. 1887). Black Cross, New Mexico. 1929. *Art Institute of Chicago.*

plate p. 296]) did not return to his native America from Germany till 1936, but the elegance of his precise, geometrical work with its strong romantic feeling appears closer to American Precisionist artists such as Demuth than to German Expressionism. In 1913 two Americans living in Paris, Stanton MacDonald-Wright (b. 1890) and Morgan Russell (1886–1953) [1124] launched in Munich the movement called Synchromism. In its reaction against the monochrome colours of Cubism and its visualisation of form through colour rhythms, Synchromism resembled Orphism.

In the 1920s and afterwards there were still a number of important figurative painters: Charles Burchfield [1125] (b. 1893) and Edward Hopper (b. 1882) [1126], who evoked the small town and the provincial city, mean suburban streets and isolated deserted houses; the regional painters Thomas Hart Benton (b. 1889), John Steuart Curry (1897–1946) and Grant Wood (1892–1942) [1127], the last famous for his satirical *Daughters of Revolution*; Ivan Le Lorraine Albright (b. 1897) [1128], whose detailed, intense and haunting studies of people, in which every blemish is recorded, have a hallucinatory quality which is also present in the realism of Andrew Wyeth (b. 1917) [643]. Magic Realism, with its realistic style and sinister or fantastic subject matter, is seen in the work of George Tooker (b. 1920) [1130], Louis Guglielmi (1906–1956) [1132] and Peter Blume (b. 1906). The industrial civilisation was portrayed by Niles Spencer (1893–1952), Charles Sheeler (b. 1883) [1133] and Joseph Stella (1880–1946) [1129]. Charles Demuth (1883–1935) [1131] employed Cubist analysis

1137. LOREN MacIVER (b. 1909).
Venice. 1949. *Whitney Museum of
American Art, New York.*

1140. MORRIS GRAVES (b. 1910).
Bird in the Spirit. 1940–1941.
*Whitney Museum of American Art,
New York.*

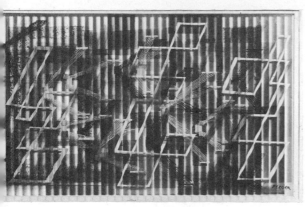

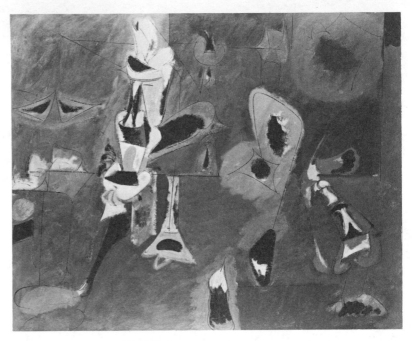

1138. *Above.* IRENE RICE PEREIRA
(b. 1905). Shooting Stars. Mixed
media on glass and panel. 1952.
Metropolitan Museum of Art.

1139. *Below.* WILLEM DE KOONING
(b. 1904). Woman and Bicycle.
1952–1953. *Whitney Museum of
American Art, New York.*

1141. *Above.* ARSHILE GORKY. Agony.
1947. *Museum of Modern Art, New York.*

1142. *Below.* BRADLEY WALKER
TOMLIN. No. 10. 1952–1953. *Munson-
Williams-Proctor Institute, Utica.*

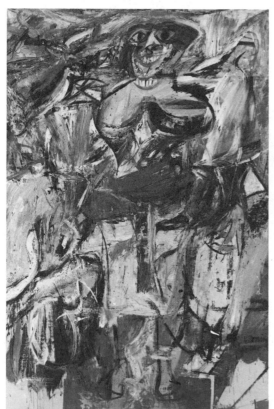

1143. WILLIAM BAZIOTES (1912–1963). Primeval Landscape.
1953. *Fleisher Art Memorial, Philadelphia*.

1144. THEODOROS STAMOS (b. 1922). High Snow–Low Sun.
1957. *Whitney Museum of American Art, New York*.

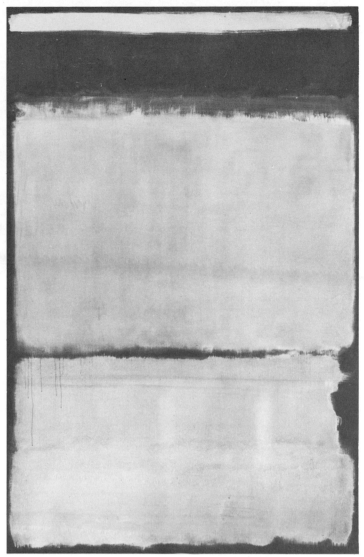

1145. MARK TOBEY (1890–1976). Harvest. 1958. *Marian Willard
Johnson Collection*.

1146. MARK ROTHKO. No. 10. *Museum of Modern Art, New York*.

1147. ADOLPH GOTTLIEB. Green Expanding. 1960. *Tate Gallery*.

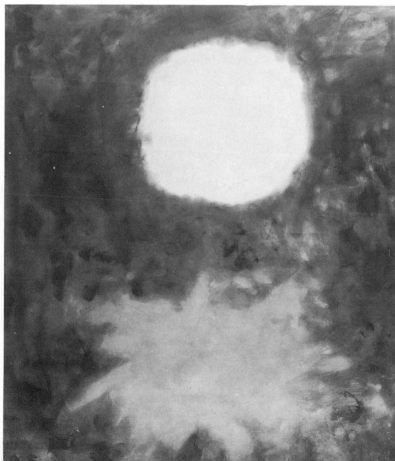

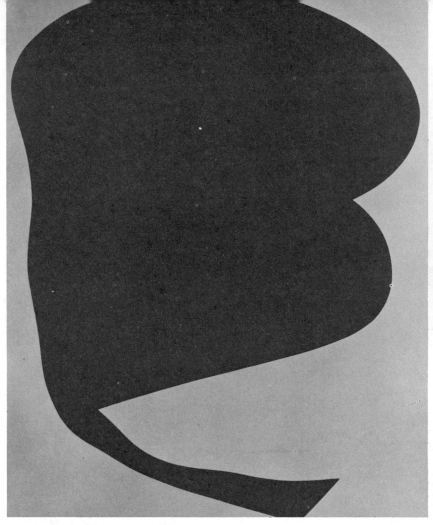

1148. ELLSWORTH KELLY (b. 1923).
Blue on White. 1961. *S. C. Johnson and Son Collection, Racine.*

1149. CLYFFORD STILL (b. 1904).
Jamais. 1944. *Peggy Guggenheim Collection, Venice.*

in his paintings. He was connected with the Stieglitz gallery, as was Arthur Dove (1880–1946) [**1134**], who painted in an extremely personal abstract style. Stieglitz's wife Georgia O'Keeffe (b. 1887) [**1136**] has come close to the abstract in her studies of flowers, skulls, etc. Painters of 'social content' include Ben Shahn (1898–1969) [**786**], Philip Evergood (b. 1901) [**782**], Jack Levine (b. 1915) and Jacob Lawrence (b. 1917). The Dada movement was represented by one native American, Man Ray (b. 1890) [**831**], who was also a Surrealist.

Earlier abstract artists include Stuart Davis (1894–1964), Arshile Gorky (1904–1948) [**1141**], Irene Rice Pereira (b. 1905) [**1138**] and Loren MacIver (b. 1909) [**1137**]. By the 1940s abstraction had become the dominant trend in American painting.

Abstract Expressionism, with its concern with the act of painting as a prime instrument of expression, developed in New York during the early 1940s. Large in size, unconcerned with illusionistic depth, action painting aims at transmitting or suggesting inner emotion. An important influence on its formation was the presence in New York during the War of Surrealist painters, notably Max Ernst, André Masson, Marcel Duchamp and Matta Echaurren. Chief among their supporters was Peggy Guggenheim, whose gallery served as the principal centre of avant garde painting. Other influences were the philosophy of Zen Buddhism, and Oriental calligraphy. Mark Tobey (b. 1890) [**1145**], an important forerunner, owes part of his rhythmic quality to Chinese calligraphy, with its emphasis on the handwriting of the artist. This influence is also seen in the powerful canvases of Franz Kline (1910–1962) [**819**], with their striking tension between black and white. In 1948 William Baziotes (b. 1912) [**1143**], Robert Motherwell (b. 1915) [**1150**], Mark Rothko (b. 1903) [**1146**; see colour plate p. 368] and Barnett Newman (b. 1905) founded the Subjects of the Artist school, out of which grew the Club. The first abstract works of Jackson Pollock (1912–1956) [**816**; see colour plate p. 368] date from 1945, and in 1947 he developed his highly individual 'drip' technique, with its superimposed layers of paint. Willem de Kooning (b. 1904) [**1139**], who came from Holland in 1926, entered the movement in 1948 and quickly became a major figure. Bradley Walker Tomlin (1899–1953) [**1142**], Philip Guston (b. 1912), Jack Tworkov (b. 1900), Grace Hartigan (b. 1922), Adolph Gottlieb (b. 1903) [**1147**], Theodoros Stamos (b. 1922) [**1144**] and Sam Francis (b. 1923) [**931**] all turned to Abstract Expressionism, some in mid-career, others while still students. Francis, settled in Paris, is the only painter whose reputation has been made without the benefit of New York (see under *France*). The abstract 'black on blacks' of Ad Reinhardt (b. 1913) are his own distinctive contribution. Clyfford Still (b. 1904) [**1149**], who taught in California for many years, helped inspire the Pacific (or West Coast) school, whose visionary ideals are reflected in the art of Morris Graves (b. 1910) [**1140**].

In contrast to the abstraction of previous decades, the 1960s produced the figurative movement known as Pop Art. Leading exponents are Robert Rauschenberg (b. 1925) [**1153**], Jasper

1150. ROBERT MOTHERWELL (b. 1915). Elegy to the Spanish Republic, No. 78. Oil and plastic on canvas. 1962. *Yale University Art Gallery, New Haven.*

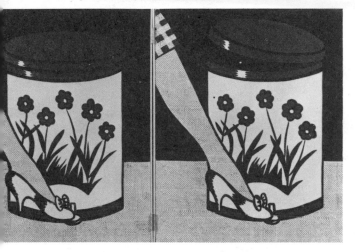

1151. ROY LICHTENSTEIN (b. 1923). Step-on Can with Leg. Diptych. 1961. *Philip Johnson Collection, New York.*

1152. JIM DINE (b. 1935). Black Bathroom No. 2. Porcelain, metal, oil and drawing on canvas. 1962. *Sidney Janis Gallery, New York.*

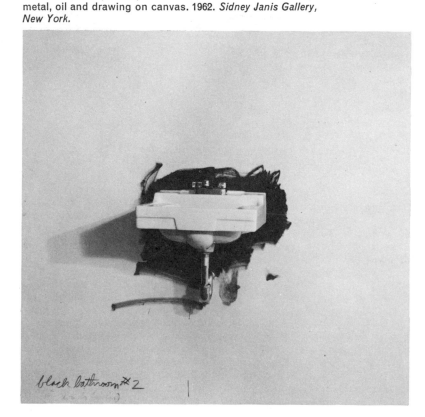

black bathroom #2

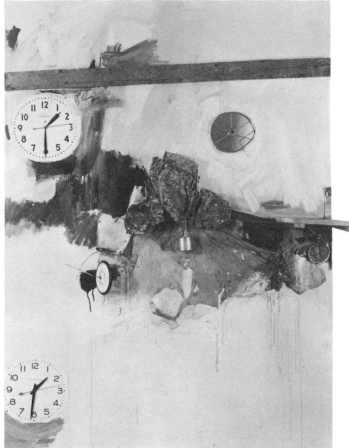

1153. ROBERT RAUSCHENBERG (b. 1925). Reservoir. Combine-painting. 1961. *S. C. Johnson and Son Collection, Racine.*

Johns (b. 1930), Larry Rivers (b. 1923) Roy Lichtenstein, Jim Dine (b. 1935), Robert Indiana (b. 1928), Wayne Thiebaud (b. 1920), James Rosenquist (b. 1933), Tom Wesselman (b. 1931), Mel Ramos (b. 1935) and Andy Warhol (b. 1928).

A more commonplace view of reality was presented by Photo-Realists such as Noel Mahaffey (b. 1944), Lowell Nesbitt (b. 1933) with his large flower studies, Bruce Everett (b. 1942), Don Nice (b. 1932), Ben Schonzeit, Janet Fish (b. 1938), Josef Raffael (b. 1939), Philip Pearlstein (b. 1924), Frances Kuehn (b. 1943), Paul Staiger (b. 1941), Chuck Close (b. 1940) and Alan Katz (b. 1927).

Meanwhile, painters such as Frank Stella (b. 1936), Kenneth Noland (b. 1924), and Al Held (b. 1928) were being influenced by the teachings of the German painters Josef Albers (1888–1976) [**1065**] and Hans Hoffman (1880–1966). Encouraged by the critic Clement Greenberg, they were exploring the effects of colour and line on the flat surface of the canvas.

Non-figurative artists include Cy

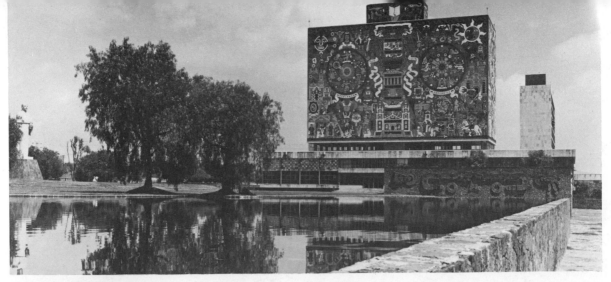

1154. MEXICO. O'GORMAN, SAAVEDRA and MARTINEZ DE VELASCO. Central library, University City, Mexico City. 1951–1953.

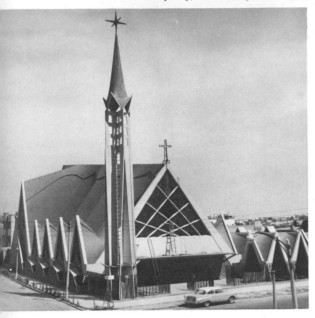

1155. MEXICO. FELIX CANDELA (b. 1910). Church of Nuestra Señora de los Milagros, Mexico City. 1955.

1156. DAVID ALFARO SIQUEIROS (1896–1964). Self-portrait, 1943 *Museo de Arte Moderno, Mexico City.*

Twombly (b. 1929), Ron Lavis (b. 1937), Gene Davis (b. 1920) and Deborah Remington (b. 1935). Minimalist painters, following the lead taken by Ad Reinhardt (b. 1913), include Robert Mangold (b. 1937), Robert Ryman (b. 1930), Brice Marden (1938) and Agnes Martin (b. Canada, 1912). Pattern painters include Joyce Kozloff. Valerie Jaudon, Robert Kushner and Robert Zakanitch. Abstract painters with a basis of reality are Robert Stanley (b. 1932), Allan d'Arcangelo (b. 1930) and Richard Diebenhorn (b. 1922).

CANADA

Sculpture. Jocelyn Chewett (1906–1979), practised direct carving; she was deeply interested in the geometry of form. Louis Archambault (b. 1915) verges on Surrealism. Anne Kahane employs wood, as does Robert

Roussil (b. 1925), whose first exhibition caused a scandal owing to the frankness of his realistic nudes. Ronald Bladen (b. 1918) is a leading Minimalist, while William Vazan (b. 1933) is a conceptual sculptor.

Painting. The most advanced elements of the Montreal school, which grew up between 1942 and 1946, have for the most part opted for abstraction, with the exception of Jacques de Tonnancour (b. 1917). The best representatives are Alfred Pellan (b. 1906) and Jean Paul Riopelle (b. 1923) [**695**]. Toronto artists include W. Ronald, Kazuo Nakamura and Harold Town. Quebec has its artistic centre, which includes Jean Paul Lemieux, who recalls Belgian Expressionism, and Jean Dallaire (1916–1965). Alex Colville (b. 1920) and Tom Forrestall are Magic Realists, while Ken Danby (b. 1940) is a Photo-Realist

painter. Jack Bush (1909–1977) was concerned with colour and surface.

Architecture. Notable modern buildings include the dramatic Toronto City Hall (1965) by Viljo Rewell, the Simon Fraser University in British Columbia (1965) by Erickson and Massey and the Vancouver Court House by Arthur Erickson Architects.

MEXICO

Architecture. Mexico was the first of the Latin American countries to be directly affected by modern architecture. The revolt against the imitation of traditional building forms in the mid-1920s found expression in the work of José Villagrán García (b. 1901) and in that of his pupils Legorreta, O'Gorman and Yañez. At the beginning of the 1950s, Mexico's masterpiece of

420

1157. JOSÉ CLEMENTE OROZCO (1883–1949). Christ Destroying His Cross. Fresco. 1932–1934. *Baker Library, Dartmouth College, Hanover, New Hampshire.*

modern architecture — the University City [**1154**] (lay-out by Mario Pani and Enrique del Moral), Mexico City — was built. With the collaboration of nearly a hundred young architects and engineers the project, for twenty thousand students, was finished in three years. Mexico's building tradition, with its strong roots in the Pre-Columbian past, has left its mark on the University City in the dimensions of its open spaces and the passion for decoration. All available surfaces are covered with murals, mosaics and reliefs in a social realist style (library by Juan O'Gorman; stadium by Diego Rivera). Mexico's greatest contribution to modern architecture is the development of shell vaulting by Felix Candela (b. 1910), in free organic shapes having a sculptural quality [**1155**].

Sculpture. The ideological and social transformations brought about by the Mexican Revolution, which began in 1910, had a profound effect on aesthetic values and changed the course of Mexican art. Mexico's sculpture is not as original as its painting and has been slower to break with academicism and to look to the indigenous Mexican tradition in art. Luis Ortiz Monasteri (b. 1906) explores this tradition. Inspired by the popular genius of his country, he treats the human figure schematically. Mathias Goeritz (b. Germany, 1915) has lived in Mexico since 1949. An architect as well as a sculptor, he has built an experimental museum. His sculptures of stylised animals and his

religious sculptures are in the Mexican spirit. He has had a strong influence on the artists of his generation. Ignacio Asunsolo, renowned for his portraits, and Geles Cabrera have a direct, primitive feeling for simple, basic, nearly abstract forms. The more Expressionistic work of Francisco Marini is dominated by a feeling for the tragedy of human existence.

Painting. The Mexican Revolution, which started in 1910, became a national movement. It brought about a revaluation of Mexico's history which emphasised the importance of the individual and led to a new assessment of Mexico's ancient Indian art; this resulted in a renaissance in mural painting. Powerful and original, this body of work provides a monumental record of Mexican history — which is treated as world history through the use of expressive and forceful allegory. Diego Rivera (1886–1957) [**785**], who studied in Paris, became the pioneer of the monumental style of this new Mexican school by adopting the traditions of Mayan and Aztec art. His vast frescoes for public buildings were inspired by the political and social history of Mexico. He aimed at the creation of a folk image and made use of popular subject matter. José Clemente Orozco (1883–1949) [**1157**; see colour plate p. 350], equally a pioneer, was a more tragic and dramatic artist, revealing in his monumental work a profoundly humane spirit and a fierce sense of identification with his times. Deeply involved in left-wing politics, David Alfaro Siqueiros (1896–1974) [**1156**] was in prison on several occasions. His tragic, passionate painting — almost Baroque in its movement and juxtapositions — is deeply rooted in the Mexican tradition.

Rufino Tamayo (b. 1899) [**1158**] has closer affinities with European modern movements through his residence in New York. His world is a borderland between the animal and the human; it is a world of harsh, broken lines relieved by colour and filled with obsessive symbols. The architect Juan O'Gorman (b. 1905) is also a fresco painter. Luis Cuevas is one of the leading Mexican painters today. In the realist and social vein are the sober compositions of Ricardo Martinez (b. 1918). Close to abstraction is the work of Carlos Mérida (b. Guatemala, 1893). Alfonso Michel (d. 1957) produced mystical works of great stylistic simplicity. Frida Kahlo (b. 1910) paints self-portraits. Reyes Fereira, whose Baroque tendency is derived from the reliefs in Mexican churches, does paintings on paper. Many European artists of a Surrealist tendency have settled in Mexico.

1158. RUFINO TAMAYO (b. 1899). The Singer. 1950. *Musée d'Art Moderne, Paris.*

Graphic arts. Through long tradition Mexican graphic work has a popular flavour and often deals with political subjects. The end of the century produced one great artist, José Guadalupe Posada (1851–1913), whose work was an inspiration to the following generation. His vast output of woodcuts and engravings, which included thousands of illustrations for *corridos* and *cuentos*, was of a popular nature. Profound and humane, ironic, humorous and fantastic, his work provides a searching criticism of his age. Other prominent engravers are Leopoldo Mendez (b. 1903) and Alfredo Zalce (b. 1908); Alberto Beltrán (b. 1923) belongs to the younger generation.

CUBA

Sculpture. Augustín Cardenas (b. 1927), a pupil of Sicré in Havana, is a follower of Bourdelle. Figurative at first, he soon began experimenting with plastic distortions; he belonged to the Group of Eleven, which united Cuban avant garde artists against official art. His trip to Paris in 1956 led him to the abstraction of his soaring totems, which are charged with magic.

Painting. The leading Cuban painter is Wilfredo Lam (b. 1902) [**1159**], whose strange figures, like primitive gods, are linked with Surrealist painting. Other painters range from emotional realism to abstraction.

HAITI

Painting. In 1943 DeWitt Peters, an American, became interested in the

work of the self-taught Haitian painters and founded an art centre. Hector Hippolyte and Philomé Obin are the most famous of these painters. Their naive form of expressionism, sincere and completely original, has attracted much notice in the United States.

DOMINICAN REPUBLIC

The extraordinary impetus given to the arts by Brazil and Mexico has had its impact in this country on artists such as Gausach-Armengol (b. 1889), Tavares (b. 1906) and Vela-Zanetti (b. 1913).

GUATEMALA

Sculpture. Adalbert de León Soto (b. 1919), a pupil in Paris of Etienne-Martin, is a vigorous sculptor in stone. Eduardo de León (b. 1921) is less traditional in his forms, which have a poetic quality. An engraver, his graphic work is closely related in its rhythm to his sculpture. He is figurative. Roberto Gonzalez Goyri (b. 1924) assisted Julio Vasquez in the execution of decorative sculptures for the Palacio Nacional. His work became Expressionist about 1950, before it became abstract (1954).

Painting. The work of Carlos Mérida (b. 1891) stems indirectly from Surrealism; other painters include Arturo Martinez (b. 1912) and Juan Antonio Franco (b. 1920).

EL SALVADOR

Painting. Painters include Canas (b. 1924), Montes (b. 1934), Barrière (b. 1937), Flores-Serrano (b. 1939) and Hernandez-Aceman (b. 1939), who specialises in landscapes.

NICARAGUA

An artistic movement is now growing up around Rodrigo Penalba, who has founded an art school.

PANAMA

Painting. The pioneers of painting in Panama were Manuel Amador (1869–1952) and Roberto Lewis (1884–1949), who lived in Paris.

BRAZIL

Architecture. Characterised by daring forms, lyrical harmony and strong spiritual links with its colonial past, Brazilian modern architecture developed from two rebel movements, the Modern Art Week in São Paulo (1922) and the Regionalist movement in Recife (1926), which aimed at giving new shape to Brazilian intellectual life by destroying the alien influences which had domi-

nated the country since 1816. The revolution of 1930 led to a programme of important new public works, including the Ministry of Education and Health, Rio de Janeiro (1937–1943) — the work of a team headed by Lucio Costa (b. 1902) and including Oscar Niemeyer (b. 1907), Jorge Machado Moreira, Affonso Eduardo Reidy (b. 1909), Ernani Vasconcellos and Carlos Leão, all decisively influenced by the visit in 1936 of Le Corbusier. From 1937 to 1944 an impressive number of distinguished works included the day nursery, Rio de Janeiro, by Niemeyer (1937), the Brazilian pavilion at the New York World's Fair, by Costa and Niemeyer (1939) and the São Francisco chapel, Pampulha, by Niemeyer (1943) [685].

After the War the country entered a phase of rapid industrial growth which helped to raise the level of construction. Architects include Paulo Antunes Riberio, João Vilanova Artigas, Sergio Bernardes, Icaro Castro Mello, Francisco Bolonha and Giancarlo Palanti. The most important achievements since 1950 are Niemeyer's Ibirapuera Park exhibition pavilions in São Paulo, Reidy's Pedregulho housing estate and his Museum of Modern Art, Rio de Janeiro (begun in 1954), and Moreira's University City (from 1953). Roberto Burle Marx has made an important contribution in his skilful linking of buildings and surrounding gardens through the use of colour.

Niemeyer is the leading exponent of modern architecture in Brazil by virtue of the extent, scope and character of his work. Decisively influenced by Le Corbusier, he soon branched out into a personal style that has an imaginative exuberance and lightness of touch; he uses curved lines with spontaneity and lyricism. His crowning achievement is the design of the main public buildings for Brasilia. This new capital, created by President Kubitschek and located inland, is in many ways remarkable. It was begun in 1960, only three years after the approval of Costa's plan with its clear expression of the city's unique function. Niemeyer's designs are perfectly suited to this plan and are handled with restraint and purity (President's Palace; cathedral) [**1160, 1161**].

Sculpture. For a century art continued to be taught according to the rules introduced by the French mission in 1830. The founding in 1947–1948 of the Museum of Modern Art in São Paulo and that in Rio de Janeiro brought about a renaissance in the plastic arts. Lasar Segall (1891–1957), who was also a pioneer in painting, produced some little known sculptures (*Two Sisters*,

1929); he has had a considerable influence on the younger generation. Victor Brecheret (1894–1955) was a pupil of Meštrovic (see under *Yugoslavia*); though his simple, denuded forms bear the traces of his master, he does preserve a native flavour of his own; he was an active member of avant garde movements. Maria Martins (Maria; b. 1900) [**1162**], a musician and a painter, took up sculpture in 1926. She began doing ceramics during a stay in Japan (1936–1939); later Oscar Jespers (see under *Belgium*) had a decisive influence on the course of her career. The tumultuous rhythms of her open compositions are inspired by memories of the exuberant vegetation of her home country; she was in charge of the decoration of the Alvarada Gardens in Brasilia. Bruno Giorgi (b. 1908) [**1161**] lived in Paris (1936–1939) and studied with Maillol; he worked in the classical tradition until 1947, when he gave up his opulent forms for thin, elongated shapes reduced to the bare essentials and having tremendous vitality; he collaborates with present-day Brazilian architects in the sculpture for their buildings. Felicia Leirner (b. 1904), Zelia Salgado (b. 1909), Franz Weissmann (b. 1911) and Julian Althabe (b. 1911) are all abstract, as is Mary Vieira (b. 1927), a pupil of Max Bill (see under *Switzerland*); her works are purely linear or are made up of an assemblage of flat plates of aluminium or polished steel; she works for Brasilia. Mario Cravo (b. 1923), once a follower of Meštrovic and now free of his influence, is inspired by popular Brazilian life and uses iron in lively, vigorous works of great technical dexterity.

Painting. The Modern Art Week in São Paulo in 1922 was an important event in the cultural history of Brazil. Di Cavalcanti (b. 1897), a pioneer of modern painting in Brazil, endeavours, as did Lasar Segall (1891–1957), to depict in a highly personal way a tragic aspect of man and the countryside. Candido Portinari (1903–1962) painted powerful figurative works based on the life of the Brazilian working classes. Among artists representative of the younger generation are: José Antonio da Silva (b. 1909); Elisa Martins da Silveira (b. 1912); Inima de Paula (b. 1918); Clara Heteny (b. 1919); Hermelindo Flaminghi (b. 1920); Judith Luand (b. 1922); Decio Vieira (b. 1922); Ivan Serpa (b. 1923); Paulo Rissone (b. 1925); Waldemar Cordeiro (b. 1925); Aluisio Magalhaes (b. 1927); Paulo Becker (b. 1927); Loio Persio (b. 1928); Flavio Shiro Tanaka (b. 1928); Abraham Palatnik (b. 1928); Teresa Nicolão (b. 1928); Mauricio Nogueira Lima (b. 1930). There are also some excellent naive painters in Brazil.

1159. WILFREDO LAM (b. 1902).
Astral Harp. 1944. *Urvater
Collection, Brussels.*

1160. BRAZIL. OSCAR NIEMEYER
(b. 1901). The cathedral, Brasilia.
Begun 1959.

1161. BRAZIL. OSCAR NIEMEYER.
View of the Congress buildings,
Brasilia. 1960. Sculpture by Bruno
Giorgi.

1162. MARIA MARTINS (b. 1900).
Rituel du Rythme. Bronze. 1958.
President's Palace, Brasilia.

CHILE

Sculpture. Samuel Roman Rojas (b. 1907) is the most celebrated Chilean artist of his generation. He employs all the traditional sculptural materials and remains figurative. Of peasant origin, he models in clay with exceptional skill. His sculpture has a monumental grandeur and a powerful lyricism. María Teresa Pinto (b. 1910) trained in France with Laurens and Brancusi. She then spent several years in Mexico where she studied Pre-Columbian Mexican sculpture before returning to live in Paris. Her former teachers and her contact with an ancient civilisation account for the asceticism of her work (bronze or marble) and her predominant interest in simplified forms. Lily Garafulic (b. 1914) has had a brilliant career after having received a Guggenheim fellowship to the United States. A teacher at the art school in Santiago, she has executed capitals for the Chilean basilica at Lourdes; she has gradually become abstract since 1957. Marta Colvin (b. 1917), a pupil of Julio Antonio Vasquez, went to Paris in 1948 on a grant. She studied with Zadkine and met Laurens and Brancusi,

and later Henry Moore. Returning to Chile in 1954, she taught sculpture at the Santiago Academy. Her predominantly non-figurative work is inspired by the natural aspects of her country, its geology and vegetation, and by Pre-Columbian America. Her pupil, the Constructivist Servio Castillo, is a leading abstract sculptor.

Painting. Chilean painting today tends to be non-figurative. The leading representative is Matta (Matta Echaurren; b. 1912 [**1163**; see colour plate p. 350]), whose abstract canvases (often suggestive of some fabulous display of fireworks) have Surrealist overtones. Other painters include Matilda Perez (b. 1916), James Smith (b. 1924) and Marta León (b. 1931).

PERU

Sculpture. The leading sculptor is J. Pocarey (b. 1923), who teaches at the school of art in Lima. He uses iron, steel and welded metal plates in his geometrical constructions.

Painting. Enriched by an exceptional artistic tradition, contemporary Peruvian

1163. MATTA (b. 1912). The
Un-Nominator Renominated. 1953.
Peggy Guggenheim Collection, Venice.

painting bears traces of autoch-
thonous and Spanish art. Painters of a
modern tendency include: Ricardo
Grau (b. 1907), Ricardo Sanchez (b.
1912) and Juan Barreto (b. 1913). The
national art school in Lima is the leading
centre of plastic art in Peru; the teaching
encompasses the ancient indigenous
tradition as well as the most recent
trends in international art. Among the
most dynamic of the younger painters
are Gonzalez-Basurgo (b. 1926), José
Milner (b. 1932), Alfredo Aysanoa (b.
1932), Enrique Galdos (b. 1933) and
Gerardo Chavez (b. 1937).

ARGENTINA

Sculpture. The sculptor-diplomat
Pablo Manes (b. 1891) was a pupil of
Bourdelle in Paris in 1914; his work is
influenced by Lipchitz and Zadkine.
Antonio Sibellino (b. 1891) was a pupil
at the Albertina Academy in Turin; in
1911 in Paris he joined the Cubists.
Returning home in 1915, he worked
from 1916 to 1918 in the classical
tradition; despite the general lack of
understanding, he dared to introduce
the modern trends into Latin America;
he is now abstract. Sesostris Vitullo
(1899–1953) was influenced by Rodin
and Bourdelle. His severe work is made
up of dense volumes (San Martín
monument, 1952). Noemi Gerstein (b.
1910) worked with Zadkine in France;
her sculpture, which is abstract, is in
metal — bronze, silver and sheet iron.

Carmelo Ardenquín (b. Uruguay,
1913) came to Buenos Aires in 1938; in
1944 he published the review *Arturo* and
in 1946 founded the Arte Madi move-
ment. Since 1948 he has lived in Paris;
he does mobiles and reliefs. Carlisky
(b. 1914) produces slim weightless
bodies pierced with light and having
voluminous heads. Libero Badii (b.
Italy, 1916) has been influenced by Con-
structivism. Magda Frank (b. 1916), of
Hungarian origin, trained in Budapest
and then studied under Gimond in
Paris. Alicia Penalba (b. 1918) was
a painter at first; she studied sculpture
in Paris with Zadkine in 1948; her
large sculptures, rather like totems, are
composed of several different elements
having a rhythmic arrangement. Marino
di Teana (b. 1920), of Italian origin,
settled in Argentina in 1936; an abstract
sculptor, he is concerned with the dis-
integrating of volume. Gregorio Vardá-
nega (b. Italy, 1923) does geometrical
spatial constructions in plastics or Plexi-
glas with touches of colour. Oswald
Stimm (b. 1923) and Juan Mele (b.
1923) make reliefs with coloured
geometrical planes; Gyula Kosice (b.
1924) employs wire and Plexiglas.

Painting. All the main currents in
painting are represented in Argentina.
Painters include: Emilio Pettoruti (b.
1895) [**1164**], influenced by Futurism
and Cubism; Paul Russo (b. 1912);
Alberto Altalef (b. 1913); Bruno
Vernier (b. 1914); Ideál Sanchez (b.

1916). Among the abstract painters of
the younger generation are Gyula
Kosice (b. 1924) and Berta Guido (b.
1930).

BOLIVIA

Sculpture. Marina Nuñez del Prado
(b. 1912) taught at the La Paz
Academy. After some years in the
United States she exhibited figurative
works in Paris. Her present style, which
is abstract, is lyrical and harmonious.

Painting. Roberto Berdecio (b. 1913)
combines a highly personal Surrealist
vision with a feeling for abstraction.
The work of María Luisa de Pacheco
(b. 1920) is a curious mixture of geo-
metrical construction and sentiment.

URUGUAY

Sculpture. Bernabé Michelena (1888–
1963), who lived in Europe several
times, fought academicism in his coun-
try. He executed several monuments
and some fine portraits. Germán Cab-
rera (b. 1903) worked with Despiau and
Bourdelle in Paris. After 1938 he
moved towards abstraction and has be-
come more monumental and schematic.

Painting. One of the most important
figures was Joaquín Torres-Garcia
(1874–1949) [**1165**], who broke with his
early naturalistic style and devoted
himself to experiments ranging from
geometrical stylisation to abstraction.
Other painters include: Juli Verdie (b.
1900); Vicente Martín (b. 1911); Luis
Solari (b. 1918); María Rosa de Ferrari
(b. 1920); L. Silva Delgado (b. 1930).

PARAGUAY

Painting. Among the most charac-
teristic artists of the younger school are
Lily del Monico (b. 1910), Hermino
Gamarra Frutos (b. 1912), Francisco
Torne Galvada (b. 1917), Olga Blinder
de Schwartzman (b. 1921) and Aldo
Delpino (b. 1939).

VENEZUELA

Sculpture. Francisco Narvaez (b.
1908) studied in Paris and was in-
fluenced by the work of Rodin and
Maillol. Back in Venezuela, he turned
to the indigenous civilisation and its
myths. Gradually he moved away from
figurative representation, stripping the
human form down to its essentials.
He has executed various public monu-
ments.

Painting. French art has had a con-
siderable influence on Venezuelan
painters. These include María Andrade
(b. 1912), Gonzalez Bogen (b. 1920),

Dora Hersen (b. 1924), Angel Hurtado (b. 1927) and Jesús Rafael Soto (b. 1923), who belongs to the school of Paris.

COLOMBIA

Sculpture. Edgar Negret (b. 1920), the most original of Colombian sculptors, studied at the art school in Cali and later settled in New York. In 1958 a UNESCO grant enabled him to study the Indian art of North America. He abandoned the figurative style of his early period for geometrical sculptures built up of highly coloured pieces of metal (series of masks and magical instruments).

Painting. The younger generation are influenced by Europe: Carlos Granada (b. 1933) belongs to the realist tendency; Ignazio Gomez-Jaramillo (b. 1910) is influenced by Expressionism. Cubist theories have influenced Jorge Elias Triana (b. 1920), Manuel Hernandez Gomez (b. 1928) and Francisco Cardenas (b. 1931). Non-figurative painters include: Eduardo Ramirez Villamizer (b. 1923); Jorge Pineros (b. 1929); Carlos Rojas-Gonzalez (b. 1933); Marco Ospina (b. 1915); Alejandro Obregón (b. 1920), who is especially concerned with tonal values; Luis Chaux (b. 1924); Omar Royo (b. 1928); Fernando Botero (b. 1932).

ECUADOR

Painting. The tendencies in Ecuador range from Expressionism to abstraction by way of Surrealist influences. Manuel Rendón (b. 1894) is the leader of the older painters. Younger painters include Jan Schrender (b. 1904), Diogenes Paredes (1910–1968) and Eduardo Kingman (b. 1913).

AFRICA

In Morocco, Algeria and Tunisia new schools have appeared which do not necessarily wish to adopt the abstract tendencies of western Europe. Certain older, non-Arabic painters of the school of Paris (Limouse, Atlan, Clot, all born in Algeria) received their initial training in Africa. Egypt was first drawn to western European art with the Expressionist paintings of M. M. Naghi (1888–1956) and the sculptures of Gamal El Saghini (b. 1917), whose style derives from Cubism. G. H. Sabbagh belongs to the school of Paris, as does the sculptor Daria Gamsaragan (b. 1907), who creates a fantastic world of animals and signs.

The best known painters of South Africa are Irma Stern (b. 1894), of German origin, whose work is reminiscent of Expressionism, and Maurice van Essche, of Belgian origin, who guides the younger generation.

THE MIDDLE EAST

The Middle East has been very much affected by developments in European art. In Turkey about 1914 an Impressionist influence was evident; after 1923 Turkish artists frequently went to live in other countries, particularly France. Leading painters include Cemal Tollu (b. 1899) and Turgut Zaim (b. 1904). Between 1930 and 1940 more strongly defined tendencies appeared with the formation of the Society of Independent Painters and Sculptors, which continues the academic tradition, and of Group II, which is subversive in its bold originality. Sculptors include Hadi Bara (b. 1906), Muritoglu (b. 1906), Sadi Calik, Zorlu and K. Acar. Iran, with its rich artistic tradition, encourages its artists to travel frequently, mainly to Paris, where an exhibition of the work of Hossein Behzad was organised in 1955. Sculptors include Minassian and Tanavoli; the avant garde painter Assar (b. 1928) belongs to the school of Paris. Lebanon has also been affected by the main trends in European painting; Lebanese sculpture is represented by the Basbous brothers.

Art in Israel is the outcome of plastic ideas that have come from all parts of the world. Figurative sculptors include Robert Baser, Rudolf Lehmann and Dov Feigin; abstract sculpture is represented by Shamai Haber, Zahara Schatz, David Malkin, Hemel Sheml and Menashe Kadishman (b. 1932). Many painters have been influenced by their birthplaces. Rubbin (1893–1974) and Janco (b. 1895) were from Rumania; Kahana is from Russia, as are Gutman (b. 1898) and Stematsky (b. 1908), both of whom studied at the Bezalel school in Jerusalem.

THE FAR EAST

Chi Hwang (1863–1957), the landscape painter Hwang Ping (1863–1954), Kao Chen (1879–1951), who painted birds and insects, and Hsu Pei-hung (1895–1953) all combined Chinese and European techniques. Zao Wou-ki (b. 1920) [**923**], an abstract painter, studied in Hangchow. His work is calligraphic. He lives in Paris (see under *France*).

Taiwan has its official painter Ho Tit-wah (b. 1908), who is abstract, and some calligraphic painters, as well as a number of figurative artists such as Ting Yen-yung (b. 1904), who is influenced by Matisse.

In India painting fell into a decline in the 19th century; there were only mediocre and superficial works. Then came a reaction, symbolised by a desire to liberate art from Western influences by reverting to the great tradition of the past. A European, Havell, made an effort to bring the poorly appreciated

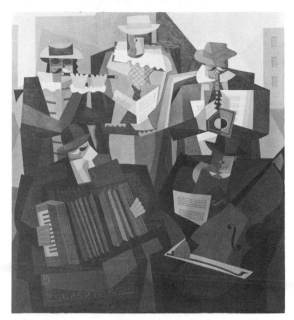

1164. EMILIO PETTORUTI (b. 1895). The Quintet. 1927. *San Francisco Museum of Art.*

1165. JOAQUÍN TORRES-GARCIA (1874–1949). Composition. 1939. *Philadelphia Museum of Art.*

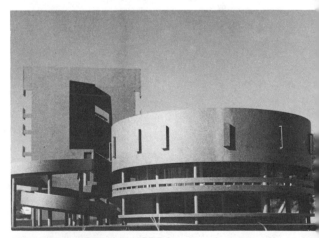

1166. INDIA. JEET MALHOTRA. Model for cafeteria, Chandigarh. Building completed 1965.

1168. JAPAN. KENZO TANGE (b. 1913). Interior of the town hall, Kurashiki.

1167. KENZO OKADA (b. 1902). Above the White. 1960. *Peggy Guggenheim Collection, Venice.*

1169. JAPAN. NIKKEN SEKKER KOMU. Town hall and town council, Kobe. 1955.

1170. RUSSELL DRYSDALE (b. 1912). Mullaloonah Tank. 1953. *National Gallery of South Australia, Adelaide.*

art of Indian painting back into popular favour. The revival started in Bengal under the influence of the painter Abanindranath Tagore, nephew of the great poet Rabindranath Tagore, who encouraged a return to themes from the past. Despite certain influences of Art Nouveau and later of Cubism, a new style did emerge, a style which combined traditional Indian influences with European techniques. Among contemporary painters is Jainini Roy. Lalit Kala Akademi has trained a number of artists, and Calcutta has a flourishing school of painters. In Ceylon the 43 Group is run by Ranjit Fernando. Sayed Haider Raza paints landscapes imbued with a strange magic. In the field of town planning, Chandigarh [**1166**] is a considerable achievement. Designed by Le Corbusier as the new metropolis of the Punjab, it is an extension of his project for a community centre for St Dié and embodies his theories of a grid-type lay-out, zoning and traffic separation. The symbolic significance of the composition is stressed by the dramatic treatment of individual buildings yet is harmoniously combined with the practical function of law courts and ministries [**676, 858**].

European modern architecture found its way into Japan through contacts made by younger Japanese architects with modern groups in Europe [**1169**]. Kenji Imai studied in Europe in 1926 and met Gropius, Le Corbusier and Mies. Kunio Maekawa (b. 1905) studied under Le Corbusier. Iwao Yamawaki and Takehiko Mizutani studied at the Bauhaus. Bruno Taut and Frank Lloyd Wright visited Japan in the 1920s; the latter's Imperial Hotel has had a great influence.

In 1937 the Kosaku Bunka Renmai (Japanese Werkbund) was founded, leading members of the group including Hideo Kishida, Shinji Koike, Sutemi, Horiguchi, Yoshiro Taniguchi, Takeo Sato, Kenzo Tange (b. 1913) [**1168**] and Kunio Maekawa. War halted their activities, and it was not until after the San Francisco Peace Treaty in 1951 that architecture flourished again. The leading architects, Yamada, Maekawa, Kameki Tsuchiura, Tange and Taniguchi have all been connected with the Japanese Werkbund. Their work includes the Welfare Hospital by Yamada (1953), the International House by Maekawa, Sakakura and Yoshimura (1955), the Peace Centre in Hiroshima by Kenzo Tange and the Nagasaki Cultural Centre by Takeo Sato (1955).

Maekawa has had a considerable influence on younger Japanese architects, and Tange joined him in 1938. The latter's creative talent developed rapidly after the War, and among his designs are the Shimizu town hall (1954) and the Kurayoshi town hall (1956). His aim has been to integrate Japan's architectural traditions into a modern society; a generation of younger architects (Kioyonori; Kikutake; Masato Otaka; Yoshinobu Ashihara) are making similar efforts to revive and adapt Japanese architectural traditions.

An important sculptor in wood is the pop artist Fumio Yoshimura. Among the abstract sculptors are Shindo Tsuji (b. 1909), Tadahiro Ono (b. 1913), who uses iron, and Bushiro Mohri (b. 1923). Yukihisa Isobe (b. 1932) and Ay-O (b. 1931) create large-scale environments.

Painting in Japan was opened to outside influences in the second half of the

1171. SIDNEY NOLAN (b. 1917).
Glenrowan. 1956–1957. *Tate Gallery.*

1172. BRETT WHITELEY (b. 1939).
Giraffe. 1964. *Marlborough Fine Art Ltd, London.*

19th century. A reaction then set in which favoured a return to a national tradition, but new Western techniques have had wide repercussions in Japanese art. Kosaka Gajin (1877–1953) devoted himself to a national form of painting derived from calligraphy, a form of expression also employed by the avant garde artists Jukei Tejima and Yuichi Inoue. Kenzo Okada (b. 1902) [1167] is abstract. Tadanori Yoko-o and Miki Tomio examine the elements of American Pop Art. On Kawara (b. 1933) and Shusaku Arakawa (b. 1936) are conceptual artists.

OCEANIA

The best known 20th-century artist in Indonesia is Kusuma Affandi (b. 1910), whose fantastic, tortured work is unrelated to any school.

Australian Impressionism grew out of a desire to give visual expression to a new awareness of Australia's way of life. The initiator, acknowledged leader and greatest exponent was Tom Roberts (1856–1931). Born in England, he studied in Melbourne under the Swiss painter Louis Buvelot. He returned to Europe and in 1885 brought back with him the Impressionist ideal. This had a profound effect on other artists in Melbourne, especially F. McCubbin (1855–1917), Charles Conder (1868–1909) and Arthur Streeton (1867–1943), with whom Roberts founded a

sketching camp at Box Hill; later they were joined by W. Withers (1854–1911). Their efforts led to the foundation of a national school of landscape painting.

In the 1920s a formalist Post-Impressionism was current in Sydney with Roland Wakelin (b. 1887) and Roi de Maistre (1894–1968). 1939 saw the first large exhibition of French and British modern art and William Dobell's (1899–1976) return from Europe; he began to paint his penetrating portraits of businessmen and the urban proletariat. In the 1940s the influence of modern French painting was reflected in the work of Jean Bellette (b. 1919), Justin O'Brien (b. 1917), Jeffrey Smart (b. 1921), Tom Thompson (b. 1923), Ray Crooke (b. 1922) and Donald Friend (b. 1915).

Russell Drysdale (b. 1912) [1170] is the leading exponent of a new kind of national painting. After training in Melbourne, London and Paris he settled in Sydney (1940) and began to paint the people of the country and the outback, especially the Aboriginal north. Sidney Nolan (b. 1917) [1171] has a style that is more imaginative and light-hearted. There is a visual freshness in his scrubby landscapes and mountain ranges and an element of folklore in his narrative series of Ned Kelly. Arthur Boyd (b. 1920) has remained in Melbourne. The influence of Surrealism has led him to Expressionist landscapes of

menacing grey bush. In 1944 he founded a pottery with John Perceval at Murrumbuna. Other Melbourne artists of Expressionist tendency include John Perceval (b. 1923) and Albert Tucker (b. 1914). In Sydney abstraction triumphed in 1956 with the exhibition Direction I. Exponents include M. Lewers (b. 1908), F. Hodgkinson (b. 1919), T. Gleghorn (b. 1925) and J. Coburn (b. 1925). The younger generation of painters working in a lyrical, non-figurative style include David Aspden (b. 1935), John Firth-Smith (b. 1943), John Olsen (b. 1928) and Sydney Ball (b. 1933). Contemporary painters working in a figurative tradition include Alan Oldfield (b. 1943), John Brack (b. 1920), Charles Blackman (b. 1928) and Peter Powditch (b. (1942). Fred Williams (b. 1927) and Brett Whiteley (b. 1939) [1172] depict the Australian landscape in their own distinctive styles.

Australian sculpture is represented by the following: Arthur Fleischmann (b. Czechoslovakia, 1896), Daphne Mayo, Ewa Pachuka (B. Poland, 1936), Rosemary Madigan (b. 1926) and J. Mason (b. 1923) who interpret the human form; C. Meadmore (b. 1929), Noel Hutchinson (b. 1940) and Nigel Lendon are non-figurative; John Armstrong (b. 1948), Ti Parks (b. England, 1939), Alexsander Danko (b. 1950) and John Davis are working in a witty Art Povera style.

VISUAL ART OF THE RECENT PAST *Susan Johnson*

After an uncertain and imitative start, the young American artists of the 1950s and 1960s emerged as the innovators of Modern Art. They were imbued with an optimism and confidence that was shared by an enthusiastic avant-garde audience. The 1960s was a decade of movements, produced by artists working in groups or created by a series of influential exhibitions and publications. Towards the end of the decade however a reaction against the expectations and confines of the art world set in and resulted in the rejection of the art object altogether. Loose terms such as 'Post Modernism' and 'Post Minimalism' were used to describe the more traditional works, which were variations of the products of the 1960s. Modern Art has also become international in character with no particular city or country as its centre, making it difficult to assess the significance and value of art works. In examining the recent past the art historian takes the role of the art critic in the evaluation and presentation of artists who are typical or representative of particular styles.

POP ART

The term 'Pop Art' refers to the work produced by the young, primarily British and American, artists working independently in the 1950s and early 1960s whose subject matter was taken from the highly industrial and commercialised world in America. The images, symbols and objects of a society based on mass-production and advertising were selected and reproduced, either singly or in combination, without social or political comment.

Antecedents for the use of popular imagery can be seen in the Dada collages and assemblages of Duchamp, Max Ernst, Kurt Schwitters and Raoul Haussman, whose works were of a political or surreal nature. The American, Gerald Murphy, took bland and mass-produced objects as his subject matter in the 1920s, and Stuart Davis included symbols and lettering from the world of advertising in his abstract geometric paintings. However, the images selected by the 'Pop' artists were neither chosen for their formal qualities, nor for their potential criticism of the system

that produced them. The initial choice was arbitrary, and the subject was presented in a bland and mechanical manner.

In Britain, artists such as Eduardo Paolozzi (b. 1924) and Richard Hamilton (b. 1922) were involved in exhibitions entitled *Man, Machine and Motion* (Institute of Contemporary Arts, 1955) and *This is Tomorrow* (Whitechapel Art Gallery, 1956), in which the images of soap powder cartons, Marilyn Monroe and robots first appeared in a variety of formats. Paolozzi presented reproductions from the popular press, science fiction novels and pulp magazines in an unaltered form. In his concern for the relationship between art and technology, he made bronze and aluminium casts of an assemblage of machine parts which were formed into appealing mechanical beings. In the 1960s, these creatures became de-humanized and formalized, without losing their demanding presence.

Richard Hamilton's photo-silkscreen poster based on the collage *Just What Is It That Makes Today's Homes So Different, So Appealing?* (1956) [**1173**] is one of the first examples of Pop Art, including as it does a montage of modern domestic appliances, comic strips, pin-ups, tinned food and cinema advertising, which were to become the hallmarks of the movement. Hamilton was a commercial artist, and in paintings such as *Hommage à Chrysler Corps* (1957), he not only takes his subject matter from the commercial world, but employs the techniques of advertising art, such as the depiction of a glossy surface painted in and out of focus.

The nature of 'photographic texture as truth' was examined by Peter Blake (b. 1932), who combines printed matter and real or *trompe l'oeil* photographs in his works, in which three-dimensional reality has already been translated onto the two-dimensional plane. He has a childlike and nostalgic fascination for the elements of popular culture such as postcards, badges, heroes

1173. RICHARD HAMILTON (b. 1922). Just What Is It That Makes Today's Homes So Different, So Appealing? 1956. *Edwin Janss Jr, Los Angeles, California.*

1174. DAVID HOCKNEY (b. 1937). Doll Boy. *Photograph: Kasmin Gallery, London.*

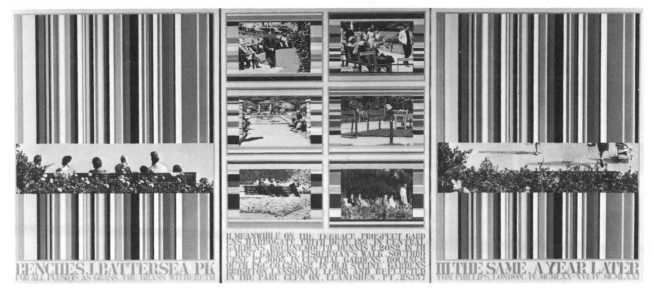

and toys. Joe Tilson also took a delight in toys and games and produced a series of collages at the beginning of the 1960s using ready-made images.

The early works of David Hockney (b. 1937) incorporated elements of cheap packaging graffiti and children's art in his stylised, naïve renderings of banal stories. He went on to paint figurative works of an autobiographical nature in a cool, hard-edge style using photography to aid his compositions [1174].

Although the work of Tom Phillips is autobiographical in nature, his commonplace subject matter is derived from postcards, snapshots and commercial lettering. His paintings are made up of coloured dots in imitation of the colour printing process. The colour scheme is analysed and presented beside the picture in the form of stripes, creating a non-figurative pattern as in the work of the American painter Gene Davis [1175].

1175. TOM PHILLIPS (b. 1937). Benches. 1970–71. Acrylic on canvas. *The Tate Gallery, London.*

Since 1964, Peter Phillips (b. 1939) has been using an airbrush, the tool of the commercial artist, to imitate photographs of large cars, pinball machines and popular heroes and personalities. He combines these cult figures and status symbols on large painted panels, impressive for their bright acrylic colours and metallic finish.

Patrick Caulfield (b. 1936) deals with the ambiguity of a realistically rendered image, such as a view through a window, set upon a flat, unmodulated area of colour, where objects and furnishings are delineated by a thin black line. His range of subject matter covers Mediterranean seaside resorts and stylish interiors but his concerns are more formal than the earlier generation of

1177. RONALD B. KITAJ (b. 1932). From London (James Joll and John Golding). 1976. *Photograph: Marlborough Fine Art, London.*

British Pop artists [1176].

The same may be said for the American painter Ronald B. Kitaj (b. 1932), who was working with the British Pop artists. Kitaj's paintings present a literary and intellectual subject matter in the form of a colourful multiple-imagery which dissolves into pools of colour and vaporous line, set in an ambiguous perspective space. His portraits extend beyond the physical depiction of the sitter and include objects and aspects of their physical environment, as well as quotes from their writings [1177].

Allen Jones (b. 1937) takes the erotic world of shiny black leather and stiletto heels for his subject matter. Rendered in bright colours with a variety of finishes, sometimes sharply focused, at other times imprecise, areas of colour and line depicting a shapely silhouetted limb dissolve and re-form into a theatre curtain or piece of bodywear. Jones has also created life-sized sculptures of

1176. PATRICK CAULFIELD (b. 1936). Greece expiring on the ruins of Missolonghi. *Allan Power, London. Photograph: Hamlyn Group Picture Library.*

women presented as the ultimate sex object, transformed into hat stands or coffee tables.

From its early interest in the imagery, products and advertising techniques of popular culture, Pop Art in Britain became more concerned with formal qualities of representation and design. The artist's view of the commercial environment in the United States was distanced, and, to a certain extent, sentimental, whereas the American Pop artists presented the images of advertising in the bold and aggressive manner in which they were marketed. Pop Art in America developed more or less independently of the earlier movement in Britain and unlike the London based group of Pop artists, the Americans worked in isolation.

In 1960, Andy Warhol (b. 1928), who was a successful commercial artist before boldly entering the art work, used

1178. ANDY WARHOL (b. 1928). Coca Cola. *Whitney Museum of American Art, New York. Photograph: Leo Castelli Gallery, New York.*

comic strips such as *Dick Tracy* as the subject matter for his first paintings. He then turned to standardised and popular brand images such as *Coca Cola* and *Campbell's Soup*. The images were mechanically repeated in paint, silk-screen or in three-dimensional form, as they appear on the supermarket shelf or production line. The repetition and boredom of a society based on mass-production were presented without alteration or comment. His activities as a film maker are also based on the repetition of a single action such as *The Kiss* (1965). Warhol claims that he does not intend any social or political criticism in his works, and certainly the ease with which he repeats his ideas and the impersonal nature of the mechanical screen print carried out by assistants prevent him from being labelled an Expressionist. However, when the artist's style becomes impersonal or nonexistent, the initial choice, on which Duchamp placed his emphasis, becomes all important. In choosing subjects such as *The Electric Chair* (1964) or the *Disaster* series (1963–1964), Warhol appears to be showing some concern for the state of

American life, and the way in which horror is anaesthetized by the various forms of mass-communication [**1178**, **1179**].

Roy Lichtenstein (b. 1923), whose previous paintings and assemblages included subjects taken from the American environment, painted his first comic-strip characters in 1961. Unlike the multiple prints of Warhol, Lichtenstein began painting the individual 'benday' dots and block shading in primary colours which make up the comic strip technique. This style is impersonal and mechanical and taken from an already abstracted and codified two-dimensional rendering of reality. Once the image is chosen, the artist is left to enlarge it and isolate it from its narrative context so it can be raised from the depths of the popular press to the heights of the art market and gallery. These powerful, figurative and familiar images were more readily accepted by the general public than the art world who at first doubted the value of commercial art, in the terms of High Art. Lichtenstein retained the 'benday' dot technique, so that it became his personal style, and applied it to a wide variety of likeable subjects such as still lifes, classical remains, sunsets and explosions. His prints and paintings are sometimes witty parodies on previous styles of painting such as his codified gestural brush strokes of the abstract expressionists of his *Bull* series which shows the gradual abstraction of the best in the tradition of *De Stijl* [**1180**].

Other American artists who derive their subject matter and style from popular imagery and advertising are Mel Ramos, who depicts sexy heroines, and Tom Wesselman (b. 1931), who paints glossy magazine images of 'The Great American Nude' and he-men surrounded by the products of a capitalist society. James Rosenquist used his experience as a billboard artist to paint large canvases which are a montage of bright, deadpan renderings of the stereotypes of cars, food and sex. Wayne Thiebaud, another

1179. ANDY WARHOL (b. 1928). Electric Chair. 1965. *Photograph: Leo Castelli Gallery, New York.*

commercial artist, enlarges mundane domestic objects and foodstuffs to give them significance than the advertising world gave them. Robert Indiana (b. 1928) works in the more formalist tradition of Léger and Stuart Davis, producing highly finished renderings of numbers and lettering. His logogram *LOVE* has been translated from paint on canvas to aluminium sculpture and even into a hologram.

Jasper Johns (b. 1930) and Robert Rauschenberg (b. 1925) take their images and objects from the popular press and the supermarket, but the neo-dada nature of the encaustics of the former and the motley assemblages of the latter set them apart from the bold, bright and clean works of the Pop artists already mentioned. In the mid-1950s, Jasper Johns was taking sterotyped formats such as the American flag, targets, beer cans, lettering and numbers and translating them into the traditional formats of paint on canvas and bronze. Unlike the Pop artists, he was questioning the processes and sources of art, and their relation to reality [**1181**].

Rauschenberg, who had been involved with the musicians and artists working with John Cage, is concerned with acting in the gap between art and reality. His large scale *Combines* are amalgams of real objects such as clocks and brooms, printed matter and the painted image, all of which are covered with patches of gestural, non-figurative colour. He describes them as a 'palette of objects'. In the 1960s Rauschenberg began his montage of silk-screen images taken from newspaper photographs, whereby people and places of differing scale and viewpoint are brought together. Although no political comment is intended, the subjects selected become an historical record of the concerns of America during the period.

Another artist on the borders of Pop is Larry Rivers (b. 1923) who produces large mixed-media figurative montages. Unlike Rauschenberg, his works have a theme or narrative behind them such as the monumental *History of the Russian Revolution from Marx to Mayakovsky* (1965) or the satire on art and racism in *Black Olympia* (1970), which are typical of his reworking of the nineteenth century *Beaux-arts* tradition.

These artists, with their use of popular imagery and their textured surfaces, bridge the gap between the mechanical Pop artist and the individualistic canvases of the abstract expressionists.

Sculpture has also been subjected to the Pop style. Lichtenstein has applied his comic strip technique to tea-sets and heads of mannikins. He has recently produced elegant and highly finished brass fixtures and fittings in the styles of Art Deco and Depression Modern.

The work of Claes Oldenburg (b. 1929) ranges from maquettes and drawings for monumental reproductions of commonplace and ridiculous objects such as *Hot-Dog with*

1181. JASPER JOHNS (b. 1930). Numbers in Color. Encaustic and collage on canvas. 1959. *Albright-Knox Art Gallery, Buffalo, New York, gift of Seymour H. Knox.*

1182. LUCAS SAMARAS (b. 1936). 1969–70. Plastic flowers on wire. *Whitney Museum of American Art, New York. Photograph: the Pace Gallery, New York.*

1180. ROY LICHTENSTEIN (b. 1923). Bull II. 1973. *Photograph: Leo Castelli Gallery, New York.*

Toothpick (1965) to his witty 'soft-sculptures' of ladders and ice packs. He has also made roughly shaped and painted wall reliefs depicting girdles and over-sized wrist watches.

Clive Barker, the British sculptor, also works in a humorous Pop vein. He gives greater significance to mundane objects and events by rendering them in a bizarre material, such as his aluminium *Splash* (1967). Other sculptors creating false objects are Marjorie Strider with her *trompe l'oeil* strawberries made of painted bronze (1974) or Fumio Yoshimura who makes finely constructed wooden typewriters and motor bikes. Lucas Samaras makes delightful *Chair Transformations* (1969–1970), in which a simple dining chair is rendered in a variety of materials including wire mesh, plastic flowers and coloured wool [**1182**].

Edward Keinholz assembles menacing tableaux of the furniture, fixtures and lighting of downtown bars or lonely apartments inhabited by semihuman life-sized beings who have clocks or bottles for heads. The whole environment, which is sometimes accompanied by a sound tap, is covered with a muddy

1183. *Top:* EDWARD KEINHOLZ (b. 1927). The Beanery. Mixed media. *Los Angeles County Museum of Art, California. The Kleiner Foundation Collection. Photograph: Los Angeles County Museum of Art, California.*

1184. *Above:* GEORGE SEGAL (b. 1924). The Gas Station. Plaster and mixed media. *The National Gallery of Canada, Ottawa.*

encaustic, adding to the surreality [1183]. Another commentator on the sordid side of life in America is George Segal (b. 1924). In simply reconstructed environments such as cafés, cinemas and lonely streets, he places the rough external layer of white plaster casts taken from live models. His works are full of desolation and dispair, and are far removed from the brash fantasy worlds of Lichtenstein and Warhol [1184].

Although artists in Europe incorporated the materials and imagery of the industrialised world, they continued the Dadaist and Surrealist tradition of the assemblage, in which unrelated ready-made components are brought together in bizarre combinations. Marcel Broodthaers, working in the tradition of his fellow countryman Magritte, creates witty, fetish-like amalgams of natural food containers such as eggshells and mussel shells. He is also interested in the function of museums, and recreates the glass cases and potted palms of the 19th century gallery [958].

Martial Raysse (b. 1936) produced garish mixed-media assemblages based on life along the Mediterranean coast. The Rumanian Daniel Spoerri made MAT Multiplication/Art/ Transformation) panels consisting of unfinished meals, cigarette stubs and children's shoes stained with rat urine. Both artists were members of the French movement called *Le Nouveau Réalisme*, founded by the art critic Pierre Restany and the influential innovator Yves Klein (1928–1962) in 1960. The group attempted to register 'the sociological reality without any controversial

intention', and produced art in a number of unorthodox ways. Jacques de la Villegle and Mimmo Rotella lacerated layers of billboard posters whilst Arman (b. 1928) encapsulated discarded objects such as paint tubes and doll's arms in polyester torsos. Hervé Télémaque, working in a similar way to Kitaj, fragmented images from magazines and newspapers and combined them into surprising and violent dramas. Yves Klein, with his exhibition of nothingness (1958), his 'cosmogenies', whereby wet 'International Klein Blue' paint on canvas was subjected to rain storms and his monochrome 'metaphysical' paintings anticipated art movements such as Conceptual Art, Art Povera and Minimal Art.

PHOTO-REALISM

Also known as Super-Realism, Sharp-focus Realism and New Realism, the movement generally referred to as Photo-Realism, began in America in the mid 1960s and was concentrated mainly in New York and California. Although similar in title to *Le Nouveau Réalisme*, the American artists remained in the familiar world of painting and sculpture. They took their subject matter from the ordinary Western environment, and in their aim of representing this mundane reality in an objective way, they depended on photography in the tradition of 19th century French Realism.

Based in the Pop idiom in its presentation of a ready-made

1185. CHUCK CLOSE. Frank. 1969. *The Minneapolis Institute of Arts, Minnesota.*

1187 ROBERT COTTINGHAM. Neon Shop Sign. *Ivan C. Karp. Photograph: O.K. Harris, New York.*

image in an impersonal and unbiased manner, Photo Realism differs from Pop in its choice and source of subject matter. Pop artists tend to choose the sensational, stylised images of the popular press, whereas the New Photo Realists depict ordinary people and commonplace events and situations taken from a single snapshot.

Unlike the famous faces depicted by Warhol and Rauschenberg, Chuck Close has chosen to paint large scale portraits of his personal friends. In retaining the low viewpoint, out of focus areas and detailed unflattering skin textures of the face, Close has slavishly transferred the photographic mode into paint on canvas [1185]. The unsensuous, waxy nudes of Philip Pearlstein also show the influence of photography in the unusual angles and cropped edges.

Robert Bechtle [1186] paints affluent suburban life beneath the bright Californian light. He paints from a slide projected on a screen 'as though I were looking at the actual scene'. The frame of the canvas is equal to the eye of the camera. He uses 'lousy' photographs because he says if it 'can stand up as a finished work of art by itself, there is no reason to make a painting from it.' Richard McLean works from black and white magazine photographs and adds his own colour. He treats the people and horses from rodeo shows as objects to be formally treated for their 'plastic relationships'. Jack Beal works in a stylised realism based on photography, in his depiction of nudes set in fashionable interiors, similar in mood to the paintings of David Hockney

who also works from photographs.

The highly finished paintings on silk-screen prints of Richard Estes are reproductions of well-lit, sharply focused photographs of subway stations or exteriors of shops. He is concerned as much with the reflective surfaces as he is with the urban subject matter.

The close-up camera view of reality has been taken up by Robert Cottingham, who concentrates on low, partial viewpoints of neon shop-signs [1187]; Bruce Everett chooses chrome bathroom fittings. American cars, aeroplanes and motorbikes are also viewed at close range by artists such as Don Eddy and Allan Dworkowitz. The British artist John Salt presents a nostalgic image of wrecked automobiles in his paintings and wall reliefs.

Janet Fish and Ben Schonzeit continue in the Pop vein of Warhol, Wesselman and Thiebaud by depicting packaged food and drink under the bright neon lights of the supermarket. Don Nice isolates and enlarges objects such as food and sporting equipment, and suspends them against a plain white background. As with all the American Photo-realists, the subject matter is presented without comment.

Landscape in the style of picture postcards is rendered with great fidelity by Noel Mahaffey who presents panoramic vistas of American towns. The British artist Malcolm Morley reproduces touched-up photographs or postcards of landscapes and cityscapes, which include the border and some calligraphic addition by the artist. The subject of his paintings is the photograph itself – he is concerned with the surface reality of the two-dimensional

1188. DUANE HANSON (b. 1925). Tourists. 1970.
Photograph: O.K. Harris, New York.

1189. ANTHONY GREEN. The Red Bathroom. 1976.
Photograph: Rowan Gallery, London.

image, and the banal subject matter is simply a by-product.

Photo-Realist figurative sculpture takes the representation of a typical and mundane reality to its three-dimensional conclusion. Looking like the poor and unfashionable relations of shop window mannikins, the sculptures of Duane Hanson and John de Andrea are cast from live models in fleshy polychromed polyester resin, dressed in real clothes and surrounded by appropriate personal effects. 'Tourists', 'housewives' and 'nudes' share the gallery space with the observer [1188].

Robert Graham isolates his protagonists by reducing them to a miniature scale and covering them with a glass box, through which the spectator can peer at an energetic game of beach ball or the bedroom of a sleeping girl.

Painters in other countries besides America have been producing realist works based on photography, but their attitude to the subject is usually less detached. In Britain Anthony Green depicts humorous, autobiographical domestic scenes in an unassuming style. Although he does not work from photographs, the high viewpoints and fish-eye lens distortions show the influence of the camera [1189]. Both he and the Canadian painter Tom Forrestall use shaped canvases. The work of the latter is magical in technique and in choice of subject matter, and is best described as Magical Realism. Although the subject matter is mundane, it is given a hint of mystery by the cropping of the picture plane and the cool, translucent colour tones, executed in egg tempera.

The Swiss artist Franz Gertsch also renders ordinary people with the fidelity of a snapshot. But his strange viewpoints and arbitrarily cropped edges present a menacing image in contrast to the cool, detached American scenes. The paintings of the French artist Jacques Monory are also rendered with photographic sharpness and detail, but his figures are disturbed and threatened by the imposing architectural environments in which they are placed. Maina-Miriam Munsky, in Germany, concentrates on the clinical environments of hospitals, where she takes photographs of operations. She tries to present the subject as 'objectively and truthfully' as she is able, being closer in attitude to the American Photo-Realists.

The Spaniard, Darío Villalba, a fighter for human rights, takes his disturbing imagery from black and white newspaper photographs which have strong political overtones. In a combination of photographic emulsion, bitumous paint, oil and wax, the grainy texture is retained and the violence of his subject is intensified. Although based on photography, these political horrors are far removed from the pleasant and commonplace

1190. DARIO VILLALBA (b. 1939). The Wait. Photographic emulsion and oil on canvas with aluminum and perspex. 1974.
The Solomon R. Guggenheim Museum, New York.

1191. JOHN HOYLAND (b. 1934). North Sound. 1979. *The Tate Gallery, London.*

subjects taken from the supermarket shelves and suburban streets by the Photo-Realists working in the United States [**1190**].

Narrative Art or Story can be considered an extension of Photo-Realism in its concern for presenting a series of everyday events in the form of paintings or photographs which are accompanied by a text telling the story. Bill Bechley, with his concern for the inter-relationship of objects, humans, animals and the environment and Alexis Smith with her story-collages enclosed in plexi-glass, based on the text of previous authors, are exponents of this self-conscious movement.

In contrast to the dependence on reality shown by the Pop artists and the Photo-Realists, other painters and sculptors were producing works which were totally non-referential, taking the aspects of colour, surface, the framing edge and line as their subject matter.

NON-FIGURATION: COLOUR, SURFACE AND SCALE

The generation of non-figurative painters following the Abstract Expressionists adopted the large scale canvases and overall composition of their predecessors, but there the similarity ends. The gestural drips and brush-strokes were replaced by hard edges and areas of flat unmodulated colour. The individual, spontaneous and accidental 'process' of painting was rejected in favour of pre-planned and mechanically rendered geometric shapes and formats.

The new mode was championed by the formalist art critic Clement Greenberg who produced a theoretical basis for the painters to follow. He claimed that flatness distinguished painting from the other art forms, and that the associated aspects of shape of support and the visual properties of pigment should reinforce the flatness of the surface. Therefore, the formal relationships of line, shape and interval become the subject for the artist, and the criteria upon which the viewer can analyse the canvases.

The primacy of colour was one of the results of the new mode of painting. It was no longer secondary to or determined by symbolism or the representation of reality. Colour and its formal qualities became the sole function and subject matter of painting.

The paintings, lectures and publications about chromatic behaviour and optical laws of the Bauhaus artist Josef Albers (1888–1976) were influential. His *Homage to the Square* series (1949–) examines the nature of colour, using the neutral format of the square in the same way that Monet used his haystacks: to study the effect of changing light on form [**1055**].

Hans Hofmann (1880–1966), an influential German teacher and painter who lived in the United States, created a 'pictorial reality' determined solely by the internal relationships, tensions and intervals on the surface of the painting. Space and depth were not achieved by line, but by the 'push and pull' effect of overlapping slabs of colour.

The British artist John Hoyland (b. 1934) continues this concern for balancing areas of pigment, and by a process of building up layers of paint and scraping them back, he creates rich and luminous textured surfaces [**1191**].

Another British painter, Patrick Heron (b. 1920), describes the colour in his paintings as being 'both the subject and the means, the form and the content, the image and the meaning'. He plays with bright areas of saturated colour which engulf and jostle with each other. He tries to cancel out the tendency of certain colours to fall into figure/ground relationships.

The American artist Frank Stella (b. 1936) employs 'the directional sense of colour' in his stripe paintings arranged so that the eye continually moves over the surface of the painting. In coming to terms with the boundaries of the pictorial plane, the edge of the canvas, Stella began to employ shaped canvases in 1960. The result is that the pictorial composition and the external structure become one and the same [**1192**].

Ellsworth Kelly (b. 1923), influenced by Arp and Matisse, rather than by the writings of Greenberg, has also contended with the edge of the canvas and the illusion of depth which is inherent in the painted surface. His monumental areas of unmodulated colour based on simple line drawings of natural forms, are partly cut off by the edge, but extend into the conceptual world beyond the boundaries of the canvas [**1148**].

Al Held (b. 1928), while retaining the thick impasto of his Abstract Expressionist years, also places bold areas of solid colour on the edges of the canvas. Robert Motherwell (b. 1915) reverted from his demonstrative phase of action painting to a series of meditative, low key canvases entitled the 'open' series (1968–1969), which are based on the relationship of a single, finely delineated internal frame that is set against the overall haze, contained by the external canvas frame.

1192. FRANK STELLA (b. 1936). Zambesi. 1959. *Lawrence Rubin, New York.*

1193. KENNETH NOLAND (b. 1924). New Light. Plastic paint on canvas. 1963. *Ulster Museum, Belfast.*

For painters such as Robert Natkin with his *Colour Bath* series, the 'nuagist' Frederic Benrath and Dennis Masback with his highly reflective surfaces, the frame simply becomes the cut off point for a field of endless, formless colour. The same can be said for the rich inflected fields of colour produced by the British artist William Turnbull (b. 1922), or Jules Olitski who captures on canvas the insubstantial mist of paint applied with a spray gun.

The edge is also acknowledged in the work of Kenneth Noland (b. 1924). Working in a variety of geometric formats, Noland presents an area of flat colour bordered by thin stripes of colour at some or all of the edges of the canvas. He has also painted solid stripes of colour which hover above a richly coloured and varigated ground [**1193**].

The master of the stripe was the influential painter and sculptor, Barnett Newman (1905–1970) who produced his first fields of colour, separated by a thin vertical stripe in the late 1940s. He saw himself primarily as a draughtsman rather than a colourist — his vertical 'zip' of colour is the major compositional element on a canvas whose internal shapes correspond to the edge of the frame. The monumental scale of his works, in which he wanted to encompass the entire field of vision of the spectator were also influential. Although his works appear minimal and non-figurative, Newman was not a formalist. His paintings have an 'abstract intellectual content' of a sublime nature, so that the artist is distinguished from the craftsman.

The same can be said of his contemporary Mark Rothko (1903–1970), whose diffuse banks of muted translucent colour hover ambiguously in a vaporous ground. Unlike the generation of the 1960s, he was more concerned with giving his paintings a 'significant content' than with 'formal colour-space relationships' [**1146**].

This fear of mere pattern making has been ignored by a group of artists referred to as Pattern Painters, who take delight in producing decorative and colourful designs. Joyce Kozloff uses complex geometric patterns based on Islamic lattice work and patchwork quilt designs in her canvases [**1194**]. Valerie Jaudon makes patterns of inter-webbed circular bands whilst Robert

1194. JOYCE KOZLOFF. An interior decorated. 1979. *Everson Museum, Syracuse, New York. Photograph: Jane Courtney Frisse.*

Kushner hangs decorative floral material from the gallery wall. Robert Zakanitch and Howard Hodgkin produce irregular, painted patterns resembling wallpaper or material samples. These artists ignore elitist concerns for distinguishing the decorative arts from high art.

The work of the Op artists has also been criticised for its mechanical pattern making and its dependence on the range of visual phenomena that can occur on a flat canvas, whereby there is apparent movement or ambiguities of space and colour. Op Art, which established itself in the early 1960s, was readily taken up by the fashion and advertising world.

The movement was pioneered by the Hungarian artist Victor Vasarely (b. 1908), who employs assistants to produce his geometric permutations of vibrant colour and deep tonalities. He has also applied his formulae to sculpture [**929, 932**].

Bridget Riley (b. 1931), a British exponent of Op Art, deals with 'the dynamism of visual forces' and 'visual rhythms' which are ultimately derived from nature. She tries to imbue her paintings with an emotional quality, rather than depending on purely visual phenomena [**1195**].

Larry Poons (b. 1937), a musician who has been influenced by the random compositions of John Cage, spreads small elliptical discs of colour over an unmodulated ground. These are arranged according to an invisible, mathematically controlled grid which results in a subtle movement, after-image and spacial ambiguities.

European artists interested in the visual phenomena and the technology of kinetics and light, began to form groups at the end of the 1950s. The French artist Yvaral (b. 1934), the son of Vasarely, and the Argentinian Julio Le Parc (b. 1928) were members of GRAV (Group de Recherche de L'Art Visuel) who programmed works resulting in optical colour effects. They wish to make an impersonal art that had a scientific basis. The ZERO group in Germany, of whom Otto Piene (b. 1928), Heinz Mack (b. 1931) and Günter Uecker (b. 1930), with his nail constructions, were members had similar aims. The three-dimensional work of these groups employs actual movement rather than merely providing the illusion of pulsating or vibrating forms.

The use of industrial paint and new methods of application had been explored by the action painters on their large canvases in the 1950s for both economic and practical reasons. The precedent had been set by the Mexican and American muralists working for the Federal government on the Works Progress Administration scheme in the 1930s. This interest in new textures and effects continued in the 1960s and 1970s. After seeing the stained canvas of Helen Frankenthaler entitled *Mountains and Sea* (1952) in New York in 1953, the Washington-based painter Morris Louis started to produce large diaphanous 'veils' of colour which he made by running thin washes of acrylic paint into raw cotton duck. He later applied the same technique to his 'floral', 'furl', 'unfurled' and 'stripe' formats. The colour no longer rests on the surface of the canvas, but is at one with it [**1196**].

In contrast to the weightless quality of Louis' work, David Diao, Jules Olitski, Larry Poons and John Walker (b. 1939) went through a phase of applying thick, heavy and muddy impasto to the suffocating canvas. Applied with large gestural strokes, the surface of the canvas was reinforced simply by the physical presence of the paint.

The painterly, gestural mode has also been maintained by James Harvard and Cy Twombly, with his calligraphic scrawls and scribbles of paint and pencil. William Pettet with his baroque swirls of paint and Jack Seery who scrapes, stains and sprays his large canvases are two exponents of the Lyrical Abstractionist style. Frank Stella has also broken away from the Greenbergian formula to produce painterly, textured surfaces on eccentrically shaped canvases. Video Art has its exponents of lyrical abstraction including Barbara Buckner whose fluid areas of light and colour dissolve and reform on the screen. Movement of colour is real and changing, rather than an illusion. However, the work of this new generation of artists experimenting with new materials is very different in mood to the individual and violent expression of the previous generation.

1195. BRIDGET RILEY (b. 1931). Green Dominance. 1977. *Photograph: Rowan Gallery, London.*

1196. MORRIS LOUIS. Golden Age. Acrylic on canvas. 1961. *Ulster Museum, Belfast.*

1197. HELEN FRANKENTHALER (b. 1928). Swan Lake II. 1961. Stained Canvas. *Anthony Caro. Photograph: Andre Emmerich Gallery, New York.*

Although the work of the majority of colour field painters and post-painterly abstractionists is non-referential, a few artists have produced paintings which have specific or indirect references to landscape. Clyfford Still (b. 1904), a contemporary of Newman and Rothko, painted awesome, apparently non-figurative canvases which were meant to carry the equivalent of a sublime experience felt before nature. The Abstract Expressionists Franz Kline (1910–1962), Wilhelm de Kooning (b. 1904) and Karel Appel (b. 1921) all produced representational paintings of the urban landscape. Helen Frankenthaler (b. 1928) [**1197**], with her sensuous areas of stained colour inflected with scattered gestural strokes, gives her works landscape titles. Richard Diebenkorn (b. 1922) started his *Ocean Park* series in 1967. Faint lines parallel to

the picture edge enclose subtle areas of hazy colour which are abstractions of the bright Pacific seascape. Robert Stanley illustrates the black and white patterns created by bare tree branches, but the overall effect is that of a Pollock drip painting. Allan d'Arcangelo bases his bright geometric shapes and crisp lines on highways and road-signs. The British artist Peter Lanyon (1918–1964) took to gliding to get an overall view of the landscape which he rendered in broad lush strokes of paint. In Australia, Fred Williams represents the light and space of the desert landscape in his fields of colour inflected with dabs of paint, describing the sparse vegetation.

Representation has also been made more acceptable to the avant-garde critics by Ron Davis. His work is illusionistic in that he depicts three-dimensional geometric structures which hover in a delicate, nondescript space. Davis pushed these representations to their logical conclusion by creating resin and fibre glass reliefs whose space is real, but deceptively ambiguous because of the way they are painted [**1198**].

In Britain the Pop artist Richard Smith (b. 1931) had painted canvases stretched on projecting frames in a witty allusion to the concept of the illusion of space in non-figurative painting. He then went on to produce sail-like structures, harking back to the probable origins of canvas painting. In the early 1970s, Jack Youngerman produced stylised organically-shaped canvases which seductively bulge into the surrounding space. Ron Gorchov also produces powerful 'saddle' shapes which set up simple tensions over the painted surface. Richard Tuttle dyes irregular-shaped material which he tacks to the wall and Sam Gilliam suspends stained canvas from the ceiling [**1199**]. Ellsworth Kelly (b. 1923) kept his monochrome canvases flat, but places one half of them at right angles to the wall, spreading it on the floor. In being pigment on canvas, these works are paintings, yet their three-dimensional form brings them into the realm of sculpture. In sculpture, Charles Ginnever casts flat steel structures which from a distance appear to be three-dimensional rectangular boxes set at different angles; two-dimensional illusionism has entered the three-dimensional world of sculpture.

The painter Ad Reinhardt (1913–1967) reacted against all forms of representation and figuration. He wanted an art that was totally 'non-objective, non-figurative, non-imagist, non-expressionist, non-subjective'. He realised this aim in his series of

1198. RONALD DAVIS. Bent Beam. Acrylic and dry pigment on canvas. 1974. *Hirshhorn Museum and Sculpture Garden, Smithsonian Institution, Washington D.C.*

1199. SAM GILLIAM. (b. 1933.) Simmering. Relief, acrylic on canvas. Canvas *The Tate Gallery, London.*

rectangular canvases, related to the scale of a human being. In hardly perceivable changes in the tone and colour of almost black matt paint, a neutral cruciform shape appears. A delicate tension is set up in the submerging of the line which barely delineates the form. The writings and the reductive nature of the paintings of Reinhardt became the starting point for the new movement of Minimal Art.

MINIMAL ART

The term 'Minimal Art' was coined by the philosopher Richard Wolheim in 1965 and was used to describe works as diverse as Duchamp's 'unassisted ready-mades' and Reinhardt's purist paintings, which had a lack of content as the common denominator. It was then taken up to describe the work produced by painters and sculptors throughout the 1960s. The movement has also been described as Minimalism, ABC Art, Primary Structuralism and, rather critically, Cool Art, and has been widely written about by art critics and articulate artists alike.

Precedents and parallels can be seen in the reductive paintings of Mondrian, Malevitch, Newman, Albers, Yves Klein, and Kelly or the serial works of Stella and Noland. The Mexican sculptor and architect Mathias Goeritz anticipated the movement in the 1950s with his monumental structures [**1200**]. The lofty vertical slabs of steel created by Newman or the geometric structures of David Smith show similar concerns for space and simple forms. The environmental nature of the stabiles and mobiles of Alexander Calder are also relevant to the exponents of Minimal Art.

The characteristics of Minimalism can be summarised as follows: totally non-figurative; unified and geometric in form; monochromatic and executed with a highly mechanical finish as can be seen in the work of the sculptors Donald Judd (b. 1928), Robert Morris (b. 1931) and Ulrich Rückriem. Donald Judd, feeling restricted by the Greenbergian 'problem of illusion' in painting, turned to 'three-dimensional work' in 1965. Judd multiplies a single, self-contained elemental shape and arranges the chosen unit and the intervals between the unit, in a simple mathematical sequence [**1201**]. His 'progressions' are objective and display a unity rarely seen before in sculpture. Robert Morris also works in single geometric units such as cubes, H-shapes and beams. In 1968 he cut sheets of thick felt into wide bands, which he hung loosely from the wall or piled on the floor. Being large in scale, monochrome and based on simple geometric shapes, these soft sculptures may still be regarded as Minimalist. Ulrich Rückriem uses solid rectangular blocks of granite or dolomite stone which he brings together in simple geometric configurations in which the heaviness of the material is expressed.

Carl Andre also works with a basic geometric unit. Instead of having a factory make his work to set specifications, he chooses ready-made, mass-produced industrial units such as wooden

1200. MATHIAS GOERITZ. Steel Structure. 1953. *Museo de Art Moderno, Mexico City. Photograph: Armando Salas Portugal.*

1202. CARL ANDRE. 144 Square. 1969. *The Tate Gallery, London.*

1201. DONALD JUDD (b. 1928). Untitled. 1968. *Photograph: Leo Castelli Gallery, New York.*

439

1203. LARRY BELL (b. 1939). Untitled. 1964. Metal and glass. *The Tate Gallery, London.*

1204. SOL LEWITT. ABCD 9. 1966. *Photograph: John Weber Gallery, New York.*

beams, metal plates or bricks as his compositional elements. The chosen units are arranged according to a simple mathematical formula and placed without alteration or juncture on the floor. The resulting sculpture is horizontal and low, the height determined by the minimum width of the unit. The viewer can walk around the edges of the work or stand on top of it without seeing it, because the 'peripheral downward vision is beyond the edge of the sculpture' [**1202**].

The neutral box unit becomes the subject for the Los Angeles sculptor Larry Bell who creates elegant glass boxes, vacuum-coated with metallic compounds to give a variety of opaque and transparent surfaces which dissolve the structure [**1203**]. Richard Artschwager in his *Description of a Table* (1964) presents a single cube with areas of coloured formica to represent the tablecloth, legs and underlying space of the table. Robert Morris and Dennis Oppenheim also produce non-functionalist, minimal pieces of furniture, being representational in the same way that Ron Davis' paintings of three-dimensional geometric shapes are descriptive.

The possibilities of the grid structure are explored by the painter Agnes Martin and the sculptor Sol LeWitt. LeWitt applies a rigid mathematical logic to produce intricate and multiple cage structures. The works are made in a factory to the strict specifications of the formula, so that the personal style or decision of the artist is eliminated. The resulting three-dimensional grids, consisting of thin bars, angles and joints delineate a visually chaotic space. The conceptual clarity behind the work is contrasted with the visual complexity perceived [**1204**].

Agnes Martin, inspired by the neutral squares of Albers, paints subtle variations in tone and colour in her basic grid structures in which a soft tension is set up between the slightly rectangular grids set upon a square canvas. The process of creation is extended over a series of canvases, so that the perception of the viewer is extended in time and space. The British artist Richard Allen also experiments with serial grids comprised of charcoal bound in cellulose in his search for 'the concrete' in visual systems.

Sculptors such as Michael Todd and John McCracken are dependent on the space and structure of the gallery for their works. McCracken's long, glossy plank nonchalantly leans against the wall; Todd's red beams, yellow spheres and black triangles crawl across the floor and clamber up the sides of the wall. Similarly, Richard Serra's lead pole props itself up against and holds a heavy lead sheet in *Prop* (1968).

Minimal sculpture makes great demands on the surrounding space. Large-scale works such as Ronald Bladen's *The X* (1967) or the beam constructions of Richard Nonas aggressively encroach into the gallery space, and appear to expand beyond their physical boundaries [**1206**]. Tony Smith, an architect and then sculptor from 1960, produced monumental, weighty structures of dynamic geometric arches, which dwarf the spectator.

The generation of British Primary Structuralists, who studied under Anthony Caro (b. 1924) at St. Martin's School of Art in the early 1960s, produced works which were glossier, brighter and lighter than the bulky, matt-finish work of the Americans. Caro, influenced by the welded sculpture of David Smith and the paintings of colour structuralists such as Noland, made two important contributions to the form of modern sculpture. In his application of a single colour to unify the work and hide the technical construction, he created evasive and illusionistic constructions. He also eliminated the pedestal, a parallel development to the elimination of the frame in painting, so that the sculpture lies directly on the floor. The elements are dispersed and the centre of gravity is eliminated. Caro utilises a variety of shapes and testural components which are combined in an 'open-ended process'. The spontaneous and organic quality of his works differentiates him from the pre-planned and mechanical structures produced by the Americans.

Michael Bolus produces thin, weightless components and combines them in witty and ingenious ways. He uses colour in a decorative fashion to set off tensions in the work. The inventive and amusing sculptures of Philip King (b. 1934) are comprised of cores and cross-sections of geometric shapes. His work has an organic quality in that he wants sculpture to be 'growing within its own laws'. He has now reverted from the bright, unmodulated colour he used in the 1960s to the dull and textured surfaces of wood, rusty metal, slate and brick'

William Tucker (b. 1935) rejected the solid form in favour of outline to create fluent skeletal sculptures, made of steel tubing, which cut into the surrounding space rather than enclosing it. Two sculptors of the younger generation of British sculptors also play with lines of sculpture. Nigel Hall hangs slight, painted aluminium wires from the wall, whilst Garth Evans' work is heavier and more calligraphic in nature [**1205**].

There is an organic trend in American minimalist sculpture. Sculptors such as Tom Doyle or Sven Lukin have been influenced by the British sculptors in their weightless, asymmetrical constructions. Christopher Wilmouth, with his curved forms decorated with gradations of colour, tries to give his sculptures 'a living presence' and wants to imply 'the human presence in non-objective art'. Ernest Trova is obsessed with the theme of the 'Falling Man' and the stylised profile of the human form becomes his module in a series of works ranging from graphics to kinetic light boxes.

Minimalism has its exponents in painting such as Kenneth Martin (b. 1905) with his *Chance, Order, Change* series which are created by taking the numbers given to points of intersection of a grid and randomly rearranging them, so that a new objective order is created. The large square canvases of Alan Charlton and the matt pastel wall slabs of Robert Mangold have been described as 'Opaque Paintings', because of their concentration on the

surface. Robert Ryman lays regular rows of brushstrokes and contrasts the physical qualities of the paint such as shiny/dull and thick/thin. The subtle manipulation of the material with which the work is made becomes the subject of the painter.

Minimal Art has its exponents in the field of photography. Dan Graham and Lewis Baltz both select and photograph minimal structures and surfaces [**1207**] in the urban environment.

Although very much concerned with the art object, the simplifying and reductive nature of the paintings and sculptures of the Minimal artists look ahead to the disappearance of the object altogether, which occurs in the phenomena which can be collectively called Post Object Art.

POST OBJECT ART

In order to analyse the nature of Post Object Art, in all its manifestations, one needs to determine the characteristics of the conventional art object. Firstly, traditional forms of art are visible and tangible, and are consequently relatively permanent and immutable. In contrast, Post Object Art can be insubstantial or imperceptible, such as the concepts of the Art and Language group or the electro-magnetic waves of Robert Barry. Ephemerality may be an intrinsic part of such a piece of art, for instance the 'anti-form' steam sculptures of Robert Morris (b. 1931). Object Art tends to be discrete and unified, whereas artists creating Post Object Art can ignore the limitations of space and time, by distributing their works over a wide area or period of time, such as the ecological systems of Alan Sonfist. Object Art can exist independently of its context, but works such as Robert Smithson's sites or the entwined saplings of Giuseppe Penone depend on a particular situation for their existence.

Because of the immaterial and transitory nature of Post Object Art, photography and other traditional forms of communication become an essential tool in recording the work for the art historian, and turning it into a consumer product for the collector, investor or museum.

The spectator takes on a more important role in some forms of Post Object Art. His reaction or relationship to the work of art can be the basis for close-circuit video or 'Happenings'. The work is not just perceived visually; all the senses are involved.

William Vazan's *World Line* (1971), which consists of a banal strip of white tape applied to the floors of twenty-five galleries and museums all over the world, is a typical example of Post Object Art. The tape, which is insubstantial and secondary in meaning, acts as a reference giving the direction of the next location. The line is conceptual, and depends on the spectator for its completion. The *World Line* depends on its context for its existence and is spread over a wide area. No part of it can be removed without destroying its meaning.

Happenings, Performance Art and Body Art The thin lines between the theatre, art and life had been broken by the Futurists, Dadaists and Surrealists in the early years of the 20th century. Spontaneous cabaret events and performances were staged in order to shock and involve the audience. The Bauhaus held theatre workshops to which all the arts made contributions. In the 1940s and 1950s, artists and musicians such as John Cage, Robert Rauschenberg, Jim Dine, Claes Oldenberg and Merce Cunningham collaborated on multi-media theatre pieces. The Gutai group in Japan staged Happenings and performances as did the artists in the European-based group Fluxus. Aimed at shocking a complacent audience, the latter group staged outdoor events involving violent action, destruction and change. They wanted to arouse all the senses of the spectator so that he would become more receptive to the world around him.

Alan Kaprow, who coined the word 'happening' in 1959, described them as: 'an assemblage of events . . . unlike a stage-play (which) may occur at a supermarket, driving along a highway, under a pile of rags or in a friend's kitchen, either at once or sequentially, time may extend to more than a year. The Happening is performed according to plan, but without

1205. WILLIAM TUCKER (b. 1935). Beulah i. 1971. Metal. *The Tate Gallery, London.*

1206. RONALD BLADEN (b. 1918). 3 Elements. *Photograph Fischbach Gallery, New York.*

1207. LEWIS BALTZ. Southwest Wall, Vollrath Company, 2424 McGaw Road, Irvine. *Photograph: Castelli Graphics, New York.*

rehearsal, audience or repetition. It is art, but seems closer to life.' The audience participates fully and helps to create the work of art, experiencing it directly, alongside the artist, without the hindrance of an object. *Household* was a happening commissioned by Cornell University in May, 1964. It included activities such as the men building a wooden tower on a mound of trash and women licking off jam which had been smeared on a car.

The Austrian Otto Muehl holds calculated events with edible

1208. HERMANN NITSCH AND THE ORGY MYSTERY THEATRE. *Photograph: Z.E.F.A., Munich.*

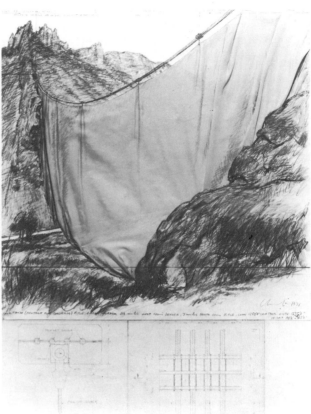

1209. CHRISTO (b. 1935). Valley Curtain (Project for Colorado) Rifle, Grand Hogback. 1971. *The Tate Gallery, London.*

substances in which he literally buries his participants in consumer products. The Filipino David Medalla in his concern for social systems and the relationships between Man and Nature, arranges events in which masses of people are required to participate. Franz Walther, a German, places his participants in an empty room with a large sheet of material, with which they must react and shape. The 'receptor' becomes the 'producer' and the object is no longer of any importance — it is the way in which the material is dealt with that counts. Claes Oldenburg creates spoof situations 'halfway between art and life'. In 1962, he staged a happening in a large department store entitled *Store Days*, in which events such as 'Something is bought' or 'A Bargain' occurred.

A group of Viennese artists 'exiled' in Germany, including Günter Brus, Otto Muehl, Hermann Nitsch and Rudolf Schwarzkogler present violent and obscene ceremonies in which entrails, blood and bodies become the materials of art [**1208**].

Body Art goes one step further than Performance Art. The artist no longer simply performs the work of art, he *is* the work of art. Self-mutilation and ritual are the elements of Body Art. Mike Parr in Australia has sewn live fish to himself and literally branded himself 'Artist'. In Britain, Stuart Brisley creates disturbing and repulsive 'life-situations' whereby the artist subjects himself to experiences such as submerging himself in a bath of rotting meat for several hours a day. Despite the grotesque and brutal nature of his works, Brisley's actions are structured and meaningful, in his wish to shock a complacent and conservative capitalist society.

The controversial German artist Josef Beuys (b. 1921), who had been a member of Fluxus along with Wolf Vostell, has become a shaman-like cult figure in his utopian anti-establishment actions. He produces a variety of assemblages, tableaux and performances in which his own body and his favourite objects, such as dead hares, are the materials for his art.

Other Body artists include Christ Burden who put himself under a heavy sheet of glass where he could watch the amused or concerned spectators; Bruce Nauman who takes plaster casts of himself; Barry Le Va who has hurled his body at a stone wall and

Dennis Oppenheim whose sunburnt flesh becomes a work of art. Vito Acconci uses film to document the duration of his performances which include banal actions such as the artist stepping on and off a chair or putting his hand in and out of his mouth.

In a lighter vein, Gilbert and George describe themselves as 'The most beautiful moving, fascinating and serious art-piece you have ever seen. It consists of two sculptors, one stick, one glove and one song'. With their skin painted bronze, they mechanically rotate singing 'Underneath the Arches'. They accompany their performance with video tapes, books and other forms of documentation. It is a performance in which the artist becomes de-humanised, rather than the art work becoming human.

Video systems have been used to record the artist's performance, as in the case of Bruce Nauman or Bas Jan Ader, who produced a series of *Fall* films in which the artist falls from a roof or into a canal whilst riding a bicycle (1970). Peter Campus concerns himself with 'projection and confrontation of self, light, space and accumulation in time' in his recording of his performances and filming of the observer. The Frenchman, Roland Baladi, also uses a close-circuit video to examine the movements and reactions of the spectator.

Video Art is potentially an art for the masses, being in a familiar medium, but because of the subjects treated by artists and their examination of the nature of the medium, it has become an elitist and self-indulgent form of art.

The photographer Bernard Faucon documents modern rituals and sacrifices which are performed by the life-size models he arranges. Although real people are not involved, his photographs are macabre and disturbing.

Environments and Land Art Kulterman describes Environments as a 'synthesis of space, equipment, significant form, content, the imagination of the individual, collective urges and consumer reality'. They have their origins in the *Merzbau* (1925) of Kurt Schwitters, the monumental structures of the

minimal sculptors, the assemblages of Kienholz or kinetic light environments. The environment can be created in the gallery space as are the magical architectural structures of Gianni Colombo who recreates the perspectival nightmares of De Chirico or the organic tent-like environments made out of material and rope by the Polish artist Magdalena Abakanowicz.

Environmental Art can also ignore the confines of the gallery walls and be constructed outdoors. Mary Miss builds wooden towers and shallow pits in 'extendable landscapes', which are to be explored by the spectator and combined into a total comprehension of space, scale and structure. Christo, who had been a member of *Le Nouveau Réalisme*, extended his wrapping of familiar objects to entire buildings and landscapes, such as Little Bay in Australia (1970–1971) or the curtain spanning Rifle Valley in Colorado (1971–1972). As with most post object art, the blueprints and photographs become the objects to be exhibited, purchased and possessed [**1209**].

Environmental Art can take on a pictorial property as seen in the works of Dennis Oppenheim with his *field pieces* on which he imposes linear patterns and contour marks on the earth or vegetation with fencing or planks.

The artists exploring Land Art create their works out of the existing materials, rather than imposing man-made elements. The artist Richard Long, working in the British landscape tradition, leaves geometric imprints and re-arrangements of stones, sticks and seaweed on natural sites such as sand, grass or mountain tops. He creates primitive and elemental circles, crosses, spirals and straight lines. His work *A Line Made by Walking* (1967) is documented in the museum space in the form of photographs, route maps and sometimes a simple arrangement of material collected from the site. Hamish Fulton is also concerned with documenting his experiences of landscape by taking photographs on his walking expeditions.

Robert Morris (b. 1931), Walter de Maria, Michael Heizer and Richard Smithson are all involved in creating large scale excavations and earth works. Smithson, who died in an aeroplane crash whilst surveying a prospective site, documents his work in the gallery with snap-shots, topographical maps, captions and samples of stone taken from the site which are held in minimal containers. These records of an absent site are 'non-sites' [**1210**].

In relation to Land Art, the influence of archeology on sculptors can be discussed. Anne and Patrick Poirier constructed a *Great Necropolis* on the side of a mountain out of coal, water and other natural materials in 1977, in their desire to re-create an undateable, anonymous structure of the past. Roy Adzak is interested in 'negative objects', based on the imprints found on archeological sites made by de-composed forms of the past. He has examined the 'dehydration of organic objects showing the effects of time on changes of form', which places him as a Process artist. Charles Simonds creates exquisite dwellings on a miniature scale out of unfired clay. He sees these as 'remnants of another people's existance frozen out of some memory or internal image and then laid out in real time'.

Art Povera and Process Art Both Art Povera and Process Art involve the use of poor materials (from which the former derives its name). The products of both are different, however, from the assemblages of the Dadaists or the junk sculpture and conglomerate amalgams of the 1950s. Against the background of environmental and ecological issues in the late 1960s and early 1970s, the movements grew out of a concern for the physical processes and life systems of nature. Art Povera and Process Art do not describe or represent nature, they *are* nature. The artist concerns himself with the mutability and physical quality of poor materials which he discovers, selects and combines.

Materials used by Art Povera artists include cowhide, grease, charred wood, ice, coal, putty, acid and earth, as shown in the works of Ger van Elk, Reiner Ruthenbeck, Giovanni Anselmo and Alighiero Boetti. The pristine gallery space is filled with live horses by Jannis Kounellis or by 1,600 cubic feet of level dirt by Walter de Maria (1968).

The Italians Gilberto Zorio and Michelangelo Pistoletto (b.

1210. ROBERT SMITHSON. Site: Non-site. 1969. *F. A. Becht, Naarden.*

1933) use fire and evaporation in their ephemeral creations, in which the artist becomes the alchemist. The American Alan Sonfist deals with the state of flux in nature and presents micro environments such as a colony of army ants (1972) or the growth of mildew on wet canvas. Ecology is also the subject matter of Newton Harrison with his miniature farming systems which include a *Portable Fish Farm*. Giuseppe Penone imposes restrictions on natural forms. In 1968 he entwined three saplings, and later marked the outline of his body which clung to a tree with nails and string. The Dutch artist Sjoerd Buisman is also interested in 'the influence of natural and artificial forces on vegetation' and turns his trees upside-down.

Charles Ross, with his exploration into optics and cycles, wishes his work to 'look beyond art as a self-referential, self-contained artifact to art as a point of contact with the universal energy system'. Energy and movement are the subject of the artist Liliane Lijn, who is concerned with 'energy transfer' in her unlimited kinetic *Liquid Reflection* (1966–1967). Klaus Rinke is interested in expansion and gravitational pull.

'Energy Images' are formulated by Gilberto Zorio who takes the five-pointed star and renders it in a variety of kinetic environments involving laser beams, javelins, mirrors and slide projections. Mario Merz employs the dynamic spiral form as his 'Energy Image'. He creates transient igloo installations out of glass, metal tubing, and neon strips which are formed into numbers and letters based on the mathematical series of the 13th century mathematician Leonardo Fibonacci.

Dan Flavin examines the nature of the artificial light of the neon strip. Because of the technological and recutive nature of his works, he can also be related to the Kinetic and Minimal Art movements. The harsh and insubstantial aura of his unbent neon strips alter the space and architectural elements of the room, and shadows become part of the over-all design.

In Process Art and Art Povera, the four elements of earth, air, fire and water are no longer personified or symbolised; they become the material and *raison d'être* of the work of art.

Conceptual Art In examining the concept of 'Art' and presenting ideas as art, Conceptual artists have eliminated the necessity for the traditional art object as a medium for communication. The role of the art critic as the interpreter of the work of art is negated, as the artist presents his intentions and ideas directly without the hindrance of the material and technical demands of the object, which becomes incidental to the piece. The documentation of the concept in the form of books, texts, photocopies, and photographs, becomes the permanent and marketable product of the movement.

Artists and writers came together to form the Anglo–American Art and Language group, who published a journal entitled *Art–Language* (first published in 1969), devoted to developing a theory of art. They also present their ideas in the form of posters, video, microfilm and elaborate mechanical teaching machines, such as John Stezaker's *Mundus*. Ian Burn, a member of the group hung a mirror on the gallery wall and examined the concept of it being a work of art in the accompanying texts and diagrams. However it is not the mirror that is the work of art, but the *concept* of it being a work of art that counts. N. E. Thing & Co. in America and Louis Cane and Marc Devade in France also publish books and catalogues devoted to the theory of art.

The nature of language and the perception of art is examined by the American Josef Kosuth. In presenting a photograph, dictionary description and actual example of a familiar object such as a chair or a hammer, Kosuth wants us to explore the relationship between our mental conception of such an object and our perception of it as presented. We can imagine the chair from the description, we accept the two-dimensional photograph as a substitute, and then we can experience the object directly.

John Blake installs 'photographic constructions' in each individual gallery space so as to form a complete environment. Photography is used to create a series of delays of perception, as words and images appear and disappear, depending on the viewpoint of the observer. Hans Haacke 'investigates the systematic relationships between actual events and conception' in the form of photographs and live evidence or both. His presentation is objective, but his initial choice of subjects such as the ownership of slum properties in New York (1971) is controversial or political in nature. The Dutch artist Marinus Boezem expresses 'a mentality and less a materiality' in his *The Absence of My Chair* (1969) in which the only evidence of his chair is its shadow. Ian Hamilton Finlay, a concrete poet, creates visual equivalents in the layout and colouring of three-dimensional lettering of images such as *Starlit Waters* (1967). Jan Dibbets is also interested in the perception of reality. In his *Perspective Corrections*, he takes a photograph of a trapezoid shape cut into the turf, so that it appears as a square on the finished print.

Photographic documentation of banal objects or events is the concern of Douglas Huebler with his *Location Pieces*. He takes a series of rapid snapshots of events such as a pedestrian walking down a London street (1973), and accompanies them with a text claiming that 'Eight photographs join with this statement to constitute the form of this piece'. He does not wish to add any more objects to the world, but wishes to document 'the existence of things in terms of time and/or place'. Edward Ruscha presents books containing objective photographic documentation of his visual experiences such as *Every Building on Sunset Strip* (1966). Since 1960, Bernd and Hilda Becher have been systematically documenting series of utilitarian industrial structures such as *Coal Bunkers* (1974) and *Pitheads* (1974). They present a tableau of photographs of these 'anonymous sculptures' to show their common features.

Other forms of Conceptual Art include the theoretical connections of unrelated events such as a theatrical performance and a swimming race (1970) of Dennis Oppenheim or the telegrams of On Kawara who sends messages to his friends to record the fact that 'I am still alive' (1978 and 1979). The postal system had been utilised by the Fluxus group in the 1960s, and it becomes the tool of artists such as George Brecht who posts descriptions of pre-set events such as *Three Aqueous Events. Ice. Water. Steam.* to his friends. The most banal concepts can be presented as works of art such as the 'events' of Lawrence Weiner which included 'one standard dye marker thrown into the sea. Art becomes an accomplished fact or action, which is in the 'collection' of the person on whose behalf the event occurred.' Weiner has also parodied non-figurative colour abstraction in his series of five sentences painted on the gallery wall describing relationships of colours, e.g. 'red over and above green over and above blue' (1972). The minimalist Sol LeWitt gives instructions for a pattern of coloured pastel lines to be applied directly to the wall — resulting in an art which lasts the duration of the exhibition (1980). The intellectual ability of the artist is presented rather than his craftsmanship.

Gerard Richter also mocks the concept of technical ability. He works in the traditional medium of paint on canvas, but since the early 1960s has oscillated between figuration and complete abstraction, breaking away from the stylistic expectations of the audience. Daniel Buren, however, never changes the style and format of his visual 'tool' which consists of alternating white and coloured vertical stripes of fixed width. It is the location of his stripes that changes, appearing on buses, billboards, in catalogues and on gallery walls throughout the world. By creating a neutral control, the effect of the environment and lighting in which an art work is placed can be examined.

Shusaku Arakawa is concerned with presenting language and symbols in the form of witty mathematical formulae. Hanne Darboven, Stanley Brouwn and Roman Opalka convey the intangible existence of time through systematic and abstract numerations which are written, typed or slavishly painted on canvas. Serialism is a common factor between Conceptual Art and works of minimal artists such as Sol LeWitt, Donald Judd, Carl Andre and Agnes Martin who have a modular and mathematical base in their works.

Concepts of space and distance are examined by Fred Sandback with his transient string installations which 'coexist' with the 'elusive' space of an interior. Ryszard Wasko uses video installations for his records of space. The concepts of weight balance and tension are the subject matter for the British sculptor Julian Hawkes, who combines materials to create tense, structural situations which reveal their physical properties [**1211**].

Because of the intangible and ephemeral nature of Post Object Art, the aspirations of the art market, collector and museum have been frustrated. Doubts are raised as to its validity as art at all, as it is difficult to discuss the various forms in terms of 'style' and 'quality'. But to the exponents of Post Object Art, it is the institutions and concepts of art that should change and adapt to the new phenomena, so that the artist is not restricted in his choice of modes or expression and communication to the rest of society.

1211. JULIAN HAWKES. Untitled. 1977. *Photograph: The Rowan Gallery.*

447

448

452

453

455

457

ACKNOWLEDGEMENTS

The Publishers wish to thank the following for supplying photographs: A.C.L., Brussels: 86, 358, 396, 397, 403, 481, 712, 957, 959, 962. Ansel Adams: 837. Albright-Knox Art Gallery, Buffalo: 463, 897, 910, 990, 1023. Alinari-Giraudon: 124, 181, 471. Alpha Atlas Lighting Ltd, London: 983. Anderson-Giraudon: 117, 118, 119, 401, 545. Wayne Andrews: 197, 198, 199, 200, 201, 202, 603, 604, 605, 607, 608, 609, 613, 797, 1089, 1091, 1093, 1095, 1099, 1100, 1105, 1154. Del Ankers: 1067. Annan-Glasgow: 560, 687. Archives Photographiques, Paris: 12, 13, 21, 22, 28, 30, 31, 32, 42, 43, 44, 45, 47, 52, 53, 61, 62, 67, 81, 141, 155, 162, 213, 223, 232, 251, 335, 350, 377, 389, 399, 414, 419, 424, 445, 472, 489, 490, 502, 514, 543, 546, 553. The Art Gallery of Ateneum, Helsinki: 597. Art Institute of Chicago: 816, 873, 1127, 1134, 1136. Arts Council of Great Britain: 23, 792, 940, 943, 948, 1083, 1149, 1163, 1167. Ashmolean Museum, Oxford: 82, 113, 115, 278, 280. Atami Art Museum, Japan: 310. Baker Library, Dartmouth College, New Hampshire: 1157. Colin Ballantyne and Partner, Melbourne: 1170. The Baltimore Museum of Art: 761, 765. Bayerische Staatsgemäldesammlungen, Munich: 382, 1031. Behnhaus, Lübeck, Germany: 80. Ben Uri Gallery, London: 1004. Bibliothèque Nationale, Paris: 361. Paul Bijtbier, Brussels: 554, 781, 965. Bildarchiv Foto Marburg, Germany: 524, 551, 561, 580, 581, 582, 664, 736, 798, 967. Bodleian Library, Oxford: 250. Boudoir-Lamotte: 216, 217, 218, 219, 859, 860, 1056. Bill Brandt: 838. Adolphe Braun: 395. Marcel Breuer and Associates, U.S.A.: 1103. British Council: 1018. British Museum: 4, 7, 112, 137, 159, 187, 188, 234, 237, 252, 324, 511. British Travel Association: 39, 573. Brooklyn Museum, New York: 207, 436, 495. Peter Cannon Brooks: 868, 878. Bulloz: 1, 5, 78, 88, 95, 149, 384, 421, 438, 442, 450, 451, 454, 461, 474, 483, 499, 711, 790. J. Allan Cash: 209, 215, 344, 1160, 1161, 1162. Max Cetto, Mexico: 1155. Chevojon: 413, 674, 683, 799. Chicago Architectural Photographing Company: 556, 606, 611, 614, 673, 678, 1088, 1090. City Art Museum of St Louis: 206. City of Birmingham Art Gallery: 989. Geoffrey Clements, New York: 782. Cleveland Museum of Art: 299, 624, 691, 752. Columbus Gallery of Fine Arts, Ohio: 1135. Connaissance des Arts, Paris: 170, 515, 516, 522, 529. Ernest A. Cook: 985. A. C. Cooper: 1151. Courtauld Institute of Art, London: 369, 432, 456, 469. Anthony Crickmay: 829. L. Czigany: 788. Department of External Affairs of Canada, Paris: 695. The Detroit Institute of Arts: 204, 1042. Deutsche Fotothek, Dresden: 193. John Donat: 208, 225, 230. Collection Philippe Dotrement: 1076. Drian Gallery: 1084. Durand-Ruel, Paris: 362,

428. Dyckerhoff and Widman KG: 1026. George Eastman House, Rochester, New York: 832. Gilles Ehrmann: 879. Ernst-Barlach-Haus, Hamburg: 718. Farbwerke Höchst AG: 1025. David Farrell: 652, 823, 999. Feher Photo, Paris: 411. Finnish Tourist Association: 1070. Karl Flinker Galerie Collection Comtesse de Beaumont: 1036. Adrian Flowers: 1002. Fogg Art Museum, Harvard University: 114, 139, 507. Foto Arnold, Germany: 66. Foto-Gnilka: 1035. Foundation Gottfried Keller, Berne: 319. Fox Photos Ltd, London: 577, 937, 978. John Freeman & Co., London: 40, 54. Freer Gallery of Art, Smithsonian Institution, Washington, D.C.: 269, 270, 271. French Government Tourist Office: 552, 684. Frick Collection, New York: 506. Fry, Drew & Partners: 980. Galerie Claude Bernard: 884. Galerie Louis Carré, Paris: 751, 791, 809, 810, 820, 866, 954. Galerie de France, Paris: 654, 885, 916, 919, 920, 922. Galerie Iolas, Paris: 921. Galerie La Hune, Paris: 880. Galerie Maeght, Paris: 918, 952. Galerie Denise René, Paris: 929. Gemäldegalerie, Berlin: 417. Gemäldegalerie, Dresden: 18. Gemeentelijke Woningstichting, Rotterdam: 968, 969. Alexandre Georges: 1106. Ghia S.P.A., Turin: 663. Ghizzoni di Scotti, Milan: 679. Giacomelli: 698. Gimpel Fils Gallery Ltd: 926. Giraudon, Paris: 3, 8, 10, 11, 19, 24, 35, 48, 50, 51, 57, 59, 63, 65, 69, 70, 71, 72, 73, 75, 87, 94, 103, 144, 145, 148, 160, 168, 173, 183, 345, 346, 347, 348, 349, 368, 373, 374, 375, 376, 386, 388, 390, 391, 405, 412, 425, 426, 427, 429, 433, 434, 435, 437, 439, 443, 444, 447, 448, 449, 455, 458, 462, 468, 486, 491, 501, 508, 517, 525, 589, 634, 647, 660, 666, 688, 689, 693, 701, 724, 727, 728, 729, 730, 738, 742, 760, 766, 771, 772, 787, 814, 855, 864. G.L.C. Photograph Library: 984. Goteborgs Konstmuseum, Sweden: 591, 592. Camilla Gray: 1080. René Groebil, Zürich: 672. Solomon R. Guggenheim Museum, New York: 669, 670, 744, 748, 819, 881, 888, 889, 912, 917, 974, 1055, 1057. Hamburger Kunsthalle: 656, 1041. Hans Hammerskiöld: 1077. Hanover Gallery: 886, 923, 928, 964, 995, 1112. Harris and Ewing, Washington: 612. Hans Hartung: 640. Hedrich-Blessing, Chicago: 668, 1098. Foto W. Heller, Hanover: 1028. Lucien Hervé: 671, 858. John Hillelson Agency: 297, 836. Hans Hinz, Basle: 815. Joseph H. Hirshhorn Collection: 869. Honolulu Academy of Arts, Hawaii: 300. Hutin, Compiègne: 407. Industrie Photo, Lyon: 487, 488. International Interiors Ltd: 704, 707. Irish Tourist Office, Dublin: 41. Leni Iselin: 883. Istituto Geografico de Agostini, Novara, Spain: 536. Sidney Janis Gallery, New York: 1152. Dott. Emilio Jesi Collection, Milan: 946. John G. Johnson Collection, Philadelphia: 431. S. C. Johnson and

Son Collection, Racine, Wisconsin: 1092, 1148, 1153. Luc Joubert, Paris: 925. Dott. Riccardo Jucker Collection: 812, 941. Kasmin Ltd: 824. A. F. Kersting: 544, 986. Kim Lim: 1001. M. Knoedler and Co., New York: 1115. Kröller-Müller Rijksmuseum, Otterlo: 505, 731, 976, 1058. Bruno Krupp: 1032. Kunsthalle, Bremen: 903, 1051. Kunsthaus, Zürich: 793. Kunstmuseum, Basle: 477, 768, 942, 961. Kunstmuseum, Berne: 713, 767, 1047, 1049. La Jolla Museum, California: 1118. R. Lakshmi, New Delhi: 240, 244, 248. Baron Léon Lambert Collection, Brussels: 1068. Landesgalerie, Hanover: 1052, 1060. Lanyon Gallery, Palo Alto, California: 1117. Ella Maillart: 226. Jeet Malhotra, India: 1166. Mansell-Alinari: 55, 68. Manso: 151. Christian Manz, Basle: 877. Marlborough Fine Art Ltd: 890, 992, 996, 1009, 1066, 1172. Marylebone Public Library: 184. Mas, Barcelona: 158, 563, 564, 681, 682, 949, 950, 951. Roger Mayne: 839. Dominique and John de Menil Collection: 804. Metropolitan Museum of Art, New York: 205, 460, 465, 615, 618, 667, 756, 1086, 1128, 1138. Joseph W. Molitor: 1101. The Montreal Museum of Fine Arts: 601. James Mortimer: 1012. Munson-Williams-Proctor Institute, U.S.A.: 1142. Musée d'Art et d'Histoire, Geneva: 585, 586. Musée des Arts Décoratifs, Paris: 169, 173, 176, 222, 224, 233, 327, 328, 330, 333, 520, 533, 534. Musée de Bagnols-sur-Cèze, France: 723. Musée des Beaux-Arts, Besançon: 320. Musée des Beaux-Arts, La Rochelle: 503, 504. Musée des Beaux-Arts, Liège: 960. Musée des Beaux-Arts, Reims: 486. Musée de Chartres: 74. Musée Fabre, Montpellier: 485. Musée Historiques des Tissus, Lyon: 334. Musée de Lyon: 152. Musée National du Château de Compiègne: 172. Musée Rodin, Paris: 453. Musée Royal de l'Afrique Centrale, Brussels: 632. Museen der Stadt. Aachen, Germany: 123. Museo de Arte Moderno, Barcelona: 404. Museo Nacional de Arte Moderno, Madrid: 473. Museo de Arte Moderno, Mexico City: 1156. Museu de Arte Moderna, São Paulo: 1000. Museu Nacional de Arte Antiga, Lisbon: 325, 336. Museum of Art, Carnegie Institute, Pittsburg, Pennsylvania: 441, 622, 722. Museum of Art, Rhode Island School of Design, Providence, Rhode Island: 513. Museum Boymans-van Beuningen, Rotterdam: 973. Museum of Fine Arts, Boston: 203, 235, 277, 284, 616. Museum of Fine Arts, Houston, Texas: 930. Museum of Finnish Architecture: 1071, 1072. Museum of Modern Art, New York: 470, 633, 643, 653, 700, 703, 706, 733, 734, 735, 750, 754, 759, 762, 789, 828, 865, 872, 1027, 1141, 1146. Collection Victor Musgrove: 1021. National Buildings Record, London: 37, 190, 191, 192, 549, 558, 559. National Film Archive, London:

840, 841, 842, 844, 845, 846, 847, 848, 849, 850, 851, 852, 853, 854. National Gallery, Berlin: 77, 122. National Gallery, London: 6, 58, 92, 98, 99, 101, 109, 430, 459, 466. National Gallery, Oslo: 595, 596, 646, 717. National Gallery of Art, Washington, D.C.: 498, 623, 753, 1024, 1038, 1120. The National Gallery of Canada, Ottawa: 165, 352, 356, 365, 600. National Museum, Stockholm: 156, 383, 593, 594, 1079. National Museum of Wales: 686. ND-Giraudon: 121, 153, 167, 182, 493, 547, 548. The New York Historical Society: 617. Newark Museum, New Jersey: 1129. Hugh Newbury: 988. Norton Gallery and School of Art, West Palm Beach: 944. Ny Carlsberg Glyptotek, Copenhagen: 416. Österreichische Galerie, Vienna: 126, 720, 1061. Clay Perry: 1089. Philadelphia Museum of Art: 143, 360, 620, 661, 696, 732, 740, 803, 806, 871, 899, 908, 913, 1045, 1046, 1048, 1165. The Phillips Collection, Washington, D.C.: 423, 476, 1119. Photo Library Inc., New York: 755. Gerd Pinsker, Basle: 1063, 1065. Paul Popper Ltd, London: 685. Puytorac, Paris: 726. Radio Times Hulton Picture Library: 38, 555, 981, 987. Rapho, Paris: 676. Réalités (J. Ph. Charbonnier): 266, 268, 288, 292. Refot: 1075. Rheinisches Bildarchiv, Cologne: 410. R.I.B.A., London: 572, 979. Rijksmuseum, Amsterdam: 398. Roger-Viollet, Paris: 171, 174, 180, 227, 229. Royal Academy of Arts, London: 111. Royal Ontario Museum, University of Toronto: 166. Sakamoto Photo Research Laboratory: 282, 283, 286, 289, 291, 311. San Francisco Museum of Art: 380 1164. Scala, Milan: 406. Jack Scheerboom: 64. Schneider-Lengyel: 359. Shell Photographic Unit, London: 1096. John D. Schiff, New York: 892. Schloss Schleissheim, Munich: 578. The Secretary of State for Commonwealth Relations: 241. Service de Documentation Photographique, Versailles: 29, 242, 243, 253, 254, 255, 256, 257, 259, 260, 261, 262, 264, 274, 276, 279, 281, 294, 295, 298, 304, 305, 307, 308, 709, 763, 769, 770, 896, 904, 906, 924, 1054, 1158. S. B. Smith Collection, Chicago: 991. R. Spreng: 1064. Staatliche Museen, Berlin: 60, 323. Städelsches Kunstinstitut, Frankfurt: 127. Städtische Kunsthalle, Mannheim: 1059. Städtische Museum, Wuppertal: 1039. Stadtmuseum im Zeughaus, Cologne: 331. State Hermitage Museum, Leningrad: 408. State Russian Museum, Leningrad: 161. Statens Museum for Kunst, Copenhagen: 116, 129, 478, 587. Stedelijk Museum, Amsterdam: 367, 479, 530, 666, 972, 975, 977, 1082. Alfred Stieglitz: 830. Walter Steinkopf, Berlin: 394. Stockholms Stads Kyrkogårdsnämnd: 1074. Ezra Stoller Associates: 1096, 1102. Struwing, Denmark: 1073. Studio Iskender, Robert de Calatchi Collection: 238. Studio Yves Hervochon: 891. Toshio

Taira, Japan: 1168. Tate Gallery, London: 76, 96, 97, 110, 409, 482, 574, 576, 619, 625, 757, 783, 802, 870, 875, 876, 882, 893, 895, 902, 914, 927, 932, 938, 945, 955, 956, 963, 993, 994, 997, 1003, 1005, 1006, 1007, 1008, 1010, 1011, 1013, 1015, 1016, 1017, 1019, 1033, 1053, 1081, 1110, 1147, 1171. Photo Thill, Brussels: 163. Thorvaldsens Museum, Copenhagen: 56. Tothill Press Ltd: 982. Town Hall, Kobe: 1169. Ullstein Bilderdienst, Berlin: 157. U.N.E.S.C.O., Paris: 857. U.S.I.S.: 1094, 1097. O. Vaering Photo, Oslo: 130, 717. Vaghi, Italy: 947. Vasari, Rome: 338, 935. Marc Vaux, Paris: 648, 677, 714, 749, 780, 807, 915. Victoria and Albert Museum, London: 108, 135, 189, 236, 341, 528. Waddington Galleries: 998. Waddington Galleries Collection, Peter Stuyvesant Foundation: 1014. Wadsworth Atheneum, Hartford, Connecticut: 784. Walker Art Center, Minneapolis: 939, 1044, 1124. Walker Art Gallery, Liverpool: 475, 1022. Wallace Collection: 79, 164. Wallraf-Richartz Museum, Cologne: 719, 1043. Edward Weston: 835. Whitney Museum of American Art: 697, 786, 813, 822, 1050, 1107, 1108, 1109, 1111, 1114, 1116, 1121, 1123, 1125, 1126, 1130, 1131, 1132, 1133, 1137, 1139, 1140, 1144. Wide World Photos, U.S.A.: 680. Wilhelm-Lehmbruck-Museum: 1030. Willard Gallery, New York: 1145. Wolfgang Museum, Essen: 1037. Yale University Art Gallery: 887, 1150. Yan, Toulouse: 214. 214, 636, 640, 645, 648, 654, 655, 661, 662, 677, 690, 694, 695, 696, 714, 715, 724, 726, 727, 728, 730, 732, 737, 745, 747, 749, 751, 767, 768, 769, 770, 771, 772, 774, 775, 777, 778, 779, 780, 787, 791, 802, 805, 807, 808, 809, 810, 811, 812, 814, 821, 831, 864, 870, 871, 872, 874, 875, 877, 878, 883, 885, 897, 898, 900, 901, 903, 905, 910, 911, 912, 915, 916, 917, 919, 920, 922, 924, 925, 926, 927, 928, 933, 954, 964, p. 228a, p. 278a, p. 314b, p. 332b, p. 349a, p. 349c © A.D.A.G.P. 1965. 93, 94, 95, 104, 141, 345, 352, 359, 360, 413, 414, 415, 416, 424, 425, 426, 428, 429, 432, 433, 434, 435, 436, 437, 438, 439, 440, 441, 444, 451, 452, 453, 455, 456, 457, 460, 461, 463, 464, 465, 469, 470, 498, 505, 507, 510, 539, 584, 585, 627, 628, 629, 630, 633, 634, 642, 651, 659, 674, 683, 686, 688, 692, 693, 708, 709, 710, 711, 712, 713, 714, 722, 723, 725, 729, 731, 735, 741, 742, 743, 746, 752, 753, 754, 755, 756, 757, 758, 759, 760, 761, 762, 763, 764, 765, 766, 773, 799, 800, 804, 806, 817, 840, 843, 865, 906, 913, 914, 921, 962, 1046, 1047, 1048, 1049, half title, p. 124a, p. 157, p. 158a, p. 210a, p. 210b, p. 227, p. 228b, p. 313, p. 314a, p. 331, p. 349b © S.P.A.D.E.M. 1965. 364, 719, 744, 1059, 1060, 1135, p. 296a, p. 296b © Roman Norbert Ketterer 1965.